√7 W9-AWU-783

dian.

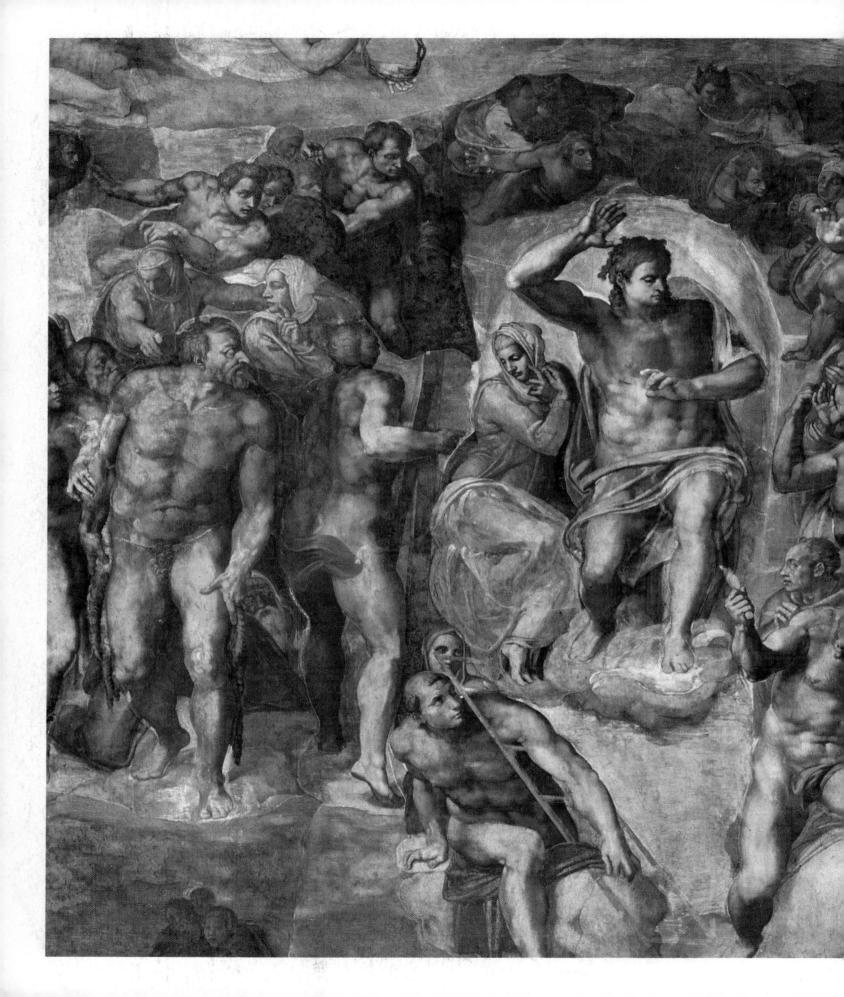

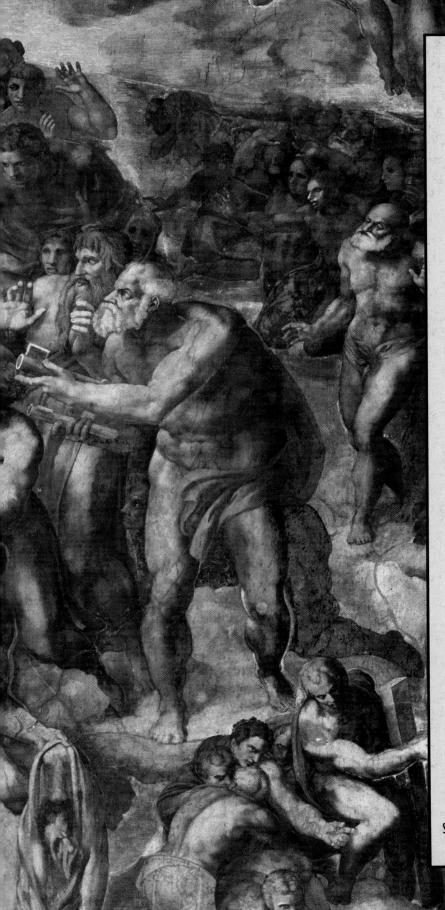

ART THROUGH THE AGES

GARDNER'S

NINTH EDITION

Renaissance and Modern Art

HORST DE LA CROIX RICHARD G. TANSEY DIANE KIRKPATRICK University of Michigan, Ann Arbor

HBJ

HARCOURT BRACE JOVANOVICH, PUBLISHERS San Diego New York Chicago Austin Washington, D.C. London Sydney Tokyo Toronto

COVER ART: David Hockney, A Walk around the Hotel Courtyard, Acatlán (detail), 1985. Oil on two canvases, 6' × 20'. © David Hockney, 1985.

Copyright © 1991, 1986, 1980, 1975, 1970, 1959, copyright 1948, 1936, 1926 by Harcourt Brace Jovanovich, Inc. Copyright renewed 1954 by Louise Gardner Copyright renewed 1964, 1976, 1987 by Harcourt Brace Jovanovich, Inc.

All rights reserved. No part of this publication may be reproduced or transmitted in any form or by any means, electronic or mechanical, including photocopy, recording or any information storage and retrieval system, without permission in writing from the publisher.

Requests for permission to make copies of any part of the work should be mailed to: Permissions Department, Harcourt Brace Jovanovich, Inc., 8th Floor, Orlando, Florida 32887.

ISBN: 0-15-503769-2 (hardbound)

0-15-503770-6 (paperbound, Vol. I) 0-15-503771-4 (paperbound, Vol. II)

Library of Congress Catalog Card Number: 90-83735 (hardbound)

90-83737 (paperbound)

Printed in the United States of America

Picture credits appear on page 1118, which constitutes a continuation of the copyright page.

PREFACE

Since publication of the first edition in 1926, Helen Gardner's *Art through the Ages* has been a favorite with generations of students and general readers who have found it an exciting and informative survey of world art. Helen Gardner's enthusiasm, knowledge, and humanity have made it possible for the beginner to learn how to see and thereby to penetrate the seeming mysteries of even the most complex artistic achievements. In this volume, we have made every effort to preserve her freshness of style and, above all, her sympathetic approach to individual works of art and the styles of which they are a part.

Helen Gardner completed the third edition shortly before her death in 1946. The fourth edition was prepared in 1959 by Professor Sumner Crosby and his colleagues at Yale University. Professors Horst de la Croix and Richard Tansey assumed editorial responsibility for the project with the fifth edition in 1970, and prepared the sixth edition in 1975, the seventh in 1980, and the eighth in 1986. For this, the ninth edition, Professor Diane Kirkpatrick joins as a third coauthor. She is responsible for the revision of the final four chapters, which deal with the art of the modern world. The authors were led to prepare this edition not only by the steady appearance of new works of art and new interpretations and re-interpretations but also by suggestions received from readers. We hope that the ninth edition of *Art through the Ages* will continue its long tradition as a standard and popular survey of the history of world art.

In this edition, in addition to emendations made throughout the book, the text and the number of pictures have been expanded to include works of art recently discovered, restudied, or considered by the authors to be particularly characteristic of their periods and illustrative of developmental trends. Fuller treatment has been given to periods and monuments when warranted. Many new pictures are in color, and a large number of pictures that were black and white in previous editions have been converted to color in this one. Every effort has been made to accommodate the results of recent research in as comprehensive and detailed a survey of the material as the physical limits of a textbook of this scope permit.

In presenting a balanced historical introduction to the art of the whole world, the hardest task is selection-in effect, limitation-of the monuments to be discussed and illustrated. Though a corpus of monuments essential to the art history survey course has long been forming, and though considerable agreement exists as to its makeup, differences of choice, deriving from differences of emphasis, will naturally occur. A radical departure from the corpus might well obliterate the outlines of the study. To avoid the random, systemless distribution of material that might result, we have generally adhered to the corpus and have only occasionally introduced movements less well known, newly discovered, or not customarily treated in a survey. The latter classifications are especially applicable to the works selected for the modern period, which have yet to be subjected to the judgment of history. In the modern section of the book, more than in any other, the selection of monuments is designed to attempt to present significant representatives of the major approaches. Our aim throughout has been to present and interpret works as reflections of an intelligible development rather than merely as items of a catalogue. We have tried to give coherence to the assortment of materials by stressing the ways in which art, in many historical variations, has expressed and participated in the crucial transformations of human beings' views of themselves and of their world.

In recent years, in what has been called a "crisis of art history," new art-historical methods have been changing the perspectives and concerns of many scholars. Theories of interpretation, built upon anthropological, sociological, psychological, semiotic, and feminist conceptual foundations, have been transforming—sometimes

v

in competition, sometimes in concert—the writing of art history as well as the way it looks at its objects. In the process, the role of the traditional method of stylistic analysis and periodicity is being minimized; there is the wish in some quarters to modify the customary apparatus of categories—style-period, master, school, influence, development, and the like. We feel that our method of presentation, rooted as it is in the recognition, differentiation, and classification of styles in art and architecture, and the firm binding of them to the times and places of their origin, is best for introducing art history. Confronted with any new domain of knowledge, beginners want to know first how to discriminate among its multitude of data. For the history of art, this means learning how to distinguish one work of art from another by style, culture, and time. The classification and chronological mapping of the world of art as an intelligible continuum is the business of the survey, and the survey has long proved its pedagogical value.

Various teaching aids accompany the ninth edition of Gardner's *Art through the Ages.* For the first time, a pronunciation guide to artists' names, compiled by Cara-lin Getty of the University of South Carolina at Sumter and Mikle Ledgerwood of Rhodes College is included at the end of the book. The *Study Guide* by Kathleen Cohen contains chapter-by-chapter drills on the identification of geographical locations, time periods, styles, terms, iconography, major art movements, and specific philosophical, religious, and historical movements as they relate to particular works of art examined in the textbook. Self-quizzes and discussion questions enable students to evaluate their grasp of the material. Kathleen Cohen is also the author of the *Instructor's Manual*, which includes sample lecture topics for each chapter, a testbank of questions in formats ranging from matching to essay, studio projects, and lists of resources. A computerized testbank consisting of questions from the *Instructor's Manual* has been put on disk for textbook users. A manual for new teachers and teaching assistants, *Opening the Doors: A Practical Guide for Teachers of Art History Survey* by Mary Sweeney Ellett of Randolph-Macon Woman's College, is also available.

A work as extensive as a history of world art could not be undertaken or completed without the counsel and active participation of experts in fields other than our own. In some cases, this took the form of preparation of portions of chapters; in others, of reviews of work in progress or already prepared. For such contributions to this edition and to previous ones, we offer our sincere thanks to James Ackerman, Harvard University; Majorie P. Balge, Mount Holyoke College; Colleen Bercsi, California State University, Northridge; Barbara W. Blackmun, San Diego Mesa College; Jacques Bordaz, University of Pennsylvania; Louise Alpers Bordaz, Columbia University; James Cahill, University of California, Berkeley; Miles L. Chappell, College of William and Mary; Herbert M. Cole, University of California, Santa Barbara; George Corbin, Lehman College, City University of New York; Gerald Eknoian, DeAnza College; Mary S. Ellett, Randolph-Macon Woman's College; Roger K. Elliott, Central Virginia Community College; Mary F. Francey, University of Utah; Ian Fraser, Herron School of Art, Indiana University; Stockton Garver, Wichita State University; Judith Paetow George, Miami University; Oleg Grabar, Harvard University; Sandra C. Haynes, Pasadena City College; Hamilton Hazelhurst, Vanderbilt University; M. F. Hearn, University of Pittsburgh; Howard Hibbard, late of Columbia University; Philancy N. Holder, Austin Peay State University; John Howett, Emory University; Joseph M. Hutchinson, Texas A & M University; Joel Isaacson, University of Michigan; R. Steven Janke, State University of New York at Buffalo; M. Barry Katz, Virginia Commonwealth University; Herbert L. Kessler, Johns Hopkins University; Fred S. Kleiner, Boston University; Robert A. Koch, Princeton University; Avra Liakos, Northern Illinois University; Elizabeth Lipsmeyer, Old Dominion University; William L. MacDonald, formerly of Smith College; A. Dean McKenzie, University of Oregon; Mary Jo McNamara, Wayne State University; Kathleen Maxwell, Santa Clara University; Milan Mihal, Vanderbilt University; Diane Degasis Moran, Sweet Briar College; Harry Murutes, University of Akron; Kristi Nelson, University of Cincinnati; Jane S. Peters, University of Kentucky;

Edith Porada, Columbia University; Bruce Radde, San Jose State University; Gervais Reed, University of Washington; Raphael X. Reichert, California State University at Fresno; Richard Rubenfeld, Eastern Michigan University; Grace Seiberling, University of Rochester; Peter Selz, University of California, Berkeley; David Simon, Colby College; Pamela H. Simpson, Washington and Lee University; David M. Sokol, University of Illinois at Chicago; Lilla Sweatt, San Diego State University; Marcia E. Vetrocq, University of New Orleans; Richard Vinograd, University of Southern California; Joanna Williams, University of California, Berkeley; and the Art History Department, Herron School of Art, Indiana University–Purdue University at Indianapolis.

We would also like to thank the following instructors, who sent helpful reactions and suggestions for the ninth edition of Art through the Ages: James Allen-Toth, Skyline College; Eric C. Apfelstadt, Santa Clara University; Peter G. Arnovick, Menlo College; Vicki Artimovich, Bellevue Community College; Helen C. Austin, John C. Calhoun State Community College; Larry Bakke, Syracuse University; C. Roy Blackwood, Southeastern Louisiana University; Art Bond, John C. Calhoun State Community College; George A. Civey III, Eastern Kentucky University; Patricia Coronel, Colorado State University; Kenneth M. Davis, Ball State University; George F. Deremo, Cerritos College; William R. Derrevere, Tulsa Junior College; Ruth Deshaies, Tallahassee Community College; Richard P. Dewitt, Merced College; Suzette J. Doyon-Bernard, University of West Florida; Peter W. Guenther, University of Houston; Janet Higgins, Middle Tennessee State University; Donald R. Johnson, Emporia State University; Klaus Kallenberger, Middle Tennessee State University; W. Eugene Kleinbauer, Middle Tennessee State University; Carolyn Kolb, University of New Orleans; Kristine Koozin, University of North Dakota; Harry D. Korn, Ventura College; Lynne Lokensgard, Lamar University; Richard A. Luehrman, Central Missouri State University; Jane C. Maller, San Francisco State University; Nina A. Mallory, State University of New York at Stony Brook; Peggy Pulliam McDowell, University of New Orleans; Robert O. Mellown, University of Alabama; Bob Owens, North Georgia College; Angelika Pagel, Weber State College; Stephen Polcari; Kenneth J. Proctor, University of Montevallo; Marceil V. Pultorak, Carroll College; Wayne L. Roosa, Bethel College; Margaret Rothman, William Patterson College; Patricia Sanders, San Jose State University; Gregory P. Senn, Eastern New Mexico University; Anthony Stansfeld, Mercer University; Thomas Sternal, Morehead State University; Duncan Stewart, University of West Florida; Grant Throp, East Central University; Mary Jane Timmerman, Murray State University; Jeanne L. Trabold, California State University at Northridge; Patricia Trutty-Coohill, Western Kentucky University; Richard J. Tuttle, Tulane University; Elizabeth M. Walter, University of North Alabama; Marilyn Wyman, San Jose State University; Jay J. Zumeta, Art Academy of Cincinnati. We owe a special debt of gratitude to Joel G. Tansey, who compiled the bibliography for the first nineteen chapters of the text and made valuable suggestions on its content, and to Cara-lin Getty and Mikle Ledgerwood, who compiled the pronunciation guide.

Among those at Harcourt Brace Jovanovich who have contributed their efforts to the management of an enormously detailed manuscript are our acquisitions editor, Julia Berrisford; our manuscript editor, Helen Triller; our production editors, Joan Harlan and Mary Allen, and their assistant Michael Ferreira; our art editor, Susan Holtz, and her assistants on this project, Cindy Robinson and Louise Sandy-Karkoutli; our designer, Cathy Reynolds; and our production manager, Lynne Bush. We would like to thank all those, named and unnamed, who have helped immeasurably in the production of this book, and hope that, as with the previous editions, it will prove a pleasurable first guide through the immense landscape of its subject, art through the ages.

Horst de la Croix Richard G. Tansey Diane Kirkpatrick

A NOTE ON THE PAPERBOUND VERSION

This volume is one of two that constitute the paperbound version of Gardner's *Art through the Ages*, ninth edition. The two volumes exactly reproduce the text of the one-volume version, including its pagination. The first of these volumes contains Part I, The Ancient World; Part II, The Middle Ages; and Part III, The Non-European World. The second volume contains Part IV, The Renaissance and the Baroque and Rococo; and Part V, The Modern World. The Introduction, pronunciation guide, glossary, bibliography, and index appear in both volumes. The two-volume printing is intended for those who have occasion to use only half of *Art through the Ages*. The differences between the one-volume and the two-volume versions of the book are differences in form only.

CONTENTS

PREFACE

INTRODUCTION 2

v

3 7

The Bases of Art History	3
The Work of Art	7
The Problem of Representation	18

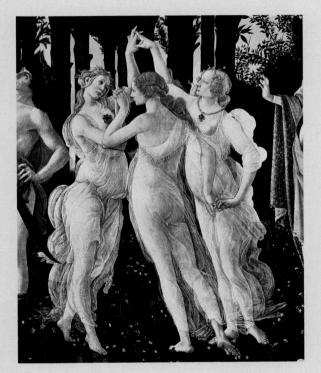

IV THE RENAISSANCE AND THE BAROQUE AND ROCOCO 550

15 THE "P	PROTO-RENAISSANCE" IN ITA	ALY 558
Sculpture		562
Painting		564

ix

x CONTENTS

16 FIFTEENTH-CENTURY ITALIAN ART	580
The First Half of the Fifteenth Century	582
The Second Half of the Fifteenth Century	608

17 SIXTEENTH-CENTURY ITALIAN ART	632
The High Renaissance	634
Mannerism	667
Venice	675

18 THE RENAISSANCE OUTSIDE OF ITALY	692
The Fifteenth Century	695
The Sixteenth Century	721

19 BAROQUE ART 748

Italy	752
Spain	775
Flanders	780
Holland	786
France	799
England	812

20 THE EIGHTEENTH CENTURY: ROCOCO AND THE BIRTH OF THE MODERN WORLD 816

The Early Eighteenth Century: Late Baroque and Rococo	819
The Later Eighteenth Century: The Birth of the	
Modern World	831

V THE MODERN WORLD 858

21 THE NINETEENTH CENTURY: PLURALISM OF STYLE 862

866
885
896
940
945

22 THE EARLY TWENTIETH CENTURY 950

Art with Formalist Concerns	954
Art with Psychological and Conceptual Concerns	967
Art with Social and Political Concerns	998

xii CONTENTS

23 THE CONTEMPORARY WORLD 1028

Art with Formalist Concerns	1032
Art with Psychological and Conceptual Concerns	1050
Art with Social and Political Concerns	1081
Epilogue	1093
PRONUNCIATION GUIDE	1094
GLOSSARY	1098
BIBLIOGRAPHY	1107
INDEX	1119

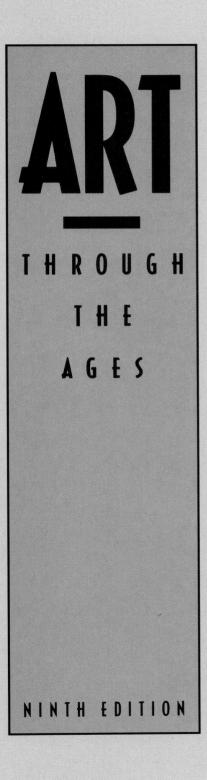

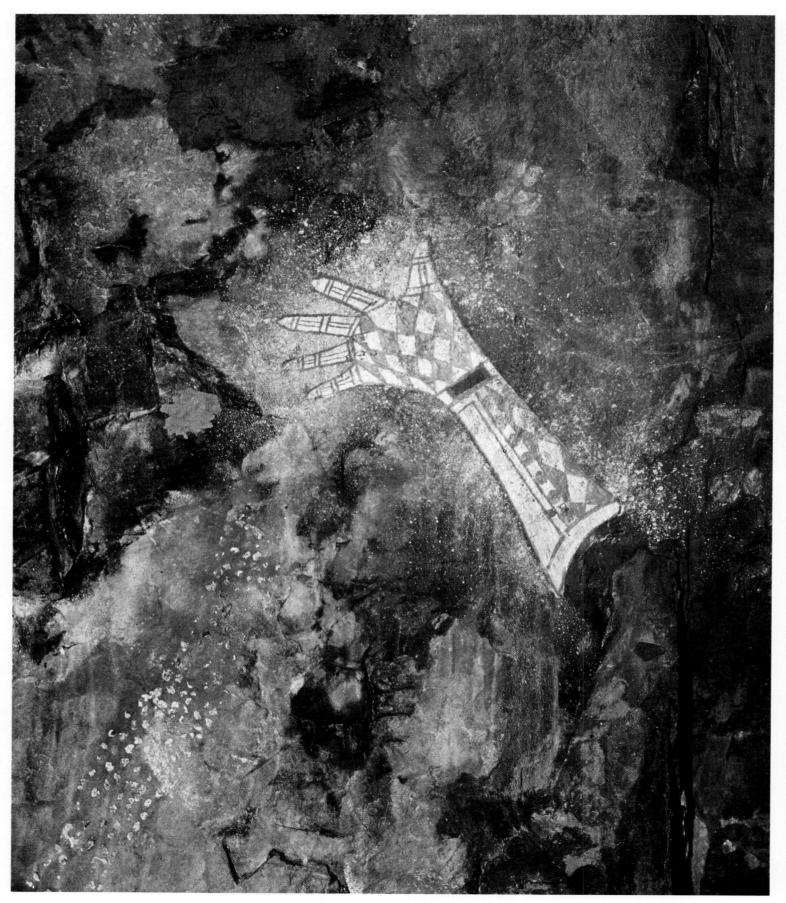

Nineteenth-century native Australians painted this hand at Inagurdurwil, West Arnhem Land. Similar motifs are found as far away in time and place as Upper Paleolithic Europe.

INTRODUCTION

The goal of art history is the discerning appreciation and enjoyment of art, from whatever time and place it may have come, by whatever hands it may have been made. Outside the academic world, the terms *art* and *history* are not often juxtaposed. People tend to think of history as the record and interpretation of past human actions, particularly social and political actions. Most think of art—quite correctly—as something *present* to the eye and touch, which, of course, the vanished human events that make up history are not. The fact is that a visible and tangible work of art is a kind of *persisting event*. It was made at a particular time and place by particular persons, even if we do not always know just when, where, and by whom. Although it is the creation of the past, art continues to exist in the present, long surviving its times; Charlemagne has been dead for a thousand years, but his chapel still stands at Aachen.

THE BASES OF ART HISTORY

Style

The time in which a work of art was made has everything to do with the way it looks—with, in one key term, its *style*. In other words, the style of a work of art is a function of its historical *period*. The historiography of art proceeds by sorting works of architecture, sculpture, and painting into stylistic classes on the bases of their similarities and the times or periods in which they were produced. It is a fundamental hypothesis of art history that works of art produced at the same time and in the same place will generally have common stylistic traits. Of course, all historiography assumes that events derive their character from the time in which they happen (and perhaps from their "great men," also products of their time). Thus, we can speak of the Periclean Age, the Age of Reason, or even the Age of Roosevelt. We also must know the time of a work if we are to know its meaning-to know it for what it is. Yet if the work of art still stands before us, persisting from the past, is not this sufficient? By virtue of its survival, is not the work in a sense *independent* of time? May not a work of art speak to people of all times as long as it survives? The key to this last question is the word speak. Indeed, it may speak, but what is its language? What does it say to us? Art

3

may be more than a form of communication, but it is certainly that, and it is the business of art history to learn the "languages" of the art of many different periods as they are embodied in the monuments from their respective times. We can assume that artists in every age express in their works some sort of meaning that is intelligible both to themselves and to others. We can discover that meaning only by comparing a particular work to other works like it that were made about the same time. By grouping works in this way, we can infer a community of meaning as well as of *form*; a style will then be outlined. In a chronological series of works having common stylistic features, we may find also stylistic *differences* between the later and the earlier works. The art historian tends to think of this phenomenon as reflecting an evolution, a *development*.

It is important to stress, however, that "development" does not mean an orderly progression of styles toward some ideal type or formal perfection, such as, for example, absolute truth to natural appearances. Although at times in the development of Western art the "imitation of nature" has been an expressed goal of the artist, photographic realism—the mechanical reporting of what the eye supposedly perceives in the visual field—has been rarely either the purpose or the result of that development. Moreover, stylistic development does not lead to ever increasing esthetic value; later phases cannot be appraised as "better" than earlier ones simply because they are presumed closer to some imagined goal of competence and achievement. Instead, we should understand stylistic development as an irregular series of steps of varying duration, in which the possibilities of a given style are worked out by artists, both independently and in collaboration with others, until those possibilities are fully realized, and new stylistic traits and tendencies appear and are distinguishable as such. Thus, when we talk of stylistic development in art, we do not mean artistic *progress*—certainly not in the sense of scientific or technological progress, whereby our knowledge appears to increase in a sequence of necessary and interdependent steps toward ever greater scope and certainty.

Chronology

It is obvious that before stylistic development can be inferred, it is necessary to be sure that each monument is correctly dated; without this certainty, art-historical order and intelligibility are impossible. Thus, an indispensable tool of the historian is *chronology*, the measuring scale of historical time. Without chronology, there could be no history of style—only a confusion of unclassifiable monuments, impossible to describe in any sequence of change.

The table of contents of this book reflects what is essentially a series of periods and subperiods arranged in chronological order—the historical sequence that embraces the sequence of art styles. Until the later eighteenth century, the history of art was really a disconnected account of the lives and the works of individual artists. We now regard art history as a record of the dynamic change of styles in time, and the art of individual masters as substyles of the overall period styles. Although one speaks of "change" in the history of art, the objects themselves obviously do not change; as we have said, they persist, although each naturally suffers some material wear and tear with time. But the fact that works of art from one period look different from those of other periods leads us to infer that *something* changes. This something can only be the points of view of the artists with respect to the meaning of life and of art. Modern historiography is heavily influenced by modern philosophies of change and evolution, and, from the terms and data of

biological science, our modern history of art was bound to borrow a sense of continuous process to help explain art-historical change.

In art history, as in the sciences and in other historical disciplines, we have made considerable progress in knowing a thing once we have classified it. Art historians, having done this, resemble experienced travelers who learn to discriminate the different "styles" peculiar to different places. Such travelers know that one must not expect the same style of life in the Maine woods as on the Riviera, and when they have seen a great many places and peoples, they are not only at ease with them, but can be said to know and appreciate them for what they are. As their experience broadens, so does their discrimination or perception of distinctive differences. As world travelers come to see that the location contributes to the unique quality and charm of a town, so students of art, viewing it in the historical dimension, become convinced that a work's peculiar significance, quality, and charm are a function of the time of its making.

Purpose

Is the historical "placing" of a work of art, then, irrelevant to the appreciation of it? Is art-historical knowledge *about* a work of art in some way different from the direct experience of it? The answers lie in the fact that uninstructed appreciators, no matter how well intentioned, still approach a work of art with the esthetic presuppositions of their own time, rather than of the time of the work itself. Their presuppositions can be tantamount to prejudices, so that their appreciation, even if genuine, may well be for the wrong reasons. It will, in fact, be undiscerning and indiscriminate, so that they may view dozens of works of art in the same way, without savoring the individual significance and quality of each. Thus, as a work of art is intended for a particular audience at a particular time and place, its purpose also may be quite particular, and its purpose necessarily enters into its meaning. For example, the famous Vladimir Madonna (FIG. 7-59, p. 296) is a Byzantine-Russian icon, a species of art produced not as a work of "fine art" but as a sacred object endowed with religio-magical power. It was considered, moreover, the especially holy picture of Russia that miraculously saved the city of Vladimir from the hosts of Tamerlane, the city of Kazan from the later Tartar invasions, and all of Russia from the Poles in the seventeenth century. We may admire it for its innate beauty of line, shape, and color, its expressiveness, and its craftsmanship, but unless we are aware of its special historical function as a wonder-working image, we miss the point. We can admire many works of art for their form, content, and quality, but we need a further characterizing experience; otherwise, we are admiring very different works without discriminating their decisive differences. We will be confused, and our judgment will be faulty.

Place of Origin

Although our most fundamental way of classifying works of art is by the time of their making, classification by *place of origin* is also crucial. In many periods, a general style (Gothic, for example) will have a great many regional variations: French Gothic architecture is strikingly different from both English and Italian Gothic. Differences of climate helped to make French Gothic an architecture with no bearing walls and with great spaces for stained-glass windows and Italian Gothic an architecture with large expanses of wall wonderfully suited to mural painting. Art history, then, is also concerned

with the spread of a style from its place of origin. Supplementing time of origin with place of origin therefore adds another dimension to our understanding of the overall stylistic development of art monuments.

The Artist

The *artist* provides still another dimension in the history of art. As we have noted, early "histories" of art, written before the advent of modern concepts of style and stylistic development, were simply biographies of artists. Biography as one dimension is still important, for through it we can trace stylistic development within the career of the artist. We can learn much from contemporaneous historical accounts, from documents such as commission contracts, and from the artist's own theoretical writings and literary remains. All of this is useful in "explaining" an artist's works, although no complete "explanation" exhausts the meaning of them. Relationships to predecessors, contemporaries, and followers can be described in terms of the concepts *influence* and *school*. It is likely that artists are influenced by their masters and then influence or are influenced by fellow artists working somewhat in the same style at the same time and place. We designate a group of such artists as a school. By this, we do not mean an academy, but a classification of time, place, and style. We speak of the Dutch school of the seventeenth century and, within it, of subschools such as those of Haarlem, Utrecht, and Leyden.

The art-historical record often has tended to exclude the contributions of women to art. Evidence from many times and places (some of it collected quite recently), however, indicates that women clearly have produced art and craftwork of extremely high quality. Women artists were known in classical antiquity and have been recognized in China, Japan, India, and many other cultures. In the Western Middle Ages, women were renowned as skilled illuminators of manuscripts and workers of textiles. With the Renaissance, women painters began to come into prominence, along with women printmakers and sculptors. Artistic talent, skill, competence, inventiveness, and refinement clearly are not functions of gender.

Iconography

The categories of time and place, the record of the artist, influences, and schools are all used in the composition of the picture of stylistic development. Another kind of classification, another key to works of art, is *iconography*—the study of the subject matter and symbolism of works of art. Iconography groups paintings and sculptures in terms of their themes rather than their styles, and the development of subject matter becomes a major focus of critical study. Iconographic studies have an ancillary function in stylistic analysis; they often are valuable in tracing influences and in assigning dates and places of origin.

Recently, a new method of analysis has been used to supplement the information acquired as a result of iconographic studies. *Semiotics* is not the study of images per se, but of images "read" as *signs* by which human beings communicate. In semiotics, pictorial images are taken to signify the conscious or unconscious attitudes, inclinations, wishes, intentions, convictions, and values of peoples in different cultures and periods. Born of the science of linguistics (the study of the common structure of all languages), semiotic analysis draws art into relation with literature, psychology, sociology, and anthropology, finding structures and meanings common to the data in all of

these fields. In the semiotic analysis of art, the intentions of the artist are reconstructed from an examination of the images made, within the context of the conventional meanings they have for a particular society. Often the analysis attempts to recover the artist's own psychological set to explain the image choices.

Historical Context

Another very broad source of knowledge about a work of art lies outside the realm of artistic concerns, yet encloses them and interacts with them. This is the *general historical context*—the political, social, economic, scientific, technological, and intellectual background that accompanies and influences specifically art-historical events. The fall of Rome, the coming of Christianity, and the barbarian invasions all had much to do with stylistic changes in architecture, sculpture, and painting in the early centuries of our era. The triumph of science and technology had everything to do with the great transformation of the Renaissance tradition that took place in what we call "modern art"—the art of our own time. The work of art, the persisting event, is, after all, a historical document.

THE WORK OF ART

This book is concerned primarily with the plastic arts, which differ from the temporal arts in several very basic ways. The temporal arts—music, dance, and poetry, for example—require time for their performance or presentation. They are transitory or ephemeral in the sense that, once performed, they cease to exist to the observer, except in memory. On the other hand, the plastic arts—painting, sculpture, and architecture, for instance—have physical bulk and a tangible, enduring existence in space. To describe and analyze a plastic work of art, we use categories and vocabularies that have become standard and that are indispensable to an understanding of this book.

General Concepts

Form, for the purposes of art history, refers to the shape of the "object" of art; in the made object, form is the shape that the expression of content takes. To create forms, to make a work of art, artists must shape materials with tools. Each of the many materials, tools, and processes available has its own potentialities and limitations; it is part of all artists' creative activity to select the tools most suitable to their purpose. The technical processes that the artists employ, as well as the distinctive, personal ways in which they handle them, we call their technique. If the material that artists use is the substance of their art, then their technique is their individual manner of giving that substance form. Form, technique, and material are interrelated, as we can readily see in a comparison of the marble statue of Apollo from Olympia (FIG. 5-40, p. 152) with the bronze Charioteer of Delphi (FIG. 5-37, p. 150). The Apollo is firmly modeled in broad, generalized planes, reflecting the ways of shaping stone that are more or less dictated by the character of that material and by the tool used-the chisel. On the other hand, the Charioteer's fineness of detail, seen in the crisp, sharp folds of the drapery, reflects the qualities inherent in cast metal. However, a given medium can lend itself to more than

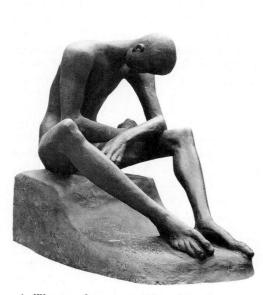

1 WILHELM LEHMBRUCK, Seated Youth, 1918. Bronze. Wilhelm-Lehmbruck-Museum, Duisburg.

2 AUGUSTE RODIN, *The Thinker*, 1880. Bronze. Metropolitan Museum of Art, New York (gift of Thomas F. Ryan, 1910).

one kind of manipulation. The technique of Lehmbruck's bronze *Seated Youth* (FIG. 1), for example, contrasts strikingly with Rodin's *The Thinker* (FIG. 2), also in bronze. The surfaces of Lehmbruck's figure are smooth, flowing, quiet; those of Rodin's figure are rough, broken, and tortuous. Here, it is not so much the bronze that determines the form as it is the sculptor's difference of purpose and of personal technique.

Space, in our commonsense experience, is the bounded or boundless "container" of collections of objects. For the analysis of works of art, we regard space as bounded by and susceptible to esthetic and expressive organization. Architecture provides us with our most common experience of the actual manipulation of space; the art of painting frequently projects an image (or illusion) of our three-dimensional spatial world onto a two-dimensional surface.

Area and plane describe a limited, two-dimensional space and generally refer to surface. A plane is flat and two-dimensional—like this page and like elements dealt with in plane geometry (a circle, square, or triangle). An area, which also can be described in terms of plane geometry, is often a plane or a flat surface that is enclosed or bounded. Bernini created an oval area when he defined the essentially plane surface in front of St. Peter's by means of his curving colonnades (FIG. 19-3, p. 753).

Mass and *volume*, in contradistinction to plane and area, describe three-dimensional space. In both architecture and sculpture, mass is the bulk, density, and weight of matter in space. Yet the mass need not be solid; it can be the exterior form of enclosed space. For example, "mass" can apply to a pyramid (FIG. 3-10, p. 81), which is essentially solid, or to the exterior of Hagia Sophia (FIG. 7-40, p. 284), which is essentially a shell enclosing vast spaces. Volume is the space that is organized, divided, or enclosed by mass. It may be the spaces of the interior of a building, the intervals between the masses of a building, or the amount of space occupied by three-dimensional objects like sculpture, ceramics, or furniture. Volume and mass describe the exterior as well as the interior forms of a work of art—the forms of the matter of which it is composed *and* the forms of the spaces that exist immediately around that matter and interact with it. For example, in the Lehmbruck statue (FIG. 1), the expressive volumes enclosed by the attenuated masses of the torso and legs play an important part in the open design of the piece. The absence of enclosed volumes in the Rodin figure (FIG. 2) is equally expressive, closing the design, making it compact, heavy, and confined. Yet both works convey the same mood—one of brooding introversion. These closed and open forms, manifest throughout the history of art, demonstrate the intimate connection between mass and the space that surrounds and penetrates it.

Line is one of the most important, but most difficult, terms to comprehend fully. In both science and art, line can be understood as the path of a point moving in space, the track of a motion. Because the directions of motions can be almost infinite, the quality of line can be incredibly various and subtle. It is well known that psychological responses are attached to the direction of a line: a vertical line is active; a horizontal line, passive; a diagonal line, suggestive of movement, energy, or unbalance; and so on. Hogarth regarded the serpentine or S-curve line as the "line of beauty." Our psychological response to line is also bound up with our esthetic sense of its quality. A line may be very thin, wirelike, and delicate, conveying a sense of fragility, as in Klee's Twittering Machine (FIG. 22-42, p. 989). Or it may alternate quickly from thick to thin, the strokes jagged, the outline broken, as in a 600-year-old Chinese painting (FIG. 12-19, p. 465) in which the effect is of vigorous action and angry agitation. A gentle, undulating, but firm line, like that in Picasso's Bathers (FIG. 3), defines a contour that is restful and quietly sensuous. A contour continuously and subtly contains and suggests mass and volume. In the Picasso drawing, the line is distinct, dark against the white of the paper. But line can be felt as a controlling presence in a hard edge, profile, or boundary created by a contrasting area, even when its tone differs only

> 3 PABLO PICASSO, detail of Bathers, 1918. Pencil drawing. Fogg Art Museum, Harvard University, Cambridge, Massachusetts (bequest of Paul J. Sachs).

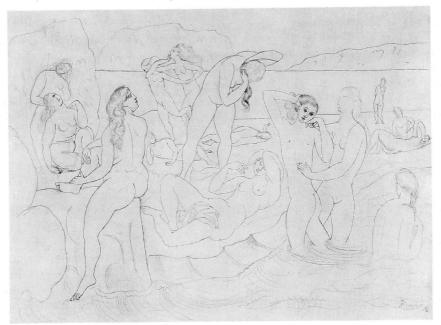

slightly from the tone of the area it bounds. A good example of this can be seen in the central figure of the goddess in Botticelli's *The Birth of Venus* (FIG. 16-60, p. 624).

An *axis* is a line along which forms are organized. The axis line itself may not be evident; several axis lines may converge (usually with one dominant), as in the layout of a city. Although we are most familiar with directional axes in urban complexes, they occur in all the arts. A fine example of the use of axis in large-scale architecture is the plan of the Palace of Versailles and its magnificent gardens (FIG. 19-66, p. 807). Axis, whether vertical, horizontal, or diagonal, is also an important compositional element in painting.

Perspective, like axis, is a method of organizing forms in space, but perspective is used primarily to create an illusion of depth or space on a two-dimensional surface. Because we are conditioned by exposure to Western, single-point perspective, an invention of the Italian Renaissance (see pages 634–67), we tend to see perspective as a systematic ordering of pictorial space in terms of a single point—a point at which lines converge to mark the diminishing size of forms as they recede into the distance (FIG. 17-16, p. 647). Renaissance and Baroque artists created masterpieces of perspective illusionism. In Leonardo's The Last Supper (FIG. 4), for example, the lines of perspective (dashed lines) converge on Christ and, in the foreground, project the picture space into the room on the wall of which the painting appears, creating the illusion that the space of the picture and the space of the room are continuous. Yet we must remember that Renaissance perspective is only one of several systems for depicting depth. Other systems were used in ancient Greece and Rome and still others in the East. Some of these other systems, as well as the Italian Renaissance perspective, continue to be used. There is no final or absolutely correct projection of what we "in fact" see.

Proportion deals with the relationships (in terms of size) of the parts of a work. The experience of proportion is common to all of us. We seem to recognize at once when the features of the human face or body are "out of proportion." If the nose or ears are too large for the face or the legs are too short for the body, an instinctive or conventional sense of proportion leads us to regard the disproportionate elements as ludicrous or ugly. Formalized

4 LEONARDO DA VINCI, *The Last Supper, c.* 1495–1498. Fresco. Santa Maria delle Grazie, Milan. (Perspective lines are dashed; lines indicating proportions are solid white or black.)

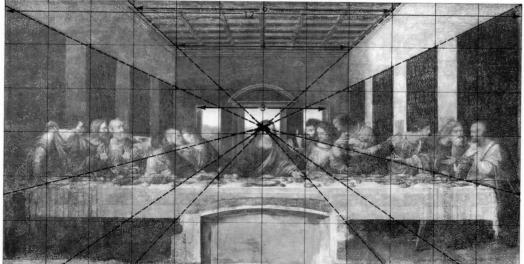

proportion is the mathematical relationship in size of one part of a work of art to the other parts within the work, as well as to the totality of the parts; it implies the use of a denominator that is common to the various parts. One researcher has shown that the major elements of Leonardo's Last Supper exhibit proportions found in harmonic ratios in music-12:6:4:3 (FIG. 4). These figures (with the greatest width of a ceiling panel taken as one unit) are the horizontal widths, respectively, of the painting, the ceiling (at the front), the rear wall, and the three windows (taken together and including interstices); they apply to the vertical organization of the painting as well. Leonardo found proportion everywhere: "not only in numbers and measures, but also in sounds, weights, intervals of time, and in every active force in existence."* The ancient Greeks, who considered beauty to be "correct" proportion, sought a canon (rule) of proportion, not only in music, but also for the human figure. The famous Canon of Polykleitos (page 163), expressed in his statue of the Doryphoros (FIG. 5-58, p. 163), long served as an exemplar of correct proportion. But it should be noted that canons of proportion differ from time to time and culture to culture and that, occasionally, artists have used disproportion deliberately. Part of the task facing students of art history is to perceive and adjust to these differences in an effort to understand the wide universe of art forms. Proportional relationships are often based on a module, a dimension of which the various parts of a building or other work are fractions or multiples. A module might be the diameter of a column, the height of the human body, or an abstract unit of measurement. For example, the famous "ideal" plan of the ninth-century monastery of St. Gall (FIG. 8-22, p. 337) has a modular base of $2\frac{1}{2}$ feet, so that all parts of the structure are multiples or fractions of this dimension.

Scale also refers to the dimensional relationships of the parts of a work to its totality (or of a work to its setting), usually in terms of appropriateness to use or function. We do not think that a private home should be as high as an office building or that an elephant's house at the zoo should be the size of a hen coop, or vice versa. This sense of scale is necessary to the construction of form in all the arts. Most often, but not necessarily, it is the human figure that gives the scale to form.

Light in the world of nature is so pervasive that we often take its function for granted. Few of us realize the extraordinary variations wrought by light, either natural or artificial, on our most familiar surroundings. Daylight, for example, changes with the hour or season. Few of us realize the full extent to which light affects and reveals form. One who did—the French artist Monet (pages 923–24)—painted the reflections in a water-lily pond according to their seasonal variations and, in a series of more than forty canvases of the façade of Rouen Cathedral, revealed its changing appearance from dawn until twilight in different seasons (FIG. 5). Light is as important for the perception of form as is the matter of which form is made.

Value is one function of light. In painting, and in the graphic arts generally, value refers to lightness, or the amount of light that is (or appears to be) reflected from a surface. Value is a subjective experience, as FIG. **6** shows. In absolute terms (if measured, for example, by a photoelectric device), the center bar in this diagram is uniform in value. Yet where the bar is adjacent to a dark area, it *looks* lighter, and where the bar is adjacent to a lighter area, it *looks* darker. Value is the basis of the quality called, in Italian, *chiaroscuro* (*chiaro*, or light; *scuro*, or dark), which refers to the gradations between light

^{*}Thomas Brachert, "A Musical Canon of Proportion in Leonardo da Vinci's Last Supper," Art Bulletin, Vol. 53, No. 4 (December 1971), pp. 461–66.

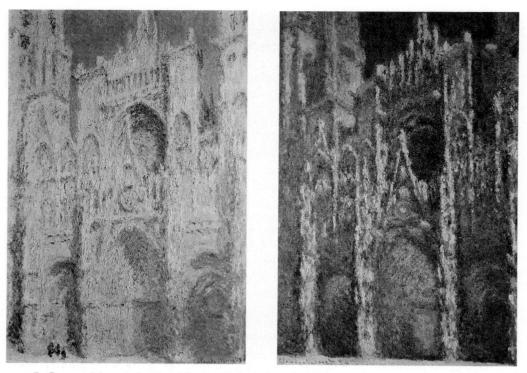

5 CLAUDE MONET, façade of Rouen Cathedral, early 1890s. (*Right*) Museum of Fine Arts, Boston (bequest of Hanna Marcy Edwards); (*left*) National Gallery of Art, Washington, D.C. (Chester Dale Collection).

and dark that produce the effect of *modeling*, or of light reflected from three-dimensional surfaces, as exemplified in Leonardo's superb rendering of *The Virgin and Child with St. Anne and the Infant St. John* (FIG. 17-2, p. 636).

In the analysis of light, an important distinction must be made for the realm of art. Natural light, or sunlight, is whole or additive light, whereas the painter's light in art-the light reflected from pigments and objects-is subtractive light. Natural light is the sum of all the wavelengths composing the visible spectrum, which may be disassembled or fragmented into the individual colors of the spectral band. (Recent experiments with lasers-light amplification by stimulated emission of radiation—have produced color of incredible brilliance and intensity, opening possibilities of color composition that, until now, were unsuspected. The range and strength of color produced in this way approach, although at considerable distance, those of the sun.) Although the esthetics of color is largely the province of the artist and can usually be genuinely experienced and understood only through intense practice and experimentation, some aspects can be analyzed and systematized. Paint pigments produce their individual colors by reflecting a segment of the spectrum while absorbing all the rest. "Green" pigment, for example, subtracts or absorbs all the light in the spectrum except that seen by us as green, which it reflects to the eye. (In the case of transmitted, rather than reflected, light, the coloring matter blocks or screens out all wavelengths of the spectrum except those of the color we see.) Thus, theoretically, a mixture of pigments that embraced all the colors of the spectrum would subtract all light—that is, it would be black; actually, such a mixture of pigments never produces more than a dark gray.

Hue is the property that gives a color its name—red, blue, yellow. Although the colors of the spectrum merge into each other, artists usually conceive of

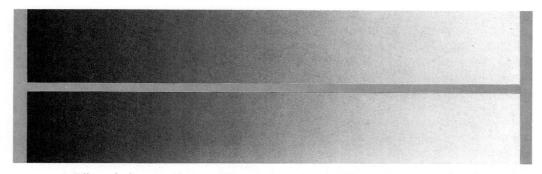

6 Effect of adjacent value on apparent value. Actual value of center bar is constant.

their hues as distinct from each other, giving rise to many different devices for representing color relationships. There are basically two variables in color—the apparent amount of light reflected and the apparent purity; a change in one must produce a change in the other. Some terms for these variables are *value* and *tonality* (for lightness) and *chroma, saturation,* and *intensity* (for purity).

One of the more noteworthy diagrams of the relationships of colors is the triangle (FIG. 7), once attributed to Goethe, in which red, yellow, and blue (the *primary colors*) are the vertexes of the triangle and orange, green, and purple (the *secondary colors*, which result from mixing pairs of primaries) lie between them. Colors that lie opposite each other, such as red and green, are called *complementary* colors, because they complement, or complete, one another, each absorbing those colors that the other reflects. The result is a neutral tone or gray (theoretically, black), which is produced when complementaries are mixed in the right proportions. The inner triangles in FIG. 7 are the products of such mixing.

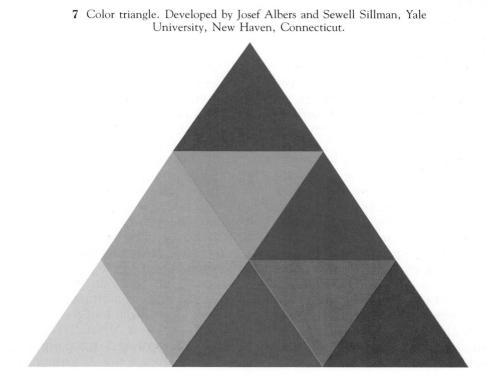

Color also has a psychological dimension: red and yellow, quite naturally, connote warmth; blue and green, coolness. Generally, *warm* colors seem to *advance* and *cool* colors seem to *recede*.

Texture is the quality of a surface (rough, smooth, hard, soft, shiny, dull) as revealed by light. The many painting media and techniques permit the creation of a variety of textures. The artist may simulate the texture of the materials represented, as in Kalf's *Still Life* (FIG. 19-55, p. 797), or create arbitrary surface differences, even using materials other than canvas, as in Picasso's *Still Life with Chair-Caning* (FIG. 22-9, p. 926).

Specialized Concepts

The terms we have been discussing have connotations for all the visual arts. Certain observations, however, are relevant to only one category of artistic endeavor—either to architecture, or to sculpture, or to painting.

IN ARCHITECTURE

Works of architecture are so much a part of our environment that we accept them as fixed and scarcely notice them until our attention is summoned. People have long known how to enclose space for the many purposes of life. The spatial aspect of the arts is most obvious in architecture. The architect makes groupings of enclosed spaces and enclosing masses, always keeping in mind the function of the structure, its construction and materials, and, of course, its design—the correlative of the other two. We experience architecture both visually and by moving through and around it, so that we perceive architectural space and mass together. The articulation of space and mass in building is expressed graphically in several ways; the principal ones include plans, sections, and elevations.

A *plan* is essentially a map of a floor, showing the placement of the masses of a structure and, therefore, the spaces they bound and enclose (FIG. 7-42, p. 286). A *section*, like a vertical plan, shows placement of the masses as if the building were cut through along a plane, often along a plane that is a major axis of the building (FIG. 3-11, p. 82). An *elevation* is a head-on view of an external or internal wall, showing its features and often other elements that would be visible beyond or before the wall (FIG. 5-54, p. 161).

Our response to a building can range from simple contentment to astonishment and awe. Such reactions are products of our experience of a building's function, construction, and design; we react differently to a church, a gymnasium, and an office building. The very movements we must make to experience one building will differ widely and profoundly from the movements required to experience another. These movements will be controlled by the continuity (or discontinuity) of the plan or by the placement of its axes. For example, in a central plan—one that radiates from a central point, as in the Pantheon in Rome (FIG. 6-58, p. 228)—we perceive the whole spatial entity at once. In the long axial plan of a Christian basilica (FIG. 7-26, p. 273) or a Gothic cathedral (FIG. 10-18, p. 392), however, our attention tends to focus on a given point—the altar at the eastern end of the nave. Mass and space can be interrelated to produce effects of great complexity, as, for example, in the Byzantine Church of the Katholikon (FIG. 7-46, p. 288) or in Le Corbusier's church at Ronchamp (FIG. 23-9, p. 1038). Thus, our experience of architecture will be the consequence of a great number of material and formal factors, including training, knowledge, and our perceptual and psychological makeup, which function in our experience of any work of art.

The architect must have the sensibilities of a sculptor and of a painter and, in establishing the plan of a building, must be able to use the instruments of a

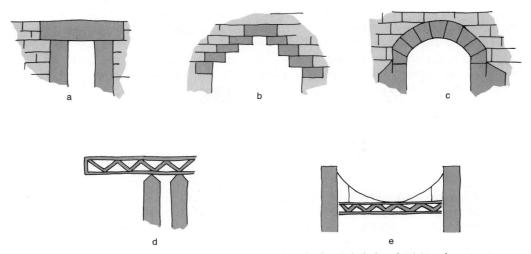

8 Basic structural devices: (a) post and lintel; (b) corbeled arch; (c) arch; (d) cantilever; (e) suspension.

mathematician. As architects resolve structural problems, they act as (or with) engineers who are cognizant of the structural principles underlying all architecture (FIG. 8). Their major responsibilities, however, lie in the manner in which they interpret the *program* of the building. We are not talking in architectural terms when we describe a structure simply as a church, a hospital, an airport concourse, or a house. Any proposed building presents an architect with problems peculiar to it alone—problems related to the site and its surroundings, the requirements of the client, and the materials available, as well as the function of the building. A program, then, deals with more than function; it addresses all of the problems embodied in a specific building.

IN SCULPTURE

Like architecture, sculpture exists in the three-dimensional space of our physical world. But sculpture as image is closer to painting than is architecture. Until recently, sculpture has been concerned primarily with the representation of human and natural forms in tangible materials, which exist in the same space as the forms they represent. However, sculpture also may embody visions and ideals and consistently has presented images of deities and people in their most heroic as well as their most human aspects (FIGS. 17-19, p. 652, and 5-76, p. 174). Today, sculpture often dispenses with the figure as image, and even with the image itself, producing new forms in new materials and with new techniques (FIGS. 23-6, p. 1036; 23-39, p. 1060; 23-44, p. 1064; 23-79, p. 1092).

Sculpture may be associated intimately with architecture, often to such a degree that it is impossible to disassociate the two (FIG. 10-15, p. 390). Sculpture is called *relief* sculpture when it is attached to a back slab or back plate (FIG. 3-44, p. 102); *high relief*, if the figures or design project boldly (FIG. 5-78, p. 175); and *low relief*, or *bas-relief*, if the figures or design project slightly (FIG. 3-44, p. 102).

Sculpture that exists in its own right, independent of any particular architectural frame or setting (FIG. 17-46, p. 673), is usually referred to as *freestanding* sculpture, or "sculpture in the round," although, in the art of Greece and of the Renaissance, freestanding sculpture has been allied closely to architecture on many occasions. Indeed, sculpture is such a powerful agent in creating a spatial as well as an intellectual environment that its presence in

9 DONATELLO, St. John the Evangelist, 1412–1415. Marble. Museo del Duomo, Florence. (Left) as seen in museum; (right) as intended to be seen on façade of Florence Cathedral.

city squares or in parks and gardens is usually the controlling factor in creating their "atmosphere" or general effect (FIG. 19-73, p. 812).

Some statues are meant to be seen as a whole—to be walked around (FIG. 17-46, p. 673). Others have been created to be viewed only from a restricted angle. How a sculpture is meant to be seen must be taken into account by the sculptor and by those who exhibit the work. The effect of ignoring this is illustrated in FIG. 9. The left photograph is taken directly from the front, as the piece is now seen in the museum; the right photograph is taken from below, at approximately the same angle from which the statue was originally meant to be seen in its niche on the façade of the cathedral of Florence.

In sculpture, perhaps more than in any other medium, textures, or tactile values, are important. One's first impulse is almost always to handle a piece of sculpture, to run one's finger over its surfaces. The sculptor plans for this, using surfaces that vary in texture from rugged coarseness to polished smoothness (FIGS. 10-56, p. 414, and 16-50, p. 615). Textures, of course, are often intrinsic to a material, and this influences the type of stone, wood, plastic, clay, or metal that the sculptor selects. There are two basic categories of sculptural technique: *subtractive* and *additive*. Carving, for instance, is a subtractive technique; the final form is a reduction of the original mass (FIG. 10). Additive sculpture is built up, usually in clay around a framework, or armature; the piece is fired and used to make a mold in which the final work is cast in a material such as bronze (FIG. 16-52, p. 617). Casting is a popular technique today. Another common additive technique is the direct construction of forms accomplished by welding shaped metals together (FIG. 23-6, p. 1036).

Within the sculptural family, we must include ceramics and metalwork, and numerous smaller, related arts, all of which employ highly specialized

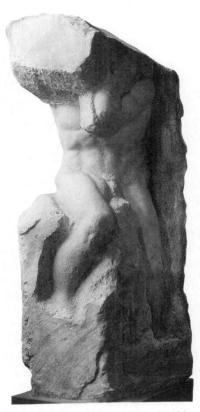

10 MICHELANGELO, Unfinished Bound Slave, 1519. Marble. Accademia, Florence.

techniques described in distinct vocabularies. These will be considered as they arise in the text.

IN THE PICTORIAL ARTS

The forms of architecture and sculpture exist in actual, three-dimensional space. The forms of painting (and of its relatives, drawing, engraving, and the like) exist almost wholly on a two-dimensional surface on which the artist creates an illusion, something that replicates what we see around us or something that is unique to the artist's imagination and corresponds only vaguely or slightly to anything we can see in the optical world. Human discovery of the power to project illusions of the three-dimensional world onto two-dimensional surfaces goes back thousands of years and marks an enormous step in the control and manipulation of the things we perceive. To achieve this illusion, the artist configures images or representations drawn from the world of common visual experience. Throughout the history of art, this world has been interpreted in an almost infinite variety of ways. Undoubtedly, there is much that all people see in common and can agree on: the moon at night, a flying bird, an obstacle in one's path. Many people may differ, though, in their interpretation of the seen. Seeing and then representing what is seen are very different matters. The difference between seeing and representing determines the variability of artistic styles, both cultural and personal. What we actually see (the optical "fact") is not necessarily reported in what we represent. In other words, in art, there is and need be little agreement between the likeness of a thing and the representation of it. This lack of agreement makes for a persisting problem in the history of art. How are we to interpret or "read" images or replicas of the seen? Is there a "correct" vision of the "real" world?

THE PROBLEM OF REPRESENTATION

The conundrum of seeing something and making a representation of it is artfully illustrated in FIG. 11, a cartoon of a life-drawing class in ancient Egypt that Gombrich uses to introduce his invaluable Art and Illusion. The cartoon and the actual representation of an Egyptian queen (FIG. 12) raise many questions: Did Egyptian artists copy models exactly as they saw them? (Did Egyptians actually see each other in this way?) Or did they translate what they saw according to some formula dictated by conventions of representation peculiar to their culture? Would we have to say—if what was seen and what was recorded were optically the same—that this is the way Egyptians must have looked? or wished to look? Beginning students usually have questions somewhat like these in mind when they perceive deviations in historical styles from the recent Western realism to which they are conditioned. They ask whether the Egyptians, or other artists, were simply unskilled at matching eye and hand, so to speak, and could not draw from what they saw. But such a question presupposes that the objective of the artist has always been to match appearances with cameralike exactitude. This is not the case, nor is it the case that artists of one period "see" more "correctly" and render more "skillfully" than those of another. Rather, it seems that artists represent what they conceive to be real, not what they perceive. They bring to the making of images conceptions that have been instilled in them by their cultures. They understand the visible world in certain unconscious, culturally agreed on ways and thus bring to the artistic process ideas and meanings out of a common stock. They record not so much what they see as what they know or

11 Alain. Drawing. Copyright © 1955, 1983, The New Yorker Magazine, Inc.

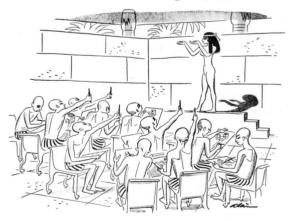

12 Queen Nofretari, from her tomb at Thebes, c. 1250 B.C. Detail of a painted bas-relief.

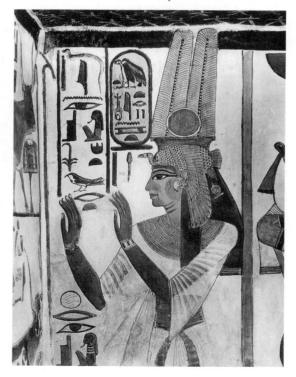

mean. Even in the period of dominant realism in recent western European art, great deviations from camera realism have set in. Moreover, in our everyday life there are images familiar to all of us that distort optical "reality" quite radically; consider, for example, the images of the ubiquitous comic strip.

Solutions to the problem of representation constitute the history of artistic style. It is useful to examine some specimens of sharp divergence in representational approach. Compare, for example, the lion drawn by the Medieval artist Villard de Honnecourt (FIG. 13) with those done by the Renaissance artist Albrecht Dürer (FIG. 14). In the de Honnecourt lionwhich, it is important to notice, the artist asserts was drawn from life-the figure is entirely adequate for identification but preconceived and constructed according to the formulas of its time. Dürer's lions, drawn some three centuries later, obviously are a much different report of what the artist saw. So are the Assyrian lions of the hunting reliefs (FIG. 2-33, p. 63), the Lion from the Processional Way of the Ishtar Gate (FIG. 2-35, p. 64), the lion in Henri Rousseau's The Sleeping Gypsy (FIG. 21-90, p. 943), or (in slight shift of species) Barye's sculpture of a jaguar in his Jaguar Devouring a Hare (FIG. 21-7, p. 870). In each case, personal vision joins with the artistic conventions of time and place to decide the manner and effect of the representation. Yet, even at the same time and place (for example, nineteenth-century Paris), we can find sharp differences in representation when the opposing personal styles of Ingres and Delacroix record the same subject (FIGS. 21-16 and 21-17, pp. 876-77).

A final example will underscore the relativity of vision and representation that differences in human cultures produce. We recognize, moreover, that close matching of appearances has mattered only in a few times and places.

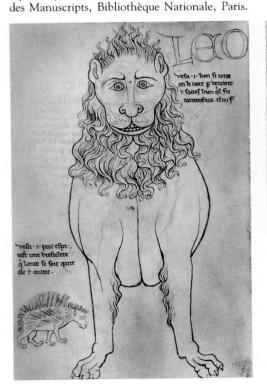

13 VILLARD DE HONNECOURT, Lion Portrayed

from Life, c. 1230-1235. Drawing. Cabinet

14 ALBRECHT DÜRER, *Two Lions, c.* 1521. Drawing. Staatliche Museen Preussischer Kulturbesitz, Kupferstichkabinet, Berlin.

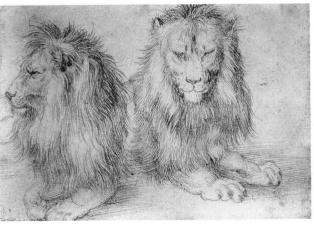

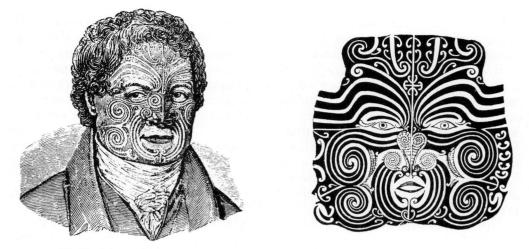

15 The Maori Chief Tupai Kupa, c. 1800. (Left) after a drawing by John Sylvester; (right) a self-portrait. From The Childhood of Man by Leo Frobenius, 1909. Reproduced by permission of J. B. Lippincott Company.

Although both portraits of a Maori chieftain from New Zealand (FIG. **15**)—one by a European, the other by the chieftain himself—reproduce his facial tatooing, the first portrait is a simple, commonplace likeness that underplays the tatooing. The self-portrait is a statement by the chieftain of the supreme importance of the design that symbolizes his rank among his people. It is the splendidly composed insignia that is his image of himself, the European likeness being superficial and irrelevant to him.

Students of the history of art, then, learn to distinguish works by scrutinizing them closely within the context of their time and place of origin. But this is only the beginning. The causes of stylistic change over time are mysterious and innumerable, and it is only through the continuing process of art-historical research that we can hope to make the picture even fragmentarily recognizable. Incomplete though the picture is and will remain, the panorama of art, changing in time, lies before students, and as their art-historical perspective gains depth and focus, they will come to perceive the continuity of the art of the past with that of the present. It will become clear that one cannot be understood without the other and that our understanding of the one will constantly change with changes in our understanding of the other. The great American poet and critic T. S. Eliot has cogently expressed this truth for all art in a passage that suggests the philosophy and method of this book:

What happens when a new work of art is created is something that happens simultaneously to all the works of art which preceded it. The existing monuments form an ideal order among themselves, which is modified by the introduction of the new (the really new) work of art among them. . . . Whoever has approved this idea of order . . . will not find it preposterous that the past should be altered by the present as much as the present is directed by the past.*

As new works of art continue to be created, old ones, buried by time, are recovered and others, known to have existed, disappear. Many come to light by chance, and many are destroyed by catastrophe or neglect. Restoration and reconstruction either damage or rescue them. The whole domain of art

^{*}T. S. Eliot, "Tradition and the Individual Talent," in *Selected Essays* 1917–1932 (New York: Harcourt, Brace, 1932), p. 5.

constantly shifts in outline and population, as does our knowledge of it. Identification of a work of art may be accepted at one time, rejected at another. Attribution of certain works to certain artists may be challenged; the chronology of stylistic change may be readjusted; and the dating of particular works may be debated and revised. Critics may disagree as to the number of works to be ascribed to a single artist. (Some credit Rembrandt with as many as 600 paintings; others credit him with as few as 350.) Reinterpretation of the meanings and functions of works of art is an ongoing process, as is the reassessment of their artistic value and stylistic importance. Our knowledge of art history is as much in flux as artistic creation itself; what seems to be certain at one time proves to be inconclusive or erroneous at another. Evidence for our conclusions is never all in; more of it is always turning up, and much of it cannot be found.

Students are therefore cautioned not to expect this book to contain an outlay of facts that are incontestable beyond all alteration. The facts are the works of art themselves, as made palpable to our senses; our descriptions of these works—our dating, attributions, classifications, interpretations—are forever provisional and open to doubt. What is not open to doubt is the presence in our world of a small universe of objects of art that expresses, in myriad, arresting forms, the highest values and ideals of the human race. It is essential to the quality of our own experience to encounter, comprehend, appreciate, and preserve these precious works.

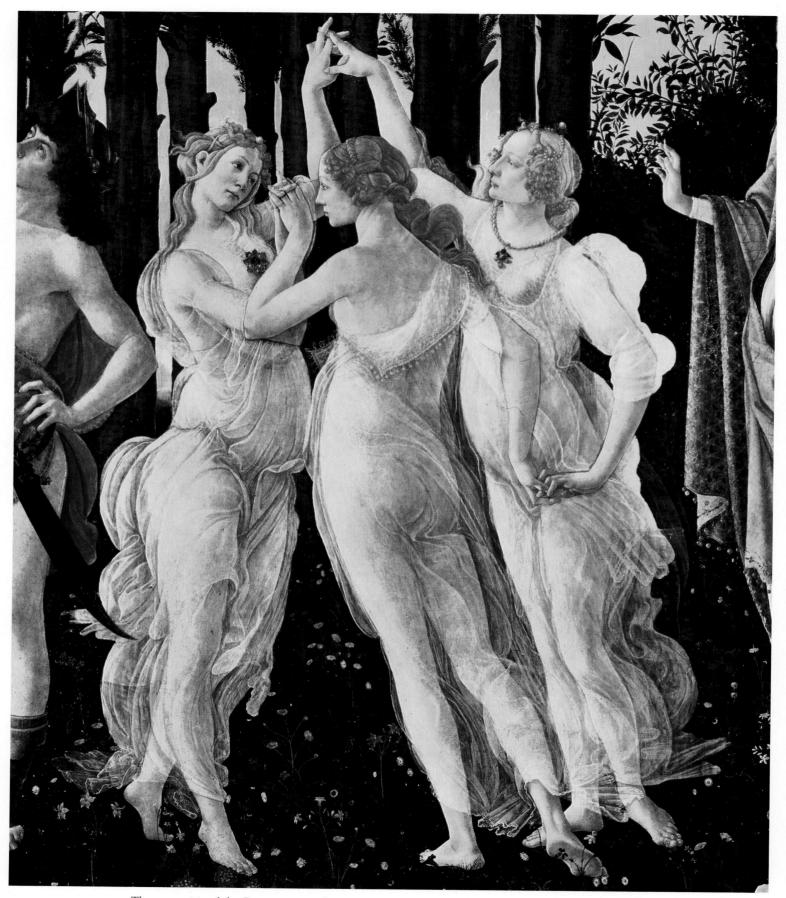

The new spirit of the Renaissance, a flowering of love for nature and human beauty, enlivens a detail of Botticelli's *La Primavera*, painted in the last quarter of the fifteenth century.

THE RENAISSANCE AND THE BAROQUE AND ROCOCO

The Medieval period once was regarded as a thousand dark and empty years separating the "good" eras of classical antiquity and modern times; the Renaissance was thought of as "early modern." But beginning in the nineteenth century, a more cosmopolitan and tolerant taste and a more discerning and accurate historical method readjusted this view, and today the Middle Ages are no longer so "dark" as once depicted. In the same way, the Renaissance (rebirth), spanning roughly the fourteenth through the sixteenth centuries, no longer seems to be the abrupt onset of the modern era, suddenly shining forth in the fifteenth century to illuminate medieval darkness with the rekindled light of classical antiquity. Much of the Renaissance has its roots in epochs that long preceded the Middle Ages, and much that is medieval continues in the Renaissance and even in later periods. Since the midnineteenth century, when Jacob Burckhardt wrote his influential and still highly valuable work, The Civilization of the Renaissance in Italy, the precise dividing line between the Middle Ages and the Renaissance and the question of whether a Renaissance ever actually took place have been disputed. Without reopening these issues, it may be useful to examine those characteristics of the Renaissance that seem to have matured and to have become influential during the period from the fourteenth through the sixteenth centuries, even though they originated during the Middle Ages.

Medieval feudalism, with its patchwork of baronial jurisdictions and sprawling, inefficient local governments, yielded slowly to the competition of strong cities and city-states, which increasingly were in league with powerful kings, both being the natural political enemies of the countryside barons. The outlines of the modern state, with its centralized administrations, organized armies, aggressive expansionism, and "realistic" politics, began to firm up at about this time. The discovery of the world outside Europe—especially the Western Hemisphere and Africa, itself so dramatically expressive of Renaissance expansiveness—brought vast treasures of gold and silver into Europe, beginning its transformation into a money economy (a process already begun in the thirteenth century in the commercial cities of Italy). Religion increasingly came under the direction of the clergy of the cities. Particularly influential were the members of the Dominican and the Franciscan orders. The claims of the popes to temporal as well as spiritual supremacy were surrendered, and they became merely splendid Italian princes. Eventually, with the upheaval of the Protestant Reformation, which fractured medieval religious unity, religion became almost a branch of the state, with kings and princes in control of its secular manifestations. Dramatic events in science, like Nicolaus Copernicus's enunciation of the heliocentric theory of the solar system, set the stage for the development of the first successful empirical science—mathematical physics. The opening of the heavens to the scrutiny of scientific investigation was attended by the renewed physical exploration of the globe and, until recently, by the increasing subjugation of it to the will of Europe. Technological advances in navigation, metallurgy, mechanics, and warfare helped greatly to that end.

The religious fanaticism that had launched the Crusades, Europe's first extended contact with non-European civilizations, was replaced during the Renaissance by motives of calculated economic interest mingled with the genuine and fruitful curiosity of the explorer. Indeed, the Renaissance was precisely what it often has been called—an "age of discovery"—when Europe saw before it an almost fantastic realm of possibility open to all those of merit who could perceive it.

Accompanying the great events that quite clearly set the Middle Ages and the Renaissance apart were subtler changes of human attitude. Emphasis slowly was turned away from the ideas and values of a supernatural orientation and toward those concerned with the natural world and human life. The meaning of these new concerns came to be couched in terms that were not exclusively religious. The spirit and dogma of medieval religion, and even its emotional color, were modified as the worldly philosophy of the Greco-Roman tradition revived and took on new strength. But the process of humanization had begun well before the full influence of the pagan tradition was felt; humanizing tendencies began to appear in the twelfth century. In the thirteenth century, the teachings of St. Francis had humanized religion itself and had called attention to the beauty of the world and of all things in it. Even though St. Francis understood the physical beauty he celebrated as a manifestation of the spiritual, his emphasis, nevertheless, was clear, and the Franciscan message calls attention to the God-made beauties of the natural order. This message had special significance for the naturalism of proto-Renaissance art. In the Middle Ages, the focus of life was to procure the salvation of one's immortal soul through the sacred offices of the Church. In the Renaissance, however, though the obligation and concern remained and the institutions of the Church retained power, nature and the relations among human beings simply became more interesting than theological questions. Theology, like institutional Christianity, persisted, as did fervent Christian devotion. But these elements were affected by a new spirit-the spirit of pagan humanism-which curiously joined with and reinforced the Christian humanism of St. Francis. The intellectual and artistic history of the modern world is as much the history of Christianity's reaction to this new spirit as it is a history of the challenge of that spirit to Christianity. Actually, the challenge and the reaction interacted, modifying each other. The dialogue between the late Greco-Roman world and nascent Christianity commenced again in the Renaissance; since that time, it has been supplemented and amplified by other, even stronger voices, especially those of modern science.

Whereas the veritable face and body of the human being emerged in the transition from Romanesque to Gothic sculpture, Renaissance art brings

Western humanity rapidly into full view—a phenomenon that resembles the manifestation of the human figure in Greek art during the sixth and fifth centuries B.C. The Renaissance stresses the importance of the individual, especially individuals of merit. In life and in art, the focus is sharpened. At last, individuals are real and solid; they cast a shadow. During the Middle Ages, people saw themselves as corrupt and feeble of will, capable of acting only by the agency of God's grace. Although many thinkers, both Protestant and Catholic, insisted on this view for centuries, the Renaissance view is different: individuals may create themselves. They are assumed to have a power of agency-God-given, to be sure-that, in the greatest of achievers, becomes the divine gift of "genius." Thus, in the Renaissance, those who think may overcome the curse of original sin and, in so doing, rise above its devastating load of guilt to make themselves, if they will, what they will. In his Oration on the Dignity of Man (the very title of which constitutes a bold new claim), Giovanni Pico della Mirandola, an ingenious and daring Renaissance philosopher, represents God giving the following permission to every human being in a way that reflects a sharp departure from the medieval sense of humanity's natural helplessness:

The nature of all other beings is limited and constrained within the bounds of laws prescribed by Us. Thou, constrained by no limits, in accordance with thine own free will... shalt ordain for thyself the limits of thy nature. We have set thee at the world's center ... and have made thee neither of heaven nor of earth, neither mortal nor immortal, so that with freedom of choice and with honor ... thou mayest fashion thyself in whatever shape thou shalt prefer.*

This option would have been almost unthinkable in the Middle Ages. Could one really aspire beyond the angels or debase oneself below the beasts and inanimate nature, given one's place in the carefully articulated "chain of being" that God had made permanent?

Whether or not one could indeed so rise or fall, the leaders of the Renaissance were acutely aware of the new possibilities open to their talents and did not fail to recognize, and often advertise, the powers they were confident they possessed. The wide versatility of many Renaissance artists, men like Alberti, Brunelleschi, Leonardo da Vinci and Michelangelo, led them to experimentation and to achievement in many of the arts and sciences. Their accomplishments gave substance to that concept of the archetypal Renaissance genius-l'uomo universale (the universal man). Class distinctions and social hierarchies had loosened, and the ambitious and talented now could take their places even as the friends, companions, and advisers of princes. Such persons could win the award of everlasting fame, and what has been called the "cult of fame" went naturally with the new glorification of individual genius. Indeed, the immortality won through fame may have been more coveted by many great men of the time than the spiritual immortality promised by religion. When the painter Fra Filippo Lippi died in 1469, the town of Spoleto requested that it be allowed to keep his remains. The town fathers argued that Florence, his native city, already had many celebrated men buried within the bounds of its walls.

Petrarch, the great Italian poet and scholar of the fourteenth century, who may be said to have first propounded those peculiarly Renaissance values of versatile individualism and humanism nourished by the study of classical antiquity, has been called the high priest of the "cult of fame" and, by many, the founder of the Renaissance. Petrarch himself was crowned with the ancient symbol of triumph and fame, the laurel wreath, on the Capitoline Hill

*Giovanni Pico della Mirandola, Oratio de hominis dignitate (1485), trans. by E. L. Forbes, in Ernst Cassirer et al., eds., The Renaissance Philosophy of Man (Chicago: University of Chicago Press, 1956), pp. 224–25.

in Rome; the occasion was a celebration of his superb sonnets (written in native Italian), which opened the age of Renaissance literature. Petrarch, in his development of the "cult of fame," postulated that public recognition never is given to an unworthy work of talent and that, therefore, public glory is proof of excellence. After Petrarch, it would be possible to call both great works and great men "divine," as if they belonged to a kind of religious congregation of a new elect; thus it was with *La Divina Commedia* of Dante and with Michelangelo after his death.

Petrarch's eager acceptance of a new concept of Humanism encouraged the resurrection of the spirit of classical antiquity from a trove of ancient manuscripts, which were hunted eagerly, edited, and soon to be reproduced in books made by the new process of mechanical printing. With the help of a new interest in and knowledge of Greek (stimulated by the immigration of Byzantine refugee-scholars after the fall of Constantinople to the Turks), the Humanists of the later fourteenth and fifteenth centuries recovered a large part of the Greek as well as the Roman literature and philosophy that had been lost, left unnoticed, or cast aside in the Middle Ages. The Humanists' greatest literary contribution was, perhaps, the translation of these works, but they also wrote commentaries on them, which they used as models for their own historical, rhetorical, poetic, and philosophical writings. What the Humanists perceived with great excitement in classical writing was a philosophy for living in this world, a philosophy primarily of human focus, that derived not from an authoritative and traditional religious dogma but from reason. The model for the Renaissance is thus no longer the world-despising holy man but rather the great-souled, intelligent man of the world.

Though the Humanism inspired by Petrarch matured and flourished between the late fourteenth and early sixteenth centuries in Renaissance Italy, it was a phenomenon of great complexity, with varying tendencies and emphases, diverging as well as converging doctrines, and personalities often in wordy conflict with one another. Thus, Humanism is not easy to define with comprehensive sureness. The modern philosophy called "humanism," for example, is quite different in many ways from that of the Renaissance. Yet we can say that the early Humanism embraced the ideal of a new kind of practical knowledge, extracted from the literature of classical antiquity and applied to the problems of secular and civil life prevailing in the city culture of the Renaissance. The Humanists thought of themselves as a new kind of professionals, distinct from the clergy, who could improve the human condition by propagating the new knowledge through education and public service. They were educators, publicists, administrators, secretaries, and advisers to princes just as much as they were philosophers, scholars, historians, and poets-and, as we shall see, they were very important for Renaissance art. Though they prized literature and scholarship for their own sake, they sought not so much to recover classical antiquity in all its completeness and correctness, but rather to use it as a basis for pointing a new way to the understanding, conduct, and enjoyment of life.

Medieval scholars possessed a vast body of knowledge that was embodied in the inherited culture of antiquity, but they had viewed this heritage in a different light from that prevalent in the Renaissance. The medieval scholar, usually a theologian, had valued classical learning mostly for its usefulness in arguing Christian dogma; thus, Aquinas could use Aristotle as the authority for arguments based on scriptural revelation, while others could point to secular classical literature as a tool for tempting souls to damnation through atheism and sensuality. The Renaissance Humanists found inspiration in the heroes of antiquity, especially in the accounts of their careers given in Plutarch's *Parallel Lives*. By the fifteenth and sixteenth centuries, even the lives

The lunette in the Sistine Chapel portraying Eleazar and Matthan, ancestors of Christ, has been restored after nearly a decade of meticulous cleaning.

of prominent contemporaries were viewed as appropriate exemplars of life's rule of reason intelligently and nobly followed. The biographies of famous men no longer dealt exclusively with the heroes of antiquity, and artists painted portraits of illustrious contemporaries. The confident, new, "modern" tone rings in Alberti's treatise *On Painting*, in which he congratulates his generation on its achievements:

And I reveal to you, that if it was less difficult for the ancients, having as they had so very many to learn from and imitate, to rise to a knowledge of those supreme arts that are so toilsome for us today, then so much the more our fame should be greater if we, without teachers or any model, find arts and sciences unheard of and never seen.*

Almost prophetically, Alberti asserts that the moderns will go beyond the ancients, but the ancient example had first to be given—both as a model and as a point of departure.

Although the Humanists of the Renaissance received the new message from pagan antiquity with enthusiasm, they did not look on themselves as pagans. It was possible, for example, for the fifteenth-century scholar Lorenzo Valla to prove the forgery of the Donation of Constantine (an early medieval document purporting to record Constantine's bequest of the Roman Empire to the Church) without feeling that he had compromised his Christian faith. The two great religious orders founded in the thirteenth century, the Dominicans and the Franciscans, were as dominant in setting the tone of fourteenth- and fifteenth-century Christian thought as they had been earlier, and they continued to be patrons of the arts. Within these established religious orders, Humanist clerics strengthened rather than weakened the reputation of the Church. Humanists, sometimes while members of religious orders, were appointed to important posts in city government; the Florentine office of chancellor, for example, was held by distinguished men of letters. On the other hand, secular lords like Federigo da Montefeltro, Lord of Urbino (a skilled general, generous governor of his people, Humanist patron of the arts and letters, and renowned lover of books) chose to die in the arms of the Church after a long and pious spiritual preparation. Here and there, the antagonism between the pagan and the Christian traditions may have manifested itself-and certainly it was bound to continue to exist-but, in general, the Renaissance achieved a natural, sometimes effortless, reconciliation of the two.

Not least among the leaders of the new age were the artists who, it appears to a number of modern historians, were among its most significant producers. Indeed, the products of the plastic arts may have been the most characteristic and illustrious of the Renaissance. Although we now perceive much more of the value of Renaissance literature, philosophy, and science, these branches of human creativity seem, in comparison with the plastic arts, to have been less certain, complete, and developed. But it is noteworthy that the separation of the great disciplines was not as clear-cut as it now is; mathematics and art, especially went hand in hand, many Renaissance artists being convinced that geometry was fundamental to the artist's education and practice. In The School of Athens (FIG. 17-16, p. 647), Raphael places his portrait and the portraits of his colleagues among the mathematicians and philosophers, not among the poets. The medieval distinction of ars and scientia is replaced by a concept (now becoming current again) that views them as interrelated. Albrecht Dürer will insist that art without science-that is, technique without a theory relating the artist's skills and observations-is fruitless. The careful observations of the optical world made by Renaissance artists and the integration of

*In E. G. Holt, ed., Literary Sources of Art History (Princeton, NJ: Princeton University Press, 1947), p. 109.

these observations by such a mathematical system as perspective (derived from medieval optics) foreshadow the formulations of the natural sciences. The twentieth-century thinker and mathematician Alfred North Whitehead believed that the habit and temper of modern science are anticipated in the patient and careful observation of nature practiced by the artists of the Renaissance. The methodical pursuit of a system that could bring order to visual experience may necessarily precede the scientific analysis of what lies behind what we see. Thus, the art of the Renaissance may be said to be the first monument to the Western search for order in nature.

The search for order in nature continued in the seventeenth and early eighteenth centuries and was rewarded by the triumph of science in the revolutionary theories developed by Galileo, Kepler, and Newton—theories that stated universal laws of physical nature. In the history of human intelligence, this period has been called the Age of Reason or the Enlightenment. During the Enlightenment, answers to the age-old questions about the structure and causes of the world were sought not so much in the revelations of religion as in the deliverances of experimental science. The spiritual interpretation of nature was replaced by the mechanical, the dynamic. The world came to be seen as a magnificent machine contrived and set in motion by God, who, in the laws offered by the new physics, was thought to have revealed the secret operations that govern creation.

The Age of Reason was also the age of Europe's expansion around the globe, that period of roughly a century and a half between 1600 and 1750 in which the foundations of Europe's colonial empires were secured. It began with the last great wars of religion and closed with the world-transforming industrial, economic, social, and political revolutions that produced the secular, modern world.

For art, this period was the age of the Baroque and Rococo, when a great new surge of creativity took place. Architecture, sculpture, painting, and all the arts of design flourished magnificently throughout Europe, encouraged and patronized by sovereigns royal and aristocratic or republican. In Protestant, republican Holland, as in the lands of the Catholic dynasts of France, Spain, and papal Italy, and in the domains of the Hapsburg emperors, art reached the very highest peaks of accomplishment. The dynamism and expansiveness of the age are reflected in the very projects and principles of artistic design: in the scale and movement of composition, brilliance of color, profusion and opulence of ornament, and in stylistic variety and coherence. Rivaling the ambition and achievement of the scientists, artists in all fields literature, drama, music, and the visual arts-created works of supreme perfection and imperishable worth. They produced and performed with a breadth of inspiration, skill, and virtuosity that emulated the great Renaissance, which indeed they continued. The Age of Reason, the Enlightenment, was also—as it has been called—the Age of Genius.

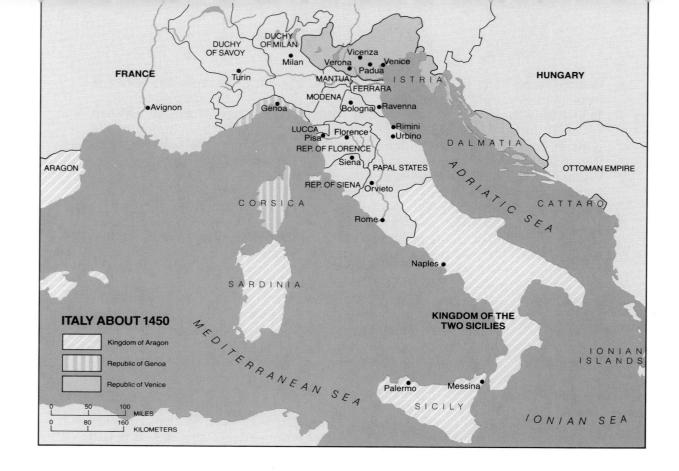

15 The "proto-renaissance" in italy

CHOLARS HAVE LONG been uncertain about how to classify the art of the late thirteenth and the fourteenth centuries. Most of it still looks quite Byzantine or Gothic; in the countries outside Italy, Gothic traits last into the sixteenth century. In Italy, however, a new spirit begins to be felt in art in the late thirteenth century. As this new spirit is in fact that of the emerging Renaissance, it is misleading to define its monuments exclusively as "Gothic," even though Gothic traits are obvious in them. (To be sure, Gothic art itself represents a quickening of naturalism, although not the naturalism of the Renaissance; Gothic naturalism is a principal ingredient in the stylistic complex of the late Medieval world.) What appears in Italy in the thirteenth century is destined to commence a new epoch, one that will have a quite recognizable continuity for centuries-indeed, almost until our own times. To stress the initiative that Italian art takes at this time and to prevent the new epoch from being cut off from its beginnings, we have classified Italian art of the later thirteenth and the fourteenth centuries as "proto-Renaissance." Although it is not until the fifteenth century that Renaissance art makes its not always clear break with the Gothic, one can discern in the proto-Renaissance the advance of novel tendencies that will lead to the new era.

Of course, Italy does not come into historical view only with the Renaissance. After the long period of disorganization in Europe, attendant on the passing of Rome and the age of the migrations, the Italian peninsula held a commanding position in the Mediterranean world, commercially and politically, from the eleventh until the fifteenth century. The power of its city-states on the one hand and of the papacy on the other kept Italy largely independent of the rest of Europe, although Italian influence remained strong. During this time, the country remained politically divided. Economic life as we know it had its beginnings in Italy. Via their fleets, the merchants of Pisa, Genoa, and Venice controlled commerce with Islamic Spain, North Africa, Byzantium, Russia, the Near East, and, overland, with China. The banking houses of Florence and Milan managed the finances of Europe. Southern Italy and Sicily were the sites of cosmopolitan civilizations. Indeed, Italy was powerful and influential centuries before what we call the period of the Renaissance. Ironically, the Renaissance had begun to flower at the time when Italian dominance in the Mediterranean was declining in the face of the expanded role being played by the Ottoman Turks in the east and Spain in the west.

French Gothic art developed and flourished in the regions around Paris under the patronage of the

kings of France. In Italy, the art of the Renaissance was supported by the prosperous merchant classes that ruled the cities after ousting the aristocracies. The reconstitution and expansion of city culture, which began as early as the eleventh century, increasingly had broken down old feudal barriers to the advancement of ambitious people of merit from all classes. Communal government (the Italian cityrepublics were called communes) came into the hands of guilds of merchants and bankers. These magnates and their families ruled not by hereditary right but by the authority of power-a power that, often as not, favored republican institutions; thus, the Medici came to rule in Florence, not as raw tyrants but as a kind of "first among equals." Behind their power was commercial success (their own as well as the city's) and their skill in business government. During the proto-Renaissance, the growth in wealth and power of many Italian cities corresponded with a rise in their wool trade. Florence, in particular, was noted for finished cloth that was sold all over Europe. As their wealth increased, the guilds, including the powerful wool guild, commanded ever-greater political influence; eventually the city, and, with it, much of the patronage of art, was in their hands. Commercial setbacks or jealousies within the guild coalitions created a highly unstable government in which authority frequently changed hands overnight.

In 1378, workmen in Florence attempted to wrest the government from the merchant guilds. This rebellion (the Ciompi revolt) was only one of many social upheavals that followed the disaster of the great plague (the "Black Death"), which almost depopulated the continent in the years 1348-1351. Peasants revolted all over Europe and unrest was widespread among laboring men in the cities. A great and desolating war, destined to last a hundred years, broke out between France and England. The papacy suffered a humiliation that ultimately would destroy its prestige; the popes became puppets of the French monarchy and their residence was moved from Rome to Avignon in southern France. Their sojourn there for some seventy years was climaxed by the Great Schism, when the throne of St. Peter was claimed simultaneously by three popes, who excommunicated one another. Christendom was changed permanently by this scandal, which contributed mightily to the advent of the Protestant Reformation in the sixteenth century.

Yet, despite turbulence and devastation, a powerful vitality was stirring, and confusion was but one aspect of significant and beneficial change. Old ideas and institutions were being challenged and, to a degree, discredited, and people of merit—in this age of Petrarch and Giotto—could feel that the times encouraged setting off in new directions.

Events from the twelfth to the fourteenth centuries constitute a kind of long overture, announcing the advent of full, naturalistic representation in European art. Whether we regard the proto-Renaissance as the end of the overture or the raising of the curtain on the first act, the event, especially in painting, is singularly dramatic. Medieval artists had for centuries depended chiefly on prototypes (pictures and carvings) for representations of the human figure, with an occasional searching glance at objects and persons in the optical world. In the proto-Renaissance, it is the optical world that offers prototype and authority to the artist, though not all at once, of course. Not until the fifteenth century will the "imitation of nature" as an objective give artists direction, and not until the sixteenth will it become theory and doctrine. In the proto-Renaissance, artists' procedures are tentative, as if many were suspicious of an approach that involves fleeting appearances and is devoid of traditionally authoritative formulations. Nevertheless, the experimental groping of artists carefully treading the threshold of discovery infuses the art of the period with a spirit that is hopeful and often confident, if somewhat unsystematic.

Artists are not philosophers, although in the Renaissance they come very close to sharing in the philosophical enterprise. Certainly, in the fourteenth century, the way was opening to tremendous new possibilities that would have to be thought through as well as worked through. In many ways, the situation was similar to that of art today: so many possibilities and such diverse directions that, though rich conclusions may be anticipated, the way to them seems confused.

As the Christian Middle Ages evolved out of the disintegration of the Roman Empire, so a new way of looking at the world emerged from the disintegration of what might be called the medieval style of thought. Distinct from and in opposition to the balanced Scholasticism of Aquinas, the new views were only in part products of the Christian humanism of St. Francis and the secular humanism of Petrarch and the classicizing scholars. The attack on the rationalism of Aquinas made by the later Scholastics and theologians led to the discrediting of philosophy as a valid form of knowledge and to the unseating of reason, with its logical method, as the ruling faculty that produces knowledge. The unity of theology and philosophy, which Aquinas had achieved by bringing together Christian dogma and Aristotelian thought, was broken with theology going off in the direction of mysticism and pure faith, and philosophy yielding to skepticism and the first faint manifestation of that inquisitive bent of mind that would later mature into experimental science. If knowledge of God was impossible to achieve through philosophy and pure reason, so also was knowledge of nature and the world, God's creation. Thus, pure reason came to be despised for its failure to make the mysteries of faith or the world intelligible. In the fifteenth century, Nicholas of Cusa would disparage philosophy as mere "learned ignorance"; in the sixteenth, Martin Luther would call reason a "whore."

A new approach was needed to understand and explain nature and God, and it is necessary to examine the great changes in the Western view of nature that lie behind and accompany fundamental changes in art. William of Ockham, one of the most subtle and ingenious Scholastics who attacked the rationalism of Aquinas, seemed to be providing such an approach when, on the verge of a great insight, he stressed the importance of the role of intuitive knowledge and individual experience in the process of knowing: "Everything outside the soul is individual . . . [and] knowledge which is simple and peculiarly individual . . . is intuitive knowledge. . . . Abstractive individual knowledge presupposes intuitive knowledge . . . our understanding knows sensible things intuitively."

The placement of intuition before abstraction was common to both the mystical and skeptical critics of Aquinas in the fourteenth century and, in effect, put human intuition squarely in front of individual knowledge, whether of God (for the mystic) or of the world (for the skeptic). This elevation of direct human experience constitutes a kind of exaltation of the knowing, human agent. Of course, since Early Christian times and especially since St. Augustine in the fifth century, the tradition of Christian mysticism had been that the experience of God must be personal; knowledge otherwise must be the result of divine illumination. The fourteenth-century advocacy of intuitive experience, therefore, is a kind of renewal of the idea that prevailed before the conviction held by Abelard and Aquinas in the twelfth and thirteenth centuries that truth could be achieved by the intellect only by following rules of rational demonstration. Even in the thirteenth century, the importance of experience in acquiring knowledge had been stressed by the remarkable Roger Bacon, the English philosopher, who bore out his convictions on this point with many astonishingly precocious discoveries and inventions in what now would be called the physical sciences and technology. Calling attention to the existence and necessity of experimental science, Bacon insisted that the experimenter "should first examine visible things . . . without experience nothing can be known sufficiently . . . argumentation [that is, logical, rational demonstration in Aquinas's manner] does not suffice, but experience does." In the universities of the fourteenth century (especially Oxford), the followers of men like Bacon and Ockham discussed questions in physics (the acceleration of freely falling bodies, inertia, the center of gravity, and the like) anticipating by centuries the age of Galileo.

Interestingly, many of the later thirteenth- and fourteenth-century mystical and skeptical thinkers who emphasized personal intuition and experience in seeking divine and natural knowledge were Franciscans. In view of St. Francis's humanizing of medieval religion-making it a matter of intense personal experience and drawing attention to the handiwork of God in the beauty of natural things—it is natural that his successors should inspect nature more closely, with a curiosity that would lead to scientific inquiry. St. Francis's independence and his critical posture toward the religious establishment were passed down to many Franciscans, the more radical of whom often were accused by the Church of association with outright heretics. The Franciscans-conspicuously, William of Ockham-challenged the papacy itself, especially its claim of secular lordship over all Christendom. In these challenges, the rebelliousness that will take mature shape in the Protestant Reformation already is being sounded.

What might be called Franciscan "radicalism," then, stresses the primacy of personal experience, the individual's right to know by experiment, the futility of formal philosophy, and the beauty and value of things in the external world. It was in the stimulating intellectual and social environment created in part by the Franciscans that the painters and sculptors of the proto-Renaissance began a new epoch—an epoch in which the carved and painted image took its shape from the authority of the optical world and what could be found of that authority in the Classical antique. Individual artists, breaking with the formal traditions of a thousand years, now came to depend on their own inspection of the world before their eyes. Applying the Baconian principle of personal discovery through experience-in the artist's case, the experience of seeing-artists began to project in painting and sculpture the infinitely complex and shifting optical reticulum that we experience as the world.

SCULPTURE

Many imitations of the art of classical antiquity may be encountered during the Carolingian, Ottonian,

Romanesque, and French Gothic periods. The statues of the Visitation group on the west façade of Reims Cathedral (FIG. 10-33) show an unmistakable interest in Late Roman sculpture, even though the modeling of the faces reveals their Gothic origin. However, the thirteenth-century sculpture of NICOLA PISANO (active c. 1258–1278), contemporary with the Reims statues, exhibits an interest in the forms of the Classical antique unlike that found in the works of his predecessors. This interest was perhaps due in part to the influence of the humanistic culture of Sicily under its brilliant king, Holy Roman Emperor Frederick II, who, for his many intellectual gifts and other talents, was known in his own time as "the wonder of the world." Frederick's nostalgia for the grandeur that was Rome fostered a revival of Roman sculpture and decoration in Sicily and southern Italy before the mid-thirteenth century. Nicola may have received his early training in this environment, although recently scholars have suggested that his style merely continues that of Romanesque Pisa. After Frederick's death in 1250, Nicola traveled northward and eventually

15-1 NICOLA PISANO, pulpit of the baptistry of Pisa Cathedral, 1259–1260. Marble, approx. 15' high.

settled in Pisa, which was then at the height of its political and economic power and was clearly a place where a proficient artist could hope to find rich commissions.

In typically Italian fashion, Nicola's sculpture was not applied in the decoration of great portals; it is, therefore, quite unlike the French sculpture of the period. Nicola carved marble reliefs and ornament for large pulpits, the first of which he completed in 1260 for the baptistry of Pisa Cathedral (FIG. 15-1). Some elements of the pulpit's design carry on Medieval traditions (for example, the lions supporting some of the columns and the tri-lobed arches), but Nicola evidently is trying to retranslate a Medieval type of structure into Classical terms. The large, bushy capitals are a Gothic variation of the Corinthian; the arches are round rather than ogival; and the large, rectangular relief panels, if their proportions were altered slightly, could have come from the sides of Roman sarcophagi. The densely packed, large-scale figures of the individual panels also seem to derive from the compositions found on Late Roman sarcophagi. In one of these panels, representing The Annunciation and the Nativity (FIG. 15-2), the Virgin of the Nativity reclines in the ancient fashion seen in Byzantine ivories, mosaics, and paintings. But the face-types, beards, coiffures, and draperies, as well as the bulk and weight of the figures are inspired by Classical models and impart a Classical flavor to the relief that is stronger than anything seen in several centuries.

Nicola's classicizing manner was reversed strongly by his son GIOVANNI PISANO (c. 1250-1320). Giovanni's version of The Annunciation and the Nativity (FIG. 15-3), from his pulpit in Sant' Andrea of Pistoia, was finished some forty years after the one by his father in the Pisa baptistry and offers a striking contrast to Nicola's thick carving and placid, almost stolid presentation of the theme. Giovanni's figures are arranged loosely and dynamically; an excited animation twists and bends them, and their activeness is emphasized by spaces that open deeply between them, through which they hurry and gesticulate. In the Annunciation episode, which is combined with the Nativity (as in the older version), the Virgin shrinks from the sudden apparition of the angel in an alarm touched with humility. The same spasm of diffidence contracts her supple body as she reclines in the Nativity scene. The principals of the drama share in a peculiar, nervous agitation, as if they all suddenly are moved by spiritual passion; only the shepherds and the sheep, appropriately, do not yet share in the miraculous event. The swiftly turning, sinuous draperies, the slender figures they enfold, and the general emotionalism of

15-2 NICOLA PISANO, The Annunciation and the Nativity (detail of FIG. 15-1). Marble relief, approx. $34'' \times 45''$.

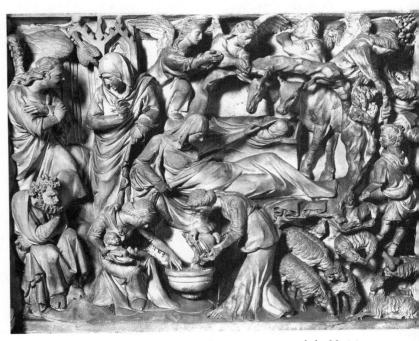

15-3 GIOVANNI PISANO, The Annunciation and the Nativity, 1297–1301, detail of the pulpit of Sant' Andrea, Pistoia. Marble relief, approx. $34'' \times 40''$.

the scene are features to be found not in Nicola's interpretation but in the Gothic art of the north in the fourteenth century. (These linear rhythms and deep currents of Gothic naturalism are evident in most sculpture in Italy throughout the fourteenth century.)

15-4 ANDREA PISANO, south door of the baptistry of Florence Cathedral, 1330–1335. Gilt bronze, approx. 17' high.

15-5 ANDREA PISANO, *The Visitation* (detail of FIG. 15-4). Gilt bronze, approx. 20" high.

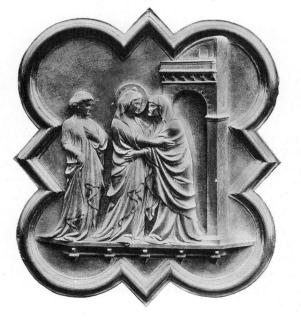

Thus, the works of Nicola and of Giovanni show, successively, two novel trends of great significance for Renaissance art: a new contact with the Classical Antique and a burgeoning, native Gothic naturalism.

Sculpture seems to have been pursued more actively in centers other than Florence until ANDREA PISANO (c. 1270-1348), unrelated to Nicola and Giovanni, was commissioned by the city to make bronze doors for the cathedral baptistry (FIG. 15-4). Each door has fourteen panels, and each panel enframes a quatrefoil, a motif found in Gothic sculpture and illuminations. Within these, as in The Visitation panel (FIG. 15-5), Andrea placed low reliefs with smoothly flowing lines admirably adapted to the complex space of the Gothic frame. The gentle sway of the figures and the bladelike folds of their drapery are quite in the general Late Gothic manner, but Andrea's skill at composition and the quiet eloquence of his narrative make him an outstanding master among the fourteenth-century sculptors who followed the earlier Pisani. The simplicity of Andrea's statements and the amplitude and clear placement of his forms in shallow space also point to the influence of his great contemporary, the painter Giotto di Bondone.

PAINTING

Maniera Greca

Throughout the Middle Ages, Italian painting was strongly dominated by the Byzantine style. This Italo-Byzantine style, or maniera greca, is shown in a panel of the St. Francis Altarpiece (FIG. 15-6) and is a descendant of those tall, aloof, austere figures that people the world of Byzantine art. Painted in tempera (a water-base paint that uses a binder such as glue or egg yolk) on wood panel, St. Francis wears the cinctured canonicals of the order that he founded. He holds a large book and displays the stigmata-the wounds of Christ, imprinted as a sign of Heavenly favor—on his hands and feet. The saint is flanked by two very Byzantine angels and by scenes from his life that strongly suggest that their source is in Byzantine illuminated manuscripts. The central scene on the saint's right represents St. Francis Preaching to the Birds. The figures of St. Francis and his two attendants are aligned carefully against a shallow, stageproperty tower and wall, a stylized symbol of a town or city from Early Christian times. In front of the saint is another stage-scenery image of nested, wooded hills populated by alert and sprightly birds and twinkling plants. The strict formality of the composition (relieved somewhat by the sharply observed birds and the lively stippling of the plants), the shallow

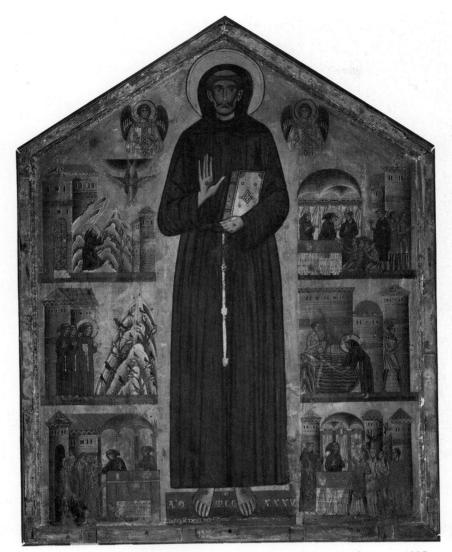

15-6 BONAVENTURA BERLINGHIERI, panel from the St. Francis Altarpiece, 1235. Tempera on wood, approx. $60'' \times 42''$. San Francesco, Pescia.

space, and the linear flatness in the rendering of the forms are all familiar traits of a long and august tradition, soon suddenly and dramatically to be replaced.

BONAVENTURA BERLINGHIERI, artist of the *St. Francis Altarpiece*, was one of a family of painters in the Tuscan city of Lucca. The stirrings of the new artistic movement began largely in the busy cities of Tuscany (Lucca, Pisa, Siena, Florence). Florence was destined to lead the great development toward the new pictorial manner of the Renaissance, just as politically it gradually absorbed the other cities in Tuscany to form the Florentine republic. But during the fourteenth century, its defiant rival, Siena, which had long and stubbornly resisted the encroachment of Florence, was the seat of a rich and productive school of painting of its own.

Duccio

The works of Duccio (Duccio di Buoninsegna, active *c*. 1278–1319) represent the Sienese tradition at its best. Among his large altarpieces, the *Maestà*, showing the Madonna enthroned in majesty as Queen of Heaven amidst choruses of angels and saints, was commissioned for the high altar of Siena Cathedral in 1308 and completed in 1311. As originally executed, it consisted of a seven-foot-high panel with seven pinnacles above and a *predella* below it, all painted on both sides. Unfortunately, the work no longer can be seen in its entirety; it was dismantled in the sixteenth century, and its panels now are scattered throughout the museums of the world. On the front side, the predella showed seven scenes depicting the early life of Christ. Scenes from the last days

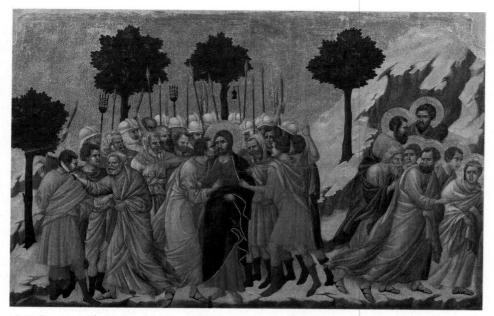

15-7 DUCCIO, The Betrayal of Jesus, detail from the back of the Maestà Altarpiece, 1309–1311. Tempera on wood, size of detail approx. $22\frac{1}{2}'' \times 40''$. Museo dell'Opera del Duomo, Siena.

of the Virgin were represented on the pinnacles. In the numerous panels on the back, Duccio illustrated the later life of Christ—his ministry (on the predella), Passion (on the main panel), the Resurrection and appearances to his disciples (on the pinnacles). On this single large altarpiece, Duccio rivaled the scope and complexity of monumental fresco cycles, such as Giotto's stunning works in the Arena Chapel (see FIG. 15-12).

The altarpiece illustrates the two major aspects of Duccio's mature style. The main panel on the front,

showing the Madonna in majesty, represents the formal, monumental side of his art, which remains essentially Byzantine. In the accompanying small narrative pictures, on the other hand, Duccio relaxed the formalism appropriate to the iconic, symbolic representation of the *Maestà* and revealed his ability not only as a narrator but as an experimenter with new pictorial ideas. In a synoptic sequence on one of the small panels, *The Betrayal of Jesus* (FIG. **15-7**), the artist represents several episodes of the event: the betrayal of Jesus by Judas's false kiss, the disciples fleeing in

15-8 DUCCIO, The Annunciation of the Death of Mary, detail from the Maestà Altarpiece, 1309–1311. Tempera on wood, size of detail approx. 16" × 21". Museo dell'Opera del Duomo, Siena. terror, St. Peter cutting off the ear of the high priest's servant. Although the background, with its golden sky and its cheeselike rock formations, remains traditional, the figures before it have changed quite radically. They are no longer the flat, frontal shapes of Byzantine art but have taken on mass; they are modeled through a range from light to dark, and their draperies articulate around them convincingly. Only their relation to the ground on which they stand remains somewhat in doubt, as they tend to sway, glide, and incline with a kind of disembodied instability. Even more novel and striking is the manner in which the figures seem to react to the central event. Through posture, gesture, and even facial expression, they display a variety of emotions, as Duccio extends himself to differentiate between the anger of Peter, the malice of Judas (echoed in the faces of the throng about Jesus), and the apprehension and timidity of the fleeing disciples. No longer the abstract symbols of Byzantine art, these figures have become actors in a religious drama, which, in a lively performance, is interpreted in terms of thoroughly human actions and reactions. In this and similar narrative panels, Duccio takes a decisive step toward the humanization of religious subject matter-an approach that will become an ever-stronger undercurrent in the development of painting in the centuries to follow.

In *The Annunciation of the Death of Mary* (FIG. **15-8**), from one of the pinnacles of the same altarpiece, Duccio shows that, in the study of interior space, he is the equal of his contemporaries. Although his perspective is approximate, he creates the illusion of an architectural space that *encloses* a human figure. If we could be sure that the sophisticated ancient Roman

painters had not achieved this effect also, we might say that it had never been done before. Certainly, nothing like it is to be found in painting during the nine hundred years preceding Duccio, and it must be regarded as epoch-making even though it was accomplished in a similar manner by Giotto in the Arena Chapel in Padua (FIG. 15-16) a few years before Duccio painted his Maestà. While the angel's position remains ambiguous, the Virgin clearly has been placed in a cubical space that recedes from the picture plane. The illusion is made quite emphatic by the convergence of the three beams in the ceiling, a phenomenon that Duccio observed and recorded. As yet the perspective is not entirely unified, each of Duccio's planes tending to have its own point of convergence. Nevertheless, the illusion is convincing enough and represents the first step in the progressive construction of a true, geometrically ordered, perspective space—an achievement that will be completed in the next century.

Giotto

Duccio resolved his problems within the general framework of the Byzantine style, which he never really rejected. His great Florentine contemporary, GIOTTO (Giotto di Bondone, c. 1266–1337), made a much more radical break with the past. The sources of Giotto's style still are debated, although one must have been the style of the Roman school of painting represented by PIETRO CAVALLINI (active c. 1273–1308). As is shown in a detail from Cavallini's badly damaged fresco of *The Last Judgment* in the church of Santa Cecilia in Trastevere (FIG. **15-9**), the style is

15-9 PIETRO CAVALLINI, Seated Apostles, detail of The Last Judgment, c. 1291. Fresco.* Santa Cecilia in Trastevere, Rome. *Dimensions for wall paintings will not be given from this point on.

15-10 GIOVANNI CIMABUE, Madonna Enthroned with Angels and Prophets, c. 1280–1290. Tempera on wood, 12' 7" × 7' 4". Galleria degli Uffizi, Florence.

characterized by a great interest in the sculptural rendering of form. Cavallini, perhaps under the influence of Roman paintings now lost, abandons Byzantine linearism for a soft, deep modeling from light to dark and achieves an imposing combination of Byzantine hieratic dignity with a long-lost impression of solidity and strength.

Another, perhaps less significant, formative influence on Giotto may have been the work of the man presumed to be his teacher, GIOVANNI CIMABUE (c. 1240–1302). A Florentine, Cimabue must have

been an older rival of Giotto, as Dante suggests in Il Purgatorio (XI, 94–96): "Cimabue thought to hold the field in painting, and now Giotto has the cry, so that the fame of the other is obscured." Inspired by the same impulse toward naturalism as Giovanni Pisano and also influenced, no doubt, by Gothic sculpture, Cimabue (like Cavallini) pushed well beyond the limits of the Italo-Byzantine style. In an almost ruined fresco of the Crucifixion in San Francesco in Assisi, Cimabue's style (like Giovanni Pisano's) can be seen to be highly dramatic; the figures are blown by a storm of emotion. On the other hand, Cimabue is much more formal in his Madonna Enthroned with Angels and Prophets (FIG. 15-10), as the theme here naturally calls for unmoving dignity and not for dramatic presentation. Despite such progressive touches as the three-dimensional appearance of the throne, this vast altarpiece is a final summing-up of centuries of Byzantine art before its utter transformation. Giotto's version of the same theme (FIG. 15-11) shows us what that transformation looked like in its first phase.

The art of Cimabue, the art of Cavallini and of the Roman painters like him (whom Giotto must have seen at work in San Francesco at Assisi), the art of the Gothic sculptors of France (perhaps seen by Giotto himself, but certainly received by him from the sculpture of Giovanni Pisano), and the ancient art of Rome, both sculpture and painting—all must have provided the elements of Giotto's artistic education. Yet no synthesis of these varied influences could have sufficed to produce the great new style that makes Giotto the father of Western pictorial art. Renowned in his own day, his reputation never has faltered. No matter the variety of his materials of instruction, his true teacher was nature—the world of visible things.

Giotto's revolution in painting did not consist only of the displacement of the Byzantine style, the establishment of painting as a major art for the next six centuries, and the restoration of the naturalistic approach invented by the ancients and lost in the Middle Ages. He also inaugurated a firm method of pictorial experiment through observation, and, in the spirit of the experimenting Franciscans, initiated an age that might be called "early scientific." Giotto and his successors, by stressing the preeminence of the faculty of sight in gaining knowledge of the world, laid the trails that empirical science would follow. They recognized that the visual world must be observed before it can be analyzed and understood. Praised in his own and later times for his fidelity to nature, Giotto is more than an imitator of it; he reveals nature in the process of observing it and divining its visible order. In fact, he showed his generation a new way of seeing. With Giotto, Western artists turned

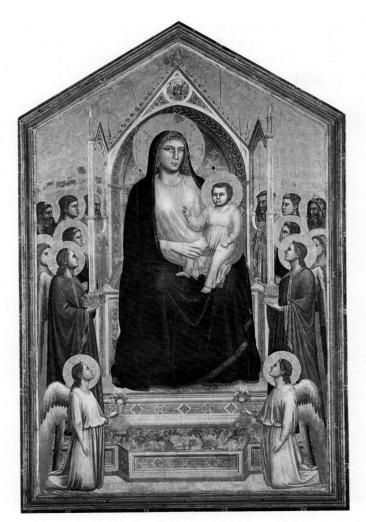

15-11 Giotto, Madonna Enthroned, c. 1310. Tempera on wood, 10' 8" × 6' 8". Galleria degli Uffizi, Florence.

resolutely toward the visible world as the source of knowledge of nature. This new *outward* vision replaced the medieval *inward* vision that searched not for the secrets of nature but for union with God.

In nearly the same great scale as the Madonna painted by Cimabue, Giotto presents her (FIG. **15-11**) in a work that offers an opportunity to appreciate his perhaps most telling contribution to representational art—sculptural solidity and weight. The Madonna, enthroned with angels, rests within her Gothic throne with the unshakable stability of a marble goddess out of antiquity. The slender Virgins of Duccio and Cimabue, fragile beneath the thin ripplings of their draperies, are replaced by a sturdy, queenly mother, corporeally of this world, even to the swelling of the bosom. The body is not lost; it is asserted. The new art aims, before all else, to construct a figure that will have substance, dimensionality, and bulk. Works painted in the new style portray figures, like those in sculpture, which project into the light and throw a shadow or give the illusion that they do. In this work of Giotto, the throne is deep enough to contain the monumental figure and breaks away from the flat ground to project and enclose it.

In Roman painting, we have seen formulas for creating perspective illustration of the spatial world (see FIGS. 6-27, 6-29, 6-32, 6-36, 6-37). But the arrangement of figures in relation to the space they are supposed to occupy is not consistent; most often figures are crowded into the front plane, or seem to move in haphazardly placed planes, much like stage flats. In the art of Byzantium, perspective space is discarded and the figures are set against a flat and often featureless ground (see FIGS. 7-28, 7-36, 7-39, 7-53). Details of the environment, when they are included, are all inscribed, as it were, on the same plane (see FIGS. 7-30 and 7-56). The Islamic illuminated page presents spatial cues, diagonal screens fitted to the surface of the page as color fields to which the figures are attached (see FIG. 7-85). Romanesque painting shows the same disregard of perspective illusion; the figures are simply silhouetted on the neutral space of the picture plane (see FIGS. 9-38, 9-39, 9-40, 9-41, 9-42). Gothic stained glass exhibits similar nonspatial representation (see FIGS. 10-35 and 10-36), though in illumination we begin to feel the painter's concern with spatial description of the environment of the narrative in settings not yet perspectively ordered (see FIG. 10-38). When we match these nonspatial representations of Western figural art between late Roman times and Giotto, we may appreciate the revolutionary character of his work.

THE ARENA CHAPEL

The projection on a flat surface of an illusion of solid bodies moving through space presents a double problem. The construction of the illusion of a body requires, at the same time, the construction of the illusion of a space sufficiently ample to contain that body. In Giotto's fresco cycles (he was primarily a muralist), he constantly is striving to reconcile these two aspects of illusionistic painting. His frescoes in the Arena Chapel (Cappella Scrovegni) at Padua (FIG. 15-12) show us his art at its finest. The Arena Chapel, which takes its name from an ancient Roman amphitheater nearby, was built for Enrico Scrovegni, a wealthy Paduan merchant, on a site adjacent to his now razed palace. This small building, intended for the private use of the Scrovegni family, was consecrated in 1305, and its design is so perfectly suited to its interior decoration that some scholars have suggested that Giotto himself may have been its architect.

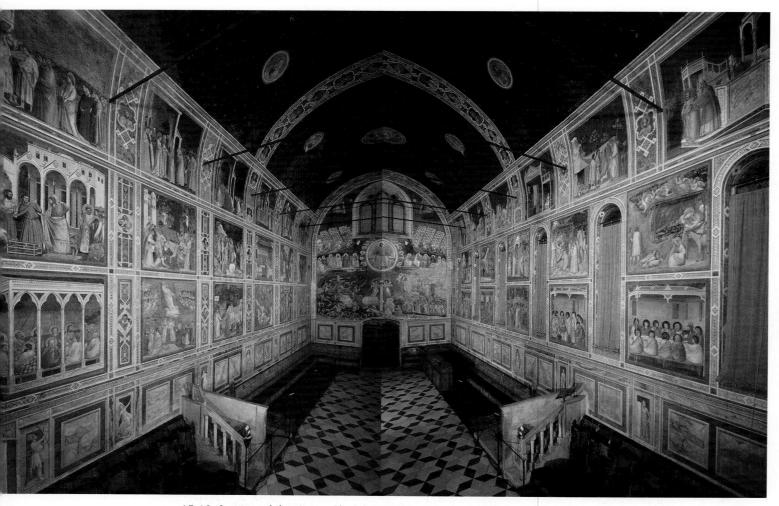

15-12 Interior of the Arena Chapel (Cappella Scrovegni), Padua, 1305-1306.

The rectangular, barrel-vaulted hall has six narrow windows in its south wall only, leaving the entire north wall an unbroken and well-illuminated surface for painting. The entire building seems to have been designed to provide Giotto with as much flat surface as possible for his presentation of one of the most impressive and complete pictorial cycles of Christian Redemption ever rendered. With thirty-eight framed pictures, arranged on three levels, the artist relates the most poignant incidents from the lives of the Virgin and her parents, Joachim and Anna (top), the life and mission of Christ (middle), and his Passion, Crucifixion, and Resurrection (bottom). These three pictorial levels rest on a coloristically neutral base on which imitation marble veneer (reminiscent of the incrustation style of ancient Roman wall decoration [see page 206], which Giotto must have seen) alternates with representations of the Virtues and Vices, which are painted in grisaille (monochrome grevs) to resemble sculpture. The climactic event of the cycle of

human salvation, the Last Judgment, covers most of the west wall above the chapel's entrance.

The hall's vaulted ceiling is blue—an azure sky symbolic of Heaven; it is dotted with golden stars and medallions bearing images of Christ, Mary, and various prophets. The blue of the sky is the same as the color in the backgrounds of the narrative panels on the walls below and functions as a powerful unifying agent for the entire decorative scheme; it serves as visual reinforcement for the spiritual unity and the thematic continuity of the numerous pictured episodes. For the visitor to this remarkable little chapel, the formal and coloristic unity of the decorative ensemble become memorable standards against which other decorative schemes must be measured.

The individual panels are framed with decorative borders, which, with their delicate tracery, offer a striking contrast to the sparse simplicity of the figured representations they surround. Subtly scaled down to the chapel's limited space (the figures are

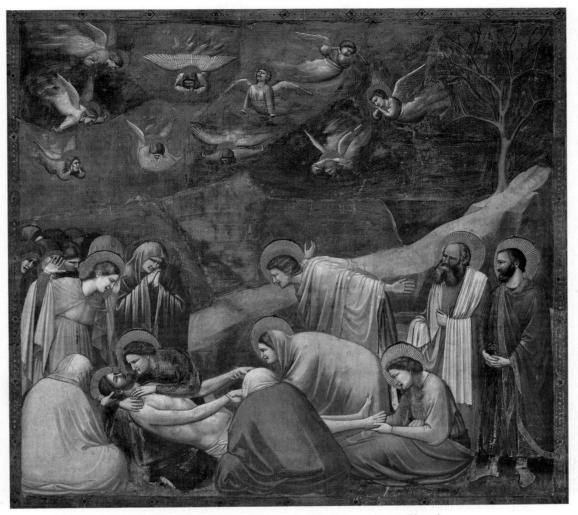

15-13 GIOTTO, Lamentation, c. 1305. Fresco. Arena Chapel.

only about one-half life size), Giotto's stately and slow-moving actors present their dramas convincingly and with great restraint. The essentials of his style are well illustrated by the Lamentation (FIG. 15-13). In the presence of angels, who dart about in hysterical grief, Christ's mother, his disciples, and the holy women mourn over the dead body of the Savior just before its entombment. Giotto has arranged a shallow stage for the figures, bounded by a thick, diagonal scarp of rock that defines a horizontal ledge in the foreground. The rocky landscape links this scene with the adjoining one. Giotto connects the framed scenes throughout the fresco cycle, much as Dante joins the cantos in his epic poem, the Divina Comedia. Though rather narrow, the ledge provides the figures with firm visual support, while the scarp functions as an indicator of the picture's dramatic focal point at the lower left. The centralizing and frontalizing habits of Byzantine art are dismissed

here. The figures are sculpturesque, simple, and weighty, but they are not restrained by their mass from appropriate action. Postures and gestures that might have been only rhetorical and mechanical now convincingly express a broad spectrum of grief that ranges from Mary's almost fierce despair through the passionate outbursts of Mary Magdalene and John, to the philosophical resignation of the two disciples at the right and the mute sorrow of the two hooded mourners in the foreground. Although Duccio makes an effort to distinguish shades of emotion in The Betrayal of Jesus (FIG. 15-7), he does not match Giotto in his stage management of a great tragedy. Giotto, indeed, has constructed a kind of stage, which will serve as a model for those on which many human dramas will be depicted in subsequent paintings. He is now far removed from the old isolation of episodes and actors seen in art until the late thirteenth century. In the Lamentation, a single event provokes a single,

intense response within which degrees of psychic vibration, so to speak, are quite apparent. This integration of the formal with the emotional composition was rarely attempted, let alone achieved, in art before Giotto.

The formal design of the Lamentation fresco, the way the figures are grouped within the contrived space, is worth close study. Each group has its own definition, and each contributes to the rhythmic order of the composition. The strong diagonal of the rocky ledge, with its single dead tree (the tree of knowledge of good and evil, which withered at the fall of Adam), concentrates our attention on the group around the head of Christ, whose positioning is dynamically offcenter. All movement beyond this group is contained, or arrested, by the massive bulk of the seated mourner in the left corner of the painting. The seated mourner to the right establishes a relation with the center group, the members of which, by their gazes and gestures, draw the viewer's attention back to the head of Christ. Figures seen from the back, which are frequent in Giotto's compositions, emphasize the foreground, helping visually to place the intermediate figures further back in space. This device, the very contradiction of the old frontality, in effect puts the

viewer behind the "observer" figures, which, facing the action as spectators, reinforce the sense of stagecraft as a model for paintings with a human "plot." In this age of dawning Humanism, the old Medieval, hieratic presentation of holy mysteries evolved into full-fledged dramas employing a plot. By the thirteenth century, the drama of the Mass was extended first into one- and two-act tableaus and scenes and then into simple shows, often presented at the portals of churches. (The portal statuary of the Gothic period suggests a discourse among the represented saints, and the architectural settings serve to enframe and enclose them, as a stage does the movement of its actors.) Thus, the arts of illusionistic painting and of drama were developing simultaneously, and the most accomplished artists of the Renaissance and later periods became masters of a kind of stage rhetoric of their own. Giotto, the first master of the tradition, was one of the most expert in the matching of form and action; it is difficult to exaggerate his trailblazing achievement.

SANTA CROCE

For the Franciscan church of Santa Croce in Florence, Giotto painted a St. John cycle and frescoes of

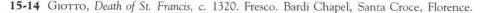

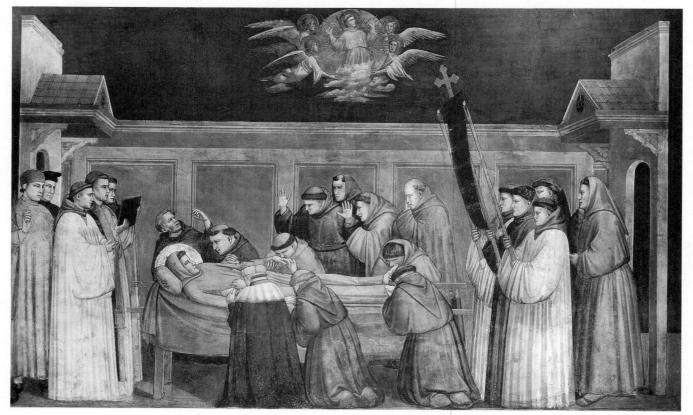

the life and death of St. Francis. Our illustrations show the *Death of St. Francis*, as restored in the nineteenth century (FIG. **15-14**) and with the restorations removed (FIG. **15-15**).* Fortunately, despite the removal of the restorations and the resultant gaps in the composition, enough of the original *Death of St. Francis* remains to give us an idea of the later style of Giotto. Although the St. Francis painting has considerable spiritual affinity with the *Lamentation*, it also shows significant changes. The Gothic agitation has quieted, and the scene has little of the jagged emotion of the *Lamentation*. It seems, indeed, as if the artist had watched the solemn obsequies from offstage. We see the saint, at center on his bier, flanked by kneeling and standing monks; the kneeling figures

*This painting exemplifies another aspect of the problem of attribution and authenticity. Until the historically sensitive twentieth century, it had long been the custom to "renew" old pictures by painting over damaged or faded areas. Modern scholars, in their zeal to know the "real" painter, have advocated stripping even where this leaves only fragments that are perhaps esthetically unsatisfactory. The practice remains controversial, and the historian of art, the expert, the connoisseur, and, ultimately, the layman always have before them the question of the authenticity of the given work.

are seen from behind, in Giotto's fashion. Stately processions of friars in profile come from left and right, as they would be seen in actuality-not frontally, as in a Byzantine procession like that of Justinian and Attendants at San Vitale (FIG. 7-36). The figures are accommodated carefully on an architecture-enclosed, stagelike space that has been widened and no longer leaves any doubt that the figures have sufficient room in which to move about. They are taller and have lost some of their former sacklike bulk; Giotto now makes a distinction between the purely form-defining function of the robes and the fact that they are draped around articulated bodies. The impressive solemnity of the procession is enhanced by the omission of the casual and incidental beauties of the world so dear to Sienese and Gothic painters. Giotto sees and records nature in terms of its most basic facts: solid volumes resting firmly on the flat and horizontal surface of the earth. He arranges his figures in meaningful groups and infuses them with restrained emotions that are revealed in slow and measured gestures. With the greatest economy of means, Giotto achieves unsurpassed effects of monumentality, and his paintings, because of the simplicity and directness of their statements, are among the most memorable in world art.

15-15 GIOTTO, Death of St. Francis (FIG. 15-14 after removal of nineteenth-century restorations).

15-16 GIOTTO, The Meeting of Joachim and Anna, c. 1305. Fresco. Arena Chapel.

15-17 TADDEO GADDI, *The Meeting of Joachim and Anna*, 1338. Fresco. Baroncelli Chapel, Santa Croce, Florence.

Giotto's murals in the Bardi and Peruzzi chapels of Santa Croce served as textbooks for generations of Renaissance painters from Masaccio to Michelangelo and beyond. These later artists were able to understand the greatness of Giotto's art better than his immediate followers, who never were capable of absorbing more than a fraction of his revolutionary innovations. Their efforts usually remained confined to the emulation of his plastic figure description. Giotto's foster son and his assistant for many years, TADDEO GADDI (c. 1300–1366), is a good example of a diligent follower. The differences between the work of a great artist and that of a competent one are readily apparent if we compare Giotto's The Meeting of Joachim and Anna in the Arena Chapel (FIG. 15-16) with Taddeo's version of the same subject in the Baroncelli Chapel in Santa Croce (FIG. 15-17). Giotto's composition is simple and compact. The figures are related carefully to the single passage of architecture (the Golden Gate), where the parents of the Virgin meet in triumph in the presence of splendidly dressed ladies. The latter mock the cloaked servant who refused to believe that the elderly Anna (St. Anne) would ever bear a child. The story, related in the Apocrypha, is managed with Giotto's usual restraint, clarity, and dramatic compactness. Taddeo allows his composition (FIG. 15-17) to become somewhat loose and unstructured. The figures have no clear relation to the background; the elaborate cityscape, though pleasant in itself, demands too much attention and detracts from the action in the foreground. Gestures have become weak and theatrical, and the hunter (discreetly cut off and unobtrusive in Giotto's painting) here strides boldly toward the center of the scene—a picturesque genre subject that weakens the central theme. Although his figures retain much of Giotto's solidity, Taddeo's painting weakens the dramatic impact of the story by elaborating its incidental details. Giotto stresses the essentials and, by presenting them with his usual simplicity and forceful directness, gives the theme a much more meaningful interpretation. Yet we must not seem to disparage Giotto's contemporaries and followers. Taddeo presses forward the investigation of perspective, as his cityscape reveals, and the genre figure attests to the development of a keen interest in realism.

Simone Martini and the International Style

Duccio's successors in the Siena school display even greater originality and assurance than did Duccio himself. SIMONE MARTINI (c. 1285–1344) was a

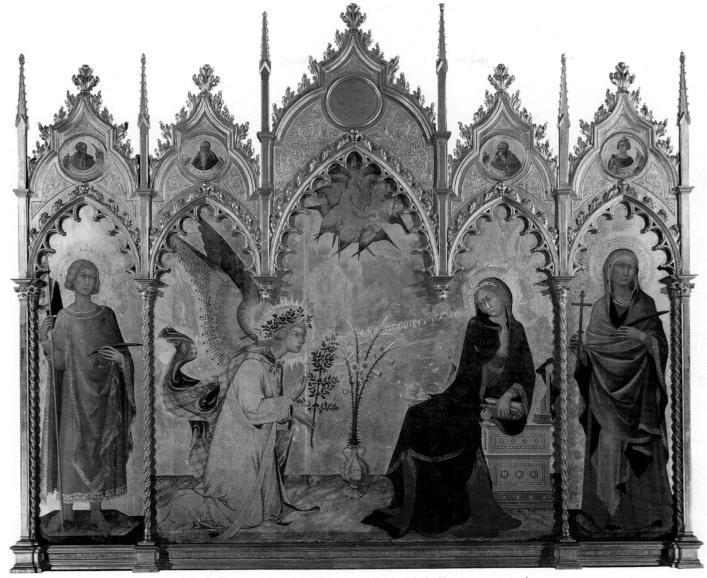

15-18 SIMONE MARTINI, *The Annunciation*, 1333. Tempera on wood, approx. $10' 1'' \times 8' 8_4^{3''}$ (frame reconstructed in the nineteenth century). Galleria degli Uffizi, Florence.

pupil of Duccio and a close friend of Petrarch, who praised him highly for his portrait of "Laura" (the woman to whom Petrarch dedicated his sonnets). Simone worked for the French kings in Naples and Sicily and, in his last years, was employed at the papal court at Avignon, where he came in contact with northern painters. By adapting the insubstantial but luxuriant patterns of the French Gothic manner to Sienese art and, in turn, by acquainting northern painters with the Sienese style, Simone became instrumental in the formation of the so-called International style, which swept Europe during the late fourteenth and early fifteenth century. This style appealed to the aristocratic taste for brilliant color, lavish costume, intricate ornament, and themes involving splendid processions in which knights and their ladies, complete with entourages, horses, and greyhounds, could glitter to advantage.

Simone's own style does not quite reach the full exuberance of the developed International style, but his famous *Annunciation* altarpiece (FIG. **15-18**) is the perfect antithesis of the style of Giotto, whose work Simone certainly must have been aware of, but whose art just as certainly left him untouched. The Annunciation is characterized by elegant shapes and radiant color; flowing, fluttering line; and weightless figures in a spaceless setting. The complex etiquette of the chivalric courts of Europe dictates the presentation. The angel Gabriel has just alighted, the breeze of his passage lifting his mantle, his iridescent wings still beating. The white and gold of his sumptuous gown heraldically represent the celestial realm whence he bears his message. The Virgin, putting down her book of devotions, shrinks demurely from Gabriel's reverent genuflection, an appropriate gesture in the presence of royalty. She draws about her the deep blue, golden-hemmed mantle, the heraldic colors she wears as the Queen of Heaven. Despite the Virgin's modesty and diffidence and the tremendous import of the angel's message, the scene subordinates drama to court ritual and structural experiments to surface splendor. The painted splendor is matched by the intricate tracery of the richly tooled, late Gothic frame. Of French inspiration, it replaces the more sober, clean-cut shapes that were traditional in Italy, and its appearance here is eloquent testimony to the two-way flow of transalpine influences that fashioned the International style.

The altarpiece is dated 1333 and signed by Simone Martini and his student and assistant, Lippo Memmi. Lippo's contribution to the Annunciation is still a matter of debate, but historians now generally subscribe to the theory that he painted the two lateral saints, St. Ansano and his godmother, St. Maxima (?). These figures, which are reminiscent of the jamb statues of Gothic church portals, are drawn a little more solidly and lack the linear elegance of Simone's central pair. Given medieval and Renaissance workshop practices, it is often next to impossible to distinguish the master's hand from that of his assistants, especially if part of the latters' work was corrected or partially redone by the master. Generally, assistants were charged with the gilding of frames and backgrounds, the completion of decorative work, and, occasionally, the rendering of architectural settings. Figures, especially those that were central to the represented subject, were regarded as the most important and difficult parts of a painting and were the master's responsibility. Assistants might be allowed to paint some of the less important, marginal figures, but only under the master's close supervision. Among the numerous contracts for paintings that have survived from this period some are quite specific in spelling out the master's responsibilities, stipulating that the major parts of the work be executed by his hand and his alone. As we move from the anonymity of Medieval art toward the artist's emancipation during the Renaissance (when he rises from the rank of artisan to that of artist-scientist), the value of his individual skillsand his reputation—become increasingly important to his patrons and clients.

The Lorenzetti

The brothers Lorenzetti, also students of Duccio, share in the general experiments in pictorial realism that characterize the fourteenth century, especially in their seeking of convincing spatial illusions. Going well beyond his master, PIETRO LORENZETTI (active 1320–1348) achieved remarkable success in a large panel representing The Birth of the Virgin (FIG. 15-19). The wooden architectural members that divide the panel into three compartments are represented as extending back into the painted space, as if we were looking through the wooden frame (apparently added later) into a boxlike stage, where the event takes place. The illusion is strengthened by the fact that one of the vertical members cuts across one of the figures, blocking part of it from view. Whether this architecture-assisted perspective illusion was intentional is problematical; in any case, the full significance of the device of pictorial illusion enhanced by applied architectural parts was not realized until the next century. No precedent for it exists in the history of Western art, but a long, successful history of such visual illusions produced by a union of real and simulated architecture with painted figures was to develop during the Renaissance and Baroque periods. Pietro did not make just a structural advance here; his very subject represents a marked step in the advance of worldly realism. St. Anne, reclining wearily as the midwives wash the child and the women bring gifts, is the center of an episode that takes place in an upper-class Italian house of the period. A number of carefully observed domestic details and the scene at the left, where Joachim eagerly awaits the news of the delivery, place the events in an actual household, as if we had moved the panels of the walls back and peered inside. The structural innovation in illusionistic space becomes one with the new curiosity that leads to careful inspection and recording of what lies directly before our eyes in the everyday world.

Pietro's brother, AMBROGIO LORENZETTI (active 1319–1348), elaborated the Sienese advances in illusionistic representation in spectacular fashion in a vast mural in the Palazzo Pubblico. The effects of good and bad government are allegorically juxtaposed here in the *Good Government* fresco. Good Government is represented as a majestic, enthroned figure flanked by the virtues of Justice, Prudence, Temperance, and Fortitude, as well as by Peace and Magnanimity; above hover the theological virtues of Faith, Hope, and Charity. In the foreground, the citizens of Siena advance to do homage to Good Government

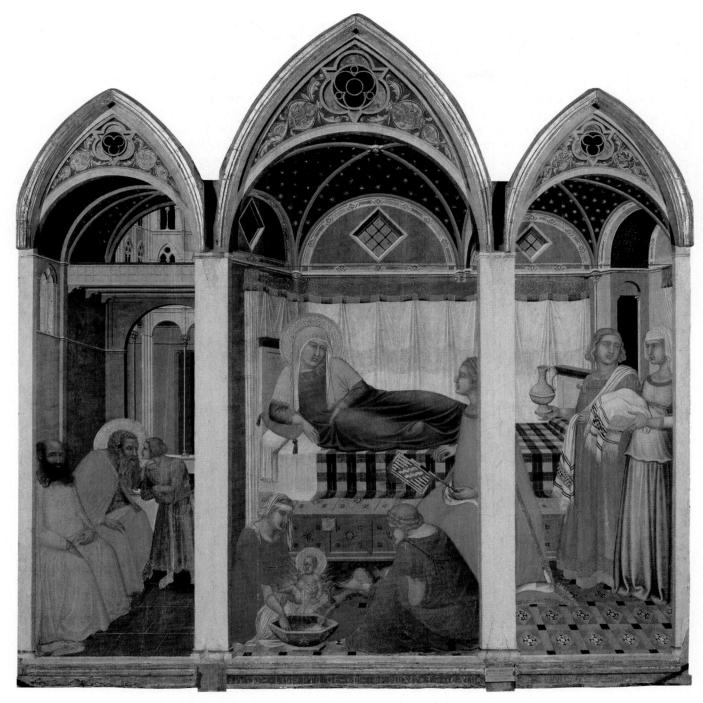

15-19 PIETRO LORENZETTI, *The Birth of the Virgin*, 1342. Tempera on wood, approx. $6' 1'' \times 5' 11''$. Museo dell'Opera del Duomo, Siena.

ment and all the virtues that accompany it. The turbulent politics of the Italian cities, the violent party struggles, the overthrow and reinstatement of governments would certainly have called for solemn reminders of the value of justice in high places, and the city hall would be just the place for a painting like Ambrogio's. Beyond the allegories and the dedication scene stretch the depictions of the fruits of Good Government, both in the city and the countryside. The *Peaceful City* (FIG. **15-20**) is a panoramic view of Siena itself, with its clustering palaces, markets, towers, churches, streets, and walls. The traffic of the city moves peacefully, the guildsmen ply their trades and crafts, and a cluster of radiant maidens, hand in

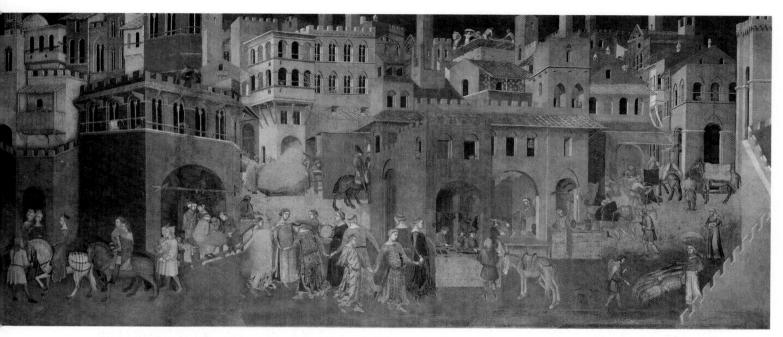

15-20 AMBROGIO LORENZETTI, Peaceful City, detail from the fresco Allegory of Good Government: The Effects of Good Government in the City and the Country, Sala della Pace, Palazzo Pubblico, Siena, 1338–1339.

hand, perform a graceful, circling dance. The artist fondly observes the life of his city, and its architecture gives him an opportunity to apply Siena's rapidly growing knowledge of perspective. Passing through the city gate to the countryside beyond its walls, Ambrogio's *Peaceful Country* (FIG. **15-21**) presents a bird's-eye view of the undulating Tuscan countryside—its villas, castles, plowed farmlands, and peasants going about their seasonal occupations. An allegorical figure of Security hovers above the landscape, unfurling a scroll that promises safety to all who live under the rule of the law. In this sweeping view of an actual countryside, we have the first appearance of landscape since the ancient world. The difference is

15-21 AMBROGIO LORENZETTI, Peaceful Country, detail from the fresco Allegory of Good Government: The Effects of Good Government in the City and the Country.

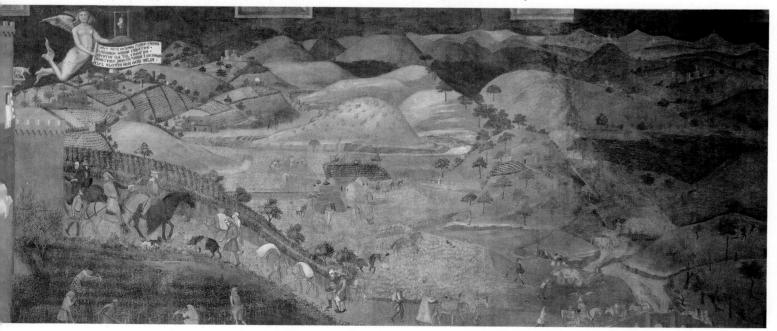

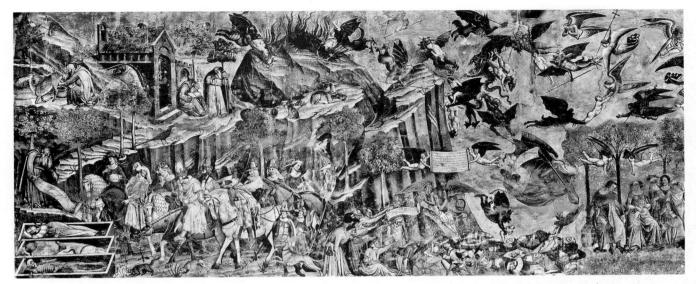

15-22 BUONAMICO BUFFALMACCO OF FRANCESCO TRAINI (?), The Triumph of Death, c. 1340. Fresco. Campo Santo, Pisa.

that now the landscape—as well as the view of the city—is particularized by careful observation, being given almost the character of a portrait of a specific place and environment in a desire for authenticity. By combining some of Giotto's analytical powers with the narrative talent of Duccio, Ambrogio is able to achieve more spectacular results than those of either of his two great predecessors.

The Black Death may have ended the careers of both Lorenzettis; nothing is heard of them after 1348, the year that brought so much horror to defenseless Europe. An unusual and fascinating painting relates this common late Medieval theme. In *The Triumph of Death* (FIG. **15-22**) in the Campo Santo at Pisa, attributed to FRANCESCO TRAINI (active *c*. 1321–1363) and, more recently, to BUONAMICO BUFFALMACCO (active during the early fourteenth century), three young aristocrats and their ladies, mounted in a stylish cavalcade, encounter three coffin-encased corpses in differing stages of decomposition. As the horror of the

confrontation with death strikes them, the ladies turn away with delicate and ladylike disgust and a gentleman holds his nose (the animals, horses and dogs, sniff excitedly). A holy hermit unrolls a scroll that demonstrates the folly of pleasure and the inevitability of death. In another section to the right, the ladies and gentlemen, wishing to forget dreadful realities, occupy themselves in an orange grove with music, gallantries, and lapdogs, while all around them death and judgment occur and angels and demons struggle for souls. The medieval message is as strong as ever, but gilded youth refuses to acknowledge it. The painting applies all the stock of Florentine-Sienese representational craft to present the most worldlyand mortal-picture of the fourteenth century. It is an irony of history that, as Western humanity draws both itself and the world into ever-clearer visual focus, it perceives ever more clearly that corporeal things are perishable.

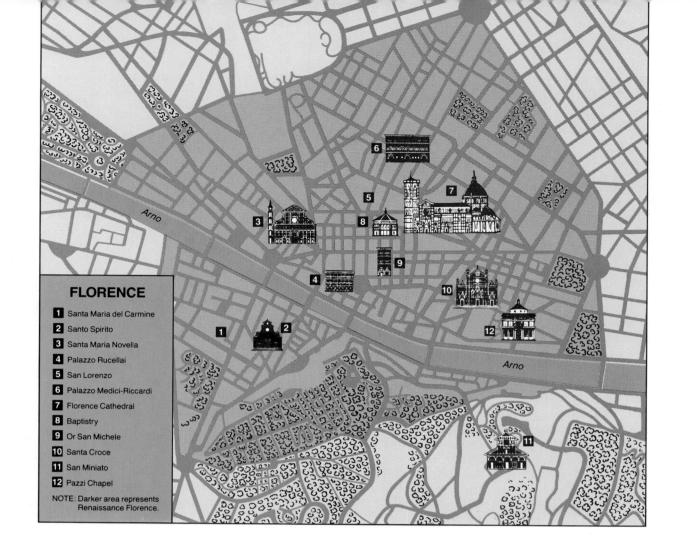

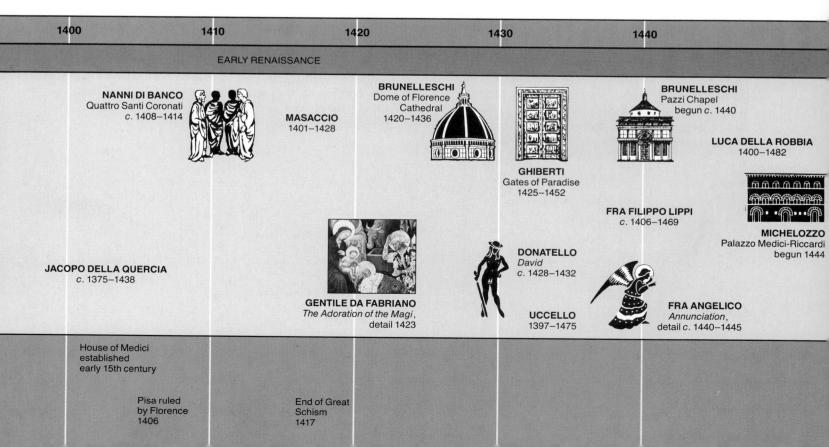

FIFTEENTH-CENTURY ITALIAN ART

16

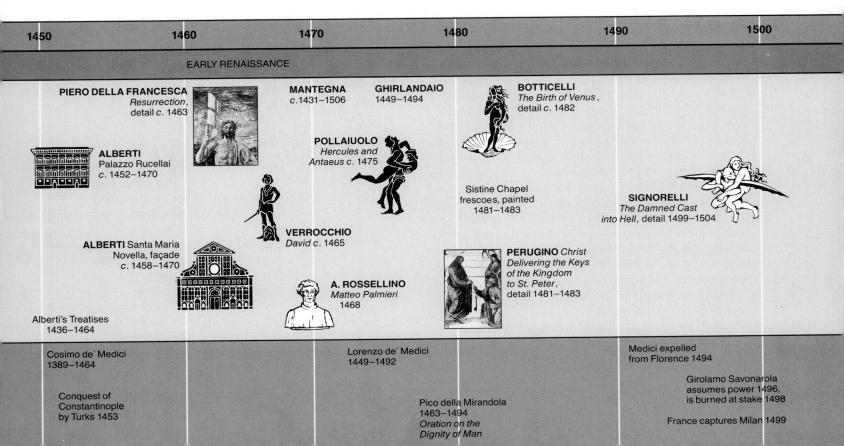

LORENCE took cultural command of Italy early in the fifteenth century, inaugurating the Renaissance and establishing itself as the intellectual and artistic capital of southern Europe—a position of dominance it was to retain until the end of the century. According to John Addington Symonds, a nineteenth-century historian of the Renaissance:

Nowhere else except at Athens has the whole population of a city been so permeated with ideas, so highly intellectual by nature, so keen in perception, so witty and so subtle, as at Florence. . . . The primacy of the Florentines in literature, the fine arts, law, scholarship, philosophy, and science was acknowledged throughout Italy.*

The power and splendor of Florence had been building for many years; the fifteenth century marked its perfection. Like the Athenians after the repulse of the Persians, the citizens of Florence (who felt a historical affinity with the Athenians) responded with conscious pride to the repulse of the dukes of Milan, who had attempted the conquest of Tuscany. The Florentines also developed a culture that was stimulated and supported by a vast accumulation of wealth, a situation much like that in Athens, but only a few illustrious Florentine families controlled that wealth.

The Medici, bankers to all Europe, became such lavish patrons of art and learning that, to this day, the name "Medici" means a generous patron of the fine arts. For centuries, the history of Florence is the history of the House of Medici. Early in the fifteenth century, Giovanni de' Medici had established the family fortune. His son Cosimo, called the "father of his country" by the Florentines, secured the admiration and loyalty of the people of Florence against the noble and privileged. With this security, the Medici gradually became the discreet dictators of the Florentine republic, disguising their absolute power behind a mask of affable benevolence. Scarcely a great architect, painter, sculptor, philosopher, or Humanist scholar was unknown to the Medici. Cosimo began the first public library since the ancient world, and historians estimate that in some thirty years he and his descendants expended almost \$20 million for manuscripts and books; such was the financial power behind the establishment of Humanism in the Renaissance. Careful businessmen that they were, the Medici were not sentimental about their endowment of art and scholarship. Cosimo declared that his good works were "not only for the honor of God but . . . likewise for my own remembrance." Yet the astute

businessman and politician had a sincere love of learning, reading Plato in his old age and writing to his tutor, the Neo-Platonic philosopher Marsilio Ficino, "I desire nothing so much as to know the best road to happiness."

Cosimo is the very model of the cultivated, Humanist grandee. His grandson, Lorenzo the Magnificent, went even beyond his grandfather in munificence, as his name suggests. A talented poet himself, he gathered about him a galaxy of artists and gifted men in all fields, extending the library Cosimo had begun, revitalizing his academy for the instruction of artists, establishing the Platonic Academy of Philosophy, and lavishing funds (often the city's own) on splendid buildings, festivals, and pageants. If his prime motive was to retain the affection of the people and, thus, the power of the House of Medici, he nevertheless made Florence a city of great beauty, the capital of all the newly flourishing arts. His death, in 1492, brought to an end the golden age of Florence, and the years immediately following saw Italy invaded by the "barbarian" nations (as the Italians called them) of France, Spain, and the Holy Roman Empire. The Medici were expelled from Florence; the reforming, fanatical Girolamo Savonarola preached repentance in the cathedral of Florence; and the Renaissance moved its light and its artists from Florence to Rome. But one of the most prominent patrons of the Roman Renaissance, Pope Leo X, benefactor of Raphael and Michelangelo, was himself a Medici, the son of Lorenzo the Magnificent. Never in history was a family so intimately associated with a great cultural revolution. We may safely say that the Medici subsidized and endowed the Renaissance.

THE FIRST HALF OF THE FIFTEENTH CENTURY

Sculpture

The spirit of the Medici and of the Renaissance was competitive and desirous of fame. But even before Medici rule, civic competitiveness and pride had motivated the adornment of Florence. The history of the Early Renaissance in art begins with an account of a competition for a design for the east doors of the baptistry of Florence (doors later moved to the north entrance). Andrea Pisano had designed the south doors of the same structure almost three generations earlier (FIG. 15-4). LORENZO GHIBERTI (1378–1455), the sculptor who won the competition, describes his victory in terms that reflect the egoism and the "cult of fame" characteristic of the period and of Renaissance artists in general:

^{*}John Addington Symonds, *Renaissance in Italy* (New York: Modern Library, 1935), Vol. 1, p. 125.

To me was conceded the palm of the victory by all the experts and by all . . . who had competed with me. To me the honor was conceded universally and with no exception. To all it seemed that I had at that time surpassed the others without exception, as was recognized by a great council and an investigation of learned men . . . highly skilled from the painters and sculptors of gold, silver, and marble. There were thirty-four judges from the city and the other surrounding countries. The testimonial of the victory was given in my favor by all. . . . It was granted to me and determined that I should make the bronze door for this church.*

This passage also indicates the esteem and importance now attached to art, with leading men of a city bestowing eagerly sought-for commissions and great new programs of private and public works being undertaken widely.

The contestants seeking to design the doors represented the assigned subject, *The Sacrifice of Isaac*, within panels shaped like the Gothic quatrefoil used by Andrea Pisano for the south doors of the baptistry. Only the panels by FILIPPO BRUNELLESCHI and Ghiberti have survived. Brunelleschi's panel (FIG. **16-1**) shows a sturdy and vigorous interpretation of the theme, with something of the emotional agitation

*In E. G. Holt, ed., *Literary Sources of Art History* (Princeton, NJ: Princeton University Press, 1947), pp. 87–88.

16-1 FILIPPO BRUNELLESCHI, *The Sacrifice of Isaac*, competition panel for the east doors of the baptistry of Florence, 1401-1402. Gilt bronze relief, $21'' \times 17''$. Museo Nazionale del Bargello, Florence.

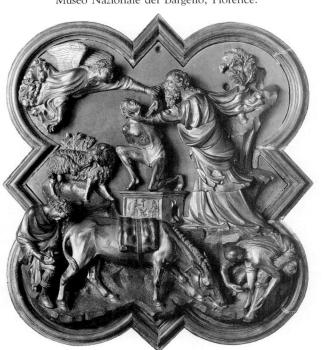

of the tradition of Giovanni Pisano (FIG. 15-3). Abraham seems suddenly to have summoned the dreadful courage needed to kill his son at God's command; he lunges forward, draperies flying, exposing Isaac's throat to the knife with desperate violence. Matching Abraham's energy, the saving angel darts in from the left, arresting the stroke just in time. Brunelleschi's figures are carefully observed and display elements of a new realism. Yet his composition is perhaps overly busy, and the figures of the two servants and the donkey are not subordinated sufficiently to the main action.

We can make this criticism more firmly when we compare Brunelleschi's panel to Ghiberti's (FIG. 16-2). In the latter, vigor and strength of statement are subordinated to grace and smoothness; little of the awfulness of the subject appears. Abraham sways elegantly in the familiar Gothic S-curve and seems to feign a deadly thrust rather than aim it. The figure of Isaac, beautifully posed and rendered, recalls ancient Classicism and could be regarded as the first really classicizing nude since antiquity. Ghiberti was trained as both a goldsmith and a painter, and his skilled treatment of the fluent surfaces, with their sharply and accurately incised detail, evidences his goldsmith's craft. As a painter, he shares the painter's interest in spatial illusion. The rocky landscape seems to emerge from the blank panel toward us, as

16-2 LORENZO GHIBERTI, *The Sacrifice of Isaac*, competition panel for the east doors of the baptistry of Florence, 1401–1402. Gilt bronze relief, $21'' \times 17''$. Museo Nazionale del Bargello, Florence.

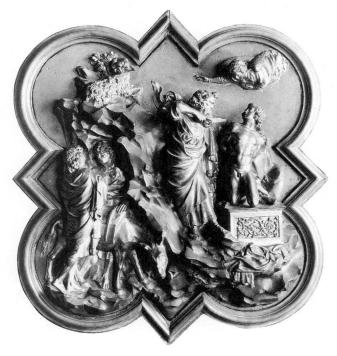

does the strongly foreshortened angel. These pictorial effects, sometimes thought alien to sculpture, are more developed in Ghiberti's later work. The execution of a second pair of doors for the baptistry (FIG. 16-10) testifies to his extraordinary skill in harmonizing the effects peculiar to sculpture and painting. Here, however, within the limits of the awkward shape of the Isaac panel, Ghiberti achieves a composition that is perhaps less daring than Brunelleschi's but more cohesive and unified, and the jury's choice probably was fortunate for the course of art, despite accusations of collusion by Brunelleschi's biographer, Manetti. One result of the decision was, apparently, that it helped Brunelleschi to resolve his indecision about his proper calling. Subordinating sculpture to a less important role, he became the first great architect of the Renaissance. As for Ghiberti, his conservative style would be modified greatly by the discoveries of his contemporaries, and their influence on him would be visible in the set of doors he designed later for the east entrance of the baptistry.

The artists of Florence in the early Renaissance sometimes are classified as "conservative" or "progressive," depending on whether they cling to the International Gothic style or take up the new pictorial experimentalism. The classification cannot be applied consistently, however, for some artists who keep to the old conventions still occasionally adopt what they can use from their more experimental contemporaries when they can make it consistent with their own styles. Both conservative and progressive works may be of the highest quality, and we should not think that their excellence is merely a function of their being up to date or avant-garde. In some cases, too fertile and inventive an imagination may outrace the artist's powers to systematize his efforts and become detrimental to his development.

JACOPO DELLA QUERCIA (c. 1375–1438), a Sienese sculptor competing for the baptistry commission, was perhaps the only non-Florentine sculptor of first rank in the fifteenth century. In comparison with the early work of Ghiberti, Jacopo's is progressive. His panel, The Expulsion from the Garden of Eden (FIG. 16-3), from a series of reliefs enframing the portal of San Petronio in Bologna, is carved in shallow relief and set into the frame in a closely knit pattern of curves and diagonals. The figures are constructed so that they seem capable of breaking out of the confines of the relief. A robust energy animates the powerful, heavily muscled forms and recalls the ideal Classical athletes. The conventional Gothic slenderness and delicacy are gone, and Jacopo's massive, monumental forms herald the grand style of the Renaissance. Indeed, although his style is without influence in Florence, he was to be rediscovered by Michelangelo at the end of

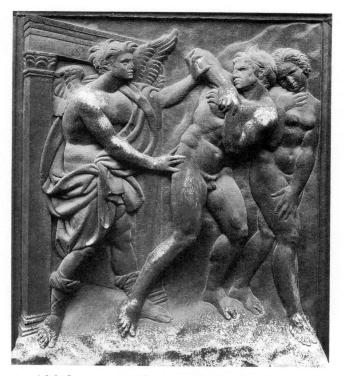

16-3 JACOPO DELLA QUERCIA, The Expulsion from the Garden of Eden, c. 1430. Istrian stone, $34'' \times 27''$. Main portal, San Petronio, Bologna, Italy.

the fifteenth century; the latter's debt to Jacopo is clearly visible in the great Florentine's painting of the same subject in the Sistine Chapel ceiling.

As the Sienese artist turned to the observation of the mechanics of the human body, a Florentine artist, NANNI DI BANCO (c. 1380–1421), began to explore that other popular avenue of Humanistic research, the antique. His life-size figures of four martyred saints, Quattro Santi Coronati (FIG. 16-4), represent the patron saints of the Florentine guild of sculptors, architects, and masons. The group, set into the outside wall of the Medieval church of Or San Michele in Florence, is an early near-solution to the Renaissance problem of integrating figures and space on a monumental scale. With these figures, we are well on the way to the great solutions of Masaccio and of the masters of the High Renaissance. The emergence of sculpture from the architectural matrix, a process that began in such works as the thirteenth-century statues of the west front of Reims Cathedral (FIG. 10-33), is almost complete in Nanni's figures, which stand in a niche that is in but that confers some separation from the architecture. This spatial recess permits a new and dramatic possibility for the interrelationship of the figures. By placing them in a semicircle within their deep niche and relating them to one another by their postures and gestures, as well as by the arrangement of draperies, Nanni has achieved a wonderfully unified spatial composition. The persisting dependence on the architecture may be seen in the abutment of the two forward figures and the enframement of the niche and in the position of the two recessed figures, each in front of an engaged half-column. Nevertheless, these unvielding figures, whose bearing (as in Roman art and stoicism) expresses the discipline through which men of passionate conviction attain order and reason, are joined in a remarkable psychological unity. While the figure on the right speaks, pointing to his right, the two men opposite listen and the one next to him looks out into space, pondering the meaning of the words. Such reinforcement of the formal unity of a figural group with psychological crossreferences will be exploited by later Renaissance artists, particularly Leonardo da Vinci.

16-4 NANNI DI BANCO, Quattro Santi Coronati, c. 1408–1414. Marble, figures approx. life size. Or San Michele, Florence.

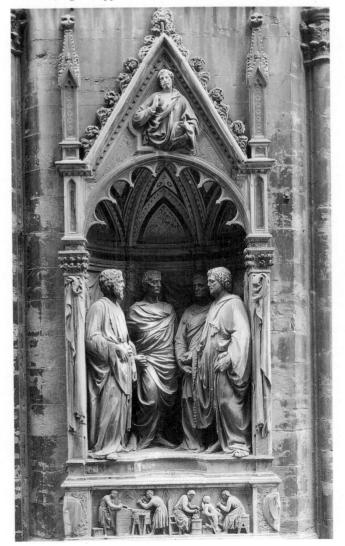

Nanni has before him the example of the sculpture of antiquity. If we compare his statues with those of the *Visitation* group at Reims (FIG. 10-34) or of Nicola Pisano (FIG. 15-2), we find the Classicism of the older works lacking in authority and, as yet, unsure. The *Quattro Santi Coronati* figures have achieved a level of accomplishment that, if not identical with the Roman norm, is at least its equal. Renaissance artists have begun to comprehend the Roman meaning, even if they do not duplicate the Roman form. But duplication is not their purpose; rather, they strive to interpret or offer commentary in the manner of the Humanist scholars dealing with Classical texts.

DONATELLO

The Humanist, Roman Classicism expressed in the sculpture of Nanni was not exclusively of his devising. The whole city of Florence, in its last, fierce war with the Visconti of Milan at the turn of the century, modeled itself on the ancient Roman republic. The Humanist chancellor of Florence, Coluccio Salutati, whose Latin style of writing was widely influential, exhorted his fellow citizens to take as their own the republican ideal of civil and political liberty they believed to be that of Rome, and to identify themselves with its spirit. To be Florentine was to be Roman; freedom was the distinguishing virtue of both.

A new realism based on the study of humanity and nature, an idealism found in the study of Classical forms, and a power of individual expression characteristic of genius are the elements that define the art and the personality of the sculptor DONATELLO (1386–1466). In the early years of the century, he carried forward most dramatically the search for innovative forms capable of expressing the new ideas of the Humanistic Early Renaissance. Working side by side, Donatello and Nanni collaborated on sculpture for the cathedral of Florence and the church of Or San Michele. They shared the Humanistic enthusiasm for Roman virtue and form; their innovations in style, expressive of a new age, are parallel. Donatello's greatness lies in an extraordinary versatility and depth that led him through a spectrum of themes fundamental to human experience and through stylistic variations that express these themes with unprecedented profundity and force.

A principal characteristic of greatness is authority. Great artists produce work that their contemporaries and posterity accept as authoritative; their work becomes a criterion and a touchstone for criticism. Judgments of what is authoritative and "best" will of course vary with time and place, but the greatest artists seem to survive this relativity of judgment, apparently because they reveal something deeply and permanently true about human nature and broadly applicable to human experience. Shakespeare, for example, seems miraculously familiar with almost the whole world of human nature. Similarly, Donatello is at ease not only with the real, the ideal, and the spiritual, but with such diverse human forms and conditions as childhood, the idealized human nude, practical men of the world, military despots, holy men, derelict prelates, and ascetic old age. Others who follow Donatello in the school of Florence may specialize in one or two of these human types or moods, but none commands them so completely and convincingly. In the early fifteenth century, Donatello defined and claimed as his province the whole terrain of naturalistic and Humanistic art.

Early in his career, he took the first fundamental and necessary step toward the depiction of motion in the human figure-recognition of the principle of weight shift (ponderation). His St. Mark (FIG. 16-5), commissioned for Or San Michele, was completed in 1413. With it, Donatello closed a millennium of Medieval art and turned a historical corner into a new era. We have seen the importance of weight shift in the ancient world, when Greek sculptors, in works like the Kritios Boy (FIG. 5-19) and the Doryphoros (FIG. 5-58), grasped the essential principle that the human body is not rigid, but a flexible structure that moves by continuously shifting the weight from one supporting leg to the other with the main masses of the body moving in consonance. An illuminating comparison may be made between Donatello's St. Mark and Medieval portal statuary, the sculpture of Nicola and Giovanni Pisano, or even the early work of Ghiberti. The principle of weight shift has not been grasped in any of these figures except Donatello's St. Mark. All at once, with the same abruptness with which it appeared in ancient Greece in Early Classical art (FIG. 5-19), this crucial concept has been rediscovered. In sculpture and painting, Donatello's successors gradually mastered the representation of bodily motion of the most complex kind.

As the body now "moves," its drapery "moves" with it, hanging and folding naturally from and around bodily points of support, so that we sense the figure as a draped nude, not simply as an integrated column with arbitrarily incised drapery. This development further contributes to the independence of the figure from its architectural setting. We feel that *St. Mark* can and is about to move out of the deep niche in which he stands, as the stirring limbs, the shifting weight, and the mobile drapery suggest. It is easy to imagine the figure as freestanding, unenframed by architecture, without loss of any of its basic qualities.

In his *St. George* (FIG. **16-6**), also designed for Or San Michele (between 1415 and 1417), Donatello pro-

vides an image of the proud idealism of youth. The armored soldier-saint, patron of the guild of armorers (for whom the statue was commissioned), stands with bold firmness—legs set apart, feet strongly planted, the torso slightly twisting so that the left shoulder and arm advance with a subtle gesture of haughty and challenging readiness. As the dragon approaches, St. George's head is erect and turned slightly to the left; the noble features beneath the furrowed brows are intent, concentrated, yet composed in the realization of his power, intelligence, and reso-

> 16-5 DONATELLO, St. Mark, 1411–1413. Marble, approx. 7' 9" high. Or San Michele, Florence.

lution. In its regal poise and tense anticipation, the figure contrasts strikingly with its earlier Gothic counterpart, *St. Theodore* (FIG. **16-7**), from Chartres Cathedral. *St. Theodore*, the soldier, appearing essentially weightless, seems lost in some mystic reverie, removed from the world and unaware of his surroundings. The elements of his body are not coordinated in the unity of action we find in *St. George*. The Medieval figure conveys the *idea* of the chivalric knight but nothing of the *fact* of the soldier confronting his enemy.

 16-6 DONATELLO, St. George, 1415–1417, from Or San Michele. Marble (has been replaced by a bronze copy),
 approx. 6' 10" high. Museo Nazionale del Bargello, Florence.

Between 1416 and 1435, Donatello carved five statues for the niches on the campanile of Florence Cathedral—a project that, like the figures for Or San Michele, had originated in the preceding century. Unlike the Or San Michele figures, however, which were installed only slightly above eye level, those for the campanile were placed in niches at least 30 feet above the ground. At that distance, delicate descriptive details (hair, garments, and features) no longer can be recognized readily and become meaningless. Massive folds that can be read from afar and a much

16-7 St. Theodore, jamb statue, c. 1215–1220. Stone, over life size. South portal, Chartres Cathedral, Chartres, France.

16-8 DONATELLO, prophet figure (Zuccone), 1423–1425, from the campanile of Florence Cathedral. Marble, approx. 6' 5" high. Museo dell'Opera del Duomo, Florence.

broader, summary treatment of facial and anatomical features are required for the campanile figures and are used effectively by Donatello. In addition, he takes into account the elevated position of his figures and, with subtly calculated distortions, creates images that are at once realistic and dramatic when seen from below (see also Introduction, FIG. 9).

The most striking of the five figures is that of a prophet, generally known by the nickname *Zuccone*, or "pumpkin-head" (FIG. **16-8**). This figure shows Donatello's peculiar power for characterization at its most original. All of his prophets are represented with a harsh, direct realism reminiscent of ancient Roman portrait sculpture. Their faces are bony, lined, and taut; each is strongly individualized. The *Zuccone* is also bald, a departure from the conventional representation of the prophets. He is dressed in an awk-wardly draped and crumpled togalike garment with

deeply undercut folds. At first view, one might suspect Donatello of simply draping a gaunt, uncouth assistant, placing him in a casual stance, and rendering the subject just as he saw it. The head discloses an appalling personality—full of crude power, even violence. The deep-set eyes glare under furrowed brows, nostrils flaring, the broad mouth agape, as if the prophet were in the very presence of disasters that would call forth his declamation.

In a bronze relief, The Feast of Herod (FIG. 16-9), on the baptismal font in the baptistry at Siena, Donatello carries his talent for characterization of single figures to the broader field of dramatic groups. Salome (toward the right), still seems to be dancing, even though she already has delivered the severed head of John the Baptist, which the kneeling executioner offers to King Herod. The other figures recoil in horror into two groups: at the right, one man covers his face with his hand; at the left, Herod and two terrified children shrink back in dismay. The psychic explosion that has taken place drives the human elements apart, leaving a gap across which the emotional electricity crackles. This masterful stagecraft obscures the fact that on the stage itself another drama is being played out-the advent of rationalized perspective space, long prepared for in the proto-Renaissance and recognized by Donatello and his generation as a means of intensifying the reality of the action and the characterization of the actors.

Proto-Renaissance artists, like Duccio and the Lorenzetti brothers, used several devices to give the effect of distance, but with the invention of "true" linear perspective (a discovery generally attributed to Brunelleschi), Early Renaissance artists were given a way to make the illusion of distance mathematical and certain. In effect, they had come to understand the picture plane as a transparent window through which the observer looks into the constructed, pictorial world. From the observer's fixed standpoint, all orthogonals (lines perpendicular to the picture plane) meet in a single point on the horizon (a horizontal line that corresponds to the viewer's eye level) and all objects are unified within a single space system—the perspective. This discovery was of enormous importance, for it made possible what has been called the "rationalization of sight." It brought all of our random and infinitely various visual sensations under a simple rule that can be expressed mathematically.

Indeed, the discovery of perspective by the artists of the Renaissance reflects the emergence of science itself, which is, put simply, the mathematical ordering of our observations of the physical world. The artists of the Renaissance were often mathematicians, and one modern mathematician asserts that the most creative work in mathematics in the fifteenth century

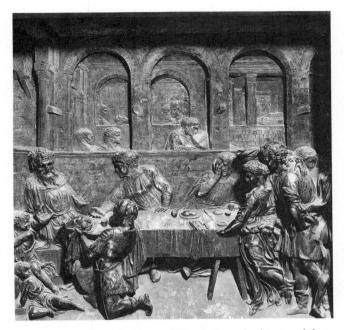

16-9 DONATELLO, The Feast of Herod, from the baptismal font,
 c. 1425. Gilt bronze relief, approx. 23" × 23".
 Siena Cathedral, Siena, Italy.

was done by artists. The experimental spirit that had animated many Franciscans, like Roger Bacon, now came firmly to earth; indeed, Bacon's essays on optics had considerable influence on Renaissance theorists like Alberti. The position of the observer of a picture, who looks "through" it into the painted "world," is precisely that of any scientific observer fixing his gaze on the carefully placed or located datum of his research. Of course, the Early Renaissance artist was not primarily a scientist; he simply found perspective a wonderful way to order his composition and to clarify it. Nonetheless, we cannot doubt that perspective, with its new mathematical authority and certitude, conferred a kind of esthetic legitimacy on painting by making the picture measurable and exact. According to Plato, "the excellence of beauty of every work of art is due to the observance of measure." This dictum certainly is expressed in the art of Greece, and in the Renaissance, when Plato was discovered anew and read eagerly, artists once again exalted the principle of measure as the foundation of the beautiful in the fine arts. The projection of measured shapes on flat surfaces now influenced the character of painting and made possible scale drawings, maps, charts, graphs, and diagrams-those means of exact representation without which modern science and technology would be impossible. Mathematical truth and formal beauty became conjoined in the minds of Renaissance artists. In his relief panel The Feast of Herod (FIG. 16-9), Donatello, using the device of pictorial perspective, opens the space of the action well into the distance, showing two arched courtyards and groups of attendants in the background. This penetration of the panel surface by spatial illusion replaces the flat grounds and backdrop areas of the Medieval past. The ancient Roman illusionism returns, but it is now based on a secure principle never possessed by the ancients.

It is worth comparing Donatello's Siena panel with a panel from Ghiberti's famous east doors of the baptistry of Florence Cathedral (FIG. **16-10**), which were later declared by Michelangelo to be "so fine that they might fittingly stand as the Gates of Paradise." The east doors (1425–1452) were composed differently from Ghiberti's earlier north doors. Three sets of doors provide access to the baptistry. The first set was made by Andrea Pisano for the east doorway (1330–1335), which faces the cathedral and is the most important entrance. This set of doors was moved to the south doorway to make way for Ghiberti's first pair of doors (1403–1424), which, in turn, was moved to the north doorway so that Ghiberti's second pair of doors, the "Gates of Paradise," could be

16-10 LORENZO GHIBERTI, east doors (Gates of Paradise), 1425–1452. Gilt bronze relief, approx. 17' high. Baptistry of Florence.

Beer and a way as the second A market a

placed in the east doorway. After 1425, Ghiberti abandoned the quatrefoil pattern of the earlier doors and divided the space into ten square panels, each containing a relief set in plain moldings. When gilded, the glittering movement of the reliefs created an effect of great splendor and elegance.

The individual panels of Ghiberti's doors, such as Isaac and His Sons (FIG. 16-11), clearly recall painting in their depiction of space as well as in their treatment of the narrative. Some exemplify more fully than painting many of the principles Alberti formulated in his treatise, On Painting. In his relief, Ghiberti creates the illusion of space partly by pictorial perspective and partly by sculptural means. Buildings are represented according to the painter's one-point perspective construction, but the figures (in the lower section of the relief, which actually projects slightly toward the viewer) appear almost in the full round, some of their heads standing completely free. As the eye progresses upward, the relief increasingly becomes flatter until the architecture in the background is represented by barely raised lines, creating a sort of "sculptor's aerial perspective" in which forms are less distinct the deeper they are in space. Ghiberti describes the work as follows:

I strove to imitate nature as closely as I could, and with all the perspective I could produce [to have] excellent compositions rich with many figures. In some scenes I placed about a hundred figures, in some less, and in some more. I executed that work with the greatest diligence and the greatest love. There were ten stories, all [sunk] in frames because the eye from a distance measures and interprets the scenes in such a way that they appear round. The scenes are in the lowest relief and the figures are seen in the planes; those that are near appear large, those in the distance small, as they do in reality. . . . Executed with the greatest study and perseverance, of all my work it is the most remarkable I have done and it was finished with skill, correct proportions, and understanding.*

Thus, an echo of the ancient and Medieval past is harmonized by the new science: "proportion" and "skill" are perfected by "understanding." Ghiberti has achieved a greater sense of depth than has ever before been possible in a relief. However, his principal figures do not occupy the architectural space he has created for them; rather, they are arranged along a parallel plane in front of the grandiose architecture. (According to Alberti, in his *De re aedificatoria*, the grandeur of the architecture reflects the dignity of events shown in the foreground.) Ghiberti's figure style mixes a Gothic patterning of rhythmic line,

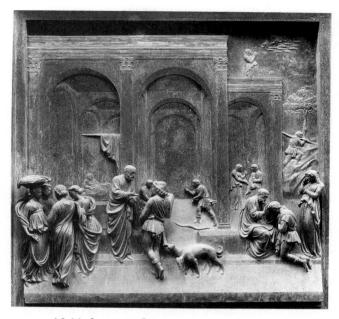

16-11 LORENZO GHIBERTI, Isaac and His Sons (detail of FIG. 16-10). Approx. $31\frac{1}{2}'' \times 31\frac{1}{2}''$.

Classical poses and motifs, and a new realism in characterization, movement, and surface detail. The Medieval narrative method of arranging several episodes within a frame persists. In Isaac and His Sons (FIG. 16-11), the group of ladies in the left foreground attends the birth of Esau and Jacob in the left background; Isaac sends Esau and his hunting dogs on his mission in the central foreground; and, in the right foreground, Isaac blesses the kneeling Jacob as Rebecca looks on (Genesis 25–27). Yet the groups are so subtly placed that no crowding or confusion is apparent. The figures, in varying degrees of projection, gracefully twist and turn, appearing to occupy and move through a convincing stage space, which is deepened by showing some figures from behind. The Classicism, particularly of the group of visiting ladies, derives from Ghiberti's close study of ancient art. From his biography, we know that he admired and collected Classical sculpture, bronzes, and coins, and their influence is seen throughout the panel. The beginning of the practice of collecting Classical art in the fifteenth century had much to do with the appearance of Classicism in the Humanistic art of the Renaissance.

For a time, Donatello forgot his earlier realism under the spell of Classical Rome, the ruins and antiquities of which he studied at some length. His bronze statue of *David* (FIG. **16-12**), designed between about 1428 and 1432, is the first freestanding nude statue since ancient times, and here Donatello shows himself once more to be an innovator. The nude, as such, proscribed in the Christian Middle Ages as both

^{*}In E. G. Holt, ed., *Literary Sources of Art History* (Princeton, NJ: Princeton University Press, 1947), pp. 90–91.

indecent and idolatrous, had been shown only rarely-and then only in biblical or moralizing contexts, like the story of Adam and Eve or descriptions of sinners in Hell. Donatello reinvented the Classical nude, even though, in this case, we have neither god nor athlete but the young David, slayer of Goliath, biblical ancestor and antitype of Christ, and symbol of the Florentine love of liberty. The classically proportioned nude-a balance of opposing axes, of tension and relaxation-recalls, and perhaps is derived from, Roman copies of Hellenic statues. Although the body has an almost Praxitelean radiance and a sensuous quality unknown to Medieval figures, David is involved in a complex psychological drama unknown to Antique sculpture. The glance of this youthful, still adolescent hero is not directed primarily toward the severed head of Goliath, which lies between his feet, but toward his own graceful, sinuous body, as though, in consequence of his heroic deed, he is becoming conscious for the first time of its beauty, its vitality, and its strength. This self-awareness, this discovery of the self, is a dominant theme in Renaissance art.

16-12 DONATELLO, David, c. 1428–1432. Bronze, 624" high. Museo Nazionale del Bargello, Florence.

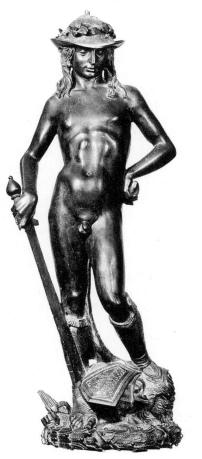

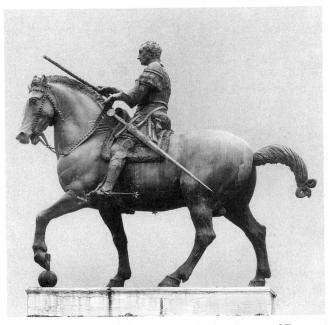

16-13 DONATELLO, Gattamelata, equestrian statue of Erasmo da Narni, c. 1445–1450. Bronze, approx. $11' \times 13'$. Piazza del Santo, Padua, Italy.

In 1443, Donatello left Florence for northern Italy to accept the rewarding commission of an equestrian statue of the Venetian condottiere Erasmo da Narni, for the square of San Antonio in Padua. With this work (FIG. 16-13), called Gattamelata (slick cat), Donatello recovered the grandeur of the mounted leader as it existed in the great Roman equestrian statue of Marcus Aurelius (FIG. 6-77), which the artist must have seen in Rome. The figure stands high on a lofty, elliptical base to set it apart from its surroundings and becomes almost a celebration of the liberation of sculpture from architecture. Massive and majestic, the great horse bears the armored general easily; together, they make an overwhelming image of irresistible strength and unlimited power. Compared to the Gattamelata, a Medieval equestrian statue like the Bamberg Rider (FIG. 10-55), still attached to the wall, looks positively fragile, even ghostlike. The Italian rider, his face set in a mask of dauntless resolution and unshakable will, is the very portrait of the Renaissance individualist: a man of intelligence, courage, and ambition, frequently of humble origin, who, by his own resourcefulness and on his own merits, rises to a commanding position in the world.

Donatello's ten-year period of activity in Padua (he received additional commissions for statues and reliefs for the high altar of the church of San Antonio) made a deep and lasting impression on the artists of the region and contributed materially to the formation of a Renaissance style in northern Italy. After his

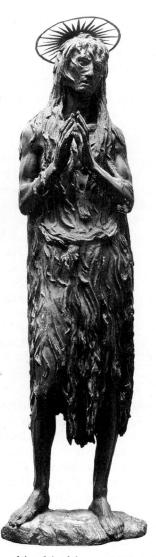

16-14 DONATELLO, Mary Magdalene, c. 1454–1455. Polychromed and gilded wood, approx. 6' 2" high. Baptistry of Florence.

return to Florence in 1453, Donatello's style changes once more. His last period is marked by an intensely personal kind of expression, in which his earlier realism returns, but with purposeful exaggeration and distortion. He turns away from Classical beauty and grandeur toward a kind of expressionism that seems deliberately calculated to jar the sensibilities; he gives us the ugly, the painful, and the violent. He may, in his last years, have felt religious remorse for such works as his David and may have set about to achieve a kind of anti-esthetic manner, well exemplified in his Mary Magdalene (FIG. 16-14). The repentant saint in old age, after years of wasting mortification, stands emaciated, hands clasped in prayer. Donatello, in what appears to be a rekindling of Medieval piety, here rejects the body as merely the mortal shell of the

immortal soul. The beautiful woman has withered, but her soul has been saved by her denial of physical beauty. Donatello's originality, independence, and insight into the meaning of religious experience are asserted here as he reinterprets Medieval material in his own terms. But Medieval as *Mary Magdalene* might first appear, we realize that this work also was carved by the man who created the *David*, and Donatello again is best characterized as we first described him—a man with the vast versatility that distinguishes the great artist from the good artist.

Architecture

BRUNELLESCHI

FILIPPO BRUNELLESCHI (1377–1446), one of the unsuccessful competitors for the commission to design the doors of the baptistry of Florence in 1401, was (like Ghiberti) trained as a goldsmith, but his ability as a sculptor must have been well known even at the time of the baptistry competition. Although his biographer, Manetti, tells us that Brunelleschi turned to architecture out of disappointment over the loss of the baptistry commission, he continued to work as a sculptor for several years and received commissions for sculpture as late as 1416. In the meantime, however, his interest turned more and more toward architecture, spurred by several trips to Rome (the first in 1402, probably with his friend Donatello), where he too was captivated by the Roman ruins. It may well be in connection with his close study of Roman monuments and his effort to make an accurate record of what he saw that Brunelleschi developed the revolutionary system of geometric, linear perspective that was so eagerly adopted by fifteenth-century artists and that has made him the first acknowledged Renaissance architect.

Brunelleschi's broad knowledge of the principles of Roman construction, combined with an analytical and inventive mind, permitted him to solve an engineering problem that no other fifteenth-century architect could have solved-the design and construction of a dome for the huge crossing of the unfinished cathedral of Florence (FIGS. 16-15, 16-16, and 10-58). The problem was staggering; the space to be spanned (140 feet) was much too wide to permit construction with the aid of traditional wooden centering. Nor was it possible (because of the plan of the crossing) to support the dome with buttressed walls. Brunelleschi seems to have begun work on the problem about 1417; in 1420, he and Ghiberti jointly were awarded the commission. The latter, however, soon retired from the project and left the field to his associate.

With exceptional ingenuity, Brunelleschi not only

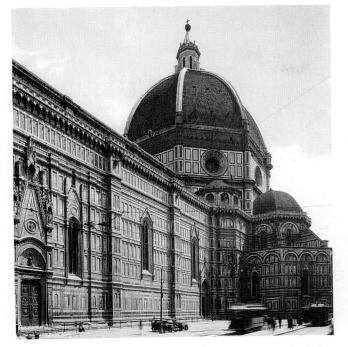

16-15 FILIPPO BRUNELLESCHI, dome of Florence Cathedral, 1420–1436 (view from the southwest).

16-16 Section of dome, Florence Cathedral. (After Stierlin.)

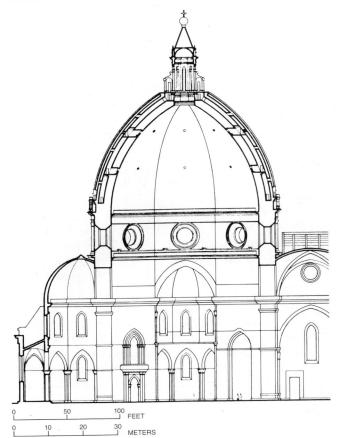

discarded traditional building methods and devised new ones, but he also invented much of the machinery that was necessary for the job. Although he might have preferred the hemispheric shape of Roman domes, Brunelleschi raised the center of his dome and designed it around an ogival section, which is inherently more stable, as it reduces the outward thrust around the dome's base. To reduce the weight of the structure to a minimum, he designed a relatively thin double shell (the first in history) around a skeleton of twenty-four ribs, the eight most important of which are visible on the exterior. Finally, in almost paradoxical fashion, Brunelleschi anchored the structure at the top with a heavy lantern, which was built after his death, but in accordance with his design. This lantern, although it added to the weight of the dome, has the curious effect of stabilizing the entire structure; without the pressure of its weight, the ribs had a tendency to tilt outward from the center, spreading at the top.

In spite of the fact that Brunelleschi knew of and much admired Roman building techniques, and even though the dome of Florence Cathedral is his most outstanding engineering achievement, his solution to this most critical structural problem was arrived at through what were essentially Gothic building principles. Thus, the dome does not really express Brunelleschi's own architectural style, which is shown for the first time in a building that he began shortly before he accepted the commission for the dome. The basic element of the design of that building, the Ospedale degli Innocenti (Foundling Hospital) in Florence (FIG. 16-17), is a series of round arches supported by slender columns and framed by pilasters that carry a flat, horizontal entablature. These arches appear to have been inspired either by the church of San Miniato al Monte (FIG. 9-20) or by the baptistry of Florence Cathedral, both Romanesque buildings. In Brunelleschi's time, the latter mistakenly was believed to be a Roman temple, but even if he had known that it was not Roman, Brunelleschi may well have mistaken it for an Early Christian building of the fourth or fifth century, constructed in a style that he associated closely with Classical Roman architecture and that had just as much authority for him. Regardless of these sources of stylistic inspiration, the hospital expresses quite a different style from that of its possible Medieval prototypes. The stress on horizontals, the clarity of the articulation, and the symmetry of the design, combined with the use of such Classical elements as Corinthian capitals and pilasters, as well as windows topped by pediments, create an impression of rationality and logic that, in spirit at least, relates the Ospedale degli Innocenti more to Classical than to Medieval architecture.

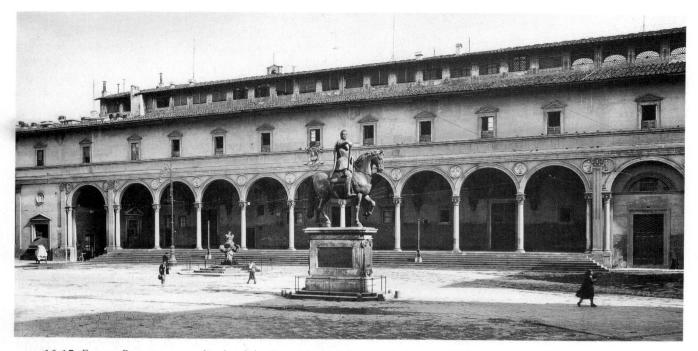

16-17 FILIPPO BRUNELLESCHI, façade of the Ospedale degli Innocenti, Piazza della S. Annunziata, Florence, 1419–1424.

The same clarity of statement is to be found in San Lorenzo and Santo Spirito, the two basilican churches that Brunelleschi built in Florence. Of the two, the later Santo Spirito shows the architect's mature style (FIGS. 16-18 and 16-19). Begun in 1436 and completed, with some changes, after Brunelleschi's death, this cruciform building is laid out on the basis of either multiples or segments of the dome-covered crossing square in a manner reminiscent of Romanesque planning. But this segmentation is not reflected in the nave, which is a continuous, unbroken space in the tradition of Early Christian basilicas. The aisles, subdivided into small squares covered by shallow, saucer-shaped vaults, run all the way around the flatroofed central space and have the visual effect of compressing the longitudinal design into a centralized one, because the various aspects of the interior resemble each other, no matter where the observer stands. Originally, this effect of centralization would have been even stronger; Brunelleschi had planned to extend the aisles across the front of the nave as well, as shown on the plan (FIG. 16-19). Because of the modular basis of the design, adherence to his design would have demanded four entrances in the façade, instead of the traditional and symbolic three, a feature that was hotly debated during Brunelleschi's lifetime and that was changed after his death. The appearance of the exterior walls also was changed later, when the recesses between the projecting, semicircular chapels were filled in to convert an originally highly plastic wall surface into a flat one.

16-18 FILIPPO BRUNELLESCHI, interior of Santo Spirito, Florence, begun 1436 (view facing east).

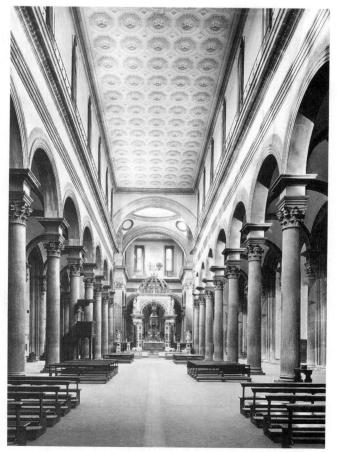

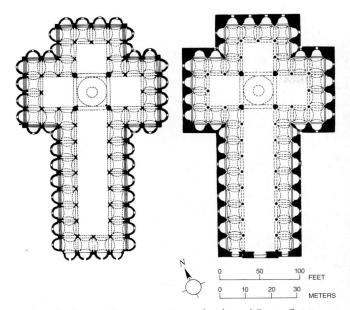

16-19 FILIPPO BRUNELLESCHI, early plan of Santo Spirito (*left*) and plan as constructed (*right*).

The major features of the interior, however, are much as Brunelleschi designed them. Compared with those of the Ospedale degli Innocenti, the forms have gained in volume. The moldings project more boldly, and the proportions of the columns more closely approach the Classical ideal. Throughout the building, proportions in a ratio of 1:2 have been used with great consistency. The nave is twice as high as it is wide; arcade and clerestory are of equal height, which means that the height of the arcade equals the width of the nave; and so on. These basic facts about the building have been delineated for the observer by crisp articulations, so that they can be read like mathematical equations. The cool logic of the design may lack some of the warmth of Medieval buildings, but it fully expresses the new Renaissance spirit that places its faith in reason rather than in the emotions.

Brunelleschi's evident effort to impart a centralized effect to the interior of Santo Spirito suggests that he was intrigued by the compact and self-contained qualities of earlier central-plan buildings, such as the Pantheon and Medieval baptistries. His Old Sacristy, built onto the left transept of San Lorenzo, expresses his admiration of the central plan. He nearly realized his ideal with the Pazzi Chapel (FIGS. 16-20 to 16-22), begun around 1440 and completed in the 1460s, long after his death. The exterior probably does not reflect Brunelleschi's original design; the narthex, admirable as it is, seems to have been added as an afterthought, perhaps by sculptor-architect GIULIANO DA MAIANO. Behind this narthex stands one of the first independent buildings of the Renaissance to be conceived basically as a central-plan structure. Although the

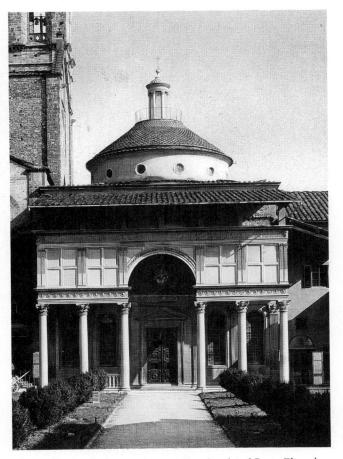

16-20 FILIPPO BRUNELLESCHI, west façade of Pazzi Chapel, begun c. 1440. Santa Croce, Florence.

16-21 FILIPPO BRUNELLESCHI, plan of Pazzi Chapel.

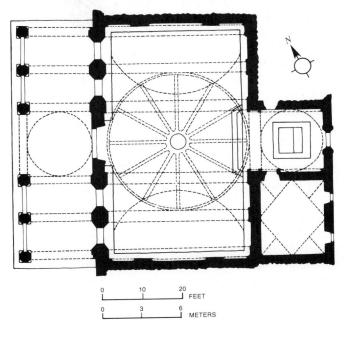

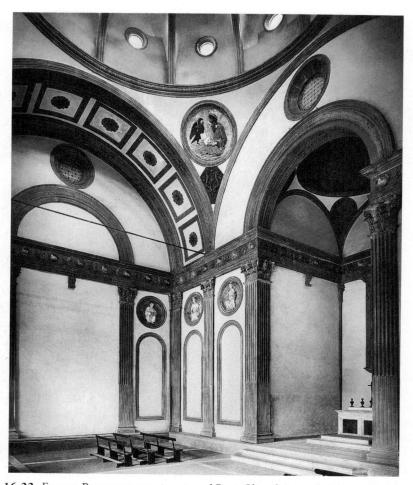

16-22 FILIPPO BRUNELLESCHI, interior of Pazzi Chapel (view facing northeast).

plan is rectangular, rather than square or round, all emphasis has been placed on the central, domecovered space. The short, barrel-vault sections that brace the dome on two sides appear to be no more than incidental appendages. Articulations and trim in the interior are done in grey stone, the so-called *pietra serena*, which stands out against the white, stuccoed walls and crisply defines the modular relationships of plan and elevation. Medallions with glazed terracotta reliefs representing the Four Evangelists in the dome's pendentives and the Twelve Apostles on the pilaster-framed wall panels provide the tranquil interior with striking color accents.

Brunelleschi only approximated the central plan in the Pazzi Chapel. He planned to give it full realization in Santa Maria degli Angeli (FIG. **16-23**). Begun in 1434, this project was abandoned, unfinished, in 1437. The plan shows a central octagon, the corner piers of which undoubtedly were intended to carry a dome. Around this core, eight identical chapels are arranged (one was to have served as the entrance). The chapels seemingly are carved out of the massive

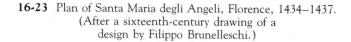

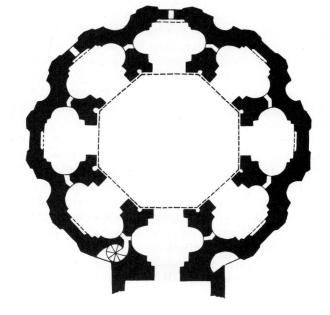

masonry that surrounds them. The plastic handling of both exterior and interior wall surfaces recaptures the ancient Roman "sculptured" wall principle and is so far ahead of its time that it does not appear again until the very end of the fifteenth century. Alberti must have seen the unfinished building and may well have had it in mind when he praised the central plan in his treatise and instilled a taste for it in generations of later architects.

It seems curious that Brunelleschi, the most renowned architect of his time, did not participate in the upsurge of palace-building that Florence experienced in the late 1430s and 1440s and that testified to the soundness of the Florentine economy and the affluence and confidence of the city's leading citizens. His efforts in this field were confined to work on the Palazzo di Parte Guelfa and to a rejected model for a new palace that Cosimo de' Medici intended to build. Cosimo evidently felt that Brunelleschi's project was too imposing and ostentatious to be politically wise. Instead, he awarded the commission to MICHELOZZO DI BARTOLOMMEO (1396–1472), a young architect who had been Donatello's collaborator in several sculptural enterprises. Michelozzo's architectural style was influenced deeply by Brunelleschi, and, to a limited extent, the Palazzo Medici-Riccardi (FIG. 16-24) may reflect Brunelleschian principles.

Built for the Medici and later bought by the Riccardi family, who almost doubled the length of the facade in the eighteenth century, the palace is a simple, massive structure. Heavy rustication on the ground floor accentuates its strength. The building block is divided into stories of decreasing height by long, unbroken horizontal bands (stringcourses), which give it articulation and coherence. The severity of the ground floor is modified in the upper stories by dressed stone, which presents a smoother surface with each successive story, so that the building appears progressively lighter as the eye moves upward. This effect is dramatically reversed by the extremely heavy, classicizing cornice, which Michelozzo related not to the top story but to the building as a whole. It is a very effective lid for the structure, clearly and emphatically defining its proportions.

The palace is built around an open, colonnaded court (FIG. **16-25**) that clearly shows its architect's debt to Brunelleschi. The round-arched colonnade, although more massive in its proportions, closely resembles that of the Ospedale degli Innocenti; however, Michelozzo's failure to frame each row of arches with piers and pilasters, as Brunelleschi might have, causes the structure to look rather weak at the angles. Nevertheless, this *cortile* was the first of its kind and was to have a long line of descendants in Renaissance domestic architecture.

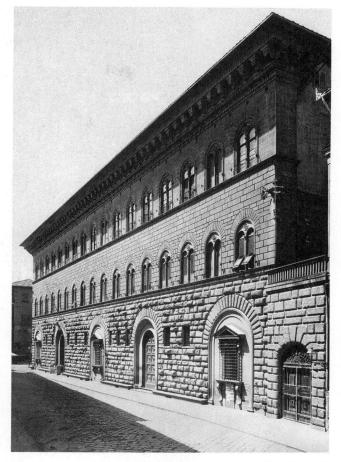

16-24 MICHELOZZO DI BARTOLOMMEO, Palazzo Medici-Riccardi, Florence, begun 1444.

16-25 MICHELOZZO DI BARTOLOMMEO, interior court of the Palazzo Medici-Riccardi.

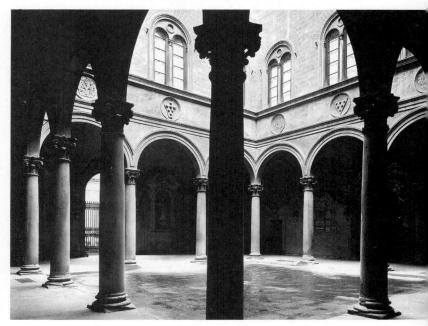

Painting

The three leading innovators of the early fifteenth century were Donatello, Brunelleschi, and the young painter MASACCIO (Tommaso Guidi, 1401-1428). To understand the almost startling nature of his innovations, we should look again at the International style in painting, which was the dominant style around 1400 and one that persisted well into the fifteenth century. The International style developed side by side with the grand new style of Masaccio and his followers. Gentile da Fabriano (c. 1370–1427), who was working in Florence at the same time as Masaccio, produced what may be the masterpiece of the International style, The Adoration of the Magi (FIG. 16-26). Gentile's purpose was to create a gorgeous surface, spreading across it scores of sumptuously costumed kings, courtiers, captains, and retainers accompanied by a menagerie of exotic and ornamental animals. All of these elements were portrayed in a

rainbow of color with much display of gold. This painting presents all the pomp and ceremony of chivalric etiquette in a picture that proclaims the sanctification of aristocracy in the presence of the Madonna and Child. The stylistic apparatus used by Gentile differs only slightly from that used in the century following the junction of Gothic and Sienese painting. Into this traditional framework, however, Gentile inserts striking bits of radical naturalism. Animals are seen from a variety of angles and are foreshortened convincingly, as are tilted human heads and bodies. (Note the man removing the spurs from the standing magus in the center foreground.) On the right side of the predella, Gentile shows the Presentation scene in a "modern" architectural setting. (The arcade in the right background looks much like Brunelleschi's Ospedale degli Innocenti, FIG. 16-17.) And on the left side of the predella, he paints what may be the very first nighttime Nativity in which the light source is introduced into the picture itself. Although domi-

16-26 GENTILE DA FABRIANO, *The Adoration of the Magi* altarpiece, 1423. Tempera on wood, approx. 9' $11'' \times 9'$ 3". Galleria degli Uffizi, Florence.

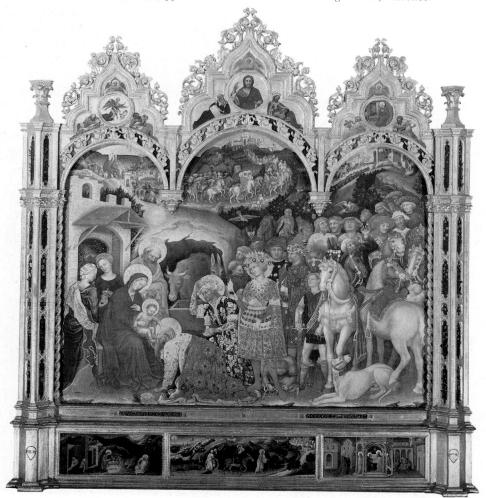

nantly conservative, Gentile shows that he is not oblivious to contemporary experimental trends, and that he is able to blend naturalistic and inventive elements skillfully and subtly into a traditional composition without sacrificing Late Gothic coloristic splendor.

MASACCIO

Masaccio was much less compromising. Although his presumed teacher, MASOLINO DA PANICALE, had worked in the International style, Masaccio moved suddenly, within the short span of only six years, into wide-open and unexplored territory. No other painter in history is known to have contributed so much to the development of a new style in so short a time as Masaccio, whose creative career was cut short by his death at age twenty-seven. Masaccio is the artistic descendant of Giotto, whose calm, monumental style he revolutionized through a whole new repertory of representational devices that generations of Renaissance painters would later study and develop. Masaccio also knew and understood the innovations of his great contemporaries, Donatello and Brunelleschi, and he introduced new possibilities for both form and content into painting.

Masaccio's innovations are seen best in the frescoes he painted in the Brancacci Chapel of Santa Maria del Carmine in Florence. In *The Tribute Money* (FIG. **16-27**), painted shortly before his death, Masaccio groups three episodes. In the center, Christ, surrounded by his disciples, tells St. Peter that in the mouth of a fish he will find a coin to pay the imperial tax demanded by the collector who stands in the foreground, his

back to the spectator. At the left, in the middle distance, St. Peter struggles to extract the coin from the fish's mouth, while at the right, with a disdainful gesture of great finality, he thrusts the coin into the tax collector's hand. Masaccio's figures recall Giotto's in their simple grandeur, but they stand before us with a psychological and moral self-realization that is entirely new. Masaccio realizes the bulk of the figures not through generalized modeling with a flat, neutral light lacking an identifiable source, as Giotto does, but by means of a light that comes from a specific source outside the picture. This light strikes the figures at an angle, illuminating the parts of the solids that obstruct its path and leaving the rest in deep shadow. This placement of light against strong dark (chiaroscuro) gives the illusion of deep sculptural relief. Between the extremes of light and dark, the light is a constantly active but fluctuating force, almost a tangible substance independent of the figures. As Masaccio's and Donatello's generation learn the separation of body and drapery and the functional interrelation of them as independent fabrics, so light, which in Giotto is merely the modeling of a mass, in Masaccio comes to have its own nature, and the masses we see are visible only because of the direction and intensity of the light. We imagine the light as playing over forms-revealing some and concealing others, as the artist directs it. In the creation of a space filled with atmosphere, Masaccio anticipates the achievements of the High Renaissance; few painters between Masaccio and Leonardo da Vinci have so realistically created the illusion of space as a substance of light and air existing between our eyes and what we see.

16-27 MASACCIO, The Tribute Money, c. 1427. Fresco. Brancacci Chapel, Santa Maria del Carmine, Florence.

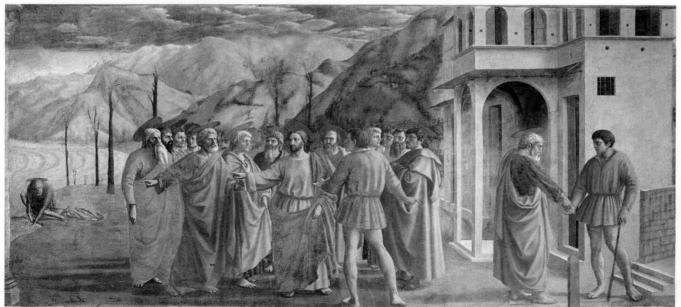

The individual figures in *The Tribute Money* are solemn and weighty, but they also express bodily structure and function, as do Donatello's statues. We feel bones, muscles, and the pressures and tensions of joints. Each figure conveys a maximum of contained energy. Both the stately stillness of Nanni di Banco's *Quattro Santi Coronati* (FIG. 16-4) as well as the weightshifting figures of Donatello (FIG. 16-5) are here. The figure of Christ and the two appearances of the tax collector make us understand what the biographer Vasari* meant when he said: "Masaccio made his figures stand upon their feet."

The arrangement of the figures is another important innovation or invention. They no longer appear as a stiff screen in the front planes. Here, they are grouped in circular depth around Christ, and the whole group is shown in a spacious landscape, rather than in the confined stage space of Giotto's frescoes. The foreground space is generated by the group itself, as well as by the architecture on the right, shown in a one-point perspective construction in which the location of the vanishing point coincides with the head of Christ. The foreground is united with the distance by aerial perspective, which employs the diminution in light and the blurring of outlines that come with distance. This device, used by Roman painters, was forgotten during the Middle Ages and rediscovered by Masaccio, apparently independently. Masaccio realized that light and air interposed between ourselves and what we see are parts of the visual experience we call "distance." With this knowledge, the world as given to ordinary sight can become for the painter the vast pictorial stage of human action.

In *The Holy Trinity* fresco in Santa Maria Novella (FIG. **16-28**), the dating of which is still in dispute, Masaccio gives a brilliant demonstration of the organizing value of Brunelleschi's perspective; indeed, this work is so much in the Brunelleschian manner that some historians have suggested that Brunelleschi may have directed Masaccio. The composition is painted on two levels of unequal height. Above, in a coffered, barrel-vaulted chapel, the Virgin Mary and St. John are represented on either side of the crucified Christ, whose arms are supported by God the Father. The Dove of the Holy Spirit rests on Christ's halo. The donors of the painting, husband and wife, are portrayed kneeling just in front of the pilasters that enframe the chapel. Below the altar—a masonry in-

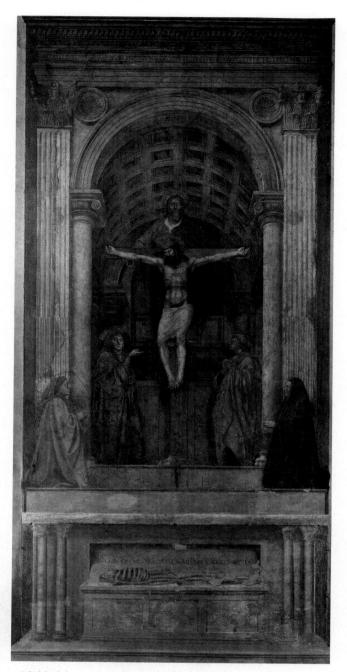

16-28 Masaccio, The Holy Trinity, 1428 (?). Fresco. Santa Maria Novella, Florence.

sert in the painted composition—the artist has painted a tomb containing a skeleton, said to represent Adam. An inscription in Italian painted above the skeleton reminds the spectator that "I was once what you are, and what I am you will become." Masaccio places the vanishing point, where all the orthogonals of the perspective converge, at the center of the masonry altar. With this point at eye level, the

^{*}GIORGIO VASARI (1511–1574), a versatile painter and architect, is best known for his *Lives of the Most Eminent Italian Architects, Painters, and Sculptors* (1550), a series of biographies that, although not always reliable, remains one of the most important art-historical sources for the Italian Renaissance.

spectator looks up at the Trinity and down at the tomb. About 5 feet above the floor level, the vanishing point pulls the two views together, creating the illusion of an actual structure that transects the vertical plane of the wall. While the tomb projects, the chapel recedes visually behind the wall, and takes on the appearance of an extension of the space in which the spectator is standing. This adjustment of the pictured space to the position of the viewer is a first step in the development of illusionistic painting, which fascinated many artists of the Renaissance and the later Baroque period. Masaccio has been so exact in his metrical proportions that we can actually calculate the numerical dimensions of the chapel (for example, the span of the painted vault is 7 feet; the depth of the chapel, 9 feet). Thus, he achieves not only successful illusion, but a rational, metrical coherence that, by maintaining the mathematical proportions of the surface design, is responsible for the unity and harmony of this monumental composition. The Holy Trinity, a work created at the very beginning of the history of Renaissance painting, embodies two principal Renaissance interests: realism based on observation and the application of mathematics to pictorial organization in the new science of perspective.

UCCELLO, CASTAGNO, AND VENEZIANO

Masaccio's discoveries, like Donatello's, led to further experiments by his contemporaries and successors, who tended to specialize in one or the other of the branches of pictorial science (either perspective or figure treatment) that Masaccio founded. PAOLO UCCELLO (1397–1475), a Florentine painter trained in the International style, discovered perspective well along in his career and became obsessed with it, though he was not always successful in harmonizing the old and the new. In The Battle of San Romano (FIG. 16-29), one of three wood panels painted for the Palazzo Medici to commemorate the Florentine victory over the Sienese in 1432, Uccello creates a composition that recalls the processional splendor of Gentile da Fabriano's Adoration of the Magi (FIG. 16-26). But the world portrayed by Uccello, in contrast with the surface decoration of the International style, is constructed of immobilized, solid forms; broken spears and lances and a fallen soldier are foreshortened and carefully placed along the converging orthogonals of the perspective to create a base plane like a checkerboard, on which the volumes are then placed in measured intervals. All this works very well as far back as the middle ground, where the horizontal plane is met abruptly by the up-tilted plane of an International style background. Beyond that, Uccello's sense of design is impeccable. The careful rendering of threedimensional form, used by other painters for representational or expressive purposes, became for Uccello a preoccupation; for him, it had a magic of its own, which he exploited to satisfy his inventive and

16-29 PAOLO UCCELLO, The Battle of San Romano, c. 1455. Tempera on wood, approx. $6' \times 10' 5''$. Reproduced by courtesy of the Trustees of the National Gallery, London.

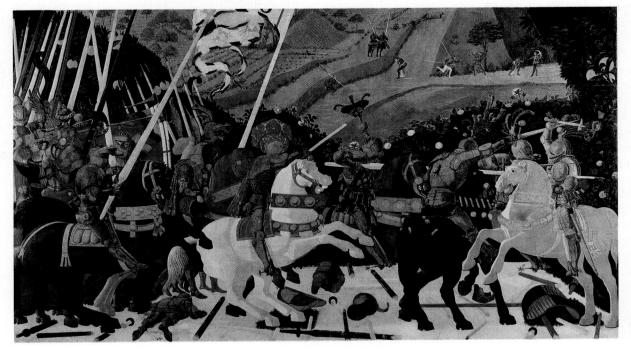

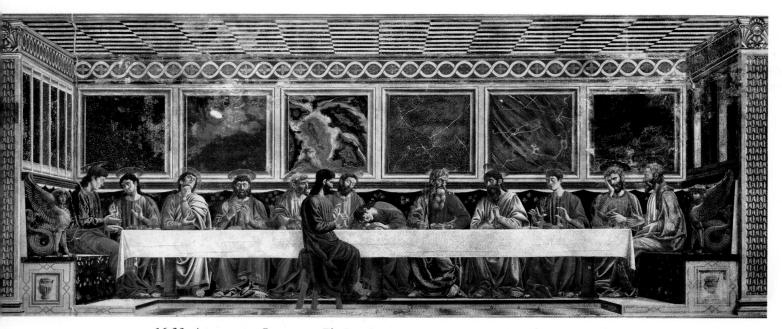

16-30 ANDREA DEL CASTAGNO, The Last Supper, c. 1445-1450. Fresco. Museo di Sant' Apollonia, Florence.

original imagination. His fascination with perspective had little in common with the rationality in Masaccio's concern for defining the dimensionality of space. Uccello had an irrational passion for arranging the forms of solid geometry in space, and it is perhaps not surprising that he became one of the favorite masters of the Cubists of the early twentieth century.

ANDREA DEL CASTAGNO (c. 1423–1457) interested himself both in perspective and in the representation of imposing, strong, structurally convincing human figures. In his Last Supper (FIG. 16-30), painted in the late 1440s to cover a wall of the refectory of the convent of Sant' Apollonia in Florence, we see a severity and clarity of form characteristic of this phase of Florentine painting. Christ and the disciples, with Judas isolated at the front of the table in the traditional manner, are painted as static, sculptural solids. Here, Andrea faced the problem of setting his figures within a space arranged to give (as in Masaccio's Holy Trinity) the illusion that the space in which the observer stands is continuous with that of the marblepaneled alcove where the principals are sitting. But the perspective construction is so strict that it serves to limit action; its rigid frame stiffens the figures it controls, and it will not be until Leonardo's famous version of this theme, painted at the end of the century, that the architectural setting will serve the action rather than constrict it.

Andrea is seen at his best in the group of figures of famous people he painted in the Villa Pandolfini near Florence around 1450. (This group was transferred first to the Castagno Museum in Sant' Apollonia and, more recently, to the Uffizi Gallery.) One figure, a portrait of the general called *Pippo Spano* (FIG. **16-31**), is the very image of the swaggering commander—his feet firmly planted, "powerful among peers," and

16-31 ANDREA DEL CASTAGNO, Pippo Spano, c. 1448. Fresco. Galleria degli Uffizi, Florence.

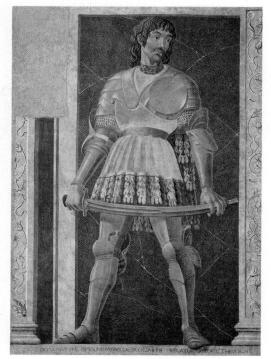

bristling with insolent challenge. The figure is meant to be seen as standing in a *loggia*, the space of which is continuous with that occupied by the spectator. The illusion is reinforced by the heavy, armored, foreshortened foot that seems to protrude over a sill of the opening. If Masaccio first "made his figures stand upon their feet," then Andrea followed him faithfully and made the point more emphatically in this splendid figure, which is alive with truculent energy. And by having parts of the figure appear to project into the space of the viewer, Andrea takes a step beyond Masaccio's *Holy Trinity* in the direction of Baroque illusionism.

Andrea's sometime collaborator DOMENICO VENE-ZIANO (*c*. 1420–1461) was born and trained in Venice, but settled in Florence in the late 1430s. The sixteenth-century architect, painter, and biographer Giorgio Vasari tells us that Andrea, in a fit of jealous rage, killed Domenico by hitting him with an iron bar; in fact, Andrea fell victim to the plague some four years before Domenico died. Vasari also claims that Domenico introduced the mixed-oil technique to Florence, but the artist himself seems to have painted in the traditional tempera. Although he fully assimilates Florentine forms, Domenico retains some International-style traits that he may have acquired from northern painters active in Venice. He also may have brought from Venice his sensitivity to color and outdoor light, which goes well beyond that of his Florentine contemporaries; indeed, Domenico makes his major contribution to Florentine art of the midcentury in connection with considerations of color and light. His St. Lucy Altarpiece (FIG. 16-32) is one of the earliest examples of a type of painting that will enjoy great popularity from this time on. In a sacra conversazione (holy conversation), saints from different epochs are joined in a unified space to form a company and seem to be conversing either with each

16-32 DOMENICO VENEZIANO, *The St. Lucy Altarpiece*, center panel, c. 1445. Tempera on wood, approx. 6' $7\frac{12''}{2} \times 7'$. Galleria degli Uffizi, Florence.

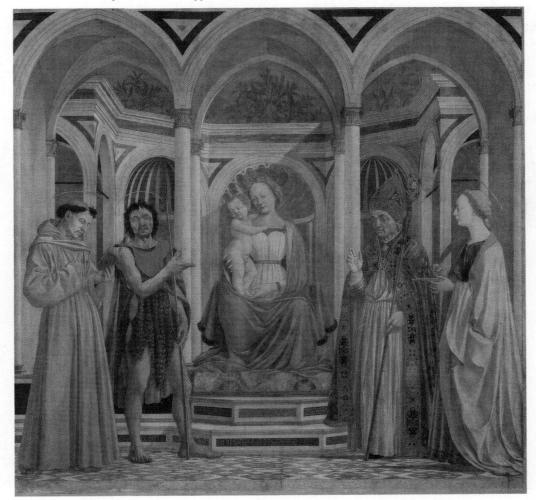

604 CHAPTER 16 / FIFTEENTH-CENTURY ITALIAN ART

other or with the audience. Here, in the presence of the enthroned Madonna, are St. Francis, John the Baptist, St. Zenobius, and St. Lucy. The clarity and precision of the architectural setting and the individualization, weight, and solemn dignity of the figures show Domenico to be a worthy heir to both Masaccio and Donatello. The composition recalls Nanni di Banco's Quattro Santi Coronati (FIG. 16-4); here, however, the vaulted niche has been converted to an airy loggia open to the sky and flooded with bright, outdoor light. The brilliant local colors and ornate surfaces of the International style are muted by this directed light, which falls into the loggia from the upper right and bathes the scene with atmospheric luminosity. Reflected from the architecture, it lightens the shadows, and the modeling of the figures becomes less harsh than that in Masaccio, to whom effects of relief were more important than those of color. The resultant overall blonde tonality is characteristic of the paintings of Domenico and his followers.

PIERO DELLA FRANCESCA

Domenico's most important disciple and his assistant in Florence during the early 1440s was PIERO DELLA FRANCESCA (c. 1420–1492). Piero's art is the projection of a mind cultivated by mathematics and

convinced that the highest beauty is found in forms that have the clarity and purity of geometric figures. Toward the end of his long career, Piero, who was a skilled geometrician, wrote the first theoretical treatise on systematic perspective, after having practiced the art with supreme mastery for almost a lifetime. His association with the architect Alberti at Ferrara and at Rimini around 1450-1451 probably turned his attention fully to perspective (a science in which Alberti was an influential pioneer) and helped to determine his later, characteristically architectonic compositions. One can fairly say that Piero's compositions are determined almost entirely by his sense of the exact and lucid structures defined by mathematics. Within this context, he developed Domenico's sophistication in the handling of light and color, so that color became the matrix of his three-dimensional forms, lending them a new density as well as fusing them with the surrounding space.

A damaged but still beautiful panel, Piero's *The Flagellation of Christ* (FIG. **16-33**), is almost a painted exposition of the rules of linear perspective and its inherent pictorial possibilities. The painting has been designed with such precision that modern architects, using the division of the brick floor paneling along the painting's baseline as a module, have been able to

16-33 PIERO DELLA FRANCESCA, *The Flagellation of Christ, c.* 1455 (?). Tempera on wood, $32\frac{3''}{4} \times 23\frac{1''}{3}$. Palazzo Ducale, Galleria Nazionale delle Marche, Urbino, Italy.

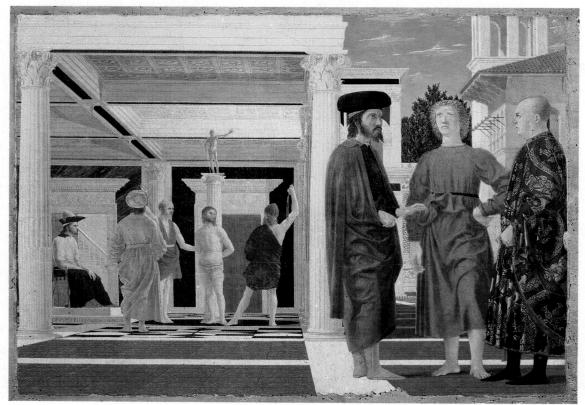

reconstruct accurately the floor plans of the depicted court and building and the positions of the figures within them.

The dating of the panel is uncertain; historians have assigned dates that range from 1445 to 1472. Since the depicted loggia has a distinctly "modern" (that is, Albertian) look, the painting seems to presuppose Piero's contact with the architect Alberti in the early 1450s, so that its date might fall into the middle of that decade. As exact as the architectural rendering of the portico appears to be, its structure has been modified for pictorial reasons. Stalactiteshaped forms at the beam crossings denote the positions from which two interior columns have been removed in order to create a continuous space that encloses the martyrdom scene and permits a full view of Pontius Pilate, who watches impassively as the executioners raise their whips to chastise Christ. The column to which Christ is tied is topped by a golden statue of a nude man holding a rod in one hand and a ball in the other, attributes that appear on coins portraying Roman emperors. The meaning of this figure within the context of the flagellation scene is uncertain; apparently a pagan symbol, it may represent the pagan power that Christianity had to confront and overcome.

The lighting is not as clearly legible as the perspective rendering. All outdoor forms are illuminated from the left, but the interior of the loggia receives its light from the right, either reflected from the buildings across the court or from a stipulated secondary light source behind the second column of the right colonnade. Even more ambiguous are the identities of the three figures in the right foreground and their relation to the central event; none of many tentative identifications, nor their meanings in relation to the central event, have found universal acceptance. Perhaps we should be content with viewing and experiencing the formal aspects of a masterful painting. In a composition that is at once clear, complex, and marvelously subtle, the perspective design is reinforced by visual cross-references that create a compact, pictorial unity. In the foreground figure group, which, at first glance, seems to have little relation to the depicted event, the pose of the central figure is almost identical to that of Christ. In addition, the relation of the turbaned man with his back to us (Herod?) to the flagellation scene is the same as that of the viewer of the painting to the foreground figure group. Thus, in a unique and ingenious manner, the artist draws the spectator past the foreground triad toward the main subject in the middle ground. By manipulating perspective and the disposition of volumes and voids, Piero creates pictorial tension using forms that are essentially static, in a composition that is firmly contained within its frame and, at the same time, highly dynamic. By placing the massed volumes of his three foreground figures off-center into a relatively restricted space, Piero poses the question of how much mass balances how large an empty space. The proportional relationships Piero shows us in this painting provide one possible (and certainly most satisfying) answer.

Piero's most important work is the fresco cycle in the apse of the church of San Francesco in Arezzo, which represents ten episodes from the legend of the True Cross (the cross on which Christ died). Painted between 1452 and 1456, the cycle is based on a thirteenth-century popularization of the Scriptures, the Golden Legend by Jacobus de Varagine. The Annunciation from this cycle (FIG. 16-34) perhaps best illustrates Piero's manner. One of the problems that occupied him all his life was how to establish a convincing architectonic relation between animate and inanimate objects. The key to Piero's solution in this painting is the conspicuously placed column that divides the depicted space into two vertical, cubic sections. The cylindrical shape of the column is echoed in the simplified, solemn, and immobile form of the Virgin. To

16-34 PIERO DELLA FRANCESCA, Annunciation from the Legend of the True Cross, c. 1455. Detail of fresco. San Francesco, Arezzo, Italy.

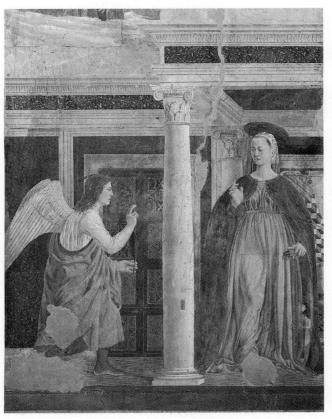

make his figures conform to the static quality of the architecture that surrounds them, Piero reduces all actions and gestures to the slowest, simplest signals; all emotion is banished. The composition is essentially a cylinder inscribed in a cubic void, and this geometricality of the forms gives the depiction of the event a trancelike and abstract quality.

In addition, of course, Piero's work shows an unflagging interest in the properties of light and color. He suspects that one is the function of the other; he observes that colors turn cool (bluish) in shadow and that they lose intensity with increasing distance from the observer. In his effort to make the clearest possible distinction between forms, he floods his pictures with light, imparting a silver-blue tonality. To avoid heavy shadows, he illumines the dark sides of his forms with reflected light. By moving the darkest tones of his modeling toward the centers of his volumes, he separates them from their backgrounds. As a result, Piero's paintings lack some of Masaccio's relieflike qualities but gain in spatial clarity as each shape becomes an independent unit, surrounded by an atmospheric envelope and movable to any desired position, like a figure on a chessboard.

In the *Resurrection* fresco in the town hall of Borgo San Sepolcro (FIG. **16-35**), Piero introduces a composi-

16-35 PIERO DELLA FRANCESCA, *Resurrection*, c. 1463. Fresco. Palazzo Comunale, Borgo San Sepolcro, Italy.

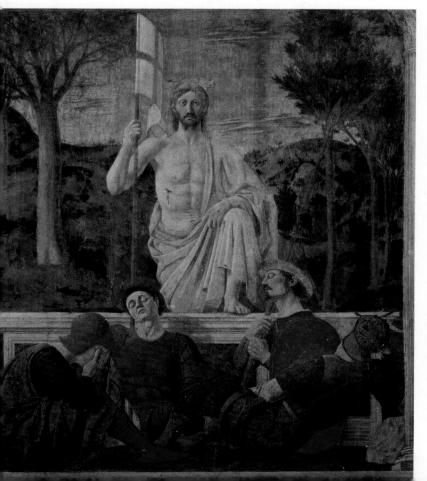

tional device—the figure triangle—that will enjoy great favor with later Renaissance artists. To stabilize his composition, Piero arranges his figures in a group that can be circumscribed by a triangle centrally placed in the painting. The figure of the risen Christ, standing with columnar strength in the attitude of eternal triumph at the edge of the sepulcher, occupies the upper portion of a triangular arrangement that rests on the broad base of the sleeping soldiers in the foreground. This triangular massing of volumes around a picture's central axis gives a painting great compositional stability and is one of the keys to the symmetry and self-sufficiency that Renaissance artists strove for in their work.

Piero was at home with realism and could paint exact and unflattering likenesses of human subjects, quite unlike the generalized heads and features of his customary type. His work summarizes most of the stylistic and scientific developments in painting during the first half of the fifteenth century: realism, descriptive landscape, the structural human figure, monumental composition, perspective, proportionality, and light and color.

FRA ANGELICO AND FRA FILIPPO LIPPI

But other good artists were active during this period whose styles remain rooted in an earlier age and whose interest in the new tendencies remained marginal. One of these, the Dominican painter-monk FRA ANGELICO (c. 1387-1455), was conservative by training and inclination. Although he was fully aware of what was being done by his more experimentally inclined contemporaries, Fra Angelico adopted into his essentially conservative style only those innovations he could incorporate without friction. While accepting realistic details in anatomy, drapery, perspective, and architecture, he rejected Masaccio's heavy modeling, which would have dulled his bright Gothic coloring. In the Annunciation (FIG. 16-36), one of numerous frescoes with which Fra Angelico decorated the Dominican convent of San Marco in Florence between 1435 and 1445, the Brunelleschian loggia is neatly designed according to the rules of linear perspective, but the fact that the vault is too low to allow the figures to stand would have been unacceptable to Piero della Francesca and other less conservative artists. However, such considerations were secondary to Fra Angelico; what he wanted above all was to stress the religious content of his paintings, and he did so by using the means, past and present, that he felt were most appropriate. In our example, the simplicity of the statement recalls Giotto, as does the form of the kneeling, rainbow-winged angel; the elegant silhouette of the sweetly shy Madonna descends from Sienese art, and the flower-carpeted, enclosed

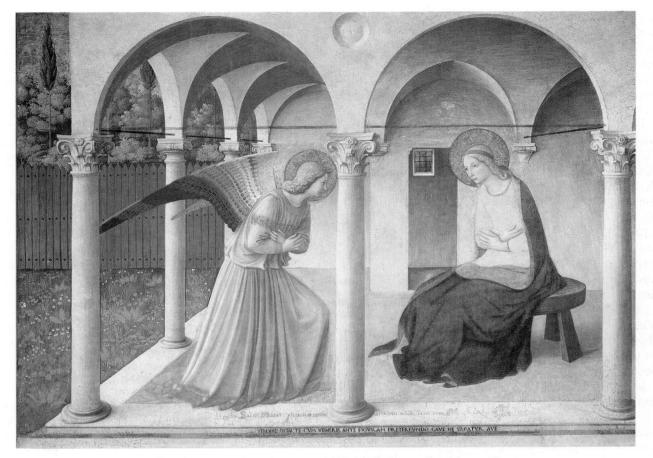

16-36 FRA ANGELICO, Annunciation, c. 1440-1445. Fresco. San Marco, Florence.

garden (symbolic of the virginity of Mary) is a bit of International Gothic. All these elements have been combined with lyrical feeling and a great sense for decorative effect, so that nothing seems incongruous. Like most of Fra Angelico's paintings, the naïve and tender charm of the *Annunciation* still has an almost universal appeal and fully reflects the character of the artist, who, as Giorgio Vasari tells us, "was a simple and most holy man .'. most gentle and temperate, living chastely, removed from the cares of the world . . . humble and modest in all his works."

A strong, though perhaps somewhat unlikely, contributor to the pictorial humanization of religious subject matter was FRA FILIPPO LIPPI (*c*. 1406–1469). Like Fra Angelico, Fra Filippo was a monk, but there all resemblance ends. From reports, he seems to have been a kind of amiable scapegrace quite unfitted for monastic life, who indulged in misdemeanors ranging from forgery and embezzlement to the abduction of a pretty nun, Lucretia, who became his mistress and the mother of his son, the painter FILIPPINO LIPPI. Only the Medici's intervention on his behalf at the papal court preserved Fra Filippo from severe punishment and total disgrace. An orphan, Fra Filippo was raised in a monastery adjacent to the church of Santa Maria del Carmine, and, when about eighteen, he must have met Masaccio there and witnessed the decoration of the Brancacci Chapel. Fra Filippo's early work survives only in fragments, but these show that he tried to work with Masaccio's massive forms. Later, probably under the influence of Ghiberti's and Donatello's relief sculptures, he developed a linear style that emphasizes the contours of his figures and permits him to suggest movement through flying and swirling draperies.

A fresh and inventive painting from Fra Filippo's later years, a *Madonna and Child with Angels* (FIG. **16-37**) shows his skill in manipulating line. Beyond noting its fine contours and modeling, we soon become aware of the wonderful flow of line throughout the picture; the forms are precisely yet smoothly delineated, whether they are whole figures or the details within them. Even without the reinforcing modeling, the forms would look three-dimensional and plastic, as the line is handled in a sculptural rather than in a two-dimensional sense. Fra Filippo's skill in the use of line is rarely surpassed; in the immediate future, only his most famous pupil, Botticelli, will use

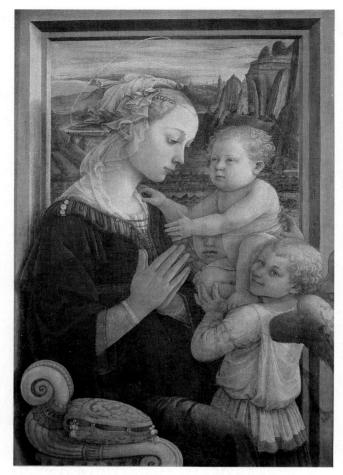

16-37 FRA FILIPPO LIPPI, Madonna and Child with Angels, c. 1455. Tempera on wood, approx. 36" × 25". Galleria degli Uffizi, Florence.

it with greater subtlety. Fra Filippo has interpreted his subject here in a surprisingly worldly manner. The Madonna, a beautiful young mother, is not at all spiritual or fragile, and neither is her plump bambino, the child Christ, who is held up to her by two angels, one of whom turns toward us with the mischievous, puckish grimace of a boy refusing to be subdued by the pious occasion. Significantly, all figures reflect the use of models (that for the Madonna may even have been Lucretia). Fra Filippo plainly relishes the charm of youth and beauty as he finds it in this world. He prefers the real in landscape also, and the background, seen through the window, has, despite some exaggerations, recognizable features of the Arno River valley. Compared with the earlier Madonnas by Duccio (FIG. 15-8) and Giotto (FIG. 15-11), this work shows how far the humanization of the theme has been carried. Whatever the ideals of spiritual perfection may have meant to artists in past centuries, those ideals now are realized in terms of the sensuous beauty of this world.

THE SECOND HALF OF THE FIFTEENTH CENTURY

In the early fifteenth century, Florence led Italy in the development of the new Humanism; later, the city shared its leadership role with other Italian cities. Under the sponsorship of local rulers, important cultural centers developed in other parts of Italy and began to attract artists and scholars: Urbino under the Montefeltri, Mantua under the Gonzaga, Milan under the Sforza, Naples under the kings of Aragon, and so forth.

This later period of Humanism is marked by a new interest in the Italian language and literature, the beginnings of literary criticism (parallel to the development of theory in art and architecture), the foundation of academies (especially the Platonic Academy of Philosophy in Florence), and the introduction of the printing press—and all that these elements could mean for the dissemination of culture.

The conquest of Constantinople by the Turks in 1453 caused an exodus of Greek scholars, many of whom fled to Italy, bringing with them knowledge of ancient Greece to feed the avid interest in Classical art, literature, and philosophy. That same conquest closed the Mediterranean to Western shipping, making it necessary to find new routes to the markets of the East. Thus began the age of navigation, discovery, and exploration.

In art and architecture, a theoretical foundation could now be placed under the more or less "intuitive" innovations of the earlier generation of artists. We must emphasize again the high value that Renaissance artists placed on theory. In their view, if any occupation or profession were to have dignity and be worthy of honor, it must have an intellectual basis. We still recognize this requirement; a "scientific" pursuit wins utmost respect in our age, and, for somewhat similar reasons, "fine" artists today are likely to consider their pursuits superior to those of "commercial" artists. Renaissance artists strove to make themselves scholars and gentlemen, to associate with princes and the learned, and to rise above the longstanding ancient and medieval prejudice that saw them as mere handicraftsmen.

Beginning with Alberti's treatises on painting and architecture, theoretical studies multiplied. The rediscovered text of the ancient Roman architect and theoretician, Vitruvius, became the subject of exhaustive examination and interpretation (partly because the recovered text was only a copy, which, unlike the original, was not illustrated, rendering passages that referred to illustrations obscure and subject to varying interpretations). Brunelleschi's invention of perspective and Alberti's and Piero's treatises on the subject provided the Renaissance artist with the opportunity to demonstrate the scientific basis of the visual arts.

The genius and creative energy required to achieve the new social and intellectual status claimed by the artist were available in abundance. The Renaissance ideal of *l'uomo universale* (the universal man) here finds its full realization; indeed, in LEON BATTISTA ALBERTI (1407–1472), it finds one of its first personifications. Writing of himself in the third person, Alberti gives us a most revealing insight into the mind of the brilliant Renaissance man—his universal interests, broad capabilities, love of beauty, and hope of fame:

In everything suitable to one born free and educated liberally, he was so trained from boyhood that among the leading young men of his age he was considered by no means the last. For, assiduous in the science and skill of dealing with arms and horses and musical instruments, as well as in the pursuit of letters and the fine arts, he was devoted to the knowledge of the most strange and difficult things. And finally he embraced with zeal and forethought everything which pertained to fame. To omit the rest, he strove so hard to attain a name in modeling and painting that he wished to neglect nothing by which he might gain the approbation of good men. His genius was so versatile that you might almost judge all the fine arts to be his. . . . He took extraordinary and peculiar pleasure in looking at things in which there was any mark of beauty. . . . Whatever was done by man with genius and with a certain grace, he held to be almost divine.*

It is probably no accident that this autobiography sounds like a funeral oration on a great man.

Architecture

ALBERTI

Alberti scarcely mentioned architecture as a prime interest. He entered the profession rather late in life, but today we know him chiefly as an architect. He was the first to seriously study the treatise of Vitruvius (*De architectura*), and his knowledge of it, combined with his own archeological investigations, made him the first Renaissance architect to understand Roman architecture in depth. Alberti's most important and influential theoretical work, *De re aedificatoria*, although inspired by Vitruvius, contains much new and original material. For later architects, some of Alberti's most significant observations were the advocations of a system of ideal proportions,

*In J. B. Ross and M. M. McLaughlin, eds., *The Portable Renaissance Reader* (New York: Viking, 1953), pp. 480ff.

a central-type plan as the ideal Christian church, and the avoidance of the column-arch combination (which had persisted from Spalatum in the fourth century to Brunelleschi in the fifteenth) as incongruous. By arguing that the arch is a wall-opening that should be supported only by a section of wall (a pier), not by an independent sculptural element (a column), Alberti (with a few exceptions) disposed of the Medieval arcade for centuries.

Alberti's own architectural style represents a scholarly application of Classical elements to contemporary buildings. His Palazzo Rucellai in Florence (FIG. 16-38) probably dates from the mid-1450s. The façade, built over a group of three Medieval houses, is much more severely organized than that of the Palazzo Medici-Riccardi (FIG. 16-24). Each story of the Palazzo Rucellai is articulated by flat pilasters, which support full entablatures. The rustication of the wall surfaces between the smooth pilasters is subdued and uniform, and the suggestion that the structure becomes lighter toward its top is made in an adaptation of the ancient Roman manner by using different articulating orders for each story: Tuscan (resembling the Doric order) for the ground floor, Composite (combining Ionic volutes with the acanthus leaves of the Corinthian) for the second story, and Corinthian

16-38 LEON BATTISTA ALBERTI, Palazzo Rucellai, Florence, c. 1452–1470.

for the third floor. Here, Alberti has adapted the articulation of the Colosseum (FIG. 6-48) to a flat façade, which does not allow the deep penetration of the building's mass that is so effective in the Roman structure. By converting the plastic, engaged columns of the ancient model into shallow pilasters that barely project from the wall, Alberti has created a large-meshed, linear net that, stretched tightly across the front of his building, not only unifies its three levels but also emphasizes the flat, two-dimensional qualities of the wall.

The design for the façade of the Gothic church of Santa Maria Novella in Florence (FIG. 16-39) also was commissioned by the Rucellai family. Here, Alberti takes his cue (just as Brunelleschi did occasionally) from a pre-Gothic Medieval design-that of San Miniato al Monte (FIG. 9-20). Following his Romanesque model, he designs a small, pseudo-Classical portico for the upper part of the façade and supports it with a broad base of pilaster-enframed arcades that incorporate the six tombs and three doorways of the extant Gothic building. But in the organization of these elements (FIG. 16-40), Alberti takes a long step beyond the Romanesque planners. The height of Santa Maria Novella (to the tip of the pediment) equals its width, so that the entire façade can be inscribed in a square. The upper structure, in turn, can be encased in a square one-fourth the size of the main square; the cornice of the entablature that separates the two levels halves the major square, so that the lower portion of the building becomes a rectangle that is twice as wide as it is high; and the areas outlined by the columns on the lower level are squares with sides that are about one-third the width of the main unit. Throughout the façade, Alberti defines areas and relates them to each other in terms of proportions that can be expressed in simple numerical ratios (1:1, 1:2, 1:3, 2:3, and so on). In his treatise, Alberti uses considerable space to propound the necessity of such harmonic relationships for the design of beautiful buildings. He shares this conviction with Brunelleschi, and it is basically this dependence on mathematics-a belief in the eternal and universal validity of numerical ratios as beauty-producing agents-that distinguishes the work of these two architects from that of their predecessors.

The façade of Santa Maria Novella is an ingenious solution to a difficult design problem. On one hand, it adequately expresses the organization of the structure to which it is attached; at the same time, it subjects diffused and preexisting features, including the large round window on the second level, to a rigid geometrical order that instills a quality of Classical calm and reason. This façade also introduces a feature of great historical consequence: the scrolls that form

16-39 LEON BATTISTA ALBERTI, west façade of Santa Maria Novella, Florence, c. 1458–1470.

16-40 West façade, Santa Maria Novella.

the transition from the broad lower level to the narrow upper level and that screen the sloping roofs over the aisles solve a problem that had vexed architects for centuries. With variations, such spirals will appear in literally hundreds of church façades throughout the Renaissance and Baroque periods.

At San Francesco in Rimini (FIG. **16-41**), Alberti again modernized a Gothic church—in this case, at the behest of one of the more sensational tyrants of the Early Renaissance, Sigismondo Pandolfo Malatesta, Lord of Rimini. Malatesta wanted a temple in which to enshrine the bones of great Humanist scholars like Gemistus Pletho, who dreamed of a neopagan religion that would supersede Christianity and whose remains Malatesta had brought from Greece. He intended his "temple" also to memorialize his

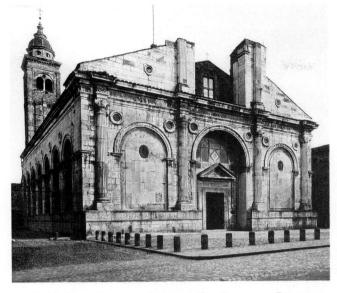

16-41 LEON BATTISTA ALBERTI, San Francesco, Rimini, Italy, begun 1451 (view from the northwest).

mistress, Isotta. Alberti's thoroughly Roman design is a monument both to the tyrant's love of Classical learning and to his arrant paganism. Alberti redesigned the exterior shell of San Francesco, making a cubic structure, complete within itself, and fronting it with a façade like a Roman triumphal arch. Four massive engaged columns frame three recessed arches and carry a flat entablature that projects sharply, making a ressaut, or "jump," above each capital. Alberti intended the second story, which remains incomplete, to have an arched window framed by pilasters. The heavy relief of this façade contrasts with the flat, bandlike elements in most of Alberti's other buildings. The deep, arched niches, rhythmically deployed along the flanks of the building, which contain sarcophagi for the remains of famous men, are in keeping with Alberti's conviction that arches should be carried on piers, not columns. These niches, along with the elements of the façade, provide an effect of monumental scale and grandeur that approaches ancient Roman architecture.

Adjusting the Classical orders to façade surfaces occupied Alberti throughout his career. In 1470, in his last years, he designed the church of Sant' Andrea in Mantua (FIGS. **16-42** to **16-44**) to replace an older eleventh-century church. In the ingeniously planned façade, which illustrates the culmination of Alberti's experiments, he locks together two complete Roman architectural motifs—the temple front and the triumphal arch. His concern for proportion made him equalize the vertical and horizontal dimensions of the façade, which leaves it considerably lower than the church behind it. This concession to the demands of a

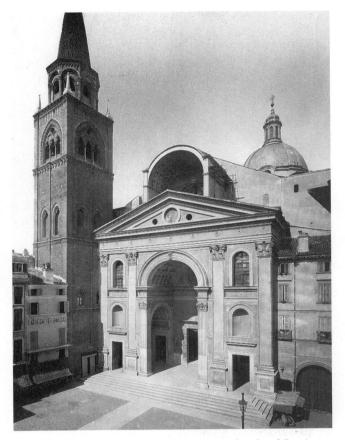

16-42 LEON BATTISTA ALBERTI, west façade of Sant' Andrea, Mantua, Italy, designed c. 1470.

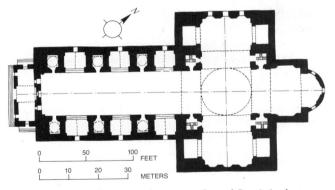

16-43 LEON BATTISTA ALBERTI, plan of Sant' Andrea.

purely visual proportionality in the façade and to the relation of the façade to the small square in front of it, even at the expense of continuity with the body of the building, is frequently manifest in Renaissance architecture, where considerations of visual appeal are of first importance. On the other hand, structural correspondences do exist in the Sant' Andrea façade. The façade pilasters are the same height as those on the interior walls of the nave, and the central barrel vault over the main entrance, from which smaller barrel

16-44 LEON BATTISTA ALBERTI, interior of Sant' Andrea.

vaults branch off at right angles, introduces (in proportional arrangement but on a smaller scale) the system used on the interior. The façade pilasters, becoming part of the wall, run uninterrupted through three stories in an early application of the "colossal" or "giant" order that will become a favorite motif of Michelangelo.

The interior of Sant' Andrea (FIG. 16-44) suggests that Alberti may have been inspired by the tremendous vaults of the ruined Basilica of Constantine (FIG. 6-91). The Medieval columned arcade, still used by Brunelleschi in Santo Spirito, now is forgotten, and the huge barrel vault, supported by thick walls alternating with vaulted chapels and interrupted by a massive dome over the crossing,* returns us to the vast interior spaces and dense enclosing masses of Roman architecture. In his treatise, Alberti calls the traditional basilican plan (in which continuous aisles flank the central nave) impractical, because the colonnades conceal the ceremonies from the faithful in the aisles; for this reason, he designed a single, huge hall, from which independent chapels branch off at right angles. This break with a Christian building tradition that had endured for a thousand years was extremely influential in later Renaissance and Baroque church planning.

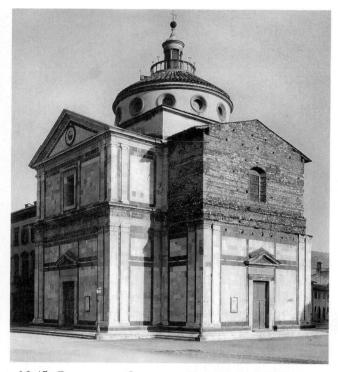

16-45 GIULIANO DA SANGALLO, Santa Maria delle Carceri, Prato, Italy, 1485 (view from the northwest).

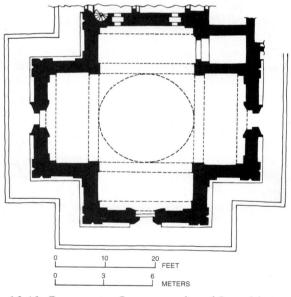

16-46 GIULIANO DA SANGALLO, plan of Santa Maria delle Carceri.

For many Renaissance architects and theoreticians, the circle was the ideal geometric figure; without a beginning or an end and with all points equidistant from a common center, it seemed to reflect the nature of the universe. This is one reason why the central plan was felt to be so appropriate for religious architecture. (Figures that approached the circle, such as

^{*}No one knows what kind of dome Alberti planned for the crossing; the present dome was added by FILIPPO JUVARA in the eighteenth century.

16-47 GIULIANO DA SANGALLO, interior of Santa Maria delle Carceri (view facing northeast).

polygons, were considered adequate.) But as firm as this conviction of the architects may have been, the clergy was almost as firm in its demands for traditional longitudinal churches, which, of course, are much more practical for Christian religious services. In addition to the question of how to accommodate the congregation in central-plan churches, architects were confronted with the question of where to put the main altar, and they were permitted to realize their ideal relatively rarely.

A compromise solution, suggested first in Alberti's San Sebastiano in Mantua (his one, abortive attempt at building a central-plan church), was realized by GIULIANO DA SANGALLO (1443–1516) in Santa Maria delle Carceri in Prato (FIGS. **16-45** to **16-47**). This building was built according to the plan of a Greek cross, with the cross arms so short that the emphasis is on the central, dome-covered square, very closely approaching the central-plan ideal. Blocklike, the structure is as high as it is wide, the cross arms are twice as wide as they are deep, and the Ionic second story is two-thirds the height of the Doric first floor. The whole building can be read in terms of the simple numerical relations that Alberti advocates. Interior articulation, however, is much closer to Brunelleschi and resembles that of the Pazzi Chapel (FIG. 16-22). The building seems to be a hybrid of the styles of Giuliano's two great predecessors, but it is also a neat and compact near-realization of an ideal central-plan Renaissance church.

Sculpture

Like the work of Alberti in the latter half of the fifteenth century, the sculpture of the Florentine school realizes new triumphs of Humanist Classicism. Donatello's successors refined his innovating art and each specialized in one of its many forms and subjects. No monument made by the next generation expresses more beautifully and clearly this dedication to the values of pagan antiquity than the tomb of Leonardo Bruni in Florence (FIG. **16-48**). Its sculptor,

 16-48 BERNARDO ROSSELLINO, tomb of Leonardo Bruni,
 c. 1445–1450. Marble, approx. 20' high to top of arch. Santa Croce, Florence.

BERNARDO ROSSELLINO (1409–1464), like the man whose tomb he built in Santa Croce, was at one time a resident of Arezzo. Rossellino strove mightily to immortalize his fellow citizen. The wall tomb has a history that reaches back into the Middle Ages, but Rossellino's version is new and definitive and the expression of an age deliberately turning away from the medieval past.

Leonardo Bruni was one of the most distinguished men of Italy, and his passing was mourned widely. As an erudite scholar in Greek and Latin, a diplomat and apostolic secretary to four popes, and a member of the chancery of the city of Florence, Bruni's career sums up the Humanistic ideal. The Florentines particularly praised him for his *History of Florence*. In his honor, the practice of the funeral oration was revived, as was the ancient custom of crowning the deceased with laurel. The historic event of the crowning of the dead Humanist may have given Rossellino his theme and the tomb may have been intended as a kind of memorialization of the laureate scene.

The deceased lies on the catafalque in a long gown, the *History of Florence* on his breast, the drapery of his couch caught up at the ends by imperial Roman eagles. Winged genii at the summit of the arch above the catafalque hold a great escutcheon; on the side of the sarcophagus, other genii support a Latin inscription that describes the Muses' grief at the scholar's passing. Roman funeral garlands are carved on the narrow platform at the base of the niche. The only Christian reference is a Madonna and Child with angels in the tympanum. As in Alberti's churches, a Humanist and pagan Classicism controls the mood of the design in an evocation of the ancient Greco-Roman world.

Few could hope for a funeral and tomb like those given Leonardo Bruni, but in a Humanistic age, many people wanted to see their memory, if not their fame, perpetuated. In addition, Renaissance man probably enjoyed seeing likenesses of himself. Roman portrait busts were being found and preserved in ever-greater numbers during the latter half of the fifteenth century, and, given this model, it was almost inevitable that the Renaissance would develop a similar portrait type. The form may have originated in the shop of ANTONIO ROSSELLINO (c. 1427–1479), the younger brother of Bernardo. The portrait bust of Matteo Palmieri (FIG. 16-49), apostolic delegate for Pope Sixtus IV, is an example of Antonio's work. Palmieri, who held high rank in Florence, was a learned man and author of a theological poem, City of Life, based formally on Dante's writing. After his death, parts of the poem were declared heretical because the souls of men originally were represented as fallen angels. However, at the time of his death, Palmieri received a state funeral like Bruni's; his book was placed on his breast and a funeral oration was delivered. Antonio's portrait of Palmieri is extremely realistic but avoids the hardness of Roman Republican visages, which suggest the lifeless exactitude of the death maskfrom which, indeed, they must have been made. Palmieri's almost clownlike face, with its enormous nose and endless mouth, is filled with a bright, intelligent animation, and the fine eyes seem those of a man engaged in a quick and subtle dialogue. The unsparing realism in the depiction of the ugly yet beguiling

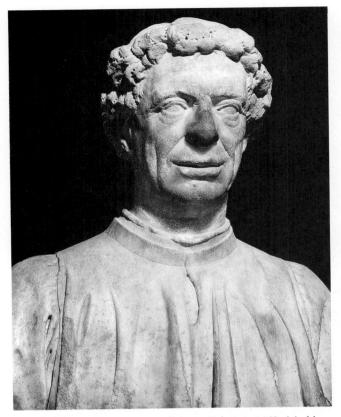

16-49 ANTONIO ROSSELLINO, Matteo Palmieri, 1468. Marble, life size. Museo Nazionale del Bargello, Florence.

16-50 DESIDERIO DA SETTIGNANO, Bust of a Little Boy, c. 1455. Marble, life size. National Gallery of Art, Washington, D.C. (Andrew W. Mellon Collection).

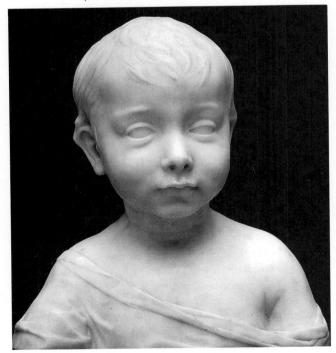

face is not surprising for a subject who probably had little difficulty in detecting flattery and rejecting it.

Donatello has shown the sternly real and the gently idealized in his forms; indeed, realism and idealism are parallel tendencies in the later fifteenth century. DESIDERIO DA SETTIGNANO (1428–1464) specialized in the sensitive reading of the faces of women and children, which he idealized without diminishing character, as we may see in his Bust of a Little Boy (FIG. 16-50). The proportions and soft contours of the head are wonderfully understood, as is the psychological set-a wondering innocence-captured by Desiderio in the ambiguous pout and in the uplifted brows and large eyes directed wide at an adult world. The marble has been carved to give a remarkable smoothness to the planes, so that the light will be modulated softly and the impression of living, tender flesh conveyed. The subtlety of Desiderio's surfaces and the consequent effect of life they give have long been admired by the Italians, as is evident in their phrase, il vago Desiderio, si dolce bello (the charming Desiderio, so sweetly beautiful). A whole school of sculptors worked in this manner, and attributions, often quite uncertain, range from Desiderio to the young Leonardo da Vinci. The soft, misty, shadow effects certainly point ahead to the sfumato ("smoky" light and shade) in Leonardo's paintings.

Since the thirteenth and fourteenth centuries, the Madonna and Child theme has become increasingly humanized, until, in the fifteenth century, we might almost speak of a school of sweetness and light in which many sculptors attempt to outdo each other in rendering the theme ever gentler and prettier, especially in relief. In the latter half of the fifteenth century, increasing demand for devotional images for private chapels and shrines (rather than for large public churches) contributed to an increasing secularization of traditional religious subject matter. LUCA DELLA ROBBIA (1400-1482), a sculptor in the generation of Donatello and a leader of the trend toward sweetness and light, discovered a way to multiply the images of the Madonna so that they would be within the reach of persons of modest means. His discovery (around 1430), involving the application of vitrified potters' glazes to sculpture, led to his production, in quantity, of the glazed terra-cotta reliefs for which he is best known. Because they were cheap, durable, and decorative, these works became extremely popular and provided the basis for a flourishing family business. The tradition was carried on by Luca's nephew ANDREA, whose colors tend to become a little garish, and by the latter's sons, GIOVANNI and GIROLAMO, whose activity extends well into the sixteenth century, when the product tends to become purely commercial; we still speak today of "della

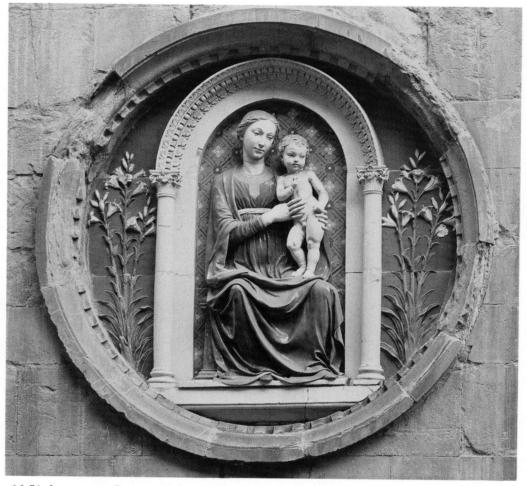

16-51 LUCA DELLA ROBBIA, Madonna and Child, c. 1455–1460. Terra-cotta with polychrome glaze, diameter approx. 6'. Or San Michele, Florence.

Robbia ware." An example of Luca's specialty is the Madonna and Child set into a wall of Or San Michele (FIG. 16-51). The figures are composed within a tondo, a circular frame that will become popular with both sculptors and painters, particularly within the della Robbia family, in the later part of the century. The introduction of high-key color into sculpture adds a certain worldly gaiety to the theme, and the customary light blue grounds (and here the green and white of lilies and the white architecture) suggest the festive season of Easter and the freshness of May, the month of the Virgin. Of course, the somber majesty of the old Byzantine style has long since disappeared. The young mothers who prayed before images like this new form easily could identify with the Madonna, and doubtless did. The distance between the observed and the observer has vanished.

VERROCCHIO

The most important sculptor during the second half of the century was ANDREA DEL VERROCCHIO

(1435-1488). A painter as well as a sculptor, with something of the versatility and depth of Donatello, Verrocchio directed a flourishing bottega (studio-shop) in Florence that attracted many students, among them Leonardo da Vinci. Verrocchio, like Donatello, also had a broad repertory. He too made a figure of David (FIG. 16-52), one that contrasts strongly in its narrative realism with the quiet, esthetic Classicism of Donatello's David (FIG. 16-12). Verrocchio's David, a sturdy, wiry young apprentice clad in a leathern doubtlet, stands with a jaunty pride, the head of Goliath at his feet. He poses like any sportsman who has just won a game, or a hunter with his kill. The easy balance of the weight and the lithe, still thinly adolescent musculature, in which the veins are prominent, show how closely Verrocchio read the text and how clearly he knew the psychology of brash and confident young men. Although the contrast with Donatello's interpretation need hardly be labored, we might note the "open" form of the Verrocchio David, the sword and pointed elbow sharply breaking

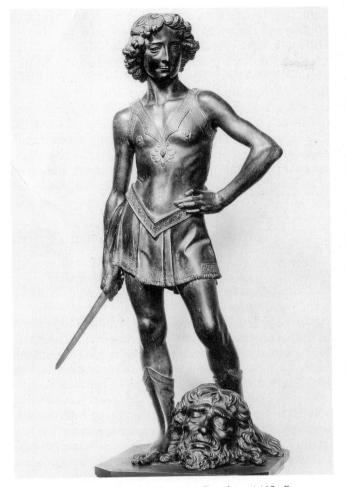

16-52 ANDREA DEL VERROCCHIO, David, c. 1465. Bronze, approx. 49" high. Museo Nazionale del Bargello, Florence.

through the figure's silhouette and stressing the live tension of the still alert victor. Donatello's *David*, on the other hand, has a "closed" silhouette that emphasizes its Classical calm and relaxation. The description of the anatomy of the two figures—specific in the former, generalized in the latter—puts further accent on the difference between them. Both statues are masterpieces and show how two skillful and thoughtful men approach the same theme very differently.

Verrocchio competes with Donatello again in an equestrian statue of another *condottiere* of Venice, *Bartolommeo Colleoni* (FIG. **16-53**), who, eager to emulate the fame and the monument of Donatello's *Gattamelata* (FIG. 16-13), provided for the statue in his will. Both Donatello's and Verrocchio's statues were made after the deaths of their subjects, so that neither artist knew the person being portrayed. The result is a fascinating difference of interpretation (like that between the two *Davids*) as to what a professional captain of armies would look like. On a pedestal even higher than that used in Donatello's *Gattamelata*, Ver-

rocchio's statue of the bold equestrian general is placed so that the dominating, aggressive figure can be seen above the rooftops, silhouetted against the sky, its fierce authority unmistakably present from all major approaches to the piazza (the Campo dei Santi Giovanni e Paolo). In contrast with the near repose of the Gattamelata, the Colleoni horse moves in a prancing stride, arching and curving its powerful neck, while the commander seems suddenly to shift his whole weight to the stirrups and, in a fit of impassioned anger, to rise from the saddle with a violent twist of his body. The figures are charged with an exaggerated tautness; the bulging muscles of the animal and the fiercely erect and rigid body of the man unify brute strength and rage. The commander, represented as delivering the battle harangue to his troops before they close with the enemy, has worked himself into a frenzy that he hopes to communicate to his men. In the Gattamelata, Donatello gives us a portrait of grim sagacity; Verrocchio's Bartolommeo Colleoni is a portrait of savage and merciless might. Machiavelli writes that the successful ruler must combine the traits of the lion and the fox; one feels that Donatello's Gattamelata is a little like the latter and that Verrocchio's Bartolommeo Colleoni is much like the former.

16-53 ANDREA DEL VERROCCHIO, Bartolommeo Colleoni, c. 1483–1488. Bronze, approx. 13' high. Campo dei Santi Giovanni e Paolo, Venice.

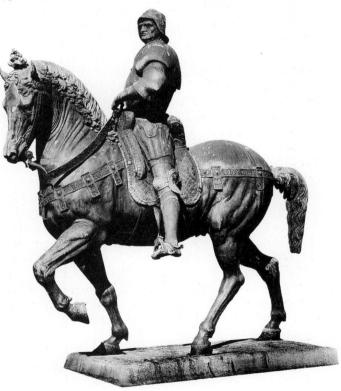

POLLAIUOLO

Closely related in stylistic intent to the work of Verrocchio is the work of Antonio Pollaiuolo (c. 1431-1498). Pollaiuolo, who is also important as a painter and engraver, infuses the nervous movement and emotional expressiveness of Donatello's late style with a new linear mobility, spatial complexity, and dramatic immediacy. He has a realistic concern for movement in all its variety and for the stress and strain of the human figure in violent action. These qualities are apparent in Pollaiuolo's small-scale group of Hercules and Antaeus (FIG. 16-54); not quite 18 inches high, it embodies the ferocity and vitality of elemental, physical conflict. The group illustrates the legend of a wrestling match between Antaeus (Antaios), a giant and son of the earth, and Hercules (Herakles). We already have seen this story represented by Euphronios on an ancient Greek vase (FIG.

16-54 ANTONIO POLLAIUOLO, Hercules and Antaeus, c. 1475. Bronze, approx. 18" high with base. Museo Nazionale del Bargello, Florence.

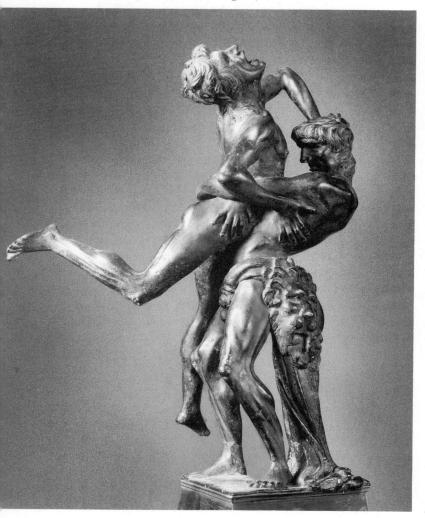

5-9). Each time Hercules threw him down, Antaeus sprang up again, his strength renewed by contact with the earth. Finally, Hercules held him aloft, so that he could not touch the earth, and strangled him around the waist. The artist strives to convey the final, excruciating moments of the struggle—the straining and cracking of sinews, the clenched teeth of Hercules, the kicking and screaming of Antaeus. The figures are interlocked in a tightly wound coil, and the flickering reflections of light on the dark, gouged surface of the bronze contribute to the effect of agitated movement and a fluid play of planes.

Painting and Engraving

The twisting of figures through space shows the growing interest in realistic action among artists during the second half of the century. Now an enthusiasm, this interest is further revealed in Pollaiuolo's Battle of the Ten Nudes (FIG. 16-55). Pollaiuolo belongs to the second generation of experimentalists, who, in their pursuit of realism, were absorbed in the study of anatomy, and he may have been one of the first artists to perform human dissection. The problem of rendering human anatomy had been rather well solved by earlier artists like Donatello and Andrea del Castagno, but their figures usually are shown at rest or in restrained motion. As we can see in his Hercules and Antaeus, Pollaiuolo takes delight in showing violent action and finds his opportunity in subjects dealing with combat. He conceives the body as a powerful machine and likes to display its mechanisms; knotted muscles and taut sinews activate the skeleton as ropes pull levers. To show this to best effect, Pollaiuolo developed a figure so thin and muscular that it appears écorché (as if without skin or outer tissue), with strongly accentuated articulations at the wrists, elbows, shoulders, and knees. His Battle of the Ten Nudes shows this figure type in a variety of poses from numerous points of view. If the figures, even though they hack and slash at one another without mercy, seem somewhat stiff and frozen, it is because Pollaiuolo shows all the muscle groups at maximum tension. The fact that only part of the body's muscle groups are involved in any one action, while the others are relaxed, was to be observed only several decades later by an even greater anatomist, Leonardo da Vinci.

Pollaiuolo's *Battle of the Ten Nudes* is an *engraving*, a print made by pressing an inked metal plate, into which a drawing has been incised, against a sheet of paper. Developed around the middle of the fifteenth century, probably in northern Europe, engraving proved to be more flexible and durable than the older

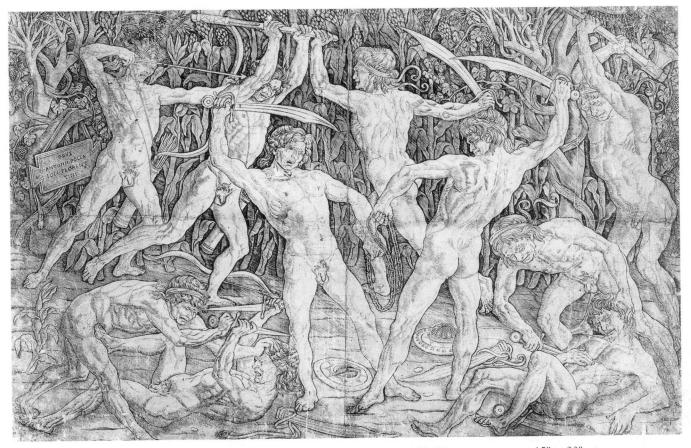

16-55 ANTONIO POLLAIUOLO, Battle of the Ten Nudes, c. 1465. Engraving, approx. 15" × 23". Metropolitan Museum of Art, New York (bequest of Joseph Pulitzer, 1917).

woodcut, which it gradually replaced during the later part of the century. As numerous prints could be made from the same plate, they were cheap and could be circulated widely, bringing art to all levels of society and spreading new and stimulating pictorial ideas among artists. Because they were easy to transport, prints were a quick and easy means of interartist communication. Italian prints had important influence on such northern painters as Albrecht Dürer, and the prints of that great master of engraving were admired widely by Italian artists.

The versatile Pollaiuolo experimented in painting, especially with the problem of representing figures in a landscape setting. The problem of relating figures to architecture already had been solved by Piero della Francesca, but the landscape setting presented a different set of requirements, some of which had been met by Masaccio. The panel representing *Hercules and Deianira* (FIG. **16-56**), a work contemporaneous with the sculptured group of *Hercules and Antaeus*, indicates that Pollaiuolo is a master not only of anatomy but also of landscape and light. In this, one of three paintings (the subjects of which were the labors of

Hercules, the legendary Greek hero) commissioned by Piero de' Medici for the Medici palace, the centaur Nessus has abducted Deianira, the bride of Hercules, and Hercules is in the act of slaying him with a poisoned arrow. The dramatic action and play of muscle and sinew is what we would expect of Pollaiuolo, but here he sets the bounding Nessus, the gesticulating Deianira, and the bow-taut Hercules in a broad landscape, the valley of the river Arno. The winding river takes the viewer's gaze all the way to the horizon, past the city of Florence, dim in the distance (the cathedral can be seen just beyond Deianira's left hand). Pollaiuolo's observation of deep landscape space and atmospheric effects, like the luminous glaze on the river and the fade-out of the contours of the far distant hills, complements his knowledge of the human figure; the broad, quiet, natural perspective serves to set off the tense movements of the figures. From midcentury on, a sharply increased interest developed in the pagan mythologies as subjects for painting and sculpture, an interest that will persist well into the nineteenth century. Here, a mythological subject has been imagined so vividly that it has been made part

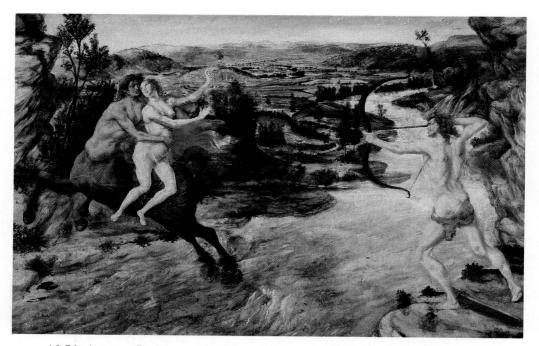

16-56 ANTONIO POLLAIUOLO, Hercules and Deianira, c. 1470. Egg tempera and oil (?) on canvas, $21\frac{12''}{16''} \times 31\frac{3}{16''}$. Yale University Art Gallery, New Haven, Connecticut (university purchase from James Jackson Jarves).

of the actual Florentine scene. Instead of relating figures and space in a rationally clear perspective, abstracted from nature, Pollaiuolo represents human figures in their natural environment. This image of the world is not fixed, like Piero della Francesca's, but is fluid and changing.

DOMENICO GHIRLANDAIO (1449–1494) differs in character from Pollaiuolo. Neither an innovator nor an experimenter, Ghirlandaio is rather a synthesizer who, profiting from everything done before, summarizes the state of Florentine art by the end of the century. His works express his times to perfection, and, for this, he enjoyed great popularity among his contemporaries. Ghirlandaio's paintings also show a deep love for the city of Florence, its spectacles and pageantry, its material wealth and luxury. His most representative pictures, a cycle of frescoes representing scenes from the lives of the Virgin and St. John the Baptist, are found in the choir of Santa Maria Novella. In our illustration, *The Birth of the Virgin* (FIG. **16-57**), Mary's mother, St. Anne, reclines in a palace room embellished with fine *intarsia* (wooden mosaic)

16-57 DOMENICO GHIRLANDAIO, The Birth of the Virgin, 1485–1490. Fresco. Cappella Maggiore, Santa Maria Novella, Florence.

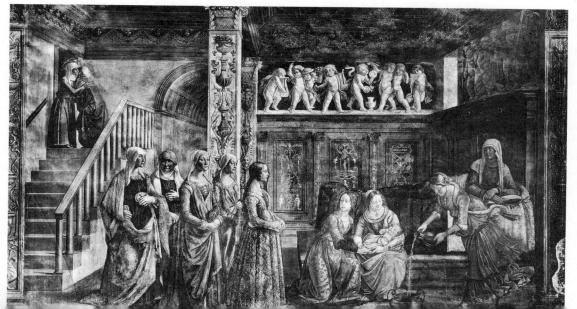

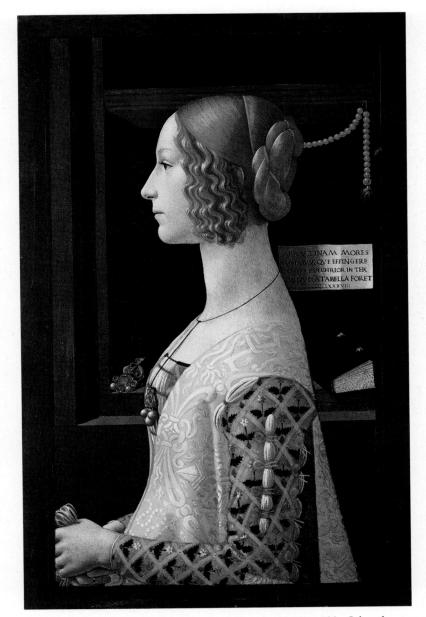

16-58 DOMENICO GHIRLANDAIO, Giovanna Tornabuoni (?), 1488. Oil and tempera on wood, approx. 30" × 20". Sammlung Thyssen-Bornemisza, Lugano, Switzerland.

and sculpture, while midwives prepare the infant's bath. From the left comes a grave procession of ladies, led by a member of the Tornabuoni family (the donors of the paintings). This splendidly dressed young woman holds as prominent a place in the composition (close to the central axis) as she must have held in Florentine society; her appearance in the painting (a different female member of the house appears in each of the frescoes) is conspicuous evidence of the secularization of sacred themes commonplace in art by this time. Living persons of high rank now are not only represented as present at biblical dramas but, as here, often steal the show from the saints. The display of patrician elegance absorbs and subordinates the devotional tableau.

The composition epitomizes the achievements of Early Renaissance painting: clear spatial representation; statuesque, firmly constructed figures; and rational order and logical relation among these figures and objects. If anything of earlier traits remains, it is in the arrangement of the figures, which still somewhat rigidly cling to layers parallel to the plane of the picture.

Giovanna Tornabuoni may be the subject of a portrait by Ghirlandaio (FIG. **16-58**), the cool formality of which recalls the lady in the fresco and sets off the

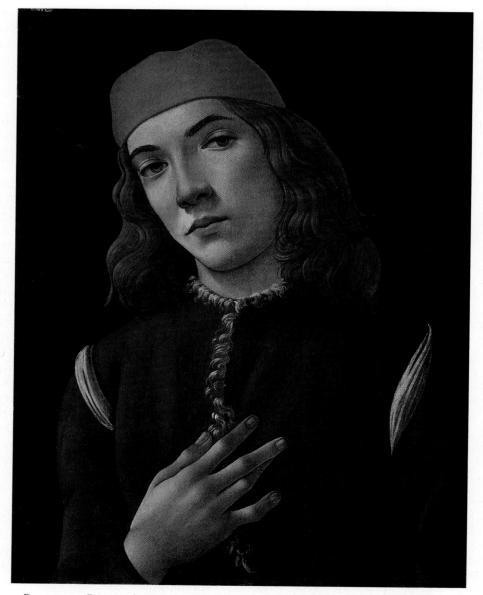

16-59 SANDRO BOTTICELLI, Portrait of a Young Man, c. 1489–1490. Tempera on panel, approx. $16\frac{1}{8}'' \times 12\frac{1}{4}''$. National Gallery of Art, Washington, D.C. (Andrew W. Mellon Collection).

proud, sensitive beauty of the aristocratic features. Although the profile pose is not intended primarily to convey a reading of character, this portrait tells us much about the high state of human culture achieved in Florence, the value and careful cultivation of beauty in life and art, the breeding of courtly manners, and the great wealth behind it all.

BOTTICELLI

The profile pose was customary in Florence until about 1470, when three-quarter and full-face portraits began to replace it. In about the last decade of the fifteenth century, SANDRO BOTTICELLI (Alessandro di Mariano dei Filipepi, 1444–1510) painted the nearly full-face *Portrait of a Young Man* (FIG. **16-59**). Threequarter and full-face views were made common earlier in the century by the painters of northern Europe. The Italian painters now adopt them, perceiving that they increase the viewer's information about the subject's appearance and allow the artist to reveal the subject's character, although Italian artists will long prefer an impersonal formality that conceals the private, psychological person. An apparent exception, Botticelli's young man is highly expressive psychologically. The delicacy of the pose, the graceful tilt of the head, the sidelong glance, and the elegant gesture of the hand compose an equivocal expression half-musing and half-insinuating. Feminine and masculine traits are merged to make an image of rarified, epicene beauty.

Botticelli was the pupil of Fra Filippo Lippi, from whom he must have learned the method of "drawing" firm, pure outline with light shading within the contours. The effect clearly is apparent in the explicit and sharply elegant form of the portrait. In the hands of Botticelli, this method will be refined infinitely, and he is known in world art as one of the great masters of line. One of the most important monographs on Botticelli was written by a Japanese;* in Botticelli, the Orient recognizes a master from the West.

No discussion of Botticelli can be fully meaningful without some reference to the environment that peculiarly encouraged him-the circle of Lorenzo de' Medici and the Platonic Academy of Philosophy. Here, he studied the philosophy of Plato, or rather of Neo-Platonism, for scholars had not yet developed the critical sense that would distinguish between Plato and the Neo-Platonic mystics of Alexandria, who came centuries after and quite transformed Plato's thought in the direction of a religious system. It was this spiritualized and mystical Platonism that Botticelli absorbed, believing that it was close to Christianity in essence and that the two could be reconciled. He must have heard the Humanists gathered around Lorenzo discoursing on these new mysteries in one of the Medici villas-surroundings highly conducive to reflection. A modern historian writes:

In a villa overhanging the towers of Florence, on the steep slope of that lofty hill crowned by the mother city, the ancient Fiesole, in gardens which Cicero might have envied, with Ficino, Landino, and Politian at his side, he [Lorenzo] delighted his hours with the beautiful visions of Platonic philosophy, for which the summer stillness of an Italian sky appears the most genial accompaniment.⁺

Botticelli had the power to materialize the "beautiful visions," and this he did in a number of works for the Medici villas, among them the famous *Birth of Venus* (FIG. **16-60**), inspired, it is believed, by a poem by Politian on that theme. Botticelli is of his generation in his enthusiasm for themes from Classical mythology as well as in his suiting of the ancient pagan materials to a form prepared by the Early Renaissance, a form realistic yet still modified by something of the Medieval past. Competent in all the new representational methods, he seems deliberately to sacrifice them in the interest of his own original manner, rarefying the realism of the Early Renaissance into an inimitable decorative and linear system that generates its own kind of figure and space.

Venus, born of the sea foam, is wafted on a cockle shell, blown by the Zephyrs, to her sacred island, Cyprus, where the nymph Pomona, descended from the ancient goddess of fruit trees, runs to meet her with a brocaded mantle. The lightness and bodilessness of the Zephyrs move all the figures without effort. Draperies undulate easily in the gentle gusts, perfumed by rose petals that fall on the whitecaps stirred by the Zephyrs' toes. The presentation of the figure of Venus nude was, in itself, an innovation; as we have seen, the nude, especially the female nude, had been proscribed in the Middle Ages. Its appearance on such a scale and the use of an ancient Venus statue of the Venus pudica (modest Venus) type as a model could have drawn the charge of paganism and infidelity. But under the protection of the powerful Medici, a new world of imagination could open freely with the new Platonism.

In Botticelli's hands, the pagan myth is transmuted into a Neo-Platonic allegory of the human soul. The high priest of the Neo-Platonic cult (for which The Birth of Venus almost could have been an altarpiece) was the Humanist Marsilio Ficino, certainly known to Botticelli through Lorenzo de' Medici's circle. Ficino taught that God, the Supreme One, had created the universe as a hierarchy of descending orders of being that extended from the perfection of the angelic spheres down to the inert being of base matter. The human soul, before its birth, had perfect existence; coming into the world of matter, it had become corrupt. Now it occupied the central place in the great chain of being. It could regain its original perfection and ascend to fullest being only by the love of God as manifested in the beauty of creation. By the contemplation of beauty, the soul could progress from the love of the material to the love of the abstract, and then to the love of the spiritual. The goal of the quest is the vision of God—Dante's experience at the end of the Comedia. Venus, the pagan goddess of beauty, is transformed into the Heavenly Venus, purged of all mundane sensuality; it is she whom the soul must contemplate.

Botticelli gives us the Heavenly Venus. The lovely figure of the goddess, strangely weightless and ethereal, is the intellectual or spiritual apparition of beauty. At the same time, she personifies the human soul. The *Birth of Venus* is an allegory of the primal innocence and truth of the soul, before its birth into gross matter, its fall into lesser being. Here, the soul naked as truth is naked—is blown upon by the winds of passion but is soon to be clothed in the robe of

^{*}Y. Yashiro, Sandro Botticelli and the Florentine Renaissance, rev. ed. (Boston: Hale, 1929).

⁺Henry Hallam, in J. A. Symonds, *Renaissance in Italy* (New York: Modern Library, 1935), Vol. 1, p. 477.

reason. The coarse, pagan myth of the goddess is conflated with the Neo-Platonic account of the journey of the soul to God through the contemplation of beauty. The ascent of the soul to the ultimate ecstasy, the vision of God, is the main theme of Christian mysticism; the concept that the ascent is made possible by the contemplation of beauty is Neo-Platonic. The beauty of the pagan goddess becomes the beauty of the perfected soul.

This kind of mystical approach, so different from the earnest search of the early fifteenth century to comprehend humanity and the natural world through a rational and empirical order, finds expression in Botticelli's strange and beautiful style, which seems to ignore all of the scientific ground gained by experimental art. His style parallels the allegorical pageants in Florence, which were staged as chivalric tournaments but revolved completely around allusions to Classical mythology; the same trend is evident in the poetry of the 1470s and 1480s. Artists and poets at this time did not directly imitate classical antiquity, but used the myths, with delicate perception of their charm, in a way still tinged with medieval romance.

Botticelli's style, the sensitive vehicle of an intensely sensitive mind, changed with the fortunes of Florence; as he responded to the Humanist and Neo-Platonic ideas of the circle of Lorenzo de' Medici, so he responded to the overthrow of the Medici, the incursion of the French armies, and especially to the preaching of the Dominican monk Girolamo Savonarola, the reforming priest-dictator who denounced the paganism of the Medici and their artists, philosophers, and poets. Savonarola called on the citizens of Florence to repent their iniquities, and, when the Medici fled, he prophesied the doom of the city and of Italy and took absolute power over the state. Together with a large number of citizens, Savonarola believed that the Medici had been a political, social, and religious influence for the worse-corrupting Florence and inviting the scourge of foreign invasion. Modern scholars still debate the significance of Savonarola's brief span of power. Apologists for the undoubtedly sincere monk deny that his actions played a role in the decline of Florentine culture at the end of the century. But he did rail at the Neo-Platonist Humanists as heretical gabblers, and his banishing of the Medici, Tornabuoni, and other noble families from

16-60 SANDRO BOTTICELLI, *The Birth of Venus*, c. 1482. Tempera on canvas, approx. 5' $8'' \times 9'$ 1". Galleria degli Uffizi, Florence.

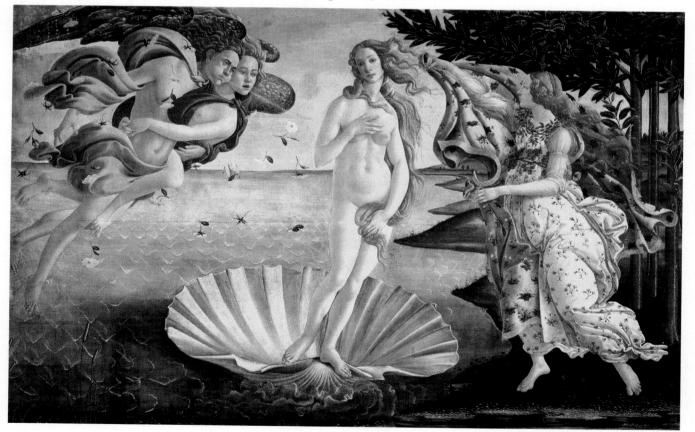

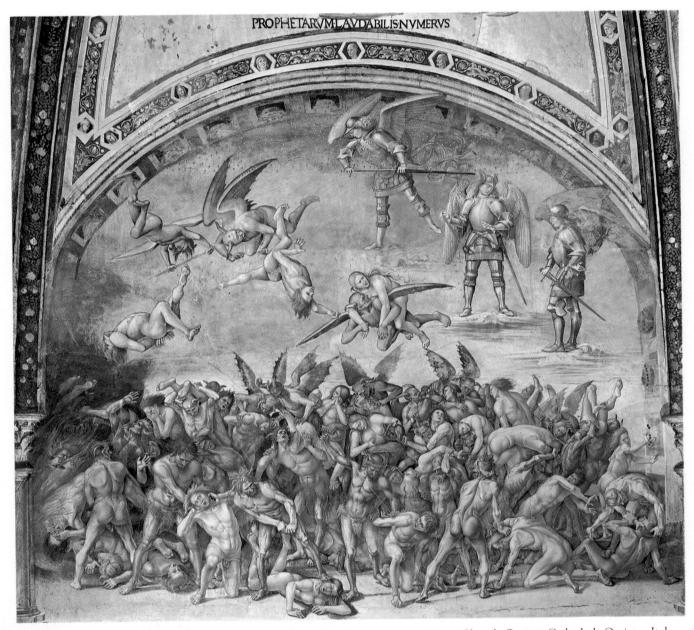

16-61 LUCA SIGNORELLI, The Damned Cast into Hell, 1499-1504. Fresco. San Brizio Chapel, Orvieto Cathedral, Orvieto, Italy.

Florence deprived local artists of some of their major patrons. Florence lost its position of cultural leadership at the end of the century and never regained it. Certainly, the puritanical spirit that moved Savonarola—and that was soon to appear throughout Europe in the reforming preachments of the Protestant Reformation—must have dampened considerably the neopagan enthusiasm of the Florentine Early Renaissance.

The sensitive, highly personal, and exotic style of Botticelli closed the great age of Florentine art on an exquisitely refined note. Artists of his generation outside Florence, but within the circuit of its influence, elaborated on the experiments introduced earlier in the century. An Umbrian painter, LUCA SIGNORELLI (*c.* 1445–1523), further developed the interest of Antonio Pollaiuolo in the depiction of muscular bodies in violent action in a wide variety of poses and foreshortenings. In the San Brizio Chapel in Orvieto Cathedral, Signorelli's painted scenes depicting the end of the world include *The Damned Cast into Hell* (FIG. **16-61**). Few figure compositions of the fifteenth century have the same awesome psychic impact. St. Michael and the hosts of Heaven hurl the damned

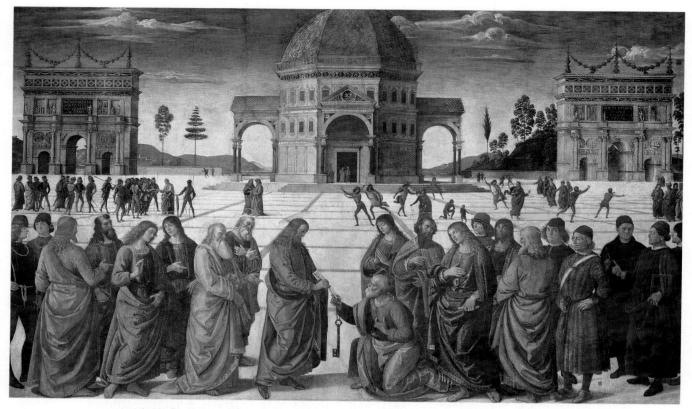

16-62 PERUGINO, Christ Delivering the Keys of the Kingdom to St. Peter, 1481–1483. Fresco. Sistine Chapel, Vatican, Rome.

into Hell, where, in a dense, writhing mass, they are tortured by vigorous demons. The figures-nude, lean, and muscular-assume every conceivable posture of anguish. Signorelli's skill at foreshortening the human figure is one with his mastery of its action, and although each figure is clearly a study from a model, he fits his theme to the figures in an entirely convincing manner. Terror and rage pass like storms through the wrenched and twisted bodies. The fiends, their hair flaming and their bodies the color of putrefying flesh, lunge at their victims in ferocious frenzy. Not even Pollaiuolo achieves such virtuosity in the manipulation of anatomy for dramatic purpose. Doubtless, Signorelli influenced Michelangelo, who makes the human nude his sole and sufficient expressive motif. In The Last Judgment in the Sistine Chapel, Michelangelo shows that he was much aware of Signorelli's version of the theme.

Signorelli's fellow Umbrian, PERUGINO (Pietro Vannucci, *c*. 1450–1523), was concerned not with the human figure in violent action, as Signorelli was, but with the calm, geometric ordering of pictorial space. Between 1481 and 1483, Perugino, Botticelli, Ghirlandaio, and Signorelli were among a group of artists summoned to Rome to decorate the walls of the

newly completed Sistine Chapel with frescoes. Perugino painted Christ Delivering the Keys of the Kingdom to St. Peter (FIG. 16-62), the event on which the papacy had, from the beginning, based its claim to infallible and total authority over the Church. Christ hands the keys to St. Peter, standing at the center of solemn choruses of saints and citizens, who occupy the apron of a great stage space that marches into the distance to a point of convergence in the doorway of a central-plan temple. (The intervening space is stepped off by the parallel lines of the pavement.) Figures in the middle distance complement the near group, emphasizing its density and order by their scattered arrangement. At the corners of the great piazza, triumphal arches resembling the Arch of Constantine (FIG. 6-95) mark the base angles of a compositional triangle having its apex in the central building. Christ and Peter are placed on the central axis, which runs through the temple's doorway, within which is the vanishing point of the perspective. Thus, the composition interlocks both two-dimensional and three-dimensional space, and the central actors are integrated carefully with the axial center. This spatial science provides a means for organizing the action systematically. Perugino, in this single picture, incor-

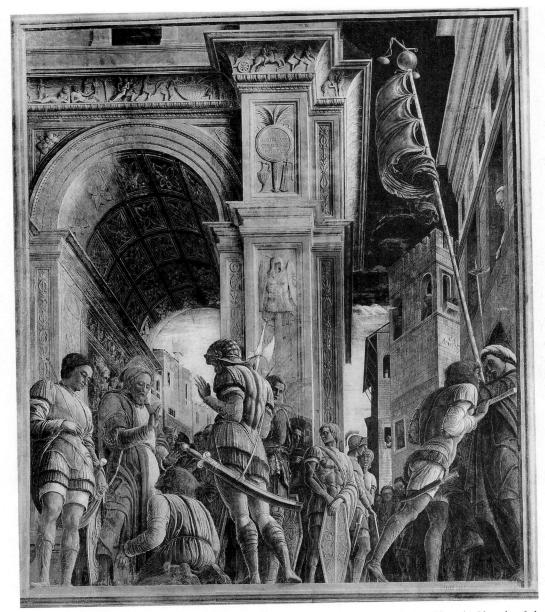

16-63 ANDREA MANTEGNA, St. James Led to Martyrdom, c. 1455. Fresco. Ovetari Chapel, Church of the Eremitani, Padua (largely destroyed, 1944).

porates the learning of generations. His coolly rational, orderly style and the uncluttered clarity of his compositions left a lasting impression on his bestknown student, Raphael.

MANTEGNA

Many Florentine artists worked in northern Italy: Donatello in Padua; Paolo Uccello, Andrea del Castagno, and Fra Filippo Lippi in Venice. Gradually, the International style, which lingered long in the north, yielded to the new Florentine art. Around midcentury, one of the most brilliant talents of the entire Renaissance, ANDREA MANTEGNA (c. 1431–1506) of Padua, appeared in northern Italy; there he must have met Donatello, who greatly stimulated and influenced his art. Mantegna's frescoes in the Ovetari Chapel in the Church of the Eremitani in Padua (largely destroyed in World War II) bring northern Italian painting into line with the Humanist art of Florence. *St. James Led to Martyrdom* (FIG. **16-63**) reveals the breadth of Mantegna's literary, archeological, and pictorial learning. The motifs that appear on

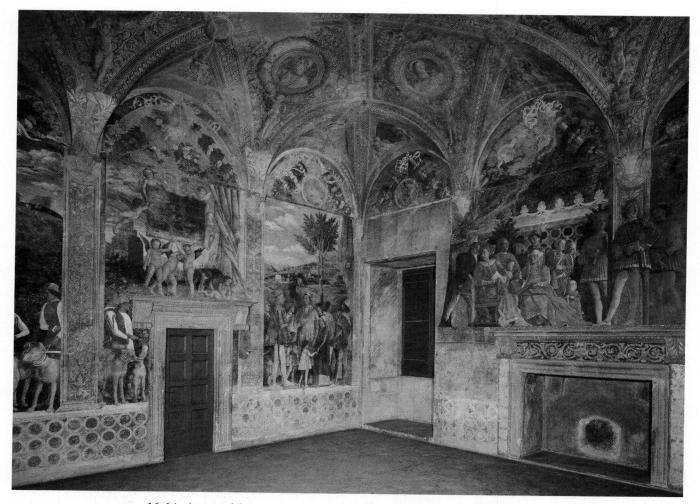

16-64 ANDREA MANTEGNA, Camera degli Sposi, 1474. Ducal palace, Mantua.

the barrel-vaulted triumphal arch are taken from the Classical ornamental vocabulary. The soldiers' costumes are studied from antique models; the painter strives for historical authenticity, much as did the antiquarian scholars of the University of Padua. Mantegna sets himself difficult problems in perspective for the joy of solving them. Here, the observer views the scene from a very low point, almost as if looking up out of a basement window at the vast arch looming above. The lines of the building to the right plunge down dramatically. Several significant deviations from true perspective are apparent, however. Using artistic license, Mantegna ignores the third vanishing point (seen from below, the buildings should converge toward the top). Disregarding the facts of perspective, he prefers to work toward a unified, cohesive composition in which pictorial elements are related to the picture frame. The lack of perspective logic is partly compensated for by the insertion of strong diagonals in the right foreground (the staff of the banner, for example).

From about 1460 onward, Mantegna worked predominantly for the Gonzaga family of Mantua, who were great art patrons like the Medici. Unlike the Medici, however, who were the most powerful members of a merchant oligarchy, the Gonzaga were hereditary dukes. In the ducal palace at Mantua, Mantegna performed a triumphant feat of pictorial illusionism, producing the first completely consistent illusionistic decoration of an entire room-the socalled Camera degli Sposi (Room of the Newlyweds, FIG. 16-64). Utilizing actual architectural elements, Mantegna paints away the walls of the room in a manner that forecasts later Baroque decoration. He represents members of the House of Gonzaga welcoming home a son, a prince of the Church, from Rome. The family members, magnificently costumed, are shown in both domestic and landscape settings and are rendered carefully in portrait realism. The poses are remarkably unstudied and casual, conveying the easy familiarity of a family reunion. The painting is a celebration of fifteenth-century court life

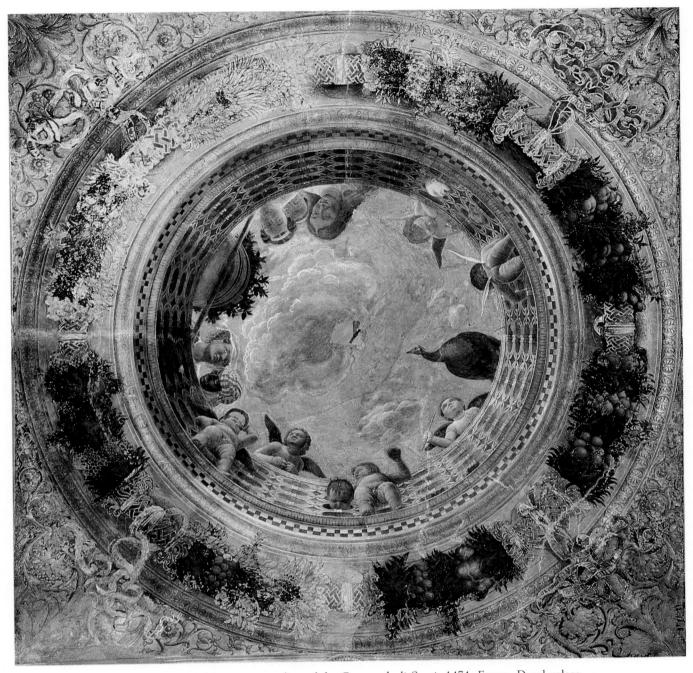

16-65 ANDREA MANTEGNA, ceiling of the Camera degli Sposi, 1474. Fresco. Ducal palace.

and a glorification of the Gonzaga, as well as the century's major depiction of a current event. The lunettes are filled with garlands and medallions *all' antica* (in the antique manner), motifs that are standard features in northern Italian painting.

Mantegna's daring experimentalism leads him to complete the room's decoration with the first *di sotto in sù* (Italian: from below upwards) perspective of a ceiling (FIG. **16-65**). This technique was broadly developed later by the northern Italian painter, Correggio,

and the Baroque ceiling decorators. In the Room of the Newlyweds, we look directly up at figures looking down at us. Italians traditionally have a great deal of fun with newlyweds; spying on them is part of the fun. The dome of the room is positioned directly over the marriage bed. The oculus is itself an "eye" looking down. Cupids (the sons of Venus), strongly foreshortened, set the amorous mood, as the painted spectators (who are not identified) smile down on the scene. The peacock is an attribute of Juno, the bride of Jupiter, who is the patroness of lawful marriage and the goddess of women. This tour de force of illusionism climaxes almost a century of experiment in perspective.

One of Mantegna's later paintings, The Dead Christ (FIG. 16-66), is a work of overwhelming power, despite the somewhat awkward insertion of the two mourning figures on the left. What seems to be a strikingly realistic study in foreshortening, however, is modified by a reduction in the size of the figure's feet, which, as every photographer knows (and as Mantegna must have known), would cover the body if properly represented. Thus, tempering naturalism with artistic license, Mantegna presents both a harrowing study of a strongly foreshortened cadaver and an intensely poignant presentation of a cosmic tragedy. The harsh, sharp line seems to cut the surface as if it were metal and conveys, by its grinding edge, the corrosive emotion of the theme; the observer thinks immediately of Ernest Hemingway's "the bitter nail holes in Mantegna's Christ." Mantegna's presentation is unrelievedly bitter, an unforgiving reproach to guilty mankind. What is remarkable is that all the science of the fifteenth century here serves the purpose of devotion. A Gothic religious sensitivity of great depth and intensity still lingers in northern Italy at the end of the Middle Ages and is embodied in an image created by a new science.

Mantegna's work was highly influential in northern Italy, especially in the school of Ferrara—but also in Venice, where his style had a strong, formative influence on Giovanni Bellini, who may be viewed as the progenitor of Venetian painting (see FIG. 17-55). Mantegna's influence went even further, however, for he was a great engraver (the line in *The Dead Christ* certainly suggests engraving), and his prints found their way across the Alps to where they influenced Albrecht Dürer, German father of the Northern Renaissance.

By itself, the influence of Mantegna might have stunted Giovanni Bellini's development, and the arrival in Venice of an artist with a style very different

16-66 ANDREA MANTEGNA, The Dead Christ, c. 1501. Tempera on canvas, approx. 26" × 31". Pinacoteca di Brera, Milan.

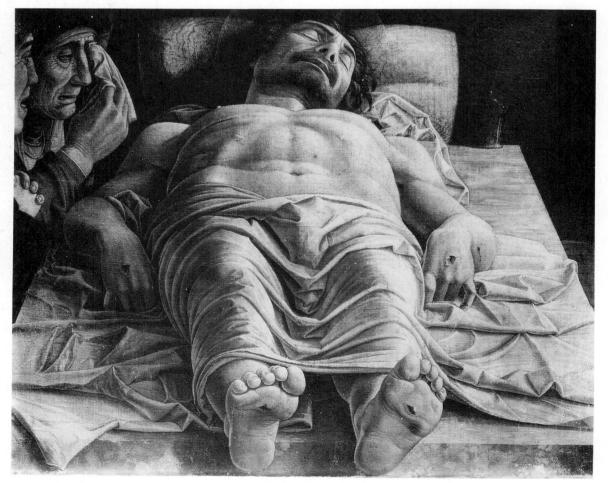

from Mantegna's probably was most opportune for Bellini's artistic growth. ANTONELLO DA MESSINA (c. 1430–1479) is an enigmatic figure about whose background little is known. He was born in Sicily (the only major artist of the fifteenth century to be born south of Rome) and received his early training in Naples, where he must have come in close contact with Flemish painting. The Flemish influence in some of his works is so strong that it has long been assumed that Antonello actually spent some time in Flanders, a possibility that now seems unlikely. Historians also have speculated that Antonello may have had direct contact with the Flemish artist Petrus Christus in Milan during the mid-1450s-a most intriguing possibility, as the styles of the two artists have many similarities. But the presence of either man in Milan at that time cannot definitely be proved. In any case, Antonello arrived in Venice in 1475, with a full mastery of the mixed-oil technique, and made a strong impression there during his twoyear stay.

How greatly Antonello's style differs from Mantegna's can be seen in one of his later works, The Martyrdom of St. Sebastian (FIG. 16-67), which has none of Mantegna's brittle, sometimes harsh linearity. The forms are modeled in broad, simplified planes, reminiscent of the style of Piero della Francesca, whose work Antonello must have studied very closely. The crisp clarity of the spatial composition, the subdued emotion, and the solemn calm with which the saint suffers his martyrdom are also suggestive of Piero's work. But Antonello goes even beyond Piero in bathing his painting in atmospheric luminosity, and his colors tend to be warm rather than cool, with golden brown tones dominating. Compared to earlier works, the painting has a "juicy" colorism that is due, in good part, to Antonello's use of mixed oil-a more flexible medium that is wider in coloristic range than tempera or fresco. Thus, by combining elements of Piero's style with Flemish painting techniques, Antonello fuses monumental qualities with coloristic effects of unrivaled richness. Giovanni Bellini was one of the first to appreciate the value of Antonello's gift to Venice and to abandon Mantegna's "hard" style, which, within a decade of Antonello's visit to Venice, became hopelessly outdated.

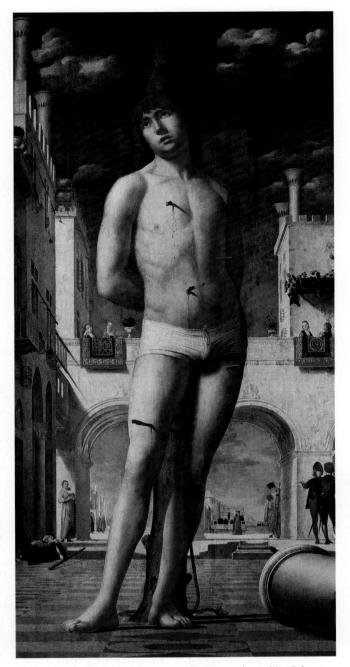

16-67 ANTONELLO DA MESSINA, The Martyrdom of St. Sebastian,
 c. 1475–1477. Oil on wood, approx. 68" × 34". Gemäldegalerie,
 Abt. Alte Meister, Staatliche Kunstsammlungen,
 Dresden, East Germany.

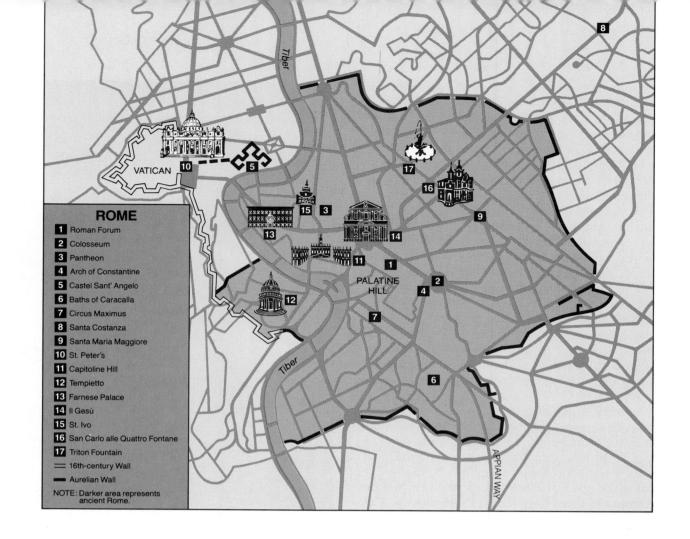

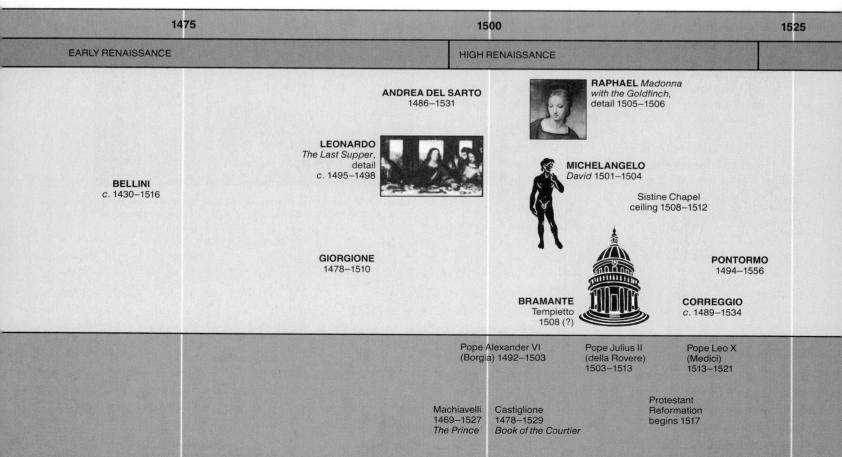

17 SIXTEENTH-CENTURY ITALIAN ART

EFORE THE END of the fifteenth century, Florence had lost her unique position of leadership in the arts, and the innovations of her artists had become the property of Italian artists, regardless of local political boundaries. We do not mean to suggest that Florence no longer produced the artistic giants of an earlier age. Leonardo and Michelangelo called themselves Florentines, even though they spent a great part of their lives outside the city, and the turning point in Raphael's artistic education occurred as a result of his experience of Florentine art. In addition, Florence, with the early work of Leonardo, already had become the source of sixteenth-century style and later shared with Rome the beginnings and growth of Mannerism, a style that was to dominate western European art during much of the sixteenth century. But Florence was faced with a time of crisis that began with the expulsion of the Medici and the brief and stormy dictatorship of Girolamo Savonarola and ended with the subversion of the Florentine republic by the Spanish and the return of the Medici (a collateral line of the original family) as tyrants under Spanish protection. Finally, in the 1530s, Florentine independence became a thing of the past when the state was made into a grand duchy under the crown of the Hapsburgs.

THE HIGH RENAISSANCE

Between about 1495 and the date of its own invasion and sack in 1527, Rome took the place of Florence and laid claim to its artistic preeminence. A series of powerful and ambitious popes-Alexander VI (Borgia), Julius II (della Rovere), Leo X (Medici), and Clement VII (Medici)—created a new power in Italy: a papal state, with Rome as its capital. At the same time, Rome became the artistic capital of Europe. The popes, living in the opulent splendor of secular princes, embellished the city with great works of art, inviting artists from all over Italy and providing them with challenging tasks. In its short duration, the artists of this High Renaissance produced works of such authority that generations of later artists were instructed by them. The art of Leonardo, Raphael, Michelangelo, and Titian belongs to no school but is, in the case of each, something unique. The masters had of course inherited the pictorial science of the fifteenth century, and they learned from one another. Yet they made a distinct break from the past, occupying new and lofty ground—so lofty as to discourage emulation by their successors.

The High Renaissance produced a cluster of extraordinary geniuses and found in divine inspiration

the rationale for the exaltation of the artist-genius. The Neo-Platonists found in Plato's Ion his famous praise of the poet: "All good poets compose their beautiful poems not by art, but because they are inspired and possessed. . . . for not by art does the poet sing, but by power divine." And what the poet could claim, the Renaissance artist claimed also, raising visual art to the status formerly held only by poetry. Thus, at the threshold of the modern world, painters, sculptors, and architects came into their own, successfully claiming for their work a high place among the fine arts. In the High Renaissance, the masters in a sense created a new profession, having its own rights of expression, its own venerable character, and its own claims to recognition by the great. The "fine" artist today lives, often without realizing it, on the accumulated prestige won by preceding artists, beginning with those who made the first great gains of the High Renaissance.

Leonardo da Vinci

A man who is the epitome of the artist-genius as well as of the "universal man," LEONARDO DA VINCI (1452–1519) has become a kind of wonder of the modern world, standing at the beginning of a new epoch like a prophet and a sage, mapping the routes that art and science are to take. The scope and depth of his interests were without precedent-so great as to frustrate any hopes he might have had of realizing all that his feverishly inventive imagination could conceive. We still look with awe on his achievements and, even more, on his unfulfilled promise. His mind and personality seem to us superhuman; the man himself was mysterious and remote. Jacob Burckhardt writes: "The colossal outlines of Leonardo's nature can never be more than dimly and distantly conceived."

Although we are concerned here primarily with Leonardo as an artist, we scarcely can hope to do his art credit in isolation from his science; his scientific drawings are themselves works of art, as well as models for that exact delineation of nature that is one of the aims of science. Leonardo's unquenchable curiosity is revealed best in his voluminous notes, liberally interspersed with sketches dealing with matters of botany, geology, zoology, hydraulics, military engineering, animal lore, anatomy, and aspects of physical science, including mechanics, perspective, light, optics, and color. Leonardo's great ambition in his painting, as well as in his scientific endeavors, was to discover the laws underlying the flux and processes of nature. With this end in mind, he also studied the human body and contributed immeasurably to our knowledge of physiology and psychology. Leonardo believed that reality in an absolute sense is inaccessible and that we can know it only through its changing images. He considered the eyes to be the most vital organs and sight the most essential function, as, through these, the images of reality could be grasped most directly and profoundly. He stated many times in his notes that all his scientific investigations merely were aimed at making himself a better painter.

Leonardo was born near Florence and was trained in the studio of Andrea del Verrocchio, but he left Florence around 1481, offering his services to Ludovico Sforza, Duke of Milan. The political situation in Florence was uncertain, and the Neo-Platonism of Lorenzo de' Medici and his brilliant circle may have proved uncongenial to the empirical and pragmatic Leonardo. It also may be that Leonardo felt that the artistic scene in Milan would be less competitive. He devoted most of a letter to the Duke of Milan to advertising his competence and his qualifications as a military engineer, mentioning only at the end his supremacy as a painter and sculptor:

And in short, according to the variety of cases, I can contrive various and endless means of offence and defence. . . . In time of peace I believe I can give perfect satisfaction and to the equal of any other in architecture and the composition of buildings, public and private; and in guiding water from one place to another. . . . I can carry out sculpture in marble, bronze, or clay, and also I can do in painting whatever may be done, as well as any other, be he whom he may.*

The letter illustrates the new relation of the artist to his patron, as well as Leonardo's breadth of competence. That he should select military engineering and design to interest a patron is an index of the dangerousness of the times. Weaponry now had been developed to the point, especially in northern Europe, that the siege cannon was a threat to the feudal castles of those attempting to resist the wealthy and aggressive new monarchs. When, in 1494, Charles VIII of France invaded Italy, his cannon easily smashed the fortifications of the Italian princes. By the turn of the century, when Italy's liberties and unity were being trampled by the aspiring kingdoms of Europe, not only soldiers and architects, but artists and Humanists, were deeply concerned with the problem of designing a system of fortifications that might withstand the terrible new weapon.

During his first sojourn in Milan, Leonardo painted The Virgin of the Rocks (FIG. 17-1), a group that, al-

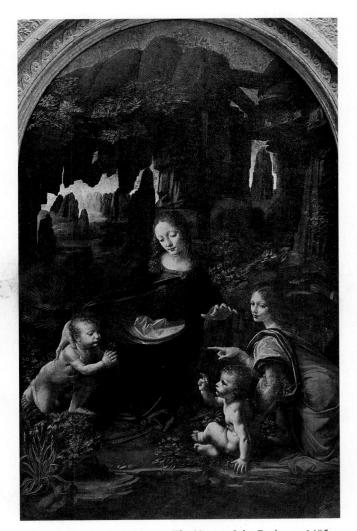

17-1 LEONARDO DA VINCI, The Virgin of the Rocks, c. 1485. Oil on wood (transferred to canvas), approx. 6' $3'' \times 3'$ 7". Louvre, Paris.

though it may derive ultimately from Fra Filippo Lippi, is well on its way out of the older tradition. The old triangular composition now broadens out into three dimensions, making a weighty pyramid. The linear approach, with its musical play of undulating contours and crisp edges, is abandoned, as Leonardo journeys back through the generations of the fifteenth century to Masaccio's great discovery of chiaroscuro, the subtle play of light and dark. What we see is the result of the moving together and interpenetration of lights and darks. "Drawn" representations, consisting of contours and edges, can be beautiful, but they really are not true to the optical facts. Moreover, a painting must embody not only physical chiaroscuro but the lights and darks of human psychology as well. Modeling with light and shadow and the expression of emotional states were, for Leonardo, the heart of painting:

^{*}In E. G. Holt, ed., *Literary Sources of Art History* (Princeton, NJ: Princeton University Press, 1947), p. 170.

A good painter has two chief objects to paint—man and the intention of his soul. The former is easy, the latter hard, for it must be expressed by gestures and the movement of the limbs. . . . A painting will only be wonderful for the beholder by making that which is not so appear raised and detached from the wall.*

The figures in The Virgin of the Rocks are knit together not only as a pyramidal group but as figures sharing the same atmosphere, a method of unification first seen in Masaccio's The Tribute Money (FIG. 16-27). The Madonna, Christ Child, infant John the Baptist, and angel emerge through subtle gradations and nuances of light and shade from the half-light of the cavernous, visionary landscape. Light simultaneously veils and reveals the forms of things, immersing them in a layer of atmosphere between them and our eyes. The ambiguity of light and shade (familiar in the optical uncertainties of dusk) functions here in the service of the psychological ambiguity of perception. The group depicted, so strangely wrapped in subtle light and shade, eludes our precise definition and interpretation. The figures pray, point, and bless, and these acts and gestures, although their meanings are not certain, visually unite the individu-

*In Anthony Blunt, Artistic Theory in Italy, 1450–1600 (London: Oxford University Press, 1964), p. 34.

17-2 LEONARDO DA VINCI, cartoon for The Virgin and Child with St. Anne and the Infant St. John, 1498 (?). Charcoal heightened with white on brown paper, approx. 54" × 39". Reproduced by courtesy of the Trustees of the National Gallery, London.

als portrayed. The angel points to the infant John, who is blessed by the Christ Child and sheltered by the Virgin's loving hand. The melting mood of tenderness, enhanced by the caressing light, is compounded of yet other moods. What the eye sees is fugitive, as are the states of the soul, or, in Leonardo's term, its "intentions."

The style of the High Renaissance fully emerges in a cartoon (a full-size drawing) for a painting of The Virgin and Child with St. Anne and the Infant St. John (FIG. 17-2). The glowing light falls gently on the majestic forms and on a tranquil grandeur, order, and balance. The figures are robust and monumental, moving with a stately grace reminiscent of the Phidian sculptures of the Parthenon. Every part is ordered by an intellectual, pictorial logic into a sure unity. The specialized depiction of perspective, anatomy, light, and space is a thing of the past. Leonardo has assimilated the learning of two centuries and applies it wholly, in a manner that is Classical and complete. This High Renaissance style, as Leonardo authoritatively presents it here, is stable without being static, varied without being confused, and dignified without being dull. As was the case in Greece, this brief, Classical moment inaugurated by Leonardo unifies and balances the conflicting experiences of an entire culture. This style will prove difficult to maintain. In a rapidly changing world, the artist may either repeat the compositions and forms of the day in a sterile, academic manner or revolt against the practices of the time by denying or exaggerating their principles. For these reasons, the High Renaissance was of short duration-even shorter than the brief span of the golden age of Athens in the fifth century B.C.

For the refectory of the church of Santa Maria delle Grazie in Milan, Leonardo painted *The Last Supper* (FIG. **17-3**). Despite its ruined state (in part the result of the painter's own unfortunate experiments with his materials), and although it has often been ineptly restored, the painting is both formally and emotionally his most impressive work.* It is the first great

*Since 1977, the painting has been undergoing painstaking, scientifically controlled restoration (a square inch at a time!). Although much of it is lost permanently, enough already has been recovered and repaired to reveal Leonardo's actual intentions and performance. The restored portions, freed from five hundred years' dark accumulation of dirt, mold, glue, and overpainting, reveal bright and strong colors and firm and elegant contours. Restoration also shows that Leonardo's style is rooted firmly in the practice of fifteenth-century Italian painting. Beneath the many mistaken overpaintings, the true characters of the disciples emerge from the blurred, murky, out-of-focus forms of the damaged picture. They are vividly realized individuals, of the kind we find in Leonardo's preserved preparatory drawings. Through their attitudes, gestures, personal traits, and facial expressions, they compellingly play the roles Leonardo designed for them, consistent with his own highly personal conception of this drama and its protagonists.

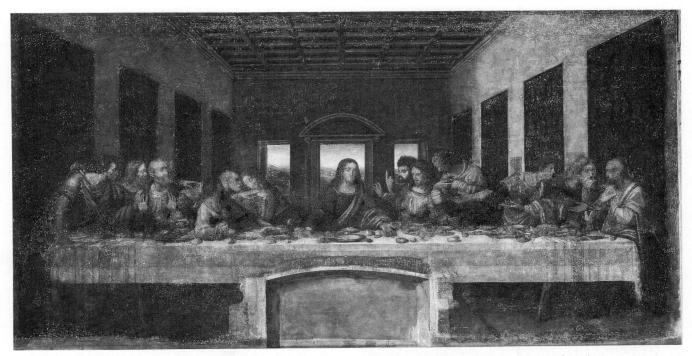

17-3 LEONARDO DA VINCI, The Last Supper, c. 1495–1498. Fresco (oil and tempera on plaster). Refectory, Santa Maria delle Grazie, Milan.

figure composition of the High Renaissance and the definitive interpretation of its theme. Christ and the Twelve Disciples are seated at a long table set parallel to the picture plane in a simple, spacious room. The highly dramatic action of the painting is made still more emphatic by the placement of the group in the austerely quiet setting. Christ, with outstretched hands, has just said, "One of you will betray me." A wave of intense excitement passes through the group, as each disciple asks himself and, in some cases, his neighbor, "Is it I?" Leonardo has made a brilliant conjunction of the dramatic "One of you will betray me" with the initiation of the ancient liturgical ceremony of the Eucharist, when Christ, blessing bread and wine, said "This is my body and this is my blood: do this in remembrance of me." The force and lucidity with which this dramatic moment is expressed are due to the abstract organization of the composition.

In the center, Christ is in perfect repose, the still eye of the swirling emotion around him. Isolated from the disciples, his figure is framed by the central window at the back, the curved pediment of which arches above his head. The pediment is the only curve in the architectural framework, and it serves here as a halo. Christ's head is the focal point of all perspective lines in the composition. Thus, the still, psychological focus and cause of the action is, at the same time, the perspective focus as well as the center of the two-dimensional surface. One could say that the two-dimensional, the three-dimensional, and the psychodimensional focuses are one and the same. The agitated disciples, registering a whole range of rationally ordered, idealized, and proportionate responses, embracing fear, doubt, protestation, rage, and love, are represented in four groups of three, united among and within themselves by the gestures and postures of the figures. Leonardo sacrifices traditional iconography to pictorial and dramatic consistency by placing Judas on the same side of the table as Jesus and the other disciples. His face in shadow, Judas clutches a money bag in his right hand and reaches his left forward to fulfill the Master's declaration: "Behold, the hand of him that betrayeth me is with me on the table." The two disciples at either end of the table are more quiet than the others, as if to enclose the overall movement, which is more intense closer to the figure of Christ, whose calm at the same time halts and intensifies it.

We know from numerous preparatory studies that Leonardo thought of each figure as carrying a particular charge and type of emotion. Like a skilled stage director (perhaps the first, in the modern sense), he has read the gospel story carefully and scrupulously cast his actors as their roles are described. With him begins that rhetoric of Classical art that will direct the compositions of generations of painters until the nineteenth century. The silence of Christ is one such powerful rhetorical device. Indeed, Heinrich Wölfflin saw that the Classical element is precisely here, for in

17-4 LEONARDO DA VINCI, Mona Lisa, c. 1503–1505. Oil on wood, approx. $30'' \times 21''$. Louvre, Paris.

the silence following Christ's words, "the original impulse and the emotional excitement continue to echo and the action is at once momentary, eternal and complete."* The two major trends of fifteenthcentury painting—monumentality and mathematically ordered space at the expense of movement, and freedom of movement at the expense of monumentality and controlled space—are here harmonized and balanced. *The Last Supper* and Leonardo's career leading up to it are at once a synthesis of the artistic developments of the fifteenth century and a first statement of the High Renaissance style in Italy during the early sixteenth century.

If Leonardo's *Last Supper* is the world's most famous religious picture, the *Mona Lisa* (FIG. **17-4**) is probably the world's most famous portrait. Since the nineteenth century and perhaps earlier, this enigmatic face has been a part of Western folklore. Painted after Leonardo returned from Milan to Flor-

*Heinrich Wölfflin, *Classic Art*, 2nd ed. (London: Phaidon, 1953), p. 27.

ence, the lady (thought by many to be La Gioconda, wife of the banker Zanobi del Giocondo) originally was represented in a loggia with columns that have been cut from the painting. She is shown in halflength view, her hands quietly folded and her gaze directed at the observer. The ambiguity of the famous "smile" is really the consequence of Leonardo's fascination and skill with atmospheric chiaroscuro, which we have seen in his Virgin of the Rocks and Virgin and St. Anne groups and which here serve to disguise rather than reveal a human psyche. The light is adjusted subtly enough, but the precise planes are blurred (a useful comparison can be made between the Mona Lisa and the portraits by Domenico Ghirlandaio and Sandro Botticelli that we saw in Chapter 16) and the facial expression is hard to determine. Commentators during the romantic nineteenth century made perhaps too much of the enigma of the "smile," without appreciating Leonardo's quite scientific concern with the nature of light and shadow. On the other hand, Leonardo himself must have enjoyed the curious effect he achieved here. This was one of his favorite pictures-one with which he could not bear to part. The superb drawing present beneath the fleeting shadow is a triumph in its rendering of both the head and the hands, the latter exceptionally beautiful. The artist's intention may well have been to confuse observers or to enchant them by allowing them to interpret the secret personality as they pleased.

Leonardo completed very few paintings; his perfectionism, restless experimentalism, and far-ranging curiosity scattered his efforts. Yet an extensive record of his ideas is preserved in the drawings in his notebooks, one of which was discovered in Madrid in the 1960s. Science interested him increasingly in his later years, and he took knowledge of all nature (given first to the eye) as his proper province. His investigations in anatomy yielded drawings of great precision and beauty of execution. The Embryo in the Womb (FIG. 17-5) is so true to fact that, despite some inaccuracies, it could be used in medical instruction today. Although Leonardo may not have been the first scientist of the modern world (at least not in the modern sense of "scientist"), he certainly originated the method of scientific illustration, especially cutaway and exploded views. The importance of this has been stressed by Erwin Panofsky: " . . . anatomy as a science (and this applies to all the other observational or descriptive disciplines) was simply not possible without a method of preserving observations in graphic records, complete and accurate in three dimensions."*

^{*}Erwin Panofsky, "Artist, Scientist, Genius," in *The Renaissance*, ed. Wallace K. Ferguson (New York: Harper & Row, 1962), p. 147.

me (fre pring that felle 133 -in spinning winn Transit agen D 2 War hard have by the mount progr scontran no and a firming Multi min sicure alla our normal for (maken , willing medulary alla merence dolla parte makildesse oprophiles sos to nor alla peresse it un no allower hon nois to good branning p In forman int alla tothe prover bur freed ar bill Birdfilld manifund Love of duride we being anon Continue proprior forman (critic ati n be was ano worther NTIM - all here a present of here vite in the second seco inter a stand of the format and low solis to 0 With A Innorth & flut Lucieso cp hor sofration ny ny simil ulary rules union this applications In all in the sol ADid All's issuthation) : SIND CHO COMIS Manna Cerene magune Macolbiene . w. chia po debutualitation NEW Game TILINIAN remaining all it a maining Plaint all all our page intra andi dian residence outo) Budaoli A sugar NINI WIMPIN Allader MAN ON , A dwill have no putte itak 0 atokni BUR, al ammen I by surflage of the among marine הכללי כולט מלואייי זיט לור ארים א מיור שריילאון identic aparameter ana sucher min me an anne L'action metrices a course estimate l'altres avents de la matter con matter production de l'épices (altres avents ester mus filme avents matters products estate en la filme de carps de l'entre este matters de course estimate l'altres d'arter avents course estate est estate en l'artres d'arter avents avents and course estate estate estate est l'artres d'arter avents course estate estate estate avents artres avents artres and course estate estate estate estate avents artres arter and artres artres artres artres artres artres arter artres for it river an or שבלי להמואמות ל גיליאות כט לאוי שכט אם לה puburo fu fui ochi en chila and pilipines pala ma quick mich pilipines pala ma quick mich pilipines (aquah wan alle mark use & Dulis ל התוצאו איו כני שאול מולה אם כשאוני ול אין לני אני אש to a fibrar (about of the start es calle étudition deur deur de fui de fui de la contra l'an l'ante l'an ante de l'ante de la contra de la co 1900 SNOP OS USADEN

17-5 LEONARDO DA VINCI, Embryo in the Womb, c. 1510. Pen and ink. Royal Collection, Windsor Castle. Windsor Castle, Royal Library, copyright 1990 Her Majesty Queen Elizabeth II.

640 CHAPTER 17 / SIXTEENTH-CENTURY ITALIAN ART

Leonardo was well known in his own time as both architect and sculptor, though no actual buildings can be attributed to him and no sculpture that is certainly by him has survived. From his many drawings of central-plan buildings, it appears that he shared the interest of other Renaissance architects in this building type. In Milan, Leonardo must have been in close contact with the architect Bramante, who may well have remembered a drawing by Leonardo when he prepared his original designs for the great church of St. Peter's in Rome (FIG. 17-7). As for sculpture, Leonardo left numerous drawings of monumental equestrian statues, one of which ripened into a full-scale model for a monument to the Sforza; used as a target, it was shot to pieces by the French when they occupied Milan in 1499. Leonardo left Milan outraged at this treatment of his work and worked for a while as a military engineer for Cesare Borgia, who, with the support of his father, Pope Alexander VI, tried to conquer the cities of the Romagna and create a Borgia duchy. At a later date, Leonardo returned to Milan in the service of the French. At the invitation of King Francis I, he then went to France, where he died at the château of Cloux in 1519, without leaving any noticeable impact on French contemporary art.

Bramante and His Circle

Raphed 's

The most important artist with whom Leonardo came into contact in Milan was BRAMANTE (Donato d'Angelo, 1444-1514). Born in Urbino and trained as a painter (perhaps by Piero della Francesca), Bramante went to Milan in 1481 and, like Leonardo, stayed there until the arrival of the French in 1499. In Milan, he abandoned painting to become the greatest architect of his generation. Under the influence of Filippo Brunelleschi, Leon Battista Alberti, and perhaps Leonardo, all of whom had been influenced strongly by the Classical antique, Bramante developed the High Renaissance form of the central-plan church. But it was not until after his arrival in Rome in 1499 that Bramante built what was to be the perfect prototype of Classical, domed architecture for the Renaissance and subsequent periods. This buildingthe Tempietto (FIG. 17-6)—received its name because, to contemporaries, it had the aspect of a small pagan temple from antiquity. The building's traditional date of 1502 is disputed, and dates as late as 1508 have been advanced, but not universally accepted. It was commissioned by the king of Spain to mark the conjectural location of St. Peter's crucifixion. Standing inside the cloister alongside the church of San Pietro in Montorio, the Tempietto resembles a sculptured reliquary and would have looked even more like one

17-6 BRAMANTE, the Tempietto, 1504 (?). San Pietro in Montorio, Rome.

inside the circular, colonnaded courtyard that was planned for it but never executed.

All but devoid of ornament, this little building relies for its effect on the composition of volumes and masses and on a sculptural handling of solids and voids that set it apart from anything built in the preceding century. If one of the main differences between the Early and the High Renaissance styles of architecture is the former's emphasis on the articulation of flat wall surfaces and the latter's sculptural handling of architectural masses, then the Tempietto certainly breaks new ground and stands at the beginning of a new era.

At first glance, the structure may seem overly formalistic and rational with its sober, circular stylobate and the cool Tuscan order of the colonnade, neither of which gives any indication of the placement of an interior altar or of the location of the entrance. However, Bramante achieved a truly wonderful balance and harmony in the relationship of the parts (dome, drum, and base) to each other and to the whole. The balustrade echoes, in shorter beats, the rhythm of the colonnade and averts a too-rapid ascent to the drum, while the pilasters of the drum itself repeat the ascending motif and lead the eye past the cornice to the exposed ribs of the dome. The play of light and shade around columns and balustrade and across alternating deep-set, rectangular windows and shallow, shell-capped niches in cella walls and drum enhances the experience of the building as an articulated sculptural mass. Although the Tempietto, superficially at least, may resemble a Classical tholos, and although all of its details have been studied closely from antique models, the combination of parts and details is new and original (Classical tholoi, for instance, had neither drum nor balustrade!). Conceived as a tall, domed cylinder projecting from the lower, wider cylinder of its colonnade, this small building incorporates all the qualities of a sculptured monument.

The significance of the Tempietto was well understood in the sixteenth century. The architect Andrea Palladio, an artistic descendant of Bramante, included it in his survey of ancient temples because "Bramante was the first who brought good and beautiful architecture to light, which from the time of the ancients to his day had been forgotten. . . ." Round in plan, elevated on a base that isolates it from its surroundings, the Tempietto conforms with Alberti's and Palladio's strictest demands for an ideal church, demonstrating "the unity, the infinite essence, the uniformity, and the justice of God."

The same architectural concept guided Bramante's plans for the new St. Peter's, which was commissioned by Pope Julius II in 1505 to replace the Constantinian basilica, Old St. Peter's (FIG. 7-6). The earlier structure had fallen into considerable disrepair and, in any event, did not suit this ambitious and warlike pope's taste for the colossal; Julius wanted to gain sway over the whole of Italy and to make the Rome of the popes more splendid than the Rome of the caesars. As originally designed by Bramante, the new St. Peter's (FIG. 17-7) was to have consisted of a cross with arms of equal length, each terminated by an apse. The new building was intended as a martyrium to mark St. Peter's grave; Julius also hoped to have his own tomb in it. The crossing would have been covered by a large dome, and smaller domes over subsidiary chapels would have covered the diagonal axes of the roughly square plan. Bramante's ambitious plan called for a boldly sculptural treatment of the walls and piers under the dome. The interior space is complex in the extreme, with the intricate symmetries of a crystal. It is possible to detect in the plan some nine interlocking crosses, five of which are domed. The scale was titanic; Bramante is said to have boasted that he would place the dome of the Pantheon over the Basilica of Constantine. A commemorative medal by CARADOSSO (FIG. 17-8) shows how Bramante's scheme would have attempted to do just that. The dome is hemispherical, like the Pantheon's, but otherwise the exterior, with two towers and

17-7 BRAMANTE, plan for the new St. Peter's, the Vatican, Rome, 1505.

17-8 CHRISTOFORO FOPPA CARADOSSO, medal showing Bramante's design for the new St. Peter's, 1506. British Museum, London.

a medley of domes and porticoes, breaks the massive unity, resulting in a still essentially anthropometric design scaled down to human proportions in the Early Renaissance manner. During Bramante's lifetime, the actual construction did not advance beyond the building of the piers of the crossing and the lower walls of the choir. With his death, the work passed

17-9 Santa Maria della Consolazione, Todi, Italy, begun 1508 (view from the south).

from one architect to another and finally to Michelangelo, who was appointed by Pope Paul III in 1546 to complete the building.

After Bramante's Tempietto, the closest realization of the High Renaissance Classical ideals—order, clarity, lucidity, simplicity, harmony, and proportion—is found in the pilgrimage church of Santa Maria della Consolazione at Todi, begun in 1508 (FIG. **17-9**). This church's hillside site outside the town makes it visible from far away, and its sturdy, carefully proportioned silhouette offers an attractive goal for the faithful approaching through the valley below. Although the identity of its designer is uncertain, it is quite clearly in the manner of Bramante, and we can call it "Bramantesque."

In its plan, the church takes the form of a domed cross, with its lobelike arms ending in polygonal apses. The interior space, showing a Classical purity of arrangement in which the layout is immediately open to the eye and volumes and spaces are in exquisite adjustment, finds its exact expression on the exterior. Here, each level is carefully marked off by projecting cornices, and the rhythm increases steadily from bottom to top. The unfenestrated first story, marked off into blank panels by pilasters, provides a firm base for the upper structure. The second story is fenestrated, the windows topped by alternating triangular and segmental pediments. The attic story makes a transition to the half-domes, and the halfdomes serve the same function in relation to the balustraded platform that sets off drum and dome as it makes a transition to them. The rhythm of fenestration of the second floor reappears in the drum, where it is quickened by the interpolation of round-headed niches between the windows, like the appearance of a second voice in a fugue.

Regardless of the side from which it is seen, the building presents a completely balanced and symmetrical aspect. Like a three-dimensional essay in rational order, all of its parts are in harmonious relation to each other and to the whole, yet each is complete and independent. To appreciate the wide difference between the Medieval and the High Renaissance views of the nature of architecture, one need only recall the design of a typically Gothic building. In both scale and complexity, Santa Maria della Consolazione stands between the Tempietto and the design for the new St. Peter's. More amply than the former, with greater purity than the latter, it expresses the architectural ideals of the High Renaissance. Its spirit is that of classical antiquity and, though it is modern, it speaks only the Classical language.

The palaces designed by Bramante have been preserved only in drawings or engravings. His Palazzo Caprini (FIG. **17-10**), bought by Raphael in 1517, was

17-10 BRAMANTE, Palazzo Caprini (House of Raphael), Rome. (Drawing attributed to ANDREA PALLADIO.)

17-11 ANTONIO DA SANGALLO THE YOUNGER, Farnese Palace, Rome, c. 1530-1546 (view from the northwest).

torn down during the rebuilding of the area around St. Peter's. Still, it was one of the most important and influential palace designs of the sixteenth century. In it, Bramante reduced the typical three-story façade of the fifteenth century to two stories, with the strongly rusticated first story serving as a robust support for the elegantly articulated piano nobile. This arrangement not only differentiates the two stories, but emphatically puts the residential level of the building above the commercial. (The ground floor was occupied by shops and offices.) The pedimented windows of the second story are flanked by pairs of engaged Tuscan columns supporting an entablature in which the frieze is pierced by the windows of an attic story. The total aspect of the building is one of rugged plasticity, and its influence on contemporary and later architects, including Palladio and Inigo Jones, was lasting. With Baroque modifications, Bramante's scheme can be recognized in Claude Perrault's Louvre façade (FIG. 19-64), erected almost two centuries later.

Less plastic, perhaps, than Bramante's design, but equally imposing, is the Farnese Palace in Rome (FIGS. **17-11** to **17-13**), designed by ANTONIO DA SANGALLO THE YOUNGER (1483–1546), which fully expresses the Classical order, regularity, simplicity, and dignity of the High Renaissance. Antonio, the youngest of a family of architects, received his early training from his uncles Giuliano, the designer of Santa Maria delle Carceri in Prato (FIG. 16-45), and Antonio the Elder. Antonio the Younger went to Rome around 1503 and became Bramante's draftsman

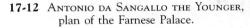

0	25 50	FEET	\sim
0	10 I	20 METERS	\sum
			4

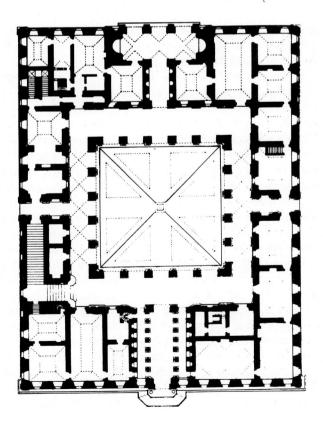

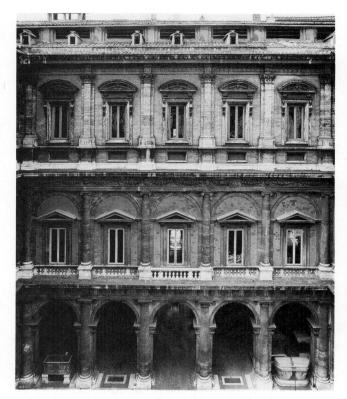

17-13 ANTONIO DA SANGALLO THE YOUNGER, courtyard of the Farnese Palace. Third story and attic by MICHELANGELO in 1548.

and assistant. As Paul III's favorite architect, he received many commissions that might have gone to Michelangelo. He is the perfect example of the professional architect, and his family constituted an architectural firm, often working up the plans and doing the drafting for other architects. Essentially a developer, Antonio frequently has been criticized as unimaginative, but if this is so, it is only by comparison with Michelangelo. He built fortifications for almost the entire papal state and received more commissions for military than for civilian architecture. Although he may not have invented it, Antonio certainly developed the modern method of bastioned fortifications to a high degree and, in this accomplishment, he demonstrated his ingenuity and originality.

The Farnese Palace, built for Cardinal Farnese (later Pope Paul III), sets a standard for the High Renaissance palazzo. The sixteenth century was the beginning of the age of the great dynasties that would dominate Europe until the French Revolution. It was an age of royal and princely pomp, of absolute monarchy rendered splendid by art. The broad, majestic front of the Farnese Palace asserts to the public the exalted station of a great family. This proud frontispiece symbolizes the aristocratic epoch that followed the stifling of the nascent, middle-class democracy of European cities (especially the Italian cities) by powerful kings heading centralized states. It is thus significant that the original, rather modest palace was greatly enlarged to its present form after Paul's accession to the papacy in 1534, reflecting the ambitions of the pope both for his family and the papacy. Unfinished at the time of Antonio's death in 1546, the building was completed by Michelangelo.

The façade (FIG. 17-11) is the very essence of princely dignity in architecture. Facing a spacious paved square, the rectangle of the smooth front is framed and firmly anchored by the quoins (rusticated building corners) and cornice, while lines of windows (with alternating triangular and segmental pediments, in Bramante's fashion) mark a majestic beat across it. The window casements are no longer flush with the wall, as in the Palazzo Medici-Riccardi (FIG. 16-24), but project from its surface, so that instead of being a flat, thin plane, the façade becomes a spatially active, three-dimensional mass. Each casement is a complete architectural unit, consisting of a socle (a projecting under-member), engaged columns, entablature, and pediment. The variations in the treatment of these units prevent the symmetrical scheme from becoming rigid or monotonous. The rusticated doorway and second-story balcony, surmounted by the Farnese coat of arms, emphasize the central axis and bring the horizontal and vertical forces of the design into harmony. This centralizing feature, not present in the palaces of Alberti or Michelozzo di Bartolomeo, is the external opening of a central-corridor axis (FIG. 17-12) that runs through the whole building and continues in the garden beyond; around this axis, the rooms are disposed with strict regularity. The interior courtyard (FIG. 17-13) displays stately Colosseum arch-orders on the first two levels and, on the third, Michelangelo's sophisticated variation on that theme, with overlapping pilasters replacing the weighty columns of Antonio's design.

Raphael

The artist most typical of the High Renaissance is RAPHAEL (Raffaello Santi, 1483–1520). The pattern of his growth recapitulates the sequence of artistic tendencies of the fifteenth century, and although strongly influenced by Leonardo and Michelangelo, Raphael developed an individual style that, in itself, clearly states the ideals of High Renaissance art. His powerful originality prevailed while he learned from everyone; he assimilated what he best could use and rendered into form the Classical instinct of his age. He worked so effortlessly in the Classical mood that his art is almost the resurrection of Greek art at its height. Goethe, the renowned German poet and critic, said of Raphael that he did not have to imitate the Greeks, for he thought and felt like them.

Born in a small town in Umbria near Urbino, Raphael probably learned the rudiments of his art from his father, GIOVANNI SANTI, a provincial painter connected with the court of Federigo da Montefeltro. While still a child, Raphael was apprenticed to Perugino, who had been trained in Verrocchio's shop with Leonardo. We have seen in Perugino's Christ Delivering the Keys of the Kingdom to St. Peter (FIG. 16-62) that the most significant formal quality of his work is the harmony of its spatial composition. While Raphael was still in the studio of Perugino, the latter painted a panel of The Marriage of the Virgin (not shown), which, in its composition, very closely resembles the central portion of his Sistine Chapel fresco. Perugino's panel, now in the Museum of Caen, probably served as the model for Raphael's Marriage of the Virgin (FIG. 17-14). Although scarcely twenty-one, Raphael was able to recognize and to remedy some of the weaknesses of his master's composition. By relaxing the formality of Perugino's foreground figure screen and disposing

17-14 RAPHAEL, The Marriage of the Virgin, 1504. Oil on wood, $67'' \times 462''$. Pinacoteca di Brera, Milan.

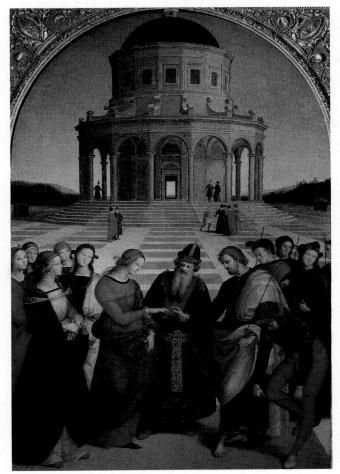

his actors in greater depth, the young artist not only provides them with greater freedom of action but also bridges the gap between them and the building in the background more successfully. The result is a painting that, although it resembles its model very closely, is nevertheless more fluid and better unified.

Raphael spent the four years from 1504 to 1508 in Florence. Here, in the home of the Renaissance, he discovered that the style of painting he had learned so painstakingly from Perugino already was outmoded. The two archrivals, Leonardo and Michelangelo, were engaged in an artistic battle. Crowds flocked to Santissima Annunziata to see the recently unveiled cartoon for Leonardo's Virgin and Child with St. Anne and the Infant St. John (FIG. 17-2), the original version of which was done about 1498. Michelangelo responded with the Doni Madonna. Both artists were commissioned to decorate the council hall in the Palazzo Vecchio with pictures memorializing Florentine victories of the past. Although only Leonardo completed this task and although only some small preparatory sketches and small copies survive, the effect on artists in Florence, especially on one as gifted as Raphael, must have been considerable.

Under the influence of Leonardo, Raphael began to modify the Madonna compositions he had learned in Umbria. In the Madonna with the Goldfinch (Madonna del Cardellino) of 1506 (FIG. 17-15), Raphael uses the pyramidal composition of Leonardo's Virgin of the Rocks (FIG. 17-1). The faces and figures are modeled in subtle chiaroscuro, and Raphael's general application of this technique is based on Leonardo's cartoon for The Virgin and Child with St. Anne and the Infant St. John (FIG. 17-2). At the same time, the large, substantial figures are placed in a Peruginesque landscape, with the older artist's typical feathery trees in the middle ground. Although Raphael experimented with Leonardo's dusky modeling, he tended to return to Perugino's lighter tonalities. Raphael preferred clarity to obscurity, not being, as Leonardo was, fascinated with mystery. His great series of Madonnas, of which this is an early example, unify Christian devotion and pagan beauty; no artist ever has rivaled Raphael in his definitive rendering of this sublime theme of grace and dignity, sweetness and lofty idealism.

Had Raphael painted nothing but his Madonnas, his fame still would be secure. But he was also a great muralist, a master in the grand style begun by Giotto and carried on by Masaccio and other artists of the fifteenth century. In 1508, Raphael was called to the court of Pope Julius II in Rome, perhaps on the recommendation of his fellow townsman, Bramante. There, in competition with older artists like Perugino and Luca Signorelli, Raphael received one of the largest commissions of the time: the decoration of the

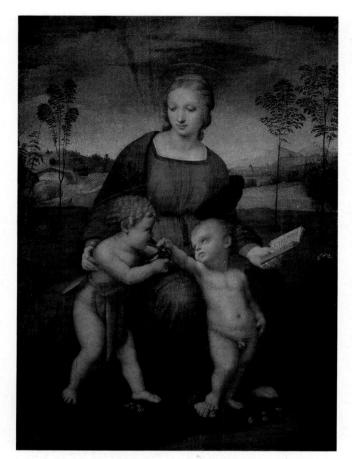

17-15 RAPHAEL, Madonna with the Goldfinch (Madonna del Cardellino), 1505–1506. Oil on wood, $42'' \times 29\frac{1}{2}''$. Galleria degli Uffizi, Florence.

papal apartments in the Vatican. Of the several rooms *(stanze)* of the suite, Raphael painted the first, the Stanza della Segnatura; the others were done mostly by his pupils, following his sketches. On the four walls of the Stanza della Segnatura, under the headings of Theology, Law, Poetry, and Philosophy, Raphael deploys a host of magnificent figures that symbolize and sum up Western learning as it was understood in the Renaissance. His intention was to indicate the four branches of human knowledge and wisdom, while pointing out the virtues and the learning appropriate to a pope.

The iconographic scheme is most complex, and Raphael probably received advice from the brilliant company of Classical scholars surrounding Julius. On one wall, in the so-called *School of Athens* (FIG. **17-16**), the artist presents a composition that, in and of itself, constitutes a complete statement of the High Renaissance in its artistic form and spiritual meaning. The setting is not a "school" but rather a concourse of the great philosophers and scientists of the ancient

world, who-rediscovered by the Renaissance-hold a convention, where they teach one another once more and inspire a new age. In a vast hall covered by massive vaults that recall Roman architecture (and approximate the appearance of the new St. Peter's in the year the painting was executed [1509]), the figures are arranged ingeniously around the central pair, Plato and Aristotle. The ancient philosophers, men concerned with the ultimate mysteries that transcend this world, stand on Plato's side; on Aristotle's side are the philosophers and scientists concerned with nature and the affairs of men. At the lower left, Pythagoras writes as a servant holds up the harmonic scale. In the foreground, Heraclitus (probably a portrait of Michelangelo) broods alone. Diogenes sprawls on the steps. At the right, students surround Euclid, who demonstrates a theorem. This group is especially interesting; Euclid may be a portrait of the aged Bramante. At the extreme right, Raphael includes his own portrait. The groups move easily and clearly, with eloquent poses and gestures that symbolize their doctrines and are of the greatest variety. Their self-assurance and natural dignity bespeak the very nature of calm reason, that balance and measure so much admired by the great minds of the Renaissance as the heart of philosophy.

Significantly, in this work, Raphael places himself among the mathematicians and scientists, and certainly the evolution of pictorial science comes to its perfection in *The School of Athens*. A vast perspective space has been created, in which human figures move naturally, without effort—each according to his own intention, as Leonardo might say. The stage setting, so long in preparation, is finally complete; the Western artist knows now how to produce the human drama. That this stagelike space is projected onto a two-dimensional surface is the consequence of the union of mathematics with pictorial science, which yields the art of perspective, here mastered completely.

The artist's psychological insight has matured along with his mastery of the problems of physical representation. Each character in Raphael's *School of Athens*, like those in Leonardo's *The Last Supper* (FIG. 17-3), is intended to communicate a mood that reflects his beliefs, and each group is unified by the sharing of its members in the mood. The design devices by which individuals and groups are related to each other and to the whole are wonderfully involved and demand close study. From the center, where Plato and Aristotle stand, silhouetted against the sky within the framing arch in the distance, the groups of figures are rhythmically arranged in an elliptical movement that swings forward, looping around the

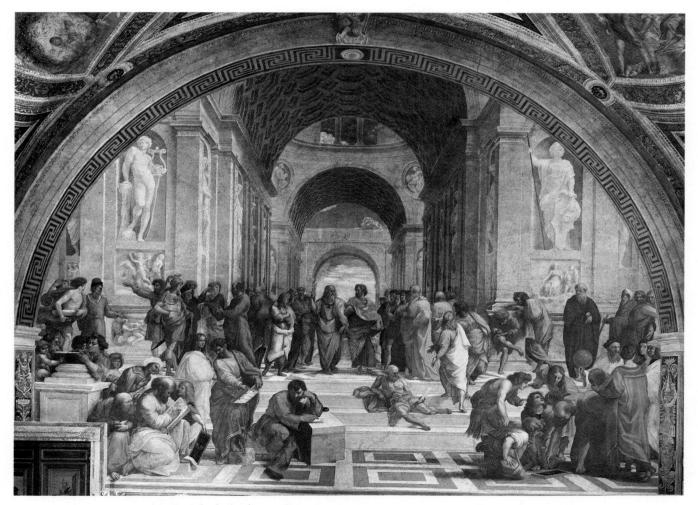

17-16 RAPHAEL, The School of Athens, 1509–1511. Fresco. Stanza della Segnatura, Vatican Palace, Rome.

two forward groups to either side, and then back again to the center. Moving through the wide opening in the foreground along the perspective pattern of the floor, we penetrate the assembly of philosophers and are led, by way of the reclining Diogenes, up to the here-reconciled leaders of the two great opposing camps of Renaissance philosophy. In the Stanza della Segnatura, Raphael reconciles and harmonizes not only the Platonists and Aristotelians, but paganism and Christianity, in the same kind of synthesis manifest in his Madonnas.

Pope Leo X, the son of Lorenzo de' Medici, succeeded Julius II as Raphael's patron. During Leo's pontificate, Rome achieved a splendor it had not known since ancient times. Leo was a worldly, pleasure-loving prince, who spent huge sums on the arts, of which, as a true Medici, he was a sympathetic connoisseur. Raphael moved in the highest circles of the papal court, the star of a brilliant society. He was

young, handsome, wealthy, and adulated, not only by his followers but by the city of Rome and all Italy. His personality contrasts strikingly with that of the aloof, mysterious Leonardo or the tormented and intractable Michelangelo. Genial, even tempered, generous, and high-minded, Raphael was genuinely loved. The pope was not his only patron. His friend, Agostino Chigi, an immensely wealthy banker who managed the financial affairs of the papal state, commissioned Raphael to decorate his palace on the Tiber with scenes from Classical mythology. Outstanding among the frescoes painted by Raphael in the small but splendid Villa Farnesina is the Galatea (FIG. 17-17), which takes its theme from the popular Italian poem "La giostra," by Politian. Botticelli took the theme for his Birth of Venus (FIG. 16-60) from the same work.

In Raphael's fresco, Galatea flees from her uncouth lover, the giant Polyphemus, on a shell drawn by leaping dolphins. She is surrounded by sea creatures

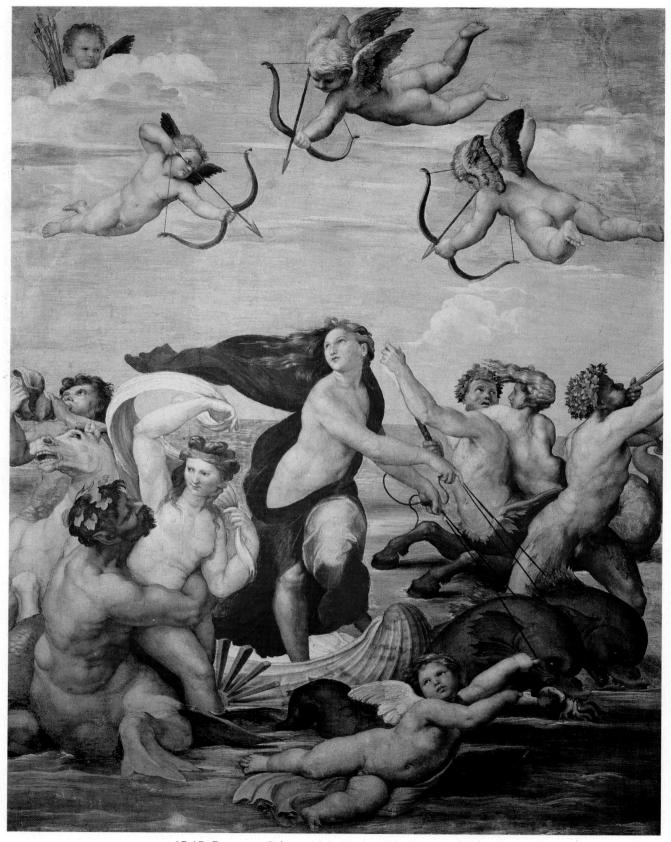

17-17 RAPHAEL, Galatea, 1513. Fresco. Villa Farnesina, Rome.

and playful cupids. The painting erupts in unrestrained pagan joy and exuberance, an exultant song in praise of human beauty and zestful love. The composition artfully wheels the sturdy figures around Galatea in bounding and dashing movements that always return to her as the energetic center. The cupids, skillfully foreshortened, repeat the circling motion. Raphael's figures are sculpturally conceived, and the body of Galatea—supple, strong, and vigorously in motion-should be compared with Botticelli's delicate, hovering, almost dematerialized Venus. Pagan myth presented in monumental form, in vivacious movement, and in a spirit of passionate delight brings back the seminal substance of which the naturalistic art and poetry of the Classical world was made. Raphael revives the gods and heroes and the bright world they populated, not to venerate them but to make of them the material of art. From Raphael almost to the present, Classical matter will hold as prominent a place in art as religious matter. So completely does the new spirit embodied in the Galatea take control that it is as if the Middle Ages had never occurred.

Raphael was also an excellent portraitist. His subjects were the illustrious scholars and courtiers who surrounded Pope Leo X, among them Count Baldassare Castiglione, a close friend of Raphael and the author of a handbook on High Renaissance criteria of genteel behavior. In the Book of the Courtier, Castiglione portrays an ideal type of the High Renaissance, a courageous, sagacious, truth-loving, skillful, and cultivated man-in a word, the completely civilized man, a culmination of the line that runs from the rude barbarian warriors who succeeded to the Roman Empire through the half-literate knights and barons of the Middle Ages. Castiglione goes on to describe a way of life based on cultivated rationality in imitation of the ancients. In Raphael's portrait of him (FIG. 17-18), Castiglione, splendidly yet soberly garbed, looks directly at us with a philosopher's grave and benign expression, clear-eyed and thoughtful. The figure is in half-length and three-quarter view, in the pose made popular by the Mona Lisa (FIG. 17-4), and we note in both portraits the increasing attention paid by the High Renaissance artist to the personality and psychic state of the subject. The tones are muted and low-keyed, as would befit the temper and mood of this reflective, middle-aged man; the background is entirely neutral, without the usual landscape or architecture. The head and the hands are both wonderfully eloquent in what they report of the man, who himself had written so eloquently in the Courtier of the way to enlightenment by the love of beauty. Raphael, Castiglione, and other artists of their age were animated by such love, and we know from his

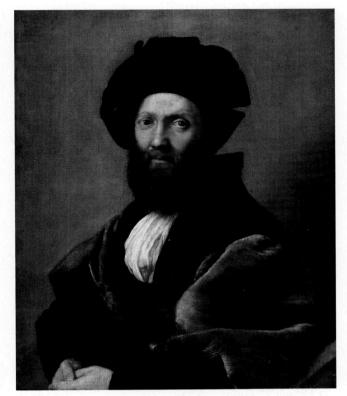

17-18 RAPHAEL, Baldassare Castiglione, c. 1514. Oil on wood transferred to canvas, approx. $30_4'' \times 26_2''$. Louvre, Paris.

poetry that Michelangelo shared in this widely held Neo-Platonic belief that the soul rises to its enlightenment by the progressively rarefied experience of the beautiful.

Michelangelo

MICHELANGELO (Michelangelo Buonarroti, 1475-1564) is a far more complex personality than Raphael, and his art is not nearly so typical of the High Renaissance as that of his somewhat younger contemporary. Frequently irascible, Michelangelo was as impatient with the shortcomings of others as he was with his own. His jealousy of Raphael, his dislike of Leonardo, and his almost continuous difficulties with his patrons are all well known. Perhaps these personal problems arose out of his strong and stern devotion to his art, for he was always totally absorbed in the work at hand. He identified himself completely with the task of artistic creation, and his reactions to his rivals often were impulsive and antagonistic. In this respect, Michelangelo's character often has been compared with Beethoven's, but the personal letters of both reveal a deep sympathy and concern for those close to them, and a profound understanding of humanity informs their works.

Whatever his traits of character, Michelangelo's career realizes all those Renaissance ideals that we conceptualize as being characteristic of an "inspired genius" and a "universal man." His work has the authority of greatness we already have attributed to Donatello. His confidence in his genius was unbounded; the demands of that genius determined his choices absolutely, often in opposition to the demands of his patrons. His belief that nothing worth preserving could be done without genius was attended by the conviction that nothing could be done without persevering study.

Although he was an architect, a sculptor, a painter, a poet, and an engineer, Michelangelo thought of himself first as a sculptor, regarding that calling as superior to that of a painter because the sculptor shares in something like the divine power to "make man." In true Platonic fashion, he believed that the image produced by the artist's hand must come from the idea in the artist's mind; the idea is the reality that has to be brought forth by the genius of the artist. But artists are not the creators of the ideas they conceive; rather they find their ideas in the natural world, reflecting the absolute idea, which, for the artist, is beauty. In this way, the strongly Platonic strain makes the Renaissance theory of the imitation of nature a revelation of the high truths hidden within nature. The theory that guided Michelangelo's hand, though never complete or entirely consistent, appears in his poetry:

Every beauty which is seen here below by persons of perception resembles more than anything else that celestial source from which we all are come . . .

My eyes longing for beautiful things

together with my soul longing for salvation

have no other power

to ascend to heaven than the contemplation of beautiful things.*

One of the best-known observations by Michelangelo is that the artist must proceed by finding the idea the image, locked in the stone, as it were—so that, by removing the excess stone, he extricates the idea, like Pygmalion bringing forth the living form:

The best artist has no concept which some single marble does not enclose within its mass, but only the hand which obeys the intelligence can accomplish that. . . . Taking away . . . brings out a living figure in alpine and hard stone, which . . . grows the more as the stone is chipped away.[†]

The artist, Michelangelo felt, works through many years at this unceasing process of revelation and "arrives late at lofty and unusual things and . . . remains little time thereafter."

Michelangelo did indeed arrive "at lofty and unusual things," for he broke sharply from the lessons of his predecessors and contemporaries in one important respect: he mistrusted the application of mathematical methods as guarantees of beauty in proportion. Measure and proportion, he believed, should be "kept in the eyes." Giorgio Vasari quotes Michelangelo as declaring that "it was necessary to keep one's compass in one's eyes and not in the hand, for the hands execute, but the eye judges." Thus, he would set aside Vitruvius, Alberti, Leonardo, Albrecht Dürer, and others who tirelessly sought the perfect measure, being convinced that the inspired judgment could find other pleasing proportions and that the artist must not be bound, except by the demands made by the realization of the idea. This insistence on the artist's own authority is typical of Michelangelo and anticipates the modern concept of the right of talent to a self-expression limited only by its own judgment. The license thus given to genius to aspire far beyond the "rules" led Michelangelo to create works in architecture, sculpture, and painting that depart from High Renaissance regularity and put in its stead a style of vast, expressive strength with complex, eccentric, often titanic forms that loom before us in tragic grandeur. His self-imposed isolation (Raphael described him as "lonely as the hangman"), his creative furies, his proud independence, and his daring innovations led Italians to speak of the dominating quality of the man and his works in one word: terribilità, the sublime shadowed by the awesome and the fearful.

As a youth, Michelangelo was apprenticed to the painter Domenico Ghirlandaio, whom he left before completing his training. He soon came under the protection of Lorenzo the Magnificent and must have been a young and thoughtful member of the famous Neo-Platonic circle. He studied sculpture under one of Lorenzo's favorite artists, Bertoldo di Giovanni, a former collaborator of Donatello who specialized in small-scale bronzes. When the Medici fell in 1494, Michelangelo fled from Florence to Bologna, where he was impressed by the sculpture of Jacopo della Quercia (FIG. 16-3). Besides his study of Jacopo's works, although he claimed that in his art he owed nothing to anyone, Michelangelo made studious drawings after the great Florentines, Giotto and Masaccio, and his consuming interest in representing the male nude both in sculpture and painting in all likelihood was much stimulated by Signorelli (FIG. 16-61).

^{*}In Robert J. Clements, *Michelangelo's Theory of Art* (New York: New York University Press, 1961), p. 9. © 1961 by Robert J. Clements. Reprinted by permission of the publisher. [†]Ibid., p. 16.

Michelangelo's wanderings took him to Rome, from which he returned to Florence in 1501, partly because the city might permit him to work a great block of marble, called the Giant, left over from an earlier, abortive commission. With his sure insight into the nature of stone and a proud, youthful confidence that he could perceive its idea, Michelangelo added to his already great reputation by carving his David (FIG. 17-19). This colossal figure again takes up the theme that Donatello and Verrocchio had used successfully, but it reflects Michelangelo's own highly original interpretation of the subject. David is represented not after the victory, with the head of Goliath at his feet, but rather turning his head to his left, sternly watchful of the approaching foe. His whole muscular body, as well as his face, is tense with gathering power. The ponderated pose, suggesting the body at ease, is misleading until we read in the tightening sinews and deep frown what impends.

Here is the characteristic representation of energy in reserve that gives the tension of the coiled spring to Michelangelo's figures. The anatomy plays an important part in this prelude to action. The rugged torso and sturdy limbs of the young David and the large hands and feet, giving promise of the strength to come, are not composed simply of inert muscle groups, nor are they idealized by simplification into broad masses. They serve, by their active play, to make vivid the whole mood and posture of tense expectation. Each swelling vein and tightening sinew amplifies the psychological vibration of the monumental hero's pose.

Michelangelo doubtless had the Classical nude in mind—Antique statues, which were being found everywhere, were greatly admired by Michelangelo and his contemporaries for their skillful and precise rendering of heroic physique—but if we compare the *David* with the *Doryphoros* (FIG. 5-58), we realize how widely his intent diverges from the measured, almost bland quality of the Antique statue. As early as the *David*, then, Michelangelo's genius, unlike Raphael's, is dedicated to the presentation of towering, pent-up passion rather than to calm, ideal beauty. His own doubts, frustrations, and torments of mind passed easily into the great figures he created or planned.

The tomb of Julius II, a colossal structure that would have given Michelangelo the room he needed for his superhuman, tragic beings, became one of the great disappointments of Michelangelo's life when the pope, for unexplained reasons, interrupted the commission, possibly because funds had to be diverted for Bramante's rebuilding of St. Peter's. The original project called for a freestanding, two-story

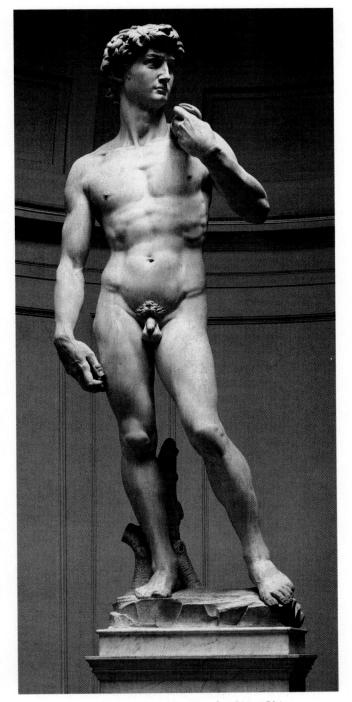

17-19 MICHELANGELO, David, 1501–1504. Marble, approx. 13' 5" high. Galleria dell' Accademia, Florence.

structure with some twenty-eight statues. After the pope's death in 1513, the scale of the project was reduced step by step until, in 1542, a final contract specified a simple wall tomb with less than one-third of the originally planned figures.

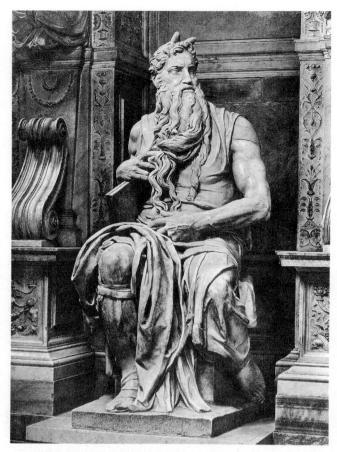

17-20 MICHELANGELO, Moses, c. 1513–1515. Marble, approx. 8' 4" high. San Pietro in Vincoli, Rome.

The spirit of the tomb may be summed up in the figure of Moses (FIG. 17-20), which was completed during one of the sporadic resumptions of the work in 1513. Meant to be seen from below, and balanced with seven other massive forms related in spirit to it, the Moses now, in its comparatively paltry setting, can hardly have its full impact. The leader of Israel is shown seated—the tables of the Law under one arm, his other hand gripping the coils of his beard. We may imagine him pausing after the ecstasy of receiving the Law on Mount Sinai, while, in the valley below, the people of Israel give themselves up once more to idolatry. Here again, Michelangelo uses the turned head (as in the David), which concentrates the expression of awful wrath that now begins to stir in the mighty frame and eyes. One must study the work closely to appreciate Michelangelo's sense of the relevance of each detail of body and drapery in forcing up the psychic temperature. The muscles bulge, the veins swell, the great legs begin slowly to move. If this titan ever rose to his feet, says one writer, the world would fly apart. The holy rage of Moses mounts to the bursting point, yet must be contained, for the

free release of energies in action is forbidden forever to Michelangelo's passion-stricken beings.

Two other figures, *The Dying Slave* (FIG. **17-21**) and *The Bound Slave* (FIG. **17-22**), believed to have been intended for the Julius tomb (although this is now doubted by some), may represent the enslavement of the human soul by matter when the soul falls from Heaven into the prison house of the body. With the imprisoned soul slumbering, our actions, as Marsilio Ficino says, are "the dreams of sleepers and the ravings of madmen." Certainly, the dreams and ravings are present in these two figures. Originally, some twenty slaves, in various attitudes of revolt and exhaustion, were to have been designed for the tomb.

17-21 MICHELANGELO, The Dying Slave, 1513–1516. Marble, approx. 7' 5" high. Louvre, Paris.

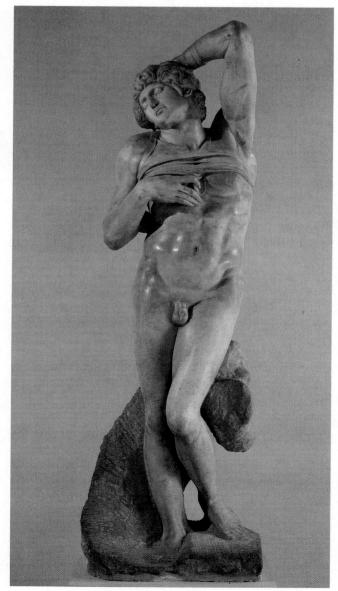

In the two slaves shown, as in the *David* and the *Moses*, Michelangelo makes each body a total expression of the idea, so that the human figure serves not so much as a representation of a concept, as in Medieval allegory, but as the concrete realization of an intense feeling. Indeed, Michelangelo's own powerful imagination communicates itself in every plane and hollow of the stone. The beautiful, Praxitelean lines of the swooning captive present—in their slow, downward pull—the weight of exhaustion; the violent contrapposto of the defiant captive is the image of frantic, impotent struggle. Michelangelo's whole art depends on his conviction that whatever can be

17-22 MICHELANGELO, The Bound Slave, 1513–1516. Marble, approx. 6' 10¹/₂" high. Louvre, Paris.

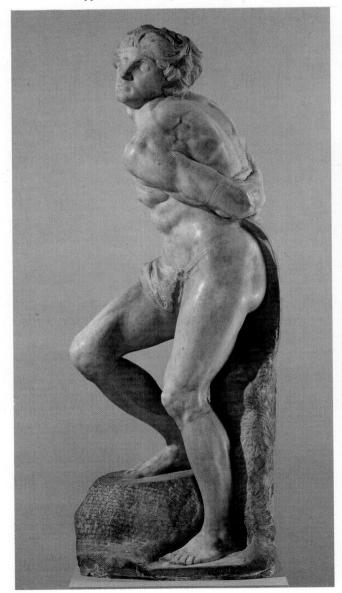

said greatly through sculpture and painting must be said through the human figure.

A group of four unfinished slaves, one of which is illustrated in the Introduction (FIG. 10), was probably meant for one of the later versions of the Julius tomb. These figures serve not only as object lessons in the subtractive method of sculpture, but also as revelations of the creative process in which abstract ideas in effect, encased in blocks of stone—are converted into dynamically expressive, concrete forms. If Michelangelo's slaves indeed symbolize the struggle of the human soul to find release from the bonds of its material body, then this idea can find no fuller expression than in these partly finished figures that, with superhuman effort, struggle to cast off the inert masses of stone that imprison them.

With the failure of the tomb project, Julius II gave the bitter and reluctant Michelangelo the commission to paint the ceiling of the Sistine Chapel (FIG. **17-23**). The artist, insisting that painting was not his profession, assented only in the hope that the tomb project could be revived. The difficulties facing Michelangelo were enormous: the inadequacy of his training in the

17-23 Interior of the Sistine Chapel (view facing east). The Vatican, Rome.

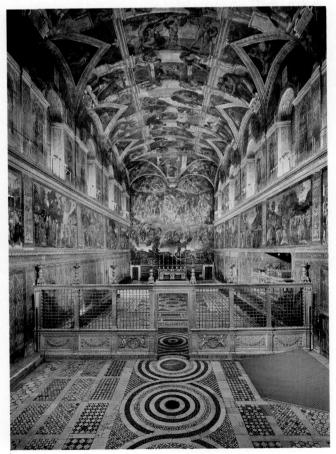

17-24 MICHELANGELO, ceiling of the Sistine Chapel, 1508–1512. Fresco.

art of fresco; the dimensions of the ceiling (some 5,800 square feet); its height above the pavement (almost 70 feet); and the complicated perspective problems presented by the height and curve of the vault. Yet, in less than four years, Michelangelo produced an unprecedented work—a one-man masterpiece without parallel in the history of world art (FIG. **17-24**). Taking the most august and solemn themes of all, the Creation, Fall, and Redemption of man, Michelangelo spread a colossal decorative scheme across the vast surface, weaving together more than three hundred figures in an ultimate grand drama of the human race. A long corridor of narrative panels describing the creation recorded in Genesis runs along the crown of the vault, from God's *Separation of Light and Darkness* (above the altar) to the *Drunkenness of Noah* (nearest the entrance). The Hebrew prophets and pagan sibyls who foretold the coming of Christ

are seated on either side, where the vault curves down. At the four corner pendentives Michelangelo placed four Old Testament scenes with David, Judith, Haman, and the Brazen Serpent. Scores of lesser figures also appear: the ancestors of Christ in the triangular compartments above the windows, the nude youths who punctuate the corners of the central panels, and the small pairs of putti in grisaille (grey monochrome to imitate sculpture), who support the painted cornice surrounding the whole central corridor. The conception of the whole design is astounding enough in itself; the articulation of it in its thousand details is a superhuman achievement. But Michelangelo *was* human; in the first few months of work, he made mistakes in the technical application of the fresco that spoiled all he had done up to that time. In the first three panels, beginning at the entrance with the *Drunkenness of Noah*, he did not estimate the scale properly, and the compositions are crowded, without the simplicity of the panels beginning, in the center, with the *Temptation and Fall*.

Unlike Andrea Mantegna's decoration of the Camera degli Sposi in Mantua (FIG. 16-64), the strongly marked, unifying architectural framework in the Sistine Chapel is not used to construct "picture windows" through which we may look up into some illusion just above. Rather, our eyes seize on figure after figure, each sharply outlined against the neutral tone of the architectural setting or the plain background of the panels. Here, as in his sculpture, Michelangelo relentlessly concentrates his expressive purpose on the human figure. To him, the body is beautiful not only in its natural form but also in its spiritual and philosophical significance; the body is simply the manifestation of the soul or of a state of mind and character. Michelangelo represents the body in its most simple, elemental aspect: in the nude or simply draped, with no background and no ornamental embellishment, and always with a sculptor's sense that the figures could be tinted reliefs or full-rounded statues.

One of the central panels of the ceiling will evidence Michelangelo's mastery of the drama of the human figure. *The Creation of Adam* (FIG. **17-25**) is not the traditional representation but a bold, entirely Humanistic interpretation of the primal event. God and Adam, members of the same race of superbeings, confront each other in a primordial, unformed landscape of which Adam is still a material part, heavy as earth, while the Lord transcends it, wrapped in his billowing cloud of drapery and borne up by his genius powers. Apprehensively curious but as yet uncreated, the female figure beneath his sheltering arm, long held to represent Eve, recently has been interpreted as the Virgin Mary (with the Christ Child at her knee). Life leaps to Adam like an electric spark from the extended and mighty hand of God. The communication between gods and heroes, so familiar in Classical myth, is here concrete: both are made of the same substance; both are gigantic. This blunt depiction of the Lord as ruler of Heaven in the Olympian, pagan sense is an indication of how easily the High Renaissance joined pagan and Christian traditions; we could imagine Adam and the Lord as Prometheus and Zeus.

The composition is dynamically off-center, its focus being the two hands that join the great bodies by the energy that springs between their fingers. The bodies themselves are complementary—the concave body of Adam fitting the convex body of the Lord. The straight, architectural axes we find in the compositions of Leonardo and Raphael are replaced by curves and diagonals; thus, motion directs not only the figures but the whole composition. The reclining poses, the heavy musculature, and the twisting contrapposto are all a part of Michelangelo's stock, which he will show again later in the sculptured figures of the Medici tombs.

The *Creation of Adam* soon will present a new appearance; the paintings of the Sistine Chapel, like Leonardo's *Last Supper*, are in the process of being restored. Centuries of accumulated grime, overpainting, and protective glue are being removed, and restorers have uncovered much of the artist's original

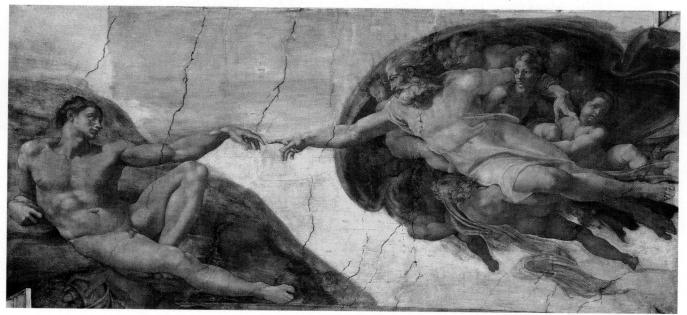

17-25 MICHELANGELO, The Creation of Adam (detail of FIG. 17-24).

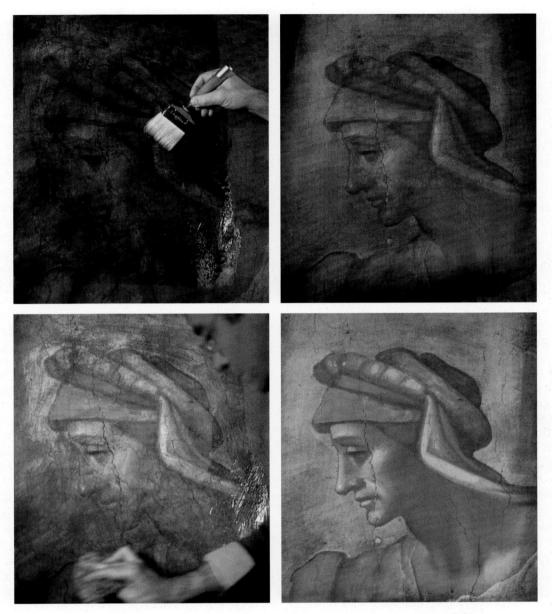

17-26 Detail of the left side of the Azor-Sadoch lunette at various stages of the restoration process, lunettes over the windows of the Sistine Chapel.

craft in form, color, style, and procedure. The restoration work, part of a twelve-year program (1980– 1992), began on the lunettes above the windows (FIG. 17-23). In these semicircular spaces, Michelangelo painted figures representing the ancestors of Christ (Matthew 1:1–17). These figures, once thought to be purposefully dark, now show brilliant colors of high intensity, brushed on with an astonishing freedom and verve. A detail from the *Azor-Sadoch* lunette (FIG. **17-26**) shows the startling result of the restorers' procedure, as the original work emerges from the dark film laid down by time and faulty repair. The fresh, luminous hues, boldly joined in unexpected harmonies, have seemed uncharacteristically dissonant to some experts and have aroused brisk controversy. Some believe the restorers are removing Michelangelo's work along with the accumulated layers and that the apparently strident coloration cannot possibly be his. Others insist that the artist's real intentions and effects only now are being revealed to modern eyes. The issues raised are similar to those we have noted (in a footnote on page 573) with reference to Giotto's paintings in the Bardi Chapel (FIG. 15-15). In any event, when the restoration is completed, it is likely that the pictorial art of Michelangelo and its influence will have to be restudied and reassessed.

LATER WORKS

Following the death of Julius II, Michelangelo went once again into the service of the Medici popes, Leo X and Clement VII. These pontiffs were not interested in perpetuating the fame of their predecessor by letting Michelangelo complete Julius's tomb; instead, they commissioned him to build a funerary chapel, the New Sacristy, in San Lorenzo in Florence. Brunelleschi's Old Sacristy was off the left transept of San Lorenzo, and Michelangelo built the new addition off the right. He attempted a unification of architecture and of sculpture, designing the whole chapel as well as the tombs. This relationship between the two arts (and, in this case, painting as well) was a common Medieval feature; we think of the sculptured portals and stained glass of the Gothic cathedral. But the relationship had been broken in the fifteenth century, when sculpture fought free of its architectural matrix and asserted its independence-so much so that Brunelleschi could complain that Donatello's architectural and sculptural additions to his Old Sacristy spoiled the purity of his design. This new integration

17-27 MICHELANGELO, tomb of Giuliano de' Medici, 1519–1534. Marble, central figure approx. 71" high. New Sacristy (Medici Chapel), San Lorenzo, Florence.

by Michelangelo, though here unfinished, pointed the way to Baroque art, in which the architecturalsculptural-pictorial ensemble again will become an effective standard.

At opposite sides of the New Sacristy stand the tombs of Giuliano, Duke of Nemours, and Lorenzo, Duke of Urbino, son and grandson of Lorenzo the Magnificent. The tomb of Giuliano (FIG. 17-27) is compositionally the twin of Lorenzo's. Both are unfinished; scholars believe that pairs of recumbent river gods were to be placed at the bottom of the sarcophagi, balancing the pairs of figures that rest on the sloping sides. The composition of the tombs has been a long-standing puzzle. How were they ultimately to look? What is their relationship to one another? What do they signify? The present arrangement seems quite unstable. Were the sloping figures meant to recline on a flat surface, or were they to be partly supported by the river-gods below them? We can do little more here than to state some of the questions; we cannot answer them in full. Art historians have suggested that the arrangement planned by Michelangelo, but never completed, can be interpreted as the ascent of the soul through the levels of the Neo-Platonic universe. The lowest level, represented by the river-gods, would have signified the underworld of brute matter, the source of evil. The two statues on the sarcophagi would then symbolize the realm of time: the specifically human world of the cycles of dawn, day, evening, and night. Man's state in this world of time is one of pain and anxiety, frustration and exhaustion. At left, the female figure of Night and, at right, the male figure of Day appear to be chained into never-relaxing tensions. Both exhibit that anguished twisting of the masses of the body in contrary directions seen in The Bound Slave (FIG. 17-22) and in the Sistine Chapel paintings. This contrapposto is the signature of Michelangelo. Day, with a body the thickness of a great tree and the anatomy of Hercules, strains his huge limbs against each other, his unfinished visage rising menacingly above his shoulder. Night, the symbol of rest, twists as if in troubled sleep, her posture wrenched and feverish. The artist has surrounded her with an owl, poppies, and a hideous mask symbolic of nightmares.

On their respective tombs, the figures of Lorenzo and Giuliano, rising above the troubles of the realm of time, represent the two ideal human types: the contemplative man (Lorenzo) and the active man (Giuliano). They thus become symbols for the two means by which human beings might achieve union with God: meditation or the active life fashioned after that of Christ. Michelangelo disdained to make portraits of the actual persons; who, he asked, would care what they looked like in a thousand years? What counted was the contemplation of what was beyond the corrosion of time. Giuliano, the active man (FIG. 17-27), his features quite generalized, sits clad in the armor of a Roman emperor, holding the baton of a commander, his head turned alertly, as if in council (he looks toward the statue of the Virgin at one end of the chapel). Across the room, Lorenzo, the contemplative man, sits wrapped in thought, his face in deep shadow. In these works, as in many others, Michelangelo suggests powerful psychic forces that cannot be translated into action but are ever on the verge of it. His prevailing mood is tension and constraint, even in the figures that seem to aspire to the ideal, to the timeless, perfect and unmoving. Michelangelo's style was born to disturb. It brings the serene, brief High Renaissance to an end.

The tensions and ambiguities of Michelangelo's style, which will pass over into the general style called Mannerism, are felt strongly in his architecture. His building activity for the Medici in Florence centered in and around San Lorenzo, and his Laurentian Library, built to house the great collections of the

Medici, adjoins it. The building's peculiar layout was dictated by its special function and by its rather constricted site. Michelangelo had two contrasting spaces to work with: the long horizontal of the library proper, and the vertical of the vestibule. In the latter, everything is massive and plastic, but the planes and solids of the reading room are shallow and played down (perhaps so as not to distract the readers). The need to place the vestibule windows up high determined the narrow verticality of its elevation and proportions (FIG. **17-28**).

The vestibule, much taller than it is wide or long, gives the impression of a vertically compressed, shaftlike space. A vast, flowing stairway that almost fills the interior greatly adds to a sense of oppressiveness. Anyone schooled exclusively in the Classical architecture of Bramante and the High Renaissance would have been appalled by Michelangelo's indifference here to Classical norms in the use of the orders or in proportion. He uses columns in pairs and sinks them into the walls. He breaks columns around corners. He places consoles beneath columns that are

17-28 MICHELANGELO, vestibule of the Laurentian Library, San Lorenzo, Florence, begun 1524. Stairway designed 1558–1559.

not meant to support them. He arbitrarily breaks through pediments, as well as through cornices and stringcourses. In short, Michelangelo disposes willfully and abruptly of Classical architecture as it was valued by other artists of the High Renaissance. But some features, often called Manneristic, were dictated by structural necessity. The recessed columns, for example, which seem neither to support nor to be supported, recently have been shown to perform a supporting function, in contrast with the standard, applied Classical orders, which are purely decorative. These paired stone columns, due to their greater compressive strength, actually add rigidity to the relatively thin brick walls and support the upper part of the structure. The "ambiguity" of the resulting wall surface is illusory, as the columns clearly have been recessed into the wall.

In any event, with his usual trailbreaking independence of mind, Michelangelo has sculptured an interior space that conveys all the strains and tensions we find in his statuary and in his painted figures. But, unlike Mannerist architects, especially his contemporary, Giulio Romano, in the Palazzo del Tè (FIGS. 17-47 and 17-48), he never tried to baffle or to confuse. His style in all three arts is wonderfully consistent. The key to that consistency may be found in his own words: "The members of an architectural structure follow the laws exemplified in the human body. He who . . . is not a good master of the nude . . . cannot understand the principles of architecture." His whole inspiration came from the beauty and majesty of the human body-the visible aspect of the human soul.

THE CAPITOLINE HILL

In his later years, Michelangelo turned increasingly to architecture. In 1537, he undertook to reorganize the Capitoline Hill (the Campidoglio) in Rome (FIGS. 17-29 and 17-30), receiving from Pope Paul III a flattering and challenging commission. The pope wished to transform the ancient hill, which once had been the spiritual as well as the political capitol of Rome, into a symbol of power of the new Rome of the popes. The great challenge of the project was that Michelangelo was required to incorporate into his design two existing buildings—the medieval Palazzo dei Senatori (Palace of the Senators) on the east, and the fifteenth-century Palazzo dei Conservatori (Palace of the Conservators) on the south. These buildings formed an eighty-degree angle. Such preconditions might have defeated a lesser architect, but Michelangelo converted what seemed to be a limitation into the most impressive design for a civic unit formulated during the entire Renaissance.

Michelangelo reasoned that architecture should follow the form of the human body to the extent of

17-29 MICHELANGELO, the Capitoline Hill (the Campidoglio), Rome, designed c. 1537.

17-30 MICHELANGELO, plan for the Capitoline Hill. (Engraving by Étienne Dupérac, c. 1569).

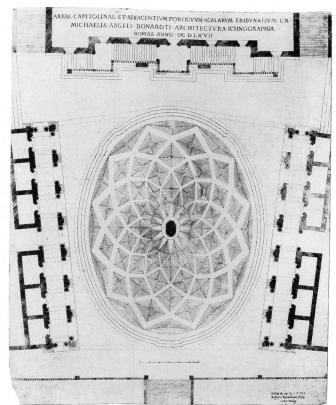

disposing units symmetrically around a central and unique axis, as the arms are related to the body or the eves to the nose. It must have been with arguments like this that he convinced his sponsors of the necessity of balancing the Palazzo dei Conservatori, for which he was going to redesign the façade, with a similar unit on the north side of the square. To achieve balance and symmetry in his design, Michelangelo placed the new building (the Museo Capitolino, originally planned only as a portico with single rows of offices above and behind it) so that it stood at the same angle to the Palazzo dei Senatori as the Palazzo dei Conservatori, yielding a trapezoidal rather than a rectangular plan for the piazza (FIG. 17-30). All other design elements subsequently were adjusted to this unorthodox but basic feature.

The statue of Marcus Aurelius (FIG. 6-77), the only one of many equestrian statues of Roman emperors to survive the Middle Ages, became the focal point for the whole design. It was brought to the Capitoline Hill on the pope's orders and against the advice of Michelangelo, who might have preferred to carve his own centerpiece. The symbolic significance of the statue, which seemed to link the Rome of the caesars with the Rome of the popes, must have appealed to Paul III. To connect this central monument with the surrounding buildings, Michelangelo provided it with an oval base and placed it centrally in an oval pavement design (FIG. 17-30), the twelve points of which may have had ancient or medieval cosmological connotations. Michelangelo's choice of the oval is significant, as it was considered to be an unstable geometric figure and was shunned by earlier Renaissance architects. Given the trapezoidal shape of the piazza, however, the oval (which combines centralizing with axial qualities) was the figure best suited to relate the various elements of the design to one another. The oval later was to become the favorite geometric figure of the Baroque period.

Facing the piazza, the two lateral palazzi have identical, two-story façades (FIG. 17-31). They introduce us again to the giant order, first seen in somewhat timid fashion in Alberti's Sant' Andrea in Mantua (FIG. 16-42). Michelangelo uses the giant order with much greater gusto and authority. The huge pilasters not only tie the two stories of the building together but provide a sturdy skeleton that actually functions as the main support of the structure. Walls have been all but eliminated. At ground level, the transition from the massive bulk of the pilaster-faced piers to the deep voids between them has been softened by the interposed columns. These columns carry straight lintels, in the manner earlier advocated by Alberti, but Michelangelo uses them with even greater logic and consistency than Alberti did. The façade of the third building on the piazza, the threestoried Palazzo dei Senatori, uses the same design elements as the other two palazzi, but in a less plastic fashion. The axial building, with its greater height, thus becomes a distinctive and commanding accent for the ensemble, providing variety within the design without disrupting its unity.

17-31 MICHELANGELO, Museo Capitolino, Capitoline Hill.

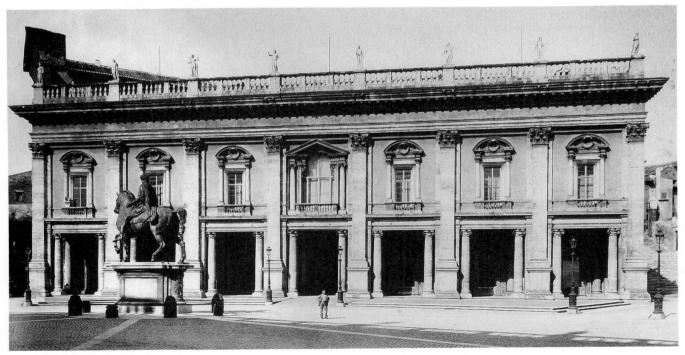

The piazza might have become a roomlike enclosure, as Renaissance squares often were and as Alberti, in his treatise, had advised that they be. But again Michelangelo parts with tradition and points to the future. Instead of enclosing his piazza with four walls punctuated by entrances leading through their centers, as a roomlike enclosure would seem to demand, he left the fourth side open. A fourth wall is merely suggested by a balustrade and a thin screen of Classical statuary that effectively defines the limits of the piazza without obstructing a panoramic view across the city's roofs toward the Vatican. The accidental symbolism of this axis must have pleased the pope just as much as the piazza's dynamic design, and the sweeping vista must have pleased later Baroque planners.

ST. PETER'S

Michelangelo took over the supervision of the building of the new St. Peter's a few years after he had designed the Capitoline Hill; neither project was finished at the time of his death. His work on St. Peter's, after efforts by a succession of architects following the death of Bramante, apparently became a show of dedication, thankless and without pay, on his own decision. Writing in May 1557 to his friend Giorgio Vasari, Michelangelo complained:

God is my witness how much against my will it was that Pope Paul forced me into this work on St. Peter's in Rome ten years ago. If the work had been continued from that time forward as it was begun, it would by now have been as far advanced as I had reason to hope.*

Among Michelangelo's difficulties had been his struggle to preserve and carry through Bramante's original plan (FIG. 17-7), which he praised even as he changed it:

It cannot be denied that Bramante was a skillful architect and the equal of any one from the time of the ancients until now. It was he who drew up the original plan of St. Peter's, not full of confusion but clear and straightforward. . . . It was considered to be a fine design, and there is still evidence that it was so: indeed, every architect who has departed from Bramante's plan . . . has departed from the right way.[†]

We already have seen Michelangelo's respect for a good plan in his willingness to carry out Sangallo's design for the Farnese Palace (FIG. 17-12) with only minor modifications. With Bramante's plan for St. Peter's, Michelangelo managed a major concentration, reducing the central fabric from a number of interlocking crosses to a compact, domed Greek cross inscribed in a square and fronted with a Pantheonlike, double-columned portico (FIG. **17-32**). Without destroying the centralizing features of Bramante's plan, Michelangelo, with a few strokes of the pen, converted its snowflake complexity into massive, cohesive unity.

The same striving for a unified and cohesive design is visible in Michelangelo's treatment of the building's exterior. Later changes to the front of the church make the west (apse) end (FIG. 17-33) the best place to see his style and intention. The colossal order again serves him nobly, as the giant pilasters march around the undulating wall surfaces, confining the movement without interrupting it. The architectural sculpturing, which Michelangelo began in the Laurentian Library (FIG. 17-28), here extends up from the ground through the attic stories and moves on into the drum and the dome, pulling the whole building together into a unity from base to summit. Baroque architects will learn much from this kind of integral design, which ultimately is based on Michelangelo's conviction that architecture is one with the organic beauty of the human form. The domed west end-as majes-

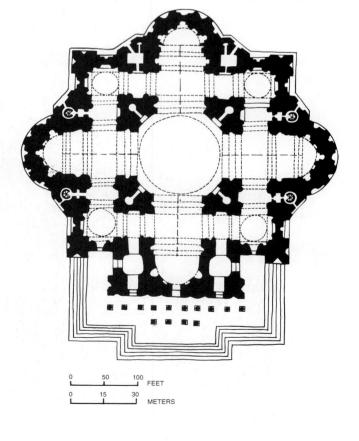

17-32 MICHELANGELO, plan for St. Peter's, the Vatican, Rome.

^{*}In Robert J. Clements, ed., *Michelangelo: A Self-Portrait* (Englewood Cliffs, NJ: Prentice-Hall, 1964), p. 57.

^tIn E. G. Holt, ed., *Literary Sources of Art History* (Princeton, NJ: Princeton University Press, 1947), p. 195.

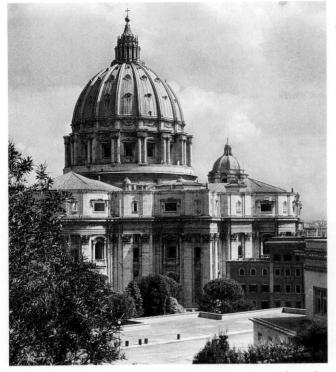

17-33 MICHELANGELO, St. Peter's, 1546–1564 (view from the northwest). Dome completed by GIACOMO DELLA PORTA in 1590.

tic as it is today and as influential as it has been on architecture throughout the centuries—is not quite as it was intended to be. Originally, Michelangelo had planned a dome with a raised silhouette, like that of Florence Cathedral. But in his final version he decided on a hemispheric dome (FIG. 17-34) to moderate the verticality of the design of the lower stories and to establish a balance between dynamic and static elements. However, when GIACOMO DELLA PORTA executed the dome after Michelangelo's death, he restored the earlier high design, ignoring Michelangelo's later version. Giacomo's reasons were probably the same ones that had impelled Brunelleschi to use an ogival section for his Florentine dome (FIG. 16-15): greater stability and ease of construction. The result is that the dome seems to be rising from its base, rather than resting firmly on it—an effect that Michelangelo might not have approved. Nevertheless, the dome of St. Peter's is probably the most impressive and beautiful in the world and has served as a model to generations of architects to this day.

THE LAST JUDGMENT

While Michelangelo endured the tribulations of age and the long frustrations of art, his soul was further oppressed by the events that had been erupting

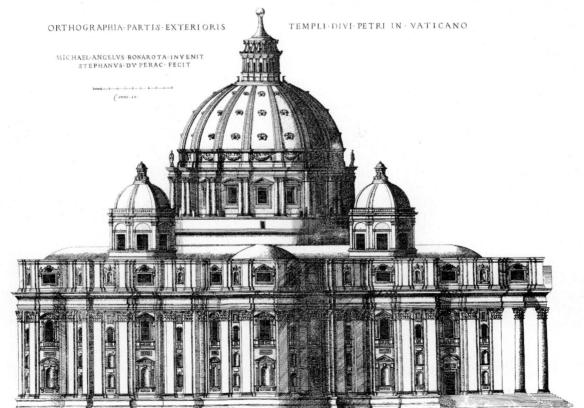

17-34 MICHELANGELO, south elevation of St. Peter's. (Engraving by Étienne Dupérac, c. 1569.)

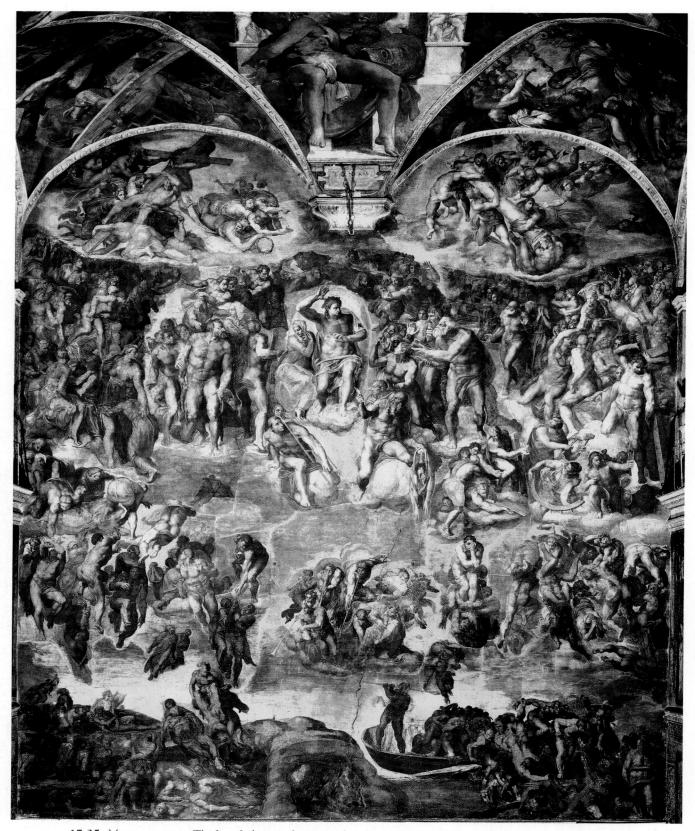

17-35 MICHELANGELO, The Last Judgment, fresco on the altar wall of the Sistine Chapel (before restoration), 1534–1541. The Vatican, Rome.

around him from the time he fled Florence as a young man after the fall of the Medici. The liberties of Florence were destroyed; the Medici had returned as tyrants, and Michelangelo felt himself an exile, even while he worked for them. Italy was laid to waste by the French and Spanish invasions, and the Protestant Reformation divided Christendom into warring camps. The Catholic Counter-Reformation gained force, and Europe was to be racked by religious war for more than a century. The glories of the High Renaissance faded, and the philosophy of Humanism retreated before the resurgence of a religious spirit that was often pessimistic, moralizing, and grimly fanatical, whether Protestant or Catholic. Michelangelo himself turned from his Humanist beginnings to a deep religious preoccupation with the fate of man and of his own soul. His sense that the world had gone mad and that man, forsaking God, was doomed must have been sharpened by his still vivid memory of Savonarola's foreboding summons of sinners to repent and by his very close reading of Dante.

In this spirit, Michelangelo undertook the great Last Judgment fresco on the altar wall of the Sistine Chapel (FIG. 17-35). The change in this fresco from the mood of the ceiling paintings of twenty years before is radical. In the ceiling frescoes, fallen man was to have been exalted by the coming of the Redeemer, announced everywhere in the thronging figures of the ceiling panels. Now, on the altar wall, Christ indeed has come, but as the medieval judge of the world—a giant whose mighty right arm is lifted in a gesture of damnation so broad and universal as to suggest he will destroy all creation, Heaven and earth alike. The choirs of Heaven surrounding him pulse with anxiety and awe. The spaces below are crowded with trumpeting angels, the ascending figures of the just, and the downward-hurtling figures of the damned. On the left, the dead awake and assume flesh; on the right, the damned are tormented by demons whose gargoyle masks and burning eyes revive the demons of the Romanesque tympana (FIG. 9-31). Martyrs who suffered especially agonizing deaths crouch below the Judge. One of them, St. Bartholomew, who was skinned alive, holds the flaying knife and the skin, in which hangs a grotesque selfportrait of Michelangelo. We cannot find any trace of the old Neo-Platonic aspiration to beauty anywhere in this fresco. The figures are grotesquely huge and violently twisted, with small heads and contorted features. The expressive power of ugliness and terror in the service of a terrible message reigns throughout the composition.

Michelangelo's art began in the manner of the fifteenth century, rose to an idealizing height in the High Renaissance, and, at the end, moved toward the Baroque. Like a colossus, he bestrides three centuries. He became the archetype of the supreme genius who transcends the rules by making his own. Few artists could escape his influence, and variations on his style will constitute much of artistic experiment for centuries.

Andrea del Sarto and Correggio

The towering achievements of Raphael and Michelangelo in Rome tend to obscure everything else that was done during their time. Nevertheless, aside from the flourishing Venetian school, some excellent artists were active in other parts of Italy during the first part of the sixteenth century. One of these, the Florentine ANDREA DEL SARTO (1486–1531), expresses, in his early paintings, the ideals of the High Renaissance with almost as much clarity and distinction as does Raphael.

Andrea's *Madonna of the Harpies* (FIG. **17-36**) shows the Madonna standing majestically on an altarlike base decorated with sphinxes (figures misidentified by Vasari as harpies—hence, the name of the painting). The composition is based on a massive and imposing figure pyramid, the static qualities of which are relieved by the opposing contrapposto poses of the flanking saints—a favorite and effective High

17-36 ANDREA DEL SARTO, Madonna of the Harpies, 1517. Oil on wood, approx. 6' $9'' \times 5'$ 10". Galleria degli Uffizi, Florence.

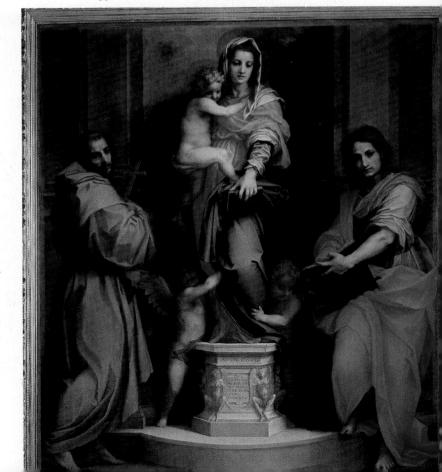

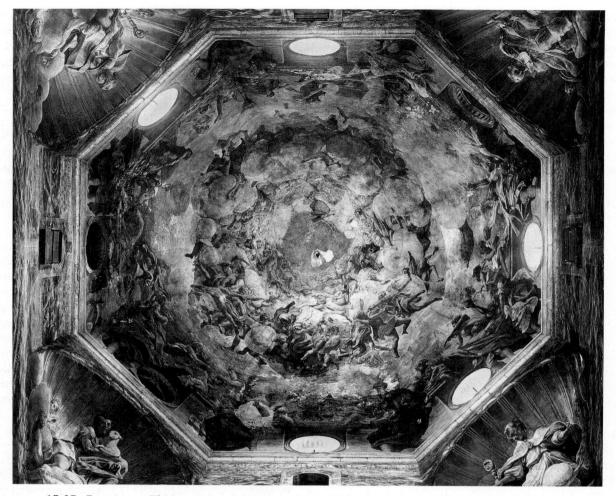

17-37 CORREGGIO, The Assumption of the Virgin, 1526–1530. Fresco. Dome of Parma Cathedral, Italy.

Renaissance device to introduce variety into symmetry. The potentially rigid pyramid is softened further by the skillful coordination of the figures' poses into an organic movement that leads from St. Francis (on the left) to the Virgin, to St. John the Evangelist, and downward from him toward the observer. This main movement is either echoed or countered by numerous secondary movements brought into perfect formal balance in a faultless compositional performance. The soft modeling of the forms is based on Leonardo but does not affect the colors, which are rich and warm. Andrea's sense of and ability to handle color set him apart from his central Italian contemporaries; he is perhaps the only Renaissance artist to transpose his rich color schemes from panels into frescoes. Andrea's later compositions tend to be less firmly knit and his color schemes move toward the cool harshness that will become typical of Mannerist painting. Although he was greatly admired in the sixteenth and seventeenth centuries, Andrea's fame has waned; today, he seems to be remembered primarily

as the teacher of Jacopo da Pontormo, Rosso Fiorentino, and Vasari and, thus, as one of the forerunners of Mannerism.

Andrea del Sarto may still be placed firmly in the High Renaissance, but his northern Italian contemporary, Correggio (Antonio Allegri da Correggio, c. 1489–1534), of Parma, is almost impossible to classify. A solitary genius, Correggio brings together many stylistic trends, including those of Leonardo, Raphael, and the Venetians. Yet he developed a unique personal style, which, if it must be labeled, might best be called "proto-Baroque." Historically, his most enduring contribution was the development of illusionistic ceiling perspectives to a point seldom surpassed by his Baroque emulators. At Mantua, Mantegna had painted a hole into the ceiling of the Camera degli Sposi (FIG. 16-65); some fifty years later, Correggio painted away the entire dome of the cathedral of Parma (FIG. 17-37). Opening up the cupola, the artist shows his audience a view of the sky, with concentric rings of clouds among which hundreds of

soaring figures perform a wildly pirouetting dance in celebration of *The Assumption of the Virgin*. These angelic creatures will become permanent tenants of numerous Baroque churches in later centuries. Correggio was also an influential painter of religious panels, in which he forecast many other Baroque compositional devices. As a painter of erotic mythological subjects, he had few equals. *Jupiter and Io* (FIG. **17-38**) depicts a suavely sensual vision out of the pagan past. The painting is one of a series on the loves of Jupiter that Correggio painted for the Duke of Man-

17-38 CORREGGIO, Jupiter and Io, c. 1532. Oil on canvas, approx. $64\frac{1}{2}^{"} \times 29\frac{3}{4}^{"}$. Kunsthistorisches Museum, Vienna.

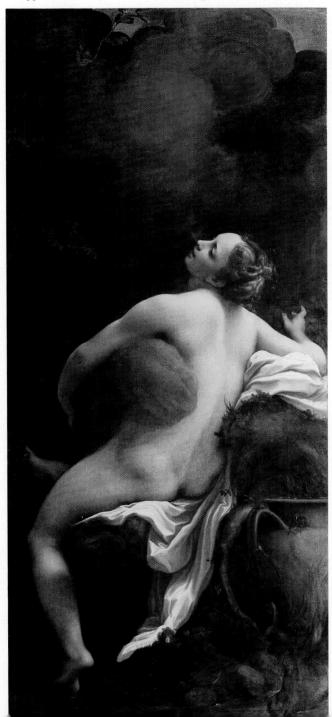

tua, Federigo Gonzaga. The god, who assumed many disguises to hide his numerous liaisons from his wife, Juno, appears here as a cloud that embraces the willing nymph. The soft, smoky modeling (sfumato), derived from Leonardo, is fused with glowing color and renders the voluptuous moment with exquisite subtlety. Even Titian, in his mythological paintings, rarely was able to match the sensuous quality expressed here by Correggio. Unlike Andrea del Sarto, Correggio was little appreciated by his contemporaries; later, during the seventeenth century, Baroque painters recognized him as a kindred spirit.

MANNERISM

The term *Mannerism* refers to certain tendencies in the art of the Late Renaissance—the period from the death of Raphael (1520) to the end of the sixteenth century. In its broadest sense, the word means excessive or affected adherence to a distinctive manner, especially in art and literature. In its early application to these tendencies, it also carried the pejorative connotation of the term when applied to a description of individual behavior. Today, we view these styles in art and literature more objectively and appreciate much that is excellent in them.

The artists of the Early Renaissance and the High Renaissance developed their characteristic styles from the studious observation of nature and the formulation of a pictorial science. By the time Mannerism matured (after 1520), all the representational problems had been solved; a vast body of knowledge was there to be learned from. In addition, an age of antiquarianism and archeology now was bringing to light thousands of remnants of ancient Roman art. The Mannerists, instead of continuing the earlier research into nature and natural appearance, turned for their models to the masters of the High Renaissance (especially Michelangelo) and to Roman sculpture (especially relief sculpture). Instead of nature as their teacher, they took art. One could say that whereas their predecessors sought nature and found their style, the Mannerists looked first for a style and found a manner.

Following Michelangelo's example in one respect, the Mannerists declared each artist's right to a personal interpretation of the rules, looking for inspiration to the Platonic Idea, which they referred to as the *disegno interno* and with which they fired their creative fervor. They saw a roughness in nature that needed refining, and they turned to where it had already been refined in art.

From the Antique and the High Renaissance, artists, to the limits of their own ingenuity and skill,

668 CHAPTER 17 / SIXTEENTH-CENTURY ITALIAN ART

abstracted forms that they idealized further, so that the typical Manneristic picture or statue looks like an original essay in human form somewhat removed from nature. As maniera (the name given the style by Mannerist theorists) is almost exclusively an art of the human figure, its commonest expression is in paintings of numerous figures performing what appears to be a complicated dance and pantomime, in which the compositions, as well as the fanciful gestures and attitudes, are deliberately intricate. The movements are so studied and artificial that they remind us not of the great stage dramatics of the High Renaissance but of an involved choreography for interpretive dancers. Where the art of the High Renaissance strives for balance, Mannerism seeks instability. The calm equilibrium of the former is replaced by a restlessness that leads to distortions, exaggerations, and bizarre posturings on the one hand and sinuously graceful, often athletic attitudes on the other. The positions and actions of the figures often have little to do with the subject. The Mannerist requirement of "invention" leads its practitioner to the maniera, a self-conscious stylization involving complexity, caprice, bizarre fantasy (the "conceit"), elegance, preciosity, and polish. Mannerism is an art made for aristocratic patrons by artists who sense that their profession is worthy of honor and the admiration of kings. It is an age when monarchs and grandees would plead for anything from the hands of Raphael and Michelangelo, if only a sketch. The concepts of "classic" and "old master" are abroad, and artists are being called *divino*. Artists become conscious of their own personalities, powers of-imagination, and technical skills; they acquire learning and aim at virtuosity. They cultivate not the knowledge of nature but the intricacies of art.

In Painting

The Descent from the Cross (FIG. 17-39) by JACOPO DA Ромтоямо (1494–1556) exhibits almost all the stylistic features characteristic of the early phase of Mannerism in painting. The figures crowd the composition, pushing into the front plane and almost completely blotting out the setting. The figure masses are disposed around the frame of the picture, leaving a void in the center, where High Renaissance artists had concentrated their masses. The composition has no focal point, and the figures swing around the edges of the painting without coming to rest. The representation of space is as strange as the representation of the human figure. Mannerist space is ambiguous; we are never quite sure where it is going or just where the figures are in it. We do not know how far back the depicted space extends, although its limit is defined by the figure at the top. But we do know that the

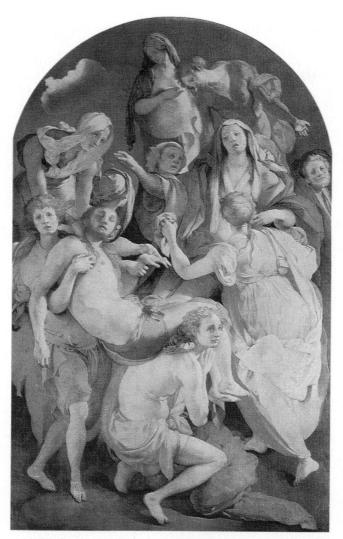

17-39 Јасоро да Ролтогмо, *The Descent from the Cross*, 1525–1528. Oil on wood, approx. 10' 3" × 6' 6". Capponi Chapel, Santa Felicità, Florence.

space is really too shallow for what is taking place in it. For example, Pontormo does not provide any space for the body belonging to the head that appears immediately over Christ's.

The centrifugal effect of the positions of the figures is strengthened by the curiously anxious glances that the actors cast out of the picture in all directions. Many figures are characterized by an athletic bending and twisting, with distortions (a torso cannot bend at the point at which the foreground figure's does), an elastic elongation of the limbs, and a rendering of the heads as uniformly small and oval. The composition is jarred further by clashing colors, which are unnatural and totally unlike the sonorous primary color chords used by painters of the High Renaissance. The mood of the painting is hard to describe; it seems the vision of an inordinately sensitive soul, perhaps itself driven, as are the actors, by nervous terrors. The psy-

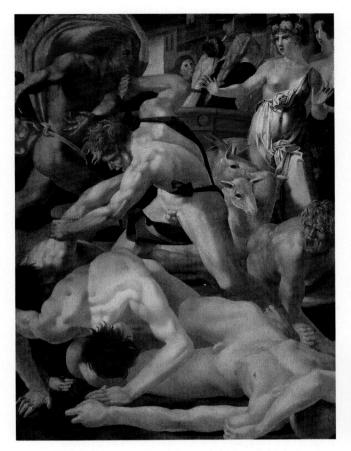

17-40 Rosso FIORENTINO, Moses Defending the Daughters of Jethro, 1523. Oil on canvas, approx. 63" × 46". Galleria degli Uffizi, Florence.

chic dissonance of the composition would indeed appear out of tune to a Classical artist.

Rosso FIORENTINO (1494–1540), who was, like Pontormo, a pupil of Andrea del Sarto, compresses space in a manner similar to that used by Pontormo but fills it with turbulent action. Rosso's painting of Moses Defending the Daughters of Jethro (FIG. 17-40) recalls the titanic struggles and powerful musculature of Michelangelo's figures on the Sistine Chapel ceiling, but Rosso's purpose is not so much expressive as it is inventive of athletic poses. At the same time, although the figures are modeled for three-dimensional effect, they are compressed within a limited space, so that surface is emphasized as a two-dimensional pattern. By 1530, when Francis I of France called him to decorate the palace at Fontainebleau, Rosso had all but forsaken this early furor for more graceful, elongated forms (FIG. 18-49).

Correggio's pupil PARMIGIANINO (Girolamo Francesco Maria Mazzola, 1503–1540), in his best-known work, *Madonna with the Long Neck* (FIG. **17-41**), achieves the elegance that is a principal aim of Mannerism. He smoothly combines the influences of Correggio and Raphael in a picture of exquisite grace and precious sweetness. The small, oval head of the Madonna; her long, slender neck; the unbelievable length and delicacy of her hand; and the sinuous, swaying elongation of her frame are all marks of the aristocratic, gorgeously artificial taste of a later phase of Mannerism. Here is Leonardo distilled through Correggio. On the left stands a bevy of angelic creatures, melting with emotions as soft and smooth as their limbs (the left side of the composition is quite in the manner of Correggio). On the right, the artist has included a line of columns without capitals-an enigmatic setting for an enigmatic figure with a scroll, whose distance from the foreground is immeasurable and ambiguous.

The Mannerists sought a generally beautiful style that had its rules, but rules, as we have seen, that still

17-41 PARMIGIANINO, Madonna with the Long Neck, c. 1535. Oil on wood, approx. 7' 1" × 4' 4". Galleria degli Uffizi, Florence.

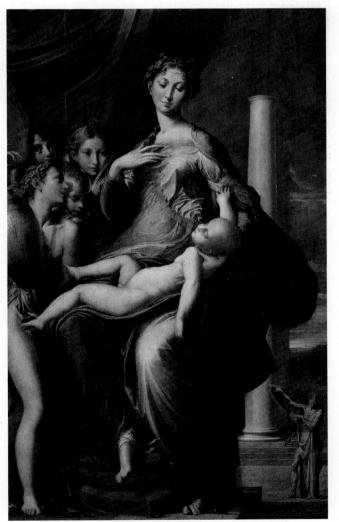

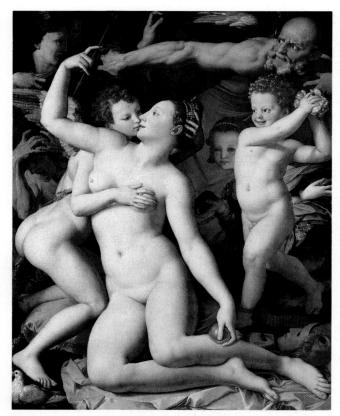

17-42 BRONZINO, Venus, Cupid, Folly, and Time (The Exposure of Luxury), c. 1546. Oil on wood, approx. 61" × 56³/₄". Reproduced by courtesy of the Trustees of the National Gallery, London.

permitted artists the free play of their powers of invention. Thus, although all Mannerist paintings share common features, each artist, as it were, has an individualized, recognizable signature.

All the points made thus far about Mannerist composition are recognizable in Venus, Cupid, Folly, and Time (or The Exposure of Luxury, FIG. 17-42) by BRONZINO (Agnolo di Cosimo, 1503-1572). A pupil of Pontormo, Bronzino was a Florentine and painter to Cosimo I, first Grand Duke of Tuscany. In this painting, he manifests the Mannerist fondness for extremely learned and intricate allegories that often have lascivious undertones; we are now far from the simple and monumental statements and forms of the High Renaissance. Venus, fondled by her son Cupid, is uncovered by Time, while Folly prepares to bombard them with roses; other figures represent Hatred and Inconstancy. The masks, a favorite device of the Mannerists, symbolize falseness. The picture seems to convey that love-accompanied by its opposite, hatred, and plagued by inconstancy—is foolish, and its folly will be discovered in time. But, as in many Mannerist paintings, the meaning is ambiguous, and

interpretations vary. The figures are drawn around the front plane and almost entirely block the space, although there really is no space. The contours are strong and sculptural, the surfaces, of enamel smoothness. Of special interest are the heads, hands, and feet, for the Mannerists considered the extremities to be the carriers of grace and the clever depiction of them evidence of skill in maniera.

The sophisticated elegance sought by the Mannerist painter most often was achieved in portraiture, in which the Mannerists excelled. Bronzino's Portrait of a Young Man (FIG. 17-43) is exemplary of Mannerist portraiture. The subject is a proud youth-a man of books and intellectual society, rather than a man of action or a merchant. His cool demeanor is carefully affected, a calculated attitude of nonchalance toward the observing world. This austere and incommunicative formality is standard for the Mannerist portrait. It asserts the rank and station of the subject, but not his personality. The haughty poise, the graceful, longfingered hands, the book, the masks, and the severe architecture all suggest the traits and environment of the high-bred, disdainful patrician. The somber Spanish black of the young man's doublet and cap (this is the century of Spanish etiquette) and the

17-43 BRONZINO, Portrait of a Young Man, c. 1550. Oil on wood, approx. $37\frac{5''}{5''} \times 29\frac{1}{2''}$. Metropolitan Museum of Art, New York (H. O. Havemeyer Collection, bequest of Mrs. H. O. Havemeyer, 1929).

17-44 SOFONISBA ANGUISSOLA, detail of Portrait of the Artist's Sisters and Brother, c. 1555. Methuen Collection, Corsham Court, Wilshire, England.

slightly acid olive green walls of the room make for a deeply restrained color scheme—a muted background for the sharply defined, busily active, Manneristic silhouette that contradicts the subject's impassive pose.

The aloof formality of Bronzino's portrait is much relaxed in the portraiture of SOFONISBA ANGUISSOLA (1532-1625). A northern Italian from Cremona, Anguissola uses the strong contours, muted tonality, and smooth finish familiar in Mannerist portraits. But she introduces, in a group portrait of irresistible charm (detail, FIG. 17-44), an informal intimacy of her own. Like many of her other works done before 1559, this is a portrait of members of her family. Against a neutral ground, she places one of her sisters and her brother in an affectionate pose meant not for official display but for private showing, much as they might be posed in a modern photo-studio portrait. The sister, wearing a striped gown, flanks her brother, who caresses a lap dog. The young girl has summoned up the dignity required for the occasion, while the boy looks quizzically at the portraitist with an expression of naive curiosity.

The naturalness of poses and expressions, the sympathetic, personal presentation, and the graceful treatment of the forms did not escape the attention of famous contemporaries. Vasari praised Anguissola's art as wonderfully lifelike, and declared that she "has done more in design and more gracefully than any other lady of our day." She was praised, moreover, for her "invention," and, though the word does not now have quite the meaning it had then, Anguissola can be considered to have introduced the intimate, anecdotal, and realistic touches of genre painting into formal portraiture. This group portrait could be simply a good-natured portrayal of the members of any happy, middle-class family; names, titles, and elegance of dress are not flourished to gain public respect. Anguissola lived long and successfully. She knew and learned from the aged Michelangelo, was court painter to Philip II of Spain, and, at the end of her life, gave advice on art to a young admirer of her work, Anthony Van Dyck, the great Flemish master. Circumstances generally prevented women artists from having the training and renown that favored Anguissola's career in Italy. We have knowledge of women who were painters as far back as the thirteenth century, and although they came into their own in the sixteenth century, they were few in number and did not achieve prominence. Social conventions, restricted education, and guild rules tended to exclude women from training and practice in the arts.

In Sculpture

With Bronzino, Florentine Mannerism in painting passed its high-water mark. But a remarkable person, as Mannerist in his action as in his art, has left us, in his sculpture, the mark of the prevailing style. To judge by his fascinating *Autobiography*, BENVENUTO CELLINI (1500–1571) had an impressive proficiency as an artist, statesman, soldier, lover, and many other things. He was, first of all, a goldsmith. The influence of Michelangelo led him to attempt larger works, and, in the service of Francis I, he cast in bronze the *Diana of Fontainebleau* (FIG. **17-45**), which sums up Italian and French Mannerism. The figure is derived

from the reclining tomb figures in the Medici Chapel (FIG. 17-27), but it exaggerates their characteristics. The head is remarkably small, the torso stretched out, and the limbs elongated. The contrapposto is more apparent than real, for it is flattened out almost into the forward plane, as Mannerist design sense dictates. This almost abstract figure, along with Mannerist works by Rosso and others, greatly influenced the development of French Renaissance art, particularly in the school of Fontainebleau.

Italian influence, working its way into France, had strength enough to draw a brilliant, young French sculptor, Jean de Boulogne, to Italy, where he practiced his art under the Italian cognomen GIOVANNI DA BOLOGNA (1529–1608). Although Giovanni's quality and importance have not always been recognized, he is the most important sculptor in Italy after Michelangelo and his work provides the stylistic link between the sculpture of that great master and that of the Baroque sculptor Gianlorenzo Bernini. Giovanni's *Rape of the Sabine Women* (FIG. **17-46**) wonderfully exemplifies the Mannerist principles of figure composition and, at the same time, shows an impulse to break out of the Mannerist formulas of representation.

The title was given to the group after it was raised

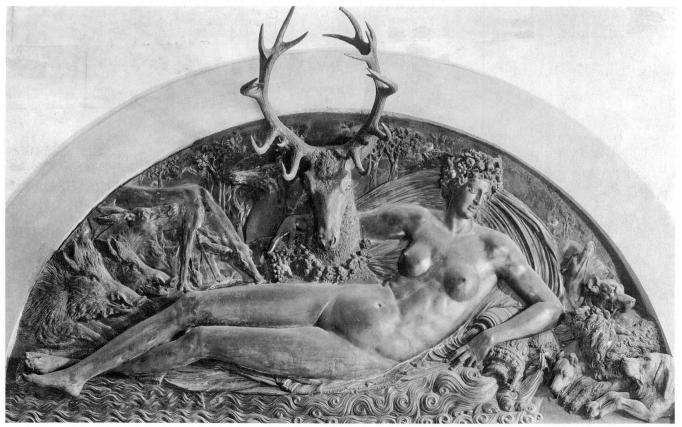

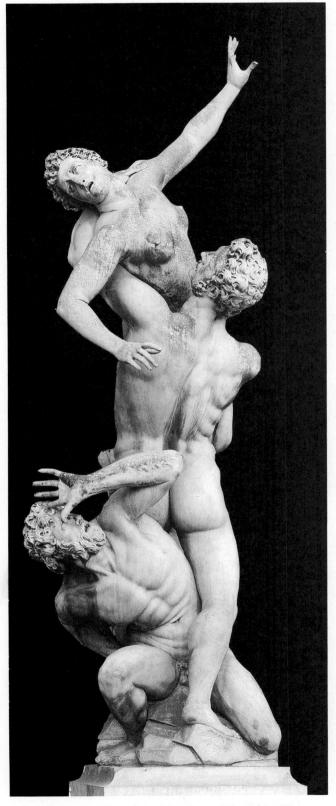

17-46 GIOVANNI DA BOLOGNA, Rape of the Sabine Women, completed 1583. Marble, approx. 13' 6" high. Loggia dei Lanzi, Piazza della Signoria, Florence.

(Giovanni probably intended to present only an interesting figure composition involving an old man, a young man, and a woman). The story, derived from mythic Roman history, tells how the Romans took wives for themselves from the neighboring Sabines. The amateurs, critics, and scholars who flocked around works of art in this age of Mannerism, naming groups in any way they found appropriate, serve to indicate how important and how valued the visual arts had become. The artist himself is learned in his artistic sources; here, Giovanni twice adapts the Laocoön (FIG. 5-79) discovered early in the centuryonce in the figure of the crouching old man and again in the gesture of the woman with one arm flung up. The three bodies interlock on an axis, along which a spiral movement runs; significantly, the figures do not break out of this vortex but remain as if contained within a cylinder. The viewer must walk around the sculpture to appreciate that, despite its confinement, the aspect of the group changes radically according to the point from which it is viewed. One reason is that the open spaces that pass through the masses (for example, the space between an arm and a body) have as great an effect as the solids. This sculpture is the first large-scale group composed to be seen from multiple points of view, but, as yet, the figures do not reach freely out into space and relate to the environment. The fact that they remain "enclosed" prevents our calling them Baroque. Yet the Michelangelesque potential for action and the athletic flexibility of the figures are there. The Baroque period will see sculptured figures released into full action.

In Architecture

Mannerism in painting and sculpture has been studied fairly extensively since the early decades of this century, but only in the 1930s was it discovered that the term also could be applied to much of sixteenth-century architecture. The corpus of Mannerist architecture that has been compiled since then, however, is far from homogeneous and includes many works that really do not seem to fit the term "Mannerist." The fact that Michelangelo was using Classical architectural elements in a highly personal and unorthodox manner does not necessarily make him a Mannerist architect. In his designs for St. Peter's, he certainly was striving for those effects of mass, balance, order, and stability that are the very hallmarks of High Renaissance design, and even some of the most unusual features in the Laurentian Library (FIG. 17-28) were dictated by structural necessity. As we have seen, Michelangelo never really aimed to baffle or to confuse, but this was the precise goal of GIULIO Romano when he designed the Palazzo del Tè in

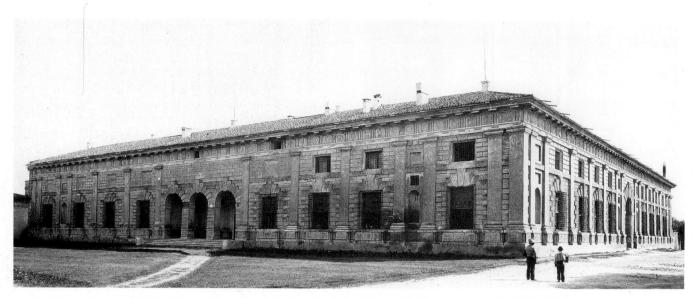

17-47 GIULIO ROMANO, north façade of the Palazzo del Tè, Mantua, Italy 1525–1535.

Mantua (FIGS. 17-47 and 17-48) and, with it, formulated almost the entire architectural vocabulary of Mannerism.

GIULIO ROMANO AND THE PALAZZO DEL TÈ

Giulio Romano was born either in 1492, if we accept Vasari's suggestion, or in 1499, if we disallow the possibility of error in a document that states that he died in Mantua in 1546 at the age of forty-seven. If we give credence to the latter birthdate, however, Giulio must have been one of the most precocious young prodigies in the history of world art, as he could then have been little more than sixteen when he became Raphael's chief assistant in the decoration of the Vatican stanze. After Raphael's premature death in 1520, Giulio became his master's artistic executor, completing Raphael's unfinished frescoes and panel paintings. In 1524, Giulio went to Mantua, where he found a patron in Federigo Gonzaga, for whom he built and decorated the Palazzo del Tè between 1525 and 1535.

The Palazzo del Tè was intended to combine the functions of a suburban summer palace with those of a stud farm for the duke's famous stables. Originally

17-48 GIULIO ROMANO, court façade of the Palazzo del Tè.

planned as a relatively modest country villa, Giulio's building so pleased the duke that he soon commissioned his architect to enlarge the structure. In a second building campaign, the villa was expanded to a palatial scale by the addition of three wings, which were placed around a square central court. This oncepaved court, which serves both as a passage and as the focal point of the design, has a near-urban character and, with its surrounding buildings, forms a selfenclosed unit to which a large, stable-flanked garden has been attached on the east side.

The first impression of the north façade (FIG. 17-47) is that of a fairly standard Renaissance structure with rusticated walls that have been articulated with smooth Doric pilasters. Closer study reveals a number of startling departures from the Renaissance norm. Most immediately noticeable is the ambiguity of the elevation, which can be read either as a onestory or a two-story system. Other discrepancies gradually reveal themselves. The distances from the central loggia to the corners of the building are unequal; the windows are located eccentrically between pilasters; the pilasters are paired at varying distances from each other; and the voussoirs above the windows and portals are handled in a way that makes them seem to tumble outward from the building. These divergences from convention serve as an overture to a building so laden with structural surprises and contradictions that, taken all together, it becomes an enormous parody on the Classical style of Bramante. To be sure, the appreciation of the joke required a highly sophisticated audience, and the recognition of some quite subtle departures from the norm presupposed a thorough familiarity with the established rules of Classical architecture. It speaks well for the duke's sophistication that he accepted Giulio's form of architectural humor.

It has recently been claimed that the irregularities of the north façade were forced on Giulio by the need to adjust the design of the façade to the features of the already completed villa behind it. Such impediments, however, rarely kept Renaissance architects from designing regular and symmetrical façades (compare Alberti's Palazzo Rucellai, FIG. 16-38). In any case, Giulio's intent seems to be expressed clearly enough in the palace's garden façade, where the irregularly spaced arches do not have to conform to any preexisting conditions. Even more chaotic is the design of the façades that face the interior courtyard (FIG. 17-48), where keystones (central voussoirs) either have not fully settled or seem to be slipping from the arches. The massive Tuscan columns carry incongruously narrow architraves whose structural insufficiency is stressed by the fact that they break midway between the columns, evidently unable to support

17-49 GIULIO ROMANO, The Fall of the Giants (detail), 1532–1534. Fresco. Sala dei Giganti, Palazzo del Tè.

the weight of the triglyphs above. And if this architectural chaos does not suffice to shock the visitor, Giulio delivers the coup de grace in the Sala dei Giganti (FIG. **17-49**). In a panoramic sequence that covers the ceiling and all the walls of this room, Giulio has represented Jupiter destroying the palaces of the rebellious giants with thunderbolts. Viewers cringe involuntarily as the entire universe appears to be collapsing around them in a tour de force of pictorial illusionism and wild Mannerist convulsion.

In short, in the Palazzo del Tè, most of the Classical rules of order, stability, and symmetry have been flouted deliberately, and every effort has been made to startle and shock the beholder. This desire to create ambiguities and tensions is as typical of Mannerist architecture as it is of Mannerist painting, and many of the devices invented by Giulio Romano for the Palazzo del Tè will become standard features in the formal repertoire of later Mannerist building.

VENICE

In the sixteenth century, Venetian art became a strong, independent, and influential school in its own right, touched only very slightly (if at all) by the fashions of Mannerism sweeping Western Europe. Venice had been the proud maritime mistress of the Mediterranean and its coasts for centuries; as the gateway to the Orient, it "held the gorgeous east in fee; and was the safeguard of the west." At the height

of its commercial and political power during the fifteenth century, Venice saw its fortunes decline in the sixteenth century. Even so, Venice and the papal state were the only Italian sovereignties to retain their independence during the century of strife; all others were reduced to dependency on either France or Spain. Although the fundamental reasons for the decline of Venice were the discoveries in the New World and the economic shift from Italy to the Hapsburg Germanies and Netherlands, other even more immediate and pressing events drained her wealth and power. Venice was constantly embattled by the Turks, who, after their conquest of Constantinople, began to contest with Venice over control of the eastern Mediterranean. Early in the century, Venice also found itself attacked by the European powers of the League of Cambrai, formed and led by Julius II, who coveted Venetian holdings on the mainland. Although this wearing, two-front war sapped its strength, Venice's vitality endured, at least long enough to overwhelm the Turks in the great sea battle of Lepanto in 1571. This time, Europe was on Venice's side.

Architecture: Sansovino and Palladio

Venice was introduced to the High Renaissance style of architecture by a Florentine called JACOPO SANSOVINO (Jacopo Tatti, 1486–1570). Originally trained as a sculptor under ANDREA SANSOVINO, whose name he adopted, Jacopo went to Rome in 1518, where, under the influence of Bramante's circle, he increasingly turned toward architecture. When he arrived in Venice as a refugee from the Sack of Rome in 1527, he quickly established himself as that city's leading and most admired architect; his buildings frequently inspired the architectural settings of the most prominent Venetian painters, including Titian and Veronese (FIG. 17-67).

Sansovino's largest and most rewarding public commissions were La Zecca (Mint) and the adjoining State Library (FIG. **17-50**) in the heart of the island city. The Zecca, begun in 1535, faces the Canale San Marco with a stern and forbidding three-story façade. Its heavy rustication gives it an intended air of strength and impregnability. This fortresslike look is emphasized by a boldly projecting, bracketsupported cornice reminiscent of the machicolated galleries of medieval castles.

A very different spirit is expressed by the neighboring State Library of San Marco, begun a year after the Zecca, which Palladio referred to as "probably the richest and most ornate edifice since ancient times." With twenty-one bays (only sixteen of which were

completed during Sansovino's lifetime), the library faces the Gothic Doge's Palace (FIG. 10-64) across the Piazzetta, a lateral extension of Venice's central Piazza San Marco. The relatively plain ground-story arcade has Doric columns attached to the archsupporting piers in the manner of the Roman Colosseum (FIG. 6-48). It serves as a sturdy support for the higher, lighter, and much more decorative Ionic second story, which housed the reading room, with its treasure of manuscripts, keeping them safe from notuncommon flooding. On this second level, the stern system of the ground story has been softened by the introduction of Ionic colonnettes that flank the piers and are paired in depth, rather than in the plane of the façade. Two-thirds the height of the main columns, they rise to support the springing of arches, the spans of which are two-thirds those of the lower arcade. The main columns carry an entablature with a richly decorated frieze on which, in strongly projecting relief, putti support garlands. This favorite decorative motif of the ancient Romans is punctuated by the oval windows of an attic story. Perhaps the most striking feature of the building is its roofline, where Sansovino replaces the traditional straight and unbroken cornice with a balustrade (reminiscent of the one on Bramante's Tempietto, FIG. 17-6) interrupted by statue-bearing pedestals. The spacing of the latter corresponds to that of the orders below, so that the sculptures become the sky-piercing finials of the building's vertical design elements. The deft application of sculpture to the massive framework of the building (no walls are visible) mitigates the potential severity of its design and gives its aspect an extraordinary plastic richness.

One feature rarely mentioned is the subtlety with which the library echoes the design of the lower two stories of the Doge's Palace (FIG. 10-64) opposite it. Although he uses a vastly different architectural vocabulary, Sansovino manages admirably to adjust his building to the older one. Correspondences include the almost identical spacing of the lower arcades, the rich and decorative treatment of the second stories (including their balustrades), and the dissolution of the rooflines (by use of decorative battlements in the palace and a statue-surmounted balustrade in the library). It is almost as if Sansovino set out to translate the Gothic architecture of the Doge's Palace into a "modern" Renaissance idiom. If so, he was eminently successful; the two buildings, although of different spiritual and stylistic worlds, mesh and combine to make the Piazzetta one of the most elegantly framed urban units in Europe.

When Jacopo Sansovino died, he was succeeded as chief architect of the Venetian Republic by ANDREA

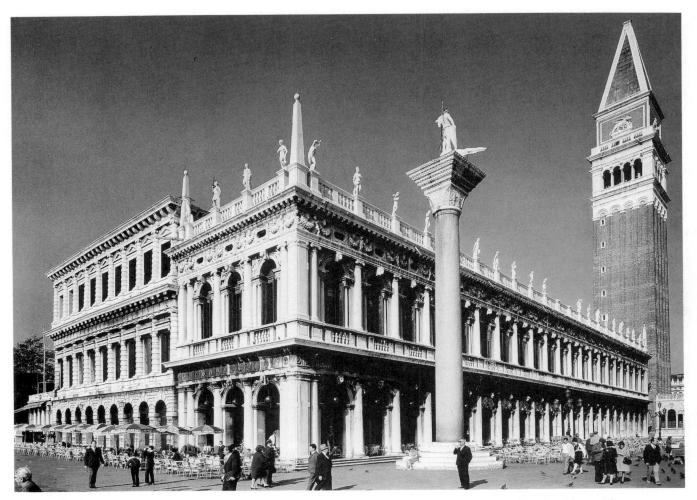

17-50 JACOPO SANSOVINO, La Zecca (Mint), 1535–1545 (left) and State Library, begun 1536, San Marco, Venice.

PALLADIO (1508–1580). Beginning as a stonemason and decorative sculptor, at the age of thirty, Palladio turned to architecture, the ancient literature on architecture, engineering, topography, and military science. Unlike the universal scholar, Alberti, Palladio became more of a specialist. He made several trips to Rome to study the ancient buildings at first hand. He illustrated Daniele Barbaro's edition of Vitruvius (1556), and he wrote his own treatise on architecture, I quattro libri dell' architettura (Four Books on Architecture), originally published in 1570, which had a wideranging influence on succeeding generations of architects throughout Europe. Palladio's influence outside Italy, most significantly in England and in colonial America, was stronger and more lasting than that of any other architect.

Palladio is best known for his many villas built on the Venetian mainland, of which nineteen still stand; the villas were especially influential on later architects. The same Arcadian spirit that prompted the ancient Romans to build villas in the countryside, and that will be expressed so eloquently in the art of the Venetian painter Giorgione, motivated a similar villabuilding boom in the sixteenth century. One can imagine that Venice, with its very limited space, must have been more congested than any ancient city. But a longing for the countryside was not the only motive; declining fortunes prompted the Venetians to develop their mainland possessions with new land investment and reclamation projects. Citizens who could afford it were encouraged to set themselves up as gentlemen farmers and to develop swamps into productive agricultural land. Wealthy families could look on their villas as providential investments. The villas were thus gentleman farms (like the much later American plantations, which were architecturally influenced by Palladio) surrounded by service outbuildings that Palladio generally arranged in long, low wings branching out from the main building and enclosing a large, rectangular court area.

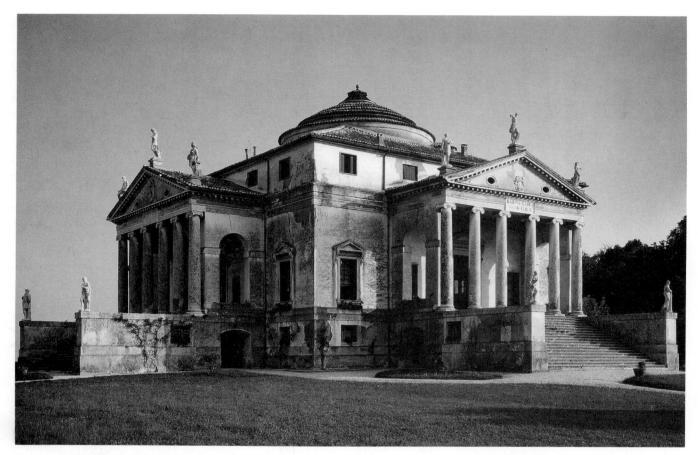

17-51 ANDREA PALLADIO, Villa Rotonda (formerly Villa Capra), near Vicenza, Italy, c. 1566–1570.

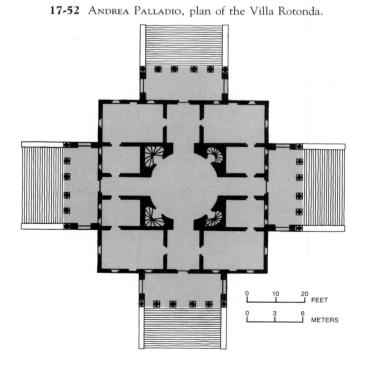

Although it is the most famous, Villa Rotonda (FIG. 17-51), near Vicenza, is not really typical of Palladio's villa style. It was not built for an aspiring gentleman farmer, but for a retired monsignor who wanted a villa for social events. Located on a hilltop, Villa Rotonda was planned and designed as a kind of belvedere, without the usual wings of secondary buildings. Its central plan (FIG. 17-52), with four identical façades and projecting porches, is therefore both sensible and functional; each of the porches can be used as a platform from which to enjoy a different view of the surrounding landscape. In this design, the central dome-covered rotunda logically functions as a kind of revolving platform, from which the visitor can turn in any direction for the preferred view. The result is a building with parts that are functional and systematically related to one another in terms of calculated mathematical relationships. Villa Rotonda, like Santa Maria della Consolazione at Todi (FIG. 17-9), thus embodies all the qualities of self-sufficiency and formal completeness that most Renaissance architects dreamed of. In his formative years, Palladio was influenced by Alberti, by Bramante, and, briefly, by Giulio Romano. By 1550, however, he had developed

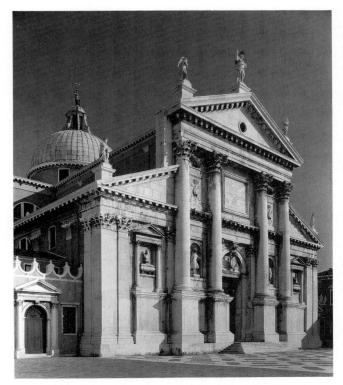

17-53 ANDREA PALLADIO, west façade of San Giorgio Maggiore, Venice, 1565.

17-54 ANDREA PALLADIO, interior of San Giorgio Maggiore (view facing east).

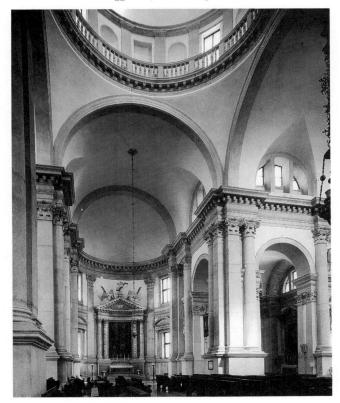

his own personal style, which, in its clarity and lack of ambiguity, was as different from contemporary Mannerism as it was, in its static qualities and rather dry, "correct" Classicism, from the dynamic style of Michelangelo.

San Giorgio Maggiore (FIG. 17-53), directly across a broad canal from the Piazza San Marco, is one of the most dramatically placed buildings in Venice. Dissatisfied with earlier solutions to the problem of integrating a high central nave and lower aisles into a unified façade design, Palladio solved it by superimposing a tall, narrow, Classical porch on a low, broad one. This solution not only reflects the interior arrangement of the building, but also introduces the illusion of three-dimensional depth, an effect that is intensified by the strong projection of the central columns and the shadows they cast. Although at first the result seems to be a rigid formalism, the play of shadow across the building's surfaces, its reflection in the water, and its gleaming white against sea and sky create a remarkably colorful effect. The interior of the church (FIG. 17-54) is flooded with light, which crisply defines the contours of the rich wall articulations (pedestals, bases, shafts, capitals, entablatures), all beautifully and "correctly" profiled—the exemplar of what Classical architectural theory means by "rational" organization.

Painting: Giovanni Bellini and Giorgione

The soft, colored light of Venice, which relaxes the severe lines of Palladio's architecture, lives at its fullest in Venetian painting. In the career of GIOVANNI BELLINI (c. 1430–1516), we find the history of that style. In his long productive life, Bellini, always alert to what was new, never ceased to develop artistically and, almost by himself, created what is known as the Venetian style, which will be so important to the subsequent course of painting. Trained in the tradition of the International style by his father, a student of Gentile da Fabriano, Bellini worked in the family shop and did not develop his own style until after his father's death in 1470. His early independent works show him to be under the dominant influence of his brother-in-law, Andrea Mantegna. But in the late 1470s, impressed by the possibilities offered by the new oil technique that Antonello da Messina (FIG. 16-67) introduced during a visit to Venice, Bellini abandoned the Paduan's harsh, linear style and developed a sensuous, coloristic manner that was to become characteristic of Venetian painting.

Bellini is best known for his many Madonnas, which he painted both in half-length (with or without accompanying saints) on small devotional panels and

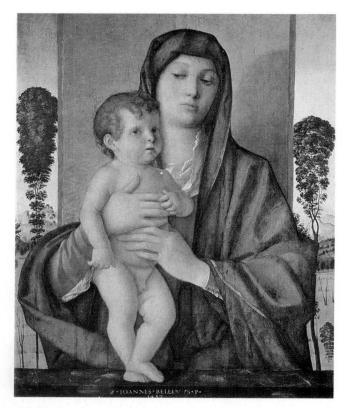

17-55 GIOVANNI BELLINI, Madonna of the Trees, c. 1487. Oil on wood, 29" × 22". Galleria dell' Accademia, Venice.

on large, monumental altarpieces of the sacra conversazione type (FIG. 16-32). Judging by what appears to have been an unending string of commissions, his half-length Madonnas were especially popular. More than eighty of these are still extant, and, if arranged chronologically, they provide an almost gapless overview of the painter's artistic development. Our example, Madonna of the Trees (FIG. 17-55) dates from 1487 (a year or two after Bellini's adoption of the oil technique) and stands about halfway between his early linear, Mantegnesque approach and the fully developed, painterly style of his later years.* Placed before a wide strip of green satin, the grave and pensive Madonna steadies her child's uneasy pose, her somber expression suggesting foreknowledge of the infant's eventual fate. Although firmly modeled, the forms are softly rounded and, combined with warm and luminous colors, instill the painting with a quality of subdued voluptuousness that will become a trademark of much later Venetian painting.

Despite the large number of similar works he painted, Bellini never repeated himself and always found some new variation on his Madonna theme. In

most of his versions, the Madonna is placed behind a low parapet and, quite often, before a hanging drapery-devices that detach without completely isolating the sacred subject from its worldly surroundings. The Christ Child is shown standing or sitting on the parapet, cradled in the Madonna's arms, or seated on her lap; he is shown facing his mother or the viewer. At times, the drapery in back of the figures is moved off-center and its width is varied to show more or less of the background landscape. The drapery may extend into the picture from either the left or the right frame to permit a view into the distance on one side only, creating the kind of asymmetrical composition that will enjoy great favor with Bellini's most illustrious student, Titian. After 1500, the landscape backgrounds become more and more important, to the point that the artist often omits the middle-ground drapery and sometimes changes his format from vertical to horizontal to show a greater expanse of landscape behind his Madonnas. His landscapes also take on an increasingly Arcadian character.

If the long series of Bellini's half-length Madonnas reveals the gradual change in his painting style, two of his large altarpieces, the San Giobbe Altarpiece, c. 1490 (FIG. 17-56), and the San Zaccaria Altarpiece, 1505 (FIG. 17-57), illustrate not only two stages in the artist's stunning development but also the essential differences between the Early and the High Renaissance treatments of the same subject. In the earlier work, the San Giobbe Altarpiece, although the space is large, airy, and clearly defined, the figures seem to be crowded. They cling to the foreground plane and are seen in a slightly forced, Mantegnesque, "worm's eye" perspective. The drawing remains sharp and precise, particularly in that charming Venetian trademark, the group of angel-musicians at the foot of the Madonna's throne. The figures already are arranged in the pyramidal grouping preferred by the High Renaissance, but they tend to exist as individuals rather than as parts of an integrated whole. Seen by itself, the San Giobbe Altarpiece is an orderly, wellbalanced painting that can hold its own with any produced during the Early Renaissance, but side by side with the subsequent San Zaccaria Altarpiece, it suddenly seems cluttered and overly busy. By adding simplicity to the order, balance, and clarity of the earlier painting, Bellini takes the long step into the High Renaissance.

In the *San Zaccaria Altarpiece*, in contrast to his earlier treatment of the theme, Bellini raises the observer's viewpoint and deemphasizes the perspective. The number of figures is reduced, and they are more closely integrated with each other and with the space that surrounds them. Combined into a single, cohe-

^{*}The painting suffered some damage during restoration in 1902, when the Madonna's veil was repainted in a style that does not conform with that of the rest of the painting.

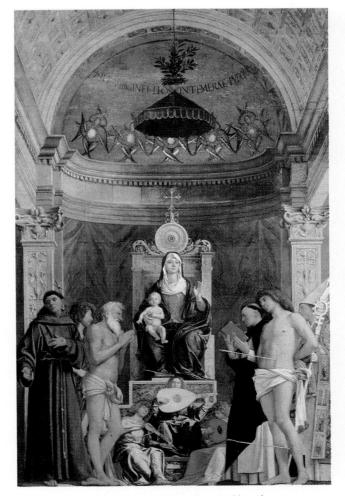

17-56 GIOVANNI BELLINI, San Giobbe Altarpiece,
c. 1490. Oil on wood, 15' 4" × 8' 4".
Galleria dell' Accademia, Venice.

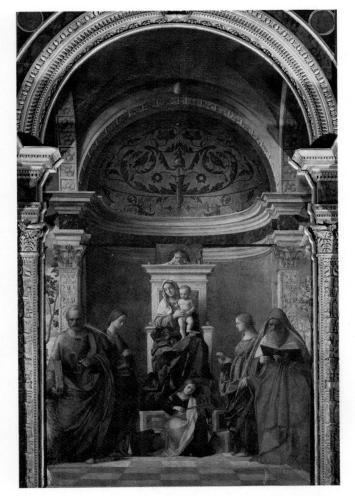

17-57 GIOVANNI BELLINI, San Zaccaria Altarpiece, 1505. Oil on wood transferred to canvas, approx. 16' 5" × 7' 9". San Zaccaria, Venice.

sive group, the figures no longer cling to the front of the painting; disposed in depth, they now move in and out of the apse instead of standing before it. Their attitudes produce a rhythmic movement within the group, but all obvious gestures have been eliminated and the former busyness has changed to serene calm. In addition, Bellini's method of painting has become softer and more luminous. Line is no longer the chief agent of form but has been submerged in a sea of glowing color—a soft radiance that envelops the forms with an atmospheric haze and enhances their majestic serenity.

The San Zaccaria Madonna is the mature work of an old man whose paintings spanned the development of three artistic generations in Florence. Departing from the Gothic, Bellini moved through the Early Renaissance and arrived in the High Renaissance even before Raphael and Michelangelo. At the very end of his long life, this astonishingly apt artist was still willing and able to make changes in his style and approach to keep himself abreast of his times; he began to deal with pagan subjects.

The Feast of the Gods (FIG. 17-58) was influenced by one of Bellini's own students, Giorgione (see page 683), who developed his master's landscape backgrounds into poetic, Arcadian reveries. (In this case, Titian, another of Bellini's pupils, repainted the right background after his master's landscape had been painted over by a lesser craftsman, Dosso Dossi, at the behest of the Duke of Ferrara.) After Giorgione's premature death, Bellini embraced his student's interests and, in The Feast of the Gods, developed a new kind of mythology in which the Olympian gods appear as peasants enjoying a heavenly picnic in a shady northern Italian glade. His source is Ovid's Fasti, which describes a banquet of the gods. The figures are spread across the foreground: satyrs attend the gods, nymphs bring jugs of wine, a child draws

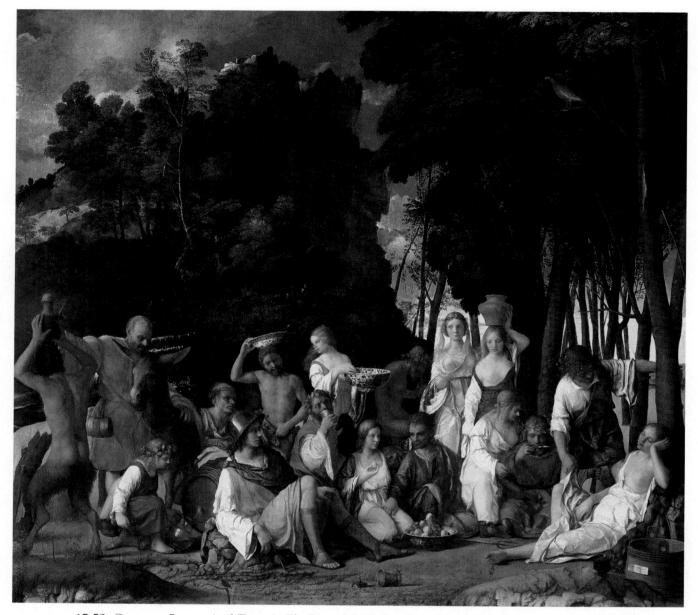

17-58 GIOVANNI BELLINI (and TITIAN), The Feast of the Gods, 1514. Oil on canvas, approx. 5' $7'' \times 6' 2''$. National Gallery of Art, Washington, D.C. (Widener Collection).

from a keg, couples engage in love play, and the sleeping nymph at the right receives amorous attention. The mellow light of a long afternoon glows softly around the gathering, touching the surfaces of colorful draperies, smooth flesh, and polished metal. Here, Bellini announces the delight the Venetian school will take in the beauty of texture revealed by the full resources of gently and subtly harmonized color. Behind the warm, lush tones of the figures, a background of cool, green, tree-filled glades reaches into the distance; at the right, a screen of trees makes a verdant shelter. The atmosphere is idyllic, a floral countryside making a setting for the never-ending pleasure of the immortal gods. The poetry of Greece

and Rome, as well as that of the Renaissance, is filled with this pastoral mood, and the Venetians make a specialty of its representation. Its elements include the smiling landscape, eternal youth, and song and revelry, always with a touch of the sensual.

Thus, with Bellini, Venetian art becomes the great complement of the schools of Florence and Rome. The Venetians' instrument is color; that of the Florentines and Romans is sculpturesque form. These two schools run parallel—sometimes touching and engaging—through the history of Western art from the Renaissance on. Their themes are different. Venice paints the poetry of the senses and delights in the beauty of nature and the pleasures of mankind. Florence and Rome attempt the sterner, intellectual themes—the epic of man, the masculine virtues, the grandeur of the ideal, the lofty conceptions of religion as they involve the heroic and the sublime. The history of later Western art broadly can be understood as a dialogue between these two traditions.

The inspiration for Bellini's late Arcadianism is to be found in paintings like the so-called *Pastoral Symphony* (FIG. **17-59**) by his illustrious student GIOR-GIONE (Giorgione da Castelfranco, 1478–1510), a work held by some to be an early Titian. Out of dense color shadow emerge the soft forms of figures and landscape. The theme is as mysterious as the light. Two nude females, accompanied by two clothed young men, occupy the rich, abundant landscape through which a shepherd passes. In the distance, a villa crowns a hill. The pastoral mood is so eloquently evoked here that we need not know (as we do not) the precise meaning of the picture; the mood is enough. The shepherd is symbolic of the poet; the pipes and the lute symbolize his poetry. The two nymphs accompanying the young men may be thought of as their invisible inspiration, their muses. One turns to lift water from the sacred well of poetic inspiration. The great, golden bodies of the nymphs, softly modulated by the smoky shadow, become the standard Venetian type. It is the Venetian school that resurrects the Venus figure from antiquity, making her the fecund goddess of nature and of love. The full opulence of the figures should, of course, not be read according to modern preferences in womanly physique but as poetic personifications of the abundance of nature.

As a pastoral poet in the pictorial medium and one of the greatest masters in the handling of light and color, Giorgione praises the beauty of nature, music, woman, and pleasure. Vasari reports that Giorgione was an accomplished lutist and singer, and adjectives from poetry and music seem best suited to describe the pastoral air and muted chords of his painting. He

¹⁷⁻⁵⁹ GIORGIONE (and/or TITIAN ?), Pastoral Symphony, c. 1508. Oil on canvas, approx. 43" × 54". Louvre, Paris.

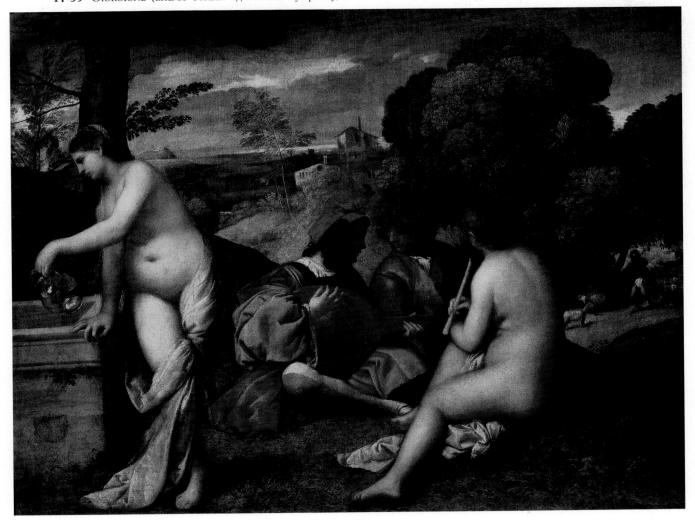

casts a mood of tranquil revery and dreaminess over the whole scene, evoking the landscape of a lost but never forgotten paradise. Arcadia and its happy creatures persist in the subconscious memory and longing of humankind. Among the Italians, the Venetians were the first to express a love of nature and a realization of its potentialities for the painter, although they never represent it except as humanly inhabited. The ancient spirits, the deities of field and woodland, still inhabit it too, and landscape—manifesting the bounty of Venus and sanctified by her beauty—as yet simply provides the inspiring setting for the poet, without whom it would be incomplete.

Titian

Giorgione's Arcadianism passed not only to his much older yet constantly learning master, Bellini, but also to Tiziano Vecelli, whose name we anglicize into TITIAN (c. 1490–1576). Titian is the most prodigious and prolific of the great Venetian painters. He is among the very greatest painters of the Western world—a supreme colorist and, in a broad sense, the father of the modern mode of painting. An important change that took place in Titian's time was the almost universal adoption of canvas, with its rough-textured surface, in place of wood panels for paintings. The works of Titian establish oil color on canvas as the typical medium of our pictorial tradition. According to a contemporary of Titian, Palma Giovane:

Titian [employed] a great mass of colors, which served . . . as a base for whatever he was going to paint over it . . . I myself have seen his determined brushstrokes laden with color, sometimes a streak of pure earth-red which served him (one might say) as a half-tone, other times with a brushstroke of white lead; and with the same brush colored with a red, black, and yellow, he formed a highlight; and with these rules of technique made the promise of an excellent figure appear in four brushstrokes.

After having laid these important foundations, he then used to turn the pictures to the wall, and leave them-sometimes for as long as several monthswithout looking at them; and when he wanted to apply his brush to them again, he [examined] them most rigorously . . . whether he could find any defects in them or discover anything which would not be in harmony with the delicacy of his intentions. . . . Working thus, and redesigning his figures, Titian brought them into a perfect symmetry which could represent the beauty of Art as well as of Nature. After this was done, he put his hand to some other picture until the first was dry, working in the same way with this other; thus gradually he covered those quintessential outlines of his figures with living flesh. . . . He never painted a figure all at once, and used to say that he who improvises his song can form neither learned nor well-turned verses. But the final polish . . . was to unite now and then by a touch of his fingers the extremes of the light areas, so that they became almost half-tints . . . at other times, with a stroke he would place a dark streak in a corner; to reinforce it he would add a streak of red, like a drop of blood. . . . in the final phase [he] painted more with his fingers than with his brushes.

Trained by both Bellini and Giorgione, Titian learned so well from them that even today no general agreement exists as to the degree of his participation in their later works. He completed several of Bellini's and Giorgione's unfinished paintings. One of his own early works, *Sacred and Profane Love* (FIG. **17-60**), is very much in the manner of Giorgione, with its

¹⁷⁻⁶⁰ TITIAN, Sacred and Profane Love, c. 1515. Oil on canvas, approx. 3' 11" × 9' 2". Galleria Borghese, Rome.

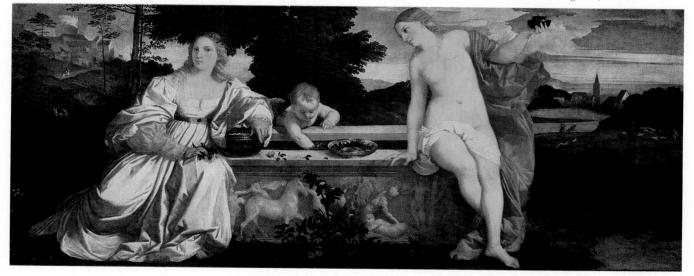

Arcadian setting, its allegory, and its complex and enigmatic meaning. Two young women, one draped, the other nude, flank a sarcophagus into which a cupid reaches. Behind them is a screen of trees and, to left and right, deep vistas into different landscapes. The two figures may represent the different levels of Neo-Platonic love: the sumptuously draped woman is a kind of allegory of vanity and the love of this world; the nude who holds aloft her lamp represents the highest level of love that can be reached (love of the divine, nudity being symbolic of truth). Titian's figures are not suffused with Giorgione's glowing, mysterious tones; they are drawn firmly and boldly and brilliantly colored, and the artist manifests his chief interest in the play of light over the rich satins and the smooth volumes of the body and glossy flesh. The world given to the eye is a world of color before it is a world of solid forms, and this truth is one that the Venetians were the first to grasp.

On the death of Giovanni Bellini in 1516, Titian was appointed painter to the republic of Venice. Shortly thereafter, he painted the Madonna of the Pesaro Family (FIG. 17-61) for the church of the Frari. This great work, which furthered Titian's reputation and established his personal style, was presented to the church by Jacopo Pesaro, Bishop of Paphos in Cyprus and commander of the papal fleet, in thanksgiving for a successful expedition in 1502 against the Turks during the Venetian-Turkish war. In a stately, sunlit setting, the Madonna receives the commander, who kneels dutifully at the foot of her throne. A soldier (St. George?) behind the commander carries a banner with the arms of the Borgia (Pope Alexander VI); behind him is a turbaned Turk, a captive of the Christian forces. St. Peter occupies the steps of the throne, and St. Francis introduces other members of the Pesaro family, who kneel solemnly in the right foreground.

The massing of monumental figures, singly and in groups, within a weighty and majestic architecture is, as we have seen, characteristic of the High Renaissance. But Titian does not compose a horizontal and symmetrical arrangement, as Leonardo did in *The Last Supper* (FIG. 17-3) or Raphael in *The School of Athens* (FIG. 17-16). Rather, he places the figures in occult balance on a steep diagonal, positioning the Madonna, the focus of the composition, well off the central axis. Attention is directed to her by the perspective lines, by the inclination of the figures, and by the directional lines of gaze and gesture. The design is beautifully brought into poise by the banner that inclines toward the left, balancing the rightward and upward tendencies of the main direction.

This kind of composition is more dynamic than what we have seen so far in the High Renaissance.

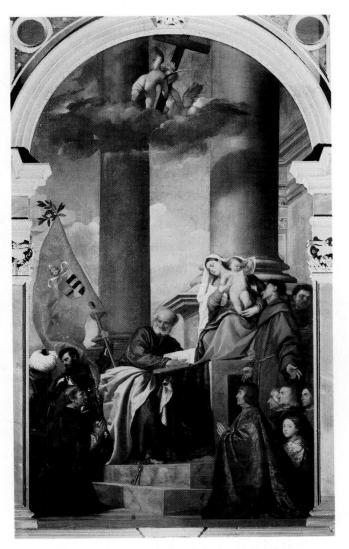

17-61 TITIAN, Madonna of the Pesaro Family, 1519–1526. Oil on canvas, approx. $16' \times 9'$. Santa Maria dei Frari, Venice.

The forces already moving in it promise a new kind of pictorial design—one built on movement rather than rest. In his rendering of the rich surface textures, Titian gives a dazzling display of color in all its nuances. The human—especially the Venetian—scene is one with the heavenly, as the Madonna and saints find themselves honoring the achievements of particular men in this particular world. A quite worldly transaction is taking place between a queen, her court, and her loyal servants; the tableau is constructed in terms of Renaissance protocol and courtly splendor.

As Praxiteles brought the motif of the feminine nude into ancient Greek art, so Giorgione and Titian re-create it for the art of the modern West. In 1538, at the height of his powers, Titian painted the *Venus of*

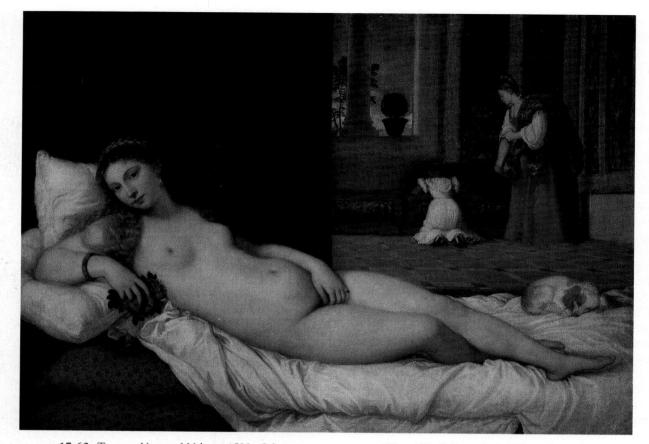

17-62 TITIAN, Venus of Urbino, 1538. Oil on canvas, approx. 48" × 66". Galleria degli Uffizi, Florence.

Urbino (FIG. 17-62), for Guidobaldo II, the Duke of Urbino. This work gives us the compositional essentials for the representation of a theme that will be popular for centuries. Titian's version, based on an earlier (and pioneering) one painted by Giorgione, was to become official for paintings of the reclining nude, regardless of the many variations that would later ensue. Venus reclines on a gentle slope made by her luxurious, pillowed couch, the linear play of the draperies contrasting with the sleek, continuous volume of her body. At her feet is a pendant (balancing) figure-in this case, a slumbering lapdog. Behind her, a simple drape serves both to place her figure emphatically in the foreground and to press a vista into the background at the right half of the picture. In the vista, two servants bend over a chest; beyond them, a smaller vista opens into a landscape. The steps backward into space and the division of the space into progressively smaller units are beautifully contrived. All of the resources of pictorial representation are in Titian's hands, and he uses them here to create original and exquisite effects of the sort that will inspire generations of painters in Italy and the north.

Deep Venetian reds set off against the pale, neutral whites of the linen and the warm ivory-gold of the

flesh are echoed in the red tones of the matron's skirt, the muted reds of the tapestries, and the neutral whites of the matron's sleeves and the kneeling girl's gown. One must study the picture carefully to realize what subtlety of color planning is responsible, for example, for the placing of the two deep reds (in the foreground cushions and in the background skirt) that function so importantly in the composition as a gauge of distance and as terminals of an implied diagonal opposed to the real one of the reclining figure. Here, color is used not simply for the tinting of preexisting forms but as a means of organization that determines the placement of forms.

Titian could paint a Virgin Mary or a nude Venus with equal zeal. Neither he nor the connoisseurs of his time were aware of any contradiction. Yet it is significant that the female nude reappears in Western art as Venus, the great goddess of the ancient world, whom medieval Christianity had especially feared and whom it damned in exalting virginity and chastity as virtues. Now Venus returns, and the great Venetian paintings of her almost constitute pagan altarpieces. The Venetian Renaissance resurrects a formidable competitor for the saints.

Titian was not only a prolific painter of mythologi-

cal and religious subjects but also a highly esteemed portraitist, and one of the very best. Of the well over fifty portraits by his hand to survive, an early example, Man with the Glove (FIG. 17-63), will suffice to illustrate his style. The portrait is a trifle more than half-length. The head is turned slightly away from the observer; the right hand gathers the drapery of a mantle, and the gloved left hand holds another glove. The blade-shaped shirtfront directs attention to the right hand; the direction of the subject's gaze controls the left. These dexterous compositional arrangements, creating a kind of "three-spot" relationship among head and hands, had already been made by Leonardo in his Mona Lisa (FIG. 17-4). Titian's portraits, as well as those of many of the Venetian and subsequent schools, generally make much of the psychological reading of the most expressive parts of the body-the head and the hands. We are not immediately aware that these subtle placements influence our response to the portrait subject. In fact, a portrait must be as skillfully composed as a great figure composition. The mood of this portrait is Giorgionesqueone of dreamy preoccupation. The eyes turn away from us, as if, in conversation, the subject has recalled something that sets him musing in silence. Titian's Man with the Glove is as much the portrait of a cultivated state of mind as of a particular individual. It is the meditative, poetic youth, who is at the same time Baldassare Castiglione's ideal courtier, perfectly

17-63 TITIAN, Man with the Glove, c. 1519. Oil on canvas, approx. 39" × 35". Louvre, Paris.

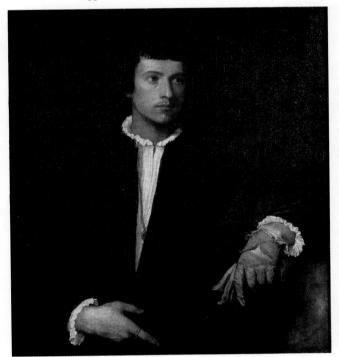

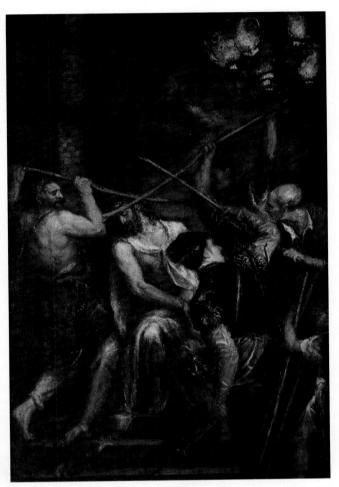

17-64 TITIAN, Christ Crowned with Thorns, c. 1573–1575. Oil on canvas, approx. $9' \times 6'$. Alte Pinakothek, Munich.

poised and self-assured, handsome, gallant, debonair, the "glass of fashion and the mold of form." No portrait gives us so much of the Renaissance manner in a single individual, unless it be Raphael's *Castiglione* (FIG. 17-18).

Honor and glory attached to Titian as he grew older. He was known and sought after by all the great of Europe. He was painter to and close friend of Emperor Charles V, who made him a knight of the Holy Roman Empire; afterward, he painted numerous pictures for Charles's son, Philip II of Spain. The great Hapsburg painting collections centered around Titian's works, and his fame and wealth recall the success of Raphael. Toward the end of his life, his work became increasingly introspective, and a religious picture like the Christ Crowned with Thorns (FIG. 17-64) seems to be a sincerely devotional theme repudiating the paganism of the artist's prime. In this picture, Titian shows Christ tormented by the soldiers of Pilate, who twist a wreath of thorns around his head. The drama is achieved by the limited number of

figures, the emphasis on the figure of Christ, and the muted, flickering light that centers the action. The color scheme is almost monochromatic; the light and color play freely within and beyond the contours, making a patchy, confused mixture of lights and darks, in which it is difficult to read the forms with precision. But this effect only enhances the mystery, the gloomy environment, and the mood of torment. Titian's intention is not so much to stage the event as to present his religious and personal response to it. His very brushstroke-broad, thick, and freely applied-bespeaks the directness of his approach. It melts and scatters solid form to produce the wavering, supernatural glow that encircles spiritual vision. Here Titian's art looks forward to the painting of Rembrandt in the next century.

Tintoretto and Veronese

TINTORETTO (Jacopo Robusti, 1518–1594) claimed to be a student of Titian and aspired to combine the color of Titian with the drawing of Michelangelo. He usually is referred to as the outstanding Venetian representative of Mannerism. He adopts many Mannerist pictorial devices, but his dramatic power, depth of spiritual vision, and glowing Venetian color schemes do not seem to fit the Mannerist mold. We need not settle here the question of whether or not Tintoretto is a Mannerist; we need only mention that he shares some common characteristics with central Italian Mannerism and that, in other respects, his work really anticipates the Baroque.

The art of Tintoretto is always extremely dramatic. In his *Miracle of the Slave* (FIG. **17-65**), we find some of his typical stageplay. St. Mark hurtles downward to the assistance of a Christian slave, who is about to be martyred for the faith, and shatters the instruments of torture. These are held up by the executioner to the startled judge as the throng around the central action stares. The dynamism of Titian is greatly accelerated, and the composition is made up of contrary and opposing motions; for any figure leaning in one direction, another figure counters it. At the extreme left, a group of two men, a woman, and a child winds contrapuntally about a column, resembling the later Mannerist twisting of Giovanni da Bologna's *Rape of*

17-65 TINTORETTO, The Miracle of the Slave, 1548. Oil on canvas, approx. $14' \times 18'$. Galleria dell' Accademia, Venice.

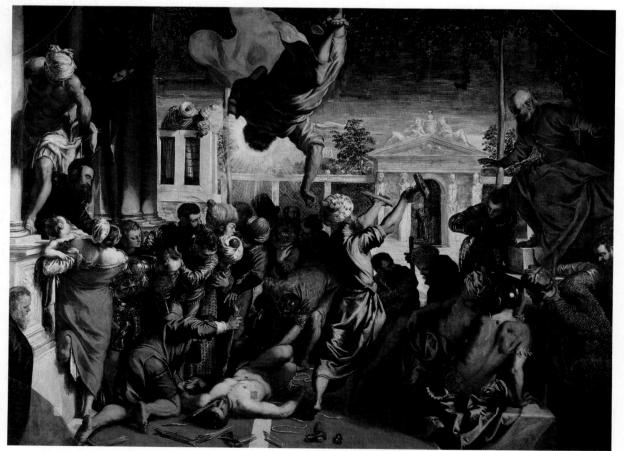

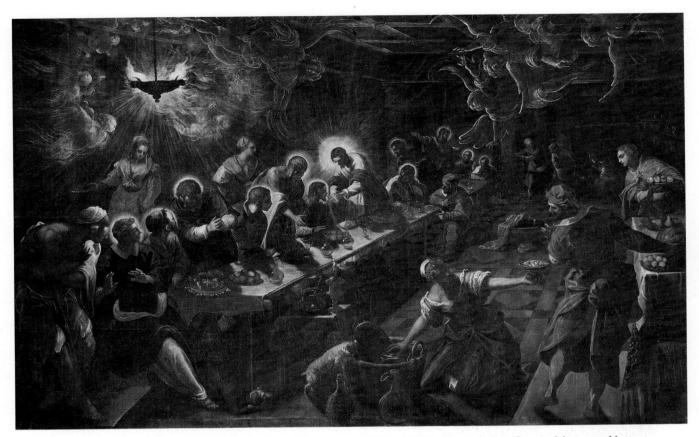

17-66 TINTORETTO, The Last Supper, 1594. Oil on canvas, 12' × 18' 8". Chancel, San Giorgio Maggiore, Venice.

the Sabine Women (FIG. 17-46). The main group curves deeply back into space, but the most dynamic touch of all is made by the central trio of the slave, the executioner, and the inverted St. Mark. The three figures sweep together in a great, upward, serpentine curve, the motion of which is checked by the plunging figure of St. Mark, moving in the opposite direction. The entire composition is a kind of counterpoint of motion characteristic of Mannerism. The motion, however, is firmly contained within the picture frame, and the robustness of the figures, their solid structure and firm movement, the clearly composed space, and the coherent action have little to do with Manneristic presentation. There is nothing hesitant or ambiguous in the depiction of the miraculous event, which is dramatized forcefully and with conviction. Tintoretto's skillful theatricality and sweeping power of execution set him apart from the Mannerists and make him a forerunner of the Baroque, the age of theater and opera. And the tonality-the deep golds, reds, and greens-is purely Venetian.

Toward the end of his life, Tintoretto's art, like Titian's, becomes spiritual, even visionary, as solid forms melt away into swirling clouds of dark, shot through with fitful light. In Tintoretto's *Last Supper* (FIG. **17-66**), painted for Palladio's church of San Giorgio Maggiore (FIG. 17-54), the actors take part in a ghostly drama; they are as insubstantial as the shadows cast by the faint glow of their halos and the flame of a single lamp that seems to breed phosphorescent spirits. All are moved by an intense, psychic commotion. The space speeds away into an unearthly darkness peopled by phantoms. Only the incandescent nimbus around his head identifies Jesus as he administers the Sacrament to his disciples.

The contrast with Leonardo's *Last Supper* (FIG. 17-3) is both extreme and instructive. Leonardo's composition, balanced and symmetrical, parallels the picture plane in a geometrically organized and closed space; Christ's figure is the tranquil center of the drama and the focus of the perspective. In Tintoretto's painting, Christ is above and beyond the converging perspective lines that race diagonally away from the picture surface, creating disturbing effects of limitless depth and motion. Tintoretto's Christ is located by light flaring beaconlike out of darkness; Leonardo's is placed by geometric and perspectival centralization. The contrast of the two expresses the direction Renaissance painting takes in the sixteenth century, as it moves away from architectonic clarity of space and

neutral lighting toward the dynamic perspectives and dramatic chiaroscuro of the coming Baroque.

The last of the great Venetian masters was VERONESE (Paolo Cagliari, 1528–1588). Where Tintoretto glories in monumental drama and deep perspectives, Veronese specializes in splendid pageantry painted in superb color and set within a majestic, Classical architecture. Like Tintoretto, Veronese painted on a huge scale, with canvases often as large as 20 by 30 feet. His usual subjects, painted for the refectories of wealthy monasteries, afforded him an opportunity to display magnificent companies at table. Christ in the House of Levi (FIG. 17-67), originally called The Last Supper, is a good example. Here, in a great open loggia framed by three monumental arches (the style of the architecture closely resembles the upper arcades of Jacopo Sansovino's library; FIG. 17-50), Christ is seen seated at the center of splendidly garbed grandees of Venice, while with a courtly gesture, the very image of gracious grandeur, the chief steward welcomes guests. The spacious loggia is crowded not only with robed magnificoes but with their colorful retainers, clowns, dogs, and dwarfs. The Holy Office of the Inquisition accused Veronese of impiety in painting such creatures so close to the Lord, and he was ordered to make changes at his own expense. Reluctant to do so, he simply changed the painting's title, converting the subject to a less solemn one. As Palladio looks to the example of the Classical architecture of the High Renaissance, so Veronese returns to High Renaissance composition,

its symmetrical balance, and its ordered architectonics. His shimmering color is drawn from the whole spectrum, although he avoids solid colors for half shades (light blues, sea greens, lemon yellows, roses, and violets), creating veritable flower beds of tone.

Tintoretto and Veronese were employed by the republic of Venice to decorate the grand chambers and council rooms of the Doge's Palace. A great and popular decorator, Veronese shows himself to be a master of imposing, illusionistic ceiling compositions like The Triumph of Venice (FIG. 17-68), where within an oval frame, he presents Venice, crowned by Fame, enthroned between two great, twisted columns in a balustraded loggia, garlanded with clouds, and attended by figures symbolic of her glories. This work represents one of the very first modern, pictorial glorifications of a state-a subject that will become very popular during the Baroque period. Veronese's perspective is not, like Mantegna's or Correggio's, projected directly up from below; rather, it is a projection of the scene at a forty-five degree angle to the spectator, a technique that will be used by many later Baroque decorators, particularly the Venetian Tiepolo in the eighteenth century.

It is fitting that we close our discussion of Italian art in the sixteenth century with a scene of triumph, for indeed the century witnessed the triumph of architecture, sculpture, and painting. They achieve the status of fine arts, and a tradition is established by these masters of prodigious genius, whose works inspire all artists who follow but never surpass them.

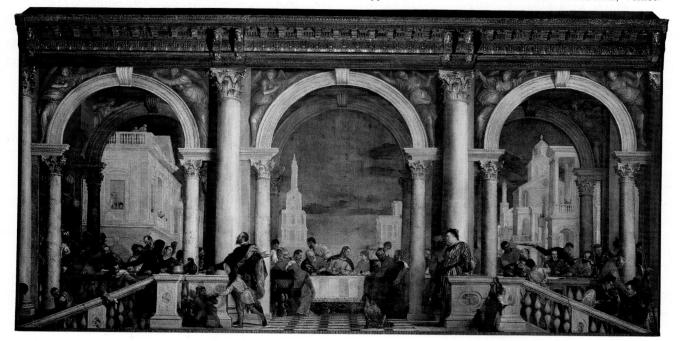

17-67 VERONESE, Christ in the House of Levi, 1573. Oil on canvas, approx. 18' 6" × 42' 6". Galleria dell' Accademia, Venice.

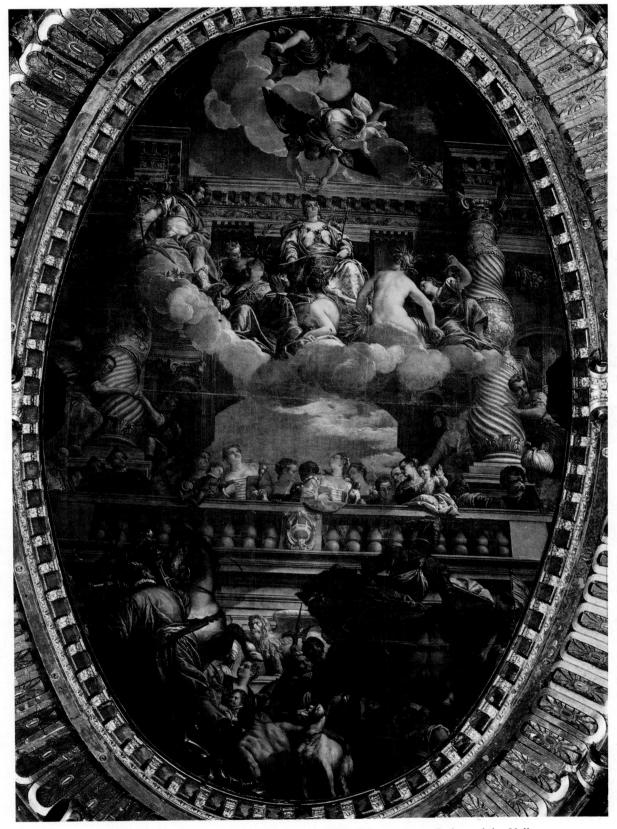

17-68 VERONESE, The Triumph of Venice, c. 1585. Oil on canvas. Ceiling of the Hall of the Grand Council, Palazzo Ducale, Venice.

18

THE RENAISSANCE OUTSIDE OF ITALY

HILE GREAT artistic events were happening in Renaissance Italy, the lands beyond the Alps still were immersed in the Gothic style that Italy never had really accepted as its own. Strictly speaking, the term Renaissance refers to the revival of ancient Roman ideals and forms in Italian art of the fifteenth century and later, and the applicability of the term to the contemporaneous art of non-Italian Europe has been questioned. Gothicism in architecture persisted well into the sixteenth century in the north, which never knew classical antiquity as the Italians knew it. In Italy, the remains of the Classical world were everywhere, and the Italians believed themselves to be descendants of the ancient Romans. The Gothic International style of the fourteenth century was, for the Italians, only a passing fashion; coming between Giotto and Masaccio, it hardly constitutes more than a brief interruption of a new stylistic movement that will carry along with it the future of European art. In the north, too, the International style will pass, giving way to a powerful realism that, even without the inspiration of the Classical Antique style, will break with the past and point directions of its own. New artistic and socioeconomic developments in northern Europe usher in changes that set the fifteenth century apart from the Middle Ages just as much as in Italy and justify the use of the term Renaissance for northern art as well.

The northern painter, evolving out of the illuminator, finds, as did the artist in Italy, a new prestige and place. Although it coexisted with a development of commerce and wealth almost modern in tone, the social structure of the north in the fifteenth century adhered to the hierarchies of the Middle Ages. The nobles and clergy continued to rule, even though the true source of wealth and power was the bourgeoisie. This large middle class, in turn, still was organized and controlled by the guild system that had taken form in the Middle Ages.

In the north, the guild dominated the life of the average man to an even greater extent than in Italy. To pursue a craft, a man had to belong to the guild controlling that craft. Painters, for example, sought admission to the Guild of St. Luke, which included the saddlers, glassworkers, and mirrorworkers as well. To secure membership in the guild, the aspiring painter was apprenticed in boyhood to a master, with whom he lived as a son and who taught him the fundamentals of his craft: how to make implements; how to prepare panels with gesso (plaster mixed with a binding material); and how to mix colors, oils, and varnishes. Once the youth mastered these procedures and learned to work in the traditional manner of his master, he usually spent several years working as a journeyman in various cities, observing and

gaining ideas from other masters. He was then eligible to become a master and was admitted to the guild. Through the guild, he obtained commissions; the guild inspected his painting for honest materials and workmanship and secured him adequate payment for his labor. The result was the solid craftsmanship that characterizes the best work of Flanders and of Italy.

We know much less about the training of women artists than we do about that of men. Certainly, far fewer women were involved in the professions of art, although a substantial number of women are recorded in the membership of the art guilds of Flemish cities like Bruges in the fifteenth century and later. Albrecht Dürer recounts women's participation in parades of the guilds as persons earning a livelihood by their art.

Women most often were tutored in art by fathers and husbands who were professionals, and whom they assisted in all technical procedures of the craft. Social and moral restraints would have forbidden women's apprenticeship in the homes of male masters and would have stringently limited their freedom of movement. Moreover, from the sixteenth century on, when academic courses of training supplement and then replace guild training, women would not as a rule expect or be permitted instruction in figure painting, insofar as it involved dissection of cadavers and study of the nude, male model. Most women, as we have seen, did not have access to the training and experience enjoyed by many male artists. Yet Lavinia Teerlinc, a Flemish counterpart of Anguissola, was an accomplished professional in Bruges before she was invited to England to paint miniatures for the courts of Henry VIII and his successors. There, she was a formidable rival of Hans Holbein the Younger and received greater compensation for her work than he did for his.

The craftsmanship that gave such distinction to men and to women artists involved mastery of the new oil medium, which had such great influence on Venetian painters at the end of the fifteenth century; we have spoken of Titian's management of it (page 684). Traditionally, Jan van Eyck is credited with the invention of oil painting a century before Titian, although the facts surrounding the early history of the medium still remain mysterious. Flemish painters built up their pictures by superimposing translucent paint layers, called glazes, on a layer of opaque monochrome underpainting, which in turn had been built up from a carefully planned drawing made on a white-grounded panel of wood. The base of the binding medium for the pigments was a fast-drying oil that had been known and used by certain painters in the Late Middle Ages. The secret of the new technique appears to have been an unidentified supplement to the usual composition of the glazes. With the

new medium, painters were able to create richer colors than previously had been possible. As a result, northern painting of the fifteenth century is characterized by a deep, intense tonality, glowing light (the new colors were seemingly lit from within), and hard, enamel-like surfaces, quite unlike the highkeyed color, sharp light, and rather matte surfaces of Italian tempera.

The brilliant and versatile new medium was exactly right for the formal intentions of the northern painters, who aimed for sharply focused, hard-edged, sparkling clarity of detail in their representation of thousands of objects ranging in scale from large to almost invisible. The Italians were interested primarily in the structure behind the appearances given to the eye-that is, in perspective, composition, anatomy, the mechanics of bodily motion, and proportion through measure. The northern painters were intent on rendering the appearances themselves-the bright, colored surfaces of things touched by light. Their traditions of stained glass and miniatures made their realism one of radiant, decorative color rather than of sculpturesque form. The differences between the painting of Italy and of northern Europe are emphasized by the fact that, when oil painting spread to Italy after the mid-century, it did not radically affect Italian sensibility to form. Although the color of Italian painting became richer, particularly in Venice, the new medium-which, in time, completely replaced tempera-was exploited in the service of the structural purposes of Italian art. On the whole, until the early sixteenth century, artistic communication between northern and southern Europe seems to have been limited to a relatively few individuals, and both areas tended to develop independently of each other.

The political background against which the development of northern art took place in the fifteenth century was not unlike that of Italy. The commercial free cities that dominated the political scene at the beginning of the fifteenth century gradually fell under the rule of princes until the beginning of the sixteenth century, when powerful states like France, England, and the Hapsburg empire, comprising Spain, the Germanies, and the Netherlands, began to emerge. As in Italy, the wealth and leisure necessary to encourage the growth of the arts were based on commerce and on the patronage of the powerful princes and rich merchants who controlled it.

THE FIFTEENTH CENTURY

Flanders

The most important of the prosperous commercial cities of the north was Bruges, which, like Florence,

derived its wealth from the wool trade and from banking. Until late in the fifteenth century, an arm of the North Sea, now silted up, reached inland to Bruges. Here, ships brought raw wool from England and Spain and carried away the fine woolen cloth that became famous throughout Europe. The wool trade brought bankers, among them representatives of the House of Medici, and Bruges became the financial clearinghouse for all of northern Europe. In its streets, merchants from Italy and the Near East rubbed shoulders with traders from Russia and Spain. Despite the flourishing economies of its sister cities-Ghent, Louvain, and Ypres-Bruges so dominated Flanders that the Duke of Burgundy chose to make the city his capital and moved his court there from Dijon in the early fifteenth century.

The dukes of Burgundy were probably the most powerful rulers in northern Europe during the first three quarters of the fifteenth century. Although cousins of the French kings, they usually supported England (on which they relied for the raw materials used in their wool industry) during the Hundred Years' War and, at times, were in control of much of northern France, including Paris. Through intermarriage with the House of Flanders, they annexed the Low Countries, and, at the height of their power, their lands stretched from the Rhône River to the North Sea. Only the rash policies of the last of their line, Charles the Bold, and his death at the battle of Nancy in 1477 brought to an end the Burgundian dream of forming a strong middle kingdom between France and the Holy Roman Empire. After Charles's death, the southern Burgundian lands were reabsorbed by France, and the Netherlands passed to the Holy Roman Empire by virtue of the dynastic marriage of Charles's daughter, Mary of Burgundy, to Maximilian of Hapsburg.

Philip the Bold of Burgundy, who ruled from 1364 to 1404, and his brother John, Duke of Berry, were the greatest sponsors of the arts of their time in northern Europe. Their interests centered on illuminated manuscripts, Arras tapestries, and rich furnishings for their numerous castles and town houses, which were located throughout their duchies. Philip's largest artistic enterprise was the foundation of the Chartreuse (Carthusian monastery) de Champmol, near Dijon. Intended as a repository of the tombs of the grandees of the House of Burgundy, its magnificent endowment attracted artists from all parts of northern Europe. The outstanding representative of this short-lived Burgundian school was the sculptor CLAUS SLUTER (active *c.* 1380–1406).

For the cloister of the Chartreuse de Champmol, Sluter designed a symbolic well in which Moses and five other prophets surround a base that once supported a Crucifixion group. The six prophets of *The*

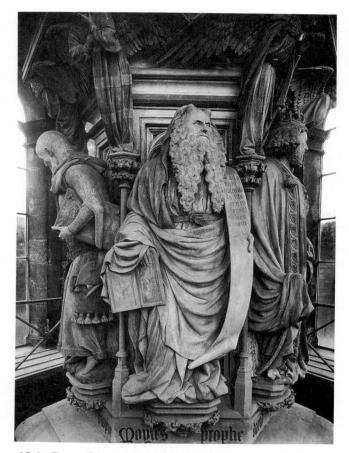

18-1 CLAUS SLUTER, The Well of Moses, 1395–1406. Figures approx. 6' high. Chartreuse de Champmol, Dijon, France.

Well of Moses (FIG. 18-1) recall the jamb figures of the Gothic portals, but they far surpass even the most realistic of those (FIG. 10-34) in the artist's intense observation of natural appearance, in the rendering of minute detail, and in their bulk, which manages to contain a wealth of descriptive information that might otherwise be distracting. The life-size figures are swathed in heavy draperies with voluminous folds, characteristic of Sluter's style, and the artist manages to make their difficult, complex surfaces seem remarkably lifelike. This effect is enhanced by the skillful differentiation of textures, from coarse drapery to smooth flesh and silky hair, and by the paint, which still is partly preserved. This fascination with the specific and tangible in the visible world will be one of the chief characteristics of fifteenth-century Flemish painting. But despite the realism of Sluter's figures, a comparison of his Moses (FIG. 18-1) and Donatello's St. Mark (FIG. 16-5) reveals what is still missing in the northern concept of the figure: the principle of interior movement, or weight shift.

The Chartreuse de Champmol must have been furnished with numerous altarpieces, but only a carved

altarpiece representing the Adoration of the Magi survives. The odd-shaped wings for this altarpiece were painted by MELCHIOR BROEDERLAM (active 1385-1409), a Flemish painter who had been drawn to Dijon. On the left wing are The Annunciation and The Visitation (FIG. 18-2); on the right wing, Broederlam depicts The Presentation and The Flight into Egypt. The paintings show that Broederlam was a major northern exponent of the International style. His compositional devices-the uptilted plane of the landscape in the Visitation scene, with its horizon topped by a castle; the serpentine recession into the background; and the elegant silhouettes of the figures, reminiscent of Sienese art-already have been seen in such southern works as Gentile da Fabriano's Adoration of the Magi (FIG. 16-26). Also suggestive of Sienese art is Broederlam's modest essay into perspective and the delicate architectural enframement of the Annunciation scene. All of these elements have been combined with the minutest observation and rendering of realistic details. Broederlam, working at Dijon, must have seen Sluter's sculptures and was influenced by them in the handling of the voluminous drapery and,

18-2 MELCHIOR BROEDERLAM, The Annunciation and The Visitation (wing of an altarpiece), 1394–1399. Tempera and oil on wood, approx. $66'' \times 49''$. Musée des Beaux-Arts, Dijon.

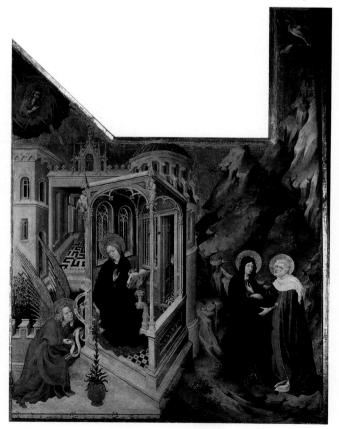

18-3 JEAN PUCELLE, David before Saul, page from the Belleville Breviary, c. 1325. Illumination, approx. $9\frac{1}{2}^{"} \times 6\frac{3}{4}^{"}$. Bibliothèque Nationale, Paris.

near the panel's right border, in the strikingly massive figure of Joseph, planted like a tree stump, taking a draft from his cup (and looking like a figure from a painting by Pieter Bruegel [FIG. 18-47] some 150 years later).

Critics sometimes point out that Broederlam's miniaturistic style is ill-suited to the size of these panels, which are some 5 feet high. This disproportion is attributable to the fact that, as some of the earliest surviving examples of northern panel paintings, these works still reflect a number of the long-standing northern painting traditions from which they are a revolutionary departure. For centuries, the characteristic painted surface in the north had been either stained glass or the illuminated manuscript page. Gothic architecture in northern Europe had eliminated solid walls and had left few continuous, blank surfaces that invited painted decorations, unlike the case in Italy, where climate and architecture favored mural painting in fresco. Northern artists were accustomed to working not only in miniature but with rich, jewel-like color, which, especially in stained glass, has a profound luminosity, with light seemingly irradiating the forms. Thus, they came into the fifteenth century habituated to deep color worked into exquisitely tiny and intricate shapes and patterns. When northern miniaturists became acquainted, through the International style, with Italian forms and ideas, they were forced to reduce to page size, or smaller, the inventions used in large compositions by Italian wall and panel painters like Duccio, Giotto, Simone Martini, and others. This development, which led to a kind of "perspective naturalism," was inconsistent with the basic function of book illumination-page decoration and the illustration of the written text. Toward the end of the fourteenth century, illuminations began to take on the character of independent paintings, expanding on the page until they occupied it completely. By about 1400, these new forces generated in miniatures seemed to demand larger surfaces, and the shift was made to panel painting.

The first steps toward the illumination's expansion within the text appear in the work of JEAN PUCELLE (active *c*. 1320–1370), a Parisian illuminator who revitalized the stagnating Gothic manner of the Paris school. A page from the so-called *Belleville Breviary*, about 1325 (FIG. **18-3**), shows how the entire page has become the province of the illuminator. The borders, extended to invade the margins, include not only decorative tendrils and a profusion of spiky ivy and floral ornaments, but also a myriad of insects, small animals, and grotesques. In addition, three narrative scenes encroach on the columns of the text, the graceful postures and flowing draperies of the figures reflecting Sienese influence. One feels that any of these

narratives could have been expanded into a full-page illustration or even a panel painting.

Such an expansion has occurred in the calendar pages of a gorgeously illustrated Book of Hours made for the Duke of Berry, brother of the king of France and of Philip the Bold of Burgundy. The manuscript, Les Très Riches Heures du Duc de Berry, was completed in 1416 by the three LIMBOURG BROTH-ERS-Pol, Hennequin, and Herman. Such books became favorite possessions of the northern aristocracy during the fourteenth and fifteenth centuries. As prayer books, they replaced the traditional psalters, which had been the only liturgical books in private hands until the mid-thirteenth century. The heart of the Book of Hours is the "Office of the Blessed Virgin," which contains liturgical passages to be read privately at eight set points during the day, from matins to compline. This part of these books usually is preceded by an illustrated calendar containing local religious feast days; it is followed by penitential psalms, devotional prayers, litanies to the saints, and other offices, including those of the dead and of the Holy Cross.

The calendar pictures of Les Très Riches Heures are perhaps the most famous in the history of manuscript illumination. They represent the twelve months of the year in terms of the associated seasonal tasks, alternating the occupations of nobility and peasantry. Above each picture is a lunette representing the chariot of the sun as it makes its yearly round through the twelve months and signs of the zodiac; numerical notations designate the zodiacal degree passed through in the course of the year. Representative is the colorful calendar picture for the month of May (FIG. 18-4). Here, a cavalcade of patrician ladies and gentlemen, preceded by trumpeters, rides out to celebrate the first day of May, a spring festival observed by courts throughout Europe. They are clad in springtime green, garlanded with fresh leaves, and sparkle with ornate finery. Behind them is a woodland and the château of Riom. These great country estates, most of which belonged to the Duke of Berry, loom in the backgrounds of most of the calendar pictures and are represented so faithfully that those that still survive today are easily recognized. The spirit of the picture is Chaucerian-lightsome, artificial, chivalric, and pleasure-loving. (The Canterbury Tales is hardly a generation older.) The elegant silhouettes, rich colors, and decorative linear effects again recall Sienese art. The varying scenes evidently were painted by different artists, but historians have never been able to assign specific pictures to the different Limbourg brothers. Nevertheless, although the artists' styles may differ, their main interests were the same. Within the confines of the International style,

18-4 THE LIMBOURG BROTHERS, May, from Les Très Riches Heures du Duc de Berry, 1413–1416. Illumination, approx. $8\frac{1}{2}^{"} \times 5\frac{1}{2}^{"}$. Musée Condé, Chantilly, France.

they represented as accurately as possible the actual world of appearances and the activities of men and women, peasants and aristocrats, in their natural surroundings at specific times of the year. Thus, the traditional field of subject matter has been expanded to include genre subjects; they are given a prominent place, even in a religious book. Secular and religious subjects remain neatly separated, but they will encroach on each other increasingly during the fifteenth century to produce as thorough a humanization of religious subject matter as we saw in Italy.

Hardly a decade after *Les Très Riches Heures*, an example of the International style at its peak, we have a work of quite different and novel conception, *The*

 18-5 ROBERT CAMPIN (Master of Flémalle), The Mérode Altarpiece (open), c. 1425–1428. Tempera and oil on wood, center panel approx. 25" × 25". Metropolitan Museum of Art, New York (Cloisters Collection purchase).

Mérode Altarpiece (FIG. 18-5) by the Master of Flémalle, now identified as ROBERT CAMPIN (c. 1378-1444), the leading painter of the city of Tournai. Here, the aristocratic taste, romantic mood, and ornamental style of the International painters are replaced with a relatively blunt, sober realism in setting and characterization. The old theme of the Annunciation occupies the central panel of the triptych, and something of Internationalism remains in its decorative line play, but the donors, depicted in the left panel, set the tone. Man and wife, they are of the grave and sedate middle class; unostentatiously prosperous, quietly attired, they kneel in a little courtyard, the man peering through the door at the mystery taking place in the central scene. Discreetly set apart from it, they take the mystery as a fact, and factualness determines the artist's whole approach.

All the objects in the Annunciation scene are rendered with careful attention to their actual appearance, and the event takes place in an everyday, middle-class Flemish interior, in which all accessories, furniture, and utensils are indicated, lest the setting be incomplete. But the objects represented are not merely that; book, candle, flowers, sink (in the corner niche), fire screen, polished pot, towels, and bench symbolize, in different ways, the Virgin's purity and her divine mission. In the right panel, Joseph has made a mousetrap, symbolic of the theological tradition that Christ is bait set in the trap of the world to catch the Devil. The carpenter's shop is completely inventoried by the painter, down to the vista into a distant city street. Thus, we have a thorough humanizing of a traditional religious theme—a transformation of it in terms of a particular time and place: a middle-class house, courtyard, and shop in a fifteenth-century city of Flanders. So close is the status of the sacred actors to the human level that they are even represented without halos; this does not happen in Italy until the end of the fifteenth century.

We have been tracing the humanization of art from the thirteenth century. The distance between the sacred and the secular has now narrowed to such a degree that they become intermixed. As Johan Huizinga, renowned modern historian of the fifteenth century, describes it:

Individual and social life, in all their manifestations, are imbued with the conception of faith. There is not an object nor an action, however trivial, that is not constantly correlated with Christ or salvation. . . . All life was saturated with religion to such an extent that the people were in constant danger of losing sight of the distinction between things spiritual and things temporal. If, on the one hand, all details of ordinary life may be raised to a sacred level, on the other hand, all that is holy sinks to the commonplace, by the fact of being blended with everyday life . . . the demarcation of the spheres of religious thought and that of worldly concerns was nearly obliterated.*

*Johan A. Huizinga, *The Waning of the Middle Ages* (Garden City, NY: Doubleday, 1954), p. 156.

Hence, the realistically rendered, commonplace objects in a Flemish painting become suffused with religious significance and take on the nature of sacramental things. With this justification for their existence in art, the ordinary things that surround us—and we ourselves—share the realm of the saints; conversely, the saints now occupy our realm. But we, as well as our things will remain when, with the secularization of art, the saints and sanctity have disappeared.

JAN VAN EYCK

One of the largest and most admired Flemish altarpieces of the fifteenth century is *The Ghent Altarpiece* in the Cathedral of St. Bavo in Ghent (FIGS. **18-6** and **18-7**). It also has been one of the most controversial ever since the discovery, in 1832, of a partly damaged, four-line Latin poem on the frame of one of the outside panels which, in part, translates: "The painter Hubert van Eyck, greater than whom no one was found, began [this work]; Jan, second in art, completed it at the expense of Jodocus Vyt. . . ." The last line of the quatrain gives the date of 1432.

For more than a century after the discovery of this inscription under a coat of greenish paint, the altarpiece was believed to be the product of a collaboration between JAN VAN EYCK (*c*. 1390–1441) and his older brother HUBERT (*c*. 1370–1426). But none of the numerous attempts to assign different parts of the many-paneled work to one or the other brother found more than partial acceptance among art historians. Even Erwin Panofsky's tightly argued conclusion that the present altarpiece is the result of an artful combination of three independent works, begun by Hubert and finished by Jan, that originally were not meant to be seen together, left considerable room for doubt and argument.*

An entirely new light was thrown on the controversy with the more recent suggestion that Hubert may not have been a painter at all, but rather a sculptor, who carved an elaborate, now lost framework for the painted panels. Lotte Brand Philip points out that the damaged word *-ictor* in the inscription, which precedes Hubert's name and had been restored to read *pictor* (painter), could also be read *fictor* (sculptor).† "Second in art" would then not mean that Jan was a less accomplished painter than his brother but would be a chronological reference to the fact that Jan worked on the altarpiece *after* Hubert. Judging from surviving contracts and commissions of the period, it seems to have been fairly common practice for a

*Lotte Brand Philip, *The Ghent Altarpiece and the Art of Jan van Eyck* (Princeton, NJ: Princeton University Press, 1972).

18-6 НUBERT and JAN VAN EYCK, The Ghent Altarpiece (closed), completed 1432. Tempera and oil on wood, approx. 11' 6" × 7' 3". Cathedral of St. Bavo, Ghent, Belgium.

painter to begin work on panels after their frames had been completed.

In 1566, the panels of the altarpiece were removed from the original frame and hidden, to protect them from Protestant iconoclasts who probably destroyed the frame. The panels were reinstalled in 1587, but without the original framework, which Lotte Brand Philip envisions to have been in the form of a richly carved, two-storied, Gothic reliquary front. Her ingenious theory and imaginative reconstruction would give sole authorship of the paintings to Jan van Eyck and solve the problem of attribution that has vexed art historians for almost a century and a half. It also would tend to explain the disparity of the scale used on the inner panels, which has disturbed some modern observers. If, indeed, the panels were originally more widely spaced and separated by richly carved, Gothic architectural elements, the formal unity of the altarpiece may have been stronger and more cohesive, especially if perspective devices in the lower level created the illusion that the smaller-scale scenes receded and were seen through, and at some distance

^{*}Erwin Panofsky, *Early Netherlandish Painting* (Cambridge, MA: Harvard University Press, 1953).

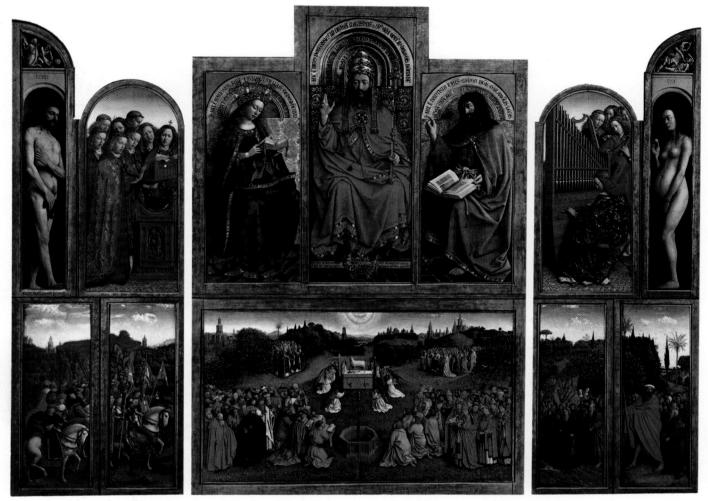

18-7 HUBERT and JAN VAN EYCK, The Ghent Altarpiece (open). Approx. 11' $6'' \times 15' 1''$.

behind, the architectural screen. On the other hand, it may well be that fifteenth-century viewers paid much less attention to formal unity than we do today and that the spiritual unity of the work was their real concern.

The Ghent polyptych remains an outstanding example of the large, folding altarpiece, typical of the north, that discloses new meanings to the observer as the unfolding panels reveal new subjects in sequence. The very form of the folding altarpiece expresses the medieval tendency to uncover truth behind natural appearances, to clothe thought in allegory, to find "essential" meaning hidden beneath layers of secondary meanings. When closed (FIG. 18-6), *The Ghent Altarpiece* shows the Annunciation and simulated statues of St. John the Baptist and St. John the Evangelist, flanked by the donors, Jodoc Vyt and his wife; above, in the lunettes, are the Prophet Zechariah with the Cumaean sibyl. All these are

symbolic references to the Coming of Christ. The Annunciation figures are set in a raftered room in which the Romanesque and Gothic architectural elements may symbolize the Old and the New Testaments, respectively. As in *The Mérode Altarpiece* (FIG. 18-5), a vista opens on a distant street. The angel and the Virgin are bundled in the heavy flannel draperies of the Burgundian school, resembling those of Sluter's *Moses* (FIG. 18-1). Although the architecture is spacious, the figures are in ambiguous relation to it and quite out of scale; as yet, the artist shows little concern for a proportioned space adjusted to the human figure.

When opened (FIG. 18-7), the altarpiece reveals a sumptuous, superbly colored representation of the medieval conception of the Redemption of man. In the upper register, God the Father—wearing the triple tiara of the papacy, with a worldly crown at his feet and resplendent in a deep-scarlet mantle—is flanked on the left by the Virgin, represented as the

Queen of Heaven, with a "crown of twelve stars upon her head," and on the right by St. John the Baptist. To either side is a choir of angels and, on the right, St. Cecilia at her organ. Adam and Eve are in the far panels. The inscriptions in the arches above Mary and St. John extol the virtue and purity of the Virgin and the greatness of St. John as the forerunner of Christ. The particularly significant inscription above the head of the Lord translates: "This is God, all-powerful in his divine majesty; of all the best, by the gentleness of his goodness; the most liberal giver, because of his infinite generosity." The step behind the crown at the Lord's feet bears the inscription: "On his head, life without death. On his brow, youth without age. On his right, joy without sadness. On his left, security without fear." This inscription is a most concise and beautiful statement of the change from the concept of God as a stern, medieval judge of mankind to the benevolent Franciscan father of the human race. This Franciscan concept of the benevolent nature of God is reinforced by the pelicans embroidered on the tapestry draped over the back of his throne, for pelicans (then thought to tear open their breasts to feed their starving young with their own blood) were symbols of self-sacrificing love. The entire altarpiece amplifies this central theme; though man, symbolized by Adam and Eve, is sinful, he will be saved because God, in his infinite love, will sacrifice his own son for this purpose.

The figures are rendered in a shimmering splendor of color that defies reproduction. Both Hubert and Jan van Eyck were trained miniaturists, and not the smallest detail has escaped their eyes. They amplify the beauty of the most insignificant object as if it were a work of piety as much as a work of art. The soft texture of hair, the glitter of gold in the heavy brocades, the luster of pearls, and the flashing of gems are all given with tireless fidelity to appearance. The new medium of oil paint shows its marvelous magic.

The panels of the lower register extend the symbolism of the upper. In the central panel, the community of saints comes from the four corners of the earth through an opulent, flower-spangled landscape. They move toward the altar of the Lamb, from whose heart blood flows into a chalice, and toward the octagonal fountain of life into which spills the "pure river of water of life, clear as crystal, proceeding out of the throne of God and of the Lamb" (Revelation 22:1). On the right, the Twelve Apostles and a group of martyrs in red robes advance; on the left, with minor prophets, the Four Evangelists arrive carrying their Gospels. In the right background come the holy virgins, and in the left background, the holy confessors. On the lower wings, other approaching groups symbolize the four cardinal virtues: the hermits, Temperance; the pilgrims, Prudence; the knights, Fortitude; the judges, Justice. The altarpiece celebrates the whole Christian cycle from the Fall to the Redemption, presenting the Church triumphant in heavenly Jerusalem. The uncanny naturalism and the precise rendering, in the miniaturist tradition, make the great event as concrete and credible as possible to the observer. The realism is so saturated with symbolism that we almost think of it as a kind of superreality or "surrealism," for what is given to the eye is more than the eye alone can report.

Jan van Eyck's matchless color craft also is evident in The Virgin with the Canon van der Paele (FIG. 18-8), painted in 1436. The figures are grouped in a manner reminiscent of the sacra conversazione paintings that appear in Florence about the same time (FIG. 16-32). The architecture, the elaborately ornamented rug, and the placement of the figures all lead the observer's eye to the Madonna and Child, who sit on a throne in the apse of a church. The rich texture of the Virgin's red robes strongly contrasts with the white surplice of the painting's donor, the kneeling Canon van der Paele. A similar contrast plays across the space between the dull glint from the armor of St. George, the patron saint of the canon, and the rich brocades of St. Donatian, the patron of the church for which the painting was commissioned. The incredibly brilliant profusion of color is controlled carefully, so that the forms are distinguished clearly in all detail. The symbolism is as profuse and controlled as the color, incorporating again the complete cycle of the Fall and the promise of Redemption. The arms of the Virgin's throne and the historiated capitals of the pilasters behind her make reference to the Old Testament prefiguration of the Coming of Christ, so well known in the Middle Ages.

Van Eyck's use of perspective is evident in the picture; he uses not a single perspective that would consistently unify the space, but several. His intention here once again appears to be accomplished indirectly, the multiple perspectives directing attention to the principal figures. For example, a projection of the line of the column base at the far right leads to the head of the canon; the orthogonals of the floor tiles converge on the midpoint of the figure of the Virgin; and the base of the throne can be projected to the infant Christ. No real spatial unification can be found here. The figures do not interrelate as we might expect. Each fills its own space with, as it were, its own perspective. Although St. George lifts his helmet to the Virgin, the direction of his gaze goes well beyond her; this disorientation is also true of the other figures. Jan van Eyck and his generation still essentially

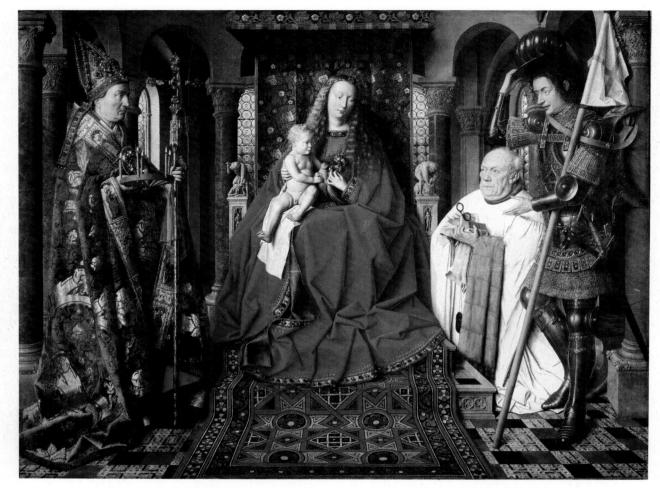

18-8 JAN VAN EYCK, The Virgin with the Canon van der Paele, 1436. Tempera and oil on wood, approx. 48" × 62". Musées Communaux, Bruges, Belgium.

conceive the organization of the two-dimensional picture surface in terms of shape, color, and symbol; they have not yet thought of it as a window into a constructed illusion of the third dimension, as the painters of the later Flemish schools will.

The portrait head of Canon van der Paele shows the same nonstructural approach. The heavy, wrinkled visage of the canon is recorded in precise detail, almost to the pores. The artist makes a relief map of his subject, delineating every minute change of the facial surface. Unlike the Italian portraitists, who think first of the structure of the head and then draw the likeness over it, Jan van Eyck works from the outside inward, beginning with the likeness and shaping the head incidentally. This procedure is what gives the masklike aspect to the canon's face, despite the portrait's fidelity to physiognomy; the surface is all there, but the illusion of three-dimensional mass is only implied.

We have seen three works that included painted portraits of their donors: *The Mérode Altarpiece* (FIG.

18-5), The Ghent Altarpiece (FIG. 18-6), and The Virgin with Canon van der Paele (FIG. 18-8). These portraits mark a significant revival of portraiture, a genre unknown since antiquity. A fourth portrait, Jan van Eyck's Man in a Red Turban (FIG. 18-9) takes another step toward the complete secularization of the portrait. In the Mérode and Ghent altarpieces, the donors were depicted apart from the saints; in the Canon van der Paele portrait, the donor associates with the saints at the throne of the Virgin. In this portrait of a man wearing a turban (possibly a depiction of the artist himself), the image of a living individual apparently needs no religious purpose for being—only a personal one; the portrait is simply a personal record of one's features interesting to the subject himself or to someone who knows him. These private portraits now begin to multiply, as both artist and patron become interested in the reality they reveal, for the painter's close observation of the lineaments of a human face is as revealing of the real world as his observation of objects in general. As

human beings confront themselves in the painted portrait, they objectify themselves as selves, as people. In this confrontation, the otherworldly anonymity of the Middle Ages must fade away. The *Man in a Red Turban* looks directly at us, or perhaps at himself in a mirror. So far as is known, this depiction is the first painted portrait in a thousand years to do so. The level, composed gaze, directed from a true threequarter pose of the head, must have impressed observers deeply. The painter gives us the illusion that from whatever angle we observe the face, the eyes still fix us. A painting of this kind by the great Rogier van der Weyden must have inspired the writing of *The Vision of God* (1453) by Nicholas of Cusa, who says, in the preface to that work:

To transport you to things divine, I must needs use a comparison of some kind. Now among men's works I have found no image better suited to our purpose than that of an image which is *omnivoyant* [all-seeing]—its face, by the painter's cunning art, being made to appear as though looking on all around it—for example . . . that by the eminent painter, Roger [*sic*], in his priceless picture in the governor's house at Brussels. . . . this I call the icon of God.

Nicholas goes on with a praise of sight and vision that amounts to a sanctification of them:

Thou, Lord . . . lovest me because Thine eyes are so attentively upon me . . . where the eye is, there is love. . . . I exist in that measure in which Thou art with me, and since Thy look is Thy being, I am because Thou dost look at me, and if Thou didst turn Thy glance from me I should cease to be.

Apart from Thee, Lord, naught can exist. If, then, Thine essence pervade all things, so also does Thy sight, which is Thine essence. . . . Thou Lord, seest all things and each thing at one and the same time.

Nicholas of Cusa is a contemporary of the great Flemish painters, and it is likely that he spoke in a sense they could understand and in a mood they could share. The exaltation of sight to divine status and the astonishing assertion that the essence of God is sight-not being, as St. Thomas tells us-are entirely in harmony with the new vision in painting. As sight and being in God are essentially the same, so the painter's sight, which is instrumental in making likenesses, brings them into being. As the contemplative man achieves union with God by making himself like God, the imitation of objects in the sight of (hence, caused by) God must be a holy act on the part of the painter: seeing what God sees, he achieves the reality of God's vision and reveals it to others. The minute realism of the Flemish painters can be understood in the light of Nicholas's doctrine. God sees everything, great and small alike, and Nicholas's fun-

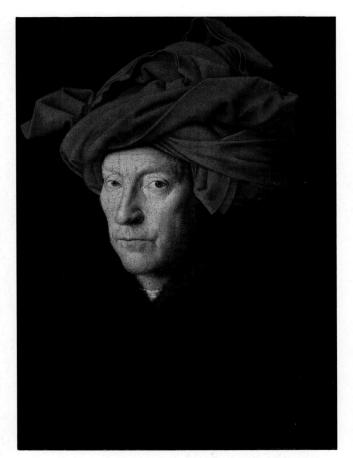

18-9 JAN VAN EYCK, Man in a Red Turban (Self-Portrait?), 1433. Tempera and oil on wood, approx. $10\frac{1}{4}'' \times 7\frac{1}{2}''$. Reproduced by courtesy of the Trustees of the National Gallery, London.

damental doctrine that all opposites and contradictions are resolved and harmonized in God makes God present in the greatest and in the smallest, in the macrocosm and in the microcosm, in the whole earth and in a drop of water. In the whole world of vision *caused* by God's sight, everything is worthwhile because it is seen by God—even the "meanest flower that blows." Nicholas's sanctification of the faculty of sight provides Flemish painters with a religious warrant to apply sight in the investigation of the given world; painters in the north will continue the investigation long after the original religious motive is gone.

Above all, an age had begun in both the Netherlands and Italy in which people gloried in the faculty of sight for what it could reveal of the world around them. Artists now began to show the Western public "what things look like," and it took extreme pleasure in recognizing a revelation. The level gaze of the *Man in a Red Turban*, in all its quiet objectivity, is not only the omnivoyant "icon of God"; in its historical destiny, it is the impartial, eternally observant face of science. It is also, significantly, humanity beginning

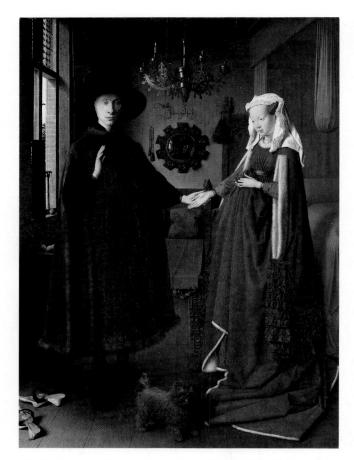

18-10 JAN VAN EYCK, Giovanni Arnolfini and His Bride, 1434. Tempera and oil on wood, approx. $32'' \times 23\frac{1}{2}''$. Reproduced by courtesy of the Trustees of the National Gallery, London.

to confront nature in terms of the human component. This step is the climax of the slow but mighty process that will bring the artist's eyes down from the supernatural to the natural world—a process that is expressed with just as much conviction and vigor in the north as it is in Italy.

The humanization of pictorial themes advances another step in Jan van Eyck's double portrait of Giovanni Arnolfini and His Bride (FIG. 18-10). The Lucca financier (who had established himself in Bruges) and his lady occupy a scene that is empty of saints but charged with the spiritual. Almost every object depicted is in some way symbolic of the holiness of matrimony. Giovanni and his bride, hand in hand, take the marriage vows. Their shoes have been removed, for the sacrament of matrimony makes the room a holy place. The little dog symbolizes fidelity (the origin of the common canine name Fido). Behind the pair, the curtains of the marriage bed have been opened. The finial of the bedpost is a tiny statue of St. Margaret, patron saint of childbirth; from the finial hangs a whisk broom, symbolic of domestic care (FIG. 18-11). The oranges on the chest below the

window may refer to the golden apples of the Hesperides, representing the conquest of death, and the presence of the omnivoyant eye of God seems to be referred to twice: once in the single candle burning in the ornate chandelier and again in the mirror, in which the entire room is reflected (FIG. 18-11). The small medallions set into the mirror's frame show tiny scenes from the Passion of Christ and represent Van Eyck's ever-present promise of salvation for the figures reflected on the mirror's convex surface. These figures include not only the principals, Arnolfini and his wife, but two persons who look into the room through the door. One of these must be the artist himself, as the florid inscription above the mirror, Johannes de Eyck fuit hic, announces that he was present. The purpose of the picture, then, is to document and sanctify the marriage of two particular persons. In this context, human beings come to the fore of their own setting; the spiritual is present, but in terms of symbol, not image.

The paintings of Jan van Eyck have a weighty formality that banishes movement and action. His symmetrical groupings have the stillness and rigidity of the symbol-laden ceremony of the Mass; each person and thing has its prescribed place and is adorned as

18-11 Detail of FIG. 18-10.

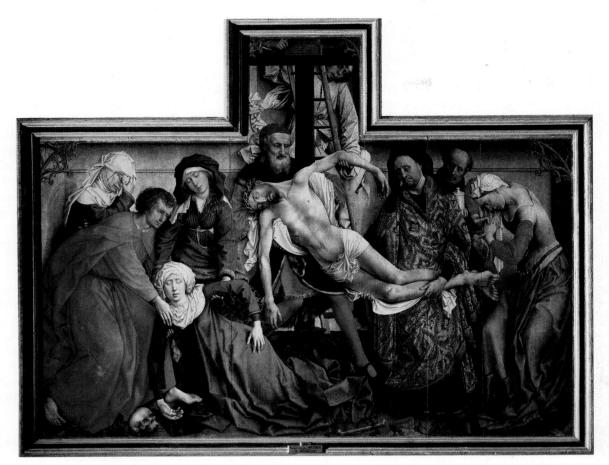

18-12 ROGIER VAN DER WEYDEN, *The Escorial Deposition*, c. 1435. Tempera and oil on wood, approx. 7' 3" × 8' 7". Museo del Prado, Madrid.

befits the sacred occasion. The long tradition of manuscript illumination accepted that the Holy Book must be as precious as the words it contains. Jan van Eyck, himself a miniaturist and illuminator, instinctively created a rich and ornamental style in which to proclaim his optimistic message of human salvation. In their own way, the paintings of Jan van Eyck are perfect and impossible to surpass. After him, Flemish painting looked for new approaches, and Van Eyck had few, if any, emulators.

VAN DER WEYDEN, CHRISTUS, AND BOUTS

The art of ROGIER VAN DER WEYDEN (*c.* 1400–1464) had a much greater impact on northern painting during the fifteenth century. A student of Robert Campin, Rogier evidently recognized the limitations of Van Eyck's style, although it had not been without influence on his early work. By sweeping most of the secondary symbolism from his paintings, Rogier cleared his pictorial stage for fluid and dynamic compositions stressing human action and drama. He concentrates on themes like the Crucifixion and the Pietà, in which he moves the observer by relating the sufferings of Christ. For Van Eyck's symbolic bleeding lamb, Rogier substitutes the tortured body of the Redeemer and his anguished mother. His paintings are filled with deep religiosity and powerful emotion, for he conceived his themes as expressions of a mystic yearning to share in the Passion of Jesus.

The great Escorial Deposition (FIG. 18-12) sums up Rogier's early style and content. Instead of creating a deep landscape setting, as Jan van Eyck might have, he compresses the figures and action onto a shallow stage to concentrate the observer's attention. Here, Rogier imitates the large, sculptured shrines so popular in the fifteenth century, especially in Germany, and the device serves well his purpose of expressing maximum action within disciplined structure. The painting resembles a stratified relief carving in the crisp drawing and precise modeling of its forms. A series of lateral, undulating movements gives the group a unity, a formal cohesion, that is underlined by psychological means—by the desolating anguish common to all the figures. Few painters have equaled Rogier in the rendering of passionate sorrow as it vibrates through a figure or distorts a tear-stained face. His depiction of the agony of loss is the most authentic in religious art; in a painting as bare of secondary symbolism as the *Deposition*, the emotional impact on the observer is immediate and direct. From this single example, we can understand why Rogier's art became authoritative for the whole fifteenth century outside of Italy.

His portraits were no less important than his altarpieces. Campin and Van Eyck had established portraiture among the artist's principal tasks. Great patrons were ready to have their likenesses painted for many different reasons: to memorialize themselves in their dynastic lines; to establish their identity, rank, and station by an image far more concrete than a heraldic coat of arms; to represent themselves at occasions of state when they could not be present; even as a kind of photograph of the betrothed to be exchanged by families who had arranged their children's marriages. Royalty, nobility, and the very rich might send painters to "take" the likeness of a prospective bride or groom. It is reported that when a bride was sought for young King Charles VI of

18-13 ROGIER VAN DER WEYDEN, *Portrait of a Lady, c.* 1460. Oil on wood, $14\frac{1''}{2} \times 10\frac{3''}{2}$. National Gallery, Washington, D.C. (Andrew W. Mellon Collection).

France, a painter was sent to three different royal courts to make portraits of the candidates, on the basis of which the king then made his choice.

We are not sure for what specific purpose Rogier's portrait of an unknown young lady (FIG. 18-13) was painted. From her dress and bearing, she was probably of noble rank. The artist is at pains to realize not only a faithful likeness of her somewhat plain features, but to read, with his uncommon perception, her individual character. Her lowered eyes, tightly locked, thin fingers, and fragile physique bespeak a personality reserved, introverted, and devout. The unflattering honesty and directness, typical in the Flemish artist's approach, reveals much, despite the formality of pose and demeanor. This style contrasts with the formality of the Italian approach (FIG. 16-58), derived from the profiles common to coins and medallions, which is more stern and admits little revelation of personality. The Italian patron and portraitist will prefer the profile view throughout most of the century, rather than the full-face and three-quarter views favored by the Flemish. Rogier is perhaps chief among the Flemish in his penetrating readings of his subjects, and, great pictorial composer that he is, he makes beautiful use here of flat, sharply pointed angular shapes that themselves so powerfully suggest an "angularity" (rigidity) of this subject's personality. Unlike Jan van Eyck, Rogier lays little stress on minute description of surface detail. Instead, he defines large, simple planes and volumes, achieving an almost "abstract" effect, in the modern sense, of dignity and elegance.

Although evidence that Rogier traveled to Italy is not unequivocal, some of his paintings clearly show his acquaintance with Italian pictorial devices. His religious sincerity and concern with sin and guilt, however, remained undimmed by them. The appearance of these mid-century Italian influences in Rogier's paintings was not an isolated instance in Flemish art. The work of PETRUS CHRISTUS (c. 1410-1472) shows so marked an interest in the depiction of space and cubic form that, although the idea now largely is discounted, he too was often felt to have traveled to Italy. Little is known of Christus's life, except that he may have been Van Eyck's student and that he settled and worked in Bruges. His style vacillates between Van Eyck's and Rogier's. Still, his interests are quite different from those of his models.

His painting of *The Legend of Saints Eligius and Godeberta* (FIG. **18-14**) seems, at first glance, to exhibit all of Van Eyck's miniaturistic traits, from the stitching on the lady's gown to the carefully enumerated attributes that identify the seated saint as a patron of the goldsmith's guild. Even the convex mirror on the table seems to have been extracted from Van Eyck's

18-14 PETRUS CHRISTUS, The Legend of Saints Eligius and Godeberta, 1449. Tempera and oil on wood, approx. 39" × 34". Metropolitan Museum of Art, New York (the Lehman Collection).

portrait of Arnolfini and his bride (FIG. 18-10), and the two "witnesses" reflected in it suggest that this also may be a wedding picture. But Christus's concept of reality and his approach to it are quite different from Van Eyck's; he is much more concerned with the underlying structure of an object's appearance and, in this respect, is more closely related to the Italian than to the northern approach. The three solidly constructed figures within the cubic void defined by the desk and the room corner represent an essentially southern essay in pictorial form that has been overlaid with Van Eyck's surface realism. Curiously, in his effort to make the structure of his picture clear, Christus resorts to the same kind of simplification of forms seen in the paintings of Paolo Uccello and Piero della Francesca (FIGS. 16-29 and 16-33). Even more striking, perhaps, is the similarity of Christus's "volumetric" portrait heads to those by Antonello da Messina (FIG. 16-67). The speculation that these two artists may have met, either in Flanders or in Italy, remains tempting, despite the lack of solid documentation.

Christus may have had some contact with DIRK BOUTS (c. 1415–1475), a slightly younger artist of similar temperament and interests. For a long time, the central panel of Bouts's *The Altarpiece of the Holy Sacrament* was believed to be the first northern painting in which the use of a single vanishing point for the construction of an interior could actually be demonstrated. Although Rogier may have known about the Italian science of linear perspective, he apparently did not use it in his paintings. Recent studies tend to give precedence in this field to Petrus Christus, from whom, in fact, Bouts may have acquired his knowledge. The setting for the altarpiece's Last Supper (FIG. 18-15) is probably the refectory of the headquarters of the Louvain Confraternity of the Holy Sacrament, by which the painting was commissioned. All the orthogonals of the depicted room lead to a single vanishing point in the center of the mantelpiece above the head of Christ. This painting is not only the most successful northern fifteenth-century representation of an interior, but it is also the first in which the scale of the figures has been adjusted realistically to the space they occupy. So far, however, the perspective unity is confined to single units of space only; the small side room has its own vanishing point, and neither it nor the vanishing point of the main room falls on the horizon of the landscape seen through the windows. The tentative manner with which Bouts solves his spatial problems suggests that he arrived at his solution independently and that the Italian science of perspective had not yet reached the north, except perhaps in small fragments. Nevertheless, the

18-15 DIRK BOUTS, The Last Supper (center panel of The Altarpiece of the Holy Sacrament), 1464–1468. Tempera and oil on wood, approx. $6' \times 5'$. St. Peter's, Louvain, Belgium.

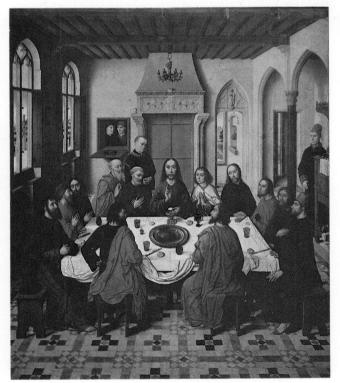

works of Christus and Bouts clearly show that, by mid-century, northern artists had become involved with the same scientific, formal problems that concerned Italian artists during most of the fifteenth century.

The mood of Bouts's *Last Supper* is neutral. The gathering is solemn enough, but it lacks all pathos and dramatic tension, almost as if the artist was more concerned with the solution of a difficult formal problem than with the pictorial interpretation, either personal or traditional, of the sacred event.

VAN DER GOES AND MEMLING

The highly subjective and introspective paintings of HUGO VAN DER GOES (c. 1440–1482) seem to express a discontent with the impersonal quality that the artist must have felt was a loss of religious meaning in the paintings of his older contemporaries. Hugo was dean of the painter's guild of Ghent from 1468 to 1475 and an extremely popular painter. At the height of his success and fame, he entered a monastery as a lay brother. While there, he suffered a mental breakdown, and a year later, in 1482, he died. His retirement to the monastery did not interrupt Hugo's career as a painter immediately; he continued to receive commissions and probably completed his most famous work, *The Portinari-Altarpiece* (FIG. **18-16**), within the monastery's walls.

Hugo painted the triptych for Tommaso Portinari, an agent of the Medici, who appears on the wings of the altarpiece with his family and their patron saints. The central panel (FIG. **18-17**) represents *The Adoration of the Shepherds*. On this large surface, Hugo displays

a scene of solemn grandeur, muted by the artist's introspective nature. The high drama of the joyous occasion is stilled; the Virgin, Joseph, and the angels seem to brood on the suffering that is to come rather than to meditate on the miracle of the Nativity. The Virgin kneels, somber and monumental, on a tilted ground that has the expressive function of centering the main actors. From the right rear enter three shepherds, represented with powerful realism in attitudes of wonder, piety, and gaping curiosity. Their lined, plebeian faces, work-worn hands, and uncouth dress and manner are so sharply characterized as to make us think of the characters in such literature of the poor as Piers Plowman and the Second Shepherd's Play. The three panels are unified by the symbolic architecture and a continuous, wintry, northern landscape. Symbols are scattered plentifully throughout the altarpiece: iris and columbine symbolize the Sorrows of the Virgin; the fifteen angels represent the Fifteen Joys of Mary; a sheaf of wheat stands for Bethlehem (the "house of bread" in Hebrew), a reference to the Eucharist; and the harp of David, emblazoned over the portal of the building in the middle distance (just to the right of the head of the Virgin), signifies the ancestry of Christ.

To stress the meaning and significance of the depicted event, Hugo revives Medieval pictorial devices and casts aside the unities of time and action so treasured by other Renaissance artists, wherein a single episode in time is confined to a single framed piece. Small scenes shown in the background of the altarpiece represent (from left to right across the three panels) the Flight into Egypt, the Annunciation to the

18-16 HUGO VAN DER GOES, The Portinari Altarpiece (open), c. 1476. Oil on wood, center panel 8' 3½" × 10'. Galleria degli Uffizi, Florence.

18-17 HUGO VAN DER GOES, The Adoration of the Shepherds, center panel of The Portinari Altarpiece (FIG. 18-16).

Shepherds, and the Arrival of the Magi—the "prelude and epilogue to the Nativity." Also reflective of older traditions is the manner in which Hugo varies the scale of his figures to differentiate them according to their importance in relation to the central event. At the same time, he puts a vigorous, penetrating realism to work in a new direction, characterizing human beings according to their social level while showing their common humanity, and thus the painting becomes a plea for all to join the Brotherhood of Man.

Portinari placed his altarpiece in the church of Sant' Egidio in Florence, where it created a considerable stir among Florentine artists. Although the painting as a whole must have seemed unstructured to them, Hugo's brilliant technique and what they thought of as incredible realism in representing drapery, flowers, animals, and, above all, human character and emotion made a deep impression on them. At least one Florentine artist, Domenico Ghirlandaio, paid tribute to the northern master by using Hugo's most striking motif, the adoring shepherds, in one of his own Nativity paintings.

Hugo's contemporary, HANS MEMLING (c. 1430– 1494), who, although like Hugo, was esteemed by all and called, at his death, the "best painter in all Christendom," was of a very different temperament. Gentle and genial, he avoided the ambitious, dramatic compositions of Rogier and Hugo, and his sweet, slightly melancholy style fits well into the twilight of the waning fifteenth century. Memling's speciality is the Madonna; the many that have survived are slight, pretty, young princesses. His depictions of the infant Christ are doll-like. A good example of his work is the center panel of a triptych representing *The Mystic*

18-18 HANS MEMLING, The Mystic Marriage of St. Catherine, center panel of The St. John Altarpiece, 1479. Oil on wood, approx. $67\frac{3}{4}^{**} \times 67\frac{3}{4}^{**}$. Hospitaal Sint Jan, Bruges.

Marriage of St. Catherine (FIG. 18-18). The composition is balanced and serene; the color, sparkling and luminous; the execution, of the highest technical quality (Memling's paintings are among the best preserved from the fifteenth century). The prevailing sense of isolation and the frail, spiritual human types contrast not only with Hugo's monumental and somber forms but also with Van Eyck's robust and splendid ones. The century began, with Van Eyck's sumptuous art, on a note of humanistic optimism. It ends with a waning strength of spirit, an erosion of confidence in the moral and religious authority of the Church. Contemporary poetry is filled with dreary pessimism and foreboding, almost in anticipation of another fall of man and the disasters that will lie ahead for Christendom in the Reformation.

HIERONYMUS BOSCH

This time of pessimistic transition finds its supreme artist in one of the most fascinating and puzzling painters in history, HIERONYMUS BOSCH (c. 1450– 1516). Interpretations of Bosch differ widely. Was he a satirist, an irreligious mocker, or a pornographer? Was he a heretic or an orthodox fanatic like Girolamo Savonarola? Was he obsessed by guilt and the universal reign of sin and death? Certainly, his art is born of the dark pessimism of his age, burdened with the fear of human fate and the conviction that man's doom is approaching. A contemporary poet, Eustache Deschamps, writes:

Now the world is cowardly, decayed and weak, Old, covetous, confused of speech: I see only female and male fools. . . . The end approaches . . . All goes badly.

In a much copied and imitated series of small panels with half-length figures, Bosch describes the Passion of Christ. *The Carrying of the Cross* (FIG. **18-19**) from this group is a bitter judgment of humanity.

18-19 HIERONYMUS BOSCH, The Carrying of the Cross, c. 1510 (?). Oil on wood, approx. $30'' \times 32''$. Musée des Beaux-Arts, Ghent.

Christ is surrounded by hate and evil. His executioners show a sadistic delight in the suffering of their victim. Heedless of spatial effects, Bosch packs the entire surface of his panel with hate-distorted faces. In the upper right corner, a grinning scoundrel in a monk's habit exhorts the repentant thief; in the lower right corner, the unrepentant thief grimaces at two leering comrades, forming with them a triad of stupidity, bestiality, and hate. At the lower left, St. Veronica, representing the Church, turns away from Christ and becomes a symbol of vanity. No further interpretation of this panel seems needed; Bosch not only makes his meaning clear but expresses it with unrivaled ferocity.

Much more difficult to understand are Bosch's large altarpieces, which are packed with obscure meaning and symbolism. But even if we do not fully understand his teeming fantasies, we can appreciate the incredible scope of an imagination that makes him the poet of the nightmarish subconscious. The dreaming and waking worlds are one in Bosch, as he draws on the tradition of beast and monster that we have followed from Mesopotamia to the Gothic gargoyle.

His most famous work, the so-called *Garden of Earthly Delights* (FIGS. **18-20** to **18-22**), is also his most puzzling, and no interpretation of it is universally accepted. The left wing of the triptych shows the *Creation of Eve* in the Garden of Eden. However, here Eve is not the mother of mankind, as she is in Van Eyck's *Ghent Altarpiece* (FIG. 18-7), but rather the seductress whose temptation of Adam resulted in the original sin, the central theme of the main panel. Evil lurks even in Bosch's paradise: a central fountain of life is surrounded by ravens, the traditional symbols for

18-20 HIERONYMUS BOSCH, triptych of The Garden of Earthly Delights, Creation of Eve (left wing), The Garden of Earthly Delights (center panel), Hell (right wing), 1505–1510. Oil on wood, center panel 86⁵/₅" × 76³/₄". Museo del Prado, Madrid.

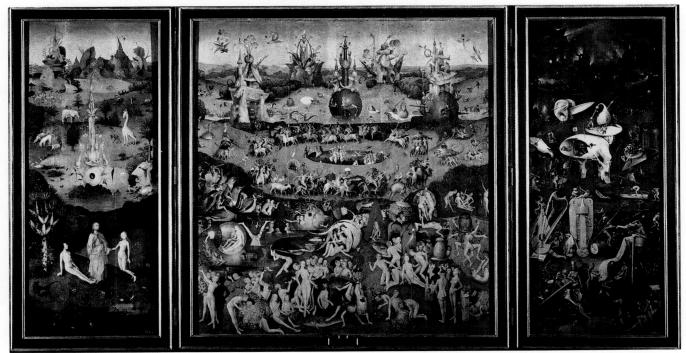

nonbelievers and magicians; an owl, hiding in the dark hole in the center of the fountain, represents witchcraft and sorcery.

The central panel, The Garden of Earthly Delights, swarms with the frail nude figures of men and women sporting licentiously in a panoramic landscape that is studded with fantastic growths of a quasisexual form. Bosch seems to be showing erotic temptation and sensual gratification as a universal disaster and the human race, as a consequence of original sin, succumbing to its naturally base disposition. The themes are derived in part from three major sources: Medieval bestiaries, Flemish proverbs, and the then very popular dream books, all mixed in the melting pot of Bosch's astoundingly inventive imagination. In addition, the artist includes frequent allusions to magic and alchemy and mingles animal and vegetable forms in the most absurd combinations. Symbols are scattered plentifully throughout the panel: fruit for carnal pleasure, eggs for alchemy and sex, the rat for falsehood and lies, dead fish for memories of past joys. A couple in a glass globe may illustrate the proverb "Good fortune, like glass, is easily broken." We have lost the key to many of Bosch's symbols, but it may be assumed that they were well known to his contemporaries.

In the right wing, the fruits of license are gathered in Hell (FIG. 18-21). There, sinful mankind undergoes hideous torments to diabolic music, while the hellish landscape burns. This symphony of damnation apparently comments on the wickedness of music, with which the Devil lures souls away from God. In this context, the ears and the musical instruments would represent the erotic, soul-destroying thoughts engendered by music. A man is crucified on a harp; another is shut up in a drum. A gambler is nailed to his own table. A girl is embraced by a spidery monster and bitten by toads. The observer must search through the hideous enclosure of Bosch's Hell to take in its fascinating though repulsive details. The great modern poet Charles Baudelaire catches the mood in his Flowers of Evil:

Who but the Devil pulls our walking-strings! Abominations lure us to their side; Each day we take another step to hell, Descending through the stench, unhorrified . . .

Packed in our brains incestuous as worms Our demons celebrate in drunken gangs . . .

... in this den of jackals, monkeys, curs, Scorpions, buzzards, snakes ... this paradise Of filthy beasts that screech, howl, grovel, grunt— In this menagerie of mankind's vice...

The triptych as a whole may represent the false paradise of this world between Eden and Hell, but

18-21 HIERONYMUS BOSCH, Hell, right wing of the triptych of The Garden of Earthly Delights (detail of FIG. 18-20).

18-22 HIERONYMUS BOSCH, The Third Day of Creation (?), exterior of the closed wings of the triptych of The Garden of Earthly Delights.

this is only one interpretation. Another explanation has it that Bosch belonged to a secret, heretical sect, the Adamites, and that the central panel was thought of as a kind of altarpiece symbolically celebrating its rites and practices. A fairly strong case has been made for an interpretation in terms of contemporaneous alchemical knowledge and practice.* In this connection, it should be pointed out that alchemy, in Bosch's time, was not an illegal and occult art but a practical and legitimate science practiced to make artist's paints, women's cosmetics, herbal cooking preparations, and healing potions. The alchemical science of distillation is basic to modern chemistry, and Philippus Aureolus Paracelsus, a physician of the early sixteenth century, stated emphatically that the true and only purpose of alchemy is to heal the sick, not to make gold.

Numerous alchemical treatises circulated during Bosch's time, and some of them may well have been known to him. Many observers have noted that the triptych is punctuated by forms and shapes similar to diagrams found in distillation texts. The most striking of these, perhaps, is the beaker-shaped "fountain of life" that appears once in the center of the left wing and again in the background of the central panel. In form, this shape strongly resembles an alchemical mixing retort. Many other distillation apparatus appear, especially in the central panel, including glass pipes and lids and transparent globes and funnels. Numerous egg shapes seem to refer to the ovoid mixing vessels in which ingredients were combined to produce the hoped-for transmutations. These vessels, called "eggs" in the symbolic language of alchemy, were considered microcosmic models of the world, which contained all the qualities of life and in which "the four elements [earth, air, fire, water] were perfectly conjoined." Egg shapes appear on all three

^{*}See Laurinda S. Dixon, "Bosch's Garden of Delights Triptych: Remnants of a 'Fossil' Science," The Art Bulletin, Vol. LXIII, No. 1 (March 1981), pp. 96–113.

panels of Bosch's altarpiece; the most prominent one, on the right panel (FIG. 18-21), forms the body of a grotesque, human-headed monster. This creature has been called the "alchemical man," and the tiny figures inside his eggshell torso, usually interpreted as embodying the sins of gluttony and lust, are seen as gathered around a table to watch the glow of an alchemical furnace hidden by the broken shell of the egg man's body.

According to this interpretation, the subject and organization of the triptych correspond to the basic (and, at the time, current) alchemical allegory, in which the distillation process—seen as the cyclical and self-perpetuating creation, destruction, and rebirth of the world and its inhabitants-takes place in four stages: "conjunction" (the marriage of opposites); "coagulation" (the multiplication of Adam and Eve into the peoples of the earth); "putrification" (the separation of the opposing elements previously joined in "matrimony"); and "cleansing" (the washing and purifying of the separated ingredients, a process compared to the Christian resurrection and purification of the soul). The final outcome of this entire allegorical distillation-union with God-is symbolized by the circle and the globe.

If interpreted in these terms, the first three stages of the distillation process are represented symbolically in sequence from left to right on the interior of the three altarpiece panels. The fourth and final stage appears on the outside of the closed wings (FIG. 18-22), where a transparent globe containing earth, water, and clouds, painted in grisaille (tones of gray), represents God's creation of the earth, which the alchemists tried to imitate in their operations.

In keeping with the cyclical and self-perpetuating process of distillation, the exterior of the altarpiece can be read either as the beginning or as the end of the cycle depicted on the interior. Placed at the end, it would provide the altarpiece with a comforting conclusion, a consolatory postscript promising that the sufferings of Hell may not be the end of everything after all. Most scholars, however, place the outside panels at the beginning of the sequence. To them, the grisaille represents the third day of Creation, when dark, light, water, land, and flora (but not the fauna) had been created. The outside thus becomes the natural prelude to the altarpiece's interior, where the remainder of Genesis is recorded on the left wing. On the central panel, the descendants of the first parents abandon themselves to the delights of the flesh, oblivious to the eventual but inevitable consequences recorded on the right wing-the apocalyptic results of the Last Judgment in the form of the fearsome destruction and tortures suffered in Hell. And if we realize how far God—a tiny figure in the upper left corner of the left exterior panel—has been removed from his creation, then Bosch's message seems to become quite clear: humanity, left to its own devices, is destined for damnation. Although far from being universally accepted, this last interpretation of *The Garden of Earthly Delights* appears to conform best with the remainder of the artist's oeuvre. Neither in this, nor in Bosch's other works, does humankind appear to advantage. Abandoned to evil by the Fall, humanity merits Hell.

Bosch was a supreme narrative painter, and the visions of his bubbling imagination demanded quick release. His technique is more rapid and spontaneous than the labored traditional Flemish manner. He seems to have had no time for the customary monochrome underpaintings or careful modeling of figures. His method forecasts the alla prima technique of the seventeenth and eighteenth centuries, as he puts down with quick and precise strokes the myriad creatures that populate his panels. His use of impasto, which did not require the traditional laborious application of numerous glazes, was ideally suited to the spinning of his mordant fantasies, and if he extends no hope of salvation for man, he only anticipates Michelangelo, who, in his Last Judgment fresco (FIG. 17-35), arrived at the same conclusion some thirty years later.

France and Germany

The bourgeoisie in France, unlike that in the Netherlands, was not wealthy, localized in strong towns, nor interested in fostering the arts. In France, the Hundred Years' War had wrecked economic enterprise and prevented stability. During the fifteenth century, the anarchy of war and the weakness of the kings resulted in a group of rival duchies. The strongest of these, as we have seen, was the duchy of Burgundy; through marriage and political alliance, it occupied the Netherlands and became essentially Flemish, particularly in art commissioned by the court. In France, artists joined the retinues of the wealthier nobility, the dukes of Berry, Bourbon, and Nemours, and sometimes the royal court, where they were able to continue to develop an art that is typically French despite its regional variations. But no artist of the fifteenth century north of the Alps could escape the influence of the great artists of Flanders. French art accepted it, and works of high quality were produced, although only one really major figure emerged.

JEAN FOUQUET (c. 1420–1481) is the outstanding French artist of the fifteenth century. During his career, he worked for the king, Charles VII, for the Duke of Nemours, and for Étienne Chevalier, the

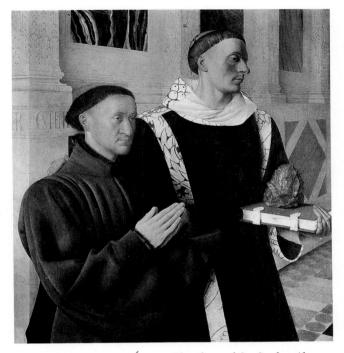

18-23 JEAN FOUQUET, Étienne Chevalier and St. Stephen (from a diptych now divided), c. 1450. Tempera on wood, $36\frac{12''}{2} \times 33\frac{12''}{2}$. Gemäldegalerie, Staatliche Museen, Berlin-Dahlem.

king's minister of finance. Fouquet's portrait of Chevalier with his patron, St. Stephen (FIG. 18-23), shows, in addition to Flemish influence, the effect of the two years the artist spent in Italy, between 1445 and 1447. The kneeling donor with his standing saint is familiar in Flemish art, as are the three-quarter stances and the sharp, clear focus of the portraits. The reading of the surfaces, however, is less particular than in the Flemish practice; the artist is trying to represent the forms underneath the surfaces, in the Italian manner. Also of Italian inspiration are the architectural background and its rendering in perspective. The secularizing tendency that advanced so rapidly in the fifteenth century is apparent in the familiar, comradely demeanor of the two men. Nothing whatever distinguishes them as being of different worlds, except possibly that St. Stephen, who holds the stone of his martyrdom, is dressed as a priest.

The Avignon Pietà* (FIG. 18-24), which has both Flemish and Italian elements, is an isolated masterpiece of great power, painted in the extreme south of France by an anonymous artist. Rogier van der Weyden's great Escorial Deposition (FIG. 18-12) comes

*Now attributed to Enguerrand QUARTON (c. 1410–1466), a French artist active in Provence in the south of France.

18-24 Attributed to ENGUERRAND QUARTON, The Avignon Pietà, c. 1455. Tempera on wood, approx. 5' 4" × 7' 2". Louvre, Paris.

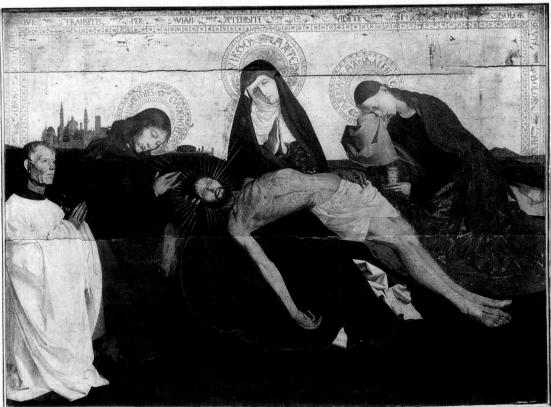

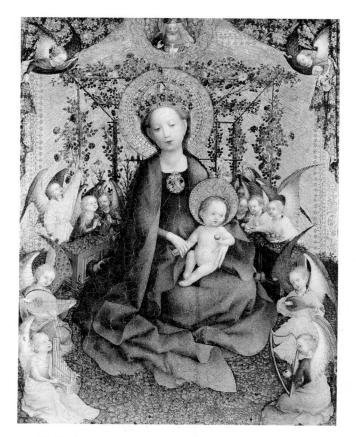

18-25 STEPHAN LOCHNER, Madonna in the Rose Garden, c. 1430–1435. Tempera on wood, approx. $20'' \times 16''$. Wallraf-Richartz Museum, Cologne.

to mind at once when we see the Avignon work, although the balanced, almost symmetrical massing clearly reflects the Italian Renaissance. (The subdued color scheme also has suggested Iberian influence to some writers.) The donor, now familiarly present at the sacred event, kneels at the left. His is a strikingly characteristic portrait, the face gnarled, oaken, and ascetic. The group of Christ and saints is united by the splendidly painted figure of Christ and by the angular shapes that seem deliberately simplified for graphic emphasis. As in Italian art, surface ornament is suppressed in the interest of monumental form. The luminous gold background, against which the figures are silhouetted and into which the halos are incised, is a strangely conservative feature, contrasting with the detailed background landscape reminiscent of Flemish paintings. No matter what his sources, the painter is deeply sensitive to his theme. Along with Rogier's version, The Avignon Pietà is one of the most memorable in the history of religious art.

To an even greater extent than in France, the development of German painting in the fifteenth century was strongly colored by the achievements of Flemish painting. In northern Germany, the influence of Jan van Eyck joined the tradition of the International style to produce the gentle, pictorially ornate world of delicacy and charm portrayed by STEPHAN LOCHNER (*c.* 1400–1451), the leading master of the school of Cologne. Lochner is noted for his compositions on the idyllic theme of the *Madonna in the Rose Garden* (FIG. **18-25**), which seems particularly well suited to his sophisticated and refined sensibilities.

Sometimes referred to as the "soft" style because of its feminine suavity and curvilinear rhythm, Lochner's manner was very different from the sculptural, blocky, "hard" style of southern Germany as we find it in the work of the Swiss painter CONRAD WITZ (c. 1400-1447). Although The Miraculous Draught of *Fish* (FIG. **18-26**) by this remarkable painter also shows Flemish influence, particularly that of Van Eyck, the painting demonstrates Witz's powerful and original sense of realism. Witz shows precocious skill in the study of water effects: the sky-glaze on the slowly moving lake surface, the mirrored reflections of the figures in the boat, and the transparency of the shallow water in the foreground. This painting is one of the first Renaissance pictures in which the landscape not only dominates the figures but is also the representation of a specific place-the shores of Lake Geneva, with the town of Geneva on the right and the ranges of the Alps in the distance.

The Late Gothic style is seen to best advantage in the works of German artists, who specialized in the carving of large retables (altar screens) in wood. The sculptor VEIT STOSS (1447-1533) carved a great altar for the church of St. Mary in Kraków, Poland (FIG. 18-27), no element of which is recognizable as having been influenced by the Italian Renaissance. Typically, the altar consists of a central, boxlike space; the shrine is flanked by hinged, movable wings-an inner pair (shown here) and an outer pair. In the shrine, huge figures (some 9 feet high) represent The Death and Assumption of the Virgin, and, in the wings, scenes from the lives of Christ and the Virgin are portrayed. The altar expresses the intense piety of Gothic culture in its late phase, when every resource of figural and ornamental design from the vocabulary of Gothic art is drawn on to heighten the emotion and to glorify the apparition of the sacred event. The disciples of Christ are gathered about the Virgin, who sinks down in death. One of them supports her; another, just above her, wrings his hands in grief; others are posed in attitudes of woe and psychic shock. The sculptor strives for minute realism in every detail. At the same time, he enwraps the figures in an almost abstract pattern of restless, twisting, curving swaths of drapery, which, by their broken and writhing lines, unite the whole tableau in a vision of agitated emotion. The massing of sharp, broken, and

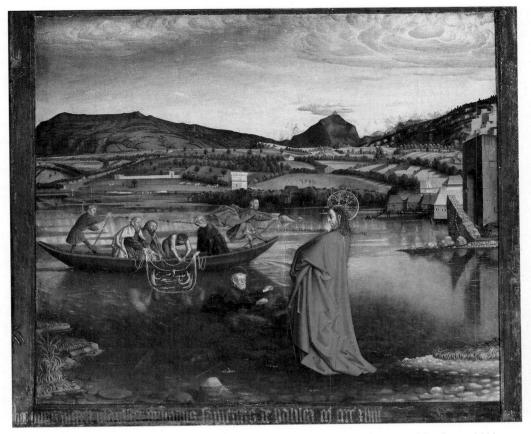

18-26 CONRAD WITZ, The Miraculous Draught of Fish, from the Altarpiece of St. Peter, 1444. Tempera on wood, approx. $51'' \times 61''$. Musée d'Art et d'Histoire, Geneva.

18-27 VEIT STOSS, The Death and Assumption of the Virgin, from the Altar of the Virgin Mary, 1477–1489. Painted and gilded wood, triptych (wings open) $43' \times 35'$. Church of St. Mary, Kraków, Poland.

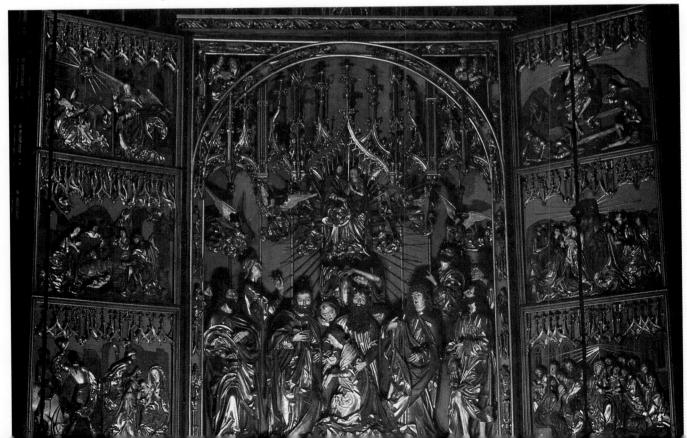

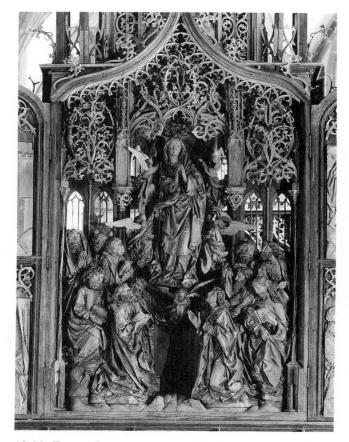

18-28 TILMAN RIEMENSCHNEIDER, The Assumption of the Virgin, center panel of The Creglingen Altarpiece, c. 1495–1499. Carved lindenwood, 6' 1" wide. Parish church, Creglingen, West Germany.

pierced forms, which dart flamelike through the composition—at once unifying and animating it—recalls the design principles of Late Gothic "flamboyant" architecture (FIG. 10-40). Indeed, in the Kraków altarpiece, sculpture and architecture are amalgamated, and their union is enhanced by painting and gilding. The distinction of the different media, familiar in Italian Renaissance art and furthered by it, is as yet unknown to this Late Gothic artist, even though, like the Italian artist, his eye focuses ever more sharply on natural appearance.

In the work of TILMAN RIEMENSCHNEIDER (1460– 1531), we find (as we do in the work of Veit Stoss) scarcely a trace of the Italian Renaissance. The canopy of Tilman's *Creglingen Altarpiece* (FIG. **18-28**) is an intricate weaving of flamboyant Gothic forms, and the endless and restless line is communicated to the draperies of the figures. The whole design is thus in motion and complication, and no element functions without the rest. The draperies float and flow around bodies lost within them, serving not as descriptions but as design elements that tie the figures to each other and to the framework. The spirituality of the figures, immaterial and weightless as they appear, is heightened by a look of psychic strain, a facial expression common to Tilman's figures and consonant with the age of troubles that is coming. They brood in pensive melancholy, their brows often furrowed in anxiety. A favorite theme in Late Gothic German sculpture was the *Schmerzensmann* (man of sorrows); for Tilman, all his actors were men of sorrow—weary, grave, and unsmiling.

With the works of sculptor-painter MICHAEL PACHER (c. 1435–1498), we come to the first important meeting of German art with the Italian Renaissance. Pacher, a Tyrolean, must have journeyed down the Po Valley and become familiar with the style of Andrea Mantegna and his school. In his painting St. Wolfgang Forces the Devil to Hold His Prayerbook (FIG. 18-29), we find the hard, wiry linearity of Mantegna and a combination of Late Gothic and Mantegna's drapery style. The figure of St. Wolfgang now has the monumental solidity of Italian form. The whole setting is Italian Renaissance. Perspective views down a street are familiar in northern Italian and Venetian compositions (the plunging orthogonals remind us of Mantegna's architecture in the St. James Led to Martyrdom fresco [FIG. 16-63]), and the figures standing on a fretted balcony, which slow the swift recession of the

18-29 MICHAEL PACHER, St. Wolfgang Forces the Devil to Hold His Prayerbook, panel from the Altar of the Fathers of the Church, c. 1481. Tempera and oil on wood, approx. 40" × 37". Alte Pinakothek, Munich.

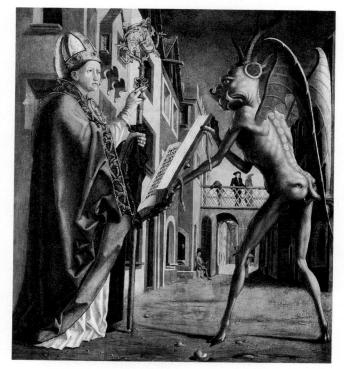

18-30 MARTIN SCHONGAUER, St. Anthony Tormented by the Demons, c. 1480–1490. Engraving, approx. $13'' \times 11''$. Metropolitan Museum of Art, New York (Rogers Fund, 1920).

perspective to the horizon, are another Italian Renaissance trait. Only the gargoylish Devil tells us that the Gothic is still very much in the northern environment.

In Germany, where printing with movable type was developed, we would expect the graphic arts to be well represented by competent masters, and indeed, MARTIN SCHONGAUER (c. 1450-1491) was the century's most skilled and subtle northern master of the new metal engraving technique. The process of printing pictures from woodblocks was developed in Europe around 1400 (the Chinese had known the technique centuries before) and remained popular, especially for book illustration, well into the 1500s. But engraving on metal surfaces-begun, as we have seen, in the 1430s and well developed by 1450proved a much more flexible technique and, in the second half of the century, widely replaced the woodcut. Schongauer's St. Anthony Tormented by the Demons (FIG. 18-30) shows both the versatility of the medium and the artist's mastery of it. Although better known for his gentle Madonnas in a style based on that of Rogier van der Weyden, here Schongauer displays almost the same taste for the diabolical as Hieronymus Bosch; his stoic saint is caught in a revolving thornbush of spiky demons, who claw and tear at him furiously. With unsurpassed skill and subtlety, the artist makes marvelous distinctions of tonal values and textures—from smooth skin to rough cloth, from the furry and feathery to the hairy and scaly. The method of describing forms with hatching that follows the forms, probably developed by Schongauer, became standard with German graphic artists. The Italians preferred parallel hatching (compare Antonio Pollaiuolo's engraving, FIG. 16-55) and rarely adopted this method, which, in keeping with the general northern approach to art, tends to describe the surfaces of things rather than their underlying structures.

THE SIXTEENTH CENTURY

Germany

The art of northern Europe during the sixteenth century is characterized by a sudden awareness of the advances made by the Italian Renaissance and by a desire to assimilate this new style as rapidly as possible. Many artists traveled to Italy to study the new art first hand; others met it either directly, in the form of Italian artists who came to the north, or indirectly, through the numerous Italian engravings that circulated throughout northern Europe. One of the most prolific Italian engravers, Marcantonio Raimondi, rarely invented his own compositions but copied those of other artists, particularly Raphael. In this way, many panel paintings and frescoes by Italian Renaissance artists became the common property of all Europe. Naturally, the impact of Italian art varied widely, according to the artist, the time, and the place. Many artists never abandoned existing local traditions; others frequently were content to borrow only single motifs or the general form of a composition. In Germany, the wealthy merchant class maintained close commercial relations with Venice, and German Humanists were in contact with the Neo-Platonic academy of Florence. As a result, Albrecht Dürer often illustrated Florentine thought clothed in Venetian and German forms.

During the fifteenth century, painting in the wealthy towns of southern Germany developed along its own expressionistic lines under the dominant influences of Flemish art. Around the turn of the century, it suddenly burst into full bloom. By 1528, with the deaths of its two greatest exponents, Dürer and Matthias Grünewald, it had spent itself. Thus, its most brilliant period corresponds almost exactly to the High Renaissance in Italy. Its decline around 1530 was just as abrupt as its rise, and the reason for this is

18-31 Albrecht Altdorfer, The Battle of Issus, 1529. Oil on wood, $52\frac{17}{4} \times 47\frac{17}{4}$. Alte Pinakothek, Munich.

uncertain. The almost incessant religious wars devastated the German lands, and puritanism, which accompanied the triumph of Protestantism in the north, may have opposed Humanistic paganism in the figurative arts. With the exception of Hans Holbein the Younger, the main representatives of the German school were born within ten years of one another and were contemporaries of Michelangelo, Raphael, Giorgione, and Titian.

ALTDORFER AND CRANACH

ALBRECHT ALTDORFER (c. 1480–1538) is the primary representative of the *Donaustil* (Danube style), which flourished along the Danube River from Regensburg (Altdorfer's hometown) eastward into Austria. The style is formed around the depiction of landscape and stresses mood, sometimes heightened to passion. Altdorfer's own style is highly personal and only occasionally modified by the influence of Dürer. As a gifted colorist and observer of atmospheric and light effects, Altdorfer loved to paint forests and ruins, in which his figure groups are half-submerged. He painted at least one landscape without figures, making *Danube Landscape*, *Near Regensburg* (c. 1522; not shown) perhaps the first landscape in Western art painted entirely for its own sake.

His most renowned work, The Battle of Issus (FIG. 18-31), bears little resemblance to a Danube setting, although it does give a bird's-eye view of an Alpine landscape. Here, Altdorfer spreads out in awesome detail the battle in which Alexander the Great overthrew the Persian king, Darius. A huge inscription hanging in the clouds relates this. Swarms of warriors from both sides contest on a plain backed by cities, mountains, seas, and the opposed forces of nature: the sun and the moon in an illuminated sky. This sudden opening up of space, with its subordination of the human figure to the cosmic landscape, bespeaks a new view of nature-a view that will see human beings as insignificant motes in an infinite universe. We need not suppose that German artists knew of the work of the contemporary astronomer, Copernicus, who was about to revise the age-old view that the earth is fixed and to suggest instead that the earth and the other "fixed" planets revolve about the sun. It is interesting that such high-horizoned, "topographical" landscapes (we might better call them "cosmographical") anticipate the coming cosmic view that the sciences of physics and physical astronomy will open to the Western world. Altdorfer's technique is still that of the miniaturist, yet his setting is no longer a page but a world, one in which his insectlike combatants are all but lost. In this first vision of the immense space and power of the cosmos, Altdorfer seems to suggest a theme that all subsequent philosophers, scientists, and churchmen, as well as artists, will confront—the insignificance of human life.

The early works of Lucas Cranach the Elder (1472-1553) are close to the Donaustil, which immerses human beings in the breadth of nature. At Wittenberg, where he was summoned by the elector of Saxony, Cranach became a friend and follower of Luther, and he has been called the outstanding representative of German Protestant painting. His later works are marked by a shift from religious to humanistic subject matter: mythology, history, and portraits. Best known are his figure compositions featuring the nude, which he renders with a charming, provincial naïveté. A good example is The Judgment of Paris (FIG. 18-32). Here, Paris and Mercury consult, while three spindly little goddesses show off their pretty contours. One of them bashfully stands on one foot; another coquettishly calls attention to her charms; the third stands by, wearing a fashionable

18-32 LUCAS CRANACH THE ELDER, The Judgment of Paris, 1530. Oil on wood, approx. $14\frac{1}{2}'' \times 9\frac{\pi}{3}''$. Staatliche Kunsthalle, Karlsruhe, West Germany.

18-33 MATTHIAS GRÜNEWALD, The Isenheim Altarpiece (closed), Crucifixion (center panel), c. 1510–1515. Oil on wood, center panel 9' $9\frac{1}{2}'' \times 10'$ 9", each wing 8' $2\frac{1}{2}'' \times 3' \frac{1}{2}$ ", predella 2' $5\frac{1}{2}'' \times 11'$ 2". Musée d'Unterlinden, Colmar, France.

hat. Cranach makes no effort to dress his gods after the Antique manner. They wear the functional armor of German knights attached to provincial courts. Doughty and square-faced, they could have just come in from the field of honor. The background landscape reflects Cranach's earlier Donaustil in its meticulous description of foliage. And so far, only Dürer's approach to the nude (FIG. 18-36) is tutored by Italian art.

MATTHIAS GRÜNEWALD

One of the greatest individualists of the Renaissance and an artist of highly original genius is Matthias Neithardt, known conventionally as MATTHIAS GRÜNEWALD (c. 1480–1528). Forgotten until our time, he appears to have had the wide interests of the individualistic Renaissance artists. Working for the archbishops of Mainz from 1511 on as court painter and decorator, he also served them as architect, hydraulic engineer, and superintendent of works. Undoubtedly, he had Lutheran sympathies. He participated in the Peasant Revolt in 1525, and, after its collapse, had to flee to northern Germany, where he settled at Halle in Saxony. The sources of Grünewald's style are not certain. He may have been to Italy, but few indications of Renaissance Classicism appear in his art. He knew the work of Dürer and perhaps of Bosch. A brilliant colorist, he was not interested in the construction of the monumental, idealized figure in the Italian manner. His color is characterized by subtle tones and soft harmonies on the one hand and shocking dissonance on the other. Uninterested in natural landscape, Grünewald shows us either the celestial or the infernal.

In his appalling *Crucifixion* from *The Isenheim Altarpiece* (FIG. **18-33**), Grünewald gives us perhaps the most memorable interpretation of the theme in the history of art. The altar is composed of a carved wooden shrine with two pairs of movable panels, one directly in back of the other. Painted by Grünewald between 1510 and 1515 for the monastic hospital order of St. Anthony of Isenheim, the panels show three scenes, with the *Crucifixion* outermost, when the altar is closed. The dreadful aspect of the painting may be due in part to its placement in a house of the sick, where it may have admonished the inmates that Another has suffered more. It also may have had a therapeutic function, in that it offered some hope to the afflicted. Two saints are represented on the wings flanking the central panels: on the left, St. Sebastian, whose intercession was invoked to ward off disease (especially the plague); on the right, St. Anthony, the patron saint of the order, who was identified with miraculous cure. Together, the saints establish the theme of disease and healing that is reinforced by the paintings on the inner wings.

One of the main illnesses treated at the hospital was ergotism (called "St. Anthony's Fire"), a disease caused by ergot, a fungus that grows especially on rye. Although the cause of this disease was not discovered until about 1600, its symptoms (convulsions and gangrene) were well known. The gangrene often compelled amputation, and it has been noted in this connection that the two movable halves of the predella of the altarpiece, if slid apart, make it appear as if the legs of Christ have been amputated. The same observation can be made of the two main panels. Due to the off-center placement of the cross, the opening of the left center panel would "sever" one arm from the crucified figure.

Much of this symbolism may have been dictated by his patrons, but Grünewald's own inflamed imagination produced the terrible image of the suffering Christ. Against the pall of darkness lowered on the earth, the devasted body looms-dead, the flesh already discolored by decomposition and studded with the thorns of the lash. In death, the strains of the superhuman agony twist the blackening feet, tear at the arms, wrench the head to one side, and turn the fingers into crooked spikes. One has only to tense one's fingers in the position of Christ's to experience the shuddering tautness of nerves expressed in every line of the figure. No other artist has produced such an image of the dreadful ugliness of pain. The sharp, angular shapes of anguish appear in the figures of the swooning Virgin and St. John and in the shrill delirium of the Magdalene. On the other side, the gaunt, spectral form of John the Baptist stands in ungainly pose, pointing with a finger sharp as a bird's beak to the dead Christ and indicating in a Latin inscription Christ's destiny as Redeemer and his own as mere precursor: "It is fitting that he increase and I diminish." The bright, harsh, dissonant colors-black, blood-red, acid-yellow, and the dreadful green of death—suit the flat, angular shapes. Placed in a wilderness of dark mountains, the scene is relieved by a flood of glaring light that holds the figures in a tableau of awful impact.

Death and suffering seem to be the dominant themes shown by the altarpiece in its closed state. Yet

they are combined with symbols offering hope and comfort to the viewer. Behind St. John is a body of water (the river Jordan?), which signifies baptism the healing action of water, which symbolically washes away sin. (It may also refer to the growing contemporary interest in hydrotherapy, as numerous handbooks advertising local thermal and mineral baths were being published at the beginning of the sixteenth century.) The wine-red sky behind the cross evokes the blood of Christ and may symbolize the Eucharist. These references to the sacraments of baptism and the Eucharist offer the viewer the hope of salvation through the sacrifice of Christ, should earthly cures fail.

When we turn from the Good Friday of the *Crucifixion* to the Easter Sunday of the *Resurrection* (FIG. **18-34**), an inner panel of *The Isenheim Altarpiece*, the mood changes from disaster to triumph. Christ, in a

18-34 MATTHIAS GRÜNEWALD, Resurrection, detail of the inner right panel of the first opening of The Isenheim Altarpiece. Approx. 8' $8\frac{3}{8}'' \times 4' 6\frac{3}{4}''$.

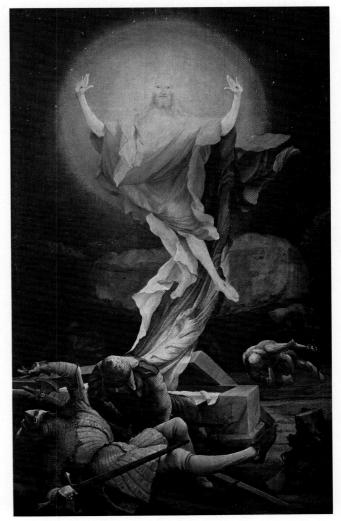

blazing aureole of light so incandescent that it dissolves his form and overwhelms the guards, rises like a great flame into the starlit heavens. The fluttering Gothic line prevails in the ascending Christ, and something of the awkward angularity of the Crucifixion scene shapes the fallen soldiers. The highly expressive light in both scenes is supernatural, not the light of common day. It is certainly not the even, flat light that models Piero della Francesca's Resurrection fresco (FIG. 16-35). Indeed, in these two pictures, we find the fundamental differences that set the German school apart from the Italian school in the Renaissance. Piero's Resurrection typically represents the event in terms of a static grouping of solidly rendered figures in a completely balanced, measured composition; the central figure of Christ stands solid as a column, one foot placed weightily on the edge of the sarcophagus. Grünewald converts everything into flowing motion; his Christ is disembodied, almost formless, and the composition has the irregularity and free form of a flaming cloud. Color determines everything here-not sculpturesque form and geometric composition, as with Piero's works. Moreover, Grünewald's intention is to render the supernatural in a bodiless way appropriate to it. Piero makes Christ as massive and corporeal as the stone sarcophagus on which he stands. From the Italian point of view, the visionary flashing and flickering of Grünewald's Resurrection must have appeared crude, formless, and utterly devoid of the order that theory, based on the study of nature and measurement, could confer.

ALBRECHT DÜRER

We know that Grünewald's great contemporary, ALBRECHT DÜRER (1471–1528), felt that much of the art of the north was crude and devoid of order and that, in comparison with Italian art, it appeared to him old-fashioned, clumsy, and without knowledge. In the introduction to an unfinished and unpublished treatise on painting, Dürer wrote:

Now, I know that in our German nation, at the present time, are many painters who stand in need of instruction, for they lack all real art theory. . . . For as much as they are so numerous, it is very needful for them to learn to better their work. He that works in ignorance works more painfully than he who works in understanding; therefore let all learn to understand art aright.

While still a journeyman, Dürer became acquainted with, and began to copy, prints by Mantegna and Pollaiuolo. Fascinated with Classical ideas, as transmitted through Italian Renaissance artists, he was the first northern artist to travel to Italy expressly to study Italian art and its underlying theories at their source. After his first journey in 1495 (he made a second trip in 1505–1506), it became his life mission to bring the modern—the Italian Renaissance—style north and establish it there. Although Dürer did not always succeed in fusing his own native German style with the Italian manner, he was the first northern artist who fully understood the basic aims of the southern Renaissance.

Dürer was also the first artist outside of Italy to become an international art celebrity. Well traveled and widely admired, he knew many of the leading Humanists and artists of his time, among them Erasmus of Rotterdam and Giovanni Bellini. A man of wide talents and tremendous energy, he became the "Leonardo of the North," achieving fabulous fame in his own time and a firm reputation ever since. Like Leonardo da Vinci, Dürer wrote theoretical treatises on a variety of subjects, such as perspective, fortification, and the ideal in human proportions. Through his prints, he exerted strong influence throughout Europe, especially in Flanders, but also in Italy. Moreover, he was the first northern artist to make himself known to posterity through several excellent self-portraits, through his correspondence, and through a carefully kept, quite detailed and immanently readable diary.

In his own time, Dürer's fame and influence depended on his mastery of the graphic arts, and we still think that his greatest contribution to Western art lies in this field. Trained as a goldsmith before he took up painting and printmaking, he developed an extraordinary proficiency in the handling of the burin, the engraving tool. This technical ability, combined with a feeling for the form-creating possibilities of line, enabled him to create a corpus of graphic work in woodcut and engraving that has seldom been rivaled for quality and number. In addition to illustrations for books, Dürer circulated and sold prints in single sheets, which people of ordinary means could buy and which made him a "people's artist" quite as much as a model for professionals. It also made him a rich man.

An early and very successful series of woodblock prints on fourteen large sheets illustrates the Apocalypse, or the Revelation of St. John, the last book of the Bible. With great force and inventiveness, Dürer represents terrifying visions of doomsday and of the omens preceding it. The fourth print of the series, *The Four Horsemen* (FIG. **18-35**), represents, from foreground to background, Death trampling a bishop, Famine swinging scales, War wielding a sword, and

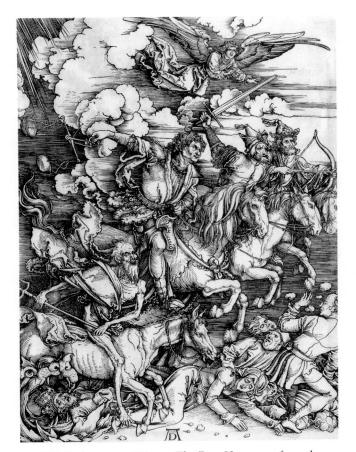

18-35 ALBRECHT DÜRER, The Four Horsemen, from the Apocalypse series, c. 1498. Woodcut, approx. $154'' \times 11''$. Metropolitan Museum of Art, New York (gift of Junius S. Morgan, 1919).

Pestilence drawing his bow. The human race, in the last days of the world, is trampled by the grim quartet.

Technically, the virtuosity of Dürer's woodcuts never has been surpassed. By adapting to the woodcut the form-following hatching from Schongauer's engravings (FIG. 18-30), Dürer converts the former's primitive contrasts of black and white into a gliding scale of light and shade, achieving a quality of luminosity never before seen in woodblock prints. *The Four Horsemen* retains some Late Gothic characteristics in the angularity of shapes and the tendency of forms to merge into one another. On the other hand, Mantegna's influence can be found in the plastic and foreshortened poses of the trampled victims in the right foreground and in the head of Famine. But despite such Italicisms, the dramatic complexity of the composition remains essentially northern.

From 1500 on, Dürer increasingly became interested in the theoretical foundations of Italian Renaissance art. An engraving of *The Fall of Man (Adam and Eve)* (FIG. **18-36**) represents the first distillation of his studies of the Vitruvian theory of human proportions. Clearly outlined against the dark background of a northern forest, the two idealized figures of Adam and Eve stand in poses reminiscent of the Apollo Belvedere and the Medici Venus—two Hellenistic statues probably known to Dürer through graphic representations. Preceded by numerous geometric drawings, in which he tried to systematize sets of ideal human proportions in balanced contrapposto poses, the final print presents Dürer's 1504 concept of the "perfect" male and female figures. Adam does, in fact, approach the southern ideal quite closely, but the fleshy Eve remains a German matron, her individualized features suggesting the use of a model. The elaborate symbolism of the background "accessories" to the main figures is also a northern trait. The choleric cat, the melancholic elk, the sanguine rabbit, and the phlegmatic ox represent the four humors of man, and the relation between Adam and Eve at the crucial moment of The Fall of Man is symbolized by the tension between cat and mouse in the foreground.

Dürer's *The Fall of Man* shows idealized forms and strongly naturalistic ones in a close combination that, depending on the viewer's attitude, may be regarded

18-36 ALBRECHT DÜRER, The Fall of Man (Adam and Eve), 1504. Engraving, approx. $10'' \times 7\frac{1}{2}''$. Centennial Gift of Landon T. Clay. Courtesy of Museum of Fine Arts, Boston.

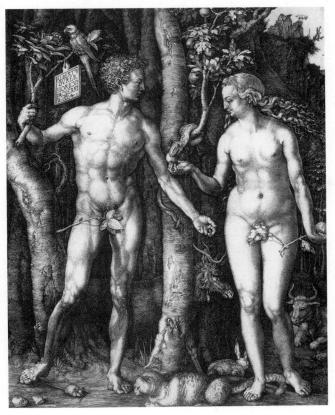

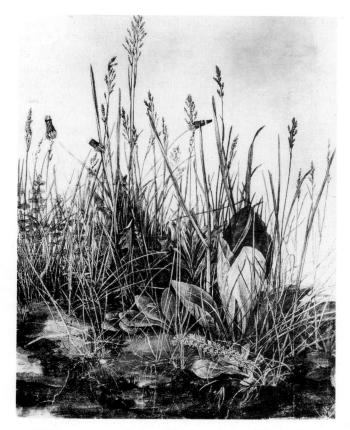

18-37 ALBRECHT DÜRER, The Great Piece of Turf, 1503. Watercolor, approx. $16'' \times 12\frac{1}{2}''$. Graphische Sammlung Albertina, Vienna.

as complementary or conflictive elements-closely allied ingredients in most of Dürer's works. Dürer agreed with Aristotle (and the new critics of the Renaissance) that "sight is the noblest faculty of man" and that "every form brought before our vision falls upon it as upon a mirror." "We regard," said Dürer, "a form and figure out of nature with more pleasure than any other, though the thing itself is not necessarily altogether better or worse." This idea is a new and important one for artists. Nature holds the beautiful, said Dürer, for him who has the insight to extract it. Thus, beauty lies even in humble, perhaps ugly things, and the ideal, which bypasses or improves on nature, may not be the truly beautiful in the end: uncomposed and ordinary nature might be a reasonable object of the artist's interest, quite as much as its composed and measured aspect. With an extremely precise watercolor study of a piece of turf (FIG. 18-37), Dürer allies himself to the scientific studies of Leonardo; for both artists, observation yields truth. Sight, sanctified by mystics like Nicholas of Cusa and artists like Jan van Eyck, becomes the secularized instrument of modern knowledge. The "mirror" that is our "vision" will later become telescope, microscope, and television screen. The remarkable *Great Piece of Turf* is as scientifically accurate as it is poetic; the botanist can distinguish each springing plant and variety of grass: dandelions, great plantain, yarrow, meadow grass, heath rush. "Depart not from nature in your opinions," said Dürer, "neither imagine that you can invent anything better. . . . for art stands firmly fixed in nature, and he who can find it there, he has it." The exquisite still life one finds in the northern paintings of the fifteenth century is irradiated with religious symbolism. Dürer's still life is of and for itself; he has found it in nature, and its representation no longer requires religious justification.

As Dürer's floral studies reveal the natural world, so he makes his portraits readings of character. The fifteenth-century portrait, like Van Eyck's *Man in a Red Turban* (FIG. 18-9) or his *Canon van der Paele* (FIG. 18-8), is a graphic description of features; Dürer's portraits, like that of *Hieronymus Holzschuher* (FIG. **18-38**), are interpretations of personality. It may be, however, that they are as much projections of Dürer's

18-38 ALBRECHT DÜRER, *Hieronymus Holzschuher*, 1526. Oil on wood, approx. $19'' \times 14''$. Gemäldegalerie, Staatliche Museen, Berlin-Dahlem.

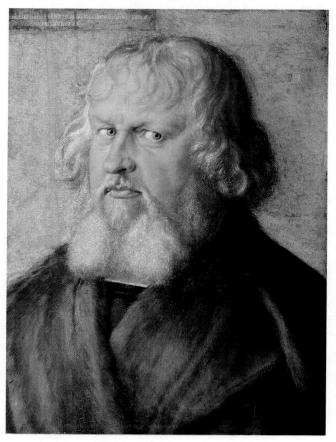

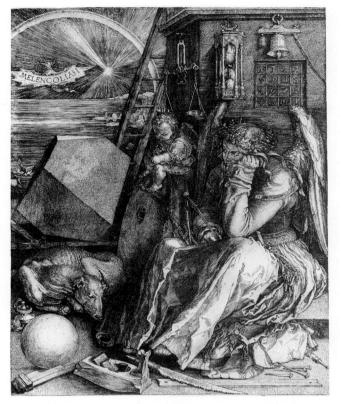

18-39 ALBRECHT DÜRER, Melencolia I, 1514. Engraving, approx. $9\frac{3}{8}'' \times 6\frac{5}{8}''$. Fogg Museum of Art, Harvard University, Cambridge, Massachusetts (bequest of Francis Calley Gray).

own personality as they are readings of his subjects', for his portraits of men all show the subject as bold and virile, square-jawed, flashing-eyed, and truculent. All the subjects appear intense and intently aware of the observer. This strong psychic relationship to the external world, when the features are precisely particularized, makes for an extremely vivid presence. Holzschuher, a friend of Dürer's and town councilor of Nuremberg, fairly bristles with choleric energy and the burly belligerence of Nuremberg citizens, who, on many an occasion, had defended the city against all comers, including the emperor himself. Leaving the background blank, except for an inscription, the artist achieves a remarkable concentration on the forceful personality of his subject. The portrait in Italy never really brings the subject into such a tense personal relationship with the observer.

Dürer always found it quite difficult to reconcile his northern penchant for precise naturalism with his intellectual, theoretical pursuits and with the demands of southern High Renaissance art for simplified monumentality. This life-long dilemma seems to be expressed in *Melencolia I* (FIG. **18-39**), one of three so-called master prints Dürer made between 1513 and 1514. These works (the other two are *Knight*, *Death*, *and the Devil* and *St. Jerome in His Study*) were probably intended to symbolize the moral, theological, and intellectual virtues. They clearly carry the art of engraving to the highest degree of excellence. Dürer used his burin to render differences in texture and tonal values that would be difficult to match even in the much more flexible medium of etching, which was developed later in the century.

The complex symbolism of Melencolia I is based primarily on concepts derived from Florentine Neo-Platonism. The instruments of the arts and sciences lie strewn in idle confusion about the seated, winged figure of Melancholy; she is the personification of knowledge that, without divine inspiration, lacks the ability to act. According to then current astrological theory, the artist, or any individual engaged in creative activity, is the subject of Saturn. Such a person is characterized by a melancholia bordering on madness that either plunges him into despondency or raises him to the heights of creative fury; Michelangelo was regarded as subject to this humor. Dürer and Michelangelo both conceived of artists (and thus of themselves) as geniuses who struggle to translate the pure idea in their minds into gross but visible matter. Thus, the monumental image of the winged genius, with burning eyes in a shaded face and wings that do not fly, becomes the symbol for divine aspirations defeated by human frailty and, in a way, is a "spiritual self-portrait of Albrecht Dürer."

Only toward the very end of his life, and in one of his very last paintings, was Dürer finally able to reconcile the two opposing tendencies of northern naturalism and southern monumentality that had struggled for dominance in his entire oeuvre. He painted The Four Apostles (FIG. 18-40) without commission and presented the two panels to the city fathers of Nuremberg in 1526 to be hung in the city hall. The work has been called Dürer's religious and political testament, in which he expresses his sympathies for the Protestant cause and warns against the dangerous times, when religion, truth, justice, and the virtues all will be threatened. The four apostles (John and Peter on the left panel; Mark and Paul on the right) stand on guard for the city. Quotations from each of their books, in the German of Luther's translation of the New Testament, are written on the frames. They warn against the coming of perilous times and the preaching of false prophets who will distort the word of God. The figures of the apostles summarize Dürer's whole craft and learning. Representing the four temperaments, or humors, of the human soul, as well as the four ages of man and other quaternities, these portraitlike characterizations of the apostles

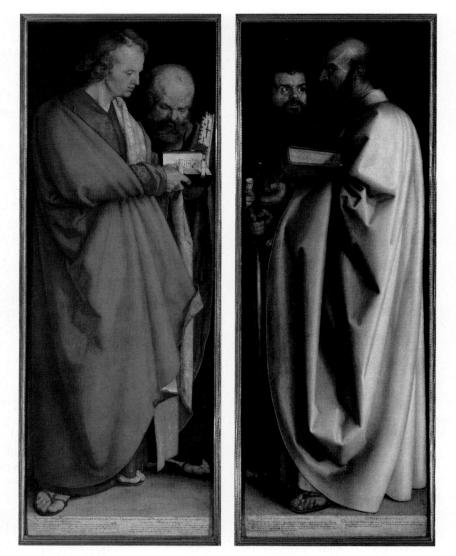

18-40 ALBRECHT DÜRER, The Four Apostles, 1526. Oil on wood, each panel 7' $1'' \times 2'$ 6". Alte Pinakothek, Munich.

have no equal in the idealized representations of Italian saints. At the same time, the art of the Italian Renaissance is felt in the monumental grandeur and majesty of the figures, which are heightened by a vivid color and sharp lighting. Here, Dürer unites the northern sense of minute realism with the Italian tradition of balanced forms, massive and simple. The result is a vindication of the artist's striving toward a new understanding—a work that stands with the greatest of the masterpieces of Italian art.

HANS HOLBEIN THE YOUNGER

What Dürer had struggled all his life to formulate and construct was achieved almost effortlessly by his younger contemporary, HANS HOLBEIN THE YOUNGER (1497–1543). Holbein's speciality was portraiture, in which he displayed a thorough assimilation of all that Italy had to teach of monumental composition, bodily structure, and sculpturesque form. He retains the northern traditions of close realism elaborated in fifteenth-century Flemish art. The color surfaces of his paintings are as lustrous as enamel; his detail, exact and exquisitely drawn; and his contrasts of light and dark, never heavy.

Holbein was first active in Basel, where he knew Erasmus of Rotterdam. Because a religious civil war was imminent in Basel, Erasmus suggested that Holbein leave for England and gave him a recommendation to Thomas More, chancellor of England under Henry VIII. Holbein did leave and became painter to the English court. While there, he painted a superb double portrait of the French ambassadors to England, Jean de Dinteville and Georges de Selve (FIG. **18-41**). The two men, both ardent Humanists, stand

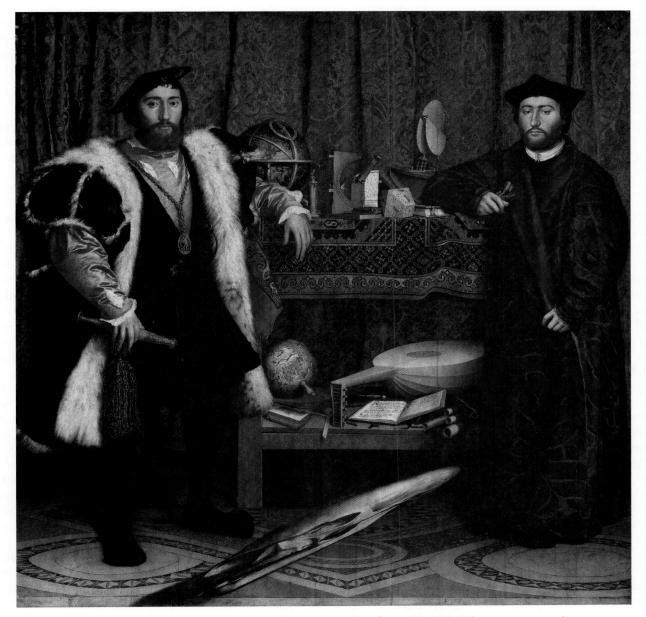

18-41 HANS HOLBEIN THE YOUNGER, The French Ambassadors, 1533. Oil and tempera on wood, approx. 6' $8'' \times 6' 9\frac{1}{2}''$. Reproduced by courtesy of the Trustees of the National Gallery, London.

at either end of a side table covered with an oriental rug and a collection of objects reflective of their interests: mathematical and astronomical models and implements, a lute with a broken string, compasses, a sundial, flutes, globes, and an open hymnbook with Luther's translation of *Veni*, *Creator Spiritus* and of the Ten Commandments. The still-life objects are rendered with the same meticulous care as the men themselves, the woven design of the deep emerald curtain behind them, and the floor tiles, constructed in faultless perspective. The stable, balanced, serene composition is interrupted only by a long, gray shape that slashes diagonally across the picture plane. This form is an *anamorphic* image that needs to be viewed by some special means (for example, reflected in a cylindrical mirror) if it is to be recognizable. In this case, the image is of a death's-head, for Holbein, like Dürer, was interested in symbolism as well as in radical perspectives. The color harmonies are adjusted in symphonic complexity and richness. The grave, even somber portraits indicate that Holbein follows the Italian portrait tradition, which gives the face a neutral expression, rather than Dürer's practice of giving it an expression of keen intensity. *The French Ambassadors* exhibits Holbein's peculiar talents: his strong sense of composition, his subtle linear patterning, his gift for portraiture, his marvelous sensitivity to color, and his faultlessly firm technique. This painting may have been Holbein's favorite; it is the only one signed with his full name.

Holbein died prematurely in 1543 and, with him, the great German school of the Renaissance. But in 1532, when he left Basel for England, he already had taken the Renaissance with him. He had no significant successors, and German art faded in the uproar of a century of religious war.

The Netherlands

The resurgence of France and the eclipse of the House of Burgundy robbed the Flemish schools of their precedence. The tremendous acclaim of Albrecht Dürer, when he visited Antwerp in 1520, indicates a reverse for Flanders; Germany, which had followed Flanders, now led developments in the north. The decay of the old Flemish tradition, both in form and content, left a void that was filled by the confusing appearance of Italian ideas, received secondhand through Dürer. As with any new, inspiring, but illunderstood fashion, a number of conflicting mannerisms arose, which, if anything, had in common only their misunderstanding of the principles behind the novel forms. This period is characterized by a great delight in decorative extravagance, in which pedantic allusion to the classics is combined with exotic settings made of piled-up fragments of Italianate ornament. For a generation or so, the north, as it has been said, "simply could not get its Renaissance on straight."

But from all this confusion, new and confident movements could begin. In a first step toward new beginnings, remnants of the Medieval tradition had to be swept away. The dominance of religious conventions yielded to experiments in subject matter and form; although religious material persisted, it no longer prevailed in art. We have seen how religious themes were modified by humanization over a period of more than a century; now they had to share the artist's interest in portraiture, mythology, landscape, and genre. The structural basis for a new, Humanistic realism had been introduced by the great German painters. It was on this foundation that an international, European art, dealing primarily with human interests, had to be built.

Changing views and attitudes were accompanied by a geographical shift in the region's commercial center. Partly as a result of the silting-up of the Bruges estuary, traffic was diverted to Antwerp, which became the hub of economic activity in the Low Countries after 1510. By mid-century, a jealous Venetian envoy had to admit that more business was transacted in Antwerp in a few weeks than in a year in Venice. As many as five hundred ships a day passed through Antwerp's harbor, and large trading colonies from England, Germany, Italy, Portugal, and Spain established themselves in the city.

QUENTIN METSYS

Antwerp's growth and prosperity, along with the propensity of its wealthy merchants for collecting and purchasing art, attracted artists to the city. Among them was QUENTIN METSYS (c. 1465-1530), who became Antwerp's leading master after 1510. Son of a Louvain blacksmith, Metsys may have been largely self-taught, which would explain, in part, his susceptibility to outside influences and his willingness to explore the styles and modes of a variety of models, from Van Eyck to Bosch, and from Van der Weyden to Dürer and Leonardo. Yet his eclecticism was subtle and discriminating and enriched by an inventiveness that gave a personal stamp to his paintings and made him a popular as well as important artist. Quentin Metsys represents both the bad and the good aspects of early sixteenth-century Flemish art in its struggle to shed fifteenth-century traditions in favor of a more "modern" Renaissance mode of expression.

Metsys painted The St. Anne Altarpiece for the Louvain Brotherhood of St. Anne between 1507 and 1509. Its central panel (FIG. 18-42) shows a stable and orderly grouping of figures before a triple-vaulted loggia, through which a finely painted distant landscape can be seen. The round-arched architecture, complete with tie-rods and a central dome, seems functional enough (except for the rectangular window, which intrudes illogically into the hemispheric dome), but it has little to do with Italian Renaissance architecture, which Metsys evidently tried to emulate. In this respect, he was no more successful than his Romanist contemporaries, whose attempts to provide their paintings with "modern" (Italian Renaissance) settings produced little more than architectural fantasies. On the other hand, the triple loggia effectively unifies the solemn, softly draped figures, whose heads are grouped in three inverted triangles. The compression of the composition may have been inspired by one of the late paintings of Hugo van der Goes, and the calm serenity of the scene evokes memories of Hans Memling's paintings (FIG. 18-18). But these and other possible sources of inspiration are thoroughly assimilated and synthesized by Metsys into a personal style. The regularized composition and the light coloration of his forms produce a tapestry-like effect that is decorative and memorable.

Metsys's explorations of the past are liberally mixed with forward-looking genre and moralizing subjects to give his oeuvre a highly diversified aspect. The variety of his inventions provides a bridge from the fifteenth into the sixteenth century and makes

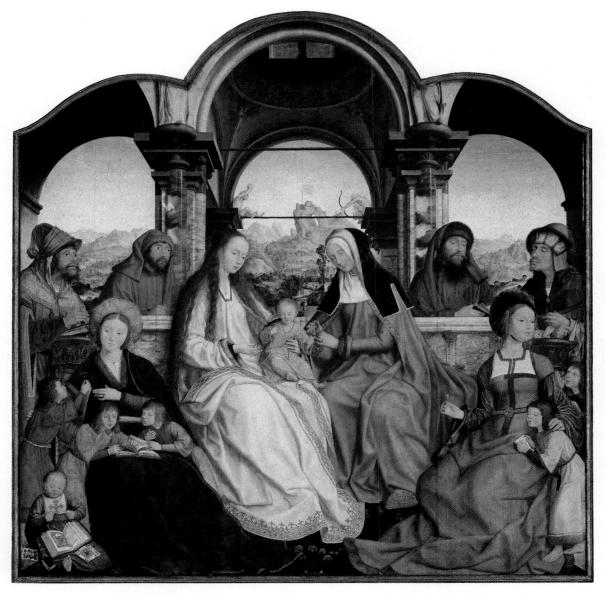

18-42 QUENTIN METSYS, The St. Anne Altarpiece, center panel, 1507–1509. Oil on wood, 7' 4¹/₂" × 7' 2¹/₄". Musées Royaux des Beaux-Arts de Belgique, Brussels.

him an influential inspiration to many of his contemporaries.

JAN GOSSAERT

More single-minded, although no more successful than Metsys in his exploration of Italian Renaissance art, was JAN GOSSAERT (c. 1478–1535), who worked for the later Philip of Burgundy, associated with Humanist scholars, and visited Italy. There, Gossaert (who adopted the name MABUSE, after his birthplace of Maubeuge) became fascinated with the Antique and its mythological subject matter. Giorgio Vasari, the Italian historian and Gossaert's contemporary, wrote that "Gossaert was almost the first to bring the true method of representing nude figures and mythologies from Italy to the Netherlands," although it is obvious that he derived much of his Classicism from Dürer.

The composition and poses in Gossaert's *Neptune* and Amphitrite (FIG. **18-43**) are borrowed from Dürer's Adam and Eve (FIG. **18-36**), although Gossaert's figures have been inflated, giving an impression of ungainly weight. The artist approximates the Classical stance but seems to have been more interested in nudity than in a Classical, ideal canon of proportions. The setting for the figures is a carefully painted architectural fantasy that illustrates a complete lack of understanding of the Classical style. Yet the painting is executed with traditional Flemish polish, and the figures are skillfully drawn and modeled. Although Gossaert also painted religious subjects in the traditional style, attempting unsuccessfully to outshine the fifteenth-

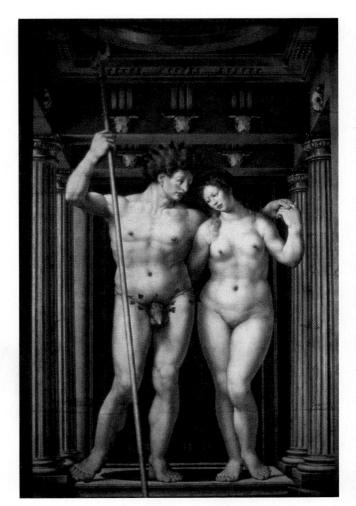

18-43 JAN GOSSAERT (MABUSE), Neptune and Amphitrite,
c. 1516. Oil on wood, 7' 2" × 4' 1". Gemäldegalerie,
Staatliche Museen, Berlin-Dahlem.

century Flemish masters, his *Neptune and Amphitrite* aligns him firmly with the so-called Romanists, in whose art Italian Mannerism joins with fanciful native interpretations of the Classical style to form a highly artificial, sometimes decorative, and often bizarre and chaotic style.

BARTHOLOMEUS SPRANGER

Much more the Romanist than Jan Gossaert, the Netherlandish painter BARTHOLOMEUS SPRANGER (1546–1611) exaggerates the stylistic peculiarities of Italian Mannerism almost to the point of caricature. Spranger traveled widely in Italy and France, studying a variety of pictorial styles that ranged from those of Jacopo da Pontormo and Parmigianino to the painters of the school of Fontainebleau (FIG. 18-49). What he learned from them merged with his earlier training in the Netherlands to form a highly sophisticated and imaginative style.

For the connoisseur Emperor Rudolph II, whose court painter he became at Prague, Spranger fashioned such classically learned, intricately composed, and suggestively erotic pictures as Hercules and Omphale (FIG. 18-44), a work much to the taste of his bachelor patron. Hercules was enslaved by the beautiful Omphale, who garbed him in the attributes of womanhood. Here, he wears women's satins and jewels and does women's work, spinning with distaff and spindle. His massive wrist is braceleted, and his hand is bent in an effeminate movement. Behind him, an ugly hag makes the gesture of cuckoldry. The nude Omphale, her form androgynous (the emperor had a penchant for the epicene), smiles coquettishly over her shoulder. She carries Hercules' club and wears his lion's skin teasingly. Spranger's themes, lascivious and pagan, find their appropriate vehicle of expression in Italian Mannerism. The Manneristic traits are all here: the gliding, bending, turning poses; the constricted space; the crowded surface; the bright, decorative colors. Worldly, sensuous, and ornamental, these pictures express a luxurious, courtly taste that contrasts markedly with the reverent art of the bourgeois towns in which the Netherlandish master painters worked.

18-44 BARTHOLOMEUS SPRANGER, Hercules and Omphale, c. 1598. Paint on copper, $9_4^{1''} \times 7_2^{*''}$. Kunsthistorisches Museum, Vienna.

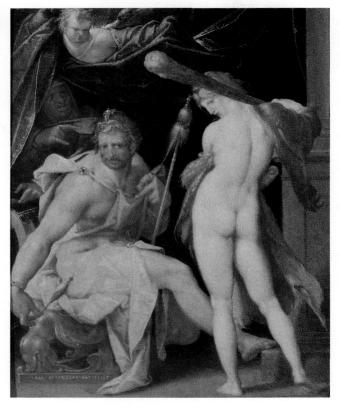

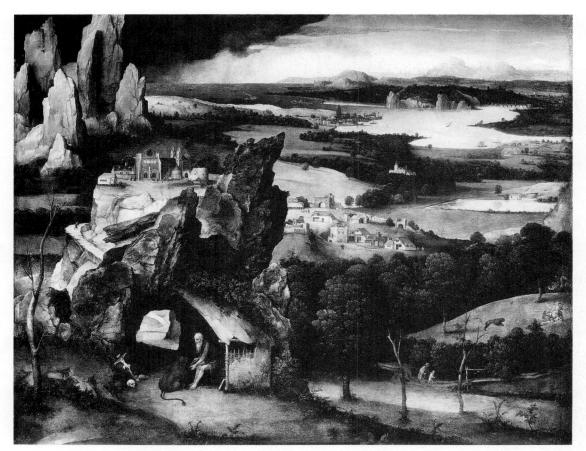

18-45 JOACHIM PATINIR, Landscape with St. Jerome, с. 1520 (?). Oil on wood, $30'' \times 36''$. Museo del Prado, Madrid.

JOACHIM PATINIR

An outstanding representative of a very different trend in sixteenth-century Flemish art is JOACHIM PATINIR (1475-1524), the first Netherlandish landscape painter and the counterpart of the German Albrecht Altdorfer. A highly valued specialist in this field, Patinir often collaborated with other artists, letting them paint figures into his landscapes. Little is known of his background, and, although no definite links can be established between the two artists, Bosch may well have provided the initial inspiration for Patinir's panoramic vistas. Significantly, however, the landscapes in Bosch's paintings are of secondary importance and serve only as broad stages on which his figures perform their fantastic frolics; in Patinir's works, the landscapes take on primary importance, and the figures become mere accessories.

In his *Landscape with St. Jerome* (FIG. **18-45**), the insignificant figure of Patinir's title saint is almost hidden in the left middle ground. The vast panorama is seen from a mountaintop, and the artist works like a cartographer, building up his landscape in strips or layers parallel to the picture plane. The effect of recession is achieved by the careful diminution of familiar things (houses, trees, figures) and by the emphatic use of aerial perspective, in which the generally warm foreground colors shift to greens in the middle distance and to cool blues in the far distance. Realism is confined to the description of details. Plants are painted with botanical accuracy, and trees and rock formations are rendered with great feeling for their textural differences. The rich multiplicity of Patinir's paintings, with activity almost everywhere, is drawn together by a strong design and an extremely effective dark–light pattern. The tiny figures scattered throughout his landscape effectively contrast human frailty and the power of nature.

PIETER BRUEGEL THE ELDER

A similar interest in the interrelationship of human beings and nature is expressed in the works of the greatest and most original Flemish painter of the sixteenth century, PIETER BRUEGEL THE ELDER (*c.* 1525– 1569), whose early, high-horizoned, "cosmographical" landscapes probably were influenced by Patinir. But in Bruegel's paintings, no matter how huge a slice

18-46 PIETER BRUEGEL THE ELDER, Hunters in the Snow, 1565. Oil on wood, approx. $46'' \times 64''$. Kunsthistorisches Museum, Vienna.

of the world he shows, human activities remain the dominant theme. Bruegel was apprenticed to a "Romanist," Pieter Coecke, and, like many of his contemporaries, traveled to Italy, where he seems to have spent almost two years, going as far south as Sicily. Unlike his contemporaries, however, Bruegel was not overwhelmed by Classical art, and his Italian experiences are reflected only incidentally in his paintings, usually in the form of Italian or Alpine landscape features that he recorded in numerous drawings made during his journey. On his return from Italy, Bruegel was exposed to Bosch's works, and the influence of that strange master, strongly felt in Bruegel's early paintings, must have swept aside any Romanist inclinations he may have had.

Hunters in the Snow (FIG. **18-46**) is one of five surviving paintings of a series of six in which Bruegel illustrated seasonal changes in the year. It shows human figures and landscape locked in winter cold. The weary hunters return with their hounds, wives build fires, skaters skim the frozen pond, the town and its church huddle in their mantle of snow, and beyond this typically Flemish winter scene lies a bit of alpine landscape. Aside from this trace of fantasy, however, the landscape is realistic and quite unlike Patinir's. It develops smoothly from foreground to background and draws the viewer diagonally into its depths. The artist's consummate skill in the use of line and shape and his subtlety in tonal harmony make this one of the great landscape paintings in history and an Occidental counterpart of the masterworks of classical Chinese landscape.

Bruegel, of course, is not simply a landscapist. In his series of the months, he presents—in a fairly detached manner, occasionally touched with humor human activities at different times of the year. And he chooses for his purpose the social class that is most directly affected by seasonal changes, the peasantry. But usually Bruegel is much more personal as he makes satirical comments on the dubious human

18-47 PIETER BRUEGEL THE ELDER, *The Peasant Dance, c.* 1567. Oil on wood, approx. $45'' \times 65''$. Kunsthistorisches Museum, Vienna.

condition. His meaning in specific cases is often as obscure as Bosch's, and he seems to delight in leading us into his pictures through devious paths and confronting us with mystery, with an appalling revelation. As a vehicle for his sarcasm, he again chooses the peasant, whom he sees as an uncomplicated representative of humanity—a member of society whose actions and behavior are open, direct, and unspoiled by the artificial cultural gloss that disguises but does not alter the city dweller's natural inclinations.

These good countryfolk are shown enjoying themselves in *The Peasant Dance* (FIG. **18-47**), which is no mincing quadrille, but a boisterous, whirling, hoedown in which plenty of sweat is shed. One can almost hear the feet stomping to the rhythm of the bagpipe. With an eye much more incisive than any camera lens, the artist grasps the entire scene in its most characteristic aspect and records it in a broad technique that discards most of the traditional Flemish concern for detail. Strong but simplified modeling emphasizes the active, solidly drawn silhouettes, which, combined with strong local colors, give the painting the popular robustness so suited to its sub-

ject. From the hilltop that he shared with the Hunters, Bruegel descends into the village to look more closely at its life and amusements, and he finds that all is not well in this rustic paradise. A fight is brewing at the table on the left; everyone's back is turned to the church in the background; nobody is paying the least attention to the small picture of a Madonna tacked to the tree on the right; the man next to the bagpiper is wearing the feather of a peacock (a symbol of vanity) in his cap; and what about the young couple kissing unashamedly in public in the left middle ground? Is Bruegel telling us, like Bosch in his Hell (FIG. 18-21), that music is an instrument of the Devil and a perverter of morals? A closer inspection of the painting reveals that Bruegel is telling much more than the simple story of a country festivity. He is showing that a kermess, a festival celebrating a saint, has become a mere pretext for people to indulge their lust, anger, and gluttony.

Toward the end of his life, Bruegel's commentary on the human condition takes on an increasingly bitter edge. The Netherlands, racked by religious conflict, had become the seat of cruel atrocities, made even more cruel by the coming of the power of Catholic Spain to put down the Reformation. We do not know whether Bruegel took sides; like the great satirist he was, he may have preferred to make all mankind, not just partisans, the object of his commentary. His secret meanings may be explained partly by the danger of too much outspokenness. His biographer, Karel van Mander* (1548–1606), writes:

Many of Bruegel's strange compositions and comical subjects one may see in his copper engravings . . . he supplied them with inscriptions which, at the time, were too biting and too sharp, and which he had his wife burn during his last illness, because of . . . fear that most disagreeable consequences might grow out of them.

Bruegel knew well how to disguise his intent—so well that in his day he was called "Peter the Droll," because, as Van Mander writes, "there are very few works from his hand that the beholder can look at seriously, without laughing."

France

Divided and harried during the fifteenth century, France was reorganized by decisive kings and was strong enough to undertake an aggressive policy toward her neighbors by the end of the century. Under the rule of Francis I, the French held a firm foothold in Milan and its environs. The king eagerly imported the Renaissance into France, bringing Leonardo da Vinci and Andrea del Sarto to his court, but they left no permanent mark on French art. It was Florentine Mannerists like Rosso Fiorentino and Benvenuto Cellini who implanted the Italianate style that replaced the Gothic in France. Francis's attempt to glorify the state and himself meant that the religious art of the Middle Ages finally was superseded, for it was the king and not the Church who now held power.

A portrait of *Francis I* (FIG. **18-48**), painted by JEAN CLOUET (*c.* 1485–1541) in the Franco-Italian manner, shows a worldly prince magnificently bedizened in silks and brocades, wearing a gold chain, and caressing the pommel of a dagger. One would not expect the king's talents to be directed to spiritual matters, and legend has it that the "merry monarch" was a great lover and the hero of hundreds of "gallant" situations. The flat light and suppression of modeling give equal emphasis to head and costume, so that the king's finery and his face enter equally into the effect

18-48 JEAN CLOUET, Francis I, c. 1525–1530. Tempera and oil on wood, approx. 38" × 29". Louvre, Paris.

of royal splendor. Yet, despite this Mannerist formula for portraiture, the features are not entirely immobile; the faintest flicker of an expression that we might read as "knowing" lingers on the king's features.

The personal tastes of Francis and his court must have run to an art at once suave, artificial, elegant, and erotic. The sculptors and painters working together on the decoration of the new royal palace at Fontainebleau, under the direction of Florentines Rosso and FRANCESCO PRIMATICCIO (1504-1570), are known as the school of Fontainebleau. Rosso became the court painter of Francis I shortly after 1530. In France, his style no longer showed the turbulent harshness of Moses Defending the Daughters of Jethro (FIG. 17-40) but became consistently more elegant and graceful. When Rosso and Primaticcio decorated the Gallery of Francis I at Fontainebleau, they combined painting, fresco, imitation mosaic, and stucco sculpture in low and high relief (FIG. 18-49). The abrupt changes in scale and texture are typically Mannerist, as is the composition of the central painting, which shows Venus Reproving Love in compressed Mannerist space with elongated grace and mannered poses. The same artificial grace can be seen in the stucco relief figures of Hermes and caryatids flanking the central

^{*}Karel van Mander's *Het Schilderboeck (The Painter's Book)* was published in Haarlem in 1604. It contains a section with biographies of Netherlandish and German painters that is the northern equivalent of Giorgio Vasari's *Vite*.

18-49 Rosso Fiorentino and Francesco Primaticcio, Venus Reproving Love, c. 1530–1540. Gallery of Francis I, Fontainebleau, France.

painting, and the viewer is jarred by the shift in scale between the painted and the stucco figures. However, the combination of painted and stucco relief decorations became extremely popular from this time on and remained a favorite decorative technique throughout the Baroque and Rococo periods.

It has been said of Francis I that, besides women, his one obsession was building. During his reign, which lasted from 1515 to 1547, several large-scale châteaux were begun, among them the Château de Chambord (FIG. 18-50), on which construction was started in 1519. Reflecting the more peaceful times, these châteaux, developed from the old countryside fortresses, served as country houses for royalty, and usually were built near a forest, for use as hunting lodges. The plan of Chambord, originally drawn by a pupil of Giuliano da Sangallo, imposes Italian concepts of symmetry and balance on the irregularity of the old French fortress. A central square block with four corridors, in the shape of a cross, leads to a broad, central staircase that gives access to groups of rooms-ancestors of the modern suite of rooms or apartments. The square plan is punctuated at each of the four corners by a round tower, and the whole is surrounded by a moat. From the exterior, Chambord presents a carefully contrived horizontal accent on three levels, its floors separated by continuous moldings. Windows are placed exactly over one another.

This matching of horizontal and vertical features is, of course, derived from the Italian palazzo, but above the third level, the lines of the structure break chaotically into a jumble of high dormers, chimneys, and lanterns that recall soaring, ragged, Gothic silhouettes on the skyline.

18-50 Château de Chambord, France, begun 1519.

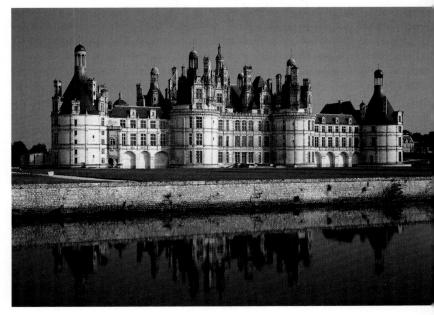

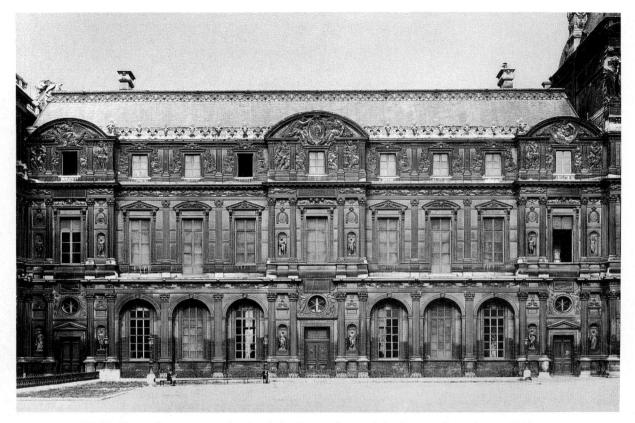

18-51 PIERRE LESCOT, west façade of the Square Court of the Louvre, Paris, begun 1546.

The architecture of Chambord is still French at heart. During the reign of Francis's successor, Henry II (1547-1559), however, treatises by Italian architects were translated and Italian architects came to work in France; at the same time, the French turned to Italy for study and travel. This interchange brought about a more thoroughgoing revolution in style, although it never eliminated certain French elements that persisted from the Gothic tradition. Francis began the enlargement of the Louvre in Paris (FIG. 18-51) to make a new royal palace, but he died before the work was well begun. His architect, PIERRE LESCOT (1510–1578), continued under Henry II and, with the aid of the sculptor JEAN GOUJON (c. 1510-1565), produced the Classical style of the French Renaissance. Although Chambord incorporated the formal vocabulary of the Early Renaissance, particularly from Lombardy, Lescot and his associates were familiar with the High Renaissance of Bramante and his school. Each of the stories of the Louvre forms a complete order, and the cornices project enough to furnish a strong horizontal accent. The arcading on the ground story reflects the ancient Roman arch-order and is recessed enough to produce more shadow than in the upper stories, strengthening the visual base of the design. On the second story, the pilasters

rising from bases and the alternating curved and angular pediments supported by consoles have direct antecedents in several Roman High Renaissance palaces. On the other hand, the decreased height of the stories, the proportionately much larger windows (given the French weather!), and the steep roof are northern. Especially French are the pavilions that jut from the wall. These are punctuated by a feature that the French will long favor-double columns framing a niche. The vertical lines of the building remain strong. The wall is deeply penetrated by openings and (in un-Italian fashion) profusely sculptured. This French Classical manner-double-columned pavilions, tall and wide windows, profuse statuary, and steep roofs-will be imitated widely in other northern countries, with local variations. The mannered Classicism produced by the French will be the only Classicism to serve as a model for northern architects through most of the sixteenth century. The west courtyard façade of the Louvre is the best of French Renaissance architecture; eventually, the French will develop a quite native Classicism of their own, cleared of Italian Mannerist features.

The statues of the Louvre courtyard façade, now much restored, are the work of Goujon. We can appreciate the quality of Goujon's style best by examin-

18-52 JEAN GOUJON, Nymphs, from the dismantled Fountain of the Innocents, Paris, 1548–1549. Marble reliefs. Louvre, Paris.

ing his *Nymphs* reliefs from the Fountain of the Innocents in Paris (FIG. **18-52**). Like the architecture of the Louvre, Goujon's nymphs are intelligent and sensitive French adaptations of the Italian Mannerist canon of figure design. Certainly, they are Mannerist in their ballet-like contrapposto and in their flowing, clinging draperies, which recall the ancient "wet" drapery of Hellenic sculpture—the figures on the parapet of the Temple of Athena Nike (FIG. 5-57), for example. Goujon's slender, sinuous figures perform their steps within the structure of Mannerist space, and it is interesting that they appear to make one continuous motion, an illusion produced by reversing the gestures, as they might be seen in a mirror. The style of Fontainebleau, and ultimately of Primaticcio

and Cellini, guides the sculptor here, but Goujon has learned the manner so well that he can create originally within it. The nymphs are truly French masterpieces, with lightness, ease, grace, and something of a native French chic that saves them from being mere lame derivatives of the Italian Mannerist norm.

In France, as in all of Europe in the sixteenth century, the influence of Italian art was direct and overpowering. But as the century progressed, native French artists adapted the new elements to the strong Gothic traditions and created a distinctively French expression. An example of this maturing style is seen in the works of the sculptor GERMAIN PILON (*c.* 1535– 1590), who made his reputation with monumental tomb sculpture, especially that he created for the

18-53 GERMAIN PILON, Descent from the Cross, 1583. Bronze relief, $19'' \times 32\frac{1}{2}''$. Louvre, Paris.

monument of Henry II and Catherine de' Medici in St. Denis, Paris. Like Goujon and other French sculptors, Pilon began in the Fontainebleau style, emphasizing artifice in pose and gesture and graceful, sinuous contour. Gradually, his style changed as he made contact with the still strong tradition of Late Gothic realism. A bronze relief, Descent from the Cross (FIG. 18-53), recalls monumental compositions of Rogier van der Weyden (FIG. 18-12) and the master of The Avignon Pietà (FIG. 18-24). Unlike them, Pilon shows the influence of Mannerism in the great, elongated, muscular Christ; like them, he expresses a quiet yet profound pathos that Mannerism could not convey sincerely. The realistic element appears in the very staging of the drama. The Virgin, consoled by a holy woman, is removed from the center of the action. Those in authority stand at the head and feet of Christ. Pilon presents a curiously steady, almost serene reading of the emotions of those portrayed. The curving lines of the draperies have lost the angularity of the Gothic but are not arranged in the contrived patterns of Mannerism. Pilon, from a fusion of the old tradition with the new fashion, has risen to a bold statement of his own-a statement that makes use of both while transcending them in a moving, personal interpretation of the Medieval theme.

Spain

In some respects, the sixteenth century is the Spanish century. Under Charles V of Hapsburg and his son, Philip II, the Spanish Empire dominated a territory greater in extent than any ever known: a large part of Europe, the western Mediterranean, a strip of North Africa, and vast expanses in the newly discovered Western Hemisphere. The Hapsburg empire, enriched by the plunder of the New World, supported the most powerful military force in Europe, which backed the ambitions and the ventures of the "Most Catholic Kings." Spain defended and then promoted the interests of the Catholic church in its battle against the inroads of the Protestant Reformation. What we call the Catholic Counter-Reformation was funded, directed, fought for, and then enforced by Spain. By force and influence—by the preaching and the propaganda of the newly founded Spanish order of the Society of Jesus (the Jesuits)-Spain drove Protestantism from a large part of Europe and sponsored the internal reform of the Catholic church at the great Council of Trent. The Spaniards humbled France; trampled the Netherlands; reclaimed much of Germany, Poland, and Hungary for Catholicism; and held England at bay (until the end of the century), while they converted the native empires of the New World to the Catholic faith and destroyed them in a relentless search for treasure. The material and the spiritual exertions of Spain-the fanatical courage of Spanish soldiers and the incandescent fervor of the great Spanish mystical saints-went together. The former became the terror of the Protestant and pagan worlds, while the latter served as the inspiration of the Catholic faithful. The crusading spirit of Spain, nourished by centuries of war with Islam, engaged body and soul in the formation of the most Catholic

civilization of Europe and the Americas. In the sixteenth century, for good or for ill, Spain left the mark of Spanish power, religion, language, and culture on two hemispheres.

Yet Spain, like all of Europe at this time, came under the spell of Renaissance Italy; Spanish architecture especially shows that influence, but not all at once. During the fifteenth century and well into the sixteenth, a Late Gothic style of architecture, the Plateresque, prevailed side by side with buildings influenced by Italy. ("Plateresque" is derived from the Spanish platero, meaning silversmith, and is applied to the style because of the delicate execution of its ornament.) The Colegio de San Gregorio (FIG. 18-54) in the Castilian city of Valladolid handsomely exemplifies the Plateresque manner. The Spanish were particularly fond of great carved retables, like the German altar screens that influenced them (FIGS. 18-27 and 18-28)—so much so that they made them a conspicuous decorative feature of their exterior architecture, dramatizing a portal set into an otherwise blank wall. The Plateresque entrance of San Gregorio is a lofty, sculptured stone screen that bears no functional relation to the architecture behind it. On the entrance level, ogival, flamboyant arches are hemmed with lacelike tracery reminiscent of Moorish design. A great screen, paneled into sculptured compartments, rises above the tracery; in the center, the coat of arms of Ferdinand and Isabella is wreathed by the branches of a huge pomegranate tree (symbolizing Granada, the Moorish capital of Spain, captured by the "Catholic Kings" in 1492). Cupids play among the tree branches, and, flanking the central panel, niches enframe armed pages of the court, heraldic wildmen, and armored soldiers, attesting to the new, proud militancy of the united kingdom of Spain. In typical Plateresque and Late Gothic fashion, the whole design is unified by the activity of a thousand intertwined motifs, which, in sum, create an exquisitely carved panel greatly expanded in scale.

A sudden and surprising Italianate Classicism makes its appearance in the unfinished palace of Charles V in the Alhambra in Granada (FIG. 18-55), the work of the painter-architect PEDRO MACHUCA (active 1520–1550). The circular central courtyard is ringed with superposed Doric and Ionic orders, which support continuous horizontal entablatures rather than arches. Ornament consists only of the details of the orders themselves, which are rendered with the simplicity, clarity, and authority we find in the work of Bramante and his school. The lower story recalls the ring colonnade of the Tempietto (FIG. 17-6), although here, of course, the curve is reversed. This pure Classicism, entirely exceptional in Spain at this time, may be a reflection of Charles V's personal

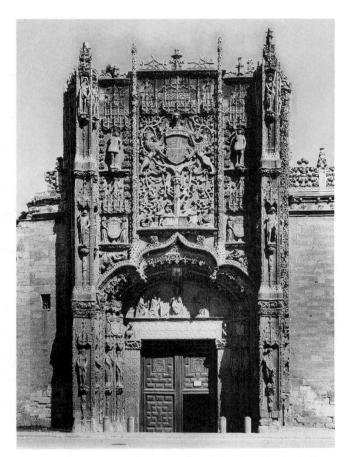

18-54 Portal, Colegio de San Gregorio, Valladolid, Spain, c. 1498.

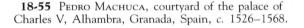

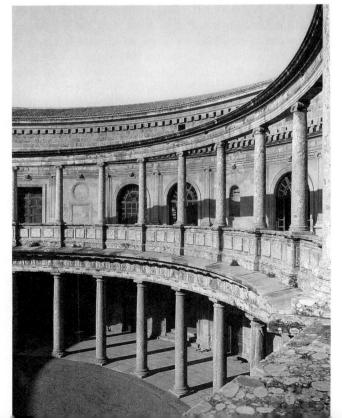

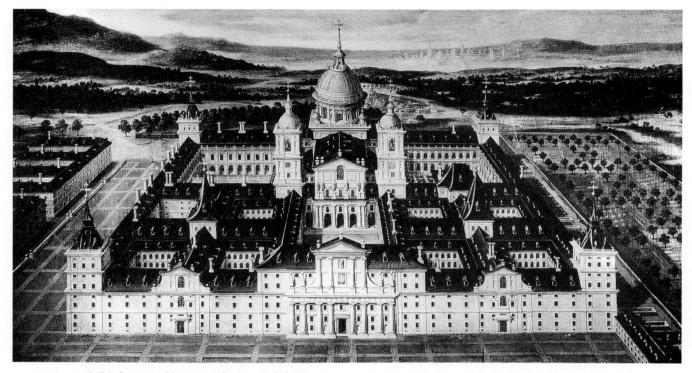

18-56 JUAN DE HERRERA, the Escorial (bird's-eye view after an anonymous eighteenth-century painting), near Madrid, Spain, c. 1563–1584.

taste, acquired on one of his journeys to Italy. (It should be remembered that the emperor was an enthusiastic patron of Titian.) Machuca himself had sojourned in Italy, and the courtyard may be the consequence of his endeavor to revive this feature of the ancient Classical palace.

But the Spanish spirit of the time seemed to disdain the ideal purity of feature and correctness of proportion sought in Classical design. Spanish builders seemed to feel a need to do something different with what was received from Italy. What could be done is visible in the great complex called the Escorial (FIGS. 18-56 to 18-58), which was constructed for Philip II by Juan Bautista de Toledo (d. 1567) and Juan DE HERRERA (1530-1597), principally the latter. The king, perhaps the greatest in Spanish history, must have had much to do with the design. Certainly Philip and his architects collaborated closely. The whole vast structure is in keeping with his austere and conscientious character, his passionate Catholic religiosity, his proud reverence for his dynasty, and his stern determination to impose his will worldwide. Philip wrote to Herrera to outline what he expected from him: "Above all, do not forget what I have told you-simplicity of form, severity in the whole, nobility without arrogance, majesty without ostentation." The result is a Classicism of Doric severity, ultimately derived from Italian architecture and with the grandeur of St. Peter's implicit in the scheme, but unique in Spanish and European architecture—a style inimitably of itself, even though later structures will reflect it.

In his will, Charles V stipulated that a "dynastic pantheon" be built to house the remains of past and future monarchs of Spain. Philip II, obedient to his father's wishes, chose a site some thirty miles northwest of Madrid, in rugged terrain with barren mountains. Here, he built the Escorial, not only a royal mausoleum, but a church, a monastery, and a palace. Legend has it that the gridlike plan for the enormous complex, 625 feet wide and 520 feet deep, was meant to symbolize the gridiron on which St. Lawrence, patron of the Escorial, was martyred.

The long sweep of the severely plain walls of the complex is broken only by the three entrances, with the dominant central portal framed by superposed orders and topped by a pediment in the Italian fashion. The corners of the wall are punctuated by massive square towers. The stress on the central axis, with its subdued echoes in the two flanking portals, forecasts the three-part organization of later Baroque palace façades. Like the whole complex of buildings, the domed-cross church, with similarly heavy towers, is constructed of granite, expressing, in its grim starkness of mass, the obdurate quality of a material most difficult to work. The massive façade of the

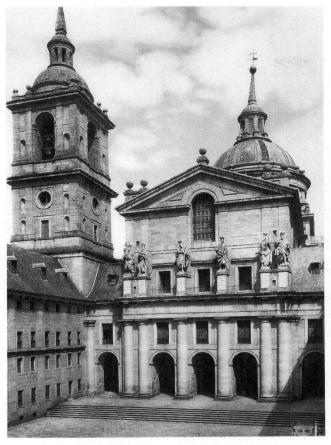

18-57 JUAN DE HERRERA, the Escorial, façade of church.

18-58 JUAN DE HERRERA, the Escorial, interior of church.

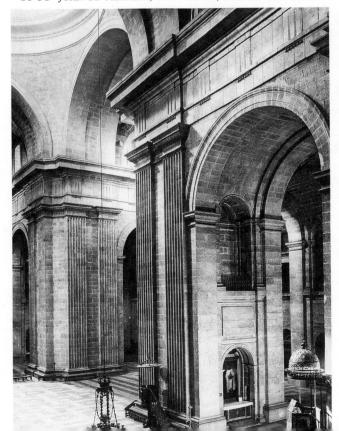

church (FIG. 18-57) and the austere geometry of its interior, with its blocky walls and ponderous arches (FIG. 18-58), dominate the Classical forms, producing an effect of overwhelming strength and weight that contradicts the grace and elegance we associate with much of the Renaissance architecture of Italy.

The Escorial is a monument to the collaboration of a great king and a remarkably understanding architect, who made of it an original expression of a unique idea and personality—the embodiment of the stern virtues of a monarch, a realm, and an age conscious of their peculiar power and purpose. The visitor to the Escorial is awed by the overpowering architectural expression of the spirit of Spain in its heroic epoch and of the character of Philip II, the extraordinary monarch who directed it.

EL GRECO

There appear to be two sides to the Spanish genius in the period of the Counter-Reformation: fervent religious faith and ardent mysticism, on the one hand, and an iron realism on the other. St. Theresa of Ávila and St. John of the Cross can be considered representative of the first; the practical St. Ignatius of Loyola, founder of the Jesuit order, represents the latter. It is possible for the two tempers to be found in the same persons and works of art, but it is more common to find them apart. Interestingly enough, a painter of foreign extraction was able to combine them in a single picture.

Kyriakos Theotokopoulos (c. 1547–1614), called EL GRECO, was born in Crete but emigrated to Italy as a young man. In his youth, he was trained in the traditions of Late Byzantine frescoes and mosaics. While still young, El Greco went to Venice, where he was connected with the shop of Titian, although Tintoretto's painting seems to have made a stronger impression on him. A brief trip to Rome explains the influences of Roman and Florentine Mannerism on his work. By 1577, he had left for Spain to spend the rest of his life in Toledo.

El Greco's art is a strong, personal blending of Late Byzantine and Late Italian Mannerist elements. The intense emotionalism of his paintings, which naturally appealed to the pious fervor of the Spanish; the dematerialization of form; and a great reliance on color bind him to sixteenth-century Venetian art and to Mannerism. His strong sense of movement and use of light, however, prefigure the Baroque. El Greco's art is not strictly Spanish (although it appealed to certain sectors of that society), for it had no Spanish antecedents and little effect on later Spanish painters. Nevertheless, the paintings of this hybrid genius interpret Spain for us in its Catholic zeal and yearning spirituality. This statement is especially true

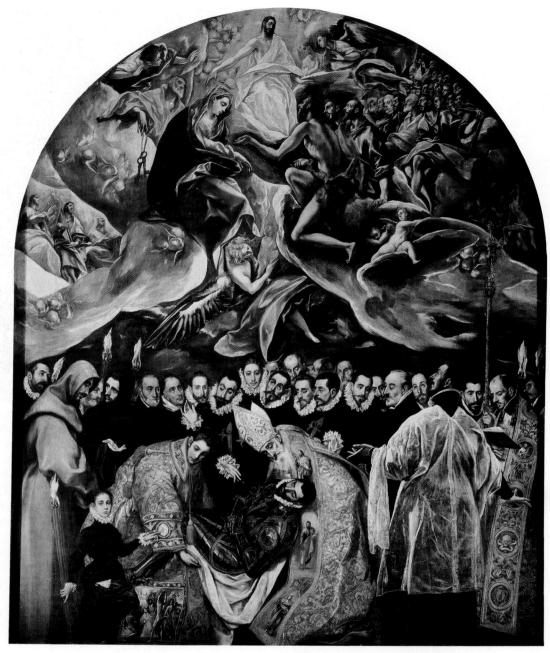

18-59 EL GRECO, The Burial of Count Orgaz, 1586. Oil on canvas, approx. $16' \times 12'$. Santo Tomé, Toledo, Spain.

of the artist's masterpiece, *The Burial of Count Orgaz* (FIG. **18-59**), painted in 1586 for the church of Santo Tomé in Toledo. The theme illustrates the legend that the Count of Orgaz, who had died some three centuries before and who had been a great benefactor of the church of Santo Tomé, was buried in the church by Saints Stephen and Augustine, who miraculously descended from heaven to lower the count's body into its sepulcher. The earthly scene is irradiated by the brilliant heaven that opens above it, as El Greco

carefully distinguishes the terrestrial and celestial spheres. The terrestrial is represented with a firm realism; the celestial, in his quite personal manner, is shown with elongated, undulant figures, fluttering draperies, cold highlights, and a peculiar kind of ectoplasmic, swimming cloud. Below, the two saints lovingly lower the count's armor-clad body, the armor and heavy draperies painted with all the rich sensuousness of the Venetian school. The background is filled with a solemn chorus of black-clad Spanish grandees, in whose carefully individualized features El Greco shows us that he was also a great portraitist. These are the faces that looked on the greatness and glory of Spain when it was the leading power of Europe—the faces of the *conquistadores*, who brought Spain the New World and who, two years after this picture was completed, would lead the Great Armada against both Protestant England and Holland.

The lower and upper spheres of the painting are linked by the upward glances of the figures below and by the flight of an angel above, who carries the soul of the count in his arms as St. John and the Virgin intercede for it before the throne of Christ. El Greco's deliberate change in style to distinguish between the two levels of reality gives the viewer the opportunity to see the artist's early and late manners in the same work, one above the other. The relatively sumptuous and realistic presentation of the earthly sphere is still strongly rooted in Venetian art, but the abstractions and distortions that El Greco uses to show the immaterial nature of the Heavenly realm will become characteristic of his later style. Pulling Heaven down to earth, he will paint worldly inhabitants in the same abstract manner as celestial ones. His elongated figures will exist in undefined spaces, bathed in a cool light of uncertain origin. For this, El Greco has been called the last and greatest of the Mannerists, but it is difficult to apply that label to him without reservations. Although he used Manneristic formal devices, El Greco was not a rebel, nor was he aiming for elegance in his work. He was concerned primarily with emotion and with the effort to express his own religious fervor or to arouse the observer's. To make the inner meaning of his paintings forceful, he developed a highly personal style in which his attenuated forms become etherealized in dynamic swirls of unearthly light and color. Some ambiguity may be found in El Greco's forms, but none exists in his meaning, which is mystical, spiritual, ecstatic devotion.

Toward the end of his life, El Greco painted a portrait of his friend, the theologian, poet, and Trinitarian priest, *Fray Hortensio Félix Paravicino* (FIG. **18-60**). It is one of the most distinguished portraits of the age. Father Hortensio, clad in the black-and-white vesture of his order, is represented seated, which,

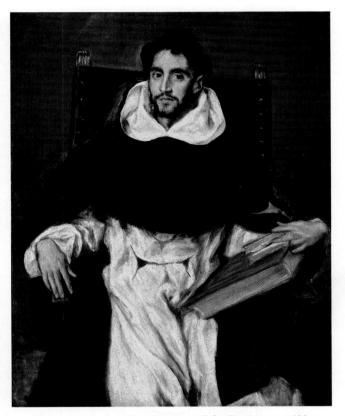

18-60 EL GRECO, Fray Hortensio Félix Paravicino, 1609. Oil on canvas, $44\frac{17}{2} \times 33\frac{37}{4}$. Isaac Sweetser Fund, Museum of Fine Arts, Boston.

since the time of Raphael, was the customary pose used in portraits of ecclesiastics of high rank. In his left hand, he holds books, attributes of intellectual dedication and accomplishment. The vividly contrasting black and white of his canonicals and the square-backed leather chair, with its gilt bronze studs and finials, magnificently set off the pale, ascetic face, accented by the dark hair, eyebrows, and beard. El Greco renders the character of a man given wholly to other-worldly concerns as a kind of apparition not quite of this world. The likeness fades into the image of a typical El Greco saint. As is often the case when a great painter makes the likeness of a great-souled subject, the latter becomes more than an individual person. He becomes, as here, generalized into a type, that of the spiritually exalted priest, protagonist in the drama of Spanish history in its great century.

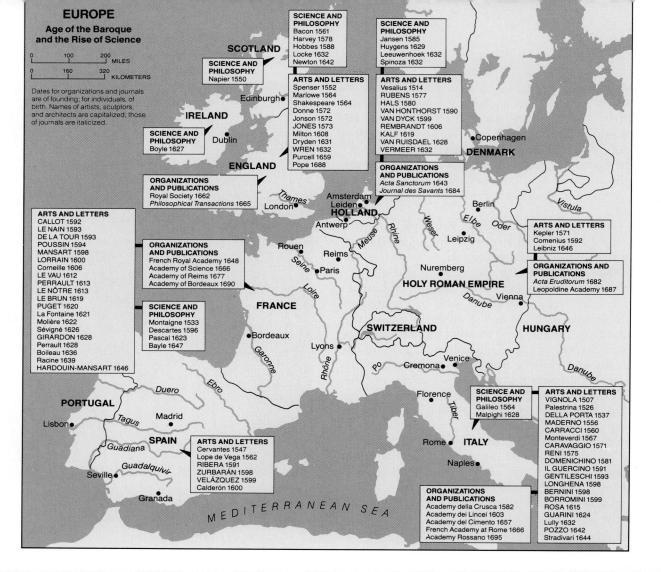

1600	16	510	1620	1	630	1640	1650	
	JAMES I OF ENGLAND CHARLES			RLESIOFENGLAND				
PHILIP III OF SPAIN				PHILIP IV OF SPAIN				
HENRY IV OF FRANCE LOUIS XIII OF FRA			ANCE (dominated by Cardinal Richelieu)					
GIACOMO DE I Gesù façade c. 1575–1584	1581- ELLA PORTA	IICHINO -1641 JONI		ion Hunt, 1617–1618 RIBERA 1591–1652 P 15	20USSIN 594–1665	ZURBARÁN St. Francis in Meditation c. 1639 juite juite Killem Coymans, detail 1645		
	Pope 1605-	Paul V -1621 Kepler's law planetary m 1609, 1619			Ŀ	Galileo's laws of falling bodies, projectile motion 1638 Descartes's <i>Discourse</i> on Method 1637	French Royal Academy of Painting and Sculpture founded 1648 Thirty Years' War ends 1648	

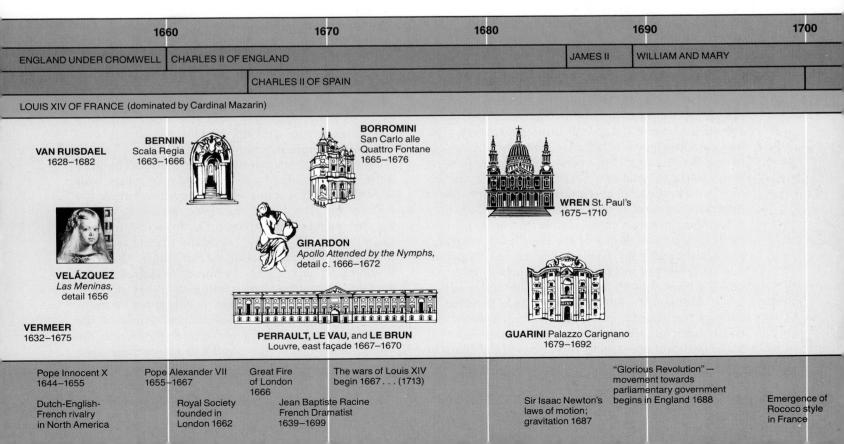

HE GENERAL PERIOD WE have labeled "Renaissance" continues without any sharp stylistic break (except for the interrupting episode of Mannerism) into the seventeenth and eighteenth centuries. We call the art of this later period Baroque, although no one Baroque style or set of stylistic principles actually has been defined. The origin of the word is not clear. It may come from the Portuguese word *barroco*, meaning an irregularly shaped pearl. Certainly, the term originally was used in a disparaging sense, especially in connection with post-Renaissance architecture, which nineteenth-century critics perceived as decadent Classical: unstructural, overornamented, theatrical, and grotesque. The use of "Baroque" as a pejorative has faded, however, and the term has been included in the art-historical vocabulary for many years as a blanket designation for the art of the period roughly covering 1600 to 1750.

Scholars gradually came to see that the Baroque styles were quite different from those of the Renaissance. The Baroque, for example, looks dynamic; Renaissance styles are relatively static. This basic difference led to the claim that the two are fundamentally in opposition; scholars still disagree about the historical and formal relation of the two stylistic periods, especially since it is clear that the Classicism of the High Renaissance is restored and flourishes in the Baroque. The historical reality lies in the flow of stylistic change, and Baroque is a useful classification for isolating the tendencies and products of stylistic change. We shall designate as Baroque those traits that the styles of the seventeenth and earlier eighteenth centuries seem to have in common.

Like the art it produced, the Baroque era was manifold—spacious and dynamic, brilliant and colorful, theatrical and passionate, sensual and ecstatic, opulent and extravagant, versatile and *virtuoso*. It was an age of expansion following on an age of discovery, and its expansion led to still further discovery. The rising national powers colonized the globe. Wars between Renaissance cities were supplanted by wars between continental empires, and the history of Europe was influenced by battles fought in the North American wilderness and in India.

Baroque expansiveness extended well beyond earth in the conceptions of the new astronomy and physics proposed by Galileo, Kepler, and Newton. The same laws of mechanics were found to govern a celestial body moving at great velocity and a falling apple. Humanity's optical range was expanding to embrace the macroscopic spaces of the celestial world and the microscopic spaces of the cellular. The Baroque is almost obsessively interested in the space of the unfolding universe. Descartes makes extension (space and what occupies it) the sole physical attribute of being; only mind and extension exist, the former proving the reality of the latter in Descartes's famous phrase, *Cogito, ergo sum* (I think, therefore I am). Pascal confesses in awe that "the silence of these infinite spaces frightens me." Milton expresses the Baroque image of space in a phrase: "the vast and boundless deep."

The Baroque scientist comes to see physical nature as matter in motion through space and time; the latter two are thought of as the conditions of the first. The measurement of motion is made possible by the new mathematics of analytical geometry and the infinitesimal calculus, and experiment comes to be accepted as the prime method for getting at the truth of physical nature. Time, like space and motion, is a preoccupation of the creative Baroque mind, in art as well as in science. The age-old sense of time, rich with religious, philosophical, psychological, and poetic import, persists alongside the new concept of it as a measurable property of nature. Time, "the subtle thief of youth" that steals away the lives of all of us; that, in the end, reveals the truth, vindicates goodness, and rescues innocence; that demolishes the memory of great empires; and that points to the ultimate judgment of humankind by God-this sense of time pervades the art and literature of the Baroque. The sonnets of Shakespeare dwell on the mutability and brevity of life and on time's destruction of beauty ("that time will come/and take my love away"). The great landscapes of Van Ruisdael suggest the passage of time in hurrying clouds, restless sea, and everchanging light. Painters and sculptors, eager to make action explicit and convincing, depict it at the very moment it is taking place, as in Bernini's David (FIG. 19-10). Countless allegorical representations portray time as the fierce old man carrying his scythe or devouring his children. For the Baroque artist, then, time has acquired its new "scientific" connotations of the instantaneous and the infinite, yet without any loss of its significance for each human life.

Scarcely less fascinating to the Baroque mind is light. Light, which for thousands of years was thought of and worshiped as the godlike sun or the truth of the Holy Spirit, now becomes a physical entity, propagated in waves (or corpuscles) through Pascal's "infinite spaces," capable of being refracted into color by a prism. But, as with time, the newfound materiality of light by no means diminishes its ancient association with spirituality in the religion, poetry, and art of the Baroque. It still stands for inspiration, truth of dogma, the mystical vision of the transcendental world, the presence of the Divine, the "inner light" (FIG. 19-12). And it can have these associations in a commonplace setting or in one of splendor and magnificence (FIG. 19-9). Yet the age of the new science, adapting the old metaphor of light to the dawn of a new day, would be called the "Enlightenment," signifying that the old, dark, mythical way of reading the world has been given up and that the light of knowledge brings a new day. Alexander Pope, expressing the enthusiasm of his day for the discoveries of Newton, makes them out to be a kind of second revelation:

Nature, and Nature's laws lay hid in night. God said: "Let Newton be!" and all was Light!

The elements of perception in naturalistic Baroque art are the elements of nature described by Baroque science: matter in motion through space, time, and light. And the ingredients of an increasingly precise method for the scientific study of nature observation and measurement, representation and experimental testing—are analogous to the naturalistic artist's careful study and reproduction of natural appearances.

Although the exclusive and exacting report of these elements is a most important enterprise in the age of the Baroque, the mechanical simulation of appearances for its own sake is by no means the naturalistic artist's intention. Although each artist obviously delights in the achievement of astonishing illusion, the images that are rendered embody spiritual and metaphysical meanings of nature so persuasively real and present that their significance and truth are strongly reinforced. In this way, the artist brings before us the reality of the unseen world by means of the seen, the visible objects that are regarded as symbolic or emblematic of invisible and unchanging truth. Baroque naturalism remains largely religious in content.

While naturalism thrived in Baroque art, Classicism was revised and further developed, and the two styles divided the taste of the age with a third: the dynamic, colorful, sensuous style characteristic of Rubens and Bernini. The differences among these three styles were not so definitive as to disallow exchanges of influence or even occasional collaboration, although the esthetic doctrines or presuppositions of naturalism were fundamentally opposed to those of the other two, and the French Academy could debate the virtues of the Classical (formalistic) Poussin over the coloristic Rubens. Art theory flourished, and most of it was on the side of Classicism. The cause of Classicism also was favored by an increasing antiquarian literature, the fruit of an expanding enthusiasm for ancient civilization and art and an increasingly sophisticated and systematic study of it. The Classical masters of the Baroque took as their models the great artists of the High Renaissance, Antique statuary, and nature; artists of whatever stylistic bent often were learned in Classical literature and antiquities. Although the Classical masters' philosophy of art proclaimed the ideal rather than the real as the only worthy subject and form for painting and sculpture, they believed that study of nature was essential to the full and valid realization of the idea in its purity and perfection. This concept was manifest in their insistence on the careful observation and depiction of the human figure from life.

Nevertheless, the opposition of Classicism to the dramatic dynamism of painters like Rubens becomes conscious and fixed in the Baroque. This dualism will hold well into the nineteenth and even the twentieth century. Indeed, it reaches through the entire Western tradition, exclusive of the Middle Ages; an ancient statement of it may be seen in the art of Greece and Rome (compare FIGS. 5-50 and 5-78). Classicism in art and thought amounts to calm rationality; we see it in the landscapes of Poussin (FIG. 19-61). Its opposite-turbulent action stirred by powerful passions-(later, we shall call it "Romanticism") appears in the painting of Rubens (FIG. 19-41) and in the sculpture of Bernini (FIG. 19-12). A central theme of Baroque art and literature is the conflict of reason with passion. The representation of that conflict is, of course, as ancient as Plato and survives as a great dualism in Western thinking about human nature.

The exploration of the elementary structure of physical nature is accompanied, quite consistently, by the exploration of human nature, the realm of the senses and the emotions. The function of the representational arts is to open that realm to full view. The throwing open to human scrutiny of the two physical universes of macrocosm and microcosm did not distract Baroque humanity from the age-old curiosity about the nature of humankind. After all, it was now perceived that if we are one with nature, the knowledge of ourselves must be part of the knowledge of nature. The new resources given to Baroque artists allow them to render, with new accuracy and authority, the appearances of the world and of the beings that people it. Painting and sculpture, equipped with every device of sensuous illusion now available, provide a stage for the enactment of the drama of human life in all its variety. Baroque is preeminently the age of theater. Art shares with the actor's stage the purpose (as Shakespeare puts it in Hamlet)

to hold, as 'twere, the mirror up to nature, to show virtue her own feature, scorn her own image, and the very age and body of the time his form and pressure. (III:2)

Shakespeare urges us to present and analyze the spectrum of human actions and passions in all its degrees of lightness, darkness, and intensity. In this

great era of the stage, tragedy and comedy are reborn. At the same time, the resources of music greatly expand, creating the opera and refining the instruments of the modern orchestra. All the arts approve the things of the senses and the delights of sensuous experience. Although here and there the guilty fear of pleasure lingers from the times of Hieronymus Bosch, poetry and literature in all countries acquire a richly expressive language capable of rendering themes that involve the description, presentation, conflict, and resolution of human emotions. In the Catholic countries, every device of art is used to stimulate pious emotions-sometimes, to the pitch of ecstasy. Luxurious display and unlimited magnificence and splendor frame the extravagant life of the courts, cost notwithstanding; the modes of furniture and dress are perhaps the most ornate ever designed. Even in externals, a dramatic, sensuous elaborateness is the rule. However, what people wear and what they do must approach perfection, with the added flourish of seeming effortlessness. Courtiers, at one end of Baroque society, and brigands and pirates at the other, are brilliant performers, as are those who fashion the arts and the sciences. All are virtuosi, proud of their technique and capable of astonishing quantities of work.

ITALY

The age of the Baroque has been identified with the Catholic reaction to the advance of Protestantism. Although it extends much more widely in time and place than seventeenth-century Italy and is by no means only a manifestation of religious change, Baroque art doubtless had papal Rome as its birthplace. Between the pontificates of Paul III (Farnese) from 1534 to 1549 and of Sixtus V (Peretti) in the 1580s, the popes led a successful military, diplomatic, and theological campaign against Protestantism, wiping out many of its gains in central and southern Europe. The great Council of Trent, which met in the early 1540s and again in the early 1560s, was sponsored by the papacy in an effort to systematize and harden orthodox Catholic doctrine against the threat of Protestant persuasion. The Council firmly resisted Protestant objection to the use of images in religious worship, insisting on their necessity in the teaching of the laity. This implied separation of the priest from an unsophisticated congregation was to be reflected in architecture as well, the central type of church plan being rejected in favor of the long church and of other plans that maintained the distinction between clergy and laity; an example is the addition of the nave to the central plan of Bramante and Michelangelo for St. Peter's (FIGS. 19-3 and 19-6).

Interrupted for a while, the building program begun under Paul III (with Michelangelo's Capitoline Hill design) was taken up again by Sixtus V, who had augmented the papal treasury and who intended to construct a new and more magnificent Rome, an "imperial city that had been subdued to Christ and purged of paganism." Sixtus was succeeded by a number of strong and ambitious popes-Paul V (Borghese), Urban VIII (Barberini), Innocent X (Pamfili), and Alexander VII (Chigi)-the patrons of Bernini and Borromini and the builders of the modern city of Rome, which bears their Baroque mark everywhere. The energy of the Catholic Counter-Reformation, transformed into art, radiated throughout Catholic countries and even into Protestant lands, which found a response to it in their own art.

Architecture and Sculpture

The Jesuit order, newly founded (in 1534, in the pontificate of Paul III), needed an impressive building for its mother church. Because Michelangelo was dilatory in providing the plans, the church, called Il Gesù (Church of Jesus, FIG. **19-1**), was designed and built between 1568 and 1584 by GIACOMO DA VIGNOLA (1507–1573), who designed the ground plan, and GIACOMO DELLA PORTA (1537–1602), who is responsible for the façade. Chronologically and stylistically,

19-1 GIACOMO DELLA PORTA, façade of Il Gesù, Rome, c. 1575–1584. Interior by GIACOMO DA VIGNOLA, 1568. (Engraving by JOACHIM VON SANDRART.)

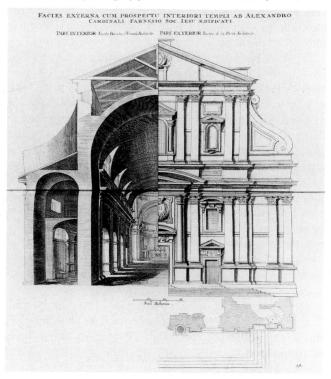

the building belongs to the Late Renaissance, but its enormous influence on later churches marks it as one of the major seminal monuments for the development of Baroque church architecture. Its façade is an important model and point of departure for the facades of Roman Baroque churches for two centuries, and its basic scheme is echoed and reechoed throughout the Catholic countries, especially in Latin America. The design of the façade is not entirely original; the union of the lower and upper stories, effected by scroll buttresses, goes back to Leon Battista Alberti's Santa Maria Novella in Florence (FIG. 16-39); its Classical pediment is familiar in Alberti and Andrea Palladio; and its paired pilasters appear in Michelangelo's design for St. Peter's. But the façade is a skillful synthesis of these already existing motifs; the two stories are well unified, the horizontal march of the pilasters and columns builds to a dramatic climax at the central bay, and the bays of the façade snugly fit the navechapel system behind them. The many dramatic Baroque façades of Rome will be architectural variations on this basic theme.

In plan (FIG. **19-2**), a monumental expansion of Alberti's scheme for Sant' Andrea in Mantua (FIG. 16-43), the nave takes over the main volume of space, so that the structure becomes a great hall with side chapels. The approach to the altar is emphasized by a dome. The wide acceptance of the Gesù plan in the Catholic world, even until modern times, seems to attest that it is ritually satisfactory. The opening of the church building into a single great hall provides an almost theatrical setting for large promenades and processions (that seemed to combine social with sac-

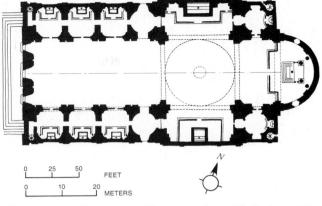

19-2 GIACOMO DA VIGNOLA, plan of Il Gesù.

erdotal functions) and, above all, a space adequate to accommodate the great crowds that gathered to hear the eloquent preaching of the Jesuits. The Jesuits had a strong, indirect influence on art and architecture through the teachings of Saint Ignatius of Loyola, their Spanish founder. Loyola, in his *Spiritual Exercises*, advocated that the spiritual experience of the mysteries of the Catholic faith be intensely imagined, so much so as to be visible to the eye. The content of faith was to be visualized, and the sacred objects of the Church were to be venerated as defenses against false doctrine and the powers of Hell. This is still the function and warranty of religious art throughout the Roman Catholic world.

The great Baroque project in Rome was the completion of St. Peter's (FIG. **19-3**). Bramante's and Michelangelo's central plan was unsatisfactory to the clergy

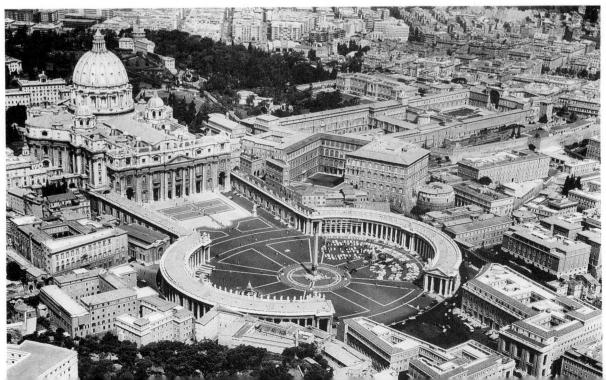

19-3 Aerial view of St. Peter's, the Vatican, Rome.

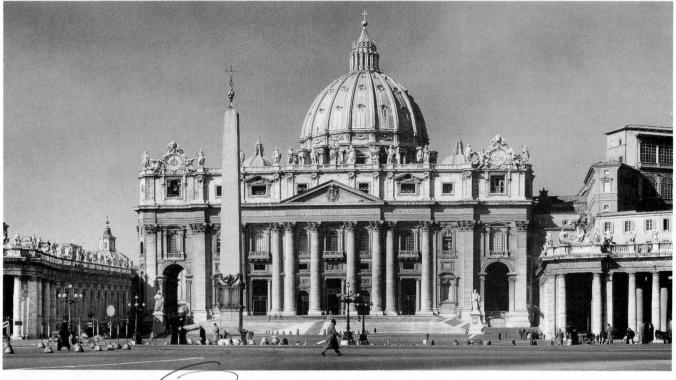

19-4 CARLO MADERNO, façade of St. Peter's, 1606-1612.

of the seventeenth century, who thought it smacked of paganism and who felt it was inconvenient for the ever-growing assemblies. Under Paul V, CARLO MADERNO (1556–1629) was commissioned to add three bays of a nave to the earlier nucleus and to provide the building with a façade (FIG. **19-4**). Before he received the St. Peter's commission, Maderno had designed the façade of Santa Susanna (FIG. **19-5**), concentrating and dramatizing in it the major features of the façade of II Gesù. Strong shadows cast by the vigorously projecting columns and pilasters of Santa Susanna mount dramatically toward the emphatically stressed central axis; the sculptural effect is enhanced by the recessed niches, which contain statues.

The façade of St. Peter's (FIG. 19-4) is a gigantic expansion of the elements of Santa Susanna's first level, but Maderno overextends his theme, and the compactness of Santa Susanna's façade is lost. The elements are spread too wide, and the quickening rhythm of pilasters and columns from the sides toward the center becomes slack. The role of the central pediment is reduced to insignificance by the façade's excessive width. In fairness to Maderno, it must be pointed out that his design for the façade never was completely executed. The two outside bays are the first stages of two flanking towers, which never were built; their vertical accents might have visually compressed the central part of the façade. As it stands,

this unfinished, watered-down frontispiece is criticized almost universally by artists and historians and has, unfortunately, become the dominant feature of the church's exterior. Lengthening the nave moves the façade outward and away from the dome, and the effect that Michelangelo had planned—a structure pulled together and dominated by its dome—is seriously impeded. When viewed at close range, the dome hardly emerges above the soaring cliff of the façade; seen from farther back, it appears to have no drum. One must go back beyond the piazza to see the dome and drum together and to experience the effect that Michelangelo intended. Today, to see the structure as it was originally planned, it must be viewed from the back (FIG. 17-33).

BERNINI

The design of St. Peter's, which had been evolving since the days of Bramante and Michelangelo and had engaged all of the leading architects of the Renaissance and Baroque periods, was completed (except for details) by Gianlorenzo Bernini (1598–1680). Bernini was an architect, a painter, and a sculptorone of the most brilliant and imaginative artists of the Baroque era and, if not the originator of the Baroque style, probably its most characteristic and sustaining spirit. Bernini's largest and most impressive single project was the design for a monumental piazza in front of St. Peter's (FIGS. 19-3 and 19-6). In much the way that Michelangelo was forced to reorganize the Capitoline Hill, Bernini had to adjust his design to some preexisting structures on the site: an ancient obelisk brought from Egypt and a fountain designed by Maderno. He used these features to define the long axis of a vast oval embraced by colonnades that are joined to the façade of St. Peter's by two diverging wings. Four files of huge Tuscan columns make up the two colonnades, which terminate in severely Classical temple fronts. The dramatic gesture of embrace made by the colonnades (FIG. 19-3) symbolizes

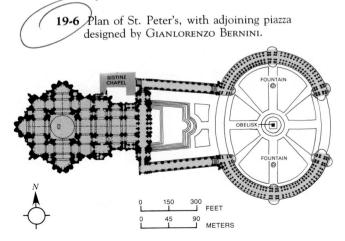

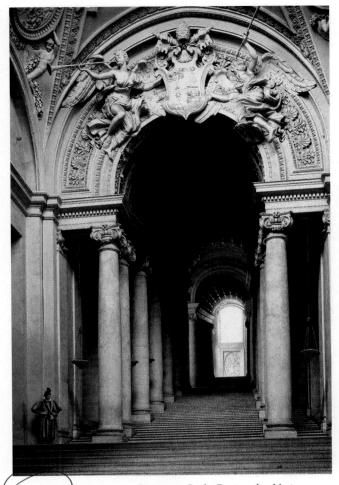

19-7 CIANLORENZO BERNINI, Scala Regia, the Vatican, Rome, 1663–1666.

the welcome given its communicants by the Roman Catholic church. Thus, the compact, central designs of Bramante and Michelangelo are expanded by a Baroque transformation into a dynamic complex of axially ordered elements that reach out and enclose spaces of vast dimension. Where the Renaissance building stood in self-sufficient isolation, the Baroque design expansively relates it to its environment.

The wings that connect St. Peter's façade with the oval piazza flank a trapezoidal space also reminiscent of the Capitoline Hill, but here the latter's visual effect is reversed; as seen from the piazza, the diverging wings counteract the natural perspective and tend to bring the façade closer to the observer. Emphasizing the façade's height in this manner, Bernini subtly and effectively compensates for its excessive width.

The Baroque delight in illusionistic devices is expressed again in the Vatican in the Scala Regia (FIG. **19-7**), a monumental stairway connecting the papal apartments and the portico and narthex of the

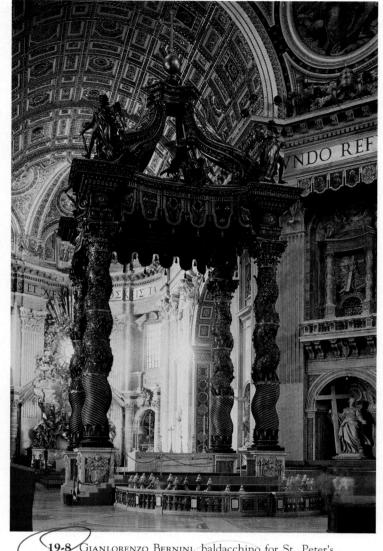

19-8 GIANLORENZO BERNINI, baldacchino for St. Peter's, 1624–1633. Gilded bronze, approx. 100' high.

church. Because the original passageway was irregular, dark, and dangerous to descend, Pope Alexander VII commissioned Bernini to replace it. Bernini, like Michelangelo at the Campidoglio, here makes architectural virtue of necessity by using illusionistic techniques characteristic of stagecraft. The stairway, its entrance crowned by a sculptural group of trumpeting angels and the papal arms, is covered by a barrel vault (in two stages) carried on columns that form aisles flanking the central corridor. By gradually reducing the distance between columns and walls as the stairway ascends, Bernini actually eliminates the aisles on the upper levels, while creating an illusion of uniformity of width and continuity of aisle for the whole stairway. At the same time, the space between the colonnades also narrows with ascent, reinforcing the natural perspective and making the stairs appear to be longer than they actually are. To minimize this

effect, Bernini made the lighting at the top of the stairs brighter, exploiting the natural human inclination to move from darkness toward light. To make the long ascent more tolerable, he provided an intermediate goal in the form of an illuminated landing that promises a midway resting point. The result is a highly sophisticated design, both dynamic and dramatic, which repeats on a smaller scale, but perhaps even more effectively, the processional sequence found inside St. Peter's.

Long before the planning of the piazza and the completion of the Scala Regia, Bernini had been at work decorating the interior of St. Peter's. His first commission, completed between 1624 and 1633, called for the design and erection of the gigantic bronze *baldacchino* above the main altar under the cathedral's dome (FIG. **19-8**), which was built to mark and memorialize the tomb of St. Peter. Almost

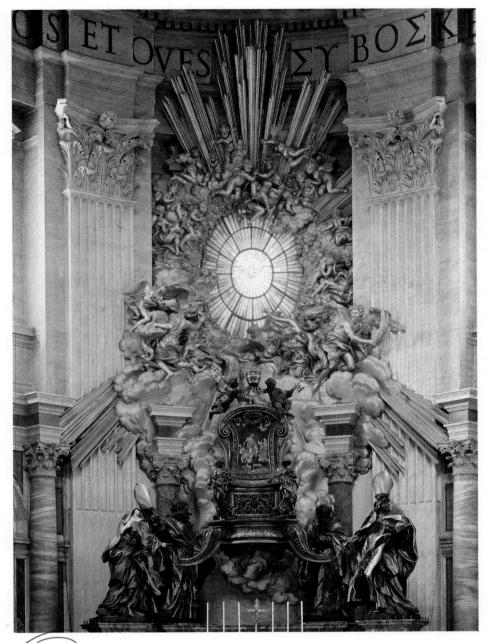

(19-9) GIANLORENZO BERNINI, Cathedra Petri, 1656–1666. Gilded bronze, marble, stucco, and stained glass. St. Peter's.

100 feet high (the height of an average eight-story building), this canopy is in harmony with the tremendous proportions of the new church and is a focus of its splendor. Its four spiral columns recall those of the ancient baldacchino over the same spot in Old St. Peter's. Partially fluted and wreathed with vines, they seem to deny the mass and weight of the tons of bronze resting on them. At the same time, they communicate their Baroque energy to the four colossal angels standing guard at the upper corners and to the four serpentine brackets that elevate the orb and the cross, symbols of the triumph of the Church. Indeed, it is this theme of triumph that dictates the architectural as well as sculptural symbolism both inside and outside St. Peter's. Suggesting a great and solemn procession, the main axis of the complex traverses the piazza (slowed by the central obelisk) and enters Maderno's nave. It comes to a temporary halt at the altar beneath the baldacchino, but it continues on toward its climactic destination at another great altar in the apse, the Cathedra Petri (FIG. **19-9**), also the work of Bernini. In this explosively dramatic composition, the Chair of St. Peter is exalted in a burst of light, in which the Dove of the Holy Ghost appears

amidst flights of angels and billowing clouds. Four colossal figures in gilt bronze seem to support the chair miraculously, for they scarcely touch it. The two in the foreground represent two fathers of the Latin church, Saints Ambrose and Augustine. Behind them, less conspicuously, stand Saints Athanasius and Chrysostom, representing the Greek church. The grouping of the figures constitutes an appeal for unity within Christianity and, at the same time, suggests the subservience of the Eastern church to the Western. The Cathedra Petri is the quintessence of Baroque composition. Its forms are generated and grouped not by clear lines of structure but by forces that unfold from a center of violent energy. Everything moves, nothing is distinct, light dissolves firmness, and the effect is visionary. The vision asserts the triumph of Christianity and the papal claim to doctrinal supremacy.

Much of Bernini's prolific career was given to the adornment of St. Peter's, where his works combine sculpture with architecture. Although Bernini was a great and influential architect, his fame rests primarily on his sculpture, which, like his architecture, expresses the Baroque spirit to perfection. It is expansive and dramatic, and the element of time usually plays an important role in it. Bernini's version of David (FIG. 19-10) aims at catching the split-second action of the figure and differs markedly from the restful and tense figures of David portrayed by Donatello (FIG. 16-12), Verrocchio (FIG. 16-52), and Michelangelo (FIG. 17-19). Bernini's David, his muscular legs widely and firmly planted, is beginning the violent, pivoting motion that will launch the stone from his sling. A moment before, his body was in one position; the next moment, it will be in a completely different one. Bernini selects the most dramatic of an implied sequence of poses, so that the observer has to think simultaneously of the continuum and of this tiny fraction of it. The implied continuum imparts a dynamic quality to the statue that suggests a bursting forth of the energy one sees confined in Michelangelo's figures (FIGS. 17-19 and 17-20). Bernini's statue seems to be moving through time and through space. This is not the kind of statue that can be inscribed in a cylinder or confined to a niche; its implied action demands space around it. Nor is it self-sufficient in the Renaissance sense, as its pose and attitude direct the observer's attention beyond itself and to its surroundings (in this case, toward an unseen Goliath). For the first time since the Hellenistic era (FIG. 5-75), a sculptured figure moves out into and partakes of the physical space that surrounds it and the observer.

The expansive quality of Baroque art and its refusal to limit itself to firmly defined spatial settings are

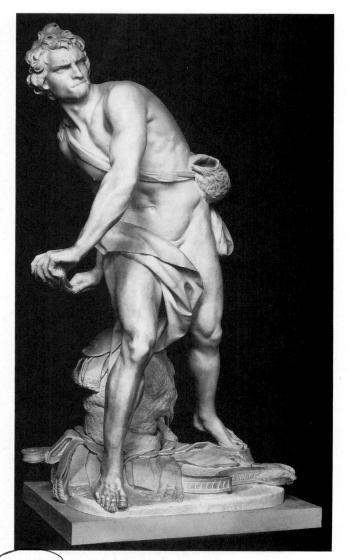

19-10 GIANLORENZO BERNINI, *David*, 1623. Marble, life size. Galleria Borghese, Rome.

encountered again in The Ecstasy of St. Theresa in the Cornaro Chapel of the church of Santa Maria della Vittoria (FIG. 19-11). In this chapel, Bernini draws on the full resources of architecture, sculpture, and painting to charge the entire area with crosscurrents of dramatic tension. St. Theresa was a nun of the Carmelite order and one of the great mystical saints of the Spanish Counter-Reformation. Her conversion took place after the death of her father, when she fell into a series of trances, saw visions, and heard voices. Feeling a persistent pain in her side, she came to believe that its cause was the fire-tipped dart of Divine love, which an angel had thrust into her bosom and which she described as making her swoon in delightful anguish. The whole chapel becomes a theater for the production of this mystical

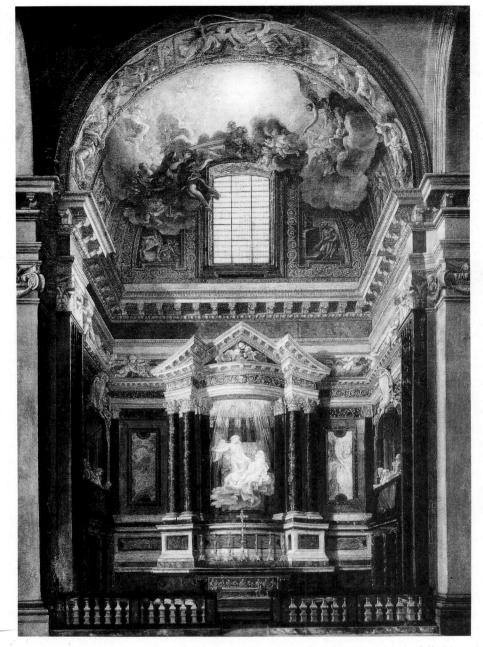

19-11 GIANLORENZO BERNINI, interior of the Cornaro Chapel, 1645–1652, Santa Maria della Vittoria, Rome. Eighteenth-century painting, Staatliches Museum, Schwerin, East Germany.

drama. The niche in which it takes place is a proscenium crowned with a broken Baroque pediment and ornamented with polychrome marble (FIG. 19-11). On either side of the chapel, portraits of the Cornaro family in sculptured opera boxes represent an audience watching the denouement of the heavenly drama with intent piety. Bernini shows the saint in ecstasy (FIG. **19-12**), unmistakably a mingling of spiritual and physical passion, swooning back on a cloud, while the smiling angel aims his arrow. The group is of white marble, and the artist goes to extremes of virtuosity in his management of textures: the clouds, rough monk's cloth, gauzy material, smooth flesh, and feathery wings are all carefully differentiated, yet harmonized in visual and visionary effect. Light from a hidden window pours down bronze rays that are meant to be seen as bursting forth from a painting of Heaven in the vault (FIG. 19-11). Several tons of marble seem to float in a haze of light, the winds of Heaven buoying draperies as the cloud ascends. The

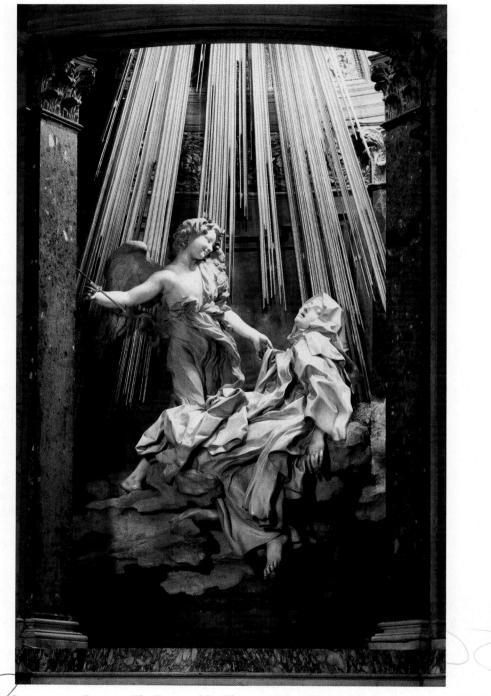

(19-12/ GIANLORENZO BERNINI, The Ecstasy of St. Theresa, 1645–1652. Marble, height of group 11' 6". Cornaro Chapel, Santa Maria della Vittoria.

remote mysteries of religion, taking on recognizable form, descend to meet the human world halfway, within the conventions of Baroque art and theater. Bernini had much to do with the establishment of the principles of visual illusion that guided both. He was perfectly familiar with the writing of plays, theatrical production, and stagecraft. The young English traveler, John Evelyn, sojourning in Rome in 1644, wrote that "Bernini, a Florentine sculptor, architect, painter, and poet, gave a public opera . . . wherein he painted the scenes, cut the statues, invented the engines, composed the music, writ the comedy and built the theater." The community of the Baroque arts is reflected in the universal genius of Bernini.

Given the virtuosity, versatility, and vast output of Bernini, we should not suppose that he carried out the execution of each piece unaided. He presided over a whole corps of assistants who performed the heavy manual labor involved in rough shaping of the stone, transferring the figure from clay model to marble block, cutting the main forms and outlines, and casting the bronze. The essential tasks were always under the supervision of the master, who would direct each stage of production and place the finishing touches himself. Rudolf Wittkower observes that "in a critical study of Bernini's work, one would have to differentiate between works designed by him and executed by his own hand; those to a greater or lesser extent carried out by him; others where he firmly held the reins but contributed little or nothing to the execution; and finally, those works for which he did no more than a few preliminary sketches."*

The evident desire of the time to instill designs with dynamic qualities finds expressive release in the design of monumental fountains. The challenge of

*Rudolf Wittkower, Sculpture: Processes and Principles (New York: Harper & Row, 1977), p. 181.

19-13 Granlorenzo Bernini, Triton Fountain, 1642–1643. Travertine. Piazza Barberini, Rome.

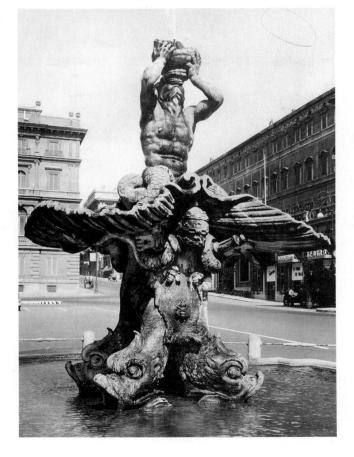

working with an element that actually is in motion fascinated Baroque artists, and not surprisingly, Bernini was one of the most inventive and most widely imitated designers in this field. It is largely his doing that Rome is a city of fountains. One of his most charming inventions is the Triton Fountain (FIG. 19-13), in which Bernini shows the male counterpart of the mermaid, seated on a shell supported by dolphins, blowing a jet of water toward the sky. The jet falls back into the shell, and the water dribbles in thin rivulets from its corrugated edges into the collecting basin below. The maritime group, risen from the depths of the ocean, is enveloped in rising and falling sprays of water. Sunlight reflected from the constantly agitated surface of the collecting pool around the base of the monument ripples across the stone surfaces of the sculptured group in ever-changing patterns that make the Triton seem alive, his bellowslike chest heaving with the effort of blowing into his shell. For centuries, he has performed his task for Urban VIII, the Barberini Pope, whose emblems (the bees) decorate the fountain's base.

BORROMINI

It seems curious that Bernini, whose sculpture expresses the very essence of the Baroque spirit, should remain relatively conservative in his architecture. Frequently planning on a vast scale and employing striking illusionistic devices, Bernini tends to use the Classical orders in a fairly sober and traditional manner. Obvious exceptions include his baldacchino in St. Peter's and the St. Theresa altar (FIGS. 19-8 and 19-11). One might call his architectural style academic, in comparison with the unorthodox and quite revolutionary manner of his contemporary, FRANCESCO BORROMINI (1599–1667). A new dynamism appears in the little church of San Carlo alle Quattro Fontane (FIGS. 19-14 and 19-15), where Borromini goes well beyond any of his predecessors or contemporaries in the plastic handling of a building. Maderno's facades of St. Peter's and Santa Susanna (FIGS. 19-4 and 19-5) are deeply sculptured, but they develop along straight, lateral planes. Borromini, perhaps thinking of Michelangelo's apse wall in St. Peter's (FIG. 17-33), sets his whole façade in serpentine motion forward and back, making a counterpoint of concave and convex on two levels (note the sway of the cornices), and emphasizes the sculptured effect by deeply recessed niches. This façade is no longer the traditional, flat frontispiece that defines a building's outer limits; it is a pulsating membrane inserted between interior and exterior space, designed not to separate but to provide a fluid transition between the two. This functional interrelation of the building and its environment is underlined by the curious fact that it has not one but two façades. The second, a narrow bay crowned with its own small tower, turns away from the main façade and, following the curve of the street, faces an intersection. (The upper façade was completed seven years after Borromini's death, and we cannot be sure to what degree the present supplemented and complex structure reflects his original intention.)

The interior is not only an ingenious response to an awkward site, but also a provocative variation on the theme of the centrally planned church. In plan (FIG. 19-15) it looks like a hybrid of a Greek cross and an oval, with a long axis between entrance and apse. The side walls move in an undulating flow that reverses the motion of the façade. Vigorously projecting columns articulate the space into which they protrude just as much as they do the walls to which they are attached. This molded interior space is capped by a deeply coffered, oval dome that seems to float on the light entering through windows hidden in its base. Rich variations on the basic theme of the oval, dynamic relative to the static circle, create an interior that appears to flow from entrance to altar, unimpeded by the segmentation so characteristic of Renaissance buildings.

19-14 FRANCESCO BORROMINI, façade of San Carlo alle Quattro Fontane, Rome, 1665–1676.

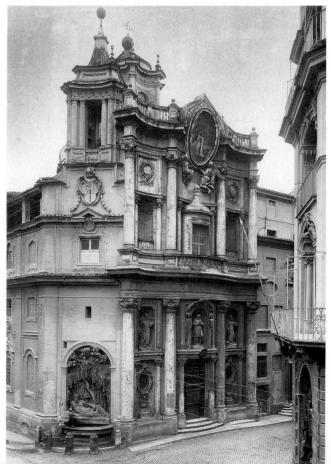

The unification of interior space is carried even further in Borromini's Chapel of St. Ivo in the courtyard of the College of the Sapienza (wisdom) in Rome (FIG. 19-16). In his characteristic manner, Borromini plays concave off against convex forms on the upper level of the exterior of his chapel. The lower stories of the court, which frame the bottom façade, were already there when Borromini began work. Above the inward curve of the facade—its design adjusted to the earlier arcades of the court-rises a convex, drumlike structure that supports the lower parts of the dome. Powerful pilasters restrain the forces that seem to push the bulging forms outward. Buttresses above the angle pilasters curve upward to brace a tall, plastic lantern topped by a spiral that seems to fasten the structure, screwlike, to the sky.

The centralized plan (FIG. **19-17**) is that of a star, having rounded-off points and apses on all three sides. Indentations and projections along the angled, curving walls create a highly complex plan, all the elements of which are fully reflected in the interior elevation. From floor to lantern, the wall panels rise in a continuously tapering sweep that is halted only momentarily by a single, horizontal cornice (FIG. **19-18**). The dome is thus not, as in the Renaissance, a separate unit placed on the supporting block of a

19-15 FRANCESCO BORROMINI, plan of San Carlo alle Quattro Fontane, 1638–1641.

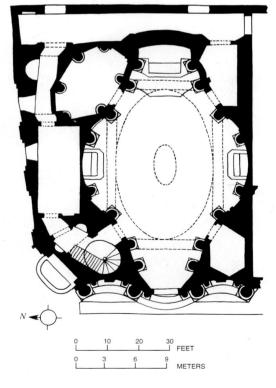

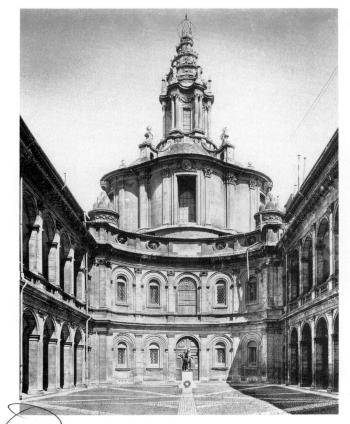

19-16 FRANCESCO BORROMINI, Chapel of St. Ivo, begun 1642. College of the Sapienza, Rome.

19-17 FRANCESCO BORROMINI, plan of Chapel of St. Ivo.

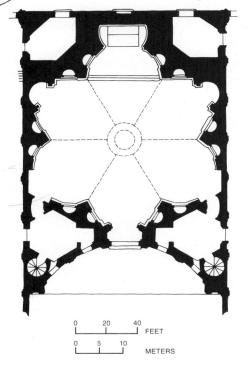

19-18 View into the dome of Chapel of St. Ivo.

building; rather it is an organic part that evolves out of and shares the qualities of the supporting walls, from which it cannot be separated. The complex, horizontal motion of the walls is transferred fully into the elevation, creating a dynamic and cohesive shell that encloses and energetically molds a scalloped fragment of universal space. Few architects have matched Borromini's ability to translate extremely complicated designs into such masterfully unified and cohesive structures as that of St. Ivo.

GUARINI AND LONGHENA

The heir to Borromini's sculptured architectural style was Guarino Guarini (1624-1683), a priest, mathematician, and architect who spent the last seventeen years of his life in Turin, converting that provincial Italian town into a fountainhead of architectural theories that would sweep much of Europe. In his Palazzo Carignano (FIG. 19-19), Guarini effectively applies Borromini's principle of undulating façades. He divides his long façade into three units, the central one of which curves much like the façade of San Carlo alle Quattro Fontane (FIG. 19-14) and is flanked by two blocklike wings. This lateral, three-part division of façades, characteristic of most Baroque palazzi, probably is based on the observation that the average human instinctively can recognize up to three objects as a unit; a greater number will require the observer to count each object individually. A three-part organization of extended surfaces thus gives the artist the opportunity to introduce variety into his design without destroying its unity. It also

19-19 UARINO GUARINI, Palazzo Carignano, Turin, Italy, 1679–1692.

permits him to place added emphasis on the central axis, which Guarini has done here most effectively by punching out deep cavities in the middle of his convex central block. The variety of his design is enhanced by richly textured surfaces (all executed in brick) and by pilasters, which further subdivide his units into three bays each. High and low reliefs create shadows of different intensities and add to the deco-

19-20 GUARINO GUARINI, Chapel of the Santa Sindone, Turin, 1667–1694 (view into dome).

rative effect, making this one of the finest façades of the late seventeenth century.

Guarini's mathematical talents must have been guiding him when he designed the extraordinarily complex dome of the Chapel of the Santa Sindone (Holy Shroud), a small, central-plan building attached to the cathedral of Turin. A view into this dome (FIG. 19-20) reveals a bewildering display of geometric figures that appear to wheel slowly around a circular focus that contains the bright Dove of the Holy Ghost. Here, the traditional dome has been dematerialized into a series of figures that seem to revolve around each other in contrary motion; they define it, but they no longer limit the interior space. A comparison of Guarini's dome with that of the church of Sant' Eligio degli Orifici in Rome (FIG. 19-21), attributed both to Bramante and to Raphael and reconstructed about 1600, indicates that a fundamental change has taken place. The static "dome of heaven" of architecture and philosophy has been converted into the dynamic apparition of a mathematical heaven of calculable motions.

The style of Borromini and Guarini will move across the Alps to inspire architecture in Austria and South Germany in the late seventeenth and early

19-21 Dome of Sant' Eligio degli Orifici, Rome, attributed to BRAMANTE and RAPHAEL, c. 1509 (reconstructed c. 1600; view into dome).

eighteenth centuries. Popular in the Catholic regions of Europe and the New World (especially in Brazil), it will exert little influence in France, where the more conservative style of Bernini will be favored.

In Venice, something of the Late Renaissance Classicism of Andrea Palladio survives, paradoxically, in the very Baroque church of Santa Maria della Salute

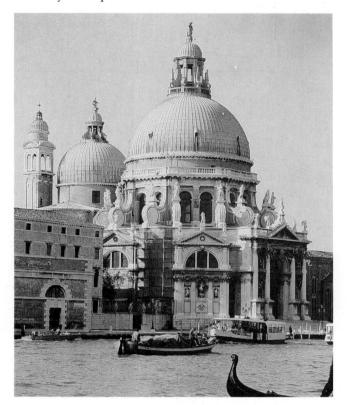

19-22 BALDASSARE LONGHENA, Santa Maria della Salute, Venice, 1631–1648 (consecrated 1687).

19-23 BALDASSARE LONGHENA, plan of Santa Maria della Salute. (After Christian Norberg-Schulz.)

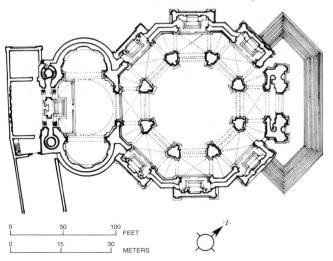

(FIGS. 19-22 and 19-23), often called simply the "Salute" (health). Built by Baldassare Longhena (1598-1682), the church was commissioned by the republic in thanksgiving to the Virgin Mary for ridding the city of plague. Standing at the head of the Grand Canal, the main thoroughfare of Venice, the Salute has for centuries dominated it like a gorgeous crown, the admiration of generations of travelers and artists. Longhena was well aware of the architectural value of the site; the two domes of the Salute harmonize with the family of domes in its vicinity, among them those of St. Mark's (FIG. 7-47) and of the Palladian churches of San Giorgio Maggiore (FIG. 17-53) and Il Redentore (The Redeemer). Together, they make a skyline of surpassing beauty, floating above the city or reflected in its waters in ever-changing groupings as the admiring visitor moves.

Central plans were largely foreign to Venice, and it may be that the domes and central plan of St. Mark's suggested the design of the Salute, although Longhena insisted his design had not been done before. The plan of the building (FIG. 19-23) is an octagon with an auxiliary choir. The greater of the two domes is over the octagon; the lesser is over the choir and is flanked by campaniles. Both in plan and elevation, the grouping of the masses and spaces is essentially Renaissance, without the intricacies of Bernini, Borromini, or Guarini. This observation is especially true of the interior, which has the clear arrangement, the correct orders, and the steady grey-white color of Palladio's wall-and-column features, as in San Giorgio Maggiore (FIG. 17-54). But the exterior elevation is dramatic. The façadelike faces of the octagon play counterpoint with the main facade, and the highest excitement of Baroque invention is apparent in the great scroll buttresses that seem to open organically from the main body and to sprout statuary (FIG. 19-22). The Salute is a splendid example of an architecture rooted in a native (Venetian) tradition, yet flowering successfully in a new stylistic climate.

The style of Palladio and the Venetian Renaissance could be and was transplanted into a widely different environment. While Longhena was building the Salute, the Palladian style was already being naturalized in the distant north, in England (FIG. 19-74).

Painting

Italian painters of the seventeenth century, with the possible exception of Caravaggio and the later decorators, were somewhat less adventurous than the sculptors and architects. The painters of the High Renaissance had bequeathed to them an authoritative tradition as great as that of classical antiquity. After the sixteenth century, European artists drew from both sources, and the history of painting well into the nineteenth century-that is, well into modern timesis an account of the interpretation, development, and modification of these two great traditions. The three most influential stylistic bequests of the High Renaissance were the styles of Raphael, Michelangelo, and Titian, with an additional subdominant trend inspired by Correggio. Baroque painting is the consequence of the many varied interchanges among these styles, with the Antique sometimes supplementing them and sometimes used against them. A style that seems hostile to both authorities and that is based on the assumption that the artist should paint what he sees, without regard for either the Antique or the Renaissance masters, might be called "native naturalism." This native naturalism appears as a minority style in Italy and France but plays an important role in Spain and a predominant one in the Dutch school.

THE CARRACCI AND THE BOLOGNESE ACADEMY

The Baroque gets well under way in Italian painting around the year 1600, with the decoration of the gallery of the Farnese Palace by ANNIBALE CARRACCI (1560–1609). His generation, weary of the strained artifice of Mannerism, returned for a fresh view of nature, but only after they had studied the Renaissance masters carefully. Annibale had attended an academy of art in his native city of Bologna. Founded cooperatively by members of his family, among them LODOVICO and AGOSTINO CARRACCI, the Bolognese academy is the first significant institution of its kind in the history of Western art. It was founded on the premises that art can be taught-the basis of any academic philosophy of art-and that the materials of instruction must include the Antique and the Renaissance traditions, in addition to the study of anatomy and life drawing. The Bolognese painters were long called academics, and sometimes eclectics, for they appeared to assume that the development of a correct style in painting is learned and synthetic. In any event, we can tell from the gallery of the Farnese Palace that Annibale was familiar with Michelangelo, Raphael, and Titian, and also that he could make clever, illusionistic paintings. The Farnese ceiling (FIG. 19-24) is a brilliant and widely influential revision of High Renaissance painting. It restores the Renaissance interest in human themes and emotions, renouncing the artificialities of Mannerism to return to the study of nature, and forming a firm bridge between the Renaissance and the Baroque. The style is a vigorous, sensuous, and adroit naturalism, modified by the Classical form inherited from the masters.

The iconographical program of the ceiling is the *Loves of the Gods*, interpretations of the subtle and various stages and degrees of earthly and Divine love (see Titian's treatment of the theme in *Sacred and Profane Love*, FIG. 17-60). Despite the apparent paganism of the subjects here, we find them to have Christian overtones. The human nude is the principal motif, as it is in Michelangelo's frescoes and in much of Venetian art. Luxuriantly pagan images from classical literature, especially Ovid's *Metamorphoses*, throng the vault (FIG. 19-24), binding the composition together and filling it with exuberant and passionate life.

The scenes are arranged in panels resembling framed paintings on a wall, but here they are on the surfaces of a shallow, curved vault; the Sistine Ceiling (FIG. 17-24), of course, comes to mind, although it is not an exact source. This type of simulation of wall painting for ceiling design is called quadro riportato (carried picture). The great influence of the Carracci will make it fashionable for more than a century. The framed pictures are flanked by seated, nude youths, who turn their heads to gaze at the scenes above them, and by standing giants-motifs taken directly from Michelangelo's Sistine Ceiling. It is noteworthy that the chiaroscuro is not the same for both the pictures and the painted figures surrounding them. The figures inside the pictures are modeled in an even, sculptured light; the outside figures are lit from beneath, as if they were three-dimensional statues illuminated by torches in the gallery below. This interest in illusion, already manifest in the Renaissance, will continue in the grand ceiling compositions of the seventeenth century. In the crown of the vault, a long panel representing the Triumph of Bacchus is a quite ingenious mixture of Raphael and Titian and represents Annibale's adroitness in adjusting their authoritative styles to make something of his own.

Another artist trained in the Bolognese academy, GUIDO RENI (1575–1642), selected Raphael for his inspiration, as we see in his Aurora (FIG. 19-25), a ceiling painting conceived in quadro riportato. Aurora, the dawn, leads the chariot of Apollo, while the Hours dance about it. The fresco exhibits a suave, almost swimming motion, soft modeling, and sure composition, without Raphael's sculpturesque strength. It is an intelligent interpretation of the master's style, but in every sense learned, or "academic." However, "academic" should not be burdened here with the unfortunate connotation it will later acquire as art that is mechanical, imitative, dull, and uninspired. The Aurora is a masterpiece of the Bolognese style and of its age. Guido was so much admired in his own day and well into the nineteenth century that he was known as "the divine Guido."

19-24 ANNIBALE CARRACCI, ceiling frescoes in the Palazzo Farnese, Rome, 1597–1601.

19-25 GUIDO RENI, Aurora, 1613–1614. Ceiling fresco in the Casino Rospigliosi, Rome.

Another member of the Bolognese school, Giovanni Francesco Barbieri, called IL GUERCINO (1591– 1666), also painted a ceiling *Aurora* (FIG. **19-26**), but with a very different effect. Guercino abandons the method of quadro riportato to emulate that of Veronese, whose figures are seen from below at a forty-five-degree angle (FIG. 17-68). By this method, the subject of the picture is painted as if happening above our heads and seen from beneath; it is not simply a transfer of a painting from wall to ceiling. Taking his cue from the illusionistic figures in the Farnese Gallery and from its central ceiling panel (FIG. 19-24), Guercino converts the ceiling into a limitless space, through which the procession sweeps past. The observer's eye is led toward the celestial parade by converging, painted extensions of the room's architecture. While the perspective may seem a little forced, Guercino's *Aurora* inspired a new wave of enthusiasm for illusionistic ceiling paintings that culminated in some of history's most stupendous decorations.

19-26 IL GUERCINO, Aurora, 1621–1623. Ceiling fresco in the Villa Ludovisi, Rome.

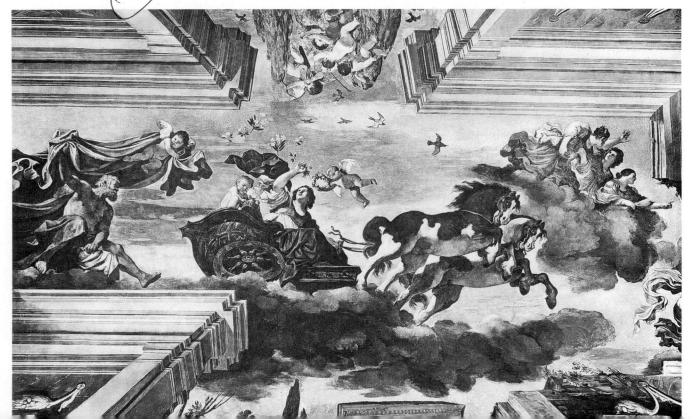

CARAVAGGIO

Although the Bolognese painters were willing to imitate nature as directly as possible, they believed that the Renaissance and the Antique masters already had captured much of nature's essence and that the works of the Renaissance and of the Antique masters would prepare them for the study of nature. Michelangelo Merisi (1571–1610), called CARAVAGGIO after the northern Italian town from which he came, thought very much otherwise. His outspoken disdain for the Classical masters (probably more vocal than real) drew bitter criticism from many painters, one of whom denounced him as the "anti-Christ of painting." Yet many paid him the genuine compliment of borrowing from his innovations.

The unconventional life of this great painter was consistent with the defiant individualism of his art. We know almost as much about Caravaggio from police records as from other documents. Violent offenses and assaults reaching to murder trace his tragic, antisocial career through restless, tormented wanderings, which, nevertheless, did not prevent him from producing a large number of astonishing works. His very association with lowlifes and outcasts may help to account for his unglorified and unfashionable view of the great themes of religion, as well as his indifference to the Renaissance ideals of beauty and decorum. In his art, he secularizes both religion and the classics, reducing them to human dramas that might be played out in the harsh and dingy settings of his time and place. He employs a cast of unflattering characters selected from the fields and the streets; these, he was proud to declare, were his only teachers—to paint from them gave him sufficient knowledge of nature.

We easily can appreciate how startling Caravaggio's methods must have been for his contemporaries when we look at The Conversion of St. Paul (FIG. 19-27), which he painted for the Roman church of Santa Maria del Popolo. The scene illustrates the conversion of the Pharisee Saul by a light and a voice from Heaven (Acts 9:3–9). The saint-to-be is represented flat on his back, his arms thrown up, while an old ostler appears to maneuver the horse away from its fallen master. At first inspection, little here suggests the awful grandeur of the spiritual event that is taking place. We seem to be witnessing a mere stable accident, not a great saint overcome by a great miracle. The saint is not specifically identified; he could be anyone. The ostler is a swarthy, bearded old man, who looks well acquainted with stables. The horse

19-27 CARAVAGGIO, The Conversion of St. Paul, c. 1601. Oil on canvas, * approx. 7' $6'' \times 5' 9''$. Cerasi Chapel, Santa Maria del Popolo, Rome.

*Unless stated otherwise, all subsequent paintings are in oil on canvas.

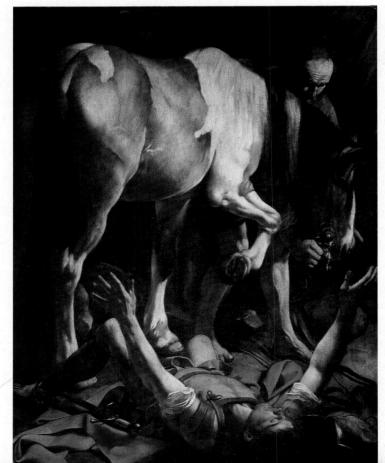

fills the picture as if it were the hero, and its explicitness and the angle from which it is viewed might betray some irreverence on the part of the artist for this subject. Although Caravaggio found numerous sympathetic patrons in both church and state, a number of his works were refused on the ground that they lacked propriety (that is to say, decorum). He sometimes appears to pay no attention to the usual dignity appointed to scenes from scripture and to go too far in dismissing the formal graces of Renaissance figure composition and color.

The fact is that, above all, Caravaggio seeks to create a convincing copy of the optical world as a vehicle of spiritual meanings; his intention in this respect is like Bernini's in the St. Theresa (FIG. 19-12). To this end, he uses a perspective and a chiaroscuro designed to bring viewers as close as possible to the space and action of the scene, almost as if they were participating in it. The Conversion of St. Paul is placed on the chapel wall and is composed with an extremely low horizon or eye level; the painting is intended to be on the viewers' line of sight as they stand at the entrance of the chapel. The sharply lighted figures are meant to be seen as emerging from the dark of the background. The actual light from windows outside the chapel functions as a kind of stage lighting for the production of a vision, analogous to the rays in Bernini's St. Theresa. Thus, Caravaggio, like Bernini, makes use of the world of optical experience to stage the visionary one. In The Conversion of St. Paul, what we see first as merely commonplace is in fact the elevation of the commonplace to the miraculous.

The stark contrast of light and dark was the feature of Caravaggio's style that first shocked and then fascinated his contemporaries. The sharp and sudden relief it gives to the forms and the details of form emphasizes their reality in a way that an even or subtly modulated light never could. Dark next to light is naturally dramatic; we do not need a director of stage lighting to tell us this. Caravaggio's device, a profound influence on European art, has been called tenebrism (Italian: tenebroso) or the "dark manner." This technique goes quite well with material that is realistic and is another mode of Baroque illusionism by which the eye is almost forced to acknowledge the visual reality of what it sees. Although tenebrism is widespread in Baroque art, it will have its greatest consequences in Spain and the Netherlands.

A contemporary observed that Caravaggio had "abandoned beauty and was interested in depicting reality," and Giovanni Pietro Bellori, the most influential critic of the age and an admirer of the Carracci, wrote: "Caravaggio deserves great praise, as he was the only one who attempted to imitate nature as opposed to the general trend in which painters

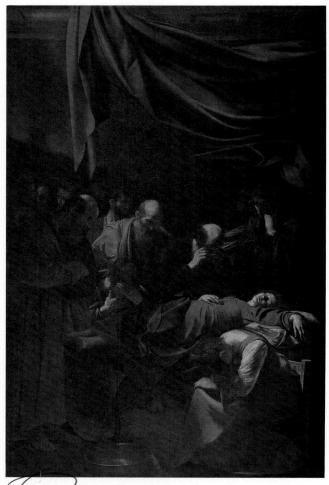

19-28 CARAVAGGIO, Death of the Virgin, 1605–1606. Approx. 12' × 8'. Louvre, Paris.

imitated other painters." The instrumentalities of this unorthodox realism find full orchestration in Caravaggio's Death of the Virgin (FIG. 19-28). The painting, refused as an altarpiece for Santa Maria della Scala in Rome (on the grounds of irreverence), represents the dead Virgin Mary, mourned by the disciples and friends of Christ. The Virgin is indeed unceremoniously laid out in the awkward stiffness of death, her body swollen, limbs uncomposed, and feet uncovered (the last feature considered indecent at the time). Contemporaries complained that Caravaggio had used as his model for the mother of Christ the corpse of a young woman who had drowned. Around the dead woman, in attitudes of genuine if uncouth grief, without rhetoric or declamation, Caravaggio portrays the customary plebeian types that he usually casts in his pictorial dramas of reality. The drawn curtain emphasizes the stagelike setting, into which the grouping of the figures invites the viewer as participant. The harsh light plunges into the space from a single source, shattering the darks into broken

areas of illumination that reveal the coarse materialities of the scene. But again (as in *The Conversion of St. Paul*, although in a different way) we can read the artist's interpretation not as diminishing the spiritual import of the theme but rather as informing it with a simple, honest, unadorned piety that is entirely sincere—the very piety that moves the humble watchers of the dead to tears.

DOMENICHINO AND GENTILESCHI

One would think that Annibale and Ludovico Carracci and their colleagues at the Bolognese academy would have carefully avoided the dangerous art of Caravaggio. To the contrary, many borrowed from it (some more than others), unconsciously integrating it into the tradition and into their own work. *The Last Communion of St. Jerome* (FIG. **19-29**) is a painting so typical of the Catholic Baroque—so expressive of the Counter-Reformation and its ideals—that we can

¹⁹⁻²⁹ DOMENICHINO, The Last Communion of St. Jerome, 1614. Approx. $13' 9'' \times 8' 5''$. Vatican Museums, Rome.

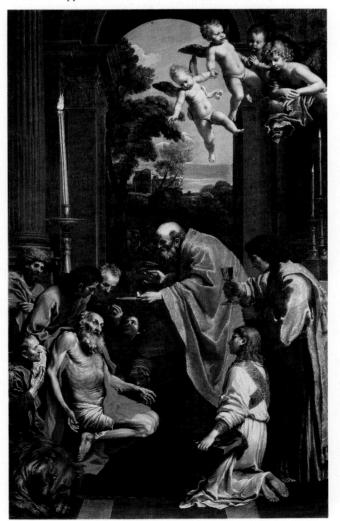

hardly find its equal as a document of the times. The artist is another Bolognese disciple, DOMENICHINO (Domenico Zampieri, 1581–1641). In a Renaissance loggia that opens into a Venetian landscape background, St. Jerome, propped up to receive the viaticum (Eucharist), is surrounded by sorrowing friends. The realism of Caravaggio stamps the old man's sagging features, his weakened, once-rugged body, and the faces of at least three of his attendants and of the grave old priest. The sharpened darks and lights are also out of Caravaggio; the general composition, the architecture, the floating putti, and the turbaned spectator echo Titian, Correggio, and the mood of the High Renaissance. A painting like this would seem to be, of necessity, an academic pastiche, but all of its borrowed elements are synthesized successfully in a rare, effective unity. Domenichino's St. Jerome is a successful "school" picture, nourished as it is by all the sources, traditional and contemporary, available to him.

We already have mentioned the spread of Caravaggio's style outside Italy. Of course, he had many followers within its borders also, and they were artists more directly in tune with his message than eclectics like Domenichino. One of the best, whose work is increasingly appreciated by many modern critics, is ARTEMISIA GENTILESCHI (1593–1653). Gentileschi was instructed by her artist father, ORAZIO, who was himself strongly influenced by Caravaggio. Her successful career, pursued in Florence, Venice, Naples, and Rome, helped to propagate Caravaggio's manner throughout the peninsula. In her Judith and Maidservant with the Head of Holofernes (FIG. 19-30), we find the dark manner (tenebroso) and what might be called the "dark" subject matter favored by the "Caravaggisti," the painters of "night pictures." The heroism of Judith, often a subject in Italian painting and sculpture, is depicted here. The story, which is told in an Apocryphal work of the Old Testament, the Book of Judith, relates the delivery of Israel from its enemy Holofernes. Having succumbed to the charms of Judith, Holofernes invites her to his tent for the night. When he has fallen asleep, Judith cuts off his head. Here, the act performed, her maidservant is putting the severed head in a sack. The action takes place in a curtained, oppressively closed space. The atmosphere of menace and horror is thickened by the heavy darks, scarcely relieved by the feeble candle, the sole source of light. Yet the light falls on the courtly splendor of the women's raiment and exhibits forms and characters intended by the artist to be convincingly real. The light is interrupted dramatically by Judith's hand, which casts a shadow on her face. This device is a favorite of the "night painters": a single source of illumination within the painting-partly or wholly concealed by an object in front of it or, as in

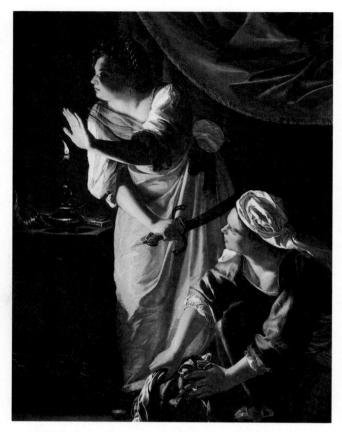

19-30 ARTEMISIA GENTILESCHI, Judith and Maidservant with the Head of Holofernes, c. 1625. Approx. $6' \times 4' 8''$. Detroit Institute of the Arts (gift of Leslie H. Green).

this case, intercepted by an object—casting an abrupt shadow. The effect is like opening the shutter of a lantern for a brief moment in a pitch-black cellar where unspeakable things are happening.

LANDSCAPE: ANNIBALE CARRACCI AND ROSA

The Carracci and Caravaggio powerfully influenced the art of figure painting for two centuries, but the Carracci largely determined the dominant course taken by landscape painting over the same period. In his Flight into Egypt (FIG. 19-31), Annibale Carracci created the "ideal" or "classical" landscape. Adopted and developed in France by Nicolas Poussin and Claude Lorrain (FIGS. 19-61 and 19-62), this kind of landscape would come to prevail as the accepted pictorial representation of nature ordered by Divine law and human reason. The roots of the style are in the landscape backgrounds of Venetian paintings of the Renaissance (compare FIGS. 19-31 and 17-59). Tranquil hills and fields, quietly gliding streams, serene skies, unruffled foliage, shepherds with their flocks-all the props of the pastoral scene and mood-expand to fill the picture space. They are introduced regularly by a screen of trees in the foreground, dark against the even light of the sky. Attenuated streams or terraces, carefully placed one above the other, make a compositional direction left or right through the terrain. In the middle ground, many landscape artists place compositions of architecture (as in FIG. 19-31) -walled towns or citadels, towers, temples, monu-

19-31 ANNIBALE CARRACCI, Flight into Egypt, 1603–1604. Approx. 4' × 7' 6". Galleria Doria Pamphili, Rome.

19-32 SALVATOR ROSA, St. John the Baptist in the Wilderness, c. 1640. Approx. $5' 8'' \times 8' 6''$. Glasgow Art Gallery and Museum, Scotland.

mental tombs, villas—the constructed environment of idealized antiquity and the idyllic life, undisturbed by the passions. The subjects are drawn from religious or heroic story; here, Mary, with the Christ Child, and St. Joseph wend their slow way to Egypt, after having been ferried across a stream (Matthew 2:13–14). The figures shrink in scale and importance, relative to the landscape, and are sometimes simply its excuse. Now, in the seventeenth century, landscape comes fully into its own as a major subject for the painter.

But there are landscape types other than the Classical during the seventeenth century. A landscape by SALVATOR ROSA (1615–1673), *St. John the Baptist in the Wilderness* (FIG. **19-32**), contrasts dramatically with Carracci's *Flight into Egypt*. Rosa's painting also has a sacred theme, and the figures in it are subordinate to the landscape, but the two paintings obviously have nothing else in common. Instead of the calm of idealized nature in Annibale's landscape, in Rosa, we have nature in a violent mood, a savage wilderness abandoned by Heaven. A ragged tree, blasted by generations of thunderbolts, writhes before a chaos of barren rocks. For Rosa, nature appears malevolent, the home only of wild beasts, of holy or of desperate men. The broken surfaces, jagged contours, and harsh textures in confused arrangement here should be compared with the smooth volumes and contours and regular placement of forms that characterize the Classical landscape. The alternative style of Rosa will exercise a great deal of influence on the next century's taste for the "picturesque"—sublime and awesome scenes, filled with terror and foreboding, which will indulge the Romantic temperament and fuel its enthusiasm.

PERSPECTIVE ILLUSIONISM

The development of landscape painting was contemporary with that of ceiling painting, the latter form being stimulated anew by the large, new churches of Baroque Rome. The problems associated with ceiling painting are, of course, special. Looking *up* at a painting is different from simply looking *at* a painting. The experience of looking at what is above us carries with it an element of awe, particularly when we are viewing something located at considerable height. Guercino recognized this when he painted his *Aurora* (FIG. 19-26), but Guido Reni apparently did not. In his *Aurora* fresco (FIG. 19-25), he either did not realize the special power of ceiling painting, or perhaps preferred or was required to use the quadro riportato method. The Baroque artist found a

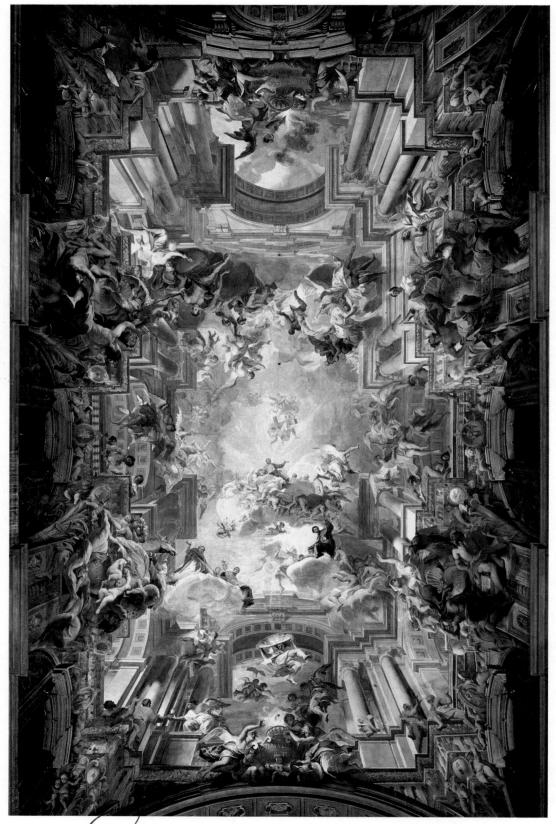

19-33 FRA ANDREA POZZO, The Glorification of St. Ignatius, 1691–1694. Ceiling fresco in the nave of Sant' Ignazio, Rome.

ceiling surface high above the ground a natural field for the projection of visual illusion. The devout Christian, thinking of Heaven as "up," must be overwhelmed with emotion when, looking up, he sees its image before his eyes. In the Sistine Ceiling, Michelangelo made no attempt to project an image of the skies opening into Heaven; rather, he represented an epic narrative of events of no physical place or time that could be read almost as well from walls as from ceilings. The *illusion* of bodies actually soaring above was of no interest to him; the truth of certain events in the history of Genesis was, and these events and figures could be shut off in their own compartments, self-contained.

A Baroque master of ceiling decoration like FRA ANDREA POZZO (1642–1709) takes an entirely different approach. A lay brother of the Jesuit order and a master of perspective, on which he wrote an influential treatise, Pozzo designed and executed the vast ceiling fresco depicting The Glorification of St. Ignatius (FIG. 19-33) for the church of Sant' Ignazio in Rome. This fresco is indeed the culmination of the di sotto in sù (from below upwards) experiments of Mantegna (FIG. 16-65) and Correggio (FIG. 17-37). The artist intends to create the illusion that Heaven is opening up above the heads of the congregation-indeed, of the very congregation that fills this church of Sant' Ignazio. For, in painted illusion, Pozzo continues the actual architecture of the church into the vault, so that the roof seems to be lifted off, as Heaven and earth commingle and St. Ignatius is carried to the waiting Christ in the presence of figures personifying the four corners of the world. A metal plate in the nave floor marks the standpoint for the whole perspective illusion. Looking up from this point, the observer takes in the celestial-terrestrial scene as one, for in Pozzo's design the two are meant to fuse without the interruption of a boundary. To achieve his visionary effects, the artist employs all means offered by architecture, sculpture, and painting and unites them in a fusion that surpasses even the Gothic effects of total integration.

Sound, as well as light, is a vehicle of ecstasy and vision in the Baroque experience. We know that churches were designed with acoustical effect in mind, and, in a Baroque church filled with Baroque music, the power of both light and sound would be vastly augmented. Through simultaneous stimulation of both the visual and auditory senses, the faithful might be transported into a trancelike state that would indeed, in the words of Milton, "bring all Heaven before [their] eyes." But this transport always would have to be effected by physical means; although the devout in the Middle Ages were able to find the vision within, in the Baroque period they demanded that that mystery be made visible to the outward sight. To be credible, Heaven must more and more visually resemble the domain of earth. Dante could see Heaven in a dream, but Pozzo wanted to see it unfold above him while he was awake and walking in a church. Medieval humanity aspired to Heaven; Baroque humanity wanted Heaven to come down to their station, where they might see it, or even inspect it. Optical vision is the supreme faculty in seventeenth-century art and science.

Baroque expansiveness is expressed not only in the characteristic movement toward the infinite horizontal but in an emphasis on the vertical as well. The heavens are more and more within reach; Galileo and Newton will penetrate them to find the laws of their movement. The clouds of Heaven are not simply the seat of angels; seventeenth-century scientists discover that they are water vapor. The bright air through which light is propagated has density and weight. As the heavens become physical, human beings begin to dream of taking possession of them someday by flight—not the flight of the soul, but the flight of the body. The Baroque period transforms spirit into matter in motion, as Pozzo's ceiling relates.

SPAIN

In Spain, as in the other countries of Europe, Italianate Mannerism was adopted in the sixteenth century and cast off in the Baroque period. But along with Mannerism, Spain seemed to reject most of what the Italian Renaissance stood for, just as it would reject, for a long time, the scientific revolution and the Enlightenment. Since the Middle Ages, Spain had maintained a proud isolation from the events of Europe—an isolation that today has apparently ended.

In the art of El Greco, we have seen the mystical side of the Spanish character (FIG. 18-59). The hard, unsentimental realism that is the other side appears in the painting of José de RIBERA (1591-1652), who, because he emigrated to Naples as a young man and settled there, is sometimes called by his Italian nickname, Lo Spagnoletto, "the little Spaniard." The realism of his style, a mixture of a native Spanish strain and the "dark manner" of Caravaggio, gives shock value to Ribera's often brutal themes, which express at once the harsh times of the Counter-Reformation and a Spanish taste for the representation of courageous resistance to pain. His Martyrdom of St. Bartholomew (FIG. 19-34) is grim and dark in subject and form. St. Bartholomew, who suffered the torture of being skinned alive, is being hoisted into position by

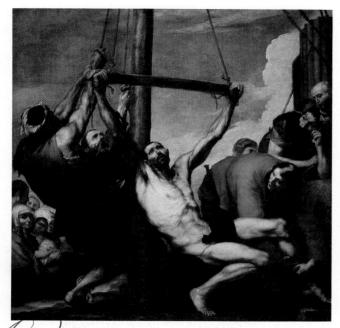

19-34 JOSÉ DE RIBERA, The Martyrdom of St. Bartholomew, 1639. Approx. $92\frac{1}{8}'' \times 92\frac{1}{8}''$. Museo del Prado, Madrid.

19-33 FRANCISCO DE ZURBARÁN, St. Francis in Meditation, c. 1639. Approx. 60" × 39". Reproduced by courtesy of the Trustees of the National Gallery, London.

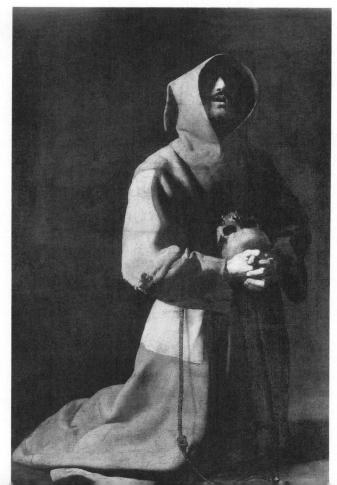

his executioners. The saint's rough, heavy body and swarthy, plebeian features express a kinship between him and his tormentors, who are members of the same cast of characters we found in the painting of Caravaggio and the Neapolitan school he so strongly influenced. In this painting, Ribera scorns idealization of any kind, and we have the uncomfortable feeling that he is recording rather than imagining the grueling scene. In an age of merciless religious fanaticism, torture, as a means of saving stubborn souls, was a common and public spectacle.

FRANCISCO DE ZURBARÁN (1598-1664) softens realism with an admixture of the mystical. His principal subjects are austere saints, represented singly in devotional attitudes and usually sharply lighted from the side. He shows us St. Francis in Meditation (FIG. 19-35), his uplifted face almost completely shadowed by his cowl, clutching a skull to his body. The skull is the memento mori, a constant reminder to the contemplative individual of his own mortality. The bare, unfurnished setting and the stark light and somber dark are the bleak environment of this entranced soul. We see enough to read this as an image of rapt meditation-the parted lips, the tensely locked fingers, the rigid attitude of a devotee utterly unaware of his surroundings and mystically in contact with God. Here, Zurbarán gives us a personification of the fierce devotion of Catholic Spain.

VELÁZQUEZ

In the Baroque age, visions and the visual go together. DIEGO VELÁZQUEZ (1599–1660), an artist who set aside visions in the interest of what is given to the eye in the optical world, stands among the great masters of visual realism. Although he painted religious pictures, he was incapable of idealism or high-flown rhetoric, and his sacred subjects are bluntly real. Velázquez, who trained in Seville, came to the attention of the king, Philip IV, as a young man, and became the court painter at Madrid, where, save for two extended trips to Italy and a few excursions, he remained for the rest of his life. His close personal relationship with Philip and his high office of marshal of the palace gave him prestige and a rare opportunity to fulfill the promise of his genius with a variety of artistic assignments.

In an early work, *Los Borrachos (The Drinkers*, FIG. **19-36**), Velázquez shows his cool independence of the ideals of Renaissance and Baroque Italy in a native naturalism that has the strength and something of the look of Caravaggio. Commissioned to paint Bacchus among his followers, presenting them the liberating gift of wine, Velázquez seems to mock Classical conventions in both theme and form. He burlesques the stately, Classical Bacchic scenes, making the god

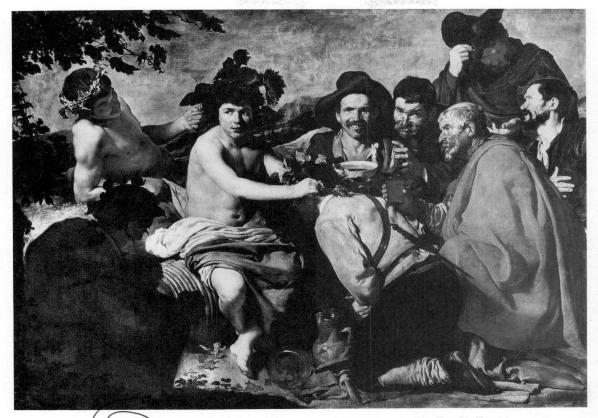

(19-36) Diego Velázquez, Los Borrachos, c. 1628. Approx. 5' 6" × 7' 6". Museo del Prado, Madrid.

a mischievous young *bravo*, stripped to the waist, crowning a wobbly tippler who kneels before him. The rest of the company is of the same type: weatherbeaten, shabby roisterers of the tavern crowd, who grin and jape at the event uncouthly, enjoying the game for what it is. Painting the crude figures in strong light and dark that is evenly distributed so as not to obscure them, Velázquez makes sharp characterizations of each person, showing not only his instinct for portraiture but a Baroque interest in human "types." And, typically Spanish, he caricatures, through realism, an Italianate subject that ordinarily would be idealized. Enrique Lafuente, a modern critic, states the Spanish attitude, as he perceives it:

Spain refuses to accept the basic ideas which inspire the Italian Renaissance because they are repugnant to its sense of the life of the Spanish man. The Spaniard knows that reality is not Idea, but Life. . . . The supreme value of life is linked with experience and the moral values that are based on personality. Idea, beauty, formal perfection, are abstractions and nothing more. Art, in its turn, is bound to concern itself with realities and not with dreams.*

*Enrique Lafuente, *Velázquez* (New York: Oxford University Press, 1943), p. 6.

To Velázquez, as to many Spanish artists, the academic styles of Baroque Italy must have seemed pretentious and insincere, not to say pagan. He turned away from them to concentrate instead on the world before his eyes.

One could hardly find in art a better example of Lafuente's dictum that "reality is not Idea, but Life" than Velázquez's portrait of Juan de Pareja (FIG. 19-37). At the height of his powers, Velázquez painted his assistant when they were in Rome together in 1650. He was intending to paint a portrait of Pope Innocent X, a patron of Bernini, and he did the study of Pareja as a kind of trial run. Today, we probably would agree that it is a masterpiece in its own right. The work was exhibited in the Pantheon and drew the admiration of the many artists in Rome, Italian and foreign alike. They perceived in it an almost incredible knowledge of the structure of appearance, a matchless technique of execution, and an eloquent simplicity of composition that rejected conventional Baroque props and rhetoric. The apparent simplicity of the formal means matches the simplicity of presentation. Placed before an entirely neutral ground, Pareja looks directly at us with a calm dignity and quiet pride, a man perfectly self-contained. His character

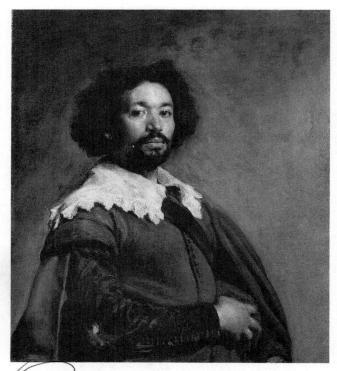

((19-37) DIEGO VELÁZQUEZ, Juan de Pareja, 1649–1650. Approx. $33'' \times 28''$. Metropolitan Museum of Art, New York.

gives him a natural poise, utterly without arrogance or affectation. His level gaze, the easy gesture of arm and hand, and his erect carriage place him directly in front of us, and Velázquez introduces him.

Velázquez's uncanny power of penetration of the form and meaning before him, though in some ways unique, was not entirely untaught. He had studied the works of other artists carefully and was fully aware of the achievements of the great masters like Michelangelo and the Venetians. He knew the latter from the king's collections, of which he had charge, and he also studied them in Italy, where he journeyed at the suggestion of the great Flemish painter Peter Paul Rubens, whom he met when the older Rubens was copying the Venetians in the collections at the Madrid court. His studies in Italy did not make a "Romanist" of Velázquez, however. Their most notable effects were a softening of his earlier, somewhat heavy-handed realism (seen in Los Borrachos) and a lighter palette, which gave his paintings brighter and subtler tonality.

Looking at his masterpiece, *Las Meninas (The Maidsin-waiting*, FIG. **19-38**), with our experience of his portrait of *Juan de Pareja*, we recognize Velázquez as a master of a brilliant optical realism that seldom has been approached and never has been surpassed. The painter represents himself in his studio before a large

canvas, on which he may be painting this very picture or, perhaps, the portraits of the king and queen, whose reflections appear in the mirror on the far wall. The little infanta, Margarita, appears in the foreground with her two maids in waiting, her favorite dwarfs, and a large dog. In the middle ground are a duenna and a male escort; in the background, a gentleman is framed in a brightly lit open doorway. The personages present have been identified, though we need not enumerate them here. On the wall above the doorway and mirror, two faintly recognizable pictures represent the immortal gods as the source of art. Our first impression of Las Meninas is of an informal family group (the painting was long called "The Family" by the Austrian kings of Spain), casually arranged and miraculously lifelike; one could think of it as a genre painting—"A Visit to the Artist's Studio" rather than as a group portrait.

As first painter to the king and as chief steward of the palace, Velázquez was conscious not only of the importance of his court office but of the honor and dignity belonging to his profession as painter. In this painting, he appears to bring the roles together, asserting their equivalent value. A number of pictures from the seventeenth century show painters with their royal patrons, for painters of the time continually sought to aggrandize their profession among the arts and to achieve by it appropriate rank and respect. Throughout his career, Velázquez hoped to be ennobled by royal appointment to membership in the ancient and illustrious Order of Santiago, from which, he must have expected, his profession as painter would not disqualify him. Because some of the required patents of nobility were lacking in his background, he achieved this only with difficulty at the very end of his life, and then only through a dispensation from the pope. In the painting, he wears the red cross of the order on his doublet, painted there, legend tells us, by the king himself; the truth is that the artist painted it. In Velázquez's mind, Las Meninas might have embodied the idea of the great king visiting his artist's studio, as Alexander the Great visited the studio of Apelles in ancient times. We now know that the room represented in the painting was in the palace of the Alcázar in Madrid. After the death of Prince Baltasar Carlos in 1646, his chambers were partly converted into a studio for the use of Velázquez. The picture was designed to hang in the personal office of King Philip, in another part of the palace. It was intended for the king as private viewer and was not to be displayed in a gallery for general viewing. The figures in the painting all acknowledge the royal presence. Placed among them in equal dignity is Velázquez, face-to-face with his sovereign. The

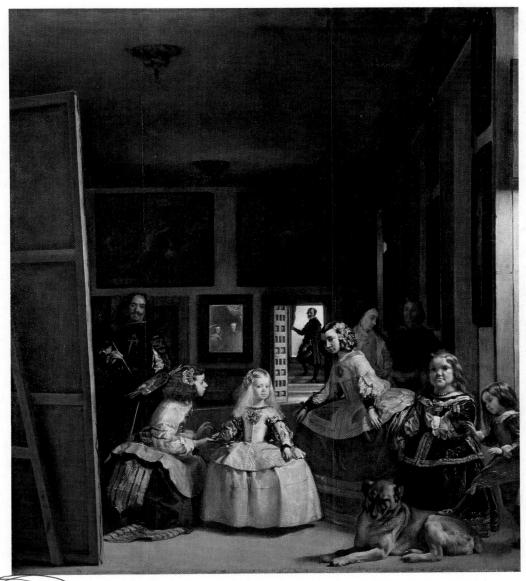

19-38 DIEGO VELÁZQUEZ, Las Meninas, 1656. Approx. 10' $5'' \times 9'$. Museo del Prado, Madrid.

art of painting, in the person of the painter, is elevated to the highest status. Velázquez sought ennoblement not for himself alone, but for his art.

Although Velázquez intends an optical report of the event, authentic in every detail, he also seems to intend a pictorial summary of the various kinds of images in their different levels and degrees of "reality"—the "reality" of canvas image, of mirror image, of optical image, and of the two imaged paintings. This work—with its cunning contrasts of mirrored spaces, "real" spaces, picture spaces, and pictures within pictures—itself appears to have been taken from a large mirror reflecting the whole scene, which would mean the artist has not painted the princess and her suite, but himself in the process of painting them. In the Baroque period, when artists were taking Leonardo's dictum that "the mirror is our master" very seriously, it is not surprising to find mirrors and primitive cameralike devices used to achieve optimum visual fidelity in painting. *Las Meninas* is a pictorial summary as well as a commentary on the essential mystery of the visual world and on the ambiguity that results when we confuse its different states or levels.

How does Velázquez achieve this stunning illusion? He opens the spectrum of light and the tones that compose it. Instead of putting lights abruptly beside darks, as Caravaggio, Ribera, and Zurbarán

would do or as he himself had done in earlier works like Los Borrachos (FIG. 19-36), Velázquez allows a great number of intermediate values of grey to come between the two extremes. Thus, he carefully observes and records the subtle gradations of tone, matching with graded glazes what he sees in the visible spread of light and dark, using strokes of deep dark and touches of highlight to enliven the neutral tones in the middle of the value scale. This essentially cool, middle register of tones is what gives the marvelous effect of daylight and atmosphere to the painting. Velázquez's matching of tonal gradations approaches effects that the age of the photograph later will discover. His method is an extreme refinement of Titian's. Velázquez does not think of figures as first drawn, then modeled into sculptural effects, and then colored. He thinks of light and tone as the whole substance of painting-the solid forms being only suggested, never really constructed. Observing this reduction of the solid world to purely optical sensations in a floating, fugitive skein of color tones, one could say that the old, sculpturesque form has disappeared. The extreme thinness of Velázquez's paint and the light, almost accidental touches of thick pigment here and there destroy all visible structure; we examine his canvas closely, and everything dissolves to a random flow of paint. As a wondering Italian painter exclaimed of a Velázquez painting, "It is made of nothing, but there it is!" And viewing Las Meninas, the artist's biographer, Palomino, exclaimed, "It is truth, not painting!" Painters three hundred years later will realize that Velázquez's optical realism constitutes a limit. Their attempts to analyze it and to take it further will lead in an opposite direction to the one taken by the great Spanish master-to the abstract art of our own time.

FLANDERS

In the sixteenth century, the Netherlands came under the crown of Hapsburg Spain when the emperor Charles V retired, leaving the Spanish throne and his Netherlandish provinces to his only son, Philip II. Philip's repressive measures against the Protestants led to the breaking away of the northern provinces from Spain and the setting up of the Dutch republic under the House of Orange. The southern provinces remained with Spain, and their official religion continued to be Catholic. The political distinction between modern Holland and Belgium more or less reflects this original separation, which, in the Baroque period, signalized not only religious but also artistic differences. The Baroque art of Flanders (the Spanish Netherlands) remained in close contact with the Baroque art of the Catholic countries, while the Dutch schools of painting developed their own subjects and styles, consonant with their reformed religion and the new political, social, and economic structure of the middle-class Dutch republic.

RUBENS

The brilliant Flemish master PETER PAUL RUBENS (1577-1640) preceded Bernini in the development and dissemination of the Baroque style. Rubens's influence was international; he drew together the main contributions of the masters of the Renaissance (Michelangelo and Titian) and of the Baroque (the Carracci and Caravaggio) to synthesize in his own style the first truly European manner. Thus, Rubens completes the work begun by Albrecht Dürer in the previous century. The art of Rubens, even though it is the consequence of his wide study of many masters, is no weak eclecticism but an original and powerful synthesis. From the beginning, his instinct was to break away from the provincialism of the old Flemish Mannerists and to seek new ideas and methods abroad. His aristocratic education, his courtier's manner, diplomacy, and tact, as well as his classical learning made him the associate of princes and scholars. He became court painter to the dukes of Mantua (descended from the patrons of Mantegna), friend of the king of Spain and his adviser on art collecting, painter to Charles I of England and Marie de' Medici, queen of France, and permanent court painter to the Spanish governors of Flanders. Rubens also won the confidence of his royal patrons in matters of state, and he often was entrusted with diplomatic missions of the highest importance. In the practice of his art, he was assisted by scores of associates and apprentices, turning out large numbers of paintings for an international clientele. In addition, he functioned as an art dealer, buying and selling works of contemporary art and classical antiquities. His numerous enterprises made him a rich man, with a magnificent town house and a château in the countryside. Wealth and honors, however, did not spoil his amiable, sober, self-disciplined character. We have in Rubens, as in Raphael, the image of the successful, renowned artist, the consort of kings, and the shrewd man of the world, who is at the same time the balanced philosopher. Rubens more than makes good the Renaissance claim for the preeminence of the artist in society.

Rubens became a master in 1598 and went to Italy two years later, where he remained until 1608. During these years, he formulated the foundations of his style. Shortly after his return from Italy, he painted *The Elevation of the Cross* (FIG. **19-39**) for Antwerp Cathedral. This work shows the result of his long study

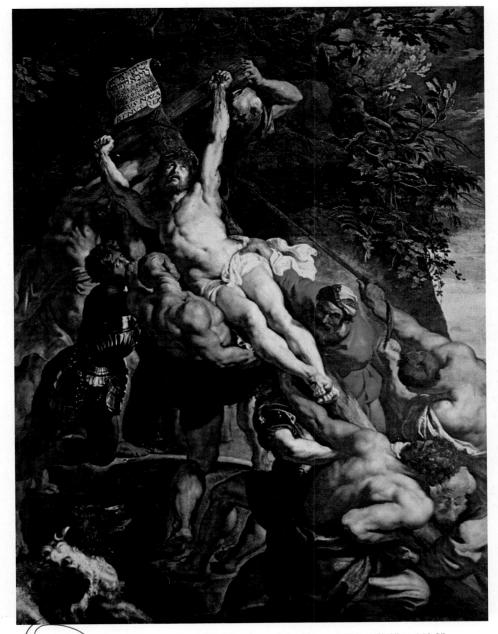

19-39 PETER PAUL RUBENS, The Elevation of the Cross, 1610. 15' 2" × 11' 2". Antwerp Cathedral, Belgium.

of Italian art, especially of Michelangelo, Tintoretto, and Caravaggio. The scene is a focus of tremendous, straining forces and counterforces, as heavily muscled giants strain to lift the cross. Here, the artist has the opportunity to show foreshortened anatomy and the contortions of violent action—not the bound action of Mannerism, but the tension of strong bodies meeting resistance outside themselves. The body of Christ is a great, illuminated diagonal that cuts dynamically across the picture and, at the same time, inclines back into it. The whole composition seethes with a power that we feel comes from genuine exertion, from elastic human sinew taut with effort. Strong modeling in dark and light marks Rubens's work at this stage of his career; it gradually will give way to a much subtler, coloristic style.

The vigor and passion of Rubens's early manner never leave his painting, although the vitality of his work is modified into less strained and more subtle forms, depending on the theme. Yet Rubens has one general theme—the human body, draped or undraped, male or female, freely acting or free to act in an environment of physical forces and other interacting bodies. Rubens's conception of the human scene

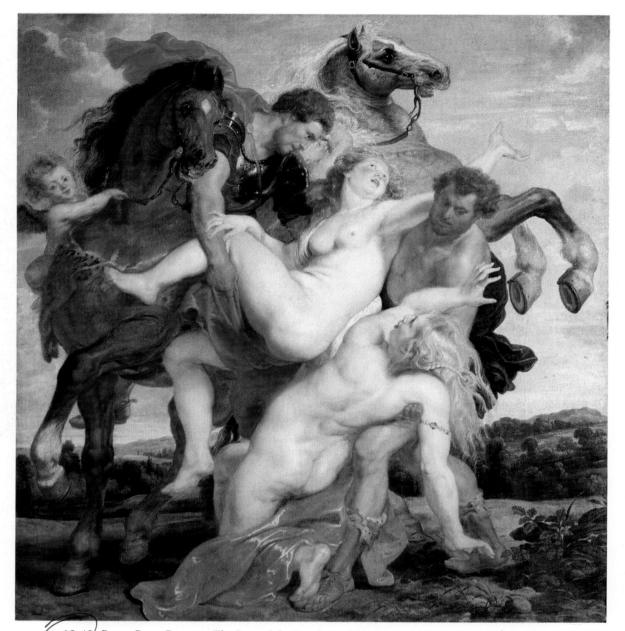

19-40 PETER PAUL RUBENS, The Rape of the Daughters of Leucippus, 1617. Approx. $7' 3'' \times 6' 10''$. Alte Pinakothek, Munich.

does not contain profoundly tragic elements nor anything manneristically intellectual, enigmatic, or complex. His forte is the strong animal body described in the joyful, exuberant motion natural to it. His *Rape of the Daughters of Leucippus* (FIG. **19-40**) describes the abduction of two young mortals by the gods Castor and Pollux, who have fallen in love with them. The amorous theme permits departures from realism, especially in the representation of movement and exerted strength. The gods do not labor at the task of sweeping up the massive maidens—descendants of the opulent Venuses of Giorgione and Titian (FIGs. 17-59 and 17-62)—nor do the maidens energetically resist. The figures are part of a highly dynamic, slowly revolving composition that seems to turn on an axis; they form a diamond-shaped group that defies stability and the logic of statics. The surface pattern, organized by intersecting diagonals and verticals, consists of areas of rich, contrasting textures: the soft luminous flesh of the women, the bronzed tan of the muscular men, lustrous satins, glinting armor, and the taut, shimmering hides of the horses. All around this surface pattern, a tight massing of volumes moves in space. The solid forms are no longer described simply in terms of the dark-light values of Florentine draftsmanship but are now built up in

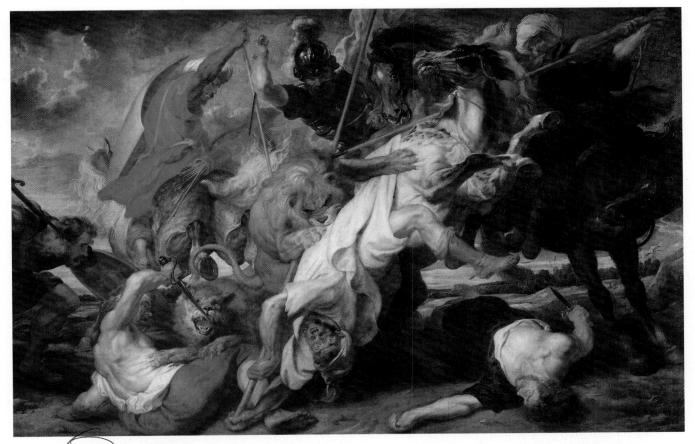

19-41 PETER PAUL RUBENS, The Lion Hunt, 1617–1618. Approx. 8' 2" × 12' 5". Alte Pinakothek, Munich.

color and defined by light, as in Venetian painting.

The impact of Rubens's hunting pictures lies in their depiction of ferocious action and vitality. In *The Lion Hunt* (FIG. **19-41**), a cornered lion, three lances meeting in his body, tears a Berber hunter from his horse. A fallen man still grips his sword, while another, in a reversed position, stabs at a snarling cat. Horsemen plunge in and out of the picture space, and the falling Berber makes a powerful, diagonal cut across the composition. The wild melee of thrusting, hacking, rearing, and plunging is almost an allegory of the confined tensions of Mannerism exploding into the extravagant activity that characterized the Baroque.

Rubens shared heartily in the Baroque love of magnificent pomp, especially as it set off the majesty of royalty, in which Rubens, born courtier that he was, heartily believed. The Baroque age saw endless, extravagant pageants and festivals produced whenever the great or even lesser dynasts moved. Their authority and right to rule were forever being demonstrated by lavish display. We have seen that the popes themselves, the princes of the Church, made of St. Peter's a permanently festive monument to papal supremacy. And Marie de' Medici, a member of the famous Florentine house, commissioned Rubens to paint a cycle memorializing and glorifying her career and that of her late husband, the first of the Bourbon kings, Henry IV. Between 1622 and 1626, Rubens, working with amazing creative energy, produced by his own hand twenty-one huge historical-allegorical pictures, designed to hang in the queen's new palace, the Luxembourg, in Paris.

Perhaps the most vivacious and dexterously composed of the series is the Arrival of Marie de' Medici at Marseilles (FIG. 19-42); it can be taken as exemplary of the mood and style of the others. Marie has arrived in France after the sea voyage from Italy. Surrounded by her splendid ladies, she is welcomed by an allegory of France, a figure draped in the fleur-de-lis. The sea and sky rejoice at her safe arrival; Poseidon and the Nereids salute her, and a winged, trumpeting Fame swoops overhead. Conspicuous in the opulently carved stern-castle of the Baroque galley, under the coat of arms of the Medici, stands the imperious commander of the vessel. In black and silver, his figure makes a sharp accent in the midst of the swirling tonality of ivory, gold, and red. He wears the cross of a Knight of Malta, which may identify this as a ship belonging to that order. The only immobile figure in the composition, he could be director of and witness to the boisterous ceremonies. Broad and florid

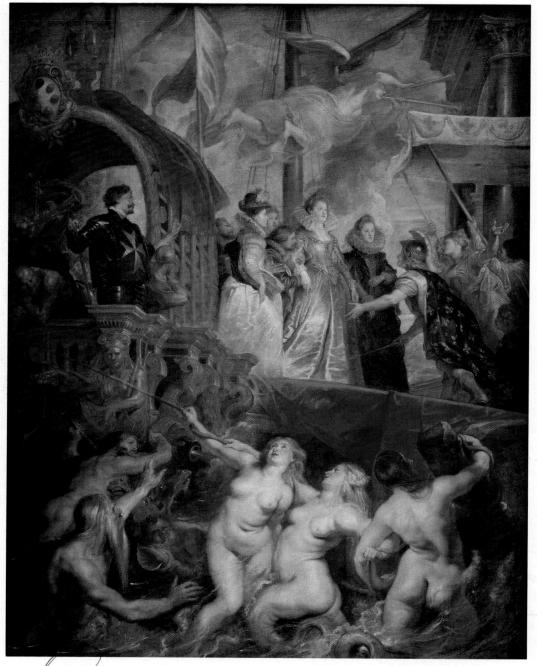

19-42 PETER PAUL RUBENS, Arrival of Marie de' Medici at Marseilles, 1622–1625. Approx. $61'' \times 45\frac{22'}{3}$. Louvre, Paris.

compliments, in which Heaven and earth join, are standard in Baroque pageantry, where honor is done to royalty. (We already have met the collaboration of the celestial and earthly spheres in the glorification of religious themes in Italian Baroque art.) The artist enriches his surfaces here with a decorative splendor that pulls the whole composition together, and the audacious vigor that customarily enlivens Rubens's figures, beginning with the monumental, twisting sea creatures, vibrates through the entire design. Rubens's imposing, dynamic figure compositions were not his only achievement; he also produced rich landscapes and perceptive portraits. His portrait of *Thomas Howard, Earl of Arundel* (FIG. **19-43**), is a painting of singular power. This great English nobleman played a leading role in the complicated diplomacy and statecraft of the age of Charles I, when England was on the verge of a tragic civil war between the Stuart king and Parliament. Arundel is best remembered, however, as a lover of art, who built a collec-

tion of ancient statuary and other works of art unsurpassed in the Europe of his time. Rubens was a friend of Arundel and an admirer of his taste and learning. The artist's admiration for the man himself, regarded by contemporaries as the bringer of "true virtu"knightly gallantry and magnanimity-to England, is clearly expressed in the portrait. The earl is posed in an attitude of regal majesty. He directs a sharp, stern, haughty glance over his shoulder, creating instant distance between his rank and that of the observer. The look given by the aquiline features is that of a commander of armies silencing a subordinate; it is full of an authority not to be questioned. Rubens gives us not the sensitive lover of art but the fearless captain. We realize that the earl himself must have stipulated that this aspect of his character and career be shown. To this end, Rubens has garbed him in magnificent ceremonial armor. His gauntleted hand rests on the commander's staff; his plumed helmet sits on a table at his side. Behind him, a curtain is drawn aside, revealing a severe Classical architecture that echoes his mood. Rubens lavishes all of his rich resources of color tone in the rendering of the splendid accoutrements of high rank and latter-day chivalry. This imperious image speaks for an autocratic age-for the great dynasts of the Baroque, whom Rubens knew well and who were his patrons.

19-43 PETER PAUL RUBENS, Thomas Howard, Earl of Arundel, c. 1630. Approx. 54" × 45". Isabella Stewart Gardner Museum, Boston.

19-44 ANTHONY VAN DYCK, Charles I Dismounted, c. 1635. Approx. $9' \times 7'$. Louvre, Paris.

Most of Rubens's successors in Flanders had been his assistants. The most famous, ANTHONY VAN DYCK (1599–1641), probably worked with his master on the canvas of The Rape of the Daughters of Leucippus. Quite early, the younger man, unwilling to be overshadowed by the undisputed stature of Rubens, left his native Antwerp for Genoa and then London, where he became court portraitist to Charles I. Although Van Dyck created dramatic compositions of high quality, his specialty became the portrait, and he developed a courtly manner of great elegance that would be influential internationally. His style is felt in English portrait painting down to the nineteenth century. In one of his finest works, Charles I Dismounted (FIG. 19-44), he shows the ill-fated Stuart king standing in a Venetian landscape (with the river Thames in the background), attended by an equerry and a page. Although the king impersonates a nobleman out for a casual ride in his park, no one can mistake the regal poise and the air of absolute authority that his Parliament resented and was soon to rise against. The composition is exceedingly artful in the placement of the king. He stands off-center, but balances the picture with a single keen glance at the observer. The fulllength portraits by Titian and the cool composure of the Mannerists both contribute to Van Dyck's sense of pose and arrangement of detail. For centuries to come, artists who make portraits of the great— Thomas Gainsborough, Joshua Reynolds, and John Singer Sargent, among them—will keep Van Dyck very much in mind.

HOLLAND

For all intents and purposes, the style of Peter Paul Rubens is the style of Baroque Flanders; he had few rivals of significance and held a monopoly on commissions. The situation is so completely different in Holland that it is difficult to imagine how, within such a tiny area, two such opposite artistic cultures could flourish. The Dutch Protestants and the Flemish Catholics went their separate ways after the later sixteenth century. Although closer in outlook to the Germans, the Dutch were ethnically the same as the Flemish, who were, in turn, closer in viewpoint to their neighbors to the south-the French. A Catholic, aristocratic, and traditional culture reigned in the Flanders of Rubens. In Holland, severe, Calvinistic Protestantism was puritanical toward religious art, sculptural or pictorial, although many of the Dutch were Catholics, including a number of painters. The churches were swept clean of images, and any recollection of the pagan myths, the material of Classicism, or even historical subjects, was proscribed in art. During the Middles Ages and the Renaissance, religious subjects and, later, Classical and historical subjects had been the major stimuli for artistic activity. Divested of these sources, what remained to enrich the lives of wealthy Hollanders? For they were wealthy! During the early part of the Spanish rule, the Dutch, like the Flemish, prospered. The East India Company was formed, and the discovery of the New World opened up further opportunities for trade and colonization. The wars of independence from Spain made Holland the major maritime country of Europe; its closest rival was England, another Protestant power in the times of the Spanish decline. The great Dutch commercial cities, such as Haarlem and Amsterdam, had been stimulated and enriched, and civic pride was strong. Although it was not internationally recognized until the Peace of Westphalia in 1648, Holland in fact had been independent from Spain since about 1580 and was extremely proud of its hard-won freedom. Under these circumstances, writes the nineteenth-century French painter Eugène Fromentin,

Dutch painting . . . was and could be only the portrait of Holland, its exterior image, faithful, exact, complete, with no embellishments. Portraits of men and places, citizen habits, squares, streets, countryplaces, the sea and the sky—such was to be . . . the program followed by the Dutch school, and such it was from its first day to the day of its decline.*

Dutch painters increasingly pried into the pictorial possibilities of everyday life and kept an eye on their customers, the middle-class burghers, who wanted paintings to hang on their walls as evidence of their growing wealth and social position.

We have followed the secularization and humanization of religious art since the thirteenth century. In the Dutch school of the seventeenth century, the process is completed. A thousand years and more of religious iconography are dismissed by a European people who ask for a view of the world from which angels, saints, and deities have been banished. The old Netherlandish realism remains, but it no longer serves religious purposes. The Dutch artists rise to the occasion, matching the open, competitive, Dutch society, which is thoroughly middle-class, with an equally open arrangement of their own, in which the painter works not for a patron but for the market. Dutch artists become specialists in any one of a number of subjects-genre, landscape, seascape, cattle and horses, table still life, flower still life, interiors, and so on. In short, they paint subjects that they feel will appeal to the public and therefore be marketable. This independence from the patron gives the Dutch painter a certain amount of freedom, even if it is only the freedom to starve on the free-picture market. With respect to the artist-market relationship, the contrast between Flanders and Holland in the seventeenth century is poignantly reflected in the careers of Rubens and Rembrandt. The former is the market in Flanders; his genius determines it. The latter, after finding a place in the market, is rejected by it when his genius is no longer marketable.

The realism of Dutch art is made up of the old tradition, which goes back to Hubert and Jan van Eyck, and of the new "realism of light and dark," brought back to Holland by Dutch painters who had studied Caravaggio in Italy. One of these "night painters" (as they were called), GERARD VAN HONTHORST (1590– 1656) of Utrecht, spent several years in Italy absorbing Caravaggio's style. He is best known for merry genre scenes like *The Supper Party* (FIG. **19-45**), in which unidealized, human figures are shown in an informal gathering. Although these "merry companies," naturalistically rendered in night settings, were popular and widely produced in the Baroque

^{*}Eugène Fromentin, *The Masters of Past Time: Dutch and Flemish Painting from Van Eyck to Rembrandt*, trans. A. Boyle (London: Phaidon, 1948), p. 130.

19-45 Gerard van Honthorst, The Supper Party, 1620. Approx. $7' \times 4' 8''$. Galleria degli Uffizi, Florence.

period, they were not necessarily taken simply as pictures of people enjoying themselves. We must remember the Baroque mental habit of allegorizing and symbolizing even the most realistic images. Here, for example, we may be expected to witness the loose companions of the Prodigal Son (Luke 15:13)panders and prostitutes, drinking, singing, strumming, laughing. Perhaps, at the same time, we have an allegory of the Five Senses through which sin can enter the soul: taste, touch, sight, sound, scent. Fascinated by nocturnal effects, Van Honthorst frequently places a hidden light source (two, in this case) in his pictures and uses it as a pretext to work with dramatic and violently contrasted dark-light effects. Without the incisive vision of Caravaggio, Van Honthorst nevertneless is able to match, and sometimes to surpass, the former's tenebristic effects.

FRANS HALS

The Dutch schools were centered in various cities (Utrecht, Haarlem, Leiden, Amsterdam), but all had in common the lesson of Caravaggio as interpreted by Dutch Caravaggisti like Van Honthorst. FRANS HALS (*c.* 1580–1666) was the leading painter of the Haarlem school and one of the great realistic painters of the

Western tradition. Hals appropriates what he needs from the new lighting to make portraiture (his specialty) an art of acute psychological perception as well as a kind of comic genre. The way light floats across the face and meets shadow can be arranged by the artist, as can the pose and the details of costume and facial expression. Hals shows himself to be a master of all the devices open to a portraitist who no longer needs to maintain the distance required by the strictly formal portrait.

The relaxed relationship between the portraitist and his subject is apparent in the engaging portrait of *Willem Coymans* (FIG. **19-46**), dated 1645. Although the subject is a young man of some importance, the artist seems to be taking a great many liberties with his portrait. The young man leans on one arm with a jaunty air of insolence, his hat cocked at a challenging angle, a look of contemptuous drollery in his eyes. The illusion of life is such that we take cues from the subject's expression as if we were face to face with him. Hals's genius lies in capturing the minute, expressional movements by which we appraise the man across from us in everyday life. Until now, this kind of intimate confrontation rarely had been seen in painting. It is a kind of contradiction of the masks of

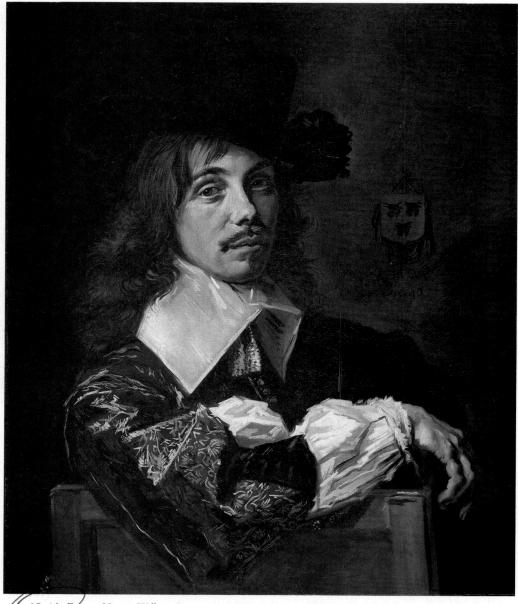

(19-46 Erans Hals, Willem Coymans, 1645. Approx. $30\frac{1''}{4} \times 25''$. National Gallery of Art, Washington, D.C. (Andrew W. Mellon Collection).

formal portraiture created in the Renaissance. We are in the presence of an individual without formal introduction; the gap between us and the subject is reduced until we are almost part of his physical and psychological environment. The casualness, immediacy, and intimacy are intensified by the manner in which the painting is executed. The touch of the painter's brush is as light and fleeting as the moment in which the pose is caught; the pose of the figure, the highlights on the sleeve, the reflected lights within face and hand, and the lift of the eyebrow are all the instant prey of time. Thus, the evanescence of time that Bernini caught in his *David* (FIG. 19-10) is

recorded far to the north a few years later in a different subject and medium. Both are Baroque.

Frans Hals is a genius of the comic. He had precedents in the gargoylism and grotesquerie of the northern Middle Ages and, in later times, in the works of Hieronymus Bosch and Pieter Bruegel. But Hals's comedy is that of character rather than situation. He shows us—as Aristotle would demand of comedy—people as they are and somewhat less than they are; this puts us at ease, out of superiority, so that we can laugh at others and at ourselves. Hals takes his comic characters, as did Shakespeare, his contemporary, from the lower levels of society.

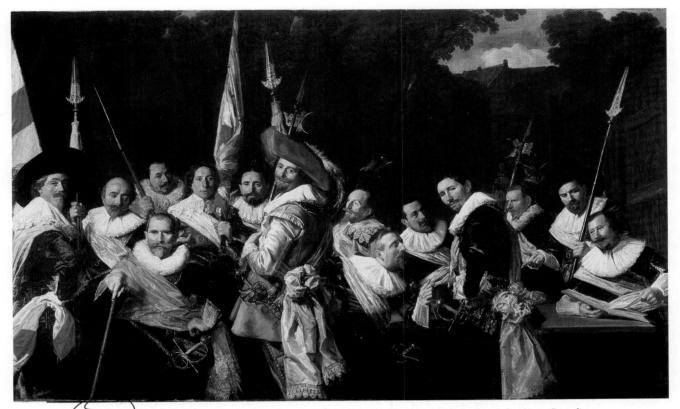

19-47 FRANS HALS, Archers of St. Adrian (Assembly of Officers and Subalterns of the Civic Guard), c. 1633. Approx. 6' 9" × 11'. Frans Halsmuseum, Haarlem, Netherlands.

Good-humored stageplay also brightens Hals's great canvases of units of the Dutch civic guard, which played an important part in the liberation of Holland. These companies of archers and musketeers met on their saints' days in dress uniform for an uproarious banquet, giving Hals an opportunity to attack the problem of adequately representing each subject of a group portrait while retaining action and variety in the composition. Earlier group portraits in the Netherlands represent the sitters as so many jugs on a shelf. Hals undertakes to correct this and, in the process, produces dramatic solutions to the problem, like that found in his Archers of St. Adrian (FIG. 19-47). Here, the troopers have finished their banquet, the wine has already gone to their heads, and each in his own way is sharing the abundant high spirits. As a stage director, Hals has few equals. In quite Baroque fashion, he balances direction of glance, pose, and gesture, making compositional devices of the white ruffs, broad-brimmed black hats, and banners. Although the instantaneous effect—the preservation of every detail and facial expression—is, of course, the result of careful planning, Hals's vivacious brush seems to have moved spontaneously, directed by a plan in the artist's mind but not traceable in any preparatory scheme on the canvas. The bright optimism of this early period of Dutch freedom is caught in the swaggering bonhomie of the personalities, each of whom plays his particular part within the general unity of mood. This gregariousness goes with the new democracy, as well, perhaps, as with the fellowship that grows from a common experience of danger.

REMBRANDT

With Hals, Baroque realism concentrates on the human subject so intimately that we are forced to relate it to ourselves. We and the subject look at each other, as if in a sharing of mood; Hals purposely attempts to set up a confrontation of personalities. Yet most subjects still prefer to present only a public image, and even Hals has not entirely broken away from the tradition of formal portraiture that goes back to the fifteenth century. The first deep look into the *private* person will be made by Hals's younger contemporary, REMBRANDT VAN RIJN (1606–1669).

Rembrandt's way was prepared spiritually by the Protestant Reformation and the Dutch aspiration to freedom, and formally by the Venetian painters, Rubens, and Caravaggio and his Dutch imitators. The richness of this heritage alone, however, cannot account for the extraordinary achievement of this artist, one of the very greatest among those geniuses who excel in revealing Western humanity to itself. Rembrandt used painting as a method for probing the states of the human soul, both in portraiture and in his uniquely personal and authentic illustrations of the Scriptures. The abolition of religious art by the Reformed church in Holland did not prevent him from making a series of religious paintings and prints that synopsize the Bible from a single point of view. His art is that of a believing Christian, a poet of the spiritual, convinced that the biblical message must be interpreted for human beings in human terms. In Rembrandt, the humanization of medieval religion is now completed in the vision of a single believer. In the Baroque age, this is roughly parallel to the sighting of a new planet by some single "watcher of the skies."

Rembrandt's pictorial method involves refining light and shade into finer and finer nuances, until they blend with one another. (Caravaggio's "absolute" light has, in fact, many shadows; his "absolute" dark is brightened by many lights.) We have seen that Velázquez renders optical reality as a series of values a number of degrees of lightness and darkness. The use of abrupt lights and darks gives way in the works of men like Rembrandt and Velázquez to gradation, and, although the dramatic effects of violent chiaroscuro may be sacrificed, the artist gains much of the truth of actual appearances. This happens because the eye perceives light and dark not as static but as always subtly changing. Changing light and dark can suggest changing human moods; we might say that the *motion* of light through a space and across human features can express emotion, the changing states of the psyche.

The Renaissance represents forms and faces in a flat, neutral, modeling light (even Leonardo da Vinci's shading is of a standard kind), just as it represents action in a series of standard poses. The Renaissance painter represents the idea of light and the idea of action, rather than the actual look of either. Light, atmosphere, change, and motion are all concerns of Baroque art, as well as of Baroque mathematics and physics. The difference between the Baroque view and what went before lies largely in the new desire to measure these physical forces. For example, as the physicist in the seventeenth century is concerned not just with motion, but with acceleration and velocity degrees of motion—so Baroque painters discover degrees of light and dark, of differences in pose, in the movements of facial features, and in psychic states. They arrive at these differences optically, not conceptually or in terms of some ideal. Rembrandt found that by manipulating light and shadow in terms of direction, intensity, distance, and texture of

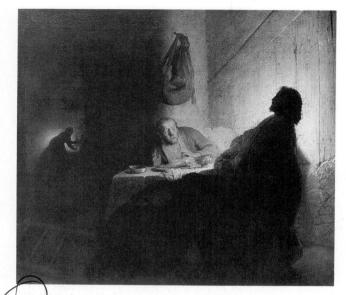

19-48 REMBRANDT VAN RIJN, Supper at Emmaus, c. 1628–1630. $14\frac{12''}{2} \times 16\frac{16}{3}$ ". Musée Jacquemart-André, Paris.

surface, he could render the most subtle nuances of character and mood, of persons, or of whole scenes. Rembrandt discovers for the modern world that differences of light and shade, subtly modulated, can be read as emotional differences. In the visible world, light, dark, and the wide spectrum of values between the two are charged with meanings and feelings that sometimes are independent of the shapes and figures they modify. The lighted stage and the photographic arts have accepted this for many decades as the first assumption behind all their productions. What Masaccio and Leonardo began, the age of Rembrandt completes.

In his early career in Amsterdam, Rembrandt's work was influenced by Rubens and by Dutch Caravaggesque painters like Van Honthorst. Thus, in a work like his early Supper at Emmaus (FIG. 19-48), which dates from about 1630, he represents the subject with high drama-in sharp light and dark contrast—even using the device, familiar among his contemporaries, of placing the source of illumination behind an obstructing form (in this case, the head of Christ). This placement puts the darkest shadow in front of the brightest light, creating an emphatic, if obvious, dramatic effect. The poses of the two alarmed disciples to whom the risen Christ reveals himself are likewise a studied stage maneuver. Some eighteen years later, in another painting of the same subject (FIG. 19-49), the mature Rembrandt forsakes the earlier melodramatic means for a serene and untroubled setting. Here, with his highly developed instinct for light and shade, he gives us no explosive contrasts; rather, a gentle diffusion of light mellows

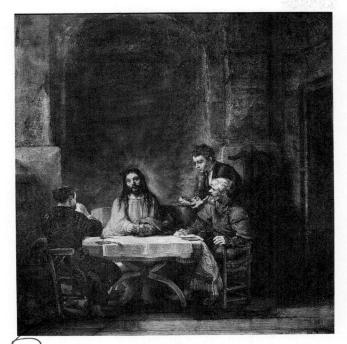

19-49 REMBRANDT VAN RIJN, Supper at Emmaus, с. 1648. Approx. 27" × 26". Louvre, Paris.

the whole interior, condensing just slightly to make an aureole behind the head of Christ. The disciples only begin to understand what is happening; the servant is unaware. This Christ is Rembrandt's own interpretation of the biblical picture of the humble Nazarene—gentle, with an expression both loving and melancholy.

The spiritual stillness of Rembrandt's religious painting is that of inward-turning contemplation, far from the choirs and trumpets and the heavenly tumult of Bernini or Pozzo. Rembrandt gives us not the celestial triumph of the Church, but the humanity and humility of Jesus. His psychological insight and his profound sympathy for human affliction produce, at the very end of his life, one of the most moving pictures in all religious art, The Return of the Prodigal Son (FIG. 19-50). Tenderly embraced by his forgiving father, the son crouches before him in weeping contrition while three figures, immersed in varying degrees in the soft shadows, note the lesson of mercy. The scene is determined wholly by the artist's inward vision of its meaning. The light, everywhere mingled with shadow, controls the arrangement of the figures, illuminating the father and son and largely veiling the witnesses. Its focus is the beautiful, spiritual face of the old man; secondarily, it touches the contrasting, stern face of the foremost witness. There is no flash or glitter of light or color; the raiment is as sober as the characters are grave. Rembrandt, one feels, has put the official Baroque style far behind him and has developed a personal style completely in tune with the simple eloquence of the biblical passage. One could not help but read the Bible differently, given the authority of Rembrandt's pictorial interpretations of it.

Rembrandt carries over the spiritual quality of his religious works into his later portraits by the same means-what we might call the "psychology" of light. Light and dark are not in conflict in his portraits; they are reconciled, merging softly and subtly to produce the visual equivalent of quietness. The prevailing mood is that of tranquil meditation, of philosophical resignation, of musing recollectionindeed, a whole cluster of emotional tones heard only in silence. He records the calamities of his own life and the age-old tragedies of the Jewish people (he had many friends in the Jewish quarter of Amsterdam) in the worn faces of aged and silent men. His study of the influence of time on the human features was one with his study of light. The mood of reflection conveyed by the slow movement of lights and darks complements the appearance of the aged face in slanting light: a sunken terrain crisscrossed with deep lines. In a long series of self-portraits, Rembrandt preserved his own psychic history from the

19-50 REMBRANDT VAN RIJN, The Return of the Prodigal Son, c. 1665. Approx. 8' $8'' \times 6' 8_4^{3''}$. Hermitage Museum, Leningrad.

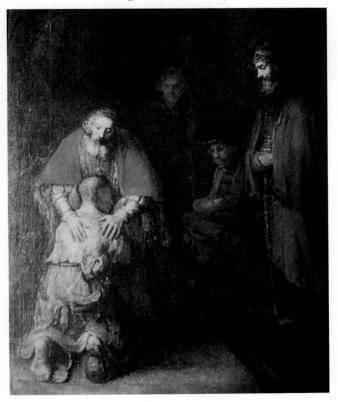

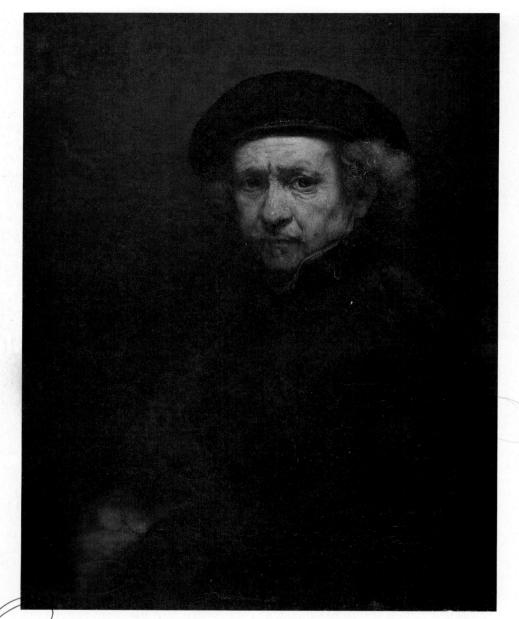

19-51 REMBRANDT VAN RIJN, Self-Portrait, с. 1659. Approx. 33" × 26". National Gallery of Art, Washington, D.C. (Andrew W. Mellon Collection).

bright alert optimism of youth to the worn resignation of his declining years. These last years, when he was at the height of his artistic powers, cost him much physically.

In a late self-portrait (FIG. **19-51**), the light from above and from the artist's left pitilessly reveals a face ravaged by anxiety and care. The pose is that of Raphael's *Baldassare Castiglione* (FIG. 17-18), which Rembrandt had seen in Holland and copied in an earlier self-portrait. The difference between Raphael's and Rembrandt's portraits tells us much about the difference between the approaches of the artists and the philosophies of their times. In Raphael's subject, the ideal has modified the real. Rembrandt, on the other hand, shows himself as he appears to his own searching and unflattering gaze. Here, an elderly man is not idealized into the image of the courtly philosopher; he is shown merely as he is, a human being in the process of dwindling away. For some, the portrait and the self-portrait, which began as a medium for the recording of likeness, came to be painted out of motives of vanity. With Rembrandt, they are the history of Everyman's painful journey through the world.

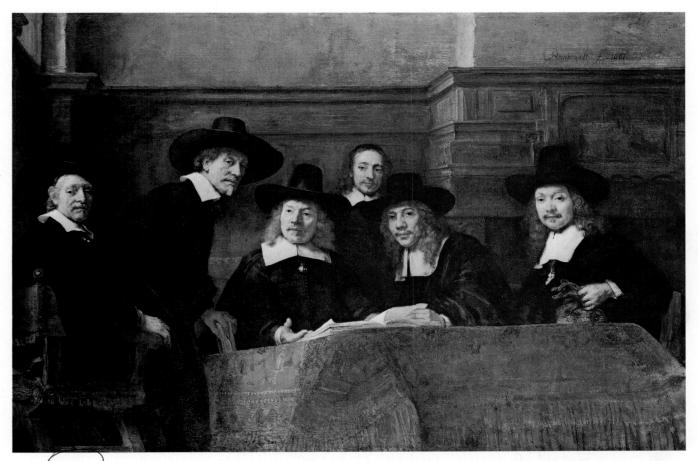

19-52 REMBRANDT VAN RIJN, Syndics of the Cloth Guild, 1662. Approx. 6' 2" × 9' 2". Rijksmuseum, Amsterdam.

In the group portrait, an area of painting in which Frans Hals excelled, Rembrandt shows himself to be the supreme master. In Syndics of the Cloth Guild (FIG. 19-52), representing an archetypal image of the new businessmen, Rembrandt applied all that he knew of the dynamics and the psychology of light, the visual suggestion of time, and the art of pose and facial expression. The syndics, or board of directors, are going over the books of the corporation. It would appear that someone has entered the room and they are just at the moment of becoming aware of him, each head turning in his direction. Rembrandt gives us the lively reality of a business conference as it is interrupted; yet he renders each portrait with equal care and with a studied attention to personality that one would expect to be possible only from a long studio sitting for each man. Although we do not know how Rembrandt proceeded, this harmonizing of the instantaneous action with the permanent likeness seems a work of superb stage direction that must have needed long rehearsal. The astonishing harmonies of light, color, movement, time, and pose have few rivals in the history of painting.

Rembrandt's virtuosity also extends to the graphic media, in particular, to etching. Here again, he ranks at the summit, alongside the original master, Dürer, who was actually an engraver. Etching, perfected early in the seventeenth century, rapidly was taken up by many artists; it was far more manageable than engraving and allowed greater freedom in drawing the design. In etching, a copper plate is covered with a layer of wax or varnish in which the design is drawn with an etching needle or any pointed tool, exposing the metal below but not cutting into its surface. The plate is then immersed in acid, which etches, or eats away, the exposed parts of the metal, acting in the same capacity as the burin in engraving. The softness of the medium gives the etcher greater freedom than the woodcutter and the engraver, who work directly in their more resistant media of wood and metal. Thus, prior to the invention of the lithograph in the nineteenth century, etching was the most facile of the graphic arts and the one that offered the greatest subtlety of line and tone.

If Rembrandt had never painted, he still would be renowned, as he principally was in his lifetime, for

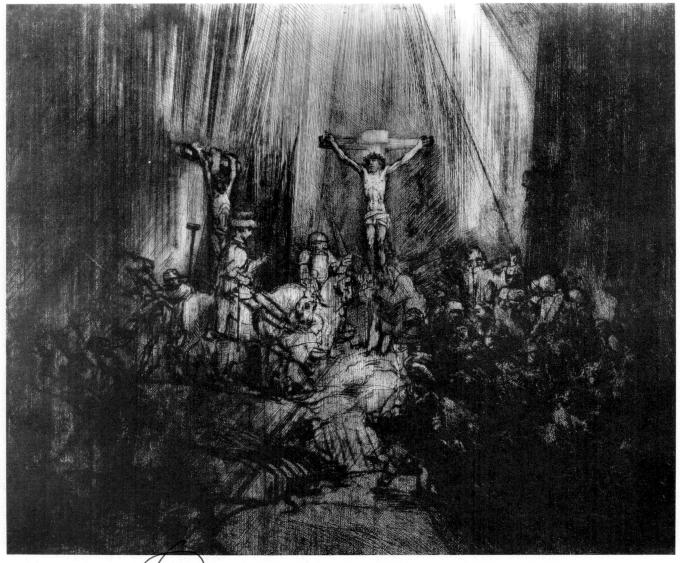

(19-53) REMBRANDT VAN RIJN, *The Three Crosses*, 1653. Fourth-state etching, approx. 15" × 18". British Museum, London.

his prints. Prints were a major source of income for him, and he often reworked the plates so that they could be used to produce a new issue or edition. The illustration here shows the fourth state, or version, of his *Three Crosses* (FIG. **19-53**). In the earlier states, he represents the hill of Calvary in a quite pictorial, historical way, with crowds of soldiers and spectators, all descriptively and painstakingly rendered. In this last state, not the historical but the symbolic significance of the scene comes to the fore. As if impatient with the earlier detail, Rembrandt furiously eliminates most of it with hard, downward strokes of the needle, until what appears like a storm of dark lines pours down from Heaven, leaving a zone of light on the lonely figure of the crucified Christ. Here, Rembrandt seems clearly to show that, in the words of theologian William Vischer-T'Hooft, "the entire biblical story is meant to lead us to the cross."

The art of his later years was not really acceptable to Rembrandt's contemporaries (although he occasionally received important commissions, like that for *Syndics of the Cloth Guild*). It was too personal, too eccentric. Many, like the Italian biographer Filippo Baldinucci, thought Rembrandt was a tasteless painter, concerned with the ugly and ignorant of color. This prejudice lasted well into the nineteenth century, when Rembrandt's genius finally was acknowledged. We see him now as one of the great masters of the whole tradition, an artist of great versatility, and the unique interpreter of the Protestant conception of scripture.

At the same time, modern scholarship and connoisseurship are revising our notion of Rembrandt's uniqueness and our view of him as an isolated and courageous master, who found his own way to new heights of expression, no matter the barriers of misunderstanding raised against him. Though his greatness is still conceded, Rembrandt now is understood to have been very much a part of his time, society, and stylistic school. He had numerous colleagues and pupils, with whom he shared stylistic traits and technical methods—so much so, that it is often difficult and sometimes impossible to determine which of the many paintings attributed to him are actually his. For twenty years, a team of Dutch scholars, the Rembrandt Research Project, has been carefully examining paintings attributed to Rembrandt in museums and private collections throughout the world. The results of their investigation, which still continues, have raised vehement debate, controversy, and consternation among art historians, museum curators, collectors, and dealers. Millions of dollars are at stake. The Rembrandt research team does not seem willing to allow more than 350 pictures to be credited with certainty to Rembrandt; at one time, twice that number had been so attributed. None of this subtracts, of course, from the esthetic value of Rembrandt's contribution, which certainly is inestimable; nor does it in any way diminish his stature in the history of world art. It *does* remind us once again that the facts of art history are always open to review, and our interpretations of them to revision.

THE "LITTLE DUTCH MASTERS"

The pictorial genius of the Dutch masters of the seventeenth century surpassed all others in its comprehensiveness of subject, taking all that is given to the eye as its province. The whole world of sight is explored, but especially the things of ordinary use and aspect with which human beings surround themselves. In some ways, the old Netherlandish tradition of Jan van Eyck lives on in the rendering of things in the optical environment with a loving and scrupulous fidelity to their appearances. Dutch painters came to specialize in portraiture, genre, interiors, still life, landscape and seascape, and even in more specialized subdivisions of these. With many, the restriction of their professional interest is all to the good; they may not create works of grand conception, but, within their small compass, they produce exquisite art.

JAN VERMEER

The best-known and most highly regarded of these painters, once referred to as the "little Dutch masters," is JAN VERMEER (1632–1675) of Delft, who was rediscovered in the nineteenth century. Vermeer's pictures are small, few, and perfect within their scope. While the fifteenth-century Flemish artists usually painted interiors of houses occupied by persons of sacred significance, Vermeer and his contemporaries composed neat, quietly opulent interiors of Dutch middle-class dwellings, in which they placed men, women, and children engaged in household tasks or some little recreation-totally commonplace actions, yet reflective of the values of a comfortable domesticity that has a simple beauty. Vermeer usually composed with a single figure, but sometimes with two or more. His Young Woman with a Water Jug (FIG. 19-54) can be considered typical, although we cannot be sure of the precise action being depicted or the precise moment of action. The girl may be opening the window to water flowers in a window box outside. This action is insignificant in itself and only one of hundreds performed in the course of a domestic day. Yet Vermeer, in his lighting and composing of the scene, raises it to the level of some holy, sacramental act. The old Netherlandish symbolism that made every ordinary object a religious sign is gone, but this girl's slow, gentle gesture is almost liturgical. The beauty of humble piety, which Rembrandt finds in human faces, is extended here to a quite different context. The Protestant world, renouncing magnificent churches, finds a sanctuary in a modest room illuminated by an afternoon sun. Yet the light is not the mysterious, spiritual light that falls on the face in a Rembrandt portrait as an outward manifestation of the "inner light" of grace stressed in Protestant mysticism; it is instead ordinary daylight, observed with a keenness of vision unparalleled in the history of art, unless we think of Velázquez.

Vermeer is master of pictorial light and so comprehends its functions that it is completely in the service of the artist's intention, which is to render a lighted depth so faithfully that the picture surface is but an invisible glass through which we look immediately into the constructed illusion. We know that Vermeer made use of mirrors and of the *camera obscura*, an ancestor of the modern camera in which a tiny pinhole, acting as a lens, projected an image on a screen or the wall of a room. (In later versions, the image was projected on a ground-glass wall of a box, the opposite wall of which contained the pinhole.) This does not mean that Vermeer merely copied the image; these aids helped him to obtain results that he reworked

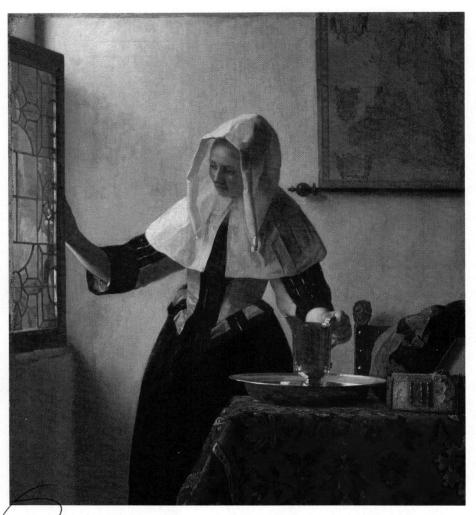

19-54 JAN VERMEER, Young Woman with a Water Jug, c. 1665. Approx. 18" × 16". Metropolitan Museum of Art, New York (gift of Henry G. Marquand, 1889).

compositionally, placing his figures and the furniture of the room in a beautiful stability of quadrilateral shapes that gives his designs a matchless Classical calm and serenity. This quality is enhanced by a color so true to the optical facts and so subtly modulated that it suggests Vermeer was far ahead of his time in color science. A detail of FIG. 19-54 would show, for one thing, that Vermeer realized that shadows are not colorless and dark, that adjoining colors affect one another,* and that light is composed of colors. Thus, the blue drape is caught as a dark blue on the side of the brass pitcher, and the red of the carpet is modified in the low-intensity gold hue of the basin. It has been suggested that Vermeer also perceived the phenomenon photographers call circles of confusion, which appear on out-of-focus films; Vermeer could have seen them in images projected by the primitive lenses of the camera obscura. He approximates these effects in light dabs and touches that, in close view, give the impression of an image slightly "out of focus"; when we draw back a step, however, as if adjusting the lens, the color spots cohere, giving an astonishingly accurate illusion of a third dimension. All of these technical considerations reflect the scientific spirit of the age, but they do not explain the exquisite poetry of form and surface, of color and light, that could come only from the sensitivity of a great artist. In Marcel Proust's Swann's Way, the connoisseur hero, trying unsuccessfully to write a monograph on Vermeer, admits that no words could ever do justice to a single patch of sunlight on one of Vermeer's walls.

^{*}Due to the phenomenon of *complementary afterimage*, in which, for example, the eye retains briefly a red image of a green stimulus; thus, a white area adjoining a green will appear "warm" (slightly pink), and a blue adjoining the same green will shift toward violet (blue plus the afterimage red).

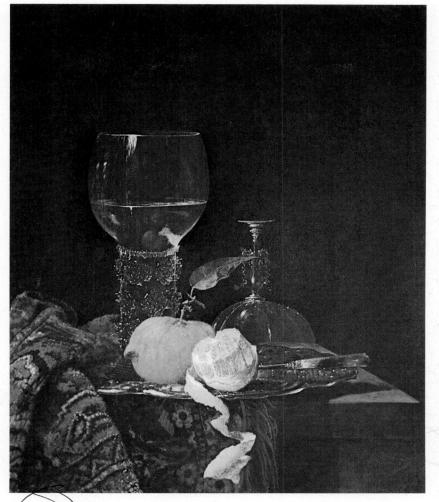

19-55 WILLEM KALF, Still Life, 1659. Approx. $20'' \times 17''$. Royal Picture Gallery (Mauritshuis), The Hague, Netherlands.

STILL LIFE: KALF

The "little Dutch masters" treat the humblest objects, which receive their meaning by their association with human uses, as reverently as if they were sacramentals. The Dutch painters of still life isolate these objects as profoundly interesting in themselves, making of their representation both scientific and poetic exercises in the revelation of the functions and the beauties of light. Many fine examples of Dutch still life have come down to us, each painted with the expertness of the specialist in analytical seeing. A still life (FIG. 19-55) by WILLEM KALF (1619–1693) can serve as exemplary of the school. Here, against a dark ground, the artist arranges glass goblets, fruit, a silver salver, and a Turkish carpet, making a rich, luminous counterpoint of absorptive and reflective textures. The glossy, transparent shells of the goblets gleam like night skies with galaxies of sparklets and light filaments, contrasting with the duller highlights that edge the salver's rim. There is a textural gradation from the glass to the silver, from a lemon to a pomegranate to the muted glow of the lightabsorbing Turkish carpet. The luminous flesh of the peeled lemon gleams as if lighted from within. (Oranges, emblem of the ruling House of Orange, occur more frequently in Dutch still life than do lemons.) This little masterpiece shows how this age of seeing must have taken pleasure in the infinite variety of the play of light in the small universe as well as the large. Such work is not dull imitation; it is revelation of what can be seen if the eye will learn to see it.

LANDSCAPE: VAN RUISDAEL

The Baroque world discovers the infinite, whether it is the infinitely small or the infinitely great. The minute spark of light that lifts the rim of a glass out

(19-56) JACOB VAN RUISDAEL, View of Haarlem from the Dunes at Overveen, c. 1670. Approx. 22" × 25". Royal Picture Gallery (Mauritshuis), The Hague, Netherlands.

of darkness becomes, when expanded, the sunlit heavens. The globule of dew on a leaf in a Dutch flower becomes the aqueous globe of Earth itself. The space that began to open behind the figures of Giotto (FIG. 15-14) now, in Dutch landscape, takes flight into limitless distance, and the human being dwindles to insignificance—"his time a moment, and a point his place." In some of the works of JACOB VAN RUISDAEL (1628–1682), the human figure does not appear at all or appears only minutely. In View of Haarlem from the Dunes at Overveen (FIG. 19-56), Van Ruisdael gives us almost a portrait of the newly discovered, infinite universe, allowing the sky to take up two-thirds of the picture space. One of the great landscape painters of all time, the artist turns to the vast and moody heavens that loom above the flat dunelands of Holland. His sullen clouds, in great droves never quite scattered by the sun, are herded by the winds that blew the fortunes of Holland's fleets as well as the disasters of the invading sea. Storms always are breaking up or gathering; the earth always is drenched, or about to be. As Rembrandt reads the souls of men in their faces, so Van Ruisdael reads the somber depths of the heavens. No angels swoop through his skies or recline on his clouds, for clouds now are simply water vapor. Like Rembrandt's, his is a "Protestant" reading of nature. The difference between northern and southern Baroque is evident at once in a comparison of Pozzo's Glorification of St. Ignatius (FIG. 19-33) and Van Ruisdael's View of Haarlem. It is the difference between the heavens of Jesuit vision and the heavens of Newton and Leibniz.

FRANCE

In the second half of the seventeenth century, the fortunes of both Holland and Spain sank before those of France, whose "Sun King," Louis XIV, dominated the period of European history between 1660 and 1715. The age of Louis XIV saw the ascendancy of French power in Europe, politically and culturally, and the achievement of an international influence in taste that France still has not entirely lost. The French regard this period as their golden age, a time when Paris began to replace Rome as the art center of Europe; when the French language became the polished instrument of discourse in diplomacy and in the courts of all countries; and when French art and criticism, fashion and etiquette, were imitated universally. Art and architecture came into the service of the king, as once they had been in the service of the Church, and the unity of style so conspicuous in them is the result of the taste of Louis XIV himselfimposed on the whole nation through his able minister Jean Baptiste Colbert and through the new academies Colbert set up to regularize style in all the arts.

The king's taste and, therefore, the taste of France favored a stately and reserved Classicism in place of the lavish and emotional Baroque of Italy and most of the rest of Europe. The severe Classical regularity of form—in the plays of Pierre Corneille and Jean Baptiste Racine, in the Corinthian colonnade of the Louvre (FIG. 19-64), and in the paintings of Nicolas Poussin (FIGS. 19-60 and 19-61)—is exceptional in the age of the Baroque. Even though we can find much that is Baroque in the "Classical" art produced in the time of *le Roi Soleil*, Classicism came to be thought of as standard by the French, and continued to be so for centuries.

Painting

During the earlier part of the seventeenth century, France began a slow recovery from the anarchy of the religious wars. While Cardinals Richelieu and Mazarin painfully rebuilt the power and prestige of the French throne, French art remained under the influence of Italy and Flanders. Even so, artists of originality emerged. Among them was GEORGES DE LA TOUR (1593–1652), a painter who learned of Caravaggio possibly through the Dutch school of Utrecht. Much as De La Tour uses the devices of the northern Caravaggisti, his effects are strikingly different from theirs. His *Adoration of the Shepherds* (FIG. **19-57**) shows us the night setting favored by that

19-57 Georges de La Tour, Adoration of the Shepherds, 1645–1650. Approx. $42'' \times 54''$. Louvre, Paris.

school, much as we have seen it in Van Honthorst (FIG. 19-45). But here, the light, its source shaded by the hand of an old man, falls upon a very different company in a very different mood. We see a group of humble men and women, coarsely clad, gathered in prayerful vigil around a luminous infant. If we did not know that this is a representation of the sacred event of the Nativity, we would consider it a genre piece, a narrative of some happening from peasant life. Nothing in the environment, placement, poses, dress, or attributes of the figures might distinguish them as the scriptural Virgin Mary, Joseph, Christ Child, or shepherds. The artist has not portrayed haloes, choirs of angels, stately architecture, or resplendent grandees (FIGS. 16-26, 18-17). The light is not spiritual but material; it comes from a candle. De La Tour's scientific scrutiny of the effects of material light, as it throws precise shadows on surfaces that intercept it, nevertheless, has religious intention and consequence. It illuminates a group of ordinary people, held in a mystic trance induced by their witnessing of the miracle of the Incarnation. The dogmatic significance and traditional iconography of the Incarnation are absorbed without trace in this timeless tableau of simple people, who are in reverent contemplation of something they regard as holy. As such, the painting is readable to the devout of any religious persuasion, whether or not they know of this central mystery of the Christian faith. Yet the effect of rapt religiosity is created by essentially the same devices of composition, chiaroscuro, and commonplace subject that we find in the worldly art of the Dutch Caravaggisti.

The supernatural calm that pervades this picture is characteristic of the mood of the art of Georges de La Tour. It is achieved by the elimination of motion and emotive gesture (only the light is dramatic), by the suppression of surface detail, and by the simplification of body volumes. These traits of style we associate with art of Classical substance or tendency for example, that of Piero della Francesca (FIG. 16-34). Several apparently contrary elements meet in the work of De La Tour: Classical composure, fervent spirituality, and genre realism.

LOUIS LE NAIN (*c*. 1593–1648) and his contemporary, De La Tour, bear comparison with the Dutch. Subjects that in Dutch painting are an opportunity for boisterous good humor are managed by the French with a cool stillness. *Family of Country People* (FIG. **19-58**) expresses the grave dignity of a family close to the soil, one made stoic and resigned by hardship. Obviously, Le Nain sympathizes with his subjects and seems here to want to emphasize their rustic virtue, far from the gorgeous artificiality of the courts.

19-58 LOUIS LE NAIN, Family of Country People, c. 1640. Approx. 44" × 62". Louvre, Paris.

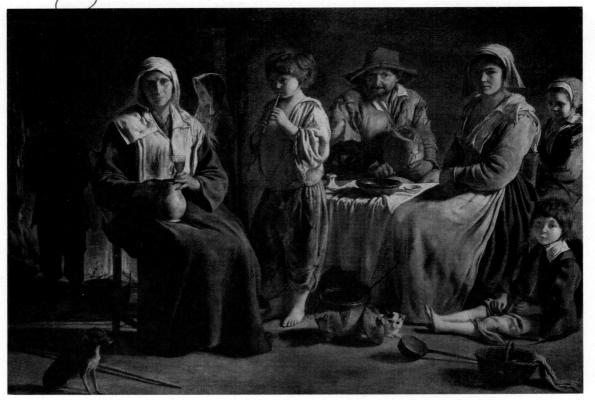

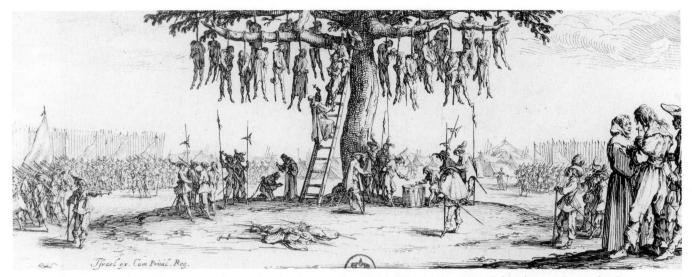

19-59 JACQUES CALLOT, Hanging Tree, etching from the Miseries of War series, 1621. Bibliothèque Nationale, Paris.

Stress on the honesty, integrity, and even innocence of uncorrupted country folk in the following century will become sentimentality. However, Le Nain's objectivity permits him to record a group of such genuine human beings that the picture rises above anecdote and the picturesqueness of genre. These still, sombre country folk could have had little reason for merriment. The lot of the peasant, never easy, was miserable during the time Le Nain painted. The terrible conflict we call the Thirty Years' War (1618–1648) was raging. The last and most devastating of the wars of religion between Protestants and Catholics, which had begun a century before, spread atrocity and ruin throughout France, Italy, and the Germanies. The anguish and frustration of the peasantry, suffering from the cruel depredations of unruly armies living off the country, often broke out in savage revolts that were savagely put down.

A record of the times appears in a series of etchings by JACQUES CALLOT (1592–1635) called Miseries of War. Callot, the first great master of the art of etching, a medium to which he confined himself almost exclusively, was widely influential in his own time and since; Rembrandt was among those who knew and learned from his work. Callot perfected the medium and the technique of etching, developing a very hard surface for the copper plate, to permit fine and precise delineation with the needle. In one small print, he may assemble as many as twelve hundred figures, which only close scrutiny can discriminate. His quick, vivid touch and faultless drawing produce a panorama sparkling with sharp details of life—and death. In the Miseries, he observes these coolly, presenting without comment things he himself must have seen in the wars in his own country, Lorraine. In one etching, he depicts a mass execution by hanging (FIG. 19-59). The unfortunates may be war prisoners or defeated peasant rebels. The event takes place in the presence of a disciplined army, drawn up on parade, with banners, muskets, and lances, their tents in the right background. Hanged men sway in clusters from the branches of a huge, cross-shaped tree. A monk climbs a ladder, holding up a crucifix to a man, around whose neck the noose is being adjusted. At the foot of the ladder, another victim kneels to receive absolution. Under the tree, men roll dice on a drumhead for the belongings of the executed. (This may be an allusion, in the Baroque manner, to the soldiers who cast lots for the garments of the crucified Christ.) In the right foreground, a bound man is consoled by a hooded priest. Callot's Miseries are the first realistic, pictorial record of the human disaster of war. They foreshadow Goya's great prints on the same theme (not shown).

POUSSIN

The brisk animation of Callot's manner contrasts with the quiet composure in the art of De La Tour and Le Nain, his exact contemporaries. Yet although calm simplicity and restraint characterize the latter two, in comparison with other northern painters inspired by Caravaggio, and although these qualities suggest the Classical, it remains for another contemporary, NICOLAS POUSSIN (1594–1665), to establish Classical painting as peculiarly expressive of French taste and genius in the seventeenth century. Poussin, born in Normandy, spent most of his life in Rome. There, inspired by its monuments and the landscape of the Campagna, he produced his grandly severe and regular canvases and carefully worked out a theoretical

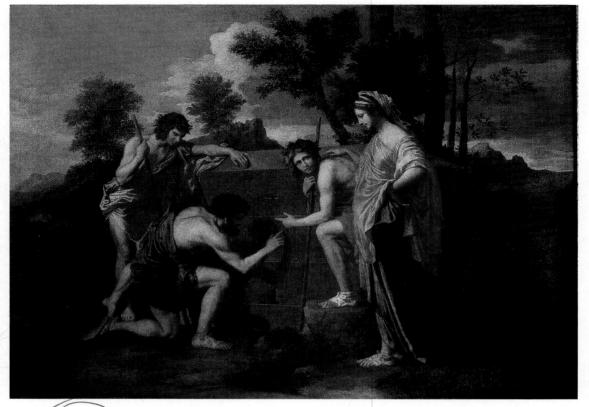

(9-60 DICOLAS POUSSIN, Et in Arcadia Ego, c. 1655 (?). Approx. 34" × 48". Louvre, Paris.

explanation of his method. He worked for a while under Domenichino but shunned the exuberant Italian Baroque; Titian and Raphael were the models that he set for himself. Of his two versions of a single theme titled Et in Arcadia Ego (I, too, in Arcadia or Even in Arcadia, I [am present]), the earlier is strikingly Titianesque, with all the warm, rich tonality of the Venetian master and the figure types familiar in Titian's idyllic "bacchanals." But, in the end, the rational order and stability of Raphael proved most appealing to Poussin. His second version of Et in Arcadia Ego (FIG. 19-60) shows what he learned from Raphael, as well as from Antique statuary; landscape, of which Poussin became increasingly fond, expands in the picture, reminiscent of Titian but also indicative of Poussin's own study of nature. The theme is somewhat obscure and of interest to some modern scholars. As three shepherds living in the idyllic land of Arcadia spell out an enigmatic inscription on a tomb, a stately female figure quietly places her hand on the shoulder of one of them. She may be the spirit of death, reminding these mortals, as does the inscription, that death is found even in Arcadia, where naught but perfect happiness is supposed to reign. The compact, balanced grouping of the figures, the even light, and the thoughtful, reserved, elegiac mood set the tone for Poussin's art in its later, Classical phase.

In notes for an intended treatise on painting, Poussin outlines the "grand manner" of Classicism, of which he became the leading exponent in Rome. One must first of all choose great subjects: "The first requirement, fundamental to all others, is that the subject and the narrative be grandiose, such as battles, heroic actions, and religious themes." Minute details should be avoided, as well as all "low" subjects, like genre ("Those who choose base subjects find refuge in them because of the feebleness of their talents"). This dictum rules out a good deal of both the decorative and realistic art of the Baroque, and will lead to a doctrinaire limitation on artistic enterprise and experiment in the rules of the French Royal Academy, which, under Charles Le Brun in the 1660s, will take Poussin as its greatest modern authority. Although Poussin can create with ease and grandeur within the scope of his rather severe maxims, his method can become wooden and artificial in the hands of academic followers.

Poussin represents that theoretical tradition in Western art that goes back to the Early Renaissance and that asserts that all good art must be the result of good judgment—a judgment based on sure knowledge. In this way, art can achieve correctness and propriety, two of the favorite categories of the classicizing artist or architect. Poussin praises the ancient Greeks for their musical "modes," by which, he says,

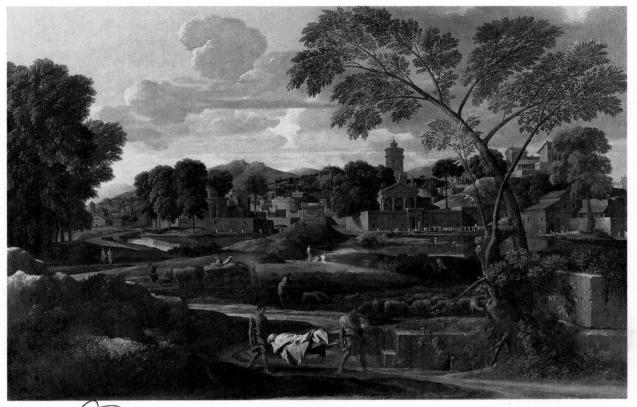

19-61 NICOLAS POUSSIN, The Burial of Phocion, 1648. Approx. $47'' \times 70''$. Louvre, Paris.

"they produced marvelous effects." He observes that "this word 'mode' means actually the rule or the measure and form which serves us in our production. This rule constrains us not to exaggerate by making us act in all things with a certain restraint and moderation." "Restraint" and "moderation" are the very essence of French Classical doctrine; in the age of Louis XIV, we find this doctrine preached as much for literature and music as for art and architecture. Poussin tells us further that

the Modes of the ancients were a combination of several things . . . in such a proportion that it was made possible to arouse the soul of the spectator to various passions. . . . the ancient sages attributed to each style its own effects. Because of this they called the Dorian Mode stable, grave, and severe, and applied it to subjects which are grave and severe and full of wisdom.*

Poussin's finest works, like *The Burial of Phocion* (FIG. **19-61**), are instances of his obvious preference for the "Dorian Mode." His subjects are chosen carefully from the literature of antiquity, where his age would naturally look for the "grandiose," and it is

with Poussin that the visual arts draw closer to literature than ever before. Here, he takes his theme from Plutarch's life of Phocion, an Athenian hero who was unjustly put to death by his countrymen but then given a public funeral and memorialized by the state. In the foreground, Poussin represents the body of the hero being taken away, his burial on Athenian soil having at first been forbidden. The two massive bearers and the bier are starkly isolated in a great landscape that throws them into solitary relief, eloquently expressive of the hero abandoned in death. The landscape is composed of interlocking planes that slope upward to the lighted sky at the left, carefully arranged terraces that bear slowly moving streams, shepherds and their flocks, and, in the distance, whole assemblies of solid geometric structures (temples, towers, walls, villas). The skies are untroubled and the light is even and form-revealing. The trees are few and carefully arranged, like curtains lightly drawn back to reveal a nature carefully cultivated as a setting for a single human action. Unlike Van Ruisdael's View of Haarlem (FIG. 19-56), this scene is not intended to represent a particular place and time; it is the construction of an *idea* of a noble landscape to frame a noble theme, much as we have seen it in Annibale Carracci's Classical landscape (FIG. 19-31). The Phocion landscape is nature subordinated to a

^{*}In E. G. Holt, ed., *Literary Sources of Art History* (Princeton, NJ: Princeton University Press, 1947), p. 380.

rational plan, much like the gardens of Versailles (FIG. 19-66); it is eminently of the Age of Reason.

CLAUDE LORRAIN

The disciplined, rational art of Poussin, with its sophisticated revelation of the geometry of landscape, is modulated in the softer style of Claude Gellée, called CLAUDE LORRAIN (1600-1682) and sometimes only Claude. Unlike Poussin's pictures, Claude's are not "Dorian." The figures in his landscapes tell no dramatic story, point out no moral, and praise no hero; indeed, they often appear added as mere excuses for the radiant landscape itself. For Claude, painting involves essentially one theme: the beauty of a broad sky suffused with the golden light of dawn or sunset that makes its glowing way through a hazy atmosphere, and reflects scintillatingly from the rippling water. In one realization of Claude's landscape ideal the setting is a seaport, where the Queen of Sheba is embarking for home (FIG. 19-62). Servants are loading boats with the rich gifts bestowed upon the queen by King Solomon (1 Kings 10:1–10, 13). The queen, with her stately entourage, descends to the quay from a majestic palace,

the style of which is familiar in the classicizing architecture of the seventeenth century. Occupying the dark left foreground is a lofty fragment of a Roman ruin. The ships, their sails still furled, await their cargoes. A tower, arched bridge, and tall trees are grouped in the distance. These are the stage properties invented by Claude to set off his theme; they are not to be thought of as authentic representations of the time and place of his narrative. The firm architectural shapes, the busy diagonals of the ships' rigging, and the perfunctory, small figures are meant solely to frame (like the wings of a stage) the central actor and the pictorial focus, which is the effulgent sun and the trail of sparkling accents it leaves upon the sea. The dark foreground, lighter middleground, and dim background recede in serene orderliness, until all form dissolves in a luminous mist. Atmospheric and linear perspective reinforce one another to turn a vista into a typical Claudian vision, an ideal Classical world conjured up in the sunlit infinity of Baroque space.

In formalizing nature with balanced groups of architectural masses, screens of trees, and sheets of water, Claude is working in the great tradition of

19-62 CLAUDE LORRAIN, Embarkation of the Queen of Sheba, 1648. Approx. 58⁴/₄" × 76". Reproduced by courtesy of the Trustees of the National Gallery, London.

Classical landscape that opens in the backgrounds of Venetian painting (FIGS. 17-58 and 17-59) and continues in the art of Annibale Carracci (FIG. 19-31) and Poussin (FIG. 19-61). At the same time, Claude, like the Dutch painters, studies the actual light and the atmospheric nuances of nature, making a unique contribution. He recorded carefully in hundreds of sketches the veritable look of the Roman Campagna, its pellucid air, its gentle terrain variegated by stonepines, cypresses, and poplars, and by ever-present ruins of ancient aqueducts, tombs, and towers. He made these the fundamental accessories of his compositions; travelers could learn of and could recognize the picturesque beauties of the Campagna in Claude's landscapes.

His marvelous effects of light were achieved by painstaking placement of infinitesimally small value gradations, which imitated, though on a very small scale, the actual range of values of out-of-door light and shade. Avoiding the problem of high noon, Claude preferred, and could convincingly represent, the disc of the sun as it gradually radiates the morning sky, or with its dying glow sets the pensive mood of evening. Thus he matches the moods of nature and of the human subject. Claude's infusion of nature with human feeling, while re-composing it in a calm equilibrium, would have great appeal to the landscape painters of the eighteenth and earlier nineteenth centuries, especially Turner, whose lifelong admiration of Claude's art was almost obsessive.

The softening of Poussin's stern manner in Claude parallels the reaction of other painters of the time against the severe rules and regulations of the French Royal Academy under the dictatorial administration of Le Brun. Established in 1648, the Academy had been intended to free artists from the constraints of the old guild system of art training; to improve the social status of painters and sculptors, so that they would be seen as more than mere handicraftsmen; to regularize instruction in the arts; and to centralize art production in the interest of the absolute monarchy. Above all, the Academy was to develop and propagate a Classical taste, based on the study and imitation of ancient works of art and such classicizing modern masters as Raphael, the Carracci, and Poussin himself. Students were taught the supremacy of drawing over coloring, of sculpturesque form over painterly tonality, of symmetrical and closed composition over the dynamic and open-in short, the superiority of Poussin over Rubens. Yet well before the end of the century, the painting of Rubens was increasingly admired, and his influence would weaken the doctrine of the Academy and shape the taste of eighteenth-century Rococo.

Architecture

In architecture, as in painting, France maintained an attitude of cautious selectivity toward the Italian Baroque. The Classical bent asserted itself early in the work of FRANÇOIS MANSART (1598–1666), as seen in the Orléans wing of the Château de Blois (FIG. **19-63**), built between 1635 and 1638. The polished dignity and sobriety evident here will become the hallmarks

9-63 FRANÇOIS MANSART, Orléans wing of the Château de Blois, France, 1635–1638.

19-64 Claude Perrault, Louis Le Vau, and Charles Le Brun, east façade of the Louvre, Paris, 1667–1670.

of French "classical-baroque," contrasting with the more daring, excited, and fanciful styles of the Baroque in Italy and elsewhere. The strong, rectilinear organization and a tendency to design in terms of repeated units remind us of Italian Renaissance architecture, as does the insistence on the purity of line and sharp relief of the wall articulations. Yet the emphasis on a focal point—achieved through the curving colonnades, the changing planes of the walls, and the concentration of ornament around the portal—is characteristic of Baroque architectural thinking in general.

The formation of the French Classical style accelerated with the foundation of the Royal Academy of Painting and Sculpture in 1648, of which Poussin was a director, and with the determination of Louis XIV and Colbert to organize art and architecture in service of the state. No pains were spared to raise great symbols and monuments to the king's absolute power and to regularize taste under the academies. The first project undertaken by the young king and Colbert was the closing of the east side of the Louvre court, left incomplete by Lescot in the sixteenth century. Bernini, as the most renowned architect of his day, was summoned from Rome to submit plans, but he envisioned an Italian palace on a monumental scale that would have involved the demolition of all previous work. His plan rejected, Bernini returned to Rome in high indignation. The east facade of the Louvre (FIG. 19-64) is the result of a collaboration between Claude Perrault (1613–1688), Louis Le Vau (1612-1670), and CHARLES LE BRUN (1619-1690), with

Le Vau probably playing a preponderant role. The design is a brilliant adjustment of French and Italian Classical elements, culminating in a new and definitive formula. The French pavilion system is retained; the central pavilion is in the form of a Classical temple front, and a giant colonnade of paired columns, resembling the columned flanks of a temple folded out like wings, is contained by the two salient pavilions at either end. The whole is mounted on a stately basement, or podium. An even roof line, balustraded and broken only by the central pediment, replaces the traditional French pyramidal roof. All memory of Gothic verticality is brushed aside in the emphatically horizontal sweep of this façade. Its stately proportions and monumentality are both an expression of the new official French taste and a symbol for centrally organized authority.

VERSAILLES

Work on the Louvre hardly had begun when Louis XIV decided to convert a royal hunting lodge at Versailles, a few miles outside Paris, into a great palace. A veritable army of architects, decorators, sculptors, painters, and landscape architects was assembled under the general management of former Poussin student Le Brun, the king's impresario of art and dictator of the Royal Academy. In their hands, the conversion of a simple hunting lodge into the Palace of Versailles (FIGS. **19-65** and **19-66**) became the greatest architectural project of the age.

Planned on a gigantic scale, the project called not only for a large palace facing a vast park but also for

19-65 Aerial view of the Palace of Versailles, France, and a small portion of the surrounding park. The white trapezoid in the lower part of the plan (FIG. 19-66) outlines the area shown here.

19-66 Plan of the park, palace, and town of Versailles (after a seventeenth-century engraving by FRANÇOIS BLONDEL). The area outlined in the white trapezoid (lower center) is shown in FIG. 19-65.

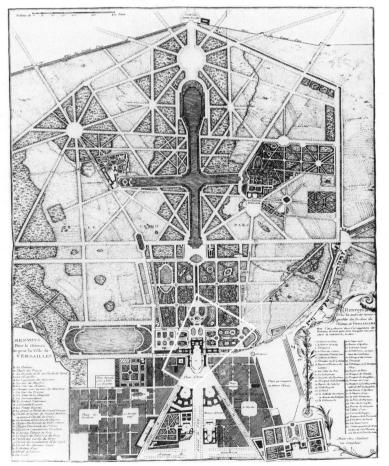

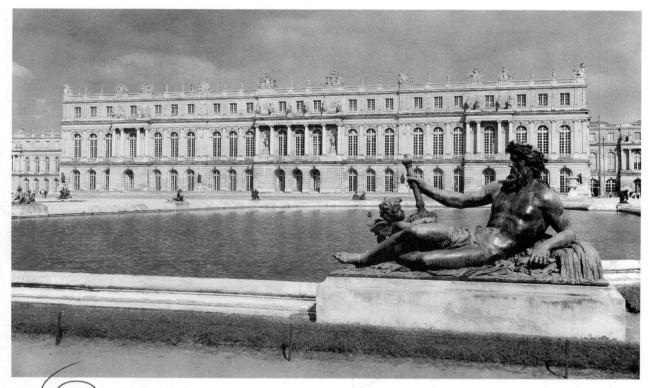

19-67 JOUIS LE VAU and JULES HARDOUIN-MANSART, garden façade of the Palace of Versailles, 1669–1685.

the construction of a satellite city to house court and government officials, military and guard detachments, courtiers, and servants. This town is laid out to the east of the palace along three radial avenues that converge on the palace structure itself; their axes, in a symbolic assertion of the ruler's absolute power over his domains, intersect in the king's bedroom. (As the site of the king's morning levée, this bedroom was actually an audience room, a state chamber.) The palace itself, over a quarter of a mile long, is placed at right angles to the dominant east-west axis that runs through city and park. Its most impressive feature is the garden façade (FIG. 19-67), which was begun by Le Vau and continued in his style by JULES HARDOUIN-MANSART (1646–1708, a great-nephew of François Mansart), who took over the project after Le Vau's death in 1670. In typical Baroque fashion, the vast lateral extension of the façade has been broken up into units and subunits of threes, an effective organizational device even on this scale.

Careful attention has been paid to every detail of the extremely rich decoration of the palace's interior; everything from wall paintings to doorknobs is designed in keeping with the whole and is executed with the very finest sense of craftsmanship. Of the literally hundreds of rooms within the palace, the most famous is the Galerie des Glaces, or Hall of Mirrors (FIG. **19-68**), which overlooks the park from the second floor and extends along most of the width of the central block. Although deprived of its original sumptuous furniture, which included gold and silver chairs and bejeweled trees, the Galerie des Glaces retains much of its splendor today. Its tunnel-like quality is alleviated by hundreds of mirrors, set into the wall opposite the windows, that illusionistically extend the width of the room. The mirror, that ultimate source of illusion, was a favorite element of Baroque interior design; here, it must have harmonized as it augmented the flashing splendors of the great festivals of which Louis XIV was so fond.

The enormous palace might appear unbearably ostentatious, were it not for its extraordinary setting in the vast park to which it becomes almost an adjunct. The Galerie des Glaces, itself a giant perspective, is dwarfed by the sweeping vista (seen from its windows) down the park's tree-lined central axis and across terraces, lawns, pools, and lakes toward the horizon. The park of Versailles (FIG. 19-66), designed by ANDRÉ LE NÔTRE (1613–1700), must rank among the world's greatest works of art, not only in size but also in concept. Here, an entire forest has been transformed into a park. Although the geometric plan may appear stiff and formal, the park, in fact, offers an almost unlimited variety of vistas, as Le Nôtre uti-

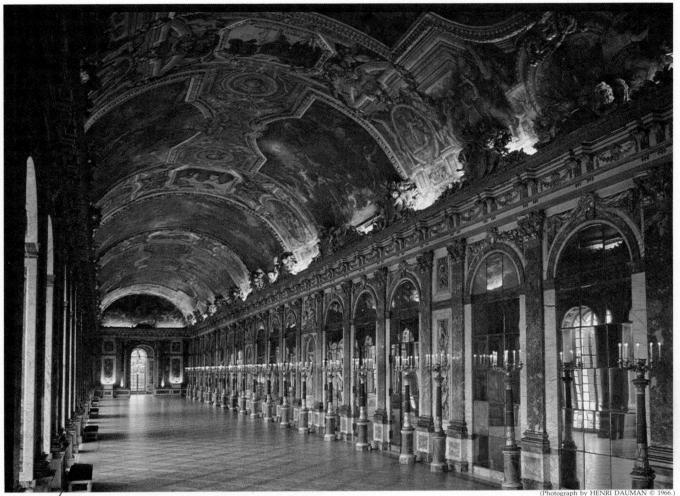

19-68 JULES HARDOUIN-MANSART and CHARLES LE BRUN, Galerie des Glaces, Palace of Versailles, c. 1680.

lized not only the multiplicity of natural forms but also the slightly rolling contours of the terrain with stunning effectiveness.

A rational transition from the frozen forms of the architecture to the living ones of nature is provided by the formal gardens near the palace. Here, tightly designed geometric units are defined by the elegant forms of trimmed shrubs and hedges, each one different from its neighbor and having a focal point in the form of a sculptured group, a pavilion, a reflecting pool, or perhaps a fountain. Farther away from the palace, the design becomes looser as trees, in shadowy masses, screen or frame views into bits of open countryside. All vistas are composed carefully for maximum effect. Dark and light, formal and informal, dense growth and open meadows-all are played off against each other in unending combinations and variations. No photograph or series of photographs can reveal the full richness of the design; the park unfolds itself only to the person who actually walks through it. In this respect, it is a temporal work of art; its aspects change with time and with the relative position of the observer.

As a symbol of the power of absolutism, Versailles is unsurpassed. It also expresses, in the most monumental terms of its age, the rationalistic creed, based on the mathematical philosophy of Descartes, that all knowledge must be systematic and all science must be the consequence of the imposition of the intellect on matter. The whole stupendous design of Versailles proudly proclaims the mastery of human intelligence over the disorderliness of nature.

On the garden façade of Versailles, Hardouin-Mansart follows the style of his predecessor, Le Vau. When commissioned to add a Royal Chapel to the palace in 1698, he was in a position to give full play to his talents. The chapel's interior (FIG. **19-69**) is a masterful synthesis of Classical and Baroque elements. It

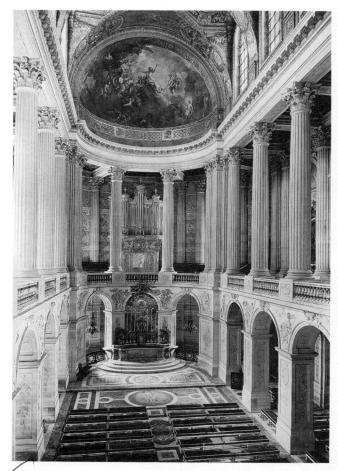

19-69 JULES HARDOUIN-MANSART, Royal Chapel of the Palace of Versailles, 1698–1710. (Ceiling decorations by ANTOINE COYPEL.)

is essentially a rectangular building with an apse as high as the nave, which gives the fluid central space a curved Baroque quality. But the light entering through the large clerestory windows lacks the directed, dramatic effect of the Italian Baroque and illuminates the precisely chiseled details of the interior brightly and evenly. Pier-supported arcades carry a majestic row of Corinthian columns that define the royal gallery, the back of which is occupied by the royal pew, accessible directly from the king's apartments. The decoration is restrained and, in fact, only the illusionistic ceiling decorations, added in 1708– 1709 by Antoine Coypel, can be called Baroque without reservation. Throughout the architecture, Baroque tendencies are severely checked by Classicism.

Although checked, such tendencies are not suppressed entirely in Hardouin-Mansart's masterwork, the Église de Dôme, Church of the Invalides in Paris (FIGS. **19-70** and **19-71**). An intricately composed domed square of great scale, the church is attached to the veterans' hospital set up by Louis XIV for the dis-

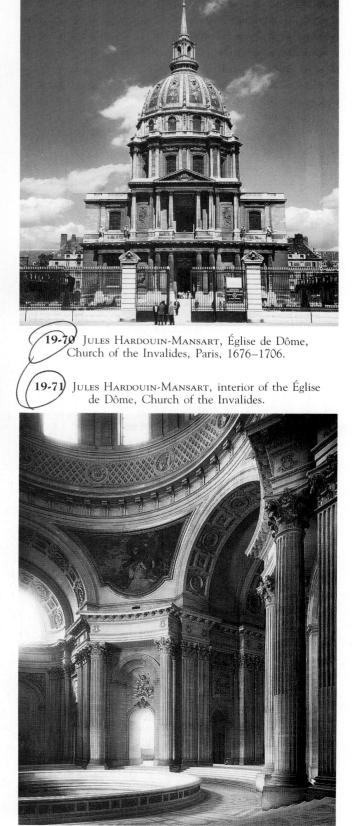

abled soldiers of his many wars. The frontispiece is composed of two firmly separated levels, the upper pedimented. The grouping of the orders and the bays they frame is not unlike that in Italian Baroque. The compact facade is low and narrow in relation to the vast drum and dome, for which it seems to serve simply as a base. The overpowering dome, conspicuous on the skyline of Paris, is itself expressive of the Baroque love for dramatic magnitude. The way that its design aims for theatrical effects of light and space is especially Baroque. The dome is built of three shells, the lowest cut off so that the visitor looks up through it to the one above, which is painted illusionistically with an apotheosis of St. Louis, patron of France. This second dome, filled with light from hidden windows in the third, outermost dome, creates an impression of the open, limitless space and brightness of the heavens. Below, the building is only dimly illuminated and is designed in a Classicism only less severe than that of the Escorial (FIG. 18-56). The rapid vertical gradation from the austerely membered masses below to the ethereal light and space above is entirely Baroque. Yet we feel here the dominance of the Classical style in substance, despite the soaring illusion for which it serves as a setting.

Sculpture

The stylistic dialogue between Classicism and the Italian Baroque in seventeenth-century French sculpture also ends with a victory for Classicism. The strained dramatic and emotional qualities in the work of PIERRE PUGET (1620–1694) were not at all to the court's taste. His *Milo of Crotona* (FIG. **19-72**)

19-72 FIERRE PUGET, Milo of Crotona, 1671–1682. Marble, approx. 8' 10" high. Louvre, Paris.

19-73' FRANÇOIS GIRARDON, Apollo Attended by the Nymphs, c. 1666–1672. Marble, life size. Park of Versailles.

represents the powerful ancient hero, his hand trapped in a split stump, helpless before the attacking lion. With physical and psychic realism, Puget presents a study of immediate and excruciating agony an attitude that ran counter to the official taste for heroic design dictated by the king and Le Brun. Although Puget was very briefly in vogue, the most original French sculptor of his time never found acceptance at the French court.

Much more fortunate was FRANÇOIS GIRARDON (1628–1715), who admirably adjusted his style to the taste of his sponsors. His *Apollo Attended by the Nymphs* (FIG. **19-73**) was designed as a tableau group for the Grotto of Thetis in the gardens of Versailles. (The arrangement of the figures was altered slightly when the group was moved to a different grotto in the eighteenth century.) Both stately and graceful, the nymphs have a compelling charm as they minister to the god-king at the end of the day. The style of the figures is heavily conditioned by the artist's close study of Hellenistic sculpture, the central figure imitating the ancient Apollo Belvedere in the Vatican; the

arrangement is inspired by Poussin's figure compositions (FIG. 19-60). And if this combination did not suffice, the group's rather florid reference to Louis XIV as the "god of the sun" was bound to assure its success at court. Girardon's style and symbolism were well suited to the glorification of royal majesty.

ENGLAND

English art has been mentioned little since the Middle Ages because, except for its architecture, England stands outside the main artistic streams of the Renaissance and the Baroque periods. It is as if the English genius were so occupied with its prodigious creation in dramatic literature, lyric poetry, and music, that it did not find itself particularly suited to the purely visual arts. Not until the eighteenth century does England develop an important native school of painting and extend its distinguished architectural tradition.

Gothic practices lived on in English, as in French, building, long after Renaissance architects in Italy

19-74 INIGO JONES, Banqueting House at Whitehall, London, 1619–1622. British Crown Copyright.

struck out in new directions. During the sixteenth century, the English made minor concessions to Italian architectural ideas. Classical ornament appeared frequently in the decoration of buildings, and a distinct trend developed toward more regular and symmetrical planning. But not until the early seventeenth century did England wholeheartedly accept the principles that govern Italian architectural thinking. The revolution in English building was primarily the work of one man, INIGO JONES (1573–1652), surveyor (architect) to James I and Charles I. Jones spent considerable time in Italy. He disliked Michelangelo's work as intensely as he admired Palladio's, whose treatise on architecture he studied with great care. From the stately palaces and villas of Palladio, Jones selected certain motifs and systems of proportion to use as the basis of his own architectural designs. The nature of his achievement is evident in the Banqueting House at Whitehall (FIG. 19-74). In this structure, a symmetrical block of great clarity and dignity, Jones superimposes two orders, using columns in the center and pilasters near the ends. The balustraded roof line, uninterrupted in its horizontal sweep, anticipates the façade of the Louvre (FIG. 19-64) by more than forty years. There is almost nothing here that Palladio would not have recognized and approved, but the building as a whole is not a copy. While working within the architectural vocabulary and syntax of the revered Italian, Jones retained his own independence as a designer; for two centuries his influence was almost as authoritative in English architecture as Palladio's. In a fruitful collaboration recalling the combination of painting by Veronese and architecture by Palladio in northern Italian villas, Jones's interior at

19-75 CHRISTOPHER WREN, new St. Paul's Cathedral, London, 1675–1710.

Whitehall is adorned with several important paintings by Rubens.

Until almost the present day, the dominant feature of the London skyline has been the majestic dome of St. Paul's (FIG. **19-75**), the work of England's most renowned architect, CHRISTOPHER WREN (1632–1723). A mathematical genius and skilled engineer, whose work won the praise of Isaac Newton, Wren began as a professor of astronomy and took an amateur's interest in architecture. Asked by Charles II to prepare a plan for the restoration of the old Gothic church of St. Paul, he proposed to remodel the building "after a good Roman manner" rather than "to follow the Gothic rudeness of the old design." Within a few months, the Great Fire of London, which destroyed the old structure and many churches in the city in 1666, gave Wren his opportunity. He built not only the new St. Paul's but numerous other churches as well. Wren was a Baroque virtuoso of many talents, the archetype of whom we see in Bernini. He was strongly influenced by the work of Jones, but he also traveled in France, where he must have been much impressed by the splendid palaces and state buildings being created in and around Paris at the time of the competition for the Louvre design. Wren also must have closely studied prints illustrating Baroque architecture in Italy, for Palladian, French, and Italian Baroque features are harmonized in St. Paul's. In view of its size, the cathedral was built with remarkable speed—in a little over thirty years—and Wren lived to see it completed. The form of the building was constantly refined as it went up, and the final appearance of the towers was not determined until after 1700. The splendid skyline composition, with the two foreground towers acting effectively as foils to the great dome, must have been suggested to Wren by similar schemes devised by Italian architects to solve the problem of the facade-dome relation of St. Peter's in Rome (FIGS. 17-34 and 19-4). Perhaps Borromini's solution at Sant' Agnese in Piazza Navona influenced him. Certainly, the upper levels and lanterns of the towers are Borrominesque, the lower levels are Palladian, and the superposed, paired columnar porticoes remind us of the Louvre façade. Wren's skillful eclecticism brings all of these foreign features into a monumental unity.

Wren's designs for the city churches are masterpieces of Baroque planning ingenuity. His task was never easy, for the churches often had to be fitted into small, irregular areas. Wren worked out a rich variety of schemes to meet awkward circumstances. In designing the exteriors of the churches, he concentrated his attention on the towers, the one element of the structure that would set the building apart from its crowding neighbors. The skyline of London, as left by Wren, is punctuated with such towers, which will serve as prototypes for later buildings both in England and in colonial America.

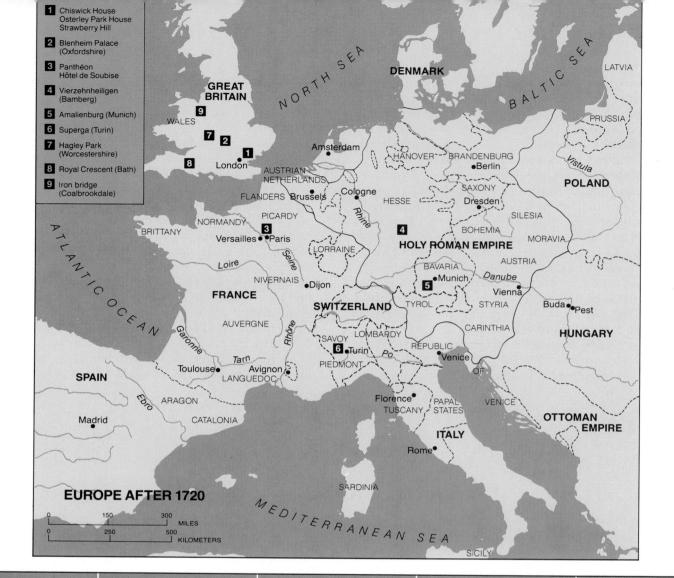

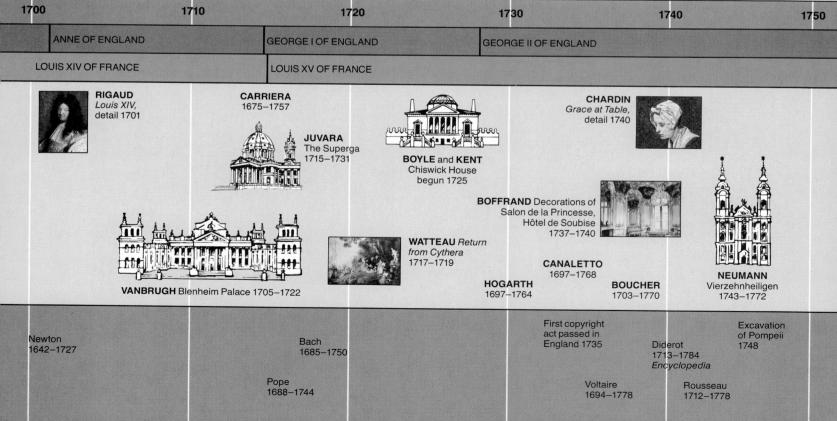

20 THE EIGHTEENTH CENTURY: ROCOCO AND THE BIRTH OF THE MODERN WORLD

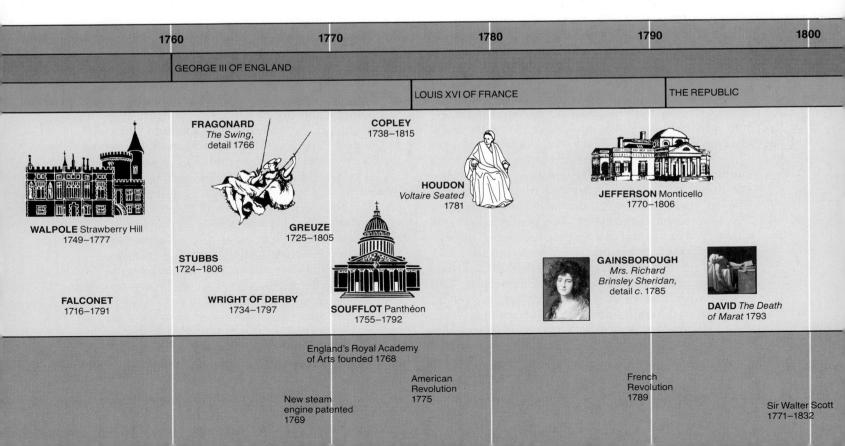

HE EIGHTEENTH CENTURY had a dual character; its two parts corresponded chronologically to an earlier and a later stage. The earlier stage was a continuation of the Baroque seventeenth century, with a number of distinctive differences; the later stage was the period in which the foundations of the modern world were laid. The present chapter, in its title and arrangement, reflects this bipartite division. However, a brief view of the century as a whole also can be useful.

The political world took new shapes in the eighteenth century. The maritime British Empire achieved great power and pursued disputes with France over the continent of North America and the subcontinent of India. The majority of Europe was divided into small political units governed by princes, by highranking priests, or, in a few cases, by democratic councils. Once-powerful Spain was crippled by war and corrupt rule. Italy and much of Germany, as we now know them, were patchworks of principalities, duchies, and other small governing bodies. Against the awkward and shaky Holy Roman (later Austrian) Empire rose the small but aggressive state of Prussia, soon to become a significant military power. Farther to the east loomed the still dormant might of half-Asiatic Russia, accelerating its slow turn toward the West under Peter the Great.

Older patterns of life and society continued and obscured for a time the emergence of the new forces of change. On the continent, the decades between the death of Louis XIV in 1715 and the middle of the century were a period of relative relaxation after the exhausting "world" wars conducted by the great kings. Wars still were fought, but they were more often balancing maneuvers among the various states, waged by professional soldiers, with a kind of chessboard formality. In the arts, the wealthy remained eager to follow the royal taste for Baroque splendor, but this eagerness was modified everywhere by changes in society. Members of the aristocracy continued to be the primary patrons of the arts in many countries, and much of the century's art made before the French Revolution expressed their philosophy. The art that won aristocratic favor was luxurious, frivolous, sensual, and clever. The great religious and Classical themes and the grand manner of the Baroque gradually were overshadowed. Intricate and witty artifice now became the objective in all the artsdrama, music, painting, sculpture, architecture. The French were leaders in creating this art. In France, members of the court increasingly lived more in Paris than at Versailles, and they surrounded themselves with objects created in a delicately elegant Late Baroque variant called the Rococo style. Something of the quality of the Rococo also spread to the rest of

Europe, competing in Italy with a lingering enjoyment of the heavier monumentality of the Classical Baroque, and being transformed in Germany and Austria by a distinctively buoyant and festive air.

The Rococo style had little effect in England, where an appetite for Palladian Classicism reflected to some degree developments in society and thought that were to inaugurate the modern age throughout Europe later in the century. At the beginning of the century, England already had started to point the way to the future with a parliamentary form of government, a free press, and a high degree of religious toleration, all of which tempered the power of the monarchy. Throughout the century, England enjoyed great material prosperity, generated by inventions in industry and agriculture, and by international trade. Englishmen set the tone of much of the new thinking as well. In John Locke's Essay Concerning Human Understanding (1690), he argued that all true knowledge is derived from perceptions of the sense organs and from the mind's reflections on those perceptions. Sir Isaac Newton's theories of gravity and the laws of motion reinterpreted physical nature to demonstrate that it was mechanically (rather than spiritually or organically) constituted.

From such sources, new ideas were propagated that would threaten the authority of both church and state. As the result of a visit to England in 1726, the French writer Voltaire "discovered" England for the rest of Europe. In writings such as his Philosophical Letters on the English (1734), the ideas of English thought, science, and government became matters for general discussion. These ideas were to inspire campaigns to reform the abuses and limit the privileges of royalty, the aristocracy, and the clergy. In 1762, Jean Jacques Rousseau wrote in his Social Contract that organized society should be based not on a contract between a ruler and a people, but on a contract among the people themselves. In most of his other writings, he touted people's natural goodness, a goodness corrupted only by civilization. He trusted feelings over thought, intuition over reason. Adhering as he did to the ideal of the individual as a person guided by an innate "natural" intuition or conscience, Rousseau was feared by churches as a dangerous influence. He was also a forerunner to Romanticism and a source of the modern world's interest in the nonrational and the subconscious.

The eighteenth century in Europe is known as the Age of Enlightenment, an age in which reason and common sense were put forth as the real remedies of society's ills and "progress" was seen as a law of human development. In support of this philosophy of progress, knowledge burgeoned in all fields. Important advances from the emerging natural sciences dealt with the nature of such phenomena as living matter, electricity, combustion, and oxygen. For its immediate application, the most important practical invention of the age was, undoubtedly, the development of steam power, with its enormous significance as a substitute for human labor. The use of steam engines for production and, later, for transportation, began in England, as part of the initial phase of the machine age. Soon, England and all of Europe were transformed by the harnessed power of steam, coal, oil, iron, and steel.

The political, economic, and social consequences of these changes were tremendous. The era of industrial capital and labor was born, as people flocked to cities to take jobs in the new steam-powered factories. The growth of the urban working class was so swift that social services could not evolve fast enough to serve new city residents. A split between employer and employee widened. The merchant rich became captains of industry, demanding that production and trade be free from government regulation and, at the same time, that the heads of industry participate in the fiscal decisions of government. Antagonisms between the powerful, wealthy few and the workers helped to fuel political revolutions organized under the banners of democracy and free trade later in the century. All of these developments helped to initiate the era we call "modern," and many of the ideas and institutions that originated mid-century are still with us today.

The ruling aristocracies, as if conscious of their waning historical significance, gradually abandoned their administrative and executive functions to members of the increasingly wealthy and influential middle class, the Third Estate. Without fully realizing it, royalty and the nobility were slowly becoming obsolete. Stubbornly insisting on their ancient privileges, the nobility helped precipitate the French Revolution. Still, earlier in the century, these patrons of the arts and sciences followed with great interest the theories and discoveries exchanged by scholars in official groups like England's Royal Society and Royal Academy of Arts and France's Academies of science and painting, and joined intellectuals and members of the wealthy middle class in "salons" to discuss the latest ideas. Aristocrats helped fund the scientists and artists who accompanied Captain James Cook on his round-the-world voyages of discovery. They also encouraged the production of vast compendia of knowledge, such as Georges Louis Leclerc Buffon's Natural History, which contained descriptions of all known animals, and the vast Encyclopedia compiled by Denis Diderot and a group of fellow intellectuals (known as the philosophes), which included knowledge in many disciplines.

Art reflected all of these changes. By mid-century, the marked changes in culture and society had begun

to produce new forms of art that reflected the beginnings of the modern era. A reaction against the Rococo style generated a new "naturalness," especially in portraits and landscapes. The Enlightenment brought with it a desire for art that would help to better the world by using new technology to create an improved physical environment, by providing people with facts about their world, and by instructing viewers about correct moral conduct. Yet the last half of the century also saw the return of nostalgia for the past, in part inspired by the excitement accompanying the archeological excavations of the ancient Roman communities of Pompeii and Herculaneum, and in part connected to the convulsive changes in society that resulted from the American and French revolutions and the rise of Napoleon. The excitement over the discovery of ancient ruins was accompanied by a renewed interest in things Classical. The upheavals in society sparked a taste for "Gothic" in architecture and an investigation in painting of sublime and terrible subjects that reflected human fantasies and nightmares.

THE EARLY EIGHTEENTH CENTURY: LATE BAROQUE AND ROCOCO

During the first half of the eighteenth century, royalty and the members of the European aristocracy still held much economic and social power, although their political power was in decline. Monarchs and nobles still wished to surround themselves with visible signs of their wealth and position. In England, a bent for austerity tempered aristocratic desires for opulent grandeur. In France, the monumentality of Louis XIV's Baroque taste was recast in a more intimate and enjoyable guise—the Rococo style. Rococo proved so appealing to the nobility that it spread rapidly throughout Europe, replacing the earlier, heavier Baroque style.

Late Baroque and Palladian Classicism in England

In England, early in the century, the monumentality of the Baroque inspired one vast palace, Blenheim (FIG. **20-1**), which was commissioned by the government to commemorate the British victory over the French led by John Churchill, Duke of Marlborough. Designed by JOHN VANBRUGH (1664–1726), Blenheim was one of the largest of the splendid country houses built during the period of prosperity that resulted from Great Britain's expansion into the New World.

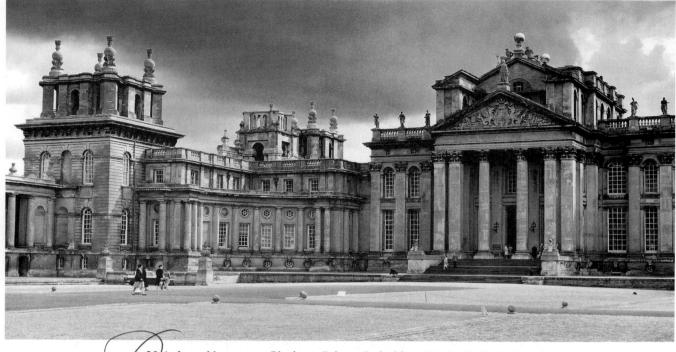

20/1 JOHN VANBRUGH, Blenheim Palace, Oxfordshire, England, 1705-1722.

During this period, a small group of architects associated with the aging Sir Christopher Wren were responsible for a brief return to favor of the Baroque over the Palladian Classicism of Inigo Jones. Vanbrugh was the best known of this group. The picturesque silhouette he created for Blenheim, with its massing and its inventive architectural detail, is thoroughly Baroque. The design demonstrates his love of variety and contrast, tempered by his ability to create areas of focus like those found so frequently in the Baroque architecture of the seventeenth century. The tremendous forecourt, the hugely projecting pavilions, and the extended colonnades simultaneously recall St. Peter's and Versailles (FIGS. 19-3 and 19-65). Perhaps because Vanbrugh had begun his career as a writer of witty and popular comedies and as the builder of a theater in which to produce them, all of his architecture tended toward the theatrical on a mighty and extravagant scale. Like many Baroque architects, he even sacrificed convenience to dramatic effect, as in the placement of the kitchen at Blenheim some 400 yards from the majestic dining salon. Vanbrugh's architecture pleased his patrons in the beginning, but even before Blenheim was completed, critics were condemning what they considered its ponderous and bizarre qualities.

The criticism of buildings like Blenheim gradually was broadened to encompass the defects of the Baroque style in general. Soon, preference swung from the "irrationality" and "artificiality" of Baroque pomp, vast scale, theatrical effects, irregular forms, exuberant details, and grandiose rhetoric toward the "good sense" found in simple, harmonious, and useful Palladian designs. The British may also have come to connect the Baroque style with the showy rule of absolute monarchy—something to be played down in parliamentary England. In English architecture, the instinct for an unostentatious and commonsensical style led straight from the authority of Vitruvius, through the work of Andrea Palladio (FIG. 17-51), and on to that of Inigo Jones (FIG. 19-74). As Alexander Pope, in his "Fourth Moral Epistle" (1731), advised his friend, the statesman and architectural amateur RICHARD BOYLE, Earl of Burlington (1695–1753):

You, too, proceed! make falling arts your care, Erect new wonders, and the old repair; Jones and Palladio to themselves restore And be whate'er Vitruvius was before.

Lord Burlington took the advice and strongly restated the Palladian doctrine of Inigo Jones in a new style in Chiswick House (FIG. **20-2**), which he built on the outskirts of London with the help of the talented professional WILLIAM KENT (1685–1748). The way had been paved for this shift in style by, among other things, the publication of Colin Campbell's *Vitruvius Britannicus* (1715), three volumes of engravings of ancient buildings in Britain, prefaced by a denunciation of Italian Baroque and high praise for Palladio and Inigo Jones.

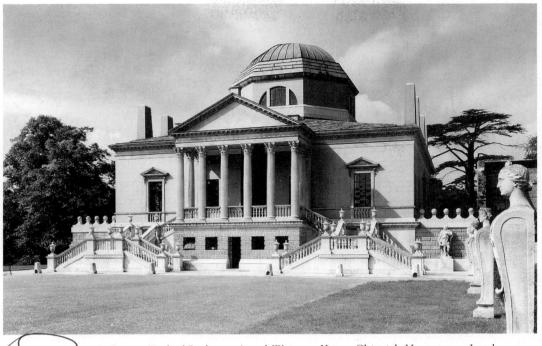

20-2 BICHARD BOYLE (Earl of Burlington) and WILLIAM KENT, Chiswick House, near London, begun 1725. British Crown Copyright.

Chiswick House is a free variation on the theme of Palladio's Villa Rotonda (FIG. 17-51). The exterior design provided a clear alternative to the colorful splendors of Versailles. In its simple symmetry, unadorned planes, right angles, and stiffly wrought proportions, Chiswick looks very Classical and "rational," but, like so many Palladian villas in England, the effect is modified by its setting within informal gardens, where a charming irregularity of layout and freely growing, uncropped foliage dominate the scene. The development of the "English garden" as a rival to the formality of the continental garden is an important chapter in the history of eighteenth-century taste about which we will say more later. Just as irregularity was cultivated in the landscaping surrounding English Palladian villas, so the interiors of buildings sometimes were ornamented in a style more closely related to the Rococo decoration fashionable on the continent than to the severity of the Classical Palladian exteriors. At Chiswick, the interior design created a luxurious Late Baroque foil to the stern symmetry of the exterior and the plan. Despite such "lapses," Palladian Classicism prevailed in English architecture until about 1760, when it began to evolve into Neoclassicism.

Rococo: The French Taste

The death of Louis XIV in 1715 brought many changes in French high society. The court of Ver-

sailles was at once abandoned for the pleasures of town life. The hôtels (town houses) of Paris soon became the centers of a new, softer style we call Rococo. The sparkling gaiety cultivated by the new age, associated with the regency that followed Louis XIV's death and with the reign of Louis XV, found perfectly harmonious expression in this new style. Rococo appeared in France in about 1710, primarily as a style of interior design. The French Rococo exterior was most often simple, or even plain, but Rococo exuberance took over the interior. The word Rococo came from the French rocaille, which literally means "pebble," but the term referred especially to the small stones and shells used to decorate the interiors of grottoes. Such shells or shell forms were the principal motifs in Rococo ornament.

The feminine look of the Rococo style suggests that the age was dominated by the taste and the social initiative of women—and, to a large extent, it was. Women—Madame de Pompadour in France, Maria Theresa in Austria, Elizabeth and Catherine in Russia—held some of the highest positions in Europe, and female influence was felt in any number of smaller courts. The Rococo salon was the center of early eighteenth-century Parisian society, and Paris was the social capital of Europe. Wealthy, ambitious, and clever society hostesses competed to attract the most famous and the most accomplished people to their salons. The medium of social intercourse was conversation spiced with wit, repartee as quick and

20-3) Salon de la Princesse, Hôtel de Soubise, Paris, 1737–1740. Decorations by Germain Boffrand. © Arch. Photo. Paris/S.P.A.D.E.M.

deft as a fencing match. The masculine heroics and rhetoric of the Baroque era were replaced by dainty gallantries and pointed sallies of humor. Artifice reigned supreme, and it was considered in bad taste to be enthusiastic or sincere.

A typical French Rococo room is the Salon de la Princesse (FIG. **20-3**) in the Hôtel de Soubise in Paris, decorated by GERMAIN BOFFRAND (1667–1754). If we compare this room with the Galerie des Glaces at Versailles (FIG. 19-68), we see the fundamental difference at once. The strong architectural lines and panels of the earlier style were softened here into flexible, sinuous curves. The walls melt into the vault; the cornices are replaced by irregular painted shapes, surmounted by sculpture and separated by the typical shells of rocaille. Painting, architecture, and sculpture make a single ensemble. The profusion of curving tendrils and sprays of foliage combine with the shell forms to give an effect of freely growing nature and to suggest

that the Rococo room is permanently decked for a festival. Rococo was a style preeminently evident in small art; furniture, utensils, and accessories of all sorts were exquisitely wrought in the characteristically delicate, undulating Rococo line. French Rococo interiors were designed as lively, total works of art in which the architecture, relief sculptures, and wall paintings were complemented by elegant furniture, enchanting small sculpture, delightful ceramics and silver, a few "easel" paintings, and decorative tapestry. As we see them today, French Rococo interiors, like that of the Salon de la Princesse, have lost most of the moveable "accessories" that once adorned them. We can imagine, however, how such rooms, with their alternating gilded moldings, vivacious relief sculptures, and daintily colored ornament of flowers and garlands, must have harmonized with the chamber music played in them, with the elaborate costumes of satin and brocade, and with the equally elegant etiquette and sparkling wit of the people who graced them.

The painter above all others whom we associate with the French Rococo is ANTOINE WATTEAU (1684-1721). The differences between the age of the Baroque and the age of Rococo can be seen clearly if we contrast the portrait of Louis XIV (FIG. 20-4) by HYACINTHE RIGAUD (1659-1743) with one of Watteau's paintings, L'Indifférent (FIG. 20-5). Rigaud portravs pompous majesty in slow and stately promenade, as if the French monarch were reviewing throngs of bowing courtiers at Versailles. The other painting represents a languid, gliding dancer, whose mincing minuet might be seen as mimicking the monarch's solemn pacing. In Rigaud's portrait, stout architecture, bannerlike curtains, flowing ermine, and fleur-de-lis exalt the king, while fanfares of trumpets blast. In Watteau's painting, the dancer moves in a rainbow shimmer of color, emerging onto the stage of the intimate comic opera to the silken sounds of strings. The portrait of the king is very large, the "portrait" of "the indifferent one," guite small. The first painting is Baroque; the second is Rococo.

20-4 HYACINTHE RIGAUD, Louis XIV, 1701. Approx. 9' $2'' \times 6' 3''$. Louvre, Paris.

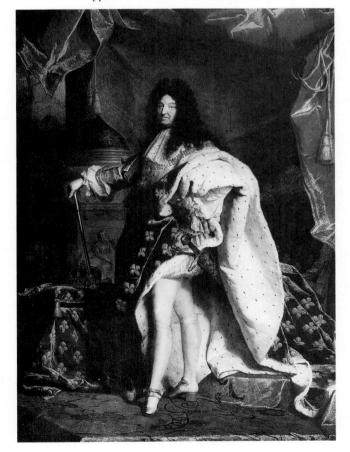

20-5 ANTOINE WATTEAU, L'Indifférent, c. 1716. Approx. 10" × 7". Louvre, Paris.

Watteau's masterpiece (of which he painted two different versions) is Return from Cythera (FIG. 20-6), completed between 1717 and 1719 as the artist's acceptance piece for admission to the French Royal Academy. Watteau was Flemish, and his style was a beautiful derivative of the style of Rubens-a kind of rarefaction and refinement of it. At the turn of the century, the French Royal Academy was rather sharply divided between two doctrines. One doctrine upheld the ideas of Le Brun (the major proponent of French Baroque under Louis XIV), who followed Nicolas Poussin in teaching that form was the most important element in painting, while "colors in paintings were . . . blandishments to lure the eyes," something added for effect, and not really essential. The other doctrine, with Rubens as its model, proclaimed the supremacy of color as natural and the coloristic style as the proper guide to the artist. Depending on which side they took, members of the Academy were called "Poussinistes" or "Rubénistes." With Watteau, the Rubénistes carried the day, and the Rococo style in painting was established on the colorism of Rubens and the Venetians.

Watteau's *Return from Cythera* represents a group of lovers preparing to depart from the island of eternal

20-6 APTOINE WATTEAU, Return from Cythera, 1717–1719. Approx. 4' $3'' \times 6'$ 4". Louvre, Paris.

youth and love, sacred to Aphrodite. Young and luxuriously costumed, they perform, as it were, an elegant, tender, graceful ballet, moving from the protective shade of a woodland park, peopled with amorous cupids and voluptuous statuary, down a grassy slope to an awaiting golden barge. The attitudes of the figures were studied carefully; Watteau has never been equaled for his distinctive poses, which combine elegance and sweetness. He composed his generally quite small paintings from albums of superb drawings that have been preserved and are still in fine condition. In these, we find him observing slow movement from difficult and unusual angles, obviously with the intention of finding the smoothest, most poised, and most refined attitudes. As he sought nuances of bodily poise and movement, Watteau also strove for the most exquisite shades of color difference, defining in a single stroke the shimmer of silk at a bent knee or the iridescence that touches a glossy surface as it emerges from shadow. Art historians have noted that the theme of love and Arcadian happiness in Watteau's pictures (which we have seen since Giorgione and which Watteau may have seen in works by Rubens) is slightly shadowed with wistfulness, or even melancholy, as if Watteau, during his own short life, meditated on the swift passage of youth and pleasure. The haze of color, the

subtly modeled shapes, the gliding motion, and the air of suave gentility were all to the taste of the Rococo artist's aristocratic patronage. The unifying power of that taste drew the arts together. The titles, as well as the mood of many musical compositions by Watteau's contemporary, Jean Philippe Rameau, are perfectly suited to Watteau's pictures. The mood is also wonderfully echoed in a passage from Alexander Pope's *Rape of the Lock* (1714), showing that Rococo taste touched even the English arts on occasion:

But now secure the painted vessel glides, The sunbeams trembling on the floating tides; While melting music steals upon the sky, And softened sounds along the waters die.

The lucid squadrons round the sails repair: Soft o'er the shrouds aërial whispers breathe, That seemed but zephyrs to the train beneath. Some to the sun their insect wings unfold, Waft on the breeze, or sink in clouds of gold; Transparent forms too fine for mortal sight, Their fluid bodies half dissolved in light, Loose to the wind their airy garments flew, Thin glittering textures of the filmy dew.

Watteau's successors never quite matched his taste and subtlety. Their themes were concerned with love, artfully and archly pursued through erotic frivolity and playful intrigue. After Watteau's untimely death, his follower, FRANÇOIS BOUCHER (1703–1770), painter to Madame de Pompadour, rose to the dominant position in French painting. Although he was an excellent portraitist, Boucher's fame rests primarily on his gay and graceful allegories, in which Arcadian shepherds, nymphs, and goddesses cavort in shady glens, engulfed in pink and sky-blue light. *Cupid a Captive* (FIG. **20-7**) presents the viewer with a rosy pyramid of infant and female flesh, set off against a cool, leafy background, with the nudity of the figures

FRANÇOIS BOUCHER, Cupid a Captive, 1754. Approx.
 34". Reproduced by permission of the Trustees of the Wallace Collection, London.

20-8 JEAN HONORÉ FRAGONARD, *The Swing*, 1766. Approx. 35" × 32". Reproduced by permission of the Trustees of the Wallace Collection, London.

both hidden and revealed by fluttering draperies. Boucher used the full range of Baroque devices to create his masterly composition: the dynamic play of crisscrossing diagonals, curvilinear forms, and slanting recessions. But powerful Baroque curves in his work were dissected into a multiplicity of decorative arabesques, and Baroque drama dissipated into sensual playfulness. Gay and superficial, Boucher's artful Rococo fantasies became mirrors in which his patrons, the French aristocracy, could behold the ornamental reflections of their cherished pastimes.

JEAN HONORÉ FRAGONARD (1732–1806), Boucher's student, was a first-rate colorist whose decorative skill almost surpassed his master's. An example of his manner can stand as characteristic not only of him, but of the later Rococo in general. *The Swing* (FIG. **20-8**) is a typical "intrigue" picture. A young gentleman has managed an arrangement by which an unsuspecting old bishop swings the young man's pretty sweetheart higher and higher, while her lover stretches out to admire her ardently from a strategic position on the ground. The young lady flirtatiously and boldly kicks off her shoe at the little statue of the god of discretion, who holds his finger to his lips. The landscape setting is out of Watteau—a luxuriant, perfumed bower in a park that very much resembles a

(20-9) CLODION, Nymph and Satyr, c. 1775. Terra-cotta, approx. 23" high. The Metropolitan Museum of Art, New York (bequest of Benjamin Altman, 1913).....

stage scene for the comic opera. The glowing pastel colors and soft light convey, almost by themselves, the sensuality of the theme.

The Rococo mood of sensual intimacy also permeated much of the small sculpture designed for the salons of the day. Artists like CLODION (Claude Michel, 1738-1814) specialized in small, lively sculptures that combined the sensuous fantasies of the Rococo with lightened echoes of Bernini's dynamic Baroque figures. Perhaps we should expect such influence in the works of Clodion; he lived and worked in Rome for some years after discovering the charms of the city during his tenure as the recipient of the cherished Prix de Rome. Clodion's small group, Nymph and Satyr (FIG. 20-9), has an open and vivid composition suggestive of its dynamic Baroque roots, but the artist has overlaid that source with the erotic playfulness of Boucher and Fragonard to energize his eager nymph and the laughing satyr into whose mouth she pours a cup of wine. Here, the sensual exhilaration of the Rococo is caught in diminutive scale and fragile terra-cotta; as with so many Rococo artifacts, and most of Clodion's best work, this group was designed for a tabletop.

The Rococo style in small sculpture was so popular with patrons at court that it was even used to transform portraiture into incidents from dream fêtes. In

20-10 ÉTIENNE-MAURICE FALCONET, Madame de Pompadour as the Venus of the Doves, date unknown.
Marble, 29¹/₂ × 28" × 18". National Gallery of Art, Washington, D.C. (Samuel H. Kress Collection).

Madame de Pompadour as the Venus of the Doves (FIG. 20-10) by Étienne-Maurice Falconet (1716–1791), the artist demonstrated his special gift for portraying the soft, warm qualities of the human body. As the director of sculpture at the Sèvres Porcelain Manufactory, Falconet developed great skill in designing compositions in small scale. In this graceful marble piece, he fitted the portrait head of his famous patroness onto an idealized nude body, which sits gracefully between two attendant putti. The lyrical linking in this work between the Classical goddess of love and the eighteenth-century ex-mistress of the king of France, who remained the powerful arbiter of court taste in France for many years, must have pleased its subject as a particularly appropriate concept and design.

Rococo and Late Baroque in Italy and Germany

French Rococo did not immediately penetrate into Italy and other places where the titled grandees of Europe sought to emulate the Baroque splendor of Versailles or the glories of Counter-Reformation Italian Baroque churches designed by architects like Bernini, Borromini, and Guarini. One of the finest early eighteenth-century ecclesiastical structures is the Superga (FIG. 20-11), located near Turin in northwestern Italy. This church was designed by FILIPPO JUVARA (1678-1736) for Victor Amadeus II, king of Savoy, to commemorate Savoy's victory over the French in 1706 during the War of the Spanish Succession. Juvara had begun his career as royal architect at Turin by practicing the lavish Baroque style of his predecessor, Guarino Guarini (FIG. 19-19), but a period of study in Rome turned Juvara toward a more Classical approach. The style of the Superga reflects this shift, although the building's setting is entirely Baroque. The layout of the church and the monastery, of which it is the frontispiece, is similar to that of the Church of the Invalides in Paris (FIG. 19-70). The great dome and drum of the Superga are close to the dimensions of the Invalides and may reflect Juvara's knowledge of that building. At the same time, the Superga's deep, four-columned portico, surmounted by a balustrade that continues around the building, echoes Palladian Classicism, and the relation of the portico to the rotunda-like structure behind it recalls the ancient Pantheon (FIG. 6-56). The severity of the portico and of the colossal orders that articulate the walls is offset by the light, fanciful bell towers that flank the dome. In its adroit adjustment of Classical features and Baroque grouping, the building is an impressive example of Juvara's intelligent eclecticism.

By the second quarter of the century, the grandeur of the Late Baroque was being modified by French Rococo overtones in much of Germany and Austria. A brilliant example of French Rococo in Germany is the Amalienburg (FIGS. **20-12** and **20-13**), a small

20-Th FILIPPO JUVARA, the Superga, near Turin, Italy, 1715–1731.

lodge built by FRANÇOIS DE CUVILLIÉS (1698–1768) in the park of the Nymphenburg Palace in Munich. Although we have seen that the Rococo was essentially a style of interior design, the Amalienburg beautifully harmonizes the interior and exterior elevations through the curving flow of lines and planes that cohere in a plastic unity of great elegance. The *bombé* (outward-bowed) shape of the central bay of the Amalienburg façade was a common feature of Rococo

20-12/ FRANÇOIS DE CUVILLIÉS, the Amalienburg, Nymphenburg Park, Munich, West Germany, 1734–1739.

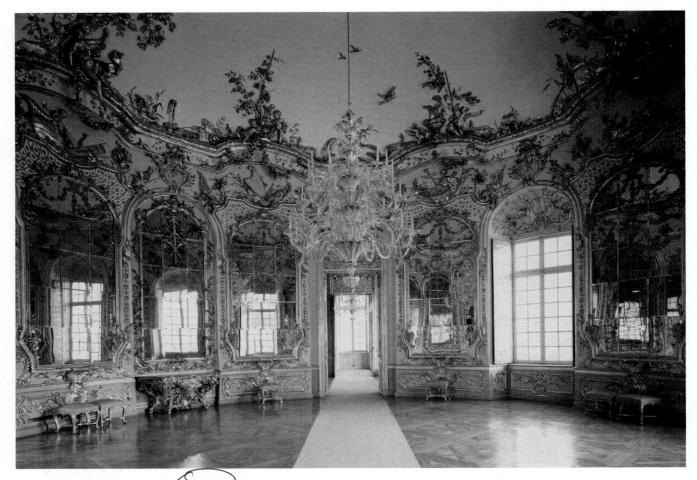

20-13 FRANÇOIS DE CUVILLIÉS, Hall of Mirrors, the Amalienburg.

furniture design; indeed, the compactness, diminutive scale, graceful lines, and exquisite detail invest the Amalienburg with the appearance of a kind of precious furnishing set down on the manicured greensward of its park setting. The most spectacular interior room in the lodge is the circular Hall of Mirrors (FIG. 20-13), a silver and blue ensemble of architecture, stucco relief, silvered-bronze mirrors, and crystal that dazzles the eye with myriad scintillating motifs, forms, and figurations borrowed from the full Rococo repertory of ornament. This is the zenith of the style. Facets of silvery light, multiplied by windows and mirrors, sharply or softly delineate the endlessly proliferating shapes and contours that weave rhythmically around the upper walls and the coves of the ceiling. Everything seems organic, growing and in motion, an ultimate rarefaction of illusion created with virtuoso flourishes by the team of architect, artists, and artisans, all magically in command of the resources of their varied media.

Even the ceilings of Late Baroque palaces sometimes became painted festivals for the imagination. The master of such works, GIAMBATTISTA TIEPOLO (1696–1770), was the last great Italian painter to have an international impact until the twentieth century. Of Venetian origin, Tiepolo worked for patrons in Austria, Germany, and Spain, as well as in Italy, leaving a strong impression wherever he went. His bright, cheerful colors and his relaxed compositions are ideally suited to Rococo architecture. The Apotheosis of the Pisani Family (FIG. 20-14), a ceiling fresco in the Villa Pisani at Stra in northern Italy, shows airy populations fluttering through vast sunlit skies and fleecy clouds, their figures making dark accents against the brilliant light of high noon. As the word apotheosis indicates, members of the Pisani family are elevated here to the rank of the gods in a heavenly scene that recalls the ceiling paintings of Correggio (FIG. 17-37) and Pozzo (FIG. 19-33). While retaining the illusionistic tendencies of the seventeenth century, Tiepolo discards all rhetoric to create gay and brightly colored pictorial schemes of great elegance and grace, which, for sheer effectiveness as decor, are unsurpassed.

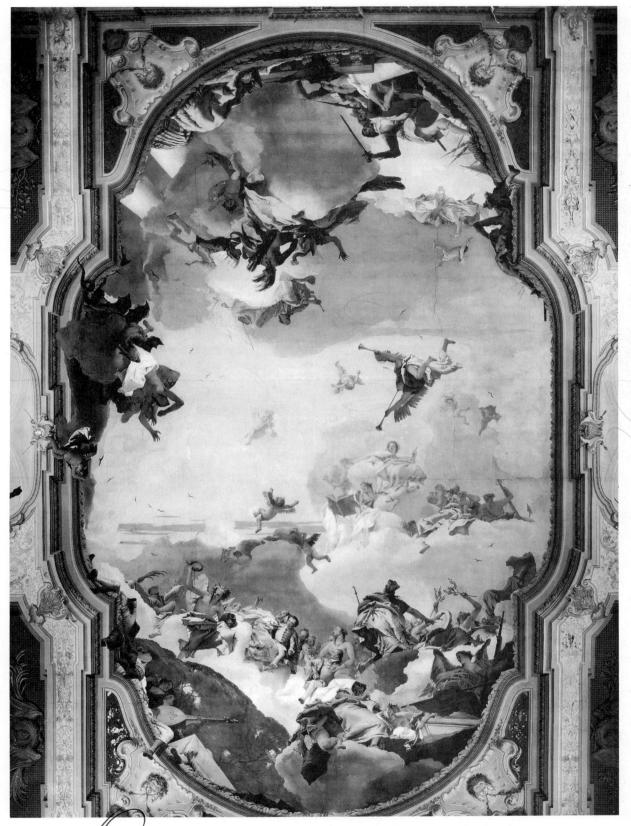

C20-14 GIAMBATTISTA TIEPOLO, The Apotheosis of the Pisani Family, 1761–1762. Ceiling fresco in the Villa Pisani, Stra, Italy.

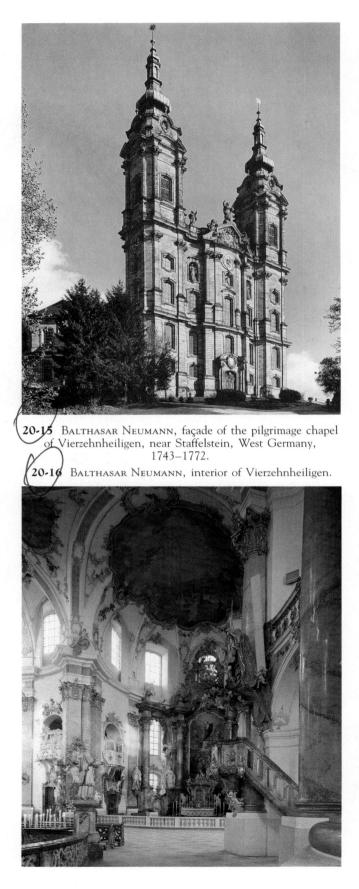

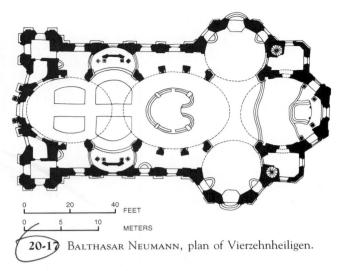

The Rococo style spread beyond palaces to ecclesiastical architecture in an area of southern Germany and Austria that had lain dormant artistically throughout the seventeenth century. In a great wave of church building here in the eighteenth century, the new style was not confined to interiors but appeared in exteriors and plans as well. The chief influence, moreover, was not French but Italian, stemming from the architecture of Borromini and Guarini, so that it is perhaps more accurate to think of this style as Late Baroque with strong stylistic affinities to Rococo. One of the most splendid of the German buildings is the pilgrimage church of Vierzehnheiligen (Fourteen Saints), designed by BALTHASAR NEUMANN (1687-1753). Born in the German part of Bohemia, Neumann traveled in Austria and northern Italy and studied in Paris before returning home to become one of the most active architects working in his native land. The rounded corners and the undulating center of the façade of Vierzehnheiligen (FIG. 20-15) recall the style of Borromini, without approaching his dramatic intensity. Numerous large windows in the richly articulated but continuous walls flood the interior with an even, bright, and cheerful light. The pilgrimage church sanctuary (FIG. 20-16) exhibits a vivacious play of architectural fantasy that retains the dynamic energy but banishes all the dramatic qualities of Italian Baroque. The complexity of Vierzehnheiligen is readable in its ground plan (FIG. 20-17), which has been called "one of the most ingenious pieces of architectural design ever conceived." The straight line deliberately seems to have been banished. The composition is made up of tangent ovals and circles, so that, within the essential outlines of the traditional Gothic church (apse, transept, nave, and western towers), a quite different interior effect is achieved, one of undulating space in continuous motion, creating unlimited vistas bewildering in their

variety and surprise effects. The features of the structure pulse, flow, and commingle as if they were ceaselessly in the process of being molded. The fluency of line, the floating, hovering surfaces, the interwoven spaces, and dematerialized masses of the design combine to suggest a "frozen" counterpart to the intricacy of voices in a fugue by Bach. We must think of this kind of church as a brilliant ensemble of architecture, sculpture, music, and painting, in which the boundaries of the arts dissolve in a visionary unity.

Pictorial embellishment of German and Austrian churches, often in the style of Tiepolo, was supplemented by sculpture conceived to produce entirely pictorial effects. The group of the Assumption of the Virgin (FIG. 20-18) was created by EGID QUIRIN ASAM (1692–1750) for the space above the altar in the monastery church at Rohr, Germany. The church was designed with his brother COSMAS DAMIAN ASAM (1680–1739). The brothers were influenced in their building designs by the Late Baroque architecture they saw on a trip to Rome. What they brought home was a feeling for the illusionistic spectacle we have just seen in Tiepolo's ceiling painting (FIG. 20-14). In Egid Quirin Asam's Assumption of the Virgin, as in Bernini's Ecstasy of St. Theresa (FIG. 19-12), the miracu-

(20-18) EGID QUIRIN ASAM, Assumption of the Virgin, monastery church at Rohr, West Germany, 1723.

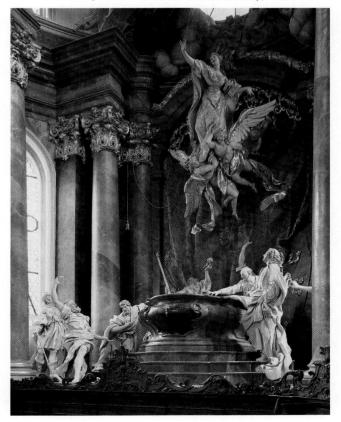

lous is made real before our eyes, a spiritual vision materially visible. The Virgin, effortlessly borne aloft by angels, soars to the glowing paradise above her, while the apostolic witnesses below gesticulate in astonishment around her vacant tomb. The figures ascending to Heaven have gilded details that set them apart from those that remain on earth. The setting is a luxuriously ornamented theater; the scene itself, pure opera-an art that was perfected and became very popular in the eighteenth century. One can imagine the Virgin as the protagonist in an operatic production, singing the climactic aria, with all appropriate gestures, to the excited accompaniment of a chorus, while a virtuoso designer directs the stagecraft. Here, sculpture dissolves into painting, theater, and music, its mass rendered weightless, its natural compactness of composition broken up and diffused. In this instance, the art of the sculptor was used, paradoxically, to disguise substance and function, weight and tactility, in the interest of eye-deceiving mystical illusion.

THE LATER EIGHTEENTH CENTURY: THE BIRTH OF THE MODERN WORLD

The second half of the eighteenth century quickened in tempo and changed in mood as the course of history swept toward the climax of the revolutions that opened the modern epoch. An uneasiness and then an impatience with the status quo bred a new and restless spirit of criticism that, here and there, edged toward rebellion against what was thought to be the wanton lavishness and profligacy of the Rococo. An impulse toward the simple, the earnest, and the moral began to rise. Side by side with the waning of the Rococo ran a rising belief in the importance of using reason and one's senses in free inquiry to achieve a better understanding of oneself and the world. These ideas were part of the "enlightened" thinking of Voltaire and Diderot, who taught the importance of understanding gained by the systematic gathering and ordering of data about the physical world. Related to these teachings was a belief in the power of knowledge and education to improve human life. A renewed taste for naturalism in art arose, bringing with it a resurgence of interest in carefully detailed landscapes and cityscapes, and a desire for natural effects in portraiture that recalled those of seventeenth-century Holland.

The later eighteenth century was also the time of Rousseau, the "age of sensibility" whose leading thinkers preached the value of sincere feeling and natural human sympathy over artful reason and the cold calculations of courtly societies. The slogan of sensibility was "Trust your heart rather than your head," or, as Goethe put it, "Feeling is all!" Werther, the young Goethe's archetype of Romantic sensibility, cried: "We desire to surrender our whole being, that it may be filled with the perfect bliss of one glorious emotion!" All that was false and artificial was to be banished as the enemy of honest emotion. In art, sensibility joined with the idea of Enlightenment thinkers that paintings with a moral theme could move the hearts of viewers toward correct social behavior.

Sensibility was swiftly overtaken by the heroic emotions of the revolutionary age. Archeological discoveries of ancient Roman cities in the early and mideighteenth century helped to reinforce a rising belief that people in the days of ancient Greece and Rome had lived by a splendid moral code, which had governed their behavior and their allegiance to the wider society. Eighteenth-century thinkers were quick to link models of self-sacrificing virtue from the Greek and Roman past with some from the rebellious present-heroes like Cato and Washington, Regulus and Marat-to touch the hearts of viewers and readers and to inspire thoughts and deeds of civic idealism. A revived Classical style was developed in architecture, painting, and sculpture to help encourage modern citizens toward exemplary acts of civic behavior.

Contemporary with both the sentimental and the heroic came the taste for the sublime in art and nature. The sublime inspired feelings of awe mixed with terror—the feelings we experience when we look on vast, impassable mountain peaks or great storms at sea. Accompanying the taste for the sublime was the taste for the fantastic, the occult, the grotesque, the macabre—for the adventures of the soul voyaging into the dangerous reaches of consciousness. Images of the sublime and the terrible often combined something of Baroque dynamism with natural details in their quest for the presentation of grippingly convincing visions.

Everything that moved the emotions of artists and their audience—the sentimental, the heroic, the sublime, the "Gothic," or combinations of them—was marked by a shift in emphasis from reason to feeling, from calculation to intuition, from objective nature to subjective emotion. Here, that attitude of the modern mind we call Romanticism first emerges.

J. P. Eckermann's *Conversations with Goethe* throw a strong, revealing light on the emotional side of Romanticism, especially on its supposed opposition to Classicism. Goethe is recorded as declaring:

The distinction between Classical and Romantic poetry, which is now spread over the whole world and occasions so many quarrels and divisions, came originally from Schiller and myself. [Goethe is looking back some forty years in time.] I laid down the maxim of objective treatment in poetry, and would allow no other; but Schiller, who worked quite in the subjective way, deemed his own fashion right, and to defend himself against me, wrote the treatise upon Naïve and Sentimental Poetry. He proved to me that I, against my will, was romantic, and that my Iphigenia, through the predominance of sentiment, was by no means so much in the Antique spirit as some people supposed. The Schlegels took up this idea, and carried it further, so that it has now been diffused over the whole world; and everybody talks about Classicism and Romanticism-of which nobody thought fifty years ago.*

Goethe wanted his drama, *Iphigenia*, to be in the Antique spirit and, "against his will," discovered that he had been romantic all the time. This discovery was probably made by many artists throughout the era of Romanticism. The break with tradition forced the artist to look at tradition historically; if Classical art was preferred, then a "classic" bent of mind must be assumed or affected, but the artist would still be representing Classical form, not *creating* it. In the end, it was the emotional response to Classical form that counted, and the emotional response to Classical form was precisely Romantic!

Reaction Against the Rococo: "Naturalness" in Landscape and Portraiture

By mid-century, accompanying the diminishing power of the aristocracy and the rise of a new moneyed bourgeois class, a reaction had developed against the sweet sensual fantasies of Rococo art. A desire for "naturalism" in art complemented the increased interest in the workings of the natural world that was fostering scientific attempts to assemble and organize data about every aspect of the earth and the universe beyond it. Documentation of particular places became popular, both to serve the needs of the many scientific expeditions mounted during the century, and to satisfy the desires of genteel tourists for mementos of their journeys. By this time, a "grand tour" of the major sites of Europe was considered part of every well-bred person's education. Naturally, those on tour wished to bring home things that

^{*}John Oxenford, trans., and J. K. Moorehead, ed., Conversations of Goethe with Eckermann (New York: Dutton, 1935), p. 366.

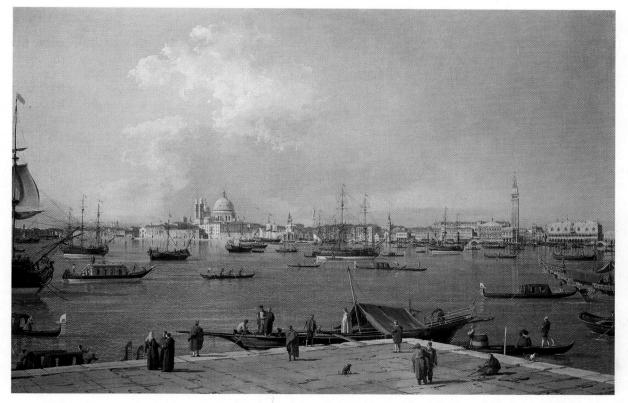

20-19 ANTONIO CANALETTO, Basin of San Marco from San Giorgio Maggiore. Wallace Collection, London.

would help them remember their experiences and would impress those at home with the wonders they had seen.

The English were especially eager collectors of pictorial souvenirs. Certain artists in Venice specialized in painting the most characteristic scenes (veduta) of that city to sell to British visitors. The veduta paintings of (Giovanni) Antonio Canaletto (1697–1768) were eagerly acquired by English tourists, who hung them on the walls of homes like Chiswick and Blenheim as visible evidence of their visit to the city of the Grand Canal. It must have been very cheering in the midst of a grey winter afternoon in England to look up and see a sunny, panoramic view like that in Canaletto's Basin of San Marco from San Giorgio Maggiore (FIG. 20-19), with its cloud-studded sky, calm harbor, varied water traffic, picturesque pedestrians, and well-known Venetian landmarks all picked out in scrupulous perspective and minute detail. Canaletto had trained as a scene-painter with his father, but his easy mastery of detail, light, and shadow soon made him one of the most popular "vedutista" in Venice. Occasionally, he painted his scenes directly from life, but usually he made drawings "on location" to take back to his studios as sources for canvases to be painted there. To help make the on-site drawings true

to life, he often used a camera obscura (see page 795). Like Van Ruisdael (FIG. 19-56), Canaletto was interested in painting the visible facts of the scene he had chosen, but unlike the Dutch painter, the Venetian artist's main subject was the architectural setting and the space it created. His paintings give the impression of capturing every detail, with no "editing." Actually, he presented each site within the rules of Renaissance perspective and exercised great selectivity about which details to include and which to omit to make a coherent and engagingly attractive picture. In addition, the mood in each of his works was carefully constructed to be positive and alluring. Everything in the world presented by Canaletto is clean, orderly, and tidy. The sun always shines, and every aspect of the weather is serene.

Perhaps not surprisingly, the desire for naturalism in art was felt most strongly in the area of portraiture. Even many of the powerful and noble patrons of Rococo art were delighted to see themselves portrayed in a more natural guise. The Venetian artist ROSALBA CARRIERA (1675–1757) made an international reputation for herself with vividly natural pastel portraits of the gentry, nobility, and royalty of Europe. Pastels are chalklike crayons made of ground color pigments mixed with water and a binding medium. They lend

20-20 ROSALBA CARRIERA, Cardinal de Polignac, 1732. Pastel. Gallerie dell' Accademia, Venice.

themselves to quick execution, particularly of portraits, and provide the artist with a wide range of colors and subtle variations of tone, characteristics well suited to the rendering of nuances of value and fleeting expressions of feature. Carriera was a pioneer of the pastel medium, and her art became the fashion in Paris, so much so that she had offers for more commissions than she could accept. Her efforts raised the medium of pastel to the level of the art of painting from its hitherto exclusive use for preliminary drawings. Her pastel portrait of Cardinal de Polignac (FIG. 20-20), diplomat and collector of ancient art, shows her portrait method. Essentially informal, the composition includes only the head and bust, eliminating all details not needed to record the features and status of the subject. The design is simple; the pose and presentation are forthright and unpretentious. The pomp and rhetorical flourishes of the Baroque and the sensual playfulness of the Rococo are missing. As is typical for the pastel medium, the colors are highkeyed and luminous, shading is minimal, and the cardinal's grave features are modulated by a slightly hazed, soft focus, suggestive of sunlit atmosphere. By the end of her life, esteem for works such as this had won Carriera election to membership in both the Accademia de San Luca in Rome and the French Royal Academy in Paris.

In England, the tradition of Van Dyck was still strong, but now it was taken up by a whole school of painters, who gradually modified it for the more modern taste. SIR JOSHUA REYNOLDS (1723–1792) specialized in portraits of contemporaries who participated in the great events that ushered in modern times. Reynolds was an influential theorist. In his Discourses and as the first president of the British Royal Academy of Arts, founded in 1768, he expounded a doctrine close to that of the academic Baroque, maintaining that "general" nature, as represented by the Carracci and others, was always superior to "particular" nature, as rendered by the Dutch. Yet Reynolds could respond to a portrait subject like Lord Heathfield (FIG. 20-21) by combining careful attention to appearance with a dramatic pose and setting that owed much to the Baroque, while dynamically expressing the character of the sitter. Reynolds was at his best with a subject like this burly, brandy-flushed English officer, commandant of the fortress of Gibraltar during the American Revolution. Lord Heathfield had doggedly defended the great

20-21 SIR JOSHUA REYNOLDS, Lord Heathfield, 1787. Approx. 56" × 45". Reproduced by courtesy of the Trustees of the National Gallery, London.

rock against the Spanish, and his victory is symbolized here by the huge key to the fortress, which he holds thoughtfully. He stands in front of a curtain of dark smoke rising from the battleground, flanked by one cannon that points ineffectively downward and another whose tilted barrel indicates that it lies uselessly on its back. The features of the general's heavy, honest face and his uniform are portrayed with a sense of unidealized realism, but his posture and the setting dramatically suggest the heroic theme of battle and also refer to the actual revolutions then taking shape in deadly earnest, as the old regime faded into the past.

A contrasting blend of naturalistic representation and Romantic mood is found in the portrait of *Mrs. Richard Brinsley Sheridan* (FIG. **20-22**) by THOMAS GAINSBOROUGH (1727–1788). This portrait shows the lovely lady, dressed informally, seated in a rustic landscape faintly reminiscent of Watteau in its softhued light and feathery brushwork. Gainsborough intended to match the unspoiled beauty of the natu-

20-22 Тномая GAINSBOROUGH, Mrs. Richard Brinsley Sheridan, c. 1785. Approx. 7′ 2″ × 5′. National Gallery of Art, Washington, D.C. (Andrew W. Mellon Collection).

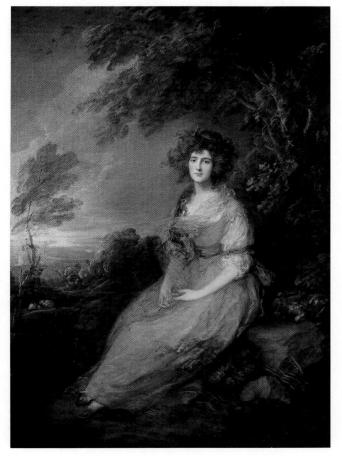

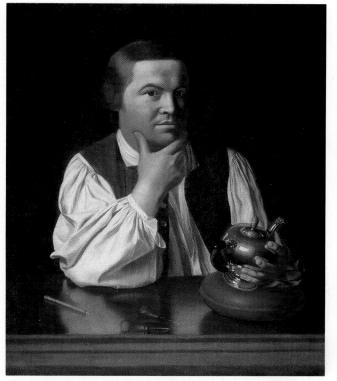

20-23 JOHN SINGLETON COPLEY, *The Portrait of Paul Revere*, c. 1768–1770. $35'' \times 28\frac{1}{2}''$. Museum of Fine Arts, Boston (gift of Joseph W., William B., and Edward H. R. Revere).

ral landscape with the natural beauty of the subject, whose dark brown hair blows freely in the slight wind and whose clear, unassisted "English" complexion and air of ingenuous sweetness contrast sharply with the pert sophistication of continental Rococo portraits. The artist originally had planned to give the picture "an air more pastoral than it at present possesses" by adding several sheep, but he did not live long enough to paint them in. Even without this element, we can sense Gainsborough's deep interest in the landscape setting; although he won greater fame in his time for his portraits, he had begun as a landscape painter and always preferred painting scenes of nature to the depiction of human likenesses.

The Portrait of Paul Revere (FIG. **20-23**), by the American artist JOHN SINGLETON COPLEY (1738–1815), is a painting in a different vein. Revere, like Carriera's Cardinal de Polignac, gazes directly out at the viewer. In contrast to the Cardinal's softened forms, however, everything in Copley's painting is in sharp focus. Each texture is carefully rendered, and every millimeter of the surface is given equal attention. Copley had matured as a painter in Massachusetts and later emigrated to England, where he absorbed

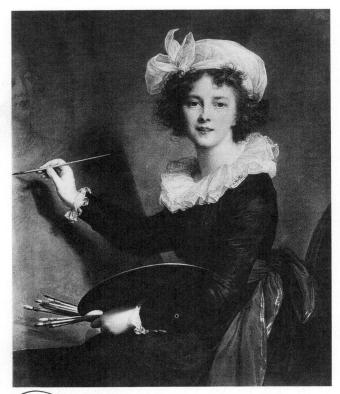

20-24 ÉLISABETH LOUISE VIGÉE-LEBRUN, Self-Portrait, 1790. & 4" × 6' 9". Galleria degli Uffizi, Florence.

the fashionable English style of Gainsborough and others. The Portrait of Paul Revere, painted before Coplev left Boston, conveys a sense of no-nonsense directness and faithfulness to visual fact that marked the taste for "downrightness" and plainness noticed by many visitors to America during the eighteenth and nineteenth centuries. At the time the portrait was painted, Revere was not yet the familiar hero of the American Revolution. In the picture, he is working at his everyday profession of silversmithing. The setting is plain, the lighting clear and revealing. The subject sits in his shirtsleeves, bent over a teapot in progress; he pauses and turns his head to look the observer straight in the eye. The artist has treated the reflections in the polished wood of the tabletop with as much care as Revere's figure, his tools, and the teapot resting on its leather graver's pillow. Special prominence was given to the figure's eyes by means of the intense reddish light that reflects onto the darkened side of the face and hands. The informality and the sense of the moment link this painting to contemporaneous English and European portraits, but the spare style and the emphasis on the sitter's down-toearth character differentiate this American work from its British and continental counterparts.

The *Self-Portrait* (FIG. **20-24**) by ÉLISABETH LOUISE VIGÉE-LEBRUN (1755–1842) is a fifth variation of the

naturalistic impulse in eighteenth-century portraiture. In the new mode, Vigée-Lebrun looks directly at the viewer like Cardinal de Polignac and Paul Revere; like Revere, she pauses in her work to return our gaze. Although her mood is more light-hearted than that of either de Polignac or Revere and details of her costume echo the serpentine curve beloved by Rococo artists and aristocratic patrons, nothing about Vigée-Lebrun's pose or her mood speaks of Rococo frivolity. Hers is the self-confident stance of a woman whose art has won her an independent role in her society. Like many of her contemporaries, Vigée-Lebrun lived a life of extraordinary personal and economic independence, working for the nobility throughout Europe. She was famous for the force and grace of her portraits, especially those of high-born ladies and royalty. Although she was successful during the age of the late monarchy in France, she survived the fall of the French aristocracy through her talent, her wit, and her ability to forge connections with those in power in the post-revolutionary period. In her Self-Portrait, Vigée-Lebrun shows herself to us, in a close-up, intimate view, at work on one of the portraits that won her renown. The naturalism and intimacy of her expression are similar to those in Houdon's Voltaire (FIG. 20-25), reflecting the ideals of the French leaders of the Enlightenment, while the independence and self-reliance she exhibits here as a woman point the way to the modern world.

20-25 JEAN ANTOINE HOUDON, Voltaire Seated, 1781. Marble, 65" high. Comédie-Française, Paris.

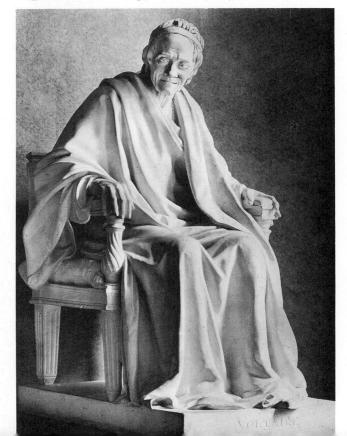

The Enlightenment: Science, Technology, and Moral Education

The second half of the eighteenth century is often called the Age of Enlightenment or the Age of Reason. In this period, many thinkers came to believe that the world operated rationally, according to natural laws that could be discovered through the systematic collection and organization of facts. Leading philosophers of the Enlightenment even encouraged the taking of a scientific, rational approach to political, religious, and socioeconomic matters, holding that people were, above all, reasonable beings who would behave with exemplary civic and social virtue if provided with proper facts and educational examples. Enlightenment ideas appealed almost immediately to those tired of the excesses of the Rococo age, and the teachings spread rapidly as former Rococo salons turned their attention to the new concepts.

The center of the Age of Reason on the continent was Paris, and, as already noted, a leading figure in the development of Enlightenment thinking in France was Voltaire. Voltaire was at the center of a group of thinkers who championed the power of reason, education, and enlightened action. His image was captured by the French sculptor JEAN ANTOINE HOUDON (1741–1828) in *Voltaire Seated* (FIG. **20-25**). The artist has dressed the aging philosopher in a flowing robe, like that of a Greek or Roman sage, and seated him in a chair reminiscent of the earlier Classical age. Houdon's training in Paris and Rome inspired him to create a host of sculptures with Classical themes, like *Minerva*, *Diana*, and *Morpheus*, but his mastery of the three-dimensional portrait brought him special fame and many commissions to portray the great men of his time. In addition to Voltaire, Houdon completed sculptural portraits of Rousseau, Benjamin Franklin, George Washington, Thomas Jefferson, and the Marquis de Lafayette. In all his portraits, Houdon's strong, perceptive realism penetrates at once to personality, catching its most subtle shade. Voltaire is captured in a thoughtful moment. His hands suggest that he is about to gesture in response to something that has just made him smile. This lively depiction of Voltaire, with its blend of naturalism and a reference to Classical values, remains a telling embodiment of his beliefs.

Enlightenment thinking's urge toward the rational, pragmatic uses of science led to inventions that modified and changed everyday life. Eighteenth-century engineering foreshadowed the future, particularly in its use of industrial materials. The first use of iron in bridge design came when a cast-iron bridge was built in England over the river Severn, near the site at Coalbrookdale where Abraham Darby III (1750-1789) ran his family's cast-iron business. The Darby family had spearheaded the evolution of the iron industry in England, and they vigorously supported the investigation of new uses for the material. The fabrication of cast-iron rails and bridge elements inspired Darby to work with architect THOMAS F. PRITCHARD (1723-1777) in designing the Coalbrookdale bridge (FIG. 20-26). The utilitarian shapes in this structure are still breathtakingly beautiful. The castiron armature that supports the roadbed springs from stone pier to stone pier until it leaps the final 100 feet

20-26 Авганам Darby III and THOMAS F. PRITCHARD, iron bridge at Coalbrookdale (first cast-iron bridge over the Severn River), 1776–1779.

across the Severn River gorge. The style of the graceful center arc echoes the grand arches of Roman aqueducts (FIG. 6-42). At the same time, the exposed structure of the cast-iron parts of the bridge prefigures the skeletal use of iron and steel in the nineteenth century, when visible structural armatures will be expressive factors in the design of buildings like the Crystal Palace (FIG. 21-95) and the Eiffel Tower (FIG. 21-96).

The vast *Encyclopedia* published in France under the direction of Denis Diderot was representative of the thirst for accumulated and organized knowledge that characterized the Enlightenment. Its model was echoed elsewhere in Europe in vast compendia of facts and in more narrowly focused collections of information about individual sectors of learning, such as anatomy. A few gifted artists like BERNARD SIEGFRIED ALBINUS (1697–1770) were able to combine their interest in creating anatomy "textbooks" with a talent for dramatic poses and settings that linked their sci-

20-27 BERNARD SIEGFRIED ALBINUS, Plate IV, The Fourth Table of the Human Muscles (frontal view), from Tabulae skeleti et musculorum corporis humani, 1749 edition. Alfred H. Taubman Medical Library, University of Michigan (the Crammer Collection).

entific illustrations with the blend of naturalism and drama developed by artists like Hogarth and Greuze (FIGS. 20-30 and 20-31). Albinus was a professor of anatomy at Leyden University in Holland. His special interest was in comparing the proportions of the human skeleton with those of other fauna, and his masterpiece was the multiple-volume Tables of the Skeleton and Muscles of the Human Body (Tabulae skeleti et musculorum corporis humani). Working with the engraver Jan Wandelaar, Albinus created a series of illustrations that combine the meticulous dissectionbased realism of Leonardo da Vinci's remarkable anatomical drawings (FIG. 17-5) with an enchanting mid-eighteenth-century sense of the fantastic. Any student of medicine would find in Albinus's books the exact details of human structure, but Albinus was not content to depict his human subjects in static isolation. Instead, he created a series of theatrical moments in which his skeletal actors—in various stages of skin and muscle dress or undress—pose in lively landscape settings that might have graced a painting by Boucher or Fragonard. In Plate IV, The Fourth Table of the Human Muscles (frontal view) (FIG. 20-27) of Albinus's book, a partially muscle-clad skeleton strikes a pose reminiscent of both Watteau's L'Indifférent (FIG. 20-5) and of the Roman statue of Augustus of Primaporta (FIG. 6-62). Albinus's figure has a companion, however; a rhinoceros munches placidly on a patch of grass nearby, as unperturbed as any less animate detail of this outdoor scene. The comparative anatomy here has a witty edge, but the plates of rhinoceros armor are depicted as carefully as the muscle coverings of the human form.

The excitement and awe that scientific knowledge held for many mid-eighteenth-century viewers is the subject of A Philosopher Giving a Lecture at the Orrery (in which a lamp is put in place of the sun) (FIG. 20-28), by the English painter Joseph Wright of Derby (1734-1797). Wright specialized in the dramatic lighting of candlelight and moonlit scenes. He loved subjects like the orrery demonstration, which could be illuminated by a single light from within the picture. The effect recalls Gerard van Honthorst's Supper Party (FIG. 19-45), but Wright's subject is thoroughly one from the Age of Reason. A scholar uses a special scientific model (called an "orrery") to demonstrate the theory that the universe operates like a gigantic clockwork mechanism. Light from the lamp used to represent the sun pours forth from behind the figure of the boy silhouetted in the foreground to create dramatic light and shadows that heighten the drama of the scene. Awed children crowd close to the tiny metal orbs that represent the planets within the arcing bands that symbolize their orbits. An earnest listener makes notes, while the lone woman seated at the left

20-28 JOSEPH WRIGHT OF DERBY, A Philosopher Giving a Lecture at the Orrery (in which a lamp is put in place of the sun), c. 1763–1765. Derby Museums and Art Gallery, Derby, England.

and the two gentlemen at the right look on with rapt attention. Everyone in Wright's painting is caught up in the wonders of scientific knowledge; an ordinary lecture takes on the qualities of a grand "history painting." Wright has scrupulously rendered with careful accuracy every detail of the figures, the mechanisms of the orrery, and even the books and curtain in the shadowy background. The mood created by the lighting and the intensity of the poses, however, suffuse this realistic rendering with an aura of largerthan-life energy that is linked to the sense of emotional drama underlying much of the evolving vision of Romanticism. Wright's blend of Romanticism and realism appealed to the great industrialists of his day. Works like Orrery were often purchased by scientificindustrial innovators like Josiah Wedgwood (who pioneered many techniques of mass-produced pottery) and Sir Richard Arkwright (whose spinning frame revolutionized the textile industry). To them, Wright's elevation of the theories and inventions of the Industrial Revolution to the plane of history painting was excitingly and appropriately in tune with the future.

The ideas of the Enlightenment fostered a genre of painting in which pictures were constructed for the purpose of instructing and inspiring viewers. Such art appealed especially to those who disapproved of the licentious gallantries of Fragonard and other courtly Rococo artists. Early examples of such morally inspiring Enlightenment works come from both France and England. The moral paintings of Jean Baptiste Siméon Chardin and William Hogarth are filled with details based on accurate observations from life, but such natural particulars are submerged in compositions that follow the Rococo spirit. Rococo colors, however, were exchanged for naturalistic and earthy hues more appropriate to images intended to provide viewers with telling examples of correct social and moral behavior.

The Frenchman JEAN BAPTISTE SIMÉON CHARDIN (1699–1779), who very briefly served as Fragonard's teacher, made a specialty of simple interiors and still lifes, which he painted masterfully in his own mode, rivaling the Dutch masters of the previous century. In *Grace at Table* (FIG. **20-29**), Chardin gives us an unpretentious room in which a mother and her small

20-29 JEAN BAPTISTE SIMÉON CHARDIN, Grace at Table, 1740. $19'' \times 15''$. Louvre, Paris.

daughters are about to dine. The mood of quiet attention is at one with the hushed lighting and mellow color and the closely studied still-life accessories, with worn surfaces that tell their own humble domestic history. We are witnesses to a moment of social instruction, when mother and older sister supervise the younger sister in the simple, pious ritual of giving thanks to God before a meal. The mood of attendant maternal devotion will surface again late in the nineteenth century in the works of Gertrude Käsebier (FIG. 21-62) and Mary Cassatt (FIG. 21-77). In his own way, Chardin was the poet of the commonplace and the master of its nuances. A gentle sentiment prevails in all of his pictures, an emotion not contrived and artificial but born of the painter's honesty, insight, and sympathy.

The taste of the newly prosperous and confident middle classes was expressed in the art of WILLIAM HOGARTH (1697–1764), who satirized contemporary life with comic zest and with only a modicum of Rococo "indecency." With Hogarth, a truly English style of painting emerged. England had had few painters or sculptors who could match the accomplishments of English architects; traditionally, painters (such as Holbein, Rubens, and Van Dyck) were imported from the continent. Hogarth waged a lively campaign throughout his career against the English feeling of dependence on, and inferiority to, continental artists. Although Hogarth himself would have been the last to admit it, his own painting owed much to the work of his contemporaries across the channel in France, the artists of the Rococo. Yet his subject matter, frequently moral in tone, is distinctively English. It was the great age of English satirical writing, and Hogarth (who knew and admired this genre and included Henry Fielding, the author of *Tom Jones*, among his closest friends) clearly saw himself as translating satire into the visual arts:

I therefore turned my thoughts to . . . painting and engraving modern moral subjects. . . . I have endeavored to treat my subjects as a dramatic writer; my picture is my stage, and men and women my players, who by means of certain actions and gestures, are to exhibit a dumb show.

Hogarth's favorite device was to make a series of narrative paintings and prints, in a sequence like chapters in a book or scenes in a play, that follow a character or group of characters in their encounters with some social evil. He is at his best in pictures like the Breakfast Scene (FIG. 20-30) from Marriage à la Mode, in which the marriage of a young viscount, arranged through the social aspirations of one father and the need for money of the other, is just beginning to founder. The anglicized Rococo style is admirably suited to the scene, but we must read the situation carefully from its large inventory of naturalistic detail if we are to enjoy it fully. The moment portrayed is just past noon; husband and wife are tired after a long night spent in separate pursuits. The music and the musical instrument on the overturned chair in the foreground and the disheveled servant straightening the chairs and tables in the room at the back indicate that the wife has stayed at home for an evening of cards and music making. She stretches with a mixture of sleepiness and coquettishness, casting a glance toward her young husband, who clearly has been away from the house for a night of suspicious business. Still dressed in hat and social finery, he slumps in discouraged boredom on a chair near the fire. His hands are thrust deep into the empty money-pockets of his breeches, while his wife's small dog sniffs inquiringly at a lacy woman's cap protruding from his coat pocket. A steward, his hands full of unpaid bills, raises his eyes to heaven in despair at the actions of his noble master and mistress. The house is palatial, but Hogarth has filled it with witty clues to the dubious taste of its occupants. The mantelpiece is crowded with tiny statuettes and a Classical bust, which hide everything in the architecturally framed painting on the wall behind except a winged Eros fig-

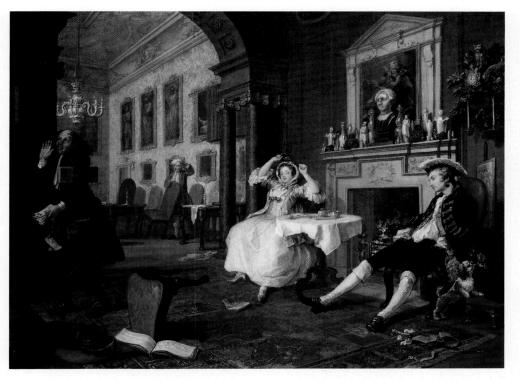

20-30 WILLIAM HOGARTH, Breakfast Scene, from Marriage à la Mode, c. 1745. Approx. 28" × 36". Reproduced by courtesy of the Trustees of the National Gallery, London.

ure. Paintings of religious figures hang on the upper wall of the distant room, contradicted by the curtained canvas at the end of the row (partially hidden by the columnar supports of the arched doorway). The curtain undoubtedly covers a canvas with an erotic subject, discretely hidden from the eyes of casual visitors and ladies, according to the custom of the day, but available at the pull of a curtain cord for the gaze of the master and his male guests. In this composition, as in all his work, Hogarth proceeded as a novelist might, elaborating on his subject with carefully chosen detail, which, as we continue to discover it, heightens the comedy. This scene is one in a sequence of six paintings that satirize the immoralities practiced within marriage by the moneyed classes in England. Hogarth designed the marriage series to be published as a set of engravings. The prints of this and his other moral narratives were so popular that unscrupulous entrepreneurs produced unauthorized versions almost as fast as the artist created his originals.*

By the 1760s, Hogarth's example had helped to spur a taste in France for the new moral seriousness, which generated praise for the kind of sober, moralizing, narrative paintings that were the speciality of JEAN BAPTISTE GREUZE (1725-1805). Greuze's art expressed perfectly the transition of taste from the Rococo to nineteenth-century Romanticism. Almost overnight, many people in France-and Europeabandoned the wanton frivolity and luxuriance of the Rococo and became not only serious and moralistic but especially "sensible" and "feeling," which is to say "emotional." Jean Jacques Rousseau called for the sincere expression of sympathetic and tender emotions to counter what he saw as the cold, heartless, selfish culture of courts. He exalted the simple life of the peasant as the most "natural" and set it up as a model to be imitated. The joys and sorrows of uncorrupted, "natural" people, now described everywhere in novels, soon drowned Europe in a flood of tears; it became fashionable to weep, to fall to one's knees, to swoon, and to languish in hopeless love. This kind of contrived and melodramatic emotion-this sentimentality-has remained a fundamental ingredient of popular art from the time of its appearance in the eighteenth century until the present. Greuze won wide acclaim with paintings entitled The Father of the Family Reading the Bible to His Children, The Village Bride, and The Father's Curse, in all of which he

^{*}To protect himself against the loss of revenue from such theft, Hogarth helped write and win support for a proposal to include prints in the protections provided by the Copyright Act, which finally was passed by the British Parliament in 1735. Unfortunately, the Act could not prevent rival printers from sending spies to memorize details of Hogarth's latest paintings and rush them into mimicking versions before he had a chance to issue them as prints.

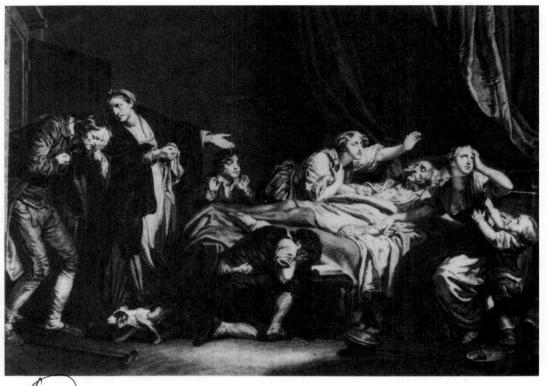

20-31 JEAN BAPTISTE GREUZE, The Son Punished, 1765–1777, from studies for the painting The Return of the Prodigal Son, 1777–1778.

pointed out a moral and sentimentalized his characters. Denis Diderot, the great Enlightenment philosophe and scholar, praised Greuze for his high moral themes. In the Salon of 1765, Diderot described Greuze's sketch for *The Return of the Prodigal Son:*

This is the sight which meets the eyes of the ungrateful son. He comes forward, he is on the threshold. . . . His mother meets him at his entrance; she is silent, but with her hand points to the corpse as if to say: "See what you have done."

The ungrateful son is struck with amazement; his head falls forward, and he strikes his forehead with his hand. What a lesson is here depicted for fathers and children! . . . I do not know what effect this short and simple description . . . will produce on others, but for my own part I could not write it without emotion.*

The public took Greuze so much to their hearts that, following Hogarth's custom in England, he made the scenes of his most popular designs available to a wide audience by having them copied in engravings. *The Son Punished* (FIG. **20-31**) is the engraved version of the studies for *The Return of the Prodigal Son*. The scene in the engraving duplicates that of the painting,

*In E. G. Holt, *A Documentary History of Art* (Princeton, NJ: Princeton University Press, 1958), vol. 2, p. 319.

but the design in the print reverses the original from left to right. Hogarth and Greuze sought through their art to prompt individual viewers to improved personal conduct. Their goals would soon be expanded by Neoclassical painters like Jacques Louis David in paintings intended to teach citizens how better to serve their nation state.

A moral of a very different sort underlies the history paintings based on the events of his time created by the expatriate American artist BENJAMIN WEST (1738–1820). Born in Pennsylvania, on what was then the colonial frontier, West was sent to Europe early in life to study art and then went to England, where he had almost immediate success. He was a cofounder of the Royal Academy of Arts and succeeded Sir Joshua Reynolds as its president. He became official painter to King George III and retained that position during the strained period of the American Revolution. In The Death of General Wolfe (FIG. 20-32), West depicted the mortally wounded young English commander just after his defeat of the French in the decisive battle of Quebec in 1759, which gave Canada to Great Britain. Unlike Renaissance, Baroque, and Rococo artists, West chose to portray a contemporary historical subject, and his characters wear contemporary costume (although the military uniforms are not completely accurate in all details). However, West

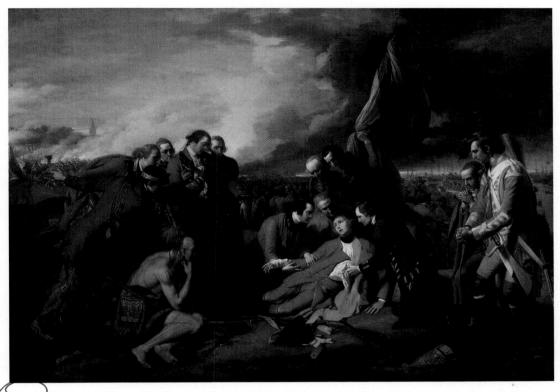

20-32 BENJAMIN WEST, The Death of General Wolfe, 1771. Approx. $5' \times 7'$. National Gallery of Canada, Ottawa (gift of the Duke of Westminster, 1918).

blended this realism of detail with the grand tradition of history painting by arranging his figures in an essentially Baroque composition, and his modern hero dies among grieving officers on the field of victorious battle in a way that suggests the familiar Pietà theme found in earlier works like Giotto's *Lamentation* (FIG. 15-13) and Quarton's *The Avignon Pietà* (FIG. 18-24). West wanted to present this hero's death in the service of the state as a martyrdom, and his innovative combination of the conventions of traditional heroic painting with a look of modern realism was so effective that it won the hearts of viewers in his own day and continued to influence history painting well into the nineteenth century.

The Onset of Romanticism: "Gothic" and Neoclassical Taste

The late eighteenth century was increasingly a period under the spell of Romanticism. For almost two centuries, scholars have debated the definition and the historical scope of Romanticism; to this day, the controversy has not ended. The very widest definition would equate Romanticism and Modernism, making Romanticism the mood of the modern world and coextensive with its history. More narrowly, Romanticism was a phenomenon that began around 1750 and ended about 1850. Still more narrowly, Romanticism was just another among a miscellany of styles that rose and declined in the course of modern art, flourishing from about 1800 to 1840 and coming between Neoclassicism and Realism. In this book, we take the middle position, defining Romanticism as a way of perceiving the world, above all, with strong feelings. This attitude influenced art most strongly between 1750 and 1850.

The term *Romanticism* originated toward the end of the eighteenth century among German literary critics, who aimed to distinguish peculiarly "modern" traits from the Classical traits that already had displaced elements of Baroque and Rococo design. "Romance," which could refer as much to the novel, with its sentimental hero, as it does to the old medieval tales of fantastic adventure written in the "romance" languages, never quite fit with the broader term "romantic," nor has "romantic" ever comfortably covered all that might be understood by it.

In art, Romanticism might be said to wear two faces: one connected to the renewed interest in Classicism, and the other, less controlled and more associated with the emotions of mystery, the exotic, terror, and the sublime. The diversity of Romantic styles developed partly as a result of the fact that Enlightenment thinkers believed in the good of nature and the natural human being but had no universally agreedupon meaning for "nature." Some considered nature to be, in the Classical sense, a regularity of proportion. Others argued that it meant the irregularity of growing things, with their wildness and accidents, their picturesqueness, and even their primitiveness. In the end, *all* historical styles were declared to be "natural," as each had evolved historically from the artistic instinct of people, who were, after all, part of nature. In the eighteenth century, this position led to a number of almost simultaneous "revival" styles, which tantalized the eyes, imaginations, and feelings of the public with visions of the past.

An attraction to faraway places and societies produced the enjoyment of exotic styles that suggested distant cultures and periods. This Romantic taste emerged first in garden design. In England, a revolt against the "regularity" of French Classical architecture had begun as early as the late seventeenth century, with the growth of an enthusiasm for Chinese art, especially the Chinese garden. An English critic of the time, Sir William Temple, described the Chinese garden as "without . . . order or disposition of parts that shall be commonly or easily observed," clearly unlike the carefully ordered gardens of France and other European countries. Within a generation of Temple's observation, gardens in England were being designed along informal, "naturalizing," Oriental lines. In the eighteenth century, the "English" garden became a vogue throughout Europe, while the formality of such gardens as those at Versailles was

now thought unnatural. Similarly, "naturalness" was soon prized over formal order in architecture, and "natural" styles, like the Gothic, which had never entirely died out in England, became very popular.

HORACE WALPOLE (1717-1797), a novelist and wealthy architectural dilettante, renovated Strawberry Hill, his "villa" at Twickenham (FIG. 20-33), in the rising "Gothic" fashion, converting it into a sprawling "castle" with turrets, towers, battlements, galleries, and corridors. Sir Walter Scott was captivated by the effect and wrote that the structure's "fretted roofs, carved panels, and illuminated windows were garnished with the appropriate furniture of escutcheons, armorial bearings, shields, tilting lances, and all the panoply of chivalry." At Strawberry Hill, the master (and any visitor) could fully enjoy Walpole's favorite pastime, which was "to gaze on Gothic toys through Gothic glass." The features of the structure are, of course, pseudo-Gothic, but Walpole's version of Gothic architecture would be as influential for later architecture as his gothic novels would be for subsequent literature.

Strawberry Hill provided a setting that encouraged romantic flights of fancy about damsels in distress, ghouls, and other imaginings of the darker side of the psyche. These things were part of the sensibility for sublime terror that would become an important part of nineteenth-century Romanticism. The thrill produced by contemplating the supposed remains of a vanished past was cultivated by garden designers in England, who inserted replicas of period architecture

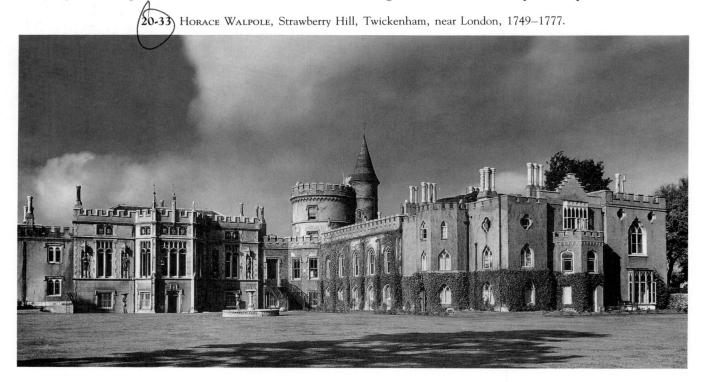

amid the random copses of trees, rustic bridges, and winding streams that filled the stately gardens of the time. Sometimes a single garden would boast structures in four or five different styles. Typical are the gardens at Hagley Park, where a sham Gothic ruin erected in 1747 (FIG. 20-34) stands near a Doric portico built in 1758 (FIG. 20-35). The portico is of special interest as the work of JAMES STUART (1713–1788), who, with Nicholas Revett, introduced to Europe the splendor and originality of Greek art in the enormously influential Antiquities of Athens, the first volume of which appeared in 1762. These volumes firmly distinguished Greek art from the "derivative" Roman style that had served as the model for Classicism since the Renaissance. Stuart's efforts, as shown in the Doric portico, were greeted with enthusiasm by those who had no use for the Rococo or any of the later "irregular" styles in art. A contemporary journal voiced the hope that the writings of Stuart and Revett and Robert Wood's magnificently illustrated Ruins of Palmyra (1753) and Ruins of Baalbek (1757) would "expel the littleness and ugliness of the Chinese and the barbarity of the Goths, that we may see no more useless and expensive trifles; no more dungeons instead of summer houses." Instead, the journal's author hoped that all eyes would rest only on the tantalizing echoes of proper Classical civilization.

As the presence of a Doric building in the gardens at Hagley Park indicates, a renewed interest in the style of ancient art developed side by side with the "Gothic" and other exotic styles. By mid-century, the rediscovery of Greek art and architecture had inspired a renewed taste for a serenely Classical style. The expanding desire for things connected with ancient Greece and Rome sparked the style we call Neoclassicism, which is based on the idea of a changeless generality that transcends the accidents of time. Neoclassicism, once thought of as a style in opposition to Romanticism, is now understood as simply one of the many fashions within that general movement but opposed to the "irregularity" of styles like Neo-Gothic, Neo-Baroque, and Chinese. By the late eighteenth and early nineteenth centuries, a Neoclassical taste for the more or less exact replication of Greek and Roman buildings spread rapidly throughout Europe and America.

The enthusiasm for classical antiquity permeated much of the scholarship of the time. More and more in the late eighteenth century, attention turned toward the ancient world. Edward Gibbon was stimulated on a visit to Rome to begin his monumental *Decline and Fall of the Roman Empire*, which appeared between 1776 and 1788. Earlier, in 1755, Johann Winckelmann, the first modern historian of art, published his *Thoughts on the Imitation of Greek Art in*

20-34 SANDERSON MILLER, sham Gothic ruin, Hagley Park, Worcestershire, England, 1747. Copyright, *Country Life*, London.

20-35 JAMES STUART, Doric portico, Hagley Park, 1758. Copyright, Country Life, London.

Painting and Sculpture, in which he uncompromisingly designated Greek art as the most perfect to come from the hands of man, and a model that, if followed, would confer "assurance in conceiving and designing works of art, since they [the Greeks] have marked for us the utmost limits of human and divine beauty." Winckelmann characterized Greek sculpture as manifesting a "noble simplicity and quiet grandeur." In his *History of Ancient Art* (1764), he undertook to describe each monument as an element in the development of a single grand style. Before Winckelmann, the history of art had been a matter of biography, as with Giorgio Vasari. Winckelmann thus initiated one

modern method thoroughly in accord with Enlightenment ideas of ordering knowledge; his was clearly a method that undertook the classification and description of art on the basis of general stylistic traits that change over time. Strangely enough, Winckelmann did not know much about original Greek artat least not much beyond the Laocoön group (FIG. 5-79) and other late Greek works in the Vatican collections, of which he was custodian. For the most part, he had only late Roman copies for study, and he never visited Greece, where he might have seen the genuine thing. Despite the obvious defects of his work, however, its pioneering character cannot be overlooked. Winckelmann had wide influence, and his writings laid a theoretical and historical foundation for the enormously widespread taste for Neoclassicism that was to last well into the nineteenth century.

The Romantic fascination with ruins like those in Hagley Park was combined with an Enlightenment curiosity about archeological facts to create a taste for images like Giovanni Battista Piranesi's Views of Rome (FIG. 7-5) and Giovanni Pannini's meticulously painted scenes of ancient Roman buildings (FIG. 6-58). In architecture, the Roman ruins at Baalbek in Syria, especially a titanic colonnade, provided much of the inspiration for the Neoclassical portico of the church of Ste. Geneviève (FIG. 20-36), now the Panthéon, in Paris, designed by JACQUES-GERMAIN SOUF-FLOT (1713-1780). The columns, reproduced with studied archeological exactitude, are the first revelation of Roman grandeur in France. The walls are severely blank, except for a repeated garland motif in the attic level. The colonnaded dome, a Neoclassical version of the domes of St. Peter's in Rome, the

20-36 JACQUES-GERMAIN SOUFFLOT, the Panthéon (Ste. Geneviève), Paris, 1755–1792.

Church of the Invalides in Paris, and St. Paul's in London (FIGS. 17-33, 19-70, 19-75), rises above a Greek-cross plan. Both dome and vaults rest on an interior grid of splendid, freestanding Corinthian columns, as if the colonnade of the portico were continued within. Although the whole effect, inside and out, is Roman, the structural principles employed are essentially Gothic. Soufflot was one of the first eighteenth-century builders to suggest that Gothic engineering was highly functional structurally and could be applied in modern building. In his work, we have the curious, but not unreasonable conjunction of Gothic and Classical in a structural integration that foreshadows nineteenth-century admiration of Gothic engineering.

Eighteenth-century Neoclassical interiors were directly inspired by new discoveries of "the glory that was Greece / And the grandeur that was Rome," and summarized the conception of a noble Classical world. The first great archeological event of modern times, the discovery and initial excavation of the ancient buried Roman cities of Pompeii (FIGS. 6-21 and 6-23) and Herculaneum in the 1730s and 1740s, startled and thrilled all of Europe. The excavation of these cities was the veritable resurrection of the ancient world, not simply a dim vision of it inspired by a few moldering ruins; historical reality could now replace fancy with fact. The wall paintings and other artifacts of Pompeii inspired the slim, straight-lined, elegant "Pompeian" style that, after mid-century, almost entirely displaced the curvilinear Rococo. In France, the new Pompeian manner was associated with Louis XVI; in England, it took the name of its most artful practitioner, ROBERT ADAM (1728–1792), whose interior architecture was influential throughout Europe. The Etruscan Room in Osterley Park House (FIG. 20-37) was begun in 1761. If compared with the Rococo salons of the Hôtel de Soubise (FIG. 20-3) and the Amalienburg (FIG. 20-13), this room shows how completely symmetry and rectilinearity have returned, but this return is achieved with great delicacy and none of the massive splendor of the style of Louis XIV. The decorative motifs (medallions, urns, vine scrolls, sphinxes, and tripods) were taken from Roman art and, as in Roman stucco work, are arranged sparsely within broad, neutral spaces and slender margins. Adam was an archeologist as well as an architect, and he had explored and written accounts of the ruins of the palace of Diocletian at Split (FIG. 6-80). Kedleston House in Derbyshire, Adelphi Terrace in London, and a great many other structures that he designed also show the influence of Split on his work.

The eighteenth century's Neoclassical taste in architecture also affected city planning. Designs for

20-37) ROBERT ADAM, Etruscan Room, Osterley Park House, Middlesex, England, begun 1761. By courtesy of the Board of Trustees of the Victoria and Albert Museum, London.

entire city sections, like the Circus and the Royal Crescent in Bath, England (FIG. 20-38), by JOHN WOOD THE YOUNGER (1728–1782), reflect this Neoclassical influence. The town square was a keynote of eighteenth-century city planning. Throughout Europe, community after community was rebuilt to include gracious sequences of open-air plazas, designed on a more intimate scale than the grand spaces commanded by Baroque princes and popes. The Circus (begun by Wood's father) and the Royal Crescent at Bath integrated inviting park spaces with luxurious housing for the well-to-do members of society who came to "take the waters" at the city's hot springs, which had been famous since Roman times. In both the Circus and the Royal Crescent, the houses are linked into rows behind a single Palladian façade, which transforms each complex into a monumental palatial edifice. The design is especially felicitous in the Royal Crescent (entirely the younger Wood's work), where giant Ionic columns are attached to the walls along the entire length of the façade, setting up a regular rhythm and rising through two tall stories to create a central body resting between an unornamented basement story and the area where the architrave and the balustrade rail mark the beginning of the steeply sloped roof level. The roof is punctuated every four bays by a regular, crowning mini-wall of chimney pots.

20-38 JOHN WOOD THE YOUNGER, Circus, 1764, and Royal Crescent, 1769, Bath, England.

In painting, the sober Neoclassical manner was adopted eagerly by many late eighteenth-century painters who wished to include moral teaching in their art. In France, with the approaching revolution, the temper of the times was more severe and the type and quality of emotion changed. At the end of the "age of sensibility," the stern values of moral virtue, civic dedication, heroism, and self-sacrifice replaced romance, gentleness, and the expression of tenderness. Interest shifted from the intimate world of private life to the public theater of action. Noble attributes of human nature were now supposed to emerge naturally, cleansed of those past and present corruptions denounced by writers like Rousseau. Naturalness of behavior, formerly associated with the simple people of the French countryside, now came to be identified with the heroes of Classical Greece and Rome, who were considered to be natural paragons of goodness, truth, beauty, and "right" action. "Natural" and "Classical" were considered identical in much Neoclassical thinking.

In the art of ANGELICA KAUFFMANN (1741–1807), the simple figure types, homely situations, and contemporary settings of Greuze's moral pictures were transformed by a Neoclassicism that still contained

elements of the Rococo style. Born in Switzerland and trained in Italy, Kauffmann spent many of her productive years in England. A protégeé of Sir Joshua Reynolds and the decorator of the interiors of many houses built by Robert Adam, she was a founding member of the British Royal Academy of Arts and enjoyed a fashionable reputation. Her Cornelia, Pointing to Her Children as Her Treasures (FIG. 20-39) is a kind of "set piece" of early Neoclassicism. Its subject is an *exemplum virtutis* (example or model of virtue) of the didactic kind, drawn from the history and literature of Greece and Rome. This turning away from the frivolous and sensuous subjects of the Rococo to themes thought to be noble and elevating became general in the late eighteenth century. The moralizing pictures of Hogarth and Greuze had already marked a change in taste, but the modern setting of their works was replaced by Kauffmann, who clothed her actors in ancient Roman garb and posed them in classicizing Roman attitudes within Roman interiors. The theme in this painting is the virtue of Cornelia, mother of the future political leaders Tiberius and Gaius Gracchus, who, in the second century B.C., attempted to reform the Roman republic. Cornelia's character is revealed in this scene, which takes place

20-39 ANGELICA KAUFFMANN, Cornelia, Pointing to her Children as her Treasures, or Mother of the Gracchi, c. 1785. 40" × 50". Virginia Museum of Fine Arts, Richmond (the A. D. and W. C. Williams Fund).

(20-4) JACQUES LOUIS DAVID, Oath of the Horatii, 1784. Approx. 11' × 14'. Louvre, Paris.

after a lady visitor has shown off her fine jewelry and then haughtily requested that Cornelia show hers. Instead of rushing to get her own precious adornments, Cornelia brings her sons forward, saying, *"These* are my jewels!" The architectural setting is severely Roman, with no Rococo motif in evidence, and the composition and drawing have the simplicity and firmness of low relief carving. Only the charm and grace of the Rococo style linger—in the arrangement of the figures, the soft lighting, and in Kauffmann's own tranquil manner.

Within a few years, Kauffmann's sentimental Neoclassicism had hardened into the public, programmatic stoicism of JACQUES LOUIS DAVID (1748-1825), the painter-ideologist of the Neoclassical art of the French Revolution and the Napoleonic empire. David was a distant relative of Boucher and followed Boucher's style until a period of study in Rome won the younger man over to the tradition of Classical art and to the academic teachings about the elements of art based on rules taken from the ancients and from the great masters of the Renaissance. In his own quite individual and often non-Classical style, David reworked the Classical and academic traditions. He rebelled against the Rococo as an "artificial taste" and exalted Classical art as, in his own words, "the imitation of nature in her most beautiful and perfect form." He praised Greek art enthusiastically, although he, like Winckelmann, knew almost nothing about it firsthand: "I want to work in a pure Greek style. I feed my eyes on ancient statues; I even have the intention of imitating some of them." David's doctrine of the superiority of Classical art was not based solely on an isolated esthetic, however. Believing that "the arts must . . . contribute forcefully to the education of the public," he was prepared both as an artist and as a politician when the French Revolution offered him the opportunity to create a public art—an art of propaganda.

David played many roles in the French Revolution: he was a Jacobin friend of the radical Maximilien Robespierre, a member of the National Convention that voted for the death of King Louis XVI, and the quasi dictator of the Committee on Public Education. David joined scholars and artists in persuading the revolutionary government to abolish the old French Royal Academy and to establish in its place panels of experts charged with reforming public taste. His position of power made him dominant in the transformation of style, and his own manner of painting was the official model for many years.

Although painted in 1784, before the French Revolution, David's *Oath of the Horatii* (FIG. **20-40**) reflects his politically didactic purpose, his doctrine of the educational power of Classical form, and his method of composing a Neoclassical picture. David agreed

with the Enlightenment belief that subject matter should have a moral and should be presented so that the "marks of heroism and civic virtue offered the eyes of the people will electrify its soul, and plant the seeds of glory and devotion to the fatherland." The Oath of the Horatii depicts a story from pre-Republican Rome, the heroic phase of Roman history that had been pushed to the foreground of public interest by the sensational archeological discoveries at Pompeii and Herculaneum. The topic was not an arcane one for David's audience. This story of conflict between love and patriotism, first recounted by the ancient Roman historian Livy, had been retold in a play by Pierre Corneille that was performed in Paris several years earlier, making it familiar to David's viewing public. According to the story, the leaders of the Roman and Alban armies, poised for battle, decided to resolve their conflicts in a series of encounters waged by three representatives from each side. The Roman champions, the three Horatius brothers, would face the three sons of the Curatius family, the Alban warriors. A sister of the Horatii, Camilla, was the bride-to-be of one of the Curatius sons.

David's painting shows the Horatii as they swear on their swords to win or die for Rome, oblivious to the anguish and sorrow of their sisters. In its form, Oath of the Horatii is a paragon of the Neoclassical style. The theme is stated with admirable force and clarity. In a shallow picture box, defined by a severely simple architectural framework, the statuesque and carefully modeled figures are deployed across the space, close to the foreground, in a manner reminiscent of ancient relief sculpture. The rigid and virile forms of the men effectively eclipse the soft, curvilinear shapes of the mourning women in the right background. Such manly virtues as courage, patriotism, and unwavering loyalty to a cause are emphasized over the less heroic emotions of love, sorrow, and despair symbolized by the women. The message is clear and of a type with which the prerevolutionary French public could readily identify. The picture created a sensation when it was exhibited in Paris in 1785, and, although it had been painted under royal patronage and was not at all revolutionary in its original intent, its Neoclassical style soon became the semiofficial voice of the revolution. David may have been painting in the academic tradition, but he made something new of it; he created a program for arousing his audience to patriotic zeal. From David's Oath of the Horatii onward, art became increasingly political—if not often in the strict sense of serving a state or party, then at least in its passionate adherence to selected trends, movements, and ideologies.

In David's later paintings, like *The Death of Marat* (FIG. **20-41**), the Classical elements of closed outline

20-41 JACQUES LOUIS DAVID, *The Death of Marat*, 1793. Approx. 63" × 49". Musées Royaux des Beaux-Arts de Belgique, Brussels.

and compact composition, though present, are made to serve the ends of a carefully controlled dramatic realism, investing an event from David's own time with a strong, psychic impact. Marat, a revolutionary radical and a personal friend of David, had been stabbed to death in his bath by Charlotte Corday, a political enemy. David depicted the aftermath of the fatal attack with the directness and simple clarity of Zurbarán's painting of St. Francis (FIG. 19-35). The cold, neutral space above Marat's figure, slumped in the tub, makes for a chilling oppressiveness. Narrative details-the knife, the wound, the blood, the letter by which the young woman gained entrance-are vividly placed to sharpen the sense of pain and outrage, and to confront the viewer with the scene itself. David's depiction was shaped by historical fact, not Neoclassical theory, but his stele-like composition reveals his close study of Michelangelo, especially the Renaissance master's Christ in the Pietà in St. Peter's in Rome (not illustrated in this volume). The Death of Marat is convincingly real, yet it is masterfully composed to present Marat to the French people as a tragic martyr who died in the service of their state. In this way, the painting was meant to function as an "altarpiece" for the new civic "religion"; it was designed to inspire viewers with the saintly dedication of their slain leader. This depiction is a more severe version of modern martyrdom than *The Death of General Wolfe* by Benjamin West (FIG. 20-32). West's *Wolfe* was imbued with the grandeur of spectacle in a way that foreshadowed the dramatic and demonstrative side of nineteenth-century history painting. David's *Marat* has been stripped to a severe Neoclassical spareness that may appeal more to our late twentieth-century taste for minimalism.

In architecture, Neoclassicism proved to be such an expressively versatile style that it continued well into the nineteenth century, as we will see. By the end of the eighteenth century, however, in architecture, as in painting and sculpture, Neoclassicism was being used to symbolize moral and heroic links with the ancient past. Napoleon supported its use as appropriate for new buildings in his imperial state. In the new American republic, THOMAS JEFFERSON (1743-1826) spearheaded a movement for the adoption of a symbolic Neoclassicism (a style he saw as representative of the democratic qualities of the United States) as the national architecture. Scholar, economist, educational theorist, statesman, and gifted amateur architect, Jefferson was, by nature, attracted to Classical architecture. He worked out his ideas in his design for his own home, Monticello (FIG. 20-42), which was begun in 1769. Jefferson admired Palladio immensely and read carefully the Italian architect's Four Books of Architecture. While minister to France, Jefferson studied French eighteenth-century Classical architecture and city planning, and visited Maison Carrée, the Roman temple at Nîmes (FIG. 6-46). After his European trip, Jefferson completely remodeled Monticello, which had first been designed in an English Georgian style. In his remodeling, he emulated the manner of Palladio, with a façade inspired by the work of Robert Adam. The final version of Monticello is somewhat reminiscent of the Villa Rotonda (FIG. 17-51) and of Chiswick House (FIG. 20-2), but its materials are the local wood and brick used in Virginia. Its hilltop setting was originally designed to open onto a garden façade designed in a less Classical style, and to provide an extended view over the surrounding countryside, linking people and nature in a manner that anticipated nineteenth-century ideas of the sublime in the picturesque.

Turning from the private domain to that of public space, Jefferson began to carry out his dream of developing a Classical style for the official architecture of the United States. Here, his Neoclassicism was an extension of the Enlightenment belief in the perfectability of human beings and in the power of art to help bring about that perfection. As Secretary of State to George Washington, Jefferson supported the logically ordered city plan for Washington, D.C., created in 1791 by Major Pierre L'Enfant, which extended

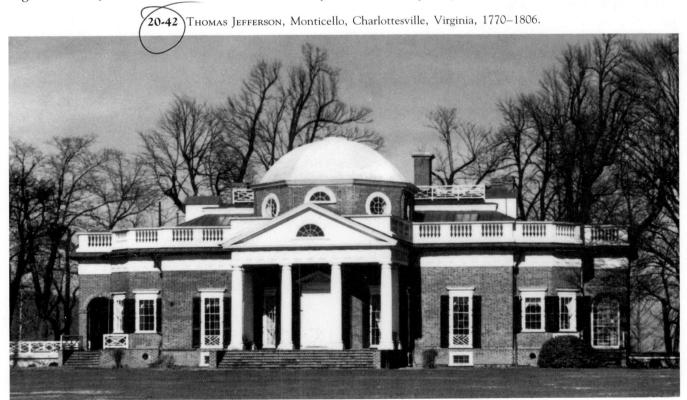

20-43 View of Washington, 1852, showing BENJAMIN LATROBE'S Capitol and Major L'Enfant's plan of the city.

20-44

Tномаs Jefferson, University of Virginia, Charlottesville, Virginia, 1809–1825. Later buildings (center left) designed by Stanford White, 1890, 1899.

earlier ordered designs for city sections, like Woods's designs for Bath (FIG. 20-38), to an entire community. As an architect, Jefferson also incorporated the specific look of the Maison Carrée into his design for the Virginia State Capitol building in Richmond. He approved William Thornton's initial Palladian design for the federal Capitol building in 1793, and in 1803, as President, he selected B. H. LATROBE (1764-1820) to take over the design of the structure (FIG. 20-43), with the goal of creating "a building that should . . . stand out as a superb visible expression of the ideals of a country dedicated to liberty." Jefferson's choice of a Roman-Classical style was influenced partly by his admiration for its beauty and partly by his associations of it with an idealized Roman republican government, and, through that, with the democracy of ancient Greece. Latrobe wrote that he wanted in his design for the Capitol to recreate "the glories of the Greece of Pericles in the woods of America." To that end, in the architecture of the Capitol, the symbol of the Roman Eagle became the American bald eagle, a special new Corinthian order was devised in which corn plants replaced acanthus leaves, and the sculptured representation of Liberty was designed to abandon traditional trappings and to hold a liberty cap in one hand and rest her other hand on the Constitution.

For Jefferson, if Classical architecture could embody the ideals of a new country, it also could help educate the young, especially when placed in a proper relationship to nature. In 1817, with help from Thornton and Latrobe, he began designing the University of Virginia (FIG. 20-44) in Charlottesville as an "academical village." The original plan was a rectangle. A library modeled on the Roman Pantheon stood at one end. The other end originally was open, providing an extended vista into a panorama of wooded hills, a design element intended to indicate the perfect and balanced relationship between the works of human beings and those of nature. Along the sides of the rectangle, the designer placed pavilions, each built in a different Classical style and arranged with the goal of providing living architectural lessons to the students.

Romanticism of the Sublime and the Terrible

While some Enlightenment thinkers and proponents of the Age of Reason found a rational ideal in Neoclassical art, many artists felt that neither reason nor Neoclassical art could do justice to human reality. For these individuals, imagination could reach farther to find (by suprarational intuition and enkindled emotion) a higher and a deeper experience. Rather than produce images that could edify or educate their viewers, these artists chose to portray subjects that evoked feelings of the sublime and the terrible. The Romantic esthetic of the sublime was shaped in large part by ideas in Edmund Burke's *A Philosophical Enquiry into the Origin of Our Ideas of the Sublime and the Beautiful* (1757). For Burke, the sublime was related to our instinct for self-preservation.

The passions which concern self-preservation turn mostly on pain or danger. The ideas of pain, sickness, and death fill the mind with strong emotions of horror; but life and health, though they put us in a capacity of being affected with pleasure, they make no such impression. . . . The passions therefore which are conversant about the preservation of the individual, turn chiefly on *pain* and *danger*, and they are the most powerful of all the passions. . . . Whatever is fitted in any sort to excite the ideas of pain and danger . . . is a source of the *sublime*. The passions which belong to self-preservation . . . are simply painful when their causes immediately affect us; they are delightful when we have an idea of pain and danger, without being actually in such circumstances. . . . Whatever excites this delight, I call sublime.*

Burke named the qualities that arouse feelings of the sublime: terror, obscurity, power, privation, vastness, infinity, magnificence, suddenness, feeling, pain—and also, special conditions of light, color, sound, smell, and taste. These qualities, in various combinations, suffused much Romantic art of the late eighteenth century and inspired much nineteenth-century Romantic art as well.⁺

For some artists, excursions into the sublime were only part of their activity. We already have noted how the etched Views of Rome by GIOVANNI BATTISTA PIRANESI (1720–1788) appealed to the Romantic taste for subjects from Rome's ancient past. His dramatic presentations of the city's majestic Classical ruins in this series of prints were so convincing that they have served for generations as the standard image of Roman grandeur, but Piranesi also exercised his imagination to create fantastic interiors that could not exist in the real world. No aid to the recording of nature could help the master etcher when he turned from the printing of dramatic scenes of existing Roman buildings to the creation of eerie prison interiors (carceri) that stirred the viewer's imagination with their sublime suggestions of vastness, power, and terror. Piranesi's early experience as an architect

^{*}In J. T. Boulton, ed., (Oxford, UK: Basil Blackwell Ltd., 1987), pp. 38–39, 51ff.

⁺Burke saw beauty linked to passions connected with love—both sexual (mixed with lust) and societal. Burke's ideas about beauty were of less importance for Romantic art than his ideas about the sublime.

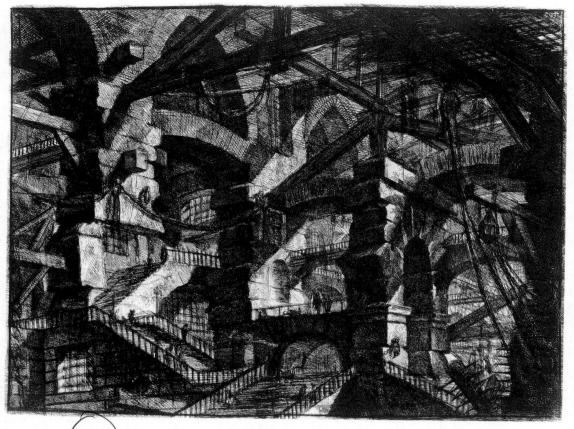

20-45 GIOVANNI BATTISTA PIRANESI, Carceri 14, c. 1750. Etching, second state, approx. $16'' \times 21''$. Ashmolean Museum, Oxford.

in Venice, which may have provided the inspiration for his project recording the monuments of Rome, began shortly after he moved to the Eternal City in 1740. He was not satisfied for long, however, with simply dramatizing existing Roman buildings with patterns of light and shadow. Soon he was conjuring up awe-inspiring visions of bafflingly complicated architectural masses, piled high and spread out through gloomy spaces. In such pictures, vistas are multiplied and broken by a seeming infinity of massive arches, vaults, piers, and stairways, through which small, insectlike human figures move stealthily. Despite wandering, soaring perspectives, the observer is overwhelmed by a suffocating sense of enclosure; the spaces are locked in, and no exit is visible. These grim places are filled with brooding menace and hopelessness. Piranesi etched a series of them, often darkening subsequent editions to make them even more sinister. Our picture, Carceri 14 (FIG. 20-45), is one of these. It reminds us that the gaiety of the Rococo and the rationality of the Enlightenment coexisted with an eighteenth-century sensibility for the sublime that returned to haunt the night imaginings of many a Romantic artist and poet in the nine-teenth century.

Like Piranesi, many painters at the end of the eighteenth century worked in more than one mode. The Englishman George Stubbs (1724–1806) won a reputation for his naturalistic paintings of horses, but he also enjoyed creating scenes of natural struggle and horror. Stubbs began his career painting human portraits to support himself while he studied his lifelong passion, anatomy. Soon, he was specializing in the anatomy of horses and using this knowledge to create "portraits" of the mares, stallions, and foals owned by the English gentry. These were naturalistic images linked in spirit to the works of Canaletto (FIG. 20-19), but Stubbs was not content to remain tied always to a careful rendering of visual facts. He also invented a new type of picture, the "animal history painting," which depicted dramatic episodes from the lives of wild animals. This type of subject fit well with the teachings of Rousseau and others who idealized life far from any taint of civilization, which they believed distorted the innate "goodness" of the natural order. Horse Being Devoured by a Lion (FIG. 20-46) shows the

20-46 GEORGE STUBBS, Horse Being Devoured by a Lion, 1763. Enamel on metal. Tate Gallery, London.

violent side of nature in the raw. A flash of light illuminates the struggle of a terrified white horse, trying in vain to shake off a hungry lion that is already biting deeply into the horse's vulnerable back. The composition of Horse Being Devoured by a Lion may seem a "wilder" version of the lion attack on a man in Puget's Milo of Crotona (FIG. 19-72), but Stubbs's animal struggle also resembles an ancient Classical sculpture of a lion on the back of a horse, which the artist could have seen in Rome during a visit there. The scene also may have been inspired in part by an attack Stubbs witnessed in North Africa on his way back to England after studying Classical and Renaissance art in Italy. Whatever the source, the subject was so popular that Stubbs did nine versions of this Romantic scene. For the eighteenth-century viewer, the emotional shudders aroused by the horse-lion confrontation would have sweetened philosophical thoughts about the nobility of the natural state and the inevitable connections between life and death. In the nineteenth century, the emotions in such sublime Romantic themes will be fused into a fuller exploration of the qualities of the sublime in nature.

HENRY FUSELI (1741–1825) attempted to arouse delectable terror of a different sort. He specialized in night moods of horror and in "gothic" fantasies-in the demonic, the macabre, and often the sadistic. Swiss by birth, Fuseli settled in England and eventually became a member of the Royal Academy and an instructor there. Largely self-taught, he contrived a distinctive manner compounded of the influence of Michelangelo, the Antique style, and his own extravagant invention to express the fantasies of his vivid imagination. The twisted poses and frantic gestures of his figures go well beyond exaggeration and often suggest the influence of Italian Mannerism. The Nightmare (FIG. 20-47) was the first of four versions of this terrifying theme. The beautiful young woman, tormented by some terrible dream and still not awake, has thrown herself partly from her couch. She lies helpless beneath the incubus that squats malignantly on her body, as a horse with flaming eyes bursts into the scene from beyond the curtain. The sublime vein of violent emotion and of perverse and tragic action in this composition will be heavily mined in the nineteenth century. Fuseli's art was among the

0-47 HENRY FUSELI, The Nightmare, 1781. Approx. $57\frac{17}{2''} \times 47\frac{17}{2''}$. The Detroit Institute of the Arts (gift of Mr. and Mrs. Bert L. Smokler and Mr. and Mrs. Lawrence A. Fleishman).

first that attempted to depict the dark terrain of the human subconscious.

The visionary English poet, painter, and engraver, WILLIAM BLAKE (1757–1827), combined in his art calm Neoclassicism and the storm and stress of late eighteenth-century sublime Romanticism. Blake greatly admired both the art of ancient Greece and Gothic art. Gothic for him was the style best suited to the expression of personal religious emotions, while Classical Greek art exemplified the mathematical, and thus eternal, in a different way. Yet Blake joined neither the prominent figures of the Age of Reason nor any organized religious group. He would have been an uneasy member of any group because he treasured the fact that the compositions of many of his paintings and poems were given to him by spirit visitors in dreams. The importance he attached to these experiences led him to believe that rationalism's search for material explanations of the world stifled the spiritual side of human nature, while the stringent rules of behavior imposed by orthodox religions killed the individual creative impulse. Blake's vision of the Almighty in Ancient of Days (FIG. 20-48) combines his ideas and interests in a highly individual way. For Blake, this figure combined the concept of the Creator with that of Wisdom as a part of God. The Ancient of Days, printed as the frontispiece for Blake's book, Europe: A Prophesy, was published with a quote ("When he set a compass upon the face of the deep") from the Book of Proverbs (8:22-23, 27-30) in the Old Testament of the Bible. Most of that chapter is spoken

WILLIAM BLAKE, Ancient of Days, frontispiece of Europe-A Prophesy, 1794. Metal relief etching, hand-colored. Whitworth Art Gallery, University of Manchester, England.

by Wisdom, identified as a female, who tells the reader how she was with the Lord through all the time of the Creation:

The Lord possessed me in the beginning of his way, before his works of old. I was set up from the everlasting, from the beginning, or ever the earth was. . . . When he prepared the heavens, I was there; when he set a compass upon the face of the deep; When he established the clouds above; when he strengthened the fountains of the deep; When he gave to the sea his decree, that the waters should not pass his commandment; when he appointed the foundations of the earth; Then I was by him, I as one brought up with him; and I was daily his delight, rejoicing always before him.

Energy fills this composition. The Ancient of Days leans forward from a fiery orb, peering toward earth and unleashing power through his outstretched left arm into twin rays of light, which emerge between his spread fingers like an architect's measuring instrument. A might wind surges through his thick hair and beard. Only the strength of his Michelangelesque physique keeps him firmly planted within his heavenly perch. Here, Baroque vigor and ideal Classical anatomy merge with the inner, dark dreams of Romanticism, which we will meet often in the nineteenth century. In his independence and in the individuality of his artistic vision, Blake was very much a man of the modern age.

The world of dreams and visions provided wonderful sublime materials for artists who yearned to escape the rules of reason. Blake wrote: "I will not reason and compare, my business is to create. . . . The road of excess leads to the palace of wisdom." Yet, grave risks imperiled such an approach. Raw feeling could lead the soul astray, perhaps beyond the limits of sanity. The Spanish master FRANCISCO GOYA (1746–1828), whose works we will consider at greater length in the next chapter, graphically pictured this danger in a print he captioned *The Sleep of*

20-49 BRANCISCO GOVA, The Sleep of Reason Produces Monsters, from Los Caprichos (Plate 43), c. 1794–1799. Etching and aquatint, approx. 5" × 8". Pomona College, Claremont, California (gift of Norton Simon).

Reason Produces Monsters (FIG. **20-49**), from a series called *Los Caprichos*. Here, the rational mind is stilled as the human figure sleeps, while around him throng the winged monsters who have sprung easily into being in the absence of thoughtful control.

At the heart of the modern artistic experience, as seen in Joanne Leonard's Julia and the Window of Vulnerability, lie many personal reflections of our new knowledge of the vastness of the universe and both the fragility and enormous potential of human existence.

THE MODERN WORLD

Our era, the modern era, began to take form in the eighteenth century. As we saw in Chapter 20, the beginning of the modern age was influenced by political, economic, and social revolutions more widespread than any change affecting human society since prehistoric times, when agriculture replaced hunting and gathering as a major way of life. By the end of the eighteenth century, political revolutions had relegated royalty to positions of diminished influence in the power structure, allowing many nations to establish political systems with broader and more democratic power bases. The Industrial Revolution, initiated in the inventions and ideas of the eighteenth century, was transforming the social order in industrializing nations. Scientific investigation was providing new knowledge about the world as the accumulation of facts, begun during the Enlightenment, accelerated, and interest in distant cultures was awakened.

During the nineteenth century, many countries reorganized to fit a pattern that would become the modern nation-state. Nationalistic attitudes spurred ambitious governments in Europe to extend their authority and the influence of European culture to overseas colonies in Asia, Africa, and the Americas. The pace of discovery and development quickened, bringing other major changes in society. The Renaissance belief in a human capacity for rational control over self and nature was increasingly undermined as the social sciences adapted biological concepts to explain human culture and individual differences. Machines began to replace physical labor, which altered the nature of work, while new technologies began to revolutionize transportation and communication.

In the twentieth century, political power has continued to shift; the old Eurocentric view of the world has changed as former colonies have become nations in their own right, and countries like the Soviet Union, China, and Iran have gradually assumed new political importance. Marxist and capitalist philosophies and government structures based on totalitarianism or democratic models have continued to vie for dominance. New theories from the sciences and social sciences have continually altered our views of ourselves and our planet. The physical and biological sciences have delved more deeply than ever before into the basic structures of matter and the universe. Theories proposed by Albert Einstein have shown that everything has existence only in relation to everything else and that all life takes place in a continuum of space and time. The printed media have largely been supplanted by radio, television, and electronic telecommunications, affecting our perception of the reality of events. Psychiatry and psychology have probed the inner workings of the human mind, showing us how individual the "reality" each of us perceives really is. Old conventions and beliefs have been abandoned and traditional values have been called into question. Our comprehension of reality also has shifted to accommodate the ways in which new technologies have expanded our range of sensory perception. The multitude of changes that have taken place since the late eighteenth century have contributed to the problematic quality of modern life. Nothing is certain and everything is in question—especially the definition of what is real. Reality is now understood to be infinitely complex and, perhaps, ultimately elusive. Although people continue to believe in the potential of innovation, invention, and science to create a better world, a mood of doubt, restlessness, and challenge to authority persists.

The shifting conditions of society have been accompanied by a shift in the position of the artist within society. Eighteenth-century artists, content in their belief that knowledge, science, and industry could help individuals to achieve their full potential for happy, productive lives, held secure places in the social hierarchy. In the nineteenth century, many artists criticized society and its values. Others saw self-expression in art as a vehicle for realization of the whole self. In the twentieth century, artists have worked more and more apart from the mainstream, creating works based on personal inspiration. Artists with individual vision gradually came to consider themselves as prophets or seers with particular gifts for creating culturally revolutionary art.

Most of the art in the modern era has fallen into "movements" whose adherents have sought to establish the authority of their particular beliefs about the role of art. The names for many of these movements were bestowed by outsiders—critics or scholars—attempting to describe something about the content, form, or intention of the pieces created by artists working from a particular esthetic position. "Neoclassicism," "Romanticism," "Realism," "Impressionism," and "Post-Impressionism" are major nineteenth-century movements; "Fauvism," "Cubism," "Expressionism," "Futurism," and "Surrealism" are some early twentieth-century movements.* Each movement had a commonly held set of principles and positions on all issues involving art. Most recently, Postmodern artists have tended to avoid group doctrines, basing their art instead on a personal analysis of the whole history of art and learning. During the modern era, works have been marketed after completion; salon exhibitions and private dealers have grown steadily more important, and art has become more of a commercial business.

Throughout the modern period, the expression and fabric of art have been affected by the introduction of new media. The invention of photography in the late 1830s provided a new tool for recording reality and challenged painters to reassess what they would represent in their work and how they would represent it. New theories of color and optics, synthetic pigments, primed canvas, and paint packaged in tubes allowed artists to paint more easily and rapidly. In the twentieth century, modern media, ferroconcrete,

^{*}In this text, when words such as these are used to designate art movements, they are capitalized. Some of these terms, however, also can be used more broadly. For example, *realism* might be used to describe all art that emphasizes a literal reproduction of the appearance of the physical world, as with the works of Velázquez or Vermeer during the Baroque period. When a word is used with this broader sense, it will not be capitalized.

new welding techniques, and electronic tools have provided new possibilities for form in architecture, sculpture, and image-making that have allowed expressions impossible with the older media of painting and drawing. One notable characteristic of art in the modern period has been its emphasis on the expressive power of each medium in itself. In the words of the Canadian theorist Marshall McLuhan, more and more in Modern art, "the medium has become the message."

Both Modern art and Postmodern art have tended to be international in their sources and influence, as have modern science, technology, scholarship, and politics. Beginning in the late nineteenth century, modern artists were increasingly inspired by the physical forms of non-Western art—the art of Islam, India, China and Japan and artworks brought to European collections from Africa and Oceania. In the twentieth century, more and more people have turned away from a view of Western culture as the culmination of societal evolution and toward a belief that all cultures have an important place in the world and its history. In addition, art made by non-Europeans, women, African-Americans, Latinos, and Native Americans has become increasingly visible.

What we have said here to provide background to the ensuing discussion of the art of the modern world is a simplification; it should be viewed as only a partial explanation of the ways in which Modern (and Postmodern) art either looks different from the art of the past or plays a role very different from that played by art in the past. The story of the artist in the modern period is the story of a multistranded search for the means to express what it is like to be alive in a complex and rapidly changing era.

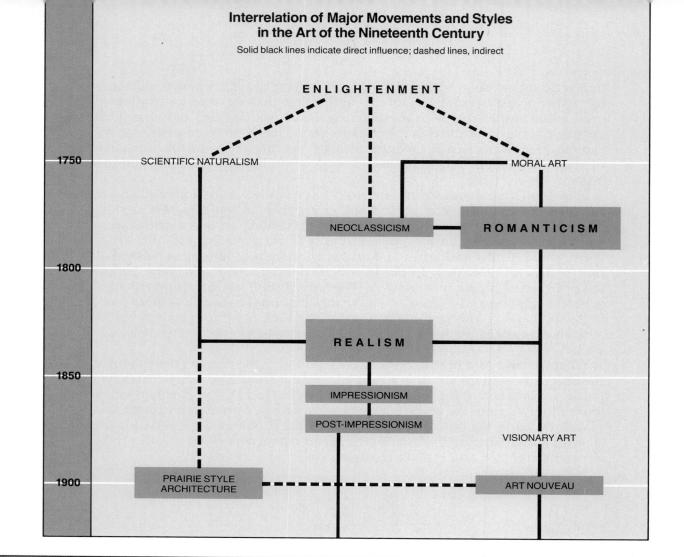

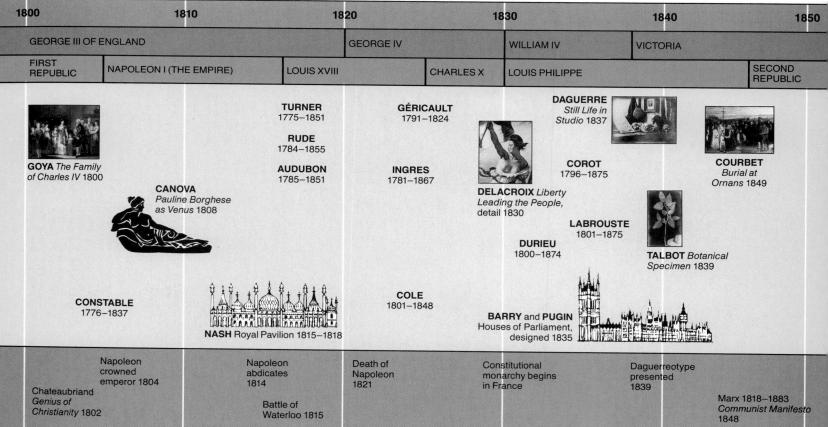

21 The nineteenth century: pluralism of style

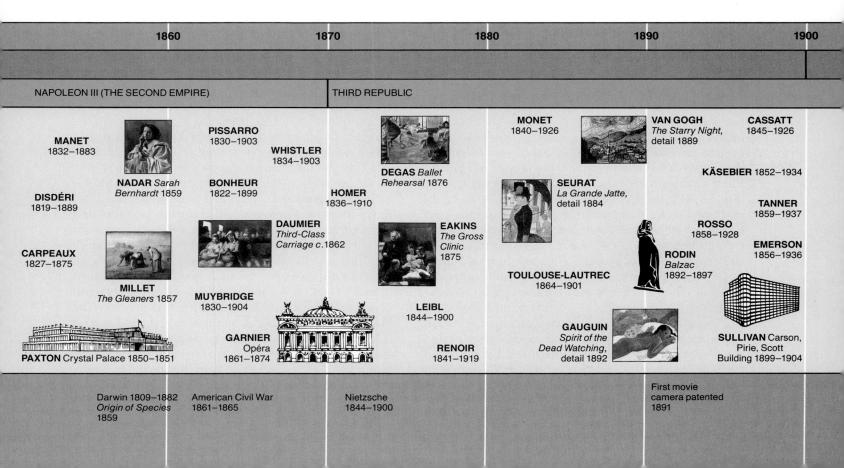

OR EUROPE, the nineteenth century was an age of radical change during which the modern world took shape. In a world that was experiencing a population explosion of unparalleled magnitude, revolution followed revolution, a pattern punctuated by counterrevolution and conservative reaction. This was the era in which the modern nation-state and accompanying ideas of nationalism were born. European governments extended their rule to virtually every part of the globe, spreading the influence of European culture into colonies in Africa, the Americas, India, Asia, and Australasia, and clearing the way for influences from those areas to flow back to Europe. The formation of empires abroad was supported by the enthusiasm of popular nationalism at home, and patriotism and imperialism went hand in hand.

Social and economic struggle pitted industrial capitalism and the bourgeoisie (the middle class) against the widely impoverished masses. The rapid industrialization initiated in the eighteenth century created abrupt changes in age-old living patterns and an acute sense of dislocation for many. The Industrial Revolution, which mechanized agriculture, and periodic crop failures brought thousands of people from the countryside to the city in search of jobs and sent thousands of others overseas. The result of these changing patterns was that in urban and rural areas alike, the disparity between the rich and the poor widened unprecedentedly.

In thought as well as science, the nineteenth century was an era of grand new theories through which visionary thinkers attempted to unify whole bodies of knowledge into precise, well-ordered systems. These efforts can largely be seen as a natural extension of the Enlightenment thirst for encyclopedic collections of facts. Practitioners of psychiatry and psychology, sciences both in their infancy during the later decades of the century, attempted systematic studies of the human psyche to discover the "laws" of human behavior. On a more material level, science was contributing advancements that would improve living conditions dramatically. Louis Pasteur and Joseph Lister produced new standards for public sanitation and health, while the combined work of several scientists, Georg Ohm and Thomas Edison among them, led to the development of electricity for use in homes, factories, and theaters, making possible the new medium of cinema. Due to an ever-increasing demand on the part of government, business, and the scientific community for documentary information of all kinds, ambitious explorers in this expansionist period made meticulous records of what they discovered in lands then little known to the centers of Western civilization. Revolutionary new theories about life and

society were formulated on the basis of some of this information. While many of these theories challenged accepted views, none caused more widespread controversy than Charles Darwin's theory of evolution as put forth in the *Origin of Species* (1859). In this seminal work, Darwin hypothesized that humans evolved from simian ancestors, thus contradicting and threatening Judeo-Christian beliefs and teachings.

A profound sense of history pervaded the century. The past was rapidly receding, and a unique present was asserting its originality as decisively as the early Christian world had asserted *its* values against the defeated and devalued pagan past. The new age, created by the great revolutions, was *modern*, and modern, for many, was good. What was not modern was rejected, for what was to come would be better. These concepts constituted the "doctrine of progress," whose supporters maintained the permanency of change for the better. As early as 1750, Turgot had predicted that the doctrine of progress would replace that of the will of God.

Many in the nineteenth century did not accept the doctrine of progress; others did so with reservations or with grave misgivings. Such critics saw much of value being lost through change and feared for the traditions, institutions, customs, and mores that knit society together and gave meaning to life. They could accept neither the depreciation of human value implicit in scientific explanations of human nature like Darwin's, nor the alienation and degradation of human beings by a mechanized and impersonal industry. They had a special distaste for the type of modern society built by new wealth, with all its ostentatious materialism. Many of those who objected to the vulgarity and banality of taste predominant in such a society were artists—some of them, the best artists of the century.

The liberal belief in progress is a belief that the course of history can be changed by thought and action, as long as people are not impeded by authority. The great debate of the nineteenth century was about authority-the questions of what should be believed, respected, defended, and conformed to. Revolutionary shake-ups of authority reverberated throughout the century, carrying people's hopes for something newer, better, truer, and purer. Humanity was thought to be perfectible, and the principle of utility, calling for the greatest good for the greatest number, was advocated for law, government, and economic life. Confusion arose, however, over the means to these ends, a confusion that produced a wide variety of philosophies rationalizing change and the reactions to change. These ideologies, which provided the maxims and slogans of the countless movements that agitated the nineteenth century and remain current today, are the "-isms": liberalism, radicalism, socialism, communism, conservatism, nationalism. We will presently meet their counterparts in the world of art: Romanticism, Realism, Impressionism, and the rest.

The element that all of these ideologies had in common was dissatisfaction with a status quo in which the past lingered, and disagreement about how it should be corrected-that is, modernized. For the arts, this meant continuing debate over the relative values of the "traditional" and the "modern"-a debate restimulated as each new style was itself rapidly superseded by yet a newer one. This rapid appearance and obsolescence of a variety of artistic styles (analogous to the concurrent rapid turnover in types of mechanically produced commodities and to the quick progression of scientific and technological discoveries and inventions) transformed painting, the graphic arts, sculpture, and architecture so radically that the transformations amounted to a dismantling of tradition altogether and the appearance of something utterly novel. This process was the reverse of the development of science, which built on its tradition in largely unbroken continuity within the expanding language of mathematics.

The nineteenth-century artist had to face formidable changes on all sides. The church and the secular nobility were replaced as sources of artists' commissions by the triumphant middle class, the national state, and national academies. The uncultivated taste of a vast new audience, concerned, above all, with money and property and guided and manipulated by professional critics writing in the press created an uncertain and risky market for the artist working alone. Competition forced crowds of artists, whose numbers had more than doubled since the end of the previous century, to bid for the public's attention by flattering its taste. Like small, independent capitalists with their own stocks and stores, artists took chances in the market, aiming to please. If they were unwilling to take such chances, they risked the suspicion and the hostility of the public. These developments contributed to the gradual alienation of artists and the emergence of their often isolated and difficult situation in modern society.

Artists who were dissatisfied with standards of public taste and the kind of art designed to satisfy it used their own work and the writings of friendly critics to protest what they viewed as the degeneration of art into shallow entertainment. Imbued with the romantic ideals of self-expression, they called for a new, highly individualistic vision, one that was original and sincere, free from the sentimentalities, trivialities, and hypocrisies of conventional taste. Rejecting the authority of prevailing taste and of the institutions backing it, these artists claimed the right to an authority of their own, often with a sense of mission not unlike that of the seer and prophet; they would restore or re-create art. These artists tended to group or be grouped into parties or "movements" analogous to those in political life and recognizable by their opposition to the status quo. Whichever side they occupied in the complex, stylistic dialogues that took place, they were, in fact, debating in a new way the very nature of art and the function of the artist. As it turns out, they were dealing with the question of a *modern* art, one fundamentally different from that of the past, even though it might be constructed out of the "tradition" of the past to a greater or lesser degree.

The Tradition, as we will refer to it, was the whole corpus of art acknowledged to be good or great: the art of Greece and Rome, of the Renaissance, and of the Baroque. Such art spanned a stylistic spectrum from "classical idealism" to "optical realism" and seemed to exhaust the physical possibilities of the media as well as their thematic content. The Tradition was first challenged and, by the end of the century, rejected for an art "of our own times," a modern art. In the course of the century, challenge was met by response, and response by new challenge, so that the modes of traditional and modern were interwoven, combined, recombined, and separated by independent artists, producing a bewildering plurality of individual styles not easily categorized. Although we will use the conventional categories of art history-Romanticism, Realism, Impressionism, and so onas markers, these terms cannot help but be indefinite and often misleading. What we do perceive by midcentury is a bifurcation not seen previously in the arts. It is a bifurcation of emphasis and purpose: one branch, optical realism, is linked to scientific discoveries about the physical world and to the development of photography and the motion picture; the other branch is connected with psychological and spiritual investigations leading to the abstract art of the twentieth century. The former is directed to the public and popular taste; the latter is aimed, for the most part, at a select, specially trained audience.

Various factors contributed to this historical division. Artists in the nineteenth century were confronted by three innovations that fatefully affected their craft: the camera, the mass-produced print, and the printed reproduction. The almost infinite proliferation of the products of these new media flooded the world with images that became formidable rivals of the unique work made by hand. In a way, the nineteenth-century artist was technologically displaced, much as the manuscript illuminator of the sixteenth century had been displaced by the printer. Moreover, the collective techniques of an industrial age forced nineteenth-century artists, as individual craftspeople, to analyze their function and to study closely the physical nature of their medium. Photographic images challenged the iconic function of traditional art by accurately capturing the optical world of human experience. Toward the end of the century, artists found themselves using the elements of line, shape, and color to represent their private world, the realm of imagination and feeling. The functions of the artist and of the artist's medium were decisively transformed by the modern world, and the art of that world broke firmly away from the Tradition.

NINETEENTH-CENTURY ROMANTICISM

In art, stylistic change never occurs neatly at the beginning of a new century. The revolutions that ushered in the modern world were accompanied by a widespread agitation of spirit, a kind of collective mental revolution-the emotional response to accelerating change. We have already been introduced to Romanticism in the eighteenth century and have examined its onset, its rise, and the problems of defining its period. In the nineteenth century, Romanticism continued to center around concerns for the abrogation of traditions, institutions, and privileges that were seen to have impeded human progress. Romanticism as a view of life, as well as a state of mind, inherited the Enlightenment's admiration of nature and the natural over convention and artifice, and continued to uncover history as a storehouse of natural lessons for correcting the defects of the present.

The emphasis on human rights in the public sphere was accompanied by the assertion of the value of feeling and emotion in private experience. Truth could be sought and found inwardly more surely than in doctrines of religion or rules of reason; Romanticism's orientation was subjective, and the intensity of the religious and mystical emotions associated with traditional Christianity could live on in the individual, with or without reference to specific creeds. The ardor of Romanticism was also religious, as were its soul-searching and truth-seeking through feeling and vision. The pantheistic union of the soul with naturenature, for many, replacing the Christian God-was part of the Romantic ritual and excitement. T. E. Hulme defined Romanticism as "spilled religion": the old doctrinal vessels were broken, and their volatile contents spread widely and indefinitely.

The contents spread indefinitely, because no fixed doctrines for Romanticism could really be identified.

How could such doctrines be defined in a world of decisive change in which all that was fixed, dogmatic, and categorical was challenged? On issues of the day, we can find Romantic spirits on opposing sides: progressive and conservative, democratic and monarchistic, religious and agnostic, hoping and despairing, satanic and angelic. The world of history, for example, in the process of being systematically recovered, could be valued as serving the hopes of new nations by showing them the heroic past, by supplying them with an identity. Or it could be regarded as a nightmare from which the present was trying to wake: "The world," wrote Percy Bysshe Shelley, in *Hellas*, "is weary of the past / Oh, might it die, or rest at last!"

Romanticism, protean as the modern world it reflected and, like the modern mind, incorrigibly romantic, had one firm conviction at its center. This belief was the identification of reality as rooted in the self, not in the external, man-made world. The search for this identity—the revelation and expression of it in art and life—was the objective and meaning of personal existence. Jean Jacques Rousseau preached the religion of the value of the individual in a single assertion: "I may be no better than anyone else; at least I am different." For the Romantic, it was the difference that counted.

Despite the plurality of styles in the nineteenth century, the artist's claim of autonomy was a constant, and this individualism sometimes resulted in alienation. The right to be an individual authority justified this procedure, even when an artist chose to accept the authority of, say, the academies. The broad right to select a mode of expression was then matched by the broad range of materials supplied by the Tradition, which the artist could either adopt or turn aside. The artist's motives might be various: to stir an audience with drama or melodrama; to reconstruct historical incident; to exhibit the beauty of the human figure, a landscape, a still life, or other traditional subjects; to present the genre of modern life; to paint the inventions of a fertile imagination; to externalize dreams as images, private and strange. The subjects, modes of representation, and techniques of the artists of the nineteenth century, various as they may have been, were all derived from a common attitude and claim of autonomy.

In this earlier century of the modern era, then, much of the subject matter in art was mainly romantic, in that the artist stressed dramatic emotion or ideal beauty, or combinations of these with other material. Romantic artists discovered their themes in history, literature, nature and religion, the exotic, and the esoteric, and drew on the pictorial modes of the Tradition—the Classical, the Renaissance, and the Baroque. Romantic architects recovered the historical styles of Western architecture and those of the non-European world and paraded them dramatically. Historical and literary material, often produced with a photographic realism, predominated. It is this retrospective subject matter, seeming separate or escaping from the specifically modern scene, that, in part, invites the use of the term *Romanticism*. Yet we will see that some aspects of Romanticism survived into the twentieth century and that much contemporary art has been, in essence, subjective—an intellectual and emotional reflection of challenging and continual change.

Continuation of Neoclassicism

The Romantic Neoclassical taste for the more or less exact replication of Greek and Roman buildings, as we have seen it expressed in Thomas Jefferson's University of Virginia buildings (FIG. 20-44), spread throughout Europe and America. From Virginia to Munich, from Paris to St. Petersburg, Neoclassicism was associated with everything from revolutionary aspirations for democratic purity to imperial ambitions for unshakable authority. In France, the early years of the century were dominated by Napoleon Bonaparte, a figure of romantically enlightened temperament and enormous ego, who embraced all links with the Classical past as sources of symbolic authority for his short-lived imperial state. La Madeleine (FIG. 21-1) was briefly intended to be a "temple of glory" for Napoleon's armies and a monument to the newly won glories of France. Begun as a church in 1807, at the height of Napoleon's power (some three years after he proclaimed himself emperor), the structure reverted again to a church after his defeat and long before its completion in 1842. Designed by PIERRE VIGNON (1763–1828) as an octastyle peripteral temple, its high podium and the broad flight of stairs leading to a deep porch simulate the buildings of the time of the first caesars, making La Madeleine a symbolic link between the Napoleonic and the Roman empires. Curiously, the building's Classical shell surrounds an interior that is covered by a sequence of three domes, a feature found in Byzantine and Aquitanian Romanesque churches, as though this Christian church had been clothed in the costume of pagan Rome.

Under Napoleon, Classical models were apparent in all the arts. The emperor's favorite sculptor was ANTONIO CANOVA (1757–1822), who somewhat reluctantly left a successful career in Italy to settle in Paris and serve the emperor. Once in France, Canova became an admirer of Napoleon and made numerous portraits, all in the Classical mode, of the emperor

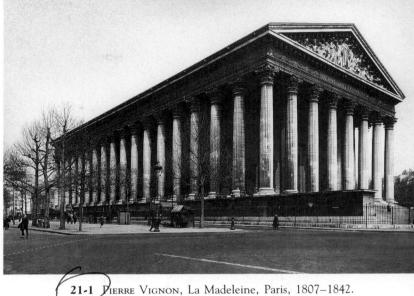

1-1 PIERRE VIGNON, La Madeleine, Taris, 1007–1042

and his family. Perhaps the best known of these works is the portrait of Napoleon's sister, *Pauline Borghese as Venus* (FIG. **21-2**). The sensuous pose and form of Canova's figure recall the Greek sculpture of Praxiteles (FIG. 5-62), while the sharply detailed rendering of the couch and drapery echo a later Hellenistic style. With remarkable discretion, Canova created a daring image of seductive charm, generalized enough to personify the goddess of love, yet still suggestive of the living person. Despite a lingering Rococo charm, this work shows the artist to have been

1-2 ANTONIO CANOVA, Pauline Borghese as Venus, 1808. Marble, life size. Galleria Borghese, Rome.

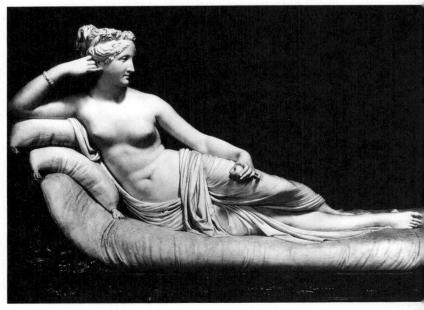

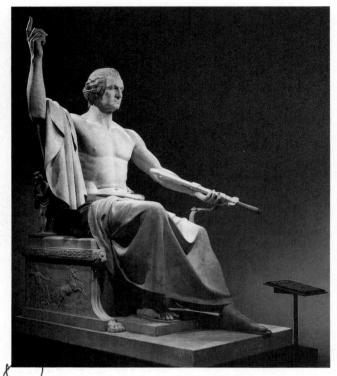

21.3 HORATIO GREENOUGH, George Washington, 1832–1841. Marble, approx. 11' 4" high. National Museum of American Art, Smithsonian Institution, Washington, D.C.

firmly Neoclassical in his approach. Canova was considered to be the greatest sculptor of his time, but suffered greatly in reputation later. Current criticism has restored him somewhat, although he still carries, as the most typical of the Neoclassicists, something of the burden of negative criticism leveled against this often doctrinaire style.

The defects of the Neoclassical style are apparent in a statue of George Washington (FIG. 21-3) by the American sculptor Horatio Greenough (1805–1852). Here, the Neoclassical style Jefferson had championed so successfully for the architecture of the new democracy (FIG. 20-43) turned out to be less suitable for commemorative portraits. Commissioned by the United States Congress to honor Washington as the country's first president, the sculptor used as a model for the head a popular bust of Washington by Houdon (a work with the same lively realism as Houdon's Voltaire Seated [FIG. 20-25]). In the body of the statue, Greenough aimed at the monumental majesty inspired by a lost, but famous, sculpture by Phidias of the Greek god Zeus. The sheathed sword, offered hilt forward, was intended to symbolize "Washington the peacemaker," rather than "Washington the revolutionary war general." The representation of the "father of his country," deified as a halfnaked pagan god, however, was, at the time, beyond the taste of the American public. As social observer and commentator Alexis de Tocqueville wrote: "Americans will habitually prefer the useful to the beautiful, and they will require that the beautiful be useful." The statue was considered to be a failure in Greenough's time precisely because it manifested, more than many sculptures of the Neoclassical style, the contradictions that sometimes develop when idealistic and realistic illusion meet. Canova appeared to harmonize these two trends; Greenough put them in opposition. Although Greenough's statue was never thrown into the Potomac river, "to hide it from the world," as one Congressman suggested, it also was never placed in its intended site beneath the Capitol dome. Today, the work is more highly regarded and is displayed at the National Museum of American History in Washington, D.C. While to some, it may seem stiff, cold, or simply unconvincing, it does have an imperious majesty appropriate to the national memory of its subject.

Eclectic Romanticism in Architecture and Sculpture

While Romantic Neoclassicism flourished, the Romantic Gothic taste begun in the eighteenth century by Walpole and others, in places like Strawberry Hill, was by no means extinguished. On the contrary, its development paralleled that of Romantic Neoclassicism and took on new significance in connection with religious meanings and the century's rising tide of nationalism. In 1802, the eminent French writer François René de Chateaubriand published his influential Genius of Christianity, a defense of religion on the grounds not of its truth, but of its beauty and mystery. A work such as this was in direct opposition to the skeptical rationalism of the Enlightenment and many of the ideals of the French Revolution. In this treatise, Chateaubriand says, "There is nothing of beauty, sweetness, or greatness in life that does not partake in mystery." (How different this statement is from the Age of Reason's injunction, "Be thou clear!") Christian ritual and Christian art, born of mystery, could move adherents by their strange and ancient beauty. Gothic cathedrals, according to Chateaubriand, were translations into stone of the sacred groves of the Druidical Gauls and must be cherished as manifestations of France's holy history. In his view, the history of Christianity and that of France merged in the Middle Ages. As the nineteenth century gathered the documentary materials of European history in stupendous historiographic enterprises, each nation came to value its past as evidence

of the validity of its ambitions and claims to greatness. The art of the remote past was now appreciated as a product of racial and national genius. In 1773, Goethe, praising the Gothic cathedral of Strasbourg in *Of German Architecture*, announced the theme by declaring that the German art scholar "should thank God to be able to proclaim aloud that it is German architecture, our architecture"; he also bid the observer, "approach and recognize the deepest feeling of truth and beauty of proportion emanating from a strong, vigorous German soul."

Modern nationalism thus helped to bring about a new evaluation of the art in each country's past. In London, when the old Houses of Parliament burned in 1834, the Parliamentary Commission decreed that designs for the new building should be either "Gothic or Elizabethan." CHARLES BARRY (1795-1860), with the assistance of A. W. N. PUGIN (1812-1852), submitted the winning design (FIG. 21-4) in 1835. By this time, style had become a matter of selection from the historical past. Barry had traveled widely in Europe, Greece, Turkey, Egypt, and Palestine, studying the architecture in each place. He preferred the Renaissance Classical styles, but he had designed some earlier Neo-Gothic buildings, and Pugin influenced him successfully in the direction of English Late Gothic. Pugin was one of a group of English artists and critics who saw moral purity and spiritual authenticity in the religious architecture of the Middle Ages and glorified the careful medieval craftsmen who had produced it. The Industrial Revolution was now flooding the market with cheaply made and illdesigned commodities. Handicraft was being replaced by the machine. Many, like Pugin, believed in the necessity of restoring the old craftsmanship, which had honesty and quality. The design of the Houses of Parliament, however, is not genuinely Gothic, despite its picturesque tower groupings (the Clock Tower, containing Big Ben, at one end, and the Victoria Tower at the other). The building has a formal axial plan and a kind of Palladian regularity beneath its Tudor detail. Pugin himself is reported to have said of it: "All Grecian, Sir. Tudor details on a classic body."*

While the Neoclassical and Neo-Gothic styles were dominant in the early nineteenth century, exotic new styles of all types soon began to appear, in part as a result of European imperialism. Great Britain's forays into all areas of the world, particularly India, had exposed English culture to a broad range of non-Western artistic styles. The Royal Pavilion (FIG. **21-5**), designed by JOHN NASH (1752–1835), exhibits a wide

*In Nikolaus Pevsner, An Outline of European Architecture (Baltimore, MD: Penguin, 1960), p. 627.

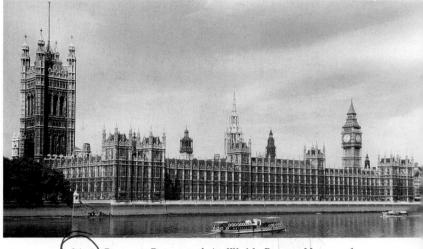

21-4) CHARLES BARRY and A. W. N. PUGIN, Houses of Parliament, London, designed 1835.

variety of these styles. Nash was an established architect, known for Neoclassical buildings in London, when he was asked to design a royal pleasure palace in the seaside resort of Brighton for the prince regent (later King George IV). The structure's fantastic exterior is a confection of Islamic domes, minarets, and screens that has been called "Indian Gothic," while the decor of the interior rooms was influenced by sources ranging from Greece and Egypt to China. Underlying the exotic façade is a cast-iron skeleton, an early (if hidden) use of this material in noncommercial building. Nash also put this metal to fanciful use in its own right, creating life-size, cast-iron palmtree columns to support the Royal Pavilion's kitchen ceiling. The building, an appropriate enough backdrop for gala throngs pursuing pleasure by the seaside, served as the prototype for numerous playful

(21-5) JOHN NASH, Royal Pavilion, Brighton, England, 1815–1818.

21-6 FRANÇOIS RUDE, La Marseillaise, Arc de Triomphe, Paris, 1833–1836. Approx. 42' × 26'.

architectural exaggerations still to be found in European and American resorts.

Among the styles renewed with enthusiasm to express heroic and dramatic themes was the Baroque. In Paris, the Baroque was merged with a certain Classical rigor in *La Marseillaise* (FIG. **21-6**), a sculpture by

FRANÇOIS RUDE (1784-1855) that exhibited the national glories of France's more recent past. The colossal figures, in bold relief against the Arc de Triomphe, represent French volunteers leaving to defend the borders of France against the foreign enemies of the revolution in 1792. The volunteers are dressed in Classical armor, and the Roman war goddess Bellona (who may be thought of here as La Marseillaise, or the Goddess of Liberty) shouts the battle cry as she rallies the militia forward. The Classical accessories do not disguise the essentially Baroque qualities of the group: densely packed masses, jagged contours, violence of motion. If we were to think here of the Classical at all, it would be of the "post-classical baroque" of Hellenistic works like the great frieze at Pergamon (FIG. 5-78).

A different variation of the renewed Baroque taste for the exotic is found in Jaguar Devouring a Hare (FIG. 21-7) by Antoine Louis Barye (1795–1875). Painful as the subject is, Barye draws us irresistibly to it by the work's fidelity to brute nature. The bellycrouching cat's swelling muscles, hunched shoulders, and tense spine-even the switch of the tailtell of the sculptor's long sessions observing the animals in the Jardin des Plantes in Paris. This work shows the influence of the vast new geographies opening before the naturalistic eyes and temper of the nineteenth century, while demonstrating Romanticism's obsession with strong emotion and untamed nature. Nineteenth-century sensibility generally prevented animal ferocity from being shown in human beings but enthusiastically accepted its portrayal in Romantic depictions of wild beasts. Barye's portrayal of a beast with its dead prey contrasts with the more sublime depiction by Stubbs of a ferocious struggle to the death between two more equal natural enemies (FIG. 20-46).

21-7 ANTOINE LOUIS BARYE, Jaguar Devouring a Hare, 1850–1851. Bronze, approx. 16" × 37". Louvre, Paris.

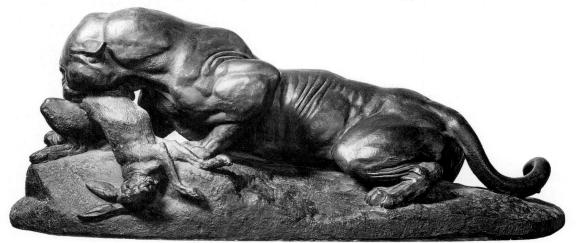

21-8 J. L. CHARLES GARNIER, the Opéra, Paris, 1861–1874.

The Baroque was also adapted in architecture, to convey a new grandeur worthy of the riches acquired during this age of expansion by those who heeded the advice of the French historian and statesman François Guizot to "get rich." The opulence reflected in the lives of these few was mirrored in the Paris Opéra (FIG. 21-8), designed by J. L. CHARLES GARNIER (1825-1898). The Opéra parades a festive and spectacularly theatrical Neo-Baroque front that should be compared with the façade of the Louvre (FIG. 19-64), which it mimics to a degree. The interior is ingeniously planned for the convenience of human traffic. Intricate arrangements of corridors, vestibules, stairways, balconies, alcoves, entrances, and exits facilitate easy passage throughout the building and provide space for entertainment and socializing at intermissions. The Baroque grandeur of the layout and of the ornamental appointments of the opera house proclaims and enhances its function as a gathering place for glittering audiences in an age of conspicuous wealth. The style was so attractive to the moneyed classes who supported the arts that theaters and opera houses continued to reflect the design of the Paris Opéra until World War I transformed society.

Near the end of the nineteenth century, RICHARD MORRIS HUNT (1828–1895) brought European Baroque and Renaissance style to the mansions he designed for members of America's "aristocracy" entrepreneurs and industrialists whose enormous wealth had been derived from the profits of the era's new industries. Hunt had developed his architectural knowledge through study in Switzerland and Paris. The Breakers (FIG. **21-9**), built by Hunt for Cornelius

21-9 RICHARD MORRIS HUNT, The Breakers, Newport, Rhode Island, 1892.

Vanderbilt II, is a splendid private palace in Newport, Rhode Island, a favorite summer vacation spot for the affluent. Occupying a glorious promontory, the residence resembles a sixteenth-century Italian palazzo more than a large summer cottage. The interior rooms are grand in scale and sumptuously rich in decor, each having its own variation of Classical columns, painted ceilings, lavish fabrics, and sculptured furbelows. The entry hall, rising some 45 feet above the majestic main stairway, signals the opulence of the rooms beyond. This hall and most of the main rooms of the house offer a magnificent view over the grounds and the ocean, a view assured by Hunt's siting of the building. As Garnier's Opéra influenced theater design well into the twentieth century, so the grandeur and lavishness of Hunt's palatial domestic style were to remain popular with the ultra-rich until World War I shattered the bright period known as la belle époque. As we will see, however, architecture at this time was also developing along a very different line, one that would break finally with the Romantic styles to forge a new direction based on other themes and materials of the industrial and technological age.

Romanticism in Figure Painting

Painting, in the early nineteenth century, proved to be an extraordinarily sensitive medium for the romantically subjective, personal expression of the time. In France, Jacques Louis David demanded that his pupils select their subjects from Plutarch, the ancient author of *Lives of the Great Greeks and Romans* and a principal source of standard Neoclassical subject

21-10 ANNE LOUIS GIRODET-TRIOSON, The Burial of Atala, 1808. Approx. 6' $11'' \times 8'$ 9". Louvre, Paris.

matter. David's students, however, often found their subjects elsewhere, and it was this distinction in subject matter that divided his style from the Romanticism of his successors.

One of David's students, ANNE LOUIS GIRODET-TRIOSON (1767–1824), turned to a popular novel by Chateaubriand (*Atala*) for the subject of his *Burial of Atala* (FIG. **21-10**). This painting could be a set piece for Romanticism. Atala, sworn to lifelong virginity,

falls passionately in love with a wild, young savage of the Carolina wilderness. Rather than break her oath, she commits suicide and is buried in the shadow of a cross by her grief-stricken lover. By representing the Holy Church in the person of the cloaked priest, Girodet daringly puts religion and sexual passion side by side, binding them with the theme of death and burial. Hopeless love, perished beauty, the grave, the purity of primitive life, and the consolation of religion are some of the Romantic themes Girodet successfully showed in this work. The picture's composite style combines classicizing contours and modeling with a dash of the erotic sweetness of the Rococo and the dramatic illumination of the Baroque. Unlike David's appeal to the feelings that manifest themselves in public action in the Oath of the Horatii (FIG. 20-40), the appeal here is to the viewer's private world of fantasy and emotion. If David's purpose was to "electrify the soul," Girodet's was, in the language of Rousseau, to "wring the heart." The artist speaks here to our emotions, rather than inviting philosophical meditation or revealing some grand order of nature and form. The Romantic artist, above all else, wanted to excite the emotions of the audience.

Another pupil of David, the Baron ANTOINE JEAN GROS (1771–1835), deviated from his master's teachings as much as Girodet did but in a much more influential way for the development of the Romantic style. In his *Pest House at Jaffa* (FIG. **21-11**), painted in 1804,

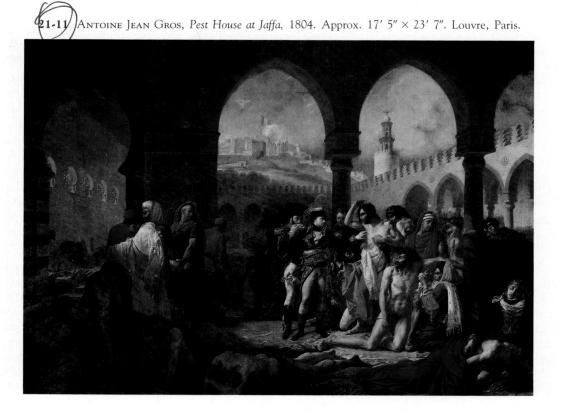

Gros took a then radically independent tack, sorting through and selecting numerous Baroque pictorial devices of light, shade, and perspective to create a dramatic tableau testifying to the superhuman power and glory of Napoleon Bonaparte. This work is similar to David's Oath of the Horatii in that both artists stage the action within an architectural enframement, deploying the figures in front of an arcade. Where David's arcade is Roman, however, Gros's is Moorish. The vista through Gros's arcade is of a distant landscape dominated by a fortress flying the French tricolor. Time has changed the setting, and the painter's means have changed to suit the present. In Pest House, Gros dismissed theoretical considerations of Classical balance and modeling by depicting Napoleon as a stage director might and making the fullest use of stage lighting and dramatic darkness to center attention on the figure of the chief protagonist. The result is the elevation of history painting to an art of almost religious significance and solemnity-one in which Napoleon, the Messiah of democracy, simultaneously plays the roles of Alexander, Christ, and Louis XIV.

Napoleon, portrayed here as the First Consul and not yet as Emperor Napoleon I, is at the end of the disastrous Egyptian campaign and in the process of retreating with his troops up the coast of Palestine (modern Israel). His army is stricken with the plague. He is shown visiting his sick and dying soldiers in a hospital in the ancient city of Jaffa. In the midst of the dead and dying, the fearless genius of the New Order touches the plague sores of a sick soldier, who stares at him in awe, as if he were the miracle-working Christ. Napoleon's staff officers cover their noses against the stench of the place, but the general is calm and unperturbed, like the king curing by the King's Touch. In the left foreground, men brood, crouch, and sprawl in a gloom of misery and anguish; these figures will be of special interest to later Romantic artists like Théodore Géricault and Eugène Delacroix. The entire scene is wrapped in the glamor of its Near Eastern setting. As in the work of Girodet, identifiable Romantic themes are evident-suffering and death, faith and personal heroism, the allure of distant places, patriotism. All of these held a certain appeal to the modern need for emotional stimulation.

THÉODORE GÉRICAULT (1791–1824) studied with an admirer of David (P. N. Guérin), but in the pupil the rigid Neoclassicism of the Davidian school receded to allow David's use of sharp light and shade to come to the fore. Géricault's work is also characterized by a maturing of the naturalistic element and further movement toward the dramatic presentation of contemporary events on huge canvases. For Géricault (unlike his predecessors), these events did not always demand a central hero. His masterpiece, *Raft of the Medusa* (FIG. **21-12**), shows these influences as well as those of Michelangelo and Peter Paul Rubens.

21-12 Théodore Géricault, Raft of the Medusa, 1818–1819. Approx. $16' \times 23'$. Louvre, Paris.

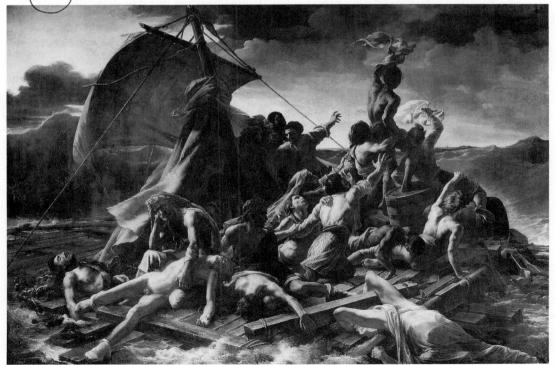

Géricault took for his subject the ordeal of the survivors of the French ship Medusa, which had foundered off the west coast of Africa in 1816, laden with Algerian immigrants. This incident was the result of tragic mismanagement and provoked scandal in France when the survivors were able to tell their stories. Géricault's depiction of the anguish of the event also was construed by the government as an outright political attack. The artist avoided showing the most horrific aspects of the tragedy-murder, cannibalism, and immense hardship-in choosing to depict the dramatic moment when the frantic castaways attempted to attract the attention of the distant ship that was eventually to rescue them. Fifteen survivors and several corpses are piled onto one another in every attitude of suffering, despair, and death (recalling Gros's Pest House) and are arranged in a powerful X-shaped composition. One light-filled diagonal axis stretches from bodies at the lower left up to the figure of the black man, raised on the shoulders of his comrades and waving a piece of cloth toward the horizon. The cross-axis descends from the storm clouds and dark, wind-filled sail at the upper left to the shadowed upper torso of the body trailing in the open sea.

Although Baroque devices abound, Géricault's use of shock tactics, stunning the viewer's sensibilities, amounted to something new—a new tone and intention that distinguished the "high" phase of Romanticism. In this phase, an instinct for the sublime and the terrible, qualities celebrated in the esthetic theory and art of the eighteenth century (see, for example, Fuseli's *Nightmare* [FIG. 20-47]), found sharpest expression in a method of reportorial accuracy far more stringent than that found in certain works by David (FIG. 20-41). The value Géricault placed on accuracy in *Raft of the Medusa* is indicated by the fact that he carried out prodigious research and completed numerous preliminary studies for the work, even going so far as to interview survivors of the wreck.

An interest in mental aberration, which contributed to the development of modern psychopathology later in the nineteenth century, was part of another Romantic fascination-an interest in the irregular and the abandoned. The inner storms that overthrow rationality could hardly fail to be of interest to the rebels against the Age of Reason. Géricault, like many of his contemporaries, examined the influence of mental states on the human face and believed, as others did, that a face accurately revealed character, especially in madness and at the instant of death. He made many studies of the inmates of hospitals and institutions for the criminally insane (indeed, he spent some time as a patient in such places), and he studied the severed heads of victims of the guillotine. Scientific and artistic curiosity were not easily sepa-

 71-13 Théodore Géricault, Insane Woman (Envy), 1822– 1823. Approx. 28" × 21". Musée des Beaux-Arts, Lyons.

rated from the morbidity of the Romantic interest in derangement and death. Géricault's Insane Woman (Envy) (FIG. 21-13)—her mouth tense, her eyes redrimmed with suffering-is one of several "portraits" of insane subjects that have a peculiar, hypnotic power and present the psychic facts with astonishing authenticity. Insane Woman is only another example of the increasingly realistic core of Romantic painting. The closer the Romantics became involved with nature, sane or mad, the more they hoped to get at the truth. For painting, this increasingly came to mean the optical truth, as well as the truth of "the way things are." Meanwhile, for the Romantic, the real was nature, wild and untamed. In Géricault's paintings, suffering, death, and madness amounted to nature itself, for nature, in the end, is formless and destructive.

JEAN AUGUSTE DOMINIQUE INGRES (1781–1867) arrived at David's studio after Gros and Girodet-Trioson had left to establish independent careers of their own. His study there was to be short-lived, however, as he soon broke with David on matters of style. This difference of opinion involved Ingres's adoption of a manner based on what he believed to be a truer and purer Greek style than that employed by David. The younger man adopted flat and linear forms approximating those found in Greek vase painting. In a good deal of Ingres's work, the figure is placed in the foreground, much like a piece of lowrelief sculpture. The value Ingres placed on the flow of the contour is a characteristic of his style throughout his career. Contour, which is simply shaded line, was *everything* for Ingres, and drawing was the means of creating contour. Ingres has been credited with the famous slogan that became the battle cry of his school: "Drawing is the probity of art." In content, Ingres first adopted David's Neoclassical subjects, but he later also traversed the complete range of Romantic sources.

It was this rather strange mixture of artistic allegiances-the precise adherence to Classical form conveyed in Romantic content-that provoked one critic to ridicule Ingres's work as the vision of "a Chinaman wandering throughout the ruins of Athens." In both form and content, Ingres initially was seen by critics as a kind of rebel; they did not cease their attacks until the mid-1820s, when another enemy of the official style, Eugène Delacroix, appeared. Then they suddenly perceived that Ingres's art, despite its innovations and deviations, still contained many elements that adhered to the official Neoclassicism. Ingres soon was to become the leader of the academic forces in their battle against the "barbarism" of Géricault, Delacroix, and their "movement." Gradually, Ingres warmed to the role in which he had been cast by the critics, and he came to see himself as the conservator of good and true art, a protector of its principles against its would-be "destroyers."

While the painting drew acid criticism when first shown in 1814 ("She has three vertebrae too many," "No bone, no muscle, no life"), Ingres's Grande Odalisque (FIG. 21-14) seems today to sum up the painter's artistic intentions. Ingres treats the figure in his own "sculpturesque style"—polished surfaces and simple, rounded volumes controlled by rhythmically flowing contours. The smoothness of the planes of the body is complemented by the broken, busy shapes of the drapery. His subject, the reclining nude figure, is traditional enough and goes back to Giorgione and Titian (FIG. 17-62), but by converting the figure to an odalisque (a member of a Turkish harem), Ingres made a strong concession to the contemporary Romantic taste for the exotic. The work also shows his admiration for Raphael in his borrowing of that master's type of female head, but Ingres did not draw only from the period of the High Renaissance. His figure's languid pose, her proportions (small head and elongated limbs), and the generally cool color scheme also reveal his debt to such Mannerists as Parmagianino (FIG. 17-41). Often criticized for not being a colorist, Ingres, in fact, had a superb color sense. It is true that he did not seem to think of his paintings primarily in terms of their color, as did Delacroix, but he did far more than simply tint his drawings for emphasis, as recommended by the Academy. In his best paintings, Ingres created color and tonal relationships so tasteful and subtle as to render them unforgettable.

Although he always aspired to become a history painter in the academic sense, Ingres never really was successful with multifigured compositions. He was at

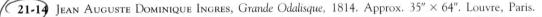

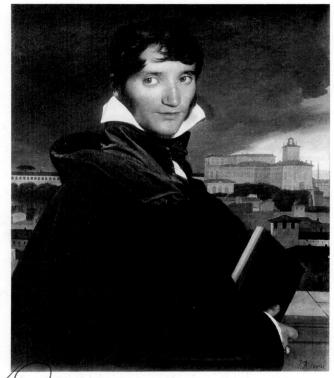

21-15 JEAN AUGUSTE DOMINIQUE INGRES, François Marius Granet, 1807. Approx. 28" × 24". Musée Granet, Aix-en-Provence.

his best with single figures and portraits. It is as a portraitist that he must be ranked among the greatest masters in a field that would soon be dominated by the camera. The portrait of his friend, the painter François Marius Granet (FIG. 21-15), is not by itself sufficient to demonstrate Ingres's great distinction in this genre. It does show, however, his skill in arranging the pose and adjusting the costume to highlight Granet's sensitively introspective face and cap of picturesquely tousled hair. In this work, Ingres infused a clear Neoclassical style with a Romantic energy, an energy heightened by the dramatically draped cape and the stormy sky threatening the city in the background. In his portraits, as with his nudes, Ingres also contrasted the simple and regular volume of the head with the broken, irregular, and complicated folds of costume. His apparently cool detachment from his models, and his search for "pure form" commend him to the twentieth-century taste for the "abstract."

The history of nineteenth-century painting in its first sixty years has often been interpreted as a contest between two major artists—Ingres, the draftsman, and Delacroix, the colorist. Their dialogue reached back to the end of the seventeenth century in the quarrel between the Poussinistes and the Rubénistes, a quarrel most recently alluded to in the discussion of Rigaud and Watteau (FIGS. 20-4 and 20-5). The Poussinistes were conservative defenders of academism who held drawing to be superior to color, while the Rubénistes proclaimed color's importance over line (the quality of line being more intellectual and thus more restrictive than color). While their differences were clear, Ingres and his great rival Delacroix, in the end, complemented rather than contradicted each other, their work being a part of the great Romantic dialogue.

A comparison of Ingres's pencil portrait of the great violin virtuoso Niccolò Paganini (FIG. **21-16**) with Delacroix's painted version of the same personality (FIG. **21-17**) discloses the difference in approach that separated the two artists. Both painters were passionately fond of music, and Ingres was a creditable violin amateur who knew Paganini personally. His portrait, executed with that marvelously crisp precision of descriptive line that we find in all of his pencil portraits, is quite literal, relative to Delacroix's. Ingres gives us the man's appearance and public deportment—one might say his official likeness—enhanced by a suggestive characterization and sense of setting.

(21-16) JEAN AUGUSTE DOMINIQUE INGRES, Paganini, 1819. Pencil drawing, approx. 12" × 8½". Louvre, Paris.

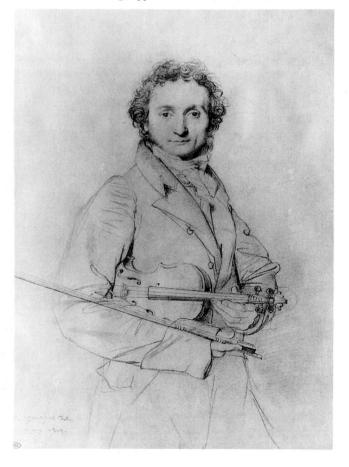

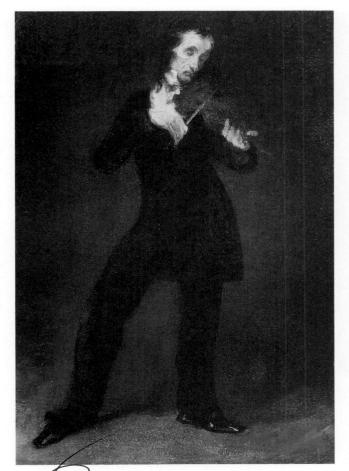

21-17 EUGÈNE DELACROIX, Paganini, c. 1832. Approx. $17'' \times 11\frac{12}{2}''$. The Phillips Collection, Washington, D.C.

Paganini, sharing a certain fragility and suppleness with his violin and bow, seems about to make his introductory obeisance to his audience. Above all, Ingres's portrait is *formal*, as is his subject, face to face with the public world; it is a graceful, not a stiff formality, however. Delacroix's Paganini presents a likeness not of the virtuoso's form but of his performance. Forgetting his audience, no longer in formal confrontation with his listeners, Paganini yields himself completely to the whirlwind of his own inspiration, which envelopes his reedlike frame, making it vibrate in tune to the quivering strings of his instrument. Delacroix tries to suggest the portrait, as it were, of Paganini's music, as it plays to his own ear and spirit. Where Ingres gave us the outside aspect of his subject and tried to perfect the form as presented to the eye, Delacroix represented the inner substance-the musician transformed by his music-in an attempt to realize the truth as given to the imagination.

While critics now regard both masters as equally great, it was this celebration of the imagination, the

faculty that captures the essential in life and transforms mundane experience, that defined the fundamental difference between Ingres and Eugène DELACROIX (1798–1863). Delacroix called the art of Ingres "the complete expression of an incomplete intellect," incomplete because it was unleavened with imagination. In a passage from his famous Journal, Delacroix wrote: "Baudelaire . . . says that I bring back to painting . . . the feeling which delights in the terrible. He is right."* Delacroix, who knew and admired Géricault, greatly expanded the expressive possibilities of Romantic art by developing its themes and elaborating its forms in a direction of ever-greater emotional power-in Romantic parlance, of "sublimity." While Delacroix denigrated Ingres's art, he also found much to admire in his rival's work, especially the drawings. The two artists continued to go their separate ways, Ingres even being instrumental in preventing Delacroix's election to the Académie des Beaux Arts until 1857.⁺

Although the faculty of mind most valued by the Romantic was imagination (to be intensely imaginative was to be intensely alive), Delacroix realized that skill and restraint must accompany it. Baudelaire, writing of Delacroix, observed that "in his eyes imagination was the most precious gift, the most important faculty, but [he believed] that this faculty remained impotent and sterile if it was not served by a resourceful skill which could follow it in its restless and tyrannical whims." Nevertheless, Delacroix's works were products of his view that the artist's powers of imagination would in turn capture and inflame the imagination of the viewer.

Literature of similar imaginative power served Delacroix (and many of his contemporaries) as a useful source of subject matter. Since David, literature and the other arts had been developing in ever-more intimate association. Baudelaire remarked that Delacroix "inherited from the great Republican and Imperial school [of David] a love of the poets and a strangely impulsive spirit of rivalry with the written word. David, Guérin, and Géricault kindled their minds at the brazier of Homer, Vergil, Racine, and Ossian. Delacroix was the soul-stirring translator of Shakespeare, Dante, Byron, and Ariosto." The relationship between the arts went back as far as the Renaissance,

^{*}In *The Journal of Eugène Delacroix,* trans. Walter Pach (New York: Grove Press, 1937, 1948). Charles Baudelaire (1821–1867), one of the nineteenth century's finest and most influential poets, was also a perceptive art critic.

⁺The personal antagonisms between the two artists may have softened eventually. Of an accidental encounter between them late in their careers on the steps of the French Institute, the painter Paul Joseph Chevanard recounted that, after an awkward pause, Ingres impulsively extended his hand to Delacroix, who shook it sincerely.

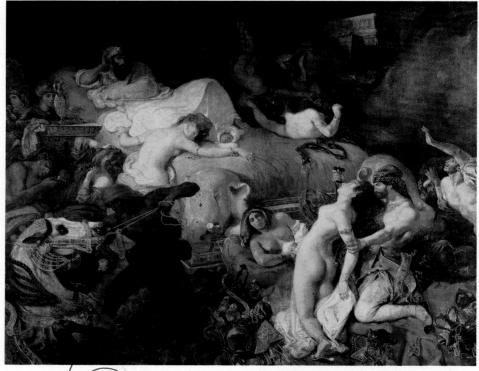

21-18 EUGÈNE DELACROIX, The Death of Sardanapalus, 1826. Approx. $12' 1'' \times 16' 3''$. Louvre, Paris.

but in the Romantic age, the association became so close that the paintings it produced could almost be said to be "programmed" by literature. The same held for music, as attested by Hector Berlioz's Harold in Italy, patterned after Lord Byron's Childe Harold. This trend that began with David culminated with Delacroix in the literature-inspired staging of exciting and disturbing human events, real or imaginary, and in a concern for the most accurate visual means of conveying them. The belief inherent in this practice was that the purpose of art was to stir, to "electrify," and to render the modern spirit with a modern look, accurately and sympathetically. It was an art also meant to appeal to the new, rapidly expanding democratic society. The "story picture" resulting from the painter's translation of literature into art, when further merged with the dramatic and musical theater, would evolve into the new medium of the motion picture-a composite of drama, narrative, sound, and pictures.

Delacroix's *The Death of Sardanapalus* (FIG. **21-18**), which he painted in 1826, is an example of pictorial grand opera on a colossal scale. Undoubtedly, Delacroix was inspired by Lord Byron's narrative poem *Sardanapalus*, but the painting does not illustrate that text. Instead, Delacroix depicted the last hour of the ancient king in a much more tempestuous and

crowded setting than Byron described, with orgiastic destruction replacing the sacrificial suicide found in the poem. In the painting, on hearing of the defeat of his armies and the enemies' entry into his city, the king orders all of his most precious possessions-his women, slaves, horses, and treasure-destroyed in his sight while he watches gloomily from his funeral pyre, soon to be set alight. The king presides like a genius of evil over the panorama of destruction, most conspicuous in which are the tortured and dying bodies of his Rubenesque women, the one in the foreground dispatched by an ecstatically murderous slave. This carnival of suffering and death is glorified by superb drawing and color, by the most daringly difficult and tortuous poses, and by the richest intensities of hue and contrasts of light and dark. The king is the center of the calamity, the quiet eye of a hurricane of form and color. It is a testament to Delacroix's genius that his center of meaning is placed away from the central action yet entirely controls it.

Delacroix's composition in *Death of Sardanapalus* is an early example in painting of the newly invented Romantic picture type called the *vignette*, an image with a strong center that becomes less defined at its edges. In *Death of Sardanapalus*, everything swirls around the empty foot of the bed, but details fade toward the edge of the canvas. Similarly vortical com-

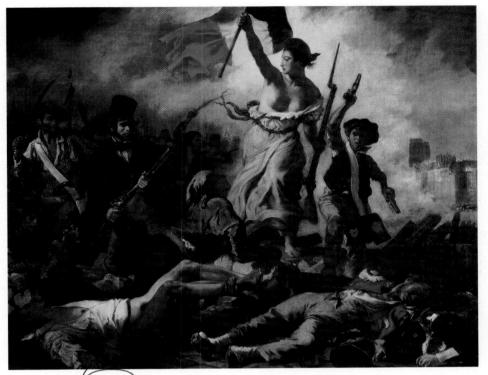

21-19 EUGÈNE DELACROIX, Liberty Leading the People, 1830. Approx. 8' 6" × 10' 8". Louvre, Paris.

positions were common in painters of the dynamic Baroque (FIG. 19-40), but in Delacroix's work this device extended its effect to a then unknown, and not entirely appreciated, degree (the work pleased none of the critics of the day). The Romantic vignette first appeared in book illustrations in which Romantic artists attempted to recapture the kind of total unity of text and illustration that they admired in medieval illuminated manuscripts. Cultural historians Charles Rosen and Henri Zerner offer an explanation for the vignette's eager adoption by painters:

The vignette, by its general appearance, presents itself both as a global metaphor for the world and as a fragment. Dense at its center, tenuous on the periphery, it seems to disappear into the page: this makes it a naïve but powerful metaphor of the infinite, a symbol of the universe; at the same time, the vignette is fragmentary, . . . incomplete, mostly dependent upon the text for its meaning. . . . The vignette launches a powerful attack on the classical definition of representation, a window on the world. The vignette is not a window because it has no limit, no frame. The image, defined from its center rather than its edges, emerges from the paper [or canvas] as an apparition or a fantasy.*

*Charles Rosen and Henri Zerner, *Romanticism and Realism: The Mythology of Nineteenth-Century Art* (London: Faber and Faber, 1984), p. 81.

Generally, Delacroix chose his subjects from either non-Classical or post-Classical periods and literature, but sometimes he dealt with a Greek subject that moved him. Other sources of subjects were the events of his own time, notably popular struggles for freedom: the ill-fated revolt of the Greeks against Turkish rule in the 1820s; the Parisian revolution of 1830, which overthrew the restored Bourbons and placed Louis Philippe on the throne of France. In Liberty Leading the People (FIG. 21-19), done in 1830, Delacroix makes no attempt to represent a specific incident seen in actuality. Instead, he gives us a full-blown allegory of revolution itself, teeming with unidealized and carefully presented details. Liberty, a majestic, partly nude woman, whose beautiful features wear an expression of noble dignity, waves the people forward to the barricades, the familiar revolutionary apparatus of Paris streets. She carries the tricolor banner of the republic and a musket with a bayonet and wears the cap of liberty. Her advance is over the dead and dying of both sides-the people and the royal troops. Arrayed around her are bold Parisian types: the street boy brandishing his pistols, the menacing prolétaire with a cutlass, the intellectual dandy in plug hat with sawed-off musket. In the background, the towers of Notre Dame rise through the smoke and clamor, witnessing the tradition of liberty

(21-2) EUGÈNE DURIEU and EUGÈNE DELACROIX, Draped Model (back view), c. 1854. Albumen print, $7\frac{5}{16}'' \times 5\frac{1}{8}''$. The J. Paul Getty Museum, Malibu.

that has been cherished by the people of Paris throughout the centuries.

In terms of form, Liberty Leading the People still reflected the strong impression made on Delacroix by the art of Géricault, especially Raft of the Medusa (FIG. 21-12); the fact that Delacroix made an allegory of Liberty shows that he was familiar with traditional conventions. The clutter of sprawling bodies in the foreground provides a kind of base for the pyramid of figures in the center, which builds from the heavy, inert forms of the dead and dying to the frantic energy of Liberty and the citizens still engaged actively in the struggle. The flashes of light suggest gunfire, while the intermingling of light and shadow echoes the confusion of battle and the dense atmosphere stirred up by the conflict. The forms were generated from the Baroque, as they were in Géricault, but Delacroix's sharp agitation of them created his own special brand of tumultuous excitement.

Delacroix's early use of the vignette shows him to have been an innovator. He was always studying the problems of his craft and always searching for fresh materials to supply his imagination. These were conscious efforts on his part; he said, "style can only re-

sult from great research." He made numerous studies for each of his projects and even worked with the photographer Eugène Durieu (1800-1874) to create photographic studies for paintings. A camera study was a supremely practical tool, if only because a photographic model would pose untiringly for just the cost of making the initial print. More important to the Romantic (and later Realist) interest in the depiction of nature was the camera's ability to record, with absolute fidelity, the physical facts of what was before it. Draped Model (back view) (FIG. 21-20) is an early example of the photographic nudes Delacroix used for this purpose. Although such images were sought for their accuracy of detail, Durieu was able to create a romantic mood through careful lighting and the draping of the cloth. On one occasion, Delacroix shared some of the photographic studies he had made with visitors and then showed them some engravings by the famous Renaissance artist Marcantonio Raimondi. Writing of this event in his Journal, Delacroix recorded that

[After] they had studied these photographs of nude models, some of whom were poorly built, oddly shaped in places and not very attractive generally, I put before their eyes engravings by Marcantonio. We all experienced a feeling of revulsion, almost disgust, for their incorrectness, their mannerisms, and their lack of naturalness, despite their quality of style. . . . Truly, if a man of genius should use the daguerreotype as it ought to be used, he will raise himself to heights unknown to us.*

An enormously influential event in Delacroix's life, and one that affected his art in both subject and form, was his visit to North Africa in 1832. Things he saw there shocked his imagination with fresh impressions that would last throughout the rest of his life. He discovered, in the sun-drenched landscape and in the hardy and colorful Arabs dressed in robes reminiscent of the Roman toga, new insights into a culture built on proud virtues—a culture that he believed to be more Classical than anything European Neoclassicism could conceive. "The Greeks and the Romans," he wrote to a friend, "they are here, within my reach. I had to laugh heartily about the Greeks of David." The gallantry, hardihood, valor, and fierce love of liberty made the Arabs, in Delacroix's eyes, "nature's noblemen"-unspoiled heroes, uninfected by European decadence.

Delacroix's African experience also further heightened his already considerable awareness of the expressive power of color and light. What Delacroix knew about color he passed on to later painters of the

^{*}In Aaron Scharf, Art and Photography (Baltimore: Penguin, 1974), p. 122.

nineteenth century, particularly to the Impressionists. He observed that pure colors are as rare in nature as lines, that color appears only in an infinitely varied scale of different tones, shadings, and reflections, which he tried to re-create in his paintings. He recorded his observations in his Journal, which became a veritable corpus of pre-Impressionistic color theory and was acclaimed as such by the Post-Impressionist painter Paul Signac in 1898-1899. Delacroix anticipated the later development of Impressionist color science, but that art-science had to await the discoveries by Michel Eugène Chevreul and Hermann von Helmholtz of the laws of light decomposition and the properties of complementary colors before the problems of color perception and juxtaposition in painting could be properly formulated. Nevertheless, Delacroix's observations were significant: "It is advisable not to fuse the brushstrokes," he wrote, "as they will [appear to] fuse naturally at [a] . . . distance. In this manner, color gains in energy and freshness." This observation, suggested to him by his examination of a group of landscapes by John Constable, the great English landscape painter (FIG. 21-30), had strongly impressed Delacroix even before his color experiences in Morocco. He wrote:

Constable said that the superiority of the green he uses for his landscapes derives from the fact that it is composed of a multitude of different greens. What causes the lack of intensity and of life in verdure as it is painted by the common run of landscapists is that they ordinarily do it with a uniform tint. What he said about the green of meadows can be applied to all other tones.

Inspired by Constable's example, Delacroix developed a more radical colorism, which he described forcibly in the following statement: "Speaking radically, there are neither lights nor shades. There is only a color mass for each object, having different reflections on all sides." These observations were stimulated by Delacroix's Moroccan visit and do not consistently apply to the early works he did under the influence of Géricault. His conception of the optical world as planes of color would find a new realization in the art of Paul Cézanne (FIG. 21-81), who made color planes serve a structural purpose in locking the composition together.

No other painter of the time explored the domain of Romantic subject and mood as thoroughly and definitively as Delacroix, and none matched his style and content. Delacroix's technique—impetuous, improvisational, and instinctive, rather than deliberate, studious, and cold—epitomizes Romantic painting, catching the impression at the very beginning and developing it in the process of execution. We know how furiously Delacroix worked once he had an idea, keeping the whole painting progressing at once. The fury of his attack matched the fury of his imagination and his subjects. He was indeed the artist of passion. Baudelaire sums him up as "passionately in love with passion . . . an immense passion, reinforced with a formidable will—such was the man." In the end, his friend Silvestre, in the language of Romanticism, delivered a eulogy that amounts to a definition of the Romantic artist:

Thus died, almost with a smile on August 13, 1863, that painter of great race, Ferdinand Victor Eugène Delacroix, who had a sun in his head and storms in his heart; who for forty years played upon the keyboard of human passions and whose brush—grandiose, terrible, or suave—passed from saints to warriors, from warriors to lovers, from lovers to tigers, and from tigers to flowers.

The Romantic Landscape

Romanticism elevated the previously minor genre of landscape painting to a level of first importance, a level once occupied exclusively by figure painting. Early in the century, most landscape painting to some degree expressed the Romantic, pantheistic view (first extolled by Jean Jacques Rousseau) of nature as a "being" that included the totality of existence in organic unity and harmony. It was in nature-"the living garment of God," as Goethe called it-that the artist found an ideal subject to express the Romantic theme of the soul in union with the natural world. Romanticism in the arts, it could be said, made a kind of personal religion of nature, a religion based in profound esthetic emotion-of mystery and beauty, to recall the ideas of Chateaubriand. If nature was akin to religion, the artist could be likened (in the thought of the Idealist philosopher Schiller) to a priest, who in the act of creation duplicates or becomes one with the creative powers of nature itself, thus resolving the contradictions of the inner (subjective) and the outer (objective) worlds. The landscape would reveal the divine being of nature to the artist who was prepared by innocence, sincerity, and intuitive insight to receive the revelation. As all nature was mysteriously permeated by "being," the landscape artist had the task of interpreting the signs, symbols, and emblems of universal "spirit" disguised within visible material things. The artist was no longer a mere beholder of the landscape but a participant in its spirit, no longer a painter of mere things but the translator of nature's transcendent meanings, arrived at through feelings inspired by the landscape.

Artists in northern Europe were the first to depict the Romantic transcendental landscape. One, PHILIPP

21-21 PHILIPP OTTO RUNGE, The Times of Day: Morning (large version), 1809. Approx. 60" × 45". Kunsthalle, Hamburg.

OTTO RUNGE (1777–1810) declared that true art could be understood only through the deepest mystical experience of religion. In words, as well as images, he celebrated

the feeling of the whole universe with us; this united chord which in its vibrations touches every string of our heart; the love which keeps us and carries us through life. . . . each leaf and each blade of grass teems with life and stirs beneath me, all resounds together in a single chord. . . . I hear and feel the living breath of God who holds and carries the world, in whom all lives and works; here is the highest that we divine—God!*

Considering nature to be a part of God, and human beings to be part of nature, Runge said, "Once we see in all of nature only our own life, then it follows clearly, the right landscape can come about." Runge designed a four-part series, *The Times of Day*, as sacred pictures for a chapel dedicated to a new religion of nature. In *Morning* (FIG. **21-21**), from this series, he created an allegory of dawn enriched with his personal flower and color symbolism. In this piece, all plants are descended from Paradise and are emblematic of the states of the human soul, as are colors and musical harmonies. The image of the great lily floating in the sky is the floral manifestation of light and the symbol of Divine knowledge and purity. The morning star, Venus, glows above, under the arc of the earth; below it, on the central axis, is the graceful figure of the goddess herself in the guise of Aurora. On the ground below, the supine figure of an infant is an allusion to the Christ Child, as well as a symbol of regeneration and redemption and all the promise of the newborn day. The composition has the symmetry and formality of traditional religious painting and the mood of supernatural mystery, but the careful, objective study of color tone—the actual hues of dawn, with its tincture of rose turning to radiance shows Runge's concern for the truth of appearance as the vehicle of symbolic truth. Fusing the empirical world with the transcendental, he gives us an apparition of the supernatural in a natural sky. Like William Blake, whose work he must have known (FIG. 20-48), Runge was a religious visionary who believed in angels; unlike Blake, Runge revered nature as given to the eye.

Runge's ideas are believed to have influenced the art of his great contemporary, CASPAR DAVID FRIED-RICH (1774–1840); in the work of both, as art historian Robert Rosenblum has remarked, "the experience of the supernatural has . . . been transposed from traditional religious imagery to nature."[†] Nature, as immanent God, requires no personifications other than its organic and inorganic subjects and objects, things visible to the eye, which symbolically express through their forms the truth of nature, which is to say, Divine truth. For Friedrich, landscapes were temples; his paintings themselves were altarpieces. His reverential mood demands from the viewer the silence appropriate to sacred places filled with a divine presence. Cloister Graveyard in the Snow (FIG. 21-22) is like a solemn requiem. Under a winter sky, through the leafless oaks of a snow-covered cemetery, a funeral procession bears a coffin into the ruins of a Gothic chapel. The emblems of death are everywhere: the desolation of the season, leaning crosses and tombstones, the black of mourning worn by the grieving and by the skeletal trees, the destruction wrought by time on the chapel. The painting is a kind of meditation on human mortality, as Friedrich himself remarked: "Why, it has often occurred to me to ask myself, do I so frequently choose death, tran-

[†]Robert Rosenblum, *Modern Painting and the Northern Romantic Tradition: Friedrich to Rothko* (New York: Harper & Row, 1975), p. 22.

^{*}From letters translated in R. M. Bisanz, *German Romanticism and Philipp Otto Runge* (De Kalb: Northern Illinois University Press, 1970), pp. 48–51.

21-22 CASPAR DAVID FRIEDRICH, Cloister Graveyard in the Snow, 1810. Approx. 47" × 70". (Painting destroyed during World War II.)

sience, and the grave as subjects for my paintings? One must submit oneself many times to death in order some day to attain life everlasting."* The sharpfocused rendering of details demonstrates the artist's keen perception of everything in the physical environment relevant to his message. In the work of Friedrich, we find a balance of inner and outer experience. "The artist," he wrote "should paint not only what he sees before him, but also what he sees within him. If, however, he sees nothing within him, then he should also refrain from painting that which he sees before him."

A very different kind of natural symbolism is found in the widely influential school of English landscape painting. Just as literature and history are keys to the art of the French Romantics, English Romantic poetry is key to the paintings of the English landscapists. In the works of JOSEPH MALLORD WILLIAM TURNER (1775–1851), we find readings of nature in its terror and grandeur somewhat more often than in its peace and serenity, although the artist was capable of realizing all of nature's emotions. The critic John Ruskin wrote of Turner's *The Slave Ship* (FIG. **21-23**) in *Modern Painters* (1846):

But I think the noblest sea that Turner has ever painted, and if so, the noblest certainly ever painted by man, is that of *The Slave Ship*, the chief Academy

*In H. Börsch-Supan, *Caspar David Friedrich* (New York: Braziller, 1974), p. 7.

picture of the exhibition of 1840. . . . I believe, if I were reduced to rest Turner's immortality upon any single work, I should choose this.

The full title of the painting is Slavers Throwing Overboard the Dead and Dying-Typhoon Coming On. Its subject is an incident that took place in 1783 in which the captain of a slave ship threw sick and dying slaves overboard in hopes of collecting insurance on the claim that they were "lost at sea." The horror of the event is matched by Turner's turbulently emotional depiction of it. The sun is transformed into an incandescent comet amid flying, scarlet clouds that swirl above a sea choked with the bodies of slaves jettisoned from the ship by its ruthless master. The particulars of the event are almost lost in the boiling colors of the work. Turner was a great innovator whose special invention in works like The Slave Ship was to release color from any defining outlines in order to express the forces of nature, as well as the painter's emotional response to them. In works like this, the reality of color is one with the reality of feeling. Turner's methods had an incalculable effect on the development of modern art. His discovery of the esthetic and emotive power of pure color (the most fundamental element of the painting medium), and his pushing of the fluidity of the medium to a point at which the subject is almost manifest through the paint itself, were important steps toward twentiethcentury abstract art, which dispenses with shape and form altogether.

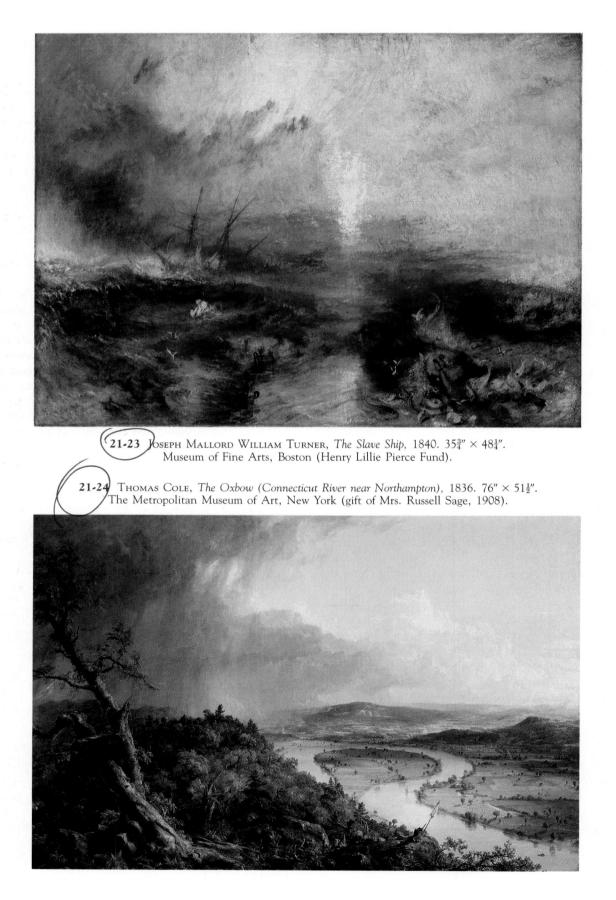

The American painter THOMAS COLE (1801–1848) was less concerned with pioneering advances in color and technique, and his work typified the landscape of reflection and mood so romantically appealing to the public, especially in the English-speaking world. Best known as the leading painter of the Hudson River school, whose members drew their subjects from the uncultivated regions of the Hudson River valley, Cole celebrated the wonders of the North American landscape in many of his works. He wrote:

Whether he [the American] beholds the Hudson mingling waters with the Atlantic, explores the central wilds of this vast continent, or stands on the margin of the distant Oregon, he is still in the midst of American scenery—it is his own land; its beauty, its magnificence, its sublimity—all are his; and how undeserving of such a birthright, if he can turn towards it an unobserving eye, an unaffected heart!*

In The Oxbow (Connecticut River near Northampton) (FIG. 21-24), the viewer looks out from a high promontory over a peaceful plain dotted with signs of human habitation and dominated by the lazy oxbow turning of the Connecticut River. Our hilly perch is densely forested; at the near left is an ancient, craggy tree. In contrast with the valley below, this high realm seems still part of the untouched wilderness. Just below, on a rock to the right, are the artist's stool and parasol; nearby we see the artist himself at work on a painting. The broad vista suggests the public fascination with the panorama, which Cole shared. Originally, "panoramas" were specially designed buildings that housed colossal circular murals; the buildings' curved walls surrounded spectators who stood on a central platform to view vast paintings of historical scenes or landscapes. Soon, the panorama experience was translated outdoors in Europe and America to viewing platforms overlooking spectacular landscape vistas. In his affection for his adopted country (Cole was born in England), the artist may have combined the natural drama of the panoramic view with the widely held notion that America was a New Eden, which, in its unspoiled and pristine virtue, might avoid the fateful cycle of European decay and decadence that had doomed earlier empires. This thoroughly Romantic myth of the innocence of America in contrast to the corruption of Europe was widely believed on both sides of the Atlantic in the nineteenth century.

THE RISE OF REALISM: THE RECORDING EYE

While Romanticism dominated the early decades of the century with its goals of expressing dramatic emotion or ideal beauty and its subject matter, taken for the most part from scenes outside common, everyday experience, another vein of expression also was beginning to address the century's growing appetite for optical reality in art. Increasingly during this period, real events were becoming subjects for artists who were willing to report or reconstruct scenes in visual modes faithful to appearance. These artists produced images that invited comparison to everyday optical experience in life, using simple recognition as a new criterion for judgment.

A technological device of immense consequence for the modern experience was invented at precisely this time: the camera, with its attendant art of photography. We are all familiar with what the camera equips us to do-report and record optical experience at will. We assume that a very close correlation exists between the photographic image and the fragment of the visual world it records. The evidence of the photograph is proof that what we think we see is really there. In other words, the camera can be a check on what is "real," "true," or "factual" in our visual experience. Photography was celebrated as embodying a kind of revelation of visible things from the time Louis J. M. Daguerre and Henry Fox Talbot announced the first practical photographic processes in 1839. The medium, itself a product of science, was an enormously useful tool for recording the discoveries of the century. The relative ease of the process seemed a dream come true for scientists and artists, who for centuries had grappled with less satisfying methods for capturing accurate images of their subjects. Photography was also perfectly suited to an age that saw artistic patronage continue to shift away from the elite few and toward a broader base of support, away from noble patronage and toward that of the growing and increasingly powerful middle class, who embraced the more practical and immediately comprehensible images of the new medium, and also its lower cost.

For the traditional artist, photography suggested new answers to the great debate about what is real and how to represent the real in art, but it also presented a challenge to the place of traditional modes of pictorial representation that had originated in the Renaissance. Artists as diverse as Delacroix, Ingres, Courbet, and Degas welcomed photography as a helpful auxiliary to painting and were increasingly intrigued by the manner in which photography

^{*}In John W. McCoubrey, American Art 1700–1960: Sources and Documents (Englewood Cliffs, NJ: Prentice-Hall, 1965), pp. 98, 106 and passim. Cole's sensitivity for the sublime quality of landscape also inspired him to produce heroic symbolic landscape cycles with themes like "The Voyage of Life."

translated three-dimensional objects onto a twodimensional surface. Other artists, however, saw photography as a mechanism capable of displacing the painstaking work of a skilled painter dedicated to representing the truth of a chosen subject. The challenge of photography to painting, both historically and technologically, seemed to some an expropriation of the realistic image, until then the exclusive property of painting. As one painter, Maurice de Vlaminck, declared at the end of the century: "We [painters] hate everything that has to do with the photograph." But just as some painting looked to the new medium of photography for answers on how best to render an image in paint, so some photographers looked to painting for suggestions about ways to imbue the photographic image with qualities beyond simple reproduction-the near-symbiotic relationship already seen in the collaborative efforts of Delacroix and Durieu's Draped Model (FIG. 21-20).

In any event, at this time, painting and photography, whether in collaboration or opposition, were destined to replace the Tradition altogether—a tradition still very much alive in Romanticism. In substance and direction, in subject matter, and in form and technique, painting and photography were to topple the conventions of the Tradition through visual means faithful to Realism's new concerns with the optically real. Realism, the style of art that would dominate the latter part of the nineteenth century, came into being slowly. At first, it was combined with some of the qualities of Romanticism.

Seeds of Realism in Painting

At the very beginning of the modern period stood the imposing figure of FRANCISCO GOYA (1746–1828), the great independent painter of Spain. Founder of no school and acknowledging indebtedness to Velázquez, Rembrandt, and "nature," Goya was a great transitional figure who changed the Tradition while he manifested the present and prophesied the future. In his long life, he produced masterworks in a variety of artistic styles, and, from a higher vantage point than most of his contemporaries, he often depicted humanity's capacity for evil in bitter and unsparing revelation. Great Spanish painting has rarely been sentimental; it has insisted, often with ruthless honesty, on the cruel facts of life.

Little of the grim account of humanity foreshadowed in *The Sleep of Reason* (FIG. 20-49), a visionary work linked to the art of William Blake (FIG. 20-48), can be seen in Goya's early, vivacious manner, which

21-25 FRANCISCO GOYA, The Family of Charles IV, 1800. Approx. 9' 2" × 11'. Museo del Prado, Madrid.

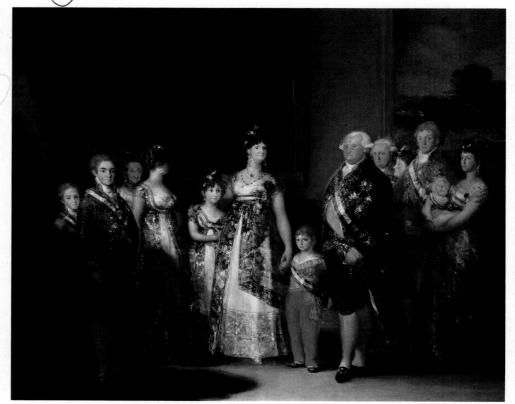

was brilliantly adapted from Tiepolo. At the royal court in Madrid, where his precocious talent had brought him early in his career, Goya produced a series of genre paintings (not illustrated) designed to serve as models for tapestries. Their prevailing mood of gaiety was the mood of the Rococo, but the blitheness of Goya's early style soon waned. His experiences as painter to Charles IV, at whose sensationally corrupt court he lived, must have fostered the unsentimental, hard-eyed realism of his later style. In his large painting of The Family of Charles IV (FIG. 21-25), probably inspired by Velázquez's Las Meninas (FIG. 19-38), Goya presented, with a straight face, a menagerie of human grotesques who, critics have long been convinced, must not have had the intelligence to realize that the artist was presenting them with unflinching and unflattering truth. This superb revelation of stupidity, pomposity, and vulgarity, painted in 1800, led a later critic to summarize the subject as the "grocer and his family who have just won the big lottery prize." The painter, behind his canvas, is dimly discernible at the left; his features impassively ironical, he looks beyond his subjects to the observer. In this work, Goya exhibited his extraordinary skill as a colorist and manager of the oil medium. The colors float with a quiet iridescence across the surface, and the paint is applied with deft economy. Great solidity is suggested by the most transparent tones. A magician of optical pictorialism, Goya used the methods of his great predecessor, Velázquez.

The Third of May, 1808 (FIG. 21-26) is perhaps the most compelling of all Goya's works. The subject is an incident that took place in 1808 during Napoleon's intervention in Spain when a French firing squad executed a "token" number of civilians in Madrid in retaliation for the murder of some of Napoleon's troops by Spanish troops the day before. Here, Goya showed the horrors of war without national bias (although he was a patriot) and without mercy for the viewer's sensibilities. Goya was in Madrid at the time the execution took place and visited the site later to make sketches of it to ensure the accuracy of his depiction of the bleak hillside and distant city. His main concern, however, was not the accurate recording of fact, but the expression of empathetic horror for the psychological agonies of men facing execution. Unlike the subtle, even suave realism of The Family of Charles IV, Goya's method here is coarse and extreme in its departure from optical fact. The postures and gestures of the figures are shockingly distorted to signal defiance and terror. The French firing squad has

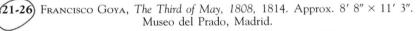

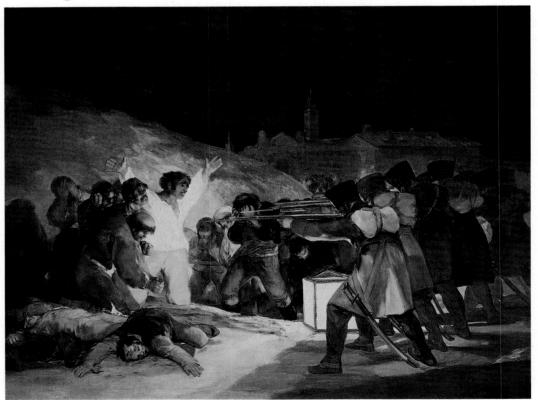

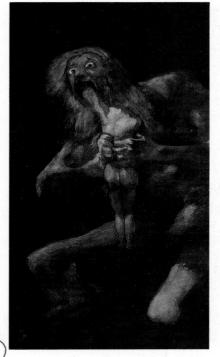

(21-27/ FRANCISCO GOYA, Saturn Devouring His Children, 1819–1823. Detail of a detached fresco on canvas, full size approx. 57" × 32". Museo del Prado, Madrid.

become an anonymous, murderous wall, while the victims are portrayed as separate individuals, each facing the moment of death in his own way. The intense psychological reality is modern in its stress on the experience of the individual as one among many (quite different from the more traditional, carefully choreographed Baroque staging in Callot's *Miseries of War* [FIG. 19-59]), and foreshadows Picasso's twentieth-century masterpiece on a related theme, *Guernica* (FIG. 22-83).

Toward the end of his life, the follies and brutalities he had witnessed and his own increasing infirmities, including deafness, combined to depress Goya's outlook further, as evidenced in his so-called Black Paintings, done for the walls of his own home. In ominous midnight colors, he created whole populations of subhuman monsters who worship the devil and swarm in nightmares. Saturn Devouring His Children (FIG. 21-27) was one product of this pessimistic and misanthropic style. Saturn (Time) glares in lunatic frenzy while devouring part of a small body clutched in his hands. The forms are torn and jagged, the colors raw. Here, Goya's tragic vision returns to the haunted interior world of The Sleep of Reason. This appalling late work is not only a savage expression of man's inhumanity to man, but a recognition of the desperate conditions of life itself. Life is in time, and time devours all.

Similar to Goya's *Third of May* in its depiction of harsh social reality is *Rue Transnonain* (FIG. **21-28**), a print by the French lithographer and painter HONORÉ DAUMIER (1808–1879). At the time of this work, Daumier had been known primarily for the satirical lithographs he contributed to the liberal French Republican journal, *Caricature*. In these works, he lampooned the foibles and misbehavior of politicians, lawyers, and middle-class gentry. Daumier, however, was also in close touch with the acute political and social unrest in Paris at that time, unrest brought about by

-28/ HONORÉ DAUMIER, Rue Transnonain, 1834. Lithograph, approx. $12'' \times 17\frac{1}{2}''$. Philadelphia Museum of Art.

(21-29) HONORÉ DAUMIER, The Third-Class Carriage, c. 1862. $25_4^{3''} \times 35_2^{5''}$. The Metropolitan Museum of Art, New York (Havemeyer Collection, bequest of Mrs. H. O. Havemeyer, 1929).

the rapid development of an urban industrial society. As might be expected, the sharpness of his political criticism (in any form) often put him in conflict with the government. The title Rue Transnonain identified the incident being portrayed to Daumier's contemporaries; it was an event that occurred after a civil guard, part of a government force trying to repress a worker demonstration, was killed by a sniper. Because the fatal shot had come from a workers' housing block, the remaining guards immediately stormed the building and massacred all of its inhabitants. With the power of Goya, Daumier created a view of the atrocity from a sharp, realistic angle of vision. We see not the dramatic moment of execution, but the terrible, quiet aftermath. The broken, scattered forms, lying in the midst of violent disorder, are reported as if newly found. Daumier used every available device of his skill to make the situation real. The harsh facts speak for themselves; the artist did not have to interpret them for us. The print's significance lies in its *factualness*. What we find here is an example of an increasing artistic bias toward using fact as subject, if not yet always with the optical realization of fact as method. Daumier's manner is rough and spontaneous; the way it carries expressive exaggeration is part of its remarkable force. Daumier is true to life in content, but his style is uniquely personal.

Daumier brought the same concerns to the paintings he did, especially after 1848. His unfinished *The Third-Class Carriage* (FIG. **21-29**) gives us a glimpse into the rude railway compartment of the 1860s. The inhabitants are poor and can afford only third-class tickets. The disinherited masses of nineteenthcentury industrialism were Daumier's indignant concern, and he made them his subject over and over again. He shows them to us in the unposed attitudes and unplanned arrangements of the millions thronging the modern city-anonymous, insignificant, dumbly patient with a lot they cannot change. Daumier saw people as they ordinarily appeared, their faces vague, impersonal, blank—unprepared for any observer. He tried to achieve the real by isolating a random collection of the unrehearsed details of human existence from the continuum of ordinary life, a vision that paralleled the spontaneity and candor of scenes being captured by the end of the century with the modern snapshot camera.

The realization of "fact" in both content and method was the goal of JOHN CONSTABLE (1776–1837), Turner's great contemporary, in the depiction of the English landscape. Constable's landscapes—for the most part placid, untroubled views of the English (Suffolk) countryside—are careful studies of nature rendered in the local colors of woodland, meadow pond and stream, hill and sky, interspersed with the architecture of mill, cottage, and country church. Constable portrayed these, his favorite subjects, as lighted by a mild sun or shadowed briefly by a changing cloud, bathed in an atmosphere fresh with dew or rain, moved by soft winds. He did not depict heroic

(21-3) JOHN CONSTABLE, The Haywain, 1821. 4' $3'' \times 6' 2''$. National Gallery, London.

action, nor has the landscape been constructed to stage it. In The Haywain (FIG. 21-30), which was a great success at the Paris Salon of 1824, a farmer in a cart fords a stream. Living nature includes him as it does the dog, the cottage, the stream, the copse, the distant park, the scudding clouds. Constable portrayed the oneness with nature sought by the Romantic poets; man is not the observer, but a participant in the landscape's being. The image is not a dream vision. The artist has insisted on the reality of the landscape as given to the eye and rendered with the brush: "I hope to show that our profession as painters is scientific as well as poetic; that imagination never did, and never can, produce works that are to stand by comparison with *realities''* (emphasis added). Constable made countless studies from nature for each of his canvases, which produced the convincing sense of reality in his works that was praised by his contemporaries. In his quest for the reality of landscape, Constable studied it like a meteorologist (which he was by avocation). His special gift was for capturing the texture given to landscape by atmosphere (the climate and the weather, which delicately veil what is seen) and for revealing that atmosphere as the key to representing the ceaseless process of nature, which changes constantly through the hours of the day, and through shifts of weather and season. Constable's use of tiny dabs of local color, stippled with white, created a sparkling shimmer of light and hue across the surface of the canvas-the vibration itself suggestive of movement and process. In speaking of the qualities he intended in his pictures, Constable mentioned "light-dews-breezes-bloom-and freshness, not one of which . . . has yet been perfected on the canvas of any painter in the world." These are the qualities that we sense in the fleeting states of changing nature—the qualities that startled the young Delacroix when he saw *The Haywain* in the Paris Salon. Constable's certainty that the painting of nature partook of science was his challenge and his bequest to the Impressionists.

Echoing the scientific thrust found in Constable and exemplifying the entire century's exploding interest in the recording and cataloguing of known and newly discovered natural realms is the work of JOHN JAMES AUDUBON (1785–1851), who devoted almost

the whole of his career to naturalist paintings of the birds and animals of North America. Born of Creole and French parentage in what is now Haiti, Audubon studied painting in France (for a short while as a pupil of David) before coming to the United States in 1806. He began his American career as a portrait painter but soon turned his attention to works that would be collected and shown in a book entitled *The* Birds of North America, which was published in four volumes between 1827 and 1838. The paintings reproduced in this great work as hand-colored aquatints were not achieved without struggle. The artist collected specimens from the wild and brought them back to his studio, where he created paintings in a mixture of watercolor and pastel. Gyrfalcon (FIG. 21-31) illustrates well how Audubon used the clarity and purity of David's Neoclassical style to present the naturalistic details of a North American bird. The white silhouettes of the birds fill the page, artfully arranged to display the avian forms as they posture against a clear blue sky. Audubon creates a drama of

21-31 JOHN JAMES AUDUBON, Gyrfalcon from The Birds of North America, 1827–1838. Watercolor on paper, $25\frac{1}{2}^{"} \times 38\frac{1}{4}^{"}$. The New–York Historical Society, New York.

the wild while detailing the birds' features. The male gyrfalcon swoops down toward his mate in a way that magnificently shows the feather display on his back and head, while the female responds by lifting her wings, thus showing her talons and the understructure of her body. Their habitat is identified by the cliff ledge on which she stands, an extension of the mountain range in the background to the right and high above the plains and hills at the lower left. The scientific accuracy of Audubon's work still is a standard resource, and his images, as works of art, are still praised for the eloquent strength of their rich, yet simple composition. Working in the tradition of scientific illustration practiced at least from the time of Leonardo da Vinci and seen more recently in the work of Albinus (FIG. 20-27), Audubon's concern with the "living" qualities of his subjects carried an echo of Romanticism very different from the unmodulated scientific objectivity of his predecessors.

The Beginnings of Photography

"Reality," "truth," "fact"-that elusive quality sought by artists throughout time with painstaking effort in the traditional media of paint, crayon, and pen-and-ink-could be captured readily and with breathtaking accuracy in the new mechanical medium of photography. Artists themselves were instrumental in the development of this new technology. As early as the seventeenth century, as we saw with Vermeer (FIG. 19-54), artists had used an optical device called the camera obscura (literally, dark room) to help them render the details of their subjects more accurately. These instruments were darkened chambers (some virtually portable closets) with optical lenses fitted into a hole in one wall through which light entered to project an inverted image of a subject onto the chamber's opposite wall. The artist could trace the main details from this image for later reworking and refinement. In 1807, the invention of the camera lucida (lighted room) replaced the enclosed chamber with an arrangement in which a small prism lens, hung on a stand, projected the image of the object at which it had been "aimed" downward onto a sheet of paper. Artists using these two devices found this preliminary stage of the artistic process long and arduous, no matter how accurate the resulting work. All yearned for a better way of capturing the image of a subject directly. Two very different scientific inventions that accomplished this were announced, almost simultaneously, in France and England in 1839.

The first new discovery was the development of the *daguerreotype* process, named for LOUIS JACQUES MANDÉ DAGUERRE (1787–1851), one of its two inventors. Daguerre had trained as an architect before becoming a set painter and designer in the theater. This

21-32 LOUIS JACQUES MANDÉ DAGUERRE, Still Life in Studio, 1837. Daguerreotype. © Collection Société Française de Photographie, Paris.

background led him to open (with a friend) a popular entertainment called the Diorama, in which audiences witnessed performances of "living paintings" created by changing the lighting effects on a "sandwich" composed of a painted backdrop and several layers of painted, translucent front curtains. Daguerre used a camera obscura to make studies for the paintings for the Diorama, but he wanted to find a more efficient and effective procedure. Through a mutual acquaintance, he was introduced to Joseph Nicéphore Nièpce who, in 1826, had successfully made a permanent picture of the cityscape outside his upper-story window by exposing, in a camera obscura, a metal plate covered with a light-sensitive coating. Although the eight-hour exposure time needed to record Nièpce's subject hampered the process, Daguerre's excitement over its possibilities led to a partnership between the two men to pursue its development. Nièpce died in 1833, but Daguerre continued to work on his own. His contributions to the process consist of the discovery of latent development (in which the image is brought out through chemical solutions, considerably shortening the length of time needed for exposure) and the discovery of a better way to "fix" the image (again chemically) by stopping the action of light on the photographic plate, which otherwise would continue to darken until the image could no longer be discerned.

The French government presented the new daguerreotype process at the Academy of Science in Paris on January 7, 1839, with the understanding that the details of the process would be made available to all interested parties without charge (although the inventor received a large annuity in appreciation). Soon, people all over the world were taking pictures with the daguerreotype "camera" (a name shortened from camera obscura) in a process almost immediately christened "photography," from the Greek *photos* (light) and *graphos* (writing). From the start, painters were intrigued with the possibilities of the process as a new art medium. Paul Delaroche, a leading painter of the day, wrote in an official report to the French Government:

Daguerre's process completely satisfies all the demands of art, carrying certain essential principles of art to such perfection that it must become a subject of observation and study even to the most accomplished painters. The pictures obtained by this method are as remarkable for the perfection of the details as for the richness and harmony of the general effect. Nature is reproduced in them not only with truth, but also with art.*

Each daguerreotype is a *unique* work, possessing amazing detail and finely graduated tones from black to white. Both qualities are evident in *Still Life in Studio* (FIG. **21-32**), which is one of the first success-

^{*}Letter from Delaroche to François Arago, in Helmut Gernsheim, *Creative Photography* (New York: Bonanza Books, 1962), p. 24.

21-33) FRIEDERICH VON MARTENS, Panorama of Paris, c. 1844–1845. Panoramic daguerreotype, approx. $4_4^{I''} \times 14_8^{T''}$. International Museum of Photography at George Eastman House, Rochester, New York.

ful plates Daguerre produced after perfecting his method. The process captured every detail-the subtle shapes, the varied textures, the diverse tones of light and shadow-in Daguerre's carefully constructed tableau. The three-dimensional forms of the sculptures, the basket, and the bits of cloth spring into high relief and are convincingly there within the image. The composition of this work was clearly inspired by seventeenth-century Dutch still lifes such as those of Willem Kalf (FIG. 19-55). Like Kalf, Daguerre arranged his objects to reveal clearly their textures and shapes. Unlike a painter, however, Daguerre could not alter anything within his arrangement to effect a stronger image. However, he could suggest a symbolic meaning within his array of objects. Like the peeled fruits and half-filled glasses of wine in Kalf's painting, Daguerre's sculptural and architectural fragments and the framed print of an embrace suggest that even art is vanitas and will not endure forever.*

The use of the daguerreotype spread quickly, with later photographic inventors and enthusiasts rapidly devising a host of improved cameras and techniques to extend the range of the new medium. Among these advancements was the swiveling panorama camera, for which photographers used special elongated and curved daguerreotype plates to make extreme wide-angle photographs in direct imitation of the panoramic view that had inspired Cole (FIG. 21-24), among others. The first photographer to master the special technical requirements of the panoramic daguerreotype was Friederich von Martens (1809–1875). In his Panorama of Paris (FIG. 21-33), Von Martens recorded the entire sweep of vision possible from the vantage point of the position of the camera, in this instance one of the pavilions of the Louvre overlooking the Seine. The angle is too wide for our

eyes to encompass the view in a single look. Instead, the image must be scanned; as the eye moves across the plate, the viewer has a sense of traveling along and into the space of the image in a way not possible with a composition that can be absorbed with one glance. The luxurious expanse given to the viewer in photographs like *Panorama of Paris* suggests a vastness of the world akin to that in the Romantic landscape, but panoramic daguerreotype views also were intended as documents of the dramatic urban development occurring during the middle of the nineteenth century.

In the United States, where the first daguerreotype was taken within two months of Daguerre's presentation in Paris, two particularly avid and resourceful advocates of the new medium were JOSIAH JOHNSON HAWES (1808–1901), a painter, and ALBERT SANDS SOUTHWORTH (1811–1894), a pharmacist and teacher. Together, they ran a daguerreotype studio in Boston that specialized in portraiture, now popular due to the shortened exposure time required for the process (although it was still long enough to require a head brace to help the subject remain motionless while the photograph was being taken). The partners also, however, took their equipment outside of the studio to record places and events of particular interest to them. One such image is Early Operation under Ether, Massachusetts General Hospital (FIG. 21-34). This daguerreotype was taken from the vantage point of the gallery of a hospital operating room, putting the viewer in the position of a medical student looking down on a lecture-demonstration of the type common in medical education midway through the nineteenth century. An image of historic record, this early daguerreotype gives the viewer a glimpse into the whole of Western medical practice. The focus of attention in Early Operation is the white-draped figure of the patient, who is surrounded by a circle of darkly clad doctors. The details of the figures and the furnishings and equipment of the room are recorded

^{*}Evidently Daguerre was well satisfied with the artistic merit of *Still Life in Studio*, because he presented it to the curator of the Louvre, who accepted it for the state collections.

21-34 JOSIAH JOHNSON HAWES and ALBERT SANDS SOUTHWORTH, Early Operation under Ether, Massachusetts General Hospital, c. 1847. Daguerreotype. Massachusetts General Hospital, Boston.

clearly, but the slight blurring of several of the figures betrays motion during the exposure. The concentration of the action in the center of the work creates an image reminiscent of the vignette composition favored by the Romantics, while the elevated viewpoint flattens the spatial perspective and emphasizes the relationship of the figures in ways that will be of immense interest to the Impressionists, especially Degas.

The daguerreotype reigned supreme in photography until the 1850s, but the second major photographic invention-the ancestor of the modern negative-print system—was announced less than three weeks after Daguerre's method was unveiled in Paris, and eventually replaced it. On January 31, 1839, WILLIAM HENRY FOX TALBOT (1800-1877) presented a paper on his "photogenic drawings" to the Royal Institution in London. A scientist and student of the classics who dabbled in painting, Talbot had for several years been experimenting with ways to capture the images of the camera obscura and camera lucida directly onto paper by using chemical coatings (emulsions) similar to those used to coat the daguerreotype's metal plates. As early as 1835, Talbot made "negative" images by placing objects on sensitized paper and exposing the arrangement to light, creating a design in which white silhouettes recorded the places where opaque or translucent objects had blocked light from darkening the emulsion on the paper. An example of the resulting images—said by Talbot to be "photogenic drawings" created with the "pencil of nature"-is the eerily attractive Botanical Specimen (FIG. 21-35). The leaves and stem of the specimen emerge vividly from the dark ground as pale and mid-grey silhouettes. Talbot added no Romantic trappings, yet the evocative qualities of his negative image create a mysterious beauty in this composition that evokes the Romantic appreciation for nature. Photogenic drawings also were valued by scientists as records of the shape and structure of objects in the natural world. However, the process was limited both by the size of the subjects it could record and by the fact that its images incorporated the texture of the paper on which they were recorded, producing a slightly blurred effect very different from the crisp detail and wide range of tones available with the daguerreotype.

In his efforts to improve on his early work, Talbot soon discovered that if he let light shine through a negative image onto another sheet of sensitized paper, the result was a positive image of the original subject. Because the negative image was separate from the positive image (unlike the daguerreotype, in which both were contained on a single plate), many

copies could be made from a single paper negative. This finding, combined with Talbot's work in latent development as it applied to paper-based photography and his incorporation of the "hypo" fixing solution (discovered by his friend, the physicist Sir John Herschel), which allowed the making of a more permanent image, led to the photographic process Talbot named the *calotype*, a term he derived from the Greek term kalos, meaning beautiful. Although the calotype image still retained a grainy and shadowy effect due to the texture of the papers used, its widespread adoption was precluded primarily by the stiff licensing and equipment fees charged for many years after Talbot patented his new process in 1841. As a result of both the look and cost of the calotype, many photographers elected to stay with the daguerreotype until photographic technology could overcome these problems.

21-35 WILLIAM HENRY FOX TALBOT, Botanical Specimen, 1839. Photogenic drawing. Royal Photographic Society, Bath, England.

21-36 DAVID OCTAVIUS HILL and ROBERT ADAMSON, Sandy Linton and His Boat and Bairns, 1843–1847. Calotype. National Portrait Gallery, London.

Two Scotsmen, DAVID OCTAVIUS HILL (1802–1870) and ROBERT ADAMSON (1821–1848) were enthusiastic proponents of the calotype process, however, and they embraced Talbot's process to capture a wide variety of Scottish and English scenes. Hill, a wellknown British painter, first contacted Adamson, who had been making calotypes since 1842, seeking help in the production of photographic studies for a monumental painting of a historic moment in the history of the Church of Scotland. Hill was to pose and arrange the subjects, while Adamson was responsible for the calotypes. This collaboration was the beginning of a partnership in which the two men extended their subject matter to encompass the calotyping of Romantic scenery and costume dramas, the major cities and monuments of Scotland, and straight genre scenes depicting the daily life of fisherfolk along the Scottish sea coast. Sandy Linton and His Boat and Bairns (FIG. 21-36) is an example of the latter classification. Linton, the fisherman, dominates the composition as he leans against his boat, slanting into the frame of the picture from the left. The lively shapes of the three children (*bairn* is Scottish for child) animate the archlike space created between Linton and his boat and provide a kind of footnote commentary on the life of their father. The scene is given to us without any particular statement about the fisherman's situation or personality. No allusion is made to anything outside the immediacy of this particular, commonplace experience, although the slight diffuseness of the calotype image might invite such symbolic insights. In the end, the scene is but a frozen moment in the life of an actual person of the 1840s, captured with all the detail and fidelity to fact that this particular photographic process could produce.

REALISM IN THE SECOND HALF OF THE CENTURY

We already have seen realism in the first half of the century, particularly in the art of Constable, and we have seen realistic images mechanically produced by the camera. Actually, realism, in different degrees of focus, has been an ingredient in Western art for centuries, from Van Eyck to Velázquez and Vermeer and beyond. The nineteenth-century kind of realism can be described technically and iconographically. Technically, realism deals with the replication of an optical field achieved by matching its color tones on a flat surface, whether or not the subject matter has or could have been seen by the artist. Iconographically, nineteenth-century Realism can be described as the subject matter of everyday, contemporary life as seen or seeable by the artist, whether recorded photographically or by other modes of visual report. The quarrel between Realism and Romanticism at midcentury was primarily over subject matter. Realists disapproved of traditional and fictional subjects on the grounds that they were not real and visible and were not of the present world. These artists argued that only the things of one's own times, the things one can see, are "real." The Realist vision and method resulted in a modern style-one, by definition, cut off from the past.

The Realist position in art and literature was strengthened by the scientific and technological achievements of the nineteenth century. Proponents of scientific positivism asserted that only scientifically verified fact was "real" and that the scientific method was the only legitimate means of gaining knowledge; all other means—religion, revelation, intuition, imagination—produced only fictions and illusions. Writing in 1892, Karl Pearson insisted confidently that "science claims for its heritage the whole domain to which the word knowledge can be legitimately applied. . . . It refuses to admit any coheirs to its possession." Modern science was indeed the most prestigious of all nineteenth-century intellectual enterprises; its authority rose from its triumphs. Its rigorous practicality and its search for the facts necessarily served as an example to artists searching for a modern truth and a modern style free from fable and fantasy. Realism stood for what the eye could see in the modern world—for actuality in all subject matter and verisimilitude in all images. Works of imagination based on subjects from myth and history were believed false.

Numerous Realist painters (foremost among them, Gustave Courbet and Édouard Manet) recorded the life of their times in factual images of it, yet their styles had little in common. At the same time, many artists embodied imaginative subject matter in strikingly realistic forms. Indeed, a dialogue between Realism and Romanticism went on throughout the century, and, although technical Realism seemed predominant during the latter half of the century, Romantic subject matter and arbitrary formal experiment persisted, and by the end of the century, appeared to carry the day for pure artistic subjectivity.

The realism of Manet, which became the realism of the Impressionists, reveals the striking paradox in Realism. To capture the entire optical field spread before them, artists must paint it just as they see it. To record this instantaneous impression, however, painters must work swiftly in a sketchlike execution that blurs the visual field as it increasingly emphasizes the brush stroke and the blot of color. The wholeness of the field disintegrates into a plurality of color functions. Scientists would say that these artists are not painting the world, but only individual sensations of it. As those sensations belong to each artist's private world, the Realist artists found that the external reality they sought so avidly was *really* determined by their own inescapable subjectivity.

Courbet and the Theme of Realism

From fragmentary observations like the following, made by JEAN DÉSIRÉ GUSTAVE COURBET (1819–1877), we get some general idea of Realism as the Realists and their friendly critics understood it.

To be able to translate the customs, ideas, and appearances of my time as I see them—in a word, to create a living art—this has been my aim. . . . The art of painting can consist only in the representation of objects visible and tangible to the painter . . . , [who must apply] his personal faculties to the ideas and the things of the period in which he lives. . . . I hold also that painting is an essentially *concrete* art, and can consist only of the representation of things

both *real* and *existing*. . . . An *abstract* object, invisible or nonexistent, does not belong to the domain of painting. . . . Show me an angel, and I'll paint one.*

Courbet has long been regarded as the father of the Realist movement in nineteenth-century art; certainly, he used the term "realism" in exhibiting his own works, even though he shunned labels. "The title of Realist," he insisted, "was thrust upon me, just as the title of Romantic was imposed upon the men of 1830. Titles have never given a true idea of things." In and since Courbet's time, confusion about what Realism is has been widespread. Writing in 1857, Champfleury, one of the first critics to recognize and appreciate Courbet's work, declared: "I will not define Realism. . . . I do not know where it comes from, where it goes, what it is. . . . The name horrifies me by its pedantic ending; . . . there is enough confusion already about that famous word." Confusion, or at least disagreement, about Realism still exists among historians of nineteenth- and, for that matter, twentieth-century art. Yet from Courbet's own brief statements, we gather that he wished to be only of his own time and to paint only what it made visible to him. Born into a wealthy family in the primarily rural area of Franche-Comté, Courbet became an anticlerical painter who took as his subjects the working-class people and ordinary landscapes around him. Although his early career was distinguished by self-portraits displaying a wildly Romantic mood, in most of his works he made a sharp break with the Tradition; all mythological, religious, and purely imaginative subjects were ruled out as not visible to the modern eye. The critic Jules Antoine Castagnary, writing in 1863, said of Courbet: "[His] great claim is to represent what he sees. It is, in fact, one of his favorite axioms that everything that does not appear upon the retina is outside the domain of painting." At this time, critics looking for an expressly modern art could find their hero in Courbet.

A man of powerful personality, Courbet was cut out to be the truculent champion of the Realist cause, defying both public taste and the art juries that rejected two of his major works for the Paris International Exhibition in 1855 on the grounds that his subjects and figures were too coarsely materialistic (so much so as to be plainly "socialistic") and too large. Plain people of the kind Courbet shows us in his work were considered by the public to be unsuitable for artistic representation and were linked in the middle-class mind with the dangerous, newly defined working class, which was finding outspoken champions in men like Marx, Engels, Proudhon, Balzac, Flaubert, Zola, and Dickens. Rejected by the exhibition jury, Courbet set up his own gallery outside the grounds, calling it the Pavilion of Realism. Courbet's pavilion and his utterances amounted to the manifestoes of the new movement. Although he maintained that he founded no school and was of no school, he did, as the name of his pavilion suggests, accept the term "realism" as descriptive of his art. With the unplanned collaboration of Millet, Daumier, and other artists, Courbet challenged the whole iconographic stock of the Tradition and called public attention to what Baudelaire termed the "heroism of modern life," which Courbet felt should replace all the heroism of traditional subject matter. For the public, it was a contest between the painters of the "ugly" (Courbet) and the painters of the "beautiful" (those who opposed Courbet), as the public understood those qualities.

Representative of Courbet's work is Burial at Ornans (FIG. 21-37), which depicts a funeral in a bleak, provincial landscape, attended by obscure persons "of no importance," the type of people presented by Balzac and Flaubert in their novels. While an officious clergyman reads the Office of the Dead, those in attendance cluster around the excavated gravesite, their faces registering all degrees of response to the situation. Although the painting has the monumental scale of a traditional history painting, contemporary critics were horrified not only by the ordinariness of the subject matter, but also by the starkly antiheroic composition. Arranged in a wavering line extending across the broad width of the canvas, the figures are portrayed in groups-the somberly clad women at the back right, a semicircle of similarly clad men by the open grave, and assorted churchmen at the left. The observer's attention, however, is wholly on the wall of figures, seen at eye-level, that blocks any view into deep space. The faces of the figures are portraits; some of the models were friends of Courbet. Behind and above the figures are bands of overcast sky and barren cliffs. The dark pit of the grave opens into the viewer's space in the center foreground. Despite the unposed look of the figures (which in conjunction with the cut-off figures at the edges of the canvas, may owe something to Courbet's interest in photography), the artist controlled the composition in a masterful way by his sparing use of bright color. Patches of white carry the eye across the bank of figures. The strong red of the clerics' cassocks appears in the caps and skirts of the acolytes to the left; the red is then countered by its complement in the green-blue stockings of the mourner whose hand is extended toward the grave. The long, narrow rectangle of the canvas has something of the panoramic effect embraced by Cole and Martens; the viewer's eye cannot take in the

^{*}In Robert Goldwater and Marco Treves, eds., *Artists on Art*, 3rd ed. (New York: Pantheon, 1958), pp. 295–97.

(21-37) JEAN DÉSIRÉ GUSTAVE COURBET, Burial at Ornans, 1849. Approx. $10' \times 22'$. Louvre, Paris.

whole with one glance but must scan across the composition from group to group. The heroic, the sublime, and the terrible are not found here—only the drab facts of undramatized life and death. In 1857, Champfleury wrote of *Burial at Ornans*, ". . . it represents a small-town funeral and yet reproduces the funerals of *all* small towns." Unlike the superhuman or subhuman actors on the grand stage of the Romantic canvas, this Realist work moves according to the ordinary rhythms of contemporary life.

Beyond his new subject matter, Courbet's intentionally simple and direct methods of expression in composition and technique seemed to many of his more traditional contemporaries to be unbearably crude, and he was called a primitive. Although his bold, somber palette was essentially traditional, Courbet often used the palette knife, with which he could quickly place and unify large daubs of paint, producing a roughly wrought surface. His example inspired the young men who worked with him (and later Impressionists like Claude Monet and Auguste Renoir), but the public accused him of carelessness and critics wrote of his "brutalities."

Although often embattled with critics over the spirit and form of Realism, Courbet had secure official backing from the late 1850s onward, and, in his later years, painted with greater intention to please the public. Indeed, the mode of these later pictures recalls traditional methods, with dark underpainting, heavy chiaroscuro, and subject matter familiar in the popular Salon. This conservatism disappointed younger artists who had come to rely strongly on Courbet's vigorous style and technique, as well as on his courageous individualism. Most of the Impressionists had associated and exhibited with him in their early years, but Courbet failed to catch the spirit of the new style that was emerging in their work. Despite this, neither the Impressionists, nor history itself, could deny the impetus Courbet's art had given the movement toward a modern style based on observations of the modern environment.

Where Courbet favored heavy paint, a dark palette, and a style in which he simplified details into planes of color, JEAN BAPTISTE CAMILLE COROT (1796–1875) achieved a cooler Realist style. In Corot's *The Harbor of La Rochelle* (FIG. **21-38**), we can see his interest in the full tonal spread—the careful arrangement of dark and light values—which the new medium of photography was achieving automatically. Corot's method was to be as faithful as possible to the scale of light to dark. His procedure was interesting. He wrote in his notebooks:

The first two things to study are form and values. For me, these are the bases of what is serious in art. Color and finish put charm into one's work. In preparing a study or a picture, it seems to me very important to begin by an indication of the darkest values . . . and continue in order to the lightest value. From the darkest to the lightest I would establish twenty shades.

In Corot's *Harbor*, we can appreciate these careful gradations of tone. The forms in the work are thoughtfully placed, and the general ordering of them recalls the landscape tradition of Nicolas Poussin (FIG. 19-61). Indeed, Corot employed such a firm definition of the forms and such gradation of the half-tones that he was said to "Ingres-ize" the landscape. Both Constable and Corot point toward the Impressionists, but in different ways. Constable foreshadows their work in his brilliant freshness of color and

JEAN BAPTISTE CAMILLE COROT, The Harbor of La Rochelle, 1851. Approx. 20" × 28". Yale University Art Gallery, New Haven, Connecticut (bequest of Stephen Carlton Clark, B.A., 1903).

(21-39) JEAN FRANÇOIS MILLET, The Gleaners, 1857. Approx. $33'' \times 44''$. Louvre, Paris.

divided brush stroke, while Corot prefigures their concerns for the rendering of outdoor light and atmosphere in terms of values.

Corot painted in close association with members of the "Barbizon school," a group of landscape and figure painters who settled near the village of Barbizon in the forest of Fontainebleau. The objective, carefully realistic landscapes of many of the painters of the Barbizon school, like Théodore Rousseau, Charles François Daubigny, and Narcisse Virgile Diaz, will powerfully influence the Impressionists and Post-Impressionists. However, the work of one of the chief Barbizon painters, JEAN FRANÇOIS MILLET (1814–1875), exemplified a different Realist intent. Of peasant stock himself, Millet took the humble country folk of France as his subjects. In *The Gleaners* (FIG. **21-39**), done in 1857, he characteristically posed three toiling female peasants as monumental figures

(21-40) ROSA BONHEUR, The Horse Fair, 1853. 8' $\frac{4}{4}$ " × 16' $7\frac{1}{2}$ ". The Metropolitan Museum of Art, New York (gift of Cornelius Vanderbilt, 1887).

in the foreground of a harvested field that stretches back to a rim of haystacks, cottages, trees, and distant workers near the horizon. The quiet design of Millet's painting shares the careful arrangement and calm mood of Corot's *Harbor*, but Millet's emphasis was on the figures; everything in the composition accents his scrupulous truth of detail and contributes to the dignity he gave to even the simplest rural tasks. The solemn grandeur with which Millet invested the poor caused him to be identified with a kind of socialism that was prevalent at the time he was painting. Actually, this socialist movement was a late echo of Enlightenment and Romantic intuition, held by such men as Jean Jacques Rousseau and Wordsworth, which found a touch of nobility in the humblest lives.

Courbet, Corot, and Millet depicted quiet moments in everyday life. Many French Realist artists, however, Rosa BONHEUR (1822–1899) among them, chose more naturally dramatic subjects for their work. Trained as an artist by her father, Bonheur founded her career on his belief that, as a woman and an artist, she had a special role to play in creating a new and perfect society. In her work, she combined a naturalist's knowledge of equine anatomy and motion with an honest love and admiration for the brute strength of wild and domestic animals. Driven by a Realist passion for accuracy in her painting, she observed the anatomy of living horses at the great Parisian horse fair, where the animals were shown and traded, and also spent long hours studying the anatomy of car-

casses in the Paris slaughterhouses. For her bestknown work, The Horse Fair (FIG. 21-40), she adopted a panoramic composition similar to that in Courbet's Burial at Ornans, painted a few years earlier. In contrast to the still figures in Burial, Bonheur filled her broad canvas with the sturdy farm animals and their grooms seen on parade at the annual Parisian horse sale. Some horses, not quite broken, rear up; others plod or trot, guided on foot or ridden by their keepers. The uneven line of the march, the thunderous pounding, and the seemingly overwhelming power of the Percherons were clearly based on close observations from life, even though Bonheur acknowledged some inspiration from the Classical model of the Parthenon frieze (FIG. 5-49). The dramatic lighting, loose brushwork, and roiling sky also reveal her admiration of the style of Géricault. Bonheur's depiction of Realist drama in The Horse Fair captivated viewers, who eagerly bought engraved reproductions of the work, making it one of the most well known paintings of the century.

Variations of Form in Realism

Although French artists took the lead in promoting Realism, lending especially strong support to the idea that Realism should be the depiction of the realities of modern life, Realism was not exclusively French. Often influenced by the appearance of photography and almost always inspired by the optical truth of the physical world, Realism appeared in all countries in a variety of forms and was taken for granted by the end of the century.

In the United States, a dedicated appetite for showing the realities of the human condition made THOMAS EAKINS (1844–1916) a master Realist portrait and genre painter. Eakins studied both painting and medical anatomy in Philadelphia before undertaking further study under Jean-Léon Gérôme (FIG. 21-60). Despite three years of study with Gérôme in Paris, Eakins turned out to have little of the Romantic in him. Instead, he was resolutely a Realist; his ambition was to paint things as he saw them rather than as the public might wish them to be portrayed. This attitude was very much in tune with nineteenth-century American taste, which was said to combine an admiration for accurate depiction with a hunger for truth. These twin attributes are reflected in Ralph Waldo Emerson's observation that "Our American character is marked by a more than average delight in accurate perception," and in Henry David Thoreau's declaration: "Let us not underrate the value of a fact. It will one day flower in a truth."

Eakins's early masterpiece, The Gross Clinic (FIG. 21-41), was rejected for its too-brutal Realism by the art jury for the exhibition in Philadelphia that celebrated the centennial of American independence. The work represents the renowned surgeon Dr. Samuel Gross in the operating amphitheater of the Jefferson Medical College in Philadelphia, where the painting now hangs. The surgeon is accompanied by colleagues, all of whom have been identified, and by the patient's mother, who covers her face. Dr. Gross, with bloody fingers and scalpel, lectures on his procedure. The painting is indeed an unsparing description of a contemporary event, with a good deal more reality than many viewers could endure: "It is a picture," said one critic, "that even strong men find difficult to look at long, if they can look at it at all." True to the program of "scenes from modern life," Eakins put the surgeon in the context of his business, as Southworth and Hawes had done in their daguerreotype of a similar setting (FIG. 21-34). Each image records a particular event at a particular time.

Like Constable before him, Eakins believed that knowledge—and where relevant, *scientific* knowledge—was a prerequisite to his art. As a scientist (in his anatomical studies), Eakins preferred a slow, deliberate method of careful invention based on his observations of the perspective, the anatomy, and the actual details of his subject. His concern for anatomical correctness led him to investigate the human form and the human form in motion, both with regular photographic apparatus and with a special camera devised by the French kinesiologist (scholar of mo-

THOMAS EAKINS, The Gross Clinic, 1875. $8' \times 6'$ 6". Jefferson Medical College, Philadelphia.

tion) Étienne-Jules Marey. Eakins's later collaboration with Eadweard Muybridge in the photographic study of animal and human action of all types drew favorable attention in France, especially from Degas, and anticipated the motion picture.

The Realist photographer and scientist EADWEARD MUYBRIDGE (1830-1904) came to the United States from England in the 1850s and settled in San Francisco, where he established a prominent international reputation for his photographs of the western United States. (His large-plate landscape images of the Yosemite region won him a gold medal at the Vienna Exposition of 1873.) In 1872, the governor of California, Leland Stanford, sought Muybridge's assistance in settling a bet about whether, at any point in a stride, all four feet of a horse galloping at top speed are off the ground. Through his photography, Muybridge was able to prove that they were. This experience was the beginning of Muybridge's photographic studies of the successive stages in human and animal motion-detail too quick for the human eye to capture. These investigations culminated in 1885 at the University of Pennsylvania with a series of multiplecamera motion studies that recorded separate photographs of each progressive moment in a single action.

(21-42) EADWEARD MUYBRIDGE, Hand-spring, a flying pigeon interfering, June 26, 1885, Plate 365 of Animal Locomotion, 1887. Print from original master negative. International Museum of Photography at George Eastman House, Rochester, New York.

The results of this research were widely publicized in Muybridge's book Animal Locomotion (1887). Handspring, a flying pigeon interfering (FIG. 21-42) is a typical plate (No. 365) from the book. Taken with two batteries of cameras placed at right angles to one another, this photograph combines the side and front views of the successive instants in an athletic stunt. At the top is the series of twelve images shot from the side view, split into two rows to match in width the twelve narrower front views that are spread across the bottom. With our Western habit of reading type in books, we begin at the upper left and scan along the top two rows to reconstruct the hand-spring, perhaps wondering as we do so where the pigeon mentioned in the title comes in. The drama is revealed at the bottom, where we see the strolling pigeon startled into flight as the hand-spring unfolds, almost upsetting the athlete in the process. Muybridge's motion photographs earned him a place in the history of science as well as art. His sequential studies of motion, along with those of Eakins and Marey, influenced many other artists, including their contemporary, the painter and sculptor Edgar Degas, and twentiethcentury artists like Marcel Duchamp.

Muybridge presented his work to scientists and general audiences by means of a device called the *zoopraxiscope*, which he invented to project his sequences of images (mounted on special glass plates) onto a screen. The effect was so lifelike that one viewer said it "threw upon the screen apparently the living, moving animals. Nothing was wanting but the clatter of hoofs upon the turf."* The illusion of motion here was created by a physical fact of human eyesight called "persistence of vision," which, stated simply, means that whatever the eye sees is held in the brain for a fraction of a second after the eye stops seeing it, causing a rapid succession of different images to merge one into the next and producing the illusion of continuous change.⁺ This illusion lies at the heart of the "realism" of all cinema.

The expatriate American artist JOHN SINGER SARGENT (1856–1925) was a younger contemporary of Eakins and Muybridge. In contrast to Eakins's carefully rendered details, Sargent developed a looser, more dashing Realist portrait style. Sargent studied art in Paris before settling in London, where he was

^{*}Scientific American, May 1880, cited in Kenneth MacGowan, Behind the Screen (New York: A Dell Book, Delta Publishing Co., 1965), p. 49.

^tNews of Muybridge's zoopraxiscope spread rapidly. One interested person was the inventor Thomas Alva Edison, who had just perfected the phonograph and wanted to add sound to Muybridge's moving images. Edison and his assistant, William Kennedy Laurie Dickson, eventually developed a true motionpicture camera (patented in 1891) that used strips of photographic film newly invented by George Eastman. Innovations such as these helped lay the foundations of the art of cinema.

renowned as a cultivated and cosmopolitan gentleman, and as a facile and fashionable painter of portraits. His fluent brushing of paint in thin films and his effortless achievement of quick and lively illusion were learned from his study of Velázquez, whose masterpiece, Las Meninas (FIG. 19-38), may have influenced Sargent's family portrait, The Daughters of Edward Darley Boit (FIG. 21-43). The four girls (the children of one of Sargent's close friends) are grouped casually within a hall and small drawing room in their Paris home. The informal, eccentric arrangement of their slight figures suggests how much at ease they are within this familiar space and with objects like the monumental Japanese vases, the red screen, and the fringed rug, whose scale subtly emphasizes the diminutive stature of the children. Sargent must have known the Boit daughters well and liked them. Relaxed and trustful, they gave the artist an opportunity to record a gradation of young innocence in which he sensitively captured the naïve, wondering openness of the little girl in the foreground, the grave artlessness of the ten-year-old child, and the slightly selfconscious poise of the adolescents. From the positioning of the figures and the continuity of the space of hall and drawing room (conveyed by the lighting), we sense how spontaneously they function within this setting. They seem to be attending momentarily to an adult who has asked them to interrupt their activity and "look this way." Here is a most effective embodiment of the Realist belief that the business of

(21-43) JOHN SINGER SARGENT, The Daughters of Edward Darley Boit, 1882. 7' 3" × 7' 3". Museum of Fine Arts, Boston (gift of Mary Boit, Florence D. Boit, Jane H. Boit, and Julia O. Boit, in memory of their father).

the artist is to record the modern being in modern context. Through devices like the cut-off vase and rug, we see the beginnings of the way in which Realist painters increasingly will move into the space of their works, regulating the distance of the artist's (and viewer's) standpoint from the objects represented, so that the action and environment in the painting seem one with those outside it.

As Realism spread throughout the world, Realist artists expanded and diversified their subject matter to embrace all classes and levels of society, all types of people and environments: the urban and rural working class, the denizens of the big city, the burghers of the small town, the leisure class at its resorts, the rustics of the provinces. Added to the social sympathies we found in Daumier, Courbet, and Millet were motives of an anthropological kind, reflecting interest in national and regional characteristics, folk customs and culture, and the quaintness and picturesqueness of local color. WILHELM LEIBL (1844–1900), perhaps the most important German Realist painter in the later nineteenth century, is a master of the quaint and picturesque detail of country life. Influenced by Courbet, but lacking his breadth and depth, Leibl exemplified the Realist credo. His masterpiece, Three Women in a Village Church (FIG. 21-44), is the record of a sacred moment—the moment of prayer—in the life of three country women of different generations. Dressed in rustic costume, their Sunday best, they pursue their devotions unselfconsciously, their prayer books held in big hands roughened by work. Their manners and their dress proclaim them innocent of the affectations and refinements of the metropolis, which they probably have never seen. Leibl chose to show their natural virtues: simplicity, honesty, steadfastness, patience. He could subscribe, doubtless, to the words of a poet from another country and another time: "Far from the madding crowd's ignoble strife / . . . / they kept the noiseless tenor of their way."* Leibl himself wrote in a letter: "Here in the open country and among those who live close to nature, one can paint naturally." For three years, he worked from his peasant models in the little church, often under impossible conditions of lighting and temperature. The light in Three Women is hard and neutral, without cast shadows and with only the slightest modeling. The focus is sharp, the forms and space flattening out into pattern. We are aware of the documentary power of the photograph-like approach. Yet, for all its objectivity, the picture is a moving expression of the artist's intelligent sympathy for his subjects, a reading of character without a trace of sentimentality, rare for a subject like this.

*Thomas Gray, Elegy Written in a Country Churchyard.

21-44 WILHELM LEIBL, Three Women in a Village Church, 1878–1881. Approx. 29" × 25". Kunsthalle, Hamburg.

Unlike the literature of nineteenth-century Russia, which has received a great deal of attention, nineteenth-century Russian art has been little known outside the Soviet Union. The Realist impulse was prized in Russia, and the painting A Religious Procession in the Kursk District (FIG. 21-45), by ILYA REPIN (1844–1930), is a Realist work of extraordinary power. Simultaneously drama and document, this work makes us witness to a dense throng of people traveling along a road past us. They move in measured procession behind a shrine carried on the shoulders of monks, and beneath religious banners held proudly on high. Priests, peasants, burghers, students, soldiers, police, provincial officials, and bureaucrats all join in this homage to a saint on his feast day. Alongside the procession straggle beggars and cripples, perhaps hoping for a healing miracle. It is a multitude that, in itself, characterizes the society of "Holy Russia" before the revolutions of the twentieth century. The throng tramps along a country road, raising clouds of dust in the heat of noon as it crosses a featureless Russian landscape where trees recently have been hacked down. Closer inspection reveals two files of mounted riders-some in uniform, some priestly in appearance-coming slowly forward through the crowd. Their way is being cleared by men who savagely ply whips and cudgels to open a path. In the left foreground, a boy on a crutch has just been struck heavily with a staff wielded by the priest behind him. We can read in the crowded details of Repin's Procession the sullen poverty and misery of the people; the dogged, almost primitive religion; the

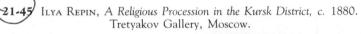

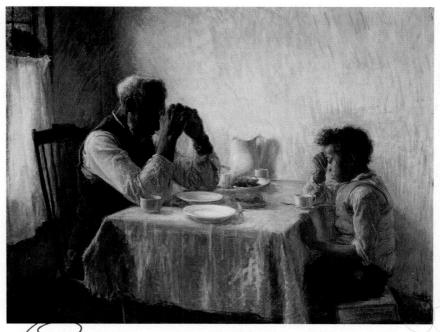

21-46 HENRY OSSAWA TANNER, The Thankful Poor, 1894. $49'' \times 35\frac{1}{2}''$. Private collection of William and Camille Cosby.

officious arrogance; and the pitiless harshness of the old Russian scene. These elements are much as they have been described in the novels of Dostoevsky (*Procession* and *The Brothers Karamazov* are contemporaneous works). One need suspect no interinfluence; painter and novelist are simply confronting the same realities.

Repin's painting expanded the program of Realism formulated in his time. It was a scene taken directly from modern life, at a particular place and time, objectively recorded with little of the artist's comment, unless it be a touch of sad irony or protest. The artist reconstructed the scene using his acute visual memory. He may have used sketches but certainly portrayed the event close to the way he saw it, in a manner similar to Eakins's method. The space is fluent and is assumed to continue, along with the action, beyond the frame. The light is out-of-doors, rather than of the studio, and the color, with its myriad modulations and accents, is suited to the time of day and the local color of landscape and costume.

Repin's crowd scene is unusual for Realist painting, which more often emphasized the dignity of individuals. Typical of the Realist painter's desire to depict the lives of ordinary people is the early work of the American artist HENRY OSSAWA TANNER (1859– 1937). Tanner studied art with Eakins before moving to Paris, where he combined Eakins's belief in careful study from nature and reverence for the light and mood in Rembrandt's portraiture with a desire to portray with dignity the life of the ordinary people

among whom he had been raised as the son of an African-American minister in Pennsylvania. The mood of quiet devotion in The Thankful Poor (FIG. 21-46) is as intense as that in Leibl's Three Women in a Village Church (FIG. 21-44), but Tanner's lighting is softer (more Rembrandtesque) and his style incorporates a selective focus different from, but linked to the Realism of Millet (FIG. 21-39) and to photography. In Tanner's painting, the grandfather, grandchild, and main objects in the room are painted with the greatest detail, while everything else dissolves into loose strokes of color and light that owe something to Impressionism but here remain more tied to the surfaces of things. Expressive lighting reinforces the reverent spirit of the painting, with deep shadows intensifying the devout concentration of the man and golden light pouring in the window to illuminate the quiet expression of thanksgiving on the younger face. The deep sense of sanctity that is expressed here in terms of everyday experience became increasingly important for Tanner. Within a few years of completing The Thankful Poor, he was painting only biblical subjects, seen in his imagination but still grounded in direct study from nature and the love of Rembrandt that had inspired him from his days as an art student in Philadelphia.

A very different mood fills *The Fox Hunt* (FIG. **21-47**) by Tanner's contemporary, WINSLOW HOMER (1836–1910), a leading American painter. Homer began his career making newspaper illustrations of daily life and went on to become famous for his paintings of

21/47 WINSLOW HOMER, *The Fox Hunt*, 1893. $38'' \times 68^{1''}_2$. The Pennsylvania Academy of the Fine Arts, Philadelphia (Joseph E. Temple Fund).

unspoiled nature—especially the turbulent sea—and of individual human beings caught up in the natural world. Fox Hunt is rare among his works, both for its subject and for its composition. A fox, bogged down in heavy winter snow, is attacked by crows made fierce by starvation. The fox is trapped and its fate is certain. The figure of the fox is silhouetted against the flat white of the snowy ground; above, the dark shapes of the crows fill the sky, overshadowing and overwhelming the fox. Homer's method is objective and simple, conveying with Realist directness the mood of struggle and death in nature. Form and color convey the grim mood of the scene in reinforcement of what the images literally depict. The artist is "present" but powerless to intervene. In any event, this is a fact of nature. The color areas are sharp-edged and icy cold, except for the faintly warm tonality of the fox's coat and the spangle of red berries against the snow. The broad, short rectangle of the composition presents a low, panoramic view similar to that in Courbet's Burial at Ornans or Bonheur's Horse Fair, but Homer has filled most of his picture with the field of white snow, which pushes the action of fox and crows so close to the foreground (and the space of the viewer) that parts of the bodies of the leading attackers are cut off by the frame. This spacing emphasizes the double irony of the title: in the uneasy world of man and nature, where a fox is often hunted by mounted human beings for sport, it is now hunted by hungry crows in a morbid reversal of the process of nature that usually finds the fox hunting birds for food. In this work, Homer expressed with Realist intensity the impersonal, cruel competition of natural species asserted as a rule of life in the Darwinian-Spencerian theory of the survival of the fittest.

PHOTOGRAPHY

The Realist approach to art affected all media. Even in photography, a medium that could so effortlessly record the details of a subject, photographic artists sought to explore the new medium thoroughly and struggled to achieve its fullest expression. They often took their lead from painting, trying to combine the wonder of photographic details recorded directly from nature with the kind of control over composition and mood achieved by Realist painters.

The French photographer GUSTAVE LE GRAY (1820– 1862), like his contemporary Rosa Bonheur, sought to portray the drama, as well as the reality, of everyday scenes. Having trained as a painter before becoming a photographer, Le Gray brought his painterly eye to his photographs of still lifes, cityscapes, and landscapes. He is best known, however, for seascapes topped with awe-inspiring, cloud-filled skies. The mood of *Seascape and Rough Waves* (FIG. **21-48**) was inspired by Constable's landscape paintings, which Le Gray admired, and also recalls the Baroque glimpse of the infinite universe found in paintings by Van Ruisdael, like *View of Haarlem from the Dunes at Overveen* (FIG. 19-56). The stirring play of light through the

(21-48) GUSTAVE LE GRAY, Seascape and Rough Waves, 1856. Albumen print, $13\frac{17}{2} \times 16\frac{17}{2}$. The J. Paul Getty Museum, Malibu.

heavens and across the water and beach in *Seascape* was not as easy to record as it might look today. Struggling to overcome the blank, lackluster skies caused by the limited exposure range of the calotype process he used, Le Gray devised a method of making a single print by combining a waxed-paper negative (which captured nuances of light and shadow better than a plain paper negative) of the terrestrial regions with a separate negative of the sky. Viewers were enthralled by the way these photographs captured the spectacular effects of backlit clouds and sun-speckled sea, and Le Gray's work won wide acclaim from both art critics and members of the public.

Perhaps the person most determined to prove that photographers could exercise as much expressive control over their medium as painters could over theirs was the British photographer HENRY PEACH ROBINSON (1830–1901), who brought to his work with the camera his experience as a painter and printmaker. Although Robinson earned his living as a portrait photographer almost from the moment he opened his studio in 1852, he felt that his most serious works were his "art photographs," of which he made at least one each year. He planned these photographs with great care,

to set forth the laws which govern—as far as laws can be applied to a subject which depends in some measure on taste and feeling—the arrangement of a picture, so that it shall have the greatest amount of pictorial effect, and to illustrate by examples those broad principles without regard to which imitation, however minute or however faithful, is not picturesque, and does not rise to the dignity of art.*

To accomplish all of this with camera equipment required dedication and skill. For each of his art photographs, Robinson began with a pencil sketch of the final work. For complex compositions, he made a composite print from many negatives; for simpler arrangements, he posed models in a specially constructed theatrical setting in his studio. The scene in Women and Children in the Country (FIG. 21-49) was inspired by genre paintings of middle-class people in contemporary dress enjoying themselves on an outing in the country (a subject that would shortly become a favorite with the Impressionists). For this print, Robinson posed each of the three groups of figures separately to fit the design in his preliminary sketch, and he may have taken a separate negative of the background trees as well. From his individual prints, he cut out the desired details, pasted them on a study sketch (FIG. 21-50), and rephotographed the whole for a final presentation print. To many of his contemporaries, Robinson proved that a photographer could be just as inventive as a painter; as one

*In Beaumont Newhall, *The History of Photography* (New York: The Museum of Modern Art, 1982), p. 76.

21-49 HENRY PEACH ROBINSON, Women and Children in the Country, 1860. Gelatin silver print. International Museum of Photography at George Eastman House, Rochester, New York.

21-50 HENRY PEACH ROBINSON, study for a composite picture, 1860. Sketch of a woman and children with a gelatin silver print insert. Gernsheim Collection, Harry Ransom Humanities Research Center, The University of Texas at Austin.

critic said of him: "The photographer artist does no more than the Royal Academician does; he makes each figure an individual study, and he groups those separate 'negatives' together to form a complete positive picture."*

*Art Journal review, in Aaron Scharf, Art and Photography (Baltimore: Penguin, 1968), p. 109.

Another Englishman, DR. PETER HENRY EMERSON (1856–1936), took a somewhat different approach to establishing photography as a Realist art medium. Influenced by his early study of medicine and science, Emerson equated photography with science and argued that true photographic art represented only what the human eye saw, an idea he based on

21-51 DR. PETER HENRY EMERSON, Gathering Water Lillies from the album Life and Landscape of the Norfolk Broads, 1886. Platinum print, $7\frac{34''}{4} \times 11\frac{12''}{4}$. Collection, The Museum of Modern Art, New York (given anonymously).

Hermann von Helmholtz's Handbook of Physiological Optics. Emerson published his theories in a widely influential treatise, Naturalistic Photography for Students of the Art (1889), and illustrated them in photographs, like those in Life and Landscape of the Norfolk Broads (1886), which depicted the life of working people in the marshy lands of eastern England. Both the subject matter and composition of Gathering Water Lilies (FIG. 21-51) were patterned after the peasant paintings by Millet, which Emerson greatly admired. In Emerson's image, as in Millet's Gleaners, our gaze is drawn to the workers and their task, both by their placement in the center foreground of an open landscape and by the graduated or differential focus, which shows everything in the foreground clearly while everything else is less distinct. Emerson believed that this differential focus mimicked the way the human eye actually sees and that photographers should imitate it carefully:

A picture . . . should be made just as sharp as the eye sees it and no sharper, for it must be remembered that the eye does not see things as sharply as the photographic lens. . . . The chief point of interest should be slightly—very slightly—out of focus, while all things out of the plane of the principal object . . . should also be slightly out of focus, not to the extent of producing destruction of structure or fuzziness, but sufficiently to keep them back and in place.* Emerson's ideas about selective focus influenced the work of the so-called Pictorialist photographers at the end of the nineteenth century, but their style was based on an overall soft focus that so horrified Emerson that he eventually repudiated his early ideas about photographic art in favor of the belief that photography could never be anything but a tool for science.

As might be expected, the Realist impulse inspired a widespread interest in portraiture, which had been a high art form in painting and sculpture throughout the ages for those who could afford it. Now photography made portraits available to ordinary men and women. Photographic portraits were not only less expensive, but they required much less of the sitter's time and were readily available (especially after the invention of the negative photographic processes) through the host of portrait studios that had sprung up everywhere. Portraiture was an important economic component in the work of most photographers, as we have seen with Daguerre, Southworth and Hawes, and Hill and Adamson, but the greatest of the early portrait photographers was undoubtedly the Frenchman Gaspard Félix Tournachon (1820-1910), who adopted the name NADAR for his professional career as novelist, journalist, enthusiastic balloonist, and caricaturist. Photographic studies for his caricatures, which followed the tradition of Daumier's most satiric lithographs (not illustrated), led Nadar to open a portrait studio. So talented was he at capturing the essence of his subjects that the most

^{*}In Vicki Goldberg, *Photography in Print* (New York: A Touchstone Book, Simon & Schuster, 1981), p. 194.

21-52 NADAR (Gaspard Félix Tournachon), Sarah Bernhardt, 1859. Woodburytype. Bibliothèque Nationale, Paris.

important people in France, including Daumier, Courbet, and Manet, flocked to his studio to have their portraits made. Nadar said he sought in his work "that instant of understanding that puts you in touch with the model-helps you sum him up, guides you to his habits, his ideas, and character and enables you to produce . . . a really convincing and sympathetic likeness, an intimate portrait."* Nadar's skill in the genre can be seen in Sarah Bernhardt (FIG. 21-52), one of a series of portraits he did of this famous actress. In this photograph, the actress appears with remarkable presence; even in half-length, her gestures and her expression create a revealing mood that seems to tell us much about her. Perhaps Bernhardt responded to Nadar's famous gift for putting his clients at ease by assuming the pose that best expressed her personality. The rich range of tones in Nadar's images was made possible by new photographic materials. The glass negative and albumen printing paper could record finer detail and a wider range of light and shadow than Talbot's calotype process, and the Woodburytype process produced grainless, permanent, nonsilver positive prints. In Sarah

*In Naomi Rosenblum, A World History of Photography (New York: Abbeville Press, 1984), p. 69.

Bernhardt, as in all his portraits, Nadar used lighting and composition to place the emphasis on the face; the effect may remind us of both Rembrandt's Self-Portrait (FIG. 19-51) and Ingres's Granet (FIG. 21-15). Unlike these painters, however, Nadar had to capture everything within his composition at the time he exposed his negative, and it was this direct impression from nature that amazed his contemporaries and continues to fascinate us today. The veracity of Nadar's portraits was recognized by Ingres, who sent some clients to have their photographic portraits taken as studies for his paintings. While Nadar had a scientific bent as well as an artistic one-he took the first aerial photographs (from a balloon) and some of the first photographs illuminated with flash powder (in the catacombs of Paris)—it was as a portraitist that he influenced most strongly the painters and photographers who came after him.

Nadar's portraits of celebrities were made for the sitter and perhaps a few friends. Soon, however, in response to a growing desire on the part of the public for copies of photographs of celebrities, several methods for creating mass-produced prints were invented. One such product—the carte de visite (visiting card) photograph—was invented in Paris in 1854 by André-Adolphe-Eugène Disdéri (1819–1889). Disdéri used a camera with four lenses and a special sliding plate-holder that allowed him to take eight or ten separate photographs on a single negative, with the sitter either holding one pose for all images or changing poses between exposures. A print of the whole negative could then be cut into individual pictures. The individual pictures were mounted on a card the size of the standard calling card, although few of these prints were probably ever used for calling cards. Instead, as each could be sold separately and inexpensively, a craze for collecting carte de visite images of famous people swept Europe and the United States. Princess Buonaparte-Gabrielli (FIG. 21-53) is an example of an uncut sheet of carte de visite photographs. The princess assumed five different poses, which present an intriguing sequence suggestive of her daily activities. Clues to her personality are evoked by her dress, her body language, and the props around her. Political leaders immediately saw the value of carte de visite photographs in building and reinforcing their public personae; Abraham Lincoln credited a carte de visite portrait taken of him by the American photographer Matthew Brady with having helped him win his first term of office as president of the United States. The low cost of carte de visite portraits and their slice-of-life quality made them the darling of the masses as well. Disdéri's work here can be seen as a Realistic portrait of aristo-

21-53 ANDRÉ-ADOLPHE-EUGÈNE DISDÉRI, Princess Buonaparte-Gabrielli, uncut sheet of carte de visite portraits, c. 1862. Albumen print, $7\frac{7}{16}'' \times 9\frac{5}{16}''$. Gernsheim Collection, Harry Ransom Humanities Research Center, The University of Texas at Austin.

cratic life; however, the carefully posed series of shots in works like *Princess Buonaparte-Gabrielli* is very different from the literal motion sequences that would be captured within a few years by Eadweard Muybridge (FIG. 21-42).

SCULPTURE

The three-dimensional art of sculpture was not readily adaptable to the optical realism favored by many painters and the public. Sculpture, by its very nature, occupies the same physical space as the viewer—it is palpably very much *there*. As art, traditionally, it has turned toward emphasizing a sense of its permanence as an enduring form. The timeless ideal, not the evanescent real, best suits it.

In the work of the French artist AUGUSTE RODIN (1840–1917), however, Realism found its sculptural counterpart and regained the artistic preeminence it had lost to the pictorial media in the nineteenth century. Primarily a Realist by impulse, Rodin ably assimilated and managed the century's other concurrent esthetic styles—Romanticism, Impressionism, and Symbolism, generating in the process a unique personal style that anticipated twentieth-century Expressionism. Avoiding the stilted formulas of the

Academy, Rodin looked carefully, as would Carpeaux (FIG. 21-63), at the sculpture of Michelangelo and Pierre Puget (FIG. 19-72), learning from them to appreciate the unique possibilities of the human body for emotional expression. Rodin wanted to express the "existential situation of modern man, his inability to communicate, his despair." His goal, as he put it, was "to render inner feelings through muscular movement." He achieved this aim by joining his profound knowledge of anatomy and movement with special attention to the body's surfaces, saying, "The sculptor must learn to reproduce the surface, which means all that vibrates on the surface, soul, love, passion, life. . . . Sculpture is thus the art of hollows and mounds, not of smoothness, or even polished planes." Primarily a modeler of pliable material rather than a carver of hard wood or stone, Rodin worked his surfaces with fingers sensitive to the subtlest variations of plane, catching the fugitive play of living motion as it changed fluidly under light, a kind of "expressionist realism." Like Muybridge and Eakins, Rodin was fascinated by the human body in motion. Often in his studio, he would have a model move around in front of him, while he modeled sketches with coils of clay. Walking Man (FIG. 21-54)

 21-54 AUGUSTE RODIN, Walking Man, 1905. Bronze, 83³//
 high. Hirshhorn Museum and Sculpture Garden, Smithsonian Institution, Washington, D.C. (gift of Joseph H. Hirshhorn, 1966). was the first major sculpture in which he captured the sense of a body in motion. Headless and armless, the figure is caught in mid-stride at the moment when weight is transferred across the pelvis from the back leg to the front. As with many of his other early works, Rodin executed Walking Man with such careful attention to details of muscle, bone, and tendon, that it is filled with forceful reality, despite the sketchy modeling of the torso. Rodin conceived this figure as a study for his sculpture of St. John the Baptist Preaching, part of the process by which he built his conception of how the human body would express the symbolism of the larger theme. Similarly, he made many nude and draped studies for each of the figures in the life-size group Burghers of Calais (FIG. 21-55). This monument was commissioned to commemorate a heroic episode in the Hundred Years' War, in which, during the English siege of Calais in 1347, six of the city's leading citizens agreed to offer their lives in return for the English king's promise to lift the siege and spare the rest of the populace. Each of the individual figures is a convincing study of despair, resignation, or quiet defiance. The psychic effects were achieved through the choreographic placement of the members of the group and through the manipulation of a few simplified planes in each figure, so that the rugged surfaces catch and disperse the light. Rodin designed the monument without the traditional high base in the hope that modern-day citizens of Calais

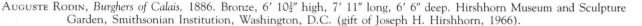

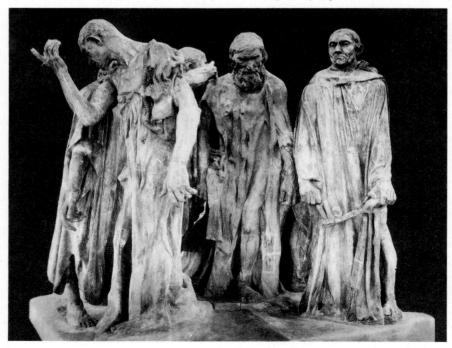

would be inspired by the sculptured representations of their ancestors standing in the city center and preparing eternally to set off on their sacrificial journey. The government commissioners found the Realism of Rodin's vision so offensive, however, that they banished the monument to an out-of-the-way site and modified the impact of the work by placing it high on an isolating pedestal.

Many of Rodin's projects were left unfinished or were deliberate fragments. Seeing the esthetic and expressive virtue of these works, modern viewers and modern sculptors have developed a taste for the way in which the sketch, the half-completed, the fragment, and the vignette lifted out of context, all have the power of suggestion and understatement. Rodin's *Balzac* (FIG. **21-56**) carries out the method on a

21-56 AUGUSTE RODIN, *Balzac*, 1892–1897. Plaster, approx. 9' 10" high. Musée Rodin, Paris.

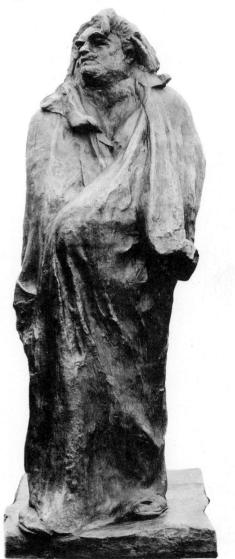

heroic scale. The facial features are not clearly delineated but only suggested by indefinite surfaces that catch light and dark in deft blurs and smudges, producing a sketchlike effect. Contours melt away; volumes are not permitted to assert themselves. The great novelist, who surveyed mankind in his La Comédie Humaine (The Human Comedy), draws himself up to a towering height. Wrapped in a dressing gown that seems like an enormous cloak, he again surveys the littleness of man from the lofty standpoint of immortality. Characteristically, although we feel the power of Rodin's art, we cannot quite describe exactly which traits make us feel it. His methods, grounded in Realism, achieved an overwhelmingly moving effect through daring emphasis and distortion.

Romantic Responses to Realism

Realism stood for what the eye could see-for actuality in all subject matter and verisimilitude in all images. Reflecting the Realist credo of art, philosopher Friedrich Nietzsche wrote, "We do not demand beautiful, illusory lies from it. . . . Brutal positivism reigns, recognizing facts without becoming excited." Like the positivists of science, the Realists believed in the supremacy of cold fact and made it the basis of esthetic truth and personal honesty. Some artists who subscribed to the Realist view, however, found Realist doctrine arbitrary and too restrictive of that play of artistic imagination long honored in the Tradition. While using Realist techniques scrupulous to truth and detail, these artists gave full play to their imaginative faculties in idea and content in order to render their subject Romantically.

PAINTING

In England, JOHN EVERETT MILLAIS (1829–1896) was among a group of artists who refused to be limited to the contemporary scenes portrayed by the strict Realist. These artists chose instead to represent fictional, historical, and fanciful subjects, but to do so using the techniques of Realism. So painstakingly careful in his study of visual facts closely observed from nature that Baudelaire called him "the poet of meticulous detail," Millais was a founder of the socalled Pre-Raphaelite Brotherhood. This group of artists, organized in 1848, wished to create fresh and sincere art, free from what they considered to be the tired and artificial manner propagated by the successors of Raphael in the academies. Millais's method is seen to advantage in his Ophelia (FIG. 21-57), which he exhibited in the Universal Exposition in Paris in 1855, where Courbet set up his Pavilion of Realism. The subject, from Shakespeare's Hamlet, is the drowning

of Ophelia, who, in her madness, is unaware of her plight:

Her clothes spread wide, And mermaid-like awhile they bore her up; Which time she chanted snatches of old tunes. IV.vii.176–78

Attempting to make the pathos of the scene visible, Millais became a faithful and feeling witness of its every detail, reconstructing it with a circumstantial stagecraft worthy of the original poetry. While Millais's technique is Realistic, the orthodox Realist would complain that the subject is not-that it is playacting. Yet it is unlikely that an impartial observer of the painting, familiar with Hamlet, would object that, as the subject is not of the artist's time and place, it is, of necessity, deficient in truth. It is certainly not deficient in truth to appearance. It may be that this conflict between the seen (in everyday experience) and the seeable (in plausible reconstructions of fictitious or past events) is resolved in modern cinema. The kind of picture drama we have in Ophelia, which brings the fictive action of a nonpictorial medium before our eyes with all optical fidelity, anticipates the dramatic motion picture in which fictions and facts are presented to the eye as equally real. Nineteenth-century Realists might have objected that the picture-drama was not painting, but stage production, and could only be judged as such.

A younger member of the Pre-Raphaelite Brotherhood, Edward Burne-Jones (1833-1898) was one of the many painters during this period who did not accept Realism in terms of either subject or technique. A friend and protégé of John Ruskin and an associate of William Morris and Dante Gabriel Rossetti (who, as we shall see in our discussion of Manet, slurred the work of the Realists), Burne-Jones agreed with their distaste for the materialism and ugliness of the contemporary, industrializing world and shared their appreciation for the spirituality and idealism (as well as the art and craftsmanship) of past times, especially the Middle Ages and the Early Renaissance. Like Millais, Burne-Jones drew his subjects from literature, but he chose to depict them in a soft, languid style much influenced by Sandro Botticelli (FIG. 16-60). Burne-Jones's King Cophetua and the Beggar Maid (FIG. 21-58) illustrates a poem of the same name, written by Alfred Tennyson in 1842, which itself was a

1-57 JOHN EVERETT MILLAIS, Ophelia, 1852. 30" × 44". Tate Gallery, London.

(21-58) EDWARD BURNE-JONES, King Cophetua and the Beggar Maid, 1884. Approx. 9' $7'' \times 4'$ 5". Tate Gallery, London.

modern reworking of an ancient and popular ballad. The situation is given in the last lines:

So sweet a face, such angel grace In all that land had never been. Cophetua sware a royal oath:

"This beggar maid shall be my queen!"

The king, in grave reverie, contemplates the maiden, who sits serenely above him, like some pedestaled perfection oblivious to mortal presence. Although Burne-Jones insisted that he wanted the maid to resemble a beggar, she does not. Like the atmosphere, she belongs to the world of trance and dream, in which images arise from some lost age of beauty and innocence. The composition, planar and still, recalls the mural tableau of the Renaissance, the suspended action of stained glass and tapestry. Burne-Jones's dreamy, decorative manner was perfectly suited to the somewhat precious, estheticizing taste of the later nineteenth century. How far we are here from Realism, as well as the great diversity of style at the time, can be appreciated if we compare Burne-Jones's beggar maid with Manet's barmaid (FIG. 21-67), especially if we consider that the two paintings were completed only two years apart.

In the painting of Adolphe William Bouguereau (1825-1905), Realism was blended with a different kind of fantasy. Bouguereau depicted Classical, mythological subjects with a dynamic Rococo exuberance of composition, and an optical Realism that achieved a startling illusionism, as in his Nymphs and Satyr (FIG. 21-59), where the playful and ideally beautiful nymphs strike graceful poses, yet seem based as closely on nature as are the details of their leafy surroundings. The painter even created the figure of his mythical beast-man by combining Realist depictions of a goat's hind quarters and horns and a horse's ears and tail with the upper body of a man. A painting like this presses the question of whether the subjects of myth, fancy, and fiction could be painted with the techniques of Realism without evoking incredulity and, perhaps, a sense of absurdity in the observer. For the Classicist, Bouguereau's Nymphs and Satyr would fail to fulfill a longing "for nothing more than the moment in which conception and representation will flow together." The Realist would find the picture false due to the incongruence of its form and content and the unrealistic nature of its subject. The obvious conflict of conception and representation in many of Bouguereau's pictures, as well as in those of other recognized artists of the time, did not displease the public. Bouguereau was immensely popular, enjoying the favor of state patronage throughout his career. His reputation has fluctuated violently; the moderns of his century damned him as the very archetype of the official painter, but critics of our own day acknowledge his love of beauty and his undeniable painterly skills, if not always his esthetic wisdom and taste.

The French painter JEAN-LÉON GÉRÔME (1824–1904) specialized in Romantic historical subjects rendered

ADOLPHE WILLIAM BOUGUEREAU, Nymphs and Satyr, 1873. Approx. 8' 6" high. Clark Institute, Williamstown, Massachusetts.

with almost photographic detail. In his painting Pollice Verso (Thumbs Down!) (FIG. 21-60), the inherited formulas of the Tradition have been almost entirely transformed. The time and place specifications are as exact as they can be. Although we do not know the day, month, and year of the event portrayed, nor the names of the principals involved, we recognize it for what it is and where it is happening; we can even guess the time of day. Gladiatorial combats were part of the Roman imperial games held regularly in great arenas or amphitheaters like the one pictured-the Colosseum in Rome (FIG. 6-47). The incident represented here must have happened countless times, and its very ordinariness makes it dramatic and factual. A triumphant gladiator bestrides his fallen opponent and looks toward the box where the vestal virgins are seated. The fallen man gestures for mercy. The vestals deny his appeal by turning their thumbs down; he will be killed on the spot. Gérôme authenticates the scene to the last detail: the vestals, the emperor's party (in the box fronted with columns and trophies), the streaks of light (clue to the time of day) thrown on the tapestried barrier walls by chinks in the great awnings overhead, the texture of the bloodstained sand, and, conspicuously, the fantastic garb of the gladiators, their splendid helmets replicating originals found at Pompeii. The scenic illusion is produced by a smooth continuum of tone that runs through the whole scale of values. Gérôme is scrupulously faithful to optical fact. Evidence of brush strokes is suppressed in an exquisitely finished,

21-60 JEAN-LÉON GÉRÔME, Pollice Verso (Thumbs Down!), c. 1872. $39\frac{1}{2}^{"} \times 58\frac{1}{2}^{"}$. Phoenix Art Museum (museum purchase).

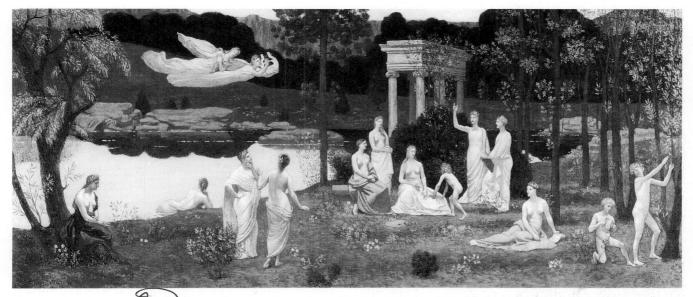

21-61 PIERRE PUVIS DE CHAVANNES, *The Sacred Grove*, 1884. 2' $11\frac{1}{2}$ " × 6' 10". (Potter Palmer Collection) © The Art Institute of Chicago. All rights reserved.

glassy surface. The effect is photographic; the brush stroke is intended to be invisible. In this way, the artist reduced to the barest minimum any evidence of his own imagination or feeling, or even of the agent of that feeling, his "hand." Like a director in the theater, he expects to be judged on his interpretation, which is manifest in the characterizations he elicits, in the species of action, scene design, and authenticity of detail. Gérôme makes use of an off-centered, dynamic placement for his figures to make the viewers of the work spectators at a *real* event, which we witness from *within* the framed space of the action. The curving wall sweeps toward us, and we can feel that our own vantage point is continuous with that of the vestal virgins.

Much of the reputation of the popular, "official," "academic" art of the nineteenth century, which won the admiration of the public and the support of the government at the time, has since suffered both decline and resurgence in acceptance. Some painters, touched lightly or heavily by Realism, borrowed from it or compromised with it but remained independent of its principal dogma-that the artist must see and represent modern life in a modern way. A turning away from both Realism and the modern world that called for it can be seen in the work of PIERRE PUVIS DE CHAVANNES (1824–1898). Puvis sought to adapt Classical mood and form to his own esthetic ends, an art that was ornamental and reflective, and removed from the noisy world of Realism. In The Sacred Grove (FIG. 21-61), he deployed statuesque figures in a tranquil landscape with a Classical shrine. Their motion has been suspended in timeless poses, their contours are simple and sharp, their modeling as shallow as bas-relief. Primarily a mural painter, Puvis was obedient to the requirements of the wall surface, neutralizing and restraining color, and banishing pictorial illusionism with its perspective and tone matching. The calm, almost bland atmosphere suggests some consecrated place, where all movements and gestures, undisturbed by the busyness of life, have a perpetual, ritual significance. The stillness and simplicity of the forms, the linear patterns created by their rhythmic contours, and the suggestion of their symbolic import amount to a kind of program of anti-Realism that impressed younger painters like Paul Gauguin and the Symbolists, who saw in Puvis the prophet of a new style that would replace Realism. Puvis had a double reputation: he was accepted by the Academy and the government for his Classicism, and he was revered by the avant-garde for his vindication of imagination and his artistic independence from the world of materialism and the machine. He asked a question significant for artists of his time and later: What will become of artists in the face of the invasion of engineers and mechanics?

PHOTOGRAPHY AND SCULPTURE

Many late nineteenth-century photographers, like the painters we have just studied, wanted to use their medium to depict fictional, historical, or religious subjects. These photographers often arranged symbolic scenes in suggestive settings, with figures dressed in costumes appropriate to the selected theme, and shot the photographs in soft light with slightly fuzzy focus to create a "pictorial" mood reminiscent of a painting by Rembrandt, Gainsborough, or another admired old master.

One of the leading practitioners of the Pictorial style in photography was the American GERTRUDE KÄSEBIER (1852–1934). Käsebier took up photography in 1897 after raising a family and working as a portrait painter. She soon became famous for photographs with symbolic themes, such as *Blessed Art Thou Among Women* (FIG. **21-62**). The title repeats the phrase used in the New Testament by the angel Gabriel to announce to the Virgin Mary that she will be the mother

21-62 GERTRUDE KÄSEBIER, Blessed Art Thou Among Women, c. 1900. Platinum print on Japanese paper, $9\frac{98}{8}'' \times 5\frac{1}{2}''$. Collection, The Museum of Modern Art, New York (gift of Mrs. Hermine M. Turner).

of Jesus. In the context of Käsebier's photograph, the words suggest a parallel between the biblical "Mother of God" and the modern mother in the image, who both protects and sends forth her daughter. The white setting and the mother's pale gown shimmer in soft focus behind the serious figure of the girl, who is dressed in darker tones and captured with sharper focus. Here, as in her other works, Käsebier was influenced by Peter Henry Emerson's ideas about naturalism in photography, but deliberately ignored his teachings about differential focus in favor of achieving an "expressive" effect by blurring the entire image slightly. In Blessed Art Thou, the whole scene is invested with an aura of otherworldly peace by the soft focus, the appearance of the centered figures, the vertical framing doors, and the relationship between the frontally posed girl and her gracefully bending mother. As one contemporary critic wrote: "The manner in which modern dress was handled, subordinated, and made to play its proper part in the composition . . . evidenced great artistic feeling."* Blessed Art Thou is a superb example of Käsebier's moving ability to invest scenes from everyday life with a sense of their connection to the realm of the spirit and the divine.

In sculpture, JEAN BAPTISTE CARPEAUX (1827–1875) combined his Realist intention with a love of Baroque and Antique sculpture and of the work of Michelangelo. Carpeaux's group *Ugolino and His Children* (FIG. **21-63**) is based on a passage from Dante's *Inferno* (XXXIII, 58–75) and shows Count Ugolino with his four sons shut up in a tower to starve to death. In Hell, Ugolino relates to Dante how, in a moment of extreme despair,

I bit both hands for grief. And they, thinking I did it for hunger, suddenly rose up and said, "Father"...

and offered him their own flesh as food. The powerful forms—twisted, intertwined, and densely concentrated—suggest the self-devouring torment of frustration and despair that wracks the unfortunate Ugolino. A careful student of the male figures of Michelangelo, Carpeaux also said that he had the *Laocoön* group (FIG. 5-79) in mind. Certainly the storm and stress of the *Ugolino* recalls the Hellenistic "baroque" of that group and others, like the battling gods and giants on the frieze of the Pergamon altar

^{*}Joseph T. Keiley, "Mrs. Käsebier's Prints," *Camera Notes* (July, 1899), in Robert A. Sobieszak, *Masterpieces of Photography from the George Eastman House Collection* (Rochester, NY: International Museum of Photography, 1985), p. 214.

(FIG. 5-78). Regardless of such influences, the sense of vivid reality about the anatomy of the *Ugolino* figures shows Carpeaux's interest in study from life.

AUGUSTUS SAINT-GAUDENS (1848-1907), an American sculptor trained in France, used realism effectively in a number of his portraits, where realism was highly appropriate. For the design of a memorial monument of Mrs. Henry Adams, wife of the historian (FIG. 21-64), Saint-Gaudens chose a Classical mode of representation, which he modified freely. Of course, he had no need to specify a particular character; he wanted to represent a generality outside of time and place. The resultant statue is that of a woman of majestic bearing sitting in mourning, her classically beautiful face partly shadowed by a sepulchral drapery that voluminously enfolds her body. The immobility of her form, set in an attitude of eternal vigilance, is only slightly stirred by a natural, yet mysterious and exquisite gesture. Saint-Gaudens's masterpiece is a work worthy of the grave stelae of Classical Athens (FIG. 5-56).

21-63 JEAN BAPTISTE CARPEAUX, Ugolino and His Children, 1865–1867. Marble, 6' 5" high. The Metropolitan Museum of Art, New York (Josephine Bay Paul and C. Michael Paul Foundation and the Charles Ulrick and Josephine Bay Foundation gifts, 1967).

21-64 AUGUSTUS SAINT-GAUDENS, Adams Memorial, 1891. Bronze, 70" high. Rock Creek Cemetery, Washington, D.C.

Manet and Impressionism

The Realism of Courbet and his followers had hardly established one kind of Realism before a different version, leading away from Courbet, took its place. In the fall of 1864, the English painter Dante Gabriel Rosetti wrote home describing French Realism as he had seen it in visits to the studios of Courbet and Manet: "There is a man named Manet . . . whose pictures are for the most part mere scrawls, and who seems to be one of the lights of the Realist school. Courbet, the head of it, is not much better." This somewhat priggish dismissal of Courbet and Manet linked the two artists as Realists, yet overlooked the differences between them. Courbet, himself, said of Manet's work in 1867: "I myself shouldn't like to meet this young man. . . . I should be obliged to tell him I don't understand anything about his paintings, and I don't want to be disagreeable to him." It was with Édouard Manet (1832–1883), however, that the course of modern painting shifted into a new phase, one that, in addition to accurately

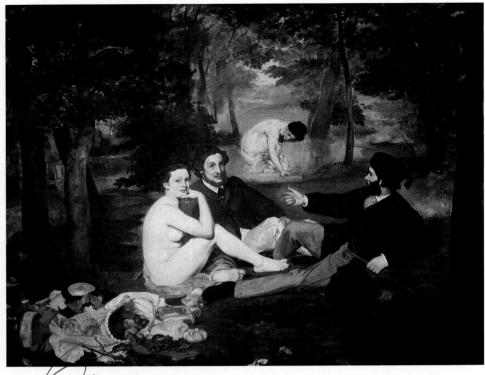

21-65' ÉDOUARD MANET, Le Déjeuner sur l'herbe, 1863. Approx. 7' × 8' 10". Musée d'Orsay, Paris.

recording the appearance of the physical world, had as its aim the authentic representation of the color and light that reveal that world to the eye. In his work, Manet, the Realist, became the point of departure for the later Impressionist transformation of the great tradition in painting that had begun with Giotto.

Although the term Impressionism was first used in 1874 by a journalist ridiculing a landscape by Monet called Impression-Sunrise, the battle over the merits of Impressionist painting began eleven years earlier with Manet's Le Déjeuner sur l'herbe (Luncheon on the Grass, FIG. 21-65). In 1863, Manet exhibited this then controversial painting at the Salon des Refusés (Salon of the Rejected) in Paris. As the name suggests, the exhibit consisted of a large number of works rejected by the jury for the major Academy Salon that year. The Academy Salons were government-subsidized arbiters of French art-"warehouses," as Zola called them-where the artists of France annually exhibited thousands of canvases. Prizes or recognition at the Salon could ensure professional success; refusal or rejection often led to neglect or failure. The Salon, at least until the 1880s, was the field of intense professional competition among artists and the battleground of "modern" versus "traditional." Ironically, it was a public seeking the avant-garde at the Salon des Refusés that was shocked by Manet's Le Déjeuner sur l'herbe, originally titled simply The Bath.

Manet may have been "a child of the century," as Zola called him in praise of his daring modernity, but he did not care to isolate himself as such. Instead, he wished to shine in the Salon with works (preferably figure paintings) as strong as the masterpieces of the Tradition. In Le Déjeuner, Manet does not attempt to revive "great painting," but tries to speak in a new voice and with an authority equal to that of his celebrated predecessors. The source of the work is proper enough; it takes as its theme the pastoral paradise familiar in paintings from Giorgione to Watteau. We know that at first Manet had Giorgione's (and Titian's?) Pastoral Symphony (FIG. 17-59) in mind as the source for Le Déjeuner, but for the actual composition, he used an engraving by Marcantonio Raimondi, a pupil of Raphael. Manet also may have been mindful of Baudelaire's observation (made as early as 1845) that "we are surrounded by the heroism of modern life, [but there is as yet no painter] who will know how to tear out of life its epic side and make us see, with color or drawing, how grand we are in our neckties and varnished boots!"

Nothing about the foreground figures in *Le Déjeuner* is very heroic. In fact, the foreground figures were all based on living, identifiable people. The seated nude was Victorine Meurand (Manet's favorite model at the time) and the gentlemen were his brother Eugène (with cane) and the sculptor Ferdinand Leenhof. The two men wear fashionable Parisian attire of the 1860s, and the foreground nude is not only a distressingly un-idealized figure type, but she seems disturbingly unabashed and at ease, looking directly at the viewer without shame or flirtatiousness.

This outraged the public—the pastoral brought up to date in a manner that seemed merely to represent the promiscuous in a Parisian park. One hostile critic, no doubt voicing public opinion, said:

A commonplace woman of the demimonde, as naked as can be, shamelessly lolls between two dandies dressed to the teeth. These latter look like schoolboys on a holiday, perpetrating an outrage to play the man. . . This is a young man's practical joke—a shameful, open sore.*

Manet's work would have been accepted had he shown men and women as nymphs and satyrs in Classical dress or undress, as did his contemporary, Bouguereau (FIG. 21-59). In *Le Déjeuner*, Manet raised the veils of allusion and reverie, and bluntly confronted the public with reality.

The public and the critics disliked Manet's subject matter only slightly less than the method he used to present his figures. The landscape and the background pool, in which the second woman bathes, are rendered in soft focus and broadly painted compared to the clear forms of the harshly lit trio of figures in the foreground and the pile of discarded female attire and picnic foods at the lower left.[†] The lighting displays the strong contrasts between darks and highlighted areas found in many contemporaneous photographs. In the main figures, the middle values, so carefully observed and recorded by Corot, and even Courbet, are blotted out; in a "crowding of the lights" and a compensating "crowding of the darks," many values are summed up in one or two lights or darks. The effect is both to flatten the form and to give it a hard, snapping presence, similar to that in early photographs. A detail (FIG. 21-66) shows Manet's broadly painted tones, a method which he learned primarily from Velázquez and Frans Hals. The paint directly reports what is given to the eye, without any presuppositions of form, structure, or contour. Form, here, no longer a matter of line, is only a function of paint and light. Manet himself declared that the chief

21-66 Detail of Le Déjeuner sur l'herbe (FIG. 21-65).

actor in the painting is the light. The public and the critics, guardians of public taste, knew nothing of this. They saw only a crude sketch without the customary "finish."

Manet's masterpiece, A Bar at the Folies-Bergère (FIG. 21-67), was painted in 1882, after the artist had become associated with the Impressionists. This work shows both an impersonality toward the subject and Manet's fascination with the effects of light spilling from the gas globes onto the figures and the objects around them. In this study of artificial light (both direct light and that reflected in the mirrored background), the artist tells us little about the barmaid[‡] and less about her customers, but much about the optical experience of this momentary pattern of light, in which the barmaid is only another motifanother still life amid the bottles on the counter. The painting tells no story, and has no moral, no plot, and no stage direction; it is simply an optical event, an arrested moment, in which lighted shapes of one kind or another participate. One is reminded of the novels of Manet's friend, Émile Zola, especially of Nana, whose heroine is nothing but a meaningless human consequence of the intersecting of social forces that create and destroy her. The barmaid in Manet's painting is primarily a compositional device automatic and nonpersonal.

^{*}In G. H. Hamilton, *Manet and His Critics* (New Haven, CT: Yale University Press, 1954), p. 45.

⁺An interesting comparison can be drawn between the foreground and background in Manet's *Le Déjeuner* and the lighting and focus in Robinson's *Women and Children in the Country* (FIG. 21-49).

[‡]Or is it *barmaids*? A lively debate currently rages about whether Manet has depicted two different girls or just one girl and her reflection.

922 CHAPTER 21 / THE NINETEENTH CENTURY: PLURALISM OF STYLE

The Folies-Bergère illustrates another quality that first made its appearance in Le Déjeuner sur l'herbe and was to loom with increasing importance in the works of later painters. Although the effect was perhaps unplanned, Manet's painting made a radical break with the Tradition by redefining the function of the picture surface. Ever since the Renaissance, the picture had been conceived as a "window" through which the viewer looked at an illusory space developed behind it. By minimizing the effects of modeling and perspective, Manet forced the viewer to look at the painted surface and to recognize it once more as a flat plane covered with patches of pigment. This "revolution of the color patch," combined with Manet's cool, objective approach, pointed painting in the direction of abstraction, with its indifference to subject matter and its emphasis on optical sensations and the problems of organizing them into form. In most nonobjective twentieth-century work, not only the subject matter, but even its supposed visual manifestation in the external world, will disappear.

Throughout his entire career, Manet suffered the hostility of the critics as surrogates of the public. This attitude wounded him deeply. He never understood their animosity and continued to seek their approval, but the doses of the real that he administered in his art were too harsh. His contemporary, the philosopher and historian Ernest Renan, expressed the real moral threat some of the public feared from the new realism in art:

It is possible, then, that the ruin of idealistic beliefs is destined to follow the destruction of supernatural beliefs, and that a real abasement of human morality dates from *the day it saw the reality of things* [emphasis added].*

After the mid-1860s, Impressionist painters such as Monet, Pissarro, Renoir, and Degas followed Manet's lead in depicting scenes of contemporary middleclass Parisian life and landscape. Their desire for a more modern expression led them to prize the immediacy of visual impression and persuaded the landscapists, especially Monet, to work out of doors. From this custom of painting directly from nature came the spontaneous representation of atmosphere and climate so characteristic of Impressionist painting. The rejection of idealistic interpretation and literary anecdote was paralleled by an intense scrutiny of

*In J. C. Sloane, French Painting Between the Past and the Present (Princeton, NJ: Princeton University Press, 1951), p. 57.

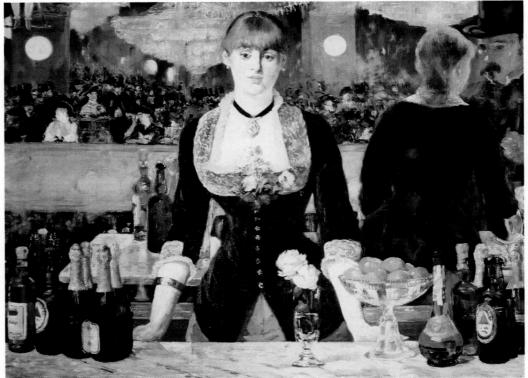

color and light. Scientific studies of light and the invention of chemical pigments increased artistic sensitivity to the multiplicity of colors in nature and gave artists new colors with which to work.* Most of the eight cooperative Impressionist exhibitions held between 1874 and 1886 irritated the public. However, Impressionist technique was actually less radical than it seemed at the time; in certain respects, these artists were simply developing the color theories of Leonardo and the actual practice of Rubens, Delacroix, Constable, and Turner.

The Impressionists sought to create the illusion of forms bathed in light and atmosphere. This goal required an intensive study of outdoor light as the source of our experience of color, which revealed the important truth that local color—the actual color of an object—is usually modified by the quality of the light in which it is seen, by reflections from other objects, and by the effects produced by juxtaposed colors. Shadows do not appear grey or black, as many earlier painters had thought, but seem to be composed of colors modified by reflections or other con-

*Special luminance was achieved by using new colors like viridian green and cobalt violet (both invented in 1859) and cerulean blue (invented in 1860). These pigments, applied with newly available flat-bound brushes, often were placed on canvases covered with a base of white pigment (white ground), rather than with the brown or green tones favored by earlier artists.

ditions. (One earlier artist, Jan Vermeer, evidently observed this.) In painting, if complementary colors are used side by side over large enough areas, they intensify each other, unlike the effect of small quantities of mixed pigments, which blend into neutral tones. Furthermore, the juxtaposition of colors on a canvas for the eye to fuse at a distance produces a more intense hue than the mixing of the same colors on the palette. Although it is not strictly true that the Impressionists used only primary hues, juxtaposing them to create secondary colors (blue and yellow, for example, to produce green), they did achieve remarkably brilliant effects with their characteristically short, choppy brush strokes, which so accurately caught the vibrating quality of light. The fact that the surfaces of their canvases look unintelligible at close range and their forms and objects appear only when the eye fuses the strokes at a certain distance accounts for much of the early adverse criticism leveled at their work, such as the conjecture that the Impressionists fired their paint at the canvas with pistols.

Of the Impressionists, CLAUDE MONET (1840–1926), whose *Impression—Sunrise* was mentioned earlier, carried the color method furthest. Monet called color his "day-long obsession, joy and torment." When he looked at scenes such as those found in his *Cliff at Étretat* (FIG. **21-68**), painted at a favorite location on

21-68 CLAUDE MONET, Cliff at Étretat, 1868. $31'' \times 39\frac{1}{3}''$. Courtesy of The Fogg Art Museum, Harvard University, Cambridge (gift of Mr. and Mrs. Joseph Pulitzer, Jr.).

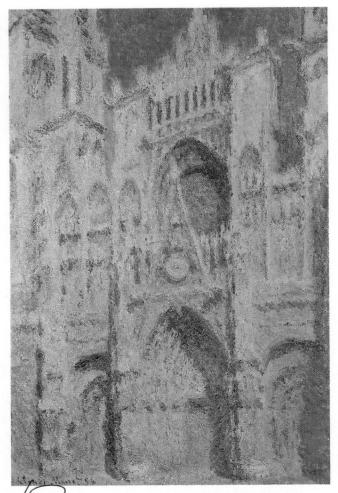

21-69 CLAUDE MONET, Rouen Cathedral (façade), 1894. Approx. 39" × 26". The Metropolitan Museum of Art, New York (Theodore M. Davis Collection, bequest of Theodore M. Davis, 1915).

the coast near Le Havre, he responded to lighting and atmospheric conditions in terms of color, which he applied to the canvas with thick, dabbing strokes that caused the surface of the painting to shimmer. In *Étretat*, color is dominated by the glow of the sun low on the horizon, which bounces off the clouds in the sky and streams across the rippling water to reflect back up onto the side of the rock arch that faces us. The rock face is a symphony of greys, browns, and golds, and our eyes feel bathed in colored light that seems to emanate from the painting itself. Lila Cabot Perry, a student of Monet's late in his career, gave this description of his approach:

I remember his once saying to me: "When you go out to paint, try to forget what objects you have before you—a tree, a house, a field, or whatever. Merely think, here is a little square of blue, here an oblong of pink, here a streak of yellow, and paint it just as it looks to you, the exact color and shape, until it gives your own naïve impression of the scene before you." He said he wished he had been born blind and then had suddenly gained his sight so that he could have begun to paint in this way without knowing what the objects were that he saw before him.*

Monet's contribution was especially evident in several series of paintings of the same subject. He painted sixteen views of Waterloo Bridge in London and some forty views of Rouen Cathedral (FIG. 21-69 and Introduction FIG. 5). In each canvas in the latter series, the cathedral was observed from the same point of view but at different times of the day or under various climatic conditions. Monet, with a scientific precision, created an unparalleled and unexcelled record of the passing of time as seen in the movement of light over identical forms. Later critics accused Monet and his companions of destroying form and order for the sake of fleeting atmospheric effects, but we may feel that light is properly the "form" of Monet's finest paintings, rather than accept the narrower definition that recognizes "formal" properties only in firm, geometric shapes. The Impressionist artists ignored much that was prized by the Realists-the world of Corot's "values," of graduated tones of lights and darks; rather, the Impressionists recorded their own sensations of color, and the outlines and solidities of the world as interpreted by common sense melt away.

The Impressionist emphasis on the prime reality of sensation in the process of apprehending nature or the world had its parallel in the work of contemporaneous scientists, philosophers of science, and psychologists who asserted that reality is sensation and that knowledge could be based only on the analysis of our sensations. Indeed, the Austrian physicist Ernst Mach held that the sole reality is sensation and all the laws and principles of physics are only a kind of shorthand referring to complex linkages of the data of sense. Modern experimental psychology began its history with measurements of sense experience before turning a large portion of its attention, in the early twentieth century, toward studying how emotion, past experience, and memory affect perceptual activity. Artists who shared the belief that a single, accepted model of unchanging optical truth no longer existed—just as a standard way of seeing could not be mandated—considered "nature," in the broadest sense of whatever the world reveals, to be the source of all sensation. In The Place du Théâtre Français (FIG. 21-70), CAMILLE PISSARRO (1830–1903) records a panorama of blurred, dark accents against a light ground that represents clearly the artist's visual sensations of a crowded Paris square, viewed from several stories

^{*}In Linda Nochlin, *Impressionism and Post-Impressionism 1874–1904* (Englewood Cliffs, NJ: Prentice-Hall, 1966), p. 35.

21-70 CAMILLE PISSARRO, Place du Théâtre Français, 1895. Approx. $28\frac{1}{2}^{"} \times 36\frac{1}{2}^{"}$. Los Angeles County Museum of Art (the Mr. and Mrs. George Gard De Sylva Collection).

above street level. Like Monet, Pissarro sought to depict the fugitive effects of light at a particular moment, but the moment in Pissarro's *Place du Théâtre*, unlike those in Monet's work, is not so much one of light itself as of the life of the street, achieved through a deliberate casualness in the arrangement of his figures that is related to that in early photographs of street scenes. When Pissarro wrote in a letter to his son Lucien, "we have to approach nature sincerely, with our own modern sensibilities," he spoke of the Impressionist belief that what was real in nature was the light and color stimuli it revealed to the analytic eye of the modern painter.

Like many of his fellow Impressionists, Pissarro sometimes used the amazing "reality" of photography to supplement work directly from a model. Although he may not have known this particular example, the effect of Pissarro's Place du Théâtre is remarkably similar to that in the stereo photograph* The Pont Neuf, Paris (FIG. 21-71) by HIPPOLYTE JOUVIN (active mid-1800s). In this stereograph, we look from the upper story of a building along the roadway of the "New Bridge," which stretches diagonally from lower left to upper right. Hurrying pedestrian figures become dark silhouettes, and the scene moves from sharp focus in the foreground to soft focus in the distance. These qualities, plus the arbitrary cutting off of figures at the edge of the frame and the curious flattening spatial effect caused by the high viewpoint, were of special interest to Pissarro and the other Impressionists.

Although the Impressionist artists were linked by what we might call "color sensationism" and fugitive effects of light and motion, each had very much an individualistic manner. AUGUSTE RENOIR (1841–1919),

*Stereo photographs were made with special twin-lensed cameras and viewed with special apparatus to recreate the illusion of seeing the world with two eyes (in three dimensions). Jouvin specialized in views of Paris and like many other stereographers, chose subjects or view points that exaggerated the dramatic effects of deep space.

21-71 HIPPOLYTE JOUVIN, *The Pont Neuf, Paris, c.* 1860–1865. Albumen stereograph. Collection, The Museum of Modern Art, New York.

No. 49.-PONT NEUF, & PARIS.-VUE INSTANTANÉE.-(No. 2.)

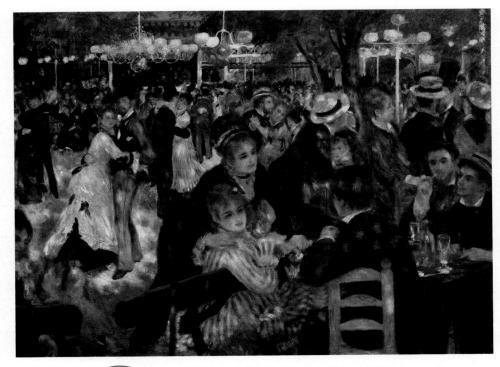

21-72 AUGUSTE RENOIR, Le Moulin de la Galette, 1876. Approx. 51" × 68". Louvre, Paris.

for example, was a specialist in the human figure, a sympathetic admirer of what was beautiful in the body and what was pleasurable in the simple round of human life. The bright gaiety of his Le Moulin de la Galette (FIG. 21-72), where a Sunday throng enjoys a popular Paris dance hall, is characteristic of his celebration of vivacious charm. Some people crowd the tables and chatter, while others dance energetically. The whole scene is dappled by sunlight and shade, artfully blurred into the figures themselves to produce just that effect of floating and fleeting light so cultivated by the Impressionists. The casual, unposed placement of the figures, and the suggested continuity of space, spreading in all directions and only accidentally limited by the frame, introduce us, as observers, into the very scene. We are not, as with the Tradition, observing a performance on a stage set; rather, we ourselves are part of the action. Renoir's subjects are quite unconscious of the presence of an observer; they do not pose but merely go about the business of the moment. As Classical art sought to express universal and timeless qualities, so Impressionism attempted to depict just the oppositethe incidental, momentary, and passing aspects of reality.

EDGAR DEGAS (1834–1917) is usually included in any discussion of Impressionism. Although actively sympathetic with the Impressionists, he stood somewhat apart from them, an independent talent of great power. More than any of his contemporaries, Degas studied the infinite variety of particular movements and, even more, the kinesthetic qualities of bodies in motion-especially race horses, bathers, laundresses, milliners, and ballet dancers. Ballerinas in arrested movements-split-second poses cut from the sequence of their dance-were one of his favorite subjects. In Ballet Rehearsal (Adagio) (FIG. 21-73), Degas used several devices to bring the observer into the pictorial space: the frame cuts off the spiral stair, the windows in the background, and the group of figures in the right foreground; the figures are uncentered and "accidental" in arrangement; the rapid diagonals of the wall bases and floorboards carry us into and along the directional lines of the dancers; and, as is customary in Degas's ballet pictures, a large, offcenter, empty space creates the illusion of a continuous floor that connects us with the pictured figures. By seeming to stand on the same surface with them, we are drawn into their space. The often arbitrarily cutoff figures in this and other works by Degas reveal his fascination with photography. He not only studied the photography of others, but he used the camera consistently himself to make preliminary studies for his own works, particularly with figures in interiors. The cunning spatial projection in Ballet Rehearsal derived not only from careful observation and the artist's interest in photography, but was also undoubtedly inspired by eighteenth-century Japanese

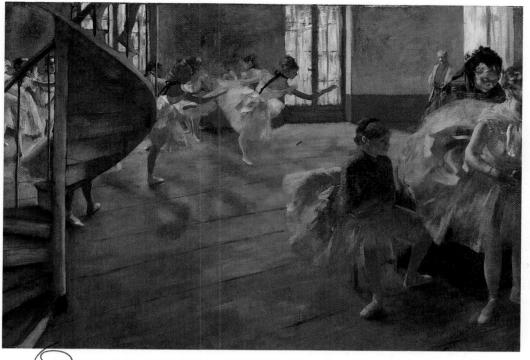

(21-73) EDGAR DEGAS, Ballet Rehearsal (Adagio), 1876. 23" × 33". Glasgow Art Galleries and Museum (Burrell Collection).

woodblock prints (FIG. **21-74**), in which diverging lines not only organize the flat shapes of the figures but function as lines directing the viewer's attention into the picture space. The Impressionists, familiar

21-74 SUZUKI HARUNOBU, *The Evening Glow of the Andon*, 1765. 11⁴″ × 8¹″. (Clarence Buckingham Collection) © The Art Institute of Chicago. All rights reserved.

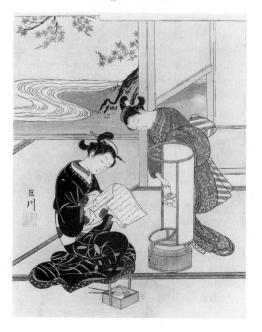

with these prints as early as the 1860s, greatly admired their spatial organization, the familiar and intimate themes, and the flat, unmodeled color areas, and drew much instruction from them. These popular Japanese prints, "discovered" by European artists in the mid-nineteenth century, were the first definitive non-European influence on European pictorial design. Earlier borrowings from China, India, and Arabia had been superficial.

Viscount Lepic and His Daughters (FIG. 21-75), painted by Degas in 1873, summarizes what the artist had learned from photography, from his own painstaking research, and from what his generation in general absorbed from the Japanese print: the clear, flat pattern; the unusual point of view; the informal glimpse of contemporary life. Whatever his subject, Degas saw it in terms of clear line and pattern, observed from a new and unexpected angle. In the divergent movements of the father and his small daughters, of the man entering the picture at the left, and of the horse and carriage passing across the background, we have a vivid pictorial account of a moment in time at a particular position in space, much as Monet, in his own way, defined such space and time in landscape painting. In another instant, this picture would disappear, for each of the figures would move in a different direction, and the group would dissolve. Here again, Degas made clever use of the empty space of the street to integrate the viewer into the

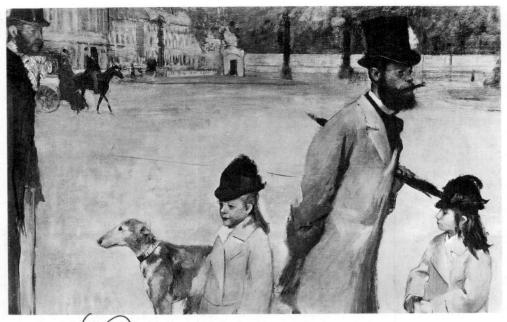

21-75) EDGAR DEGAS, Viscount Lepic and His Daughters, 1873. Approx. $32'' \times 47''$. Location unknown.

21.76 EDGAR DEGAS, The Morning Bath, c. 1883. Pastel on paper, 27³/₄ × 17". (Potter Palmer Collection) photograph © 1990, The Art Institute of Chicago. All rights reserved.

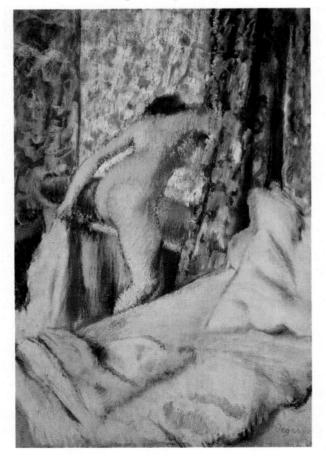

space containing the figures. Actually, the painter seems to have taken into account the range of the sweep of our glance—everything that we would see in a single split-second inspection; indeed, the picture resembles a snapshot made with a hastily aimed camera.

When Degas was a very young man and about to enter into a career as a painter, he met Ingres, whose work he greatly admired and who advised him to "draw lines, . . . many lines, from memory or from nature; it is this way that you will become a good painter." Degas, faithful to the old linearist's advice, became a superb master of line, so much so that his identification as an Impressionist, in the sense that Monet, Pissarro, and Renoir are Impressionists, seems a mistake to many critics. Certainly, Degas's designs do not cling to the surface of the canvas, as do Manet's and Monet's; they are developed in depth and take the viewer well behind the picture plane. We are always aware of the elastic strength of his firmly drawn contours. However, Degas did specialize in studies of figures in rapid and informal movement, recording the quick impression of arrested motion, and he did use the spectral color—the fresh, divided hues of the Impressionist-especially when he worked in his favorite medium, pastel. These dry sticks of powdered pigment cannot be "muddied" by mixing them on a palette, so they produce, almost automatically, those fresh and bright colors so favored by the Impressionists. All of these qualities are seen in The Morning Bath (FIG. 21-76), which is like Renoir's treatment of the same subject (not illustrated) in its informality and intimacy but unlike Renoir's work in its indifference to either formal or physical beauty. Degas's concern was with the unplanned realism of the purely accidental attitude of the human figure, seen in an awkward yet natural enough moment. The broken volume of the nude body twists across "Japanese" angles, flat planes, and patterns. The informality and spontaneity of the pose again suggest snapshot photography, but photographic materials available at the time (including those of the motion picture, then just in its infancy) could not capture the range of light and the verity of motion that Degas sought to depict above all else.

In the Salon of 1874, Degas admired a painting by a young American artist, MARY CASSATT (1845-1926), the daughter of a Philadelphia banker. "There," he remarked, "is a person who feels as I do." Cassatt was befriended and influenced by Degas and exhibited regularly with the Impressionists. She had trained as a painter before moving to Europe to study masterworks in France and Italy. Her choice of subject matter was limited by the facts that, as a woman, she could not easily frequent the cafés with her male artist friends, and that she was responsible for the care of her aging parents, who had moved to Paris to join her. Because of these restrictions, Cassatt's subjects were principally women and children, whom she presented with an inimitable conjunction of objectivity and genuine sentiment. Works like The Bath (FIG. 21-77) show the tender relationship between a mother and child. The mother's torso shelters the child against the diagonal slope of her lap. Color binds mother, child, and wash basin into one central form that is pushed against the flattened space of the darker-hued rug, wallpaper, and bureau by placement of the remarkably solid jug at the lower right. Cassatt's style in this work owed much to the compositional devices of Degas and of Japanese prints, but the painting's design has an originality and strength all its own.

JAMES ABBOTT MCNEILL WHISTLER (1834–1903) was an American expatriate artist, who worked on the Continent before settling finally in London. In Paris, he knew many of the Impressionists, and his art is an interesting mixture of some of their concerns and his own. He shared their interests in the subject matter of contemporary life and the sensations produced on the eye by color. To these influences he added his own interest in creating visual harmonies paralleling those achieved in music:

Nature contains the elements, in color and form, of all pictures, as the keyboard contains the notes of all music. But the artist is born to pick, and choose, and group with science, these elements, that the result may be beautiful—as the musician gathers his notes,

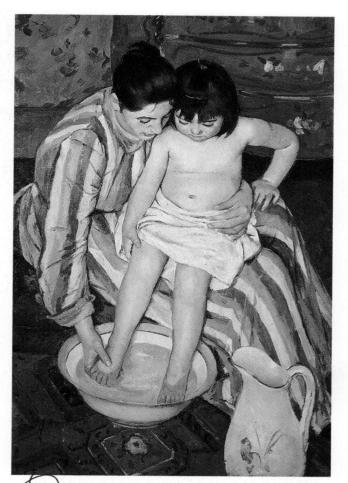

(21-77 MARY CASSATT, The Bath, c. 1892. 39" × 26". Photograph © 1990, The Art Institute of Chicago. All rights reserved.

and forms his chords, until he brings forth from chaos glorious harmony.*

To underscore his artistic intentions, Whistler began calling his paintings "arrangements" or "nocturnes." Nocturne in Blue and Gold (Old Battersea Bridge, FIG. 21-78) is a daring composition in which evening light simplifies shapes into hazy silhouettes. We are so close to the bridge that all we see is the thick T-shape made by a single buttress-support, the silhouette of a lone boat near its base, a band of distant shore, and the cropped section of the bridge roadway high overhead. Blue tones fill the canvas, relieved only by touches of yellow and red, indicating shore lights and the effects of the setting sun on the heavy clouds in the sky. The artist was clearly more interested in creating an elegantly simple color harmony for this spare arrangement of shapes than he was in giving details of the actual scene. In works like Nocturne, Whistler has taken the "impression" of what our eye sees in

*In Harold Spencer, American Art: Readings from the Colonial Era to the Present (New York: Scribners, 1980), pp. 154–55.

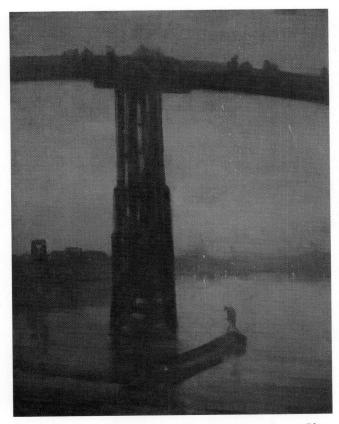

21-78 JAMES ABBOTT MCNEILL WHISTLER, Nocturne in Blue and Gold (Old Battersea Bridge), 1877. $23_3^{3''} \times 18_8^{3''}$. Tate Gallery, London.

nature further than any of the Impressionists. His emphasis was on creating a harmonious arrangement of shapes and colors on the rectangle of his canvas, an approach that will interest many twentiethcentury artists from Matisse (FIG. 22-5) to Pollock (FIG. 23-1).

Such works angered many viewers. The British critic John Ruskin accused Whistler of "flinging a pot of paint in the public's face" with his style. In reply, Whistler sued Ruskin for libel. During the trial, Whistler defended his artistic methods by describing his approach in *Nocturne:*

I did not intend it to be a "correct" portrait of the bridge. It is only a moonlight scene and the pier in the center of the picture may not be like the piers at Battersea Bridge as you know them in broad daylight. As to what the picture represents, that depends upon who looks at it. To some persons it may represent all that is intended: to others it may represent nothing [emphasis added].*

Although Whistler won the case, his victory had sadly ironic consequences for him. The judge in the

*In McCoubrey, American Art 1700-1960, p. 184.

case, showing where his sympathies—and perhaps those of the public—were, awarded the artist only one farthing (less than a penny) in damages and required him to pay all of the court costs, which ruined him financially. He continued to produce etchings and portraits for two decades after his bankruptcy.

The Impressionists' interest in representing form as the eye sees it revealed by light might seem an impossible approach for sculpture, but the Italian sculptor MEDARDO ROSSO (1858-1928) was determined to try. The motivation that inspired him to create works like Conversation in the Garden (FIG. 21-79) was not quite the same, however, as that driving the Impressionists. Instead, Rosso was attempting to overcome what the poet and critic Charles Baudelaire had described as the deficiencies of sculpture in relation to painting. Baudelaire's basic charge was that a painter could control the viewer's response to a work, because a painting has only one point of view, but the sculptor has difficulty forcing viewers to see a work from any single angle, "for the spectator who moves around the figure can choose a hundred different points of view, . . . and it often happens that a chance trick of the light, an effect of the lamp, may discover a beauty which is not at all the one the artist had in mind." A Rosso sculpture, like Conversation, makes sense only from a viewpoint along one side-the front. Forms are simplified here to what one might see in a glance at a scene: no particulars of detail, but a faithful representation of the gestures and body language that hold the meaning of an interchange between people seen at a distance. The subject in Conversation is a casual incident from upper-middle-class life. Rosso has included himself as the portly figure standing at the left. In the middle, a lively lady (wearing a hat to shield her delicate skin from the sun) turns to address him. Rosso made the second seated figure, to the far right, an unimportant participant in the scene by modeling the shape in such general terms that the figure does not come "into focus." Light is important to the viewing of Rosso's sculpture, for it animates the work, increasing the illusion that we glimpse but one instant in an ongoing event. However, lighting cannot alter Rosso's intended expression of this moment in a conversation between a man and a woman in a garden. Like the Impressionist painters, Rosso viewed the world as a constantly changing place. But unlike the Impressionists' careful attention to recording the look of a place at a particular moment, and unlike Muybridge's analysis of successive moments (FIG. 21-42), Rosso portrayed both an emotional response and the effect of light and shadow patterns on forms glimpsed at a particular instant in time.

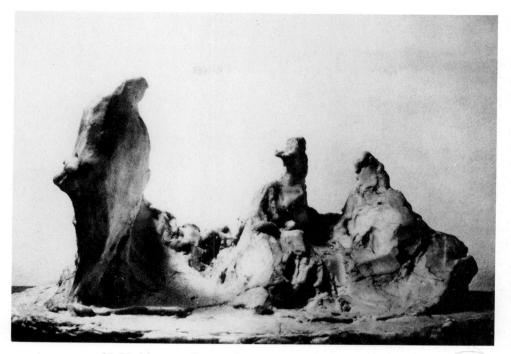

21-79 MEDARDO ROSSO, Conversation in the Garden, 1893. Wax over plaster, 17" high. Collection of Dr. Gianni Mattioli, Milan.

Post-Impressionism

By 1886, the Impressionists were accepted as serious artists by most critics and by a large segment of the public. Just at the time when their gay and colorful studies of contemporary life no longer seemed crude and unfinished, however, some of the painters themselves and a group of younger followers came to feel that too many of the traditional elements of picture making were being neglected in the search for momentary sensations of light and color. In a conversation with the influential art dealer Ambroise Vollard in about 1883, Renoir commented: "I had wrung Impressionism dry, and I finally came to the conclusion that I knew neither how to paint nor how to draw. In a word, Impressionism was a blind alley, as far as I was concerned." By the 1880s, a much more systematic examination of the properties of threedimensional space, the expressive qualities of line, pattern, and color, and the symbolic character of subject matter was being undertaken by four artists in particular: Georges Seurat, Paul Cézanne, Vincent van Gogh, and Paul Gauguin. Because their art diverged so markedly from earlier Impressionism (although each of these painters at first accepted Impressionist methods and never rejected the new and brighter palette), these four artists and others sharing their views have come to be known as the Post-Impressionists, a classification that simply signifies

their chronological position in nineteenth-century French painting.

At the eighth and last Impressionist exhibition in 1886, Georges Seurat (1859-1891) showed his Sunday Afternoon on the Island of La Grande Jatte (FIG. 21-80), which set forth the Impressionist interest in holiday themes and the analysis of light in a new and monumental synthesis that seemed strangely rigid and remote. Seurat's system of painting in small dots that stand in relation to each other was based on the color theories of Delacroix and the color scientists Hermann von Helmholtz and Michel Chevreul.* Seurat's system was a difficult procedure, as disciplined and painstaking as the Impressionist method had been spontaneous and exuberant. Seurat also developed a theory of expressive composition in which emotions were conveyed by the deliberate orchestration of the action of color and the emotional use of lines in a composition. For example, "gaiety of tone" would be created by using warm, luminous

*The method, called *divisionism* by Seurat, was often confused with *pointillism*, in which dots of color were distributed systematically on a white ground that remained partially exposed and hence visually functional. In one respect—the breaking of mass into discrete particles (and color into dots of the component colors)—Seurat's *La Grande Jatte* may be said to have been the forerunner of the modern techniques of photoengraving and color reproduction.

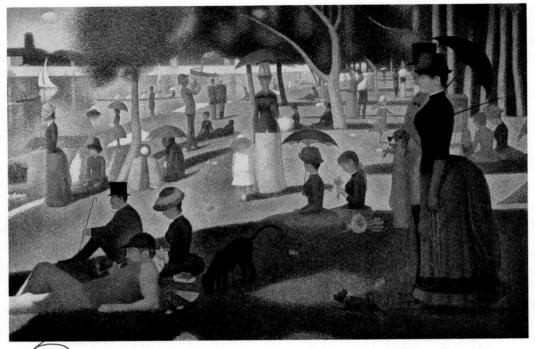

21-80 GEORGES SEURAT, Sunday Afternoon on the Island of La Grande Jatte, 1884–1886. Approx. 6' 9" × 10'. (Helen Birch Bartlett Memorial Collection) photograph © 1990, The Art Institute of Chicago. All rights reserved.

colors and placing the most active lines and shapes in the composition above the perspective horizon line.

Seurat was less concerned with the recording of his immediate color sensations than he was with their careful and systematic organization into a new kind of pictorial order. The free and fluent play of color in his work was disciplined into a calculated arrangement by prior rules of design accepted and imposed by the artist. The apparent formlessness of Impressionism has hardened into severe regularity. The pattern in La Grande Jatte is based on the verticals of the figures and trees, the horizontals in the shadows and the distant embankment, and the diagonals in the shadows and shoreline, each of which contributes to the pictorial effect. At the same time, by the use of meticulously calculated values, the painter has carved out a deep rectangular space. In creating both flat pattern and suggested spatial depth, Seurat played on repeated motifs: the profile of the female form, the parasol, and the cylindrical forms of the figures, each placed in space so as to set up a rhythmic movement in depth as well as from side to side. The picture is filled with sunshine, but not broken into transient patches of color. Light, air, people, and landscape are fixed in an abstract design in which line, color, value, and shape cohere in precise and tightly controlled organization.

Seurat's art is a severely intellectual art, of which he himself said, "They see poetry in what I have done. No, I apply my method, and that is all there is to it." His work reveals something of the scientific attitude we have found manifesting itself throughout nineteenth-century painting and also recalls Renaissance geometric formalism; Seurat's stately stage space, with its perspective and careful placement of figures, is descended from the art of Paolo Uccello and Piero della Francesca and, like theirs, moves us by its serene monumentality. Seurat, in La Grande Jatte, turned traditional pictorial stage space into pattern by applying a color formula based on the belief that our optical experience of space can only be a function of color, which makes space a fairly unimportant variable. In the tradition of Giotto and Raphael, the reality was space, with color something added, but now with Seurat (and, as we shall see, with Cézanne), color is the reality and spaces and solids are merely illusion. Having found the formula of color relationships, the artist need no longer rely on the dubious evidence of his impressions. Paul Signac, Seurat's collaborator in the design of the "neoimpressionist" method, described their discovery:

By the elimination of all muddy mixtures, by the exclusive use of the optical mixture of pure colors, by a

methodical divisionism and a strict observation of the scientific theory of colors, the Neo-Impressionist ensures a maximum of luminosity, of color intensity, and of harmony—a result that has never yet been obtained.*

Indeed, although some of the brilliance of Seurat's pigments has faded with time, the effect of his system in *La Grande Jatte* remains powerfully moving today.

Like Seurat, PAUL CÉZANNE (1839–1906) turned from Impressionism to the development of a newer style. Although a lifelong admirer of Delacroix, Cézanne allied himself, early in his career, with the Impressionists, especially Pissarro, and at first accepted their theories of color and their faith in subjects chosen from everyday life. Yet his own studies of the old masters in the Louvre persuaded him that Impressionism lacked form and structure. He said: "I want to make of Impressionism something solid and lasting like the art in the museums."

The basis of Cézanne's art was his unique way of studying nature in works like La Montagne Sainte-Victoire (FIG. 21-81). His aim was not truth in appearance, especially not photographic truth, nor was it the "truth" of Impressionism, but rather a lasting structure behind the formless and fleeting screens of color the eye takes in. If all we see is color, then color gives us every clue about structure, and color must fulfill the structural purposes of traditional perspective and light and shade; color alone must give depth and distance, shape and solidity. Rather than employ the random approach of the Impressionists when he was face to face with nature, Cézanne attempted to bring an intellectual order into his presentation of the colors that comprised it by constantly and painfully checking his painting against the part of the actual scene-he called it the "motif"-that he was studying at the moment. When he said, "We must do Poussin over again, this time according to nature," he apparently meant that Poussin's effects of distance, depth, structure, and solidity must be achieved not by perspective and chiaroscuro but entirely in terms of the color patterns provided by an optical analysis of nature.

To apply his methods to the painting of landscapes was one of Cézanne's greatest challenges. The problems of representation were complicated by the need to select from the multiplicity of disorganized natural forms those that seemed most significant and to order them into pictorial structures with cohesive unity. Just as landscape had been the principal mode of Impressionist theory and experiment, so it became

*In Goldwater and Treves, eds., Artists on Art, p. 378.

the subject for Cézanne's most complete transformation of Impressionism. His method was to use his intense powers of visual concentration to observe the motif and its colors, sustaining the process of minute inspection through days, months, and even years. He resembled the contemporary scientist who proves his hypothesis with repeated tests. With special care, Cézanne explored the properties of line, plane, and color, and their interrelationships: the effect of every kind of linear direction, the capacity of planes to create the sensation of depth, the intrinsic qualities of color, and the power of colors to modify the direction and depth of lines and planes. Through the recession of cool colors and the advance of warm ones, he controlled volume and depth. Having observed that saturation (or the highest intensity of a color) produced the greatest effect of fullness of form, he painted objects chiefly in one hue-apples, for example, in green—achieving convincing solidity by the control of color intensity alone, in place of the traditional method of modeling in light and dark.

La Montagne Sainte-Victoire (FIG. 21-81), which was done in about 1886, is one of many views that Cézanne painted of this mountain near his home in Aixen-Provence. In it, we can see how the transitory effects of changing atmospheric conditions, effects that occupied Monet, have been replaced by a more concentrated, lengthier analysis of the colors in large, lighted spaces. The main space stretches out behind and beyond the plane of the canvas (emphasized by the pattern of the pine tree in the foreground) and is made up of numerous small elements, such as roads, fields, houses, and the aqueduct at the far right, each seen from a slightly different point of view. Above this shifting, receding perspective rises the largest mass of all, the mountain, with an effect-achieved by stressing background and foreground contours equally—of being simultaneously near and far away. This portrayal is close to the actual experience a person observing such a view might have if the forms of the landscape are apprehended piecemeal so that the relative proportions of objects vary, rather than being fixed by a strict one- or two-point perspective, such as that normally found in a photograph. Cézanne immobilized the shifting colors of Impressionism into an array of clearly defined planes that compose the objects and spaces in his scene. Describing his method in a letter to a fellow painter, he wrote:

Treat nature by the cylinder, the sphere, the cone, everything in proper perspective so that each side of an object or a plane is directed towards a central point. Lines parallel to the horizon give breadth, that is a section of nature. . . . Lines perpendicular to this

21-81 PAUL CÉZANNE, La Montagne Sainte-Victoire, c. 1886–1888. Approx. $26'' \times 35\frac{1}{2}''$. The Courtauld Institute Galleries, London.

horizon give depth. But nature for us men is more depth than surface, whence the need of introducing into our light vibrations, represented by reds and yellows, a sufficient amount of blue to give the impression of air.*

*Letter from Cézanne to Émile Bernard, April 15, 1904, in Herschel Chipp, *Theories of Modern Art* (Berkeley, CA: University of California Press, 1968), p. 19. In his *Still Life with Peppermint Bottle* (FIG. **21-82**), painted in 1890, the individual forms have lost something of their private character as bottles and fruit and approach the condition of cylinders and spheres. The still life was another good vehicle for Cézanne's experiments, as a limited number of selected objects could be arranged by the artist to provide a well-

ordered point of departure. A sharp clarity of planes and of their edges set forth the objects as if they had been sculptured. Even the highlights of the glassware are as sharply defined as the solids. The floating color of the Impressionists has been arrested, held, and analyzed into interlocking planes. Cézanne created here what might be called, paradoxically, an architecture of color.

The Boy in a Red Vest (FIG. 21-83) shows Cézanne's application of his method to the human figure. Here, the breaking up of the pictorial space, the volumes of the figure, and the drapery into emphatic planes is so advanced that the planes almost begin to take over the picture surface. The geometric character of the color areas pushes to the fore, and we at once become aware of the egglike shape of the head and the flexible, almost metallic shapes of the prominent planes of the body and drapery. The disproportionately long left arm is obvious, for the distortions and rearrangement of natural forms that may go unnoticed in landscape and still-life paintings are immediately apparent in the human figure and often disturbing to the viewer. Still, we may be sure that Cézanne's distortions-and they occur in most of his figure paintingswere not accidental. What Cézanne did, in effect, was to rearrange the parts of his figure, shortening and lengthening them in such a way as to make the pattern of their representation in two dimensions conform to the proportions of his picture surface. Like the Impressionists, Cézanne de-emphasized subject matter. Although the depicted object was primarily a light-reflecting surface to the Impressionists, however, to Cézanne it became a secondary aid in the organization of the picture plane. By reducing the importance of subject matter, Cézanne automatically enhanced the value of the picture he was making, which has its own independent existence and must be judged entirely in terms of its own inherent pictorial qualities. In Cézanne's works, the simplification of shapes and their sense of sculptural relief and weight give a peculiar look of stable calm and dignity that is reminiscent of the art of the fifteenth-century Renaissance and has led modern critics to find in Cézanne some vestige of that ancient Mediterranean sense of monumental and unchanging simplicity of form that produced Classical art.

Unlike Seurat and Cézanne, who, in different ways, sought, by almost scientific investigation, new rules for the ordering of the experience of color, VINCENT VAN GOGH (1853–1890) exploited new colors and distorted forms to express his emotions as he confronted nature. The son of a Dutch Protestant pastor, Van Gogh believed that he had a religious calling and did missionary work in the slums of Lon-

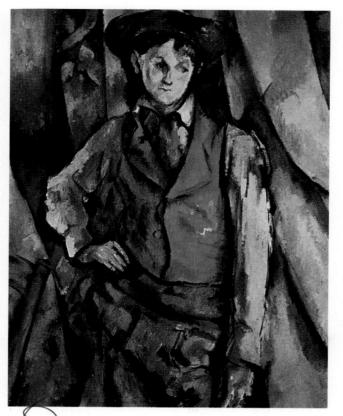

21-8) PAUL CÉZANNE, Boy in a Red Vest, 1893–1895. **354** × 28¹/₂". National Gallery of Art, Washington, D.C. (collection of Mr. and Mrs. Paul Mellon).

don and in the mining districts of Belgium. Repeated failures exhausted his body and brought him close to despair. Only after he turned to painting did he find a means of communicating his experience of the sunilluminated world in landscapes, which he represented pictorially in terms of his favorite color, yellow. His insistence on the expressive values of color led him to develop a corresponding expressiveness in his application of the paint. The thickness, shape, and direction of his brush strokes create a tactile counterpart to his intense color schemes. He moved the brush vehemently back and forth or at right angles, giving a textile-like effect, or squeezed dots or streaks onto the canvas from his paint tube. This bold, almost slapdash attack might have led to disaster had it not been controlled by sensibility.

A rich source of Van Gogh's thought on his art is left in the letters he wrote to his brother, Theo. In one of these, this minister's son who had once wanted to be a pastor wrote: "In life and in painting too I can easily do without God, but I cannot—I who suffer do without something that is bigger than I, that is my life: the power to create." For Van Gogh, the power to create involved the expressive use of color. As he

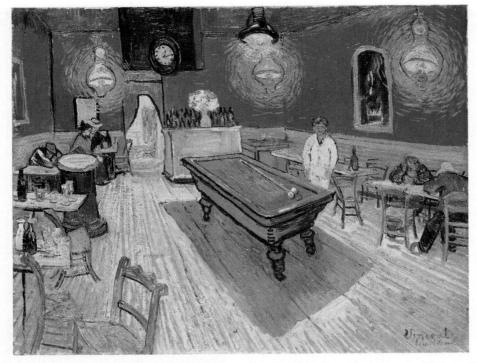

21-84 VINCENT VAN GOGH, *The Night Café*, 1888. Approx. 28¹/₂ × 36". Yale University Art Gallery, New Haven, Connecticut (bequest of Stephen Carlton Clark, B.A., 1903).

wrote to Theo: "Instead of trying to reproduce exactly what I have before my eyes, I use color more arbitrarily so as to express myself forcibly." In another letter, he explained that the color in one of his paintings was "not locally true from the point of view of the stereoscopic Realist, but color to suggest any emotion of an ardent temperament." This particular comment sounds like Delacroix, and indeed Van Gogh wrote: "And I should not be surprised if the Impressionists soon find fault with my way of working, for it has been fertilized by the ideas of Delacroix rather than by theirs," by which he seemed to mean that he took his color method from Delacroix directly rather than from the Impressionists.

The Night Café (FIG. 21-84), as Van Gogh described it, was meant to convey an oppressive atmosphere of evil, through every possible distortion of color. The scene, a café interior in a dreary provincial town, is supposed to be felt, not simply observed. Van Gogh described it in a letter to Theo:

I have tried to express the terrible passions of humanity by means of red and green.

The room is blood red and dark yellow with a green billiard table in the middle; there are four citronyellow lamps with a glow of orange and green. Everywhere there is a clash and contrast of the most disparate reds and greens in the figures of little sleeping hooligans, in the empty, dreary room, in violet and blue. The blood-red and the yellow-green of the billiard table, for instance, contrast with the soft, tender Louis XV green of the counter, on which there is a pink nosegay. The white coat of the landlord, awake in a corner of that furnace, turns citronyellow, or pale luminous green.*

The proprietor, the pale demon who rules over the place, rises like a specter from the edge of the billiard table, which is depicted in a steeply tilted perspective that suggests the spinning, vertiginous world of nausea.

Even more illustrative of Van Gogh's "expressionist" method is *The Starry Night* (FIG. **21-85**), which was painted in 1889, the year before the artist's death. In this work, the artist did not represent the sky as we see it when we look up on a clear dark night—filled with twinkling pinpoints of light against a deep curtain of blue. Rather, he felt the vastness of the universe, filled with whirling and exploding stars and galaxies of stars, beneath which the earth and men's habitations huddle in anticipation of cosmic disaster. Mysteriously, a great cypress is in the process of

*Van Gogh: A Self-portrait, Letters Revealing His Life As a Painter, selected by W. H. Auden (New York: Dutton, 1963), p. 320.

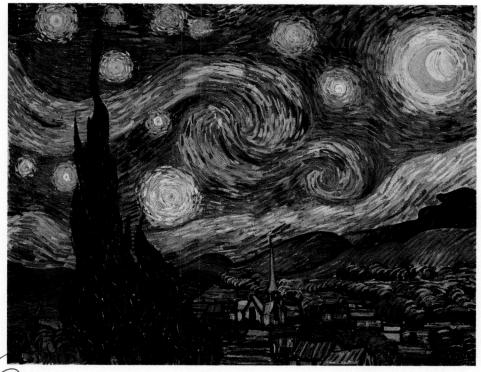

21-89 VINCENT VAN GOGH, The Starry Night, 1889. Approx. 29" × 364". Collection, The Museum of Modern Art, New York (acquired through the Lillie P. Bliss bequest).

rapid growth far above the earth's surface and into the combustion of the sky. The artist did not seek or analyze the harmony of nature here. Instead, he transformed it by projecting on it a vision that was entirely his own. This painting, more than any of his others, seems to carry the meaning of a particularly poignant passage from a letter to his brother:

Is the whole of life visible to us, or isn't it rather that this side of death we see only one hemisphere?

Painters—to take them alone—dead and buried, speak to the next generation or to several succeeding generations through their work.

Is that all, or is there more to come? Perhaps death is not the hardest thing in a painter's life.

For my own part, I declare I know nothing whatever about it, but looking at the stars always makes me dream, as simply as I dream over the black dots representing towns and villages on a map. Why, I ask myself, shouldn't the shining dots of the sky be as accessible as the black dots on the map of France? Just as we take the train to get to Tarascon or Rouen, we take death to reach a star.*

Like Van Gogh, PAUL GAUGUIN (1848–1903) rejected objective representation in favor of subjective

expression. Gauguin wrote disparagingly of Impressionism:

The Impressionists study color exclusively, but without freedom, always shackled by the need of probability. For them the ideal landscape, created from many different entities, does not exist. Their edifice rests upon no solid base and ignores the nature of the sensations perceived by means of color. They heed only the eye and neglect the mysterious centers of thought, so falling into merely scientific reasoning.[†]

Gauguin used color in new and unexpected combinations, but his art was very different from Van Gogh's. It was no less tormented, perhaps, but more learned in its combination of rare and exotic elements and more broadly decorative. Gauguin had painted as an amateur, but after taking lessons with Pissarro, he resigned from his prosperous brokerage business in 1883 to devote his time entirely to painting. Although his work did not sell and he and his family were reduced to poverty, he did not abandon his art, for he felt that, despite ridicule and neglect, he was called to be a great artist. In his search for provocative subjects, as well as for an economical place to live, he stayed for some time in small villages in Brittany and

⁺In Goldwater and Treves, eds., Artists on Art, p. 373.

*Ibid. p. 299

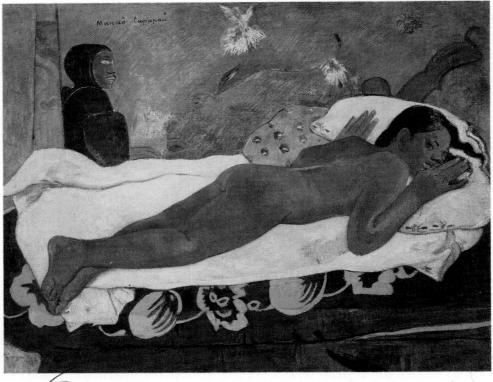

21-80 PAUL GAUGUIN, Spirit of the Dead Watching, 1892. Oil on burlap mounted on canvas, $28\frac{1}{2}'' \times 36\frac{3}{3}''$. Albright-Knox Art Gallery, Buffalo (A. Conger Goodyear Collection, 1965).

visited the tropics (Martinique). Thus, even before he settled in Tahiti in 1891, tropical color and subjects drawn from primitive life had entered his art. In his attitude toward color, Gauguin broke with the Impressionist studies of minutely contrasted hues because he believed that color above all must be expressive and that the power of the artist to determine the colors in a painting is an important part of creativity: "Art is an abstraction; derive this abstraction from nature while dreaming before it, but think more of creating than of the actual result. The only way to rise towards God is by doing as our divine Master does, create." The influence of Gauguin's art and ideas was felt especially by members of the younger generation, such as Parisian artist Maurice Denis, who wrote in Definition of Neo-Traditionalism in 1890:

Gauguin freed us from all the restraints which the idea of copying nature had placed upon us. For instance, if it was permissible to use vermilion in painting a tree which seemed reddish . . . why not stress even to the point of deformation the curve of a beautiful shoulder or conventionalize the symmetry of a bough?

Gauguin's art, too, can be understood as a complex mixture of Eastern and Western elements, of themes common to the great masters of the European Renaissance treated in a manner based on his study of earlier arts and of non-European cultures. In Tahiti and the Marquesas, where he spent the last ten years of his life, Gauguin expressed his love of primitive life and brilliant color in a series of magnificent, decorative canvases. The design was often based, although indirectly, on native motifs, and the color owed its peculiar harmonies of lilac, pink, and lemon to the tropical flora of the islands. Nevertheless, the mood of such works is that of a sophisticated, modern man interpreting an ancient and innocent way of life already threatened by European colonization. Although the figure and setting in Spirit of the Dead Watching (FIG. 21-86) are Tahitian, the theme of a reclining nude with a watching figure as a matching or balancing element belongs to the Renaissance and later periods. The simplified linear pattern and broad areas of flat color recall Byzantine enamels and Medieval stained glass, which Gauguin admired, and the slight distortion of the flattened forms is not unlike similar effects in Egyptian sculpture. Romantic art began with the admiration of "exotic" lands (and peoples) peripheral to Europe; with Gauguin, a kind of adaptation of non-European artistic styles was ini-

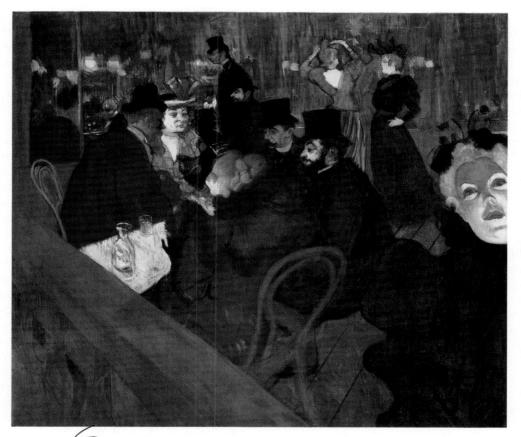

(21.37 HENRI DE TOULOUSE-LAUTREC, At the Moulin Rouge, 1892–1895.
 Approx. 48" × 55". (Helen Birch Bartlett Memorial Collection) photograph
 © 1990, The Art Institute of Chicago. All rights reserved.

tiated. He represented a new rebelliousness, not just against the artistic tradition, but against the whole of European civilization. According to Gauguin, "civilization is what makes you sick." The search for vitality in new peoples and new life styles, launched in the eighteenth century, now quickened, prefiguring the twentieth-century interest in drawing artistic inspiration from Japan, from the Pacific islands, and from much of the non-European world.

A dissatisfaction with civilization, an anxious awareness of the psychic strains it imposed, and a perception of the banality and degradation it can bring with it colored the mood of many artists toward the end of the century and during the years before World War I. This period is the *fin de siècle* (end of the century), when art and literature languished in a kind of malaise compounded of despondency, boredom, morbidity, and hypersensitivity to the esthetic. In a switch from recording the contemporary scene, with all its variety and human interest, as the Impressionists had done, painters influenced by Gauguin and Van Gogh often interpreted it in bitter commentary communicated in harsh distortion of both form and

color. In the work of Henri de Toulouse-Lautrec (1864-1901), who deeply admired Degas, the older master's cool scrutiny of modern life was transformed into grim satire and mordant caricature. Toulouse-Lautrec's art was, to a degree, the expression of his life. Self-exiled by his odd stature and crippled legs from the high society that his ancient, aristocratic name would have entitled him to enter, he became a denizen of the night world of Paris, consorting with a tawdry population of entertainers, prostitutes, and other social outcasts. His natural environment became the din and nocturnal colors of cheap music halls, cafés, and bordellos. In his At the Moulin Rouge (FIG. 21-87), the influence of Degas, of the Japanese print, and of photography can be seen in the oblique and asymmetrical composition, the spatial diagonals, and the strong patterns of line to which Toulouse-Lautrec added dissonant color. But each element, although closely studied in actual life and already familiar to us in the work of the older Impressionists, has been so emphasized or exaggerated that the tone is new. Compare, for instance, the mood of this painting with the relaxed and casual atmosphere of

Renoir's *Le Moulin de la Galette* (FIG. 21-72). Toulouse-Lautrec's scene is night life, with its glaring, artificial light, brassy music, and assortment of corrupt, cruel, and masklike faces. (He included himself in the background: the tiny man with the derby accompanying the very tall man, his cousin.) Such distortions by simplification of the figures and faces anticipated the later Expressionism, when artists would become ever more arbitrary in altering what they saw to increase the impact of their images on the observer.

LATE CENTURY ROMANTICISM: VISIONARY ART

We could argue that what seemed to be antagonistic movements-Realism, Impressionism, and Post-Impressionism-were only so many permutations of Romanticism, changing its earlier iconography, but always putting artistic autonomy at the center of the argument, no matter the subject or the technique. Nature, as given to the eye, was transformed by the artist's emotion and sensation until, by the end of the century, its representation came to be completely subjectivized, to the point that the artist did not imitate nature but created it by free interpretations of it. The optical world as given was rejected in favor of a world of fantasy, of forms conjured up and produced by the artist's free imagination, with or without reference to things conventionally seen. Technique and ideas were individual to each of these artists; color, line, and shape, separated from conformity to the optical image, might be used as symbols of personal emotions in response to the world. No requirement was recognized other than expressing reality in accord with the spirit and intuition. Deliberately choosing now to stand outside of conventional meanings and conventional images, such artists spoke like prophets, in signs and symbols. In the words of the critic Konrad Fiedler, writing in 1876:

The artist is called upon to create another world beside and above the real one. . . Artistic activity begins when man finds himself face to face with the visible world as with something immensely enigmatical. . . What art creates is the world, made by and for the artistic consciousness. . . . It is not the artist who has need of nature; nature much more has need of the artist. . . . By comprehending and manifesting nature in a certain sense, the artist does not comprehend and manifest anything which could exist apart from his activity. . . . Only through artistic activity does man comprehend the visible world.* Thus the artist became not an imitator of nature, but an arbitrary interpreter of it, trusting absolutely to a personal vision. Romanticism, in fostering this view of the artist, presided over the proliferation of individual styles, which, within the broad realm of their variation, can be thought of as Romantic in intention, method, and effect.

In the late nineteenth century, many of the artists following this path adopted an approach to subject matter and form that associated them with a general European movement called Symbolism. The term had application to both art and literature, which, as critics in both fields noted, were in especially close relation at this time. A manifesto of literary Symbolism appeared in Paris in 1886, and, in 1891, the critic Albert Aurier applied the term to the painting of Gauguin and Van Gogh. Symbolists disdained the "mere fact" of Realism as trivial and asserted that fact must be transformed into a symbol of the inner experience of that fact. Fact was thus nothing in itself; mentally transformed, it was the utterance of a sensitized temperament responding in its own way to the world. In Symbolism, the subjectivity of Romanticism became radical; it would continue to be so in much of the art of the twentieth century. The task of Symbolist visual and verbal artists was not to see things but to see through them to a significance and reality far deeper than what is given in superficial appearance. In this function, as the poet Arthur Rimbaud insisted, the artist became a being of extraordinary insight. (One group of Symbolist painters, influenced by Gauguin, called itself Nabis, the Hebrew word for prophet.) Rimbaud, whose poems had great influence on the artistic community, went so far as to say, in his Lettre *du Voyant*, that to achieve the seer's insight, the artist must become deranged—in effect, systematically unhinging and confusing the everyday faculties of sense and of reason, which served only to blur artistic vision. The objects given us in our commonsense world must be converted by the artist's mystical vision into symbols of a reality beyond that world, and, ultimately, a reality from within the individual.

The extreme subjectivism of the Symbolists led them to cultivate all the resources of fantasy and imagination, no matter how recondite and occult. Moreover, it led them to urge the exclusiveness, even the elitism, of the artist against the vulgar materialism and conventional mores of industrial and middleclass society. Above all, by their philosophy of *estheticism*, the Symbolists wished to purge literature and art of anything utilitarian, to cultivate an exquisite esthetic sensitivity, and to make the slogan "art for art's sake" into a doctrine and a way of life. As early as 1856, Théophile Gautier wrote: "We believe in the autonomy of art; art for us is not the means but

^{*}In Linda Nochlin, *Realism and Tradition in Art* (Englewood Cliffs, NJ: Prentice-Hall, 1966), pp. 168–76.

the end; any artist who has in view anything but the beautiful is not an artist in our eyes." Walter Pater, an English scholar and esthete, advanced the same point of view in 1868 in the conclusion to his work *The Renaissance*:

Our one chance lies in expanding that interval [of our life], in getting as many pulsations as possible into the given time. Great passions may give us this quickened sense of life. . . . Of such wisdom, the poetic passion, the desire of beauty, the love of art for its own sake has most. For art comes to you proposing frankly to give nothing but the highest quality to your moments as they pass.

The subject matter of the Symbolists, determined by this worshipfulness toward art and exaggerated esthetic sensation, became increasingly esoteric and exotic, weird, mysterious, visionary, dreamlike, fantastic. (Perhaps not coincidentally, contemporary with the Symbolists, Sigmund Freud, the founder of psychoanalysis, began the new century and the age of psychiatry with his *Interpretation of Dreams*, an introduction to the concept and the world of unconscious experience.)

Elements of Symbolism appeared in the works of both Gauguin and Van Gogh, but their art differed from mainstream Symbolism in their insistence on showing unseen powers as linked to the surface of physical reality, instead of attempting to depict an alternate, wholly interior life. The artists who participated in the actual Symbolist movement were less important than the writers, but two great French artists-Gustave Moreau and Odilon Redon-had a strong influence on the movement, and a number of other painters followed the Symbolist-related path of imagination, fantasy, and inner vision in their works. Prominent figures in this group were the Frenchman Henri Rousseau, the Belgian James Ensor, the Norwegian Edvard Munch, and the American Albert Ryder. All of these artists were visionaries who anticipated the strong twentieth-century interest in creating art that expressed psychological truth.

GUSTAVE MOREAU (1826–1898) sought a form to suit the content of his fantasies that would incorporate reference to the facts of the optical world when he needed them. An influential teacher, Moreau expanded his natural love of sensuous design to embrace gorgeous color, intricate line, and richly detailed shape. He preferred subjects inspired by dreaming solitude and as remote as possible from the everyday world—subjects that could be submerged in all the glittering splendor that imagination could envision and painterly ingenuity could supply. *Jupiter* and Semele (FIG. **21-88**) is one of Moreau's rare finished works. The mortal girl Semele, one of Jupiter's loves, begged the god to appear to her in all his majesty, a

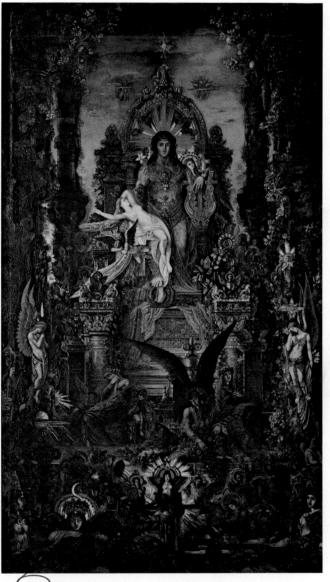

(21-88) GUSTAVE MOREAU, Jupiter and Semele, c. 1875. Approx. $7' \times 3' 4''$. Musée Gustave Moreau, Paris.

sight so powerful that she dies from it. The theme is presented within an operalike setting of towering, opulent architecture. (Moreau was a lover of the music of Wagner and, like that great composer, dreamed of a grand synthesis of the arts.) The painter depicted the royal hall of Olympus as shimmering in iridescent color, with tabernacles filled with the glowing and flashing shapes that enclose the figure of Jupiter like an encrustation of gems. In this painting, the color of Delacroix is harmonized with the exotic hues of Medieval enamels, Indian miniatures, Byzantine mosaics, and the designs of exotic wares then influencing modern artists. Semele, in the lap of Jupiter, is overwhelmed by the apparition of the god, who is crowned with a halo of thunderbolts. Her languorous swoon and the suspended motion of all the entranced figures show the "beautiful inertia" that Moreau said he wished to render with all "necessary richness." His cherishing of the enigmas of fable, myth, vision, and dream caused Manet to remark of him: "I have a lively sympathy for him, but he is taking a bad road. . . . He takes us back to the incomprehensible, while we wish that everything be understood."

The sharp difference of artistic intention expressed in this comment is even more striking in any comparison of the work of ODILON REDON (1840-1916) and of Monet, who were born in the same year. Redon used the Impressionist palette and stippling brush stroke for a very different purpose. Like Moreau, Redon was a visionary. He had been aware of an intense inner world from childhood and later wrote of "imaginary things" that haunted him. In The Cyclops (FIG. 21-89), Redon did not record a fleeting impression of a oneeved giant in love; rather, he projected a figment of the imagination as if it were seeable, coloring it whimsically with a rich profusion of fresh, saturated hues that were in harmony with the mood he felt fitted the subject. The fetal head of the shy, simpering Polyphemus, with its huge, loving eye, rises bal-

21-89 Odilon Redon, The Cyclops, 1898. $25'' \times 20''$. State Museum Kröller-Müller, Otterlo, The Netherlands.

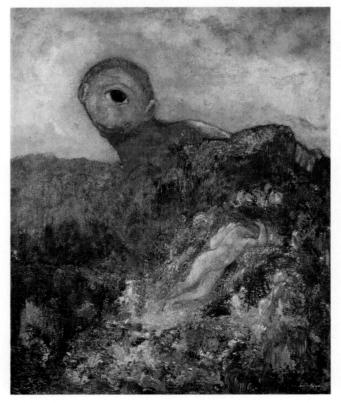

loonlike above the sleeping Galatea. The image born of the dreaming world and the color analyzed and disassociated from the waking world come together here at the will of the artist. As Redon himself observed: "My originality consists in bringing to life, in a human way, improbable beings and making them live according to the laws of probability, by putting as far as possible—the logic of the visible at the service of the invisible." To evoke his world of fantasy, Redon developed a broadly brushed and suggestive style very different from the careful naturalism in Bouguereau's mythical scenes, a new style that generated rich visionary images on which the imagination of the viewer could project additional details.

The imagination of the French artist HENRI ROUSSEAU (1844-1910) engaged a different but equally powerful world of personal fantasy. Gauguin had journeyed to the South Seas in search of primitive innocence; Rousseau was a "primitive" without leaving Paris-an untrained amateur painter who held a post as a customs collector (hence, his sobriquet, le douanier). Rousseau produced an art of dream and fantasy in a style that had its own sophistication and made its own departure from the artistic currency of the fin de siècle. His apparent visual, conceptual, and technical naïveté was compensated by a natural talent for design and an imagination teeming with exotic images of mysterious, tropical landscapes. In perhaps his best-known work, The Sleeping Gypsy (FIG. 21-90), a desert world, silent and secret, dreams beneath a pale, perfectly round moon. In the foreground, a lion that resembles a stuffed but somehow menacing animal doll sniffs at the gypsy. A critical encounter impends, one that is not possible for most of us in the waking world but is all too common when our vulnerable, subconscious selves are menaced in uneasy sleep. Rousseau mirrored the landscape of the subconscious, and we may regard him as the forerunner of the Surrealists in the twentieth century, who will attempt to represent the ambiguity and contradiction of waking and dreaming experiences taken together.

As Goya proved earlier, a fantastic and horrifying image of human decadence and depravity may be revealed when imagination turns a critical eye toward society. The Belgian painter JAMES ENSOR (1860–1949) created a spectral and macabre visionary world in his paintings and filled it with grotesques, masked skeletons, and hanged men populating sideshows, carnivals, and city streets. His best-known work, which was severely criticized for blasphemy, is *Christ's Entry into Brussels in 1889* (FIG. **21-91**). In spirit, it recalls the demonizing, moralizing pictures of Hieronymus Bosch (FIG. 18-19) and Pieter Bruegel (FIG. 18-46) that

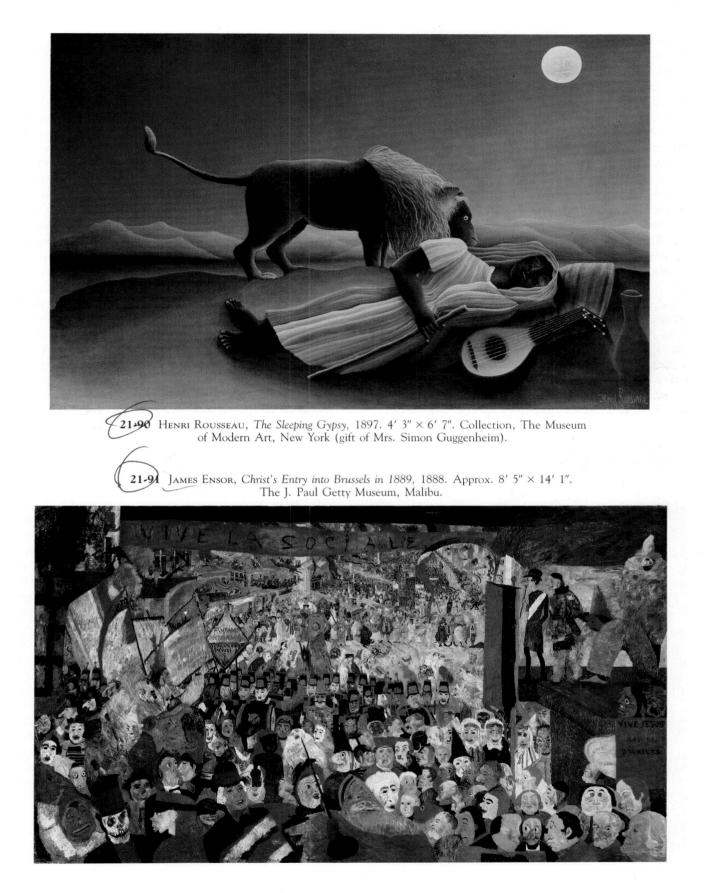

represent Christ surrounded by false and ugly creatures utterly unworthy of his mission. In Ensor's work, however, the human creatures are masked "hollow men" who have no real substance or genuine identity; they are only "images," a theme often sounded in criticism of modern civilization. Ensor's color is hard, strident, and spotted—a tonal cacophony that matches the sound of his repulsive crowd.

Linked in spirit to Ensor was the Norwegian painter and graphic artist EDVARD MUNCH (1863– 1944), another moralizing critic of modern man. Munch felt deeply the pain of human life. His Romantic belief that humans were powerless before the great natural forces of death and love became the theme of most of his art. Specific ideas came to him spontaneously.

I painted picture after picture after the impressions that my eye took in at moments of emotion—painted lines and colors that showed themselves on my inner eye... I painted only the memories without adding

²¹⁻⁹² EDVARD MUNCH, *The Scream*, 1895. Lithograph, $20'' \times 15\frac{3}{16}''$. (Clarence Buckingham Collection) photograph © 1990, The Art Institute of Chicago. All rights reserved.

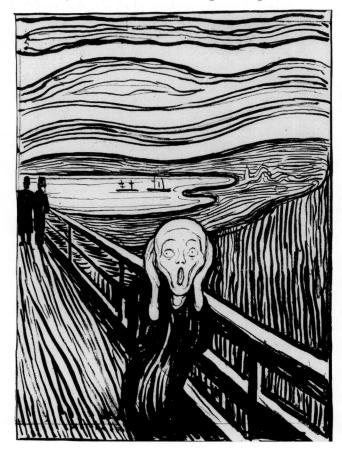

anything—without details I could no longer see. . . . By painting colors and lines and shapes that I had seen in an emotional mood I wanted to make the emotional mood ring out again as happens on a gramophone.*

Often the same composition was repeated as an oil painting and as a woodcut or lithograph. Munch's genius for creating a stark design in black and white made the latter especially effective, as is evident in the lithograph version of The Scream (FIG. 21-92). Here and in much of his other work, Munch created a disturbing vision of neurotic panic breaking forth in a dreadful but silent scream-the scream heard within the mind cracking under prolonged anxiety. Like his friend, the dramatist August Strindberg, Munch presented almost unbearable pictures of the tensions and psychic anguish that besiege human beings and the ultimate loneliness that, according to the modern philosophy of existentialism, is the inescapable lot of humanity. Influenced by Gauguin's use of strong patterns and color as well as his use of the print medium, Munch transmitted these influences through his own work to the German Expressionists of the early twentieth century.

The art of the American painter ALBERT PINKHAM RYDER (1847-1917) is filled with personal visions, most of which are based on literary or religious themes. It is the very essence of Romantic inwardness and is witness to the persistence of Romanticism and its seemingly endless variety of utterance. A recluse, shut away by choice from the world, Ryder found a depthless reservoir of subject in his own imagination, from which arose images uniquely private yet often universal. The power of Ryder's interior world was as strong as that of Munch, Redon, or Rousseau. Although he studied drawing at the American Academy of Design and made several trips abroad, Ryder's improvisational style was deeply rooted in his highly creative spirit. As he commented: "It is the first vision that counts. The artist has only to remain true to his dream, and it will possess his work in such a manner that it will resemble the work of no other man-for no two visions are alike. . . . Imitation is not inspiration, and inspiration only can give birth to a work of art."[†] Inspiration guided his Death on a Pale Horse (The Racetrack, FIG. 21-93). The scythebearing specter speeds on its ceaseless round through a dead landscape that supports only the withered stalk of a tree. In the foreground, a malignant serpent

^{*}In Johan H. Langaard and Reidar Revold, *Edvard Munch: Masterpieces from the Artist's Collection in the Munch Museum in Oslo* (New York: McGraw-Hill, 1964), p. 53.

⁺In McCoubrey, American Art 1700–1960, p. 187.

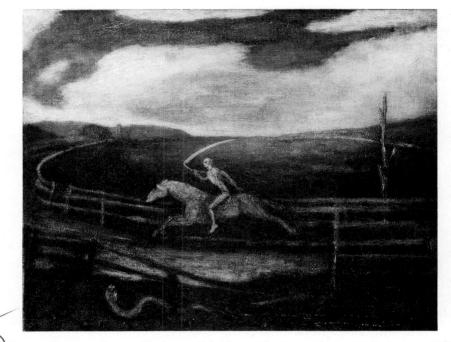

21-93) ALBERT PINKHAM RYDER, Death on a Pale Horse (The Racetrack), c. 1910. Approx. $28\frac{1}{4}'' \times 35\frac{1}{4}''$. The Cleveland Museum of Art (purchase from the J. H. Wade Fund).

with glowing eyes undulates. No one remains on earth but Death and the snake, the symbol of primordial evil. The utter simplicity of the conception and the execution require none but the barest reference to things outside the mind. Blank zones of dark and sombre light are traced through by the faint streaks of the fence rails, which remain undisturbed by the passage of the phosphorescent wraith. Ryder's indifference to the material world unfortunately extended to his material medium and technique. He painted in thick layers with badly prepared or unstable pigments, and many of his works have suffered serious deterioration.

ARCHITECTURE IN THE LATE NINETEENTH CENTURY: THE BEGINNINGS OF A NEW STYLE

The epoch-making developments in architecture that paralleled mid-century Realism in the other arts were rational, pragmatic, and functional. Toward the end of the nineteenth century, architects gradually abandoned sentimental and Romantic designs from the historical past and turned to a presentation of the honest expression of a building's purpose. Since the eighteenth century, bridges had been built of cast iron (FIG. 20-26), and most other utility architecture factories, warehouses, dockyard structures, mills, and the like—had long been built simply and without historical ornament. Iron, along with other materials of the Industrial Revolution, permitted engineering advancements in the construction of larger, stronger, and more fire-resistant structures. The tensile strength of iron (and especially of steel, available after 1860) permitted architects to create new designs involving vast enclosed spaces, as in the great train sheds of railroad stations and in exposition halls.

The Bibliothèque Ste. Geneviève (1843-1850), built by HENRI LABROUSTE (1801–1875), shows an interesting adjustment of the revived Romantic style—in this case, Renaissance-to a Realistic interior, the skeletal elements of which are cast iron (FIG. 21-94). The row of arched windows in the façade recalls the flank of Alberti's San Francesco at Rimini (FIG. 16-41), yet the division of its stories distinguishes the levels of its interior—the lower, reserved for stack space and the upper, for the reading rooms. The latter consist essentially of two tunnel-vaulted halls, roofed in terracotta, and separated by a row of slender cast-iron columns on concrete pedestals. The columns, recognizably Corinthian, support the iron roof arches, which are pierced with intricate vine-scroll ornament out of the Renaissance architectural vocabulary. One could scarcely find a better example of how the forms of traditional masonry architecture are esthetically transformed by the peculiarities of the new structural material. Nor could one find a better example of how

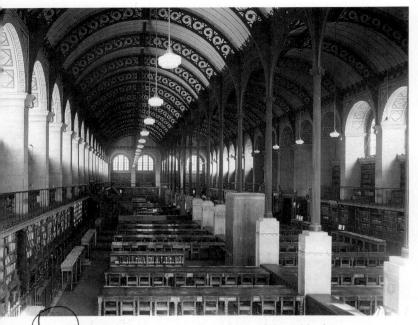

4 Henri Labrouste, reading room of the Bibliothèque Ste. Geneviève, Paris, 1843–1850.

reluctant the nineteenth-century architect was to surrender traditional forms, even when fully aware of new possibilities for design and construction. Architects would scoff at "engineers' architecture" for many years to come, and continue to clothe their steel and concrete structures in the Romantic "drapery" of a historical style.

Completely "undraped" construction first became popular in the conservatories (greenhouses) of English country estates. JOSEPH PAXTON (1801–1865) built several such structures for his patron, the Duke of Devonshire; in the largest-300 feet long-he used an experimental system of glass-and-metal roof construction. Encouraged by the success of this system, Paxton submitted a winning glass-and-iron building plan to the design competition for the hall that was to house the Great Exhibition of 1851, which was organized to gather "Works of Industry of All Nations" together in London. Paxton's exhibition building, the Crystal Palace (FIG. 21-95) was built with prefabricated parts, which allowed the vast structure to be erected in the then unheard-of time of six months, and dismantled at the closing of the exhibition to avoid permanent obstruction of the park.* The plan borrowed much from ancient Roman and Christian basilicas, with a central, flat-roofed "nave" and a barrel-vaulted crossing "transept," which allowed ample interior space to contain displays of huge machines, as well as to accommodate such decorative touches as large working fountains and giant trees.

The iron structural supports used by Labrouste and Paxton were steps on the way to the twentiethcentury skyscraper. The elegant metal skeleton structures of the French engineer-architect ALEXANDRE GUSTAVE EIFFEL (1832–1923) constituted an equally important contribution. A native of Burgundy, Eiffel trained in Paris before beginning a distinguished career designing exhibition halls, bridges, and the inte-

*The public admired the building so much that when it was dismantled, it was re-erected at a new location on the outskirts of London, where it remained until it was destroyed by fire in 1936.

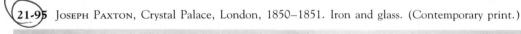

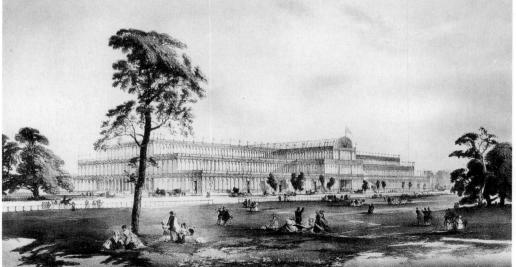

rior armature for France's anniversary gift to the United States-Bartholdi's Statue of Liberty. Eiffel's best-known work, the Eiffel Tower (FIG. 21-96), was designed for a great exhibition in Paris in 1889. Originally seen as a symbol of modern Paris, and still considered as a symbol of nineteenth-century civilization, the elegant metal tower thrusts its needle shaft 984 feet above the city, making it at the time of its construction (and for some time to come) the world's highest structure. The tower's well-known configuration rests on four giant supports, connected by gracefully arching open-frame skirts that provide a pleasing mask for the heavy horizontal girders needed to strengthen the legs. Visitors can take two elevators to the top, or they can use the internal staircase. Architectural historian Siegfried Giedion described the sense of the tower well when he wrote:

The airiness one experiences when at the top of the tower makes it the terrestrial sister of the aeroplane. . . . To a previously unknown extent, outer and inner space are interpenetrating. This effect can only be experienced in descending the spiral stairs from the top, when the soaring lines of the structure intersect with the trees, houses, churches, and the serpentine windings of the Seine. The interpenetration of continuously changing viewpoints creates, in the eves of the moving spectator, a glimpse into fourdimensional experience.*

This interpenetration of inner and outer space would become a hallmark of twentieth-century art and architecture. At the time of their construction, however, Eiffel's metal skeleton structures and the iron skeletal frames designed by Labrouste and Paxton jolted some in the architectural profession into a realization that the new materials and new processes might contain the germ of a completely new style, a radically innovative approach to architectural design, something that picturesque, historical romanticism had failed to produce.

The desire for greater speed and economy in building, as well as for a reduction in fire hazards, encouraged the use of cast and wrought iron for many building programs, especially commercial ones. Designers in both England and the United States enthusiastically developed cast-iron architecture until a series of disastrous fires in the early 1870s in New York, Boston, and Chicago demonstrated that cast iron by itself was far from impervious to fire. This discovery led to the practice of encasing the metal in masonry, combining the strength of the first material with the fireresistance of the second.

*Siegfried Giedion, Space, Time, and Architecture (Cambridge, MA: Harvard University Press, 1965), p. 282.

In cities, convenience required that buildings be closely grouped, and increased property values forced architects literally to raise the roof. Even an attic could command high rentals if the building were provided with one of the new elevators, used for the first time in the Equitable Building in New York (1868–1871). Metal could support such tall structures, and the American skyscraper was born. It was with rare exceptions, however, as in the work of Louis Sullivan (FIGS. 21-98 and 21-99), that this innovative type of building was treated successfully and produced distinguished architecture.

Sullivan's predecessor, HENRY HOBSON RICHARDson (1838–1886), frequently used heavy round arches and massive masonry walls, and because he was particularly fond of the Romanesque architecture of the Auvergne in France, his work was sometimes thought of as a Romanesque revival. This designation does not do credit to the originality and quality of most of the buildings Richardson designed during the brief eighteen years of his practice. Although Trinity Church in Boston and his smaller public libraries, residences, railroad stations, and courthouses in

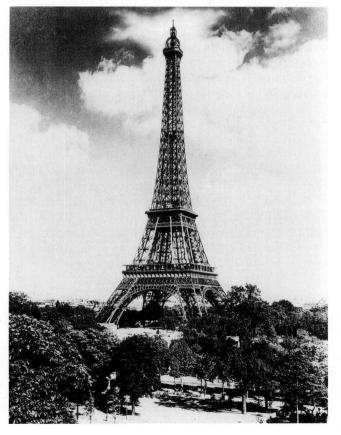

21-97 HENRY HOBSON RICHARDSON, Marshall Field Warehouse, Chicago, 1885–1887.

New England and elsewhere best demonstrate his vivid imagination and the solidity (the sense of enclosure and permanence) so characteristic of his style, his most important and influential building was the Marshall Field Warehouse (now demolished) in Chicago (FIG. 21-97), which was begun in 1885. This vast building, occupying a city block and designed for the most practical of purposes (storage) recalled historical styles without being at all in imitation of them. The tripartite elevation of a Renaissance palace or of the aqueduct near Nîmes, France (FIG. 6-42), may have been close to Richardson's mind, but he used no Classical ornament, made much of the massive courses of masonry, and, in the strong horizontality of the windowsills and the interrupted courses that defined the levels, stressed the long sweep of the building's lines, as well as its ponderous weight. Although the structural frame still lay behind and in conjunction with the masonry screen of the Marshall Field Warehouse, the great glazed arcades, in opening up the walls of a large-scale building, pointed the way to the modern, total penetration of the wall and the transformation of it into a mere screen or curtain that serves both to echo the underlying structural grid and to protect it from the weather.

LOUIS SULLIVAN (1856–1924), who has been called the first truly modern architect, recognized Richardson's architectural innovations early in his career and worked forward from them in designing his

"tall buildings," especially the Guaranty (Prudential) Building in Buffalo, New York (FIG. 21-98), built between 1894 and 1895. Here, the subdivision of the interior is expressed on the exterior, as is the skeletal (as opposed to the bearing-wall) nature of the supporting structure, with nothing more substantial than windows occupying most of the space between the terra-cotta-clad vertical members. In Sullivan's designs, one can be sure of an equivalence of interior and exterior design, not at all the case in Richardson's warehouse (FIG. 21-97) or in Labrouste's library (FIG. 21-94). Yet something of old habits of thought hung on; the Guaranty Building has a base and a cornice, even though the base is penetrated in such a way as to suggest the later free supports of twentiethcentury architecture.

The form of the building, then, was beginning to express its function, and Sullivan's famous dictum that "form follows function," long the slogan of early twentieth-century architects, found its illustration here. Sullivan did not mean by this slogan that a functional building is automatically beautiful, nor did he advocate a rigid and doctrinaire correspondence between exterior and interior design. Rather, he espoused a free and flexible relationship—one that his

21-98 LOUIS SULLIVAN, Guaranty (Prudential) Building, Buffalo, New York, 1894–1895.

21-99 LOUIS SULLIVAN, Carson, Pirie, Scott Building, Chicago, 1899–1904.

great pupil, Frank Lloyd Wright, would later describe as similar to that between the bones and tissue of the hand.

Sullivan took a further step in the unification of exterior and interior design in his Carson, Pirie, Scott Building in Chicago, Illinois (FIG. 21-99), built between 1899 and 1904. A department store, this building required broad, open, well-illuminated display spaces. The structural steel skeleton, being minimal, permitted the singular achievement of this goal. The relation of spaces and solids here is so logical that nothing in the way of facing had to be added, and the skeleton is clearly revealed in the exterior. The decklike stories, faced in white ceramic slabs, seem to sweep freely around the building and show several irregularities (notably the stressed bays of the corner entrance) that help the design to break out of the cubical formula of Sullivan's older buildings. The lower two levels of the Carson, Pirie, Scott Building are given over to an ornament in cast iron (of Sullivan's invention) made of wildly fantastic motifs that bear little resemblance to anything traditional architecture could show. In the general search for a new style at the end of the century, Sullivan was a leader. He gave as much attention to finding new directions in architectural ornament as in architecture itself. In this respect, he was an important figure in the movement called Art Nouveau, whose adherents sought an end to all traditional ornamental styles—indeed, to the whole preoccupation with historical style that had been postponing the true advent of a modern method of representing form in the arts.

By the end of the nineteenth century, the Western artist's vision of reality had changed. Throughout the century, a plurality of styles had opened new ways of seeing and expressed new understandings about visual and mental reality. Changes in architectural technique altered the possibilities for the look and shape of cities. In painting, attitudes stemming from the rise of experimental science stimulated the artist's interest in the distinction between what is seen and how it is seen, and encouraged a taste for experiment with the tools of the artist's trade-new pigments and new theories of light and color. At the same time, the invention of photography affected the pictorial mode and the artist's manner of expression. As the century progressed, sculptors and painters replaced the thematic material of Romanticism with scenes from the modern public world and a growing interest in human society and group behavior. Realism was a major impetus in art during much of the second half of the century, with the artist's method, like the scientific scholar's, being descriptive. In the latter part of the century, this approach was gradually replaced, on one hand, by formal analysis and expression, in which painters discovered that the canvas was not a transparent window opening onto the optical world of nature, but a tangible surface on which pigments could be arranged in a variety of ways. On the other hand, artists returned to valuing above all the role of imagination and fantasy in the creation of art. In the early twentieth century, Pablo Picasso clearly stated this separation between natural appearance and either formal or visionary art: "Nature and art, being two different things, cannot be the same thing. Through art we express our conception of what nature is not."

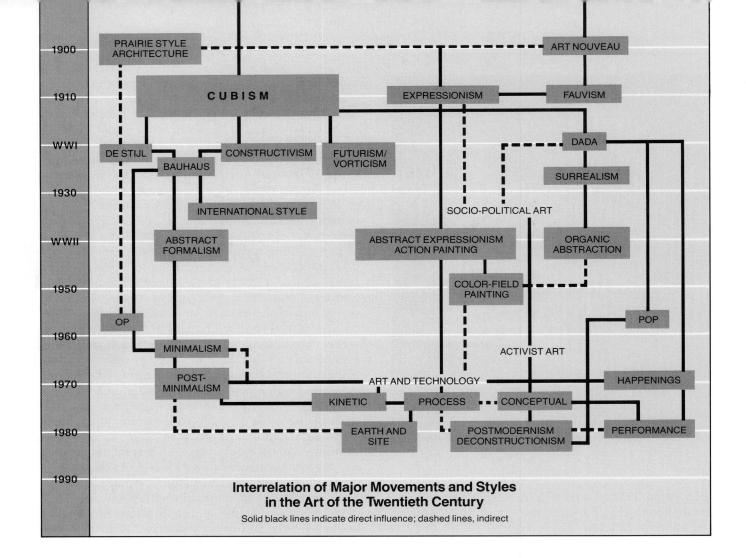

22

THE EARLY TWENTIETH CENTURY

HE EARLY TWENTIETH CENTURY WAS A time of accelerated social change and intellectual ferment. World War I engulfed a generation of young men, twisted national economies, and extinguished the gracious, upper-class way of life that had dominated European society since the late nineteenth century. Peace brought new problems: disease, hunger, labor unrest, and bank failures led to the monetary speculation and raucous life-style of the 1920s that culminated in the stock market crash of 1929 and the Great Depression. Continuing social instability also generated the hunger for strong new government that saw both the birth of Soviet Russia (1917) and the rise of Adolf Hitler (1933).

The turmoil in the general social condition was accompanied by changes in the details of daily life. By now, the Industrial Revolution had changed work patterns to provide people with more leisure time, and new inventions helped individuals to shape this time to their own liking. Public libraries, public museums, and public recreation facilities spread. Movies, invented independently in the 1890s by Thomas Alva Edison in the United States and by the brothers Pierre and Auguste Lumière in France, developed rapidly, and by the early twentieth century had become the favorite public entertainment. Radio also gained widespread popularity and, with newsreels, began to change the way in which people received and perceived the news. New magazines flourished and were soon transformed by the rise of photojournalism, which created a new appetite for information communicated through a combination of words and images. The automobile replaced the horse and buggy for personal trips. Buses added new flexibility to travel for those who could not or did not wish to drive, and commercial air travel began to shrink the physical distance between cities and nations.

The early twentieth century also was a time of revolutionary thought about all aspects of the world. Sigmund Freud described the concepts of the ego, the id, and the superego, and revealed the power childhood experience and sexuality exert on our adult lives. Psychiatrist Carl Jung focused attention on the intuitive interconnection between all human beings through what he called the "collective unconscious." The physical and biological sciences continued to change the way people thought about physical reality. In particular, the ideas expounded at the beginning of the century by the physicist Albert Einstein underlay the reasons why "seeing" was no longer necessarily grounds for "believing." The world perceived by the five physical senses was now understood not to be exactly what it seemed. Einstein's the-

ory of relativity described how the "reality" of any thing (as determined by that thing's ability to be measured) must be considered relative to the position both of the object being observed and of the person observing it, a relationship illustrated by the way in which the physical attributes and behavior of objects in a landscape appear markedly different to a passenger in a moving train and to a pedestrian on a hill near the train tracks. To know reality, all things must be understood in relationship to everything else, because every object is located on a point in a spacetime continuum filled with electrical fields in which all motion is relative to systems themselves in motion. The universe is composed of *space* and *time*, and Einstein showed that there could be no stable "center" in this expanding, four-dimensional universeno absolute standpoint that could certify our measurements of space and time, because perceptions change as a function of the location in time and space of the observer.

We have already seen how events in the late eighteenth and early nineteenth century began to shake people's faith in the moral certainties of Western society. Amid the increased pressures of the early twentieth century, many artists turned away from the certainties of art based on the Renaissance ideal, with its method of mathematical perspective. In its place, painters and sculptors increasingly drew inspiration from art not in the Western Renaissance tradition work from the Western Middle Ages and, outside Europe, from Asia, Africa, Oceania, and pre-Columbian Central and South America. In painting, artists' desires to reveal their creative activities intensified, with special emphasis being placed on the process by which a work was made. Painters continued to experiment as they had in the late nineteenth century, conducting a "dialogue" between an illusionistic representation of a subject in three-dimensional space and the clear creation of a pattern of shapes in paint on the flat surface of a canvas. Sculptors made the marks of chisel, modeling finger, or welding torch part of the expressive content of their pieces. Architects created designs in which the inner structure of their buildings became part of the final design.

Given the new view of the world, the "look" of reality seemed problematic to many artists, as did any direct copy of its appearance. Hungarian-American artist László Moholy-Nagy called for nothing less than a "new vision . . . vision in motion" to express the new age: "Vision in motion is simultaneous grasp. Simultaneous grasp is . . . seeing, feeling, and thinking in relationship and not as a series of isolated phenomena. . . . Vision in motion is a synonym for simultaneity and space-time; a means to comprehend the new dimension."* Painters, sculptors, and architects invented new patterns to reflect their understanding of this new reality. The use of materials like glass, plastics, and industrial metal generated new techniques of construction, which in turn allowed a new interplay of solid mass with carefully created spacevoid shapes. Much of the new art was abstract or nonobjective. Although many people use the words abstract and nonobjective interchangeably to refer to art that is not based on the external, visible world, in the realm of art, the subject of an abstract work has been "abstracted" from natural appearance, and vestiges of figures or objects still may be detected in it. A nonobjective work, on the other hand, has no discernible reference to the external appearance of the physical world.[†]

The twentieth century is part of the modern era, and this era has included artists working in many styles and approaches. Yet the term *Modernism* is used by most scholars only to refer to the artistic styles that call attention to the processes of making art. Often these styles include the use of modern materials and technology to express the activity of the artist as creator and to depict the essence of the modern model of reality revealed by science. According to this view, Modernism in *painting* is the exploration of the way in which that medium is basically a design made on a flat surface, while Modernist sculpture stresses, above all, the arrangement of shapes in three-dimensional space. The critic Clement Greenberg summarized Modernism as "art [used] to call attention to art."

The Modernist formalist approach led from the nature-based paintings of the Impressionists and Post-Impressionists, through the more purely formal works of the Fauves and Cubists, to fulfillment in the second half of the century in the nonobjective Color-Field paintings of artists like Mark Rothko (FIG. 23-14). Early in the century, before the outbreak of World War I, Paris remained the major art center, and her most exciting artists were engaged in the formalist approach, basing their forms on abstractions from things in the visible world. However, spurred by the dislocations of the war, two other approachesgrounded in the ideas of the Enlightenment and its nineteenth-century aftermath—gained in importance: art with psychological and conceptual concerns and art with social and political concerns.

Art with psychological and conceptual concerns carried into the twentieth century the interest in depicting the inner world of fantasy, dream, and feeling explored earlier by artists like Stubbs, Blake, Van Gogh, Rousseau, and Munch. The new psychological and conceptual approach was based on an increasing self-consciousness about the way in which the understanding and perception of all things seen are affected by everything in each viewer's mind and heart. The ideas underlying this approach were eloquently stated by the theorist and critic Hermann Bahr in 1920. Bahr made special reference to painting, but the concepts are applicable to the other arts as well:

The history of painting is nothing but the history of vision—or seeing. . . . A man views the world according to his attitude towards it. All the history of painting is therefore in a sense also a history of philosophy, especially of unwritten philosophy. . . . Seeing consists of two activities, an outer and an inner one. . . . As soon as a man realizes that his seeing is always the result of some external influence, as well as of his own inner influence, it depends on whether he trusts the outer world more—or himself. . . .—or a third choice is possible, that of halting on the boundary line between the two.[‡]

Artists following the psychological and conceptual approach early in the century produced works in all modes—figurative, abstract, and nonobjective, with artists of nonobjective works seeing their compositions, as critic Sheldon Cheney has noted, as symbols for universal qualities invisible to the eye:

Form is revelation . . . not merely of a plastic organism, but *through* the plastic of something that might be termed universal or cosmic truth, and, commonly, of human emotion. . . . The Expressionist's business then, in creating the plastic synthesis, is to reveal through it the ultimate hidden principle, the allrelating harmony, the sense of cosmic unity. . . . The picture with a vitality of its own sort, determined physically by the nature of its materials and means flat field, spatial sense, voluminous organization, dynamic colors—is in itself a universe in little, yet exhibiting the laws of original creation, and the rhythm and poise of celestial movement.[§]

^{*}László Moholy-Nagy, Vision in Motion (1946, Chicago: Paul Theobald, 1969), pp. 10–12.

[†]Determining whether a work of art is abstract or nonobjective has become more complicated as science extends our knowledge about material nature. Many artists have been attracted by new forms revealed through the microscope, the telescope, and even the naked eye taken to a new vantage point above the earth or under the sea. The mass media have made all such images part of everyone's visual experience; the images have become part of the references brought to the viewing of any artwork. It is now almost impossible for an artist to design a piece that will not seem a close visual echo of objects seen somewhere in our everyday world.

[‡]In Francis Frascina and Charles Harrison, eds., *Modern Art and Modernism: A Critical Anthology* (New York: Harper & Row, 1982), pp. 165–66.

[§]In Frascina and Harrison, eds., *Modern Art and Modernism*, pp. 171, 173. Cheney used the term *expressionism* broadly; in art history the term is more usually assigned to specific groups of artists, as we shall see.

The third approach—art with social and political concerns-attracted artists with diverse styles and goals. Adhering in varying ways to the Enlightenment belief that art could help to educate human beings and change society, these artists also represented the increasing popularity of political and sociological ideas about modern civilization. Some of these artists, especially architects, believed they could help to design better communities. Others wanted to turn attention once again to the beauty and variety of the world around them. Many sought to reinvigorate the role of the artist within society by speaking to and about ordinary people rather than the moneyed classes. A major crystallizer of ideas for those supporting this approach was the theorist Walter Benjamin, who espoused the attitude that viewers bear an important responsibility with regard to understanding the social role of any work of art and the ways in which art is produced in the modern industrial age: "Rather than asking, what is the attitude of a work to the relations of production of its time, I should like to ask, what is its position in them?"* Artist and viewer alike were to be aware of the whole sociopolitical context of the art work and of its place within that context. Toward the end of the century, these considerations would, in themselves, become the foundation of a new approach termed "Postmodernism" by critics.

Although it is possible to distinguish these three approaches within Modernism, they quite naturally overlap one another somewhat. All artists have some interest in the formal qualities of their work, but those who followed the formalist approach made this interest the major theme. Similarly, most artists want their work to touch the emotions and mind of the viewer, but this was the main motive underlying the art of those who followed the psychological and conceptual approach. Finally, many artists working within the psychological and conceptual approach addressed some of the concerns with the conditions of the society around them held by the artists who followed the approach of art with social and political concerns, but only the adherents of the social and political approach made that content the central focus of their work. Whatever the artist's approach, two common themes ran through Modernism in the early years of this century. First, artists desired above all to express in their art something of what it was to be alive in the modern world. And second, early twentieth-century Modernist art contained a heightened sense of the personal vision of the artist and of the way materials could be used to create works that expressed that vision.⁺

ART WITH FORMALIST CONCERNS

Artists with formalist concerns occupied center stage in the Paris art world early in this century. They shared a strong interest in what Clement Greenberg has described as "stressing . . . the ineluctable flatness of the support" and abandoning "the representation of the kind of space that recognizable, threedimensional objects can inhabit."[‡] First to develop the new formalist style were Art Nouveau and Fauve artists, whose works were inspired in part by the sinuous forms in the Post-Impressionist work of Van Gogh and Gauguin. Drawing on intuition and a joy in nature's flowing patterns, as well as on past art, these artists created colorful arrangements of flowing, flat shapes intended to be expressive in and of themselves. Balancing the free-flowing compositions of Art Nouveau and the Fauves were Cubist works created by artists attempting to add a twentieth-century notion of space-time to Cézanne's conceptual analysis of nature in terms of color planes.

Art Nouveau and Fauvism: Patterns of Delight

Art Nouveau was a movement whose proponents tried to synthesize all the arts, in a determined attempt to create art based on natural forms that could be mass-produced by the technologies of the industrial age.[§] The Art Nouveau style emerged at the end of the nineteenth century and adapted twining plant forms to the needs of architecture, painting, sculpture, and all of the decorative arts. Its foliate patterns, rendered in cast iron, had adorned the ground floor of Louis Sullivan's Carson, Pirie, Scott building in Chicago (FIG. 21-99). The mature style, however, was first seen in houses designed in Brussels in the 1890s

[†]Despite the rejection of Renaissance conventions of representation of space, the Modernist artist could be said to follow what John Lane has called the Renaissance "concept of the artist as hero, as . . . a unique individual striving to bring new consciousness to birth." (Lane, *The Living Tree* [Hartland, Devon: Green Books, 1988], p. 33.)

[‡]In Frascina and Harrison, eds., Modern Art and Modernism, p. 6.

⁸The international style of Art Nouveau took its name from a shop in Paris dealing with "*L'Art Nouveau*" (new art) and was known by that name in France, Belgium, Holland, England, and the United States. In other places, it had other names: *Jugendstil* in Austria and Germany (after the magazine *Der Jugend*, youth), *Modernismo* in Spain, and *Floreale* or *Liberty* in Italy.

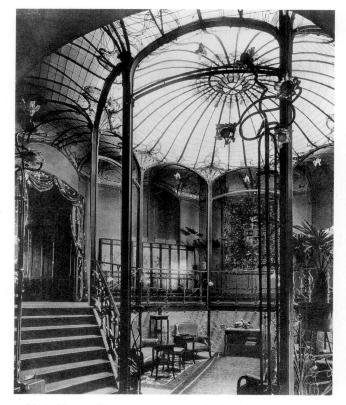

22-1 VICTOR HORTA, staircase in the Hotel van Eetvelde, Brussels, Belgium, 1895.

by VICTOR HORTA (1861–1947). The staircase in the Hotel van Eetvelde (FIG. 22-1), which Horta built in Brussels in 1895, is a good example of his Art Nouveau work. Every detail functions as part of a living whole. Furniture, drapery folds, veining in the lavish stone panelings, and the patterning of the door moldings join with real plants to provide graceful counterpoints for the metallic tendrils that curl around the railings and posts, the delicate metal tracery that fills the glass dome, and the floral and leaf motifs that spread across the fabric panels of the screen (left background).

A number of influences can be identified in Art Nouveau; they range from the rich, foliated, twodimensional ornament and craftsman's respect for materials of the "Arts and Crafts" movement in late nineteenth-century England to the free, sinuous, whiplash curve of designs in Japanese prints. Art Nouveau also borrowed from the expressively patterned styles of Vincent van Gogh (FIG. 21-85), Paul Gauguin (FIG. 21-86), and their Post-Impressionist and Symbolist contemporaries.

In all Art Nouveau pictorial art, Renaissance perspective space was rejected in favor of motifs that emphasized the plane of the composition. The work

of the Viennese artist GUSTAV KLIMT (1862-1918) graced the walls of many Art Nouveau interiors. His masterly blend of rich patterning with modeled flesh can be seen in the painting Death and Life (FIG. 22-2). A visit in 1903 to the great Byzantine mosaics in Ravenna (FIG. 7-36) added new richness to the artist's natural gifts for creating densely textured, twodimensional designs that expressed his feeling for sensual fantasies. Death and Life is a modern representation of a vanitas picture. As in Hans Holbein's The French Ambassadors (FIG. 18-41), Klimt's Death appears in the midst of Life. The figure of Death looms against a dim, featureless void, wrapped in a mantle of somber blues and greens sprinkled with chiromantic symbols and black crosses of varying sizes. He leans eagerly toward the teeming river of slumbering Life. Bright colors stud the surfaces that enwrap the voluptuously somnolent figures in the Life group, in which intertwined images of infancy, youth, maturity, and old age celebrate life bound up with love. Outlined shapes are modeled only to the extent needed to show the softness of flesh, the firmness of sinew, and the stark hardness of bone.

Art Nouveau achieved its most personal expression in the work of the Spanish architect ANTONI GAUDÍ (1852–1926). Before becoming an architect, Gaudí had trained as an ironworker. Like many young artists of his time, he longed to create a style that was both modern and appropriate to his country. Taking inspiration from Moorish-Spanish architecture and from the simple architecture of his native Catalonia, Gaudí developed a personal esthetic in which he conceived a building as a whole and molded it almost as a sculptor might shape a figure from clay. Although work on his designs proceeded slowly under the guidance of his intuition and imagination, Gaudí was a master who invented many new structural techniques that facilitated the actual construction of his visions. His apartment house, Casa Milá (FIG. 22-3), is a wondrously free-form mass wrapped around a street corner. Lacy iron railings enliven the swelling curves of the cut-stone façade, while dormer windows peep from the undulating tiled roof, which is capped by fantastically writhing chimneys that poke energetically into the air above. The rough surfaces of the stone walls suggest naturally worn rock. The entrance portals look like eroded sea caves, but their design also may reflect something of the excitement that swept Spain following the 1879 discovery of Paleolithic paintings in a cave at Altamira. Gaudí felt that each of his buildings was a symbolically living thing, and the passionate naturalism of his Casa Milá is the spiritual kin of early twentieth-century Expressionist painting and sculpture.

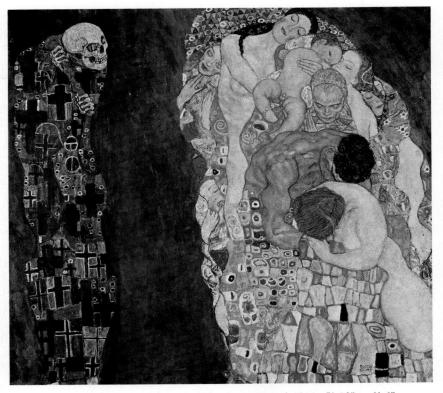

22-2 GUSTAV KLIMT, Death and Life, 1908 and 1911. 5' $10'' \times 6' 6''$. Collection of Marietta Preleuthner, Salzburg.

22-3 Antoni Gaudí, Casa Milá, Barcelona, Spain, 1907.

22-4 ANDRÉ DERAIN, London Bridge, 1906. Approx. 26" × 39". Collection, The Museum of Modern Art, New York (gift of Mr. and Mrs. Charles Zadok).

In 1905, the first signs of a specifically twentiethcentury movement in painting appeared in Paris. In that year, at the third Salon d'Automne, a group of younger painters under the leadership of Henri Matisse exhibited canvases so simplified in design and so shockingly brilliant in color that a startled critic described the artists as fauves (wild beasts). The "Fauves" were totally independent of the French Academy and the "official" Salon, and their works were heavily influenced by the art of non-European cultures. They were among the first twentiethcentury artists to be inspired by non-Western art. In African fetishes, in Polynesian decorative wood carvings, and in the sculptures and textiles of the ancient cultures of Central and South America, Fauve artists saw unexpected shapes and colors that suggested new ways of communicating emotion. These discoveries led them individually into paths of free invention and away from the traditions of the Renaissance. The Fauves produced portraits, landscapes, still lifes, and nudes of great spontaneity and verve, with rich surface textures, lively linear patterns, and boldly clashing primary colors. They were also inspired by the works of Van Gogh and Gauguin (shown in retrospective exhibitions in Paris in 1901 and 1903), but the Fauves went further than any earlier artist by bringing color to a new intensity with startling discords of vermilion and emerald green, cerulean blue and vivid

orange held together by sweeping brush strokes and bold patterns. Typical of their vibrant vision is London Bridge (FIG. 22-4) by ANDRÉ DERAIN (1880–1954). In this work, Derain rejected the harmonies of Impressionism, so expressive of atmospheric and light conditions, in favor of a distorted perspective emphasized by the contrast of the non-naturalistic colorsclashing yellows, blues, greens, reds, and orangesagainst the black accents of the arches. Derain, like the other Fauves, believed that an artist's goal should be to make the strongest possible presentation of his emotional reaction to a subject by using bold color and strong linear patterns. In Fauve works, color no longer described the local tones of an object; instead, it created the expressive content of the picture, foreshadowing later nonobjective works whose entire content was the interaction of color and form.

The Fauve group was never an official organization of painters, and it lasted only a short time. Within five years, most of the artists had modified their violent colors and found their own, more personal styles. The artist who remained most faithful to Fauve principles, while transforming them through his extraordinary sensitivity for color, was HENRI MATISSE (1869–1954). Throughout his long life, Matisse's gifts for combining colors in unexpected ways and for inventing new combinations never flagged. He had trained as a lawyer, was employed as

22-5 HENRI MATISSE, Red Room (Harmony in Red), 1908–1909. Approx. 5' $11'' \times 8' 1''$. State Hermitage Museum, Leningrad.

a designer for tapestry and textiles, and began painting as a pupil of Gustave Moreau (FIG. 21-88), working his way through a variety of earlier styles before beginning to follow Cézanne's idea that light could not be reproduced in painting, but must be represented there by color. Red Room (Harmony in Red) (FIG. 22-5) shows Matisse's mature style, one in which bold Fauve color is controlled by wonderful curving lines, partly inspired by the artist's strong interest in works as diverse as those of Duccio (FIG. 15-7) and Ingres (FIG. 21-14), as well as Japanese prints (FIG. 21-74), and Near Eastern textiles, pottery, and paintings (FIG. 7-85). The composition is a festive, lyrical arrangement of simplified interlocking shapes. The space of the room is suggested by the perspective view of the chair seat and the window's frame, but it is simultaneously transformed into a flat pattern of colored shapes and the patterned red-pink fields shared by the tablecloth and the wall paper. The work is a harmonious whole. Even the figure of the woman at the right is constructed from the same kind of forms as the other objects in the painting. Matisse himself said that his procedure was one of continuous adjustment-color to color, shape to shape, and color to shape—until he had achieved exactly the right "feel" and the painting was completed.

Composition for Matisse involved drawing on every element of color, shape, and arrangement to create a harmonious unity; he sought to soothe the mind and emotions of viewers in the midst of a demanding and often troubling world.

The whole arrangement of my picture is expressive. The place occupied by figures or objects, the empty spaces around them, the proportions, everything plays a part. Composition is the art of arranging in a decorative manner the various elements at the painter's disposal for the expression of his feelings. . . . A work of art must be harmonious in its entirety; for superfluous details would, in the mind of the beholder, encroach upon the essential elements. . . . What interests me most is neither still life nor landscape but the human figure. It is through it that I best succeed in expressing the nearly religious feeling that I have towards life. . . . What I dream of is an art of balance, or purity and serenity devoid of troubling or depressing subject matter, an art which might be for every mental worker, be he businessman or writer, like an appeasing influence, like a mental soother, something like a good armchair in which to rest from physical fatigue.*

*In Herschel B. Chipp, ed., *Theories of Modern Art* (Berkeley: University of California Press, 1973), pp. 132, 135.

Matisse's way of allowing his paintings to "emerge" out of deep, even unconscious feelings, and of letting his artistic sensitivity and instinct be his guides, was a common practice among many other modern artists as well.

Cubism

A more analytical variant of the formalist approach in early twentieth-century art was found in Cubisma style inspired partly by the desire to express the space-time qualities of reality newly revealed by scientists like Einstein. Cubism was developed jointly, between 1908 and 1913, by the Spanish artist PABLO PICASSO (1881–1973) and the French painter Georges BRAQUE (1882–1963), both through their continuing exchange of ideas and in their separate works. The new style received its name after Matisse described some of Braque's 1908 works to a critic as having been painted "avec des petits cubes" (with little cubes). The originality of Cubism lay in its discovery of a new kind of pictorial space to replace the kind that had been developing in Western art since the time of Giotto. Adopting Cézanne's suggestion that artists use the simple forms of cylinders, spheres, and cones to represent nature in art, the Cubists then expanded on his idea that each object could be depicted from a shifting point of view, as if seen from several markedly different angles at once. The central concepts of Cubism were beautifully summarized in 1913 by the French writer and theorist Guillaume Apollinaire:

Authentic Cubism [is] the art of depicting new wholes with formal elements borrowed not from the reality of vision, but from that of conception. This tendency leads to a poetic kind of painting which stands outside the world of observation; for, even in a simple cubism, the geometrical surfaces of an object must be opened out in order to give a complete representation of it. . . . Everyone must agree that a chair, from whichever side it is viewed, never ceases to have four legs, a seat and back, and that if it is robbed of one of these elements, it is robbed of an important part.*

Picasso and Braque created two different and distinct variations of the basic style—Analytic Cubism and Synthetic Cubism, each of which was widely influential on later art.

ANALYTIC CUBISM

The first Cubist style developed by Picasso and Braque was "Analytic Cubism." Since the kind of total view described by Apollinaire could not be achieved by the traditional method of drawing or painting a model from one position, these artists began to *analyze* the forms of their subjects from every possible vantage point and to combine the various views into one pictorial whole.

The first steps toward this new style were taken by Picasso in a large painting, Les Demoiselles d'Avignon (FIG. 22-6), which broke decisively with the art of the past. Picasso was a precocious student who had mastered all aspects of late nineteenth-century Realist technique by the time he entered the Barcelona Academy of Fine Art in the late 1890s. His prodigious talent led him to experiment with a wide range of visual expression, first in Spain and then in Paris, where he settled in 1904. Throughout his career, Picasso remained a traditional artist in the way he made careful studies in preparation for each major work. He was characteristic of the modern age, however, in his constant experimentation, in his sudden shifts from one kind of painting to another, and in his startling innovations in painting, graphic art, and sculpture. Inspired by Michelangelo, Rodin, and El Greco, Picasso explored the ways in which the human body could express emotion. By the time he settled permanently in Paris, his work had evolved from the sober Realism of Spanish painting, through a brightening of color in an Impressionistic manner (for a time, influenced by the early works of Toulouse-Lautrec), and into the so-called Blue Period (1901–1905), in which he used primarily blue colors to depict worn, pathetic, alienated figures in the pessimistic mood of the end of the nineteenth century.

By 1906, Picasso was searching restlessly for new ways to depict form. He found clues in African sculpture, in the sculpture of ancient Iberia, and in the late paintings of Cézanne. The three sources come together in Les Demoiselles d'Avignon (FIG. 22-6), which opened the way for a radically new method of representing form in space. Picasso began the work as a symbolic picture to be titled Philosophical Bordello, in which male clients intermingled with women in the "receiving" room of a brothel. By the time the artist began the final canvas, he had eliminated the male figures and simplified the details of the room to a suggestion of drapery and a schematic foreground still life; Picasso had become wholly absorbed in the problem of finding a new way to represent the five female figures in their interior space.⁺ Instead of representing the figures as continuous volumes, Picasso fractured their shapes and interwove them with the equally jagged planes that represent drapery and

^{*}In Edward Fry, ed., *Cubism* (London: Thames & Hudson, 1966), pp. 112–13, 116.

[†]The artist did keep a sly reference to the original subject in his final title—"Avignon" was the name of a well-known street in Barcelona's red-light district.

22-6 PABLO PICASSO, Les Demoiselles d'Avignon, Paris (begun May, reworked July 1907). $8' \times 7' 8''$. Collection, The Museum of Modern Art, New York (acquired through the Lillie P. Bliss Bequest).

empty space. The treatment of form and space used by Cézanne is pushed here to a new tension between the representation of three-dimensional space and a statement of painting as a two-dimensional design lying flat on the surface of a stretched canvas. The radical nature of Les Demoiselles is extended even further by the disjunctive styles of the heads of the figures and by the pose of the figure at the bottom right. The calm, ideal features of the three ladies at the left were inspired by the sculpture of ancient Iberia, which Picasso saw during summer visits to Spain. The energetic, violently striated features of the two heads to the right came late in the making of the work and grew directly out of the artist's increasing fascination with the power of African sculpture. As if in response to the energy of these two new heads, Picasso also revised their bodies, breaking them into more ambiguous planes that suggest a combination of views, as if the figures are being seen from more than one place in space. The woman seated at the lower right shows these multiple views most clearly, seeming to present the viewer simultaneously with a three-quarter back view from the left, another from the right, and a front view of the head that adds the suggestion that we see the figure frontally as well.

Gone is the traditional concept of an orderly, constructed, unified pictorial space that mirrors the world. In its place are the rudimentary beginnings of a new representation of the world as a dynamic interplay of time and space.

For many years, Picasso showed this extraordinary painting only to other painters. One of the first to see it was Braque, a Fauve painter, who was so agitated and challenged by it that he began reinventing his own painting style in response. One of Braque's paintings, The Portuguese (FIG. 22-7), is a striking example of Analytic Cubism. The subject is derived from the artist's memories of a Portuguese musician seen years earlier in a bar in Marseilles. In this painting, all of Braque's energy has been concentrated on dissecting the form and placing it in dynamic interaction with the space around it; color is reduced to a monochrome of brown tones. The process of analysis has been carried so far that the viewer must work diligently to discover clues to the subject. The construction of large, intersecting planes suggests the forms of a man and a guitar. Smaller shapes interpenetrate and hover in the large planes. Light and dark passages suggest both chiaroscuro modeling and transparent planes that allow us to see through from

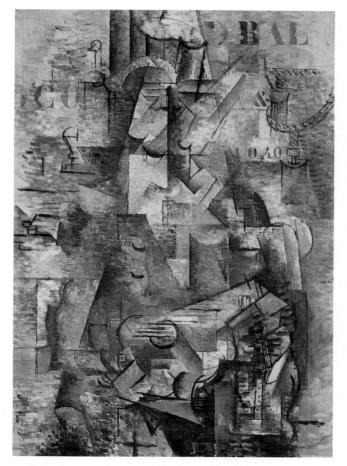

22-7 GEORGES BRAQUE, The Portuguese, 1911. $46\frac{1}{8}$ " × 32". Kunstmuseum, Basel, Switzerland (Emanuel Hoffmann-Stiftung).

one level to another. As we look, solid forms emerge only to be cancelled almost immediately by a different reading of the subject. The stenciled letters and numbers add to the painting's complexity. Letters and numbers are flat shapes; on the page of a book they exist outside of three-dimensional space, but as shapes in a Cubist painting like The Portuguese, they allow the painter to play with our perception of twoand three-dimensional space. The letters and numbers lie flat on the painted canvas surface, yet because the shading and shapes of the image seem to flow behind and underneath them, they are pushed forward into our space. Occasionally, they may seem to be attached to the surface of some object within the painting, but the combination of multiple views of each object causes such a perception to slide away in the next instant.

Analytic Cubism did not just open new ways of representing form on two-dimensional surfaces; it also inspired new approaches to sculpture. Picasso tested the possibilities of Cubism in sculpture throughout the years he and Braque were developing the style, but one of the most successful sculptors to adapt the spatial feeling of Analytic Cubist painting into three dimensions was JACQUES LIPCHITZ (1891– 1973). Lipchitz was born in Lithuania but resided for many years in France and the United States. His ideas for many of his sculptures were worked out in clay before being transferred into bronze or into stone. *Bather* (FIG. **22-8**) is typical of his Cubist style. The continuous form in this work is broken down into cubic volumes and planes. As with Cubist painting, there is no single point of view, no continuity or simultaneity of image contour. Lipchitz was part of the "second generation" of Cubists, artists who invested

22-8 JACQUES LIPCHITZ, Bather, 1917. Bronze, $34_4^{3''} \times 13_4^{3''} \times 13_4^{3''}$. The Nelson-Atkins Museum of Art, Kansas City, Missouri (gift of the Friends of Art F70-12).

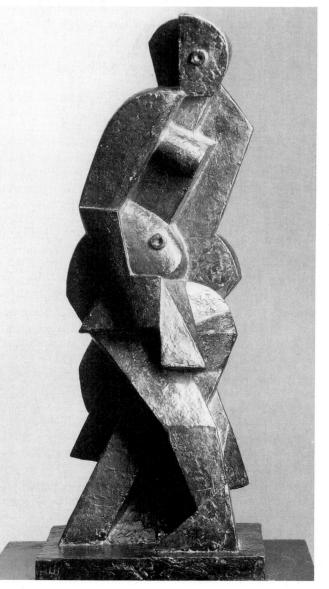

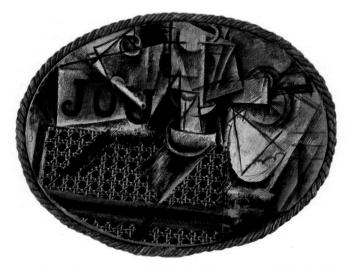

22-9 PABLO PICASSO, Still Life with Chair-Caning, 1911–1912. Oil and pasted paper simulating chair-caning on canvas. $10\frac{5\pi}{8} \times 13\frac{3\pi}{4}$. Musée Picasso, Paris.

the innovations of Braque and Picasso with theory and a more consistent technical approach. Proportion and mathematics were important analytical tools for these artists. Like many of them, Lipchitz based a considerable number of his sculptures on the system of measure called the Golden Mean, which had been used in antiquity to suggest the perfection of ideal proportion and order.* Lipchitz combined this Classical mathematical formula with a modern energy to create what he called "the sense of twisting movement, of the figure spiraling around its axis." The spiraling movement in Bather recalls both the energy of El Greco's painted figures (FIG. 18-59), which Lipchitz much admired, and the twisting tension of Mannerist works like Giovanni da Bologna's Rape of the Sabines (FIG. 17-46). Yet these qualities are modified by the way in which the cubic shapes of Bather seem to slip and slide before our eyes, presenting first one view of the body parts and then another; Lipchitz has fully invested this figure with the qualities of space-time so important to the Cubist vision.

SYNTHETIC CUBISM

In 1912, Cubism entered a new phase during which the style no longer relied on a decipherable relation to the visible world. In this new phase, called Synthetic Cubism, paintings and drawings were constructed from objects and shapes cut from paper or other materials to represent parts of a subject. The work marking the point of departure for this new style was Picasso's Still Life with Chair-Caning (FIG. 22-9), a painting done on a piece of oil cloth imprinted with the pattern of a cane chair seat and framed with a piece of rope. This work provided the means with which to play visual games with variations of illusion and reality. The photographically replicated chaircaning seems so "real" that one expects any brushstrokes laid upon it to be broken by the holes. The painted passages seem to hover magically in the air in front of the cane seat, lending the painted objects a visual tangibility that suggests relief sculpture more than painting. The visual play is extended in the way in which the letter U escapes from the space of the accompanying I and O, yet is partially covered by a painted cylindrical shape that pushes across its left side. The letters JOU appear in many Cubist paintings; these letters formed part of the masthead of the daily newspapers (journals) that were often found among the objects represented. Picasso and Braque especially delighted in the punning references to Jouer and Jeu-the French words for "to play" and "game."

22-10 GEORGES BRAQUE, Fruit Dish and Cards, 1913.
 Oil, pencil, and charcoal on canvas, 31²/₈" × 23³/₈".
 Collection Musée Nationale d'Art Moderne, Centre Georges Pompidou, Paris (gift of Paul Rosenberg).

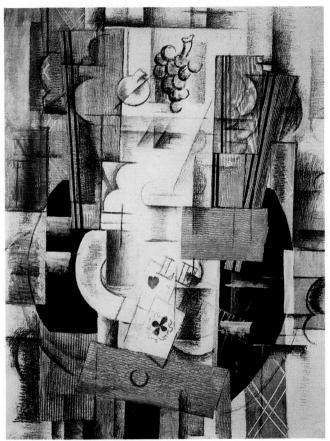

^{*}The *Golden Mean* (also known as the Golden Rule or section) is a system of measuring in which units used to construct designs are subdivided into two parts in such a way that the longer subdivision is related to the length of the whole unit in the same proportion as the shorter subdivision is related to the longer subdivision.

After Still Life with Chair-Caning, both Picasso and Braque continued to explore the new medium introduced in that work. The wonderful new possibilities offered by collage (from the French word meaning "to stick") can also be seen in Braque's Fruit Dish and Cards (FIG. 22-10), done in a variant of collage called papier collé (stuck paper), in which assorted paper shapes are glued to a drawing or painting. Charcoal and pencil lines and shadows provide us with clues to the Cubistic multiple views of table, dishes, playing cards, and fruit. Roughly rectangular strips of wood-grained, grey, and black paper run vertically up the composition, overlapping each other to create a layering of unmistakably flat planes that both echo the space suggested by the lines and establish the flatness of the surface of the work. All shapes in the image seem to oscillate between pushing forward and dropping back in space. Shading seems to carve space into the flat planes in some places and to turn them into transparent surfaces in others. The bottom edge of the ace of clubs seems to extend forward over a strip of wood-grained paper, while its top corner appears to slip behind a filmy plane. The viewer is always aware that this is a work of art created by an artist and that each observer must enter the visual game to decipher all levels of representation. Braque is no longer analyzing the three-dimensional qualities

of the physical world; here, objects and space alike are constructed or synthesized from the materials used to make the work. Picasso stated his views on Cubism at this point in its development: "Not only did we try to displace reality; reality was no longer in the object. . . . In the papier collé . . . we didn't any longer want to fool the eye; we wanted to fool the mind. . . . If a piece of newspaper can be a bottle, that gives us something to think about in connection with both newspapers and bottles, too."* Cubism's papier collé was essentially a formalist activity. Like all collage, the technique was modern in its mediummass-produced materials never before found in "high" art-and modern in the way the "message" of the art became the imagery and nature of these everyday materials.

The use of found materials in collages allowed Braque and Picasso to reintroduce color into their work. By the 1920s, both were going their separate ways as artists, and Picasso had developed a very colorful version of Synthetic Cubism into a highly personal painting style that mimicked the look of the earlier pasted works. In paintings like *Three Musicians* (FIG. **22-11**), Picasso constructed figures from simple

*In François Gilot and Carlton Lake, *Life with Picasso* (New York: McGraw Hill, 1964), p. 77.

22-11 PABLO PICASSO, *Three Musicians*, Fontainebleau, summer 1921. Approx. 6' $7'' \times 7' 3^{3''}_4$. Collection, The Museum of Modern Art, New York (gift of Mrs. Simon Guggenheim).

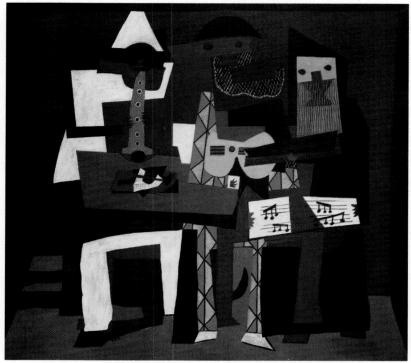

flat shapes that interlock and interpenetrate in a composition that whimsically combines a Modernist statement of the flat plane of the canvas with traditional modes of representation. The floor and walls of the room in which this lively musical trio performs suggest Renaissance perspective gone only a little awry, while the table, with an unlikely still life in its middle, is presented in reverse perspective. A jumble of flat shapes materializes into the figures of Pierrot on clarinet, Harlequin on guitar, and a mysterious masked monk as vocalist. Miraculously, the flat, syncopated shapes give each musician a different personality and simultaneously suggest the sprightly tune they are performing. Careful inspection reveals an alert dog sprawled behind the troupe, apparently beating its tail vigorously in time to the music.

Synthetic Cubism influenced many American artists. Two American painters created especially personal versions of the style. STUART DAVIS (1894–1964) tried to create what he believed was a modern American art style by combining the flat shapes of Synthetic Cubism with his own sense of jazz rhythms and his perception of the dynamism of the modern, urban industrial scene. Davis's long professional career began with the inclusion of some of his works in the Armory Show in New York City in 1913, an exhibition that introduced modern art to the general public in the United States. By the 1920s, Davis was investigating Synthetic Cubism. To master the style, he made repeated drawings, collages, and paintings of a single still life, gradually simplifying the shapes of its objects into compositions of flat, colored forms. As he described the process, he "brought drawings of different places and things into a single focus. The necessity to select and define the spatial limits of these separate drawings, in relation to the unity of the whole picture, developed an objective attitude toward size and shape."* Davis used his new style in paintings of street scenes in Manhattan and Paris. House and Street (FIG. 22-12) is a simple combination of two views of New York City-one, a detail of a building facade seen head-on and the second, a more distant view of a city street presented as if seen through a window placed at an angle to the picture surface. All details are constructed from flat, colored shapes that interlock more than they overlap. Although the play of angular and rectilinear forms and flat, hard colors does not toy as obviously with our perception of two and three dimensions as do the Synthetic Cubist works of Braque or Picasso, the details in Davis's work create an intriguing ambiguity of figure and ground in which "forward" and "backward" alternate as convincingly as in the European examples. In addition to being a double scene, the whole visual field in House and Street sets up a lively vibration of colors and shapes.

*In Chipp, ed., Theories of Modern Art, p. 526.

22-12 STUART DAVIS, House and Street, 1931. $26'' \times 42\frac{1}{4''}$. Collection of Whitney Museum of American Art, New York (purchase).

22-13 AARON DOUGLAS, *Noah's Ark, c.* 1927. Oil on masonite, $48'' \times 36''$. Afro-American Collection of Art, The Carl Van Vechten Gallery of Fine Arts, Fisk University, Nashville.

The personal Synthetic Cubism of the American painter AARON DOUGLAS (1898–1979) was filled with more symbolism and emotion than anything Davis painted. Douglas used the style to represent symbolically the historical and cultural memories of African-Americans. Born in Kansas, he studied in Nebraska and Paris before settling in New York City, where he became part of the flowering of art and literature in the 1920s known as the Harlem Renaissance. Encouraged by the German artist Winold Reiss to create an art that would express the cultural history of his race, Douglas incorporated motifs from African sculpture into compositions painted in a version of Synthetic Cubism that stressed angular, transparent planes. Noah's Ark (FIG. 22-13) was one of seven paintings based on a book of poems by James Weldon Johnson called God's Trombones: Seven Negro Sermons in Verse. Rather than combining different viewpoints in space, Douglas used the flat planes of Synthetic Cubism to evoke a sense of mystical space and miraculous happenings. In Noah's Ark, lightning strikes and rays of light crisscross the area in which pairs of animals enter the ark, while men load supplies in preparation

for departure across the heaving seas. Deep space is suggested by the difference in scale between the huge human head and shoulders of the worker in the foreground and the tiny person at work on the distant rear deck of the ship. At the same time, the unmodulated color shapes of the composition create a pattern on the surface of the masonite panel that cancels any illusion of three-dimensional depth. Here, Douglas used the formal language of Cubism to express a powerful religious vision, bending the style toward the second Modernist approach, that of art with psychological and conceptual concerns.

DERIVATIVES OF CUBISM

Early in the development of Cubism, a group of Italian artists adapted some of the style's analytic tricks to depict the emotional dynamism of modern life. The members of this group called themselves "Futurists," and their movement was inaugurated in 1909 with a manifesto written by the poet Filippo Marinetti, who called for a new art of "violence, energy, and boldness" that would proclaim the wonders of the machine age—an age "enriched by a new beauty; the beauty of speed." The Futurists believed that only a drastic overturning of traditional culture and art could accomplish this, and many of them followed Marinetti in saying that war was the most effective means to this end. In principle, the Futurist artist attempted to present aspects of modern, mechanized society in moments of violently energetic movement. In the words of a leading Futurist painter and sculptor, UMBERTO BOCCIONI (1882-1916), the Futurists proposed "to destroy the cult of the past . . . to despise utterly every form of imitation . . . to extol every form of originality . . . to sweep from the field of art all motifs and subjects that have already been exploited . . . to render and glorify the life of today, unceasingly and violently transformed by victorious science."* In practice, Futurist artists adopted the Cubist analysis of space, but by repetition of forms, they tried to impart movement to the static quality of Cubist works. Scientific discoveries about movement and time obsessed the Futurists. Boccioni's Futurist Painting, Technical Manifesto (1910) rings with a recognition of universal process:

The gesture which we would reproduce on canvas shall no longer be a fixed *moment* in universal dynamism. It shall simply be the dynamic sensation itself. . . . The figure in front of us never is still, but ceaselessly appears and disappears. Owing to the persistence of images on the retina, objects in motion are multiplied and distorted, following one another

*In Robert Goldwater and Marco Treves, eds., *Artists on Art*, 3rd ed. (New York: Pantheon, 1964), p. 435.

 22-14 UMBERTO BOCCIONI, Unique Forms of Continuity in Space, 1913 (cast 1931). Bronze, approx. 43^d/₃" high. Collection, The Museum of Modern Art, New York, (acquired through the Lillie P. Bliss Bequest).

like waves through space. Thus, a galloping horse has not four legs; it has twenty, and their movements are triangular.

Boccioni began his art career as a commercial artist who painted seriously in his spare time. He began making Futurist sculpture in 1912. By 1913, he had pushed his forms so far toward abstraction that the title of his *Unique Forms of Continuity in Space* (FIG. **22-14**) calls attention to the formal and spatial effects of the work, ignoring the fact that its source was a striding human figure. The "figure" here has been so expanded, interrupted, or broken in plane and contour that it disappears, as it were, behind the blur of its movement; only the blur remains. Although Boccioni's sculpture bears a curious resemblance to the ancient *Nike of Samothrace* (FIG. 5-75), a brief comparison reveals how far apart these two visions of a figure moving through space really are.

The influences of Cubism and Futurism merged in the Vorticist movement in England, which was led by the British painter and writer Wyndham Lewis and the American expatriate poet Ezra Pound, who gave the style its name. Vorticism shared Futurism's interest in machine forms and in the dynamism of modern life, but the Vorticists did not join in the Futurists' admiration for the cleansing power of war. Among the most interesting Vorticist works were photographs (immediately called "vortographs" by Pound) produced in London by the American artist ALVIN LANGDON COBURN (1882-1966). From his boyhood on, Coburn was interested in pushing photography into new realms. Initially a successful pictorialist photographer, he experimented with photographs of New York and London taken from the upper floors of tall buildings before turning to multiple-exposure abstract work under the inspiration of Vorticist ideas about the dynamic space-time qualities of the modern industrial world. Many of Coburn's vortographs are pure abstractions, which he created by making multiple exposures of crystals and wood fragments, placed inside a triangle whose sides were composed of strip mirrors, which transformed his subjects into strange geometric patterns. Perhaps Coburn's best-known work is his vortograph portrait of the poet Ezra Pound (FIG. 22-15). This work achieves its effect of the poet moving through space and time with a succession of exposures made on a

22-15 ALVIN LANGDON COBURN, Ezra Pound Vortograph, 1916. Gelatin silver print. International Museum of Photography at George Eastman House, Rochester, New York.

22-16 JULIO GONZALEZ, Woman Combing Her Hair, c. 1930–1933. Iron, 57" high. Moderna Museet, Stockholm.

single negative as the artist moved closer to the poet. Like Boccioni's sculptured figure, Pound's head and clothing appear to dissolve into the space around them, and the poet's physical presence flickers eloquently in a metaphoric space-time. The multiple outlines of the figure, however, also suggest the layered edges in a Cubist painting, here given a particular expressive resonance by their position one within the other.

One artist who based his sculptural style on the ambiguity of edges in Cubist works was the Spanish sculptor JULIO GONZALEZ (1876–1942). A friend of Picasso, Gonzalez was especially interested in the artistic possibilities of new materials and new methods borrowed from industrial technology and from traditional metalworking, in which he had begun his career. Welding compositions from bronze rods and wrought-iron shapes, he created works that seem like three-dimensional drawings in space. His small *Woman Combing Her Hair* (FIG. **22-16**) resembles a translation into metal lines and planes of the shapes of a section in Picasso's *Three Musicians*. As in Picasso's painting, the human figure here is freely reinterpreted as a series of bold curves and lines. Nature is

symbolized, not represented in a traditional way. The viewer must work hard to transform the visual clues in this work into hair, nose, eyes, and other body parts. In the fluent openwork of this sculptured space, the solids function only as contours, boundaries, or dividing planes. The solidity of mass has dropped away, leaving a few traces of form in a space that science had shown to be filled with invisible atoms in ceaseless motion. As in all Cubist works, the head and features of Gonzalez's figure seem to be seen from many views at once. As in all Modernist works, the viewer is very aware of the processes by which this work was made. The free linear composition and antigravity qualities of works like Woman Combing Her Hair were explored further by later artists, like David Smith (FIG. 23-6), as part of their reinvestigation of the basic nature of sculptural form.

ART WITH PSYCHOLOGICAL AND CONCEPTUAL CONCERNS

Many early twentieth-century artists strove to reintroduce into visual art the conceptual part of art they believed had been lost in the turn toward formalism. Despite this goal, their works were not dry and cerebral; like the Romanticists before them, most of these early twentieth-century artists worked not with the logic of reason, but with the dictates of their intuition and imagination. Their work can be classified as art with psychological and conceptual concerns. Some of these artists worked with figurative or abstract themes; some used completely nonobjective forms. All wanted to express something of the intellect and emotions, which they believed alone could help people perceive the true meaning in life. Many of them also thought of themselves as seers with special insight into the significance of the internal realm. One of them, the Swiss-German artist Paul Klee, described the power of their approach:

In the highest sense, an ultimate mystery lies behind the ambiguity which the light of the intellect fails miserably to penetrate. Yet one can to a certain extent speak reasonably of the salutary effect which art exerts through fantasy and symbols. Fantasy, kindled by instinct-born excitements, creates illusory conditions which can rouse or stimulate us more than familiar, natural, or supernatural ones. Symbols reassure the mind that we need not depend exclusively upon mundane experience.*

Of special importance for the conceptual side of this approach in art were the work and ideas of the

^{*}In Margaret Miller, ed., *Paul Klee* (New York: Museum of Modern Art, 1946), p. 13.

French artist Marcel Duchamp, an immensely influential figure for later artists. In his painting, sculpture, and a category of objects he invented called the "readymade," Duchamp emphasized the way in which the meaning of any work is determined not only by the intent of the artist, but also by the inherent qualities of the material used and by the mind and emotions of the viewer. Duchamp's kind of conceptual art prepared the way for the art of the late twentieth century (Postmodernist art), which selfconsciously distinguishes itself from Modernist formalist art by analyzing the operation of all art styles and the place of art in culture.

Expressionism: Bold and Dark Visions

Although antecedents to Expressionist art before the twentieth century were found in the works of artists as diverse as Stubbs (FIG. 20-46) and Van Gogh (FIG. 21-84), the term Expressionism probably first was applied to works of art in France to describe the paintings of the Fauves. Indeed, Derain and Matisse each spoke about "expression" in their art, communicating their delight in patterns based on nature and presented as eloquent arrangements of colors, tones, and shapes. Soon, however, the term was adopted to identify the works of other artists, especially in Germany, who developed expressive styles that described the stress-filled conditions of modern life. Precursors for this darker German Expressionism include the works of Matthias Grünewald (FIG. 18-33), Caspar David Friedrich (FIG. 21-22), and Edvard Munch (FIG. 21-92). Several books published early in the twentieth century contributed to the esthetic bases of German Expressionism as well. These included the writings of Alois Riegl, who perceived art history as the spiritual history of humanity; Wilhelm Worringer, who believed that all art was basically subjective and that intuition was the most important quality in creativity; and Henri Bergson, who wrote about the "life force" underlying and countering the material world and known to us through intuition. These thinkers elaborated on nineteenth-century ideas of art as something lying beyond either the imitation of nature's shifting physical appearance or the expression of literary themes. For them, art was produced by an "inner necessity" in the artist springing from the unique insights and perceptions of that one individual. Building on this concept, many of the more anguished Expressionists also sought to incorporate in their work qualities of an ecstatic awareness of the cosmos and of man's links with it.

In France, one painter dealt with the darker vein of Expressionism in colors that revealed his early links

to the Fauves. Throughout his career, GEORGES ROUAULT (1871–1958) treated themes of grave social and religious import. A member of a family of craftsmen, Rouault was apprenticed to a stained-glass maker before entering the studio of Gustave Moreau, where he met Henri Matisse. Rouault's themes reflected his deeply devout and moralistic Roman Catholic view of the evils of modern society. His grim studies of broken prostitutes, corrupt judges, and sad clowns, and his suite of anguished antiwar prints (Miserere et Guerre) express the existential misery of human beings in modern urban society. His religious pictures often show the suffering of Christ as the "man of sorrows" (owing much to Grünewald). More ambiguous subjects, like The Old King (FIG. 22-17), share the same solemn, melancholy mood. The style of this painting has something of the simplified design and expressive color of the Fauves, but the forms of the king are contained within strong black lines that isolate the layered colors like the lead banding in Medieval stained glass, which Rouault knew and

22-17 GEORGES ROUAULT, The Old King, 1916–1936.
304" × 211". The Carnegie Museum of Art, Pittsburgh (Patrons' Art Fund, 1940).

22-18 KÄTHE KOLLWITZ, *The Outbreak*, 1903. Plate No. 5 from *The Peasants' War*. Library of Congress, Washington D.C.

admired from his days as an apprentice. Dressed in a robe and crown reminiscent of the costumes in traditional paintings of Bible scenes, Rouault's king has the Semitic features of an Old Testament ruler. In contrast to the portraits of rulers we have seen so far, however, Rouault has focused on the vulnerability and human frailty of his monarch. The old king sits before us, imprisoned between the narrow arms of his throne, mysteriously clutching a spray of flowers, like a strange scepter, in his left hand.

In Germany, Expressionist qualities appeared in the work of KÄTHE KOLLWITZ (1867–1945) as early as the final years of the nineteenth century. Kollwitz poignantly expressed pity for the poor in moving prints. The daughter of parents with strong socialist beliefs and the wife of a doctor who shared this outlook, she had a life-long empathy with workers and the poor. She wanted to share her insight about the lives of these people with a wide audience and chose to do most of her art in print form so that more people could afford to purchase the images. Her first cycle of prints, completed in 1897, was inspired by a play written by Gerhart Hauptmann about a revolt of German weavers. Her next major group, The Peasants' War, contained seven prints that depicted different moments in a rebellion of German peasants in the sixteenth century. Kollwitz identified strongly with Black Anna, a woman who had led the laborers into battle against their oppressors. The first print completed in the series was *The Outbreak* (FIG. **22-18**), which shows Black Anna inciting her followers to action. Kollwitz combined the techniques of etching, aquatint, and *soft ground** to emphasize the figure of Black Anna, whose back is to the viewer as she leans to the left and raises her hands, signaling to the massed wedge of her followers to advance. The passion of the moment is conveyed in the expressions on the faces of the few individuals we can distinguish in the crowd and in the tense, forward-thrusting figure of Black Anna herself, which leads us into the picture and the onrushing fight for freedom.

The first group of artists to follow Expressionist ideas gathered in Dresden in 1905, under the leadership of ERNST KIRCHNER (1880–1938). The group's members thought of themselves as preparing the way for a more perfect age by forming a bridge from the old age to the new—a concept that gave them their

^{*}Soft ground is an etching technique in which the artist obtains textures by pressing textured materials onto a soft gelatin-like coating spread over the printing plate. The coating remains soft and elastic enough that any textured material or object pushed into the soft ground surface leaves an imprint of its texture, the deepest parts of which fully or partially expose the metal to the acid when the plate is etched.

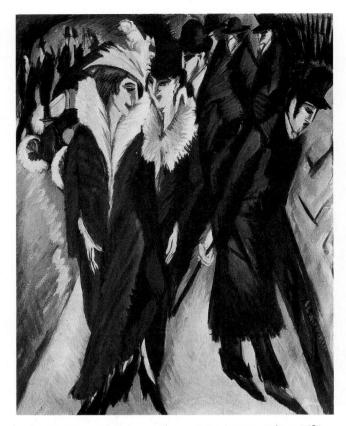

22-19 ERNST KIRCHNER, Street, Berlin, 1913. $47\frac{1}{2}'' \times 35\frac{7}{8}''$. Collection, The Museum of Modern Art, New York (purchase).

name: "the Bridge" (Die Brücke). Kirchner's early studies in architecture, painting, and the graphic arts had instilled in him a deep admiration for German Medieval art, which stirred the group to model themselves on their ideas of medieval craft guilds by living together and practicing all the arts equally. Kirchner described their lofty goals in a ringing statement: "With a profound belief in growth, a belief in a new generation of creators and appreciators, we summon the entire younger generation-and as the youth which carries within it the future, we wish to provide ourselves with a sphere of activity opposed to the entrenched and established tendencies. Everyone belongs to us who portrays his creative impulses honestly and directly."* Borrowing ideas from Van Gogh, Munch, the Fauves, and the art of Africa and Oceania, the Bridge artists created landscapes, cityscapes, genre scenes, portraits, and still lifes in which harsh colors, aggressively brushed paint, and distorted form expressed their feelings about the injustices of society or their belief in a healthful union of human beings and nature. After only a few years, many of the group, including Kirchner, moved to Berlin, where the tensions preceding World War I divided them further. By 1913, the last vestiges of the group dissolved and each of them was working independently.

In Berlin, Kirchner retained some of the Bridge group's energy and interest in social injustice in paintings like *Street*, *Berlin* (FIG. **22-19**), where steep perspective, jaggedly angular forms, acrid colors, and haunted people suggest the brittleness and fragility of life in the German metropolis as Europe moved closer to war. Kirchner's later painted and sculptured figures continued to show his interest in Medieval German woodcuts and in the fiercely emotive qualities of African and Oceanic art, which he and the members of the Bridge group had discussed in their magazine, *Die Brücke*.

As one might expect, the psychological interests and highly charged emotions of the Expressionist art of the Bridge group were well-suited to the new medium of cinema, especially in the early days of the "silent screen," before technology added synchronized sound. Silent films had already established themselves as the most democratic and the most magical of art forms, appealing to people of all ages and classes, who flocked to sit in darkened movie theaters and imagine themselves as part of the scenes unfolding on the screen before them. In German films like The Cabinet of Dr. Caligari (FIG. 22-20), the Expressionist visual devices of the Bridge group were used to evoke a haunted world of psychological distress and turmoil. This movie tells a horror story about a traveling carnival hypnotist (Dr. Caligari) who controls César, a somnambulist (sleep walker), and sends him out to murder any citizen along the carnival's route who displeases Caligari; in the film, César murders a city official in a small medieval German town. The story of Caligari was intended by the original authors, the Czech Hans Janowitz and the Austrian Carl Mayer, as an attack on unjust authority. The film's director, ROBERT WIENE (1881-1938), assigned three painters—HERMANN WARM, WALTER RÖHRIG, and WALTER REIMANN—to design sets. The three designers read the script and realized that the film needed something other than ordinary sets. Reimann, "whose painting in those days had Expressionist tendencies," according to Warm, suggested that they utilize Expressionist devices in designing the film's sets. The sets they created for Caligari used the steep perspective and angular, distorted planes found in Expressionist paintings like Kirchner's Street, Berlin. The hallucinatory effect of this setting suggested perfectly the haunted memories of the hero, transformed by Wiene in the final film into a

^{*}In Bernard S. Myers, *The German Expressionists: A Generation in Revolt* (New York: Praeger, *c.* 1956), pp. 111–12.

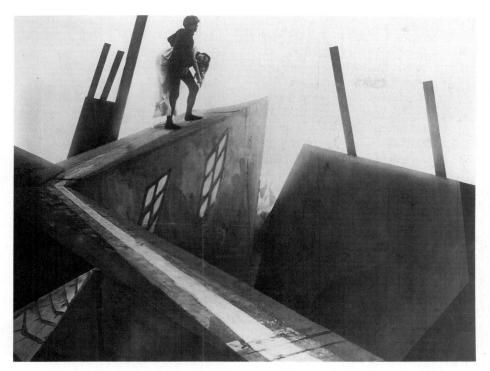

22-20 HERMANN WARM, WALTER RÖHRIG, and WALTER REIMANN, set for the film The Cabinet of Dr. Caligari, ROBERT WIENE, director, 1919.

mental patient recounting an imagined adventure. The emotive force of the Expressionist forms was heightened by creating strong highlights and deep dramatic shadows in the black-and-white movie, and by tinting whole sequences of the release prints eerie green, cold blue, or pale brown. *The Cabinet of Dr. Caligari* inaugurated the German Expressionist film, and its style affected horror films and psychological dramas in Europe and the United States throughout the 1920s and 1930s. As the French director René Clair said in 1922: "Caligari comes and affirms that the only interesting truth is the subjective. . . . We have to admit that reshaped nature is at least as expressive as 'natural' nature."*

In *Caligari*, German Expressionist distortions similar to those in the works of Kirchner and the Bridge group were used to symbolize an individual human psyche gone awry. A very different German Expressionist style was created by the sculptor WILHELM LEHMBRUCK (1881–1919) to denote a different vision of the modern human condition. Lehmbruck studied sculpture, painting, and the graphic arts in Dusseldorf before moving (in 1910) to Paris, where he developed the style of his *Standing Youth* (FIG. **22-21**). His sculpture combines the expressive qualities he much

*In Léon Barsacq, Caligari's Cabinet and Other Grand Illusions: A History of Film Design (New York: New American Library, 1978), pp. 27–30. **22-21** WILHELM LEHMBRUCK, Standing Youth, 1913. Cast stone, approx. 7'8" high, base dimensions $36'' \times 26_4^{3''}$. Collection, The Museum of Modern Art, New York (gift of Abby Aldrich Rockefeller).

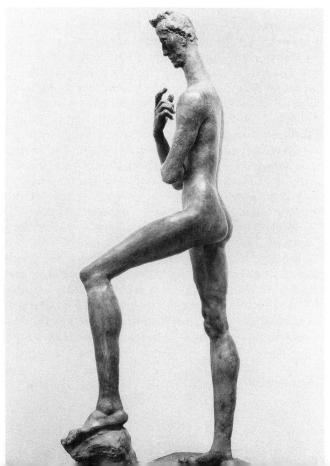

admired in the work of two fellow sculptors, reflecting the Classical idealism of Maillol (FIG. 22-44) and the psychological energies of Rodin (FIG. 21-56). In Lehmbruck's Standing Youth, the tense pose, the poignant elongation of human proportions, and the rippling hair all impart an undertone of anguish to the rather Classical figure. The Youth stands in quiet introspection, his head bowed in thought and his right hand raised toward his shoulder, as if in silent debate with himself. Lehmbruck's figure communicates by pose and gesture alone; it has no specific historical or symbolic significance. Its extreme proportions may recall Medieval (FIG. 9-37) and even Mannerist (FIG. 17-41) attenuation, but its distortions announce a new freedom in the interpretation of the human figure. Lehmbruck wrote that "sculpture is the essence of things, the essence of nature, that which is eternally human." For him, as for Rodin, the human figure could express every human condition and emotion. The introspection of Standing Youth reflects the bittersweet yearnings of an individual. Seated Youth, which we saw in the Introduction (FIG. 1), carries a broader symbolism, having been designed in grieving memory as a monument to all who gave their lives in World War I.

A work more mystical in its expression is the War Monument (FIG. 22-22) by the German sculptor ERNST BARLACH (1870–1938), created for the cathedral in his hometown. As the son of a country doctor in northern Germany, Barlach found natural symbolism in the people and forms of the rural areas of his native land: "Country life lends the smallest thing a noble shape. . . . My mother tongue is the human body or the milieu, the object, through which or in which man lives, suffers, enjoys himself, feels, thinks."* Working often in wood, Barlach sculptured single figures, usually dressed in flowing robes and portrayed in strong, simple poses that embody deep human emotions and experiences such as grief, vigilance, or self-comfort. Much influenced by Medieval carving, Barlach's works combine sharp, smoothly planed forms with intense action and keen expression. The hovering figure of his War Monument is one of the most poignant memorials of World War I. Unlike traditional war memorials, which depict heroic military figures, often engaged in battle, Barlach creates a hauntingly symbolic figure that speaks to the experience of all who have been caught in the conflagration of war. The floating human form suggests a dying soul at the moment when it is about to awaken to everlasting life-the theme of death and transfiguration. The rigid economy of surfaces concentrates at-

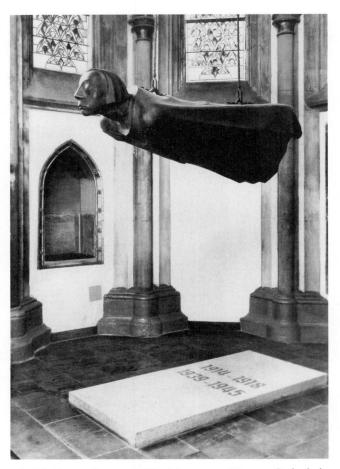

22-22 ERNST BARLACH, War Monument, Güstrow Cathedral, 1927. Bronze. Schildergasse Antoniterkirche, Cologne.

tention on the superb head (FIG. **22-23**). The spiritual anguish evoked by the disaster of war and the release from that anguish through the hope of salvation have rarely been expressed as movingly as they are in *War Monument*.

The brutality of life in post-war Europe and hope for a mythic escape from the despair and disillusionment of the period became the central themes in the works of Max Beckmann (1884–1950). Beckmann's early work was linked to a development of German Expressionism in the 1920s called New Objectivity (Neue Sachlichkeit), a movement whose members tried to build a new reality to replace the one that had been shattered by the disasters of the war. Beckmann filled his paintings with figures and objects stripped to a basic, almost sculptural simplicity. Their solidity, he said, provided a bulwark against the echoing void of space, which yawned threateningly everywhere. By the 1930s, Beckmann had evolved a more personal Expressionist style. He spoke of using a "transcendental realism" that would link "the real love for the things outside of us and the deep secrets of events

^{*}In Carl Dietrich Carls, *Ernst Barlach* (London: Pall Mall Press, 1969), pp. 8, 9.

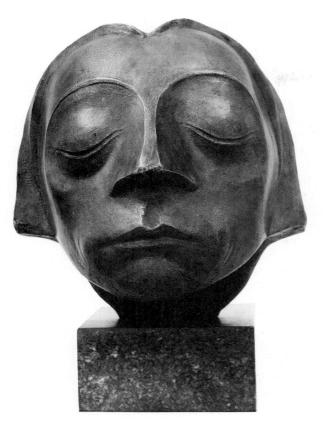

22-23 ERNST BARLACH, *Head*, study for FIG. 22-22, separately cast. Bronze, approx. 13¹/₂ high. Collection, The Museum of Modern Art, New York (gift of Edward M. M. Warburg).

within us." His was a world that mixed physical reality and the realm of the spirit:

What I want to show in my work is the idea which hides itself behind so-called reality. I am seeking for the bridge which leads from the visible to the invisible, like the famous cabalist who once said: "if you wish to get hold of the invisible you must penetrate as deeply as possible into the visible." . . . What helps me most in this task is the penetration of space. Height, width, and depth are the three phenomena which I must transfer into one plane to form the abstract surface of the picture, and thus to protect myself from the infinity of space. . . . When spiritual, metaphysical, material, or immaterial events come into my life, I can only fix them by way of painting. It is not the subject which matters but the translation of the subject into the abstraction of the surface by means of painting. Therefore I hardly need to abstract things, for each object is unreal enough already, so unreal that I can only make it real by means of painting.*

Beckmann's art was elicited by some of the darkest moments of the twentieth century, when the rise of Nazi tyranny threatened European civilization. While his message was bitter, its reference was not specific to one time or place but concerned human cruelty and suffering in general. Works like *Departure* (FIG. **22-24**) hauntingly show both Beckmann's primary

*In Myers, The German Expressionists, p. 307.

22-24 Max Beckmann, Departure, 1932–1933. Triptych, center panel $7' \frac{3''}{3} \times 3' \frac{3''}{3}$, side panels each $7' \frac{3''}{3} \times 3' \frac{3^{1''}}{3}$. Collection, The Museum of Modern Art, New York (given anonymously by exchange).

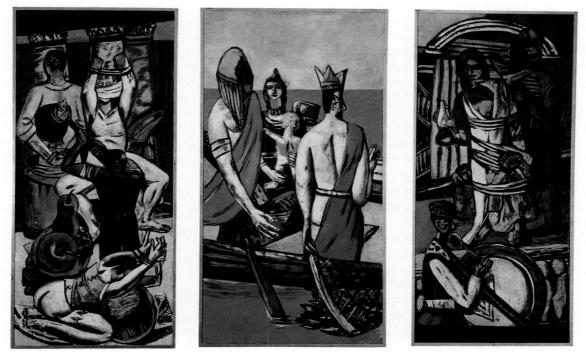

themes and the powerful tension he created between objects and space in his paintings. He used the three panels of Departure in the same way a filmmaker might use jump cuts to move between scenes that lack clear transitions. The side panels in the painting show bondage and torture. On the left, victims are mutilated by their tormenter; on the right, captive figures are helplessly bound together in a mysterious rite overseen by a blindfolded attendant, while a laconic figure passes by in the foreground, beating a bass drum. These side panels are claustrophobic; the space is crammed with figures, walls, curtains, balustrades, and other objects. The central panel is more tranquil, with a still sea, empty sky, and mysterious boat carrying the richly symbolic figures of a fisherking, a hooded oarsman, and a queenly woman hugging a child close to her. The meaning may allude to Beckmann's own flight from Nazi Germany after his work (along with that of most of the German Expressionists and other avant-garde German artists) had been condemned and banned by Hitler as "degenerate." However, the power of Departure lies not so much in any moving personal references as in its expression of universals in the human condition.

Dada and the Surreal

The dark visions of the Expressionists were one kind of response to the disintegration of society in the early twentieth century. Other artists followed a different path, traveling into the worlds of anti-logic and psychologically provocative dreams, hoping by these means to shake people loose from habits of traditional thought, which were now seen as part of a decadent past that had produced a great war, widespread suffering, and the destruction of the human spirit. These artists were engaged in what they saw as a battle to help people relearn how to operate as whole and natural beings, with integrated bodies, psyches, and minds. Two major groups of these artists, the Dadaists and the Surrealists, developed at the end of the second decade of the century.

The Dadaists undertook the project of reform by way of protest, turning the conventions of art upside down and presenting performances, publications, and exhibitions filled with content intended to shock viewers by its outrageous lack of conventional meaning. Dadaists attained their artistic goals by using a variety of improvisational methods designed to disrupt reason and engage the full resources of intuition in the making of art. Among these processes were the use of nontraditional techniques (like making rubbings of wood textures) and the playful use of commonplace materials never before used in high art. The exuberant aggression and anti-esthetic activity of the Dadaists, however, only sustained their sharp spirit for a short time; after that, most of the Dada group's practitioners were absorbed into the Surrealist movement and its determined exploration of ways to express in art the world of dreams and the unconscious. The Surrealists borrowed many of the improvisational techniques of the Dadaists, believing these to be important methods for engaging the elements of fantasy and activating the unconscious forces that lie deep within every human being. But the Surrealists also drew inspiration from the great masters of fantastic art in the past (such as Bosch and Redon) and from a select group of individuals in the early twentieth century who were seen as powerful precursors for the Surrealist enterprise.

The Dada movement began independently in both New York and Zurich during the years of World War I and soon spread throughout Europe. It was more a mind-set than a single identifiable style; wherever it arose, its artists were committed to questioning everything about traditional artistic expression, in large part as an attempt to jolt the bourgeois art audience out of the complacent behavior and beliefs that had led to the madness of World War I. Much Dada work was intentionally ephemeral. Yet it had important consequences for later art-reinforcing a tendency toward a spontaneous, intuitive expression of the whimsical, fantastic, humorous, sardonic, and absurd. A whole new realm of artistic possibility opened, in which the remnants of the optical world, shattered by scientific and compositional analysis, emerged to play expressive new roles determined by the different contexts in which they now were found. The artist's free imagination drew on materials lying deep within human consciousness, and the artistic act of expression became the proclamation of new realities that were no less real because they were psychic. Dada work paralleled the psychoanalytic views of Sigmund Freud, Carl Jung, and others, and Dada artists believed that art was a powerfully practical means of self-revelation and catharsis, and that the images that arose out of the subconscious mind had a truth of their own, independent of the world of conventional vision. The attitude of the European Dadaists was summed up by Hans Richter, a Dada filmmaker:

Possessed, as we were, of the ability to entrust ourselves to "chance," to our conscious as well as our unconscious minds, we became a sort of public secret society. . . . We laughed at everything. . . . But laughter was only the *expression* of our new discoveries, not their essence and not their purpose. Pandemonium, destruction, anarchy, anti-everything why should we hold it in check? What of the pandemonium, destruction, anarchy, anti-everything of the World War? How could Dada have been anything but destructive, aggressive, insolent, on principle and with gusto?*

Perhaps the most influential of all the Dadaists, and somewhat independent from them, was MARCEL DUCHAMP (1887–1968), the central artist of New York Dada and an active figure in Paris at the end of the Dada movement. Raised as a member of an artistic Parisian family (an older brother was a painter and a younger brother, a sculptor), Duchamp made an early reputation for expressive paintings before becoming fascinated simultaneously with the world of ideas (including a topsy-turvy pseudophysics called "pataphysics") and that of machines and their representation in the language of mechanical drawing. Soon he was producing paintings in which figures were rendered as mechanized forms. In 1913, he exhibited his first readymade sculptures, massproduced objects selected by the artist and sometimes "rectified" by modification of their substance or combination with another object. *Bicycle Wheel* (FIG. 22-25) was Duchamp's first readymade and initiated his interest in exploring the optical effects of motion in art. In Bicycle Wheel, he combined two ordinary massproduced objects and displaced them from their expected, everyday locations by mounting a single bicycle wheel atop the seat of an ordinary wooden kitchen stool. Such works, he insisted, were created free from any consideration of either good or bad taste, qualities shaped by a society that he and other Dada artists found esthetically bankrupt. In place of "taste," Duchamp gave ideas. As he wrote in a "defense" published in 1917, after the exhibition committee for an unjuried show failed to exhibit his readymade Fountain (a detached urinal, set on its side and signed visibly with a witty pseudonym derived from the Mott plumbing manufactory's name and that of the short half of the Mutt and Jeff comic-strip team): "Whether Mr. Mutt with his own hands made the fountain or not has no importance. He chose it. He took an ordinary article of life, placed it so that its useful significance disappeared under the new title and point of view-created a new thought for that object."⁺ Among the ideas in *Bicycle Wheel* are those connected with optical illusion and with motion (separated from usefulness). Spinning the wheel introduces the viewer to the visual illusions of strobing spokes, which seem to rotate forward or backward, or even to disappear completely into a shimmering blur, depending on the speed of rotation. Duchamp's

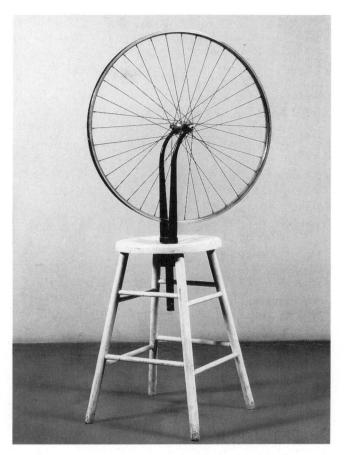

22-25 MARCEL DUCHAMP, Bicycle Wheel, 1951 (third version after lost original of 1913). Metal wheel mounted on painted wooden stool, $50\frac{1}{2}^{"}$ high, $25\frac{1}{2}^{"}$ wide; stool, $23\frac{3}{4}^{"}$ high. Collection, The Museum of Modern Art, New York (gift of the Sidney and Harriet Janis Collection).

interest in motion first appeared early in his career in diagrammatic paintings, partially inspired by the multiple-exposure, motion-study photographs of the French nineteenth-century kinesiologist Édouard Marey. Duchamp explored this interest in paintings, cinema, and various experiments in optical illusion throughout the rest of his career.

Many of Duchamp's ideas appeared in a large, two-panel painting on glass, *The Bride Stripped Bare by Her Bachelors, Even* (FIG. **22-26**), whose complex iconography he began developing as early as 1912. Intrigued by the suggestion of space with four and more dimensions in the work of mathematician Edward Abbey, Duchamp chose to paint on glass because he felt the shapes he created there in rigorous Renaissance perspective would appear to float free of their support, suggesting "the projection of a fourdimensional shape in a three-dimensional world." Unlike traditional diptychs, the two panels in this painting are placed one above the other. Each plate of

^{*}Hans Richter, *Dada: Art and Anti-Art* (London: Thames & Hudson, 1961), pp. 64–65.

[†]In Arturo Schwarz, *The Complete Works of Marcel Duchamp* (London: Thames & Hudson, 1965), p. 466.

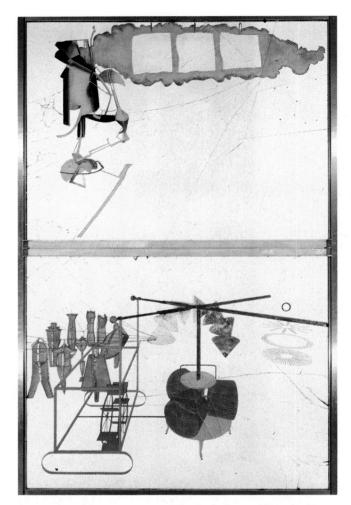

22-26 MARCEL DUCHAMP, The Bride Stripped Bare by Her Bachelors, Even (The Large Glass), 1915–1923. Oil, lead wire, foil, dust and varnish on glass, 8' $11'' \times 5'$ 7". The Philadelphia Museum of Art (bequest of Katherine S. Dreier).

glass represents a separate realm. The artist's fascination with machines led him to invent a symbolism based on mechanical forms. The upper plate of glass contains the region of the bride, whose mechanized form is seen at the far left. Next to her is a cloud shape-the "Milky Way"-designated by Duchamp as the place of "blossoming." The bottom plate of glass contains the realm of the bachelors, represented at the left in a circle of nine "malic molds," whose shapes were based on the silhouettes of uniformed Frenchmen—among them a policeman, a bellboy, and a messenger. An admirer of the wacky machines devised by the American cartoonist Rube Goldberg, Duchamp here imagined an elaborate setup by which the bachelors could attempt to disrobe the bride. At the same time, however, the artist also introduced elements that would forever prevent that desired consummation. Duchamp made careful studies for each section of the composition, but he also employed methods of chance to determine many details. For example, the shapes of the "draft pistons" within the area of blossoming at the top were determined by having Duchamp's friend, the American artist Man Ray, take three photographs of a meter-square piece of dotted net fabric as it blew in the breeze coming through an open window. The three different contours determined the shapes of the three "openings" in the cloud, and the double meaning for "draft" (work and breeze) is a good example of the verbal puns Duchamp loved to include in his work. He found the operation of chance so intriguing that he even employed it in some of the innovative techniques with which he applied color to the glass. The most unusual of these probably occurred in the series of multiple cones (or "sieves") in the lower half, which were created by allowing dust to accumulate on the surface of the glass for several weeks and then using varnish to fix the dust in place, creating a translucent, mottled, warm brown hue within these shapes.*

According to Duchamp (and the generations of artists after him who were profoundly influenced by his art and especially by his attitude), life and art were matters of chance and choice freed from the conventions of society and tradition. Within his approach to art and life, each act was individual and unique: every person's choice of found objects would be different, each person's throw of dice would be at a different instant and probably would yield a different number. This philosophy of utter freedom for the artist is fundamental to the history of art in the twentieth century. In addition, the viewer of a Duchamp work must decipher the meaning of the work in a way that makes the experience an intellectual exercise that yields different and continually shifting "meanings" for each individual. All of these factors cause Duchamp's influence to continue to be as strong for much Postmodernist art late in the twentieth century as it was for much of Modernism.

Duchamp spent much of World War I in New York, inspiring a group of American artists and collectors with his radical rethinking of the role of the artist and of the nature of art. By 1916, another group of young

^{*}Although Duchamp worked on painting the glass panels intermittently between 1915 and 1925, he had not added all planned details when the work was returned damaged to his studio after an exhibition. Regarding the pattern of diagonal cracks with some satisfaction, he declared the piece "incompleted" and did no further work on it. We know his intentions from voluminous notes he made for the painting (nicknamed "The Large Glass"), which he published in facsimile in two special "boxes," and we know the planned look of the final composition from a diagrammatic etching the artist made late in his career.

22-27 JEAN ARP, Squares Arranged According to the Laws of Chance, 1917. Cut-and-pasted papers, ink, and bronze paint, $13\frac{1}{8}'' \times 10\frac{1}{4}''$. Collection, The Museum of Modern Art, New York (gift of Philip Johnson).

European artists had gathered in neutral Zurich, filled with a similar but more boisterous reaction against the norms of the society of their day. Collectively (and idealistically), this European group set out to use their art as a weapon to shock viewers into self-awareness and to stimulate action that would change civilization into something better. They called their anti-art "Dada" (a name made up of nonsense syllables) and themselves "Dadaists." They challenged people in their gathering place, the Cabaret Voltaire, through aggressive performances based on provocative insults, nonsense speeches, and a variety of outlandish pranks or gestes, which they described as "cerebral revolver shots." As one of the Zurich group, Hans Richter, later wrote: "Dada invited, or rather defied, the world to misunderstand it, and fostered every kind of confusion. . . . Dada has reaped the harvest of confusion that it sowed. However the confusion was only a façade. Our provocations, demonstrations, and defiances were only a means of arousing the bourgeoisie to rage and through rage to shame-faced self-awareness."* Like Duchamp, the Zurich Dadaists sought ways to stop relying on the operation of reason, which they saw as conditioned by upbringing and education. Many of their methods involved either "automatism" or the operations of chance.

*Richter, Dada: Art and Anti-Art, p. 9.

Automatism was the process of yielding oneself to instinctive actions after establishing a set of conditions (such as size of paper and medium), within which a work would be carried out. One of the Zurich Dadaists, JEAN (HANS) ARP (1887-1966), specialized in automatic drawings made in a two-step process that he began by letting his pencil wander over a sheet of paper with as little intellectual control as possible. Then he scrutinized the patterns made for shapes that seemed to have significance to him and filled those contours with ink to create a final design. Arp also was a leader in the use of chance in the making of art. Tiring of the look of some Cubist-related collages he was making at the time, he took sheets of paper, tore them into roughly shaped squares, haphazardly dropped them to a sheet of paper on the floor, and glued them into the arrangement that resulted. Squares Arranged According to the Laws of Chance (FIG. 22-27) is such an art work; the rectilinearity of the shapes guaranteed a somewhat regular design, but chance had introduced an imbalance that seemed to Arp to restore to his work a special mysterious vitality that he wanted to preserve. The operations of "chance" were for the Dadaists a crucial part of this kind of improvisation. As Richter stated: "For us chance was the 'unconscious mind' that Freud had discovered in 1900. . . . Adoption of chance had another purpose, a secret one. This was to restore to the work of art its primeval magic power and to find a

way back to the immediacy it had lost through contact with . . . classicism."*

From Zurich, Dada spread throughout much of Western Europe, arriving as early as 1917 in Berlin, where it soon took on an activist political edge, partially in response to the economic, social, and political chaos in that city in the years at the end of and immediately after World War I. The Berlin Dadaists developed to a new intensity a technique used earlier in popular art postcards. Pasting parts from many pictures together into one image, the Berliners christened their version of the technique photomontage. Unlike Cubist collage, the parts of a Dada collage were made almost entirely of "found" details, usually combined into deliberately anti-logical compositions. The collage technique allowed Dada artists in Berlin to make the realm of the machine their own. One of the technique's originators was HANNAH HÖCH (1889–1979), who wrote: "Our whole purpose was to integrate objects from the world of machines and industry in the world of art. . . . In an imaginative composition, we used to bring together elements borrowed from books, newspapers, posters, or leaflets, in an arrangement that no machine could yet compose."[†] Cut With The Kitchen Knife (FIG. 22-28) illustrates Höch's approach to the chaotic, kaleidoscopic effect of much of the Berlin Dada work made in this medium. Her title makes ironic reference to the pretensions of the social scene during the Weimar period immediately following World War I. Words and images from clearly disparate sources are tumbled together in an energetic composition in which one section or another claims our attention fleetingly as our eyes dart to and fro. The difference in scale between large heads and tiny figures evokes the sense of moving backward and forward in space. Details embedded within the densely packed lower left and upper right sections merge into strange dreamlike visions that seem to combine moments across time, much as a series of quick cuts between different scenes does in a movie, suggesting the kind of cinematic montage that Sergei Eisenstein began creating in the early 1920s (see page 1020). In a different way, the collaged details within the largest head at the upper left suggest a psychological condition. The effect is disconcerting and confusing-Höch's version of the Dada attempt to shock viewers out of complacent reliance on familiar ways of seeing and into a new and active engagement with the image. Höch's friend and fellow Dadaist, Raoul Hausmann, defined their work as "a new dimension: the 'alienation' of photography." He maintained that "the Dadaists . . . were the first

22-28 HANNAH HÖCH, Schnitt mit dem Küchenmesser Dada durch die erste Weimarer Bierbauchkulturepoche Deutchlands (Cut With The Kitchen Knife Through The Last Weimar Beer Belly Cultural Epoch), 1919. Staatliche Museen Preussbischer Kulturbesitz, Nationalgalerie, Berlin.

to use photography to create, from often totally disparate spatial and material elements, a new unity in which was revealed a visually and conceptually *new* image of the chaos of an age of war and revolution."[‡]

The technique of creating a composition by pasting together pieces of paper had been used in private and popular arts long before the twentieth century. In the early decades of this century, the process was named "collage" by the Cubists (see page 963). Collage lent itself well to the Dada desire to use chance in the creation of art and anti-art, but not all Dada collage was as savagely aggressive as that of the Berlin photomontagists. The Hanover Dada artist KURT SCHWITTERS (1887–1948) followed a gentler muse. Inspired by Cubist collage, but working in a nonobjective way, Schwitters found visual poetry in the cast-off junk of modern society and scavenged in trash bins for materials, which he pasted and nailed together into designs like Merz 19 (FIG. 22-29). He borrowed the term merz from a word fragment in one of his collages (part of kommerz, "commerce"). His compositions are nonobjective, yet they still resonate with the "meaning" of the fragmented found objects

*Ibid., p. 57.

[†]In Chipp, ed., Theories of Modern Art, p. 396.

[‡]In Richter, Dada: Art and Anti-Art, p. 116.

22-29 KURT SCHWITTERS, Merz 19, 1920. Paper collage, approx. $7_4^{\mu\nu} \times 5_5^{\pi\nu}$. Yale University Art Gallery, New Haven, Connecticut (collection, Société Anonyme).

they contain. Like the readymades of Duchamp and the photomontage cutouts of Höch, the recycled elements of Schwitter's collages are invested with new meanings through their new uses and locations.

The American artist MAN RAY (1890-1976), who worked closely with Duchamp during the teens and twenties, incorporated readymades into many of his paintings, sculptures, movies, and photographs. Trained as an architectural draftsman and engineer, Man Ray earned his living as a graphic designer and portrait photographer, and brought to his personal work an interest in mass-produced objects and technology and a committed dedication to exploring the psychological realm through which we perceive the exterior world. Like Höch and Schwitters, Man Ray used chance and the dislocation of ordinary things from their everyday settings to surprise his viewers into new awareness. His displacement of found objects was particularly mysterious in works like Rayograph (FIG. 22-30), made with a variant of the photogenic-drawing technique invented by Talbot (FIG. 21-35), and renamed by Man Ray after himself.* In

*Most other twentieth-century artists who practiced this technique called the works made in this way *photograms*.

the darkroom, Man Ray assembled a collection of objects on a sheet of photosensitive paper and then exposed the composition to light. He created a range of grey and white tones by turning off the light, removing some of the objects, and re-exposing the composition to light. The ghostly white silhouettes of the shapes lend each object an eerie presence, transforming them into participants in a strange, chaotic performance in which they appear to float freely against and within a void of darkened space. The improvisational Dada method here produces an evocative abstract fantasy that prophesies Man Ray's later practice of Surrealism.

The Dadaists were not alone in trying to subvert traditional art forms in the early years of the twentieth century. They found a kindred spirit in the work of the Greco-Italian painter GIORGIO DE CHIRICO (1888–1978), whose emphatically ambiguous works also make him a precursor of Surrealism. De Chirico's paintings of cityscapes and shop windows were part of a movement called Metaphysical Painting. As the son of a railroad engineer, his childhood was flavored by the continual arrival and departure of his father's trains. Returning to Italy after study in Munich, De Chirico found inspiration in the writings of Friedrich Nietzsche, who saw hidden reality revealed through

22-30 MAN RAY, Rayograph, 1923. Camera-less image on light-sensitive paper. Collection, The Museum of Modern Art, New York.

22-31 GIORGIO DE CHIRICO, The Soothsayer's Recompense, 1913. $53\frac{2}{8}'' \times 71''$. Philadelphia Museum of Art (The Louise and Walter Arensberg Collection).

strange juxtapositions, like those seen on late autumn afternoons in the city of Turin, when its vast open squares and silent public monuments were transformed by the long shadows of the setting sun into "the most metaphysical of Italian towns." De Chirico translated this vision into paint in works like The Soothsayer's Recompense (FIG. 22-31), where the squares and palaces of Roman and Renaissance Italy are visualized in a mood of intense and mysterious melancholy. A strangely displaced reality is evoked by the clock, the distant train, the blank sky, the tilted perspective, the blank façade broken by a yawning arcade, and the empty piazza with its mysteriously alive sculpture and slanting shadows. This image is a perfect illustration of the world of Metaphysical Painting (pittura metafisica), which De Chirico described:

In the construction of cities, in the architectural forms of houses, in squares and gardens and public walks, in gateways and railway stations . . . are contained the initial foundations of a great metaphysical aesthetic. . . . We who know the signs of the metaphysical alphabet are aware of the joy and the solitude enclosed by a portico, the corner of a street, or even in a room, on the surface of a table, between the sides of a box. The limits of these signs constitute for us a sort of moral and aesthetic code of representation, and more than this, with clairvoyance we construct in painting a new metaphysical psychology of objects.*

De Chirico's paintings were reproduced in periodicals almost as soon as he completed them, and his works quickly influenced artists outside Italy, including both the Dadaists and Surrealists. The disjunctive reality in his work intrigued the Dadaists, while the eerie mood and visionary quality of paintings like *The Soothsayer's Recompense* excited and influenced those Surrealist artists who sought to portray the world of dreams.

The Surrealists found similar hallucinatory magic in the strangely disconcerting photographs of Paris and its environs made by the French artist JEAN EUGÈNE AUGUSTE ATGET (1856–1927). Atget earned a precarious living as a photographer, having set for himself the goal of recording on film everything in Paris or its suburbs that was artistic or "picturesque." He was especially eager to photograph buildings slated for demolition to make way for more modern structures. Each day he set out early in the morning with a large view camera to capture subjects before

^{*}In Massimo Carrá, Ewald Rathke, Caroline Tisdall, and Patrick Waldberg, *Metaphysical Art* (New York: Praeger, 1971), p. 90.

many people were in the streets. Even his most straightforward shot of a Paris street or a corner of the garden at Versailles often had an aura of mysterious life. His gift for seeing strangeness in the everyday, however, was most clearly expressed in pictures of shop windows, like that of Avenue des Gobelins (FIG. 22-32). In such pictures, the everyday banality of ordinary objects is transformed into a dreamlike reality. The viewer is transported into an unusual world where store mannequins seem to be participating in some strange ritual and objects merge with the fuzzy reflections of distant buildings and trees. Atget's almost metaphysical photographs of Parisian shop windows, buildings, and gardens were known only to a few Parisian artists until the 1920s, when they were discovered by Man Ray and soon after praised by the Surrealists as the work of a genuine kindred spirit who believed in the world of dreams as strongly as they did themselves.

The Surrealists' interest in the world of dreams led them also to admire the work of the early twentiethcentury French filmmaker GEORGES MÉLIÈS (1861– 1938). The world of the cinema is, in many ways, by nature, a world of dreams in which viewers partici-

22-32 JEAN EUGÈNE AUGUSTE ATGET, Avenue des Gobelins, Paris, 1925. Albumen silver print, $8\frac{4''}{4''} \times 9\frac{9}{16}''$. Collection, The Museum of Modern Art, New York (Abbott-Levy Collection. Partial gift of Shirley C. Burden).

22-33 GEORGES MÉLIÈS, film still from A Trip to the Moon, 1902.

pate only if they mentally leave their seats in a darkened hall to experience the "reality" on the screen. Interested in drawing, theater, and the miraculous from earliest childhood, Méliès's first career as an adult was as a magician in a theater that he owned. Seeing the earliest films shown in Paris in 1895, he decided to employ films to create wonderful new illusions, using persistence of vision and the successive frames of film as units in a time-collage. In films, as in dreams, objects could appear and disappear in the flash of an eye, and one thing could change quickly into another. Fantasy sequences filled his movies. A Trip to the Moon (FIG. 22-33) was inspired by the science-fiction stories of Jules Verne and H. G. Wells. This film begins plausibly enough with the launching of a rocket to the moon. From that point on, however, the filmmaker gave his imagination full play, and his space travelers find the alien lunar environment populated with hybrid creatures and other strange things that behave in enchantingly nonlogical ways. In his pioneering work on Surrealist cinema, Ado Kyrou credited Méliès with having achieved in his films "the perfect mixture of reality dreamed and dreams made real."* Méliès's filmic imaginings provided the base on which full Surrealist cinema was built.

By 1924, much of the spirit of Dada had faded, and the energies of many of its adherents were turned toward the new movement of Surrealism. The Surrealists were determined to explore the inner world of the psyche, the realm of fantasy and the unconscious. Inspired in part by the ideas of the psychoanalysts Carl Jung and Sigmund Freud, the Surrealists were especially interested in the nature of dreams. They

*Ado Kyrou, *Le surréalisme au cinéma* (Paris: Le Terrain Vague, 1963), p. 66.

viewed dreams as occurring at the level at which all human consciousness connects and as constituting the arena in which people could move beyond the constricting forces of their environment to re-engage with the deeper selves that society had long suppressed. In 1924, these Surrealist beliefs were presented in the form of a dictionary definition of Surrealism formulated by one of its leading thinkers, the young Parisian writer André Breton:

Pure psychic automatism, by which one intends to express verbally, in writing, or by any other method, the real functioning of the mind. Dictation by thought, in the absence of any control exercised by reason, and beyond any aesthetic or moral preoccupation. . . . Surrealism is based on the belief in the superior reality of certain forms of association heretofore neglected, in the omnipotence of dreams, in the undirected play of thought. . . . I believe in the future resolution of the states of dream and reality, in appearance so contradictory, in a sort of absolute reality, or surreality.*

Thus, the dominant motivation of Surrealist art was to bring the aspects of outer and inner "reality" together into a single position, in much the same way that seemingly unrelated fragments of life combine in the vivid world of dreams. The projection in visible form of this new conception required new techniques of pictorial construction. The Surrealists adapted some Dadaist devices and invented new techniques like automatic writing and various types of planned "accidents" not so much to reveal a world without meaning as to provoke reactions closely related to subconscious experience.

Originally a Dada activist in Cologne, MAX ERNST (1891–1976) became one of the early adherents of the Surrealist circle surrounding André Breton. As a child living in a small community near Cologne, Germany, Ernst had found his existence to be fantastic and filled with marvels. In autobiographical notes, written mostly in the third person, he said of his birth: "Max Ernst had his first contact with the world of sense on the 2nd April 1891 at 9:45 A.M., when he emerged from the egg which his mother had laid in an eagle's nest and which the bird had incubated for seven years." Early success as an Expressionist was swept away by Ernst's service in the German army during World War I; in his own words:

Max Ernst died on 1st August 1914. He returned to life on 11th November 1918, a young man who wanted to become a magician and find the central myth of his age. From time to time he consulted the eagle which had guarded the egg of his prenatal exis-

*In William S. Rubin, *Dada, Surrealism, and Their Heritage* (New York: Museum of Modern Art, 1968), p. 64.

tence. The bird's advice can be detected in his work." $^{\prime\prime \dagger}$

Beginning in 1918, as a Dadaist in Cologne, Ernst explored every means to achieve the sense of the psychic in his art. Like other Dadaists, he set out to incorporate chance and found objects into his works. Using a process called *frottage*, he created some works by combining the patterns achieved by rubbing a crayon or another medium across a sheet of paper that was placed over a surface with a strong and evocative texture pattern. In other works, he joined fragments of images he had cut from old books, magazines, and prints to form one hallucinatory collage.

Ernst soon began making paintings that shared the mysterious dreamlike effect of his collages. In the early 1920s, his works brought him into contact with Breton, who instantly recognized Ernst's affinity with the Surrealist group. Many of the creative bases of Surrealism (the chance association of things and events, the dislocation of images and meanings, the scrambling of conventional contexts, the exploration of the subconscious, and the radical freedom of artistic choice) are manifest in Ernst's *Two Children Are Threatened by a Nightingale* (FIG. **22-34**). In this work,

⁺Richter, Dada: Art and Anti-Art, pp. 155, 159.

22-34 MAX ERNST, Two Children Are Threatened by a Nightingale, 1924. Oil on wood with wood construction, 27²/₂ high, 22¹/₂ wide, 4¹/₂ deep. Collection, The Museum of Modern Art, New York (purchase).

22-35 SALVADOR DALI and LUIS BUÑUEL, film still from Un Chien Andalou, 1929.

Ernst displayed a private dream, which challenged the post-Renaissance idea that a painting should resemble a window looking into a "real" scene that is rendered illusionistically three-dimensional through the use of mathematical perspective. In this work, the landscape, the distant city, and the tiny flying bird are traditionally painted; the artist followed all of the established rules of aerial and linear perspective. The three sketchily rendered figures, however, clearly belong to a world of dreams, and the literally threedimensional miniature gate, the odd button-knob, and the strange, closed building "violate" the space of the bulky frame. Additional dislocation occurs in the traditional museum identification label, which has been displaced into a cutaway part of the frame. Handwritten, it announces the title of the work (taken from a poem written by Ernst before this work was painted), adding another note of irrational mystery. Like the title of many Surrealist works, that of Two Children is ambiguous and has an uneasy relation to what the spectator sees. The viewer must struggle to decipher connections between image and words. When Surrealists (and Dadaists and Metaphysical artists before them) used such titles, they intended for the seeming contradiction between title and picture to act like a "blow to the mind," knocking the spectator off balance, with all expectations challenged. Much of the impact of Surrealist works like this begins with the viewer's sudden awareness of the incongruous and the absurd in what is pictured.

Surrealist fantasy found some of its most haunting expression in cinema, and one of the most powerful Surrealist films is Un Chien Andalou (An Andalusian Dog, FIG. 22-35), made in 1929 by the Spanish painter SALVADOR DALI (1904–1989) and the filmmaker LUIS BUÑUEL (1900–1983). The pair deliberately set out to write a movie script that would have no trace of rational order or expected meaning. From the initial shocking scene, in which sight is cancelled by the slicing of an eyeball, through the illogical succession of psychologically suggestive episodes that follow, the viewer is displaced from one dreamlike moment to the next. In one of the most memorable segments, a man seeks a weapon to attack a woman. Looking behind him, his eyes light up triumphantly as he bends to pick up a rope. He starts forward and almost topples backward from the weight of the burden at the other end of the rope. He gathers all his energy, leans against the dragging load, and slowly moves forward again. The camera shifts and the viewer sees (in the words of the script): "a cork, then a melon, two Brothers from a parochial school, and last two magnificent grand pianos. The pianos are filled with the rotting corpses of donkeys whose hooves, tails, rumps, and excrement overflow. When one of the pianos passes the camera we see a big donkey head resting on the keyboard."* This jumble of things have

^{*}In J. H. Matthews, *Surrealism and Film* (Ann Arbor: The University of Michigan Press, 1971), p. 87.

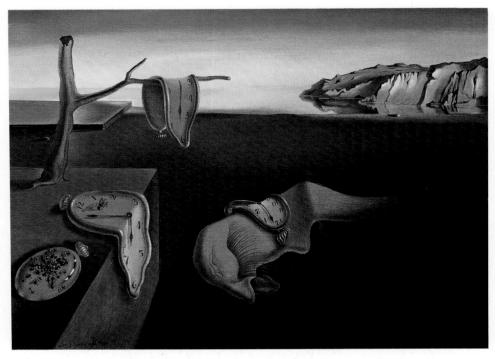

22-36 SALVADOR DALI, The Persistence of Memory, 1931. $9_2^{1''} \times 13''$. Collection, The Museum of Modern Art, New York (given anonymously).

no clear connection, no simple symbolism. Instead, their appearance and their behavior are the result of a pure Surrealist creative process, as Buñuel clearly stated in his "Notes on the Making of *Un Chien An-dalou*":

In *Un Chien Andalou*, . . . The plot is the result of a *conscious* psychic automatism, and, to that extent, it does not attempt to recount a dream, although it profits by a mechanism analogous to that of dreams. . . . Its aim is to provoke in the spectator instinctive reactions of attraction and of repulsion . . . *nothing*, in the film, *symbolizes anything*. The only method of investigation of the symbols would be, perhaps, psychoanalysis.*

To critique the madness of modern society, Buñuel used Surrealist devices in his later films. Dali, already an established Surrealist painter, continued steadily to explore his own psyche and dreams in his paintings, sculptures, jewelry, and designs for furniture and movies. Dali also probed a deeply erotic dimension through his work, studying the writings of Freud and Richard von Krafft-Ebing and inventing what he called the "paranoiac-critical method" to assist his creative process. As he described it, his aim in painting was "to materialize the images of concrete irrationality with the most imperialist fury of preci-

sion . . . in order that the world of imagination and of concrete irrationality may be as objectively evident . . . as that of the exterior world of phenomenal reality."[†] All of these aspects of Dali's style can be seen in what is perhaps his most familiar work, The Persistence of Memory (FIG. 22-36). Here, he creates a haunting allegory of empty space in which time is at an end. The barren landscape, without horizon, drifts to infinity, lit by some eerie, never-setting sun. An amorphous creature sleeps in the foreground; it is based on a figure in the Paradise section of The Garden of Earthly Delights by Hieronymus Bosch (FIG. 18-20), which Dali had studied in the Prado Museum in Madrid. Dali has draped his creature with a limp pocket watch. Another watch hangs from the branch of a dead tree that springs surprisingly from a blocky, architectonic form. A third watch hangs half over the edge of the rectangular form, beside a small timepiece resting dial-down on the block's surface. Ants swarm mysteriously over the small watch, while a fly walks along the face of its large neighbor, almost as if this assembly of watches were decaying, organic lifesoft and viscous. Dali rendered every detail of this dreamscape with precise control, striving to make the world of his paintings as convincingly real as the most meticulously rendered landscape based on an actual scene from nature. Dali based his exacting,

⁺In Rubin, Dada, Surrealism, and Their Heritage, p. 111.

^{*}In "Art in Cinema," symposium held at the San Francisco Museum of Art (reprinted, New York: Arno Press, 1968), pp. 29–30.

22-37 JOAN MIRÓ, *Painting*, 1933. Approx. 5' $8\frac{1}{2''} \times 6' 5\frac{1}{4''}$. Collection, The Museum of Modern Art, New York (Loula D. Lasker Bequest by exchange).

miniaturelike technique on careful studies of earlier art, especially that of Dutch and Spanish masters of the seventeenth century like Velázquez (FIG. 19-38), but Dali's subject matter is closer to the psychological world of Stubbs (FIG. 20-46), Fuseli (FIG. 20-47), Blake (FIG. 20-48), and Munch (FIG. 21-92).

Like the Dadaists, the Surrealists used many methods to free their creative process from reliance on the kind of conscious control they believed had been too much shaped by society. Dali used his paranoiaccritical approach to encourage the free play of association as he worked. Other Surrealists used automatism and various types of planned "accidents" to provoke reactions closely related to subconscious experience. The Spanish artist JOAN MIRÓ (1893-1983) was a master of this approach. From the beginning, his work contained an element of fantasy and hallucination. Introduced to the use of chance in the creation of art by Surrealist poets in Paris, the young Spaniard devised a new painting method that allowed him to create works like Painting (FIG. 22-37). Miró began this painting by making a scattered collage composition with assembled fragments cut from a catalogue for machinery. The shapes in the collage became motifs that the artist freely reshaped to create biomorphic black silhouettes-solid or in outline, with dramatic accents of white and vermilion-that suggest, in the painting, a host of amoeba-like organisms floating in an immaterial background space

filled with soft reds, blues, and greens. Miró described the creative process he used as switching back and forth between unconscious and conscious image making: "Rather than setting out to paint something, I begin painting and as I paint the picture begins to assert itself, or suggest itself under my brush. The form becomes a sign for a woman or a bird as I work. . . . The first stage is free, unconscious. . . . The second stage is carefully calculated."* Even the artist could not always explain the meanings of pictures like *Painting*. They are, in the truest sense, spontaneous and intuitive expressions of the littleunderstood, submerged, unconscious part of life.

JEAN (HANS) ARP adapted the automatism from his Dadaist period (see page 977) to initiate the design of biomorphic free forms in Surrealist sculptures like *Human Concretion* (FIG. **22-38**). Arp's French and German first names reflect the fact that he was born in Alsace-Lorraine, a region annexed to Germany in 1871 and returned to France in 1919. The absurdity of this political situation may have helped to color Arp's early poetry and his eager participation in the Dada and Surrealist movements. Interested at first in expressing his sense of the metaphysical qualities in everyday objects, the forms in his Surrealist works instead represent the natural processes that generate

^{*}In William S. Rubin, *Miró in the Collection of The Museum of Modern Art* (New York: The Museum of Modern Art, 1973), p. 32.

22-38 JEAN ARP, Human Concretion, 1935. Original plaster, $19\frac{17}{2''} \times 25\frac{17}{2''}$. Collection, The Museum of Modern Art, New York (gift of the Advisory Committee).

the shapes of the physical world. Borrowing a term from geology, Arp called many of his Surrealist sculptures "concretions": "Concretion signifies the natural process of condensation, hardening, coagulating, thickening, growing together. . . . Concretion designates solidification. . . . Concretion is something that has grown."* Human Concretion was designed so that it could be placed in a number of positions. The way in which its forms twist and push forward in many directions creates the effect that the piece is still in the process of growing toward its final state. Arp's definition and the title of this piece all reflect his deep belief that the whole earth is alive and that all living things share in the same vital forces. The biomorphic organicism of Human Concretion links Arp's Surrealism with the abstract forms created by Henry Moore (FIG. 22-46) in England.

Surrealism began in Europe, but its ideas spread rapidly to artists in other countries. In the United States, JOSEPH CORNELL (1903–1972) was inspired by the Surrealist collages of Max Ernst to fill open boxes with evocative groups of found images and objects arranged in compositions like *Soap Bubble Set* (FIG. **22-39**). Cornell received a classical secondary-school

*In Herbert Read, *The Art of Jean Arp* (New York: Harry N. Abrams, 1968), p. 93.

22-39 JOSEPH CORNELL, Soap Bubble Set, 1936. Glass case with inserts, $15\frac{3''}{3''} \times 14\frac{11}{4''} \times 5\frac{3''}{8}$. Wadsworth Atheneum, Hartford, Connecticut (gift of Henry and Walter Keney).

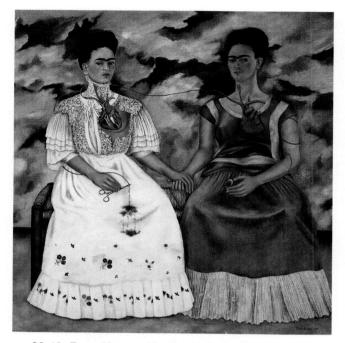

22-40 FRIDA KAHLO, *The Two Fridas*, 1939. 67" × 67". Collection of the Museo de Arte Moderno, Mexico City.

education but no formal art training. Working in New York as a salesman, he scoured the city for objects and printed images that carried for him reminiscences of astronomy, nature, and the nineteenthcentury literature, opera, and ballet that he loved. Often he pursued a theme through variations in a series of different boxes. His compositions allude to many things but express no specific meaning. The juxtaposition of unlikely objects forces each viewer to invent connections and meanings for the assembly. The Surrealists recognized at once that Cornell shared their interest in the beauty that occurs in the "chance encounter" of unrelated things in an unexpected setting. In Soap Bubble Set, the doll's head can be seen as a reference to the artist himself; the clay pipes recall those used by the early Dutch settlers of New York City; the large cork floats (some adorned with decals of zodiacal signs) speak of the sea; the star maps suggest the heavens, and the goblets and the marbles allude, among other things, to drinking and to children's games. The composition of many of Cornell's boxes reveals his fascination with the cinema. The viewer takes in one section, then abruptly shifts attention to another, rather like experiencing a jump cut from one scene to a completely unexpected successor in Surrealist films like Un Chien Andalou.

Perhaps the most autobiographical of all artists connected with Surrealism was the Mexican painter FRIDA KAHLO (1907–1954), who used the details of her own life as powerful symbols for the psychologi-

cal pain of human existence. Kahlo began painting seriously as a young student, during convalescence from a tragic accident that left her in constant pain. Her life became a heroic and tumultuous battle for survival against illness and stormy personal relationships. The Two Fridas (FIG. 22-40) is typical of Kahlo's long series of unflinching self-portraits. The twin figures sit side by side on a low bench in a barren landscape under a stormy sky. One figure wears a simple Mexican costume, while the other is dressed in what might be an elaborate wedding dress. The figures suggest different sides of the artist's personality, inextricably linked by the clasped hands and by the thin artery that stretches between them, joining their exposed hearts and culminating on one side in surgical forceps and on the other in the hallucinatory mushroom. The French Surrealist André Breton found Kahlo to be a natural Surrealist. He recognized that her deeply personal double self-portrait touches sensual and psychological memories in each of us.

The Search for Eternal Forms

One strong impulse in psychological and conceptual Modernism early in the twentieth century was the desire of artists to find and use expressive forms to embody eternal qualities. Working figuratively or abstractly, artists striving to achieve this aim believed that true reality lay hidden behind the surface of the visible world, and they devised a range of symbols to represent the patterns of that innermost essence. These artists were interested above all in expressing the human spiritual dimension. Paul Klee articulated the goal of this group as art derived from "the source of it all." He went on to say that "what springs from this source-whatever it may be called, dream, idea or fantasy-must be taken seriously only if it unites with the proper creative means to form a work of art. . . . For not only do they, to some extent, add more spirit to the seen, but they also make secret visions visible."* Each of these artists developed an individual style to represent a sense of eternal form, and all believed that the universal reality expressed in their works would be perceived by every viewer.

ABSTRACT FIGURATION

Many artists before the twentieth century considered figurative art to be the most powerful means of representing universal ideals. In the first half of the twentieth century, however, such expression assumed a heightened psychological and conceptual dimension as artists adopted expressionistic devices

^{*}In Robert L. Herbert, ed., *Modern Artists on Art* (Englewood Cliffs, NJ: Prentice-Hall, 1964), p. 89.

of bold color and simplified or exaggerated forms to invest their work with emotional power. Directing their works at the hearts of their viewers, each of these artists sought to give visual form to the eternal mysteries of life and death. To do so, they worked with symbols derived from those familiar to a wide population.

A dynamic use of symbol and fantasy was employed by the Russian artist MARC CHAGALL (1887-1985) to create works filled with the extremes of visionary joy and despair. Chagall studied and worked in Paris and Berlin, and incorporated into his work elements of Expressionism, Cubism, and Fauvism. However, he never forgot his early years in an obscure Russian village, and themes from his childhood returned as if in dreams and memories. Some, gay and fanciful, suggest the simpler pleasures of folk life; others, somber and even tragic, recall the trials and persecutions of the Jewish people. Through all of his work runs a sense of the deep religious experience that was an inextricable part of his early life. In The Falling Angel (FIG. 22-41), Chagall combined his themes to symbolize the suffering of all ordinary people as Europe slid toward and into World War II. A flaming female angel plummets across a moonlit night sky, one wing stretched upward and the other pointing toward the earth. A mother and child, floating over a slumbering village, mingle with the earthside wing. To the right is a Crucifix. To the left, a bearded peasant holds a Torah scroll. Above him, a workman tumbles through the air. From a central position at the bottom of the composition, a strange yellow beast looks directly at the viewer. This enigmatic creature is placed beside a mysteriously floating violin. A lighted candle recalls the sacred light in both Christian and Jewish ritual. The terror of wars and pogroms is suggested by the pitiful little figure trudging along the path leading from the village, while resignation and hope are expressed in other symbols. The work is a moving portrayal of the artist's feeling that faith is important in a world of war and brutality. Clearly, Chagall was a highly individual artist who intuitively used diverse avant-garde styles to help him transform the personal themes of his Jewish childhood into symbols that suggest universal human experience.

Perhaps the most inventive artist using abstract figuration to express the world of the spirit was the Swiss-German painter PAUL KLEE (1879–1940). The son of a professional musician and an accomplished violinist in his own right, Klee thought of painting as similar to music in its expressiveness and in its ability

22-41 MARC CHAGALL, The Falling Angel, 1923, 1933, 1947. Kunstmuseum, Basel, Switzerland (Emanuel Hoffmann-Stiftung).

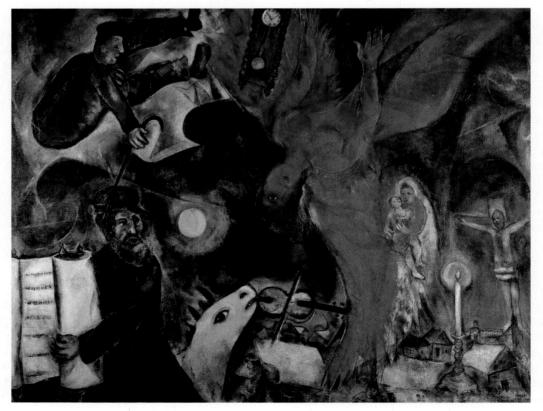

to touch the spirit of its viewers through a studied use of color, form, and line:

Art does not reproduce the visible; rather it makes visible. . . . The formal elements of graphic art are dot, line, plane, and space—the last three charged with energy of various kinds. . . . Formerly we used to represent things visible on earth, things we either liked to look at or would have liked to see. Today we reveal the reality that is behind visible things. . . . By including the concepts of good and evil, a moral sphere is created. . . . Art is a simile of the Creation.*

To penetrate the reality that is behind visible things, Klee studied nature avidly, taking special interest in analyzing processes of growth and change. He coded these studies in diagrammatic form in notebooks, and the knowledge he gained in this way became so much a part of his consciousness that it influenced the "psychic improvisation" he used to create his art.

Klee's works, like Twittering Machine (FIG. 22-42), are small and intimate in scale. A viewer must draw near to decipher the delicately rendered forms and enter this mysterious dream world. The ancient world of nature and the modern world of machines are joined in this picture, where four diagrammatic birds appear to be forced into twittering action by the turning of a crank-driven mechanism. We customarily associate birds with life and machines with man's ability to control nature. (Indeed, a 1921 drawing by Klee called Concert on a Twig shows these four birds with their double-curved perch clearly attached to a tree.) In Twittering Machine, however, Klee has linked the birds inextricably to the machine, creating an ironic vision of existence in the modern age. Each bird responds in such an individual way that we may see all of them as metaphors for ourselves-beings trapped by the operation of the industrial society we created. Some observers see an even darker meaning in Twittering Machine: the individual birds are said to represent the four temperaments of the medieval and Renaissance periods, while their loony appearance also features avian shapes capable of luring real birds into a trap in the rectangular trough at the bottom of the image. Perhaps no other artist of the twentieth century matches the subtlety of Klee as he adroitly plays with sense, creating an artistic device of ambiguity and understatement that draws each viewer into finding a unique or markedly individualistic interpretation of the work.

Klee shared the widespread modern apprehension concerning the rationalism behind a technological civilization that could be as destructive as it was constructive. As do some psychologists, he sought clues to man's deeper nature in primitive shapes and sym-

*In Chipp, ed., Theories of Modern Art, pp. 182-85.

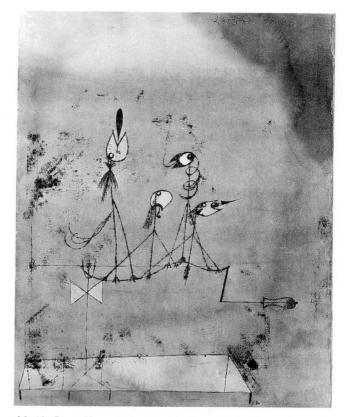

22-42 PAUL KLEE, Twittering Machine, 1922. Watercolor and pen and ink, approx. $16_4^{1''} \times 12''$. Collection, The Museum of Modern Art, New York (purchase).

bols. Like the psychologist Carl Jung, Klee seems to have accepted the existence of a collective unconscious that reveals itself in archaic signs and patterns and that is everywhere evident in the art of primitive peoples. Toward the end of his life, Klee suffered from a debilitating and painful illness. Its effects heightened his depression over the worsening of world conditions. Death and Fire (FIG. 22-43) expresses the dark mood of his last years in the style of an ideogram-a simple, picturelike sign filled with implicit meaning. A stick figure moves left toward three vertical bars. A white death's-head, heavily outlined, dominates the work and seems to rise toward a glowing sun. The features of the skull may also be letters, perhaps tod (the German word for death). The pale green, harmonized with the chords of red, may suggest the element of water reconciled with fire in the ever-changing alternation of life and death. The eerie color, the primitive starkness of the images, and the mysterious arrangement convey an almost religious sense of awe, as if one were in the presence of a totem having magical powers. Enigmatic as the subject is, we feel its sources, as definitely as those of Chagall, in the human religious experience.

22-43 PAUL KLEE, Death and Fire, 1940. Oil drawing in black paste on jute burlap, mounted on stretched jute. Approx. $18'' \times 17\frac{5}{16}''$. Paul Klee Foundation, Kuntsmuseum, Berne, Switzerland. Copyright 1990 by Cosmopress, Genf.

The physicality of sculpture presented particular problems for artists determined to create eternal forms in real space. One of the earliest sculptural visions of universal form was that of the French artist ARISTIDE MAILLOL (1861–1944). In the opening years of the century, he created a new version of the Classical human nude to express his concept of ideal beauty. Maillol began his career as a painter, executing broadly decorative designs in the manner of Gauguin, and was also known as a graphic artist through his Art Nouveau woodcut book illustrations. About 1900, Maillol turned to sculpture. He developed a serene style of massive planes and volumes to express a Classical sense of an ideal that lies beyond the endlessly changing surfaces of the visible physical world. As he put it: "The particular does not interest me; I find meaning only in a general idea. . . . For my taste, sculpture should have as little movement as possible. . . . When a movement is excessive it is frozen: it no longer represents life."* One of Maillol's first and most important sculptural works, the seated figure The Mediterranean (FIG. 22-44), was conceived as an organization of volumes based on an ideal simplification of the human female nude. This figure has weight and solidity, and the light flows evenly and quietly over the largely unbroken surfaces of the smoothly modeled masses. The pose resembles sev-

*In Goldwater and Treves, eds., Artists on Art, pp. 406-408.

eral Tahitian figures by Gauguin, whose art Maillol greatly admired, but the figure's tranquil monumentality and dignity also recall the Early Classical sculpture of ancient Greece. Unlike these earlier works, however, this figure was meant to have no meaning beyond the wonder of its beautifully composed shapes. (The title *The Mediterranean* was added later.) It is an abstract design that ponders the delight of the ideal female form.

The Romanian sculptor CONSTANTIN BRANCUSI (1876–1957) created eternal shapes by uncovering the essential shapes hidden at the core of the things we see in the world. Brancusi worked his way to Paris where he at first used a style inspired by that of Rodin. Soon, however, he was searching for ways to express an inner reality lying beyond the surface of the physical world. Inspired by the teachings of an eleventh-century Tibetan monk (Milarepa) concerning the universality of all life, Brancusi developed his own creative philosophy:

There is an aim in all things, to reach it we must detach ourselves from ourselves. . . . It is not making things that is difficult but putting ourselves in condition to make them. . . . Simplicity is not an end in art, but we arrive at simplicity in spite of ourselves as we approach the real sense of things. . . . They are fools who call my work abstract. What they think to be abstract is the most realistic, because what is real is not the outer form, but the idea, the essence of things."[†]

⁺In Carola Giedion-Welcker, *Contemporary Sculpture* (London: Faber & Faber, 1960), p. 126.

22-44 ARISTIDE MAILLOL, The Mediterranean, c. 1902–1905. Bronze, approx. 41'' high, base $45'' \times 243''$. Collection, The Museum of Modern Art, New York (gift of Stephen C. Clark).

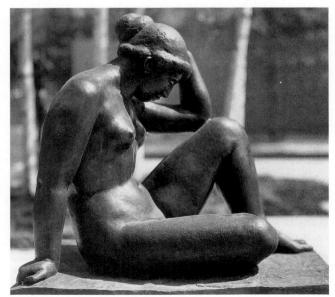

22-45 CONSTANTIN BRANCUSI, Bird in Space, 1928(?). Bronze, unique cast, approx. 54" high. Collection, The Museum of Modern Art, New York (given anonymously).

Works like Bird in Space (FIG. 22-45) were created at the end of a long process in which Brancusi began with a sculpture closer in detail to the shape of something in the world—in this case, a bird standing at rest with its wings folded at its sides. Gradually, he simplified the bird's shape until its feet and body merged, the final form suggesting that it is about to leave the ground to soar in free flight through the heavens.* Brancusi envisioned many of his works, including this one, enlarged to monumental scale. The subtitle for this work was Project of bird which, when enlarged, will fill the sky, and the sculptor spoke of the work's ability on that scale to fill viewers with comfort and peace. The polished bronze was intended to catch and reflect light. Brancusi always paid special attention to the intrinsic qualities in the materials he used. He made sculptures in wood, in marble, in stone, and in bronze. In each, he tried to create forms that respected and worked with the nature of the material itself. His stone pieces and some of his wood pieces are smooth and highly polished, allowing the patterns of the natural grain to become part of the work's meaning and expressiveness. Sometimes his wood pieces are roughly hewn, revealing the action of the chisel and adz in creating forms that in these cases seem related to those made by prehistoric people thousands of years ago. Whatever the form or subject, Brancusi said to his viewers: "Don't look for obscure formulas or mysteries. I am giving you pure joy. Look at the sculptures until you see them. Those nearest to God have seen them."[†]

The English sculptor HENRY MOORE (1898–1986) shared Brancusi's profound love of nature and knowledge of natural forms and materials. Moore maintained that every "material has its own individual qualities" and that these qualities could play a role in the creative process: "It is only when the sculptor works direct, where there is an active relationship with his material, that the material can take its part in the shaping of an idea." Moore combined this insight with memories of the shapes of the hilly Yorkshire countryside he had known as a boy to express the ways in which the shapes of landscape and the human figure echo one another in a marvelous unity of form: "The human figure is what interests me most deeply, but I have found principles of form and rhythm from the study of natural objects." One great recurring theme in Moore's work was the reclining female figure, whose simplified and massive forms were originally inspired by a tiny photograph of a Chacmool figure from pre-Columbian Mexico.[‡] Although one can recognize a human figure in most of Moore's works, the artist pushed always toward an abstract symbolism that would express a universal truth beyond the physical world. He summarized his feelings about abstract figurative form in two passages from essays written in the 1930s: "Because a work does not aim at reproducing natural appearances, it is not, therefore, an escape from life-but may be a penetration into reality. . . . My sculpture is becoming less representational, less an outward visual copy . . . , but only because I believe that in this way I can present the human psychological content of my work with the greatest directness and intensity."[§] Reclining Figure (FIG. 22-46) is a wonderful example of Moore's handling of his particular abstract symbolism. The massive shapes of the figure suggest

^{*}Many people have noted a resemblance between Brancusi's *Bird in Space* and the appearance of the streamlined *moderne* style being developed by industrial designers during the 1930s. The resemblance is fortuitous, but not surprising, as both artist and designers each based their concept on a careful study of birds in flight.

[†]In Carola Giedion-Welcker, *Constantin Brancusi* (New York: George Braziller, 1959), p. 219.

[‡]Chacmool figures are thought perhaps to represent a god or a worshiper bearing an offering. Usually carved in stone, each figure characteristically reclines on its back with the knees bent and its torso bent upright, head turning abruptly toward one side. [§]In Herbert, ed., *Modern Artists on Art*, pp. 140–41, 145–46.

22-46 HENRY MOORE, Reclining Figure, 1939. Elmwood, 37" × 6' 7" × 30". © Detroit Institute of the Arts (gift of the Dexter M. Ferry, Jr., Trustee Corporation).

the biomorphic forms of Surrealism, but Moore's recumbent woman is also a powerful earth mother, whose undulant forms and hollows suggest nurturing human energy and at the same time evoke the contours of Yorkshire hills and the wind-polished surfaces of weathered wood and stone. Allusions in Moore's work to landscape and to biomorphic Surrealist forms are heightened by the interplay of mass and void, which the sculptor based on the intriguing qualities of cavities in nature: "The hole connects one side to the other, making it immediately more threedimensional. . . . The mystery of the hole-the mysterious fascination of caves in hillsides and cliffs." The contours and openings of Reclining Figure follow the grain of the wood. Above all, Reclining Figure is filled with a tightly coiled, dynamic energy that seems to radiate from its innermost core outward through the breasts, the jutting knees, and the upthrust head.

ABSTRACT FORMALISM

For some artists, eternal qualities could only be expressed in forms so pure in their abstraction from any reference to the natural world that they appear completely nonobjective. Most of these artists wrote articulately about the actual symbolism in their individual styles. Most also believed that they were inventing a universal art language that could be understood by all peoples. These artists followed the beliefs of Wilhelm Worringer, who had written in 1908 about the way in which such forms stand above the particularities of the world:

The simple line and its development in purely geometrical regularity was bound to offer the greatest possibility of happiness to the man disquieted by the obscurity and entanglement of phenomena. For here the last trace of connection with, and dependence on, life has been effaced, here the highest absolute form, the purest abstraction has been achieved; here is law, here is necessity, while everywhere else the caprice of the organic prevails.*

The artists who based their work on abstract symbolic forms believed such compositions would help viewers to perceive the profound truth that the artists had captured. The critic Sheldon Cheney summarized this position in his 1934 essay "Abstraction and Mysticism":

At the present stage of comprehension—retarded by education—few people but an increasing group are sensitive to absolute abstraction, which they may or may not consider a sort of mystic revelation of harmonious cosmic order; and a larger group turn to partially objective painting in which the abstract skeleton or core is richly dominant. They will detect the qual-

*In Frascina and Harrison, eds., Modern Art and Modernism, p. 163.

ity in greater purity as understanding and sensitivity grow; perhaps the individual will march on till he commonly demands abstraction washed of the last remnants of objectivity.*

To the artists who followed this approach, abstract symbolism was the only true art. Although the vast majority of artists working in this style produced spare and precise compositions, the Russian painter WASSILY KANDINSKY (1866–1944) is a notable exception to that general trend. Kandinsky adapted the energetic, intuitive approach of German Expressionism to create dynamic abstract representations of emotional and mystical themes. He embarked on a painting career in Munich in 1896 after an early law career in Russia. Travel introduced him to avantgarde art and took him outside Europe on a trip to Tunis. In 1911, with the painters Franz Marc, Ernst Macke, and Paul Klee (long before he developed his mature style), Kandinsky formed a new Expressionist group, the Blue Rider (Die Blaue Reiter). The members of the Blue Rider group had no common style, but they did share the belief that an artist should use the language of color and form to create works that speak directly from the heart of the creator to the souls of viewers. Believing that rational, post-Renaissance tradition was useless in the creation of such expressive works, the Blue Rider artists looked outside the artistic mainstream of the West (as had the Bridge group) to find inspiration in the art of German and Russian peasants, the ancient world, the Middle Ages, Africa, and Oceania. The artists of the Blue Rider group also admired the art of pre-Columbian Latin America and of Arabia, and showed a special appreciation for the art of children and the mentally ill. Blue Rider artists felt that the art produced by these cultures and groups contained a straightforward expressive power lacking in the Salon art of the time.

As the leading theorist of the group, Kandinsky formulated their ideas in written form both for their publications and for his own book, *Concerning the Spiritual in Art*, which was written in 1911 and published in 1912. As the title suggests, Kandinsky believed that great art contains the spiritual power of inner harmony, expressed through eternal shapes that speak through the sense of sight to the viewer's deepest intuitive link with the source of all being:

Generally speaking, color is a power that directly influences the soul. Color is the keyboard, the eyes are the hammers, the soul is the piano with many strings. The artist is the hand which plays, touching one key or another, to cause vibrations in the soul. . . . The inner need is the basis of small and great problems in painting. We are seeking today for the road which is to lead us away from the outer to the inner basis. The spirit, like the body, can be strengthened and developed by frequent exercises. . . A work of art is born of the artist in a mysterious and secret way. From him it gains life and being. Nor is its existence casual and inconsequent; it has a definite and purposeful strength, alike in its material and spiritual life. It exists and has power to create spiritual atmosphere; and from this internal standpoint alone can one judge whether it is a good work of art or a bad one.[†]

Kandinsky wrote about how each kind of shape, each color value, each pattern of line, had certain symbolic and psychological effects, and about how the artist could compose with them as the musical composer uses tone and harmony. His research into the emotional and expressive properties of color, line, and shape soon led him in his own work to the point at which subject matter and even representational elements were highly abstracted or eliminated altogether. Like Klee, Kandinsky saw strong parallels between expression in the visual arts and music.[‡] A fine cellist and pianist, he yearned for an art that would speak as directly to the hearts of viewers as music communicated to its listeners. He gave his works titles used for musical pieces-Improvisations, Etudes, Compositions. His Compositions were characterized by carefully ordered arrangements of shapes, while his Improvisations, like Improvisation 28 (FIG. 22-47), were the result of a freer, more spontaneous approach to the canvas. Kandinsky's beliefs about the importance of the unconscious in artistic creation harmonized with Freud's conclusions concerning the subconscious and with Arthur Rimbaud's claim that the true artist is a visionary.

Kandinsky's countryman, the Russian KASIMIR MALEVICH (1878–1935) also studied art in Germany early in his career, but he then returned to Russia, where he developed an abstract formalist style to convey his belief that the supreme reality in the world is pure feeling, which rests in no object and thus calls for new, nonobjective forms in art-shapes not related to objects in the visible world. Malevich had studied painting, sculpture, and architecture, and had worked his way through most of the avant-garde styles of his youth before deciding that none was suited to the expression of the subject he found most important-"pure feeling." He christened his new artistic approach "Suprematism" and said of it: "Under Suprematism I understand the supremacy of pure feeling in creative art. To the Suprematist, the

⁺Wassily Kandinsky, *Concerning the Spiritual in Art*, trans. M. T. H. Sadler (New York: Dover, 1977), pp. 25, 35–36, 53.

[‡]Kandinsky also attempted to create a special kind of theatrical performance that would contain a synthesis of all the arts.

22-47 WASSILY KANDINSKY, *Improvisation* 28 (second version), 1912. Approx. $44'' \times 63_4^{3''}$. Solomon R. Guggenheim Museum, New York.

visual phenomena of the objective world are, in themselves, meaningless; the significant thing is feeling, as such, quite apart from the environment in which it is called forth. . . . The Suprematist does not observe and does not touch-he feels."* The basic form of his new Suprematist nonobjective art was the square. Combined with its relatives, the straight line and the rectangle, the square soon filled paintings like Suprematist Composition: Aeroplane Flying (FIG. 22-48), in which the brightly colored shapes float against and within a white space and are placed in dynamic relationship to one another. Malevich believed that his new art would be easily understood by all peoples, because it required no special education to comprehend its symbols. It used the pure language of form and color that everyone could understand intuitively. Having formulated his artistic approach, Malevich welcomed the Russian Revolution as a political act that would wipe out past traditions and begin to build a new culture in which his art could play a major role. In actuality, after a short period in which avant-garde art was in the vanguard of the new regime, the political leaders of post-Revolution Russia decided that the new society needed a more "practical" art that would teach citizens about their

*In Chipp, ed., Theories of Modern Art, pp. 341, 345.

22-48 KASIMIR MALEVICH, Suprematist Composition: Aeroplane Flying, 1915 (dated 1914). $22\frac{7}{8}^{"} \times 19^{"}$. Collection, The Museum of Modern Art, New York (purchase).

new government or produce goods that would help make their lives better. Malevich was horrified; to him, true art was forever divorced from such practical connections with life: "Every social idea, however great and important it may be, stems from the sensation of hunger; every art work, regardless of how small and insignificant it may seem, originates in pictorial or plastic feeling. It is high time for us to realize that the problems of art lie far apart from those of the stomach or the intellect."* Disappointed and unappreciated in his own country, Malevich eventually stopped painting and turned his attention to other things, such as mathematical theory.

Like Malevich, the Russian sculptor NAUM GABO (1890-1977) wanted to create a new art to express a new reality, and like Malevich, Gabo believed that such art would spring from sources separate from the everyday world. For Gabo, the new reality was the space-time world described by early twentiethcentury advances in science. As he wrote in Realistic Manifesto, published with his brother Anton Pevsner in 1920: "Space and time are the only forms on which life is built and hence art must be constructed." Later he explained: "We are realists, bound to earthly matters. . . . The shapes we are creating are not abstract, they are absolute. They are released from any already existent thing in nature and their content lies in themselves. . . . It is impossible to comprehend the content of an absolute shape by reason alone. Our emotions are the real manifestation of this content."* According to Gabo, he called himself a "Constructivist" partly because he built his sculptures up piece by piece in space, instead of carving or modeling them in the traditional way. This method freed the Constructivists to work with "volume of mass and volume of space" as "two different materials" in creating compositions filled with the "kinetic rhythms" by which humans perceive "real time." The name Constructivism may have originally come from the title Construction, which had been used by the Russian artist Vladimir Tatlin for some relief sculptures he made in 1913-1914. Tatlin shared some ideas and goals with Gabo, but soon after the Revolution, Tatlin joined a variant of Constructivism—Productivist Constructivism-that was devoted to using artists' talents in practical ways for the good of society (see page 1019). Like Malevich, Gabo believed that pure art was apart from life, and he and Tatlin parted company. Although Gabo experimented briefly with real motion in his work, most of his sculptures relied on the relationship of mass and space to suggest the nature of space-time. To indicate the volumes of mass and

*In Herbert, ed., *Modern Artists on Art*, pp. 140–41, 145–46. *In Chipp, ed., *Theories of Modern Art*, pp. 341, 345.

22-49 NAUM GABO, Column, 1922–1923. Perspex, on aluminum base, approx. $11\frac{18}{18}$ high. Family collection.

space more clearly in his sculpture, Gabo used some of the new synthetic plastic materials, including celluloid, nylon, and lucite, to create constructions in which space seems to flow through as well as around the transparent materials. In works like Column (FIG. 22-49), the depth through the sculpture is visible, because the circular mass of the column has been opened up so that the viewer can experience the volume of space it occupies. Two transparent planes extend through its diameter, crossing at right angles at the center of the implied cylindrical column shape. The opaque colored planes at the base and the inclined open ring set up counter rhythms to the crossed upright planes, establishing the sense of dynamic kinetic movement that Gabo always sought to express as an essential part of true reality.

Malevich desired to express "pure feeling" in his paintings, and Gabo sought to convey in his sculpture the reality of the newly revealed world of space and time. The Dutch artist PIET MONDRIAN (1872– 1944) went even further in representing hidden realities than any of these other artists by creating a style that he believed reflected the underlying eternal structure of existence. Inspired by the work of Van Gogh, Mondrian began in an expressionist style. He was keenly interested in conveying mystical and spiritual ideas in his art. Study in Paris, just before World War I, introduced him to modes of abstraction in avant-garde modern art such as Cubism. However, as his attraction to contemporary theological writings (especially the teachings of Theosophy) grew, Mondrian sought to purge his art of every overt reference to individual objects in the external world. He turned toward a conception of nonobjective or pictorial design—"pure plastic art"—that he believed expressed universal reality. He stated his credo with great eloquence in 1914:

What first captivated us does not captivate us afterwards (like toys). If one has loved the surface of things for a long time, later on one will look for something more. . . . The interior of things shows through the surface; thus as we look at the surface the inner image is formed in our soul. It is this inner image that should be represented. For the natural surface of things is beautiful, but the imitation of it is without life. . . . Art is higher than reality and has no direct relation to reality. Between the physical sphere and the ethereal sphere there is a frontier where our senses stop functioning. . . . The spiritual penetrates the real . . . but for our senses these are two different things. To approach the spiritual in art, one will make as little use as possible of reality, because reality is opposed to the spiritual. We find ourselves in the presence of an abstract art. Art should be above reality, otherwise it would have no value for man.*

Caught by the outbreak of hostilities while on a visit to Holland, Mondrian remained there during the war, developing his theories for what he called "Neo-Plasticism"-the new Pure Plastic Art. He believed that all great art has polar but coexistent goals: the attempt to create "universal beauty" and the desire for "esthetic expression of oneself." The first goal is objective in nature, while the second is subjective, existing within the mind and heart of the individual. To create such a universal expression, an artist must discover and work with laws of perfect equilibrium that lie beyond the disharmonies and unhappiness that occur daily, because life in the world cannot achieve this balance. To express his vision of the true balance that lies beyond the physical world, Mondrian eventually limited his formal vocabulary to the three primary colors (red, blue, and yellow), the three primary values (black, white, and grey), and the two primary directions (horizontal and vertical). Basing his ideas on a combination of teachings, he concluded that primary colors and values were the purest colors and therefore were the perfect tools to help an artist

construct a harmonious artistic composition. Similarly, to Mondrian, horizontal and vertical elements were the most basically contrasted directions. They innately symbolized, among other things, the opposites of masculine and feminine, repose and upright attention, earth and the immaterial stretch of the sun's rays descending from the heavens. When vertical and horizontal elements were joined to form a right angle, they attained perfect balance. Shapes made from right angles were therefore the elemental harmonious forms. When such shapes were colored in the primary hues and set within an asymmetrical composition of horizontal and vertical black lines on a white ground, they represented the perfectly balanced asymmetry of perfect universal harmony.[†]

In *Composition in Blue, Yellow, and Black* (FIG. **22-50**), Mondrian used the elements of his Neoplastic style very sparingly, adjusting the design so that every portion of the composition engages in a dynamic play of color and form. The power of the colors and lines to hold the viewer's attention is subtly equivalent to the attraction exercised by the much larger blank areas. The proportions of each of these areas are cunningly varied to avoid a mechanical uniformity of the general equilibrium. The whole painting resonates with the kind of calm eternal order we saw earlier in ideal Classical works like Raphael's *School of Athens* (FIG. 17-16) and Poussin's *Burial of Phocion* (FIG. 19-61).

BARBARA HEPWORTH (1903–1975) developed her own kind of essential sculptural form, combining pristine shape with a sense of organic vitality. The rugged landscape of Yorkshire, in the north of England, helped to shape her sculptural vision; she had vivid childhood memories of driving there with her father. Reflecting on these drives years later, she wrote: "the sensation of moving physically over the contours of fulnesses and concavities, through hollows and over peaks—feeling, touching, seeing, through mind and hand and eye . . . has never left me. I, the sculptor, am the landscape. I am the form and I am the hollow, the thrust and the contour." This feeling led her ever deeper into a search for

^{*}In Michel Seuphor, *Piet Mondrian: Life and Work* (New York: Harry N. Abrams, 1956), p. 177.

[†]In Herbert, ed., *Modern Artists on Art*, pp. 115–30. The meanings Mondrian attached to each of these elements were influenced by philosophical ideas that seemed to him true, especially those contained in the writings of Madame Blavatsky and Krishnamurti in *Theosophy*, and those expounded by the Dutch mathematician Dr. Schoomaekers in *The New Image of the World* and *The Principles of Plastic Mathematics* (1915 and 1916). For a time in the teens and early 1920s, Mondrian was associated with a group in Holland called *De Stijl* (see page 1004), whose members adhered to a modern version of the Enlightenment belief that art could help create a perfect environment and a more fully evolved human being. Mondrian, however, soon concentrated on his ideas for pure painting and left the practical applications of the theories to others in the group.

 PIET MONDRIAN, Composition in Blue, Yellow, and Black, 1936. Approx. 17" × 13". Kunstmuseum, Basel, Switzerland (Emanuel Hoffmann-Stiftung).

forms that would express her sense both of the landscape and of the person who is in and observes it:

The forms which have had special meaning for me since childhood have been the standing form (which is the translation of my feeling towards the human being standing in landscape); the two forms (which is the tender relationship of one living thing beside another); and the closed form, such as the oval, spherical or pierced form (sometimes incorporating colour) which translates for me the association and meaning of gesture in the landscape. . . . In all these shapes the translation of what one feels about man and nature must be conveyed by the sculptor in terms of mass, inner tension, and rhythm, scale in relation to our human size, and the quality of surface which speaks through our hands and eyes.*

Three Forms (FIG. **22-51**) was the first in a series of pieces that Hepworth began soon after she became the mother of triplets in 1934, an experience that apparently stimulated her to explore the relationships in size, shape, and position in space between three ele-

*Barbara Hepworth, A Pictorial Autobiography (London: The Tate Gallery, 1978), pp. 9, 53.

ments arranged on a thin base. In this piece, a small ovoid form nestles next to a tall, rounded, upright shape at one end of the base. A petite sphere rests on the corner of the base farthest from them. The artist has gathered here all the forms that had special meaning for her—the standing form, the two forms, and the closed form. The mysteriously irregular shapes and impeccably smooth surfaces of the units in this piece suggest both organic life and the perfection of things made by human hands and tools. Like those in all of her mature works, the shapes in Hepworth's *Three Forms* are contained and classical, expressing a sense of the timelessness of eternity.

The American sculptor ALEXANDER CALDER (1898-1976) used abstract organic forms and a sound knowledge of engineering techniques in a new kind of sculpture that used actual motion to express the innate dynamism of reality. Both the artist's father and grandfather were sculptors, but Calder initially studied to be a mechanical engineer. He was fascinated all his life by motion, and much of his sculpture explored that quality and its relationship to threedimensional form. As a young artist in Paris in the late 1920s, Calder invented a circus full of miniature performers that were activated by the artist into realistic analogues of the motion of their counterparts in life. After a visit to Mondrian's studio in the early 1930s, Calder was filled with a desire to set the brightly colored rectangular shapes in the Dutch painter's compositions into motion. Intrigued by early motorized and hand-cranked examples of Calder's moving, abstract pieces, Marcel Duchamp named them "mobiles." Calder's engineering skills

22-51 BARBARA HEPWORTH, *Three Forms*, 1935. Marble. Tate Gallery, London.

22-52 ALEXANDER CALDER, Hanging Spider, c. 1940. Painted sheet metal, wire, 51" high. Private collection.

soon helped him to fashion a series of balanced structures hanging from rods, wires, and colored biomorphic-shaped plates. Hanging Spider (FIG. 22-52), like the other works in this series, was designed to perform in response to air currents and to suggest natural patterns like those of clouds, leaves, or waves blown by the wind. The initial inspiration for the mobiles may have come from the work of Mondrian, but the organic shapes in the mobiles resemble those in the Surrealist paintings of Miró (FIG. 22-37) and were actually generated by Calder's love of nature. The compositions of each of Calder's nonmechanized mobiles were carefully planned so that any air current would set the parts moving within a pattern to create a constantly shifting dance in space, an effect splendidly described by the sculptor's friend, the British painter Ben Nicholson:

The first time I encountered a Calder was in Paris some years ago when I borrowed one and hung it from the center of the ceiling of a white room overlooking the Seine, and at night, with the river glistening outside, this mobile object turned slowly in the breeze in the light of an electric bulb hung near its center—a large black, six white, and one small scarlet, balls on their wires turned slowly in and out, around, above and below one another, with their shadows chasing, round the white walls in an exciting interchanging movement, suddenly hastening as they turned the corners and disappearing, as they crossed the windows, into the night—it was alive like the hum of the city, like the passing river, but it was not a work of art—imprisoned in a gold frame or stone-dead on a pedestal in one of our marblepillared mausoleums. It was "alive" and that, after all, is not a bad qualification for a work of art.*

Traditionally, sculpture has been designed to stand still, sometimes with new views unfolding as the observer moves about a piece. Calder's work, as it moves, presents many unexpected transformations and relationships of line and shape. His sculptures, like those of the other artists who sought to work with abstract symbolism, present a vision of universal truth—in his case, a vision of the eternal rhythms of nature.

ART WITH SOCIAL AND POLITICAL CONCERNS

Many of the artists we have discussed in this chapter believed that their art expressed something important about society, but a stronger impetus toward putting their art directly at the service of society inspired artists creating art with social and political concerns. Unlike the abstract formalists, this group of artists emphatically believed that art should be embedded within life and society. Architects dreamed of creating buildings so beautifully designed, so wellsuited to human needs, that their forms and spaces would help the people living in them and using them to attain their highest potential. Some artists believed their art could help people develop the special perception necessary to life in the modern world of space-time. Other artists, with more modest goals, revived the documentary impulse of Enlightenment scientific inquiry and applied it to recording the power of the visual world around them. Finally, yet another group of artists perpetuated the Enlightenment belief in the moral and educational benefits of art and used their work to highlight specific social and political subjects, with the goal of inspiring viewers toward conscious and responsible attitudes and actions in their communities.

Utopian Visions

Perhaps the most practically ambitious of the artists who based their work on social and political concerns were those who held the utopian belief that art

^{*}In Michel Seuphor, *The Sculpture of This Century* (New York: George Braziller, 1960), p. 85.

should be used to provide well-designed environments in which people could function closer to their full potential. Some of these artists planned entire communities. Others conceived buildings and the furnishings that would go in them. Many believed that the artist must help to improve the design of every sort of manufactured and mass-produced good—from magazine ads to fountain pens. The American architect Buckminster Fuller even invented practical yet visionary structural systems that would protect the energy sources of the planet and assure the future comfort of its human inhabitants.

One of the most striking personalities in the development of early twentieth-century architecture was FRANK LLOYD WRIGHT (1867–1959). Born in Wisconsin, Wright trained as a civil engineer and worked for a local builder before moving to Chicago to join the firm headed by Louis Sullivan. Wright set out to create "architecture for democracy." Early influences were the volumetric shapes in a set of educational blocks designed by the German educator Friedrich Froebel (from Wright's childhood), the organic unity of a Japanese building he saw at the Columbian Exposition in Chicago in 1893, and a Jeffersonian belief in individualism and the common man. Always a believer in architecture as "natural" and "organic," Wright saw it in the service of free individuals who have the right to move within a "free" space, which he envisioned as a nonsymmetrical design that interacted spatially with its natural surroundings. He sought to develop an organic unity of planning, structure, materials, and site. He identified the principle of continuity as fundamental to the understanding of his view of organic unity: "Classic architecture was all fixation. . . . Now why not let walls, ceilings,

floors become seen as component parts of each other, their surfaces flowing into each other? . . . You may see the appearance in the surface of your hand contrasted with the articulation of the bony structure itself. This ideal, profound in its architectural implications . . I called . . . continuity."* Wright's ideas were not unique to architecture. The concepts of flux, of constant change, of evolution and progress are inherent in Wright's principle of continuity and also appeared in the work of Walt Whitman and in the writings of the greatly influential philosopher Henri Bergson, a contemporary of Wright, who stressed the reality of vitalism—living process—above any other.

Wright's vigorous originality was manifested early and, by 1900, he had arrived at a style entirely his own; in his work during the first decade of this century, his cross-axial plan and his fabric of continous roof planes and screens defined a new domestic architecture.[†] Although the skeleton frame made a significant appearance in the works of Sullivan and others, Wright attacked the concept in his studies of other systems. He rejected both posts and columns: "In my work, the idea of plasticity may now be seen as the element of continuity . . . the new reality that is space instead of matter." As for architectural interiors, he declared that he "came to realize that the reality of a building was not the container but the space within."

These elements and concepts are fully expressed in Wright's Robie House (FIG. **22-53**), which was built

[†]Wright's designs for roof planes and screens were inspired by socalled shingle-plan resort houses designed in the late nineteenth century by H. H. Richardson.

22-53 FRANK LLOYD WRIGHT, Robie House, Chicago, 1907–1909.

^{*}In Edgar Kaufmann, ed., American Architecture (New York: Horizon, 1955), pp. 205, 208.

22-54 FRANK LLOYD WRIGHT, plan of the Robie House.

between 1907 and 1909. Like others in the Chicago area designed by Wright at about the same time, this building was called a "prairie house." The long, sweeping, ground-hugging lines, unconfined by abrupt limits of wall, were conceived to reach out toward and to express the great flatlands of the Midwest. All symmetry was abandoned. The façade disappeared, the roofs were extended far beyond the walls, and the entrance was all but concealed. Wright filled the "wandering" plan of the Robie House (FIG. 22-54) with intricately articulated spaces (some, large and open; others, closed), grouped freely around a great central fireplace. (He felt strongly the age-old domestic significance of the hearth.) Enclosed patios, overhanging roofs, and strip windows were designed to provide unexpected light sources and glimpses of the outdoors as one moved through the

interior space. These elements, together with the open ground plan, created a sense of space-in-motion inside and out. Wright's new and fundamental spatial arrangement of the interior was matched by his treatment of the exterior. Masses and voids were set in equilibrium; the flow of interior space determined the placement of the exterior walls. The "Cubist" aspect of the exterior, with its sharp, angular planes meeting at apparently odd angles, matches the complex play of interior solids that function not as inert, containing surfaces but as elements equivalent in role to the spaces in the design.

The Robie House is a good example of Wright's "naturalism" in the adjustment of building to site, although, in this particular case, the confines of the city lot constrained the building-to-site relationship more than did the sites of some of Wright's more

22-55 FRANK LLOYD WRIGHT, Kaufmann House (Fallingwater), Bear Run, Pennsylvania, 1936–1939. Ezra Stoller © Esto. All rights reserved.

expansive suburban and country homes. The Kaufmann House, nicknamed "Fallingwater" (FIG. 22-55), which was designed as a weekend retreat at Bear Run near Pittsburgh, is a prime example of the latter. Perched on a rocky hillside over a small waterfall, this structure extends the blocky masses of the Robie House in all four directions. Its shapes are enlivened by the contrast in textures between concrete, painted metal, and natural stone in its walls, and by the way in which Wright used full-length strip windows to create a stunning interweaving of interior and exterior space. The implied message of Wright's new architecture was space, not mass-a space designed to fit the life of the patron, being enclosed and divided as required. Wright took special pains to meet the requirements of his clients, often designing all the accessories of the house himself (including, in at least one case, gowns for his client's wife!). In the late 1930s, he acted on a cherished dream to provide good architectural design for less well-to-do people by adapting the ideas of his prairie house to plans for smaller, less-expensive dwellings called "Usonian" houses.

The publication of Wright's plans brought him a measure of fame in Europe, especially in Holland and Germany. The issuance of a portfolio of his work in Berlin in 1910 and an exhibition of his designs the following year hastened the death of Art Nouveau and stimulated younger architects to adopt some of his ideas about open plans and the freedom they afforded clients. Some forty years before the end of his career, his work was already of revolutionary significance. Another great modern architect, Ludwig Mies van der Rohe, wrote in 1940 that "the dynamic impulse from [Wright's] work invigorated a whole generation. His influence was strongly felt even when it was not actually visible."*

Wright believed that people lived better when their houses allowed them easy contact with nature, and he designed his buildings accordingly. The Swiss architect Charles Édouard Jeanneret-Gris (1887– 1965), called LE CORBUSIER, had a rather different idea about the ideal architectural setting for people. Trained as an architect in Paris and Berlin, Le Corbusier settled in Paris in 1917, where he became a painter, using his birth name, Jeanneret, for his work in this medium. With another artist, Amadée Ozenfant, Le Corbusier practiced painting in a style known as "Purism," in which he attempted to perfect Cubism by reducing it to patterns inspired by machine

*In Philip Johnson, *Mies van der Rohe*, rev. ed. (New York: Museum of Modern Art, 1954), pp. 200–201.

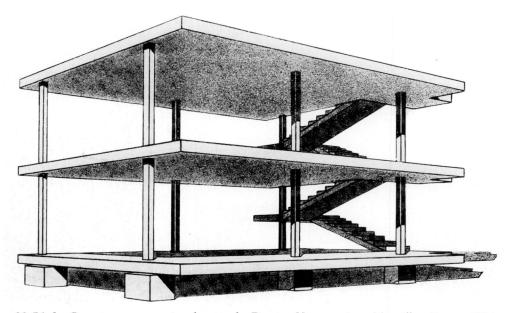

22-56 Le Corbusier, perspective drawing for Domino House project, Marseilles, France, 1914.

forms. However, Le Corbusier was best known as an influential architect and theorist on modern architecture. As such, he applied himself to the design of a "functional" living space, which he described as a "machine for living." The drawing for his Domino House project (FIG. 22-56) shows the skeleton of his ideal dwelling. Every level can be used. Reinforced concrete slabs serve the double function of ceiling and floor, supported by thin steel posts (called *pilotis*) that rise freely inside the perimeter of the interior spaces of the structure. The whole structure is raised above ground on short blocks. The space underneath, as well as that on the roof, was utilized. As Le Corbusier later wrote: "The house is in the air, far from the soil; the garden spreads under the house; the garden is also on top of the house, on the roof." Exterior walls can be suspended from the projecting edges of the concrete slabs in this model, like freehanging curtains. Because the skeleton is selfsupporting, an architect using this plan has complete freedom to subdivide the interior, wherever desired, with light walls that bear no structural load. The scheme allowed the architect to provide for what Le Corbusier saw as the basic physical and psychosomatic needs of every human being-sun, space, and vegetation combined with controlled temperature, good ventilation, and insulation against harmful and undesired noise. He also believed that human scale must be the measure of dwelling design, because the house is the assertion of man within nature. The main principles of the Domino system had been anticipated about half a decade earlier in the designs of the German architects Walter Gropius and Peter Behrens (with whom Le Corbusier worked early in his career). However, Le Corbusier's drawing stated the ideas with such elegant simplicity that his image had enormous influence as the primary statement of the design concepts governing the structural principles used in many modern office buildings and skyscrapers, concepts practiced by so many architects (including Gropius and Mies van der Rohe) that the "look" was soon named the International Style.

Le Corbusier used the basic ideas of the Domino project in many single-family dwellings, the most elegant of which is the Villa Savoye (FIG. 22-57), located at Poissy-sur-Seine, near Paris. The Villa Savoye is set conspicuously within its site, tending to dominate it, and has a broad view of the landscape. In this way, it resembles a Palladian villa and contrasts sharply with Frank Lloyd Wright's dwellings, which hug and adjust to the landscape, almost as if they were intended to be part of it and concealed by it. The Villa Savoye is a cube of lightly enclosed and deeply penetrated space. The ground floor (containing a three-car garage, some bedrooms, a bathroom, and some utility rooms) is only partially enclosed. Much of the house's interior is open space, with the main living floor and the roof garden area supported by the thin pilotis. Here one sees a parallel with Wright's open floor plans. The major living rooms in the Villa Savoye are on the second floor, wrapping around an open central court and lighted by strip windows that run along the membranelike exterior walls. From the second floor court, a ramp leads up to a flat roofterrace and garden, protected by a curving windbreak along one side. The approach does not define an en-

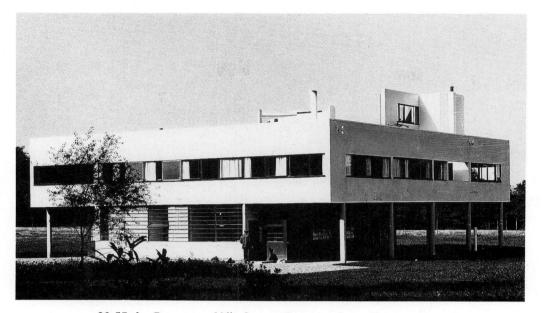

22-57 LE CORBUSIER, Villa Savoye, Poissy-sur-Seine, France, 1929.

trance; the building has no traditional facade. One must walk around and through the building to comprehend its layout. Spaces and masses interpenetrate so fluently that "inside" and "outside" space intermingle. The machine-planed smoothness of the surfaces, entirely without adornment, the slender "ribbons" of continuous windows, the buoyant lightness of the whole fabric-all present a total effect that is the reverse of the traditional country house (compare Andrea Palladio's Villa Rotunda and John Vanbrugh's Blenheim, FIGS. 17-51 and 20-1). Le Corbusier inverted the traditional design practice that placed light elements above and heavy ones below by refusing to enclose the ground story of the Villa Savoye with masonry walls, creating the effect that the "load" of the Villa Savoye's upper stories hovers lightly on the slender piloti supports. His use of color in this building-originally, dark-green base, cream walls, and rose-and-blue windscreen-was a deliberate analogy for that in the contemporary, machineinspired Purist style of painting, in which he was actively engaged.

The Villa Savoye was a marvelous house for a single family, but Le Corbusier also dreamed of extending his ideas of the house as a "machine for living" to designs for efficient and humane cities. He believed that "great cities are the spiritual workshops in which the work of the world is done," and proposed to correct the deficiencies caused by poor traffic circulation, inadequate living "cells," and the lack of space for recreation and exercise in existing cities by replacing them with three types of new communities. Vertical cities would house workers and the business and ser-

vice industries. Linear-industrial cities would run as belts along the routes between the vertical cities and would serve as centers for the people and processes involved in manufacturing. Finally, separate centers would be constructed for those people involved in intensive agricultural activity. Le Corbusier's cities would provide for human cultural needs in addition to serving every person's physical and psychosomatic comfort needs. The Domino project was a key part of Le Corbusier's thinking because the design was a module that could be repeated almost indefinitely, both horizontally and vertically. Its volumes could be manipulated and interlocked to provide interior spaces of different sizes and heights. It was not sitespecific and could stand comfortably in any setting. Later in his career, Le Corbusier was able to design a few of his vertical cities, most notably the Unité d'Habitation in Marseilles (1945-1952). He also created the master plan for the entire city of Chandigarh, the capital city of the Punjab, India (1950–1957). He would end his career with a personal expressive style in the Chapel of Notre Dame du Haut at Ronchamp (FIGS. 23-9 and 23-10).

Le Corbusier wanted to create model cities in which each individual had dwelling spaces, work spaces, and recreation spaces suited to his or her needs. His approach was very different from that of Frank Lloyd Wright, who wanted to design houses that would bring their inhabitants into a close relationship with nature. In 1917, a group of young artists in Holland formed a new movement and began publishing a magazine; both movement and magazine were called *De Stijl* (the Style). The group was

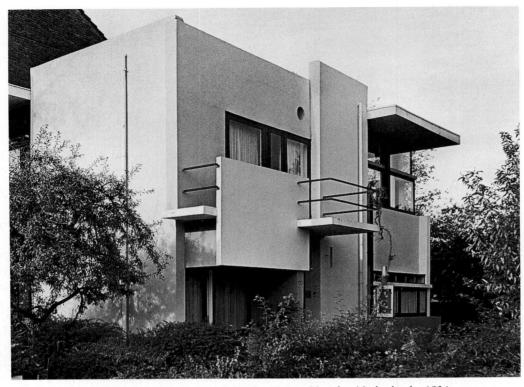

22-58 GERRIT RIETVELDT, Schröder House, Utrecht, Netherlands, 1924.

cofounded by Mondrian and the painter THEO VAN DOESBURG (1883–1931), and brought together some of the ideas expounded by Wright and Le Corbusier. Group members believed that a new age was being born in the wake of World War I—that it was a time of balance between individual and universal values, when the machine would bring a better life to all, and pure, open forms would assure ease of living: "There is an old and a new consciousness of the age. The old one is directed towards the individual. The new one is directed towards the universal."* The goal would be a total integration of art and life:

We must realize that life and art are no longer separate domains. That is why the "idea" of "art" as an illusion separate from real life must disappear. The word "art" no longer means anything to us. In its place we demand the construction of our environment in accordance with creative laws based upon a fixed principle. These laws, following those of economics, mathematics, technique, sanitation . . . are leading to a new, plastic unit.⁺

Although Mondrian was associated with the De Stijl group early in his career, he embraced abstract formalism, leaving the practical application of these ideas to other artists, especially to architects and designers.

One of the masterpieces of De Stijl architecture is the Schröder House in Utrecht, Holland (FIG. 22-58), built in 1924 by GERRIT RIETVELDT (1888-1964). Rietveldt came to the group as a cabinetmaker and made De Stijl furnishings throughout his career. His architecture carries the same spirit into a larger, integrated whole. Like Le Corbusier's Savoye House, the main living rooms of the Schröder House are on the second floor, with more private rooms on the ground floor. However, Rietveldt's house has an open plan and a relationship to nature more like the houses of Frank Lloyd Wright than those of Le Corbusier. The entire second floor is designed with sliding partitions that can be closed to define separate rooms or pushed back to create one open space broken into units only by the arrangement of the furniture. This shifting quality appears also on the outside, where railings, free-floating walls, and long rectangular windows give the effect of cubic units breaking up before our eves. The Schröder House is the perfect expression of Van Doesburg's definition of De Stijl architecture:

The new architecture is anti-cubic, *i.e.*, it does not strive to contain the different functional space cells in a single closed cube, but it throws the functional space (as well as canopy planes, balcony volumes, etc.) out from the centre of the cube, so that height,

^{*}In Kenneth Frampton, A Critical History of Modern Architecture (London: Thames & Hudson, 1985), p. 142. *Ibid., p. 147.

width and depth plus time become a completely new plastic expression in open spaces. . . . The plastic architect . . . has to construct in the new field, time-space.*

The link between all the arts in De Stijl is clear in Rietveldt's design, where the rectangular planes, which seem to slide across each other on the façade of the Schröder House like movable panels, make this structure a kind of three-dimensional projection of the rigid but carefully proportioned flat planes in Mondrian's paintings.

The De Stijl group and Le Corbusier each dreamed of harnessing the machine to create whole environments. In reality, both actually built more private than public buildings. In Europe, German architects pioneered new industrial techniques for commercial and factory buildings, often under the inspiration of American silos, warehouses, and the early high-rise structures of Richardson and Sullivan (FIGS. 21-97 and 21-98). A particular vision of "total architecture" was developed by the German architect WALTER GROPIUS (1883–1969), who made this concept the foundation not only of his own work but also of the work of generations of pupils who came under his influence. Gropius's revolutionary ideas about the nature of architecture and architects developed during his early career in designs for objects and structures intended to serve large sections of the population: group farm dwellings, diesel locomotives, and model factories. In 1919 he had a chance to broaden his sphere of influence and to gain additional exposure for his ideas when he became the director of an art school in Weimar, East Germany. Founded in 1906 as the Weimar School of Arts and Crafts, with an educational program that emphasized craftsmanship, free creativity, and experimentation, under Gropius the school was renamed Das Staatliche Bauhaus (roughly translated as "State School of Building") and its mission was transformed to fit his ideas about the training of the modern architect:

The complete Building is the final aim of the visual arts. . . . The objective of all creative effort in the visual arts is to give form to space. . . . But what is space, how can it be understood and given form? . . . True creative work can be done only by the man whose knowledge and mastery of the physical laws of statics, dynamics, optics, acoustics, equip him to give life and shape to his inner vision. In a work of art, the laws of the physical world, the intellectual world and the world of the spirit function and are expressed simultaneously. . . . We want to create a clear, organic architecture, whose inner logic will be

radiant and naked, unencumbered by lying façades and trickeries; we want an architecture adapted to our world of machines, radios and fast motor cars, an architecture whose function is clearly recognizable in the relation of its forms. . . . A new esthetic of the Horizontal is beginning to develop which endeavors to counteract the effect of gravity. At the same time the symmetrical relationship of parts of the building and their orientation toward a central axis is being replaced by a new conception of equilibrium which transmutes this dead symmetry of similar parts into an asymmetrical but rhythmical balance.[†]

Gropius reorganized the various departments of the original Weimar school and redesigned its curriculum to stress the search for solutions to contemporary problems in such areas as housing, urban planning, and high-quality, utilitarian mass productionall vital needs in impoverished post-World War I Germany. Under the guidance of teachers like Kandinsky, Klee, and László Moholy-Nagy, the Bauhaus offered courses not only in architecture, but also in music, drama, painting, typography, and most crafts. In design, the study of handicraft was considered the natural way for artists to master the qualities of materials and form so that they could design well for mass production. In these respects, and in the minimizing of philosophy and other "verbal" disciplines, the Bauhaus was the earliest working example of much contemporary design education. Gropius worked actively to make the Bauhaus into a "consulting center for industry and the trades." By the time he designed new quarters for the school in 1925, in preparation for its move to a new location in Dessau, East Germany, a new generation of teachers had been trained as artists-craftsmen-industrial designers, and Bauhaus students and faculty were designing buildings, stainedglass windows, furniture, lighting, fabrics, pottery, metal objects of every kind, advertising, books, and commercial displays—all for mass production. Gropius's design for the Bauhaus buildings included a glass-walled workshop (FIG. 22-59), a block of studio-bedrooms for students, and a building for technical instruction. Linking these three main blocks were other units, such as the administrative offices, which were located on the bridge that spans the road in our illustration. Gropius also designed houses nearby for himself and six major Bauhaus teachers. Planned as a series of units, each with its own specific function, the Bauhaus design is the direct expression, in glass, steel, and thin concrete veneer, of the technical program it housed. The forms are clear, cubic shapes—the epitome of classicizing purity. The workshop block is a cage of glass that extends beyond

⁺In Herbert Bayer, Walter Gropius, Ise Gropius, et al., *Bauhaus:* 1919–1928 (Boston: Branford, 1959), *passim*.

^{*}In Hans L. Jaffé, *De Stijl* (New York: Harry N. Abrams, n.d.), pp. 185–88.

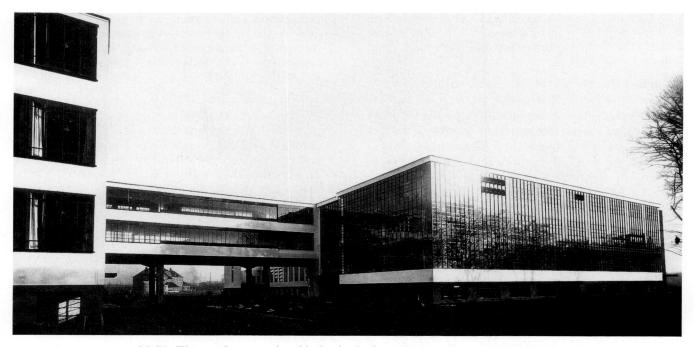

22-59 WALTER GROPIUS, shop block, the Bauhaus, Dessau, Germany, 1925–1926.

and encloses its steel supports in a way that echoes Le Corbusier's Domino project (FIG. 22-56). The transparent block makes an equilibrium of inner and outer space. The whole fulfilled Gropius's original dream for the kind of architecture that should be created by the Bauhaus. Bauhaus style spread rapidly as its students and faculty fled the rise of Nazi power, firmly establishing the principles of the International Style throughout much of the industrialized world during the next three decades.* The buildings themselves were abandoned for many years but are now in use again as an art school.

One of the most important ex-Bauhaus teachers to carry its style abroad was the Hungarian-American LászLó MOHOLY-NAGY (1895–1946), who taught at the Bauhaus during Gropius's directorship and later extended the school's ideas of total architecture to embrace the concept of the total artist as an individual who puts personal talent at the service of humanity in any way possible. Born in Hungary, Moholy-Nagy studied law before experiences as a soldier during World War I made him realize he wanted to serve humanity as an artist. He moved from Hungary to Vienna and then Berlin before joining the faculty of the Bauhaus in 1923 to teach the "preliminary course" and to direct the metal workshop. MoholyNagy was a visionary who saw clearly the nature of the modern age and believed that society in this period was

heading toward a kinetic, time-spatial existence; toward an awareness of the forces plus their relationships which define all life and of which we had no previous knowledge and for which we have as yet no exact terminology. . . . Space-time stands for many things: relativity of motion and its measurement, integration, simultaneous grasp of the inside and outside, revelation of the structure instead of the façade. It also stands for a new vision concerning materials, energies, tensions, and their social implications.[†]

Moholy-Nagy believed that artists should create works to help ordinary people develop this "vision in motion . . . seeing, feeling, and thinking in relationship and not as a series of isolated phenomena." Such art would capture the ways our space-time perceptions have been expanded as our eyes, ears, and senses of balance and equilibrium increasingly have functioned from within speeding cars, trains, and planes, and through x-ray cameras, telescopes, and microscopes. For himself, Moholy-Nagy experimented with light and color in painting, sculpture, prints, photograms, photography, experimental cinema, typography, advertisements, stage sets, and special effects for movies. Photography was an especially important medium for expressing his ideas. The bird's-eye view that he took from the top of the Radio

[†]László Moholy-Nagy, *Vision in Motion* (Chicago: Paul Theobald, 1969), p. 268.

^{*}The ideals of the Bauhaus were taken to the United States when its artists were forced to emigrate to escape the effects of Nazi power. Gropius headed the architecture program at Harvard University. In Chicago, Moholy-Nagy founded the New Bauhaus (later the Institute of Design) and Mies van der Rohe shaped the architecture department at Illinois Institute of Technology.

22-60 László Моноly-Nagy, From the Radio Tower Berlin, 1928. Gelatin silver print. Photograph © 1990, The Art Institute of Chicago. All rights reserved.

Tower in Berlin (FIG. **22-60**) is an exercise in his "new vision" of "seeing, feeling and thinking in relationship and not as a series of isolated phenomena." The abrupt shift from normal, eye-level viewing reveals new patterns of reality, unexpected formal associations, and an enchantingly different way of looking at the world.

When Walter Gropius resigned as head of the Bauhaus in 1930, LUDWIG MIES VAN DER ROHE (1886– 1969) became its director, moving it to Berlin before political pressures forced it to close in 1933. Mies van der Rohe, who taught at the Bauhaus for a time before assuming the directorship, combined his father's and mother's surnames for his own professional name. In his architecture and furniture, he made such a clear and elegant statement of the International Style that his work had enormous influence on modern architecture. Taking as his motto "less is more" and calling his architecture "skin and bones," his esthetic was already fully formed in the model for a glass skyscraper office building he conceived in 1921 (FIG. **22-61**). Working with glass provided him with new freedom and many new possibilities: "I discovered by working with glass models that the important thing is the play of reflections and not the effect of light and shadow as in ordinary buildings. . . . At first glance the curved outline . . . seems arbitrary. These curves, however, were determined by three factors: sufficient illumination of the interior, the massing of the building viewed from the street, and lastly, the play of reflections."* In the glass model, three irregularly shaped towers flow outward from a central court designed to hold a lobby, a porter's room, and a community center. Two cylindrical entrance shafts rise at the ends of the court, each containing elevators, stairways, and toilets. The perimeter walls are wholly transparent, revealing the regular horizontal patterning of the cantilevered floor planes and their thin, vertical supporting elements. The weblike delicacy of the lines of the glass model, its radiance, and the illusion of movement created by reflection and by light changes seen through it prefigure many of the glass skyscrapers of major cities

*In A. James Speyer with Frederick Koeper, *Mies van der Rohe* (Chicago: The Art Institute of Chicago, 1968), p. 16.

22-61 LUDWIG MIES VAN DER ROHE, model for a glass skyscraper, 1920–1921. Present location of model unknown.

22-62 GEORGE HOWE and WILLIAM E. LESCAZE, Philadelphia Savings Fund Society Building, Philadelphia, 1931–1932.

throughout the world, like the Seagram Building, designed in New York in the 1950s by Mies van der Rohe and Philip Johnson (FIG. 23-17).

Many of the architects who adopted the International Style were wholly traditional in their approach to their métier-that is, they were specialists in the design of buildings according to the prevailing taste of their day. In America, something of the new International manner began to appear in the early 1930s. In the Philadelphia Savings Fund Society Building (FIG. 22-62), designed by GEORGE Howe (1886-1955) and WILLIAM E. LESCAZE (1896-1969), for example, the horizontal banding, ribbon windows, and clean, geometric planes of the International Style appear on the soaring scale of the American urban office building. This kind of assembly of cubic volumes was so quickly accepted as the perfect expression of urban corporate business that its look transformed the skylines of most modern cities. Unfortunately, although the International Style swept across the world, welldesigned structures in this mode were never the norm; such buildings required more money to construct and more effort to maintain than less radical International Style buildings, many of whose designers stressed only the cubic volumes and basic patterns of steel-girder high-rise construction and demonstrated little gift for creating with the powerful geometric simplicity of the style's greatest monuments.

In the United States, one architect in particular, BUCKMINSTER FULLER (1895-1983), shared with Le Corbusier and the Bauhaus a belief that technology could be used to help people create a better world. Fuller studied for two years at Harvard University and served as a naval officer in World War I. Thereafter, he was self-educated through a number of jobs in business and industry. In 1927, Fuller set out "to rethink everything I knew" and decided, as had eighteenth-century Enlightenment thinkers before him, that he "must commit . . . to reforming the environment and not man; being absolutely confident that if you give man the right environment he will behave favorably." Fuller was acutely aware that stores of resources and energy on our planet are limited and that only a careful use of them would provide indefinitely for all of the earth's population.

One of the first designs Fuller conceived to conserve resources was that of the Multiple-Deck 4-D [four-dimensional] House (FIG. 22-63). (The 4-D concept was renamed "Dymaxion" in 1929 by combining two of Fuller's favorite words, dynamic and maximum.) Of the 4-D House, he wrote: "I was thinking then of housing as shelters that could be massproduced and delivered as finished dwellings to any place its owner wanted it to be; this ten-deck building was designed to be so light and so strong that it could have been carried by the Graf Zeppelin, which was then being built, and was perfectly flyable economically to the North Pole where it could be anchored."* Like Le Corbusier's vertical city, Fuller's 4-D House was planned to be self-contained, with utilities, elevators, stores, and recreation and sports facilities, in addition to living spaces. However, Fuller's concept was a radical structural and conceptual departure from the traditional architectural practice of selecting a site and then carefully preparing it to receive its new structure. Fuller planned that a zeppelin carrying one of his prefabricated 4-D houses would hover over a site, anchor itself, drop a small bomb that would create a hole for the foundation, and lower the dwelling tower into the hole, where it would be held upright by temporary wire supports fastened to the airship, while cement was poured around the foot of the mast and allowed to harden. The self-contained utilities, installed in the mast at the factory, could then be activated and the building would be ready for occupancy. Fuller took the design of the functioning details of his buildings seriously, and he filed patents for such innovations as waterless toilets; water-

^{*}R. Buckminster Fuller with Robert Snyder, *Buckminster Fuller: An Autobiographical Monologue Scenario* (New York: St. Martin's Press, 1980), passim.

22-63 BUCKMINSTER FULLER, Multiple-Deck 4-D House, 1960. © 1980 Estate of Buckminster Fuller. Courtesy, the Buckminster Fuller Institute, Los Angeles.

conservative, intensive-spray showers; transparent but rapidly darkening vacuum-glass material to be used in place of window walls; a system for maintaining a dust-free environment through air that is cleaned, heated, and circulated in the central mast; and revolving storage wheels filled with different kinds of compartments to store every type of household good in a very compact space. Fuller's architecture did not lead to a movement like the International Style, perhaps because his emphasis was always on use and function rather than on beautiful form. Although he obtained funding to build only a few of these early structures, the effects of his work are to be found all around us in manufactured versions of many of the inventions he designed for his 4-D and Dymaxion systems. In addition, the geodesic dome, which Fuller invented in the early 1950s, won widespread adoption for use in structures ranging in scale from private homes to giant pavilions at international expositions. Fuller's planned projects and executed designs were among the most utopian of the works connected with the artists who followed a dream of building a more perfect world.

The Power of the Visual World

Many artists whose work was motivated by social or political concerns used their art to inspire a more ideal future or to criticize conditions in the present, but one group used art primarily to document and affirm the world around them. For this group, capturing the appearance of the visible world was an important impetus. Photography, from its beginning, had excelled in the documentary recording of physical reality, and many of the artists in this group were photographers, although some painters also sought to capture the qualities of the natural or urban scene. Photographers and painters alike wanted to heighten viewer awareness of the environment around them, sensitizing them to both the beauty and the variety of nature and the industrial/urban setting.

The American photographer ALFRED STIEGLITZ (1864-1946) took his camera everywhere he went, photographing whatever he saw around him, from the bustling streets of New York City to cloudscapes in upstate New York and the faces of friends and relatives. He believed in making only "straight, unmanipulated" photographs-those exposed and printed using basic photographic processes, without resort to techniques like double-exposure or doubleprinting that would add information not present in the subject at the time the shutter was released. Stieglitz said he wanted the photographs he made with this direct technique "to hold a moment, to record something so completely that those who see it would relive an equivalent of what has been expressed." He began a lifelong campaign to win a place for photography among the fine arts while a student of photochemistry in Germany. Returning to New York, he founded the Photo-Secession group, which mounted traveling exhibitions in the United States and sent loan collections abroad, and "291" gallery (located at 291 Fifth Avenue), where he exhibited avant-garde photography, painting, and sculpture from the United States and Europe. (Indeed, the works of many avant-garde European artists were introduced to a United States audience as the result of exhibitions at "291".) In his own works, Stieglitz specialized in photographs of scenes he found around him in his environment. He saw these subjects in terms of form and the "colors" of his black-and-white materials, being attracted above all to arrangements of form that stirred his deepest emotions. His esthetic approach crystallized during the making of one of his bestknown works, The Steerage (FIG. 22-64), taken during a voyage to Europe with his wife and daughter in 1907. Traveling first-class, Stieglitz rapidly grew bored with the company of the well-to-do passengers in the firstclass section of the ship and walked as far forward on that level as he could, being brought up short by the rail around the opening onto the lower deck reserved for "steerage" passengers (those with the cheapest tickets). Later, he described what happened next:

The scene fascinated me: A round hat; the funnel leaning left, the stairway leaning right; the white drawbridge, its railings made of chain; white suspenders crossed on the back of a man below; circular iron machinery; a mast that cut into the sky, completing a triangle. I stood spellbound. I saw shapes related to one another—a picture of shapes, and underlying it, a new vision that held me: simple people; the feeling of ship, ocean, sky; a sense of release that I was away from the mob called rich. Rembrandt came into my mind and I wondered would he have felt as I did . . . I had only one plate holder with one unex-

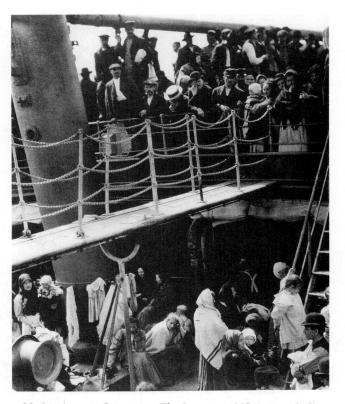

22-64 ALFRED STIEGLITZ, The Steerage, 1907 (print 1915). Photogravure (on tissue), $12\frac{3''}{8''} \times 10\frac{1}{8''}$. Courtesy Amon Carter Museum, Ft. Worth.

posed plate. Could I catch what I saw and felt? I released the shutter. If I had captured what I wanted, the photograph would go far beyond any of my previous prints. It would be a picture based on related shapes and deepest human feeling—a step in my own evolution, a spontaneous discovery.*

The finished print fulfilled Stieglitz's vision so well that it shaped his future photographic work, and its haunting mixture of found patterns and human activity has continued to stir the emotions of viewers to this day.

The American painter GEORGIA O'KEEFFE (1887– 1986) was especially inspired by light and by the patterns of nature, stripping her subjects to their purest forms and colors to heighten their expressive power. Born in rural Wisconsin, O'Keeffe worked as a commercial artist and an art teacher as she developed a personal style that incorporated the ideas of the art theorist Arthur Wesley Dow and his follower, the artist-theorist-teacher Alon Bement, both of whom stressed "the idea of filling a space in a beautiful

^{*}In Dorothy Norman, *Alfred Stieglitz: An American Seer* (Middleton, NY: Aperture, 1973), pp. 9–10, 161.

way," especially a space created with the simple flat shapes characteristic of Japanese paintings and prints. The look of things in the world inspired O'Keeffe's paintings of flowers, landscape, objects, and sun in Texas and New Mexico (the spiritual home in which she lived much of each year), and scenes in upstate New York and Manhattan, where she made her home part of the year with her husband, Alfred Stieglitz, until his death. In all her works, O'Keeffe reduced the incredible details of her subject to a symphony of basic colors, shapes, textures, and vital rhythms. Her style is fully realized in the watercolor Light Coming on the Plains II (FIG. 22-65), where a few strokes of paint on dampened paper evoke the sun rising above the horizon in the vast, flat land of the Southwest. Light was a recurrent theme in O'Keeffe's work and in Light Coming on the Plains II, the miracle of light filling the world is rendered in a composition so simple that its abstraction becomes a serenely organic counterpart to Kandinsky's explosive nonobjective works or Mondrian's rectilinear absolutes.

22-65 GEORGIA O'KEEFFE, Light Coming on the Plains II, 1917. Watercolor, $11\frac{8''}{8} \times 8\frac{7}{8''}$. Amon Carter Museum, Ft. Worth. Reproduced with permission of the Georgia O'Keeffe Estate.

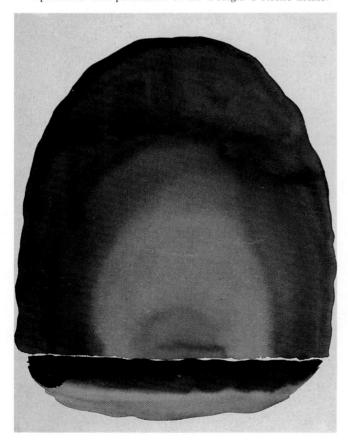

22-66 EDWARD WESTON, Cabbage Leaf, 1931. Gelatin silver print, 7⁹/₁₆" × 9⁷/₁₆". Collection, The Museum of Modern Art, New York (gift of T. J. Maloney). © 1981 Arizona Board of Regents, Center for Creative Photography, Tucson.

In addition to her landscapes and cityscapes, O'Keeffe was well-known for her close-up paintings of flowers, a vision that links her to the American photographer Edward Weston (1886–1958), who also found beauty in the appearance of the natural world. Raised in Chicago, Weston began taking photographs with a simple camera as a boy and extended his technical knowledge working in professional photo studios. The settings in California and Mexico helped him to develop a style that captured the beauty he found in organic forms. Moving close and filling his picture with a subject like that in Cabbage Leaf (FIG. 22-66), Weston detached the common vegetable from its everyday place in garden and kitchen and transformed it into a wonderfully sensual visual pattern. He set for himself the goal of recording life, of rendering the essence and substance of the thing he was photographing "whether it be polished steel or palpitating flesh." Weston termed himself "a realist, but not a literalist," saying, "To me good composition is simply the strongest way to put over my emotional reaction. I do not consciously compose. I make my negative entirely under the effect of my emotion in response to a given subject."* Weston's vision was so sensitive that even a humble leaf of cabbage is transfigured into a sensual, poetic vision of

*In Ben Maddow, *Edward Weston* (Boston: Aperture, 1963), pp. 55, 56.

rippled texture and undulant curves. Like Stieglitz, Weston believed that the photographer must see all elements of the finished picture in the camera before exposing the negative. He felt the artist must be carefully attuned to the qualities in a subject that touch the emotions and must seek a composition that expresses these in the clearest way. In Weston's case, he moved his camera carefully until the elements of his subject made a composition on the ground-glass focusing screen that conveyed to him the powerful complex of feelings that had initially attracted him to that particular subject in the first place.

The drama of the natural wilderness as a contrast to the urban scene was the primary subject of the American photographer ANSEL ADAMS (1902-1984). Born in San Francisco, Adams was a professional pianist before the vistas of Yosemite Valley inspired him to switch to photography as a profession. Trudging into the wilderness with the kind of large-plate view camera used by many nineteenth-century American photographers to capture western landscape, Adams set out to record the natural grandeur of scenery that moved him. He found his vision on a trip into Yosemite in 1927 during the making of Monolith, the Face of Half Dome, Yosemite Valley, California (FIG. 22-67). He set up his tripod at the location from which he had the most dramatic view of the cliff face, arranged the camera, and covered the lens with a yellow filter, which would darken the sky somewhat in the final black-and-white print. Later he vividly described the process of recording the image:

I began to think about how the print was to appear, and if it would transmute any of the feeling of the monumental shape before me in terms of its expressive-emotional quality. I began to see in my mind's eye the finished print I desired; the brooding cliff with a dark sky and the sharp rendition of distant, snowy Tenaya Peak. I realized that only a deep red filter would give me anything approaching the effect I felt emotionally.*

The change of filter created the dramatic contrasts that express so powerfully Adams's emotional response to this dazzling part of the landscape in Yosemite National Park. The rough, sheer-rock face of the cliff rises dramatically against the darkened sky. Every detail across its broad surface is in sharp focus, which is a tribute to Adams's skill in using the smallest possible aperture for his lens. Like Stieglitz, Adams believed that the photographer must master the techniques of the medium so thoroughly that they can be used almost instinctively at the moment a

22-67 ANSEL ADAMS, Monolith, the Face of Half Dome, Yosemite Valley, California, c. 1927. Gelatin silver print. Courtesy of the Trustees of the Ansel Adams Publishing Rights Trust. All rights reserved.

subject appears before the camera's lens. Adams called this kind of preparation "visualization." "A photograph," he said, "is not an accident—it is a concept. It exists at, or before, the moment of exposure of the negative." Every aspect of photo technology must be so perfectly mastered that the photographer and his equipment are one when the negative is exposed. Head and heart, technique and art must balance perfectly to achieve Adams's ultimate goal: "To photograph truthfully and effectively is to see beneath the surfaces and record the qualities of nature and humanity which live or are latent in all things."[†] During his long career, the most powerful images Adams "visualized" were those that captured the breathtaking grandeur of America's mountain wilderness—scenes such as Monolith.

The American artist CHARLES SHEELER (1883–1965) was inspired more by the precise geometry of the new industrial and architectural shapes than by land-scape. Trained as a traditional painter, Sheeler be-

^{*}Ansel Adams with Mary Street Alinder, Ansel Adams: An Autobiography (Boston: Little, Brown, 1985), p. 76.

⁺In Nathan Lyons, ed., *Photographers on Photography* (Englewood Cliffs, NJ: Prentice-Hall, 1966), pp. 30, 31.

came interested in the forms of the man-made environment after he began supporting himself as a commercial photographer in 1912. His photographs of details of Shaker buildings and Chartres Cathedral. of the streets and buildings of Manhattan, and of a Ford automobile plant in Detroit captured the pure geometric compositions that caught his eye. In 1929 he was commissioned by a German steamship company to do a series of photographs of the S.S. Majestic for a publicity brochure. One image (FIG. 22-68), which shows a detail of the ship's upper deck and ventilation system, intrigued Sheeler so much that he used it as the "blueprint" for a painting he called Upper Deck (FIG. 22-69). In the painting, Sheeler has eliminated every trace of his painter's hand, the better to render the sleek forms. He simplified details in the photograph, eliminating rivets and rust and modifying the shadow patterns into a symphony of tawny and rosy whites. This painting was special for Sheeler; it signaled the attainment of an artistic goal: "This is what I have been getting ready for. I had come to feel that a picture could have incorporated in it the structural design implied in abstraction and be presented in a wholly realistic manner."* Inspired by

*In Carol Troyen and Erica E. Hirshler, *Charles Sheeler: Paintings and Drawings* (Boston: Museum of Fine Arts, 1987), p. 116.

22-68 CHARLES SHEELER, *The Upper Deck, c.* 1928. Vintage silver print, $8'' \times 10''$. Collection, Gilman Paper Company.

22-69 CHARLES SHEELER, Upper Deck, 1929. $29\frac{1}{8}'' \times 22\frac{1}{8}''$. Courtesy of the Fogg Art Museum, Harvard University, Cambridge, Massachusetts (Louise E. Bettens Fund).

the power of this work, Sheeler continued to use photographs as studies for his paintings of the shapes of man-made environments, emptied of human beings and symbolic of the beauty of the new world of perfect and precise machine forms. The clarity of the scenes he painted and the precise manner of his style linked Sheeler to a group of American artists whom the critics called the Precisionists because of their loving depiction of the new industrial environment.

The American painter EDWARD HOPPER (1882–1967) took as his subject the awesome loneliness and echoing isolation of modern life in the United States. Trained as a commercial artist, Hopper studied painting and printmaking in New York and Paris before returning to the United States and concentrating on scenes of contemporary city and country life in which the buildings, streets, and landscapes he chose to paint are curiously muted, still, and filled with empty spaces. Motion is stopped and time is suspended, as if the artist has recorded the major details of a poignant personal memory. From the darkened streets outside a restaurant in *Nighthawks* (FIG. **22-70**), we glimpse the lighted interior through huge plate-glass

22-70 EDWARD HOPPER, Nighthawks, 1942. $30'' \times 56\frac{11}{16}''$. Friends of American Art Collection. Photograph © 1990, The Art Institute of Chicago. All rights reserved.

windows, which lend the inner space the paradoxical sense of being both a safe refuge and a vulnerable place for the three customers and the counterman. The interplay between small figures and empty space recalls the compositions of Poussin, but the seeming indifference of Hopper's characters to each other and the echoing spaces that surround them evoke the unmitigated loneliness of modern humans—a very different expression from the stately interplay of humans and environment in Poussin's *The Burial of Phocion* (FIG. 19-61). Hopper invested works like *Nighthawks* with the straightforward mode of representation valued by Americans, creating a kind of realist vision that recalls that of nineteenth-century artists like Whistler, Homer, and Sargent.

Photographer JAMES VAN DER ZEE (1886–1983) used his camera to capture scenes from the everyday lives of middle-class and well-to-do society in the Harlem section of Manhattan during the 1920s and early 1930s. A native of Massachusetts who settled in New York, Van Der Zee worked as an amateur photographer and professional musician before turning fulltime to the compilation of a photographic record of the life and people of Harlem. Beginning in the teens, he took hundreds of straight portraits and documentary photographs of events in Harlem that form a fantastic visual record of aspects of urban life often in-

visible to those outside that neighborhood. He sometimes injected a note of fantasy into his works by adding imaginary painted backgrounds and ghostly double-exposure images that suggested a future or spiritual reality, producing pictures that combine a record of the physical appearance of his sitters with symbols representing their hopes and dreams. Future Expectations (FIG. 22-71), created in about 1915, belongs in the last group. In this image, a young bridal couple sits before a painted backdrop showing the kind of gracious fireplace and living room they hope one day to own. At their feet sits the daughter they dream will become part of their future family. The soft light sets the mood, yet the crisp focus records every nuance of lace trim, shiny shoes, bouquet, and rug. The couple is posed with the child in an off-center pyramidal arrangement suggestive of earlier paintings of the Holy Family. Here, Van Der Zee stressed the beauty and harmony of the shapes and surfaces in his subject, capturing and sharing with the viewer his appreciation and reverence for the subtle patterns of the everyday life he saw around him and the rich emotions on which it was based. Like the other documentary realists, he touches our minds and imaginations through his intense vision of things in the visual world and our emotional response to them.

22-71 JAMES VAN DER ZEE, Future Expectations, c. 1915. Gelatin silver print. Copyright 1973 by James Van Der Zee. All rights reserved.

Activism and Art

Of all of the artists working with social and political concerns in the early part of the twentieth century, the most diverse were those individuals who believed that art must serve society by inspiring its citizens to moral and ethical behavior. This aim was to be achieved as a result of artists revealing social faults or developing pride for membership in a particular class or segment of the populace. Artists of all media bent their art to this task. Photographers sought to move viewers with the accuracy of the images of society their cameras could capture. Filmmakers used all the visual and narrative power of their medium to affect and inform their audience. Painters distilled onto canvases and walls the distressing subjects that had affected them most deeply, and one Soviet sculptorarchitect even envisioned a monumental and dynamic skyscraper with parts that would provide an ongoing education to his countrymen.

The American photographer Lewis WICKES HINE (1874-1940) had great sympathy with workers and the poor. A native of Wisconsin, he studied briefly at the University of Chicago before moving to New York City to teach nature study and geography. He began taking photographs to aid in his teaching, but in 1904 he started making pictures of immigrants as they arrived in the United States and struggled to establish lives in their new land. He next became interested in the grim world of children who worked long hours in industries and businesses. Hine maintained that such practices stunted the development of children, who should be allowed to grow healthily into productive adults to assure a strong future for the country. In 1908 Hine was hired by the National Child Labor Committee to photograph child labor, and he traveled widely, photographing children at work in large and small businesses. Breaker Boys (FIG. 22-72) shows a group of grimy youngsters, prized by mine owners because their small size allowed them to work in small spaces. These children went to work at very young ages to help their impoverished families, and many died or were severely injured before they reached adulthood. The dim light in the location where Hine took Breaker Boys required the use of magnesium powder flash to illuminate the scene. The squalidness of the workplace and the helplessness of the boys is emphasized in the photograph by the quiet way the youngsters cluster together to face the camera. Like Kollwitz (FIG. 22-18), Hine knew the power of images to stir people who knew nothing

22-72 LEWIS WICKES HINE, *Breaker Boys*, South Pittston, Pennsylvania, January 1911. Gelatin silver print. International Museum of Photography at George Eastman House, Rochester, New York.

about workers and poverty. Photographs like *Breaker Boys* were remarkably effective in helping educate people about the conditions of child labor. Groups of these images were published in newspapers and magazines, and the incontrovertible testimony they provided gave such strong substantiation for the reports of the National Child Labor Committee to the U.S. Congress in the years before World War I that new laws were enacted governing child labor.

Emotional content of a much less dramatic kind was the goal of the German photographer AUGUST SANDER (1876–1964), who undertook to assemble a vast photo portrait of "man in the twentieth century"-all classes, all occupations, all ages. Sander labored as a miner and was an itinerant photographer before he went to work taking portraits in studios in Linz, Austria, and Cologne. In about 1915, he began photographing the farmers, tradesmen, and landowners of the area near Cologne, where he had been born. In an approach very much like that of the eighteenth-century Encyclopedists, he thought of his project as a way of cataloguing all human types: "These people [in a restricted area of Westerwald], whose way of life I had known from my youth, appealed to me because of their closeness to nature.... Thus the beginning was made and all the types discovered were classed under archetype, with all the characteristic common human gualities noted."* Believing that the only way to uncover true archetypes was to make "natural portraits that show the subjects in an environment corresponding to their own individuality," Sander encouraged each of his subjects to face the camera in a pose comfortable to them. The model for Lackarbeiter (Varnisher, FIG. 22-73) stands with quiet dignity and a self-conscious smile, holding the can of his trade in one hand. The vast, dark rectangle of the open door behind him isolates his figure almost as though it were part of a sculptural relief. The spareness of the composition and the potent sense of individual presence in works like this made Sander's work an inspiration to later photographers, including Robert Frank (FIG. 23-67). However, Sander's images were less satisfying to the Nazi government, who found the selection of his work published in his books Face of Our Time and German Land, German People so contradictory to their ideas about the "master race" that they confiscated all copies of the books and many of Sander's negatives as well. He managed to hide some of his archives, and the negatives and prints that survive give us a vivid glimpse into the vast human panorama he recorded with his camera.

*In John von Hartz, August Sander (Millerton, NY: Aperture, 1977), p. 7.

22-73 AUGUST SANDER, Lackarbeiter (Varnisher), 1932. Vintage silver print, $8_8^{7''} \times 6_8^{4''}$. The University of Michigan Museum of Art, Ann Arbor.

It was Sander's intention to reveal universal human archetypes in self-posed portraits of individuals. The French photographer HENRI CARTIER-BRESSON (b. 1908) wanted to reveal the depth of human drama by recording significant instants of action and interaction. He was interested in the specially revealing times-the "decisive moments"-when all that had happened before and all that will happen in future were suggested by the action in front of the lens. Cartier-Bresson began as a painter, before becoming a serious photographer and cinematographer. His inspiration in photography came not only from the work of artists like Atget, but also from early movies, like Sergei Eisenstein's Potemkin (FIG. 22-77). Cartier-Bresson worked mostly with a lightweight, smallformat Leica camera that allowed him great flexibility in moving around a subject and permitted him to take many pictures in rapid succession before having to reload with fresh film. "Above all," he said, "I craved to seize the whole essence, in the confines of one single photograph, of some situation that was in the

process of unrolling itself before my eyes." His photographs of "situations" like that shown in Seville, Spain (FIG. 22-74) sent him to many countries to record what he saw there for news magazines and newspapers throughout the nations of Europe and the United States. To get his picture, Cartier-Bresson knew how to become almost invisible. In Seville, Spain, the boys go on with their activity and, although they seem to acknowledge the photographer's presence, they do not apparently alter their behavior for his camera. The exuberance of the childhood game and the energetic participation of the youngster on crutches contrast tellingly with the rubble-filled street and the odd, blasted hole through which we view the scene. This image touches our hearts with its evocation of the resilience of the human spirit. Cartier-Bresson's work found a wide audience in magazines like Harper's Bazaar, Vu, and Life Magazine. He became a professional photojournalist, making picture stories to show readers events and lives far removed from their own. On assignments to cover a specific subject, Cartier-Bresson did not always find a single, decisive moment that revealed the human drama unfolding before him; therefore, he mastered the art of the photo story—a series of photographs that, taken together, captured the human experience at the core of the event being pictured. Seville, Spain was part of a photo story Cartier-Bresson did on Spain during 1933-1934, just before that country erupted into civil

war between the fascist troops of General Francisco Franco and the irregular forces that opposed him. The whole series shows the gathering tensions as well as the threads of life going on in the midst of crisis. On that assignment, and throughout the rest of his career, Cartier-Bresson tried to express his sense of the aggregate human nature that binds all people together.

The American photographer DOROTHEA LANGE (1895-1965) shared with Cartier-Bresson a desire to reveal the connectedness of all human experience, and like him, she worked for most of her life on assignment taking pictures for publication in books, newspapers, and magazines. Her best-known photographs, however, like those of Hine, were made for a branch of the United States government to show Americans the plight of the poor-in Lange's case the dire situation of the rural poor who had been displaced by the Great Depression of the 1930s. Lange trained to be a teacher and studied photography in New York City before moving west and opening a portrait studio in San Francisco where she gained some fame with soft-focus, Pictorialist images. The effects of the deepening Depression outside her studio window drew her out to photograph the people whose lives had been thrown into disarray. Hired in 1935 as the photographer for a sociological study of migrant agricultural workers in California, Lange went to work the following year for the Resettlement

22-74 HENRI CARTIER-BRESSON, Seville, Spain, 1933. Gelatin silver print.

Administration (RA), later the Farm Securities Administration (FSA), which had been established to oversee emergency programs designed to aid farm families caught in the Depression and to provide information to the public about both the government programs and the plight of the people such programs were intended to serve.* At the end of an assignment to document the lives of migratory pea pickers in California, Lange stopped at a camp in Nipomo and found the migrant workers there starving; the crops had frozen in the fields. Among the pictures she made on this occasion was one of the bestknown photographs ever taken, Migrant Mother, Nipomo Valley (FIG. 22-75). Generations of viewers have now been moved by the mixture of strength and worry in the raised hand and careworn face of a young mother, who holds a baby on her lap and is flanked by two older children, who cling to her trustfully while turning their faces away from the camera. Lange has described how she was able to get the picture:

[I] saw and approached the hungry and desperate mother, as if drawn by a magnet. I do not remember how I explained my presence or my camera to her, but I remember she asked me no questions. I made five exposures, working closer and closer from the same direction. . . . There she sat in that lean-to tent with her children huddled around her, and seemed to know that my pictures might help her, and so she helped me.⁺

Social historian William Stott has identified different types of documentary images common in the United States in the 1930s. They include the "objective documentary," which is an emotionally neutral record of a subject; the "human documentary," which attempts to stir viewers' emotions about the conditions portrayed; and the "social documentary," which not only attempts to arouse emotions but chooses as its subjects those things that enlightened action could change.[‡] Lange specialized in the human documentary, but many of her images, like *Migrant*

[†]In Milton Meltzer, *Dorothea Lange: A Photographer's Life* (New York: Farrar, Strauss, Giroux, 1978), pp. 133, 220.

22-75 DOROTHEA LANGE, *Migrant Mother*, *Nipomo Valley*, 1936. Gelatin silver print. Courtesy of the Dorothea Lange Collection. © The City of Oakland, The Oakland Museum, 1991.

Mother, functioned as powerful social documentary images as well. Together, Lange and her migrant mother sensed that a photograph of the desperate situation could move people to help. Having already won the right (unique among RA and FSA photographers) to develop and proof her own negatives, Lange immediately took the Nipomo story and her first prints to a San Francisco newspaper; within days food was rushed to Nipomo to feed the hungry workers. Throughout her career, Lange focused her attention on individual people. During the Depression years, she said she wanted above all "to get my camera to register the things about these people that were more important than how poor they were—their pride, their strength, their spirit."

Following the revolution in 1917, the Soviet Union was the home of a new art movement whose members were activist counterparts of the Bauhaus utopian dream of an artist-craftsperson-engineer who would devote every talent to designing a better environment for human beings. The Russians called their movement "Productivism"; it developed as an arm of the Constructivist movement and one of its most gifted leaders was VLADIMIR TATLIN (1885–1953), a painter and sculptor who had been a sailor before

^{*}The RA/FSA was one of a number of relief programs established in the 1930s that were developed to utilize the special talents of artists. Among the most important programs were those of the Treasury Relief Art Project (TRAP), established in 1934 to commission art for federal buildings and the Works Progress Administration (WPA), founded in 1935 to relieve all unemployment, including that of artists. Under the wing of the WPA were the varied activities of the Federal Art Project (FAP), which paid artists, writers, and theater people a regular wage in exchange for work in their fields.

[‡]William Stott, *Documentary Expression and Thirties America* (New York: Oxford University Press, 1973), pp. 5–45.

turning to art. Influenced by the formal analysis of Cubism, the dynamism of Futurism, and the rhythmic compositions of flat, curved planes in traditional Russian icon paintings (FIG. 7-59), Tatlin turned to abstract relief constructions and models for stage sets after a brief period as a Cubo-Futurist painter. He experimented with every kind of material-glass, iron, sheet metal, wood, plaster-to lay the basis for what he called the "Culture of Materials." The Revolution in October 1917 was the signal to Tatlin and other avant-garde artists in Russia that the hated old order was ending, and they determined to play a full role in the creation of a new world, one that would fully use the power of industrialization for the benefit of all the people. Initially, like Malevich and Gabo, Tatlin believed that abstract art was ideal for the new society, free as such art was from any symbolism from the past. For a few years, all Russian avantgarde artists worked together, designing public festivals and demonstrations, presenting plays and exhibitions designed to help educate the public about their new government and the possibilities for their future. The Russian Futurist-Constructivist poet Vladimir Mayakovskii proclaimed their new goal: "We do not need a dead mausoleum of art where dead works are worshiped, but a living factory of the human spirit—in the streets, in the tramways, in the factories, workshops, and workers' homes." Art schools like the College of Painting, Sculpture, and Architecture in Moscow were reorganized and combined with craft schools to form new educational programs—the one in Moscow was renamed the Higher Technical-Artistic Studios (Vkhutemas). Tatlin, Malevich, and Gabo's brother, sculptor Anton Pevsner, had studios there, and Gabo (a frequent visitor) described the school's activities:

[It is] both a school and a free academy where not only the current teaching of special professions was carried out (. . . Painting, Sculpture, Architecture, Ceramics, Metalwork and Woodwork, Textile, and Typography) but general discussions were held and seminars conducted amongst the students on diverse problems where the public could participate, and artists not officially on the faculty could speak and give lessons. . . During these seminars . . . many ideological questions between opposing artists in our abstract group were thrashed out.*

As Gabo's statement indicates, a split was developing between members of the avant-garde. On one side were Malevich, Gabo, Kandinsky, and all the

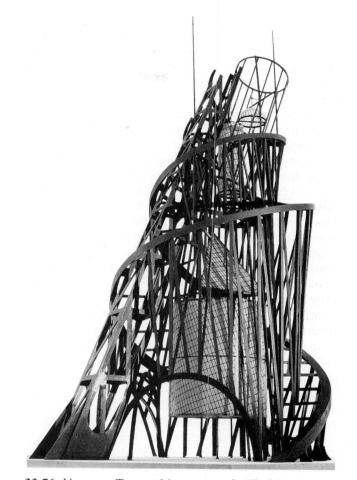

22-76 VLADIMIR TATLIN, Monument to the Third International, 1919–1920. Model in wood, iron, and glass. Re-created in 1968 for exhibition at the Moderna Museet, Stockholm.

other artists who believed that art was an expression of man's spiritual nature. On the other side were the "Productivist Constructivists"-Tatlin and other artists who felt the artist must be both creator and technician and must direct art toward the creation of useful products for the new society. The position of the Productivist Constructivists was connected to that of a group called "Proletkult" (The Organization for Proletarian Culture), which had been founded in 1906, but became free to follow its primary doctrine ("Art is a social product, conditioned by the social environment") only after the 1917 revolution. Tatlin enthusiastically abandoned abstract art for functional art by designing such things as an efficient stove and a "functional" set of worker's clothing; for a time, he even worked in a metallurgical factory near Petrograd (now Leningrad).

Tatlin's most famous work is his design for a *Monument to the Third International* (FIG. **22-76**), commissioned early in 1919 to honor the Revolution. His

^{*}In Camilla Gray, The Russian Experiment in Art 1863-1922 (New York: Harry N. Abrams, 1970), pp. 232-33.

concept was for a huge glass and iron symbol-building that would have been twice as high as the Empire State Building. On its proposed site in the center of Moscow, it would have served as a propaganda* and news center for the Soviet people. Within a dynamically tilted spiral cage, three geometrically shaped chambers were to rotate around a central axis, each chamber housing facilities for a different type of governmental activity and rotating at a different speed. At the bottom, a huge, glass cylindrical structure, meant to house lectures and meetings, was to revolve once a year. The next highest chamber was to be a cone-shaped structure assigned to administrative functions and rotating once a month. At the top, a cubic information center would revolve daily, issuing news bulletins and proclamations via the most modern means of communication, including an open air news screen (illuminated at night) and a special instrument designed to project words on the clouds on any overcast day. Tatlin envisioned the whole complex as a dynamic communications center, perfectly suited to the exhilarating pace of the new age. Due to the desperate economic situation in Russia during these years, Tatlin's ambitious design was never realized as a building; it existed only in models in metal and wood, which were exhibited on various official occasions before disappearing. The only record of the model that survives today is to be found in a few drawings, photographs, and recent reconstructions.

The early Russian filmmaker Sergei M. EISENSTEIN (1898–1948) developed a whole theory of film to create movies that depicted the revolutionary history of his country. Before the Revolution, films in Russia were produced primarily by foreigners, most of whom left the country when the tsar was overthrown. The Soviets saw cinema as a perfect medium for communication and education, and they established schools to train Russians in the art of film production. The Russian directors Dziga Vertov and Lev Kuleshov began trying to formulate methods that would allow film to be used as a precise visual language. Eisenstein was a student engineer at the time of the Revolution. He worked as a propaganda poster artist and in the Proletkult Theater before being commissioned to make several films tracing the rise of the Communist Party. Like the other avant-garde artists connected with the Revolution, Eisenstein wanted to create a new art, in his case one free from the narrative formulas of "bourgeois" film. In Strike! (1924), he

combined shots in a kind of conceptual cinematic collage, called "montage," to draw viewers emotionally into the story. In a cinematic montage, an image of a pistol firing might be followed by a picture of a teeming crowd in a great square; the next image would be that of a statue falling to create an emotional image of a political uprising. Eisenstein perfected his montage technique in Battleship Potemkin, made in 1925 to celebrate the anniversary of a failed 1905 rebellion against the tsarist government. This film is divided to depict both an uprising of the seamen on the battleship Potemkin in Odessa Harbor and the struggles of ordinary citizens against armed troops in the city. The most masterful part of the film is the "Odessa Steps Sequence" (FIG. 22-77), which shows the mass killing of citizens by soldiers relentlessly descending a long flight of steps. The scenes that make up the steps sequence were filmed with several cameras simultaneously—one running along a long track placed the length of the steps and another strapped to the waist of an acrobatic cameraman. Shots from different cameras and different moments in the scene were edited to catapult the viewer into the midst of the confusion and horror of the event.

In Germany, the filmmaker LENI RIEFENSTAHL (b. 1902) created documentary movies to arouse patriotic emotion in support of the new Nazi leader, Adolf Hitler. Once a successful actress, Riefenstahl attracted Hitler's attention with a film she directed in 1932. The mystical visual style and story of that film, Blue Light (Blaue Licht), seemed to him eminently adaptable to propaganda expressing his dreams for the future of German society. Hitler commissioned Riefenstahl to create a documentary film about the Nazi Party Congress in Nürnberg in 1934. The result was Triumph of the Will (FIG. 22-78). Hitler chose the title himself, and with his help, all of the details of the Congress-marches, meetings, rallies, speeches, activities in the camp of the Youth Corps, and the placement of banners, flowers, and onlookers throughout the city—were carefully planned in advance to serve Riefenstahl's cinematic needs. During the actual filming, she worked with 120 assistants and a host of cameras, shooting from multiple viewpoints, including a specially built track that ran for several blocks along the second story of the buildings adjacent to the main procession route. Riefenstahl spent eight months editing the film. In the final product Hitler is shown as a beloved messiah, descending from the clouds at the picture's beginning to preside benevolently over the increasingly demonstrative outpourings of mass devotion to him that culminate in an impassioned speech he makes to his followers about the future glory that will come to Germany under his leadership. A film with such a clearly propagandistic

^{*}The word propaganda comes from the Latin *propaganda fides*, and the term was originally used to designate activities designed to spread and reinforce the teachings of the Roman Catholic church. Propaganda, then, means anything designed to persuade an audience to follow a particular set of beliefs.

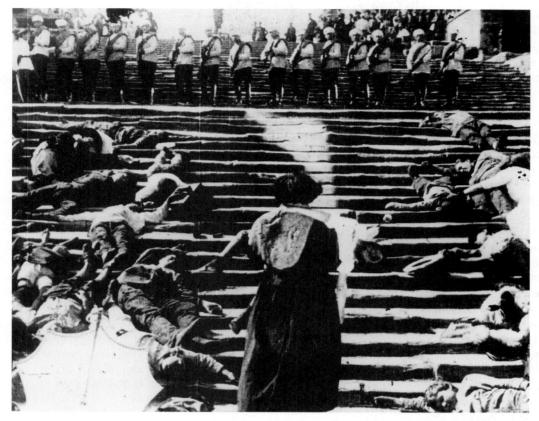

22-77 SERGEI M. EISENSTEIN, film still from Battleship Potemkin: "Odessa Steps Sequence," 1925.

22-78 LENI RIEFENSTAHL, film still from Triumph of the Will, 1935.

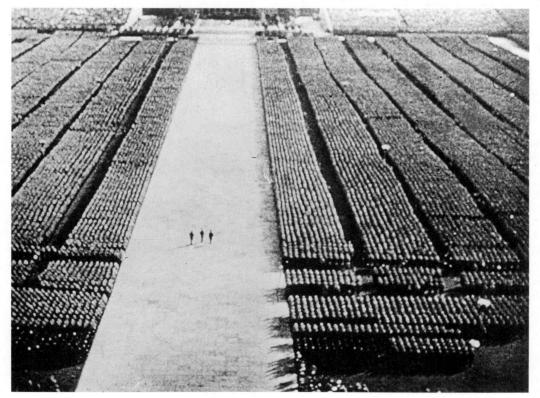

1022 CHAPTER 22 / THE EARLY TWENTIETH CENTURY

goal might have been trite or dull, but Riefenstahl managed to turn the characters and events of the Nürnberg Congress into abstract and symbolic visual patterns. She played these patterns against one another on many levels. In a tour-de-force of rhythmic editing, she achieved the highest degree of emotional and esthetic impact by juxtaposing close-ups and distant views, aerial and low-angle shots, and intercuts between people and the flag-bedecked monuments and buildings of the seemingly welcoming town. Riefenstahl shared Eisenstein's ability to use montage to create a convincing emotional environment for the viewers of her film, but the patterns she created are less dislocating than those in Potemkin. As she later boasted, she staged nothing; everything in the film happened as part of an historical event that took place in front of her. But this was history planned with the greatest care to have maximum effect and shaped to make each scene compound the effect of the one before, making an unforgettable impact on viewers. Indeed, Triumph of the Will was so effective that it was banned in several countries, including the United States, Canada, and Great Britain.

Riefenstahl's documentary showed masses of people behaving with mechanical precision, united in the happy service of their political leader. The British-American filmmaker CHARLIE CHAPLIN (1889–1977) created the character of the Little Tramp, a goodnatured, poor, and bewildered Everyman who never quite fit into the society around him. Chaplin's empathy with the poor stemmed from the poverty he himself experienced as a boy in England. He developed the great abilities that shaped the character of the Little Tramp working as a comic and mime in vaudeville. The humor surrounding the hapless adventures of the plucky and perennially impoverished "Charlot" won the hearts of viewers around the world. After 1918, this success allowed Chaplin to write, direct, produce, star in, and distribute his feature films himself. Increasingly, he made films that showed people trapped by the monolithic qualities of modern industrialized society. In 1936 he made Modern Times (FIG. 22-79), the last film in which the Little Tramp appeared, "to say something about the way life is being standardized and channelized and men turned into machines." In this film, hapless Charlie is a factory worker who tangles with the machines he is supposed to be operating. In one of the great comic sequences in the movie, he and a co-worker are trapped on a moving belt and swallowed by a large machine,

reappearing from time to time among its gears, wheels, and drive belts. Chaplin's satirical picture of modern industry in the midst of the Depression won frowns from many business magnates, who dismissed it as Communist propaganda, but the film tickled the funny bones of many viewers, who seemed to find in it a perfect expression of the feelings Chaplin put into the mouth of a character in his next film, *The Great Dictator:* "We think too much and feel too little. More than machinery, we need humanity."*

Eisenstein, Riefenstahl, and Chaplin each used the realistic recording power of the camera to transform the objects and people in their films into symbols for the ideas they wanted to express in their art. The American painter BEN SHAHN (1898-1969) used photographs as a point of departure for semi-abstract figures he felt would express the emotions and facts of social injustice that were his main subject throughout his career. Shahn came to the United States from Lithuania in 1906 and trained as a lithographer before broadening the media in which he worked to include easel painting, photography, and murals. In France in 1929, he found his life's direction in art: "If I am to be a painter, I must show the world how it looks through my eyes." He focused on the lives of ordinary people and the injustices often done to them by the structure of an impersonal society. In the early 1930s, he completed a cycle of twenty-three paintings and prints inspired by the trial and execution of the two Italian anarchists Nicola Sacco and Bartolommeo Vanzetti, whom many people considered to have been unjustly convicted of killing two men in a holdup in 1920. Shahn felt he had found in this story a subject the equal of any in Western art history: "Suddenly I realized . . . I was living through another crucifixion." Basing many of the works in this cycle on newspaper photographs of the events, Shahn devised a style that adapted his knowledge of Synthetic Cubism and his training in commercial art to an emotionally expressive use of flat, intense color in figural compositions filled with sharp, dry, angular forms. The major work in the series was called simply The Passion of Sacco and Vanzetti (FIG. 22-80). This tall, narrow painting compresses time as well as space in a symbolic representation of the trial and its aftermath. The two executed men lie in coffins at the bottom of the composition. Presiding over them are the three members of the commission chaired by Harvard University president A. Laurence Lowell, who declared the original trial fair and cleared the way for the executions to take place. Behind, on the wall of a

*In Gene D. Phillips, *The Movie Makers: Artists in an Industry* (Chicago: Nelson-Hall, 1973), pp. 25–42

22-80 BEN SHAHN, The Passion of Sacco and Vanzetti, 1931–1932. Tempera on canvas, 84¹/₂ × 48".
Collection of Whitney Museum of American Art, New York (gift of Edith and Milton Lowenthal in memory of Juliana Force).

schematized government building, is the framed portrait of Judge Webster Thayer, who pronounced the initial sentence. The grey pallor of the dead men, the stylized mask-faces of the mock-pious mourning commissioners, and the sanctimonious, distant judge all contribute to the mood of anguished commentary that makes this image one of Shahn's most powerful works.

Like Shahn, the American artist JACOB LAWRENCE (b. 1917) found his subjects in modern history, but unlike Shahn, Lawrence concentrated on the culture

22-81 JACOB LAWRENCE, No. 36: During the truce Toussaint is deceived and arrested by LeClerc. LeClerc led Toussaint to believe that he was sincere, believing that when Toussaint was out of the way, the Blacks would surrender, from l'Ouverture Series, Plate 8, 1937–1938. Tempera on paper, 11" × 19". The Amistad Research Center's Aaron Douglas Collection, New Orleans.

and history of African-Americans. Lawrence moved to Harlem in 1927 at about the age of ten. There, he studied art and came under the spell of the African art and African-American history he found in lectures and exhibitions, and in the special programs sponsored by the 125th Street Public Library, which had outstanding collections of African-American art and archival data. Inspired by the politically committed art of Goya (FIG. 21-26), Daumier (FIG. 21-28), and Orozco (FIG. 22-82), Lawrence found his subjects in the everyday life of Harlem and the history of his people. He interpreted his themes in rhythmic arrangements of bold, flat, strongly colored shapes, using a style that drew equally from his interest in the push-pull effects of Cubist space and his memories of the patterns made by the colored scatter rugs that had brightened the floors of his childhood homes. His first historical subject was a series of forty-one paintings showing key incidents from the life of Toussaint L'Ouverture, a slave who led a revolution in the late eighteenth and early nineteenth century, winning independence from French rule for Haiti and establishing the first black Western republic. No. 36: During the truce Toussaint is deceived and arrested by LeClerc. LeClerc led Toussaint to believe that he was sincere, believing that when Toussaint was out of the way, the Blacks would surrender (FIG. 22-81) is typical of Lawrence's masterful compositions and the way in which he added long narrative titles to make the series a kind of history text for younger viewers. Everything is arranged to draw the viewer's attention to the figure of Toussaint, who is held prisoner by his captors in the center of the picture space behind a wall of crisscrossed swords. The steep perspective of the walls of the room and the foreground rug, the thrusting figures of the captors, and the outspread legs of the hero dramatically draw the viewer into empathy with Toussaint's heroic defiance of foreign authority in the face of overwhelming odds. Like every other subject Lawrence painted during his long career, he believed this story had important things to teach viewers: "I didn't do it just as a historical thing, but because I

22-82 José CLEMENTE OROZCO, Epic of American Civilization: Hispano-America, c. 1932–1934. Fresco. Baker Memorial Library, Dartmouth College, Hanover, New Hampshire.

believe these things tie up with the Negro today. We don't have a physical slavery, but an economic slavery. If these people, who were so much worse off than the people today, could conquer their slavery, we certainly can do the same thing."*

Lawrence found inspiration for his early art in the example of José CLEMENTE OROZCO (1883–1949), one of a group of Mexican artists determined to base their art on the indigenous history and culture that existed in Mexico before the arrival of Europeans. The movement formed by these artists was part of the idealistic rethinking of society that took place during the political turmoil of the period of the Mexican Revolution between 1910 and the 1920s. Among the projects undertaken by these politically motivated artists were vast mural cycles placed in public buildings to dramatize and validate the history of Mexico's native peo-

*In Ellen Harkins Wheat, Jacob Lawrence: American Painter (Seattle: University of Washington Press, 1986), p. 40.

ples. Orozco worked on one of the first major cycles, painted in 1922 on the walls of the National Training School in Mexico City. He carried the ideas of this mural revolution to the United States, completing many commissions for wall paintings between 1927 and 1934. From 1932 to 1934, he worked on one of his finest mural cycles in the Baker Library at Dartmouth College, partly in honor of its superb collection of books in Spanish. The choice of subject was left up to him. What he depicted, in fourteen large panels and ten smaller ones, was a panoramic and symbolic history of ancient and modern Mexico, from the early mythic days of the feathered-serpent god, Quetzalcóatl, to a contemporary and bitterly satiric vision of modern education. The imagery in our detail, Epic of American Civilization: Hispano-America (FIG. 22-82), revolves around the monumental figure of a heroic Mexican peasant armed to participate in the Mexican Revolution. Looming on either side of him are

mounds crammed with symbolic figures of his oppressors-bankers, government soldiers, officials, gangsters, and the rich. Money-grubbers pour hoards of gold at the feet of the incorruptible peón, cannon threaten him, and a bemedaled general raises a dagger to stab him in the back. Orozco's training as an architect gave him a sense of the framed wall surface, which he easily commanded, projecting his quickly grasped figures onto the solid mural plane in monumental scale. In addition, Orozco's early training as a maker of political prints and as a newspaper artist had taught him the rhetorical strength of graphic brevity and simplicity, which he used here to assure that his allegory was easy to read. His special merging of the effects of the graphic and mural media give his work an originality and force rarely seen in mural painting after the Renaissance and Baroque periods.

Modern artists who have sought to stir the emotions of viewers about specific incidents of human injustice have found it difficult to record or symbolize enough information in a single image to accomplish their purpose. Paintings like David's *Death of Marat* (FIG. 20-41), Géricault's *Raft of the Medusa* (FIG. 21-12), Goya's *Third of May*, 1808 (FIG. 21-26), and Daumier's *Rue Transnonain* (FIG. 21-28) are rare. The greatest twentieth-century painting inspired by outrage directed toward brutal human behavior is *Guernica* (FIG. **22-83**), created by Pablo Picasso in 1937 in response to the saturation bombing of an ancient Basque city by German forces acting for Francisco Franco during the Spanish Civil War. Throughout his career, Picasso had never been content to work for long in any one style. While still painting Synthetic Cubist pictures, he also made "Ingres-like" drawings and painted figure subjects in a broadly Realistic manner often influenced by Antique sculpture. He often moved back and forth between creating works with symbolic significance, like those of his Blue Period, and works in which he explored esthetic problems of style, like Les Demoiselles d'Avignon (FIG. 22-6) and Three Musicians (FIG. 22-11). In the latter work, he had also bent Synthetic Cubism to express irony and whimsy. In the late 1920s and early 1930s, Picasso's Cubism took on a Surrealistic quality; the forms became more biomorphic and the interweaving of planes began to suggest the qualities of a dreamy metamorphosis from one state of being to another. As Franco's forces assumed power in Spain, Picasso began using motifs from bullfighting and mythology to symbolize the struggles in his homeland. His political commitment, his feelings, and his role as an artist were painfully united in a new and powerful way: "Painting is not done to decorate apartments. It is an instrument of war for attack and defence against the enemy."

In January 1937, the Spanish Republican government in exile in Paris asked Picasso to do a work for their pavilion at the Paris International Exposition to be held that summer. He agreed but had done nothing when he received word that the Basque capital, Guernica, had been almost totally destroyed in an air

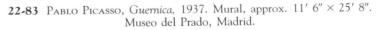

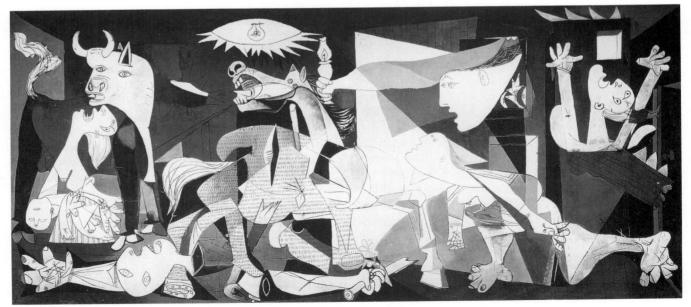

raid on April 26 by German planes acting on behalf of General Franco. The event jolted Picasso into action; by the end of June, the mural-sized canvas of Guernica was complete. Picasso used a fluid, expressive Synthetic Cubist style to organize his figures into a threepart composition with a triangular middle and two flanking rectangular wings. Forms bend and stretch in response to the emotional stress of the characters. Borrowed from the picador's mount in the bullfight, the horribly wounded dying horse at the center stands for all innocent victims, while (according to the artist) the bull represents "brutality and darkness." A slain soldier stretches awkwardly across the ground at the lower left, in front of a shrieking woman who holds her dead child in helpless agony. A searching head balloons from an upper window, accompanied by an eerily elongated arm holding an oil lamp. A woman falls in flames from a building, while, beneath, another woman attempts to run in

fright; her suddenly swollen and weighted legs and feet refuse to move. The black, white, and grey colors, the patterns of light and dark, and the action of the figures lead the viewer's eyes relentlessly back to the upthrust head of the central victim-horse and to its open mouth, exposed teeth, and agonizedly pointed tongue—the unforgettable emblem of helpless terror and suffering.

Within his own career, Picasso embodied most of the strands of Modernism that blossomed in the first half of the twentieth century. His earliest works were expressionistic; then he became one of the leaders in creating art with formalist concerns. He never followed a utopian dream nor sought to express eternal forms, but in *Guernica*, he joined a large number of his contemporaries who believed that art is the most effective means of exploring psychological truth, criticizing social evil, and affirming the preeminent worth of individual human beings.

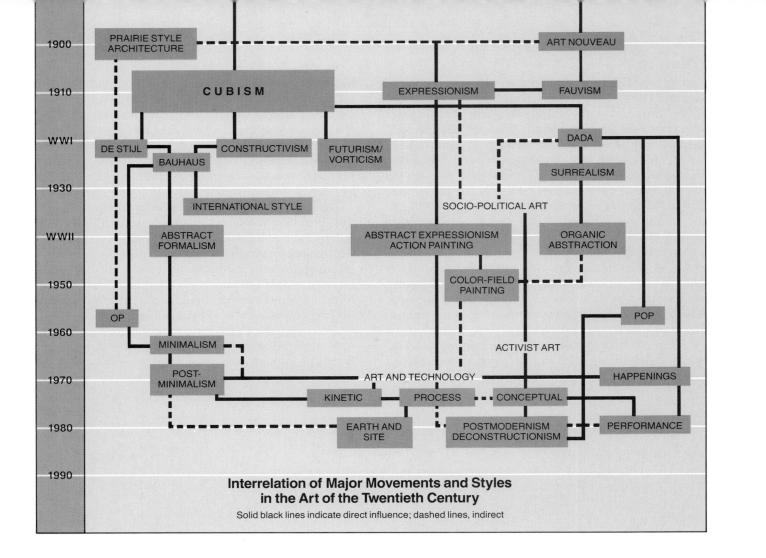

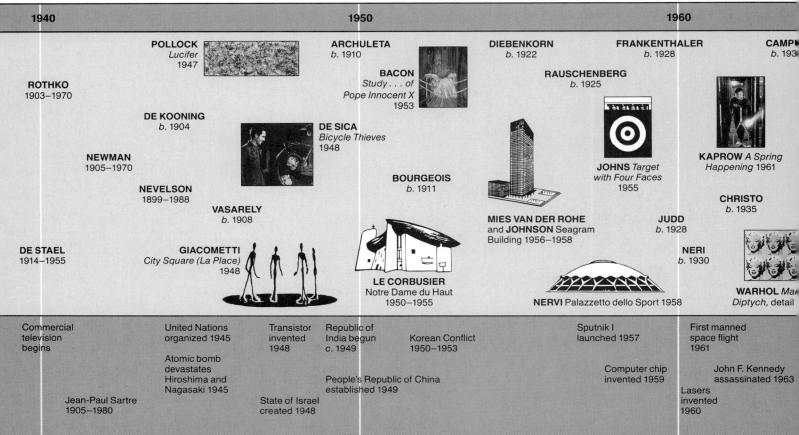

23 THE CONTEMPORARY WORLD

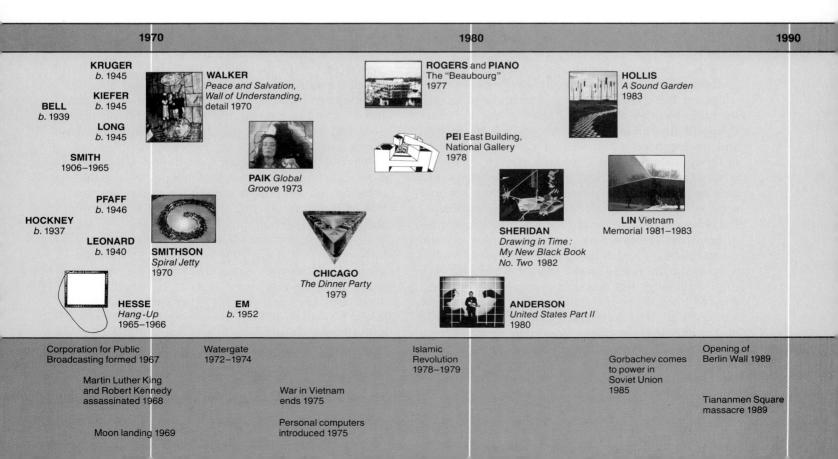

he contemporary world was ushered in by the dark period of World War II, which affected more of the globe's population than any earlier military conflict and left in its wake a twin legacy. On the one hand, the military activity of the war years spawned new technologies that changed the way humans worked, played, and thought; on the other hand, however, the war's conflagration posed the persistent threat of nuclear annihilation. A growing recognition of widespread human suffering and a haunting fear among many that life had no meaning or value contributed further to a global climate of dislocation.

Politically, the postwar world balanced between the powers of capitalism and communism. Western culture was split between those nations in Western Europe allied with the United States and those in Eastern Europe linked with the Soviet Union. In Asia, the communist leadership of Mao Tse-tung in postwar China initiated decades of change and political contests in surrounding countries, including Korea and Vietnam. One-time colonies in Asia and Africa won their independence from European control; some, like Zaire (formerly Congo), took new names to celebrate their changed status. The increased selfawareness that accompanied independence in these nations sometimes resulted in armed conflict like that which split Moslem Pakistan off from Hindu India. Religious and political conflict also erupted in South America and the Near East. More recently, the uneasy equilibrium between capitalism and communism, between Islamic and non-Islamic countries, and between established and emerging nations has been increasingly threatened by global population growth, widespread famine, disease, poverty, and an endangered natural environment.

During these same years, new technology shaped scientific theories about the nature of the universe. Powerful instruments like microscopes, telescopes, and nuclear accelerators helped generate new areas of thought. In the field of particle physics, researchers taught that everything in nature is composed of infinitely tiny particles in constant motion, whose apparent behavior is affected by the expectations of the observers who attempt to study them. Advances in medicine brought new control over physical and mental disease, and helped to develop social awareness about the needs of the sick, the handicapped, the very young, and the aged. Space exploration expanded knowledge of the universe, while affordable air travel allowed increasing numbers of people to visit cultures very different from their own and learn more about life on our planet. The widespread availability of technological innovations changed details of daily life in developed countries in ways that affected

perceptions of society. The increased availability of innovations like refrigeration, electric lighting, central heating, and air-conditioning provided a hitherto unknown degree of control over time and weather and helped to create more leisure time.

Many of the activities people chose to fill their leisure time were connected with absorbing and using information acquired, processed, and shared through the new technologies. Television displaced radio and cinema as the most common transmitter of data, sending vivid images into homes around the globe. The mass marketing of long-playing records, paperback books, special-interest magazines, and personal equipment like cameras, videotape recorders, and computers allowed each individual to create and manipulate personal stores of information. The widespread transmission of information in most industrial countries contributed to a new awareness of the multiple traditions and values that existed in the world and helped to focus attention on the fragile interconnectedness of all sectors of what Buckminster Fuller called "this spaceship earth." Increasingly, people spoke of "truths" and "beauties" rather than the truth or a single universal beauty; truth and beauty were recognized to exist in many forms, each valid in its particular place and time. Amid this questioning of values, some people found traditional religion too much caught up in past habits to provide help in the chaotic conditions of the new age, and were attracted to new spiritual paths. In the stressful years of the late 1940s and the 1950s, many individuals (especially in the United States) turned to Zen Buddhism and to existentialism, which shared an emphasis on the importance of living wholly in each moment-"the eternal now." In the 1960s, 1970s, and 1980s, the search for spiritual values often was linked to social commitment, producing action for a cause or belief and resulting in antiwar and antinuclear demonstrations and "movements" like feminism, environmentalism, and black power.

Without the kind of shared beliefs and values common to art of the past, artists became increasingly conscious of their responsibility for the content and role of their art. As the critic Michael Kirby wrote about art in the contemporary period: "The key word in aesthetic theory is not *beauty* as has been suggested by traditional aesthetics, but *significance*. . . . The creation of art depends upon the artist's personal attempt to achieve what he feels to be significant."* Significant form and content in art were strongly affected by artists' abilities to view a variety of works, both directly, in the rapidly growing number of gal-

*In Richard Kostelanetz, ed., *Esthetics Contemporary* (Buffalo, NY: Prometheus Books, 1978), p. 43.

leries and museums, and secondhand, in the burgeoning array of art magazines, films, and television programs that brought to life André Malraux's "museum without walls."

Artists responded to the vast changes in the world around them with a wide array of new styles, yet continued to work within the three major approaches discussed in the last chapter-art with formalist concerns, art with psychological and conceptual concerns, and art with social and political concerns. Many artists found continued inspiration in non-art sources like archeology, anthropology, science, and technology. New works of art were often offered for sale through a centralized commercial system located primarily in major metropolises. Many works were treated as "commodities" in an art "market" in which artists functioned almost as piecework employees of ambitious and commercially minded galleries. An increasing number of artists rebelled by working outside this system, showing their art in cooperative galleries or deliberately creating works with no obvious commercial value.

Artists with formalist concerns struggling to express feeling in abstract art were influenced by the ideas of art theorist-critic Suzanne Langer, who wrote in her widely read book *Feeling and Form: A Theory of Art* (1953): "Vital organization is the frame of all feeling, because feeling exists only in living organisms; and the logic of all symbols that can express feeling is the logic of organic processes. The most characteristic principle of vital activity is rhythm."

Some artists with formalist concerns and some artists with psychological and conceptual concerns turned again to the idea of the artist as a seer who could restore to art the power of magic and mystery they believed had been lost in the industrial age. The theorist José Argüelles proposed that these artists operated by developing a kind of rigorous and antihistorical "internal technology," which allowed them to act with their whole creative beings to uncover and communicate visions of inner truth: "What separates the art of most modern Western visionaries from the kind of integral achievement that characterizes the archaic, however, is an intense inner discipline-the development of an internal technology. ... Slowly and often painfully uncovering an authentically open and destructured vision of the world, the internal technologist appears in his or her role as a healer, one who makes whole."*

Significant rhythm and form were of primary importance to artists with formalist interests, but these qualities did not satisfy those with psychological and conceptual concerns who wanted to reflect both the

*Ibid., pp. 174, 176.

pain and the majesty of existence in this troubled period. Many of these artists used the human body expressionistically to carry their vision. Others explored the world or nature conceptually, borrowing images and objects and juxtaposing them in ways that stimulated the viewer's imagination, sharing something of the attitude described by the sculptor and theorist Allan Kaprow in 1966: "At present, any avant-garde is primarily a philosophical quest and a finding of truths, rather than purely an esthetic activity."[†]

By the late 1970s, many believed that traditional Modernist concerns had been overturned by a Postmodernist era of which the critic Craig Owens wrote: "Postmodernism is usually treated . . . as a crisis of cultural authority, specifically of the authority vested in Western European culture and its institutions."[‡] While Modernist art embraced new technology as helpful to the evolution of human society, Postmodernist art distrusted both progress and objective truth as concepts tied too completely to Western culture's view of history. All cultures were seen as equally valid, making our own assume a role of "distance" or "otherness"-just one among many of interest and worth. Postmodernist art often appropriated artistic styles and concepts in an attempt to make the viewer reexamine all "traditional" ideas and experiences.

Most artists with social and political concerns in the contemporary post-1940 period used their art to help change the perceptions and even the behavior of viewers. As the feminist Performance artists Leslie Labowitz and Suzanne Lacy wrote in 1979: "All images are political in that they portray a set of values and attitudes about how the world is or could be. . . . Whether contending with or agreeing with the flow of media images, the artist in the technological society must be cognizant as never before of the way in which his or her visual product hits its audience."§ While many artists with social and political concerns used their art to call attention to the darker side of contemporary experience, a separate group tried instead to restore to humanity a sense of connectedness with nature and the continuum of human history.

The varied strands of continuing Modernist and Postmodernist visions have made the period from 1940 to the present one of the richest and most complex in the history of art. Nevertheless, it is important to recognize the impossibility of doing historical justice to contemporary works, especially when many of

⁺In Kostelanetz, ed., Esthetics Contemporary, p. 31.

[‡]In Howard Risatti, ed., *Postmodern Perspectives* (Englewood Cliffs, NJ: Prentice-Hall, 1990), p. 186.

[§]In Richard Hertz, ed., *Theories of Contemporary Art* (Englewood Cliffs, NJ: Prentice-Hall, 1985), p. 177.

the men and women who created them are still living. The selection and presentation of certain contemporary monuments may suggest that a judgment of their superiority has already been made by history. This is not the case; historical judgment moves slowly, and identification of the masterpieces of the current epoch has scarcely begun. The fact that all of this work stands so close to us means that in this chapter, more than in any other, artists are discussed as significant representatives of the major approaches taken during the contemporary period.

ART WITH FORMALIST CONCERNS

Sometime during World War II, the center of the Western art world shifted from Europe to the United States. Emigré artists arrived and their influence merged with native American traditions to create new ideas and styles, the most important of which were formalist. The art of the moment was abstract, but its expressions took many paths. The style that first drew the eyes of the world toward America was a vigorous, freewheeling mode called New York Abstract Expressionism, Action Painting, or Gestural Abstraction. The biomorphic shapes of certain buildings and sculptures and the vast canvases of Color-Field painting, activated by subtle modulations of hue and an ambiguous sense of figure-ground, were somewhat quieter in appearance, but equally linked to the intuitive methods of Surrealism. Like the Surrealists, Abstract Expressionists, Organic and Formalist Abstractionists, and Color-Field painters favored methods that bypassed the rational mind by emphasizing feeling, emotion, and the unconscious. Equally idealistic in inspiration, but different from abstraction based on feeling and allusion, was a structured kind of abstraction that carried further the precise formalist investigations of Suprematism, Constructivism, and Neo-Plasticism. Like its predecessors, the art produced by this formalist approach was based less on the operation of intuition and process than on the exercise of reasoned control and measured design as reflections of eternal order.

Abstract Expressionism

Abstract Expressionism was the first major new abstract style developed in the United States after the influx of refugee artists from Europe in the years just before World War II. The movement was centered in New York City but rapidly spread throughout the Western world. In part as a response to the chaos of the time in which they lived, Abstract Expressionist artists turned, as had the Dadaists before them, against the use of reason. They tried to broaden their artistic processes to express what Carl Jung called the "collective unconscious" by adopting the methods of Surrealist improvisation and using their creative minds as open channels through which the forces of the unconscious could make themselves visible. The Abstract Expressionists saw themselves as leaders in the quest to find the path to the future. The New York artists viewed their art as a weapon in the struggle to maintain their humanity in the midst of the world's increasing insanity. To create, they turned inward. Their works had a look of rough spontaneity and exhibited a refreshing energy; their content was intended to be grasped intuitively by each viewer, in a state free from structured thinking. Abstract Expressionist artists believed their work could help to counter the forces of dislocation by reawakening in people a sense of interconnectedness with all living things. As the painter Robert Motherwell eloquently wrote:

The emergence of abstract art is a sign that there are still men of feeling in the world. . . . From their perspective, it is the social world that tends to appear irrational and absurd. . . . Nothing as drastic as abstract art could have come into existence save as the consequence of a most profound, relentless, unquenchable need. The need is for felt experienceintense, immediate, direct, subtle, unified, warm, vivid, rhythmic. If a painting does not make a human contact, it is nothing. But the audience is also responsible. Through pictures our passions touch. Pictures are vehicles of passion, of all kinds and orders, not pretty luxuries like sports cars. In our society, the capacity to give and receive passion is limited. For this reason, the act of painting is a deep human necessity, not the production of a hand-made commodity.*

JACKSON POLLOCK (1912–1956) is the artist most often associated with the Abstract Expressionist or Gestural Abstractionist approach, and the power of his works influenced artists throughout the world. Pollock brought to his paintings his memories of the vast open spaces of the southwestern United States, where he grew up, and of the sand painting techniques of the Native American medicine men he had seen there. After a brief period as a Socialist Realist, Pollock transformed his interest in the dynamic rhythms of Rubens (FIG. 19-40), Ryder (FIG. 21-93), and Orozco (FIG. 22-82) into a free, abstract style that had him working with his whole body in dynamic

*In Frank O'Hara, *Robert Motherwell* (New York: Museum of Modern Art, 1965), pp. 45, 50.

23-1 JACKSON POLLOCK, *Lucifer*, 1947. Oil, aluminum paint, and enamel on canvas, approx. 3' 5" × 8' 9". Collection of Mr. and Mrs. Harry W. Anderson.

swirling gestures as he poured or flung paint onto the surface of his canvases. As a rationale for his method, Pollock commented that "new needs need new techniques. . . The modern painter cannot express this age . . . in the old forms of the Renaissance or of any other past culture."*

For a work like Lucifer (FIG. 23-1), Pollock unrolled a large section of canvas directly onto the floor of his studio and dripped and splattered paint on it while moving energetically along its edge or across it. On the floor, he felt more comfortable: "I feel nearer, more a part of the painting, since this way I can walk around it, work from the four sides and internally be in the painting." Like Miró, Pollock alternated between periods of spontaneous improvisation and periods of careful scrutiny of his developing composition. However, his methods also had roots in Kandinsky's automatic and spontaneous nonobjectivity (FIG. 22-47),⁺ and even in the improvisation used by jazz musicians admired at the time by most of the New York Abstract Expressionists. The random fall and scatter of the paint in Lucifer emphasizes the liquid nature of the medium itself, but the gestures of the artist have turned the paint into loose skeins of color that loop back and forth across the canvas, thickening in some places and falling in almost straight lines in others. No easily identifiable shapes help the viewer to establish the familiar depth of a

normal figure-ground relationship; instead, the rhythmic layers of line spread out laterally across the canvas and seem to extend far beyond its edges. As he worked, Pollock looked not out (as from a viewpoint) but down, seeing his "landscape" unfold. When the works were exhibited, this "plane of action" on which they were created was transformed into a "plane of confrontation" on a vertical wall, lending the compositions a sense of floating, gravityless space. The overall pattern of interweaving lines may suggest the patterns of motion and energy found in micro- and macro-photographs of the basic structures of the physical world, but the artist intended no direct reference to nature. Instead, the painting becomes almost a record of Pollock's actions in making it. Indeed, in works like Lucifer, the sense of the process of painting is stronger than the awareness of the painted surface itself.

Gestural Abstract Expressionism had many possible methods of approach. In the work of FRANZ KLINE (1910–1962), it was a vehicle of very personal psychic revelation, possibly as mysterious to the artist as to the observer. Kline trained in Boston and London before settling in New York City. His early work was expressive and realistic, but gradually he concentrated on abstract form. He used a special opaque projector to enlarge designs onto a wall as a means of achieving simplification and abstraction in his paintings. His mature works include many large blackand-white canvases, like Painting (FIG. 23-2), which are filled with ragged bars and stripes of black that play against white slablike areas as sharp-edged as broken planes of glass. These configurations suggest Chinese characters boldly brushed and greatly magnified, a kind of ideogram of the artist's psychic state. As

^{*}In Francis V. O'Conner, Jackson Pollock (New York: Museum of Modern Art, 1967), pp. 40, 79.

⁺The label "abstract expressionism" was attached to Kandinsky's art as early as 1919. A large retrospective exhibition of the Russian artist's works in 1945 at the Museum of Non-Objective Painting (now the Solomon H. Guggenheim Museum) in New York City impressed many young artists, including Pollock.

23-2 FRANZ KLINE, Painting, 1952, 1955–1956. Approx. 6' $5'' \times 8'$ 4". Present location unknown.

hieratic and quasi-magical shapes, the forms can be interpreted as the observer pleases; as purely nonobjective forms in a wide variety of arrangements, they are expressive in their blunt esthetic force and bold, free execution.

The Dutch-born painter WILLEM DE KOONING (b. 1904) has used the techniques of New York Action Painting to make both abstract works and the energetic images of massive women for which he is best known. De Kooning embraced Gestural Abstract Expressionism after an early career in commercial art and as a figure and portrait painter, experience that gave him a special command of fluid line and subtle color. His series of huge women, like Woman I (FIG. 23-3), was inspired in part by female models on advertising billboards, but the forms also suggest fertility figures and a satiric inversion of the traditional image of Venus, goddess of love. In Woman I, the figure is defined with manic excitement, apparently slashed out at full speed with a brush held at arm's length. Shapes and colors play through, over, and across one another with no definable order. The brazen and baleful mask of the face mixes a toothpaste smile (inspired by an ad for Camel cigarettes) with the grimace of a death's head. The effect is one of simultaneous delineation and defacement, of construction and cancellation-a conflict between sketch and finished picture. As with other Action Painting, the image seems to be eternally coming into being before the eyes of the viewer, but the tension between flat design and lines in space, between image and process, is heightened by the recognizable figure whose violent power demands recognition. It is for such qualities that De Kooning has been called an "artist who makes ambiguity a hypothesis on which to build."*

The spontaneity and visible processes of New York Abstract Expressionism were used elsewhere for figurative images expressed in juicy, thick shapes of color and paint. One important group of artists, the Bay Area Figurative Painters, worked in this way during the 1950s and 1960s in the area around San Francisco. One of the best known of this group was RICHARD DIEBENKORN (b. 1922), whose admiration for the work of Hopper, Sheeler, O'Keeffe, and Matisse helped inspire him to change in the mid-1950s from an early Abstract Expressionist style to the creation of broadly brushed paintings of figures in spacious settings. Man and Woman in a Large Room (FIG. 23-4) is typical of the way Diebenkorn expressed the clear light and spreading space of California through a careful arrangement of simplified forms. Shapes pile atop one another, light and dark hues alternate, steep perspective lines push back into space at one instant and the next lie flat as a pattern of sumptu-

*Thomas B. Hess, Willem de Kooning (New York: Museum of Modern Art, 1968), p. 25.

23-3 WILLEM DE KOONING, Woman I, 1950–1952. Approx. 6' $4'' \times 4'$ 10". Collection, The Museum of Modern Art, New York (purchase).

23-4 RICHARD DIEBENKORN, Man and Woman in a Large Room, 1957. 5' $11\frac{1}{8}'' \times 5' 2\frac{1}{2}''$. Hirshhorn Museum and Sculpture Garden, Smithsonian Institution, Washington, D.C. (gift of the Joseph H. Hirshhorn Foundation, 1966).

ously colored blocks of paint. Still, the viewer does not forget that this play of forms also describes two figures pushed to one side of a vast, almost empty room whose curtainless windows reveal roughly clouded sky and whose door mysteriously opens directly onto the sea. As with De Kooning's paintings of women, Diebenkorn's paintings of figures in settings balance between existence as powerful abstract compositions and depictions of scenes with emotional resonance. The artist clearly recognized the importance of the emotional component: "A figure exerts a continuing and unspecified influence on a painting as the canvas develops. The represented forms are loaded with psychological feeling. It can't ever just be painting."* The psychological feeling in Diebenkorn's work during the late 1950s and early 1960s suggests the loneliness and isolation of contemporary human existence, but the rich patterns of abstract composition interested the California artist so much that by the late 1960s, he had abandoned direct references to the visible world and had returned to

*In Robert T. Buck, Jr., Linda L. Cathcart, Gerald Nordland, and Maurice Tuchman, *Richard Diebenkorn; Paintings and Drawings*, 1943–1980 (Buffalo, NY: Albright-Knox Art Gallery, 1980), p. 31. the creation of paintings filled with stately, nonobjective shapes.

Like Diebenkorn, the Russian-French painter NICOLAS DE STAEL (1914-1955) created figurative works in the 1950s with the direct painterliness of the Abstract Expressionist mode, but De Stael's compositions are further removed than Diebenkorn's from a sense of palpable physical forms and are imbued instead with a static, timeless mood, somewhat like a Classicism based on style rather than subject. De Stael's early nomadic life took him from his native Russia to Poland, Belgium, Morocco, and Algeria. He settled in Paris in the late 1930s. Like Matisse, De Stael used figures, objects, and their settings as the source for harmonious arrangements of colors and shapes. Musicians (FIG. 23-5) is typical of his work, presenting an image in which mosaiclike color shapes resolve themselves into a group of performing music makers. Simpler in composition and less involved with the character of each figure than Picasso's Three Musicians (FIG. 22-11), De Stael's Musicians focuses

23-5 NICOLAS DE STAEL, Musicians, 1953. 5' $6\frac{7''}{8} \times 3'$ 9". © The Phillips Collection, Washington, D.C.

23-6 DAVID SMITH, CUBI XXVI, 1965. Steel, approx. $10' \times 12\frac{1}{2}' \times 2\frac{1}{4}'$. National Gallery of Art, Washington, D.C. (Ailsa Mellon Bruce Fund, 1978).

attention instead on the process of painting, and the viewer is most aware of the way that light, color, and space fill the canvas in a serenely orchestrated manner.

Only a handful of sculptors were associated with Gestural Abstract Expressionism, and they translated its forms into a kind of drawing in space. The most influential of these artists was DAVID SMITH (1906-1965), whose mastery of spatial composition was widely admired by younger artists. Smith began as a painter, which helps explain his fascination with line and the way it can create a sense of shape and space. His early sculptures were done in a linear, open style influenced by the work of Julio Gonzalez (FIG. 22-16). In his later work, Smith used the metal-fabrication techniques he had learned earlier as a factory worker in Indiana: "The equipment I use, my supply of material comes from factory study, and duplicates as nearly as possible the production equipment used in making a locomotive." Sculptures like Cubi XXVI (FIG. 23-6) are monumental constructions in stainless steel in which Smith arranged solid, geometric masses in remarkable equilibriums of strength and buoyancy. Smith was at ease in the age of the machine: "What associations the metal possesses are those of this century: power, structure, movement, progress, suspension, destruction, brutality." His welded compositions were tough enough to allow the remarkably free balancing in space that is characteristic of his last style. Here, as in all Smith's work, the viewer has a sharp awareness of the linear outlines of the planes that make up the composition and help to create and reinforce the rhythms of the piece, including the kinesthetic sense of motion created by a strong axis and the thrusting of elements at angles against and away from that axis. Like much of the work of the other New York Abstract Expressionists, Smith's work addresses the viewer's sense of gesture in space; his sculptures always seem poised on the edge of moving between one position in space and another.

Organic and Color-Field Abstraction

Very different in approach from the improvisation and spontaneity of Abstract Expressionism were the architecture, sculpture, and painting in which suggestive organic forms and evocative fields of color hinted at myth, ritual, and the themes of psychology—especially Freud's ideas of sexuality and Jung's ideas concerning universal archetypes. The links with universal imagery were extremely important to artists working in these modes. Even architects with long careers behind them, like Frank Lloyd Wright and Le Corbusier, invested many of their buildings during the post-1940 period with powerful organic sculptural qualities.

The long, incredibly productive career of FRANK LLOYD WRIGHT ended with his design for the Solomon R. Guggenheim Museum (FIGS. 23-7 and 23-8), which was built in New York City between 1943 and 1959. Here, using reinforced concrete almost as a sculptor might use resilient clay, Wright designed a structure inspired by the spiral of a snail's shell. Wright had introduced curves and circles into some of his plans in the 1930s, and as the architectural historian Peter Blake noted: "The spiral was the next logical step; it is the circle brought into the third and fourth dimensions."* Inside the building, the shape of the shell expands toward the top, and a winding interior ramp spirals to connect the gallery bays, which are illuminated by a strip of skylight embedded in the museum's outer wall. Visitors can stroll up the ramp or be brought by elevator to the top of the building and proceed down the gently inclined walkway, viewing the works of art displayed along the way. Thick walls and the solid organic shape give the building the sense of turning in on itself, with the long viewing area opening onto a 90-foot central well of space that seems a sheltered environment secure from the bustling city outside.

*Peter Blake, *Frank Lloyd Wright* (Harmondsworth, Middlesex: Penguin Books, 1960), p. 115.

23-7 FRANK LLOYD WRIGHT, Solomon R. Guggenheim Museum, New York, 1943–1959 (exterior view from the north).

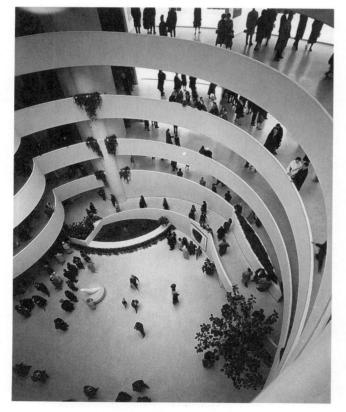

23-8 FRANK LLOYD WRIGHT, interior of the Solomon R. Guggenheim Museum.

The startling forms of LE CORBUSIER'S Notre Dame du Haut (FIG. 23-9), completed in 1955 at Ronchamp, France, challenge the viewer in their fusion of architecture and sculpture in a single expression. This small chapel on a pilgrimage site in the Vosges Mountains was designed to replace a building destroyed in World War II. The monumental impression of Notre Dame du Haut seen from afar is somewhat deceptive. Although one massive exterior wall contains a pulpit facing a spacious outdoor area for large-scale, openair services on special holy days, the interior holds at most two hundred people. The intimate scale, stark, heavy walls, and mysterious illumination (jewel tones cast from the deeply recessed stained-glass windows) give this space (FIG. 23-10) an aura reminiscent of a sacred cave or a medieval monastery. The structure of Notre Dame du Haut may look free-form to a lay person, but it is actually based, like the medieval cathedral, on an underlying mathematical system. The fabric was formed from a frame of steel and metal mesh, which was sprayed with concrete and painted white, except for two interior private chapel niches with colored walls, and the roof, which was left unpainted to darken naturally with the passage of time. The quality of mystery in the interior space is intensified by the way the roof is elevated above the walls on a series of nearly invisible blocks, which has the effect of making the roof appear to float freely

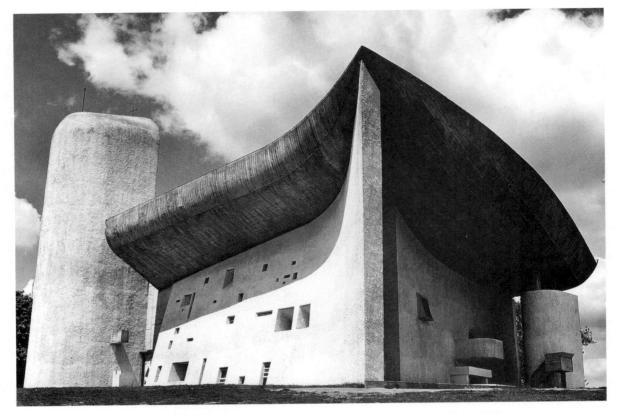

23-9 Le Corbusier, Notre Dame du Haut, Ronchamp, France, 1950–1955.

23-10 LE CORBUSIER, interior of Notre Dame du Haut.

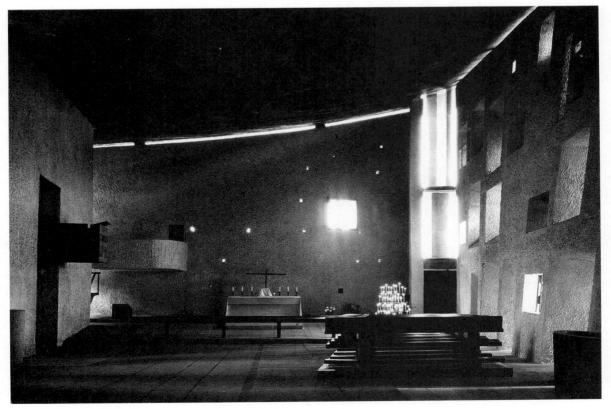

above the sanctuary. Le Corbusier's preliminary sketches for the building indicate that he linked the design with the shape of praying hands, the wings of a dove (representing both peace and the Holy Spirit), and the prow of a ship (reminding us that the Latin word used for the main gathering place in Christian churches is *nave*—"ship"). The artist envisioned that in these powerful sculptural solids and voids, human beings could find new values—new interpretations of their sacred beliefs and of their natural environment.

While Wright worked with inspiration from nature and Le Corbusier with the shared symbols and traditions of religion, LOUISE NEVELSON (1899-1988) created sculpture that combined a sense of the architectural fragment with the power of Dada and Surrealist found objects to express her personal sense of the underlying meanings of life. Multiplicity of meaning was important to Nevelson. She sought "the inbetween place . . . the dawns and the dusks" where one could sense the transition between one state of being and another. Born in Russia, Nevelson moved as a child with her family to Maine, where she began her training in music, dance, theater, painting, and the graphic arts. By the late 1950s, she was making assemblages of found wooden objects and forms, enclosing smaller sculptural compositions in boxes of

varied sizes, and joining the boxes to one another to form "walls," which she then painted in a single hueusually black, white, or gold. The monochromatic color scheme unifies the diverse parts of pieces like Tropical Garden II (FIG. 23-11) and also creates a mysterious field of shapes and shadows. The structures suggest magical environments that resemble the treasured secret hideaways dimly remembered from childhood. Yet, the boxy frames and the precision of the manufactured found objects create a rough geometrical structure over which the viewer's eye roams freely, lingering on some details before moving on. The parts of a Nevelson sculpture and their interrelation recall the Merz constructions of Kurt Schwitters (FIG. 22-29). The effect is also rather like viewing the side wall of an apartment building from a moving elevated train or looking down on a city from the air.

If Nevelson's works recall the allusive qualities of a nailed-together Dada work by Schwitters, the sculpture of the French-American artist LOUISE BOURGEOIS (b. 1911) is heir to the evocative biomorphic Surrealist shapes of Jean Arp. Bourgeois studied mathematics and art in Paris before moving to New York, where her early paintings and prints focus on the theme of the female body as a building. In her sculpture, her subject has been "groups of objects relating to each other . . . the drama of one among many." *Cumul I*

23-11 LOUISE NEVELSON, *Tropical Garden II*, 1957–1959. Wood painted black, 5' $11\frac{1''}{2} \times 10' 11\frac{3''}{4} \times 1'$. Musée National d'Art Moderne, Centre Georges Pompidou, Paris.

23-12 LOUISE BOURGEOIS, Cumul I, 1969. Marble, $22\frac{3\pi}{8''} \times 50'' \times 48''$. Musée National d'Art Moderne, Centre Georges Pompidou, Paris.

(FIG. 23-12) is a collection of round-headed units huddled within a collective cloak dotted with holes, through which the tops of the individual units protrude. The units differ in size, and their position within the group lends a distinctive personality to each. Although the shapes remain abstract, the reference to human figures is strong. Bourgeois uses a wide variety of materials in her works, including wood, plaster, latex, and plastics, in addition to alabaster, marble, and bronze. She exploits the qualities of the material to suit the expressiveness of the piece. In Cumul I, the fact that marble can take either a high gloss or a matte finish increases the sensuous distinction between the group of swelling forms and the soft folds that swaddle them. Like Hepworth (FIG. 22-51), Bourgeois connects her sculpture with the multiple relationships of the body to landscape: "[My pieces] are anthropomorphic and they are landscape also, since our body could be considered from a topographical point of view, as a land with mounds and valleys and caves and holes." However, Bourgeois's pieces are more personal and more openly sexual than those of the English sculptor. Cumul I represents perfectly the allusions Bourgeois seeks: "There has always been sexual suggestiveness in my work. Sometimes I am totally concerned with female shapes—characters of breasts like clouds—but often I merge the imagery—phallic breasts, male and female, active and passive."*

Nevelson's sculptures suggest whole environments, while Bourgeois likes to work with groupings that suggest communities. Painters with similarly expansive vision expressed a sense of limitless space by covering canvases with fields of color. Critics termed these artists "Color-Field painters." Among the earliest artists working in this way were Barnett Newman and Mark Rothko, who each explored a quieter esthetic than that followed by their contemporary associates, the New York Abstract Expressionists.

In the works of BARNETT NEWMAN (1905–1970), such "fields" of color suggest space of an almost purely perceptual kind. Newman's early works were organic abstractions inspired by his study of biology and his fascination with Native American art. Soon,

*In Deborah Wye, *Louise Bourgeois* (New York: Museum of Modern Art, 1982), pp. 22, 25, 27.

23-13 BARNETT NEWMAN, Vir Heroicus Sublimis, 1950–1951. 7' $11\frac{3''}{3} \times 17' 9\frac{4''}{3}$. Collection, The Museum of Modern Art, New York (gift of Mr. and Mrs. Ben Heller).

however, he simplified his compositions so that each canvas is filled with a single, modulated color split by narrow bands the artist called "zips," which run from one edge of the painting to the other. As the artist explained it, "The streak was always going through an atmosphere; I kept trying to create a world around it." Newman had a special feeling for scale, proportion, and the absolute quality of each particular hue, and he used these elements in large paintings to express his feelings about the tragic condition of modern life and the human struggle to survive. He said, "The artist's problem is the idea complex that makes contact with mystery-of life, of men, of nature, of the hard black chaos that is death, or the greyer, softer chaos that is tragedy." The title of his huge painting Vir Heroicus Sublimis (FIG. 23-13) suggests the epic nature of these themes. Newman used the vast color field as a way to engage even the peripheral vision of his viewers, to create a particular sense of sublime and infinite space.

The best known of the Color-Field painters is probably MARK ROTHKO (1903–1970), who, like Newman, used the Color-Field approach to represent the sublime. Rothko was born in Russia but grew up in the United States and studied liberal arts before becoming a painter. His early paintings were figurative works, but he soon came to believe that references to anything specific in the physical world conflicted with the sublime idea of the universal, supernatural "spirit of myth," which he saw as the core of meaning in art. In a statement co-written with Newman and another artist, Rothko articulated his beliefs about art: "We favor the simple expression of com-

plex thought. We are for the large shape because it has the impact of the unequivocal. We wish to reassert the picture plane. . . . We assert that . . . only that subject matter is valid which is tragic and timeless. That is why we profess spiritual kinship with primitive and archaic art."* Rothko gradually reduced his compositions to two or three large rectangles composed of layers of color with hazily brushed contours, spreading almost to the edges of the canvas. Subtle tonal variations in his works transcend the essentially monochromatic effect and create a mysterious sense of forms or images hovering in an ambiguously defined space. Works like Four Darks in Red (FIG. 23-14) are perceived at once as a whole. Their still, shimmering veils of color encourage a calm and contemplative mood in the viewer, and to maximize this effect, Rothko preferred that they be exhibited either in isolation or with other paintings by him.

Newman stretched one color to fill a vast canvas field and Rothko created radiant clouds of color that seem to float within the rectangular shape of his canvases; in the works of both artists, the paint lies on the surface of the canvas. The American painter HELEN FRANKENTHALER (b. 1928) was one of the first artists to explore the effects of drenching the fabric of the canvas with fluid paint. This technique, called *soak-stain*, was inspired by a series of paintings Pollock made in the early 1950s by pouring thinned black paint onto raw canvas—bare fabric that had not been treated with the traditional protective coating of glue

^{*}In Diane Waldman, Mark Rothko, 1903–1970: A Retrospective (New York: Solomon R. Guggenheim Museum, 1978), p. 39.

23-14 Макк Rothko, Four Darks in Red, 1958. 102" × 116". Collection of the Whitney Museum of American Art (gift of the Friends of the Whitney Museum of American Art, Mr. and Mrs. Eugene M. Schwartz, Mrs. Samuel A. Seaver, Charles Simon, and purchase).

23-15 HELEN FRANKENTHALER, Mountains and Sea, 1952. 7' $2\frac{5''}{8} \times 9' 9\frac{4''}{4}$. Collection of the artist, on extended loan to the National Gallery of Art, Washington, D.C.

23-16 SAM GILLIAM, Darted Again, 1974–1975. Acrylic on canvas, 51" × 96". Collection of the Joseph Caleb Community Center, Miami. Courtesy of the Fendrick Gallery, New York.

sizing nor covered with the traditional layer of colored or white primer paint. Frankenthaler's early work was influenced by the spatial complexity of Cubism and the free expressive abstraction of Kandinsky; these influences helped her to understand the implications for her personal style when she saw pictures of Pollock painting one of his works on raw canvas. Inspired by his method, she created Mountains and Sea (FIG. 23-15), whose forms were suggested by her memories of a summer doing watercolor studies of landscapes in Nova Scotia. For this seminal painting, Frankenthaler thinned her oil paint and choreographed the flow of liquid shapes over huge areas of raw canvas laid on her studio floor. However, she ignored Pollock's swinging lines in favor of fluid, flowing shapes, and she replaced Pollock's black-and-white color scheme with elegantly varied hues. In the 1960s, Frankenthaler began using watersoluble acrylic paint, which gave her a greater range of color and allowed a different degree of control over the creation of her shapes. The medium now soaked into the canvas support and dried without forming any of the "halo" silhouettes that occurred with the oil-based paints she used for her early soak-stain works. The method made her works look spontaneous, almost as if they had been conceived in the inspiration of a single moment. This quality is prized by the artist, but as she admits, it is not achieved without some effort, however masked that effort may seem to be in the final work:

A really good picture looks as if it's happened at once. It's an immediate image. For my own work, when a picture looks labored and overworked, and you can read in it—well, she did this and then she did that, and then she did that—there is something in it that has not got to do with beautiful art to me. And I usually throw those out, though I think very often it takes ten of those over-labored efforts to produce one really beautiful wrist motion that is synchronized with your head and heart, and you have it, and therefore it looks as if it were born in a minute.*

Since the early 1960s, African-American painter SAM GILLIAM (b. 1933) has expanded Frankenthaler's soak-stain method by exploiting the soft spreading flow of one hue into the next and by incorporating patterns made by creasing and pressing wet canvas surfaces to create rich, multicolored works. Gilliam was introduced to the soak-stain technique in Washington in 1962, after a more traditional painting career in Mississippi and Kentucky. Influenced in part by the Impressionists, Gilliam made the soak-stain approach his own by folding his canvases at various stages during the process of applying the paint. By 1968, he was designing his works to hang unframed, as pieces of stiff cloth, either pinned against the wall or standing free in space. In works like Darted Again (FIG. 23-16), Gilliam collaged together pieces cut from different stained canvases to create finished works in

^{*}In Barbara Rose, Frankenthaler (New York: Harry N. Abrams, 1975), p. 85.

which the free, amorphous stain shapes play against and with the crisp edges of the cut-out geometric fragments. The sources of this work stretch far beyond the New York and Washington art communities, as Gilliam has invested his Modernist soak-stain process with an individual energy partially based on the bold colors and patterns of tie-dye and other methods used in African and American folk art.

Formalist Abstraction

The art of abstract allusion was countered with formalist precision by artists who believed that pure form and crisp mathematical shapes were the most relevant means to express the new technological age. The majority of these artists favored the clarity of straight sides and simple shapes as eloquent representatives of scientific and man-made structures. Some architects working in this mode continued the simple block forms of the International Style. Others built fantastical structures based on curved mathematical planes or played prismatic triangular shapes against one another to create magical interior spaces. Painters and sculptors stripped their formalist abstract compositions to basic shapes and colors or pursued an opposite strategy by creating complex and lively arrangements of geometrical patterns that dazzled the eyes of their viewers.

The purest shape created in post-World War II architecture undoubtedly is the rectilinear glass and bronze tower in Manhattan (FIG. 23-17) designed for the Seagram Company by MIES VAN DER ROHE and PHILIP JOHNSON (b. 1906). By the time this structure was built (1956–1958), the concrete, steel, and glass towers of the International Style, which had been pioneered in the works of Louis Sullivan (FIG. 21-98) and in Mies van der Rohe's own models for glass skyscrapers (FIG. 22-61), had become a familiar sight in cities all over the world. Appealing in its structural logic and clarity, the style, although often vulgarized, was easily emulated and quickly became the norm for postwar, commercial high-rise buildings. The Seagram Building still stands as a perfect statement of the best aspects of the International Style. The architects deliberately designed the building as a thin shaft, leaving the front quarter of the structure's midtown site as an open pedestrian plaza. The tower appears to rise from the pavement on stilts; even the recessed lobby is surrounded by glass walls. The bronze metal and the grey glass windows give the building a richness found in few of its neighbors. Every detail, inside and out, was carefully planned to create an elegant whole; even the interior and exterior lighting were planned to make the edifice an effective sight by day or by night.

23-17 LUDWIG MIES VAN DER ROHE and PHILIP JOHNSON, Seagram Building, New York, 1956–1958.

In stark contrast to the simple, blocky form of the Seagram Building are the fanciful mathematical curves in the works of the engineer-architects Pier Luigi Nervi and Frei Otto. Like the designers of Coalbrookdale bridge (FIG. 20-26) and the Eiffel Tower (FIG. 21-96), Nervi and Otto created beautiful structures by combining mathematical form and modern construction materials. PIER LUIGI NERVI (1891-1978) used the remarkable tensile strength of prestressed concrete to cover huge spaces with designs of dazzling geometric beauty. His method and materials made it possible to omit the spare, steel supporting columns of the International Style. In 1958, he used prefabricated concrete units to create the spectacular Y-shaped flying buttresses that support the scallopedged, circular dome over his Palazzetto dello Sport in Rome (FIG. 23-18). (In an effect much like that of the buttresses in Gothic cathedrals [FIGS. 10-10 and 10-20], the buttresses here carry the lateral thrust of the vaults to the ground.) Nervi's style had a grace and crispness of detail that belong to a new vision of

23-18 PIER LUIGI NERVI, Palazzetto dello Sport, Rome, 1958.

architectural form, a vision that is organic rather than mechanical.

FREI OTTO (b. 1925) has combined different traditions in the mathematical designs of the temporary pavilions he created for events at the 1972 Olympic Games in Munich (FIG. **23-19**). Here, the gossamer plastic membrane suspended from his system of upright poles and support wires created an airy, transparent, tentlike enclosure that provided a vast area of enveloped space without the interruption of interior supports. In such works, Otto exploited the tensile strength of steel to create a structural system based on *tension*, the engineering principle used in suspension bridges. He combined this structural system

23-19 FREI OTTO, model for the roof of the Olympic Stadium, Munich, 1971-1972.

23-20 I. M. PEI, East Building of the National Gallery, Washington, D.C., 1978 (*above*); site plan of the East Building (*below*).

with the fabric walls and pole supports used in the homes of nomadic peoples and in the enclosed booths and showplaces of traveling fairs and circuses. By comparison, Nervi's Palazzetto seems massive and dense. For all his experiments with prestressed concrete, Nervi still conceived of structure in traditional terms of *compression*, the basic principle underlying all the architecture we have studied to this point, from the Egyptians onward. Otto, on the other hand, used his mathematical system to work with traditions of impermanent buildings and utilitarian structures in order to provide a festive, almost spontaneous look for his special-occasion works.

I. M. (IEOH MING) PEI (b. 1917), an American architect born in China, combined pristine geometric shapes to create versatile spaces suited to the dynamic pace of activities in a modern art museum in his award-winning design for the East Building of the National Gallery in Washington, D.C. (FIG. 23-20). An irregular, trapezoidal site had been set aside in 1937 for the expansion of the main building-a handsome, domed, Neoclassical structure of the Jeffersonian type, built in 1941. The new East Building was designed to complement the older West Building by aligning with its axis (the two structures are connected by an underground, moving walkway) and by wearing a facing of the same pink Tennessee marble that adorns the older structure. In Pei's design, the awkward building site became a virtue made of necessity, somewhat as the Campidoglio (FIG. 17-29) had in the hands of Michelangelo. Pei ingeniously maximized his use of the difficult site by bisecting the trapezoid into a large isosceles triangle and a smaller right triangle. The larger triangle, with its diamondshaped towers, provides exhibition space; the smaller, with its dramatic wedge shape (the walls meet in a sharp nineteen-degree angle), provides space for art-historical research. The two are unified by a vast, faceted skylight 80 feet above a spacious courtyard six levels high. The great central courtyard was designed both as an internal reception "piazza" and as the large public area necessary to accommodate crowds of people for the special events that are a part of the museum's role in the Washington social scene. The glass tetrahedra of the skylight (FIG. 23-21), with their complex tracery of frames, seem to change, multiply, and create shapes as one moves. The experience of fluid space and transformation of form is intensified by the Alexander Calder mobile that hangs majestically above the courtyard. Bridges, escalators, and stairways casually connect the central space with numerous irregularly shaped and randomly placed galleries, which range in size from those intimate enough to show very small pictures to those ample enough to accommodate the largest canvases of the New York school. The whole structure is a marvel of coherence and order and a triumph of craftsmanship down to the least detail; the last is creditable to the donor, who stipulated that no expense be spared in bringing the building to perfection. This collaboration of patron and architect is reminiscent of that of the Medici and the artistic geniuses of the Renaissance.

The dynamism of Otto's pavilion and Pei's museum was created through mathematical shape and line. In painting, VICTOR VASARELY (b. 1908) achieves two-dimensional visual energy by controlling color and the placement of mathematical shapes. After studying medicine and then art in Hungary, Vasarely arrived in Paris in 1938 to work in advertising. As an admirer of De Stijl, the Bauhaus, Constructivism, and the influential theories about optical illusions that can

23-21 I. M. PEI, interior of the East Building of the National Gallery. (Mobile shown in the foreground by ALEXANDER CALDER.)

be created with color developed by the chemist and philosopher Wilhelm Ostwald, Vasarely was interested in optical and structural effects, especially the three-dimensional illusions produced by introducing mathematical perspective into patterns of stripes or checkerboards. Paintings like Orion (FIG. 23-22) attract the eye with their regular order and bright colored shapes. A longer look reveals that the rows of flat squares filled with circles and ellipses do not lie flat on the surface of the canvas. Instead, the eye reads one square in relation to the next so that the darkening or lightening of the ground, any shifts from warm to cool hues, and all changes in the size or shape of the central form create illusions of movement in space as the eye travels along a row of squares. In the 1950s and 1960s, especially, Vasarely dreamed of filling whole cities with buildings whose walls would vibrate with his patterns, echoing in pure abstraction the dynamism of modern urban life. His works were sometimes connected with the so-called Op Art of the 1960s, and his theories inspired a number of younger artists in Paris to form the Groupe de Recherche d'Art Visuel (Research Group for Visual Art) to explore similar ideas.

A very different mode of formalist abstraction from Vasarely's visual complexity were paintings so cleanly brushed, so unrevealing of the process by which they were made, that they were called "Post-Painterly Abstraction" by the critic Clement Greenberg. ELLSWORTH KELLY (b. 1923) is one of the bestknown artists working in this way, which aims at a radical simplicity and purity of shape and color related to works by Malevich (FIG. 22-48) and Mondrian (FIG. 22-50). Unlike the earlier artists, however, the Post-Painterly Abstractionists do not intend their compositions to symbolize anything beyond the

23-22 VICTOR VASARELY, Orion, 1956. Paper on paper mounted on wood, $6' \ 10\frac{1}{2}'' \times 6' \ 6\frac{3}{4}''$. Hirshhorn Museum and Sculpture Garden, Smithsonian Institution, Washington D.C. (gift of Joseph H. Hirshhorn, 1966).

23-23 ELLSWORTH KELLY, Red, Blue, Green, 1963. Approx. 7' × 11' 4". Courtesy of the Sidney Janis Gallery, New York.

patterns of color and shape that can be seen by the eve. They delight in the optical effects of color against color and shape against shape, on huge canvases that fill entire walls and the entire field of a viewer's vision. Kelly studied art before serving in the camouflage unit of the U.S. Army Corps of Engineers during World War II. Intrigued by the fact that camouflage patterns are able to misdirect the eye, he began exploring parts of the visual world that generally go unnoticed-the patterns made by the shadow of a railing falling along a flight of steps, or by a series of window blinds pulled to individual heights by the inhabitants of a row of apartments. He treated such details as found images, removing them from their context and reducing them to their basic forms. He also experimented with using chance to determine the color sequence in grid paintings. Finally, he enlarged the shapes in his paintings so that just a few hard edges defined one shape against a "ground" of a different color that could itself be read as a form. The scale of Kelly's Red, Blue, Green (FIG. 23-23)-7 feet high by 12 feet long-makes it a kind of hardedge Color-Field painting, within which the three hues, shaped by the contours of their areas, act with and against each other. Indeed, Kelly's work, and that of other artists working with a similar clear, crisp Abstract Formalism was called "Hard-Edge Abstraction" by some critics.

The paintings of Post-Painterly Abstraction have no reference to the world outside of their compositions. Critics dubbed sculptures that similarly banished all reference beyond themselves "Minimal art" or "primary structures," because of the extreme reduction of their shapes and textures. By its very nature, sculpture is less illusionistic than painting. All elements of a sculptural composition are more literally a part of our physical space than are the details of most paintings. This powerful sense of the physical presence of sculpture caused many minimalist sculptors to speak of their pieces as "presences." One of the most rigorous practitioners of the Minimalist approach in sculpture is DONALD JUDD (b. 1928). To his sculpture, Judd brings his study of art history and his experience as a painter and critic. He aspired to create sculpture so unified in effect that even if a piece had more than one part, the parts would be seen as a whole rather than in relation to one another. To Judd and the other Minimalists, this unity is the basic and true statement of form in space; anything else is a distortion. Against all two-dimensional space that invites illusionistic figuration, including even Mondrian's paintings (FIG. 22-50), the Minimalist sculptors insist that only the spatial wholeness of the third dimension in the simple reductive shapes of solid geometry contains the truth of art. In the untitled work illustrated here (FIG. 23-24), Judd aligned eight identical, brightly machined stainless-steel cubes in the center of a gallery floor. Even though this grouping includes a series of distinct box forms, no single shape stands out. The only real difference among the cubes is one of placement within the group. The cubes' identical repetitiveness creates, for

23-24 DONALD JUDD, untitled, 1968. Stainless steel, each box is 4' sq. Collection of Miles Fiterman, Minneapolis.

Judd, the sense of wholeness he sought. As in Post-Painterly Abstract painting, little trace of the artist can be seen in this work; the surfaces of the cubes exhibit, in their superhuman precision and exactitude, the depersonalized technological order that produced them. Although none of Judd's structures is intended to carry an allusion to anything outside itself, he is as interested as Kelly in making us aware of how we see form in space. The scale of the whole work is huge, but the modules of each box are comprehensible in terms of human size. This characteristic can help us to sharpen our ability to perceive three-dimensional forms because the identical units serve as visual markers for measuring an area of wall space and the section of air before it. Our viewing of form in space, however, is also complicated by the playful way in which these clear, Minimal shapes appear to dissolve as their polished sides reflect their neighbors and the environment around them.

By the end of the 1960s, some Minimal artists tired of Minimal art's restrictive, reductive forms and reintroduced a sense of visible process in their work. Eva HESSE (1936–1970), a Minimalist in the early part of her career, was a leading figure in this approach, called Post-Minimalism by the critics. Using nontraditional sculptural materials like fiberglass, cord, and latex, Hesse created sculpture in which the pure forms of Minimal art appear to crumple, sag, and warp under the pressures of atmospheric force and gravity. Born a Jew in Hitler's Germany, Hesse was hidden as a child with a Christian family when her parents and elder sister had to flee the Nazis, and only was reunited with them in the early 1940s, just before her parents divorced. This complex set of extraordinary circumstances helped to give her a lasting

sense that the central qualities of modern life are strangeness and absurdity. Struggling to express these qualities in her art, she created informal sculptural arrangements in which units often hung from the ceiling, leaned against the walls, or spilled out along the floor. She said she wanted her pieces to be "non art, non connotive, non anthropomorphic, non geometric, no nothing, everything, but of another kind, vision, sort." Amazingly, Hang-Up (FIG. 23-25) fulfills these requirements. The piece looks like a carefully made, empty frame sprouting a strange feeler that extends out into the viewer's space. Hesse wrote that in this work, for the first time, her "idea of absurdity or extreme feeling came through." In her words, "[Hang-Up] has a kind of depth I don't always achieve and that is the kind of depth or soul or absurdity of life or meaning or feeling or intellect that I want to get."* Absurd and nontraditional the piece certainly is, but it also possesses a disquieting and touching presence, suggesting the fragility and grandeur of life amidst the pressures of the modern age.

*In Linda Shearer, *Eva Hesse: A Memorial Exhibition* (New York: Solomon R. Guggenheim Museum, 1972), unpaginated.

23-25 Eva Hesse, Hang-Up, 1965–1966. Acrylic on cloth over wood and steel, 6' × 7' × 6' 6". The Art Institute of Chicago (gift of Arthur Keating and Mr. and Mrs. Edward Morris by exchange).
© 1990 The Art Institute of Chicago. All rights reserved.

ART WITH PSYCHOLOGICAL AND CONCEPTUAL CONCERNS

During the second half of the twentieth century, most art could be classified as displaying some element of psychological or conceptual concerns; most artists wanted to touch the emotions of viewers as an antidote to the numbing trauma of World War II. The desire to touch the emotions of viewers underlay the improvisational methods of Abstract Expressionism, the allusive symbolism of Organic Abstraction, and the intimations of sublime space in Color-Field painting. Artists with political concerns also attempted to use the content of their work to address the feelings and psyches of viewers. But for a number of other artists, psychological and conceptual concerns affected both the content and the mode of expression in their work. Some of this latter group of artists used the human figure or images of the human environment symbolically to express the experience and conditions of human life in what often has been perceived as the dark and savage present. Others used figurative art in their exploration of the expressive possibilities of new technological media, while a different group concentrated on exploring the mechanisms of artistic expression conceptually, focusing the viewer's attention on how each medium communicates ideas. Finally, beginning in the 1970s, other groups-Postmodernists and Deconstructionistsexamined art and its communicative powers by appropriating and analyzing historic and cultural styles.

Expressionist Figuration

Just as many artists believed that only abstract art could adequately express human feelings and ideals amid the chaos of the post-1940 world, other artists continued to believe that the things of the real world remain the most powerful means to touch the hearts and minds of viewers. This second group of artists felt that any art representing the reality of the human condition could not ignore the links between the appearance of the physical world and the perceptual and psychological responses of artists and viewers to that world. Some of these individuals concentrated on the human figure. Others invented new forms of narrative to suit the conditions of modern life. Still others experimented with art that makes viewers more aware of their relationship to the physical environment. All tried to put viewers back in touch with their deepest human feelings of connectedness to each other and to the planet on which we live. For large numbers of artists, the human body remained the most potent subject by which to accomplish this

goal in art. The majority of these artists expressed, through distorted anatomy, the modern struggle for survival in an increasingly chaotic world, but some represented this distortion with humor, and even in the most troubled times, a few managed to use a calm, ideal style that stated their continued belief in beauty and the eternal qualities of the human spirit.

Among the most successful of the rare artists who used the human figure as a symbol of hope and beauty during this period is the Italian sculptor GIACOMO MANZÙ (b. 1908). Manzù's sculptures combine something of the humanism of Maillol (FIG. 22-44) with the simple expressiveness of Barlach (FIG. 22-22). Although Manzù is not a practicing Catholic, his sculptures of cardinals, serene female nudes, and relief panels on religious subjects all express his belief in the unquenchable and enduring nature of the human spirit, which survives even the brutalizing effects of the modern age. Works like *Cardinal* (FIG. **23-26**) combine the artist's love for Antique sculpture

23-26 GIACOMO MANZÙ, Cardinal, 1949–1951. Bronze, 44" high. Museum Ludwig, Cologne.

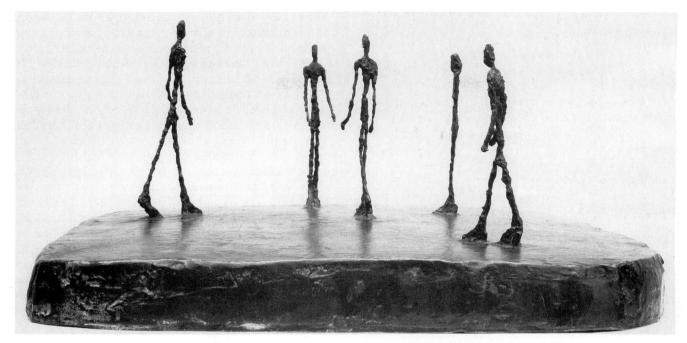

23-27 ALBERTO GIACOMETTI, City Square (La Place), 1948. Bronze, $8\frac{1}{2}'' \times 25\frac{3}{8}'' \times 17\frac{1}{4}''$. Collection, The Museum of Modern Art, New York (purchase).

and for the works of Donatello (FIGS. 16-6 and 16-12) with his admiration for the sculpture of Rodin (FIG. 21-55) and Rosso (FIG. 21-79). *Cardinal* is one of Manzù's many freestanding sculptures of clerics in which the strong, simple, elegant shapes of the cardinal's robes and ecclesiastical headgear and the still, frontal stance create a mood of protection and security. The sense of enduring calm is humanized by delicately modeled irregularities in the surface, creating a potent statement of faith in the basic strength and goodness of the human spirit.

Much more common to figurative sculpture in the postwar period than Manzù's hopeful works was the use of expressive distortion to suggest the anguish and torment of the human spirit. One of the earliest artists to adopt this approach was the Swiss sculptor ALBERTO GIACOMETTI (1901–1966), who, in the 1940s, turned from his earlier Cubist and Surrealist work to the roughly modeled, emaciated figures for which he is best known. Giacometti found that his sculptured figures seemed most real when they represented a human form at the distance from which one would be able to recognize an approaching person as an acquaintance. To achieve this effect, Giacometti covered basic wire figures with rough blobs of clay or plaster to create the impression of individual faces and body features. Seen from afar, the figures seem full of specific details, but these do not materialize as one moves closer. In sculptures like City Square (La Place, FIG. 23-27), Giacometti's pencil-thin, elongated figures stride abstractedly through endless space; they never meet. At certain angles, the forms are so attenuated that they almost disappear, just as in the human condition, people often fade noiselessly out of sight. Such figures suggest to many viewers the modern experiences of bewilderment, loss, and alienation-the increased sense of strangeness and loneliness felt by people in contemporary urban society. Giacometti denied that this was his theme; he insisted that he was merely trying to render the effect of great space as it presses around a figure and nothing more. He was apparently unwilling to recognize the way in which such a representation might echo the modern individual's awareness of the distance in physical and psychic space that separates one human being from another. If we compare Giacometti's figures with those in Rodin's Burghers of Calais (FIG. 21-55), we can readily appreciate the changes wrought during the first half of the twentieth century in the interpretation of the human form in art.

Some artists, like Giacometti, may have discounted a psychological reading of their works, but the existential anguish that permeates the work of the British artist FRANCIS BACON (b. 1909) has been a conscious part of his expression throughout his career. The human struggle against the bestial forces in society and human nature is visible in many of Bacon's paintings. Drawing inspiration from sources as varied as Muybridge's photographs of wrestlers and the image of the screaming face of a wounded nurse in

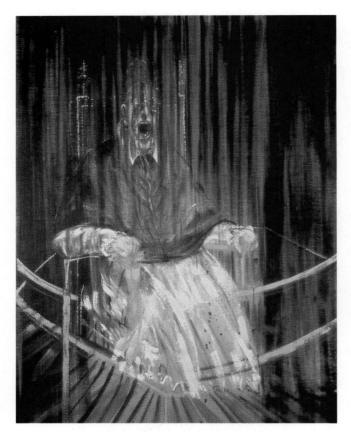

23-28 FRANCIS BACON, Study after Velásquez's Portrait of Pope Innocent X, 1953. 5' $\frac{4''}{4''} \times 3'$ $8\frac{3''}{8}$. Des Moines Art Center (Nathan Emory Coffin Collection, purchased with funds from the Coffin Fine Arts Trust).

Eisenstein's film Battleship Potemkin, Bacon has invented a setting and situation in which human figures are perpetually being stretched in extremis. In Study after Velásquez's Painting of Pope Innocent X (FIG. 23-28), the individual who once posed selfconfidently for the seventeenth-century Spanish painter has been transplanted into a twentieth-century space-cage and suffers unbearably from unseen horrors. His mouth is wrenched open in an agonized scream, at once more personal and more terrifying than that of Munch's screaming man (FIG. 21-92). The figure merges with the dark rays of the miasma surrounding it, imprisoned as if bound in an electric chair, and wracked by suffering so severe that it is almost unbearable to look at the image. The comfort, security, and promise of Manzù's Cardinal have vanished here. For Bacon, existence is fraught with change and the sense that reality is eternally elusive. His style is crafted to express this: "I would like my pictures to look as if a human being had passed between them, like a snail, leaving a trail of human presence and memory trace of past events, as the snail leaves its slime."

In Bacon's work, blur suggests the shifting, uncertain, and ongoing stress of human existence, compressing segments of time and emotion into single images; the American artist DUANE MICHALS (b. 1932) uses blur in photographs to provide glimpses into the world of dreams and unseen forces. His experience as art director for Dance Magazine, his admiration for the work of Atget (FIG. 22-32), and his study of Zen Buddhism and Surrealist art may have sharpened his interest in depicting time and psychological space in his work. Michals creates groups of separate images in series to suggest narratives occurring over time. He constructs his works in ordinary settings, using blurred or superimposed images to represent spiritual or ghostly presences. Typical of his series work is Death Comes to the Old Lady (FIG. 23-29), which visualizes its metaphysical subject in the most mundane terms. An old woman sits in a nondescript room near a doorway leading into a room behind. An old man approaches from the back room and passes in front of the woman without acknowledging her presence. As he departs, she rises to follow and her form dissolves into a blur of motion. Here, death is a familiar contemporary and companion. The quality of the moment is expressed with the casual literalness and grainy soft-focus of an ordinary snapshot. Nothing in this vision of death echoes the heroism or pathos seen in West (FIG. 20-32), David (FIG. 20-41), or Goya (FIG. 21-26); instead, Michals depicts the kind of peaceful death we all might wish for.

The stoic, everyday toughness of the human spirit is the subject of figurative works by the Polish fiber artist Magdalena Abakanowicz (b. 1930). A leader in the recent exploration in sculpture of the expressive powers of weaving techniques, Abakanowicz gained fame with experimental, freestanding pieces in both abstract and figurative modes. For Abakanowicz, fiber materials are deeply symbolic: "I see fiber as the basic element constructing the organic world on our planet, as the greatest mystery of our environment. It is from fiber that all living organisms are built—the tissues of plants and ourselves. . . . Fabric is our covering and our attire. Made with our hands, it is a record of our souls."* To all of her work, the artist brings the experiences of her early life as a member of an aristocratic family disturbed by the dislocations of World War II and its aftermath. Initially attracted to weaving as a medium that would adapt well to being used in the small space she had available for a studio, Abakanowicz gradually developed huge abstract hangings, called Abakans, which suggest organic spaces as well as giant pieces of clothing.

^{*}In Mary Jane Jacob, *Magdalena Abakanowicz* (New York: Abbeville, 1982), p. 94.

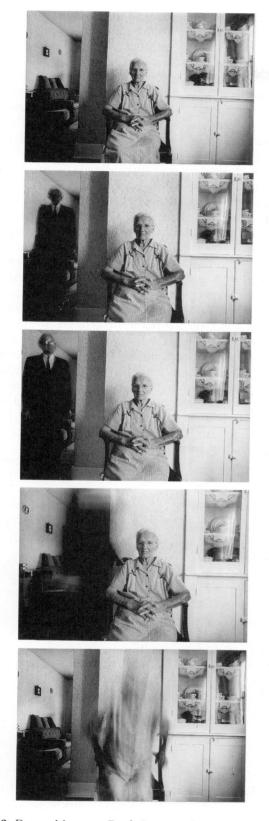

23-29 DUANE MICHALS, Death Comes to the Old Lady, 1969. Gelatin silver prints. Collection, The Museum of Modern Art, New York (The Parkinson Fund).

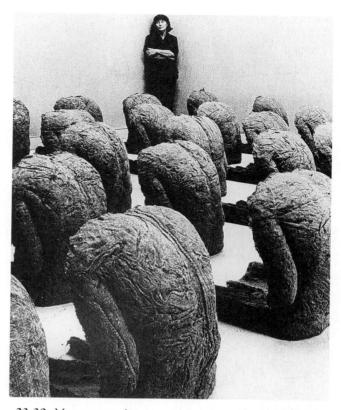

23-30 MAGDALENA ABAKANOWICZ, artist with Backs, at the Musée d'Art Moderne de la Ville de Paris, 1982.

She returned to a smaller scale with works based on human forms-Heads, Seated Figures, and Backsmultiplying each type for exhibition in groups as symbols for the individual in society, lost in the crowd yet retaining some distinctiveness. This impression is especially powerful in an installation of Backs (FIG. 23-30), each piece of which was made by pressing layers of natural organic fibers into a plaster mold depicting the slumping shoulders, back, and arms of a figure of indeterminate sex, which rests legless directly on the floor. The repeated pose of the figures in Backs suggests meditation, submission, and anticipation. Although made from a single mold, the figures achieve a touching sense of individuality by means of the slightly different posture each assumed as the material dried and as a result of the different pattern of fiber texture imprinted on each.

Abakanowicz's *Backs* have a rough, primitive look, yet they clearly are the work of a highly trained artist. Their rough quality reminds us, however, that many twentieth-century painters and sculptors admire the powerful, direct vision of artists who create without traditional academic training in art. Recent decades have seen a widespread appreciation for the expressive qualities of works like *Baboon* (FIG. **23-31**), by the self-taught Mexican-American sculptor FELIPE

23-31 FELIPE ARCHULETA, Baboon, 1978. Carved and painted wood, glue, and sawdust, 3' 10¹/₂" × 3' 6¹/₂" × 13". Herbert Wade Hemphill, Jr. Collection.

ARCHULETA (b. 1910). Coming late to sculpture, after working as a day laborer and carpenter, Archuleta specializes in imaginative, visionary representations of animal personalities. His figures owe much to a Spanish-American tradition of simple, painted wooden folk sculptures of holy figures called santos, but Baboon is the product of an authentic original vision. Its stiff alertness seems as closely related to the magical presence of figures and animals in paintings by the self-taught French painter Henri Rousseau (FIG. 21-90) as to local American versions of sacred Spanish imagery. Like all of Archuleta's work, Baboon has a jaunty vitality and a somewhat off-beat spirit that make it speak strongly as a metaphor for the powerful life of nature, which we must not ignore in our fascination with the technological age.

The primal forces suggested in the works of Abakanowicz and Archuleta are given new expression in the mixed-media works of the Mexican-American artist MANUEL NERI (b. 1930), who combines Expressionism and Classicism in sculptured and painted representations of female nudes. Trained as an Expressionist ceramist, Neri began making rough-textured improvisational sculpture with plaster and found objects, often splashing the surface of his figures with vivid strokes of paint. More recently, Neri has found a different vision in which painted compositions related to Gestural Abstract Expressionism form the background for nude bronze figures, which combine almost Classical proportions with rough modeling of some details. Typical of this work is Mujer Pegada Series No. 2 (FIG. 23-32), with its expressive interplay between multiple possible meanings of the words in the title and the complex visual dialogue that occurs between the bronze relief woman taking shape at the left, the ghostly figure silhouetted in thick paint in the center, and the swirling painted shapes in the surrounding space. Further tension between painting and sculpture springs from the fact that the figure stands on a ledge projecting from the painted back plane, which, on close inspection, turns out to be bronze rather than the canvas intimated by its appearance. Neri used expressive techniques here that recall those used by Van Gogh (FIG. 21-84), Rouault (FIG. 22-17), De Kooning (FIG. 23-3), and Bacon (FIG. 23-28), but Neri's work

23-32 MANUEL NERI, Mujer Pegada Series No. 2, 1985–1986. Bronze with enamel paint, 5' 10" × 4' 8½" × 11¼". Laila and Thurston Twigg-Smith, Honolulu.

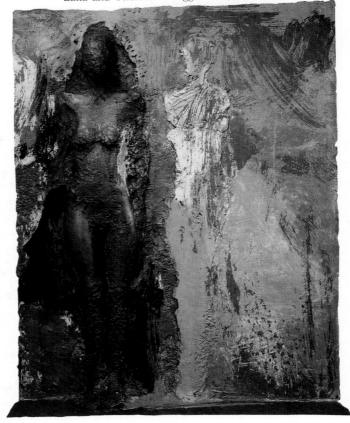

does not carry the anguished undertones of these earlier artists. Instead, *Mujer Pegada Series No. 2* evokes the total mental and emotional experiences of a woman in today's world. The way in which the painted and sculptured forms seem to slip between one state and another reinforces the resonating sense of shifting thoughts and feelings.

If Neri's Expressionism conveys the universal human experience we first saw in the Venus of Willendorf (FIG. 1-13) in a modern psychological guise, the recent paintings of American artist LEON GOLUB (b. 1923) depict the psychological effects of experiencing the world at second hand, through the news media. Golub's early subjects developed from symbolic pictures of seers and kings to paintings of heroic, damaged, Everyman figures. In the 1960s, Golub painted mythic battles between crudely rendered groups of naked giants inspired by ancient Hellenistic reliefs. The work for which he is best known, however, deals with the violent events of our own time-the implied narratives we have learned to read in news photos of anonymous characters participating in the brutalities of street violence, terrorism, and torture. Paintings in Golub's Assassins and Mercenaries series suggest not specific stories, but a condition of being. As the artist has said: "Through media we are under constant, invasive bombardment of images-from all over-and we often have to take evasive action to avoid discomforting recognitions. . . . The work [of art] should have an edge, veering

between what is visually and cognitively acceptable and what might stretch these limits as we encounter or try to visualize the real products of the uses of power."* Mercenaries (IV) (FIG. 23-33) is a huge canvas that represents a mysterious tableau in which three mercenaries (tough, free-lance, military professionals willing to fight for any political cause) cluster at the far right of the canvas, in the process of reacting with tense physical gestures to something being said by one of the two other mercenaries standing at the far left. The dark uniforms and skin tones of the four black fighters flatten their figures and make them stand out against the searing, flat red background, which seems to push their forms forward toward the picture plane and becomes an echoing void in the space between the two groups. The menacing figures loom over the viewer. Golub has painted them as if our eyes are level with their knees, placing the men so close to the front that their feet are cut off by the painting's lower edge and we are trapped with them in the painting's compressed space. Our gaze is drawn repeatedly to the scarred, light tones of the white leader's skin and to the weapons, modeled with shadow and gleaming highlights, which contrast with the harshly scraped, flattened surfaces of the figures. The feeling of peril confronts the viewer mercilessly; we become one with all the victims who have been caught by the political battles of our age.

*In Richard Marshall and Robert Mapplethorpe, 50 New York Artists (San Francisco: Chronicle Books, 1986), pp. 48–49.

23-33 LEON GOLUB, Mercenaries (IV), 1980. Figures life size. Courtesy Susan Caldwell Gallery/Barbara Gladstone Gallery.

23-34 JOANNE LEONARD, Julia and the Window of Vulnerability, 1983. Photograph with chalk pastel, 20" × 16". Collection of Rene di Rosa, Napa, California. Courtesy of Jeremy Stone Gallery, San Francisco.

Like Golub, JOANNE LEONARD (b. 1940) has been haunted by the fragility of human life in the present day. She explores this theme, however, in the light of her personal experience. Convinced from childhood that "photography should say something about people's lives," Leonard studied social sciences and used her camera to document the social environment around her, especially that of her own life and of other women she knew. Gradually she began to add details on the surfaces of her black-and-white photographs, using collage techniques and oil crayons to depict the effects of the interior, psychological world upon the exterior, physical one. Her Dreams and Nightmares series deals with the painful disintegration of a marriage. The Dream Kitchens series inserted painted, housewifely fantasies of outdoor scenes into the back walls of photographed kitchen counters and stoves. The works in the series Julia and the Window of Vulnerability (FIG. 23-34) are concerned with Leonard's fears for the future of the earth and for her young daughter, Julia. The pensive photograph of the girl is framed in a sketchily drawn window-house suspended in a dark sky. The image becomes an illustration of a narrative told in the mind of each viewer,

based on that individual's personal experiences of risk, hope, and fear.

Leonard's work approaches the fate of humankind through the life of the individual. The German artist ANSELM KIEFER (b. 1945) tackled the same theme with a personal iconography that refers to his country's mythic past, its more troubled twentieth-century history, and the vital participation of human beings in all of that history. Kiefer noted that he paints in layers: "Each layer shines through and so I work according to a kind of 'inverted archeological' principle." In later works, the layers may be tangible (crusted with paint and materials like straw and wood), as well as mental. Kiefer's earlier paintings, like Vater, Sohn, Heiliger Geist (Father, Son, Holy Ghost, FIG. 23-35), are large and relatively thinly painted, but they contain multiple strands of the symbols and themes important to him. In Vater, Sohn, Heiliger Geist, three

23-35 ANSELM KIEFER, Vater, Sohn, Heiliger Geist (Father, Son, Holy Ghost), 1973. Oil, charcoal, synthetic resin on burlap, 9' 6" × 6' 24". Collection of Jeanette and Martijn Sanders.

sketchy chairs sit in a bare, wood-paneled room patterned after the attic studio in an old schoolhouse used by Kiefer at the time this work was painted. Hovering within each seat is a briskly burning flame. Below the scene in the room is a second, slightly larger canvas, containing a view through densely packed rows of almost dead tree trunks that stand in a deserted forest. Steep perspective and carefully rendered wood grain transform the attic room into a vast hall. Rough, handwritten words-"Vater, Sohn, hl. [for heiliger] Geist"-scrawled across the top of the forest scene identify the three chairs/flames as members of the traditional Christian Trinity: "Father, Son, Holy Ghost." The forest scene, the bare room, the flames, and the words all call up associations in the viewer's mind. Memory joins with the viewing of the canvas in the present to create layers of experience for the observer. The jump between the canvases, the sketchy forms, and the unevenly brushed paint surfaces all heighten the feeling of flux related to Kiefer's belief that humans function at full power only when connected with the ongoing processes of history: "History for me is like the burning of coal, it is like a material. History is a warehouse of energy." The energy is produced, like that created when flammable materials burn, by an "exchange of materials."* In this painting, the wooden walls, chairs, and trees are all potential sources of energy for the spirit flames that govern the future.

Pop Art

Although the turmoil of World War II was responsible for the mood of desperation and suffering that inspired much expressive figurative art, the war's aftermath brought a vast increase in the production and availability of consumer goods, especially in the United States, with a concurrent rise in billboard, magazine, and newspaper advertising to entice the public to buy brand items "guaranteed" to provide a "good life." In England, Europe, and the United States, artists soon were using the images, artifacts, and style of American advertising as emblems of the sumptuous, materialistic side of modern life. For artists living under the conditions of postwar austerity outside the United States, the images spoke of a life of almost unimagined richness and surfeit. In England, the critic Lawrence Alloway invented the term "Pop Art" to describe the interest in the artifacts of popular culture, and the term was soon applied to art that adopted the look and the techniques of advertis-

*In Peter Winter, "Whipping Boy with Clipped Wings," and "Interview at Diesel Strasse," *Art International* (Spring 1988), pp. 64, 70.

ing, industrial design, Hollywood movies, and illustrations in pulp literature. A group of young artists, architects, and writers joined Alloway to form the Independent Group at the Institute of Contemporary Art in London. This group's members sought to initiate fresh thinking in art, in part by sharing their fascination with the symbol and content of American advertising, comic books, and popular movies. In America, artists used Pop images to give art the immediacy of life. Some Pop artists mixed mass-media images with gestural painting and found objects, some rendered advertising images with commercial art techniques, and some used Pop motifs to pose questions about the nature of verbal and visual symbols. By the early 1960s, Pop Art was an important force in England, New York, California, and Europe, especially France and Italy. Its success with the public was due in large part to its use of easily recognizable images, an iconography of commerce and culture as widely known in the modern world as earlier symbols tied to religion and government had been in premodern society.

Discussions at the Independent Group in London probed the role and meaning of symbols from mass culture and the advertising media. In 1956, a group member, RICHARD HAMILTON (b. 1922), made a small collage, Just What Is It That Makes Today's Homes So Different, So Appealing? (FIG. 23-36), that symbolized many of the attitudes of British Pop Art. Trained as

23-36 RICHARD HAMILTON, Just What Is It That Makes Today's Homes So Different, So Appealing?, 1956. Collage, $10_4^{1''} \times 9_4^{3''}$. Kunsthalle Tübingen, Germany.

an engineering draftsman, exhibition designer, and painter, Hamilton was very interested in the way advertising shapes our attitudes. Long intrigued by the ideas of Duchamp, Hamilton has consistently combined elements of popular art and fine art, seeing both as belonging to the whole world of visual communication. Just What Is It was created for the poster and catalogue of one section of an exhibition entitled This Is Tomorrow-an environment/installation filled with images from Hollywood cinema, science fiction, the mass media, and one reproduction of a Van Gogh painting to represent popular fine art works. The fantasy interior in Hamilton's collage reflects the values of modern consumer culture through figures and objects cut from glossy magazines by Hamilton's wife, Terry, and his friend, the artist Magda Crodell McHale, who followed a list of themes he gave them. Just What Is It reconstructs the found images into a new whole, wittily transforming an Abstract Expressionist painting into a rug, and turning a comic book cover and an automobile logo into paintings on the wall. Much has been written about the possible deep meaning of this piece, and few would deny the work's sardonic effect, whether or not the artist intended to make a pointed comment. Although Just What Is It has none of the dialogue between lushly illusionistic painting and popular iconography found in much of Hamilton's other work, the way in which this collage suggests the contents of a mass mind stimulates wide-ranging speculation by viewers about society's values, and this kind of intellectual toying with mass-media meaning and imagery typifies British and European Pop Art.

Hamilton's contemporary in the Independent Group, EDUARDO PAOLOZZI (b. 1924), has used images from mass media in a different, but equally analytical way. As a student in London and Paris, Paolozzi expanded his childhood fascination with American movies, comic books, and pulp fiction to include interest in the works of Picasso, Dada, Surrealism, non-Western culture, and the natural and physical sciences. He invested the products of mass media and mass production with a mythic dimension, seeing them almost as the sacred objects of our age. The artist used these ideas in both sculpture and screenprints. In his sculpture, by the mid-1950s, Paolozzi had devised a process for making evocative bronze figures from forms built by assembling sheets of wax into which he had pressed the shapes of multitudes of throw-away, mass-produced objects. Each object in these works had many associations for Paolozzi, and he presumed that viewers would add interpretations of their own. In the 1960s, Paolozzi's graphic work drew on the huge store of mass-media images he had collected since his student days. Using

23-37 EDUARDO PAOLOZZI, Wittgenstein in New York, from As Is When (series of 12 prints, edition of 65), 1965.
Screenprint, 22" × 32". Published by Editions Alecto and printed by Kelpra Studio. Collection of the artist.

photoscreen (a medium newly annexed by fine artists from commercial art) he incorporated these images into prints. Photoscreen employs photo processes to create stencil screens from graphic images, which in turn become part of a complex printing process that can involve an almost infinite number of colors. Typical of Paolozzi's work in this medium is Wittgenstein in New York (from the portfolio As Is When, FIG. 23-37), based on collages of images and patterns appropriated from the mass media and commercial products. Both the print's title and the text included along its borders were taken from the writings of the Austrian philosopher Ludwig Wittgenstein, whose ideas on language theory intrigued Paolozzi. Wittgenstein had actually spent some time in New York, but Paolozzi's print is not an illustration of that journey. Instead, the image is a fantasy montage of the metropolis seen by an outsider as an assemblage of symbols. The American flag, a prop-driven airplane, and a dynamic spiral float above skyscraper silhouettes. An assemblage of rectangular forms suggests a printed circuit board composed of signs representing the way a city dweller perceives life—television, machinery, traffic signals, signboards, road markers, and two cut-away heads that reveal how we process information and feed our bodies (the latter has an ironic twist, as the mannequin here is ingesting a headache remedy). Hamilton's images in *Just What Is It* had a scale that allowed him to combine them into a seemingly coherent interior space. In *Wittgenstein in New York*, Paolozzi poured out a dazzling cornucopia of symbols that represent physical and mental space and past and present time, leaving each viewer to decode the images individually out of personal experience.

Pop Art reached maturity later in the United States than in England. ROBERT RAUSCHENBERG (b. 1925) was called a "father of Pop" because he began using mass-media images in his work in the mid-1950s. For him, as an admirer of the ideas of the composer John Cage, such images were important bits of the world that could be used in an attempt to narrow the gap between art and life. Cage was a charismatic and widely influential teacher, who encouraged his students to link their art directly with life. He brought to his music composition an interest in the thoughts of Duchamp and in Eastern philosophy. In his own work, Cage used methods like chance and indeterminancy to avoid the closed structures that marked traditional music and, in his view, separated it from the unpredictable and multilayered qualities of daily existence. For example, the score for one of Cage's piano compositions instructs the performer to appear, sit down at the piano, raise the keyboard cover to mark the beginning of the piece, remain motionless at the instrument for "four minutes and twentytwo seconds" (during which time all ambient sounds "become" the music), and then close the keyboard cover, rise, and bow to signal the end of the work. Rauschenberg set out to create works that would be as open and indeterminate as Cage's pieces, and he began by making "combine paintings," in which the parts coexisted equally and simultaneously. In the 1950s, such works contained an array of art reproductions, magazine and newspaper clippings, and segments painted in an Abstract Expressionist style. In the early 1960s, Rauschenberg adopted the commercial medium of photoscreen, first in black and white and then in color, and began filling entire canvases with appropriated news images and anonymous photographs of city scenes. Estate (FIG. 23-38) is typical of his color photoscreen paintings. A jumble of images sprawls across the canvas. Familiar sights, like traffic signs, the Statue of Liberty, and a view of the Sistine Chapel in Rome showing the Last Judgment by Michelangelo (FIG. 17-35), are intermixed with ab-

23-38 ROBERT RAUSCHENBERG, *Estate*, 1963. Oil and printer's ink, $8' \times 5'$ 10". Philadelphia Museum of Art (given by the Friends of the Philadelphia Museum of Art).

stract painted shapes, and "anonymous" pictures of city buildings, human legs, a clock face, a mysterious group of objects, and a "palette" of color patches containing the tonal values and the colors red, blue, and yellow-the basic vocabulary of painting. Some of the images tilt or turn sideways; each overlays or is invaded by part of its neighbor. The compositional confusion may resemble that in a Dada collage, but the parts of Rauschenberg's combine paintings retain their individuality more than those in a Schwitters piece (FIG. 22-29), yet they lack the psychic collision of details in Berlin Dada works (FIG. 22-28). The eye scans a Rauschenberg canvas much as it might survey the environment on a walk through the city. As John Cage perceptively noted: "There is no more subject in a combine [by Rauschenberg] than there is in a page from a newspaper. Each thing that is there is a subject. It is a situation involving multiplicity."* Individually, Rauschenberg's works resist

*John Cage, Silence (Middletown, CT: Wesleyan University Press, 1961), p. 101.

23-39 CLAES OLDENBURG, one-man show at the Green Gallery, New York (including pieces from *The Store* and the first large-scale "soft" sculptures), fall 1962.

precise memorization. Collectively, they represent the experience of day-to-day life in modern cities.

Like Rauschenberg, the sculptor CLAES OLDENBURG (b. 1929) sometimes has been associated by critics with New York Pop Art because his works contain objects from everyday modern life. As with Rauschenberg, this association is imperfect, but for different reasons. In his work, Oldenburg plays with scale and texture to invest ordinary objects with something of the threat and mystery of Bacon's figures, while adding a playful twist that renders them ironic rather than darkly existential. The son of a Swedish diplomat, Oldenburg grew up in Chicago. After settling in lower Manhattan in the 1950s, Oldenburg began using found materials, plaster, and commercial paint to make sculptures and drawings of the objects he saw in the streets and shopfronts around him. He spoke about wanting to lead his viewers "deeper into things," saying, "I am for an art that takes its form from the lines of life, that twists and extends impossibly and accumulates and spits and drips and is as sweet and stupid as life itself."

In the early 1960s, Oldenburg was briefly involved in Happenings—performances whose creators were trying to suggest the dynamic and confusing qualities of everyday life.* For a Happening in 1962, Oldenburg fabricated some huge objects to use as props. He discovered that the increased scale transformed his inanimate subjects into "characters" that seemed capable of leading independent lives. The anthropomorphic quality of Oldenburg's chosen objects was heightened further when he created giant items out of sewn and stuffed cloth. Thus re-made in limp and softened shapes, ordinary things, like kitchen appliances and pieces of food, exhibited "personalities" as individual as those of people. This quality was most apparent when the artist exhibited groups of such objects in exhibitions like his one-man show at Manhattan's Green Gallery in 1962 (FIG. 23-39). In 1965, Oldenburg presented the first of his "monument" proposals: single objects were to be enlarged to huge scale and installed at specific sites where their appearance would spark laughter and create a certain uneasiness on the part of viewers. For example, Oldenburg suggested that a giant teddy bear (not illustrated) be placed at the northern end of Central Park in New York City. He said the bear would be comfort-

^{*}For a more complete discussion of Happenings and their place in contemporary art, see discussion on page 1070.

23-40 ANDY WARHOL, Marilyn Diptych, 1962. Oil, acrylic, and silkscreen enamel on canvas. Tate Gallery, London.

ing as it rose over the skyline, but it would also seem helplessly handless as it looked from Harlem toward more affluent neighborhoods downtown. Although the artist suggested such serious meanings for his "monuments," he tried always to make his pieces so allusive that their full significance could never be pinned down.

The quintessential New York Pop artist was undoubtedly ANDY WARHOL (1925–1987). Like Rauschenberg, whom he greatly admired, Warhol found his subjects in mass media, but mostly in commercial design, mass advertising, and news photos of ordinary people rather than in images of fine art, famous events, or anonymous buildings. After producing a few works in which he carefully mimicked the look of commercial printing, Warhol began using photoscreen to create paintings of subjects like Campbell's Soup can labels, sheets of stamps, ads for dance lessons and other self-improvement courses, and news photos of disasters, wanted criminals, and famous people. An early career as a commercial artist and illustrator may have helped interest Warhol in the expressive force of the harsh colors and simplified shapes to be found in labels and publicity photos, which he used to powerful effect in his celebrity se-

ries. The initial work in the celebrity series was inspired by the suicide of Marilyn Monroe in 1962. Marilyn Diptych (FIG. 23-40) contains fifty reproductions of a well-known publicity photo of the actress, twentyfive in a color panel and twenty-five in a black-andwhite panel. For the color side, Warhol simplified the areas of Monroe's hair and face into stark color patches that suggest both a mask and the high-key look of a publicity poster. The images on the blackand-white side have been screened unevenly, with one row almost obliterated by smeared paint and another so faintly imprinted as to create a ghostly effect. Although it is hard not to try to read symbolic meaning into such manipulation, Warhol denied any such intention. Yet the artist remained fascinated all of his life with the idea of fame, especially its fragility and the way in which those in its limelight can suffer from a double life of public glamour and private sorrow. Warhol predicted that the age of mass media would enable everyone to become famous for fifteen minutes at some time in the future, and he became a renowned public figure himself, as did some of those who worked with him in his studio, the Factory.

Paralleling Warhol's use of the impersonality of mass-media techniques to heighten the effect of his

23-41 EDWARD RUSCHA, Noise, Pencil, Broken Pencil, Cheap Western, 1963. 5' 11¼" × 5' 7". Virginia Museum of Fine Arts, Richmond (gift of Sydney and Frances Lewis).

work, California artist Edward Ruscha (b. 1937) has utilized the impersonality of hand-painted billboard advertising to provide an almost philosophical consideration of the arbitrariness and mystery of painted and printed representation. Noise, Pencil, Broken Pencil, Cheap Western (FIG. 23-41) illustrates Ruscha's approach. At the extreme edges of this composition, the artist placed four things: a real pulp western magazine, two illusionistically painted pencils, and letters spelling the word *noise*. The title is a literal list of the painting's contents, but the artist also is playing with levels of representation and "reality" in the work. The main field of the canvas is a dark blue, which reads as infinite space. Against it float the pulp magazine and the two painted pencils. Part of each pencil disappears beyond the edge of the canvas, and the broken one can be seen either as in the process of breaking (with chips flying from the fracture) or as lying on a solid plane amid the flakes of its ruin. The word noise is similarly equivocal. Letters of the alphabet, as the Cubists knew, usually emphasize the flatness of the surface, but modern graphic design often energizes them into dynamic, three-dimensional shapes. Here, the word blares forth as a series of bright red letters against the face of a white, threedimensional block drawn in steep perspective. Like Warhol's work, Ruscha's paintings exemplify American Pop Art; he takes as subjects the thematic clichés and appearance of advertising and popular culture and in so doing reshapes the way in which viewers see the commercially oriented aspects of the world around them.

Art and Technology

Many Pop artists adopted the technology of the mass media as an integral part of their content, but they did not exploit those techniques for new expressions. That kind of exploration was left to artists who were determined to work with technologies originally developed for the military during World War II. New materials and the world of electronic apparatus and media were eagerly explored by artists as means of expressing the qualities of space-time and "vision in motion" with renewed energy. Some of the resultant work was abstract, some of it was figurative, but all of it had content that resonated with psychological or conceptual concerns.

SCULPTURE

In sculpture, advances in technology provided the means for representing the effects of change in a new kind of kinetic art. One of the most engaging of the sculptors of kinetic works is JEAN TINGUELY (b. 1925), who creates machines that are as cranky and unpredictable as human beings. Trained as a painter in his native Switzerland, Tinguely turned to motion sculpture as the result of his growing belief that "the only stable thing is movement." In the 1950s, he made a series of metamatic machines, programmed electronically to act with an antimechanical unpredictability when viewers inserted felt-tipped marking pens into a pincer and pressed a button to initiate motion of the pen across a small sheet of paper clipped to an "easel." Different colored markers could be used in succession, and the viewer could stop and start the device to achieve some degree of control over the final image; the results of these operations were a series of small works that resembled Abstract Expressionist paintings. In 1960, Tinguely expanded the scale of his work with a piece designed to "perform" and then destroy itself in a large area of the courtyard at the Museum of Modern Art in New York City. Homage to New York (FIG. 23-42) was created with the aid of engineer Billy Klüver, who helped Tinguely scrounge wheels and other objects from a dump near Manhattan.* The completed structure, painted white to show up against the dark night sky, included a player piano modified into a metamatic painting ma-

^{*}Klüver was later involved with Robert Rauschenberg and others in the establishment of EAT (Experiments in Art and Technology), a group of artists and engineers, mostly from the New York area, who fostered interactions between art and technology in the 1960s and early 1970s.

23-42 JEAN TINGUELY, Homage to New York, 1960, just prior to its self-destruction in the garden of The Museum of Modern Art, New York.

chine, a weather balloon that inflated during the performance, vials of colored smoke, and a host of gears, pulleys, wheels, and other found machine parts. Like Tinguely's other kinetic sculptures, *Homage to New York* shared something of the satiric, Dadaist spirit of Duchamp (FIG. 22-25) and the droll import of Klee's *Twittering Machine* (FIG. 22-42). But the wacky behavior of *Homage to New York* was deliberately more playful and more endearing. Having been given a "freedom" of eccentric behavior unprecedented in the mechanical world, Tinguely's creations often seem to behave with the whimsical individuality of human actors.

The messy unpredictability of Tinguely's kinetic sculpture offers one interpretation of life in spacetime. NICOLAS SCHÖFFER (b. 1912) took a more controlled and ordered approach to expressing this theme, creating geometric constructions with parts that actually move in response to electronic stimuli from light, sound, and movement in their environment. A native of Hungary, Schöffer moved to Paris in 1936, bringing with him an admiration for the ideas about dynamic space-time art formulated by Moholy-

Nagy and Naum Gabo. After World War II, Schöffer began making what he called spatiodynamic towers, which are constructed of slender frames hung with metal or plastic planes designed to catch and reflect light in ever-changing patterns that mirror the ceaseless permutations going on in the physical world. Soon Schöffer set the parts of such towers in motion using motors programmed by the kind of electronic cells used in early computers. He called these works CYSP, for "cybernetic spatiodynamic," because they drew on research in cybernetics-the study of the operation of communication and control processes in biological, mechanical, and electronic systems, first pioneered during World War II. Some of Schöffer's CYSPs were designed to "perform" interactively with dancers in response to motion or changes in sound, color, or intensity of light. By the late 1950s, his works had become elaborate constructions with multiple shafts bearing discs and blades of steel on which he projected beams of colored light. He envisioned some of these enlarged into huge spatiodynamic towers that would operate high in the skylines of modern cities. In 1962, for a festival at Liège, Belgium, Schöffer constructed The Spatiodynamic Tower (FIG. 23-43), 171 feet tall, next to the city's Congress Palace, and added a special installation behind the building's enormous glass wall, which faced the Meuse River.

23-43 NICOLAS SCHÖFFER, The Spatiodynamic Tower, Liège, Belgium, 1961. Sound-equipped and cybernetic, $170' 7\frac{1}{4''}$ high.

23-44 LARRY BELL, Homage to Griffin, 1980. Vaporized metal on glass, 9' 6" high × 14' wide. Valley Bank of Nevada Fine Arts Collection, Reno, Nevada.

Sixty-four mirrored panels on thirty-three turning axes in the tower shifted position in response to signals from a huge electronic brain inside the Congress Palace, which collected data from wind, light, temperature, moisture, and noise sensors mounted on the tower and combined the resultant information with programs for varied motion sequences. The spectacle was accompanied by five aural collages of electronically manipulated music and city noise. At night, 120 multicolored spotlights played over the tower's mirrored blades, and, on holidays, the electronic brain also operated banks of seventy projectors that played slides of abstract colored patterns on translucent screens mounted behind the windows of the Congress Palace.

The machines created by Tinguely and Schöffer "perform" for their viewers. The works of LARRY BELL (b. 1939) encourage viewers to become performers themselves by interacting with his sculptural environments to experience strange and confounding shifts in the perception of space. From his early days as a sculptor in Los Angeles, Bell has played with perceptual illusion, especially in works made with glass and coated with various transparent, opaque, and reflective surfaces. The structures of works like *Homage to Griffin* (FIG. 23-44) are made of freestanding glass panels, coated by the artist to obtain different amounts of reflection, refraction, or opacity. Set up in a gallery, the sculptural forms dissolve as a viewer walks past and around them, one moment able to look through the glass plates into the space beyond, and the next seeing one's reflection fade into nothingness in a nonreflective area. Viewers are easily enticed into playful engagement with these pieces to discover the wonderful ways in which their visual properties continually alter one's perception of the space they inhabit. Advanced technology enables Bell to craft the surfaces of his abstract shapes in ways that use reflection and blocked vision to transform the site of one of his pieces into a magical wonderland where visual expectations are continually overturned, and the viewer comes to a new understanding of how one perceives actual forms in space.

COMPUTER GRAPHICS AND HOLOGRAPHY

While some new technologies were revolutionizing the way artists could work with sculptural space, other technologies, especially those of computer graphics and holography, were transforming the ways in which artists could create and manipulate illusionistic three-dimensional forms. Computer graphics and holography both use light for the making of images, and, like photography, both media can incorporate specially recorded camera images. However, these two media differ in that only computer graphics allows the artist to work with wholly invented forms, as a painter can.

The medium of computer graphics was developed during the 1960s and 1970s and opened up new possibilities for both abstract and figurative art. Computer graphics operates by means of electronic programs that divide the surface of the cathode-ray tube (CRT) of the computer monitor into a grid of tiny boxes called "picture elements" (pixels), which can be individually addressed electronically to create a design, much as knitting or weaving patterns use a gridded matrix as a guide for making a design in fabric. Once created, parts of a computer-graphic design can be changed quickly through the operation of an electronic program, allowing the artist to revise or duplicate shapes in the design and to manipulate at will the color, texture, size, number, and position of any desired detail. A computer-graphic picture is displayed in luminous color on the cathode-ray tube; the effect suggests a view into a vast world that exists inside the tube.

One of the best known of the artists working in this electronic painting mode is DAVID EM (b. 1952), who uses what he terms *computer imaging* to fashion fantastic imaginary landscapes that have an eerily believable existence within the "window" of the computer monitor. As artist-in-residence at the California Institute of Technology's Jet Propulsion Laboratory, Em has created brilliantly colored scenes of alien worlds using the laboratory's advanced computer graphic

23-45 DAVID EM, Nora, 1979. Computer-generated color photograph, 17" × 23". Private collection. © David Em/represented by Spieckerman Associates, San Francisco.

equipment. He also had access to software programs developed to create computer-graphic simulations of NASA missions in outer space. Creating images with the computer allows Em great flexibility in manipulating simple geometric shapes-shrinking or enlarging them, stretching or reversing them, repeating them, adding texture to their surfaces, and creating the illusion of light and shadow. In images like Nora (FIG. 23-45), Em created futuristic geometric versions of Surrealistic dreamscapes in which the forms seem familiar and strange at the same time. The illusion of space in these works is immensely vivid and seductive. It almost seems as if one could wander through the tubelike foreground "frame" and up the inclined foreground plane or hop aboard the hovering globe at the lower left for a journey through the strange patterns and textures of this mysterious labyrinthine setting.

SONIA LANDY SHERIDAN (b. 1925) is one of the most inventive artists to combine, in a single computergraphic work, images made by an electronic camera and those drawn by hand. Sheridan finds the computer-graphic medium to be a powerful means of providing psychological and conceptual insights into the human experience. From her days studying French and art in grade school, Sheridan has been fascinated with the ways in which both verbal and visual languages work. Although she trained as a painter and printmaker, she holds a strong belief (like Moholy-Nagy) that art and science belong together. In the mid-1960s, her interests led her to initiate a series of collaborations with research scientists to explore artistic uses for technological media. She brought this approach to the Generative Systems Program, which she founded at the School of the Art Institute of Chicago in 1970 to help students investigate the artistic potential of technological tools. Sheridan's personal work includes art created with diffraction gratings,* a variety of copy machines, early FAX machines, and computer graphics. Drawing in Time: My New Black Book No. 2 (FIG. 23-46) is one of the works done with Easel, the versatile computergraphic program designed by one of Sheridan's exstudents, John Dunn, to run on a computer. On this small desktop system, as on the more complex system used by Em, the artist has immense control over manipulation of color, size, shape, and texture. Sheridan can mix hand-drawn shapes with those captured by a video camera, or use each kind of image alone.

^{*}Diffraction gratings, used mainly in scientific experimentation, are sheets of glass, plastic, or metal that are inscribed with grids whose lines diffract any light directed at the gridded surface and break this light up into its color spectra so that the rays may be accurately measured.

 23-46 SONIA LANDY SHERIDAN, Drawing in Time: My New Black Book
 No. 2, 1982. Easel (John Dunn Software), Cromemco Z-2D hardware, 54" computer disc and in multiple dimensions as photographs. Artist's collection.

Although not as powerful overall as the mainframe computer program used by Em, Easel is immensely easier to use, and Sheridan can work in the intimacy of her home studio, which gives a different flavor to the content of her work. She created Drawing in Time: My New Black Book No. 2 with a combination of techniques, giving instructions to the computer through the instrument's keyboard or by moving a special pencil-shaped electronic stylus over a flat, electronic 'graphic tablet." She began by adding color (a process called colorizing) to a black-and-white image of herself working at the computer, which she had made with a video camera. She then modified the video image by adding bright-hued lines that connect her electronic pad and stylus with the picture she is creating on the computer screen. Process and content act on each other in this work-the image is both an illustration of the computer-graphic process and a personal representation of Sheridan's creative process. In addition, the drawn lines provide an intriguing variation on the Modernist tension between twoand three-dimensional space by simultaneously seeming to exist in the three-dimensional world of the camera image and to float near the surface of the monitor, in front of the artist's figure. The title Drawing in Time: My New Black Book refers both to the way layered computer-graphic images suggest multiple moments in time and to Sheridan's sketchbooks (often with black covers), which the artist has always used as a visual-verbal journal in an attempt to understand the relationship between the artist's hand and mind. Like Moholy-Nagy, Sheridan has found that technological tools, drawing, and painting each give her particular insights into the nature of art and of the world.

Holography, from the Greek words holos (whole or entire) and graphos (to write or inscribe), differs from any other medium by providing the viewer with a real, three-dimensional image (a virtual image) that duplicates in light alone the surface appearance of a subject. Although modern holographic techniques differ, basically all holographic images are recorded with a special beam of light, called a laser, which is split so that one part of the light illuminates the subject and is reflected toward the holographic film, while the other part of the light is directed away from the subject and bounced off a mirror to travel separately through space until it meets the beam from the subject just in front of the holographic film plate. The interaction (interference pattern) of the two beams of light records a virtual image of the entire half of the subject facing the film on the film plate, and this image can be re-created in the air by passing light through or into the holograph. Moving in front of a holographic plate allows one to look over and around the sides of the holographed subject, but if one tries to touch objects in a holographic image, the hand passes right through the shapes. The mesmerizing effect of holograms owes something to the observation made during the Renaissance by Leonardo da Vinci that "it is by its surface that the body of any visible thing is represented." The surface of an object is what holography encodes so faithfully on the holographic plate. Early holographic subjects had to be small, immobile, and nonbiological; today's holographer can create human portraits with a "pulsedlaser" that freezes living subjects in short bursts of light and opens the way to investing holograms with an entirely new psychological intensity.

The British artist MARGARET BENYON (b. 1940) is one of the most interesting artists currently experimenting with holographed portraits. Working in high-tech labs with scientist partners, Benyon has investigated many of the parameters of the relationship between perceptions of physical and holographic reality. Her *Tigirl* (FIG. **23-47**) is a double exposure made from a hologram of a painting of a tiger and a pulsed-laser holographic self-portrait made from life. The flat space of the painted tiger mask interweaves with, and contradicts, the stripes laid across the three-dimensional contours of the artist's face created by holographic "fringe patterns" formed in the image when Benyon moved during the expo-

23-47 MARGARET BENYON, *Tigirl*, 1985. Glass plate reflection hologram and reproduction, $11\frac{3''}{4} \times 15\frac{3''}{4}$. Collection of the artist.

sure. Benyon is not the first artist to merge the faces of a female human being and a feline, but holography has added a powerful new intensity to this combination of human and animal energy. A holographic double exposure presents an impossible dilemma to the viewer's eyes and brain, because two apparently solid objects are seen occupying exactly the same volume of space. From one angle, the viewer of Tigirl can see only the girl; from another, only the tiger is visible. No photograph can capture the startling effect of the view from the front, in which the threedimensional woman's head coexists in the same space occupied by the painted cat face. The threedimensional complexity of Benyon's holographic rendering makes it operate with exceptional power on both the physical and the metaphysical levels.

VIDEO ART

Initially, the medium of video was available only in commercial television studios and only occasionally accessible to artists. With the invention of relatively inexpensive portable video recording equipment and electronic devices that allowed the manipulation of the recorded video material, artists began to explore

in earnest the particularly expressive possibilities of this new medium. In its basic form, video technology uses a special motion-picture camera to capture images from the world and to translate them into electronic data that can be displayed on a video monitor or television screen. Video pictures resemble photographs in the amount of detail they contain, but like computer-graphic pictures, a video image is displayed as a series of points of light on a grid, giving the impression of soft focus. A viewer looking at television or video art is not aware of the surface of the monitor; instead, fulfilling the Renaissance ideal, we concentrate on the image and look through the glass surface, as through a window, into the "space" bevond. Video images combine the realism of photography with the sense that the subjects are moving in "real time" in a deep space "inside" the monitor.

PETER CAMPUS (b. 1937) has utilized all the qualities of the basic medium of video with immense imagination to tantalize viewers with his real-time recordings of "impossible" events. A native New Yorker who studied psychology and filmmaking before working in commercial television, Campus brings to his video art his keen interest in the relativity of human perception and a comprehensive knowledge of film traditions and video techniques. He has produced video environments, in which the viewer interacts with video cameras, and videotapes that confound the viewer's perception of space and reality. One of the most intriguing of the videotape pieces is Three Transitions, three short works that each document an impossible physical transition taking place in real time as we watch. The first transition (FIG. 23-48) begins with the artist standing against a plain white background wearing a simple jacket, white shirt, and dark trousers. His head turns slightly to one side while he performs, to check the live action shown on a video monitor. The action begins as Campus gestures toward the background plane with one arm. Without warning, a startling vertical slit opens down the middle of his back. A few seconds later, the rip has been extended so that when he bends down and thrusts his head forward, the top of his skull appears in the middle of his back, and he then proceeds to literally step through himself. This transition is made possible by carefully positioning two video cameras facing each other on opposite sides of a white sheet, but the psychological disorientation of seeing such an impossible physical feat take place before our eyes resonates so strongly that our imagination and reason struggle to adjust our notions of perception to fit these "facts."

The medium of video is new enough that most viewers know little about its techniques. Commercial television has taught us that video, like cinema and

23-48 PETER CAMPUS, Three Transitions, c. 1971. Videotape stills.

photography, can be said to have two expressive sides: one connected with straight recording and the other produced by manipulations like montage or double exposure. In cinema and in photography, straight recording represents direct, real-time seeing, while montage or double-exposure techniques combine images made at different moments in time. Realtime seeing in movies can occur in fictional as well as in documentary films; conventions have been developed in each ("invisible" editing and "logical" shifts in camera position, for example) to compress the experience of real-time into viewing packages of acceptable length (the one-minute news story about an event stretching over hours or the two-hour feature film that spans days or decades). Eisenstein's psychological jump cuts (FIG. 22-77) and the fantasy montages of Méliès (FIG. 22-33) clearly signal their nonnatural character.

When video introduced the possibility of doing such manipulation in real-time, artists like the Korean-born, New York-based videographer NAM June PAIK (b. 1932) were eager to work with the medium. Inspired by the ideas of American composer John Cage after studying music performance, art history, and Eastern philosophy in Korea and Japan, Paik worked with electronic music in Germany in the late 1950s before turning to performances using modified television sets. In 1965, relocated to New York City, Paik acquired the first inexpensive video recorder sold in Manhattan (the Sony Porta-Pak) and immediately recorded everything he saw out the window of his taxi on the return trip to his studio downtown. Stints as artist-in-residence at television stations WGBH in Boston and WNET in New York allowed Paik to experiment with the most advanced broadcast video technology, and a grant permitted him to collaborate with the gifted Japanese engineer-inventor Shuya Abe in the development of a video synthesizer-a special instrument that allows the artist to manipulate and change the electronic video information in various ways, causing images or parts of images to stretch, shrink, change color, or break up. Using the synthesizer, the artist also could layer images, inset one image into another, or merge images from various cameras with those from videotape recorders to make a single, visual, kaleidoscopic "timecollage." This kind of compositional freedom allowed Paik to combine his interests in the ideas of Cage, painting, music, Eastern philosophy, global politics for survival, humanized technology, and cybernetics.

Paik's best-known video work, *Global Groove* (FIG. **23-49**), combines in quick succession fragmented sequences of female tap dancers, poet Allen Ginsberg reading his work, a performance of a Paik musical composition in which cellist Charlotte Moorman uses a man's back as her instrument, Pepsi commercials from Japanese television, Korean drummers, and a shot of the Living Theater group performing a controversial piece called *Paradise Now*. Commissioned originally to be broadcast over United Nations satellite, the cascade of imagery in *Global Groove* was intended to give viewers a glimpse of the rich worldwide television menu Paik had predicted would be ours in the future. Paik called his videotape works "physical

23-49 NAM JUNE PAIK, Global Groove, 1973. Videotape still.

music" and said that his musical background made him able to understand time better than video artists trained in painting or sculpture. As critic Jonathan Price reported, Paik considered the effect on the viewer of his kind of video narrative to be similar to both the style of writing in James Joyce's *Finnegan's Wake* and to "a classical Taoist way of meditation; by becoming aware of everything going on in the present, you discover eternity right now."* James Joyce developed his writing style to express the layering of thought, feeling, and experience of the exterior physical world made apparent to us through the work of psychologists and physical scientists. Nam June Paik used the methods of new technology to extend this kind of composition into the visual world.

Conceptual Art

As the twentieth century progresses, artists and those who write about art have become increasingly interested in thinking about the way art communicates. Conceptual art self-consciously examines these matters, addressing the intellect through the visual sense. In conceptual art, the ideas generate the works. Some conceptual artists have examined the means of representation in painting, sculpture, and cinema; others have created art that operates almost like philosophical propositions. Conceptual work sometimes is a simple epigrammatic text that generates an image in the mind; at other times, it becomes a complex visual display of the relationship between ideas and visual appearance.

One of the earliest and most provocative contemporary artists working conceptually is the American JASPER JOHNS (b. 1930), who was keenly interested in the complex processes involved in perceiving simple symbols. In the mid-1950s, Johns began including generic symbols, like the American flag and targets, in his work. These objects interested him because they were common things, often seen but seldom examined with careful attention.[†] Viewers cannot ignore the presence of one of Johns's painted targets; such images fill the entire canvas and are rendered with the unmistakable texture of a hand-applied art medium—in this case, encaustic. As a representation of a target, a Johns target has no reference beyond the design and the fact that it represents a target. Such a

^{*}Jonathan Price, Video Visions: A Medium Discovers Itself (New York: New American Library, 1977), pp. 128–29.

⁺The inclusion of such commonplace subjects in his works caused some American critics in the early 1960s to link Johns with Pop Art. His subsequent work, however, has clearly reinforced the understanding of his art as concerned with issues and methods of representation very different from the ideas, techniques, and subjects of Pop Art.

23-50 JASPER JOHNS, *Target with Four Faces*, 1955. Assemblage of encaustic and collage on canvas with objects, $26'' \times 26''$, surmounted by four tinted plaster faces in wood box with hinged front, overall dimensions with box open, $33\frac{5}{8}'' \times 26'' \times 3''$. Collection, The Museum of Modern Art, New York (gift of Mr. and Mrs. Robert C. Scull).

painted target remains the replica of a target, but it also has become an art object, with no clear significance, because it cannot be used as a target and remain a painting. The puzzle of the relationship between the painting and its design was set down by Johns as a formula: "A = B. A is B. A represents B." In Target with Four Faces (FIG. 23-50), the artist has complicated the situation by adding, above the flat painted target, four boxes (with a single hinged lid), each containing a cast of the lower portion of a human face. These casts are not portraits. They seem to be the same face, although slight differences between them are evident (they were cast at four distinct but successive moments). Like the target, the faces represent only themselves. They are seen or not seen, depending on whether their lid is raised or lowered. When they are visible, they simply are. In the faces, as with the target, Johns has picked a part of life—nose and mouth—that we generally see but do not examine; it is the eyes that usually capture our attention in the human face. In Johns's work, such simple, appropriated things acquire a haunting "presence" that forces us to wrestle with the relationship between the thing and its representation. As the artist himself said: "Meaning is determined by the use of the thing, the way an audience uses a painting once it is put in public."

Allan Kaprow (b. 1927) extended Johns's concern with the "use" of art by its audience to sculpture and performance, trying to represent more fully the impermanent, shifting qualities of modern life. Using fragile materials like newspaper and compositional techniques based on the operation of chance, Kaprow constructed temporary environments whose parts viewers were invited to change. He also was instrumental in developing the art form for which he is best known-the "Happening." Influenced heavily by his knowledge of art history, his study of music composition with John Cage, and a belief that Jackson Pollock's actions in making a painting were more important than the painting itself, Kaprow's Happenings were loosely structured performances presented in varied public indoor and outdoor sites. Generally, they combined ordinary and pseudo-ritualistic actions. Kaprow's first Happening took place in 1958 at the Reuben Gallery in New York City, and the art form soon spread throughout the United States, Europe, and Japan. Happenings occurred in lofts and studios, in department stores, in auditoriums, on college campuses, and on private estates. Usually Happenings lacked specific plots, but they always contained a collage of actions that suggested a narrative or ritual reflecting the contemporary human condition. Their mood often recalled that of Dada and Futurist performances or events, but rather than taking the role of onlookers, as had the viewers of the earlier works, the audience at a Happening participated fully in the action.

Kaprow's *A Spring Happening* (FIG. **23-51**), held at the Reuben Gallery in 1961, is a good example of the

23-51 Allan Kaprow, A Spring Happening, 1961. Performance Art.

form. At the advertised time, the audience was ushered into a dark, narrow "tunnel," which had rectangular peepholes at regular intervals along its sides. In the moments that followed, lights went on and off, and figures executed mysterious actions outside the tunnel on both sides. Threatening noises poured from loudspeakers or occurred as objects were beaten, thrown, or rattled on all sides of the tunnel, and the structure vibrated. Finally, a power motor was pushed through the tunnel, crowding the spectators toward one end, where they were met by powerful blasts of air from a huge floor fan. Just at the moment when they felt completely trapped, the tunnel's plywood walls fell outward and the crowd escaped to the sides. Most Happenings shared with Spring Happening the qualities of unexpectedness, improvised ritual, aggression, discomfort, surprise, variety, quick changes, and wonder. Their spontaneous and homemade flavor made them particularly appropriate symbolic dramas for reflecting on the human condition during a period of rapid social change. Many of them, like A Spring Happening, mimicked in some way the distressing pressures of modern life, and some of them, especially those created by Europeans, contained specific political references. Happenings also encouraged viewers to think anew about the nature of sculptural representation.

While painters and sculptors were experimenting during the late 1950s and early 1960s with the expressive qualities of their media, some filmmakers were similarly exploring the expressive mechanisms of cinema and the way these acted on the minds of viewers. Taking the lead in this activity was JEAN-LUC GODARD (b. 1930), who believed that a movie should continually call attention to itself as it "plays" on the screen. Godard was part of a group of French "New Wave" (La Nouvelle Vague) film directors who developed distinctive, individual cinema styles in the 1950s and 1960s based on their deep knowledge of traditional big studio classic films. New Wave cinema characteristically attempted to subvert the expectations of viewers by substituting for the carefully designed, clearly photographed, and logically constructed plots of the big studios, a menu of ambiguity, surprise, fuzzy and shaky camera work, and abrupt changes in space, time, and mood. Godard's first feature-length film, Breathless (À bout de souffle, FIG. 23-52), is typical of the New Wave mode, and, like many New Wave works, it is also both an homage to American "B" gangster films and a selfconscious analysis and parody of their style. Breathless was loosely constructed around a minimal storyan amoral young crook drifts through a series of actions involving his mistress, car theft, a joy ride in the country, the killing of a cop, and his eventual betrayal

23-52 JEAN-LUC GODARD, film still from Breathless (À bout de souffle), 1959.

(by his mistress) to the police. The methods Godard employed, however, violated the invisible and sequential editing used in traditional commercial films. The viewer experiences everything in Godard's work in fragments that flow past in a seemingly uncoordinated way, much as we remember actual past experiences. Yet the viewer of a Godard film is never allowed to forget that he or she is watching a film. Godard worked hard to ensure that the viewer remains aware at all times of filmmaking processes at work. Scenes were shot with shaky hand-held cameras (rather than with steady, tripod-mounted equipment), on real (not designed) locations, with available light (instead of carefully controlled studio illumination). Sound was taped on-site with portable machines synchronized with the cameras (to capture all ambient sounds as they happened), rather than with separate, more easily manipulated sound tapes that could be mixed with other sounds and even partially re-recorded later in the studio. Finally, Godard never allowed his audiences to become totally immersed in the illusion of a story comfortably unfolding in traditional filmic time and space. Instead, he disrupted narrative flow by arbitrarily omitting chunks from the middle of long continuous shots to produce jump cuts that dislocated any sense of progressive action. Jump cuts were not new in themselves. Méliès had

23-53 MICHAEL SNOW, \longleftrightarrow , 1969. Section of film.

(FIG. 22-33) had used them to produce fantasy, and Eisenstein (FIG. 22-77) had utilized montage to express mental and emotional states. But Godard's editing underscores unmistakably the nature of motion-picture images unfolding as a reel of film passes through a projector.

The Canadian artist and musician MICHAEL SNOW (b. 1929) narrows his investigation of the film medium to make his central subject the motion of the camera and the effects of this motion on the recorded film and the viewer's perception. \longleftrightarrow (FIG. 23-53) is based on the real-time, back-and-forth pans of a camera mounted, at the height of a standing person's eves, on a tripod in a closed space in which its backand-forth sweep includes a view into a classroom. The space of the pan is 180 degrees from left to right. A click sound marks the end of each swing and the beginning of the return arc. At the film's start, the left-and-right movement is slow, and the viewer becomes familiar with the physical facts of the scene. Gradually, the camera swings back and forth more rapidly, and as the camera passes, it catches people who have entered the space, only to disappear again before the camera returns to that spot on its next circuit. The viewing experience rapidly becomes shaped by memory of what has been seen, anticipation of seeing that same material again, and the memories of different "states" of parts of the scene being scanned. As the film progresses, the speed of the pan increases until what is seen is a smear of color and shape as the lens sweeps along its route because of the way that the cinema camera records and the way that we perceive the sequence of recorded images projected at a steady rate onto a screen. Snow clearly described the effect of the film and the way it both calls attention to itself and to the process of viewing it:

If properly orchestrated, it [the circular sweep pan motion] can do some powerful physical-psychic things. . . . If you become completely involved in the reality of these circular movements it's *you* who is spinning surrounded with everything, or conversely, you are a stationary centre and it's all revolving around you. But on the screen it's the centre which is never seen, which is mysterious. . . . The film has a time of its own which overrides the time of the things photographed.*

In much the same way that Snow devises a shooting system to isolate certain aspects of cinema recording and viewing, the American artist MEL BOCHNER (b. 1940) uses ideas from mathematical set theory to generate sculptures, paintings, and drawings that illustrate the operation of units in a set of numbers.

^{*}In Dennis Wheeler, ed., *Form and Structure in Recent Film* (Vancouver, BC: Vancouver Art Gallery, 1972), unpaginated.

23-54 MEL BOCHNER, Triangular and Square Numbers, 1972. Installation of pebbles on floor, approx. 36" on a side, 72" overall. Galleria Marilena Bonomo, Bari, Italy.

The appearance of each of Bochner's works is determined by the system that is its subject; in that way each work is self-generating. Sculptures like Triangular and Square Numbers (FIG. 23-54), from the series The Theory of Sculpture: Counting, were constructed in gallery spaces with simple materials like pebbles arranged temporarily for each showing. The counting system at work in Triangular and Square Numbers, as indicated in the title, is related to the series of numbers necessary to generate the square shapes on one side and the triangular shapes on the other. The mystery of the ways in which these geometric shapes have "grown" along the walls is balanced by the viewer's delight in uncovering the nature of the relationship between the numbers of pebbles in the triangles and the squares: the single corner stone together with the three stones in the first triangle equal the four stones in the first square; the three stones in the first triangle plus the six stones in the second triangle equal the nine stones in the second square, and so forth.

One of the most philosophical of the painters to take a conceptual approach with a realist style is New York artist Sylvia Plimack Mangold (b. 1938), who uses illusionistically painted subjects to challenge viewers with concepts about the nature of realism in art. In the art world of the 1960s, where little acclaim was accorded illusionistic painting, Mangold devised an approach that turned realistically rendered subjects into dramatic geometric designs. Forced to paint at home by her duties as wife and mother, Mangold became interested in the visual possibilities of her studio floor and made a series of painstaking paintings of floorboards, whose space was confounded by reflections in mirrors resting on the floor's surface. Later works have explored more fully the ways in which representation can fool the eye. Two Exact Rules on Dark and Light Floor (FIG. 23-55) is a meticulously rendered painting of a section of black-and-white tiled floor, seen from above in subtle perspective, sloping away from us. This illusion is cancelled wittily and abruptly by what appear to be two identical metal "Exact Rule" yardstick fragments fastened to the surface of the canvas. These rulers suggest the precise measuring tools used to create the straight perspective lines in the painting; at the same time, they appear to lie outside the illusionistic painted space, on our side of the painted canvas surface. However, the realization that the top one is actually

23-55 SYLVIA PLIMACK MANGOLD, Two Exact Rules on Dark and Light Floor, 1975. Acrylic on canvas, 24" × 30".

smaller in scale than the bottom one, making it seem to rest further back in space, reveals that each ruler is in fact a painted replica of a ruler. Mangold has toyed here with contradictory visual cues and the paradoxes they establish about the relationship between illusion and reality.

A conceptual approach to realist painting of a different sort is found in the work of the American artist NEIL WELLIVER (b. 1929), whose lushly painted landscapes let viewers ponder the magical ability of paint strokes to be both art medium and an analogue for details from the physical world. For works like Deep Pool (FIG. 23-56), Welliver appropriated some of the qualities of nineteenth-century Impressionist and Realist painting and reworked them for his own needs. Yet the presence of the thick paint in Deep Pool maintains a shimmering life of its own, both as a pattern lying flat on the surface of the canvas and as an element calling attention to the artistic processes that create the illusion of a world seen through the canvas. The rural, wooded scene in Deep Pool has been simplified into an X-shaped pattern composed of the lighted sky, the water reflections, and the stony ledges. Where Courbet and Monet painted to reveal nature more clearly, Welliver's patiently rendered translation of his subject and the overall patterning of his even-handed strokes focus the viewer's attention as much on the process of painting as on the ostensible subjects of water, rocks, trees, light, and shadow.

The dialogue between painted illusion and the materials of art is even more intense in the mixed-

23-56 NEIL WELLIVER, Deep Pool, 1983. $8' \times 8'$. The Collection of Exxon Corporation, Courtesy Marlborough Gallery, New York.

23-57 JUDY PFAFF, *Rock/Paper/Scissors*, September 24, 1982–January 9, 1983. Mixed media installation. Albright-Knox Art Gallery, Buffalo, New York.

media pieces created by American artist JUDY PFAFF (b. 1946). Works like Rock/Paper/Scissors (FIG. 23-57) have the quality of an exploded Abstract Expressionist painting that has taken over a whole interior space. The title refers to a children's game that is played with hand-symbols for "rock," "paper," and "scissors," in which each symbol is able to "conquer" one of the others; chance alone creates a tied score between the players.* Pfaff's Rock/Paper/Scissors, thus, might be considered a metaphor for the Cold War or for the complex social maneuvering of modern urban life. The exuberant, overall clutter of Pfaff's installation counteracts such a reading, however, by evoking such subjects as the sights of a New Year's Eve party or of a giant kaleidoscope. Yet, above all, the forms in Rock/Paper/Scissors, as in all of Pfaff's installation works, remain resolutely nonobjective. The main "subject" of Rock/Paper/Scissors (like that in a painting

*In unison, the players raise and lower their right hands rapidly three times; on the third "throw" each player forms their hands into one of three symbols—fist for "stone," flat-out for "paper," or with the first two fingers spread apart for "scissors." In the game, every symbol can conquer; every symbol also can be conquered, because paper covers rock, rock breaks scissors, and scissors cut paper. For each round of throwing, the player with the dominant hand-symbol wins. If all players form the same handsymbol, the round is a tie.

by Pollock) is the variety and impact of the materials, shapes, and colors, a brilliant reflection of Pfaff's stated interest "in opening up the language of sculpture as far and as wide as I can, . . . in trying to include all the things that are permissible in painting but absent in sculpture." Installations like Rock/ Paper/Scissors are planned to activate a certain space temporarily and to vanish at the end of the special occasion or exhibition that gave them birth. Even the works that Pfaff creates for specific museum collections occupy so much space that they are designed to be taken down and stored when the space is needed for other exhibitions. Each time a Pfaff work is in place, however, it provides the viewer with an exuberant and festive sight, like a modern-day descendent of a Matisse painting expanded to a scale that can enfold the viewer in its joyous midst.

Concepts about the relationship between representation and perception, especially the comprehension of space, underlie the photographic collages of DAVID HOCKNEY (b. 1937). Trained as a painter and printmaker in his native England, Hockney was briefly associated with a group of young British artists at the Royal College of Art in London who constituted the second generation of British Pop Art.* But he soon developed a distinctive style of his own, which evolved rapidly after he moved to Los Angeles in 1963, attracted by the extraordinary light, space, and

*Hockney did include a few subjects from popular culture in his early work (such as a box of Ty-Phoo tea) and was quickly included by British and American critics among the large group of artists collected under the title of Pop Art. However, throughout his career, Hockney's approach in all media has been so distinctive and original that he really belongs to no particular movement or style. culture there. His first photographs were personal snapshots. Then he used the camera to make studies for paintings. Eager to explore ways of extending the space in his photographs, he began scanning subjects with a Polaroid camera, assembling the series of prints he had made of different parts of a scene into one picture. He capitalized on his realization that "the most important thing that we feel and seespace—the camera cannot even record," noting that the camera "is good for recording surfaces." Hockney's technique of capturing the surface of every object within the space of his subject by moving the camera from side to side and top to bottom across that space creates an effective "map" of his subject that not only documents the position and appearance of the objects in the space but also includes all evidence of shifts in location or stance by the subject during the time it took the artist to complete his scanning of the scene. The figures in his scenes often move between exposures, so the final collages are records of several points in time, as well as several positions in space, and these works reflect the path of eve movement scanning the entire site. Feeling constrained by the grids created by the white borders of the Polaroid prints, Hockney acquired a 35mm camera and began making photomontages (called joiners) that reflected his increased interest in the kind of nonperspective space found in Chinese and Japanese scroll paintings. The Grand Canyon Looking North, September 1982 (FIG. 23-58) is a fan-shaped sweep of vision across that natural monument. The image cannot be taken in without moving the eyes; viewers must scan the details much as they would the actual canyon. Sometimes Hockney's prints join almost invisibly; sometimes differences in exposure or jumps

23-58 DAVID HOCKNEY, The Grand Canyon Looking North, September 1982. Photographic collage, 3' 9" × 8' 3½". © David Hockney, 1982.

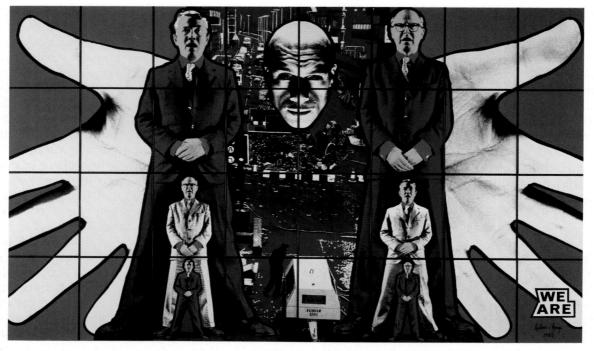

23-59 GILBERT AND GEORGE, We Are, 1985. 7' $10\frac{7}{8}$ " × 6' $7\frac{1}{8}$ ".

in detail emphasize the modular nature of the picture. Nevertheless, the artist manages in works like *The Grand Canyon* to emphasize the process of making the work at the same time that he makes us conscious of the motion that is a part of our natural process of observing the world around us.

Perhaps the boldest of all conceptual art is that produced by the British team of GILBERT AND GEORGE (Gilbert, b. 1943 in Italy, and George, b. 1942 in England), who question every aspect of traditional art and assert that they are "living sculpture" and that their entire "proper English lives" together contribute to their art. Adopting the respectable, middleclass "uniform" of conservatively cut suits, shirts, and ties, Gilbert and George have given varied forms to the ongoing artwork of their lives together through postcard collages, stylized performances, autobiographical books, drawings, and, most recently, giant "sculpture" pieces in which collages of hand-colored photographs use a personal iconography to express the pair's response to their life in London's workingclass East End and to their experiences with religion, sex, and the vision of the volatile connections between youthful vigor and the life of the urban poor in contemporary England. We Are (FIG. 23-59) is typical of their large-scale photo-sculptures, with the sculptors themselves standing frontally, in identical poses a short distance from one another, their legs spread apart and their hands clasped. Their forms are lit from each side, throwing a band of shadow down the

middle of their faces. George wears glasses; Gilbert does not. The figures repeat three times, one pair above the other in increasing size with Gilbert and George changing sides at each stage. Each set fits neatly between the spread legs of the next largest to form two hieratic human columns that frame the central "window," in which we see a confused scene of road repair and an enigmatic disembodied head, lit from the bottom to create eerie highlights and shadows. Sprouting from the figure-columns like wings are a pair of giant hands with palms facing us and fingers spread wide. The clear, formal arrangement, the bold transparent colors, and the stiff black outlines and grid lines suggest devotional stained-glass windows, but the images convey a sense of ritual bestowed upon the whole messy range of everyday life, echoing the simple declarative words of the title-"We are."

Postmodernism and Deconstructionism

In response to the increasing loss of belief in the validity of traditional Eurocentric ideas about art, style, and society, conceptual art took a new turn in the late 1970s. Artists attempted to give fair consideration to art and values from all world cultures. Adopting the posture of analysis, they borrowed tools of theory and assessment from other fields (especially anthropology, sociology, political science, and psychology) and appropriated styles from older art and other cultures to create works that questioned every aspect of art-making, the operation of the art market, and the relationship between meaning in art and the society in which it was made.

In architecture, a variety of past and current styles were combined without the traditional attempts to make them cohere as a whole. This new eclecticism has swept aside the International Style and replaced it with elements borrowed from both "low" and "high" art. One of the most influential architects to use elements from vernacular (nonprofessional, popular) architecture in his designs is the American ROBERT VENTURI (b. 1925). Venturi called for the incorporation into "high architecture" of varied "honky-tonk elements" from structures like Las Vegas casinos and the eateries, gas stations, and stores of commercial "strips" leading into and out of all big American cities. Seeing such structures as expressions of popular fantasy, Venturi has produced "collage" architectural works that reflect his ideas. At Vail, Colorado, he and his associates built a four-story vacation lodge (FIG. 23-60) whose exterior suggests a rustic mountain cabin, with some of the flavor of a chalet. Setting the building into a steep slope, Venturi reversed the traditional distribution pattern for the rooms in a dwelling. The private rooms here are on the two lower floors, while the public rooms occupy the two upper stories, taking advantage of the higher view. The fourth floor dramatically caps the design, in all its "complexity and contradiction," with a vaulted parlor, luminous with outdoor light from the lunette dormers and the sheen of cedar. The material

23-60 ROBERT VENTURI and Associates, Brant-Johnson house, Vail, Colorado, 1977.

throughout is wood (cedar siding and shingles, oak stairs, maple counters), all scrupulously handcrafted. The massive, peaked roof, pulled tightly down onto the exterior walls, contrasts with the large, lunetteshaped dormers. The free proportions, the asymmetries, and the almost random placement of features suggest an architectural montage based on inspiration from both "high" and "low" sources—Palladio, Art Nouveau, the "romantic" Finnish Internationalist architect Alvar Aalto, and Le Corbusier—that are widely separated in time and tone. Venturi's building is an expression of a self-conscious manner that deliberately looks away from any single tradition and forcefully sets itself against the rigorous consistency of the International Style.

In Paris, the short-lived partnership of British architect RICHARD ROGERS (b. 1933) and Italian architect RENZO PIANO (b. 1937) resulted in the use of motifs and techniques from ordinary industrial buildings in the design for the Georges Pompidou National Center of Art and Culture, known popularly as the "Beaubourg" (FIG. 23-61). The anatomy of this sixlevel building, which opened in 1977, is fully exposed, rather like an updated version of the Crystal Palace (FIG. 21-95). However, in the case of the Pompidou Center, the structure's "metabolism" is also visible. Pipes, ducts, tubes, and corridors are coded in color according to function (red for the movement of people; green, for water; blue, for air conditioning; yellow, for electricity), much as in a sophisticated factory. Critics who deplore the Beaubourg's vernacular qualities have pointed out that its exposed entrails require excessive maintenance to protect them from the elements and disparagingly refer to the complex as a "cultural supermarket." Nevertheless, the building has been popular with people since it opened. The flexible interior spaces and the colorful "archigraphic" revelation of the structural body provide a festive environment for the great crowds that flow through the building, enjoying its art galleries, industrial design center, library, science and music centers, conference rooms, research and archival facilities, movie theaters, rest areas, and restaurant (which looks down and through the building to the terraces outside). The sloping plaza in front of the main entrance has become part of the local scene. This "square" is filled with peddlers, street performers, Parisians, and tourists at almost all hours of the day and night. The kind of secular activity that once took place in the open spaces in front of cathedral entrances interestingly has shifted here to a center for culture and popular entertainment-perhaps the things shared now by the largest number of people. As a former director of the museum, K. G. Pontus-Hultén said: "If the hallowed, cult-like calm of the

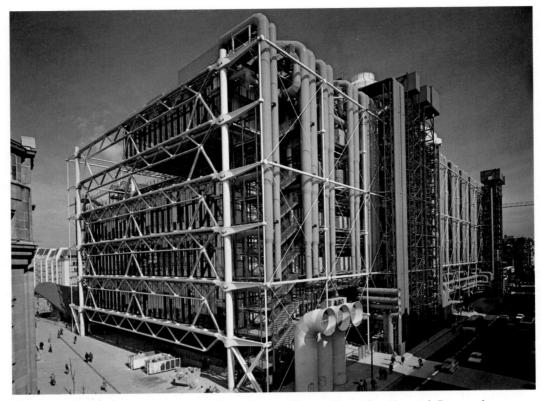

23-61 RICHARD ROGERS and RENZO PIANO, Georges Pompidou National Center of Art and Culture (the "Beaubourg"), Paris, 1977.

traditional museum has been lost, so much the better. . . . We are moving toward a society where art will play a great role, which is why this museum is open to disciplines that were once excluded by museums and which is why it is open to the largest possible public."*

The American architect JOHN PORTMAN (b. 1924) combined the look of the giant interior spaces of ancient Rome with the sleek luxurious appointments of modern corporate skyscrapers to invent a popular new kind of public building-a tower block built around a spacious central atrium. Such designs are part of the shifting focus in technological societies that is moving architects and their businessmen patrons away from a concentration on the efficiency of buildings and toward a special concern for the "humanization" of interior space to benefit the occupants. Portman's Peach Tree Plaza, Atlanta (FIG. 23-62) is a sumptuous example of the style initiated by the architect in his earlier design for the Atlanta Hyatt Regency Hotel to address what he saw as a diminishing supply of crucial public space in modern buildings: "Our approach has been to try to open things up and to let buildings breathe. . . . Within an

*K. G. Pontus-Hultén, Architectural Record (February 1978), p. 103.

23-62 JOHN PORTMAN, Peach Tree Plaza, Atlanta.

23-63 GÜNTER BEHNISCH, Hysolar Institute Building, University of Stuttgart, 1987.

urban setting, off the heavily trafficked area, we wanted to create the feeling of a resort."* Portman uses glass-sided elevator towers and corridors opening onto the atrium to allow all inhabitants of his hotels and shopping centers to feel part of the festive atmosphere created by the elegant details of carefully placed sculpture, kiosks, plants, and activity areas. The psychological effect is directed at the pleasure of the people using the space.

In the 1980s, a very different architectural approach from that of Postmodernism appeared in the work and writings of "Deconstructionist" architects who create works that challenge every aspect of accepted thought about the nature of building design and significance. Deconstructionism was originally developed as a mode of analytical thinking by the French philosopher Jacques Derrida to accommodate the present understanding of the universe as a constantly shifting state of being. Deconstructionists feel that the meaning assigned to any word or thing is always arbitrary—tied to cultural and social conditions that change constantly. Artists and architects inspired by Deconstructionism want to create works that confound all traditional expectations about architectural qualities. Günter Behnisch (b. 1922) borrows nothing from the past for the design of his buildings. The walls of structures like his Hysolar Institute Building at the University of Stuttgart (FIG. 23-63) no longer seem to enclose space; the arrangement of the parts appears as elusive as the space in one of Bell's sculptural environments (FIG. 23-44). The shapes of the Hysolar Institute's roof, walls, and windows seem to explode, avoiding any suggestion of clear, stable masses. There is not even a pastiche of vernacular or familiar forms appropriated from popular culture or earlier styles. Instead, Behnisch is aggressively playing with the whole concept of architecture and our relationship to it. The meaning of the building is dislocated by the building itself, and the viewer/inhabitant cannot avoid thinking about the nature of architecture and of building.

Typical of Postmodernism in painting is the work of MARK TANSEY (b. 1949), who took as his subject the role of mass media in the art world. Drawing fully on the resources of photographic reproductions, especially those in newspapers and magazines, and adopting the sepias and grey-greens of rotogravure pictures in the Sunday newspaper supplements early in the century, Tansey's works assemble unlikely

^{*}In Barbara Lee Diamonstein, *American Architecture Now* (New York: Rizzoli, 1980), p. 213.

23-64 MARK TANSEY, Triumph of the New York School, 1984. 6' $2'' \times 10'$. Collection of the Whitney Museum of American Art (promised gift of Robert M. Kaye).

gatherings of references to art world persons, things, times, places, and events. These are paintings for insiders who know the history of art and the people who have made it. Triumph of the New York School (FIG. 23-64) depicts, as an allegory, the historical shift of the artistic fulcrum from Paris to New York after 1945. The passing of power is dramatized here as a surrender of the French army (on the left), clad in the uniforms of World War I, to the American army (on the right), dressed in the garb of a World War II fighting unit, replete with motorized armor. The landscape is populated with recognizable portraits of the main artists and critics involved. Among the French are Pablo Picasso, Henri Matisse, the French poet and critic Guillaume Apollinaire, and the Surrealist poet and theoretician André Breton. Among the Americans are key figures of the New York school: Jackson Pollock, the painter Robert Motherwell, and the critics Clement Greenberg and Harold Rosenberg. The elegant dandyism of the French troops and the firm ground on which they stand are metaphors for the Abstract Formalism that continued to flourish in Paris. The slouchiness of the GIs and the puddles beneath their feet represent the drip and splatter techniques of Action Painting and the workingman's esthetic affected by many Abstract Expressionists in the style of their daily life. The composition of this modern "surrender" echoes that of a well-known masterpiece by Velázquez, The Surrender of Breda (The Lances), but that source is cancelled by the twentiethcentury uniforms and the modern armor. The kneeling news photographer symbolizes the vast amount of attention paid to all events in the art world today and also lends a note of "authenticity" to this allegory of a formalized single gathering as a metaphor for a transfer of power that occurred in a much more general manner.

Tansey's Triumph of the New York School can be considered the picture of an event staged to express an idea; as a "performance," it falls within the tradition of Performance Art practiced by the Zurich Dadaists, some of the Surrealists, and various other modern and contemporary artists. Postmodernist sculpture and Performance Art have found their most striking expression in the recent works of LAURIE ANDERSON (b. 1947), who has borrowed styles from all kinds of popular performing arts, from cabaret through rock music to cinema and television. Her high-energy and high-tech art incorporates the power of master storytelling into a style built on the modern audience's ability to absorb fast-paced, multilayered visual and oral fragments. Anderson trained initially as a sculptor and supported herself by teaching art history, illustrating children's books, and writing art criticism, before turning full-time to Performance Art. With a strong interest in the potency of words and in the symbols of visual communication, Anderson studied both the hand gestures (mudras) of Indian culture and the sign language of the deaf. As her style evolved toward her tour de force performance works, she mastered all kinds of technological media, including electronic musical instruments, photo projection,

23-65 LAURIE ANDERSON, United States Part II, presented by the Kitchen at the Orpheum Theater, New York, 1980. Performance Art.

manipulated video, and devices that altered the timber of her voice. Along the way, she has invented special instruments (many of which are variations on her ever-present violin) that incorporate tape players with which she accompanies herself in multilayered ways. Her four-part piece United States was part grand opera, part multimedia avant-garde performance, and part popular art-rock concert. Each section had a motif-Transportation, Politics, Money, Love. United States Part II (FIG. 23-65), the Politics section, used recurrent Anderson visual themes like the grid, magnified shadow hands, and the artist herself (dressed in a black jacket and pants and using a white violin) in a performance that included a dense collage of sounds, projected words, and spoken narrative to suggest ideas connected with the political realities in today's world. Performed first in the Orpheum Theater in New York City, rather than in the alternative spaces used by Happenings and other avant-garde Performance Art pieces, United States II appealed to an audience that crossed the lines between fans of popular music and the elite art audience. Anderson's piece was influenced by Philip Glass's Minimalist opera Einstein on the Beach, the element of shock in Dada performance, the quality of dislocating dream in Dali's and Buñuel's Un Chien Andalou (FIG. 22-35), and the high-technology fantasy of some Bauhaus theater. (An early Anderson piece re-created one of the most well-known Bauhaus works, Sharkey's Day by Oskar Schlemmer.) But United States also made hypnotic use of the clichés of ordinary speech, auto-

biographical memories, and invented fragments of allegory and ritual. Anderson's costume was deliberately androgynous; her "vocoder" transformed her voice into eight variations ranging from that of a young girl to that of an impersonal male authority figure. To the audience, seeing *United States* was like existing in a combination of past and present, fact and fantasy, the most personal reminiscences and mass-media messages. At any moment, many things happened simultaneously, not in layers as in Paik's *Global Groove* or Kaprow's *Spring Happening*, but as a collection of clear parts, each claiming attention, while Anderson was always at the center as "ringmaster," star performer, and teller of fables about modern life.

ART WITH SOCIAL AND POLITICAL CONCERNS

The increased interest in art of all cultures and times in the contemporary period led many artists to a new awareness of the power of art's role and to a belief that the artist has a responsibility to wield this power with great care. Understanding that all art is shaped to some extent by the beliefs of the artist and the culture in which it is made, some artists with political and social concerns, working in a variety of media, used their art self-consciously to share perceptions about inequities in the lives of the poor, the elderly, blacks, and women, or the effect on life of the operations of big business, government, and the military. Less strident in tone than the admonitory voice of these activist artists was the art of another group—Earth and Site artists—whose works were aimed at helping human beings return to a sense of oneness with nature and other human beings. This group created works, usually outdoors, that involved the viewer imaginatively or literally in interaction with the pieces.

Activist Art

Even in the troubled period since World War II, certain artists have retained a faith that art can teach, modify behavior, and help motivate people to create a more fully human world. The works of some of these artists give voice and visibility to parts of society hitherto less valued by the mainstream. The works of others deal with the effects of political forces. All of these artists bring to their work a contemporary version of the Enlightenment belief that art has the power and obligation to change hearts, minds, and society.

Cinema remains one of the most powerful mediums for vivid presentation of the lives of others. In Italy, Neo-Realists like VITTORIO DE SICA (1902–1974) created a new form of feature film, applying a documentary style to stories based on the everyday life of poor people in postwar Italy. In the 1940s, De Sica abandoned a career as a popular matinee idol and director of comedies to work with the screenwriter and theoretician CESARE ZAVATTINI (b. 1902) on a new kind of Italian film that abandoned artificial, contrived plots and the "falseness" of professional acting for stories based on the authentic problems of the urban poor in postwar Italy. These movies were filmed on location with performances by people who were not professional actors. Bicycle Thieves or The Bicycle Thief (Ladri di biciclette, FIG. 23-66) was the second film by De Sica and Zavattini and a Neo-Realist masterpiece. In a time when unemployment in Italy was over 20 percent, the movie tells the story of an out-ofwork family man in Rome who gets a job posting bills but must pawn the family's sheets to buy the bicycle he needs to do the work. Almost immediately, the bicycle is stolen, and the film follows the fruitless search for the stolen vehicle undertaken by the man and his small son. Toward the end of the movie, desperation drives the man to attempt to steal a bicycle himself, but he is caught in the act. Despite the filmmakers' dedication to realism, as many details of the film as possible were planned in advance. To put his actors at ease and to get them ready for their parts, De Sica spent a lot of time with them before shooting started. No part of the film's action was left to chance. Even the theft of the workingman's bicycle was timed

23-66 VITTORIO DE SICA, film still from Bicycle Thieves, 1948.

so the thief could escape through green traffic lights while six hidden cameras recorded the sequence. *The Bicycle Thief* touched audiences as being more authentic and true to life than anything they had seen before. Even today the film touches audiences with its poignant depiction of the relationship between a father and his son and its vision of individual human isolation and helplessness in a brutal, impersonal urban environment.

A somewhat similar vision of the life of ordinary people in America was captured in photographs taken on a cross-continental trip in 1955-1956 by the Swiss-born American artist ROBERT FRANK (b. 1924). Working with a lightweight 35mm camera and an unerring eye for the pervasive and uneasy edginess of much of modern life, Frank took over thirty-eight thousand photographs on his journey. The eightythree he selected for publication in his book The Americans, among them Trolley, New Orleans (FIG. 23-67), provide sometimes uncomfortable glimpses into everyday life in America. An occasional locale was depicted emptied of its human inhabitants, but even when groups of people were present, as on the New Orleans trolley car, Frank captured the sense of alienated loneliness in the most ordinary activity. These images have an informal, almost haphazard style very different from that of Cartier-Bresson's "decisive moments" (FIG. 22-74), yet each of Frank's pictures contains a slice of life. Taken as a whole in the book, they present a loose narrative about life in America, paralleling the 1950s spirit of the book On the Road by the "beat" poet-writer Jack Kerouac, who also wrote the introduction for the English language edition of The Americans.

23-67 ROBERT FRANK, Trolley, New Orleans, 1955–1956. Gelatin silver print, 9" × 13".
 © Robert Frank, courtesy Pace/MacGill Gallery, New York.

More accusatory in tone than Frank's photographs were the "tableaus" created by the American sculptor EDWARD KIENHOLZ (b. 1927) to express the empathy and distress he felt at witnessing the pathos and dignity in the lives of ordinary people. Pieces like *The Wait* (FIG. 23-68) dramatically confronted gallery visitors with uncomfortable scenes from the lives of people living on the fringes of society. *The Wait* shows an old woman sitting alone in a room filled with mementos of her earlier life. For this work, as for all his tableaus, Kienholz haunted junk shops and rummage

sales to assemble the actual objects he used here to create the room—the woman's clothing, her sampler, the sewing basket, the framed family photographs, the wallpaper, the furniture, and the taxidermiststuffed cat. The emotional effect of the tableau is intensified by the fact that the emaciation of old age is suggested by the large animal bones that serve as the woman's arms and legs, and by the distressing fact that close examination reveals her head to be an animal's skull within a bell jar that bears on its front surface a portrait taken of her on her wedding day.

23-68 Edward Kienholz, *The Wait*, 1964–1965. Tableau, 6' $8'' \times 12' 4'' \times 6'$ 6". Collection of the Whitney Museum of American Art (gift of the Howard and Jean Lipman Foundation).

The way in which real objects blend with the lavers of their possible meanings gives Kienholz's tableau the immediacy of the present moment combined with the resonance of remembered dreams or nightmares. The combined objects act to distill within this fragment of a room a situation familiar to us all, but one that we usually try to ignore, as the artist himself has noted: "The ongoing theme of my work is probably deathand how it is not used as energy by society. It's hidden and repressed, it's not talked about . . . but it's the motivation that we call upon to be successful. It's the fear of death that pushes everyone along. Immortality and fame versus ordinary, mortal, human, clay selves."* It is this resonance that makes the narrative in Kienholz's tableaus so powerfully moving and so unforgettable.

Racial injustice has been the central theme of the mural paintings of artist WILLIAM WALKER (b. 1927), who was one of the first Americans to emulate the political and cultural murals painted in the 1920s and 1930s by Orozco (FIG. 22-82) and other Mexican artists. Stimulated by the black power movement, the new mural movement began in 1967, when Walker and a group of other African-American artists filled one wall of a deserted two-story Chicago building with a montage painting (called the Wall of Respect) on the theme of the accomplishments of black leaders in all fields, aiming the content of the work toward the people who lived in the surrounding neighborhood. A painted label on the Wall of Respect read: "This Wall was created to Honor our Black Heroes, and to Beautify our Community." Unfortunately, much of the mural disappeared in urban renewal a short time after its completion, although some panels were rescued and installed at a new location at Malcolm X College in Chicago. The idea of a new "art for the people," however, inspired a public mural movement that spread throughout the United States, Europe, and Central and South America. Whether painted on the walls by teams of untrained workers from the neighborhood under the direction of a professional artist, or created by a single artist with the backing of local citizens, these murals were intended to instill pride in local people about their culture and heritage. Walker's Peace and Salvation, Wall of Understanding (FIG. 23-69) recalls the visual chaos of a Dada montage (FIG. 22-28), with abrupt jumps in scale, space, and subject. However, the images in Walker's work have none of the ambiguity of a Dada piece. Gun battles between local gangs and between residents and white policemen are depicted on the wall, as are marchers for peace (at the bottom) and a multi-

23-69 WILLIAM WALKER, Peace and Salvation, Wall of Understanding, 1970. Wall mural on four-story building at Locust and Orleans Streets, Chicago.

racial group standing on a globe of the world within the sleeve of a black arm and hand (at the top). Walker used his art to further understanding between individuals. In 1971, he wrote: "People are now realizing that public art is essential because it is relevant to each of them. Art is a universal language, destroying the barriers that stand so firm before man."[†] The idea of public mural art has been picked up in other communities by African-Americans, Asian-Americans, Latinos, and other groups who feel such art can help to affirm their cultural heritage.

"Private" art also has been affected by the new social consciousness. American artist BETTYE SAAR (b. 1926) creates personal works that draw on imagery and symbols from her heritage as an African-American and as a woman. Her pieces are small, and many of them are based on an intuitive personal iconography. Hers is an art of the found object, initially

⁺In Eva Cockcroft, John Weber, and James Cockcroft, *Toward a People's Art: The Contemporary Mural Movement* (New York: E. P. Dutton, 1977), p. 71.

inspired by the boxes of Joseph Cornell (FIG. 22-39). Saar continually scours junk stalls, antique markets, and jumble sales for objects that hold meaning for her. Her assemblages combine objects whose significance she recognizes instantly with other items whose attraction for her is more deeply hidden. The assassination of African-American leader Dr. Martin Luther King, Jr. in 1968 inspired Saar to create several series of assemblages dealing with the stereotypes developed by white society to characterize African-Americans. These assemblages were expressions of Saar's anger at the injustices continually faced by African-Americans. Into the works the artist built dolls, artifacts, news stories on lynchings, and historical newspaper notices offering African-Americans for sale that featured poignant phrases like "four children sold separately." One of her earliest series on this theme is The Liberation of Aunt Jemima, in which Saar presents the image of the faithful, smiling black woman-but with a savage twist: the introduction of rebellion in her daily household routine. In our 1972 example (FIG. 23-70), Aunt Jemima is a stereotypically plump, grinning black doll-woman, dressed in a polka-dotted dress, kerchief, and turban. The wall behind her is papered with rows of the familiar beaming face from the label of the pancake mix, and the doll's apron has been replaced by a found illustration of a smiling black servant holding a white child. Flanking this image, the doll figure holds a broom in one hand and a rifle in the other. The work is an unforgettable icon, intended to raise viewer consciousness about the history and destructive power of such stereotypes in American society.

In the 1970s, the feminist movement focused the attention of women on their history and their place in society. In art, the feminist movement was given shape by two women—Judy Chicago and Miriam Schapiro—under the auspices of the Feminist Art Program, which they founded at the California Institute of the Arts in Valencia, California. As part of this program, teachers and students joined to create projects like *Womanhouse*, for which they completely converted an abandoned house in Los Angeles in 1972 into a suite of "environments," each based on a different aspect of women's lives and fantasies.

In her own work, JUDY CHICAGO (born Judy Cohen in 1939) wanted to educate viewers about women's role in history and the fine arts. Inspired early in her career by the work of Hepworth (FIG. 22-51), O'Keeffe (FIG. 22-65), and Nevelson (FIG. 23-11), Chicago developed a personal painting style that consciously included abstract floral vaginal images. In the early 1970s, Chicago became interested in the expressive possibilities of china painting, and she began planning an ambitious piece, *The Dinner Party* (FIG. 23-71),

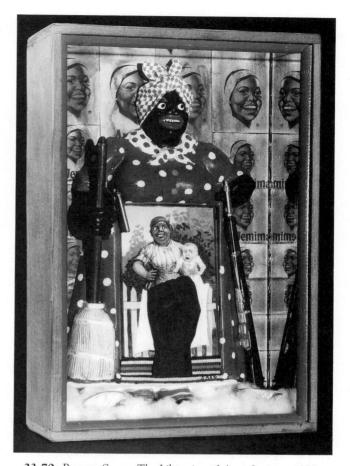

23-70 BETTYE SAAR, *The Liberation of Aunt Jemima*, 1972. Mixed media, $11_{4''}^{3''} \times 8'' \times 2_{4''}^{3''}$. University Art Museum, University of California at Berkeley (purchased with the aid of funds from the National Endowment for the Arts and selected by the Committee for the Acquisition of Afro-American Art).

23-71 JUDY CHICAGO, *The Dinner Party*, 1979. Multimedia, $48' \times 48' \times 48'$ installed. © Judy Chicago, 1979.

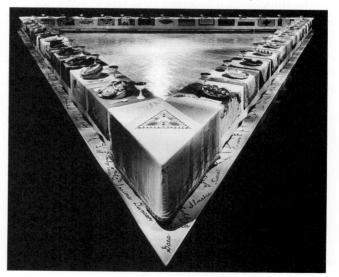

23-72 MIRIAM SCHAPIRO, Anatomy of a Kimono (section), 1976. Fabric and acrylic on canvas, 6' 8" × 11' 11". Collection of Bruno Bishofberger, Zurich.

which used "crafts" techniques traditionally practiced by women (china painting and stitchery) to depict the roles played by women throughout history. The work was originally conceived as a feminist "Last Supper" attended by thirteen women (the "honored guests"), in a selection embodying both the positive and negative meanings associated with the number thirteen (the number of persons present at the Christian Last Supper and the number of witches in a coven). Research uncovered so many worthy women that Chicago expanded the number of guests threefold to thirty-nine and placed them around a triangular table 48 feet long on a side that symbolizes both the traditional sign for woman and for the "Goddess." The piece's assembly was carried out by a team of workers under Chicago's supervision and to her designs. The Dinner Party table rests on a white tile floor inscribed with the names of 999 additional "women of achievement" to signify that the accomplishments of the thirty-nine honored guests rest on a foundation laid by other women. Among the "invited" women at the table are Georgia O'Keeffe, the Egyptian Pharaoh Hatshepsut, the British writer Virginia Woolf, the Native American guide Sacajawea, and the American suffragist Susan B. Anthony. Each guest was given a place setting with identical eating utensils and goblet. All of the guests also have an individual, oversized, porcelain plate bearing a stylized butterfly design and a long place mat or table runner filled with symbols that reflect significant facts about their lives. The plates range from simple concave shapes with chinapainted designs to dishes from which sculptured three-dimensional designs almost seem to be trying to fly away. Each table runner is worked with a combination of traditional needlework techniques, including needlepoint, embroidery, crochet, French knots, and appliqué. The rigorous arrangement of *The Dinner Party* and its sacramental qualities draw visitors in and let them experience the importance of forgotten details in the history of women.*

Pursuing a somewhat different path than that undertaken by Chicago, MIRIAM SCHAPIRO (b. 1923) tries in her work to rouse her viewers to a new appreciation of the beauty in humble materials and techniques used by women artists/craftspersons throughout history. Schapiro was in the midst of a thriving career as a Hard-Edge Abstract Formalist painter when she moved to California, co-founded the Feminist Art Program, and became fascinated with the hidden metaphors for womanhood she now saw in her Abstract Formalist paintings. Intrigued by the materials she had used to create a doll's house for her part in Womanhouse, Schapiro began to make huge sewn collages (called *femmages*), which she assembled from fabrics, quilts, buttons, sequins, lace trim, and rickrack collected at antique shows and fairs. Anatomy of a Kimono (FIG. 23-72) is one of a series of monumental femmages based on the patterns of Japanese kimonos, fans, and robes. This vast composition repeats the kimono shape in a sumptuous array of fabric fragments. Schapiro is not alone in finding magic in pattern, and her femmages were part of a movement in the 1970s called "Pattern and Decoration Painting," because its members were dedicated to making decorative pattern the content of their works. However, Schapiro's femmages are not solely formalist abstractions, as are many other Pattern and Decoration works; instead, her materials carry references to the whole history of women's crafts and needlework,

^{*}Judy Chicago formed the nonprofit Through the Flower Corporation to take charge of sending *The Dinner Party* on tour to many locations around the United States, of storing it at tour's end, and of publishing a book containing the biographical details of the women included in the piece.

and call attention to the often complex abstract compositions in handwork hitherto considered beyond the arena of fine art. Viewing her works encourages observers to rethink traditional ideas about media, subject matter, and the artistic energies of women.

Creating a broader social awareness, often with a feminist twist, is the goal of the American artist BARBARA KRUGER (b. 1945), whose best-known subject has been the manipulation of attitudes by modern mass media. Kruger's serious art career began with fiber sculpture inspired by the works of Abakanowicz (FIG. 23-30), but she soon began creating pieces that drew on her early training and work as a graphic designer for the magazine Mademoiselle. Mature works, like Untitled (Your Gaze Hits the Side of My Face, FIG. 23-73), play with media layout techniques used in the mass media to sell consumer goods. But Kruger's huge word-and-photograph collages (often 4 by 6 feet in size) express the cultural attitudes embedded in commercial advertising. In Untitled (Your Gaze Hits the Side of My Face), she has targeted feminist concerns by overlaying a readymade photograph of the head of a classically beautiful female sculpture with a vertical row of text composed

23-73 BARBARA KRUGER, Untitled (Your Gaze Hits the Side of My Face), 1985–1987. Collage.

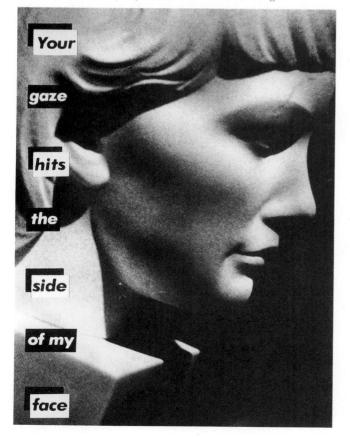

of seven words selected by the artist. The words are isolated into bold, black-and-white rectangles. They cannot be taken in with a single glance. Reading them is a staccato exercise, with an overlaid cumulative quality that delays understanding and intensifies the meaning (rather like reading one of the old Burma Shave series of roadside signs from a speeding car). The message in Kruger's piece reflects the interest of contemporary feminist theorists in the way that much of Western art has been constructed to present female beauty for the enjoyment of a "male gaze." Although many of Kruger's pieces deal with feminist concerns, she also has tackled attitudes of political and economic power. One of her best-known works in this mode calls attention ironically to the marketplace economy of the modern art world. A detail of the eyes, nose, and mouth of a Howdy-Doody puppet is overlaid with three bands of words: "when I hear the word," "culture," "I take out my checkbook." As in each of Kruger's works, viewers here can read multiple meanings into the image, drawing on their own experience, but her art forces nearly everyone into some consideration of how our attitudes are molded by the bombardment of mass media that surrounds us daily.

The social and political concerns of the German artist JOSEPH BEUYS (1921–1986) were directed at the whole condition of modern human beings, especially those in Western developed nations. Beuvs strongly believed that the spiritual nature of humans is expressed through creativity and ability, in vigorous opposition to the negative forces of what he called "the principle of Auschwitz." After narrowly escaping death as a Nazi pilot shot down in a remote part of the Crimea, Beuys dedicated himself to working for the future of humanity. First, he studied natural science but left that field to take up sculpture. He wanted to make a new kind of sculptural object that would include "Thinking Forms: how we mould our thoughts . . . Spoken Forms: how we shape our thoughts into words . . . [and] Social Sculpture: how we mould and shape the world in which we live." Believing that all art belongs to the same sphere of human activity, no matter what medium the creator uses, Beuys accepted sculptors, musicians, and writers into his classes at the Düsseldorf Art Academy. Beuys's objects and installations seem to be connected with mysterious rites. Charismatic in person, he also created one-person performances in which his stylized actions evoked a sense of mystery, profound human meaning, and sacred ritual. Iphigenia/Titus Andronicus (FIG. 23-74) was developed from an invitation to create modern performances of two historic theatrical masterpieces-Goethe's Iphigenia and Shakespeare's Titus Andronicus. Beuys contrived a

23-74 JOSEPH BEUYS, Iphigenia/Titus Andronicus, 1969. Performance Art.

divided setting, incorporating a spotlighted, tethered white horse standing on a metal plate that resounded every time the horse moved. In this dual setting, the artist read from each play and performed mysterious actions using objects positioned near a microphone, including a pair of cymbals, which he clashed when necessary to quiet boisterous behavior in the audience. In such performances, Beuys considered himself as a shaman carrying out actions to help "revolutionize human thought," so that each human being could become a truly free and creative person. As was fitting for the actions of a shaman, most of Beuys's performances were not public events, but were witnessed only by small audiences. Through the effect on the viewers, and even more, through the efficacy of the acts themselves, the artist believed that the world could be changed.

More direct in trying to sensitize large numbers of viewers to the consequences of actions by government, big business, and the military are the "countermonuments" created by the expatriate Polish artist KRZYSZTOF WODICZKO (b. 1943). Wodiczko has used special, powerful projectors to throw carefully selected slide images onto public buildings and memorial monuments, creating large-scale montages that carry political meanings. He has chosen structures

and monuments with the clearest historic and official meanings within the society-churches, museums, office buildings, housing projects, and sculptures honoring military heroes. The images he has projected most often are those of human body parts, creating the same kind of metaphor that led Le Corbusier to think of Notre Dame du Haut (FIG. 23-9) as a pair of praying hands. Although Wodiczko moved to Canada in 1977 and, since 1983, has divided his time between Toronto and New York City, he has created counter-monuments all over the world. In Australia, his projection of naked arms transformed the Gallery of New South Wales into a structure that both welcomed visitors and reminded them of the authoritarian power that governed the selection of the works of art inside. Anti-apartheid ideas inspired the artist's projection of a swastika onto the pediment of the South African embassy in London; his negative attitudes toward big business spurred his projected image of two hands-one with keys and one with a roll of money-onto the walls of a low-income hous-

23-75 KRZYSZTOF WODICZKO, Projection on the Martin Luther Kirche, Kassel, Germany, 1987. Projected images on building created for Documenta 8. Courtesy Hal Bromm Gallery, New York.

ing project in Chicago; and government ineptness sparked his proposal to project the image of a wheelchair-bound homeless person onto a statue of George Washington to call attention to the increasing plight of people without permanent housing. Industrial pollution was the target of Wodiczko's 1987 projection of a figure in a protective suit and gloves onto the façade of the Martin Luther Church (Kirche) in Kassel, West Germany (FIG. 23-75). Like his other works, this gigantic montage created an unforgettable symbol with its strong suggestion of the powerlessness and sanctimoniousness of individual piety and organized religion in the face of industrial and political authority. In works like this, Wodiczko undercut the official symbolism in public buildings with ideas about their true function in society.

Earth and Site Art

As we have seen, artists have responded to the pressures of life in the contemporary world with a variety of styles and diverse content. Perhaps the most lyrical art produced during the period is that designed to sensitize viewers to the special and wonderful qualities of the natural and urban environments around us. Working variously in remote locations or on sites in the midst of human habitation, the artists creating this art come the closest of any in the contemporary world to expressing hope for the future of humanity and our world. Depending on the individual artist's approach, their work has been called Earth Art, Environmental Art, or Site Art.

A leading member of this group was ROBERT SMITHSON (1938–1973), who used industrial construction equipment to manipulate vast quantities of earth and rock on isolated sites in order to express his ideas about the meaning for our lives of natural systems, geological time, and entropy (the amount of disorder in a closed system, which increases as the system loses energy and enters decay). Beginning with early works based on the structure and behavior of crystals, Smithson moved to a series of Site/Nonsite pieces. In these, he transported materials from specific distant locations to museum settings and displayed the collected material (with accompanying topographical maps and photographs) in constructed metal bins, establishing a dialogue for the viewer between the original site and the museum location. He then did a series of temporary on-location pieces in which he modified the landscape physically (through processes such as pouring asphalt down a rock face) or visually (through placement of mirrored plates throughout the space). In seeking to do a more permanent Site piece, Smithson was attracted to a site on the Great Salt Lake in Utah. He built Spiral Jetty (FIG. 23-76), a vast coil of earth and stone that symbolized the reality of time, on a monumental scale, so that it extended out into the lake. The idea grew from Smithson's first impression of the location: "As I looked at the site, it reverberated out to the horizons only to suggest an

23-76 ROBERT SMITHSON, Spiral Jetty, April 1970. Black rocks, salt crystal, earth, red water, algae, 1,500' long, 15' wide. Great Salt Lake, Utah.

23-77 Christo, Surrounded Islands, Biscayne Bay, Greater Miami, Florida, 1980–1983. Pink woven polypropylene fabric, $6\frac{1}{2}$ million sq. ft.

immobile cyclone while flickering light made the entire landscape appear to quake. A dormant earthquake spread into the fluttering stillness, into a spinning sensation without movement. The site was a rotary that enclosed itself in an immense roundness. From that gyrating space emerged the possibility of the Spiral Jetty."* Smithson tried in this piece for an indissoluble unity of art and nature, much like the suspension of the boundaries between "self" and "nonself" that he hoped to instill in his viewers. As was the case with many other Earth Art works, Spiral Jetty's location made it difficult for viewers to see in person. People know of such works mostly through photographs, and artists working in this mode have become increasingly self-conscious about how they document their work visually. Smithson not only recorded Spiral Jetty in photographs, but he filmed its construction in a movie that describes the forms and life of the whole site, including its relative inaccessibility. The photographs and the film have become increasingly important because shifts in the water level of the Great Salt Lake have placed Spiral Jetty underwater for several years.

CHRISTO (born Christo Javacheff in 1935) intensifies the viewer's awareness of the space and features of natural and urban sites by modifying parts of them with cloth. His pieces also incorporate the relationship between human social/political action, art, and the environment. Study of art in his native Bulgaria and in Vienna was followed by a period in Paris, where Christo began to encase objects in clumsy wrappings, in this way appropriating bits of the real world into the mysterious world of the unopened package whose contents can be dimly seen in silhouette under the wrap. Settling in New York City in 1964, Christo made storefronts like strange stage sets surrounded with windows wrapped in paper and cloth, and constructed ambitious temporary installations in which he wrapped sections or even entire buildings. Turning his attention to the environment, he created giant "air packages" in Minneapolis and Germany. Then he dealt with the land itself, carrying out projects like wrapping over 1 million square feet of Australian coast and hanging a vast curtain across a canyon at Rifle Gap, Colorado. The land pieces required years of preparation, research, and scores of meetings with local authorities and interested groups of local citizens. Christo has always considered that his Site pieces include the lobbying activity and the visual documentation that goes into them as well as the actual short-lived physical pieces themselves. Surrounded Islands (FIG. 23-77), created in Biscayne Bay in Miami, Florida, for only two weeks in May of 1983, is typical of his Site work. For this project, eleven small man-made islands in the bay were surrounded with specially fabricated pink polypropyl-

^{*}In Nancy Holt, ed., *The Writings of Robert Smithson* (New York: New York University Press, 1975), p. 111. Smithson was tragically killed in 1973, when the airplane in which he was surveying a site for a new Earth sculpture crashed near Amarillo, Texas.

23-78 RICHARD LONG, A Line in Scotland, 1981. Photograph of constructed earthworks, Cul Mór, Scotland. Photograph in collection of Philip and Psiche Hughes.

ene fabric, following two years of preparation to gain the required permissions, assemble the necessary troop of ordinary and professional workers, and raise the \$3.2 million cost of the project (which was accomplished entirely through the sale of preliminary drawings, collages, and models of the piece made by Christo). Huge crowds watched as Christo's crews stripped accumulated trash from the islands (to assure maximum contrast between their dark colors, the pink of the cloth, and the blue of the bay), anchored the huge cloth "cocoons" in the island vegetation, and then unfolded the fabric to form magical "skirts" around each tiny bit of land. Because each of his Site pieces has the quality of spectacle, some critics have compared Christo's works to Happenings, but the artist disagrees: "All Happenings are makebelieve situations. Everything in my work is strongly literal. If three hundred people are used, it is not because we want three hundred people to play roles, but because we have work for them. When we go to work, there is a tense feeling, not a relaxed, joyous feeling as in a Kaprow Happening. . . . My work may look very theatrical, but it is a very professional activity."* Despite its short actual life, Surrounded Islands

lives on in the host of stunning photographs and books that document the piece.

The British artist RICHARD LONG (b. 1945) takes as his theme the experience of walking through remote wilderness areas. Attracted to climbing, camping, and other outdoor activities as a boy, he began working with natural materials, like sand, while studying sculpture in London and Bristol. The walking pieces for which he is best known are each actually carried out by Long, before being shared with viewers through photographs, annotated maps, panels of text, and arrangements of materials gathered along his route and placed in circles, lines, or spirals on the floors or walls of art galleries. The photograph A Line in Scotland (FIG. 23-78) documents a walk by Long through the Scottish Highlands, during which he erected a line of stones atop a rocky promontory and photographed them so that the tiny backlit monoliths recall their larger brothers at Neolithic ritual sites of standing stones like Stonehenge (FIG. 1-15). Few viewers are insensitive to the aura of awesome mystery in Long's work; through pieces like A Line in Scotland, modern city-bound individuals touch the wellspring of human history in the midst of the contemporary world.

Like Long, the American sculptor DOUGLAS HOLLIS (b. 1948) has a strong empathy for natural forces.

^{*}In David Bourbon, Christo (New York: Harry N. Abrams, 1972), p. 25.

23-79 DOUGLAS HOLLIS, A Sound Garden, National Oceanic and Atmospheric Administration, Seattle, 1983. Wind-organ towers 23' high.

Hollis has selected accessible sites and designed works intended to re-awaken the sensory perception of visitors to natural processes, especially those of wind. Born in Michigan, Hollis spent many boyhood summers with a Native American family on a reservation in Oklahoma, and this experience left him with a vision of humans as an integral part of nature. This view has guided much of his art, including Site pieces like A Sound Garden (FIG. 23-79), commissioned by the National Oceanic and Atmospheric Administration (NOAA) as one of five art works for their Northwest Center on Lake Washington near Seattle. Hollis selected the hilltop site overlooking the lake for his Sound Garden because he felt a strong empathy with the place. He wanted to create an ongoing "conversation" with the wind—a sound environment that could help people become more attuned to themselves and to nature. Hollis developed his techniques for sound sculpture in earlier kite pieces, wind harps, and wind organs at sites as varied as the roof of San Francisco's Exploratorium and the Niagara River gorge running through Art Park in upstate New York. The eleven sound units of A Sound Garden have upper sections that respond, much like weather vanes, to the action of wind blowing across Lake Washington. Tuned wind-organ pipes embedded in their structures "play" chords as the wind blows across their tops (rather in the manner children use to coax sounds from pop bottles). Hollis designed a special path leading to this piece. The triangular brick paver units used in the path were specially made in different clay mixtures to create different sonic rings as people followed this route to the sculpture site. In contrast to Smithson's and Christo's pieces, which can be well appreciated through photographs and films, Hollis's works are best experienced on-location by individuals. The visitor to A Sound Garden enters a mysterious world in which the physical forms become one with the action and sound of the wind accompanied by sonorous tones created by these giant musical instruments.

One of the most dramatic pieces of political art created in the twentieth century actually shares more qualities with Earth and Site art than with Activist art. The Vietnam Memorial (FIG. 23-80), designed by MAYA YING LIN (b. 1960) while a Yale undergraduate student in architecture, does not preach, castigate, or offer inflated praise. Instead, the extraordinary simplicity of Lin's monument touches the hearts of those who visit it in ways that, in the few years since its erection in 1983, have helped to heal the divisions caused in the United States by the prolonged "police action" in Southeast Asia. Located on the Mall in Washington, D.C., the Vietnam Memorial consists of a long wall constructed of seventy slabs of highly polished granite. The wall bends in the middle to form two triangular wings that widen as they descend into the earth from a shallow height at the outer corners toward a depth of over 10 feet at their joint. Carved into the face of the wall are the names of all of the Americans who died in the Vietnam conflict, listed chronologically in the order of their deaths. The slabs are numbered and directories containing alphabetical lists of the names are placed at the entrances to the site, so visitors can find the memorial location of a loved one. Like Judy Chicago (FIG. 23-71), Lin understands the resonant power of a name to signify a person. Those who lost relatives and friends visit the wall to linger over a particular name, making paper rubbings of it and leaving photographs, mementos, and flowers at its base as tributes. But all who come are filled with the enormity of the loss as the columns of names unroll as one walks along the adjacent path. Unlike the usual monument, the names carved here do not vanish into the comfort of a list ordered by rank or alphabetical placement. Each life lost in Viet-

23-80 MAYA YING LIN, Vietnam Memorial, Washington, D.C., 1981-1983. Marble, each wing 246' long.

nam has equal importance, equal value. Furthermore, as visitors move along the wall, its highly polished surface acts as a mirror, joining viewers with those who died. Rare is the visitor to this monument who is not drawn into silent meditation on the immeasurable cost of human life lost in the Vietnam conflict. The power of the wall to heal has been so great that replicas of the panels have been made and sent on tour throughout the country; at each stop this traveling monument attracts crowds who come to make connections with the silent rows of names.*

EPILOGUE

Almost every aspect of life has changed during the modern era. Art has assumed an astonishing variety of guises during this period to express the richness and diversity of these changes and the insights they have provided about the visual world and the inner realms of ideas, emotions, and unseen powers. Art has been used to sensitize viewers to color and form, to the inequities of society, to the possibilities for selffulfillment, and to the wonders of science and nature. As we near the end of the twentieth century, the diversity of artistic expression has widened to include the esthetic approaches to cultures outside the Western and Asian traditions. As artists travel more widely than ever before, and as the mass media acquaint all of us with a wider range of artistic styles, we may be moving toward a period in which a truly international world art will develop, one more allencompassing than anything that has gone before. Should this come to pass, it may provide spiritual and esthetic experiences of incalculable worth for the whole human race.

^{*}When Lin's winning design was first announced, one group of Vietnam veterans felt that it was not a suitable memorial for their lost comrades. They lobbied successfully for an additional monument of three naturalistically modeled bronze fighting men, representing the branches of military service that were most active in the conflict. These figures stand on the Mall in a nearby grove of trees and look toward Lin's memorial. More recently, the nurses who served in Vietnam won the addition of a fourth figure, representing the women who lost their lives. Curiously, these figures draw fewer visitors than the wall, perhaps because they are more in the tradition of monuments to be looked at, whereas Lin's memorial invites its visitors to engage in active participation with its information and its symbolism.

PRONUNCIATION GUIDE*

Artist's Name

Aalto, Alvar Abakanowicz, Magdalena

Agesander Alberti, Leon Battista

Albinus, Bernard Siegfried

Altdorfer, Albrecht Andokides Painter Andrea del Castagno

Andrea del Sarto Angelico, Fra Anguissola, Sofonisba

Anthemius of Tralles

Antonello da Messina

Antonio da Sangallo the Younger Apollodorus Apollonius Aqa Mirak Archuleta, Felipe Arnolfo di Cambio

Arp, Jean Asam, Cosmas Damian

Asam, Egid Quirin Atget, Jean Eugène Auguste

Athenodoros Barlach, Ernst Bartolommeo, Michelozzo di Barye, Antoine Louis

Beckmann, Max Behnisch, Günter Bellini, Giovanni Berlinghieri, Bonaventura

Bernini, Gianlorenzo Bertoldo di Giovanni

Beuys, Joseph Bihzad Boccioni, Umberto

Bochner, Mel Bodmer, Karl Boethos Boffrand, Germain Bologna, Giovanni da Bonheur, Rosa Borromini, Francesco

Phonetic Pronunciation

AHL-toe, AHL-vore Ah-bah-KAHN-oh-veetz, Mahg-dah-LAY-nah Ag-uh-SAN-dur All-BEAR-tee, Lay-OWN Bah-TEE-stah ALL-bee-noose, BAYRN-hart SEEG-freed AHLT-dore-fur, AHL-bresht Ahn-DOH-kee-days Ahn-DRAY-ah dayl Cah-STAN-yo Ahn-DRAY-ah dayl SAAR-toe On-JAY-lee-coe, Frah On-ghee-SO-lah, So-fone-EE-spah Ahn-THAY-mee-us of **TRAH-layss** Ahn-TOHN-ay-lo dah May-SEE-nah See Sangallo, Antonio da, the Younger Ah-poe-low-DOE-russ Ah-poe-LOW-nee-oose Ah-KAH MEE-rahk Are-chu-LAY-tah, Fay-LEE-pay Are-NAWL-foe dee KAHM-bee-oh Arp, Jaw(n) Ah-SAHM, KOZ-mahs DAY-mee-en Ah-SAHM, A-gheed KEER-in Aht-JAY, Jaw(n) uh-JEN oh-GOOST Ahth-an-ah-DOHR-us BAR-lock, Airnst See Michelozzo di Bartolommeo Bah-REE(yuh), On-TWAHN Loo-EE BAYK-mahn, Mox BAYHN-ish, GOON-tare Bay-LEE-nee, Gee-oh-VAH-nee Bare-leen-ghee-AY-ree, Bone-ah-vane-TOO-rah Bare-NEE-nee, Jon-loe-REN-zoh Bear-TOLL-doh dee Gee-oh-VAH-nee Boyss, YO-zef Bee-7AHD Bo-chee-OH-nee, Oom-BEAR-toe BOKE-ner **BODE-mare** Bo-AY-toss Bohff-RAH(n), Jayr-MEH(n) See Giovanni da Bologna Bone-UR, ROE-zah Bore-oh-MEE-nee, Frahn-CHAY-skoe

Artist's Name

Bosch, Hieronymus Botticelli, Sandro Boucher, François Bouguereau, Adolphe William

Bourgeois, Louise Bouts, Dirk Bramante Brancusi, Constantin

Braque, Georges Broederlam, Melchior Bronzino Bruegel, Pieter, the Elder Brunelleschi, Filippo Brygos Painter Buffalmacco, Buonamico

Buñuel, Luis Buson, Yosa Callot, Jacques Cambio, Arnolfo di Campin, Robert Canaletto, Antonio

Canova, Antonio Caradosso, Christoforo Foppa

Caravaggio Carpeaux, Jean Baptiste Carracci, Agostino Carracci, Annibale Carracci, Lodovico Carriera, Rosalba Cartier-Bresson, Henri

Cassatt, Mary Castagno, Andrea del Cavallini, Pietro Cellini, Benvenuto Cézanne, Paul Chagall, Marc Chardin, Jean Baptiste Siméon

Chelles, Jean de Ch'i Pai-shih Chirico, Giorgio de Christo Christus, Petrus Cimabue, Giovanni

Clodion Clouet, Jean Corot, Jean Baptiste Camille

Correggio Courbet, Gustave Cranach, Lucas, the Elder Cuvilliés, François de

Phonetic Pronunciation

Bosh. He-air-ON-ee-moose Bo-tee-CHAY-lee, SAHN-droh Booh-SHAY, Frahn-swah Boo-gher-OH, Ah-DOHLF VEAL-yam Bor-JWAH Boats, Durk Brah-MAHN-tay Braun-COOSH, Cone-stahn-TEEN Brahk, Joerj Broo-dare-lam, Male-key-ORE Brone-ZEE-noh BROI-gull, PEE-ter Broo-nay-LAY-skay, Fee-LEE-poh **BRIG-ohs** Boo-fall-MA-coe, Bone-ah-MEE-coe Boon-WHALE, Lou-EESS Boo-SONE, YO-sah Kah-LOW, Jock See Arnolfo di Cambio Kah(n)-PEH(n), Roe-BEAR Kahn-ah-LAY-toe, On-TONE-ee-oh Kah-NO-vah, On-TOE-nee-oh Car-ah-DOE-so, Kree-STOW-fore-oh FO-pah Kah-rah-VAH-gee-oh Car-POH, Jaw(n) Bahp-TEESTE Car-RAH-chee, Ah-gust-EENO Car-RAH-chee, on-NEE-ball-ay Car-RAH-chee, Loo-doe-VEE-ko Car-ree-AY-rah, Roe-SAHL-bah Car-tee-AY-Bress-OH(n), On-REE Kah-SAHT See Andrea del Castagno Kah-vah-LEAN-ee, Pee-AY-troh Chay-LEE-nee, Ben-ven-OO-to Sav-ZAH(n), Pole Shah-GALL, Mark Shahr-DAH(n), Jaw(n) Bahp-TEEST See-may-OH(n) SHELL, Jaw(n) duh Chee By-shur Key-REE-coe, JOR-gee-oh day KREE-stoh KREES-tuhs, PAY-tross Cheem-ah-BOO-ay, Gee-oh-VAHN-ee Kloh-dee-OH(n) Cloo-AY, Jaw(n) Kore-OH, Jaw(n) Bahp-TEEST Kah-MEAL Core-AY-gee-oh KOOR-bay, Goo-STAVH KRAH-nahk, LOO-cus Koo-vee-YAY(s), Frahn-swah duh

*Compiled by Cara-lin Getty, University of South Carolina at Sumter, and Mikle Ledgerwood, Rhodes College.

Artist's Name

Daguerre, Louis Jacques Mandé

Dali, Salvador Daumier, Honoré David, Jacques Louis De Chelles, Jean De Chirico, Giorgio Degas, Edgar De Kooning, Willem Delacroix, Eugène De La Tour, Georges Della Francesca, Piero Della Porta, Giacomo Della Quercia, Jacopo Della Robbia, Luca Derain, André De Sica, Vittorio Desiderio da Settignano

De Stael, Nicolas Diebenkorn, Richard Disdéri, André-Adolphe-Eugène

Domenichino Domenico Veneziano

Donatello Duccio Duchamp, Marcel Dürer, Albrecht Durieu, Eugène Eakins, Thomas Eiffel, Alexandre Gustave

Eisenstein, Sergei El Greco Ergotimos Ernst, Max Euphronios Euthymides Exekias Eyck, Hubert van Eyck, Jan van Fabriano, Gentile da Falconet, Étienne-Maurice

Fan K'uan Fiorentino, Rosso Fossati, Chevalier Fouquet, Jean Fra Filippo Lippi Fragonard, Jean Honoré

Frankenthaler, Helen Friedrich, Caspar David Fuseli, Henry Gabo, Naum Gaddi, Taddeo Gainsborough, Thomas Garnier, J. L. Charles Gaudí, Antoni Gauguin, Paul Gentile da Fabriano

Gentileschi, Artemisia

Gentileschi, Orazio

Géricault, Théodore

Phonetic Pronunciation Dah-GHAIR, Loo-EE Jock

Mahn-DAY Dah-LEE, Sahl-vah-DORE DOH-mee-ay, Oh-nor-AY Dah-VEED, Jock Loo-EE See Chelles, Jean de See Chirico, Giorgio de Day-GAH, Aid-GAR Deh KOON-eeng, VIL-em Duh-lah-KRAWH, Uh-JEN See La Tour, Georges de See Piero della Francesca See Giacomo della Porta See Jacopo della Quercia See Robbia, Luca della Dare-EH(n), On-DRAY Day SEE-kah, Vee-TORE-ee-oh Day-see-DAY-ree-oh dah Say-teen-YAWN-oh See Stael, Nicolas de DEEB-in-corn Deez-DAY-ree, On-DRAY Ah-DOLF Uh-JEN Do-mane-ee-KEY-no Doh-MEH-nee-coh Vay-nee-zee-AH-no Done-ah-TAY-loh DOOCH-ee-oh Dyu-SHAH(n), Mahr-SELL DYURE-ur, ALL-brekt DURE-ree-UH, Uh-JEN AY-kinz Eh-FELL, AHL-ex-ahn-druh Goo-STAVH EYE-zen-stine, SAYR-gay Ale GRAY-koe Ehr-GOH-tee-mohs Airnst, Mox U-FROHN-ee-ohs U-THEEM-ee-days Ek-ZEE-kee-ahs IKE, HUE-beart fahn IKE, Yawn fahn See Gentile da Fabriano FAHL-cone-AY, Ay-tee-EN-Moe-REESE Fahn Kwahn See Rosso Fiorentino Foh-SAH-tee, Shev-AH-lee-ay Foo-KAY, Jaw(n) Frah Fay-LEE-poh LEE-pee Frah-goh-NAHR, Jaw(n) Oh-no-RAY FRANK-in-tall-ur FREED-reek, KOSS-par DAH-vid Foo-SAY-lee GAH-boh, Nowm Gah-DEE, Tah-DAY-oh GAINZ-burr-oh Gahr-nee-AY, Shahrl Gow-DEE, On-TONE-ee Go-GEH(n), Pole Jayn-TEE-lay dah Fah-bree-AH-no Jane-teel-ESS-key, Are-tay-MEESE-ee-ah Jane-teel-ESS-key, oh-RAH-tsee-oh Jay-ree-KOE, Tay-oh-DORE

Artist's Name

Gérôme, Jean-Léon Ghiberti, Lorenzo Ghirlandaio, Domenico

Giacometti, Alberto Giacomo da Vignola Giacomo della Porta Giorgione Giotto Giovanni, Bertoldo di Giovanni da Bologna

Girardon, François Girodet-Trioson, Anne Louis

Gislebertus Giuliano da Sangallo Godard, Jean-Luc Goes, Hugo van der Gogh, Vincent van Golub, Leon Gonzalez, Julio Gossaert, Jan Goujon, Jean Goya, Francisco Greenough, Horatio Greuze, Jean Baptiste Gropius, Walter Gros, Antoine Jean Grünewald, Matthias Guarini, Guarino Hals, Frans Han Kan

Harunobu, Suzuki Hasegawa Tohaku

Hardouin-Mansart, Jules

Hawes, Josiah Johnson Herrera, Juan de Hippodamos Höch, Hannah Holbein, Hans, the Younger Hon-Ami Koetsu Honnecourt, Villard de Honthorst, Gerard van Horta, Victor Houdon, Jean Antoine

Hsu Pei-hung Huang Kung-wang Hugo van der Goes Iktinos Il Guercino Imhotep Ingres, Jean Auguste Dominique Isidorus of Miletus Jacopo da Pontormo

Jacopo da Pontormo Jacopo della Quercia

Jones, Inigo Jouvin, Hippolyte Juvara, Filippo Kahlo, Frida Kalf, Willem Kallikrates Kandinsky, Wassily

Phonetic Pronunciation

Jay-ROME, Jaw(n) Lay-OH(n) Ghee-BEAR-tee, Lo-REN-tsoh Gear-lon-DIE-oh, Doh-MANE-ee-coe Jah-coe-MAY-tee, All-BEAR-toe See Vignola, Giacomo da See Porta, Giacomo della Gee-ore-gee-OH-nay Gee-OH-toh See Bertoldo di Giovanni Gee-oh-VAH-nee dah Bo-LOAN-va Gee-rahr-DOH(n), Frahn-SWAH Jee-roh-DAY-Tre-oh-SOH(n), On Loo-EE Geez-lay-BARE-tuss See Sangallo, Giuliano da Go-DAHR, Jaw(n)-LUKE Guhs, HYOU-go fahn dare Vahn Go (Dutch Fahn-hohk) Go-LUBE, Lee-on Goan-ZAH-lay(z), HOO-Lee-oh GO-sayrt, Yawn Goo-JOE(n), Jaw(n) GOE-yah, Frahn-SEESE-coe GREEN-oh, Hore-AY-shee-oh Gruhz, Jaw(n) Bahp-TEEST GROW-pee-oohss, VAHL-ter Groh, On-TWAHN Jaw(n) GROO-nuh-vahld, Mah-TEE-ahss Gwah-REE-nee, Gwah-REE-noh Halls, Frahnz Hahn Gahn Are-DWEH(n)-Mahn-SAHR, Iool Har-roon-NO-boo, Su-zoo-kee Hah-saw-GAH-wah Toe-HAH-coo Hawz, Joe-SIGH-uh Hay-RAH-rah, Hwahn day Ee-POH-deh-muss Hoke, HAHN-ah HOLE-bine, Hahnz Hone-AH-mee Coe-ET-sue UN-uh-coor, Vee-YA(r) duh HAUNT-horst, HAY-ralt fahn Ore-TAH, Veek-TORE Oo-DOH(n), Jaw(n) On-TWAHN Shoo Bay-hong Hwahn Gong-wang See Goes, Hugo van der Eek-TEE-nohs Eel Gwair-CHEE-no Im-HOH-tep AING(ruh), Jaw(n) Oh-GOOST Doh-mee-NEEK Ee-see-DOE-russ of My-LEE-tuss See Pontormo, Jacopo da JAH-coe-poe DAY-lah KWAIR-chee-ah IN-ago Jew-VAN, Ee-poh-LEET Jew-VAH-rah, Fee-LEE-poh KAH-low, FREE-duh Kahlf, VIL-em Kal-EE-krah-tees Kahn-DEEN-skee, VAH-see-lee

Artist's Name

Kaprow, Allan Käsebier, Gertrude Katsushika Hokusai Kauffmann, Angelica Kiefer, Anselm Kienholz, Edward Kirchner, Ernst Kivotada Klee, Paul Kleitias Klimt, Gustav Kline, Franz Koca Kollwitz, Käthe Ku K'ai-chih Labrouste, Henri La Tour. Georges de Le Brun, Charles Le Corbusier Le Gray, Gustave Lehmbruck, Wilhelm Leibl, Wilhelm Le Nain, Louis Le Nôtre, André Lescaze, William Lescot, Pierre Le Vau, Louis Liang K'ai Limbourg, Hennequin Limbourg, Herman Limbourg, Pol Lin, Maya Ying Lipchitz, Jacques Lippi, Fra Filippo Lochner, Stephan Longhena, Baldassare

Lorenzetti, Ambrogio

Lorenzetti, Pietro Lorrain, Claude Luca Signorelli Luzarches, Robert de Lysippos Ma Yuan Mabuse Machuca, Pedro Maderno, Carlo Maillol, Aristide Malevich, Kasimir Manet, Édouard Mansart, François Mantegna, Andrea

Manzù, Giacomo Martens, Friedrich von Martini, Simone Masaccio Masolino da Panicale

Matisse, Henri Méliès, Georges Memling, Hans Messina, Antonello da Metsys, Quentin Michelangelo Michelozzo di Bartolommeo

Mies van der Rohe, Ludwig

Phonetic Pronunciation

CAP-roe KAY-zuh-beer, Gayr-TRUE-duh Kaht-su-SHEE-kah Hok-oo-SIGH KOWF-mahn, Anne-JAY-lee-kah KEY-fer, On-selm **KEEN-holtz** KEERCH-nair, Airnst Key-oh-TAH-dah Clay, Pole KLAY-tee-ahs Kleemt, GOO-stahv Kline, Frahnz COE-suh COLE-vits, KATE-eh Goo Kai-jur(n) La-BROOSTE, On-REE Lah Tour, Jorg duh Luh Bruh(n), Sharl Luh Core-BOO-see-AY Luh Grav, Goo-STAHV LAME-broook, VEEL-helm LIE-bul, VEEL-helm Luh Neh(n), Loo-EE Luh NOH(treh), On-DRAY Lez-KAHZ Luh-SKOH, Pee-AIR Luh Voh, Loo-EE Lee-ong Kai Lem(h)-BOOR, En-nee-KIN Lem(h)-BOOR, Air-MAHN Lem(h)-BOOR, Pole Leen, MY-yah Yeen Leep-SHITZ, Jock See Fra Filippo Lippi LOHK-ner, STAY-fahn Loan-GAY-nah, Ball-dah-SARE-ay Low-ren-ZET-ee, Ahm-BROH-gee-oh Low-ren-ZET-ee, Pee-AY-troh Loh-REHN, Clodh See Signorelli, Luca Lose-AHRSH, ROH-bear duh Lee-SEE-poess Ma You-an Mah-BYOUZ Ma-CHEW-kah, PAY-droh Mah-DARE-no, CAR-low MY-vole, Are-ee-STEED MAH-lay-veech, Kah-zee-MEER Mah-NAY, Aid-ooh-AHR Mahn-SAR, Frahn-swah Mahn-TANE-yah, Ahn-DRAY-ah Mahn-ZOO, Gee-AH-kah-moe MAHR-tenz, FREED-rick fahn Mar-TEE-nee, See-MOAN-ay Ma-SAH-chee-oh Mah-so-LEE-no dah Pah-nee-KAH-lee Ma-TEES, On-REE May-lee-AYSS, Jee-orge Maym-LEENG, Hahnz See Antonello da Messina Met-seese, KWEN-tin Mee-kell-AHN-jay-low Mee-kell-OH-tsoe dee Bar-toe-low-MAY-oh Meese fahn dare ROE(huh), LOOD-vig

Artist's Name

Millais, John Millet, Jean François Mirak, Aqa Miró, Joan Mnesikles Moholy-Nagy, László Mondrian, Piet Monet, Claude Moreau, Gustave Munch, Edvard Mungarawai Muybridge, Eadweard Nadar Nanni di Banco Neri, Manuel Nervi, Pier Luigi Neumann, Balthasar Nièpce, Joseph Nicéphore Niobid Painter Novius Plautius Ogata Korin Okvo, Maruyama Oldenburg, Claes Olowe of Ise Orozco, José Clemente Otto, Frei Pacher, Michael Paik, Nam June Palladio, Andrea Pannini, Giovanni Paolozzi, Eduardo Parmigianino Patinir, Joachim Pei, Ieoh Ming Perrault, Claude Perugino Pfaff, Judy Phiale Painter Phidias Piano, Renzo Picasso, Pablo Piero della Francesca Pilon, Germain Piranesi, Giovanni Battista Pisano, Andrea Pisano, Giovanni Pisano, Nicola Pissarro, Camille Pollaiuolo, Antonio Pollock, Jackson Polydoros Polygnotos Polykleitos Pontormo, Jacopo da Porta, Giacomo della Poussin, Nicolas Pozzo, Fra Andrea Praxiteles Primaticcio, Francesco

Pucelle, Jean

Phonetic Pronunciation

Mee-lav Mee-LAY, Jaw(n) Frahn-swah See Aga Mirak Mee-ROE, Joe-ON Mee-NES-see-klavz Moe-HOE-lee-NAH-ghee, LAHZ-low Moan-dree-ON, Pate Moan-AY, Klohd More-OH, Goo-STAHV Moonk, ED-vahrd Mung-ar-AH-wah MY-bridge, Ed-WARD Nah-DAHR Nah-nee dee BANH-coe NAY-ree, Mahn-WHALE NAIR-vee, PEE-ayr Loo-EE-gee NOY-mahn, Ball-tar-ZAHR KNEE-eps, KNEE-say-for Nee-OH-bid NOH-vee-oohss PLOW-tee-oohss Oh-GAH-tah Coe-REEN OAK-yo, Mah-roo-YAH-mah OLD-in-burg, Klayss O-lah-WAY of EE-see Oh-ROZ-coe, Hoe-ZAY Clay-MEN-tay OH-toe, FRAY-ee Pock-er, MOEK-aisle Pike, NAHM Joon Pa-LA-dee-oh, Ahn-DRAY-ah Pah-NEE-nee, Gee-oh-VAH-nee Pow-LOH-zee, Aid-WAHR-do Par-mee-gee-ah-NEE-noh PAHT(ee)-neer, Yo-AH-keem Pay, Yueh Ming Pay-RO, Clohd Pay-roo-GEE-no P(uh)faff Fee-AH-lay FHEE-dee-ahs Pee-AH-no, REN-tzoh Pee-KaH-so, PA-bloh Pee-AY-roh DAY-lah Frahn-CHEE-skah Pee-LOH(n), Jer-MEH(n) Pee-rah-NAY-see, Gee-oh-VAH-nee Bah-TEE-stah Pee-SAHN-no, Ahn-DRAY-ah Pee-SAHN-no, Gee-oh-VAHN-ee Pee-SAHN-oh, NEE-koh-la Pee-ZAHR-oh, Kah-MEAL Poh-lie-oo-OH-loh, Ahn-TOE-nee-oh PAUL-ock Poh-lee-DOH-rahs Pol-og NO-tus Poh-lee-KLY-tohss Pone-TORE-mo, JAH-coe-poe dah PORE-tah, JAH-coe-moe DAY-lah Poo-SEH(n), NEE-koe-lah POE-tzo, Frah On-DRAY-ah Prax-EE-tell-ees Pree-mah-TEE-chee-oh, Frahn-CHAY-skoh Pyou-CELL, Jaw(n)

Artist's Name

Puget, Pierre Pugin, A. W. N. Puvis de Chavannes, Pierre

Quarton, Enguerrand Raphael Rauschenberg, Robert

Redon, Odilon Reimann, Walter Rembrandt van Rijn Reni, Guido Renoir, Auguste Repin, Ilya Ribera, José de Richter, Hans Riefenstahl, Leni Riemenschneider, Tilman

Rietveldt, Gerrit Rigaud, Hyacinthe Robbia, Luca della Rodin, Auguste Rogier van der Weyden Röhrig, Walter Romano, Giulio Rosa, Salvator Rossellino, Antonio Rossellino, Bernardo Rosso Fiorentino Rosso, Medardo Rouault, Georges Rousseau, Henri Rublëv, Andrei Rude, François Ruisdael, Jacob van Runge, Philipp Otto Ruscha, Edward Saar, Bettye Saint-Gaudens, Augustus Sangallo, Antonio da, the Younger Sangallo, Giuliano da

Sansovino, Andrea Sansovino, Jacopo Sarto, Andrea del Schöffer, Nicolas Schongauer, Martin

Schwitters, Kurt Scopas Senmut Sesshu Settignano, Desiderio da Seurat, Georges Severus Shen Chou Signorelli, Luca Sinan the Great Sluter, Claus

Phonetic Pronunciation

Pyou-JAY, Pee-AIR PYU-gin Pyou-VEE duh Shah-VAHN, Pee-AIR Kvar-TON(n), In-gher-OH(n) RAH-fah-el ROWSH-en-burg ("ow" as in "now") Ruh-DOH(n), Oh-dee-LOH(n) RYE-mahn, VAHL-tare Rem-BRAN(DT) fahn RINE RAY-nee, GWEE-doe Ruh-NWAHR, Oh-GOOSTE RYE-pin, EEL-yah Ree-BAY-rah, Ho-SAY day RICK-tur, HAHNZ REE-fen-stall, LAY-nee REE-MEN-schnigh-dare, TEEL-mahn REET-felld, GARE-it Ree-GOH, Ee-ah-SEH(n)t ROBE-ee-ah, LOO-kah DAY-lah Roe-DEH(n), Oh-GOOSTE See Weyden, Rogier van der ROAR-igg, VAHL-tare Ro-MA-no, IEW-lee-oh ROE-sah, Sal-vah-TORE Ro-say-LEE-no, Ahn-TOE-nee-oh Ro-say-LEE-no, Bear-NAHR-do ROH-so Fee-ore-in-TEE-no Roh-soe, May-DAHR-do Roo-OH, JEE-orge Roo-SO, On-REE Roob-LEY-avv, Ahn-DRAY-ee Rood, Frahn-swah ROIS-dahl, YA-kobe fahn ROON-guh, Fee-LEEP O-toe ROO-shah Sahr, Bet-ee Saint-GAW-dens Sahn-GALL-oh, Ahn-TONE-ee-oh dah Sahn-GALL-oh, Jew-lee-AH-no dah Sahn-so-VEE-no, On-DRAY-ah Sahn-so-VEE-no, YAH-coe-poe See Andrea del Sarto SHOFF-er, Neck-oh-LAH SHONE-gow-er, MAR-teen ("ow" as in "now") SHVIT-ers, Koort SKOH-pahs Sen-MOO(ut) SESS-you See Desiderio da Settignano Suh-RAH, JEE-orge Sev-AIR-oose Sun Joe Seen-yore-ALE-ee, LOO-kah SEE-nahn SLOO-ter, Klows

Artist's Name

Soufflot, Jacques-Germain Southworth, Albert Sands Spranger, Bartholomeus

Stael, Nicolas de Stieglitz, Alfred Stoss, Veit Takayoshi Tao-chi Tatlin, Vladimir Tawaraya Sotatsu Theotokopoulos, Domenikos Tiepolo, Giambattista Tinguely, Jean Tintoretto Titian Toba Sojo Toledo, Juan Bautista de Tori Busshi Toulouse-Lautrec, Henri de Tournachon, Gaspard Félix Traini, Francesco Tung Ch'i-ch'ang Uccello, Paolo Vanbrugh, John Van der Rohe Van Der Zee, James Van Dyck, Anthony Van Honthorst, Gerard Vasarely, Victor Vecelli, Tiziano Velázquez, Diego Veneziano, Domenico Venturi, Robert Vermeer, Jan Veronese Verrocchio, Andrea del Vigée-Lebrun, Élisabeth Louise Vignola, Giacomo da Vignon, Pierre Vitruvius Warhol, Andy Warm, Hermann Watteau, Antoine Welliver, Neil Wen Cheng-ming Weyden, Rogier van der Wiligelmus Witz, Conrad Wodiczko, Krzysztof Wu Chen Zavattini, Cesare Zurbarán, Francisco de

Phonetic Pronunciation

Soo-FLOH, Jock-Jayr-MEH(n) SUHTH-uhrth SPRAHN-gurr, Bar-toe-low-MAY-us STAH-ell, Neck-oh-LAH duh STEEG-litz, ALL-fred Shtohss, Fite Tah-kah-YO-shee Dao-jee Taht-LEEN, Vlah-DEE-meer Tah-WAH-rah-yah So-TAHT-sue Tay-oh-toe-KOE-poe-lohss, Doe-MANE-ee-kos Tee-EH-poh-loe. Jahm-bah-TEESE-tah Tehng-LEE, Jaw(n) Teen-toe-RAY-toe TEE-shun TOE-bah SO-jue Toe-LAY-doe, Wahn Bough-TEE-stah day TOE-ree BOO-shee TOO-looze-Low-TREK, On-REE duh Toor-nah-SHOH(n), Gah-SPAHR Fay-LEEKS Trah-EE-nee, Frahn-CHEE-skoh Dung Chee-chang Oo-CHAY-loh, Pah-OH-loh Van-BROO See Mies van der Rohe, Ludwig VAHN Dayr Zee Fahn Dike See Honthorst, Gerard van Vah-SAR-uh-lee, VEEK-tore Vay-CHAY-lee, Tee-tsee-AH-no Vay-LAHSS-kayss, Dee-AY-go See Domenico Veneziano Ven-TOO-ree Fare-MEER, Yawn Vay-roe-NAY-say Vay-RO-kee-oh, Ahn-DRAY-ah dayl Vee-JAY-Luh-BROH(n), Ay-leez-ah-BET Loo-EEZ Veen-YO-lah, JAH-koe-moe dah Veen-YOHN, Pee-AYR Vee-TROO-vee-oose WAR-hall Vahrm, HAIR-mahn Wah-TOH, On-TWAHN WELL-ih-vur Wone Jung-ming VAY-den, ROE-jeer fahn dare Vee-lee-GHELL-moose Vits Voh-DYAY-skoh, KREE-stofe Woo Jun ZAH-vah-tee-nee, Chay-sah-ruh Thoor-bah-RAHN, Frahn-SEE-skoy day

GLOSSARY

Italicized terms in definitions are defined elsewhere in the Glossary.

- **abacus** (AB-a-kus) The uppermost portion of the *capital* of a *column*, usually a thin slab.
- **abstract** In painting and sculpture, emphasizing a derived, essential character that has only a stylized or symbolic visual reference to objects in nature.
- **academy** A place of study, derived from the name of the grove where Plato held his philosophical seminars. Giorgio Vasari founded the first academy of fine arts, properly speaking, with his *Accademia di Disegno* in Florence in 1563.
- **acroterium** or **acroterion** (ak-roh-TEEri-um) In Classical buildings, a figure or ornament usually at the apex of the *pediment*.
- **acrylic** A painting medium that uses *pigment* in a synthetic base (made with acrylic thermal-plastic resins).
- addorsed Set back-to-back, especially as in heraldic design.
- **adobe** (a-DOE-bee) The clay used to make a kind of sun-dried brick of the same name; a building made of such brick.
- aerial perspective See perspective.
- **agora** (AG-o-ra) An open square or space used for public meetings or business in ancient Greek cities.
- **aisle** The portion of a church flanking the *nave* and separated from it by a row of *columns* or *piers*.
- **alabaster** A variety of gypsum or calcite of dense, fine texture, usually white, but also red, yellow, grey, and sometimes banded.
- **alla prima** (A-la PREE-ma) A painting technique in which pigments are laid on in one application, with little or no drawing or underpainting.
- **altarpiece** A panel, painted or sculptured, situated above and behind an altar. See also *retable*.
- **ambulatory** A covered walkway, outdoors (as in a *cloister*) or indoors; especially the passageway around the *apse* and the *choir* of a church.
- **amphora** (AM-fo-ra) A two-handled, eggshaped jar used for general storage purposes.
- **anamorphic image** An image that must be viewed by some special means (such as a mirror) to be recognized.
- **apadana** (ap-a-DAN-a) The great audience hall in ancient Persian palaces.
- **apse** A recess, usually singular and semicircular, in the wall of a Roman *basilica* or at the east end of a Christian church.
- **arabesque** Literally, "Arabian-like." A flowing, intricate pattern derived from stylized organic motifs, usually floral, often arranged in symmetrical *palmette* designs; generally, an Islamic decorative motif.
- **arcade** A series of *arches* supported by *piers* or *columns*.

arcading An uninterrupted series of *arches*.

- arch A curved structural member that spans an opening and is generally composed of wedge-shaped blocks (*voussoirs*) that transmit the downward pressure laterally. A **diaphragm arch** is a transverse, wall-bearing arch that divides a *vault* or a ceiling into compartments, providing a kind of firebreak. See also *thrust*.
- **architectonic** Having structural or architectural qualities, usually as elements of a nonarchitectural object.
- **architrave** (ARK-i-trayv) The *lintel* or lowest division of the *entablature;* sometimes called the *epistyle*.

archivolt (ARK-i-volt) One of a series of concentric *moldings* on a Romanesque or a Gothic arch.

- **arcuated** (AR-kew-ate-id) Of *arch-column* construction.
- **armature** In sculpture, a skeleton-like framework to support material being modeled.
- **aspara** In India, a nymph of the sky or air; in Chinese Buddhism, a heavenly maiden.
- **assemblage** A three-dimensional composition made of various materials such as *found objects*, paper, wood, and cloth. See also *collage*.
- **atlantid** A male figure that functions as a supporting *column*. See also *caryatid*.
- **atmospheric perspective** See *perspective*. **atrium** (AY-tree-um) The court of a Roman house that is near the entrance and partly open to the sky. Also, the open, colonnaded court in front of and attached to a Christian *basilica*.
- **automatism** Process of yielding oneself to instinctive actions after establishing a set of conditions (such as size of paper or medium) within which a work is to be carried out.
- avant-garde (a-vahn-GARD) Artists whose work is in the most advanced stylistic expression.
- avatar (AH-vah-tar) In Hinduism, an incarnation of a god.

axial plan See plan.

axis An imaginary line or lines about which a work, a group of works, or a part of a work is visually or structurally organized, often symmetrically.

baldacchino (bal-da-KEE-no) A canopy on columns, frequently built over an altar. **barrel vault** See *vault*.

bas (bah) relief See relief.

basilica (ba-SIL-i-kah) In Roman architecture, a public building for assemblies (especially tribunals), that is rectangular in plan with an entrance on a long side. In Christian architecture, an early church somewhat resembling the Roman basilica, usually entered from one end and with an *apse* at the other, creating an *axial plan*. **batter** To slope inward, often almost imperceptibly, or such an inward slope of a wall.

- **bay** A subdivision of the interior space of a building. In Romanesque and Gothic churches, the transverse *arches* and *piers* of the *arcade* divide the building into bays.
- **beehive tomb** A beehive-shaped type of subterranean tomb constructed as a *corbeled vault* and found at pre-Archaic Greek sites.
- **belvedere** (bell-vuh-DARE-eh) An open, roofed story built to provide a scenic view. **ben-ben** A pyramidal stone; a *fetish* of the Egyptian god Re.
- **benizuri-e** (BEN-i-ZUR-i-ee) A two-color method of Japanese printing in pink and green that produces strong color vibration.
- bevel See chamfer.
- **bhakti** (buh-HOCK-tee) In Hinduism, the devout, selfless direction of all tasks and activities of life to the service of one god; the adoration of a personalized deity.
- **black-figure technique** In early Greek pottery, the silhouetting of dark figures against a light background of natural, red-dish clay.
- **blind arcade (wall arcade)** An *arcade* having no actual openings, applied as decoration to a wall surface.
- **Bodhisattva** (bo-dee-SOT-va) In Buddhism, a being who is a potential Buddha. **bottega** (but-TAY-ga) A shop; the studio-
- shop of an Italian artist.
- **bouleuterion** (boo-loo-TEE-ri-on) In ancient Greece, an assembly hall or council chamber.
- **broken pediment** A *pediment* in which the *cornice* is discontinuous at the apex or the base.
- **bucrania** (pl.) In classical architecture, an ornament, usually in the friezes, having the shape of an ox skull.
- **Buddha** The supreme enlightened being of Buddhism; an embodiment of divine wisdom and virtue. **Buddhist** (*adj.*)
- **burin** (BYOOR-in) A pointed steel tool for *engraving* or *incising*.
- **buttress** An exterior masonry structure that opposes the lateral thrust of an *arch* or a *vault*. A **pier buttress** is a solid mass of masonry; a **flying buttress** consists typically of an inclined member carried on an arch or a series of arches and a solid buttress to which it transmits lateral *thrust*.

calidarium The hot-bath section of a Roman bathing establishment.

calligraphy Handwriting or penmanship, especially elegant or "beautiful" writing as a decorative art.

- **calotype** Photographic process in which a positive image is made by shining light throught a negative image onto a sheet of sensitized paper.
- camera lucida A device in which a small lens projects the image of an object downward onto a sheet of paper. Literally, "lighted room."
- **camera obscura** An ancestor of the modern camera in which a tiny pinhole, acting as a lens, projects an image on a screen, the wall of a room, or the ground-glass wall of a box; used by artists in the seventeenth, eighteenth, and early nineteenth centuries as an aid in drawing from nature. Literally, "dark room."
- **campanile** (kam-pa-NEEL-eh) A bell tower, usually freestanding.
- **capital** The upper member of a *column*, serving as a transition from the *shaft* to the *lintel*.
- **Caravaggisti** (kara-va-GEE-stee) Artists influenced by Caravaggio's dramatically contrasting dark–light effects; painters of "night pictures" in the "dark manner" (*tenebroso*).
- **cardo** The north–south road in Etruscan and Roman towns, intersecting the *decumanus* at right angles.
- **carte de visite** (KART duh VEE-zeet) Separate photographs made on a single negative and mounted on a card the size of the standard calling card; in the nineteenth century, an inexpensive means of creating mass-produced prints.
- **cartoon** In painting, a full-size drawing from which a painting is made. Before the modern era, cartoons were customarily worked out in complete detail; the design was then transferred to the working surface by coating the back with chalk and going over the lines with a *stylus*, or by pricking the lines and "pouncing" charcoal dust through the resulting holes.
- **cartouche** (kar-TOOSH) A scroll-like design or medallion, purely decorative or containing an inscription or heraldic device. In ancient Egypt, an oval device containing such elements as *hieroglyphic* names of Egyptian kings.
- **caryatid** (KAR-ee-AT-id) A female figure that functions as a supporting *column*. See also *atlantid*.
- **casting** In sculpture, process of duplicating a modeled or fabricated original in which a mold is used to make a cast in plaster, metal, polyester, or other hardsetting material.
- castrum A Roman military encampment.
- **cella** (SEL-a) An enclosed chamber (Greek, *naos*); the essential feature of a Classical temple, in which the cult statue usually stood.
- **centering** A wooden framework to support an *arch* or a *vault* during its construction.
- central plan See plan.
- **ceramics** The art of making objects such as pottery out of clay; also, the objects themselves.
- chaitya (CHIGHT-yuh) An Indian shrine,

especially a Buddhist assembly hall having a votive *stupa* at one end.

- **chalice** A cup or goblet, especially that used in the sacraments of the Christian Church.
- **chamfer** The surface formed by cutting off a corner of a board or post; a *bevel*.
- chandi A Javanese temple.
- chatra See parasol.
- **chevet** (sheh-VAY) The eastern end of a Gothic church, including *choir*, *ambulatory*, and radiating chapels.
- chevron A zigzag or V-shaped motif of decoration.
- **chiaroscuro** (kee-AR-o-SKOOR-o) In drawing or painting, the treatment and use of light and dark, especially the gradations of light that produce the effect of *modeling*. **chiton** (KITE-on) A Greek tunic, the essential (and often only) garment of both men and women, the other being the
- *himation* or *mantle*; a kind of cape. **choir** The space reserved for the clergy in the church, usually east of the *transept* but, in some instances, extending into the *nave*.
- **ciborium** (sih-BOR-ee-um) A canopy, often freestanding and supported by four columns, erected over an altar; also, a covered cup used in the sacraments of the Christian Church. See *baldacchino*.
- cinematic montage Motion-picture effects produced by superimposing separate, unrelated images or showing them in rapid sequence.
- cinquecento (cheenk-way-CHAIN-toh) The sixteenth century in Italian art. Literally, the "1500s."
- cire perdue (seer pair-DEW) The lost-wax process. A bronze-casting method in which a figure is modeled in wax and covered with clay; the whole is fired, melting away the wax and hardening the clay, which then becomes a mold for molten metal.
- **clerestory** (KLEER-sto-ry) The *fenestrated* part of a building that rises above the roofs of the other parts.
- **cloison** (klwa-ZOHN) Literally, a partition. A cell made of metal wire or a narrow metal strip that is soldered edge-up to a metal base to hold enamel or other decorative materials.
- **cloisonné** (klwa-zoh-NAY) A process of enameling employing *cloisons*.

cloister A court, usually with covered walks or *ambulatories* along its sides.

- **closed form** A *form*, especially in painting, with a contour that is not broken or blurred.
- cluster pier See compound pier.
- **codex** Separate pages of *vellum* or *parchment* bound together at one side and having a cover; the predecessor of the modern book. In Mesoamerica, a painted and inscribed book on long sheets of fig-bark paper or deerskin coated with plaster and folded into accordionlike pleats.
- **coffer** A sunken panel in a *soffit*, a *vault*, or a ceiling; often ornamental.

collage (kul-LAHZH) A composition made by combining on a flat surface

various materials such as newspaper, wallpaper, printed text and illustrations, photographs, and cloth. See also *photomontage*.

- **colonnade** A series or row of *columns*, usually spanned by *lintels*.
- colonnette A small column.
- color See hue, saturation, and value.
- **column** A vertical, weight-carrying architectural member, circular in cross section and consisting of a base (sometimes omitted), a *shaft*, and a *capital*.
- **complementary after-image** The image (in a *complementary color*) that is retained briefly by the eye after the stimulus is removed.
- **complementary colors** Those pairs of colors, such as red and green, that together embrace the entire spectrum. The complement of one of the three *primary colors* is a mixture of the other two. In pigments, they produce a neutral grey when mixed in the right proportions.
- **compluvium** An opening in the center of the roof of a Roman *atrium* to admit light. **compound** or **cluster pier** A *pier* composed of a group or cluster of members, especially characteristic of Gothic architecture.
- **computer graphics** Medium developed during the 1960s and 1970s that uses computer programs and electronic light to make designs and images on the surface of a computer or television screen.
- **concretion** In the work of Jean Arp, Surrealistic sculptural form characterized by twisting and growing effects.
- **connoisseur** (kon-nuh-SER) An expert on works of art and the individual styles of artists.
- **contour** A visible border of a *mass* in space; a *line* that creates the illusion of *mass* and *volume* in space.
- **contrapposto** (kon-tra-POH-stoh) The disposition of the human figure in which one part is turned in opposition to another part (usually hips and legs one way, shoulders and chest another), creating a counter-positioning of the body about its central *axis*. Sometimes called **weight shift** because the weight of the body tends to be thrown to one foot, creating tension on one side and relaxation on the other.
- **cool color** Blue, green, or blue-violet. Psychologically, cool colors are calming, unemphatic, depressive; optically, they generally appear to recede. See also *warm color*.
- **corbel** (KOR-bel) A projecting wall member used as a support for some element in the superstructure. Also, courses of stone or brick in which each course projects beyond the one beneath it. Two such structures, meeting at the topmost course, create an *arch*.
- **cornice** The projecting, crowning member of the *entablature*; also, any crowning projection.
- **cramp** (or **clamp**) A device, usually metal, to hold together blocks of stone of the same course. See also *dowel*.
- crenelated (KREN-el-ate-id) Notched or

indented, usually with respect to tops of walls, as in battlements.

- **crocket** A projecting, foliate ornament of a *capital, pinnacle, gable, buttress,* or spire.
- **Cro-Magnon** (kro-MAG-non) Of or pertaining to the *homo sapiens* whose remains, dating from the Aurignacian period, were found in the Cro-Magnon caves in Dordogne, France.
- cromlech (KROM-lek) A circle of monoliths.
- **crossing** The space in a cruciform church formed by the intersection of the *nave* and the *transept*.
- **crossing square** The area in a church that is formed by the intersection (crossing) of a *nave* and a *transept* of equal width.
- **crown** The topmost part of an *arch*, including the *keystone*; also, an open *finial* of a tower.
- **cruciform** (KROO-suh-form) Cross-shaped. **crypt** A *vaulted* space under part of a building, wholly or partly underground; in Medieval churches, normally the portion under an *apse* or a *chevet*.
- **cubiculum** A small room constructed in the wall of an Early Christian catacomb to serve as a mortuary chapel.
- **cuneiform** (kyoo-NÉE-ih-form) Literally, "wedge-shaped." A system of writing used in ancient Mesopotamia, the characters of which were wedge-shaped.
- **Cyclopean** (sike-lo-PEE-an) Gigantic; vast and rough; massive. **Cyclopean architecture** is a method of stone construction using large, irregular blocks without mortar.
- **daguerreotype** (dah-GAIR-oh-type) A photograph made by an early method on a plate of chemically treated metal; developed by Louis J. M. Daguerre.
- **decumanus** (dek-yoo-MAN-us) The eastwest road in an Etruscan or Roman town, intersecting the *cardo* at right angles.
- differential focus Photographic technique in which everything in the foreground shows clearly while everything else is less distinct.
- diffraction gratings Sheets of glass, plastic, or metal inscribed with grids whose lines or dots diffract any light directed at the gridded surface and break this light up into its color spectra so that the rays may be measured accurately.
- **diptych** (DIP-tik) A two-paneled painting or *altarpiece*; also, an ancient Roman and Early Christian two-hinged writing tablet, or two ivory memorial panels.
- di sotto in sù (dee SUH-toe in soo) A technique of representing perspective in ceiling painting. Literally, "from below upwards."
- **divisionism** System of painting in small color dots that stand in relation to each other based on certain color theories. See *pointillism*.
- **dolmen** (DOHL-men) Several large stones (*megaliths*) capped with a covering slab, erected in prehistoric times.
- **dome** A hemispheric *vault*; theoretically, an *arch* rotated on its vertical *axis*.

- **double-exposure techniques** Photographic techniques that combine images made at different moments in time. See *straight photography*.
- **dowel** In ancient architecture, a wooden or metal pin placed between stones of different courses to prevent shifting. See also *cramp*.
- dromos The passage to a *beehive tomb*.
- **drum** The circular wall that supports a *dome;* also, one of the cylindrical stones of which a non-monolithic *shaft* of a *column* is made.
- **dry point** An engraving in which the design, instead of being cut into the plate with a *burin*, is scratched into the surface with a hard steel "pencil." The process is quicker and more spontaneous than standard engraving and lends itself to the creation of painterly effects. Its disadvantage is the fact that the plate wears out very quickly. See also *engraving*, *etching*, *intaglio*.
- **duecento** (doo-ay-CHAIN-toh) The thirteenth century in Italian art. Literally, the "1200s."
- earth colors Pigments, such as yellow ochre and umber, that are obtained by mining; usually compounds of metals.
- echinus (eh-KY-nus) In architecture, the convex element of a *capital* directly below the *abacus*.
- eclecticism (eh-KLEK-ti-sism) The practice of selecting from various sources, sometimes to form a new system or style.
- **écorché** (ay-kor-SHAY) A figure painted or sculptured to show the muscles of the body without skin.
- **elevation** In drawing and architecture, a geometric projection of a building on a plane perpendicular to the horizon; a vertical projection.
- **embrasure** A *splayed* opening in a wall that enframes a doorway or a window.
- **emulsion** Chemical coatings used to transfer photographic images directly onto metal plates (for the daguerreotype), paper, fabric, or other surfaces.
- enamel A vitreous, colored paste that solidifies when fired. See also *champlevé*, *cloisonné*.
- **encaustic** A method of painting with colored, molten wax in which the wax is fused with the surface by the application of heat.
- **engaged column** A columnlike, nonfunctional form projecting from a wall and articulating it visually. See also *pilaster*.
- **engobe** (en-GOHB) A slip of finely sifted clay used by Greek potters; applied to a pot, it would form a black *glaze* in firing.
- **engraving** The process of *incising* a design in hard material, often a metal plate (usually copper); also, the print or impression made from such a plate. See also *dry point*, *etching*, *intaglio*.
- **entablature** The part of a building above the *capitals* of *columns* and below the roof or the upper story.

- **entasis** (EN-tah-sis) An almost imperceptible convex tapering (an apparent swelling) in the *shaft* of a *column*.
- epistyle See architrave.
- esthetic The distinctive vocabulary and theory of a given *style*.
- esthetics Theories about the nature of art and artistic expression.
- etching A kind of *engraving* in which the design is *incised* in a layer of wax or varnish on a metal plate. The parts of the plate left exposed are then etched (slightly eaten away) by the acid in which the plate is immersed after incising. See also *dry point, engraving, intaglio.*
- extrados (eks-TRAH-dohs) The upper or outer surface of an *arch*. See *intrados*.
- **façade** Usually, the front of a building; also, the other sides when they are emphasized architecturally.
- **faïence** (feye-AHNCE) Earthenware or pottery, especially with highly colored design (from Faenza, Italy, a site of manufacture for such ware).
- fan vault See vault.
- **fenestration** The arrangement of the windows of a building.
- ferroconcrete See reinforced concrete.
- **fête galante** (fet ga-LÁHNT) An elegant and graceful celebration; often represented in the works of Antoine Watteau and other Rococo painters.
- **fetish** An object believed to possess magical powers, especially one capable of bringing to fruition its owner's plans; sometimes regarded as the abode of a supernatural power or spirit.
- **fibula** A decorative pin, usually used to fasten garments.
- **figure-ground** In two-dimensional works of art, the visual unity, yet separability, of a form and its background.
- filigree A delicate, lacelike, intertwined, ornamental work or design.
- fin de siècle (fan duh SEE-akl) Characteristic of the progressive ideas and customs of the last years of the nineteenth century.
- **finial** A knoblike ornament (usually with a foliate design) in which a vertical member, such as a *pinnacle*, terminates.
- **flamboyant** Flamelike, flaming; applied to aspects of Late Gothic style, especially architectural tracery.
- **flute** or **fluting** Vertical channeling, roughly semicircular in cross section and used principally on *columns* and *pilasters*.
- flying buttress See buttress.
- **foreshortening** The use of *perspective* to represent in art the apparent visual contraction of an object that extends back in space at an angle to the perpendicular plane of sight.
- **form** In its widest sense, total structure; a synthesis of all the visible elements of that structure and of the manner in which they are united to create its distinctive character. The *form* of a work is what enables us to apprehend it. See also *closed form* and *open form*.

formalism Strict adherence to, or depend-

ence on, stylized shapes and methods of composition.

- **forum** The public square or marketplace of an ancient Roman city.
- **found images** (or **materials** or **objects**) Images, materials, or objects as found in the everyday environment that are appropriated into works of art.
- **fresco** Painting on plaster, either dry (**dry fresco** or **fresco** secco) or wet (**wet** or **true fresco**). In the latter method, the pigments are mixed with water and become chemically bound to the plaster. Also, a painting executed in either method.
- fret or meander An ornament, usually in bands but also covering broad surfaces, consisting of interlocking geometric motifs.
- **frieze** (freez) The part of the *entablature* between the *architrave* and the *cornice*; also, any sculptured or ornamented band in a building, on furniture, etc.
- in a building, on furniture, etc. frigidarium The cold-bath section of a Roman bathing establishment.
- **frottage** A process that combines patterns achieved by rubbing a crayon or other medium across a sheet of paper placed over a surface with a strong and evocative texture pattern.
- full round Sculpture in full and completely rounded form (not in *relief*).

gable See pediment.

- **gallery** The second story of an *ambulatory* or *aisle*.
- garbha griha The *cella* or inner sanctum of the Hindu temple.
- **gargoyle** In architecture, a waterspout (usually carved), often in the form of a *grotesque*.
- **genre** (ZHAHN-reh) A style or category of art; also, a kind of painting realistically depicting scenes from everyday life.
- **gesso** (JEŠS-oh) Plaster mixed with a binding material and used for *reliefs* and as a *ground* for painting.
- **glaze** A vitreous coating applied to pottery to seal the surface and as decoration; it may be colored, transparent, or opaque, and glossy or *matte*. In oil painting, a thin, transparent, or semitransparent layer put over a color to alter it slightly. **glory** See *nimbus*.

Golden Mean or **Golden Section** A proportional relation obtained by dividing a line so that the shorter part is to the longer part as the longer part is to the whole. The *esthetic* appeal of these proportions has led artists of varying periods and cultures to employ them in determining basic dimensions.

- **gopuram** (GO-poor-am) The massive, ornamented entrance structure of South Indian temples.
- **graphic arts** Visual arts that are linear in character, such as drawing and *engraving*; also, generally, visual arts that involve impression (printing and printmaking).
- graver A cutting tool used by engravers and sculptors.

Greek cross A cross in which all the arms are the same length.

grisaille (greez-EYE) A monochrome painting done mainly in neutral greys to simulate sculpture.

- **groin** The edge formed by the intersection of two *vaults*.
- groin vault See vault.
- grotesque In art, a kind of ornament used in antiquity—and sometimes called (imprecisely) *arabesque*—consisting of representations of medallions, sphinxes, foliage, and imaginary creatures.
- **ground** A coating applied to a canvas or some other surface to prepare that surface for painting; also, background.
- guilloche (gee-USH) An ornament consisting of interlaced, curving bands.

hallenkirche (HOLL-en-keer-sheh) A hall church. In this variety of Gothic church, especially popular in Germany, the *aisles* are as high as the *nave*.

- haniwa Sculptured pottery tubes, modeled in human, animal, or other forms, and placed around early (archaic) Japanese burial mounds.
- Happenings Loosely structured performances initiated in the 1960s, whose creators were trying to suggest the dynamic and confusing qualities of everyday life; most shared qualities of unexpectedness, variety, and wonder.

harmika A square enclosure on top of the *dome* of a *stupa* from which the *yasti* arises.

hatching A technique used in drawing, engraving, etc., in which fine lines are cut or drawn close together to achieve an effect of shading.

haunch The part of an *arch* (roughly midway between the *springing* and the *crown*) at which the lateral *thrust* is strongest.

- herringbone perspective See *perspective*. hieratic (higher-AT-tic) The priestly supernaturalism disparaging matter and material values that prevailed throughout the Christian Middle Ages, especially in Orthodox Byzantium.
- **hieroglyphic** (high-roh-GLIF-ic) A system of writing using symbols or pictures; also, one of the symbols.

himation (him-MAT-ee-on) A Greek *mantle* worn by men and women over the tunic and draped in various ways.

historiated Ornamented with representations, such as plants, animals, or human figures, that have a narrative—as distinct from a purely decorative—function. Historiated initial letters were a popular form of manuscript decoration in the Middle Ages.

holography Medium that reconstructs in light alone the surface appearance of the subject, providing a real, threedimensional image; recorded with the light of a laser.

horror vacui (VACK-ui) Literally, "fear of empty space"; crowded design.

hue The name of a color. *Pigment* colors combine differently than colors of light. The *primary colors* (in pigment: blue, red, and yellow; in light: blue, red, and green)

together with the secondary colors (in pigment: green, orange, and violet; in light: cyan, magenta, and yellow) form the chief colors of the spectrum. See also complementary colors, cool color, saturation, value, warm color.

- **hydria** (HIGH-dree-a) An ancient Greek three-handled water jar.
- **hypostyle hall** A hall with a roof supported by columns; applied to the colonnaded hall of the Egyptian *pylon* temple.
- **icon** (EYE-con) A portrait or image; especially in the Greek church, a panel with a painting of sacred personages that are objects of veneration. In the visual arts, a painting, a piece of sculpture, or even a building regarded as an object of veneration.
- **iconography** (eye-con-OG-ra-fee) The analytic study of the symbolic, often religious, meaning of objects, persons, or events depicted in works of art.
- **iconostasis** (eye-con-OS-ta-sis) In eastern Christian churches, a screen or a partition, with doors and many *tiers* of *icons*, that separates the sanctuary from the main body of the church.
- **idealization** The representation of things according to a preconception of ideal *form* or type; a kind of *esthetic* distortion to produce idealized forms. See also *realism*.
- **ideogram** A simple, picturelike sign filled with implicit meaning.
- **illumination** Decoration with drawings (usually in gold, silver, and bright colors), especially of the initial letters of a manuscript.
- **imagines** (i-MAJ-i-nees; *sing*. **imago**) In ancient Rome, wax portraits of ancestors. **imam** (eye-MAHM) One who leads worshipers in prayer in Moslem services.
- **impasto** (im-PÁH-stoh) A style of painting in which the pigment is applied thickly or in heavy lumps, as in many of Rembrandt's paintings.
- **impluvium** A depression in the floor of a Roman *atrium* to collect rainwater.
- **impost block** A stone with the shape of a truncated, inverted pyramid, placed between a *capital* and the *arch* that springs from it.
- incising Cutting into a surface with a sharp instrument; also, a method of decoration, especially on metal and pottery. incrustation A style of wall decoration in Pompeii and Herculaneum in which the wall was divided into bright, polychrome panels of solid colors with occasional, schematically rendered textural contrasts. in situ (SI-too) In place; in original position.
- **insula** A multistoried Roman apartment block.
- intaglio (in-TAL-yoh) A category of graphic technique in which the design is *incised*, so that the impression made is in *relief*. Used especially on gems, seals, and dies for coins, but also in the kinds of printing or printmaking in which the ink-bearing surface is depressed. Also, an object so decorated. See also *dry point*, *engraving*, *etching*.

- intarsia (in-TAHR-sya) Inlay work, primarily in wood and sometimes in motherof-pearl, marble, etc.
- **intercolumniation** The space or the system of spacing between *columns* in a *colonnade*.
- intrados (in-TRAH-dohs) The underside of an *arch* or a *vault*. See *extrados*.
- **isocephaly** (eye-soh-SEF-ah-lee) The arrangement of figures so that the heads are at the same height.
- **jataka** (JAH-tah-kah) Tales of the lives of the Buddha.
- jump cuts Cinema technique used to disrupt narrative flow by arbitrarily omitting chunks from the middle of long continuous shots to dislocate any sense of progressive action.
- **ka** (kah) In ancient Egypt, immortal human substance; the concept approximates the Western idea of the soul.
- **kagle** A rough, highly abstracted African (Dan) mask.
- kakemono (KAH-keh-moh-noh) A Japanese hanging or scroll.
- **karma** (KAR-muh) In Buddhist and Hindu belief, the ethical consequences of a person's life, which determine his or her fate.
- **keystone** The central, uppermost *voussoir* in an *arch*.
- **khutbah** (KOOT-bah) In Moslem worship, a sermon and a declaration of allegiance to a community leader.
- kiln A large stove or oven in which potterv is fired.
- **kinesiologist** Scholar of motion who often uses photographs to study the discrete phases of a particular movement.
- kore (KOR-ay) Greek for "girl."
- kouros (COOR-aus) Greek for "young man."
- **krater/crater** (KRAY-ter) An ancient Greek wide-mouthed bowl for mixing wine and water.
- kuang (gwahng) A Chinese covered libation vessel.
- kylix/cylix (KYE-liks) An ancient Greek drinking cup, shallow and having two handles and a stem.
- **lacquer** A resinous spirit varnish, such as shellac; often colored.
- **lantern** In architecture, a small, often decorative structure with openings for lighting that crowns a *dome*, *turret*, or roof.
- **lapis lazuli** (LA-pis LA-zyoo-lye) A rich, ultramarine, semiprecious stone used for carving and as a source of *pigment*.
- **Latin cross** A cross in which the vertical member is longer than the horizontal member.
- **lectionary** A list, often illustrated, of **lections**, selections from the Scriptures that are read in church services.
- **lierne** (lee-ERN) A short *rib* that runs from one main rib of a *vault* to another.
- **line** The mark made by a moving point, which has psychological impact according to its direction and weight. In art, a line

defines space and may create a silhouette or define a *contour*, creating the illusion of *mass* and *volume*.

linear perspective See perspective.

- **lintel** A beam of any material used to span an opening.
- **lithography** In graphic arts, a printmaking process in which the printing surface is a polished stone or a special metal or plastic plate on which the design is drawn with a greasy material. Greasy ink, applied to the moistened surface, is repelled by all surfaces except the lines of the drawing. The process permits linear and tonal *values* of great range and subtlety.
- **local color** In painting, the actual *color* of an object.
- **loggia** (LUH-jee-uh) A gallery that has an open *arcade* or a *colonnade* on one or both sides.
- lost-wax process See cire perdue.
- lotiform In the form of a lotus petal.
- **lunette** A semicircular opening (with the flat side down) in a wall over a door, a niche, or a window.
- **luster** A thin *glaze* (usually metallic) sometimes used on pottery to produce a rich, often iridescent color. Used particularly in Persian pottery and in *majolica*.
- **machicolation** (mah-CHIK-oh-lay-shun) An opening in the floor of an overhanging gallery through which the defenders of a castle dropped stones and boiling liquids on attackers.
- **madrasah** (muh-DRAH-suh) A combined Moslem school and *mosque*.
- **magazine** A room or building designed for storage.
- **majolica** (ma-JO-lik-ah) A kind of Italian Renaissance pottery coated with a whitish tin-compound enamel, brilliantly painted and often *lustered*.
- **makimono** (MAH-kee-MOH-noh) A Japanese horizontal scroll.
- **malanggan** (mah-LOHNG-gahn) Intricately carved Melanesian ceremonial masks.
- **mandala** (MAN-duh-luh) In Hinduism and Buddhism, a magical, geometric symbol of the cosmos.

mandapa (man-DOP-ah) A Hindu assembly hall, part of a temple.

mandorla An almond-shaped *nimbus*, or *glory*, surrounding the figure of Christ.

- maniera greca (man-YERA GRE-ka) A formal Byzantine style that dominated Italian painting in the twelfth and thirteenth centuries; characterized by shallow space and linear flatness.
- **mantle** A sleeveless, protective outer garment or cloak. See *himation*.
- **mass** The effect and degree of bulk, density, and weight of matter in space. As opposed to plane and area, mass is threedimensional.
- **mastaba** (MAH-sta-bah) A bench-shaped ancient Egyptian tomb.
- **matte** (mat) In painting, pottery, and photography, a dull finish.
- **mbari** Ceremonial houses filled with clay sculptures and paintings, honoring community deities of the Ibo tribe in Africa.

meander See fret.

- **medium** The substance or agency in which an artist works; also, in painting, the vehicle (usually liquid) that carries the *pigment*.
- **megalith** Literally, "great stone"; a large, roughly hewn stone used in the construction of monumental, prehistoric structures. **megalithic** (*adj.*) See also *cromlech*, *dolmen*, *menhir*.
- **megaron** (MEH-ga-ron) A rectangular hall, fronted by an open, two-columned porch, traditional in Greece since Mycenaean times.
- **menhir** (MEN-heer) A prehistoric *monolith*, uncut or roughly cut, standing singly or with others in rows or circles.
- metamatic In the work of Jean Tinguely, machines programmed electronically to act with antimechanical unpredictability. métier (MAY-tee-yay) One's area of ex-
- pertise. metope (MET-a-pee) The space between
- triglyphs in a Doric frieze.
- **mihrab** (MEE-rahb) In the wall of a *mosque*, the niche that indicates the direction of Mecca.
- **minbar** (MEEN-bar) The pulpit found near the *qiblah* wall in a *mosque*.
- **miniature** A small picture illustrating a manuscript; also, any small portrait, often on ivory or *porcelain*.
- **modeling** The shaping or fashioning of three-dimensional forms in a soft material, such as clay; also, the gradations of light and shade reflected from the surfaces of matter in space, or the illusion of such gradations produced by alterations of *value* in a drawing, painting, or print. **module** (MOD-yool) A basic unit of which
- **module** (MOD-yool) A basic unit of which the dimensions of the major parts of a work are multiples. The principle is used in sculpture and other art forms, but it is most often employed in architecture, where the module may be the dimensions of an important part of a building, such as a *column*, or simply some commonly accepted unit of measurement (the centimeter or the inch, or, as with Le Corbusier, the average dimensions of the human figure).
- **molding** In architecture, a continuous, narrow surface (projecting or recessed, plain or ornamented) designed to break up a surface, to accent, or to decorate.
- **monochrome** A painting, drawing, or print in one color; also, the technique of making such an artwork.
- **monolith** A column that is all in one piece (not built up); a large, single block or piece of stone used in *megalithic* structures.
- **monumental** In art criticism, any work of art of grandeur and simplicity, regardless of its size.
- mortice See tenon.
- **mosaic** Patterns or pictures made by embedding small pieces of stone or glass (*tesserae*) in cement on surfaces such as walls and floors; also, the technique of making such works.
- mosque A Moslem place of worship.
- **mudra** (muh-DRAH) A stylized gesture of mystical significance, usually in representations of Hindu deities.

mullion A vertical member that divides a window or that separates one window from another.

mural A wall painting; a *fresco* is a type of mural medium and technique.

- **narthex** A porch or vestibule of a church, generally colonnaded or arcaded and preceding the *nave*.
- **Naturalism** The doctrine that art should adhere as closely as possible to the appearance of the natural world. Naturalism, with varying degrees of fidelity to appearance, recurs in the history of Western art.
- **nave** The part of a church between the chief entrance and the *choir*, demarcated from *aisles* by *piers* or *columns*.
- **necking** A groove at the bottom of the Greek Doric *capital* between the *echinus* and the *flutes* that masks the junction of *capital* and *shaft*.
- **necropolis** (neh-KROP-o-lis) A large burial area; literally, a city of the dead.
- **New Wave cinema** (La Nouvelle Vague) Cinema style developed in the 1950s and 1960s that characteristically attempted to subvert viewer expectations by using ambiguity, surprize, fuzzy camera work, and abrupt changes in space, time, and mood.
- **niello** (nee-EL-o) Inlay in a metal of an alloy of sulfur and such metals as gold or silver. Also, a work made by this process, or the alloy itself.
- **nimbus** A halo, aureole, or **glory** appearing around the head of a holy figure to signify divinity.
- nirvana (neer-VAH-nah) In Buddhism and Hinduism, a blissful state brought about by absorption of the individual soul or consciousness into the supreme spirit. nonobjective Having no discernible refer-
- ence to the external appearance of the physical world.
- **objet d'art** (objay-DAR) A relatively small object (such as a figurine or vase) of artistic value.
- **obverse** On coins or medals, the side that bears the principal type or inscription. See also *reverse*.
- **oculus** A round, central opening or "eye" in a *dome*.
- **odalisque** (OH-dah-lisk) A female slave or concubine; a favorite subject of such artists as Ingres and Matisse.
- **oenochoe** (eh-NUK-oh-ee) An ancient Greek wine pitcher.
- **oeuvre** (UH-vreh) The whole of an artist's output; literally, the artist's "work."
- **ogee** (OH-jee) A *molding* having in profile a double or S-shaped curve. Also, an *arch*, each side of which has this *form*.
- **ogive** The diagonal *rib* of a Gothic *vault;* a pointed, or Gothic, *arch.* **ogival** (*adj.*)
- **oil color/paint** *Pigment* ground with oil. **open form** A *mass* penetrated or treated in such a way that space acts as its environment rather than as its limit. See also *closed form*.

order In Classical architecture, a style represented by a characteristic design of the *column* and its *entablature*. See also *superimposed order*.

orthogonal A line imagined to be behind and perpendicular to the *picture plane;* the *orthogonals* in a painting appear to recede toward a *vanishing point* on the horizon.

pagoda A Buddhist tower with a multiplicity of winged eaves; derived from the Indian *stupa*.

palestra À Roman exercise room.

palette (PAL-it) A thin board with a thumb hole at one end on which an artist lays and mixes colors; any surface so used. Also, the colors or kinds of colors characteristically used by an artist.

palmette (pal-MET) A conventional, decorative ornament of ancient origin composed of radiating petals springing from a cuplike base.

- **panorama** Originally, a specially designed building that housed colossal, circular murals. Also, any broad, spectacular vista.
- **Pantheon** (PAN-thee-on) All the gods of a people, or a temple dedicated to all such gods; especially, the Pantheon in Rome (although it is not certain that this was its function).

papier collé (PAH-pee-yay CAHL-lay) Variety of collage in which paper shapes are combined into one work of art; literally, "stuck paper."

papyrus (pah-PIE-rus) A plant native to Egypt and adjacent lands used to make a paperlike writing material; also, the material or any writing on it.

parasol An umbrella atop a Chinese *pagoda;* a vestige of the **chatra** on an Indian *stupa*.

parchment Lambskin prepared as a surface for writing or painting.

passage grave A burial chamber entered through a long, tunnel-like passage.

pastel Finely ground *pigments* compressed into chalklike sticks. Also, work done in this *medium*, or exhibiting its characteristic paleness.

pastiche (pas-TEESH) An artistic hodgepodge that imitates or ridicules another artist's style.

- **patina** (pa-TEEN-a) The colored, oxidized layer, often green, that forms on bronze and copper; also, the creation of a colored surface on metal sculpture by the application of an acid solution.
- **pediment** (PED-i-ment) In Classical architecture, the triangular space (**gable**) at the end of a building, formed by the ends of the sloping roof and the *cornice*; also, an ornamental feature having this shape.
- **pendentive** (pen-DEN-tiv) A concave, triangular piece of masonry (a triangular section of a hemisphere), four of which provide the transition from a square area to the circular base of a covering *dome*. Although they appear to be hanging (**pendent**) from the dome, they in fact support it

peripteral (per-IP-ter-al) A style of build-

ing in which the main structure is surrounded by a *colonnade*.

peristyle (PAIR-i-stile) A *colonnade* surrounding a building or a court.

- **persistence of vision** Retention in the brain for a fraction of a second of whatever the eye has seen; causes a rapid succession of images to merge one into the next, producing the illusion of continuous change and motion in media such as cinema.
- perspective A formula for projecting an illusion of the three-dimensional world onto a two-dimensional surface. In linear perspective, the most common type, all parallel lines or lines of projection seem to converge on one, two, or three points located with reference to the eye level of the viewer (the horizon line of the picture), known as vanishing points, and associated objects are rendered smaller the further from the viewer they are intended to seem. Atmospheric or aerial perspective creates the illusion of distance by the greater diminution of color intensity, the shift in color toward an almost neutral blue, and the blurring of contours as the intended distance between eye and object increases. In herringbone perspective, the lines of projection converge not on a vanishing point, but on a vertical axis at the center of the picture, as in Roman paintings.
- **photogram** An assemblage of objects on photosensitive paper exposed to light to yield an image of ghostly silhouettes floating in a void of darkened space.
- photomontage (MOHN-tahzh) A composition made by fitting together pictures or parts of pictures, especially photographs. See also *collage*.photoscreen Technique employing photo
- **photoscreen** Technique employing photo processes to create stencil screens from graphic images, which then become part of complex printing or painting processes.
- **pi** (bee) The Chinese symbol of Heaven; a jade disk.
- **piano nobile** (PEEA-no NO-bee-lay) The principal story, usually the second, in Renaissance buildings.
- **pictograph** A picture, usually stylized, that represents an idea; also, writing using such means. See also *hieroglyphic*.

picture plane The surface of a picture.

- **pier** A vertical, unattached masonry support.
- **Pieta** (pee-ay-TA) A work of art depicting the Virgin mourning over the body of Christ.
- **pigment** Finely powdered coloring matter mixed or ground with various vehicles to form paint, crayon, etc.
- **pilaster** (pil-LAS-ter) A flat, rectangular, vertical member projecting from a wall of which it forms a part. It usually has a base and a *capital* and is often *fluted*.
- **pillar** Usually a weight-carrying member, such as a *pier* or a *column*; sometimes an isolated, freestanding structure used for commemorative purposes.
- **pilotis** (pee-LOW-teez; *sing*. **piloti**) Thin steel or reinforced concrete posts used by architects in the early twentieth century to

naos See cella.

support concrete roof and floor slabs, avoiding the need for load-bearing walls. **pinnacle** A tower, primarily ornamental, that also functions in Gothic architecture to give additional weight to a *buttress* or a *pier*. See also *finial*.

- **pithos** (PITH-oss; *pl.* **pithoi**) A large, clay storage vessel frequently set into the earth and therefore possessing no flat base.
- **plan** The horizontal arrangement of the parts of a building, or a drawing or a diagram showing such an arrangement as a horizontal *section*. In **axial plan**, the parts of a building are organized longitudinally, or along a given *axis*; in a **central plan**, the parts radiate from a central point.
- **plasticity** In art, the three-dimensionality of an object. **plastic** (*adj*.)
- **plinth** The lowest member of a base; also, a block serving as a base for a statue.
- **pointillism** The method of painting of some French Post-Impressionists in which a white ground is covered with tiny dots of color, which, when viewed at a distance, blend together to produce a luminous effect. See *divisionism*.

polychrome Done in several colors.

- **polyptych** (POL-ip-tik) An *altarpiece* made up of more than three sections.
- **porcelain** Translucent, impervious, resonant *pottery* made in a base of **kaolin**, a fine white clay; sometimes any pottery that is translucent, whether or not it is made of kaolin.
- **porphyry** (POUR-feary) An Egyptian rock containing large crystals of feldspar in a purplish groundmass; used in ancient architecture and sculpture.
- **portico** A porch with a roof supported by *columns;* an entrance porch.
- **post-and-lintel system** A *trabeated* system of construction in which two posts support a *lintel*.
- **potsherds** Broken pottery, discarded by earlier civilizations, that settles into firmly stratified mounds over time and provides archeological chronologies.
- **pottery** Objects (usually vessels) made of clay and hardened by firing.
- **Poussinistes** (Poo-sehn-EESTS) Adherents to the doctrine that form, rather than color, was the most important element in painting. See *Rubénistes*.
- **predella** The narrow ledge on which an *altarpiece* rests on an altar.
- **primary colors** In *pigment*, the *hues* red, yellow, and blue. From these three colors, with the addition of white or black, it is theoretically possible to mix the full range of colors in the spectrum. In light, the hues red, blue, and green, which can be combined in varying amounts to produce the full range of colors in the spectrum. Combining the three primary colors of light in equal proportions produces pure white light. The primary colors of either pigment or light cannot be produced by mixing other colors together.
- **program** The architect's formulation of a design problem with respect to considerations of site, function, materials, and aims of the client; also, in painting and sculpture, the conceptual basis of a work.

pronaos (pro-NAY-os) The space in front of the *cella* or *naos* of a Greek temple.

- **propylaeum** (prah-pi-LAY-um; *pl.* **propylaea**) A gateway building leading to an open court preceding a Greek or Roman temple.
- **proscenium** (pro-SEEN-i-um) The stage of an ancient Greek or Roman theater.

prostyle A style of Greek temple in which the *columns* stand in front of the *naos* and extend its full width.

provenance Origin; source.

- **psalter** A book containing the Psalms of the Bible.
- **putto** (*pl.* **putti**) A young child, a favorite subject in Italian painting and sculpture. **pylon** (PIE-lon) The *monumental* entrance of an Egyptian temple.
- **qiblah** (KEEB-lah) The direction (toward Mecca) in which Moslems face in prayer. (Often *kibla*.)
- **quadro riportato** (kwahd-roh ree-por-TAHtoh) The simulation of a wall painting for a ceiling design in which painted scenes are arranged in panels resembling frames on the surface of a shallow, curved *vault*.
- **quatrefoil** (KAT-re-foyl) An architectural ornament having four lobes or **foils**. See also *trefoil*.
- **quattrocento** (KWAT-tro-CHAIN-toh) The fifteenth century in Italian art. Literally, the "1400s."

quoin (koin) A large, sometimes *rusticated*, usually slightly projecting stone (or stones) that often form the corners of the exterior walls of masonry buildings.

raking cornice The *cornice* on the sloping sides of a *pediment*.

- **Ramayana** A Sanskrit epic telling of Rama, an incarnation of the Hindu god Vishnu.
- rathas Small, freestanding Hindu temples, perhaps sculptured as architectural models.
- **rayograph** In the work of Man Ray, a *photogram*.
- **rayonnant** The "radiant" style in thirteenth-century architecture that is associated with the royal Paris court of Louis IX.
- **readymades** Manufactured objects, sometimes altered or joined with other objects and displayed as works of art to stimulate thought.
- **realism** The representation of things according to their appearance in visible nature (without *idealization*). In the nineteenth century, an approach that supported the representation of the subject matter of everyday life in a realistic mode. Iconographically, nineteenth-century Realism is the subject matter of everyday life as seen by the artist.
- **red-figure technique** In later Greek pottery, the silhouetting of red figures against a black background; the reverse of the *black-figure technique*.
- reinforced concrete (ferroconcrete) Concrete with increased tensile strength produced by iron or steel mesh or bars embedded in it.

- **relief** In sculpture, figures projecting from a background of which they are part. The degree of relief is designated high, low (**bas**), sunken (hollow), or *intaglio*. In the last, the backgrounds are not cut back and the points in highest relief are level with the original surface of the material being carved. See also *repoussé; stiacciata*.
- **reliquary** A small receptacle for a sacred relic, usually of a richly decorated, precious material.
- **repoussé** (ruh-poo-SAY) Formed in *relief* by beating a metal plate from the back, leaving the impression on the face. The metal is hammered into a hollow mold of wood or some other pliable material and finished with a *graver*. See also *relief*. **reserve column** In Egyptian rock-cut and
- **reserve column** In Egyptian rock-cut and Etruscan domed tombs, a *column* that is hewn from the living rock and serves no supporting function.
- **respond** An engaged *column*, *pilaster*, or similar structure that either projects from a *compound pier* or some other supporting device or is bonded to a wall and carries one end of an *arch*, often at the end of an *arcade*. A **nave arcade**, for example, may have nine *pillars* and two responds.
- **retable** (ruh-TAY-bl) An architectural screen or wall above and behind an altar, usually containing painting, sculpture, carving, or other decorations. See also *altarpiece*.
- **reverse** On coins or medals, the side opposite the *obverse*.
- **rhyton** (RIGHT-on) An ancient Greek ceremonial drinking vessel with a base usually in the form of the head of an animal, a woman, or a mythological creature.
- **rib** A relatively slender, molded masonry *arch* that projects from a surface. In Gothic architecture, the *ribs* form the framework of the *vaulting*.

ribbed vault See vault.

- **ridgepole** The horizontal beam at the ridge of a roof, to which the upper ends of the rafters attach.
- rinceau (ran-SO) An ornamental design composed of undulating foliate vine motifs.
- **rocaille** (row-cah-EEE) Literally, "pebble." Refers to small stone and shell motifs in some eighteenth-century ornamentation.
- **Romanitas** (Roh-MAN-ee-tahs) The religion of the Holy Roman Empire; its ritual and practice was based on imperial dominion.
- **rose** or **wheel window** The large, circular window with *tracery* and stained glass frequently used in the *façades* of Gothic churches.
- **rotulus** A long manuscript scroll used by the Egyptians, Greeks, and Romans; predecessor of the *codex*.
- **Rubénistes** (Rue-bay-NEESTS) Adherents to a doctrine proclaiming the supremacy of color, rather than form, as the proper guide for the artist. See *Poussinistes*.
- **rusticate** To give a rustic appearance by roughening the surfaces and *beveling* the edges of stone blocks to emphasize the joints between them. A technique popular

during the Renaissance, especially for stone courses at the ground-floor level.

- **sacra conversazione** (SAH-krah cone-versotz-ee-OHN-ee) In Italian, literally "holy conversation"; a grouping of the Madonna, Child, and saints in the same spatial setting, so that they appear to be conversing with one another.
- sacral-idyllic scene A landscape depicting country life and idealized nature.
- Salon (sah-LON) The governmentsponsored exhibition of works by living artists held in Paris, first biennially and (since the mid-eighteenth century) annually.
- **salon** In the eighteenth and early nineteenth centuries, a social assembly, in a private dwelling, of leaders in art and public affairs.
- samsara (som-SAH-rah) In Hindu belief, the rebirth of the soul into a succession of lives.
- **santos** (SAHN-toes) Simple, painted, wooden folk sculptures of holy figures found throughout Latin America and the Southwest.
- **sarcophagus** (sar-KOF-a-gus) A stone coffin.
- **saturation** The purity of a *hue*; the higher the *saturation*, the purer the hue. *Value* and saturation are not constantly related. For example, high-saturation yellow tends to have a high value, but high-saturation violet tends to have a low value.
- satyr (SAT-er) In Greek mythology, a kind of demi-god or deity; a follower of Dionysos; wanton and lascivious and often represented with goatlike ears and legs and a short tail.
- **scale** The dimensions of the parts or the totality of a building or an object in relation to its use or function. In architectural *plans*, the relation of the actual size of a structure to its representative size.
- scriptorium A Medieval writing room in which scrolls were also housed.
- sculpture in the round Freestanding figures, carved or modeled in three dimensions.
- **secondary colors** The colors (in pigment: green, orange, and purple; in light: cyan, magenta, and yellow) that result from mixture of pairs of *primary colors*.
- **section** In architecture, a diagram or representation of a part of a structure or building along an imaginary plane that passes through it vertically.
- **seicento** (say-CHAIN-toh) The seventeenth century in Italian art. Literally, the "1600s."
- **serdab** A small, concealed chamber in an Egyptian tomb for the statue of the deceased.
- severe style An early, pre-Classical, transitional style of mid-fifth-century Greek statuary that is formal but not rigid in pose and emphasizes the principle of weight distribution; a liberation from the Archaic limitations of frontal rigidity found in Egyptian portrait statues.
- **sfumato** (sfoo-MA-toh) A smokelike haziness that subtly softens outlines in paint-

ing; term is particularly applied to the painting of Leonardo and Correggio.

- **sgraffito** (zgra-FEE-toh) Decoration produced by scratching through a surface layer of plaster, *glazing*, etc., to reveal a different colored *ground*; also, pottery or other ware so decorated.
- **shaft** The part of a *column* between the *capital* and the base.
- **shaft grave** A grave in the form of a deep pit, the actual burial spot being at the base of the shaft or in a niche at the base.
- shaman (SHAH-mon) A priest or medicine man who can influence good and evil spirits; shamanism is the religion of some American Indians and Eskimos.
- shinto Indigenous faith of the Japanese people.
- **shoji** (SHOW-jee) A translucent ricepaper-covered sliding screen that serves as a room divider in traditional Japanese houses.
- sikhara (SHIH-ka-rah) In Hindu temples of Vishnu, the tower above the shrine.
- **silver point** A drawing technique involving the use of a silver-tipped "pencil" on a paper with a white *matte* coating; also, the delicate drawings so made.
- **sinopia** or **sinopie** Reddish-brown earth color; also, the *cartoon* or underpainting for a *fresco*.
- **sistrum** An instrument of metal rods loosely held in a metal frame, which jingle when shaken. Peculiarly Egyptian, it was used especially in the worship of Isis and is still used in Nubia.

sizing Traditional protective coat of glue applied to canvas.

slip Potter's clay dispersed in a liquid and used for *casting*, decoration, and to attach parts of clay vessels, such as handles.

- **smalto** The colored glass or enamel used in *mosaics*.
- **socle** (SOH-kel) A molded projection at the bottom of a wall or a *pier*, or beneath a pedestal or a *column* base.
- **soffit** The underside of an architectural member such as an *arch*, *lintel*, *cornice*, or stairway. See also *intrados*.
- **soft focus** A term used especially in photography to refer to an image made when the lens is thrown slightly out of sharp focus so that the contours of any object appear moderately soft and blurred.
- **space-time** A concise way of referring to the understanding of the universe as an entity composed of inextricably interwoven space and time; a conception based especially on the theories of Albert Einstein. In this view of the universe, anything that happens to alter the condition of space also affects the condition of time, and vice versa.
- **spandrel** The roughly triangular space enclosed by the curves of adjacent *arches* and a horizontal member connecting their vertexes; also, the space enclosed by the curve of an *arch* and an enclosing right angle.
- splay A large bevel or chamfer.
- **splayed opening** An opening (as in a wall) that is cut away diagonally so that the outer edges are farther apart than the inner edges. See also *embrasure*.

springing The lowest stone of an *arch*, resting on the *impost block*.

- **square schematism** A church *plan* in which the *crossing square* is used as the *module* for all parts of the design.
- **squinch** An architectural device used to make a transition from a square to a polygonal or circular base for a *dome*. It may be composed of *lintels*, *corbels*, or *arches*.
- **stave** A wedge-shaped timber; vertically placed staves embellish the architectural features of a building.
- **stele** (STEE-lee) A carved stone slab or *pillar* used especially by the ancient Greeks as grave or site markers and for similar purposes. Also found in Maya area of Mesoamerica to commemorate historical events.
- stiacciata or sciacciata (stee-ah-CHAH-tah) A kind of very low relief, originated by Donatello, that incorporates much of the illusionism of painting into carving, which in places is hardly more than a scratching of the surface.
- still life A painting representing inanimate objects, such as flowers, fruit, or household articles.
- **stoa** (STOH-a) In ancient Greek architecture, an open building with a roof supported by a row of *columns* parallel to the back wall.
- **straight photography** Photography that represents direct, "real-time" seeing as opposed to the combination of images made at different moments in time. See *double-exposure techniques* and *photomontage*.
- **stringcourse** A horizontal *molding* or band in masonry, ornamental but usually reflecting interior structure.
- **stucco** Fine plaster or cement used as a coating for walls or for decoration.
- stupa (STOO-puh) A large, moundshaped Buddhist shrine.
- **style** A manner of treatment or execution of works of art that is characteristic of a civilization, a people, or an individual; also, a special and superior quality in a work of art.
- **stylobate** (STY-loh-bate) The upper step of the base of a Greek temple, which forms a platform for the *columns*.
- stylus A needlelike tool used in *engraving* and *incising*.
- **superimposed orders** Orders of architecture that are placed one above another in an *arcaded* or *colonnaded* building, usually in the following sequence: **Doric** (the first story), **Ionic**, and **Corinthian**. Superimposed orders are found in Greek *stoas* and were used widely by Roman and Renaissance builders.
- **sutra** (SOO-truh) In Buddhism, an account of a sermon by or a dialogue involving the *Buddha*.
- **swag** A kind of decoration for walls, furniture, etc., done in *relief* and resembling garlands and gathered drapery, that was particularly popular in the eighteenth century.
- **symmetry** *Esthetic* balance that is usually achieved by disposing *forms* about a real or an imaginary *axis* so that those on one side

more-or-less correspond with those on the other. The correspondence may be in terms of shape, *color*, texture, etc.

- **tablinum** A room behind the *atrium* in a Roman house in which family archives and statues were kept.
- **tectiforms** Shapes resembling man-made structures found painted on the walls of Paleolithic caves.
- **tell** In Near Eastern archeology, a hill or a mound, usually an ancient site of habitation.
- **tempera** A technique of painting using *pigment* mixed with egg yolk, glue, or casein; also, the *medium* itself.
- **Tenebrists** (TEN-i-brists) A group of seventeenth-century European painters who used violent contrasts of light and dark. **tenebroso** Painting in the "dark manner"; a technique of the *Caravaggisti*.
- **tenon** A projection on the end of a piece of wood that is inserted into a corresponding hole (**mortice**) in another piece of wood to form a joint.
- **tepidarium** The warm-bath section of a Roman bathing establishment.
- **terra cotta** Hard-baked clay, used for sculpture and as a building material, that may be *glazed* or painted.
- tesserae (TESS-er-ee) Small, shaped pieces of glass or stone used in making mosaics.
- **tholos** (THOH-los) A circular structure, generally in Classical Greek style; also an ancient, circular tomb.
- **thrust** The outward force exerted by an *arch* or a *vault* that must be counterbalanced by *buttresses*.
- tier A series of architectural rows, layers, or ranks arranged above or behind one another.
- **tondo** A circular painting or *relief* sculpture.
- **torano** (TOR-uh-nuh) Gateway in the stone fence around a *stupa*, located at the cardinal points of the compass.
- **torus** A convex *molding* or part of a molding, usually the lowest in the base of a *column*.
- **totem** An animal or object and its representation or image, considered to be a symbol of a given family or clan.
- trabeated (TRAY-bee-ate-id) Of *post-andlintel* construction. Literally, "beamed" construction.
- **tracery** Branching, ornamental stonework, generally in a window, where it supports the glass; particularly characteristic of Gothic architecture.
- **transept** The part of a *cruciform* church with an *axis* that crosses the main axis at right angles.
- **trecento** (tray-CHAIN-toh) The fourteenth century in Italian art. Literally, the "1300s."
- **trefoil** An architectural ornament having three lobes or *foils*. See also *quatrefoil*. **triforium** In a Gothic cathedral, the blind,
- arcaded gallery below the clerestory.
- **triglyph** A projecting, grooved member of a Doric *frieze* that alternates with *metopes*. **trilithon** A pair of *monoliths* topped with a *lintel;* found in *megalithic* structures.

triptych (TRIP-tik) A three-paneled painting or *altarpiece*.

- **trompe l'oeil** (trohmp-LOY) A form of illusionistic painting that attempts to represent an object as if it exists in three dimensions at the surface of the painting; literally, "eye-fooling."
- **trumeau** (troo-MOH) A *pillar* in the center of a Romanesque or Gothic portal.
- **turret** A small, often ornamental tower projecting from a building, usually at a corner.

tympanum The space enclosed by a *lintel* and an *arch* over a doorway; also, the recessed face of a *pediment*.

ukiyo-e (OO-kee-oh-ee) A style of Japanese *genre* painting ("pictures of the floating world") that influenced nineteenthcentury Western art.

urna The whorl of hair, represented as a dot, between the brows of a Hindu diety. **ushnisha** (ush-NISH-uh) Stylized protuberance of the *Buddha*'s forehead, emblematic of his superhuman consciousness.

value The amount of light reflected by a *hue;* the greater the amount of light, the higher the value. See also *saturation*.

- vanishing point In *linear perspective*, that point on the horizon toward which parallel lines appear to converge and at which they seem to vanish.
- vanitas (VAHN-ee-tahs) Painting subject, often a still life, in sixteenth and seventeenth centuries, meant to encourage the viewer to meditate on death as the inevitable end of all human life.
- vault A masonry roof or ceiling constructed on the arch principle. A barrel or tunnel vault, semicylindrical in cross section, is in effect a deep arch or an uninterrupted series of arches, one behind the other, over an oblong space. In a crossbarrel vault, the main barrel (tunnel) vault is intersected at right angles with other barrel (tunnel) vaults at regular intervals. A quadrant vault is a half-barrel (tunnel) vault. A sexpartite vault is a rib vault with six panels. A fan vault is a development of lierne vaulting characteristic of English Perpendicular Gothic, in which radiating ribs form a fan-like pattern. A groin or cross vault is formed at the point at which two barrel (tunnel) vaults intersect at right angles. In a ribbed vault, there is a framework of ribs or arches under the intersections of the vaulting sections.
- **veduta** (veh-DUE-tah) Type of naturalistic landscape and cityscape painting popular in eighteenth-century Venice. Literally, "view" painting.
- **vellum** Calfskin prepared as a surface for writing or painting.
- vernacular architecture Nonprofessional, popular architecture.
- video synthesizer Special instrument that allows video artists to manipulate and change electronic video information, causing images to stretch, shrink, change color or break up, and to layer, inset, or merge with other images.

- vignette Originally, a decorative element of vine leaves and tendrils in the page margins of Gothic manuscripts; later, a decorative design with no distinct borders to separate it from the text of a book page. vihara (vee-HAH-rah) A Buddhist monastery, often cut into a hill.
- vimana (vih-MAH-nuh) In Hindu and Buddhist temples, the pyramidal tower above the shrine (composed of the *garbha griha* and the *sikhara*).
- volume See mass.
- **volute** A spiral, scroll-like form characteristic of the Greek Ionic *capital*.
- **voussoir** (voo-SWAHR) A wedge-shaped block used in the construction of a true *arch*. The central voussoir, which sets the arch, is the *keystone*.
- warm color Red, orange, or yellow. Psychologically, warm colors tend to be exciting, emphatic, and affirmative; optically, they generally seem to advance or to project. See also *cool color*.
- **wash** In *watercolor* painting especially, a thin, transparent film of color.
- **watercolor** A painting technique using *pigment* (usually prepared with gum) mixed with water and applied to an absorbent surface; also, the *medium* itself. The painting is transparent, with the white of the paper furnishing the lights.
- weight shift See contrapposto.
- **westwork** A multistoried *mass*, including the *facade* and usually surmounted by towers, at the western end of a Medieval church, principally in Germany.
- **woodcut** A wooden block on the surface of which those parts not intended to print are cut away to a slight depth, leaving the design raised; also, the printed impression made with such a block.
- yaksha (YAK-shah) A divinity in the Hindu and Buddhist pantheon. (*f.* yakshi) Yamato-e (yah-MAH-toh-ee) A purely Japanese style of sophisticated and depersonalized painting created for the Fujiwara nobility.
- **yasti** (YAHS-tee) The mast surmounting the *dome* of a *stupa*.
- yu A covered Chinese libation vessel.
- **Zen** A Buddhist sect and its doctrine, emphasizing enlightenment through intuition and introspection rather than the study of scripture. In Chinese, *Ch'an*.
- **ziggurat** (ZIG-oor-at) A roughly pyramidal structure, built in ancient Mesopotamia, consisting of stages; each succeeding stage is stepped back from the one beneath.
- **zoomorphism** The representation of gods in the form or with the attributes of animals; the use of animal forms in art or symbolism.
- **zoopraxiscope** (zoe-oh-PRAX-is-cope) Device invented by Eadweard Muybridge, which he developed to project sequences of images (mounted on special glass plates) onto a screen in rapid succession, creating the illusion of motion pictures. See *perspective of vision*.

BIBLIOGRAPHY

This supplementary list of books is intended to be comprehensive enough to satisfy the reading interests of the unspecialized student and general reader, as well as those of more advanced readers who wish to become acquainted with fields other than their own. The books listed range from works that are valuable primarily for their reproductions to scholarly surveys of schools and periods. No entries for periodical articles appear, but a few of the periodicals that publish art-historical scholarship in English are noted.

SELECT PERIODICALS

Archaeology The Art Bulletin Art History The Art Journal

The Burlington Magazine Journal of the Society of Architectural Historians Journal of the Warburg and Courtauld Institutes

REFERENCE BOOKS

- Arntzen, Etta, and Rainwater, Robert. Guide to the Literature of Art History. Chicago: American Li-brary Association/Art Book Company, 1980.
- (Later edition available.) Bator, Paul M. *The International Trade in Art*. Chi-cago: University of Chicago Press, 1983. (Later edition available.)
- edition available.) Bindman, David, ed. The Thames & Hudson Ency-clopedia of British Art. London: Thames & Hud-son, 1985. (Later editions available.) Broude, Norma, and Garrard, Mary D., eds. Fem-inism and Art History: Questioning the Litany. New York: Harper & Row, 1982. Chilvers, Ian, and Osborne, Harold, eds. The Ox-ford Dictionary of Art. New York: Oxford Univer-sity Press, 1988. Christer, Yves, et al. Art of the Christian World 200
- Christe, Yves, et al. Art of the Christian World, 200– 1500: A Handbook of Styles and Forms. New York: Rizzoli, 1982.
- Rizzoli, 1982. Encyclopedia of World Art. 15 vols. New York: Pub-lisher's Guild, 1959–1968. Supplementary vols. 16, 1983; 17, 1987. Feilden, Bernard B. The Conservation of Historic
- Buildings. London: Butterworth Scientific Books, 1982
- Fielding, Mantle. Dictionary of American Painters, Sculptors, and Engravers. 2nd rev. and enl. ed. Poughkeepsie, NY: Apollo, 1986. Fleming, John; Honour, Hugh; and Pevsner, Nik-olaus. Penguin Dictionary of Architecture. Balti-more: Ponguin 1980.
- more: Penguin, 1980.
- Fletcher, Sir Banister. A History of Architecture.
- 18th rev. ed. New York: Scribner, 1975. Giedion, Siegfried. The Beginnings of Architecture: The Eternal Present, a Contribution on Constancy and Change. Princeton: Princeton University Press, 1981.
- Press, 1981. . Space, Time and Architecture: The Growth of a New Tradition. 5th ed., rev. and enl. Cam-bridge: Harvard University Press, 1982. Gombrich, Ernst Hans Josef. Art and Illusion. 5th
- Gomorich, Ernst Hans Josef. Art and husson. Sur ed. London: Phaidon, 1977. Haggar, Reginald G. A Dictionary of Art Terms: Architecture, Sculpture, Painting, and the Graphic Arts. Poole, England: New Orchard Editions, 1984.
- Hall, James. Dictionary of Subjects and Symbols in Art. 2nd rev. ed. London: J. Murray, 1977. (Later edition available.)
- Harris, A. S., and Nochlin, L. *Women Artists:* 1550–1950. Los Angeles: County Museum of Art; New York: Knopf, 1976. (Later edition available.)
- Hauser, Arnold. The Sociology of Art. Chicago: University of Chicago Press, 1982. Hind, Arthur M. A History of Engraving and Etch-ing from the Fifteenth Century to the Year 1914. 3rd
- rev. ed. New York: Dover, 1963. Holt, Elizabeth G., ed. A Documentary History of Art. 2nd ed. 2 vols. Princeton: Princeton University Press, 1981.
- sity Press, 1981. Huyghe, René, ed. Larousse Encyclopedia of Byzan-tine and Medieval Art. New York: Prometheus Press, 1963; Excalibur Books, 1981. Larousse Encyclopedia of Renaissance and
- Baroque Art. New York: Prometheus Press, 1964; Hamlyn/American (paperbound), 1976. James, John, et al. The Traveler's Key to Medieval
- France: A Guide to the Sacred Architecture of Medie-
- val France. New York: Knopf, 1986. Janson, H. W., ed. Sources and Documents in the History of Art Series. Englewood Cliffs, NJ: Prentice-Hall, 1966.

- Kostof, Spiro. A History of Architecture: Settings and Rituals. Oxford: Oxford University Press, 1985. Kronenberger, Louis. Atlantic Brief Lives: A Bio-graphical Companion to the Arts. Boston: Little, Brown, 1971. Lucie-Smith, Edward. The Thames & Hudson Dic-tionerref Art Formula and The Thames & Hudson Dic-
- tionary of Art Terms. London: Thames & Hudson, 1984
- Murray, Peter, and Murray, Linda. A Dictionary of Art and Artists. New York: Penguin, 1976; (pa-perbound) 1984.
- Myers, Bernard Samuel, ed. Encyclopedia of Painting: Painters and Painting of the World from Prehis-toric Times to the Present Day. 4th rev. ed. New York: Crown, 1979.
- York: Crown, 1979. Encyclopedia of World Art, Suppl. vol. 16. Palatine, IL: McGraw-Hill/The Publishers Guild, 1983. (Later edition available.) Myers, Bernard S., and Myers, Shirley D., eds. Dictionary of 20th-Century Art. New York: McGraw-Hill, 1974. Osborne, Harold, ed. The Oxford Companion to 20th Century Art. New York: Oxford University Press 1981

- Press, 1981
- Pevsner, Nikolaus. A History of Building Types. 1979. Reprint. London: Thames & Hudson (pa-

Press, 1975. Placzek, A. K., ed. *Macmillan Encyclopedia of Archi-tects*. 4 vols. New York: Macmillan/Free Press, 1982

Podro, Michael. The Critical Historians of Art. New

Haven: Yale University Press, 1982. Quick, John. Artists' and Illustrators' Encyclopedia. 2nd ed. New York: McGraw-Hill, 1977.

- Read, Herbert, and Stangos, Nikos, eds. The Thames & Hudson Dictionary of Art and Artists. Rev. ed. London: Thames & Hudson, 1988.

Redig de Campos, D., ed. Art Treasures of the Vatican. New York: Park Lane, 1974.
Rubenstein, Charlotte Streifer. American Women Artists from Early Indian Times to the Present. Boston: G. K. Hall/Avon Books, 1982.

- Schiller, Gertrud. Iconography of Christian Art. 2 vols. Greenwich, CT: New York Graphic Soci-
- with, G. E. Kidder. The Architecture of the United States: An Illustrated Guide to Buildings Open to the Public. 3 vols. Garden City, NY: Doubleday/
- Anchor, 1981. Stierlin, Henri. Encyclopedia of World Architecture 1978. 1978. Reprint. New York: Van Nostrand, Reinhold, 1983.

Stratton, Arthur. The Orders of Architecture: Greek, Roman and Renaissance. London: Studio, 1986. Trachtenberg, Marvin, and Hyman, Isabelle. Ar-chitecture, from Prehistory to Post-Modernism. New

- York: Abrams, 1986.
- York: Abrams, 1986.
 Tufts, Eleanor. American Women Artists, Past and Present, A Selected Bibliographic Guide. New York: Garland Publishers, 1984.
 Our Hidden Heritage, Five Centuries of Women Artists. London: Paddington Press, 1974.
 Waterhouse, Ellis. The Dictionary of British 18th Century Painters in Oils and Crayons. Wood-bridge, England: Antique Collectors' Club, 1981.
 Wittkower, Rudolf. Sculpture Processes and Princi-ples. New York: Harper & Row, 1977.
 Wölfflin, Heinrich. The Sense of Form in Art. New York: Chelsea, 1958.
 Young, William, ed. A Dictionary of American Art-ists, Sculptors, and Engravers. Cambridge, MA: W. Young, 1968.

CHAPTER 1 THE BIRTH OF ART

Bandi, Hans-Georg; Breuil, Henri; et al. The Art of the Stone Age: Forty Thousand Years of Rock Art. 2nd ed. London: Methuen, 1970.

Bataille, Georges. Lascaux: Prehistoric Painting or the Birth of Art. Lausanne: Skira, 1980. Breuil, Henri, Four Hundred Centuries of Cave Art.

- Breuil, Henri. Four Hundred Centuries of Cave Art. New York: Hacker, 1979. Reprint.
 Graziosi, Paolo. Paleolithic Art. New York: McGraw-Hill, 1960.
 Hawkes, Jacquetta. The Atlas of Early Man. New York: St. Martin's Press, 1976.
 Kubba, Shamil A. A. Mesopotamian Architecture and Town-planning: From the Mesolithic to the End of the Proto-historic Period. Oxford: B. A. R., 1987.
 Lernic Guurhan Andre, The Darm of European Art.
- Leroi-Gourhan, Andre. The Dawn of European Art: An Introduction to Paleolithic Cave Painting. Cam-bridge: Cambridge University Press, 1982.
- Treasures of Prehistoric Art. New York: Abrams, 1967.
- Lewin, Roger. In the Age of Mankind: A Smithsonian Book of Human Evolution. Washington DC: Smith-
- Book of Human Evolution. Washington DC: Smith-sonian Institution Books, 1988. Megaw, J. V. S. The Art of the European Iron Age. New York: Harper & Row, 1970. Pfeiffer, John E. The Creative Explosion: An Inquiry into the Origins of Art and Religion. New York: Harper & Row, 1982. Powell, T. G. E. Prehistoric Art. New York: Prae-cor 1962.
- ger, 1966. Renfrew, Colin, ed. British Prehistory: A New Out-

- Renfrew, Colin, ed. British Prehistory: A New Outline. London: Noyes Press, 1975.
 Sandars, Nancy K. Prehistoric Art in Europe. 2nd ed. New York: Penguin, 1985.
 Sieveking, Ann. The Cave Artists. London: Thames & Hudson, 1979.
 Trump, David H. The Prehistory of the Mediterranean. New Haven: Yale University Press, 1980.
 (I ator edition evidence) (Later edition available.)
- (Later edution available.) Wainwright, Geoffrey. The Henge Monuments: Cer-emony and Society in Prehistoric Britain. London: Thames & Hudson, 1990. Windels, Fernand. The Lascaux Cave Paintings. New York: Viking, 1950.

CHAPTER 2 THE ANCIENT NEAR EAST

Amiet, Pierre. Art of the Ancient Near East. New

- Anniet, Fierre, Art of the Ancient Near East. New York: Abrams, 1980.
 Amiet, Pierre, et al. Art in the Ancient World: A Handbook of Styles and Forms. New York: Rizzoli, 1981.
- Culican, William. The Medes and Persians. London: Thames & Hudson, 1965; New York: Praeger, 1965
- Frankfort, Henri. The Art and Architecture of the Ancient Orient. Baltimore: Penguin, 1971. (Later edition available.)
- Ghirshman, Roman. Iran from Earliest Times to the Islamic Conquest. New York: Penguin, 1978. Groenewegen-Frankfort, H. A. Arrest and Move-
- ment: An Essay on Space and Time in Representa-tional Art of the Ancient Near East. Cambridge, MA: Belknap Press, 1987. Hinz, Walther. The Lost World of Elam. New York:

- Hinz, Walther. The Lost World of Elam. New York: New York University Press, 1973.
 Kenyon, Kathleen M. Digging Up Jericho. New York: Praeger, 1974.
 Kramer, Samuel N. The Sumerians: Their History, Culture, and Character. Chicago: University of Chicago Press, 1963. (Later edition available.) Leick, Gwendolyn. A Dictionary of Ancient Near Eastern Architecture. New York: Routledge, 1988.

- Lloyd, Seton. The Archaeology of Mesopotamia: From the Old Stone Age to the Persian Conquest. London: Thames & Hudson, 1978. (Later edition available.)
- able.) . The Art of the Ancient Near East. New York: Praeger, 1969. Lloyd, Seton, and Muller, Hans Wolfgang. An-cient Architecture: Mesopotamia, Egypt, Crete. New York: Electa/Rizzoli, 1986. Mellaart, James. Çatal Hüyük: A Neolithic Town in Anatolia. New York: McGraw-Hill, 1967. The Ferliet Civiliant Contention of the New Fast
- The Earliest Civilizations of the Near East. New York: McGraw-Hill, 1965.

-. The Neolithic of the Near East. New York: Scribner, 1975. Oppenheim, A. Leo. Ancient Mesopotamia. Rev.

ed. Chicago: University of Chicago Press, 1977. Paris, Pierre. Manual of Ancient Sculpture. Rev. and enl. ed. New Rochelle, NY: Caratzas, 1984. Parrot, André. The Arts of Assyria. New York:

Golden Press, 1961. Golden Press, 1961.

Golden Press, 1961.
Porada, Edith, and Dyson, R. H. The Art of An-cient Iran: Pre-Islamic Cultures. Rev. ed. New York: Greystone Press, 1969.
Wolf, Walther. The Origins of Western Art: Egypt, University

Mesopotamia, the Aegean. New York: Universe

port, CT: Greenwood Press, 1981.

CHAPTER 3 THE ART OF EGYPT

Aldred, Cyril. The Development of Ancient Egyptian Art from 3200 to 1315 B.C. 3 vols. London: Academy Edition, 1973.

Badawy, Alexander. A History of Egyptian Architec-ture. 3 vols. Berkeley: University of California

ture. 3 vols. Berkeley: University of California Press, 1973. Baines, John, and Malek, Jaromir. Atlas of Ancient Egypt. New York: Facts on File, 1980. Emery, Walter B. Archaic Egypt. Baltimore: Pen-guin, 1972. (Later edition available.) Gardiner, Sir Alan Henderson. Egypt of the Phar-aohs. London: Oxford University Press, 1978. Lange, Kurt, with Hirmer, Max. Egypt: Architec-ture, Sculpture and Painting in Three Thousand Years. 4th ed. London: Phaidon, 1968. Lurker, Manfred. The Gods and Symbols of Ancient Egypt: An Illustrated Dictionary. New York: Thames & Hudson, 1980. (Later edition avail-Thames & Hudson, 1980. (Later edition avail-

able.) Mahdy, Christine, ed. The World of the Pharaohs: A Complete Guide to Ancient Egypt. London: Thames & Hudson, 1990.

Mekhitarian, Arpag. Egyptian Painting. New York: Skira, 1978.

Skira, 1978.
Mendelsohn, Kurt. The Riddle of the Pyramids.
New York: Thames & Hudson, 1986.
Robins, Gay. Egyptian Painting and Relief. Aylesbury, England: Shire Publications, 1986.
Romer, John. Valley of the Kings. New York: William Morrow 1981

liam Morrow, 1981

Schafer, Heinrich. Principles of Egyptian Art. Rev. reprint. Oxford: Aris and Phillips, 1986. Smith, E. Baldwin. Egyptian Architecture as Cul-tural Expression. Watkins Glen, NY: American Life Foundation, 1968.

Smith, William Stevenson, and Simpson, W. The Art and Architecture of Ancient Egypt. Rev. ed.

New York: Viking, 1981. Woldering, Irmgard. Gods, Men and Pharaohs: The Glory of Egyptian Art. New York: Abrams, 1967.

CHAPTER 4 THE AEGEAN: CYCLADIC, MINOAN, AND MYCENAEAN ART

Chadwick, John. *The Mycenaean World*. New York: Cambridge University Press, 1976. Cottrell, Arthur. *The Minoan World*. New York:

Scribner, 1980.

- Demargne, Pierre. Aegean Art: The Origins of Greek Art. London: Thames & Hudson, 1964.
 Doumas, Christos. Thera, Pompeii of the Ancient Aegean: Excavations at Akrotiri, 1967–1979. New York: Thames & Hudson, 1983.
 Evans, Sir Arthur John. The Palace of Minos. 4 vols.
 1901. 1055. Parent New York: Bible & Tampon
- 1921–1935. Reprint. New York: Biblo & Tannen, 1964.

Graham, James W. The Palaces of Crete. Princeton: Princeton University Press, 1969. (Later edition available.)

Higgins, Reynold Alleyne. Minoan and Mycenaean

Art. Rev. ed. New York: Oxford University Press, 1981. Marinatos, Spyridon, with Hirmer, Max. Crete and Mycenae. London: Thames & Hudson, 1960.

Matz, Friedrich. The Art of Crete and Early Greece. New York: Crown, 1965. Palmer, Leonard R. Mycenaeans and Minoans. 2nd

rev. ed. 1963. Reprint. Westport, CT: Green-wood Press, 1980.

Pendlebury, John. The Archeology of Crete. Lon-

don: Methuen, 1967. Schliemann, Heinrich. Ilios: The City and the Coun-try of the Trojans. 1881. Reprint. New York: B.

Press, 1976. Tiryns. 1885. Reprint. New York: Arno

Press, 1976.

Vermeule, Emily. Greece in the Bronze Age. Chi-cago: University of Chicago Press, 1972. Wace, Alan. Mycenae, an Archeological History and

Guide. New York: Biblo & Tannen, 1964. Warren, Peter. *The Aegean Civilizations*. London: Elsevier-Phaidon, 1975.

Willetts, R. F. The Civilization of Ancient Crete. Berkeley: University of California Press, 1978.

CHAPTER 5 THE ART OF GREECE

Arias, Paolo. A History of One Thousand Years of *Greek Vase Painting*. New York: Abrams, 1962. (Later edition available.)

Ashmole, Bernard. Architect and Sculptor in Classi-cal Greece. New York: New York University Press, 1972.

Press, 1986.

Beazley, John D., and Ashmole, Bernard. Greek Sculpture and Painting to the End of the Hellenistic Period. Cambridge: Cambridge University Press, 1966.

1966. Berve, Helmut. Greek Temples, Theatres, and Shrines. New York: Abrams, 1963. Bieber, Margarete. Sculpture of the Hellenistic Age. 1961. Reprint. New York: Hacker, 1980. Blumel, Carl. Greek Sculptors at Work. London: Phaidon, 1969. Roardman John Greek Art Rey ed New York:

Boardman, John. Greek Art. Rev. ed. New York:

Thames & Hudson, 1987. ———. Greek Sculpture: The Classical Period: A Handbook. London: Thames & Hudson, 1987.

Branigan, Keith, and Vickers, Michael. Hellas, the Civilizations of Ancient Greece. New York: McGraw-Hill, 1980.

Brilliant, Richard. Arts of the Ancient Greeks. New York: McGraw-Hill, 1973. Buschor, Ernst. Greek Vase Painting. New York: Hacker, 1978.

1960.

Charbonneaux, Jean. Archaic Greek Art. New York: Braziller, 1971. Charbonneaux, Jean; Martin, Roland; and Vil-lard, François. Hellenistic Art. New York: Brazil-ler, 1973.

Chitham, Robert. Classical Orders of Architecture. New York: Rizzoli, 1985. Cook, Robert M. Greek Art: Its Development, Char-

acter and Influence. Harmondsworth, England:

Penguin, 1976. Coulton, J. J. Ancient Greek Architects at Work. Ith-aca, NY: Cornell University Press, 1977. (Later edition available.)

Dinsmoor, W. B. *The Architecture of Ancient Greece.* 3rd ed. New York: Norton, 1975. Hampe, Roland, and Simon, Erika. *The Birth of Greek Art.* New York: Oxford University Press, 1981.

Havelock, Christine Mitchell. Hellenistic Art: The Art of the Classical World. 2nd rev. ed. New York: Norton, 1981.

Lawrence, Arnold W. Greek Architecture. 2nd ed. Baltimore: Penguin, 1967. (Later edition available.)

Lullies, Reinhard, and Hirmer, Max. Greek Sculp

ture. Rev. ed. New York: Abrams, 1960. Martin, Roland. Greek Architecture: Architecture of Crete, Greece, and the Greek World. New York: Electa/Rizzoli, 1988.

Onians, John. Art and Thought in the Hellenistic Age: The Greek World View, 350–50 B.c. London: Thames & Hudson, 1979.

Papaioannou, Kostas. The Art of Greece. New

York: Abrams, 1989. Pfuhl, Ernst. Masterpieces of Greek Drawing and Painting. 2nd ed. Chicago: Argonaut, 1967.

Pollitt, Jerome J. The Ancient View of Greek Art. New Haven: Yale University Press, 1974.
Art and Experience in Classical Greece.
Cambridge: Cambridge University Press, 1972.
Art in the Hellenistic Age. Cambridge: Cambridge University Press, 1986.
The Art of Greece 1400–31 B.C. Englewood Cliffs, NJ: Prentice-Hall, 1965.
Richter, Gisela M. Attic Red-Figure Vases: A Survey. Naw Haven: Yale University Press, 1958.

New Haven: Yale University Press, 1958. ——. A Handbook of Greek Art. 9th ed. Oxford:

Phaidon, 1987. . The Portraits of the Greeks. Rev. ed. Ithaca,

ton: Princeton University Press, 1970. Robertson, Donald S. Greek and Roman Architecture. 2nd ed. Cambridge: Cambridge University Press, 1969

Robertson, Martin. Greek Painting. New York: Riz-zoli, 1979.

. A History of Greek Art. 2 vols. Cambridge: A History of Greek Art. 2 Vols. Cambridge: Cambridge University Press, 1976.
 A Shorter History of Greek Art. Cambridge: Cambridge University Press, 1981.
 Scranton, Robert L. Greek Architecture. New York: Barriller, 1962.

Scranton, Robert L. Greek Architecture. New Tork-Braziller, 1962. Scully, Vincent. The Earth, the Temple, and the Gods: Greek Sacred Architecture. Rev. ed. New Haven: Yale University Press, 1979. Stewart, Andrew. Greek Sculpture. 2 vols. New Haven: Yale University Press, 1990.

Haven: Yale University Press, 1990.
 Swindler, Mary H. Ancient Painting from the Earliest Times to the Period of Christian Art. 1929. Reprint. New Haven: Yale University Press, 1929.
 Travlos, John. Pictorial Dictionary of Ancient Athens. 1971. Reprint. New York: Hacker, 1980.
 Vermeule, Cornelius C. The Art of the Greek World, Prehistoric through Pericles. Boston, MA: Depart.

ment of Classical Art, Museum of Fine Arts, 1982

. Greek and Roman Sculpture in America: Masterpieces in Public Collections. Berkeley: University of California Press, 1981.

Greek Art, Socrates to Sulla. Boston, MA: Department of Classical Art, Museum of Fine Arts, 1980.

CHAPTER 6 ETRUSCAN AND **ROMAN ART**

Andreae, Bernard. The Art of Rome. New York: Abrams, 1977

Abrams, 1977. Bianchi Bandinelli, Ranuccio. Rome, the Late Em-pire. New York: Braziller, 1971. Boethius, Axel. The Golden House of Nero. Ann Arbor: University of Michigan Press, 1960. Brilliant, Richard. Roman Art, from the Republic to Constantine. New York: Praeger, 1974. Visual Narratives: Storytelling in Etruscan and Roman Art. Ithaca, NY: Cornell University Press, 1984. Brown, Frank Edward. Roman Architecture. New York: Braziller 1961.

York: Braziller, 1961. Buchthal, Hugo. Art of the Mediterranean World, A.D. 100 to 1400. Art History Series 5. Washing-

Goldscheider, Ludwig. Roman Portraits. London: Phaidon, 1940.

Hanfmann, George. Roman Art. Greenwich, CT: New York Graphic Society, 1964.Kraus, Theodor. Pompeii and Herculaneum: The Liv-ing Cities of the Dead. New York: Abrams, 1975.Leach, Eleanor Winsor. The Rhetoric of Space: Liter-

ary and Artistic Representations of Landscape in Re-

publican and Augustan Rome. Princeton: Princeton

publican and Augustan Rome. Princeton: Princeton University Press, 1988. L'Orange, Hans Peter. The Roman Empire: Art Forms and Civic Life. New York: Rizzoli, 1985. MacDonald, William L. The Architecture of the Roman Empire. Rev. ed. New Haven: Yale Uni-versity Press, 1982.

McKay, Alexander G. Houses, Villas, and Palaces in the Roman World. Ithaca, NY: Cornell University

Maiuri, Amedeo. Pompeii. 14th ed. Rome: Istituto

. Roman Painting. Geneva: Skira, 1953.

Poliografico dello Stato, 1970.

Press. 1975.

ton, DC: Decatur House Press, 1983.

- Mansuelli, Guido. The Art of Etruria and Early Rome. New York: Crown, 1965. Nash, Ernest. Pictorial Dictionary of Ancient Rome.
- Vols. New York: Hacker, 1981.
 Pollitt, Jerome J. The Art of Rome, 753 B.C.-A.D.
 337. Englewood Cliffs, NJ: Prentice-Hall, 1966.
 Richardson, Emeline. The Etruscans: Their Art and Civilization. Chicago: University of Chicago Press, 1976.
- Rivoira, Giovanni. Roman Architecture and Its Principles of Construction Under the Empire. New York: Hacker, 1972.
- Robertson, Donald S. Greek and Roman Architecture. 2nd ed. Cambridge: Cambridge University Press, 1969.
- Press, 1969.
 Sprenger, Maja, and Bartoloni, Gilda. The Etruscans: Their History, Art, and Architecture. New York: Abrams, 1983.
 Strong, Donald, and Ling, Roger. Roman Art. 2nd rev. ed. New York: Penguin, 1988.
- Vermeule, Cornelius C. Roman Art: Early Republic to Late Émpire. Boston: Museum of Fine Arts, Department of Classical Art, 1979.
- Vickers, Michael. *The Roman World*. Oxford: El-sevier-Phaidon, 1977. Ward-Perkins, John B. *Roman Architecture*. New York: Electa/Rizzoli, 1988.

- Grand Roman Architecture. 2nd inte-grated ed. New York: Penguin, 1981. Ward-Perkins, John, and Boethius, Axel. Etruscan and Roman Architecture. Harmondsworth, Eng-
- land: Penguin, 1970. Zanker, Paul. The Power of Images in the Age of Au-gustus. Ann Arbor: University of Michigan Press, 1988.

CHAPTER 7 EARLY CHRISTIAN, BYZANTINE, AND ISLAMIC ART

- Arnold, Thomas W. Painting in Islam. New York:
- Dover, 1965. Aslanapa, Oktay. Turkish Art and Architecture. London: Faber & Faber, 1971. Atil, Esin. Renaissance of Islam: Art of the Mamluks. Washington, DC: Smithsonian Institution Press, 1981.

Beach, Milo Cleveland. Early Mughal Painting.

- Cambridge: Harvard University Press, 1987. Beckwith, John. The Art of Constantinople: An Intro-duction to Byzantine Art (330–1453). New York:
- Thaidon, 1968.
 Phaidon, 1968.
 Early Christian and Byzantine Art. New York: Penguin, 1979. (Later edition available.)
 Chatzidakis, Manolis. Byzantine and Early Medieval Painting. New York: Viking, 1965.
 Crespi, Gabriele. The Arabs in Europe. New York:

- Rizzoli, 1986. Creswell, K. A. C. A Short Account of Early Muslim Architecture. Rev. and enl. ed. Aldershot, England: Scolar, 1989.
- Dalton, Ormonde M. Byzantine Art and Archaeol-ogy. New York: Dover, 1961. Demus, Otto. Byzantine Art and the West. New
- York: New York University Press, 1970.
- -. The Mosaic Decoration of San Marco, Venice. Chicago: University of Chicago Press, 1988. Du Bourguet, Pierre. Early Christian Art. New
- York: William Morrow, 1971. Ettinghausen, Richard. Arab Painting. Geneva: Skira, 1977.
- . From Byzantium to Sasanian Iran and the Islamic World. Leiden: Brill, 1972.
- Ettinghausen, Richard, and Grabar, Oleg. The Art and Architecture of Islam, 650–1250. New York: Viking Penguin, 1987. (Later edition available.) Golombek, Lisa, and Wilber, Donald. *The Timurid*

- Goionbek, Lisa, and Wiber, Donald. The Immiria Architecture of Iran and Turan. 2 vols. Princeton: Princeton University Press, 1988.
 Goodwin, Godfrey. A History of Ottoman Architec-ture. New York: Thames & Hudson, 1987.
 Gough, Michael. The Origins of Christian Art. New York: Pragage. 1973.

- . The Golden Age of Justinian: From the Death of Theodosius to the Rise of Islam. New York: Odys-
- sey Press, 1967. Grabar, André, and Chatzidakis, Manolis. Greek
- Mosaics of the Byzantine Period. New York: New American Library, 1964.

- Grabar, Oleg. The Formation of Islamic Art. Rev. and enl. ed. New Haven: Yale University Press, 1987.
- Grover, Satish. The Architecture of India: Islamic (727-1707). New Delhi: Vikas, 1981.
- Grunebaum, Gustave von. Classical Islam: A History, 600–1258. Chicago: Aldine, 1970.
 Hamilton, George H. The Art and Architecture of Russia. 2nd ed. New York: Viking, 1975. (Later edition available)
- edition available.) Hamilton, John A. *Byzantine Architecture and Deco-ration.* 1933. Freeport, NY: Books for Libraries/ ration. 1933. Freeport, NY: Books for Libraries/ Arno Press, 1972. Hoag, John D. Islamic Architecture. New York: Abrams, 1977; Rizzoli (paperbound), 1987. Hutter, Irmgard. Early Christian and Byzantine Art. London: Herbert Press, 1988. Huyghe, René, ed. Larousse Encyclopedia of Byzan-tine and Medieval Art. See Reference Books. Kitzinger, Ernst. Byzantine Art in the Making. Cambridge: Harvard University Press, 1977. Early Medieval Art with Illustrations from the British Museum Collection. Rev. ed. Blooming-

- the British Museum Collection. Rev. ed. Bloomington: Indiana University Press, 1983. Krautheimer, Richard, and Curcic, Slobodan.
- Early Christian and Byzantine Architecture. 4th rev.
- ed. New York: Penguin, 1986. Kühnel, Ernst. Islamic Art and Architecture. London: Bell, 1966.
- Lane, Arthur. Early Islamic Pottery, Mesopotamia, Egypt and Persia. New York: Faber & Faber, 1965.
- Levey, Michael. The World of Ottoman Art. New York: Scribner, 1975. Lewis, Bernard, ed. Islam and the Arab World. New
- York: Norton, 1969.
- MacDonald, William L. Early Christian and Byzan*tine Architecture.* New York: Braziller, 1962. (Later edition available.)
- Maguire, Henry. Art and Eloquence in Byzantium.
- Princeton: Princeton University Press, 1981. Mango, Cyril. Byzantine Architecture. New York: Electa/Rizzoli, 1985.
- Byzantium and Its Image: History and Cul-. Byzantium and its Image: History and Cul-ture of the Byzantine Empire and Its Heritage. Lon-don: Variorum Reprints, 1984. Meyer, Peter. Byzantine Mosaics: Torcello, Venice, Monreale, Palermo. London: Batsford, 1952. Milburn, Robert L. P. Early Christian Art and Archi-tecture. Berkeley: University of California Press, 1000
- 1988
- Perkins, Ann Louise. *The Art of Dura-Europos*. Oxford: Clarendon Press, 1973.
- Pope, Arthur, and Ackerman, Phyllis. A Survey of Persian Art from Prehistoric Times to the Present. London: Oxford University Press, 1977.
- 1959 Byzantine Art. London: Variorum Re-
- prints, 1973. Islamic Art. London: Thames & Hudson,
- 1975 Schiller, Gertrud. Iconography of Christian Art. See **Reference Books.**
- Schimmel, Annemarie. Islam in India and Pakistan. Leiden: Brill, 1982.
- Smith, Earl Baldwin. Architectural Symbolism of Imperial Rome and the Middle Ages. Princeton: Princeton University Press, 1956.
- Princeton: Princeton University Press, 1971.
- Snyder, James. Medieval Art: Painting, Sculpture, and Architecture, 4th-14th Century. New York:
- Abrams, 1989.
- Swift, Emerson H. Hagia Sophia. New York: Co-lumbia University Press, 1980.
 Volbach, Wolfgang. Early Christian Mosaics, from the Fourth to the Seventh Centuries. New York:
- the Fourth to the Seventh Centures. New York: Oxford University Press, 1946. Volbach, Wolfgang, and Hirmer, Max. Early Christian Art. New York: Abrams, 1962. Von Simson, Otto G. Sacred Fortress: Byzantine Art and Statecraft in Ravenna. Chicago: University of Chicago Press, 1976. (Later edition available.) Walter, Christopher. Art and Ritual of the Byzantine Church London: Variorum 1982.
- Church. London: Variorum, 1982. Weitzmann, Kurt. Ancient Book Illumination. Cam-
- bridge: Harvard University Press, 1959. Art in the Medieval West and Its Contacts with Byzantium. London: Variorum, 1982.

. Illustrations in Roll and Codex. Princeton: Princeton University Press, 1970. Weitzmann, Kurt, et al. *The Icon*. New York: Knopf, 1982.

CHAPTER 8 EARLY MEDIEVAL ART

Arnold, Bruce. Irish Art: A Concise History. Rev. ed. London: Thames & Hudson, 1989. Beckwith, John. Early Medieval Art: Carolingian,

- Ottonian, Romanesque. New York: Oxford University Press, 1974.
- Calkins, Robert G. Illuminated Books of the Middle
- Ages. Ithaca, NY: Cornell University Press, 1983. Conant, Kenneth. Carolingian and Romanesque Ar-chitecture 800–1200. 2nd integrated rev. ed. Harmondsworth, England: Penguin, 1978. (Later edition available.) Dodwell, C. R. Anglo-Saxon Art: A New Perspec-tive. Ithaca, NY: Cornell University Press, 1982.
- (Later edition available.) Finlay, Ian. Celtic Art: An Introduction. London: Faber & Faber, 1973. Goldschmidt, Adolf. German Illumination. New
- Gonserman, Adon. German Intumination. New York: Hacker, 1970.
 Grabar, André, and Nordenfalk, Carl. Early Medi-eval Painting from the Fourth to the Eleventh Cen-tury. New York: Skira, 1967.
 Harbison, Peter, et al. Irish Art and Architecture from Prehistory to the Present. London: Thames & Hudson, 1978.
- Hudson, 1978.
- Henderson, George. Early Medieval Art. Pelican Style and Civilization Series. New York: Pen-
- guin, 1972. Henry, Françoise. Irish Art During the Viking Inva-sions, 900–1020. Ithaca, NY: Cornell University Press, 1970.
- 800. Rev. ed. London: Methuen, 1965. Hinks, Roger P. Carolingian Art. Ann Arbor: Uni-
- Versity of Michigan Press, 1974. Klindt-Jensen, Ole, and Wilson, David M. Viking Art. 2nd ed. Minneapolis: University of Minnesota Press, 1980.
- sota Press, 1980. Laszlo, Gyula. The Art of the Migration Period. Lon-don: Allen Lane, 1974. Leeds, Edward T. Early Anglo-Saxon Art and Ar-chaeology. Westport, CT: Greenwood Press, 1970. (Later reprint available.) Lucas, A. T. Treasures of Ireland: Irish Pagan and Early Christian 44 Naw York: Vibing 1973.

- Lucas, A. I. Treasures of Ireland: Irish Pagan and Early Christian Art. New York: Viking, 1973. Megaw, Ruth, and Megaw, John V. Celtic Art: From Its Beginning to the Book of Kells. London: Thames & Hudson, 1989. Mütherich, Florentine, and Gaehde, J. E. Carolin-gian Painting. New York: Braziller, 1976. (Later edition available.) NordenFalk Carl Celtic and Analo Saxon Painting. Nordenfalk, Carl. Celtic and Anglo-Saxon Painting:

Book Illumination in the British Isles 600–800. New York: Braziller, 1977. Porter, Arthur K. The Crosses and Culture of Ireland.

Porter, Arthur K. The Crosses and Culture of Ireland. New York: Benjamin Blom, 1971.
Simons, Gerald. Barbarian Europe. New York: Time-Life Books, 1979.
Stokstad, Marilyn. Medieval Art. New York: Harper & Row, 1986.
Taylor, Harold M., and Taylor, Joan. Anglo-Saxon Architecture. 2 vols. Cambridge: Cambridge University Press, 1980. (Later volume available.)
Wilson, David M., ed. The Northern Europe A.D. 400– 1100. New York: Abrams, 1980.
Zarnecki, George. Art of the Medieval World. New

Zarnecki, George. Art of the Medieval World. New York: Abrams, 1975. (Later edition available.)

CHAPTER 9 ROMANESQUE ART

Clapham, Alfred W. English Romanesque Architec-ture After the Conquest. Oxford: Clarendon Press,

1964.

1964. . Romanesque Architecture in Western Europe. Oxford: Clarendon Press, 1959. Conant, Kenneth John. Carolingian and Roman-esque Architecture, 800–1200. 2nd integrated rev. ed. New York: Penguin, 1979. Crichton, George H. Romanesque Sculpture in Italy. London: Routledge & Paul, 1954. Decker, Heinrich. Romanesque Art in Italy. New York: Abrams, 1959. Demus, Otto. Romanesque Mural Painting. New York: Abrams, 1970. Deschamps. Paul. French Sculpture of the Roman-

Deschamps, Paul. French Sculpture of the Roman-esque Period—Eleventh and Twelfth Centuries. 1930. Reprint. New York: Hacker, 1972.

Dodwell, C. R. Painting in Europe 800-1200. Harmondsworth, England: Penguin, 1971.
Duby, Georges. History of Medieval Art, 980-1440.
New York: Skira/Rizzoli, 1986.
Evans, Joan. Art in Medieval France 987-1498. Oxford: Clarendon Press, 1969.
Forillon, Harri The Art of the Wast in the Middle

- tord: Clarendon Press, 1969. Focillon, Henri. The Art of the West in the Middle Ages. Vol. 1. 2nd ed. London: Phaidon, 1969; Ithaca, NY: Cornell University Press (paper-bound), 1980. (Later volume available.) Gantner, Joseph; Pobé, Marcel; and Roubier, Jean. Romanesque Art in France. London: Thames & Hudson, 1956.

- & Hudson, 1956. Gibbs-Smith, Charles H. The Bayeux Tapestry. London: Phaidon, 1973. Grabar, André, and Nordenfalk, Carl. Romanesque Painting. New York: Skira, 1958. Hearn, Millard F. Romanesque Sculpture in the Elev-enth and Twelfth Centuries. Ithaca, NY: Cornell University Press/Phaidon. 1981
- enth and Twelfth Centuries. Ithaca, NY: Cornell University Press/Phaidon, 1981.
 Holt, Elizabeth Gilmore, ed. A Documentary History of Art, I: The Middle Ages. Princeton: Princeton University Press, 1981.
 Kubach, Hans E. Romanesque Architecture. New York: Abrams, 1975. (Later edition available.)
 Kuenstler, Gustav, ed. Romanesque Art in Europe. New York: Norton, 1973.
 Leisinger, Hermann. Romanesque Bronzes: Church Portals in Mediaeval Europe. New York: Praeger, 1957.
- 1957.
- Male, Émile. Art and Artists of the Middle Ages. Redding Ridge, CT: Black Swan Books, 1986. Michel, Paul H. Romanesque Wall Paintings in
- France. Paris: Éditions Chêne, 1949. Morey, Charles R. Medieval Art. New York: Nor-
- ton, 1970. ton, 1970.
 Porter, Arthur K. Medieval Architecture. 2 vols. 1909. Reprint. New York: Hacker, 1969.
 ——. Romanesque Sculpture of the Pilgrimage Roads. 1923. Reprint. New York: Hacker, 1969.
 Rickert, Margaret. Painting in Britain: The Middle
 Accurated Reprint New York: Hacker, Pender Pender
- Ages. 2nd ed. Harmondsworth, England: Pen-
- Ages. 2nd ed. Hamonicswordt, Enganter ed.
 guin, 1965.
 Rivoira, Giovanni. Lombardic Architecture: Its Ori-gin, Development, and Derivatives. 1933. Reprint.
 New York: Hacker, 1975.
 Saalman, Howard. Medieval Architecture: European Generation (2000). New York: Provide Science (2000).
- Architecture 600-1200. New York: Braziller, 1962. Schapiro, Meyer. Romanesque Art: Selected Papers. London: Chatto & Windus, 1977; New York:
- Braziller, 1976.
- Brazmer, 1970.
 Stoddard, Whitney. Art and Architecture in Medie-val France. New York: Harper & Row, 1972.
 Stone, Lawrence. Sculpture in Britain in the Middle Ages. Baltimore: Penguin, 1972.
 Swarzenski, Hanns. Monuments of Romanesque Art. Chicago University of Chicago Press, 1974.
- Art. Chicago: University of Chicago Press, 1974.
- Webb, Geoffrey F. Architecture in Britain: The Mid-dle Ages. Harmondsworth, England: Penguin, 1965.

Zarnecki, George. Romanesque Art. New York: Universe Books, 1971. ———. Studies in Romanesque Sculpture. London:

Dorian Press, 1979.

CHAPTER 10 GOTHIC ART

- Adams, Henry B. Mont-Saint-Michel and Chartres. New York: Doubleday/Anchor, 1959. (Later re-
- Arnold, Hugh. Stained Glass of the Middle Ages in England and France. London: A. & C. Black, 1956. Arslan, Edoardo. Gothic Architecture in Venice. London: Phaidon, 1971. Aubert, Marcel. The Art of the High Gothic Era.
- New York: Crown, 1965.
- New York: Crown, 1965. Gothic Cathedrals of France and Their Treas-ures. London: N. Kay, 1959. Bony, Jean. The English Decorated Style. Ithaca, NY: Cornell University Press, 1979.
- . French Gothic Architecture of the XII and XIII Centuries. Berkeley: University of California Press, 1983.
- Branner, Robert. Chartres Cathedral. New York: Norton, 1969. Gothic Architecture. New York: Braziller,
- 1961.
- Duby, George. The Age of the Cathedrals. Chicago: University of Chicago Press, 1981.
 Dupont, Jacques, and Gnudi, Cesare. Gothic Painting. New York: Rizzoli, 1979.
 Evans, Joan. Art in Medieval France 987–1498. Ox-ford: Clarendon Press, 1969.

- . The Flowering of the Middle Ages. London: Thames & Hudson, 1985. Fitchen, John, The Construction of Gothic Cathedrals:
- A Study of Medieval Vault Erection. Chicago: University of Chicago Press, 1977; Phoenix Books, 1981
- Focillon, Henri. The Art of the West in the Middle Ages. Vol. 2. Ithaca, NY: Cornell University Press, 1980.
- Foster, Richard. Discovering English Churches. New York: Oxford University Press, 1982.
- Frankl, Paul. Gothic Architecture. Baltimore: Penguin, 1963.
- The Gothic Literary Sources and Interpretations. Princeton: Princeton University Press, 1960.
- Grodecki, Louis. Gothic Architecture. New York:
- ElectaRizzoli, 1985. Harvey, John H. The Gothic World. New York: Harper & Row, 1969. Huizinga, Johan. The Waning of the Middle Ages. 1924. Reprint. New York: St. Martin's Press, 1988.
- Jantzen, Hans. High Gothic: The Classic Cathedrals of Chartres, Reims, and Amiens. Princeton: Prince-
- Johnson, James. The Radiance of Chartres. New York: Random House, 1965.
- Johnson, Paul. British Cathedrals. New York: William Morrow, 1980. Katzenellenbogen, Adolf. The Sculptural Programs
- of Chartres Cathedral. Baltimore: Johns Hopkins
- Press, 1959. Male, Emile. The Gothic Image: Religious Art in the Twelfth Century. Rev. ed. Princeton: Princeton University Press, 1978.
- A Study of Medieval Iconography and Its Sources.
- 1986. (Later editions available.) Mark, Robert. Experiments in Gothic Structure. Cambridge: MIT Press, 1982.
- Renaissance. New York: McGraw-Hill, Early 1972
- Panofsky, Erwin. Abbot Suger on the Abbey Church of St. Denis and Its Art Treasures. 2nd ed. Prince-ton: Princeton University Press, 1979.
- York: Meridian Books, 1963. Pevsner, Nikolaus. *The Buildings of England*. 46 vols. Harmondsworth, England: Penguin, 1951– 1974.
- Robb, David M. The Art of the Illuminated Manu-script. Cranbury, NJ: A. S. Barnes, 1973. (Later edition available.)
- Sauerlander, Willibald, and Hirmer, Max. Gothic Sculpture in France 1140–1270. New York: Abrams, 1973. Sheridan, Ronald, and Ross, Anne. Gargoyles and
- Grotesques: Paganism in the Medieval Church. Bos-ton: New York Graphic Society, 1975.
 Stoddard, Whitney. Monastery and Cathedral in Medieval France. Middletown, CT: Wesleyan University Press, 1966. (Later editions available.)
- Swaan, Wim. The Late Middle Ages: Art and Archi-
- Swaan, Wim. The Late Midale Ages: Art and Architecture from 1350 to the Advent of the Renaissance. Ithaca, NY: Cornell University Press, 1977.
 Thompson, Daniel. The Materials and Techniques of Medieval Painting. New York: Dover, 1956.
 Von Simson, Otto Georg. The Gothic Cathedral: Origins of Gothic Architecture and the Medieval Con-cept of Order. 3rd enl. ed. Princeton: Princeton University Press, 1988.
 Zornocki. George. Art of the Medieval World. New
- Zarnecki, George. Art of the Medieval World. New York: Abrams, 1975

CHAPTER 11 THE ART OF INDIA

- Acharva, Prasanna Kumar. An Encyclopedia of Hindu Architecture. 2nd ed. New Delhi: Oriental

Asher, Frederick M. The Art of Eastern India, 300– 800. Minneapolis: University of Minnesota Press, 1980.

- Bachhofer, Ludwig. Early Indian Sculpture. 1929. Reprint. New York: Hacker, 1972. (Later edition available.)
- Balasubrahmanyam, S. R. Early Chola Art-Part I.
- New York: Asia Publishing House, 1966. _______. Early Chola Temples: Parantakat to Rajaraja I, A.D. 907–985. Bombay: Orient Longman, 1971.
- I. A.D. 907–935. Bombay: Onleaf Congress. Bombay: Barrett, Douglas E. Early Chola Bronzes. Bombay: Bhulabhai Memorial Institute, 1965.
 Barrett, Douglas E., and Gray, Basil. Painting of India. Geneva: Skira, 1963.
 Basham, Arthur L. The Wonder That Was India. 3rd
- rev. ed. Paris: Arthaud, 1976. Bhattacharji, Sukumari. The Indian Theogony, a Comparative Study of Indian Mythology. London: Cambridge University Press, 1970. (Later edition available.)
- Coomaraswamy, Ananda K. History of Indian and Indonesian Art. New Delhi: Munshiram Manaharlal, 1972. (Later edition available.)
- Yaksas. New Delhi: Munshiram Manaharlal, 1971.
- Craven, Roy C. Indian Art: A Concise History. Lon-

- Craven, Roy C. Indian Art: A Concise History. London: Thames & Hudson, 1985.
 Dehejia, Vidya. Early Buddhist Rock Temples. Ithaca, NY: Cornell University Press, 1972.
 Ghosh, Amalananda. Ajanta Murals. New Delhi: Archaeological Survey of India, 1967.
 Ghosh, Sankar Prosad. Hindu Religious Art and Architecture. Delhi: D. K. Publications, 1982.
 Gopinatha Rao, T. A. Elements of Hindu lorongraphy. 2nd ed. 4 vols. New York: Paragon, 1968.
 Gray, Basil, ed. The Arts of India. Ithaca, NY: Cornell University Press/Phaidon, 1981.
 Groslier, Bernard P., and Arthaud, Jacques. The Arts and Civilization of Angkor. New York: Prae-
- Arts and Civilization of Angkor. New York: Praeger, 1957
- Grover, Satish. The Architecture of India: Buddhist and Hindu. Sahibabad, Distt. Ghaziabad: Vikas, 1980.
- Harle, James C. The Art and Architecture of the In-dian Subcontinent. New York: Penguin, 1986. (Later edition available.)
- Fourth to the Sixth Centuries. Oxford: Clarendon Press, 1974.
- Head, Raymond. The Indian Style. Boston: Allen

- Head, Raymond. The Indian Style. Boston: Allen and Unwin, 1986.
 Huntington, Susan L, and Huntington, John C. The Art of Ancient India: Buddhist, Hindu, Jain. New York: Weatherhill, 1985.
 Khosa, Sunil. Art History of Kashmir and Ladakh, Medieval Period. New Delhi: Sagar, 1984.
 Kramrisch, Stella. The Art of India through the Ages. 3rd ed. London: Phaidon, 1965. (Later editions available.) available.)
- The Hindu Temple. 2 vols. Delhi: Motilal
- The Hindu Temple. 2 vols. Delhi: Motilal Banarsidass, 1976. (Later reprint available.)
 Indian Sculpture. The Heritage of India Series. London: Oxford University Press, 1933.
 Krishna, Deva. Temples of North India. New Delhi: National Book Trust, 1969.
 Krishna Murthy, C. Saiva Art and Architecture in South India. New Delhi: Sundeep Prakashan, 1985
- 1985
- Lee, Sherman E. Ancient Cambodian Sculpture.
- New York: Intercultural Arts Press, 1970. Manwani, S. N. Evolution of Art and Architecture in Central India: With Special Reference to the Kalachuris of Ratampur. Delhi: Agam Kala Kalachuris of
- Prakashan, 1988. Meister, Michael W. Encyclopedia of Indian Temple Architecture. Philadelphia: University of Pennsvlvania Press, 1983.
- sylvania Press, 1983. Munsterberg, Hugo. Art of India and Southeast Asia. New York: Abrams, 1970. Rawson, Philip. The Art of Southeast Asia. New York: Praeger, 1967. Rosenfield, John. Dynastic Arts of the Kushan. Berkeley: University of California Press, 1967. Rowland, Benjamin. The Art and Architecture of India: Buddhist, Hindu, Jain. Harmondsworth, England: Penguin, 1977. Sivaramamurti. C. South Indian Bronzes. New

Sivaramamurti, C. South Indian Bronzes. New Delhi: Lalit Kala Akademi, 1963.

South Indian Paintings. New Delhi: National Museum, 1968. Srinivasan, K. R. Temples of South India. New Delhi: National Book Trust, 1972. Stutley, Margaret. An Illustrated Dictionary of

- Hindu Iconography. Boston: Routledge and Kee-gan Paul, 1985. Welch, Stuart Cary. India: Art and Culture, 1300– 1900. New York: Metropolitan Museum of Art/ Holt, Rinehart & Winston, 1985. Williams, Joanna Gottfried. The Art of Gupta India:
- Empire and Province. Princeton: Princeton University Press, 1982.

Zimmer, Heinrich, and Campbell, Joseph, eds. The Art of Indian Asia; Its Mythology and Transfor-mations. Bollingen Series 39. 2 vols. Princeton: Princeton University Press, 1983.

CHAPTER 12 THE ART OF CHINA

- Bush, Susan, and Murck, Christian, eds. Theories of the Arts in China. Princeton: Princeton University Press, 1983.
- Cahill, James. Chinese Painting. New ed. Geneva: Skira, 1977; New York: Rizzoli, 1977. Davidson, J. Leroy. The Lotus Sultra in Chinese Art: A Study in Buddhist Art to the Year 1880. New Haven: Yale University Press, 1954.
- Gray, Basil, and Vincent, John B. Buddhist Cave Paintings at Tun-Huang. Chicago: University of
- Chicago Press, 1959. Honey, William B. The Ceramic Art of China and Other Countries of the Far East. New York: Beechhurst Press, 1954.
- Hutt, Julia. Understanding Far Eastern Art: A Com-plete Guide to the Arts of China, Japan, and Korea. New York: Dutton, 1987. Lee, Sherman E. Chinese Landscape Painting. 2nd ed. Cleveland: Cleveland Museum of Art, 1962. (Later edition available.)
- Past, Present, East and West. New York: Braziller, 1983.
- Loehr, Max. The Great Painters of China. New York: Harper & Row, 1980. Ritual Vessels of Bronze Age China. New
- York: Asia Society, 1968. Mizuno, Seiichi. Bronzes and Jades of Ancient China. Tokyo: Nihon Keizai, 1959.
- Mizuno, Seiichi, and Nagahiro, Toshio. A Study of Mizuno, Senchi, and iyaganiro, rosino. A shuay of the Buddhist Cave Temples at Lung-Men, Honan. Tokyo: Zanho Press, 1941. Munsterberg, Hugo. Dictionary of Chinese and Japa-nese Art. New York: Hacker, 1981. Symbolism in Ancient Chinese Art. New York: Hacker, 1986.
- York: Hacker, 1986.
- Rudolph, Richard. Han Tomb Art of West China.
- Berkeley: University of California Press, 1951.
 Berkeley: University of California Press, 1951.
 Sickman, Lawrence C., and Soper, Alexander. The Art and Architecture of China. Baltimore: Pen-guin, 1956. (Later edition available.)
 Siren, Oswald. Chinese Painting: Leading Masters and Principles. New York: Hacker, 1973.
- . Chinese Sculpture from the Fifth to the Four-teenth Centuries. 4 vols. 1925. Reprint. New York: Hacker, 1970.

- Sullivan, Michael, and Darbois, Dominique. The Cave Temples of Maichishan. London: Faber & Faber, 1969.
 Thorp, Robert L. Son of Heaven: Imperial Arts of China. Seattle: Son of Heaven Press, 1988.
 Van Oort, H. A. The Iconography of Chinese Buddhism in Traditional China. Leiden: Brill, 1986.
 Watson, William. The Art of Dynastic China. New York: Abrams, 1981. (Later edition available.)
 Weber, Charles D. Chinese Pictorial Bronze Vessels of the Late Chou Period. Ascona, Switz: Artibus Asiae, 1968.

- Ásiae, 1968
- Willetts, William. Foundations of Chinese Art. New York: McGraw-Hill, 1965.

CHAPTER 13 THE ART OF JAPAN

- Akiyama, Terukazu. Japanese Painting. Geneva:
- Skira; New York: Rizzoli, 1977. Cahill, James F. Scholar Painters of Japan: The Nanga School. New York: Arno Press, 1976. (Later edition available.)
- Drexler, Arthur. The Architecture of Japan. New York: Arno Press, 1966. Eliseef, Danielle, and Eliseef, Vadime. The Art of
- Japan. New York: Abrams, 1985.

- Fontein, Jan, and Hickman, M. C., eds. Zen Paint-ing and Calligraphy. Greenwich, CT: New York Graphic Society, 1970. Kanda, Christine Guth. Shinzo: Hachiman Imagery
- and Its Development. Cambridge: Harvard Uni-
- versity Press, 1985. Kidder, J. Edward. Early Japanese Art. London: Thames & Hudson, 1969.
- *Arabites and Solution and Solution and Solution and Architecture. Tokyo: Bijutsu Shuppansha, 1964.* Lee, Sherman E. A History of Far Eastern Art. London: Thames & Hudson, 1975. (Later edition
- available.)
- . Japanese Decorative Style. New York: Harper & Row, 1972.
- Harper & Row, 1972.
 Paine, Robert Treat, and Soper, Alexander. The Art and Architecture of Japan. 3rd rev. ed. Har-mondsworth, England: Penguin, 1981.
 Rosenfield, John M. Japanese Art of the Heian Pe-riod, 749–1185. New York: Asia Society, 1967.
 Rosenfield, John M., and Shimada, Shujiro. Tra-ditions of Japanese Art. Cambridge: Fogg Art Mu-coum Harvard University 1970.
- seum, Alexander. The Evolution of Buddhist Archi-tecture in Japan. 1942. Reprint. New York:
- Hacker, 1978.

- Stanley-Smith, Joan. Japanese Art. New York: Thames & Hudson, 1984. Stern, Harold P. Master Prints of Japan: Ukiyo-e Hanga. New York: Abrams, 1969. Sugiyama, Jiro. Classic Buddhist Sculpture: The Tempyo Period. New York: Kodansha/Harper & Bari, Idaga Stanlard, Stanl Row, 1982.

CHAPTER 14 THE NATIVE ARTS OF THE AMERICAS, AFRICA, AND THE SOUTH PACIFIC

Pre-Columbian Art of the Americas

- Anderson, Richard L. Art in Small-Scale Societies. 2nd ed. Englewood Cliffs, NJ: Prentice-Hall, 1989.
- Anton, Ferdinand, et al. Primitive Art: Pre-Columbian, North American Indian, African, Oceanic. New York: Abrams, 1979. Bennett, Wendell C. Ancient Arts of the Andes.
- New York: Museum of Modern Art/Arno Press, 1966.
- Bernal, Ignacio. The Olmec World. Berkeley: Uni-
- Bernal, Ignacio. *The Ulmc Worla*. Berkeley: University of California Press, 1977.
 Coe, Michael D. *The Maya*. London: Thames & Hudson, 1980. (Later edition available.)
 Mexico. 3rd ed. New York: Thames & Hudson, 1984. (Later edition available.)
 Coe, Michael D., and Diehl, R. A. *In the Land of the Olympic Puells*. Available. The Puells Available.
- Olmec. 2 vols. Austin: University of Texas Press, 1980
- Coe, William R. Tikal: A Handbook of the Ancient Maya Ruins. 3rd ed. Philadelphia: University Museum, University of Pennsylvania, 1970. (Later edition available.)
- Emmerich, André. Sweat of the Sun and Tears of the Moon: Gold and Silver in Pre-Columbian Art. New York: Hacker, 1977. Franch, José Alcina. Pre-Columbian Art. New
- York: Abrams, 1983.

- Fork: ADrams, 1983.
 Grider, Terence. Origins of Pre-Columbian Art. Austin: University of Texas Press, 1982.
 Heyden, Doris, and Gendrop, Paul. Pre-Columbian Architecture of Mesoamerica. New York: Abrams, 1975.
 Kubler, George. The Art and Architecture of Ancient America: The Mexican, Maya, and Andean Peoples. 2nd ed. Harmondsworth, England: Penguin, 1975. (Later edition available) 1975. (Later edition available.)
- Lapiner, Alan C. Pre-Columbia. Art of South Amer-ica. New York: Abrams, 1976. Lehmann, Walter, with Doering, Heinrich. The Art of Old Peru. New York: Hacker, 1975. Los Angeles County Museum of Art. Sculpture of Avoint Wast Marine Marine Los Argenter Letter

- Los Angeles County Museum of Art. Sculpture of Ancient West Mexico: Nayarit. Los Angeles: Los Angeles County Museum of Art, 1970.
 Mason, John Alden. The Ancient Civilizations of Peru. Rev. ed. Harmondsworth, England: Pen-guin, 1975. (Later edition available.)
 Miller, Mary Ellen. The Art of Mesoamerica: From Olmec to Aztec. New York: Thames & Hudson, 1986
- 1986
- Morley, Sylvanus G. *The Ancient Maya*. 3rd rev. ed. Stanford: Stanford University Press, 1973. (Later edition available.)

- Paddock, John, ed. Ancient Oaxaca: Discoveries in Mexican Archeology and History. Stanford: Stan-ford University Press, 1970. Pasztory, Esther. Aztec Art. New York: Abrams,
- 1983.
- Peterson, Frederick. Ancient Mexico. New York: Capricorn Books, 1962.
- Pettersen, Carmen L. The Maya of Guatemala: Their Life and Dress. Guatemala City: University of Washington Press, 1976. (Later edition available.)
- Proskouriakoff, Tatiana Avenirovna. A Study of Classic Maya Sculpture. Washington, DC: Carnegie Institute of Washington, 1950.
- Robertson, Donald. Pre-Columbian Architecture. New York: Braziller, 1963. Robertson, Merle G.; Rands, Robert L.; and Gra-ham, John A. Maya Sculpture from the Southern Lowlands. Berkeley: Lederer, Street & Zeus, 1977 1972.
- Rowe, John H. Chavín Art: An Inquiry into Its Form and Meaning. New York: Museum of Primitive Art, 1962.
- Art, 1902. Sabloff, Jeremy A. The Cities of Ancient Mexico. New York: Thames & Hudson, 1989. Schele, Linda, and Miller, Mary Ellen. The Blood of Kings: Dynasty and Ritual in Maya Art. New York: Braziller, 1986
- Steward, Julian H. Handbook of the South American Indians. 7 vols. New York: Cooper Square Publishers, 1963.
- Stierlin, Henri. Art of the Aztecs and Its Origins. New York: Rizzoli, 1982.
- Art of the Incas and Its Origins. New York: Rizzoli, 1984.
- Thompson, J. E. S. Maya History and Religion. Nor-man: University of Oklahoma Press, 1972. (Later edition available.)
- Wauchope, Robert, ed. Handbook of Middle Ameri-can Indians. 16 vols. Austin: University of Texas Press, 1964–1976.
- Weaver, Muriel Porter. The Aztecs, Maya, and their Predecessors: The Archaeology of Mesoamerica. 2nd ed. New York: Academic Press, 1981.

North America

1966.

1972.

(Later edition available.)

- Boas, Franz. Primitive Art. 1927. Reprint. Magno-
- Boas, Franz. Primitive Art. 1927. Reprint. Magno-lia, MA: Peter Smith, 1962.
 Broder, Patricia Janis. American Indian Painting and Sculpture. New York: Abbeville Press, 1981.
 Collins, Henry, et al. The Far North: Two Thousand Years of American Eskimo and Indian Art. Bloom-ington: Indiana University Press in association with the National Gallery of Art, Washington, DC 1977. DC. 1977.
- Corbin, George A. Native Arts of North America, Africa, and the South Pacific: An Introduction. New
- York: Harper & Row, 1988. Curtis, Edward S. *The North American Indian*. 30 vols. Cambridge: Cambridge University Press, 1907–1930. (Later reprint available.)
- Dockstader, Frederick. Indian Art in America: The Arts and Crafts of the North American Indian. Greenwich, CT: New York Graphic Society, 1961.
- Indian Art of the Americas. New York: Museum of the American Indian, Heye Founda-tion, 1973.
- Ewers, John C. Plains Indian Painting. Stanford: Stanford University Press, 1939. (Later reprint available.)
- Feder, Norman. Two Hundred Years of North American Art. New York: Praeger, 1972. Feest, Christian F. Native Arts of North America. New York: Oxford University Press, 1980. (Later

New York: Oxford University Press, 1980. (Later edition available.) Grant, Campbell. Rock Art of the American Indian. 1967. Reprint. New York: Promontory Press, 1974. (Later edition available.) Gunther, Erna. Art in the Life of the Northwest Coast Indiane. Benderd OD: D. the Aborthwest Coast

Indians. Portland, OR: Portland Art Museum,

Kopper, Philip. The Smithsonian Book of North

Institution Books, 1986. Murdock, George P., and O'Leary, Timothy. Eth-nographic Bibliography of North America. 4th ed. New Haven: Human Relations Area Files Press,

Ray, Dorothy J. Artists of the Tundra and the Sea. Seattle: University of Washington Press, 1961.

American Indians. Washington, DC: Smithsonian

Ritchie, Carson I. A. The Eskimo and His Art. New

York: St. Martin's Press, 1976. Snow, Dean. The Archaeology of North Americal American Indians. New York: Thames & Hudson,

1980. (Later edition available.) Whiteford, Andrew H. North American Indian Arts. New York: Golden Press, 1973.

Africa

Allison, Philip. African Stone Sculpture. New York:

- Praeger, 1968. Bascom, William R. African Art in Cultural Perspec tive: An Introduction. New York: Norton, 1973. Ben-Amos, Paula. The Art of Benin. New York: Thames & Hudson, 1980. Brentjes, Burchard. African Rock Art. London:
- Dent, 1967.
- Cornet, Joseph. Art of Africa: Treasures from the Corgo. London: Phaidon, 1971. D'Azevedo, Warren L., ed. The Traditional Artist in Africa Control Phaneter and Control Phaneter African Societies. Bloomington: Indiana Univer-sity Press, 1973. (Later edition available.)
- Delange, Jacqueline. Art and Peoples of Black Africa. New York: Dutton, 1974. Elisofon, Eliot, and Fagg, William. The Sculpture of Africa. New York: Hacker, 1978.
- Eyo, Ekpo, and Willett, Frank. Treasures of Ancient
- K. Fredskiers of Antenni Nigeria. New York: Knopf, 1980.
 Fagg, William B. Nigerian Images: The Splendor of African Sculpture. New York: Praeger, 1963.
 Forman, Werner. Benin Art. London: Hamlyn, 1960.

1960

- Fraser, Douglas F., and Cole, H. M., eds. African Art and Leadership. Madison: University of Wis-consin Press, 1972. Gaskin, L. J. P. A Bibliography of African Art. Lon-and Computer Sciences (Computer Sciences) (Computer
- don: International African Institute, 1965. Gillon, Werner. A Short History of African Art. New York: Facts on File, 1984. (Later edition
- available.)
- Available.) Laude, Jean. The Arts of Black Africa. Berkeley: University of California Press, 1973. Lieris, Michel, and Delange, Jacqueline. African Art. New York: Golden Press, 1968.
- Thompson, Robert F. Black Gods and Kings: Yoruba Art at U.C.L.A. Bloomington: Indiana University
- Press, 1976. Press, 1976. . Flash of the Spirit: African and Afro-Ameri-can Art and Philosophy. New York: Random House, 1983. Trowell, Kathleen M. Classical African Sculpture. London: Faber & Faber, 1970. Walker Art Center. Art of the Congo. Minneapolis: Walker Art Center, 1967. Wassing, René S. African Art: Its Background and Traditions. New York: Abrams, 1968. (Later edi-tion available.)

- tion available.)

Oceania

Barrow, Terence. An Illustrated Guide to Maori Art. Honolul: University of Hawaii Press, 1984. Barrow, Tui T. Art and Life in Polynesia. Rutland, VT: Charles E. Tuttle, 1973. ——— Maori Wood Sculpture of New Zealand. Rut-land, VT: Charles E. Tuttle, 1970.

- Batterberry, Michael, and Ruskin, Ariane. Primi-tive Art. New York: McGraw-Hill, 1973. Bernot, Ronald M. Australian Aboriginal Art. New York: Macmillan, 1964.
- Buck, Peter H. Arts and Crafts of Hawaii. Honolulu: Bishop Museum Press, 1964. Dodd, Edward H. Polynesian Art. New York:
- Dodd, Mead, 1967. Firth, Raymond. Art and Life in New Guinea. 1936. Reprint. New York: AMS Press, 1977.
- Fraser, Douglas. Primitive Art. London: Thames & Hudson, 1962.
- Guiart, Jean. Arts of the South Pacific. New York: Golden Press, 1963. Kooijman, S. The Art of Lake Sentani. New York:
- Museum of Primitive Art, 1959. Linton, Ralph, and Wingert, Paul. Arts of the South Seas. 1946. Reprint. New York: Arno Press, 1972.
- Newton, Douglas. Art Styles of the Papuan Gulf. New York: Museum of Primitive Art, 1961. Rockefeller, Michael C. The Asmat of New Guinea: The Journal of Michael Clark Rockefeller. Greenwich, CT: New York Graphic Society, 1967.

- Schmitz, Carl A. Oceanic Art; Myth, Man and Image in the South Seas. New York: Abrams, 1971. Stubbs, Dacre. Prehistoric Art of Australia. New
- York: Scribner, 1975.
 Taylor, Clyde R. H. A Pacific Bibliography: Printed Matter Relating to the Native People of Polynesia, Melanesia, and Micronesia. 2nd ed. Oxford: Clar-
- endon Press, 1965. Wingert, Paul. Primitive Art: Its Traditions and Styles. Cleveland: World Publishing, 1970.

CHAPTER 15 THE "PROTO-**RENAISSANCE" IN ITALY**

- Andrés, Glenn, et al. *The Art of Florence*. 2 vols. New York: Abbeville Press, 1988. Antal, Frederick. *Florentine Painting and Its Social*
- Background. London: Keegan Paul, 1948.
- Cole, Bruce. Sienese Painting: From Its Origins to the Fifteenth Century. Bloomington: Indiana Univer-
- Fifteenth Century. Bioomington: Indiana University Press, 1985. (Later edition available.) Fremantle, Richard. Florentine Gothic Painters from Giotto to Masaccio: A Guide to Painting in and near Florence. London: Secker & Warburg, 1975.
- Hills, Paul. The Light of Early Italian Painting. New
- Haven: Yale University Press, 1987. Meiss, Millard. Painting in Florence and Siena after the Black Death. New York: Harper & Row, 1973. (Later edition available.)
- Panofsky, Erwin. Renaissance and Renascences in Western Art. New York: Harper & Row, 1969. (Later edition available.)
- Phaidon, 1986. Schevill, Ferdinand. *The Medici*. New York: Harper & Row, 1960. Smart, Alastair. *The Dawn of Italian Painting*. Ith-

- Van Marle, Raimond. The Development of the Italian Schools of Painting. 19 vols. 1923–1938. Reprint. New York: Hacker, 1970.
 Venturi, Lionello, and Skira-Venturi, Rosabianca. Italian Painting: The Creators of the Renaissance. 3 vols. Geneva: Skira, 1950–1952.
 White, John. Art and Architecture in Italy 1250– 1400. 2nd integrated ed. New York: Viking Pen-cuin, 1987. (I atter edition available)
- guin, 1987. (Later edition available.)

CHAPTER 16 FIFTEENTH-CENTURY **ITALIAN ART**

- Baxandall, Michael. Painting and Experience in Fif-Baxandali, Michael. Painting and Experience in Fif-teenth Century Italy. A Primer in the Social History of Pictorial Style. 2nd ed. New York: Oxford Uni-versity Press, 1988.
 Berenson, Bernard. The Italian Painters of the Ren-aissance. Ithaca, NY: Phaidon/Cornell University Proce. 1980
- Press, 1980.
- NY: Phaidon/Cornell University Press, 1980.

NY1: Phaldon/Cornent Oniversity Press, 1980.
Bober, Phyllis Pray, and Rubinstein, Ruth. Renaissance Artists and Antique Sculpture: A Handbook of Sources. Oxford: Oxford University Press, 1986.
Borsook, Eve. The Mural Painters of Tuscany. New York: Oxford University Press, 1981.
Burschbardt Lacob. The Architecture of the Italian

Burckhardt, Jacob. The Architecture of the Italian Renaissance. Rev. ed. London: Secker & War-burg, 1985. (Later edition available.)

the Civilization of the Renaissance in Italy. 4th ed. 1867. Reprint. London: Phaidon, 1960. Chastel, André. *The Age of Humanism*. New York: McGraw-Hill, 1964.

A Chronicle of Italian Renaissance Painting.
 Achronicle of Italian Renaissance Painting.
 Ithaca, NY: Cornell University Press, 1984.
 Studios and Styles of the Italian Renaissance.

- New York: Braziller, 1971. Cole, Bruce. Masaccio and the Art of Early Renais-sance Florence. Bloomington: Indiana University
- Press, 1980.

Decker, Heinrich. The Renaissance in Italy: Architec-ture, Sculpture, Frescoes. New York: Viking, 1969. De Wald, Ernest T. Italian Painting, 1200–1600. New York: Holt, Rinehart & Winston, 1961.

- Rew Tork. Holt, Kinelart & Winsch, John M. Earls, Irene. Renaissance Art: A Topical Dictionary. New York: Greenwood Press, 1987. Edgerton, Samuel Y., Jr. The Renaissance Rediscov-ery of Linear Perspective. New York: Harper & Row, 1976.

Ferguson, Wallace K., et al. *The Renaissance*. New York: Henry Holt, 1940.

- Gadol, Joan. Leon Battista Alberti: Universal Man of the Early Renaissance. Chicago: University of Chicago Press, 1969.
- ments. Englewood Cliffs, NJ: Prentice-Hall, 1970.
- Godfrey, F. M. Early Venetian Painters, 1415–1495. London: Tiranti, 1954. Gombrich, E. H. Norm and Form: Studies in the Art of the Renaissance. 4th ed. Oxford: Phaidon, 1985. Hale, John R. Italian Renaissance Painting from Masaccio to Titian. New York: Dutton, 1977.
- Hartt, Frederick. History of Italian Renaissance Art: Painting, Sculpture, Architecture. 3rd ed. Engle-wood Cliffs, NJ: Prentice-Hall, 1987.
- Helton, Tinsley, ed. The Renaissance: A Reconsider-
- ation of the Theories and Interpretations of the Age. Madison: University of Wisconsin Press, 1964. Heydenreich, Ludwig H., and Lotz, Wolfgang. Architecture in Italy 1400–1600. Harmondsworth,
- England: Penguin, 1974. Holt, Elizabeth B. A Documentary History of Art. 2nd ed. Vol. 1. Garden City, NY: Doubleday, 1957

- 1957.
 Huyghe, René. Larousse Encyclopedia of Renaissance and Baroque Art. See Reference Books.
 Janson, Horst W. The Sculpture of Donatello. 2 vols. Princeton: Princeton University Press, 1957.
 (Later edition available.)
 Krautheimer, Richard, and Krautheimer-Hess, Trude. Lorenzo Ghiberti. Princeton: Princeton University Press, 1956. (Later edition available.)
 Lieberman, Ralph. Renaissance Architecture in Ven-ice. New York: Abbeville Press, 1982.
 Lowry. Rates, Renaissance Architecture. New York:
- Lowry, Bates. Renaissance Architecture. New York:
- Lowry, Bates. Renaissance Architecture. New York: Braziller, 1962.
 McAndrew, John. Venetian Architecture of the Early Renaissance. Cambridge: MIT Press, 1980.
 Meiss, Millard. The Painter's Choice, Problems in the Interpretation of Renaissance Art. New York: Harper & Row, 1976. (Later edition available.)
 Murray, Peter. The Architecture of the Italian Renais-sance. Rev. ed. New York: Schocken, 1986.
 Renaissance Architecture. New York: Electa/Rizzoli (paperbound), 1985.
 Murray, Peter, and Murray, Linda. The Art of the Renaissance. London: Thames & Hudson, 1981. (Later edition available.)
- (Later edition available.)
- Panofsky, Erwin. Renaissance and Renascences in Western Art. New York: Harper & Row, 1969. (Later edition available.)
- Pater, Walter. The Renaissance: Studies in Art and Poetry. Edited by D. L. Hill. Berkeley: University of California Press, 1980.
- Pope-Hennessy, John. An Introduction to Italian Sculpture. 3rd ed. 3 vols. New York: Phaidon, 1986.
- Sienese Quattrocento Painting. New York:
- Oxford University Press, 1947. Schevill, Ferdinand. *The Medici*. New York: Harper & Row, 1960.
- Seymour, Charles. Sculpture in Italy, 1400-1500.
- Baltimore: Penguin, 1966. Symonds, John Addington. *The Renaissance in Italy*. 7 vols. 1875–1886. Reprint. New York: Modern Library, 1935. (Other reprints available.)
- Van Marle, Raimond. The Development of the Italian Schools of Painting. 19 vols. 1923–1938. Reprint. New York: Hacker, 1970. Vasari, Giorgio. The Lives of the Most Eminent Painters, Sculptors, and Architects, 1550–1568. 3 vols. New York: Abrams, 1979.

Werkmeister, William H., ed.; Ferguson, Wallace, et al. Facets of the Renaissance. New York: Harper

White, John. The Birth and Rebirth of Pictorial Space. 3rd ed. Boston: Faber & Faber, 1987. Wilde, Johannes. Venetian Art from Bellini to Titian.

Wittkower, Rudolf. Architectural Principles in the Age of Humanism. 4th ed. London: Academy, 1988.

CHAPTER 17 SIXTEENTH-CENTURY

ITALIAN ART

Ackerman, James S. The Architecture of Michelangelo. Rev. ed. Chicago: University of Chicago Press, 1986. Palladio, New York: Penguin, 1978.

Oxford: Clarendon Press, 1981.

& Row, 1963.

- Bialostocki, Jan. The Art of the Renaissance in East-ern Europe. Ithaca, NY: Cornell University Press, 1976.
- Blunt, Anthony. Artistic Theory in Italy, 1450– 1600. London: Oxford University Press, 1975. Briganti, Giuliano. Italian Mannerism. London: Thames & Hudson, 1962.
- Castiglione, Baldassare. Book of the Courtier. 1528. Reprint. New York: National Alumni, 1907. (Other reprints available.)
- Cellini, Benvenuto. Autobiography. Reprint. New York: Grolier, 1969. (Other reprints available.) Freedberg, Sydney J. Painting in Italy, 1500–1600. 2nd ed. New York: Penguin, 1983.

- and Florence. Rev. ed. New York: Hacker, 1985. Friedlaender, Walter, Mannerism and Anti-Mannerism in Italian Painting. New York: Schocken, 1965.
- Holt, Elizabeth Gilmore, ed. A Documentary His-tory of Art. Vol. 2, Michelangelo and the Man-nerists. Rev. ed. Princeton: Princeton University Press, 1982.
- Levey, Michael. High Renaissance. Harmondsworth, England: Penguin, 1975. (Later edition available.)
- Murray, Linda. The High Renaissance and Manner-ism. New York: Oxford University Press, 1977. Partner, Peter. Renaissance Rome, 1500–1559: A Bertueri & C. C. B.
- Portrait of a Society. Berkeley: University of Cali-fornia Press, 1977.
- Pietrangeli, Carlo, et al. The Sistine Chapel: The Art, the History, and the Restoration. New York: Har-mony Books, 1986.
- Pope-Hennessy, John. Cellini. London: MacMillan, 1985
- . Italian High Renaissance and Baroque Sculp-ture. 3rd ed. 3 vols. Oxford: Phaidon, 1986. Shearman, John K. G. Mannerism. Baltimore: Pen-
- guin, 1978. Venturi, Lionello. The Sixteenth Century: From Leo-
- nardo to El Greco. New York: Skira, 1956.
- Von Einem, Herbert. Michelangelo. London: Me-thuen, 1976.
- Wölfflin, Heinrich. The Art of the Italian Renais-sance. New York: Schocken, 1963.

. Classic Art: An Introduction to the Italian Renaissance. 4th ed. Oxford: Phaidon, 1980. Würtenberger, Franzsepp. Mannerism: The Euro-pean Style of the Sixteenth Century. New York: Holt, Rinehart & Winston, 1963.

CHAPTER 18 THE RENAISSANCE OUTSIDE OF ITALY

- Benesch, Otto. Art of the Renaissance in Northern Europe. Rev. ed. London: Phaidon, 1965. German Painting from Dürer to Holbein. Ge-
- neva: Skira, 1966.
- Blunt, Anthony. Art and Architecture in France 1500–1700. 4th ed. Baltimore: Penguin, 1982. Chatelet, Albert, Early Dutch Painting. New York:
- Rizzoli, 1981. (Later edition available.) Cuttler, Charles P. Northern Painting from Pucelle to Bruegel. New York: Holt, Rinehart & Winston, 1968
- Evans, Joan. Monastic Architecture in France from the Renaissance to the Revolution. New York: Hacker, 1980.
- Hacker, 1980.
 Friedlander, Max J. Early Netherlandish Painting. 14 vols. New York: Praeger/Phaidon, 1967–1976.
 —. From Van Eyck to Bruegel. 3rd ed. Ithaca, NY: Cornell University Press, 1981.
 Fuchs, Rudolph H. Dutch Painting. London: Thames & Hudson, 1978.
 Hind, Arthur M. History of Engraving and Etching from the Fifteenth Century to the Year 1914. 3rd rev. ed. New York: Dover, 1963.
 —. An Introduction to a History of Woodcut. New York: Dover, 1963.

- New York: Dover, 1963.
- Hitchcock, Henry-Russell. German Renaissance Architecture. Princeton: Princeton University Press. 1981
- Huizinga, Johan. The Waning of the Middle Ages. 1924. Reprint. New York: St. Martin's Press, 1988

- 1988.
 Kaufmann, Thomas DaCosta. The School of Prague. Chicago: University of Chicago Press, 1988.
 Meiss, Millard. French Painting in the Time of Jean de Berry. New York: Braziller, 1974.
 Panofsky, Erwin. Early Netherlandish Painting. Cambridge: Harvard University Press, 1953.
 The Life and Art of Albrecht Direr. 4th ed.
 Princeton: Princeton University Press, 1974.

Princeton: Princeton University Press, 1971.

- Prevenier, Walter, and Blockmans, Wim. The Burgundian Netherlands. Cambridge: Cambridge University Press, 1986. Snyder, James. Northern Renaissance Art. New York: Abrams, 1985.

- Naterhouse, Ellis. The Dictionary of 16th and 17th Century British Painters. Woodbridge, England.
 Antique Collectors' Club, 1988.
 Wolfthal, Diane. The Beginnings of Netherlandish Canvas Painting, 1400–1530. New York: Cam-bridge University Press, 1989.

CHAPTER 19 BAROQUE ART

- Alpers, Svetlana. The Art of Describing: Dutch Art in the Seventeenth Century. Chicago: University of Chicago Press, 1983. (Later edition available.) Jazin, Germain. Baroque and Rococo Art. New Bazin, Germain. Bare York: Praeger, 1974.
- Blunt, Anthony, ed. Baroque and Rococo: Architecture and Decoration. Cambridge: Harper & Row, 1982.
- Brown, Jonathon. Velázquez: Painter and Courtier.
- New Haven: Yale University Press, 1986. Fokker, Timon H. Roman Baroque Art: The History of a Style. London: Oxford University Press, 1938
- Freedberg, Sydney J. Circa 1600: A Revolution of Style in Italian Painting. Cambridge: Harvard University Press, 1983. (Later edition available.) Gerson, Horst, and ter Kulle, E. H. Art and Archi-tecture in Belgium 1600–1800. Baltimore: Pen-guin, 1960. (Later edition available.) Haak, Bob. The Golden Age: Dutch Painters of the
- Seventeenth Century. London: Thames & Hudson, 1984.
- Held, Julius, and Posner, Donald. 17th and 18th
- Herne, Julius, and Posner, Donald. 17th and 18th Century Art. New York: Abrams, 1974. Hernpel, Eberhard. Baroque Art and Architecture in Central Europe. Baltimore: Penguin, 1965. (Later edition available.) Hibbard. Herner, P. K. K. K.
- Hibbard, Howard. Bernini. Harmondsworth,
- England: Penguin, 1976. . *Caravaggio*. New York: Thames & Hudson, 1983.
- . Carlo Maderno and Roman Architecture, 1580–1630. London: Zwemmer, 1971.
- Hinks, Roger P. Michelangelo Merisi da Caravaggio.
- London: Faber & Faber, 1953. Howard, Deborah. The Architectural History of Venice. London: B. T. Batsford, 1981.
- Huyghe, René, ed. Larousse Encyclopedia of Renais-sance and Baroque Art. See Reference Books. Kahr, Madlyn Millner. Dutch Painting in the Seven-teenth Century. New York: Harper & Row, 1978.
- Harper & Row, 1976. Kitson, Michael. The Age of Baroque. London:
- Hamlyn, 1976. Lees-Milne, James. Baroque in Italy. New York: Macmillan, 1960.
- Martin, John R. Baroque. New York: Harper & Row, 1977.

- Row, 1977.
 Millon, Henry A. Baroque and Rococo Architecture. New York: Braziller, 1965.
 Nicolson, Benedict. The International Caravag-gesque Movement. Oxford: Phaidon, 1979.
 Norberg-Schulz, Christian. Baroque Architecture. New York: Rizzoli, 1985. (Later edition avail-able) able.)
- Late Baroque and Rococo Architecture. New York: Electa/Rizzoli, 1985.
- Pope-Hennessy, Sir John. The Study and Criticism of Italian Sculpture. New York: Metropolitan Museum, 1981.
- Portoghesi, Paolo. The Rome of Borromini. London: Phaidon, 1972.
- Powell, Nicolas. From Baroque to Rococo: An Intro-
- Jowen, Alchas, From bardque to Roboe. An Infro-duction to Austrian and German Architecture from 1580 to 1790. London: Faber & Faber, 1959. Rosenberg, Jakob; Slive, Seymour; and ter Kuile, E. H. Dutch Art and Architecture, 1600–1800. Bal-

- E. H. Dutch Art and Architecture, 1000–1800. Dat-timore: Penguin, 1979.
 Spear, Richard E. Carazaggio and His Followers. New York: Harper & Row, 1975.
 Stechow, Wolfgang. Dutch Landscape Painting of the 17th Century. Oxford: Phaidon, 1981.
 Summerson, Sir John. Architecture in Britain: 1530– 1830. 7th rev. and enl. ed. Baltimore: Penguin, 1983 1983.
- Tapie, Victor-Lucien. The Age of Grandeur: Baroque Art and Architecture. New York: Praeger, 1966. Varriano, John. Italian Baroque and Rococo Architecture. New York: Oxford University Press, 1986.

- Waterhouse, Ellis Kirkham. Baroque Painting in Rome. London: Phaidon, 1976.
- . Italian Baroque Painting. 2nd ed. London: Phaidon, 1969.
- . Painting in Britain, 1530–1790. 4th ed. New York: Penguin, 1978. (Later edition available.)
- White, Christopher. Peter Paul Rubens: Man and Artist. New Haven: Yale University Press, 1987. Wittkower, Rudolf. Gian Lorenzo Bernini: The Sculptor of the Roman Baroque. 3rd rev. ed. Ox-
- ford: Phaidon, 1981. Wölfflin, Heinrich. Principles of Art History: The Problem of the Development of Style in Later Art. 7th
- ed. New York: Dover, 1950. Renaissance and Baroque. London: Collins,
- 1984 Wright, Christopher. The French Painters of the 17th
- Century. New York: New York Graphic Society, 1986.

CHAPTER 20 THE EIGHTEENTH CENTURY: ROCOCO AND THE BIRTH OF THE MODERN WORLD

- Arnason, H. H. The Sculptures of Houdon. New York: Oxford University Press, 1975. Bacou, Roseline. Piranesi: Etchings and Drawings. Boston: New York Graphic Society, 1975. Blunt, Anthony. Art and Architecture in France, 1500–1700. 2nd ed. Harmondsworth, England: Papagin 1970 Penguin, 1970.
- Braham, Allan. The Architecture of the French En-lightenment. Berkeley: University of California Press, 1980.
- Burchard, John, and Bush-Brown, Albert. The Architecture of America: A Social and Cultural His-tory. Boston: Little, Brown/The American Insti-tute of Architects, 1965.
- Chatelet, Albert, and Thuillier, Jacques. French Painting from Le Nain to Fragonard. Geneva: Skira, 1964.
- Cobban, Alfred, ed. The Eighteenth Century: Europe in the Age of the Enlightenment. New York: McGraw-Hill, 1969.
- Conisbee, Philip. Painting in Eighteenth-Century France. Ithaca, NY: Phaidon/Cornell University Press, 1981.
- Crow, Thomas E. Painters and Public Life in Eighteenth-Century Paris. New Haven: Yale Univer-sity Press, 1985.
- Hayes, John T. Gainsborough: Paintings and Draw-ings. London: Phaidon, 1975.
- Herrmann, Luke. British Landscape Painting of the Eighteenth Century. New York: Oxford University Press, 1974.
- Hitchcock, Henry Russell. Rococo Architecture in Southern Germany. London: Phaidon, 1968. Holt, Elizabeth Gilmore, ed. From the Classicists to
- the Impressionists: A Documentary History of Art and Architecture in the Nineteenth Century, Garden City, NY: Anchor Books/Doubleday, 1966.
- City, NY: Anchor Books/Doubleday, 1966.
 Irwin, David. English Neoclassical Art. London: Faber & Faber, 1966.
 Kalnein, Wend Graf, and Levey, Michael. Art and Architecture of the Eighteenth Century in France. New York: Viking/Pelican, 1973.
 Kimball, Sidney F. The Creation of the Rococo. New York: W. W. Norton, 1964.
 Curry, Michael Daiwling, Eighteeth Content
- Levey, Michael. Painting in Eighteenth-Century
- Venice. Ithaca, NY: Phaidon/Cornell University Press, 1980. Rococo to Revolution: Major Trends in Eighteenth-Century Painting. London: Thames & Hudson, 1966.

Millon, Henry A. Baroque and Rococo Architecture. New York: George Braziller, 1961, 1965. Norberg-Schulz, Christian. Late Baroque and Ro-coco Architecture. New York: Harry N. Abrams,

Pierson, William. American Buildings and Their Ar-chitects: Vol. 1, The Colonial and Neo-Classical Style. Garden City, NY: Doubleday, 1970. Pignatti, Terisio. The Age of Rococo. New York: Hamlyn, 1969.

Pevsner, Nikolaus. An Outline of European Architecture. 6th ed. Baltimore, MD: Penguin Books,

Powell, Nicolas. From Baroque to Rococo: An Intro-

duction to Austrian and German Architecture from 1580 to 1790. London: Faber & Faber, 1959. Raine, Kathleen. William Blake. New York: Oxford University Data

1974.

1960

University Press, 1970.

Rosenblum, Robert. Transformations in Late Eigh-teenth Century Art. Princeton, NJ: Princeton Uni-versity Press, 1970.

- versity Press, 1970. Waterhouse, Ellis K. Painting in Britain, 1530– 1790. 4th ed. New York: Penguin, 1978. Whinney, Margaret Dickens. English Art, 1625–1714. Oxford, England: Clarendon Press,
- 1957. Sculpture in Britain, 1530-1830. Baltimore,
- MD: Penguin, 1950-1850. Baltinore, MD: Penguin, 1964.
 Whinney, Margaret D., and Millar, Oliver. Eng-lish Sculpture, 1720-1830. London: H. M. Sta-tionery Office, 1971.
 Wittkower, Rudolf. Art and Architecture in Italy, 1600-1750. New York: Penguin, 1980.

CHAPTER 21 THE NINETEENTH **CENTURY: PLURALISM OF STYLE**

- Aslin, Elizabeth. The Aesthetic Movement: Prelude to Art Nouveau. New York: Frederick A. Praeger, 1969
- Baudelaire, Charles; Mayne, Jonathan, tr. The Mirror of Art, Critical Studies. Garden City, NY: Doubleday & Co., 1956.
 Barr, Margaret Scolari. Medardo Rosso. New York: The Measure Scolari. Medardo Rosso. New York:
- The Museum of Modern Art, 1963.
- The Museum of Modern Art, 1963.
 Bisanz, R. M. German Romanticism and Philipp Otto Runge. De Kalb: Northern Illinois University Press, 1970.
 Boime, Albert. The Academy and French Painting in the 19th Century. London: Phaidon, 1971.
 Bonnat, Jean. Degas: His Life and Work. New York: Tudor Publishing Company, 1965.
 Borsch-Supan, H. Caspar David Friedrich. New York: George Braziller, 1974.
 Brion, Marcel. Art of the Romantic Era: Romanti-cism, Classicism, Realism. New York: Frederick A. Praeger, 1966.

- Praeger, 1966. Broun, Elizabeth. Albert Pinkham Ryder. Washing-ton, DC: National Museum of American Art/
- Smithsonian Institutions, 1989. Clark, Kenneth. The Gothic Revival: An Essay in the History of Taste. New York: Humanities Press, 1970.
- Clay, Jean. Romanticism. New York: Phaidon, 1981.
- Courthion, Pierre. Romanticism. Geneva: Skira, 1961.
- Delacroix, Eugène; Pach, Walter, tr. The Journal of Eugène Delacroix. New York: Grove Press, 1937, 1948
- Dixon, Roger, and Muthesius, Stefen. Victorian Architecture. London: Thames & Hudson, 1978. Dorra, Henri. The American Muse. London:
- Thames & Hudson, 1961. Eitner, Lorenz. Neo-Classicism and Romanticism 1750–1850: Sources and Documents on the History of
- Art. 2 vols. Englewood Cliffs, NJ: Prentice-Hall, 1970. Elsen, Albert. Rodin. New York: Museum of Mod-

- Elsen, Albert. Rodin. New York: Museum of Modern Art, 1963.
 Friedlaender, Walter. From David to Delacroix. New York: Schocken Books, 1968.
 Fusco, Peter, and Janson, H. W. The Romantics to Rodin: French 19th-Century Sculpture from Ameri-can Collections. Los Angeles: Los Angeles County Art Museum/New York: George Braziller, 1980.
 Hamilton, George Heard. Manet and His Critics. New Haven, CT: Yale University Press, 1954.
 Hanson, Anne Coffin. Manet and the Modern Tradi-tion. New Haven, CT: Yale University Press,
- tion. New Haven, CT: Yale University Press, 1977
- Harker, Margaret F. Henry Peach Robinson: Master of Photographic Art, 1830–1901. Oxford, England: Basil Blackwell, 1988.
- Hawley, Henry. Neo-Classicism: Style and Motif. Cleveland: Cleveland Museum of Art, 1964.
- Hilton, Timothy. The Pre-Raphaelites. New York: Oxford University Press, 1970. Holt, Elizabeth B. From the Classicists to the Impres-
- sionists: Art and Architecture in the Nineteenth Cen-tury. Garden City, NY: Doubleday/Anchor, 1966.
- 1979
- Janson, Horst W. 19th-Century Sculpture. New
- York: Harry N. Abrams, 1985. Leymarie, Jean. French Painting in the Nineteenth Century. Geneva: Skira, 1962.

- Macaulay, James. The Gothic Revival, 1745–1845. Glasgow, Scotland: Blackie, 1975. Middleton, Robin, ed. The Beaux-Arts and Nine-
- teenth-Century French Architecture. Cambridge, MA: MIT Press, 1982. Miller, Lillian B. Patrons and Patriotism: The En-
- couragement of the Fine Arts in the United States, 1790–1860. Chicago: The University of Chicago Press, 1966.
- Newhall, Nancy. P. H. Emerson. New York: An Aperture Monograph, 1975.

- Aperture Monograph, 1975. Newton, Eric. The Romantic Rebellion. New York: Schocken Books, 1964. Nochlin, Linda. Gustave Courbet: A Study of Style and Society. New York: Garland, 1976. Impressionism and Post-Impressionism, 1874–1904: Sources and Documents. Englewood Cliffs, NJ: Prentice-Hall, 1966. Realism and Tradition in Art: Sources and Documents. Englewood Cliffs, NJ: Prentice-Hall, 1966 1966.
- Novak, Barbara. American Painting of the Nine-teenth Century. New York: Frederick A. Praeger, 1969.
- Novotny, Fritz. Painting and Sculpture in Europe: 1780-1880. 2nd ed. Harmondsworth, England: Penguin, 1978.
- Pelles, Geraldine. Art, Artists and Society: Origins of a Modern Dilemma: Painting in England and France, 1750–1850. Englewood Cliffs, NJ: Pren-tice-Hall, 1963.
- Pevsner, Nikolaus. Pioneers of Modern Design. Harmondsworth, England: Penguin, 1964. Poole, Phoebe. Impressionism. London: Thames &

- . Post-Impressionism: From Van Gogh to Gau-guin. New York: Museum of Modern Art, 1956. Rewald, John; Ashton, Dore; and Joachim, Har-old. Odilon Redon, Gustave Moreau, Rodolphe Bres-din. New York: Museum of Modern Art, 1962. Roberts, Keith. The Impressionists and Post-Impres-sionists. New York: E. P. Dutton, 1977. Rosen, Charles, and Zerner, Henri. Romanticism and Realism: The Mythology of Nineteenth-Century Art. London: Faber and Faber, 1984. Rosenblum, Robert, and Janson, Horst W. 19th Century Art. New York: Harry N. Abrams, 1984. 1984
- Russell, John. Seurat. New York: Frederick A. Praeger, 1965. Sambrook, James, ed. Pre-Raphaelitism: A Collec-
- tion of Critical Essays. Chicago: University of Chicago Press, 1974. Sloane, Joseph C. French Painting Between the Past
- and the Present: Artists, Critics, and Traditions from 1848 to 1870. Princeton, NJ: Princeton University Press, 1973.

Press, 1973. Sullivan, Louis. The Autobiography of an Idea. New York: Dover Publications, 1956. Van Gogh: A Self Portrait: Letters Revealing His Life as a Painter. Selected by W. H. Auden. New York: E. P. Dutton, 1963. Vaughan, William. German Romantic Painting. New Haven, CT: Yale University Press, 1980. Weisberg, Gabriel P. The Realist Tradition: French Painting and Drawing, 1830–1900. Cleveland: Cleveland Museum/Indiana University Press, 1980. 1980.

Wood, Christopher. The Pre-Raphaelites. New York: Viking Press, 1981.

CHAPTER 22 THE EARLY TWENTIETH CENTURY

Ades, Dawn. Dali and Surrealism. New York:

- Harper & Row, 1982. Adams, Ansel with Alinder, Mary Street. Ansel Adams: An Autobiography. Boston: Little, Brown & Co., 1985.
- a Co., 1953. Anderson, Troels. Malevich. Amsterdam, Hol-land: Stedelijk Museum, 1970. Apollinaire, Guillaume. The Cubist Painters: Aes-thetic Meditations, 1913. New York: Wittenborn, 1970. 1970.

Bayer, Herbert; Gropius, Walter; Gropius, Ise, eds. *Bauhaus* 1919–1928. Boston: Charles T. Branford Co., 1959.

Benevolo, Leonardo. History of Modern Architec*ture*. 2 vols. Cambridge, MA. MIT Press, 1977. Jake, Peter. *Frank Lloyd Wright*. Har-mondsworth, Middlesex: Penguin Books, 1960. Blake, The Master Builder. New York: W. W. Nor-

- ton, 1976. Boesinger, Willy, ed. Le Corbusier. New York: Frederick A. Praeger, 1972.
- Breton, André. Surrealism and Painting. New York:
- Harper & Row, 1972. Campbell, Mary Schmidt; Driskell, David C.; Levering, David Lewis; and Ryan, Deborah Willis. Harlem Renaissance: Art of Black America. New York: The Studio Museum, Harlem/Harry N. Abrams, 1987.
- Carls, Carl Dietrich. Ernst Barlach. London: Pall Mall Press, 1969.
- Carrá, Massimo; Rathke, Ewald; Tisdall, Caro-
- Carra, Massimo', Kattike, Ewidd, Histain, Caro line; and Waldberg, Patrick. Metaphysical Art. New York: Frederick A. Praeger, 1971. Carter, Peter. Mies van der Rohe at Work. London: Pall Mall Press, 1974. Cassou, Jean. Chagall. New York: Frederick A. Bergene 1065 Praeger, 1965.
- Cassou, Jean, and Pevsner, Nikolaus. Gateway to the Twentieth Century. New York: McGraw-Hill, 1962

- Inectinating, Pactr Police Record Parts, Record Parts, 1962.
 Dupin, Jacques. Alberto Giacometti. Paris: Maeght Editeur, 1963.
 Duthuit, Georges. The Fauvist Painters. New York: Wittenborn, Schultz, 1950.
 Edwards, Ehrlig. Painted Walls of Mexico. Austin, TX: University of Texas Press, 1966.
 Eisner, Lotte. The Haunted Screen. Berkeley: The University of California Press, 1965.
 Elderfield, John. Kurt Schwitters. New York: Museum of Modern Art/Thames & Hudson, 1985.
 —, The 'Wild Beasts'': Fauvism and Its Affinities. New York: The Museum of Modern Art/ Oxford University Press, 1976.
 Elsen, Albert. Origins of Modern Sculpture. New York: George Braziller, 1974.
 Frampton, Kenneth. A Critical History of Modern Architecture. London: Thames & Hudson, 1985.

- Frampton, Kehleuti, A Chitka Instory of Madaon, Architecture. London: Thames & Hudson, 1985.
 Friedman, Mildred, ed. De Stijl: 1917–1931, Visions of Utopia. Minneapolis: Walker Art Center/ New York: Abbeville Press, 1982.
 Fry, Edward, ed. Cubism. London: Thames & Utopian.
- Hudson, 1966. Fuller, R. Buckminster, and Marks, Robert. The
- Fuller, K. Buckminster, and Marks, Kobelt. The Dymaxion World of Buckminster Fuller. Garden City, NY: Anchor Press/Doubleday, 1960.
 Geist, Sidney. Constantin Brancusi, 1876–1957: A Retrospective Exhibition. New York: Solomon R. Guggenheim Museum/Philadelphia: Philadel-phia Museum of Art/Chicago: Chicago Art Instiphia Museum of Art/Chicago: Chicago Art Institute, 1969.
- tute, 1969. George, Waldemar, and Vierny, Dina. Maillol. London: Cory, Adams, and Mackay, 1965. Giannetti, Louis D. Understanding Movies. 2nd ed. Englewood Cliffs, NJ: Prentice-Hall, 1976. Giedion-Welcker, Carola. Constantin Brancusi. New York: George Braziller, 1959. Gilot, François, and Lake, Carlton. Life with Pi-

- Gilot, François, and Lake, Carlton. *Life with Pi-casso*. New York: McGraw-Hill, 1964. Golding, John. *Cubism: A History and an Analysis*, 1907–1914. rev. ed. Boston: Boston Book & Art
- Shop, 1968.
- Shop, 1968.
 Gowing, Lawrence. Matisse. New York: Oxford University Press, 1979.
 Gray, Camilla. The Russian Experiment in Art: 1863–1922. New York: Harry N. Abrams, 1970.
 Gray, Christopher. Cubist Aesthetic Theories. Baltimore: Johns Hopkins University Press 1953.
 Grohmann, Will. Kandinsky: Life and Work. New York: Harry N. Abrams, 1958.
 Gropius, Walter. Scope of Total Architecture. New York: Collier Books, 1962.
 Herrera, Hayden. Frida: A Biography of Frida Kahlo.

York: Collier Books, 1962.
Herrera, Hayden. Frida: A Biography of Frida Kahlo. New York: Harper & Row, 1983.
Hepworth, Barbara. A Pictorial Autobiography. London: The Tate Gallery, 1978.
Hof, August. Wilhelm Lehmbruck. London: Pall Mall Press, 1969.
Jaffé, Hans L. De Stijl. New York: Harry N. Abrams 1971

James, Hans L. De Shift, New York: Harry Y. Abrams, 1971.
 James, Philip. Henry Moore on Sculpture. New York: Viking Press, 1971.
 Janis, Sidney. Abstract and Surrealist Art in America. 1944. reprint. New York: Arno Press, 1969.

- Jean, Marcel; Taylor, Simon Watson, tr. The His-tory of Surrealist Painting. New York: Grove Press, 1960.
- Kahnweiler, Daniel H. *The Rise of Cubism*. New York: Wittenborn, Schultz, 1949. Kandinsky, Wassily; Sadler, M. T. H., tr. *Concern-ing the Spiritual in Art*. New York: Dover Publica-
- tions, 1977.
- Kyrou, Ado. Le Surréalisme au cinéma. Paris: Le Terrain Vague, 1963.
- Langaard, Johan H., and Revold, Reidar. Edvard Munch: Masterpieces from the Artist's Collection in the Munch Museum in Oslo. New York: McGraw-Hill, 1964.
- Le Corbusier. The City of Tomorrow, Cambridge, MA: MIT Press, 1971.
 Levin, Gail. Edward Hopper: The Art and the Artist. New York: Whitney Museum of American Art/ Newtron 1000 Norton, 1980.
- Leyda, Jay. Kino, A History of the Russian and Soviet Film: A Study of the Development of Russian Cinema from 1896 to the Present. New York: Collier Books, 1973
- Lodder, Christina. Russian Constructivism. New Haven, CT: Yale University Press, 1983.
- Maddow, Ben. Edward Weston. Boston: Aperture, New York Graphic Society, 1963. Martin, Marianne W. Futurist Art and Theory. Ox-ford, England: Clarendon Press, 1968.

- ford, England: Clarendon Press, 1968.
 Martinell, César. Gaudí: His Life, His Theories, His Work. Cambridge, MA: MIT Press, 1975.
 Mashek, Joseph, ed. Marcel Duchamp in Perspec-tive. Englewood Cliffs, NJ: Prentice-Hall, 1975.
 Mast, Gerald, and Cohen, Marshall, eds. Film Theory and Criticism: Introductory Readings. 2nd ed. New York. Oxford University Press. 1979.
- ed. New York: Oxford University Reams. 2nd ed. New York: Oxford University Press, 1979. Matthews, J. H. Surrealism and Film. Ann Arbor: The University of Michigan Press, 1971. Meltzer, Milton. Dorothea Lange: A Photographer's

- Life. New York: Farrar, Strauss, Giroux, 1978. Miller, Margaret, ed. Paul Klee. New York: Mu-seum of Modern Art, 1946. Moholy-Nagy, László. Vision in Motion. Chicago: Paul Theobald and Company, 1969, first pub-lished in 1946. lished in 1946.
- Mondrian, Pieter Cornelius. Plastic Art and Pure Plastic Art. 3rd ed. New York: Wittenborn,
- Schultz, 1952. Morse, John D., ed. Ben Shahn. London: Secker &
- Morse, John D., ed. ben Snann. London: Secker & Warburg, 1972. Motherwell, Robert, ed. The Dada Painters and Poets. New York: Wittenborn, Schultz, 1951. Myers, Bernard S. The German Expressionists: A
- Generation in Revolt. New York: Frederick A. Praeger, 1956. Norman, Dorothy. Alfred Stieglitz: An American Seer. Middleton, NY: Aperture, 1973.
- O'Keeffe, Georgia. Georgia O'Keeffe. New York: Penguin, 1977
- Overy, Paul. De Stijl. London: Studio Vista, 1969.
- Passuth, Krisztina. Moholy-Nagy. New York: Thames & Hudson, 1985. Raymond, Marcel. From Baudelaire to Surrealism.
- London: Methuen, 1970. Read, Herbert. *The Art of Jean Arp*. New York: Harry N. Abrams, 1968.
- , ed. Surrealism. New York: Frederick A.
- Praeger, 1971. Richter, Hans. Dada: Art and Anti-Art. London:
- Thames & Hudson, 1961. Rosenblum, Robert. Cubism and Twentieth-Century
- Art. New York: Harry N. Abrams, 1976. Rubin, William S. Dada and Surrealist Art. New York: Harry N. Abrams, 1968. Dada, Surrealism and Their Heritage. New
- York: Museum of Modern Art, 1968. Miró in the Collection of The Museum of Modern Art. New York: Museum of Modern Art,
- 1973.

- Cliffs, NJ: Prentice-Hall, 1976. Schneede, Uwe M. Surrealism. New York: Harry
- N. Abrams, 1974.
- Schwarz, Arturo. The Complete Works of Marcel Duchamp. London: Thames & Hudson, 1965.

- . Man Ray: The Rigors of Imagination. New York: Rizzoli, 1977. Selz, Peter. German Expressionist Painting. 1957.
- reprint. Berkeley: University of California Press, 1974.
- Selz, Peter, and Dubuffet, Jean. The Work of Jean Dubuffet. New York: Museum of Modern Art, 1962.
- Seuphor, Michel. Piet Mondrian: Life and Work. New York: Harry N. Abrams, 1956.
- Shattuck, Roger; Béhar, Henri; Hoog, Mitchell; Lauchner, Carolyn; and Rubin, William. *Henri Rousseau*. New York: Museum of Modern Art, 1985
- Snyder, Robert. Buckminster Fuller: An Autobio-graphical Monologue Scenario. New York: St. Martin's Press, 1980
- Soby, James Thrall. Georges Rouault: Paintings and Prints. New York: Museum of Modern Art/ Simon and Schuster, 1947.
- Sotriffer, Kristian. Expressionism and Fauvism. New York: McGraw-Hill, 1972.
- Speyer, James A. with Koeper, Frederick. Mies van der Rohe. Chicago: Art Institute of Chicago, 1968
- Stephenson, Robert C., tr. Orozco: An Autobiogra-phy. Austin, TX: University of Texas Press, 1962. Stott, William. Documentary Expression and Thirties
- America. New York: Oxford University Press, 1973.
- Taylor, Joshua C. Futurism. New York: Museum
- of Modern Art, 1961. Troyen, Carol, and Hirshler, Erica E. *Charles Sheeler: Paintings and Drawings*. Boston: Museum
- Science: Paintings and Drawings. Boston: Museum of Fine Arts, 1987. Tucker, William. Early Modern Sculpture. New York: Oxford University Press, 1974. Vogt, Paul. Expressionism: German Painting, 1905– 1920. New York: Harry N. Abrams, 1980. Von Hartz, John. August Sander. Millerton, NY: Aperture, 1977.
- Waldman, Diane. Joseph Cornell. New York: George Braziller, 1977. Wright, Frank Lloyd; Kaufmann, Edgar, ed. American Architecture. New York: Horizon, 1955.
- Wheat, Ellen Harkins. Jacob Lawrence: American Painter. Seattle: University of Washington Press, 1986

CHAPTER 23 THE CONTEMPORARY WORLD

- Albright, Thomas. Art in the San Francisco Bay Area: 1945–1980. Berkeley: University of Califor-nia Press, 1985. Alloway, Lawrence. American Pop Art. New York:
- Whitney Museum of American Art/Macmillan
- Institutions, 1976.
- . Topics in American Art Since 1945. New York: W. W. Norton, 1975. Amaya, Mario. Pop Art and After. New York: Vi-
- king Press, 1972.
- Armes, Roy. Patterns of Realism: A Study of Italian Neo-Realist Cinema. New York: A. S. Barnes and Company, 1971.
- Battcock, Gregory, ed. Minimal Art: A Critical An-
- New York: E. P. Dutton, 1978.
- . Super Realism: A Critical Anthology. New York: E. P. Dutton, 1975.
- Battcock, Gregory, and Nickas, Robert, eds. The Art of Performance: A Critical Anthology. New York: E. P. Dutton, 1984. Beardsley, Richard. Earthworks and Beyond: Con-
- temporary Art in the Landscape. New York: Abbe-
- ville Press, 1984. Beardsley, John, and Livingston, Jane. Hispanic Art in the United States: Thirty Contemporary Paint-ers and Sculptors. Houston: Museum of Fine Arts/New York: Abbeville Press, 1987
- Benthall, Jeremy. Science and Technology in Art Today. New York: Frederick A. Praeger, 1972. Bourdon, David. Christo. New York: Harry N.
- Abrams, 1972. Brion, Marcel; Hunter, Sam; et al. Art Since 1945. New York: Harry N. Abrams, 1958.

- Buck, Robert T., Jr.; Cathcart, Linda L.; Nordland, Gerald; and Tuchman, Maurice. *Rich*-
- Additional Geraid, and Huchman, Maurice. Rich-and Diebenkorn: Paintingsand Drawings, 1943–1980. Buffalo, NY: Albright-Knox Art Gallery, 1980. Carmean, E. A., Jr.; Rathbone, Elizabeth; and Hess, Thomas B. American Art at Mid-Century: The Subjects of the Artists. Washington, DC: The National Gallery of Art, 1978.
- Cassou, Jean; Hultèn-Pontus, K. G.; and Hunter,
- Sam, with statement by Schöffer, Nicolas. Two Kinetic Sculptors: Nicolas Schöffer and Jean Tin-guely. New York: Jewish Museum/October House, 1965.
- House, 1905. Chicago, Judy. The Dinner Party: A Symbol of Our Heritage. Garden City, NY: Anchor Press/ Doubleday, 1979. Cockcroft, Eva; Weber, John; and Cockcroft, James. Toward a People's Art. New York: E. P. Duttor 1077
- Dutton, 1977.
- Crichton, Michael. Jasper Johns. New York: Whit-ney Museum of American Art/Harry N. Abrams, 1977
- Cummings, Paul. Dictionary of Contemporary American Artists. 3rd ed. New York: St. Martin's Press, 1977.
- Davies, Hugh, and Yard, Sally. Francis Bacon. New York: Abbeville Press, 1986.
- Deken, Joseph. Computer Images: State of the Art. New York: Stewart, Tabori, and Chang Publishers, 1983.

- ers, 1983. Diamondstein, Barbaralee. American Architecture Now. New York: Rizzoli, 1980. Diehl, Gaston, and Hennessey, Eileen B. Vasarely. New York: Crown Publishers, 1972. Gilbert and George, and Ratcliff, Carter. Gilbert and George: The Complete Pictures, 1971–1985. London: Thames & Hudson, 1986. Glaeser, Ludwig. The Work of Frei Otto. New York: Museum of Modern Art, 1972. Goodman, Cynthia. Digital Visions: Computers and Art. New York: Harry N. Abrams, 1987. Goodyear, Frank H., Jr. Contemporary American Realism Since 1960. Boston: New York Graphic Society, 1981. Society, 1981. Gordon, John. Louise Nevelson. New York: Whit-
- ney Museum of American Art, 1967. Gough, Harry F. The Vital Gesture: Franz Kline.
- Cincinnati: Cincinnati Art Museum/New York: Abbeville Press, 1985. Graham, Peter. *The New Wave*. Garden City, NY:
- Doubleday, 1968. Gray, Cleve, ed. David Smith on David Smith: Sculpture and Writings. London: Thames & Hudson, 1968.

- son, 1968. Hamilton, Richard. Collected Words 1953–1982. London: Thames & Hudson, 1982. Hertz, Richard, ed. Theories of Contemporary Art. Englewood Cliffs, NJ: Prentice-Hall, 1985. Hess, Thomas B. Barnett Newman. New York: Walker and Company, 1969. Willem de Kooning. New York: Museum of Modern Art 1968.
- Modern Art, 1968.
- Jacob, Mary Jane. Magdalena Abakanowicz. New York: Abbeville Press, 1982. Jacobus, John. Twentieth-Century Architecture: The Middle Years, 1940–1964. New York: Frederick A.

Praeger, 1966. Jencks, Charles. Architecture 2000: Prediction and Methods. New York: Frederick A. Praeger, 1971.

Joyce, Paul. Hockney on Photography: Conversations

Joyce, Fall. Pickney on Photography: Conversations with Paul Joyce. New York: Harmony Books, 1988. Kaprow, Allan. Assemblage, Environments, and Happenings. New York: Harry N. Abrams, 1966. Kepes, Georgy. Arts of the Environment. New York: George Braziller, 1970. Kirby, Michael. Happenings. New York: E. P. Dut-ton, 1966.

Kostelanetz, Richard, ed. *Esthetics Contemporary*. Buffalo, NY: Prometheus Books, 1978. Lippard, Lucy R. *Eva Hesse*. New York: New York

, ed. Six Years: The Dematerialization of the Art Object from 1966 to 1972. New York: Frederick

Livingstone, Marco. David Hockney. London: Thames & Hudson, 1981.

Artistes Wargot, Post. Lovejoy, Margot, Postmodern Currents: Art and Artists in the Age of the Electronic Media. Ann Arbor, MI: UMI Research Press, 1989. Lucie-Smith, Edward. Movements Since 1945. new rev. ed. New York: Thames & Hudson, 1984.

ed. Pop Art. New York: Frederick A. Prae-

ton, 1966.

ger, 1966.

University Press, 1976.

A. Praeger, 1973.

1116 BIBLIOGRAPHY

- McShine, Kynaston. Andy Warhol: A Retro-spective. New York: Museum of Modern Art, 1989.
- and Sculpture. New York: Museum of Modern Art, 1984.
- Meyer, Ursula. Conceptual Art. New York: E. P. Dutton, 1972.
- Monaco, James. The New Wave: Truffaut, Godard, Chabrol, Rohmer, Rivette. New York: Oxford University Press, 1976.
- Nervi, Pier Luigi. Aesthetics and Technology in Building. Cambridge, MA: Harvard University Press, 1965.
- Norris, Christopher, and Benjamin, Andres. What Is Deconstruction? New York: St. Martin's Press, 1988-
- O'Connor, Francis V. Jackson Pollock. New York:
- O'Hara, Francis v. *Jackson Poluck*. New York: O'Hara, Frank. *Robert Motherwell*. New York: Museum of Modern Art, 1965. Price, Jonathan. *Video Visions: A Medium Dis-covers Itself*. New York: New American Library, 1977 1977
- Reichardt, Jasia, ed. Cybernetics, Art & Ideas. Greenwich, CT: New York Graphics Society, 1971
- Risatti, Howard, ed. Postmodern Perspectives. En-glewood Cliffs, NJ: Prentice-Hall, 1990. Robbins, Corinne. The Pluralist Era: American Art, 1968–1981. New York: Harper & Row, 1984.
- Robbins, David, ed. The Independent Group: Post-war Britain and the Aesthetics of Plenty. Cam-bridge, MA: MIT Press, 1990. Rose, Barbara. Claes Oldenburg. New York: Mu-
- seum of Modern Art, 1970. Frankenthaler. New York: Harry N.
- Abrams, 1975.
- Rosenberg, Harold. The Tradition of the New. New York: Horizon Press, 1959. Russell, John. Francis Bacon. London: Thames & Hudson, 1971.

- Hudson, 1971. Russell, John, and Gablik, Suzi. Pop Art Redefined. New York: Frederick A. Praeger, 1969. Sandler, Irving. The Triumph of American Painting: A History of Abstract Expressionism. New York: Frederick A. Praeger, 1970. Schneider, Ira, and Korot, Beryl. Video Art: An Anthology. New York: Harcourt Brace Jovano-vich, 1976. Schwarz, Paul Waldo. The Hand and Fue of the
- vicit, 1970. Schwarz, Paul Waldo. The Hand and Eye of the Sculptor. New York: Frederick A. Praeger, 1969. Sitney, P. Adams. Visionary Film: The American Avant-Garde. New York: Oxford University
- Press. 1974.
- Smagula, Howard. Currents: Contemporary Direc-tions in the Visual Arts. 2nd ed. Englewood Cliffs, NJ: Prentice-Hall, 1989.
- NJ: Prentice-rian, 1969. Smith, Patrick S. Andy Warhol's Art and Films. Ann Arbor, MI: UMI Research Press, 1986. Smithson, Robert; Holt, Nancy, ed. The Writings of Robert Smithson. New York: New York Univer-
- sity Press, 1975. Solomon, Alan. Jasper Johns. New York: The Jew-ish Museum, 1964.
- ISBN MUSEUIII, 1704. Sonfist, Alan, ed. Art in the Landscape: A Critical Anthology of Environmental Art. New York: E. P. Dutton, 1983. Stangos, Nikos. Concepts of Modern Art. 2nd ed.
- New York: Harper & Row, 1985.

- New York: Harper & Row, 1985. Tisdall, Carolyn. Joseph Beuys. New York: Solo-mon R. Guggenheim Museum, 1979. Tomkins, Calvin. The Scene Reports on Post-Modern Art. New York: Viking Press, 1976. Tuchman, Maurice. American Sculpture of the Six-ties. Los Angeles: Los Angeles County Museum of Art. 1967. of Art, 1967
- Venturi, Robert; Scott-Brown, Denise; and Isehour, Steven. *Learning from Las Vegas*. Cam-bridge, MA: MIT Press, 1972.
- Waldman, Diane. Mark Rothko, 1903–1970: A Ret-rospective. New York: Solomon R. Guggenheim Museum, 1978.
- Wallis, Brian, ed. Art After Modernism: Rethinking Representation. New York: New Museum of Contemporary Art in association with David R. Godine, 1984. Wheeler, Dennis, ed. Form and Structure in Recent
- Film. Vancouver, BC: Vancouver Art Gallery, 1972
- Wye, Deborah. Louise Bourgeois. New York: Mu-seum of Modern Art, 1982.
- Youngblood, Gene. *Expanded Cinema*. New York: E. P. Dutton, 1970.

Books Spanning the Eighteenth, Nineteenth, and Twentieth Centuries

Ades, Dawn. Art in Latin America: The Modern Era, 1820–1980. London: The Hayward Gallery, 1989.

- Antreasian, Garo, and Adams, Clinton. The Tama-

- Antreasian, Garo, and Adams, Clinton. The Tamarind Book of Lithography: Art and Techniques. Los Angeles: Tamarind Workshop and New York: Harry N. Abrams, 1971.
 Armstrong, John; Craven, Wayne; and Feder, Norma, et al. 200 Years of American Sculpture. New York: Whitney Museum of American Art/ Boston: David R. Godine, 1976.
 Battcock, Gregory. Minimal Art: A Critical Anthology. New York: Studio Vista, 1969.
 Brown, Milton; Hunter, Sam; and Jacobus, John. American Art: Painting, Sculpture, Architecture, Decorative Arts, Photography. New York: Harry N. Abrams, 1979.
 Canaday, John. Mainstreams of Modern Art. New York: Holt, Rinehart & Winston, 1959.
 Chipp, Herschel. Theories of Modern Art. Berkeley: University of California Press, 1968.
 Coke, Van Deren. The Painter and the Photograph New York: Weit Work Winston, Yang et al. Ministream of Log Albrid.

- Coke, Van Deren. The Painter and the Photograph From Delacroix to Warhol. rev. and enl. ed. Albu-querque: University of New Mexico Press, 1972.

- querque: University of New Mexico Press, 1972.
 Collins, Peter. Changing Ideals in Modern Architecture, 1750–1950. London: Faber & Faber, 1971.
 Condit, Carl W. The Rise of the Skyscraper: Portrait of the Times and Career of Influential Architects. Chicago: University of Chicago Press, 1952.
 Driskell, David C. Two Centuries of Black American Art. Los Angeles: Los Angeles County Museum of Art/New York: Alfred A. Knopf, 1976.
 Elsen, Albert. Origins of Modern Sculpture. New York: George Braziller, 1974.
 Fine, Sylvia Honig. Women and Art: A History of Women Painters and Sculptors from the Renaissance to the 20th Century. Montclair, NJ: Alanheld and to the 20th Century. Montclair, NJ: Alanheld and Schram, 1978.
- Flexner, James Thomas. America's Old Masters. New York: McGraw-Hill, 1982.
- Freund, Gisele. Photography and Society. Boston: David R. Godine, 1980. Gernsheim, Helmut. Creatize Photography. New
- York: Bonanza Books, 1962.
- Giedion, Siegfried. Mechanization Takes Command: A Contribution to Anonymous History. New York:
- Norton, 1948. Space, Time and Architecture: The Growth of a New Tradition. 4th ed. Cambridge, MA: Har-vard University Press, 1965.
- Giedion-Welcker, Carola. Contemporary Sculpture: An Evolution in Volume and Space. London: Faber
- An Evolution in Volume and Space. London: Faber & Faber, 1960. Goldberg, Vicki. Photography in Print. New York: A Touchstone Book, Simon and Schuster, 1981. Goldwater, Robert, and Treves, Marco, eds. Art-ists on Art. 3rd ed. New York: Pantheon, 1958. Greenough, Sarah; Snyder, Joel; Travis, David; and Westerbeck, Colin. On the Art of Fixing a Shadow: One Hundred and Fifty Years of Photogra-phy. Washington, DC: The National Gallery of Art/Chicago: The Art Institute of Chicago, 1989. Hamilton, George Heard. Nineteenth- and Twen-tice-Hall, 1972.
- tice-Hall, 1972. Hammacher, A. M. The Evolution of Modern Sculp-ture: Tradition and Innovation. New York: Harry
- N. Abrams, 1969.
- Hitchcock, Henry-Russell. Architecture: Nineteenth and Twentieth Centuries. 4th ed. Baltimore: Penguin, 1977.

- guin, 1977. Hopkins, H. J. A Span of Bridges. Newton Abbot, Devon, England: David & Charles, 1970. Hunter, Sam. Modern French Painting, 1855–1956. New York: Dell, 1966. Irving, Donald J. Sculpture: Material and Process. New York: Van Nostrand Reinhold Company, 1970 1970.
- Kaufmann, Edgar, Jr., ed. *The Rise of an American Architecture*. New York: Metropolitan Museum of Art/Frederick A. Praeger Publishers, 1970. Klingender, Francis Donald and Elton, Arthur ed. and rev. *Art and the Industrial Revolution*. Lon-don Evelyn, Adams and MacKay, 1969.
- don: Evelyn, Adams and MacKay, 1968. Licht, Fred. Sculpture, Nineteenth and Twentieth Centuries. Greenwich, CT: New York Graphic Society, 1967.
- Lover, Francois. Architecture of the Industrial Age.
 New York: Rizzoli, 1983.
 Lyons, Nathan, ed. Photographers on Photography.
 Englewood Cliffs, NJ: Prentice-Hall, 1966.
 McCoubrey, John W. American Art, 1700–1960:

Sources and Documents. Englewood Cliffs, NJ: Prentice-Hall, 1965.

- Trentice-Hail, 1900.
 Mason, Jerry, ed. International Center of Photography Encyclopedia of Photography. New York: Crown Publishers, 1984.
 Newhall, Beaumont. The History of Photography.
- Newnall, beaumont. Ine rustory of Photography. New York: The Museum of Modern Art, 1982. Pehnt, Wolfgang. Encyclopedia of Modern Architec-ture. New York: Harry N. Abrams, 1964. Peterdi, Gabor. Printmaking: Methods Old and New. New York: Margillan Company. 1961.
- New York: Macmillan Company, 1961. Pevsner, Nikolaus. An Outline of European Archi-tecture. 6th ed. Baltimore: Penguin, 1960.
- Phillipe, Robert, Political Graphics: Art as a Weapon. New York: Abbeville Press, 1980. Pierson, William. American Buildings and Their Ar-
- Pierson, William. American Buildings and Their Ar-chitects: Technology and the Picturesque. vol. 2.
 Garden City, NY: Doubleday, 1978.
 Risebero, Bill. Modern Architecture and Design: An Alternative History. Cambridge: MIT Press, 1983.
 Rosenblum, Naomi. A World History of Photogra-phy. New York: Abbeville Press, 1984.
 Rosenblum, Robert. Modern Painting and the Northern Romantic Tradition: Friedrich to Rothko. New York: Harper & Row, 1975.

- New York: Harper & Row, 1975. Ross, John, and Romano, Clare. The Complete Printmaker. New York: The Free Press, 1972.
- Ross, Stephen David, ed. Art and Its Significance: An Anthology of Aesthetic Theory. Albany, NY: SUNY Press, 1987. Sachs, Paul, Jr. Modern Prints and Drawings: A Guide to a Better Understanding of Modern Draughtsmanship. New York: Alfred A. Knopf, 1007 1954
- Schapiro, Meyer. Modern Art: 19th and 20th Centu-
- ries. New York: George Braziller, 1980. Scharf, Aaron. Art and Photography. Baltimore, MD: Penguin Books, 1974.
- Scully, Vincent, American Architecture and Urban-ism. New York: Frederick A. Praeger, 1969. Selz, Peter, Michelson, Annette, tr. Modern Sculp-
- ture: Origins and Evolution. London: Heinemann, 1963.
- 1963.
 Seuphor, Michel. The Sculpture of this Century. New York: George Braziller, 1960.
 Shikes, Ralph E. The Indignant Eye: The Artist as Social Critic, from the Renaissance to Picasso. Bos-ton: Banion Press, 1969.
 Slatkin, Wendy. Women Artists in History: From Antiquity to the 20th Century. 2nd ed. Englewood Cliffs, NJ: Prentice-Hall, 1985.
 Spencer, Harold. American Art: Readings from the Colonial Era to the Present. New York: Charles Scribner's Sons, 1980.
 Summerson, Sir John. Architecture in Britain: 1530– 1830. 7th rev. and enl. ed. Baltimore: Penguin,

- 1830. 7th rev. and enl. ed. Baltimore: Penguin, 1983
- Sypher, Wylie. Rococo to Cubism in Art and Literature. New York: Random House, 1960
- ture. New Tork: Kandom House, 1960. Szarkowski, John. Photography Until Now. New York: Museum of Modern Art, 1989. Weaver, Mike. The Art of Photography: 1839–1989. New Haven, CT: Yale University Press, 1989.

Whiffen, Marcus, and Koeper, Frederick. Ameri-can Architecture, 1607–1976. Cambridge: MIT

Wilmerding, John. American Art. Harmonds-worth, England: Penguin, 1976. The Genius of American Painting. London:

Wilson, Simon. Holbein to Hockney: A History of British Art. London: The Tate Gallery & The Bod-ley Head, 1979.

Ades, Dawn. Photomontage. Rev. and enl. ed. London: Thames & Hudson, 1976. Andersen, Wayne. American Sculpture in Process: 1930–1970. Boston: New York Graphic Society,

Andrew, J. Dudley. The Major Film Theories: An Introduction. New York: Oxford University

Press, 1976.
Arnason, H. H. History of Modern Art: Painting, Sculpture, Architecture. 3rd rev. and enl. ed. En-glewood Cliffs, NJ: Prentice-Hall 1988.
Ashton, Dore. Twentieth-Century Artists on Art. New York: Pantheon Books, 1985.
Banham, Reyner. Guide to Modern Architecture. Princeton, NJ: D. Van Nostrand, 1962.
Barsam, Richard Meran. Nonfiction Film: A Critical History. New York: E. P. Dutton, 1973.

Weidenfeld & Nicolson, 1973.

Books Spanning the Whole of the Twentieth Century

Press, 1983.

1975

Press, 1976.

Burnham, Jack. Beyond Modern Sculpture. The Ef-Burnham, Jack. Beyond Modern Scutpture. The Effects of Science and Technology on the Sculpture of This Century. New York: George Braziller, 1968. Castelman, Riva. Prints of the 20th Century: A History. New York: Oxford University Press, 1985.

- tory. New York: Oxford University Press, 1985. Compton, Susan, ed. British Art in the 20th Cen-tury. London: Royal Academy of Arts/Berlin: Prestel Verlag, 1986. Cook, David A. A History of Narrative Film. New York: Norton, 1981. Curtis, David. Experimental Cinema: A Fifty-Year Evolution. New York: Dell, 1971. Davis, Douglas. Art and the Future: A History/ Prophecy of the Collaboration Between Scientists, Technology and the Arts. New York: Frederick A. Praeger, 1973. Praeger, 1973.

- Praeger, 1973.
 Diehl, Gaston. The Moderns: A Treasury of Painting Throughout the World. Milan: Uffizi, 1961.
 Frascina, Francis, and Harrison, Charles, eds. Modern Art and Modernism: A Critical Anthology. New York: Harper & Row, 1982.
 Goldberg, Rosalee. Performance: Live Art, 1909 to the Present. New York: Harry N. Abrams, 1979.
 Haftmann, Werner. Painting in the Twentieth Cen-tury. New York: Frederick A. Praeger, 1960.
 Hamilin, Talbot F., ed. Forms and Functions of Twentieth-Century Architecture. 4 vols. New York: Columbia University Press, 1952.

- Twentieth-Century Architecture. 4 vols. New York: Columbia University Press, 1952. Hatje, Gerd, ed. Encyclopedia of Modern Architec-ture. London: Thames & Hudson, 1963. Herbert, Robert L., ed. Modern Artists on Art. En-glewood Cliffs, NJ: Prentice-Hall, 1964. Hertz, Richard, and Klein, Norman M., eds. Twentieth-Century Art Theory: Urbanism, Politics, and Mass Culture. Englewood Cliffs, NJ: Pren-tice-Hall, 1990.
- Hunter, Sam, and Jacobus, John. Modern Art: Painting, Sculpture, and Architecture. New York: Harry N. Abrams, 1985.

- Hunter, Sam. Modern American Painting and Sculp-ture. New York: Dell, 1959. Jencks, Charles. Modern Movements in Architecture. Garden City, NY: Anchor Press/ Doubleday, 1977 1973
- 1973.
 Joachimides, Christos. M.; Rosenthal, Norma; and Schmied, Wieland, eds. German Art in the 20th Century: Painting and Sculpture, 1905–1985.
 Munich: Prestel-Verlag, 1985.
 Kraus, Rosalind E. Passages in Modern Sculpture. Cambridge, MA: MIT Press, 1981.
 Lynton, Norbert. The Story of Modern Art. 2nd ed. Englewood Cliffs, NJ: Prentice-Hall, 1989.
 MacGowan, Kenneth. Behind the Screen. New York: A Dell Book, Delta Publishing Co., 1965.
 Monaco, James. How to Read a Film: The Art, Tech-nology, Language, History, and Theory of Film and Media. New York: Oxford University Press,

- Media. New York: Oxford University Press, 1977.
- 1977.
 Phaidon Dictionary of Twentieth-Century Art. Oxford: Phaidon Press, 1973.
 Phillips, Gene D. The Movie Makers: Artists in an Industry. Chicago: Nelson-Hall Company, 1973.
 Pontus-Hultén, K. G. The Machine as Seen at the End of the Mechanical Age. New York: Museum of Modern Art 1968.
- Modern Art, 1968. Popper, Frank, et. al. Electra: Electricity and Elec-tronics in the Art of the 20th Century. Paris: Musée
- d'art moderne de Paris, 1983. .; Benn, Stephen, tr. Origins and Develop-ment of Kinetic Art. Greenwich, CT: New York
- Graphic Society, 1968. Graphic Society, 1968. Raynal, Maurice. *History of Modern Painting*. 3 vols. Geneva: Skira, 1949–1950. Read, Herbert. *Concise History of Modern Painting*. 3rd ed. New York: Frederick A. Praeger, 1975.
- . A Concise History of Modern Sculpture. rev. and enl. ed. New York: Frederick A. Praeger, 1964.

Rickey, George. Constructivism: Origins and Evolution. New York: George Braziller, 1967.

- Ritchie, Andrew Carnduff, ed. German Art of the Twentieth Century. New York: Museum of Modern Art, 1957.
- ern Art, 1957. Sculpture of the Twentieth Century. New York: The Museum of Modern Art, n.d. Rose, Barbara. American Art Since 1900. rev. ed. New York: Frederick A. Praeger, 1975. Russell, John. The Meanings of Modern Art. New York: Museum of Modern Art/Thames & Hud-son 1981
- son, 1981.
- Scully, Vincent. American Architecture and Urban-ism. New York: Frederick A. Praeger, 1969. Modern Architecture. rev. ed. New York:
- George Braziller, 1974. Sloane, J. C. French Painting Between the Past and the Present. Princeton, NJ: Princeton University
- Press, 1951.
- Press, 1951. Spalding, Francis. British Art Since 1900. London: Thames & Hudson, 1986. Tomkins, Calvin. The Bride and the Bachelors, Five Masters of the Avant-Garde. New York: Viking Press, 1968.
- Press, 1968. Tuchman, Maurice, and Freeman, Judi, eds. The Spiritual in Art: Abstract Painting, 1890–1985. Los Angeles: Los Angeles County Art Museum/New York: Abbeville Press, 1986. Wescher, Herta; Wolf, Robert E., tr. Collage. New York: Harry N. Abrams, 1968. Whittick Arnold European Architecture in the
- Whittick, Arnold. European Architecture in the Twentieth Century. Aylesbury, England: Leonard Hill Books, 1974.

PICTURE CREDITS

The authors and publisher are grateful to the proprietors and custodians of various works of art for photographs of these works and permission to reproduce them in this book. Sources not included in the captions are listed below.

KEY TO ABBREVIATIONS

	KET TO ADDREVIATIONS	
ACL	Copyright A.C.L., Brussels	
AMNH	American Museum of Natural History, New York	
AL	Fratelli Alinari	
AR	Art Resource	
Bulloz	I. E. Bulloz, Paris	
C.M.N.	Cliché des Musées Nationaux, Paris	
Fototeca	Fototeca Unione at the American Acad-	
1010100	emy, Rome	
Gab	Gabinetto Fotografico Nazionale, Rome	
Gir	Giraudon	
Harding	Robert Harding Picture Library, London	
Hinz	Colorphoto Hans Hinz	
Hir	Hirmer Fotoarchiv, Munich	
Mansell	The Mansell Collection, London	
Mar	Bildarchiv Foto Marburg	
MAS	Ampliaciones y Reproducciones MAS,	
	Barcelona	
NYPL	New York Public Library	
OI	Courtesy of the Oriental Institute of the	
	University of Chicago	
PRI	Photo Researchers, Inc., New York	
R.M.N.	Photo, Reunion des Musées Nationaux	
Scala	Scala Fine Art Publishers	
Note: Al	references in the following credits are to	

figure numbers unless otherwise indicated

AR: 4, 9, 10; Hir: 12; Photo courtesy Soichi Sunami/ The Museum of Modern Art.

Part I Opening illustration: Adam Woolfitt/Susan Griggs Agency; page 24: Metropolitan Museum of Art (Egyptian Expedition).

- Art (Egyptian Expedition). Chapter 1 Courtesy Department of Library Services/ AMNH: 9, 10, 13; Arch. Phot. Paris/S.P.A.D.E.M.: 7, 8, 11; Hinz: 1, 4; Hunting Aerofilms, Ltd.: 15; Photo Láborie, Bergerac, France: 5; MAS: 14; Edwin Smith: 16; Jean Vertut: 6, 12 (Coll. Begouen). Chapter 2 ALAR: 43; British School of Archaeology in Jerusalem: 1, 2; C.M.N.: 25, 37, 40; Hir: 13, 15, 17, 20; Advandl J. 20; Archet Mollart 6, 7, 8
- in Jerusatem: 1, 2, C.M.N.: 29, 57, v6, fill: 16, 16, 27, 30, 34, Mansell: 31, 32; Arlette Mellaart: 6, 7, 8; James Mellaart: 5, OI: 16, 17, 21, 38, 41, 42; The University Museum/University of Pennsylvania: 19, 20; R.M.N.: 24, 26; Scala/AR: 22; Staatliche
- 19, 20; K.M.N. 24, 20, Scalar A. 27, Statistics Museen zu Berlin: 10. Chapter 3 Photo by Bruno Balestrini by courtesy of Elemond, Milano: 9; Bettmann Archive: 26; Bil-Elemond, Milano: 9; Bettmann Archive: 26; Bil-darchiv Preussischer Kulturbesitz, Berlin: 39; © Lee Boltin: 41; C.M.N.: 44; Egyptian Antiquities Orga-nization: 24, 46; Egyptian Museum, Cairo: 1; Har-ding: 13, 30, 42, 43; Hir: 2, 3, 14, 15, 16, 17, 18, 19, 25, 33, 38; Mar/AR: 27; Metropolitan Museum of Art (Egyptian Expedition): 22, 36; OI: 23; George Gerster/PRI: 10; Geoffrey Clifford/Wheeler Pic-tures: 6, 20, 29; Current 6, 40, 12, 62 (Coliner d'Art"; 1, 2, 3; Conway
- tures: 6, 20, 29.
 Chapter 4 AR: 13; © "Cahiers d'Art": 1, 2, 3; Conway Library/Courtauld Institute of Art, London: 25; Ail-son Frantz: 23; Gir/AR: 20; Hir: 4, 5, 7, 8, 9, 12, 15, 16, 17, 18, 19, 22, 26, 27, 28, 29; Scala/AR: 14; TAP ruice: 10 11
- Service: 10, 11. Chapter 5 AL/AR: 14, 26, 58, 62, 64, 66, 76, 86; An-derson/AR: 63, AR: 6; C.M.N.: 9, 60; Deutsches Archałologisches Institut, Rome: 12, Alison Frantz: 39, 40, 41, 51, 52; Gir/AR: 2; Harding: 55; Walter Hege: 45; Hinz: 10; Hir: 8, 11, 71, 18, 19, 22, 29, 32, 33, 37, 38, 44, 46, 47, 48, 49, 50, 53, 66, 57, 65, 75, 82, 87; Herschell Levit: 24; Barbara Malter/Institute Centrali per il Catalogo e la Documentazione: 84; Mar/AR: 69, 70; Caecilia H. Moessner, Munich: 5, 7; Mar/AR: 69, 70; Caecilia H. Moessner, Munich: 5, 7; J. Powell, Rome: 59; Frederick Ayer III/PRI: 71; Scala/AR: 34, 35, 36, 61, 79; Dr. Franz Stoedtner: 28; TAP Service: 4, 16, 68, 74, 95. Chapter 6 AL/AR: 6, 10, 11, 17, 25, 35, 41, 64, 66, 67, 68, 70, 71, 80, 94, 96, 97; Anderson/AR: 88, 56, 65, 74; Photo by Brune Balestrini by courtesy of Electa
- 74; Photo by Bruno balestrini by courses of interca Editrice, Milano: 55; C.M.N.: 46; Deutsches Ar-chaologisches Institut, Rome: 14, 73, 75, 93, 95; Walter Drayer: 2, 9, 12; Fototeca: 15 (Frank E. Brown), 16, 18, 19, 20, 21, 43, 50, 52, 59, 61, 63; Gab: 3, 76; Madeline Grimoldi Archive: 39, 98; HB Collection: 33, 36, 42; Hir; 4, 8; The Israel Museum, Collection: 33, 36, 42; Hir; 4, 9; The Israel Museum, Conection: 35, 36, 42; Fur. 4, 6, The Island Museum, Jerusalem: 90; G. E. Kidder-Smith: 91; Photo KLM: 48; Amedeo Maiuri, *Roman Painting*, Editions d'Art Albert Skira: 26; Mar/AR: 82; Monumenti Musei e Gallerie Pontificia: 31; Rapho/PRI: 77; Leonard von Matt/PRI: 69; Rheinisches Landesmuseum, Trier: 85, 86; Charles Rotkin/PRI: 47; Scala/AR: 5, 23, 28, 29, 30, 32, 34, 37, 88, 89; Gunter Heil/ZEFA: 84. Chapter 7 AL/AR: 35, 62; Anderson/AR: 17, 22, 25, 66
- hapter 7 AL/AR: 35, 62; Anderson/AR: 17, 22, 25, 66; Benedettine di Priscilla, Rome: 2; Byzanine Visual Resources, © 1989 and 1990, Dumbarton Oaks, Washington, D.C.: 41, 56; Enrico Ferotelli © 1989; 55; Sostegni/Fotocielo: 47; Alison Frantz: 43, 46; Gir/AR: 23; HBJ Collection: 5, 13, 50, 51, 69; Photo André Held: 10, 19, 57; Hir. 7, 16, 18, 20, 21, 24, 29, 32, 34, 40; Hunting Aerofilms, Ltd.: 64; State of Is-rusalem: 73; A. F. Kersting: 82; G. E. Kidder-Smith: 77; Ancelo Longo Editore, Ravena: 36, 27, 36, 37; rusalem: 73; A. F. Kersting; 22; G. E. Kudder-silluit: 77; Angelo Longo Editore, Ravenna: 26, 27, 36, 37; MAS: 67, 68, 76; NYPL: 52; Novosti from Sovfoto: 60; Pontifica Commissione Centrale per l'Arte Sacra in Italia: 3; J. Powell, Rome: 53, 54, 74; Scala/AR: 9, 11, 12, 28, 30, 31, 38, 49; TASS/Sovfoto: 59; Stata-liche Museen zu Berlin: 71; Russell A. Thompson/ Liche Museen zu Berlin: 71; Russell A. Thompson/ Taurus Photos: 79; Tourism Counselor's Office/ Turkish Embassy, Washington, D.C.: 80; Weitz-man/Princeton University: 39; Linares/Yale University Photo Collection: 75. Part II Opening illustration: Scala/AR; page 316:

Hunting Aerofilms, Ltd. **Chapter 8** ©Lee Boltin: 1; Bridgeman Art Library/AR: 2-b; Dr. Harold Busch: 20; HBJ Collection: 16, 24,

26, 27; Hir: 21; Mar/AR: 28; Copyright University 26, 27; Hir: 21; Mar/AR: 28; Copyright University Museum of National Antiquities, Oslo, Norrawy Photo by Erik Irgens Johnsen: 5; NYPL: 10, 14; R.M.N.: 2-a; @ Mick Sharp, Photographer: 11; Photo Zodiaque: 6.
Chapter 9 AL/AR: 10, 11, 12, 19, 27; @ Arch. Phot.

 Paris'S, P. A.D. E.M.: 17, 29, 30; Bulloz: 28, 32, 34; Jean Dieuziade: 3, 24; Sergio Sostegni/Fotocielo: 18; Gir/AR: 35, 38, 39; HBJ Collection: 9, 33; Hir: 8; Eve-lyn Hofer: 20; A. F. Kersting: 16; Jean Roubier: 5, 13, 22, 26, 31; Scala/AR: 21; SEFAR: 37; W. S. Stod-dard: 14; Tapisserie de Bayeux: 36; The Master and Fellows of Trinity College, Cambridge: 42.
 Chapter 10 AL/AR: 62, 63; Anderson/AR: 60; Dr. Har-old Busch/AR: 49, 52; F. Damm?ladt Köln: 57; D. P.I., Inc.: 58; Electa Editrice: 18; Gir/AR: 32, 34, 63, 39; HB Collection: 1, 35; Hir: 8, 10, 12, 13, 23; 51; 53, 55; National Monuments Record, Londow: Paris/S.P.A.D.E.M.: 1, 29, 30; Bulloz: 28, 32, 34

51, 53, 55; National Monuments Record, London: 41, 44, 45, 46; George Holton/PRI: 64; Rapho/PRI: 41, 44, 45, 40, George Harborn, Cologne: 56; Jean Roubier: 9, 15; H. Rogier-Viollet: 14, 28; Scala/AR: 27, 29, 61; Helga Schmidt-Glassner: 54; Edwin Smith: 47; W. S. Stoddard: 20; Superstock International: 42; Clarence Ward, Photographic Archives, National Gallery of Art, Washington, D.C.: 7, 22, 26 18

Part III Opening illustration, National Film Board of Canada: page 422. Chapter 11 Archaeological Survey of India, Govern

- hapter 11 Archaeological Survey of India, Government of India: 1, 2, 3, 4, 6, 9, 11, 12, 14, 15, 17; Borromeo/AR: 5, 21; Asian Art Photographic Distri-bution, Department of the History of Art, Univer-sity of Michigan: 16; Barnaby's Picture Library: 19, 20; Photograph by Ananda Coomaraswamy, Cour-tesy Fine Arts Library, Harvard University: 7; Pho-tesy Fine Arts Library. Harvard University: 7; Pho-metry International Coomaraswamy, Cour-sey Fine Arts Library. tesy Fine Arts Library, Harvard University, 7, 110-tograph by Edgar Oscar Parker, courtesy of the Vis-ual Collections, Fine Arts Library, Harvard University: 13; J. Leroy Davidson: 27; Eliot Elisofon, LIFE Magazine © Time Inc.: 28; Courtesy of the Fogg Art Museum, Harvard University, Cambridge, Mass.: 13; HBJ Collection: 22, 25; Marie J. Mattson: 32; R. Rowan/PRI: 30; © Allan Eaton/ Sheridan Photo Library: 26; Superstock Interna-tional: 33; I. Job Thomas: 23.
- tional: 33; 1. Job Inomas: 25. Chapter 12 Harry N. Abrams, Inc.: 4; Chavannes: 6; Courtesy of the Cultural Relics Bureau, Beijing and the Metropolitan Museum of Art, New York: 5; Editions d'Art, Paris: 30; HBJ Collection: 9, 13; Harding: 7, 23; © Joan Lebold Cohen: 32; © Marc Ri-boud/Magnum: 31; NYPL: 14; R.M.N.: 10, 26;
- boud/Magnum: 31; NYPL: 14; R.M.N.: 10, 26; Audrey R. Topping: 28. Chapter 13 From A History of Far Eastern Art by Sher-man E. Lee, Harry N. Abrams, Inc.: 7, 9, 26, 27; Photograph courtesy of the International Society for Educational Information, Inc.: 19, 25; Japan National Tourist Organization: 30; National Com-mission for Protection of Cultural Properties, Tokyo: 3, 10, 12; Sakamoto Photo Research Lab: 4, 8; Shashinka Photo: 15, 16, 17, 21, 22, 32; © 1981, Shogakukan Publishing Co. Ltd., Tokyo: 2, 5, 6, 11. Chapter 14 © Albert Moldvay/AR: 1; Archive of His-panic Culture, Library of Congress: 22-b; Tom panic Culture, Library of Congress: 22-b; Tom Bahti: 34; © Lee Boltin: 5, 13; by Bill Ballenberg © 1988 National Geographic Society: 19; Chicago Natural History Museum: 22-a; From H. S. and C. B. Cosgrove, The Swarts Ruin: A Typical Mimbres Site in Southwestern New Mexico, Peabody Museum Pa-Southwestern New Mexico, Peabody Museum Pa-pers, Vol. 15 No. 1. Reprinted with permission. 31; Herbert M. Cole: 51; Todd Disotel: 73; David Geb-hard, The Art Galleries, University of California, Santa Barbara: 30; Abraham Guillen: 24-b; E. Hadingham: 21; Dr. Norman Hammond, Boston University: 7; David Hiser/Photographers Aspen: 15; © Susan Holtz: 32; Peter Horner: 64; Dr. George Konnedy. University: of California Lee Angelee 55; Kennedy, University of California, Los Angeles: 65; © Justin Kerr: 8, 9, 10; Rene Millon, 1973: 4; Courtesy of the Native Land Foundation, Hampton, CT: 24; National Commission for Museums and Monutessy of the Native Latter Fouriadusti, Fraingroot, CT. 24; National Commission for Museum and Monuments, Lagos: 43, 44, 45; Peabody Museum, Harvard University, Cambridge: 11; John Running: 33; Photo Jerry Thompson: 58; From Karl von Steiner, Die Marquesner und ihre Kurst 1: 62; Frank Willett: 48; ZEFA: 14; © Neville Presho/ZEFA: 23.
 Part IV Opening illustration: Scala/AR: page 555: AR.
 Chapter 15 AU/AR: 2, 3, 45, 5, 8, 14, 15; 17; Anderson', AR: 16, 22; Dmitri Kessel/LIFE Magazine © Time Inc: 12; Scala/AR: 6, 9, 13, 14, 17, 20, 22, 42, 45; 47, 48, 49, 52, 54, 57, 63; Anderson/AR: 12, 18, 25, 47, 48, 49, 52, 54, 57, 63; Anderson/AR: 12, 18, 25, 40; 74, 48, 44; Hinz: 58; Amar/AR: 11, 15, 66; Nimatalla/AR: 58, Scala/AR: 8, 10, 26, 28, 30, 31;
- Initia and AR: 36; Scala/AR: 8, 10, 26, 28, 30, 31, 32, 33, 34, 35, 37, 51, 60, 61, 62, 64, 65; Copyright 1990 Antonio Quattrone: 27; Gerhard Reinhold,
- Leipzig-Mölkau: 67. Chapter 17 Harry N. Abrams, Inc.: 50; Alinari/AR: 3. 9, 11, 27, 28, 45, 46, 47; Anderson/AR: 31, 37; AR: 49, 55; Artothek: 64; British Architectural Library, RIBA, London: 10; Fototeca: 30, 33; HBJ Collection: 13 20: Phyllis Dearborn Massar: 51, 53, 54; NYPL 13, 20; Phyllis Dearborn Massar: 51, 53, 54; N111: 34; Nimatallah/AR: 14; 60 Nippon Television Corpo-ration: 26; R.M.N.: 4, 18, 21, 22, 59, 63; Rotkin/ P.F.I.: 29; Scala/AR: 1, 15, 16, 17, 19, 23, 24, 25, 35, 36, 39, 40, 41, 56, 57, 60, 61, 62, 65, 66, 67, 68; Edwin Smith: 48; Vanni/AR: 6.
- Edwin Smith: 48; Vanni/AK: 6. Chapter 18 ACL: 6, 7, 18, 19; Alinari/AR: 53; An-derson/AR: 45; ØArch. Phot. Paris/S.P.A.D.E.M.: 1, 24, 49; Artothek: 31, 40; Bildarchiv Preussischer Kulturbesitz: 38; Bulloz: 52; Giraudon/AR: 4, 34, 51; Hinz: 22; HBJ Collection: 23, 27, 50; Kavaler/AR: 43; MAS: 12, 20, 21, 54, 55, 56, 57, 58, 59; R.M.N.: 1, 24,

48, 49; Photo Verlag Gundermam, Würzburg; 28; Rheinisches Bildarchiv: 25; Scala/AR: 16, 17, 33, 34. Chapter 19 ACL: 39; Alinari/AR: 10, 13, 14, 25, 26, 49, hapter 19 ACL: 39; Alinati/AK: 10, 15, 14, 25, 26, 49; 72; Anderson/AR: 5, 16, 36; © Arch. Phot. Paris/ S.P.A.D.E.M.: 48, 71, 73; Artothek: 40, 41; Avery Architectural and Fine Arts Library, Columbia Uni-ter and the Arts Library and the Architectural and Fine Arts Elbrary, Columbia of versity, New York: 1; British Stationery Office: 74; © 1966, Henri Dauman. All rights reserved.: 68; Gab: 21; HBJ Collection: 19, 22, 67, 69; Hunter Gab: 21; HBJ Collection: 15, 22, 67, 65, HIIICH Aerofilms, London: 65; A. F. Kersting: 4, 64; G. E. Kidder-Smith: 18, 20; NYPL: 66; Novosti/Sovfoto: 50; MAS: 34, 38; R.M.N.: 28, 42, 44, 48, 57, 58, 60, 61, 71, 73; H. Roger-Viollet: 70; Rotkin/P.F.I.: 3; Scala/AR: 7, 8, 9, 12, 24, 27, 29, 31, 33, 45; Helga

Schmidt-Glassner: 63 Schmidt-Glassner: 00.
Chapter 20 ACL: 41; Alinari/AR: 14, 24; AR: 5; © Arch. Photo. Paris/S.P.A.D.E.M.: 3, 29; Photo Brit-ish Museum: 31; British Stationery Office: 2; HBJ Collection: 12, 15, 25; Hir: 18; Hunting Aerofilms: 38; A. F. Kersting: 16, 33, 36; Reproduced from the Collections of the Library of Congress: 43; NYPL: 11; Printing Services Collection (#NPS-2645), Spe-cial Collections Department, University Archives, University of Virginia Library: 44; R.M.N.: 4, 6, 29, 40; Rapho/PRI: 1; Royal Commission on the Histor-ical Monuments of England: 26; Scala/AR: 13, 20; Tate Gallery/AR: 46; Virginia State Library: 42.

Part V Opening illustration: Courtesy Jeremy Stone Gallery, San Francisco. Chapter 21 Alinari/AR: 2, 7; Wayne Andrews: 98; ©

- hapter 21 Alinari/AK: 2, 7; Wayne Andrews: 98; © Arch. Phot. Paris: 1, 8 (Moreau); Photograph © 1990 The Art Institute of Chicago. All rights re-served: 76, 80, 87, 92; Copyright 1990 ARS N.Y./ A.D.A.G.P.: 91; Copyright 1990 ARS N.Y./ S.P.A.D.E.M.: 54, 55, 56; Bulloz: 6, 15; Richard Cheek/The Preservation Society of Newport County: 9; Chicago Architectural Photography Co.: 97; French Government Tourist Office: 96; Gernsheim Collection, Harry Ransom Humanities Research Center, The University of Texas at Austin: Research Center, The University of Texas at Austin: 50, 53; Gir/AR: 12, 39; Hedrich-Blessing, Chicago: 99; HBJ Collection: 75, 95; A. F. Kersting; 5: Library of Congress: 64; MAS: 25, 26, 27; Mar/AR: 94; Mas-sachusetts General Hospital, News and Public Af-fairs, Boston: 34; Novosti/Sovfoto: 45; Brownlie/ PRI: 4; R.M.N.: 10, 11, 13, 14, 16, 18, 19, 37, 72, 85;
- PRI: 4; R.M.N.: 10, 11, 13, 14, 16, 18, 19, 37, 72, 88; The Royal Photographic Society, Bath, England: 35; Scala/AR: 65, 66; Staatliche Museen zu Berlin: 22; Tate Gallery/AR: 57, 58, 78. Chapter 22 Jörg P. Anders, Berlin: 28; George Roos? AR: 5; Copyright 1990 ARS N.Y./A.D.A.G.P.: 4, 7, 10, 16, 17, 25, 26, 30, 37, 45, 47, 52; Copyright 1990 ARS N.Y./S.P.A.D.E.M.: 6, 9, 11, 56, 57, 83; Copy-right 1990 ARS N.Y./S.P.A.D.E.M./A.D.A.G.P.: 34; Henri Cartier-Bresson/Magnum Photos, Inc: 74; Henri Cartier-Bresson/Magnum Photos, Inc. 74; Courtesy of the Center for Creative Photography, University of Arizona: 67; Chicago Architectural Photography Co.: 33, Photo by Geoffrey Clements, New York: 12; Courtesy of the Trustees of Dar-mouth College, Hanover, N.H.: 82; Copyright 1990 DEMART PRO ARTE/ARS N.Y.: 36; For more in-DEMART PRO ARTE/ARS N.Y.: 36; For more in-formation concerning Buckminster Fuller, please contact the Buckminster Fuller Institute, 1743 South La Cienega Blvd, Los Angeles, CA 90035: 63; @ Hans Hammarskiold: 76; HBJ Collection: 22, 58; Photo by David Headt 47; Lucien Hervé: 56, 57; Hinz: 7, 41, 50; William Lescaze and Associates: 62; Hinz: 7, 41, 50; William Lescaze and Associates: 62; Hinz: 7, 41, 50, William Lescaze and AssoCiates: 62, Library of Congress: 18; The Museum of Modern Art, New York: 1, 59, 61; The Museum of Modern Art/Film Stills Archive: 20, 33, 35, 77, 78, 79; MAS-3, 83; R.M.N.: 9; Photo by Sandak, Inc.: 80; Ezra Stoller © Eato: 55; Copyright 1990 SUCCESSION H. MATISSE/ARS N.Y.: 5; Tate Gallery/AR: 51;
- Stoller © Esto: 55; Copyright 1990 SUCCESSION H. MATISSE/ARS N.Y.: 5; Tate Gallery/AR: 51; Courtesy Donna Van Der Zee: 71.
 Chapter 23 Courtesy of Brooke Alexander, New York: 55; Photograph © 1990 The Art Institute of Chi-cago. All rights reserved: 25; Copyright 1990 ARS N.Y./ S.P.A. D. G. G.P.: 52; Copyright 1990 ARS N.Y./ S.P.A. D. E.M.: 9, 10, 22; Photo © Margaret Benyon: 47; Mel Bochner: 54; Rudolph Burckhardt: 24, 39; © Christo 1983/photo by Wolfgang Volz: 77; Photo by Geoffrey Clements: 64; Paula Court: 65; Electronic Arts. Intermix: 48, 49; Esto Photography: 21; Lee Fatherree: 1; Through the Flower Corporation: 71; David Gahr: 42; © Gianfranco Grogoni, New York: 76; Solomon R. Guggenheim Museum, New York/ Photo by Robert E. Mates: 7, 8; HBJ Collection: 2; Douglas Hollis: 79; Institut für Leichte Flachentrag-werke, Stuttgart: 19; G. E. Kidder-Smith: 10; Photo courtesy Barbara Kruger: 73; Photo courtesy Rich-ard Long: 78; Robert McElroy: 51; Middendorf Gal-lery, New York: 16; The Museum of Modern Art/ Film Stills Archive: 52, 66; Courtesy National Gal-lery of Canada/Experimental Film Office and Michael Snow: 53: @ 1990 Dolores Neuman: 80; Film Stills Archive: 52, 66; Courtesy National Gal-lery of Canada/Experimental Film Office and Michael Snow: 53; Ø 1990 Dolores Neuman: 80; Copyright 1990 Pollock-Krasner Foundation/ARS N.Y.: 1; Michel Proulx, Architectural Record: 61; George Holton/PRI: 9; Rapho/PRI: 43; Rheinische Bildarchiv, Cologne: 26; Copyright 1990 Kate Rothko-Prize and Christopher Rothko/ARS N.Y.: 24; Oscar Savio: 18; Photo by Steven Sloman: 14; Courtesy Holly Solomon Gallery, New York: 57; Coursest Complemed Callery, New York: 57; Courtesy Fronz Solonion Gallery, New York: 59, Artur Starewicz, Warsaw: 30, Bernice Steinbaum Gallery, New York: 72, Ezra Stoller © Esto: 17, James A. New York: 72 Ezra Stoller © Esto: 17, Janes A. Sugar, © National Geographic Society: 20, Tate Gallery/AR: 40; Venturi and Rauch: 60; Virginia Museum of Fine Arts: 41; © William Walker, 1970/ Photo courtes J. P. Weber: 69; Copyright 1990 The Estate and Foundation of Andy Warhol/ARS N.Y.: 40: Courtesy Westin Hotels: 62

Illustration Credits

- FIGS. 1-2, 1-3 From 'The Archeology of Lascaux Cave,' by Arlette Leroi-Gourhan. Copyright © 1982 by Scientific American. All rights reserved.
- FIGS. 2-3, 2-4 From Arlette Mellaart.
 FIGS. 2-3, 2-4 From Arlette Mellaart.
 FIG. 2-11 From E. S. Piggott, Ed., The Dawn of Civiliza-tion, London: Thames and Hudson, 1961, p. 70.
- tion, London: Inames and Fuddson, 1961, p. 70. FIG. 2-12 From H. Frankfort, The Art and Architecture of the Ancient Orient, Harmondsworth and Balti-more: Penquin, 1970, p. 69. FIG. 2-28 From © 1975 The Royal Institute of British Architects and the University of London, by per-mission of the Athlone Press.
- FIG. 2-29 From Sir Bannister Fletcher's A History of Ar-chitecture, 19th ed. Ed. John Musgrove, 1987. Plan H, p. 76. The Royal Institute of British Architects and the University of Letters
- H. p. 76. The Koyal institute of british Architects and the University of London.
 FIG. 3-4 Adapted from the "Later Canon" of Egyptian Art, figure 1 in Erwin Panofsky, Meaning in the Vis-ual Arts. Copyright © 1955 by Erwin Panofsky. Used by permission of Doubleday and Company, Inc.
- Inc. FIG. 3-7 From K. Lange and M. Hirmer, Ägypten, Ar-chitectur, Plastik, und Malerei in drei Jahrlausenden, Munich, 1957. Used by permission of Phaidon Press and Hirmer Fotoarchiv.
- rress and rimmer Potoarcinv. FIG. 3-8 From J. P. Lauer, La Pyramide à degrés: L'Ar-chitecture, 3 vols., Cairo, 1936–1939. FIGS. 3-21, 3-31, 5-27, 6-24, 6-49, 6-57a, 6-60, 7-48,
- GS. 3-21, 3-31, 5-27, 6-24, 6-49, 6-57a, 6-60, 7-46, 10-59 From Sir Bannister Fletcher, A History of Ar-chitecture on the Comparative Method, 17th ed., rev. by R. A. Cordingly, 1961. Used by permission of the Athlone Press of the University of London and the British Architectural Library, Royal Institute of British Architects, London,

- British Architects, London. FIGS. 4-6, 7-1, 7-8 Form Hirmer Fotoarchiv. FIGS. 5-23, 16-40 From Marvin Trachtenberg and Isa-belle Hyman, Architecture From Prehistory to Post-Modernism/The Western Tradition, Englewood Cliffs, NJ: Prentice Hall, 1986, p. 86, p. 293. Used by per-version
- mission.
 FIG. 554 From Sir Bannister Fletcher's A History of Ar-chitecture, 19th ed. Ed. John Musgrove, 1987. B&C elevations, p. 117. The Royal Institute of British Architects and the University of London.
 FIGS. 5549, 5509. 5592 From Richard Brilliant, Arts of the Ancient Greeks, 1973. Adapted by permission of MacGene Ull Back Co.
- McGraw-Hill Book Co.
- McGraw-Hill Book Co. FIG. 5-93 From J. Charbonneaux, et al., Hellenistic Art 330–50 B.C., 1973. Adapted by permission of George Braziller, Inc. FIG. 6-51 From The Architecture of the Roman Empire, J. FIG. 6-51 From The Architecture of the Roman Empire, J.
- Introductory Study, rev. ed. William L. MacDonald, New Haven and London: Yale University Press, 1982, Fig. 75. FIG. 6-53 From A Concise History of Western Architec-
- ture by Robert Furneaux Jordan, © 1969 by Harture by Robert Furneaux Jordan, © 1969 by Fadr-court Brace Jovanovich, Inc. Reproduced by per-mission of the publisher.FIG. 6-54 From J. B. Ward-Perkins, Roman Architec-ture, Adapted by permission of Electa Editrice,
- *ture.* Milan
- FIG. 6-81 From Deutsches Archäologisches Institut,
- FIG. 6-83 From Fiske Kimball, M. Arch, and G. H.
- FIG. 6-83 From Fiske Kimball, M. Arch, and G. H. Edgell, A History of Architecture, 1918. Used by per-mission of Harper & Row, Inc., publishers. FIG. 6-87 After George M. A. Hanfamann, Roman Art: A Survey of the Art of Imperial Rome. A New York Graphic Society Book. By permission of Little, Brown and Co.
- Brown and Co. FIGS. 7-6, 9-4, 9-17 From Kenneth J. Conant, Early Medieval Church Architecture. Used by permission o
- The John Hopkins Press. FIGS. 7-63, 7-70 From K. A. C. Creswell, Early Muslim Architecture. Adapted by permission of Clarendon Press/Oxford University Press.
 FIG. 7-65 From G. Marçais, L'Architecture Musulmane
- d'Occident. By permission of Arts et Metiers Graphiques, Paris. FIG. 7-72 Staatliche Museen zu Berlin.
- FIG. 7-72 Staatliche Museen zu Berlin.
 FIG. 7-81 Plan drawn by Christopher Woodward.
 FIG. 7-83 From "Sinan" by D. Kuban from Macmillan Encyclopedia of Architects, Adolf K. Placzek, Editor-in-Chief, Vol. 4 p. 68, © 1982 by the Free Press, a division of Macmillan, Inc.
 FIGS. 9-2, 16-16 From H. Stierlin, Die Architektur der Meth. Vol. 1, p. 147, p. 188. © 1977 Hirnter Verlag.
- Welt, Vol 1, p. 147, p. 188, © 1977 Hirmer Verlag,
- Munich. Munich. FIGS. 10-4, 10-5, 10-6 From Ernst Gall, Gotische Kathedralen, 1925. Used by permission of Klinkhardt & Biermann, publishers. FIG. 10-19 Used by permission of Umschau Verlag,
- Frankfort
- FIG. 11-8 From Benjamin Rowland, *The Art and Architecture of India*, 1953, Penquin Books. FIG. 11-29 From Madeleine Giteau, *The Civilization of*
- Angkor. Adapted by permission of Rizzoli Interna-tional Publications.
- FIG. 12-29 From William Watson, Art of Dynastic China, 1981. Used by permission of Harry N. Abrams, Inc.
- Abrams, Inc. FIG. 14-22 From 'The Serpent Mound of Adams County, Ohio' by Charles C. Willoughby from Art and Archaeology, IV, 6, © 1916. Reproduced by per-mission of the Archaeological Institute of America. FIG. 16-43 From Nikolaus Pevsner, An Outline of Euro-pean Architecture, 6th ed., 1960, Penguin Books, 1042 1060 1963.

Ltd., © Nikolaus Pevsner, 1943, 1960, 1963. FIG. 19-23 Christian Norberg-Schulz, Baroque Architec

ture, 1971. Used by permission of Harry N. Abrams, Inc.

INDEX

Page numbers in italics indicate illustrations.

- A
- Abakanowicz, Magdalena, 1052-53; Backs, 1053,
- Abbasids (Iraq), 299, 305 Abbey church of St. Michael, Hildesheim, West Germany, 339-41, 339-41
- Abbey, Deward, 975 Abelam cult sculptures, 544 Abraham and the Three Angels (Psalter of St. Louis), 404-406, 405

- Abstract art, development of, 865 Abstract Expressionism, 1032–36 Abstract figuration, 987–92 Abstract symbolism, 992–98; in Neolithic art, 45–
- Abstraction: and intuition, 561–62; in modern art, 983–98; in native arts, 501–502; representation and, 32
- Abu, sculpture of head of, 52, 52
- Abu Simple, 90–91 Abu Temple, 51–52; statuettes from, 51, 52 Achaeans, 320
- Achaeans', 320 Achaemenid Persia: architecture of, 66–68; craft art in, 69–71; Greek (Ionian) influence on art of, 69, 71; influence of Assyrian style in craft art of, 71; sculpture of, 68–69 Acropolis, Athens, 127, 134, 139–40, 153–61; plan of, 153; restoration model of, 154 Acroterium figures, 193 Action Painting, 1032–36 Activist art, 1082–89 Actor of the Ichikawa clan (Torii Kiyotada), 495, 495

- 495

- Adam and Eve Reproached by the Lord, St. Michael's, Hildesheim, 341, 341
 Adam, Robert, 846, 851; Etruscan Room, Osterley Park House, 846, 851; Etruscan Room, Osterley Park House, 846, 847
 Adams, Ansel, 1012; Monolith: The Face of Half Dome, Yosemite Valley, California, 1012, 1012
 Adamson, Robert, 895–96; Sandy Linton and His Boat and Bairns (with Hill), 895–96, 895
 Addorsed lions, 428, 428
 Adena pipe, 527, 527
 Admonitions of the Instructress to the Court Ladies (Ku K'ai-chih), 458, 458
 Adorstion of the Magi (Gentile da Fabriano), 598– 99, 598

- 99, 598
- Adoration of the Magi, Santa Maria, Tahull, 373, 373 Adoration of the Shepherds (La Tour), 799–800, 799 Adoration of the Shepherds (Hugo van der Goes), 710–11, 711
- Aegean art, 106–107; Early Minoan (pre-Palace) period in, 107–108; Late Minoan period in, 109– 18; Middle Minoan period in, 108–109. See also Cycladic civilization, Helladic civilization, Mi-noan civilization Aeolic capitals, 189–90 Africa, native arts of, 534–42. See also individual cultures

- cultures

- Age of Enlightenment, 818–19, 837–43, 866 Age of Justinian. See Byzantine art Age of Reason, 557, 837. See also Age of Enlightenment

- enment "Age of sensibility," 831-32 Agesander, 176; Head of Odysseus, 176-77, 177; Laocoön group, 176, 176; Ödysseus' Helmsman Falling, 176, 177 Agora, 127, 181 Agricultural symbolism, 44 Ajanta, India, 438-40, 439 Akhenaton, and Amarna period in Egypt, 96-99, 128

- 128

- Akhenaton, Karnak, 97, 97 Akkad, 47, 59, 65; god-kings of, 60 Al-Hiba, 47
- Al-Khazneh (the Treasury), Petra, 242–43, 243 Alain, cartoon, 18
- Albers, Josef, 13 Albers, Josef, 13 Alberti, Leon Battista, 590, 605, 608, 609–13, 640, 753; Palazzo Rucellai, Florence, 609–10, 609; San Francesco, Rimini, 610–11, 611; Sant' An-drea, Mantua, 611–12, 611, 612, 753; Santa Maria Novella, Florence, 610, 610

Albinus, Bernard Siegfried, 838; Plate IV, Ana-tomical Table of the Human Muscles, 838, 838

Henry II, 343, 345 Anthemius of Tralles, 284; Hagia Sophia, 284 Anthropology, classification of native arts and, 500–501

Antikythera Youth, Antikythera, 169, 169 Antikythera Youth, Antikythera, 169, 169 Antiquities of Athens (Stuart and Revett), 845 Antonello da Messina, 631; The Martyrdom of St. Sebastian, 631, 631 Antonius, 216 Antonius Pius, 235 Anadamo of polece at Recentling (C. 7, 6)

Antonius Pius, 235 Apadana of palace at Persepolis, 66–67, 68 Aphrodite of Chidos, North Africa, 167, 167 Aphrodite of Melos (Venus de Milo), 177–78, 178 Apocalypse series (Dürer), 726–27, 727 Apocalypse of St. Sever, 376, 376 Apollinarie, Guillaume, 959 Apollinaris, church of, 274–75, 274–75, 276 Apollo, 151, 152, 176 Apollo, 151, 152, 152

Apollo (Temple of Zeus at Olympia), 7, 152, 152, 193

Apollo Attended by the Nymphs (Girardon), 812, 812 Apollo Belvedere, 727 Apollodorus of Damascus, 222, 224, 234 Apollonius, 179; Seated Boxer, 179, 179

Apotheosis of the Pisani Family, The (Tiepolo), 828, Apoxyomenos (Lysippos), 168–69, 173 Apse, 259, 279; in Early Medieval architecture, 336–37, 339 Apse vault, 281 Aqa Mirak, 312; Laila and Majnun at School, 313, 313

Aquatint, 969 Aqueducts, 218 Aquitaine, Romanesque architecture of, 361 Ara Pacis Augustae, Rome, 231, 231, 236 Arcade: in Florence Cathedral, 417; in High Gothic architecture, 392 Arcadia, 212 Arcadia, 212

Arcadia, 212
Arcadianism, 681–83, 684
Arch, 15, 83; corbeled, 15; diaphragm, 361; double-tiered, 302; masonry, 188; pointed, 302
Arch of Constantine, Rome, 232, 249–51, 249, 250, 255, 268, 335–36
Arch of Titus, Rome, 232, 232
Archaic Doric architecture, 142–44
Archaic noricd, architecture, 142–44

Archaic period: architectural sculpture in, 147-48;

in Greek art, 128–48 Archaic style (in ancient Greece), 128–48 Archbishop Theodore, 282; sarcophagus of, 271,

Archers of St. Aaruar (traus), 107, 107 Arches, squinches and, 288 Architectural illusionism. See Illusionism Architectural orders, 222. See also Composite order, Corinthian order, Doric order, Ionic

Architectural ornamentation, Islamic, 304–308 Architectural sculpture: Etruscan, 193; Gothic, 400–402, 413–14; Greek, 146–48; Romanesque,

Architectural style, in wall painting, 206-209,

206, 207 Architecture: Achaemenid Persian, 66–68; ar-cuated, 241–42, 243; Art Nouveau, 954–55; Assyrian, 59–61; Baroque, 752–56, 761–65, 805– 11, 814–15, 819–20; basic structures in, 15; Bud-dhist, 473, 473; Byzantine, 272–74, 278–79, 281, 284–90, Carolingian, 334–38; Chinese, 471–73; 471–73; comparison of Gothic and Roman, 382– 84; compression in 1046; De Stiil 1003–1005;

471–73; comparison of Gothic and Roman, 382– 84; compression in, 1046; *De Stijl*, 1003–1005; Deconstructionist, 1079–81; development of pendentive construction in, 285; early Chris-tian, 258–62; early surface ornamentation in, 64–65; Egyptian, 67, 78–83, 89–94; of Elam, 65– 66; Etruscan, 188–90; flamboyant style in, 407; formalist abstractionist, 1044–47; Geometric and Archaic Greek, 139–46; Gothic period in, 381–88, 390–400; Gothicism in, 694; Hellenistic Greek, 180–84; High Classical Greek, 153–61; Incan, 524–25; International Style in, 1006, 1044–47, 1077; Islamic, 299–309; Japanese, 477– 78, 480, 490, 497; Late Baroque and Rococo, 826–28, 830–31, 844–47; Late Classical Greek,

1119

Archers of St. Adrian (Hals), 789, 789

Apollo, Veii, 193, 193

Apologia, 268-69

Aquatint, 969

271

order

362 - 72

206. 207

- Alchemy, 715-16
- Alchemy, 715–16 Alexander the Great, 66, 184, 421 Alhambra, Granada, Spain, 306–307, 306, 307, 743–44, 743 Allegory of Africa, Piazza Armerina, Sicily, 244, 245 Altar of the Augustan Peace, Rome, 231, 231 Altar of the Hand (Benin), Nigeria, 536, 536 Altar screens (retables), 718 Altar of the Virgin Mary, Kraców, Poland, 718– 20, 719

- 20, 719
- Altar of Zeus and Athena, Pergamon, 175-76, 175. 212
- Altarpiece of the Holy Sacrament (Bouts), 709–10, 709
- Altdorfer, Albrecht, 723; The Battle of Issus, 722, 723; Danube Landscape, Near Regensburg, 723 Alternate-support system, 361; in church design, 340–41; in Laon Cathedral, 385–86; in Roman-esque architecture, 354, 357, 358 Amalienburg, Nymphenburg Park, Munich (Cu-villiés), 827–28, 827, 828

- Amaravati, India, 436
 Ambulatory, 260–61, 279
 Ambulatory, 260–61, 279
 Ambulatory of St. Denis, 382–84, 382, 383
 Amen, cult of, 96
 Amen-Re, temple of, 92–93, 92, 93
 Amenenhet, tomb of, 87–88, 88
 Amenophis III, 96
 Amenophis IV. See Akhenaton
 Amenophis IV. See Akhenaton
 Amida Triad, The, (Shrine of Lady Tachibana), Japan, 478–79, 479
 Amiens Cathedral, 394–96, 395, 396
 Amorous Couple, Karli, 431, 431
 Amorous Couple, Karli, 431, 431
 Amorous Couple, Karli, 420, 512
 Amphiprostyle temple, 140
 Amphitheater, 221

- Amphiprostyle temple, 140 Amphitheater, 221 Amphora, 131, 131 Analytic Cubism, 959–62 Anamorphic image, 731 Anatolia, 58, 107, 299, 309 Anatomy of a Kimono (Schapiro), 1086–87, 1086 Ancestral figure, Kongo, Zaire, 539, 539 Ancestral poles, Asmat, New Guinea, 545–46, 546 546
- Ancient of Days (Blake), 856–57, 856 Anatomical Table of the Human Muscles, Plate IV (Albinus), 838, 838
- Anderson, Laurie, 1080–81; United States Part II, 1080, 1081
- Andokides Painter, 132–33, 165; Herakles and Apollo Struggling for the Tripod, 133, 133 Andrea del Castagno, 601, 602–603; Pippo Spano, 602–603, 602; The Last Supper, 602, 602 Andrea del Sarto, 665–66; Madonna of the Harpies, 665–66 665
- 665-66, 665
- Anduradhapura, Sri Lanka, 441–42 Angel Appearing to Joseph, The, Castelseprio, Italy, 291, 291
- Angelico, Fra, 606–607; Annunciation, 606–607, 607

- Angibert II, 333 Angkor site, Cambodia, 444, 445 Angkor Thom, Cambodia, 445–47, 446, 447 Angkor Wat, Cambodia, 444, 445
- Angles, 240

566, 567

- Angles, 240
 Anguissola, Sofonisba, 671–72, 694; Portrait of the Artist's Sisters and Brother (detail), 671, 671
 Animal caricatures (Japanese art), 482–83, 482
 Animal style in Early Medieval art, 321–23
 Animal-man deity, 504
 Animals: associated with fertility cults, 43; representation of in ancient art, 53–55; in Shang dynasty art, 451; totemistic use of in art, 366–67
- Annunciation (Fra Angelico), 606–607, 607 Annunciation, The (Martini), 575–76, 575 Annunciation, The, Reims Cathedral, 401, 401, 402

Annunciation, Legend of the True Cross (Piero della Francesca), 605–606, 605 Annunciation and the Nativity, The, Pisa Cathedral (Giovanni Pisano), 563, 563 Annunciation of the Death of Mary, The (Duccio), 566 567

Annunciation to the Shepherds, The, Lectionary of

Architecture (continued)
170–72; Late Minoan, 109–11; late nineteenth-century, 945–49; Mannerism in, 673–75; of mass, 228; Maya, 509–11, 515–16; Median, 67; Neoclassicism in, 832, 846–47, 851–53; organic abstraction in, 1036–39; organic movement in, 1036–39; Ottoman, 309–11; Ottonian, 339–41; Palladian Classicism in, 819–21; perpendicular style of, 410; plan in, 14; Postmodern, 1076–79; program in, 15; rayonnant style in, 397–400, 407; relationship of to sculpture, 362; Renais-sance Italian, 592–97, 609–13, 640–44, 658–64, 673–75, 676–79; in Roman Empire, 217–30, 240– 44, 247; in Roman republic, 200–205; Roman-esque, 349–61; Romantic Gothic, 844–45, 868– 69; section in, 14; of space, 228, 247; space-molding agents in, 226; specialized terms in, 14–15; Sumerian, 48–50; Teotihuacán, 506–507; Tiahuanaco, 523–24, 523; timber-frame con-struction in, 334–35, 334; Toltec, 516; trabeated, 241, 242; use of iron and steel in, 945, 946–47; utopian, 998–1009. See also City planning
Archuitat, Felipe, 1053–54; Baboon, 1053–54, 1054
Arcuated architecture, 241–42, 242
Area, concept of, 8

Area, concept of, 8 Area, concept of, 8 Arena Chapel, Padua, 569–72, 570, 571, 574 Argonaut Krater, Orvieto (Niobid Painter), 164–65, 165

- Arnhem Land, Australia, 2, 547
 Arnolfo di Cambio, 415
 Arp, Jean (Hans), 977–78, 985–86, 1039; Human Concretion, 985–86, 986; Squares Arranged According to the Laws of Chance, 977–78, 977
 Arrisos 142
- Arrises, 142 Arrival of Marie de' Medici at Marseilles (Rubens), 783-84, 784

- Arrival of Marie de' Medici at Marseilles (Rubens), 783–84, 784
 Ars de geometria, 404
 Art: abstract, 953; abstraction in, 32, 501–502; activism in, 1023–26; artifact and, 501; chronology of, 4–5; Classicism in, 246, 831–32; conventionalization in, 52–53; conventions in, 19; declassicizing style in, 246; developments in, 4; evolution of symbolic from pictorial, 37; form in, 4, 1031; formalism in, 53, 954–67, 1032–49; historical context of, 7; historical period of, 3; historical context of, 7; historical period of, 3; historigraphy of, 3–4 17; idealism in, 249–51; idealization in, 169–70; illusionism in, 211–12; modern, 865; Modernism in, 953; Modernist Formalist, 957–67; naturalism in, 116, 195, 255, 263–64, 294, 832–36, 891; naturalization in, 169–70; nonobjective, 953; personal vision in, 19; place of origin of, 5–6; Postmodernist, 968; provincial, 349; psychological and conceptual concerns in, 940–45, 955, 967–98, 1050–81; purpose of, 5; realism in, 45–46, 174–75, 230–31, 235–36, 249–51, 345, 493–94, 889–91, 896–911; representation in, 17–19, 52–53; representation of nature in, 400; rhythm in, 1031; social and political concerns in, 954, 998–1027, 1081–93; social realism in (People's Republic of China), 470–71; style of, 3–4; symbolism in, 45–46, 987–98; technology and, 1062–69; Tradition in, 855–66; union of formal and natural in, 53–55; verism in, 19 in, 198 Art Nouveau, 954–56, 990, 1001 Artaxerxes II, palace of, 67, 67

 - Artemis Brauronia, 159
- Artemis Brauronia, 159 Artifacts, native arts defined as, 501 Artist, place of, in art history, 6 Artist place of, in art history, 6 Artistic concepts, explanation of, 7–14 Artis: plastic, 7–14; temporal, 7 "Arts and Crafts" movement, 954 Arts and Crafts, Weimar School of, 1005 Asam, Cosmas Damian, 831 Asam, Egid Quirin, 831; Assumption of the Virgin, 831, 831 Ascension of Christ and the Mission of the Anostles

- Asternative Section of the Mission of the Apostles, The, La Madeleine, Vézelay, 370–71, 370
 Ashanti, culture and art of, 542
 Ashlaga period (Japanese art), 485–88
 Ashlar construction, 525
 Ashlar masonry, 222
 Ashur, god of Assyria, 61, 61
 Ashurnasirpal II, of Assyria, 61–62
 Ashurnasirpal II at War, Nimrud, 61, 61
 Ashurnasirpal II at War, Nimrud, 61, 62
 Asklepios, sanctuary of, 172
 Asmat, native arts of, 544, 546, 546
 Assumption of the Virgin (Egid Quirin Asam), 831, 831 831

- Assumption of the Virgin, The, from the Creglingen Altarpiece (Riemenschneider), 720, 720 Assyria: architecture in, 59–61; Ashur as god of, 61, 61; formality of art in, 61–62; garrison state of, 59; political structure in, 59; relief as a n, 61–63
- Asuka period (Japanese art), 478 At the Moulin Rouge (Toulouse-Lautrec), 939–40, 939
- Atget, Jean Eugène Auguste, 980-81; Avenue des

- Atget, Jean Eugène Auguste, 980–81; Avenue des Gobelins, 981, 981
 Athena Taking Young Alcyoneos by the Hair, Pergamon, 175–76, 175
 Athenodoros, 176; Head of Odysseus, 176–77, 177; Laocoön group, 176, 176; Odysseus' Helmsman Falling, 177
 Athens, 131, 166; development of democracy in, 127; influence of, 127; role of in repulsing Persians, 153; sculpture of, 162. See also Acropolis Athlete (Lysippos?), 169, 169
 Atrium, 182, 205, 206; of Old St. Peter's, 259
 Atrium of the House of the Silver Wedding, Pompei, 206, 206
 Attalid kings, 183–84
 Attic, 232

- Attic, 232
- Attic vase shapes, 131, 131 Audubon, John James, 890–91; Gyrfalcon, 891,

Augustus of Primaporta, 230, 230 Aula, 223, 223 Aula Palatina, Trier, 243–44, 244

- Aula Palatina, Trier, 243–44, 244 Aureir, Albert, 940 Aurier, Albert, 940 Aurignacian period, 28 *Aurora* (Il Guercino), 768, 768 Australia, native arts of, 547–48, 548 Automatism, 977–78 Autumn Mountains (Tung Ch'i–ch'ang), 468 Avatar, 433n Avebury, megalithic structures at, 38–39 Avenue of the Dead, Teotihuacán, 506, 506 Avenue des Gobelins (Atget), 981, 981 Avignon Pietà, The (Quarton), 717–18, 717 Avfu, 310

- Avlu, 310
- Axis, concept of, 10 Azor-Sadoch lunette (Michelangelo), 657, 657 Aztec culture and art, 516–18, 517, 518

В

- Baalbek, Syria, 845, 846
- Daaldek, Syria, 845, 846 Baboon, (Archuleta), 1053–54, 1054 Babylon, 47, 65 Babylonia, 59; destruction by Hittites, 58; Ham-murabi and, 57–58; unification of, 57–58. See also Neo-Babylonia
- also Neo-Babylonia Backs (Abakanowicz), 1053, 1053 Bacon, Francis, 1051–52; Study After Velásquez's Painting of Pope Innocent X, 1052, 1052 Bacon, Roger, 561–62, 589 Bahr, Hermann, 953 Bahr, Hermann, 953

- Baldassare Castiglione (Raphael), 649, 649 Baldinucci, Filippo, 794 Ballet Rehearsal (Adagio) (Degas), 926–27, 927 Balzac (Rodin), 913, 913 Bamberg Rider, Bamberg Cathedral, 414–15, 414, 591 591

- Bamboo (Wu Chen), 466, 467 Bangwa, Cameroon, 538–39, 538 "Banquet Scene" from Tomb of the Diver, Paes-
- Banqueto Scele Holn Folino of the Diver, Fues-tum, 164, 164
 Banqueting House at Whitehall, London (Jones), 813–14, 813
 Bar at the Folies-Bergère (Manet), 921–22, 922
 Barbieri, Giovalno Goo 2000
 See II Guercino

- Barbieri, Giovanni Francesco. See II Guercino Barbizon school, 899–900
 Bare Willows and Distant Mountains (Ma Yuan), 464
 Bark cloth (tapa), 542
 Barlach, Ernst, 972; Head (study for War Monu-ment), 972, 973; War Monument, 972, 972
 Baroque culture and art, 750–72; Classicism in, 751; English, 812–15; French, 798–812; Italian, 752–75; Netherlandish, 780–86; revived in nineteenth century, 870–71; science in, 750; Spanish, 775–80; use of light in, 750–51
 Barrel vault, 59, 224–25; longitudinal, 350; in Romanesque architecture, 352

- Barrel-vaulted corridor, 260 Barrel, Charles, 869; Houses of Parliament, Lon-don (with Pugin), 869, 869 Bartolommeo Colleoni (Verrocchio), 616–17, 617
- Barye, Antoine Louis, 870; Jaguar Devouring a Hare, 870, 870 Bas-relief, concept of, 15

247

1052

India, 439, 439

Benedictine Rule, 336

- Basalt, 504 Base, 141 Basilica, Pompeii, 204
- Basilica, Pompeli, 204
 Basilica: Constantinian, 259; early Christian designs of, 259–62; in Roman Empire, 222–23; and Western church architecture, 336
 "Basilica" at Paestum, 142–44, 143, 144
 Basilica of Constantine, Rome, 246–47, 246, 259, 612
- 612
- 612
 Basilica Ulpia, Rome, 222–23, 223, 259
 Basin of San Marco from San Giorgio Maggiore (Canaletto), 833, 833
 Bath, The (Cassatt), 929, 929
 Bather (Lipchitz), 961–62, 961
 Bathers (Picasso), 9, 9
 Baths of Caracalla, Rome, 228–30, 229, 230, 243, 247

247 Baths of Neptune, Ostia, 214–15, 214 Baths of Trajan, Rome, 225–26 Battle Between Romans and Barbarians, Ludovisi Bat-tle Sarcophagus, 267, 267 Battle of the Gods and Giants, Treasury of the Siph-nians, 146, 146 Battle of Issus, 66 Battle of Issus, House of the Faun, Pompeii, 212, 213–14, 213 Battle of Issus, The (Altdorfer), 722, 723

Battle of Issus, The (Altdorfer), 722, 723 Battle of San Romano (Uccello), 601, 601 Battle of the Ten Nudes (Pollaiuolo), 618–19, 619 Battleship Potemkin (Eisenstein), 1016, 1020, 1021,

1052 Baudelaire, Charles, 714, 877 Bauhaus, Dessau, West Germany (Gropius), 1005–1006, 1006; school, 1005–1008 Baule culture and art, 541–42, 541 Bay Area Figurative Painters, 1034–35 Bay, development of, 334–35 Bay, development of, 334–35 Bay system, Romanesque, 386–87 *Bayeux Tapestry*, 372–73, 372 Bayon, Angkor Thom, 445–46, 446, 447 *Beautiful Bodhisattva Padmapani*, Cave I, Ajanta, India 439, 439

India, 439, 439 Beauvais Cathedral, France, 399–400, 399, 406 Beckmann, Max, 972–73; Departure, 973–74, 973 Beehive tombs, 120–21, 120, 260 Behnisch, Günter, 1079; Hysolar Institute Build-ing (University of Stuttgart), 1079, 1079 Belize, pre-Columbian art of, 503, 509n. See also Maya civilization Bell, Larry, 1064; Homage to Griffin, 1064, 1064 Bellerophon, 194 Bellini, Giovanni, 679–83, 685, 726; Feast of the

Bellerophon, 194 Bellini, Giovanni, 679–83, 685, 726; Feast of the Gods, The, 681–82, 682; Madonna of the Trees, 680, 680; San Giobbe Altarpiece, 680–81, 681; San Zaccaria Altarpiece, 680, 681 Belleville Breviary (Pucelle), 697, 698 Ben-ben fetish, 81 Renedicting Rulo, 226

Benedictine Rule, 336 Beni Hasan, rock-cut tombs at, 87–88, 87, 88, 190 Benin, Nigeria, 535–36 Benyon, Margaret, 1066–67; Tigirl, 1066–67, 1067 Bergson, Henri, 968 Berlinghieri, Bonaventura, 565; St. Francis Altar-picce, 564, 565 Bernard of Clairvaux, 362, 382 Bernardus Gelduinus, 362–63; Christ in Majesty, 362–63; 362

Bernardus Gelduinus, 362–63; Christ in Majesiy, 362–63; 362
Bernini, Gianlorenzo, 755–61, 806; baldacchino for St. Peter's, 756–58, 756; Cathedra Petri, St. Peter's, Rome, 755, 757; David, 758, 758; plan of St. Peter's, Rome, 755, 755; Scala Regia, the Vatican, 755–56, 755; The Ecstasy of St. Theresa, 758–60, 760; Triton Fountain, Rome, 761, 761
Bertoldo di Giovanni, 650

60, 760; Inton Fountain, Rome, 761, 761
Bertoldo di Giovanni, 650
Betrayal of Jesus, The (Duccio), 566–67, 566, 571
Beuys, Joseph, 1087–88; Iphigenia/Titus Andronicus, 1087–88, 1088
Bhakti, 431
Bibliothèque Ste. Geneviève, Paris (Labrouste), 945–46, 946
Pirade Aforma (De Sicc), 1082, 1082

Bird-Jaguar Taking a Prisoner (Maya), Mexico, 511– 12, 511

12, 511 Birds of North America (Audubon), 891, 891 Birth of Venus (Botticelli), 10, 623–24, 624 Birth of the Virgin, The (Ghirlandaio), 620–21, 620 Birth of the Virgin, The (Lorenzetti), 576, 577 Bison with Superposed Arrows, Ariège, 32 Bison, Tuc d'Audoubert, 35, 35 Bison with Turned Head, Lascaux, 34, 35 Black Anna, 969

Bicycle Thieves (De Sica), 1082, 1082 Bicycle Wheel (Duchamp), 975, 975 Bihzad, 312 Bird in Space (Brancusi), 990, 990

Canon of Polykleitos, 11 Canopic urn, Chiusi, 192, 192 Canova, Antonio, 867–68; Pauline Borghese as Venus, 867–68, 867 Cantierbury Psalter, 376–77, 376

Cantilever, 15 Capital, 141, 143 Capitals, 367–68, 367; Aeolic, 189–90 Capitol, Washington, D.C. (Latrobe), 852, 853 Capitoline Hill, Rome, 194, 239, 660–62, 660, 661 Caprichos, Los (Goya), 857, 857 Caracalla, 239, 239 Caracol, The, observatory, Chichén Itzá, 515–16, 515

Caradosso, Christoforo Foppa, 641; commemorative medal; 641
 Caravaggio, 769–71, 789, 790; Death of the Virgin, 770–71, 770; The Conversion of St. Paul, 769–70, 769

Carnac, megalithic structures at, 38 Carolingian period: architecture in, 334–38; craft art in, 332–34; in Early Medieval art, 330–38; painting and illumination in, 330–32 **Carpeaux, Jean Baptiste**, 918–19; Ugolino and His Children, 918–19, 919 Carpet-making, Islamic, 311–12 **Carracci, Agostino**, 766 **Carracci, Annibale**, 766, 772–73, 803; ceiling of Palazzo Farnese, Rome, 766, 767; Flight into Egypt, 772–73, 772 **Carracci Lodovico**, 766

Carriera, Rosalba, 833–34; Cardinal de Polignac, 834, 834

Carrying of the Cross, The (Bosch), 712–13, 713 Carson, Pirie, Scott building, Chicago (Sullivan), 949, 949

Carte de visite photographs, 910–11 Cartier-Bresson, Henri, 1016–17; Seville, Spain,

Cartier-Bresson, Henri, 1016–17; Seville, Spain, 1017, 1017 Cartooning, in Japanese art, 482 Caryatids, 142, 145–46, 146 Casa Milá, Barcelona (Gaudí), 955, 956 Cassatt, Mary, 840, 929; The Bath, 929, 929 Castelseprio, art of, 291 Castrum, 218–19 Catacomb of Callixtus, Rome, 256 Catacomb of Saints Pietro and Marcellino, Rome, 256–57, 257

Catacombs, The, Rome, 256–58, 256, 257 Catal Hüyük, 42, 56; fertility and agricultural symbolism in, 44–45; landscape painting in, 45; mother goddess statuettes in, 44, 44; shrines of,

mother goddess statuettes in, 44, 44; shrines ot, 44, 44; town plan of, 43–44, 44 Cathedra Petri, St. Peter's (Bernini), 757–58, 757 Cathedral of the Annunication, the Kremlin, Moscow, 290, 290 Cathedral design. See Church design Cavallini, Pietro, 567–68; Seated Apostles, 567, 567 Cave painting: abstraction in, 32; in France, 28– 30; purpose and function of, 30–33; representa-tion of human figure in, 33–34; in Spain, 28

30; purpose and runction of, 50–35; representa-tion of human figure in, 33–34; in Spain, 28 Cave sculpture, 34–36 Cave temples, 434; of India, 429 Ceiling painting, 773–77 Celadon glaze, 465 Cellae, 189, 200 Callini Bergranuth, 672; Diago of Fautainellau

Cellini, Benvenuto, 672; Diana of Fontainebleau,

Centaurs, 151, 158 Centraing, 225 Centralized quatrefoil mosque, 309 Ceramics: Chinese, 465–66, 465, 467, 468–69, 469; Colima, 505; Nascan, 522 Ceremonial ax (Olmec), 505 Cerveteri (ancient Caere), 189–90; necropolis at, 190, 190

190, 190 Ceylon. See Sri Lanka Cézanne, Paul, 211, 881, 933–35, 956; Boy in a Red Vest, 935, 935; La Montagne Sainte-Victoire, 933, 934; Still Life with Peppermint Bottle, 934–35, 934 Chacmool figures, 991, 991n Chagall, Marc, 988; The Falling Angel, 988, 988 Chaitus 429

Chaitya, 429 Chaitya, 429 Chaitya hall, Karli, 430–31, 430, 431 Chaitya hall, Karli, 430–31, 430, 431 Chaitya dynasty, India, 437 Chamfered edges, 90 Chandigarh, India (Le Corbusier), 1003

Chandis (temples), 442

256-57, 257

672, 672

Celtic art, 325-30

Celtic crosses, 329–30, 330 Centaurs, 151, 158

Carceri 14 (Piranesi), 853–54, 854 Cardinal de Polignac (Carriera), 834, 834 Cardinal (Manzù), 1050–51, 1050 Cardo, 219

Carnac, megalithic structures at, 38

Cantilever, 15

- Black-figure technique of vase painting, 131–32 Blake, William, 856–57, 985; Ancient of Days, 856– 57, 856
- Blenheim Palace, Oxfordshire (Vanbrugh), 819-20, 820
- Blessed Art Thou Among Women (Käsebier), 918, 918
- 918 Blinding of Polyphemus, The, Eleusis, 130–31, 130 Bloodletting, 509 Blue Light (Riefenstahl), 1020 Blue Rider group (Die Blaue Reiter), 993 Bluestones, 38–39 Boar Avatar of Vishnu, Cave V, Udayagiri, India, 433 433

- 433, 433
- Boccioni, Umberto, 965-66; Unique Forms of Conti-
- Josefond, Omberto, 965–66; Unique Forms of Continuity in Space, 966, 966
 Bochner, Mel, 1072–73; Theory of Sculpture: Counting, 1073; Triangular and Square Numbers, 1073, 1073
- Bodhisattvas, 431 Bodmer, Karl, 533; Mandan Chief Mato-Tope, 533,
- Boethos, 179; Boy Strangling a Goose, 178–79, 179 Boffrand, Germain, 822; Salon de la Princesse, Hôtel de Soubise, Paris, 822, 822 Boghazköy, Turkey, 58, 64–65 Bolivia, pre-Columbian cultures and art of, 523– 24
- 24

- Bolognese academy, 766 Bonampak, Mexico, 512–13, 513 **Bonheur, Rosa**, 900, 906; *The Horse Fair*, 900, 900 Book of Lindisfarne, Northumberland, England, 326–28, 327, 329 Book of the Dead 102

- Book of the Dead, 102 Borgia, Cesare, 640 Borgia Codex (Mixtec), 514, 515
- Borobudur, Java, 442 Borrachos, Los (The Drinkers) (Velázquez), 776–77,
- Borromini, Francesco, 761-63, 830; Chapel of St. Ivo, 762–63, 763; San Carlo alle Quattro Fon-tane, 761–62, 762
- Bosch, Hieronymus, 712–16, 942; The Carrying of the Cross, 712–13, 713; The Garden of Earthly De-lights, 713–16, 713–15

Boscotrecase villa, Pompeii, 209, 209

- Botarical Specimen (Talbot), 894, 895 Botarical Specimen (Talbot), 894, 895 Botticelli, Sandro, 622–25, 914; Birth of Venus, 623–24, 624; Portrait of a Young Man, 622–23, 622 Boucher, François, 825; Cupid a Captive, 825, 825
- Bouguerer, François, 825; Cupid a Capitve, 825, 825
 Bouguereau, Adolphe William, 915; Nymphs and Satyr, 915, 916
 Bouleuterion of Miletus, 181–82, 182
 Bound Slave, The (Michelangelo), 652–53, 653
 Bound Slave, Unifinished (Michelangelo), 17
 Bourgeois, Louise, 1039–40; Cumul I, 1039–40, 1040

- 1040

- Bourges Cathedral, France, 393–94, 393, 394
 Bourges Cathedral, France, 393–94, 393, 394
 Bouts, Dirk, 709–10; Altarpiece of the Holy Sacrament, 709–10, 709; The Last Supper, 709–10, 709
 Bowl (Mimbres culture), 529, 529
 Boy in a Red Vest (Cézanne), 935, 935
 Boy Strangling a Goose (Boethus), 178–79, 179
 Boyle, Richard (Earl of Burlington), 820–21; Chiswick House, England (with Kent), 820–21, 821, 851 851

Brady, Matthew, 910

- Bramante (Donato d'Angelo), 640–43; new St. Peter's, Rome, 641–42, 641; Palazzo Caprini, 642–43, 642; Santa Maria della Consolazione, Todi, 642, 642; Tempietto, 640–41, 640 Brancusi, Constantin, 989–90; Bird in Space, 990,
- 990
- Brant–Johnson House, Vail, Colorado (Venturi), 1077, 1077
- Braque, Georges, 959, 960–61, 962, 963; Fruit Dish with Cards, 962, 963; The Portuguese, 960–61, 961 Breaker Boys (Hine), 1015, 1016 Breakers, The, Newport, Rhode Island (Hunt), 871, 871
- Breakfast Scene (Marriage à la Mode) (Hogarth), 840-
- 41, 841 Breathless (À bout de souffle) (Godard), 1071, 1071

- Breathless (A bout ae soughe) (Godard), 10,1, 10,1 Breton, André, 982 Breuil, Abbé, 28, 32, 33 Bride Stripped Bare by Her Bachelors, Even, The (The Large Glass) (Duchamp), 975–76, 976

- Bridge design, 837–38 Bridge design, 837–38 Bridge group (Die Brücke), 969–70 Bridge-spout vessel, Nasca, Peru, 522 **Broederlam, Melchior**, 696, 698; The Presentation and The Flight into Egypt, 696, 696, 698 Broken pediment, 241

- Bronze Age, 107
- Bronze industry of Luristan, 70
- Bronze sculpture: African, 535; Chinese, 451, 452, 454–55, 455; of Chola kingdom, India, 438; dotaku style of, 476
- Bronzino (Agnolo di Cosimo), 670–71; Portrait of a Young Man, 670–71, 670; Venus, Cupid, Folly, and Time (The Exposure of Luxury), 670, 670
- Bruce, Thomas (Earl of Elgin), 156-57 Brucegel, Pieter, the Elder, 735-38, 942; Hunters in the Snow, 736, 736; The Peasant Dance, 737, 737 Bruges, 695, 732
- Bruges, 695, 732
 Brunelleschi, Filippo, 583–85, 588, 592–97, 608– 609, 640; dome of Florence Cathedral, 593; fa-çade of Ospedale degli Innocenti, 594; Pazzi Chapel, Florence, 595, 596; Santa Maria del Angeli, Florence, 596; Santo Spirito, Florence, 594, 595; The Sacrifice of Isaac, 583–84, 583
 Bruni, Leonardo, tomb of, Florence, 613–14
 Bryons Painter, 134, Review, 134, 134
- Brygos Painter, 134; Revelers, 134, 134

- Bucrania, 200 Bucdaha, Gal Vihara, Sri Lanka, 441 Buddha, Gal Vihara, Sri Lanka, 441 Buddha, images of, 431–33, 431–33, 455–56, 456, 478–79
- Buddha Amida, 478-79
- Buddha Amida, 478–79 Buddha Sakyamuni, 427–28 Buddhism: in China, 455–57, 464–65; in India, 427–33; in Japan, 478–80, 485–86 **Buffalmacco, Buonamico**, 579; *The Triumph of Death*, 579, 579 Buffon, Georges Louis Leclerc, 819 Bull: in Mesopotamian art, 54, 60–61, 60, 71, 112– 13; in Minoan art, 112–13, 113, 122 **Buncho**, 496

- Buncho, 496 Buncho, 496 Buñuel, Luis, 983; Un Chien Andalou (An Andalu-sian Dog) (with Dali), 983–84, 983, 1081 Buonarroti, Michelangelo. See Michelangelo Buonarroti

- Buonarroti Burghers of Calais (Rodin), 912–13, 912, 1051 Burial at Ornans (Courbet), 897–98, 898 Burial carvings (Ipiutak), 526, 526 Burial of Atala, The (Girodet-Trioson), 872, 872 Burial of Atala, The (Girodet-Trioson), 872, 872 Burial of Phocion, The (Poussin), 803, 803–804 Burne-Jones, Edward, 914–15; King Cophetua and the Beggar Maid, 914–15, 915 Burning of the Sanjo Palace, The, Japan, 484–85, 485 Bury Bible, 375–76, 375 Bury St. Edmunds, 375 Buson, Yosa, 493; Enjoyment of Summer Scenery, 494

- 494
- Bust of a Little Boy (Desiderio da Settignano), 615, 615
- Buttresses, 224-25
- Buttressing system, High Gothic, 395 Buttressing system, High Gothic, 395 Byzantine art, 271–72; architecture in, 272–74, 278–79, 281, 284–90; classicism in, 291, 297–98; evolution of, 278; hieratical quality of, 282; mosaics in, 273–84, 292–94; style of, 272; as vehicle for conveyance of Christian symbolism, 272–97 276, 278
- Byzantium, 258, 272, 284; effect of, on western art and civilization, 349. *See also* Byzantine art

- C Cabaret Voltaire, 977 Cabbage Leaf (Weston), 1011, 1012 Cabinet of Dr. Caligari, The (Wiene), 970–71, 971 Cage, John, 1059–60, 1070 Calchas mirror, 195, 195 Calder, Alexander, 997–98; Hanging Spider, 997– 98, 998; mobile, 1047 Calidarium 228

Camera, development of, 865 Camera degli Sposi (Mantegna), 628–30, 628, 629,

666
Camera lucida, 891, 894
Camera obscura, 891, 894
Campanile, 275, 338, 360; of Florence Cathedral, 416; of Palazzo Pubblico, Siena, 419, 419
Campin, Robert (Master of Flémalle), 700–701; *The Mérode Altarpiece*, 700–701, 700
Campo Santo, Pisa, 579
Campus, Peter, 1067; *Three Transitions*, 1067, 1068
Canaletto, Antonio, 833; Basin of San Marco from San Giorgio Maggiore, 833, 833
Canoe prow figure, Solomon Islands, 547, 547

- Calidarium, 228 Calimachos, 170 Caliphate of Córdoba, 299
- Caliphs, 299 Callixtus, catacomb of, Rome, 256 **Callot, Jacques**, 801; *Miseries of War*, 801, 801 Calotype, 895–96 Cambodia, art of, 443–47

666

1122 INDEX

- Chandragupta, 428
- Chao Meng-fu, 466 Chapel of Henry VII, Westminster Abbey, 410,
- 410

- 410 Chapel of Notre Dame du Haut, Ronchamp (Le Corbusier), 1003 Chapel of St. Ivo, Rome, 762–63, 763 **Chaplin, Charlie**, 1022–23; Modern Times, 1022– 23, 1022; The Great Dictator, 1023 **Chardin, Jean Baptiste Siméon**, 839–40; Grace at Table, 839–40, 840 Charioteer of Delphi, The, Sanctuary of Apollo at Delphi, 7, 150–51, 150 Charlemagne, 299; and Carolingian period in Early Medieval art, 330; Palatine Chapel of, 335, 335 335
- 335
 Charles 1 Dismounted (Van Dyck), 785–86, 785
 Chartres Cathedral, France, 388–93, 388–92, 400, 587; Porch of the Confessors, 400–401, 400; St. Theodore, 587, 587
 Chartreuse de Champmol, Dijon, France, 695–96; The Well of Moses (Sluter), 696, 696
 Château de Chambord, France, 739–40, 739
 Château de Blois (Orléans wing), France (Mansart), 805–806, 805
 Château fort. 348

- Château fort, 348 Chateaubriand, François René de, 868, 872 Chavín de Huantar, culture and art of, 519–20,
- 519 Chelles, Jean de, 397; rose window at Notre Dame Cathedral, 397–98, 397 Cheops. See Khufu

Chephren. *See* Khafre Chevalier, Étienne, 716, 717 Chevet, 391

- Chevalier, Etienne, 716, 717 Chevet, 391 Chiaroscuro, 246, 502, 635, 638, 898 Chicago, Judy, 1085–86, 1092; *The Dinner Party*, 1085–86, 1085 Chichen Itzá, 515–16, 515 Chilkat blanket, 532, 532 Chimera, Arezzo, 194, 194 China: art and civilization of, 450; architecture in, 471–73, 471–73; Chin dynasty in, 464; Ch'in dynasty in, 453; Ch'ing dynasty in, 468–70; Chou dynasty in, 451–52; Five Dynasties pe-riod in, 462–63; Han dynasty in, 453–55; Ming dynasties in, 455–56; Northern and Southern dynasties in, 455–56; Northern Sung dynasty in, 463–64; Shang dynasty in, 450–51; Southern Sung dynasty in, 459–62; Three King-doms period in, 455; twentieth-century devel-opments in, 470–71; Yūan dynasty in, 466–67 Ch'in dynasty, China, 453 Chin dynasty, China, 464 *Chinese Horse*, Lascaux, 31, 34 Ch'ing dynasty, China, 468–70 **Ch'ing Hao**, 462–63 **Ch'i Pai-shih**, 468 Chi-rho monogram 271, 282 **Chirico**, Giorgio de, 979–80; *The Soothsayer's Rec-ompense*, 980, 980 Chiswick House, London (Boyle and Kent), 820– 21, 821, 851

- 21, 821, 851
- Chiton (tunic), 136
- Chlamys, 191 Cho Densu, 485
- Choir: of Amiens Cathedral, 394, 396; of Cologne Cathedral, 411, 411; of Gloucester Cathedral, 410; in Romanesque architecture, 350; of St. Denis, 382

- Denis, 382 Choir hemicycle, 400 Chola kingdom, India, 438 Chola temples, 438 Cholua, Mexico, 507 Chou dynasty, China, 451–52 Christ, depiction of in art, 257, 262, 266, 273–74, 274–75, 278, 281, 283–84, 291, 294, 298, 341–42, 362–63, 365, 368–71, 724 Christ as the Good Shepherd, mausoleum of Galla Placidia, 273–74, 273 Christ Between Angels and Saints (The Second Com-ing), San Vitale, 281–82, 282 Christ Delivering the Keys of the Kingdom to St. Peter (Perugino), 626, 626 Christ Entering Brussels in 1889 (Ensor), 942–44, 943

- 943
- Christ Enthroned in Majesty, with Saints, Santa Pudenziana, Rome, 263, 263 Christ Enthroned with Saints (Harbaville Triptych),
- 298, 298
- Christ in Majesty, Four Evangelists, and Scenes from

the Life of Christ (Codex Aureus of St. Emmeram), 332–33, 333 Christ in Majesty, St. Sernin, Toulouse, 362–63,

Collage, 963–64, 978–79; photographic, 1075–76 Cologne Cathedral, Germany, 399, 411–12, 411, 415–16, 415; towers of, 416

Colonnettes, 409 Color: chroma and, 13; esthetics of, 12; hue and, 12–13; in Impressionism, 922–23; intensity of, 13; paint pigments and, 13; pointillism and, 931n; in Post-Impressionism, 933, 935–36, 937– 38; pre-Impressionistic theory of, 880–81; satu-ration of, 13; tonality of, 13; value of, 13

Colorizing, 1066
Colors: complimentary, 13, 1099; cool, 14; primary, 13, 1104; secondary, 13, 1105; warm, 14. See also hue, saturation, value
Colossal Atlantids, Tula, Mexico, 516, 516
Colossal Buddha, Cave XX, Yunkang, 456, 456
Colosseum, 221–22, 221
Column (Gabo), 995, 995
Column of Marcus Aurelius, Rome, 235
Column of Trajan, Rome, 234–35, 234, 251, 255, 267

Columns: in antis, 140; monolithic, 200; reserve,

Composite order, 232 Composition in Blue, Yellow, and Black (Mondrian), 996, 997 Compound piers, 409 Compression, in architecture, 1046 Computer graphics, 1064–66 Conceptual art, 1069–76 Concerning the Spiritual in Art (Kandinsky), 993 Concordantia (harmony), 396 Concretions, 986

Concretions, 986 Console bracket cluster, 471, 472 Constable, John, 881, 889–90; The Haywain, 890,

890
Constantine, 238, 240, 246–47, 251, 259; Arch of, Rome, 249–50, 249, 250; architectural influence of, 261–62; Basilica of, Rome, 246–47, 246
Constantine the Great, Rome, 248, 248
Constantinople, 258; art of, 284–87; as center of traditional and Christian learning, 265; con-quered by Ottoman Turks, 309, 608
Constructivism, 995, 1018–19
Conversion in the Garden (Rosso), 930, 931
Conversion of St. Paul, The (Caravaggio), 769–70, 769

769
Cook Islands, art of, 543, 543
Copley, John Singleton, 835–36; Portrait of Paul Revere, 835–36, 835
Coptic (Christian) Egypt, art of, 330
Copyright Act, England, 842n
Corbeled arch, 15
Corbeled gallery, Tiryns, 119
Corbeled vault construction, 38
Corbeled, 288

Corbelia, 288 Córdoba, mosque of, 301–302, 301–302 Coricancha (Court of Gold), 525–26, 525 Corinthian capital, Epidauros, 170, 170 Corinthian order, 221, 232; culmination of, 170– 72; employed in Roman temples, 200–202; re-

72; employed in Roman temples, 200–202; re-vised by Latrobe, 853 Cornaro Chapel, Santa Maria della Vittoria, Rome, 758–60, 759 Cornelia, Pointing to Her Children as Her Treasures (Kauffmann), 848–49, 848 **Cornell, Joseph**, 986–87; Soap Bubble Set, 986–87, 986

Coronation Gospels, 330–31, 331 Coront, Jean Baptiste Camille, 898–99; The Harbor of La Rochelle, 898–99, 899

of La Kochelle, 898–99, 899 Correggio (Antonio Allegri da Correggio), 629, 666–67; The Assumption of the Virgm, 666–67, 666; Jupiter and Io, 667, 667 Corridor axis, 93 Corridor of the Procession, Knossos, 112 Cortés, Hernán, 500, 518 Cortile, 597 Course (Decemb Mali, 511

Cortile, 597
Couple (Dogon), Mali, 541
Courbet, Jean Désiré Gustave, 896–98; Burial at Ornans, 897–98, 898
Coyolxauhqui (Aztec), 517, 517
Craft art: Achaemenid Persian, 69–71, 70; in Car-olingian period, 332–34; early Christian, 269–71
Cranach, Lucas, the Elder, 723–24; The Judgment of Paris, 723–24, 723

Community houses, 258 Complementary afterimage, 796n Compluvium, 205

Composite order, 232

769

986 Cornices, 141

Colonnettes, 409

Color triangle, 13 Colorizing, 1066

- 362
- Christ in Majesty with Apostles, St. Génis-des-Fontaines, France, 363, 364 Christ in the House of Levi (Veronese), 690, 690

- Christ in the House of Levi (Veronese), 690, 690
 Christian art. See Early Christian art
 Christianity: development of, 254–55; as mystery cult, 282; Period of Persecution in, 255–56; Period of Recognition in, 255–56; symbolism of, in Byzantine art, 271–72, 273–74, 276, 278, 281–83, 284. See also Early Christian art
 Christo (Christo Javacheff), 1090–91; Surrounded Islands, 1090–91, 1090
 Christos, Petrus, 631, 708–709; The Legend of Saints Eligius and Godeberta, 708–709, 709
 Chroma, 13
 Chrysaor, 147

- Chrysaor, 147 Chu-jan, 463 Chun ware, 465 Church of the Blessed Savior of the Chora, Istan-
- bul, 294 Church design: acoustics in, 775; alternate-support system in, 340–41; basilica plan of, 258–60, 272–73, 336; Byzantine, 278–79, 279, 281, 285–86, 287–90; central plan in, 260–62, 272–73, 336, 609, 640, 753–54, 762; Cluniac-Burgundian style of, 351; Gothic sculpture pro-gram in, 400–402; St. Gall plan of, 336–38, 337; tower placement in, 338. *See also* Architecture Church of Holy Apostles, 288 Church of the Katholikon, Phocis, Greece, 287, 288, 288 bul, 294
- 288, 288
- Church of St. George, Thessaloniki, Greece, 264, 264
- Church of the Theotokos, Phocis, Greece, 287-88
- Church of the Theotokos, PhoCis, Greece, 267–86 Chu Ta, 468 Cimabue, Giovanni, 568; Madonna Enthroned with Angels and Prophets, 568, 568, 568 Cinema: activism in, 1020–23, 1082; as conceptual art, 1071–72; development of, 970; Expression-ism in, 970–71; Surrealism in, 981, 983–84 Circus, Bath (Wood the Younger), 847, 847 Circ perdue (lost–wax) method of casting, 149, 535 Circus, churches, 409

- Cistercian churches, 409
 Cistercian churches, 409
 Cistercian order, 348
 Citadel of Sargon II, Khorsabad, 59–60, 59, 60
 Citadel, The, Teotihuacán, 507, 507
 Citadel of Tiryns, 119–20, 119
 Citeaux, 375
 City planning: in ancient Greece, 181–82, 181; Aztec, 517; castrum type in, 203; Hippodamian plan in, 181, 181; modern approaches to, 1003– 1004; Neoclassic, 846–47, 851–52; in Roman Empire, 217–20; in Roman republic, 202–205; in Teotihuacán, 506. See also Architecture
 City Square (La Place) (Giacometti), 1051, 1051
 Classicism, 246, 832; in Baroque art, 751, 802–803,

- Clairvaux, 375
 Classicism, 246, 832; in Baroque art, 751, 802–803, 806; in sculpture, 811–12
 Clerestory: in High Gothic architecture, 392; in hypostyle halls, 92; in Laon Cathedral, 385, 385
 Cliff at Etretat (Monet), 923–24, 923
 Cliff Palace, Mesa Verde, 529, 529
 Clodion (Claude Michel), 826; Nymph and Satyr, 826
- 826, 826
- Cloisonné, 322–23 Cloisons, 323 Cloister, 336
- Cloister Graveyard in the Snow (Friedrich), 882-83, 883
- Clouet, Jean, 738; Francis I, 738, 738 Clovis, 320
- Cluniac order, 348
- Cluny, 348
- Coatlicue (Lady of the Skirt of Serpents) (Aztec), 518, 518
- Coburn, Alvin Langdon, 966–67; Ezra Pound Vor-tograph, 966–67, 966 Code of Hammurabi, 57, 58

Cole, Thomas, 885; The Oxbow (Connecticut River near Northampton), 884, 885 Colegio de San Gregorio, Valladolid, Spain, 743,

- Codex, 265

Colima culture and art, 505, 505

- Codex Amiatinus, 328, 328 Codex Amiatinus, 328, 328 Codex Aureus of St. Emmeram, 332–33, 333 Codex Grandior of Cassiodorus, 328–29 Codices (Mixtec), 515 Coffers, 228 Collect Fuence, 885; The Oxborn (Connecticu

Doric order, 141–42, 141, 676; architectural sculp-ture in, 146–48, 146–48; evolution of propor-tions in, 144, 144; frieze in, 155–56; Parthenon as example of, 154–59 Doric portico, Hagley Park (Stuart), 845, 845 Doryphoros (Polykleitos), 11, 163–64, 163, 167, 230, 586 Dotaku bronzes, 476

Dotaku bronzes, 476 Double transept, in Salisbury Cathedral, 409 Double-headed male figure, Easter Island, 543 Double-headed male figure, Easter Island, 543 Douglas, Aaron, 965; Noah's Ark, 965, 965

Draped Model (Durieu and Delacroix), 880, 880, 886

Drawing in Time: My New Black Book No. 2 (Sheri-dan), 1065–66, 1066 Dream Kitchens series (Leonard), 1056 Dreams and Nightmares series (Leonard), 1056

Drunkenness of Noah (Michelangelo), 655-56, 656-

Drunkenness of Noah (Michelangelo), 655–56, 656– 57 Dry-fresco technique, 86, 113 Dry-joined ashlar construction, 525 Duccio (Duccio di Buoninsegna), 565–67; The Annunciation of the Death of Mary, 566, 567; The Betrayal of Jesus, 566–67, 566 Duchamp, Marcel, 968, 975–77; Bicycle Wheel, 975, 975, 1058, 1059, 1063; The Bride Stripped Bare by Her Bachelors, Even (The Large Glass), 975– 76, 976; Fountain, 975 Dura-Europos, 265, 271–72, 282 Dirrer, Albrecht, 19, 726–30; Apocalypse series, 726–27, 727; Hieronymus Holzschuher, 728–29, 728; Melencholia I, 729, 729; The Fall of Man (Adam and Eve), 727–28, 727; The Four Apostles, 729–30, 730; The Four Horsemen, 726–27, 727; The Great Piece of Turf, 728, 728; Two Lions, 19 Durham Cathedral, England, 358, 358 Durieu, Eugène, 880; Draped Model (with Dela-croix), 880, 880, 886

Dutch painting. See Holland, Netherlands, Flem-

ish art Dwelling in the Fu-ch'un Mountains (Huang Kung-wang), 466, 466 Dying Gaul, Pergamon, 174–75, 174 Dying Lioness, Nineveh, 62, 63 Dying Slave, The (Michelangelo), 652–53, 652 Dymaxion system, 1008–1009

E Eadwine the Scribe, 369, 376–77; The Scribe Eadwine (Canterbury Psalter), 376–77, 377
 Eakins, Thomas, 901, 905; The Gross Clinic, 901, 905; The

Ear ornament (Moche), Sipán, 521, 521 Early Bronze Age, 107 Early Christian art, 255–58; archaizing modes in,

Early Classical (transitional) period, in Greek art, 148–53

Early Heian period, 381–90 Early Heian period (Japanese art), 480–83 Early Medieval art: animal style in, 321–23; Caro-lingian period in, 330–38; metalcraft in, 322–23; migration period in, 320–30; Ottonian period in, 338–45 Early Minoan (pre-Palace) period, 107–108 Early Operation under Ether (Hawes and South-worth), 893–94, 894 Earth and Site Art, 1089–93 Easel computer-graphic program, 1065–66

Easter Computer-graphic program, 1065–66 East Building, National Gallery, Washington, D.C. (Pei), 1046–47, 1046–47 Easter Island, art of, 543, 543 Ebbo Gospels, 331–32, 331 Ebbo of Reims (archbishop), 331 Eabinue, 141

Echinus, 141 Echinus, 141 Ecstasy of St. Theresa, The (Bernini), 758–60, 760 Edo (Tokugawa) period, Japan, 488–89 Eggshell ware, 108

Eggshell ware, 108 Eglise de Dôme, Church of the Invalides, Paris (Hardouin-Mansart), 810–11, 810 Egypt: Amarna period in, 96–99; archeological study of, 74–75; architectural influence on Achaemenid Persia, 67; architecture of, 78–83, 89–94; early building methods in, 93; early dy-nastic period in, 76–87; effect of Mesopotamian building methods in, 93–94; Eighteenth Dy-nasty in, 89, 95, 96; Fourth Dynasty in, 81–83; funerary customs of, 75–76; hypostyle halls in,

Early Gothic period, 381-90

255; architecture in, 258-62; mosaics and painting in, 262–67; sculpture and craft art in, 267–71; transition of, to Byzantine style, 271, 272,

Dromos, 121

57

ish art

901

278

Creation of Adam, The (Michelangelo), 656–57, 656 Creation of Eve (Bosch), 713, 713 Creation and Temptation of Adam and Eve, Modena Cathedral (Wilegelmus), 364, 364 Cretan labyrinth 109

- Cretan palace culture, 99
- Crete: as ancient center of Aegean civilization, 106; archeological investigation of, 106, 107; in-fluence of on Egypt, 99, 101; old palaces in, 108–109
- Cro-Magnon peoples, 28 Crossing, in Romanesque architecture, 350, 353– 54

- 54 Crow tepee lining, 533 Crucifixion (Grünewald), 724–25, 724 Crucifixion, St. Remi, Reims, 402, 404 Crucifixion, The, Daphne, 291, 291 Crusades, 348–49; importance of Vézelay in, 371 Crypt, in Chartres Cathedral, 391; of St. Denis, 382–83

- Crypt, in Chartres Catnedrai, 391; or 5t. Denus, 382–83
 Crystal Palace, London (Paxton), 946, 946
 Cubi XXVI (Smith), 1036, 1036
 Cubicula, 256–57
 Cubism, 959, 1001–1002; Analytic, 959–62; derivatives of, 965–67; Synthetic, 962–65
 Cumul I (Bourgeois), 1039–40, 1040
 Cupbearer, The, Knossos, 112, 113
 Cupid a Captive (Boucher), 825, 825
 Curia, Pompeii, 204
 Cut with the Kitchen Knife (Höch), 978, 978
 Cuvilliés, François de, 827–28; Amalienburg, 827–28, 827, 828
 Cuzco, Peru, 524–26
 Cycladic civilization, 106, 107–108
 Cyclopean walls, 119–20
 Cyclopes, The (Redon), 942, 942
 Cylinder seals, in Sumerian art, 54

D

- Dada, 974-79, 1032, 1039 Daguerre, Louis Jacques Mandé, 885, 891–92; Still Life in Studio, 892–93, 893 Daguerreotype process, 891–93 Dai Seishi, 479

- Dal Seishi, 479
 Dali, Salvador, 983; The Persistence of Memory, 984-85, 984; Un Chien Andalou (An Andalusian Dog) (with Buñuel), 983-84, 983, 1081
 Damned Cast into Hell, The (Signorelli), 625-26, 625
 Dan culture and art, 540, 540
 Dance relief, Angkor Wat, 445, 445
 Dancing Siva, Badami, India, 433-34, 433
 Danube Landscape, Near Regensburg (Altdorfer), 723, 723
 Daphne, art of, 291
 Darby, Abraham, III, 837-38; iron bridge, Coalbrookale (with Pritchard), 837-38, 837
 Darius, Palace of, 66, 66, 68

- Darius, Palace of, 66, 66, 68 Darius, Palace of, 66, 66, 68 Darted Again (Gilliam), 1043–44, 1044 Daubigny, Charles Franois, 899 Daughters of Edward Darley Boit, The (Sargent), 903, 903

- 903 **Daumier, Honoré,** 888–89; *Rue Transnonain,* 888– 89, 888, 1026; *The Third-Class Carriage,* 889, 889 *David* (Bernini), 758, 758 *David* (Donatello), 590–91, 591 *David* (Michelangelo), 651, 651 *David* (Verrocchio), 616–17, 617 **David** (Verrocchio), 616–17, 617 **David**, **Jacques Louis,** 849–50, 871–72; *The Death* of Marat, 850–51, 850, 1026; Oath of the Horatii, 849–50, 849, 873 *David betree* Saul (Pucelle), 697, 608

- b) Nutrat, 500-51, 600, 1020, 6011 6J the Horath, 849-50, 849, 873 David before Saul (Pucelle), 697, 698 Davis, Stuart, 964; House and Street, 964, 964 Dead Christ, The (Mantegna), 630, 630 Death and Assumption of the Virgin Mary (Stoss), 718-20, 719 Death and Life (Klimt), 955, 956 Death Comes to the Old Lady (Michals), 1052, 1053 Death of General Wolfe, The (West), 842–43, 843, 851 Death of General Wolfe, The (West), 842–43, 843, 851 Death of General Wolfe, The (West), 842–43, 843, 851 Death of Sardanapalus, The (Delacroix), 878–79, 878 Death of Sardanapalus, The (Delacroix), 878–79, 878 Death of the Virgin, Strasbourg Cathedral, France, 413, 413
- Death on a Pale Horse (Ryder), 944–45, 945 Deconstructionism, 1079–81

Decorative painting, Japanese, 492 Decumanus, 219

- Deep Pool (Welliver), 1074, 1074 Deep relief, 35

- Deep relief, 35
 Deer and Calligraphy (Tawaraya Sotatsu and Hon-Ami Koetsu), 492, 492
 Deer Hunt (Catal Hüyük), 44, 45
 Degas, Edgar, 902, 926–29; Ballet Rehearsal (Ada-gio), 926–27, 927; The Morning Bath, 928–29, 929; Viscount Lepic and His Daughters, 927–28, 928
 Déjeuner sur l'herbe, Le (Luncheon on the Grass) (Manet), 920, 921, 921
 De Kooning, Willem, 1034, 1045; Woman I, 1034, 1034
- 1034
- 1034
 Delacroix, Eugène, 876, 877–81; Draped Model (with Durieu), 880, 880, 886; Liberty Leading the People, 879–80, 879; Paganini, 876–77, 877; The Death of Sardanapalus, 878–79, 878
 Delaroche, Paul, 892
 Delian League, 153, 154
 Della Robbia, Andrea, 615
 Della Robbia, Giovanni, 615–16
 Della Robbia, Girolamo, 615–16
 Della Robbia, Luca, 615–16; Madonna and Child, 616

- 616
- Delport, Henri, 32–33 Demoiselles d'Avignon, Les (Picasso), 959–60, 960 Dendrochronology, 27
- Departure (Beckmann), 973–74, 973 Derain, André, 957, 968; London Bridge, 957, 957 De re aedificatoria (Alberti), 609

- Derrida, Jacques, 1079 Descent from the Cross (Pilon), 742, 742 Descent from the Cross, The (Pontormo), 668–69, 668

- Deschamps, Eustache, 712 De Sica, Vittorio, 1082; *Bicycle Thieves*, 1082, 1082 **Desiderio da Settignano**, 615; *Bust of a Little Boy*,
- 615, 615 De Stael, Nicolas, 1035; Musicians, 1035–1036, 1035
- De Stijl group, 996n, 1003–1005 Dharmaraja, India, 436–37, 436 Dherveni Krater, 173, 173

- Diana of Fontainebleau (Cellini), 672, 672

- Diana of Fontainebleau (Cellini), 672, 672 Diaphragm arch, 361 Diaz, Narcisse Virgile, 899 Diderot, Denis, 819, 831, 838 Didymaion, Miletus, 180–81, 180 **Diebenkorn, Richard**, 1034–35; Man and Woman in a Large Room, 1034–35, 1035 Diffraction gratings, 1065n Dilute glaze, 131–32 Dinner Party, The (Chicago), 1085–86, 1085 Diocletian, 216–17, 240; palace of, 214, 240–41 Dionysos (Herakles?), 157, 157 Dionysos in a Sailboat (Exekias), 132, 132 Dipteral temple, 140

Dionysos in a Sailboat (Exekias), 132, 132 Dipteral temple, 140 Diptych, in Early Christian art, 269–70, 269–70 Diptych of Anastasius, 270–71, 271 Dipylon Vase, 129, 129 Discobolos (Myron), 151, 151 Disdéri, André-Adolphe-Eugène, 910–11; Prin-cess Buonaparte-Gabrielli, 910, 911 Di sotto is eu perspectiva, 629

cess Buonaparte-Gabrielli, 910, 911 Di sotto in su perspective, 629 Disputatio, 396 District God, Cook Islands, 543, 543 Divination, in Etruscan art, 195 Divisionism, 931n Djanggavul Sisters, The (Mungarawai), 547, 548 **Doesburg, Theo van**, 1004 Doge's Palace, Venice, 419, 419, 676 Dolmen, 38

Dolphin Fresco, Queen's Megaron, Knossos,

Dome: of Florence Cathedral, 416; in Islamic ar-

Domenicohino (Domenico Zampieri), 771; The Last Communion of St. Jerome, 771, 771 Domenico Veneziano, 603–604; The St. Lucy Al-

Domestic architecture. See Architecture, Domestic Domical vault, 384 Domus Aurea, Rome, 210–11, 210, 225–26, 226,

243
Domus Transitoria, Rome, 225
Donatello, 585–92; David, 590–91, 591; The Feast of Herod, 588, 589; Gattamelata, 591, 591; Mary Magdalene, 592, 592; prophet figure (Zuccone), 588, 588; St. George, 586–87, 587; St. John the Evangelist, 16; St. Mark, 586, 586
Dordogne, cave paintings of, 28–30
Doric columns, Egyptian predecessors of, 80

Dolmen, 38

chitecture, 302

tarpiece, 603-604, 603

112n

243

- Egypt (continued)
 91-93; late period in, 99-103; Late Predynastic period in, 75; Later Canon (rule of proportion) of, 78, 78; Middle Kingdom in, 87-88; New Kingdom in, 89-103; Old Kingdom in, 76-87; painting of, 86-87, 88, 94-96; portraiture in, 85; pyramids of, 78-83, 99-101; relief of, 86-87, representation of human figure in, 77-78; rock-cut tombs of, 87-88; sculpture of, 83-85, 88, 94-96; Seventeenth Dynasty in, 89; temple design in, 89-94; tomb design in, 78-83; Tutankhamen's tomb, 99-101; Twenty-fifth Dynasty in, 103
 Eiffel, Alexandre Gustave, 946-47; Eiffel Tower,
- Eiffel, Alexandre Gustave, 946-47; Eiffel Tower,
- Paris, 947, 947 Paris, 947, 947 Eiffel Tower, Paris (Eiffel), 947, 947 Eisenstein, Sergei, 978, 1020, 1022, 1068, 1072; Battleship Potemkin, 1016, 1020, 1021, 1052 Ekkehard and Uta, Naumberg Cathedral, 413–14,

- Eisenstein, Sergei, 978, 1020, 1022, 1068, 1072; Batileship Potemkin, 1016, 1020, 1021, 1052
 Ekkehard and Uta, Naumberg Cathedral, 413–14, 414
 Elam (ancient Persian Empire), 65–66. See also Achaemenid Persia
 Elevation, in architecture, 14
 Elevation, of the Cross, The (Rubens), 780–81, 781
 Elgin marbles, 156–57
 El Greco, 745–47, 775, 962; The Burial of Count Orgaz, 746–47, 746; Fray Hortensio Félix Paravicino, 747, 747
 Eleazor and Mathan lunette (Michelangelo), 555
 Em David, 1064–65; Nora, 1064–65, 1065
 Embarkation of the Queen of Sheba (Lorrain), 804, 804
 Embarkation of the Queen of Sheba (Lorrain), 804, 804
 Embarkation of the Queen of Sheba (Lorrain), 804, 804
 Embarkation of the Queen of Sheba (Lorrain), 804, 804
 Embarkation of the Queen of Sheba (Lorrain), 804, 804
 Embarkation of the Queen of Sheba (Lorrain), 804, 804
 Emotids, 909, 909
 Encaustic technique, 137–38, 215
 Ecorché figure, 618
 English art: Age of Enlightenment in, 818–19, 837–39, "Arts and Crafts" movement in, 955;
 Baroque period in, 812–15; garden design in, 821, 844–45; Gothic, 408–10; landscape painting in, 883–85; Neoclassical architecture in, 386–58; Romantic Gothic architecture in, 844–45, 868–69; Tudor architectura istyle in, 410
 Engobe (clay slip), 132
 Engraved Reindeer, Lascaux, 30
 Engraving, 618–19, 841; Shoshone, 528; in Renaissance art, 721
 Engrawed Reindeer, Lascaux, 30
 Environmental Art, 1089–93
 Epic of American Civilization: Hispano–America (Orozco), 1025–26, 1025
 Epidauros, 170–72
 "Epistula Morales," 229–30
 Epic of American Civilization: Hispano–America (Orozco), 1025–26, 1025
 Epidauros, 131; The François Vase (with Kleitias), 131, 131
 Ernst, Max, 982–83; 7wo Children Are Threatened by a Nightingale, 982–83; 7wo Children Are Threatened by a Nightingale, 982–8

 - Etruria, 189. See also Etruscans
 - Etruscan Room, Osterley Park House (Adam), 846, 847
 - Etruscan temples, 189-90, 189
 - Etruscan temples, 189–90, 189 Etruscans: architecture of, 188–90; burial grounds of, 189–90; demonology of, 194; development of art of, 188; divination by, 195; influence of Greek art on, 193–94; painting of, 190–92; sculpture of, 192–95; tomb types of, 189–90 Euphranor, 195

Euphronios, 133; Herakles Strangling Antaios, 133,

Fountain of the Innocents, Paris (Goujon), 740-

41, 741 Fouquet, Jean, 716–17; Étienne Chevalier and St. Stephen, 717, 717 Four Apostles, The (Dürer), 729–30, 730 Four Darks in Red (Rothko), 1041, 1042 Four Horsemen, The (Dürer), 726–27, 727 Four-paneled rib vault, 395 Fow Hunt, The (Homer), 905–906, 906 Fra Filippo Lippi, 607–608, 623; Madonna and Child with Angels, 607–608, 608 Fragonard, Jean Honoré, 825–26; The Swing, 825– 26, 825 ____

26, 825
Francis I (Clouet), 738, 738
Francis I (clouet), 738, 738
Francis I (king of France), 640, 738, 739–40
François Marius Granet (Ingres), 876, 876
Francois Vase, The, 131–32, 131
Frank, Robert, 1082–83; Trolley, New Orleans, 1082, 1083
Uklas, Uklas, Uklas, 1041, 42; Mountains, and

Frankenthaler, Helen, 1041-43; Mountains and Sea, 1042, 1043 Fray Hortensio Félix Paravicino (El Greco), 746–47, 747

French Ambassadors, The (Holbein the Younger), 730-32, 731

730-32, 731
French art: Baroque, 799-812; cave paintings, 28-33; fifteenth-century, 716-18; Gothic art, 381-407, 560; Rococo style, 821-30, 823-25, 826, 829, 850-51; sixteenth-century, 738-42
French Rococo style, 821-30

Fresco painting: Baroque Italian, 766–68; in cata-combs, 256–57; of Giotto, 570, 571; Indian, 439, 439; Renaissance Italian, 620–21, 625–27, 654–

Fresco secco technique, 113 Friedrich, Caspar David, 882–83, 968; Cloister Graveyard in the Snow, 882–83, 883 Frieze, 141, 142, 146 Frieze from the Villa of the Mysteries, Pompeii, 207–208, 207

Frigidarium, 228
Fruit Dish with Cards (Braque), 962–63, 963
Fujiwara Yorimichi, 484
Fuller, Buckminster, 1008–1009, 1030; Multiple Deck 4-D House, 1008–1009, 1009
Funeral Mask, Mycenae, 122, 122
Funerary urns, Etruscan, 192, 192
Fuseli, Henry, 855–56, 985; The Nightmare, 855–56

56, 856 Future Expectations (Van Der Zee), 1014, 1015 Futurism, 965–66 Futurist Painting, Technical Manifesto (Boccioni),

Gabo, Naum, 995; Column, 995, 995 Gaddi, Taddeo, 574; Meeting of Joachim and Anna,

Gainsborough, Thomas, 835; Mrs. Richard Brins-ley Sheridan, 835, 835 Galatea (Raphael), 647–49, 648 Galerie des Glaces (Hall of Mirrors), Versailles, 808–809, 809, 821

Galla Placidia, 272; mausoleum of, Ravenna, 272-

Garbha griha (womb chamber), 435, 436 Garden design: English, 821, 844–45; French, 808– 809; Japanese, 491–92 Garden of Earthly Delights, The (Bosch), 713–16, 713–15

113-15 Garden Scene, House of Livia, Primaporta, 209, 209 Garnier, J. L. Charles, 870; Paris Opéra, 870, 870 Gasulla Gorge, Mesolithic art in, 36–37 Gates of Paradise, east doors, Baptistry of Flor-ence (Ghiberti), 589–90, 589 Gateway of the Sun, Tiahuanaco, Bolivia, 523–24, 533

523 Gatharing Water Lilies (Emerson), 909, 909 Gattamelata (Donatello), 591, 591 Gaudí, Antoni, 955; Casa Milá, 955, 956 Gauguin, Paul, 128, 917, 937–39; Spirit of the Dead Watching, 938–39, 938 Gautier, Théophile, 940–41 Genres scene(?) from House of the Dioscuri, Pom-peii, 211, 211 Gentile da Fabriano, 598–99; The Adoration of the Magi, 598–99, 598

Magi, 598–99, 598 Gentileschi, Artemisia, 771–72; Judith and Maid-servant with the Head of Holofernes, 771–72, 772

56, 663-65, 666-67

Frigidarium, 228

965-66

74, 272, 273

Geodesic dome, 1009

26, 825

- L33 Europe: A Prophesy (Blake), 856, 856 Euthymides, 133–34; Revelers, 133–34, 133 Evans, Arthur, 106, 107 Evening Glow of the Andon, The (Harunobu), 927, 927
- Exekias, 132, 133; Dionysos in a Sailboat, 132, 132 Existentialism, 944 Expulsion from the Garden of Eden, The (Jacopo della

- Expulsion from the Garden of Eden, The (Jacopo della Quercia), 584, 584
 Expression, in sculpture, 240
 Expressionist figuration, 1050–59
 Eyck, Hubert van, 701; The Ghent Altarpiece, 701–703, 701, 702
 Eyck, Jan van, 701–707; Giovanni Arnolfini and His Bride, 706, 706; Man in a Red Turban, 705–706, 705; The Ghent Altarpiece, 701–703, 701, 702; The Virgin with the Canon van der Paele, 703, 704, 704
 Fyrap Bound Vortogranh (Coburn), 966–67, 966 Ezra Pound Vortograph (Coburn), 966-67, 966

- Faiyum portraits, 215–16, 216, 238
 Falconet, Étienne-Maurice, 826; Madame de Pompadour as the Venus of the Doves, 826, 826
 Fall of the Giants, The (Giulio Romano), 675, 675
 Fall of Man (Adam and Eve) (Dürer), 727–28, 727
 Fallen Warrior, Temple of Aphaia, Aegina, 147–48, 147 Fallen Warrior, Temple of Aphaia, Aegina, 147–48, 148, 174
 Falling Angel, The (Chagall), 988, 988
 Fallingwater. See Kaufmann House
 False Face Mask (Webster), 533–34, 534
 Family of Charles IV, The (Goya), 886, 887
 Family of Country People (Le Nain), 800–801, 800
 Fan K'uan, 463; Travelers Among Mountains and Streams, 463, 463
 Farnese Palace, Rome (Antonio da Sangallo the Younger), 643–44, 643, 644
 Fasciae, 141
 Father, Son, Holy Ghost (Kiefer), 1056–57, 1056
 Fauvism, 957–59, 968
 Feast of Herod, The (Donatello), 588, 589
 Feast of the Gods, The (Bellini), 681–82, 682
 Feeding of Oryzes, Beni Hasan, 88, 88
 Female Head, Warka, 50–51, 50
 Feminist Art Program (California), 1086
 Fertility figures, 36
 Ferbula, 322
 Ficoroni Cist, The (Novius Plautius), 195, 195
 Firit et al. Antonio Streame and Streame and Streame and Streame and Streame and Stema and Streame Aspectation Stre 148, 174

- Ficoroni Cist, The (Novius Plautius), 195, 195 Fifteenth-century art. See Renaissance culture and

- art Fillets, 142 Film. See Cinema
- Film. See Cinema Fin de siècle, 939, 942 Five Dynasties, China, 462–63 Flagellation of Christ, The (Piero della Francesca), 604-605, 604

- Flamboyant style, in Gothic architecture, 407 Flanders. See Flemish Art Flavian Amphitheater. See Colosseum Flemish art: Baroque, 780–86; fifteenth-century, 695–716 Flight into Egypt, The (Broederlam), 696, 696, 698

- Flight into Egypt (Carracci), 772–73, 772 Flight into Egypt (Carracci), 772–73, 772 Florence: fifteenth-century art in, 568–601, 582– 84, 585, 587, 592–93, 597, 602–604, 608, 608–10, 613–18, 634 Florence Cathedral, Italy, 415-17, 415, 416, 587-

- Flying Storehouse, The (The Shigisan Engi), 482 Folk art, 549

Form, concept of, 7–8 Formalism, 116, 954–67, 1032–49; at beginning of historic period, 53 Formalist abstraction, 1044–49

Forum, 219; converted to atrium, 260 Forum Augustum, Rome, 220, 221 Forum Julium, (Forum of Caesar), Rome, 220

Forum of Pompeii, 203–205, 204 Forum Romanum, Rome, 203, 219–20, 220, 232 Forum of Trajan, Rome, 220, 222–24, 223, 259

Fossati, Chevalier, Interior of Hagia Sophia, 285 Fountain (Duchamp), 975

- Font-de-Gaume: cave painting of, 28; Paleolithic
- art at, 34 Forbidden City (Peking), 472–73, 472

- Geometric bronze warrior, Acropolis, Athens, 134, 135
- Geometric krater, Dipylon cemetery, 130, 130 Geometric period, in Greek art, 128–48 Geometric style, in ancient Greece, 128–48

- George Washington (Greenough), 868, 868 Georges Pompidou National Center of Art and Culture, Paris (Rogers and Piano), 1077–78, 1078
- Géricault, Théodore, 873–74; Insane Woman (Envy), 874, 874; Raft of the Medusa, 873–74, 873, 1026

German Expressionism, 968–72 Germanic peoples, Early Medieval art of, 322–23,

- 322, 323 German art: architecture, 353–56; Bauhaus, 1005– 1008; Expressionism in, 968–72; fifteenth-century, 718–21; Gothic, 410–15; Rococo and Late Baroque, 830–31; sixteenth-century, 721–
- Gérôme, Jean-Léon, 915–17; Pollice Verso (Thumbs Down!), 916–17, 916
- Gestural Abstract Expressionism, 1032–33 Ghent Altarpiece, The (Hubert and Jan van Eyck), 701–703, 701, 702
- Ghiberti, Lorenzo, 582–84; Gates of Paradise, east doors, Baptistry of Florence, 589–90, 589; Isaac and His Sons, 590, 590; The Sacrifice of Isaac, real constraints, Sons, 590, 590; The Sacrifice of Isaac, 583. 583
- Ghirlandaio, Domenico, 620-22; The Birth of the Virgin, 620–21, 620; Giovanna Tornabuoni (?), 621–22, 621
- Giacometti, Alberto, 1051; City Square (La Place), 1051, 1051
- Gilbert and George, 1076; We Are, 1076, 1076 Gilliam, Sam, 1043–44; Darted Again, 1043–44,
- 1044
- Giorgione (Giorgione da Castelfranco), 683-84; Pastoral Symphony (and/or Titian?), 683-84, 683, 920
- Giotto (Giotto di Bondone), 416, 567–74, 600; Arena Chapel interior, 569–70, 570; Death of St. Francis, 573, 572, 573; Lamentation, 570, 571; Ma-donna Enthroned, 569, 569; The Meeting of Joachim and Anna, 574, 574 Giovanni Santi, 645

- Giovanna Tornabuoni (?) (Ghirlandaio), 621-22, 621 Giovanni Arnolfini and His Bride (Jan van Eyck), 706, 706
- Giovanni da Bologna, 672–73; Rape of the Sabine Women, 672–73, 673, 962 Girardon, François, 812; Apollo Attended by the Nymphs, 812, 812

- Girodet-Trioson, Anne Louis, 872; The Burial of Atala, 872, 872 Gislebertus, 368; tympanum of St. Lazare, Autun, France, 368–69, 368

- Autun, France, 368–69, 368 Gizeh, Great Pyramids of, 81–83, 81, 82, 83 Glazes, in oil painting, 694–95 Gleaners, The (Millet), 899–900, 899 Global Grooze (Paik), 1068–69, 1069 Glorification of St. Ignatius, The (Pozzo), 774, 775 Gloucester Cathedral, England, 410, 410 Godard, Jean-Luc, 1071–72; Breathless (À bout de souffle) 1071–1071
- souffle), 1071, 1071 Goes, Hugo van der, 710–11; The Adoration of the Shepherds, 710–11, 711; The Portinari Altarpiece,
- 710, 710
- Goethe, Johann Wolfgang von, 832, 869, 881 Gogh, Vincent van, 935–37, 1054; The Night Café, 936, 936; The Starry Night, 936–37, 937 Gogi, Vinterivan, Supp. 7, 103, 71, 936, 37, 937
 Gold, use of, in Mesoamerica, 514–15; use of, in Mycenae, 121–22, 122
 Golden Mean, 307, 962
 Golub, Leon, 1055; Mercenaries (IV), 1055, 1055
 Gonzalez, Julio, 967, 1036; Woman Combing Her Hair, 967, 967
 Good Government fresco (Lorenzetti), 576–77, 578
 Good Samaritan window, Chartres Cathedral, 403
 Good Schepherd Sarcophagus, The, catacomb of Praetextatus, 268, 268
 Gorgons, Eleusis, 130–31, 130
 Gospel Book of Archibishop Ebbo of Reims, 331–32, 331
 Gospel Book of Otto III, 344, 345
 Gossaert, Jan (Mabuse), 733–34; Neptune and Amphitrite, 733–34, 734
 Gothic art: architecture, 5, 381–88, 390–400; com-

- Gothic art: architecture, 5, 381-88, 390-400; compared to Romanesque, 380–81; Early Gothic period in, 381–90; in England, 408–10; in France, 381–407; in Germany, 410–15; High Gothic period in, 390–406; in Italy, 415–19; Late Gothic period in, 406–407; manuscript illumi-nation in, 404–406; rib vault in, 383–84, 384;

sculpture in, 388–90, 400–402; stained glass in, 402–404; theology and, 381 Gothic International style, 694

- Gothic and a style, 654 Gothicism, in architecture, 694 Goths, 281; animal style of, 322–23; migration period of, 320–21
- Gotts, 281; animal style of, 322–23; migration period of, 320–21 Goujon, Jean, 740–41; Nymphs, 740–41, 741 Goya, Francisco, 857, 886–88; Los Caprichos, 857, 857; Saturn Devouring His Children, 888, 888; The Family of Charles IV, 886, 887; The Sleep of Reason Produces Monsters, 857, 857, 886–87; The Third of May, 1808, 887–88, 887, 1026 Grace at Table (Chardin), 839–40, 840 Grand Canyon Looking North, September 1982 (Hockney), 1075–76, 1075 Grande Odalisque (Ingres), 875, 875 Grave Stele of Hegeso, Dipylon cemetery, 162, 162 Grave Stele of Hegeso, Dipylon cemetery, 162, 162 Great Dictator, The (Chaplin), 1023 Great Mosque, Samarra, Iraq, 300–301, 300 Great Piece of Turf, The (Dürer), 728, 728 Great Stupa, Sanchi, India, 429–30, 429, 430 Great Stupa, Sanchi, India, 429–30, 429, 430 Great Temple, Tenochtitlán, 517, 517 Great Wall, China, 453

- Greece (Ilonian), influence on Achaemenid Per-sian art, 69, 71 Greek art: architecture, 139–46, 153–61, 170–72,
- stan art, 69, 71
 Greek art: architecture, 139–46, 153–61, 170–72, 180–84; canon of proportions in, 168–69; city design in, 181–82, 181; Early Classical (Transitional) period in, 148–53; Geometric and Archaic periods in, 128–48; High (mature) Classical period in, 163–66; influence of, on Etruscan art, 193–94; Late Classical period in, 166–72; logic in, 144, 155–56; mosaics in, 184–85; painting in, 164–66; proportion in, 111, 163–64; sculpture, 134–39, 149–53; vase painting, 129–34; vase shapes in, 131, 131
 Greek revival, 139
 Greek revival, 139
 Greek revival, 139
 Greek temple: amphiprostyle, 140; dipteral, 140; hypaethral type, 180; and megaron, 140; peripteral, 140; plan of, 140–46, 140, 143; proportions of, 141; prostyle, 140, 190. See also Corinthian order. Doric order, Ionic order
 Greek theater, Cretan influence on development of, 109

- Greek theater at Epidauros, 171–72, 171 Greenough, Horatio, 868; George Washington, 868, 868
- Greuze, Jean Baptiste, 841–42; The Son Punished, 841–42, 842 Grisaille (tones of grey), 716
- Groin vault, 225
- Groin vault, 225 Groin vault, in Romanesque architecture, 352, 356 Gropius, Walter, 1005–1006; Bauhaus, 1005– 1006, 1006 Gros, Antoine Jean, 872–73; Pest House at Jaffa, 872–73, 872 Gross Clinic, The (Eakins), 901, 901 Group de Recherche d'Art Visuel (Research Group for Visual Art), 1047 Cringwidd Matthiae, 724, 26, 068; The Lewlein

- Grünewald, Matthias, 724–26, 968; The Isenheim Altarpiece, 724–26, 724, 725 Guaranty (Prudential) Building, Buffalo (Sulli-
- van), 948, 948
- Guarini, Guarino, 763–65, 827; Chapel of the Santa Sindone, Turin, 764, 764; Palazzo Carig-nano, Turin, 763–64, 764
- nano, Turin, 763–64, 764 Guatemala, pre-Columbian art of, 503, 507–508. See also Maya civilization Gudea, of Lagash, 57 Gudea, sculpture of, 65, 84 Gudea Worshiping, Telloh, 57 Guernica (Picasso), 1026–27, 1026 Guggenheim Museum. See Solomon R. Guggen-baim Museum.

- heim Museum
- Guidobaldo II (Duke of Urbino), 685-86
- Gupta period, in Indian art, 435, 439, 443, 459 Guti peoples, 57 *Gyrfalcon* (Audubon), 891, 891
 - - Η
- Hadrian, 216, 227, 235, 237-38, 238; medallion of,
- 251, 251 Hagia Sophia, Constantinople (Istanbul), 247, 284–87, 284–86, 309, 395; plan and section of, 286
- Hagia Triada, 106

- Hagley Park, England, 844–45. See Miller, Stuart Haida mortuary poles, 531, 532 Half-barrel vaults, 350 Hall church (hallenkirche), 412 Hallenkirche (hall church), 412 Hall of Bulls, Lascaux, 29 Hall of Mirrors, Amalienburg, 828, 828 Hall of Mirrors (Galerie des Glaces), Versailles, 808–809. 809

307

- 808-809, 809 Hall of Supreme Harmony, China, 472, 472 Hall of the Two Sisters, Alhambra, Granada, 307,

Hals, Frans, 787–89; Archers of St. Adrian, 789, 789; Willem Coymans, 787–88, 788 Hamilton, Richard, 1057–58; Just What Is It That

Marker Today's Homes So Different, So Appealing?, 1057–58, 1057 Hammurabi, 47, 52; Code stele of, 57, 58 Han dynasty, China, 453–55 Han Kan, 461; Horse, 461, 461

Han Kan, 461; Horse, 461, 461
Hand-spring, a flying pigeon interfering (Muybridge), 902, 902
Hanging Spider (Calder), 997–98, 998
Hang-Up (Hesse), 1049, 1049
Haniwa figures, Japan, 476–77, 476
Haniwa sculpture, 476–77, 476
Haniwa sculpture, 476–77, 1091
Harappa, 426, 434
Harborille Triptych, 298, 298
Hardouin-Mansart, Jules, 808, 809–10; Eglise de Dôme, Church of the Invalides, Paris, 810–11, 810; garden façade of Palace of Versailles, 808, 808

810; garden façade of Palace of Versailles, 808, 808, 809–10

BUS, 809–10
 Harihara, Prasat Andet, Cambodia, 443, 443
 Harmika (enclosure), 429
 Harmony in Red. See Red Room (Harmony in Red)
 Harrowing of Hell, The, Mosque of the Ka'riye, Istanbul, 294, 295

Harunobu, Suzuki, 927; The Evening Glow of the Andon, 927, 927 Harvester Vase, The, Hagia Triada, 117, 117 Hasan Dag, 45 Hasegawa Tohaku, 488; Pine Trees, 488, 489 Hatebergut, gueap of Egrupt 89, 90, 94; tempela

Hatshepsut, queen of Egypt, 89–90, 94; temple of, 89–90, 89

Hawaii, art of, 542, 542 Hawes, Josiah Johnson, 893–94; Early Operation under Ether (with Southworth), 893–94, 894

Haywain, The (Constable), 890, 890 Headhunting, represented in the art of Oceania,

Headmaster, 390; Royal Portals, Chartres Cathe-dral, 390, 390

Head (study for War Monument) (Barlach), 973, 973

Head of a crucifix, St. Maria im Kapitol, Cologne,

414, 415 Head of an Akkadian Ruler, Nineveh, 55 Head of a Roman, 198, 199 Head of Augustus, Rome, 236–37, 236 Head of a woman (Aphrodite?), Zippori, 246, 246 Head of Odysseus, Rhodes, 176–77, 177

Head of the Procession, Parthenon, Acropolis, Ath-

Head of the Procession, Parthenon, Acropolis, Athens, 159
Hell (Bosch), 713, 714, 714
Hellenistic period, in Greek art, 172–85
Helmholtz, Hermann von, 908–909
Hepworth, Barbara, 996–97; Three Forms, 997, 997
Hera, Samos, 135–36, 135, 137
Herakles, Temple of Aphaia, Aegina, 148, 148
Herakles and Apollo Struggling for the Tripod (Andokides Painter), 133, 133
Herakles and Telephos, Herculaneum, 211–12, 212, 215

Herakles Strangling Antaios, Cerveteri (Euphroni-os), 133, 133 Herculaneum, 202, 205, 206, 211; atrium houses

Hercules and Antaeus (Pollaiuolo), 618, 618 Hercules and Omphale (Spranger), 734, 734 Hermes and Dionysos, Olympia (Praxiteles), 166–

Hermes Bringing the Infant Dionysos to Papposilenos, Vulci (Phiale Painter), 165–66, 165 Herodotus, 64, 75, 188 Herrera, Juan de, 744–45; Escorial, 744–45, 744–

Herringbone perspective, 207
 Hesse, Eva, 1049; Hang-Up, 1049, 1049
 Hiberno-Saxon art, 325–30
 Hieroglyphics, 74, 503–504
 Hieronymus Holzschuher (Dürer), 728–29, 728

Haydon, Benjamin Robert, 157

546, 546

414, 415

215

45

of, 189

67, 166, 169

1126 INDEX

- High Cross of Muiredach, Monasterboice, 329-30, 330

- High crosses, Ireland, 329–30, 330 High Gothic period, 390–406 High (Mature) Classical period, in Greek art, 153– High relief, 15
- High Renaissance, 634–67. See also Renaissance, culture and art of
- Hill, David Octavius, 895–96; Sandy Linton and His Boat and Bairns (with Adamson), 895–96, 895
- Himation (cape), 136 Hinayana Buddhism, 428, 431, 441-42
- Hinduism, art and architecture inspired by, 433-41
- Hine, Lewis Wickes, 1015–16; Breaker Boys, 1015,
- Hippodameia and the Centaur, Temple of Zeus at Olympia, 152–53, 152
 Hippodamian plan, 181, 219
 Hippodamos, 181
 Hispikawa Moronobu, 495
 Hispikawa Moronobu, 495
 Hispikawa Moronobu, 495

- Höch, Hannah, 978; Cut with the Kitchen Knife, 978, 978
- 978, 978
 Hockney, David, 1075–76; The Grand Canyon Looking North, September 1982, 1075–76, 1075
 Hogarth, William, 9, 840–41; Breakfast Scene (Mar-riage à la Mode), 840–41, 841
 Holbein, Hans, the Younger, 730–32; The French Ambassadors, 730–32, 731, 955
 Holland, Baroque art in, 786–98. See also Flemish art, Netherlands
 Hollis, Douglas, 1091–92; A Sound Garden, 1092, 1092

- 1092

- Holography, 1066–67 Holy Trinity, The (Masaccio), 600–601, 600 Homage to Griffin (Bell), 1064, 1064 Homage to New York (Tinguely), 1062–63, 1063 Homer, Winslow, 905–906; The Fox Hunt, 905– 906, 906
- Hon-Ami Koetsu, 492; Deer and Calligraphy, 492,
- 492
 Honduras, pre-Columbian art of, 503. See also Maya civilization
 Honnecourt, Villard de, 19, 404; Lion Portrayed from Life, 19, 19; page from a notebook of, 404, 104
- Honthorst, Gerard van, 786-87; The Supper Party,
- 786-87, 787 Hoodo (Phoenix Hall) of the Byodo-in Temple,
- Uji, 483–84, 483 Hopi culture and art, 529–30 Hopper, Edward, 1013–14; Nighthawks, 1013–14, 1014

- Horizontal handscroll, 463 Horse: in Chinese art, 455, 461; in Egypt, 89 Horsemen and Helicopters, Islamabad, 549, 549 Horse Being Devoured by a Lion (Stubbs), 854–55, 855

- 855
 Horse Fair, The (Bonheur), 900, 900
 Horsemen, Parthenon, Athens, 158, 158
 Horta, Victor, 955; staircase in the Hotel van Eetvelde, Brussels, 955, 955
 Hôtel de Soubise. See Salon de la Princesse
 Hotel van Eetvelde staircase, Brussels, (Horta), 955, 955
- Houdon, Jean Antoine, 836, 837, 868; Voltaire Seated, 836, 836, 837, 868 House and Street (Davis), 964, 964 House of Livia, Primaporta, 208–209, 209

- House of Livia, Primaporta, 208–209, 209 House of Neptune and Amphitrite, Hercula-neum, 215, 215 House of Pansa, Pompeii, plan of, 205, 205 House of the Dioscuri, Pompeii, 211–12, 211 House of the Faun, Pompeii, 205, 213–14, 213 House of the Vetii, Pompeii, 209–10, 210 Houses of Parliament, London (Barry and Pugin), 260
- 869, 869
- Howard, Thomas (Earl of Arundel), 784, 785
 Howe, George, 1008; Philadelphia Savings Fund Society Building (with Lescaze), 1008, 1008
 Hsia Kuei, 464, 485
 Har Bei hung, 469
- Hsu Pei-hung, 468 Huang Kung-wang, 466; Dwelling in the Fu-ch'un Mountains, 466, 466 Hui Tsung, 464

- Hui Tsung, 464 Human Concretion (Arp), 985–86, 986 Human figure: representation of, in ancient Egypt, 77–78; in Byzantine art, 282; in Gothic sculpture, 400–402; in Greek art, 128–29, 134– 39, 147–48, 149–50, 152, 163–64; in Mesolithic art, 36; in Minoan art, 117–18; in Modernist art, 959; in native arts, 502; in Paleolithic art, 36; in Bectmodernist art, 1031; in Renalissance art Postmodernist art, 1031; in Renaissance art,

591, 618, 727-28; in Romanesque art, 365-66, 373

620–21, 625–27, 654–56, 663–65, 666; Gothic, 415–19; High Renaissance, 634–91; Mannerism, 651–53, 672–73; painting, 598–608, 618–31, 634–40, 644–60, 665–66, 668–72, 679–91, 765– 75; proto-Renaissance, 562–79; Roccoc and Late Baroque art in, 826–29; sculpture in, 582–97, 613–18, 651–53, 672–73 ion Room-House of the Vetii Rompoil 200–10

Ixion Room, House of the Vetii, Pompeii, 209-10,

J Jacopo della Quercia, 584; The Expulsion from the Garden of Eden, 584, 584 Jade carving, Chinese, 452, 452 Jaggayyapeta, India, 436 Jaguar cult, 511 Jaguar Devouring a Hare (Barye), 19, 870, 870 Jana, Maya necropolis, 512 Jamb statues, Chartres Cathedral, 389–90, 390, 587

Jambs, 363, 363 Jamdat Nasr culture, 47 Japan, civilization and art of, 476; archaic period in, 476–78; architecture in, 477–78, 480, 490, 497; Ashikaga period in, 485–88; Asuka period in, 478–80; domestic architecture in, 497; Early Heian period in, 480–83; garden design in, 491– 92; Jomon culture in, 476; Kamakura period in, 484–85; Katsura palace in, 490–91; Late Heian (Fujiwara) period in, 483–84; Momoyama and Edo (Tokugawa) periods in, 488–97; Nanga school of, 492–93; painting in, 479–86, 488–89, 492–94; pottery in, 476, 488; printmaking in, 495–97; realism in, 493; sculpture in, 476–77, 478–79, 484; tea ceremony in, 486–88; Tosa and Kano schools in, 488; ukiyo-e in, 495; Yamato-e style in, 481–82, 484–85, 488 Jatakas, 442 Java, art in, 442–43

Java, art in, 442–43 Jeanneret-Gris, Charles Édouard. See Le Corbus-

ter
 Jefferson, Thomas, 851–53; Monticello, 851, 851; University of Virginia, 852, 853; Virginia State Capitol, 853
 Jemaa Head, Nigeria, 534, 534
 Jericho: human skulls with plaster features in, 43, 43; proto-Neolithic period in, 42–43; stone tower in settlement wall of, 42, 43

Jocho, 483; Amida, 483–84, 483 Johns, Jasper, 1069–70; Target with Four Faces, 1070, 1070

Johnson, Philip: Seagram Building, New York (with Mies van der Rohe), 1008, 1044, 1044 Jones, Inigo, 813–14, 820; Banqueting House, Whitehall, London, 813–14, *813*

JOU, 962 Journal (Delacroix), 880, 881 Jouvin, Hippolyte, 925; The Pont Neuf, 925, 925 Juan de Pareja (Velázquez), 777–78, 778 Judd, Donald, 1048–49; untited, 1048–49, 1049 Judgment of Paris, The (Cranach), 723–24, 723 Judith and Maidservant with the Head of Holofernes (Corritocable) 771, 72, 721

(Gentileschi), 771–72, 772 Julia and the Window of Vulnerability (Leonard),

858, 1056, 1056 Julius II (pope), 634, 645, 676; tomb of, 651–52, 651, 652

651, 652 Jump cuts, 974, 1068, 1071–72 Jupiter and Io (Correggio), 667, 667 Jupiter and Semele (Moreau), 941–42, 941 Just What Is It That Makes Today's Homes So Differ-ent, So Appealing? (Hamilton), 1057–58, 1057 Justinian, 272, 281–82 Justinian and Attendants, San Vitale, Ravenna, 280, 281

Juvara, Filippo, 612n, 827; Superga, Turin, 827,

K Ka figures, 94; defined, 76, 78 Ka-Aper (Sheikh el Beled), Saqqara, 85, 85 Kachina spirit masks, 530–31, 531 Kagle (mask), Sierra Leone, 540, 540 Kahlo, Frida, 987; The Two Fridas, 987, 987 Kalf, Willem, 797; Still Life, 797, 893 Kallikrates, 154, 160; Parthenon, Athens (with Iktinos), 155, 155 Kamakura period (Japanese art), 484–85 Kamares pitcher, 108, 109 Kamares, pottery of, 108–109, 116–18 Kandinsky, Wassily, 993, 1033; Improvisation 28, 993, 994

210

Jambs, 363, 363

ier

esus. See Christ

1011 962

281

993, 994 Kano Motonobu, 488 Kano Sanraku, 492

- Humanism, 582, 608, 613

- Humanism, 582, 608, 613 Hu-nefer, papyrus scroll, 102, 102 Hunt, Richard Morris, 871; The Breakers, New-port, Rhode Island, 871, 871 Hunter and Kangaroo, Arnhem Land, 548, 548 Hunters in the Snow (Bruegel the Elder), 736, 736 Hydria (Greek vase shape), 131, 131 Hyksos, of Egynt, 89

- Hydria (Greek vase shape), 131, 131 Hyksos, of Egypt, 89 ''Hypo'' fixing solution, 895 Hypocaust system, 244 Hypostyle halls of Egypt, 92–93 Hypostyle mosque, 300–301 Hysolar Institute Building, University of Stuttgart (Behnisch), 1079, 1079

- Iconoclastic Controversy, 290-91, 297
- Iconography, 6–7 Iconostasis, 294

- Icons, Byzantine, 292–93, 294–97 Idealism, 230–31, 249–51; in Roman Empire art,
- 230-31
- Ife king figure, Nigeria, 535, 535 Igbo Ukwu, Nigeria, 535 Ijo Iphri sculpture, 536, 536

- Ijo Iphri sculptūre, 536, 536
 Ikeno Taiga, 493
 Ikhnaton. See Akhenaton
 Iktinos, 154; Parthenon, Athens (with Kallikrates), 155, 155
 II Gesù, Rome, 752–53, 752–53
 II Guercino, 768; Aurora, 768, 768
 Illumination. See Manuscript illumination Illusionism, 211–12, 235–36
 Imhotep, 80–81, 93
 Imperial Palace, Forbidden City, Peking, 472, 472
 Impluvium, 205

- Imperial Palace, Forbidden City, Peking, 472, 472 Impluvium, 205 Import blocks, 279 Impression—Sunrise (Monet), 920, 923 Impressionism, 919–30; in catacomb paintings, 258; painting, 920–30; sculpture, 930 Inca culture and art, 524–26 Incrustation, 359–60, 361 Incrustation style, in wall painting, 206, 206 Independent Group (Institute of Contemporary Art, London), 1057–59 India: architecture in, 428–31, 433–38; Buddhist

- Art, London), 1057–59
 India: architecture in, 428–31, 433–38; Buddhist domination of, 428–33, 434, 441–42; ethnic groups in, 426; Hindu resurgence in, 433–41, 442–47; Indus civilization in, 426–27; Mauryan period in, 428–29; painting in, 438–41; sculpture in, 431–33, 433–38
 Indochina, art of, 476
 Influence, concert of, 6

Ionians, 127

725

Islam, 255

- Indochina, art of, 476 Influence, concept of, 6 Ingres, Jean Auguste Dominique, 874–76; Fran-cois Marius Granet, 876, 876; Grande Odalisque, 875, 875; Paganini, 876–77, 876 Insane Woman (Envy) (Géricault), 874, 874 Insulae, in Ostia, 217, 217 Intaglio, in Sumerian art, 54–55 Intensity, of color, 13 Interior of St. Paul's (Piranesi), 259, 259 Interior of the Partheon (Pannin), 228

Interior of the Pantheon (Pannini), 228 International style, 574–76, 598, 601, 698–99 International Style, 1006, 1044–47, 1077

Ionic order, 141–42, 141, 145–46, 232; elements of, in Parthenon, 154; examples of, in Acropolis, 160–61; in Parthenon, 158

IIS, 100-01; In Participation, 150 JphigenialTitus Andronicus (Beuys), 1087–88, 1088 Iran, ancient, 65–71; architecture in, 66–68. See also Persian Empire Iron bridge, Coalbrookdale (Darby III and Pritch-ard), 837–38, 837 Iroqueis culture and art. 533–34

arq), 53/-33, 53/ Iroquois culture and art, 533-34 Isaac and His Sons (Ghiberti), 589-90, 589 Ise shrine, Japan, 477, 478 Isenheim Altarpiece, The (Grünewald), 724-26, 724,

Ishtar Gate, Babylon, 64–65, 65 Isidorus of Miletus, 284; Hagia Sophia, 284, 284

Islamic art, 299; architecture and architectural ornament in, 299–311; illuminated manuscripts in, 312–13; mosaics in, 305–306, 305; plant mo-

Italian art: architecture, 592–97, 613–18, 640–44, 660–63, 673–75, 676–79; Baroque, 725–75; fif-teenth-century Renaissance, 581–631; frescoes,

III, 512–513, IIISales III, 502–502, 502, 502, 503, 503 Isocephalic figure arrangement, 164–65 Isoda Koryusai, 496 Isozaki, Arata, 497

Intricate style, in wall painting, 209-11

Le Vau, Louis, 806, 808; east façade of the Louvre, Paris (with Le Brun and Perrault), 806,

Louvre, Paris (with Le Brun and Perrault), 806, 806; garden façade of Palace of Versailles (with Hardouin-Mansart), 808, 808 Lescaze, William E., 1008; Philadelphia Savings Fund Society Building (with Howe), 1008, 1008 Lescot, Pierre, 740 Liang K'ai, 465, 485; The Sixth Ch'an Patriarch Chopping Bamboo, 465, 465 Liberation of Aunt Jemima, The (Saar), 1085, 1085 Liberty Leading the People (Delacroix), 879–80, 879 Li Ch'eng, 463 Life and Landscape on the Norfolk Broads (Emerson), 909

Life and Miracles of St. Audomarus (Omer), The, 373-74, 373

74, 373 Light: additive, 12; in Baroque art, 750–51; concept of, 11; in Impressionism, 922–23, 924; laser, 1066; laser production of, 12; modeling and, 11–12; natural, 12; in Romanesque church design, 352; scientia of, 384; subtractive, 12; use of, in Baroque art, 790, 795–96, 805; use of, in Gothic architecture, 397–98; value and, 11–12 Light Coming on the Plains II (O'Keeffe), 1011, 1011 Li Kung-lin, 463

Light Coming on the Plains II (O'Keeffe), 1011, 1011 Li Kung-lin, 463 Limbourg Brothers, 698–99; Les Très Riches Heures du Duc de Berry, 698–99, 699 Lin, Maya Ying, 1092–93; Vietnam Memorial, Washington, D.C., 1092–93, 1093 L'Indifférent (Watteau), 823, 823 Lindisfarne Matthew, 328–29, 329, 332 Line, concept of, 9–10 Linear A script, 107 Linear B script, 107 Linear B script, 107, 123 Line in Scotland, A (Long), 1091, 1091 Line of beauty, 9 Lintels, 288, 363 Lion from the Processional Way, Ishtar Gate, Baby-

Lion from the Processional Way, Ishtar Gate, Baby-

Lion from the Processional Way, Ishtar Gate, Baby-lon, 19, 64, 64 Lion Gate, Boghazköy, Anatolia, 58, 58 Lion Gate, Mycenae, 120–21, 120, 147 Lion Hunt mosaic, Pella, 184, 185 Lion Hunt, The (Rubens), 783, 783 Lion Portrayed from Life (de Honnecourt), 19 Lipchitz, Jacques, 961–62; Bather, 961–62, 961 "Little Dutch Masters," 795–98 Livia, Pompeii, 236, 237 Lochner, Stephan, 718; Madonna in the Rose Gar-den, 718, 718

Lomas Rishi cave, Barabar Hills, India, 429, 429

Lombards, 320
 Lombardy, architecture in, 353–56, 418
 London Bridge (Derain), 957, 957
 Long, Richard, 1091; A Line in Scotland, 1091, 1091
 Longhena, Baldassare, 765; Santa Maria della Salute, Venice, 765, 765

Lord Heathfield (Reynolds), 834–35, 834 Lorenzetti, Ambrogio, 576–77; Good Government fresco, 576–77, 578; Peaceful Country, 578–79, 578; Peaceful City, 577–78, 578

Lorenzetti, Pietro, 576; The Birth of the Virgin, 576,

Lorenzo the Magnificent. See Medici, Lorenzo dé Lorrain, Claude, 804–805; Embarkation of the Queen of Sheba, 804, 804

Lorsch Monastery, Lorsch, West Germany, 335-

Lothair, 338 Lotiform capital, 428 Louis VII (king of France), 371, 380 Louis IX (king of France) (St. Louis), 404 Louis XIV (king of France), 806, 808, 818, 821, 823 Louis XIV (Rigaud), 823, 823 Louis XVI (king of France), 846, 849 Louvain Brotherhood, 732

L'Ouverture Series No. 36 (Lawrence), 1024-25,

Lumière, Pierre, 952 Lumière, Pierre, 952 Luncheon on the Grass (Le Déjeuner sur l'herbe) (Manet), 920, 921, 921 Lunettes, 256, 555

Luster painting, 311 Luzarches, Robert de, 394; plan of Amiens Cathe-dral, 395, 395

Longitudinal barrel vault, 350, 351

36, 336 Lost-wax method of casting, 149, 535 Lothair, 338

Louvre, Paris, 740, 740, 806, 806 Low relief, concept of, 15 Lucifer (Pollock), 1033, 1033 Ludovisi Battle Sarcophagus, 267–68, 267 Lumière, Auguste, 952

Lungmen, China, 456

Luristan bronzes, 70, 70, 322

den, 718, 7 Loculi, 256

1024

Kano school, Japan, 488

- Kao, 485
- Kaprow, Allan, 1070–71; A Spring Happening, 1070–71, 1070
- Karnak: hypostyle hall at, 93, 93; as monument to Amen, 101
- Käsebier, Gertrude, 840, 918; Blessed Art Thou Among Women, 918, 918

- Among Women, 918, 918 Katholikon, Byzantine Church of the, Hosios Loukas, 14 Kato Zakro, 106, 109 Katsura Palace, Japan, 486–87, 487, 490–91, 491 Katsushika Hokusai, 496–97; The Great Wave, 496, 497; Thirty-Six Views of Mt. Fuji, 496–97 Kauffmann, Angelica, 848; Cornelia, Pointing to Her Children as Her Treasures, 848–49, 848 Kaufmann House (Fallingwater), Bear Run, Pennsylvania (Wright), 1001, 1001 Kelly, Ellsworth, 1047–48; Red, Blue, Green, 1048, 1048

- 1048 Kent, William, 820–21; Chiswick House, Eng-land (with Boyle), 820–21, 821, 851 *Khafre*, Gizeh, 84, 84 Khafre, tomb of, 81, 81, 82–83, 82 Khajuraho, India, 437–38, 437 Khirbat al-Mafjar, palace at, 305, 305 Khnumhotep, tomb of, 87, 87, 88, 88 Khorsabad, 59, 64–65; temple of Sargon II at, 59– 60, 59, 60

- 60, 59, 60 Khufu, pyramid of, 81, 81 Kiefer, Anselm, 1056–57; Vater, Sohn, Heiliger Geist (Father, Son, Holy Ghost), 1056–57, 1056 Kienholz, Edward, 1083–84; The Wait, 1083–84,
- Kinetic sculpture, 1062–64 King Cophetua and the Beggar Maid (Burne-Jones), 914–15, 915
- King Smenkhkare and Meritaten (?), Tell el-Amarna, 98, 98
- Kirchner, Ernst, 969–70; Street, Berlin, 970, 970 Kitagawa Utamaro, 496

- Kiyomasu I, 495 Kiee, Paul, 967, 988–89, 993; Death and Fire, 989, 990; Twittering Machine, 989, 989, 1063 Kleitas, 131; The François Vase (with Ergotimos), 131. 131

- 131, 131
 131, 131
 Klimt, Gustav, 955; Death and Life, 955, 956
 Kline, Franz, 1033-34; Painting, 1033-34, 1034
 Kneeling Man-Bull, Jamdat Nasr, 47, 47
 Knossos, 109-11, 110, 111; archeological investigation of, 106; palace at, 109-14, 110-14, 116
 Koça (Sinan the Great), 309; Selimiye Cami (Mosque of Selim II), 310, 310
 Kogan (tea-ceremony water jar), 488, 488
 Kollwitz, Käthe, 969; The Outbreak, 969, 969; The Peasants' War, 969
 Korau, 137-38

- Korai, 137-38

- Korai, 137–38
 Korea, pottery from, 476
 Kore figures, 135–39; from Chios (?), 138, 138
 Kouros figures, 135–39, 149, 169; from Tenea, 136–37, 136
 Kraters (Greek vase shape), 130, 131, 131; Argonaut Krater (Niobid Painter), 164, 165; The Francois Vase (Ergotimos and Kleitias), 131, 131; Geometric, 130, 131; Herakles Strangling Antaios (Euphronios), 133, 133; Hermes Bringing the Infant Dionysos to Papposilenos (Phiale Painter), 165, 165 165, 165

Krishna and Radha in a Pavilion, Punjab, India, 440, 441

- 441
 Kritios Boy, Acropolis, Athens, 139, 139, 149, 586
 Kroisos, Anavysos, 136, 137, 138–39
 Kruger, Barbara, 1087; Untitled (Your Gaze Hits the Side of My Face), 1087, 1087
 Ku K'ai-chih, 458; Lady Feng and the Bear from Ad-monitions of the Instructress to the Court Ladies, 458, 459
- 458, 458

- 405, 455 Kuan-yin, China, 470, 470 Kuang (libation vessel), 451, 451 Kuaua Pueblo, 529–30, 530 Kuba culture and art, 540, 540
- *Kukailimoku*, Hawaii, 542, 542 **Kuo Hsi**, 463 Kwakiuti mask, 531, 531
- Kylix (Greek vase shape), 131, 131, 132; Dionysos in a Sailboat (Exekias), 132, 132; Revelers (Brygos Painter), 133, 133

L

- Labrouste, Henri, 945–46; Bibliothèque Ste. Gen-eviève, Paris, 945–46, 946 Lackarbeiter (Varnisher) (Sander), 1016, 1016 Lady Chapel, Salisbury Cathedral, 409–10, 409

- Lady Feng and the Bear from Admonitions of the Instructress to the Court Ladies (Ku K'ai-chih), 458, 458

- Laila and Majnun at School, 313, 313 Lakshanas, 431–32 La Madeleine, Church of, Vézelay, France, 370– 71, 370
- La Madeleine (Vignon). See Madeleine, La Lamassu (winged bulls), 60, 60 Lamentation (Giotto), 571, 572 Lamentation Over the Dead Christ, Nerezi, 292, 292

- Lamentation Over the Dead Christ, Nerezi, 292, 292
 Landscape painting: Baroque, 772-73, 797-98;
 Chinese, 464, 464; earliest examples of, 45, 56;
 English, 883-85; naturalism in, 832-33; Post-Impressionistic, 933-34; realism in, 890-91; in
 Roman republic, 212-13; Romantic, 881-85
 Landscape with St. Jerome (Patinir), 735, 735
 Lange, Dorothea, 1017-18; Migrant Mother, Ni-pomo Valley, 1018, 1018
 Languedoc-Burgundy, architecture of, 350-52
 Laocoön group (Agesander, Athenodoros, and Polydoros), 176, 176, 673, 918-19
 Laon Cathedral, France, 384-86, 384-86
 Lao-tzu, 452

- Lao-tzu, 452
- Lapith and Centaur, Parthenon, Athens, 158, 158 Lapiths, 158
- Lara Jonggrang, Java, 443 Lascaux: Axial Gallery at, 34; cave painting of, 28– 33; diagram of caves of, 29 Lasers, 12, 1066 Last Communion of St. Jerome, The (Domenichino),
- 771. 771
- Last Judgment, The (Cavallini), 567-68, 567 Last Judgment, The (Michelangelo), 626, 663-65,
- Last Supper, The (Andrea del Castagno), 602, 602 Last Supper, The (Bouts), 709–10, 709 Last Supper, The (Leonardo), 10, 10, 11, 11, 636–
- 38, 637

- Last Supper, The (Tintoretto), 689, 689 Last Supper, The (Tintoretto), 689, 689 Late Baroque period, 819–21 Late Gothic period, 406–407 Late Gothic style, 718–21 Late Classical Greek period, 166–72 Late Heian (Fujiwara) period (Japanese art), 483–
- 84
 Late Minoan period: architecture of, 109–11; New Palace period and, 109; painting of, 111–16; pottery of, 116–18; sculpture of, 116–18
 Late Renaissance, 667
 "Later Canon" of Egyptian art, 78, 78
 La Tour, Georges de, 799–800; Adoration of the Shepherds, 799–800, 799
 Latrobe, Benjamin, Capitol, Washington, D.C., 852

- 852, 853

- Laurentian Library, Florence, (Michelangelo), 659–60, 659 La Venta, Mexico, 504–505, 504 Lawrence, Jacob, 1023–25; Toussaint L'Ouverture Series No. 36, 1024–25, 1024
- Le Brun, Charles, 806; east façade of the Louvre, Paris (with Perrault and Le Vau), 806, 806; Ga-lerie des Glaces, Versailles, (with Hardouin-Mansart), 808, 809
- Le Corbusier (Charles Édouard Jeanneret-Gris), 1001–1004, 1037–39; Notre Dame du Haut, Ronchamp, 1037–38, 1038; Skyscraper model, 1007–1008, 1007; Unité d'Habitation, Mar-seilles, 1003; Villa Savoye, Poissy-sur-Seine, 1002–1003, 1003
- Lectionary of Henry II, 342, 343, 345 Legend of Saints Eligius and Godeberta, The (Chris-tus), 708–709, 709
- tus), 708-709, 709
 Le Gray, Gustave, 906-907; Seascape and Rough Waves; 906-907, 907
 Lehmbruck, Wilhelm, 971-72; Seated Youth, 8; Standing Youth, 971-72, 971
 Leibl, Wilhelm, 903; Three Women in a Village Church, 903, 904, 905
 Lekythos (Greek vase shape), 131, 131
 L'Enfant, Pierre, 851-52
 Le Nain, Louis, 800-801; Family of Country People, 800-801, 800

- 800-801, 800
- Le Nôtre, André, 808–809; park of Palace of Ver-sailles, 807, 808–809 Saines, 807, 808–809
 Leonard, Joanne, 1056; Dream Kitchens series, 1056; Dreams and Nightmares series, 1056; Julia and the Window of Vulnerability, 858, 1056, 1056
 Leonardo da Vinci, 600, 634–40, 645; architectural

work of, 640; cartono 054–40, 645; architectural work of, 640; cartono for The Virgin and Child with St. Anne and the Infant St. John, 636, 636; Mona Lisa, 638, 638; The Embryo in the Womb, 638, 639; The Last Supper, 10, 11, 636–38, 637; The Virgin of the Rocks, 635–36, 635

Lyre Player, Keros, 108, 108 Lysippos, 167-68; Apoxyomenos, 168, 173

Μ

- Ma Yuan, 464, 485; Bare Willows and Distant Mountains, 464, 464

- tains, 464, 464 Mach, Ernest, 924 McHale, Magda Crodell, 1058 Machicolated galleries, 419 Machu Picchu, 524, 525–26 **Machuca, Pedro**, 743–44; courtyard of the palace of Charles V, Alhambra, Granada, 743, 743 Macke, Ernst, 993 Madeleine, La (Vignon), 867, 867 Madame de Pompadour as the Venus of the Doves (Fal-copet) 826, 826
- conet), 826, 826
- Maderno, Carlo, 754; Santa Susanna, Rome, 754,
- Madonna and Child (Luca Della Robbia), 616, 616 Madonna and Child with Angels (Fra Filippo Lippi), 607-608, 608
- Madonna Enthroned (Giotto), 569, 569 Madonna Enthroned with Angels and Prophets
- (Cimabue), 568, 568 Madonna in the Rose Garden (Lochner), 718, 718 Madonna of the Harpies (Andrea del Sarto), 665–66, 665

- Madonna of the Pesaro Family (Titian), 685, 685 Madonna of the Trees (Bellini), 680, 680 Madonna with the Goldfinch (Madonna del Cardellino) (Raphael), 645, 646 Madonna with the Long Neck (Parmigianino), 669,
- 669
- Madrasah and mausoleum of Sultan Hasan, Cairo, 307–308, 307 Maestà Altarpiece, The (Duccio), 565–67, 566 Magdalenian culture, art in, 28–35

- Mahabalipuram, India, 436–37 Mahabalipuram, India, 436–37 Mahendravarman I, 436 Maillol, Aristide, 972, 990; The Mediterranean, 990, 990

- 990, 990
 Maison Carrée, Nîmes, 220–21, 220, 853
 Maize God (Maya), Honduras, 511, 511
 Makimono (horizontal-scroll format), 481
 Malanggan tableau, 544, 545
 Male Nude, Harappa, 426, 426
 Malevich, Kasimir, 993–95; Suprematist Composition: Aeroplane Flying, 994, 994
 Malta, megalithic monuments of, 120
 Man with the Glove (Titian), 687, 687
 Man in a Red Turban (Jan van Eyck), 705–706, 705
 Man ad Woman in a Large Room (Diebenkorn).

- Man in a Red Turban (Jan van Eyck), 705–706, 705 Man and Woman in a Large Room (Diebenkorn), 1034–35, 1035 Manapa (assembly hall), 437 Mandala, 435, 442 Mandan Chief, Mato-Tope (Bodmer), 533, 533 Mandapa, 437 Manet, Edouard, 919–22; Bar at the Folies-Bergère, 921–22, 922; Le Déjeuner sur l'herbe (Luncheon on the Grass), 920, 921, 921 Manegia, Cook Islands, 543
- Mangaia, Cook Islands, 543 Mangold, Sylvia Plimack, 1073–74; Two Exact Rules on Dark and Light Floor, 1073–74, 1073 Maniera greca, 546–65 Maniera (Mannerism), 667–68

- Manifestatio, 396 Mannerism, 734, 740-41, 875
- 630
- 630 Mantiklos "Apollo," Thebes, 135, 135 Manuscript illumination: Carolingian, 330–32; Early Christian, 265–67; Gothic, 404–406; Hiberno-Saxon, 326–29; Islamic, 312–13; Maya, 515; Ottonian, 342–45; Renaissance, 698–99; Romanesque, 373–77 Manuscript ecroll 265
- Manuscript scroll, 265 Manzù, Giacomo, 1050–51; Cardinal, 1050–51, 1050

- Maori Chief Tupai Kupa, The (Sylvester), 20 Maori, culture and art of, 544, 544 Marching Warriors, Gasulla gorge, 36–37, 37 Marcus Aurelius, 216, 235; equestrian statue of, 238–39, 238, 591, 661
- Marcus Aurelius Sacrificing, Rome, 235–36, 235 Marey, Édouard, 975

- Mariette, Auguste, 74 Marilyn Diptych (Warhol), 1061, 1061 Marinetti, Filippo, 965 Markets of Trajan, 223–24, 223, 224
- Marquesan warrior, 543, 543

- Marriage à la Mode (Hogarth), 840–41, 841 Marriage of the Virgin, The (Raphael), 645, 645 Marseillaise, La (Rude), 870, 870 Mars from Todi, 193–94, 193 Marshall Field Warehouse, Chicago (Richardson), 948, 948

Metaphysical Painting, 979–80 Metopes, 141, 142; of Parthenon, 158 Metsys, Quentin, 732–33; The St. Anne Altarpiece,

732-33, 733

Metoyes, 141, 142; of Farmenon, 156
Metsys, Quentin, 732–33; The St. Anne Altarpiece, 732–33, 733
Meskico, pre-Columbian arts of, 503–506
Mi Fu, 463–64
Michals, Duane, 1052; Death Comes to the Old Lady, 1052, 1053
Michel, Claude. See Clodion
Michel, Claude. See Clodion (652–653, 653; Capitoline Hill, Rome, 660–62, 660, 661; The Creation of Adam, 656–57, 656; David, 651, 651; Doni Madonna, 645; The Drunkenness of Noah, 655–56, 656–57; The Dying Slave, 652–53, 652; Eleazor and Mathan lunette, 555; The Last Judgment, 663–65, 664; Laurentian Library, Florence, 659–60, 659; Moses, 652, 652; Separation of Light and Darkness, 654; Sistine Chapel, Rome, 653–57, 653–57, 663–65; St. Peter's, the Vatican, 662–63, 662–63, 753–55; tomb of Giuliano de' Medici, 658–59, 658; tomb of Julius II, 651–52, 651, 652; Unfinished Bound Slave, 17
Michelozzo di Bartolommeo, 597; Palazzo Medici, Ricardi, Florence, 597, 597
Mictlantecuhtli (Death God) (Borgia Codex), 514, 514
Middle Minoan period, 108–109
Mies van der Rohe, Ludwig, 1001, 1007–1008, 1044, 1044
Migration period, in Early Medieval art, 320–30
Milan, Italy, 418, 608
Milan Cathedral, Italy, 418, 418
Miletus, John Everett, 913–14; Ophelia, 913–14,

Miletus, bouleuterion at, 180 Millais, John Everett, 913–14; Ophelia, 913–14,

Miller, Sanderson, 845; sham Gothic ruin, Hag-

ley Park, 845, 845

Minotaur, 106

Mochlos stoneware, 107

Module, concept of, 11 Mohammed, 299

Mokuan, 485

ley Park, 845, 845 Millet, Jean François, 899–900; The Gleaners, 899– 900, 899 Milo of Crotona (Puget), 811–12, 811, 855 Mimbres pottery, 528–29, 529 Minakshi Temple, India, 438 Minaret, 301

Minimalism, 1048–49 Minoan culture and art, 106, 107; architecture in, 109–11; columns in, 111; Early (pre-Palace) pe-riod in, 107–108; and Egypt, 99; Late (New Pal-ace) period in, 109–18; Middle (Old Palace) pe-riod in, 108–109; painting in, 112–16; pottery and sculpture in, 116–18 Minotaur, 106

Minotaur, 106
Minotaur, 106
Minacle of the Loaves and Fishes, The, Sant' Apollinare Nuovo, 274–75, 275
Miracle of the Slave, The (Tintoretto), 688–89, 688
Miraculous Draught of Fish, The (Witz), 718, 719
Miró, Joan, 985, 1033; Painting, 985, 985
Miroku, Chugu-ji nunnery, Japan, 478, 479
Miseries of War (Callot), 801
Mitanni peoples, 59
Mixtec codices, 514–15, 514
Mixte culture and art. 514–15, 515

Mixtec collece, 514-15, 514 Mixtec culture and art, 514–15, 515 Mnesikles, 159, 160; the Propylaia, Acropolis, Athens, 159, 159 Mobiles, 997–98, 1047 Moche (Mochica), culture and art of, 520–22, 520, 521

Modernism: formalist approach, 954–67; psycho-logical and conceptual concerns, 967–98; social and political concerns, 998–1026

Mohammed, 299 Mohenjo-Daro, 46, 426–27; steatite seals, 426, 427 **Moholy-Nagy, László**, 952–53, 1006–1007; *Radio Tower in Berlin*, 1006–1007, *100*7 Moissac, France, sculpture, 365–68, 365, 366, 367

Momoyama period (Japanese art), 488–89 Mona Lisa (Leonardo), 246, 638, 638

Modeling, 11–12 Modena Cathedral, Italy, 364–65, 364 Modern Times (Chaplin), 1022–23, 1022

Minbar, 300 Mincho, 485 Ming dynasty, China, 467–70, 486 Minimalism, 1048–49

- Martens, Friedrich von, 893; Panorama of Paris,
- Martini, Simone, 574-76; The Annunciation, 575-76, 575

- 76, 575 Martyrdom of St. Sebastian, The (Antonello da Mes-sina), 631, 631 Mary Magdalene (Donatello), 592, 592 Masaccio, 599–601, 635, 636; The Holy Trinity, 600, 600, 601; The Tribute Money, 599–600, 599, 636 Masks: Dan, 540; Melanesian, 547; in native arts, 502, 530, 531, 537, 540, 546–47 Masolino da Panicale, 599 Masonry arch, 188

- Masonry arch, 188 Maspero, Gaston, 74 Mass, concept of, 8–9
- Mastaba (tomb) of Old Kingdom, 78–79, 78, 81 Master Hugo, 369, 375; Moses Expounding the Law, 375, 375
- 375, 375 Matisse, Henri, 957–59, 968; Red Room (Harmony in Red), 958, 958 Mato-Tope (Mandan chief) (Bodmer), 533, 533 Matteo Palmieri (Antonio Rossellino), 614–15, 615 Mausoleum of Galla Placidia, 272–74, 272, 273 Mausoleums, Islamic, 307–309, 308, 309 Maxentius, 247 Maximium, 278, 282

- Maxentius, 247
 Maximianus, 278, 282
 Maximin Daia, 251, 251, 268
 Maya art and civilization, 503–504, 507–509; architecture in, 509–11, 509, 510, 515–16, 515; books in, 514, 515; musical instruments in, 509n; painting of, 512–13, 513; sculpture of, 511–12, 511, 512
 Mazzola, Girolano Francesco Maria. See Parmioiano
- migianino

- Matzora, Grofario Francesco Warra. See Fale
 migianino
 Mbari house, Obube, Nigeria, 538–39, 538
 Mboom mask, 540, 541
 Medallion of Hadrian, 251, 251
 Medes, architecture of, 67, 70
 Medici, Cosimo de', 582, 597
 Medici, Giovanni de', 582
 Medici, Giovanni de', 582
 Medici, Lorenzo (Duke of Urbino), 658–59
 Medici, Lorenzo (Duke of Urbino), 658–59
 Medici Venus, 727
 Medieva lart: classicism and, 246; precursors of from Roman Empire, 248–51
 Mediterranean, The (Maillol), 990, 990
 Meeting of Joachim and Anna, The (Gaotto), 574, 574
 Meeting of Joachim and Anna, The (Goitto), 570, 570,
- Meeting of Joachim and Anna, The (Giotto), 570, 570,

Memmi, Lippo, 576 Men, Boats, and Animals, Hierakonpolis, Egypt, 75–76, 75

Menhirs, 38 Meninas, Las (The Maids-in-waiting) (Velázquez), 778–79, 779 Menkure, tomb of, 81, 81

Menkure, tomb of, 81, 81 Mentenhet the Governor, 103, 103 Mertenhet the Governor, 103, 103 Mercenaries (IV) (Golub), 1055, 1055 Mérode Altarpiece, The (Campin), 700–701, 700 Merz 19 (Schwitters), 978–79, 979 Mesoa Verde, Colorado, 529–30, 529 Mesoamerica: Classic period, 506–13; culture, 503–504; Postclassic period, 513–18; Preclassic period, 504–506 Mesolithic art. 36–37

period, 504–506 Mesolithic art, 36–37 Mesopotamia: Code of Hammurabi, 57–58; con-test between natural and supernatural in, 54– 55; formality of art, 61; lack of sculptural stone, 57; representation of animals in art, 53–55; sculpture, compared to Egypt, 84; worship of bull, 54, 60–61; ziggurat, 49. See also Akkad, Sumer, Babylonia, Assyria Metalcraft, Early Medieval, 322–23, 333–34 Metallurgy, Andean, 521–22; in Mesoamerica, 514–15 Metamatic machines (Tingurabit), 1062

Metamatic machines (Tinguely), 1062

- 574
- 574 Megaliths, 38, 119–20 Megaron, 42–43; construction of, 119–20 Mei-p'ing vase, 465, 465 Melanesia, native arts of, 544–47 Melencholia I (Dürer), 729, 729 Méliès, Georges, 981, 1068, 1071–72; Trip to the Moon, 981, 981 Memling, Hans, 711–12; The Mystic Marriage of St. Catherine, 711–12, 712 Memmi Lippo, 576

Nigeria, native arts of, 534-38, 534-38

63, 162 Nike of Samothrace, 173–74, 173, 966 Nimbus, 266 Nimrud (ancient Calah), 59, 61–62, 61, 62

Night Café, The (Van Gogh), 936-36, 936 Nighthawks (Hopper), 1013–14, 1014 Nightmare, The (Fuseli), 855–56, 856 Nike Fastening Her Sandal, Acropolis, Athens, 162–

Nimrud (ancient Calah), 59, 61–62, 61, 62 Nineveh, art of, 62, 63 Niobid Painter, 164–65; Argonaut Krater, 165, 165 Nishiki-e (brocade picture), 496 Noah's Ark (Douglas), 965, 965 Nocturne in Blue and Gold (Old Battersea Bridge) (Whistler), 929–30, 930 Noise, Pencil, Broken Pencil, Cheap Western (Rus-cha), 1062, 1062 Nok, Nigeria, 534–35, 534 Nora (Em). 1064–65, 1065

Nora (Em), 1064–65, 1065 Norman Cavalry Charging in the Battle of Hastings (Bayeux Tapestry), 372, 372 Normandy: flamboyant architecture in, 407; Ro-

manesque architecture of, 356–58 North America, native arts of: Eastern Wood-lands, 533–34; Great Plains, 532–33; historic era, 530–34; Northwest Coast, 531–32; pre-Columbian, 526–34; prehistoric era, 526–30; Southwest, 530–31 Northern and Southern dynasties, China, 455–56 Northern Sung dynasty, China, 463–64

Northern Sung dynasty, China, 463–56 Northern Sung dynasty, China, 463–64 Northwest Coast native arts, 531–32 Notre Dame Cathedral, Paris, 386–88, 386–88; rose window in, 397–98, 397 Notre Dame du Haut, Ronchamp (Le Corbusier), 1037–38, 1037

Novius Plautius, 195; The Ficoroni Cist, 195, 195 Nubia (the Sudan), 89 Nudity: in Greek art, 134–35, 138–39; and slav-

0 Oath of the Horatii (David), 849–50, 849, 873 Oceania, culture and arts of, 542–48. See also indi-vidual cultures

Oceania, culture and arts of, 542–48. See also individual cultures Octagonal Hall, Domus Aurea, Rome, 226, 226 Octopus Jar, The, Palaikastro, 116, 116 Oculus, 226; of Pantheon, 228 Odoacer, 272 Odysseus' Helmsman Falling, Rhodes, 176, 177 Odyssey Landscapes, Rome, 208, 208 Oenochoe (Greek vase shape), 131, 131 Ogata Kenzan, 492 Ogata Kenzan, 492; White Plum Blossoms in the Spring, 493, 493 Ogival section, of dome, 416 Oil painting, 694–95 O'Keeffe, Georgia, 1010–11; Light Coming on the Plains II, 1011, 1011 Okumura Masanobu, 495–96 Okyo, Maruyama, 493; Nature Studies, 494, 494 Old King, The (Rouault), 968–69, 968 Old Market Woman, 177–78, 178 Old Palace period, Minos, 108 Old St. Peter's, Rome, 258–60, 258–60 Old Testament Trinity Prefiguring the Incarnation, The (Rublev), 296–97, 296 Oldenburg, Claes, 1060–61; The Store, 1060, 1060

Oldenburg, Claes, 1060–61; *The Store*, 1060, 1060 Olmec art, 504–505, 504–505 Olowe of Ise, 537–38; door from the king's pal-

Olympic Stadium, Munich (Otto), 1045–46, 1045 Olynthus, Greece, 182, 183, 184; residential blocks of, 183

Optical realism, 865 Or San Michele, Florence, 584–85, 586, 616 Orans figures, 257, 264 Orders. See Architectural orders; Composite order; Corinthian order, Doric order, Ionic

Organic abstraction, 1036–40 Orion (Vasarely), 1047, 1047 Orléans wing, Château de Blois, France (Man-sart), 805–806, 805

Ornate style, in wall painting, 209 Orozco, José Clemente, 1025–26, 1032; Epic of American Civilization: Hispano-America, 1025–26,

Orvieto Cathedral, Italy, 417–18, 417, 625 Oseberg ship, 324, 324

ace, 537

order

1025

Op Art, 1047 Ophelia (Millais), 913–14, 914

ery, 138 Nymph and Satyr (Clodion), 826, 826 Nymphs and Satyr (Bouguereau), 915, 916

manesque architecture of, 356-58

- Monastery church of St. Riquier, Centula, France, 338, 338

- 338, 338 Monastery, ideal plan for, 336–38, 337 Monasticism, 325, 348 Mondrian, Piet, 995–96, 1003–1004, 1005; Compo-sition in Blue, Yellow, and Black, 996, 997 Monet, Claude, 11, 12, 920, 923–24; Cliff at Etretat, 923–24, 923; Rouen Cathedral (façade) 12, 924–924: Impression—Sturise, 920–923
- *Etretat*, 923–24, 923; *Rouen Cathedral* (façade) 12, 924, 924; *Impression—Sunrise*, 920, 923 Monk's choir, 351 *Monolith: The Face of Half Dome, Yosemite Valley, California* (Adams), 1012, 1012 Monolithic columns, 200 Monreale, royal church of, Sicily, 292, 293 Montage, 1072 *Montage Sainte-Victoire, La* (Cézanne), 933, 934 Monticello, Charlottesville (Jefferson), 851, 851 Monument of Lysikrates, Athens, 170–71, 171 Monument to the Third International (Tatlin), 1019– 20, 1019 Monumental relief in Roman Empire, 248–51

- Monumental relief in Roman Empire, 248–51 Monumental sculpture, in Early Christian era, 268–69; in Romanesque art, 362–72 Moon goddess mask (Eskimo), 526, 527 Moore, Henry, 991–92; *Reclining Figure*, 991–92, 907–902
- 997
- Moralia in Job, 374, 375
 Moralui in Job, 374, 375
 Moreau, Gustave, 941–42, 958; Jupiter and Semele, 941–42, 941
 Morning Bath, The (Degas), 928–29, 929
 Morning (Runge), 882, 882
 Morris, William, 914
 Mortisse-and-tenop exetom 478

- Morris, William, 914 Mortise-and-tenon system, 478 Mortuary poles (Haida), 531, 532 Mortuary temples of Egypt, 89–91 Mosaics: in Byzantine art, 273–84, 273, 275, 277, 278, 280, 281, 283, 292–94; early Christian, 261, 262–67, 262, 263, 264; in Greek art, 184–85, 184; in Islamic art, 305–306, 305; in Roman Empire, 244–46, 245, 246, in Roman republic, 206–16.
- 244–46, 245, 246; in Roman republic, 206–16, 213–15
- Moses (Michelangelo), 652, 652 Moses Defending the Daughters of Jethro (Rosso Fiorentino), 669, 669 Moses Expounding the Law (Bury Bible), 375–76, 375

- Moslem hypostyle system, 301–302 Moslem religious architecture, 299–311 Mosque: centralized quatrefoil, 309; Islamic, 299– 302
- Mosque of Córdoba, 301-302, 301
- Mosque of the Ka'riye, Istanbul, 294, 295 Mosque of Selim II, ancient Andrianople, 309–10, 310
- Mother goddess figures, 43, 44, 44, 46, 107 Motherwell, Robert, 1032 Motif, 933

- Moulin de la Galette, Le (Renoir), 926, 926, 939–40 Mountains and Sea (Frankenthaler), 1042, 1043 Mounted Warrior with Captive, Sinicolaul, Roma-nia, 334, 334
- Moving pictures. See Cinema Mrs. Richard Brinsley Sheridan (Gainsborough), 835, 835

- Mshatta, palace at, 304, 304 Mudra, 432, 434; Chinese interpretation of, 455n Muezzins, 301, 310 *Mujer Pegada Series No.* 2 (Neri), 1054–55, 1054 Muktesvar Temple, India, 437, 437

- Mullah, 313 Mullah, 313 Mullions, 399 Multiple Deck 4-D House (Fuller), 1008–1009, 1009

- Mummification, 76 Mummy Portrait of a Man, Faiyum, 215–16, 216 Munch, Edvard, 944, 968, 985; The Scream, 944, 944
- Mungarawai, 547; Djanggawul Sisters, The, 547, 54
- Mural painting: Etruscan, 190–91; Greek, 164–65; Postmodernist, 1084; in Romanesque art, 373– 75
- Museo Capitolino, Capitoline Hill, Rome, 661, 661
- Museum of the Ara Pacis Augustae, Rome, 231, 231

- 251
 Musical instruments, Maya, 509n
 Musicians and Dancers, Thebes, 96, 96
 Musicians (De Stael), 1035–36, 1035
 Muybridge, Eadweard, 901–902, 911, 930; Handspring, a flying pigeon interfering, 902, 902
 Mycenaean culture and art, 106, 118–23, 188
 Mycerinus. See Menkure
 Myron, 151; Discobolos, 151, 151

- Mystery cults, 207-208, 254; Christianity as one of, 282
- Mystic Marriage of St. Catherine, The (Memling), 711–12, 712 Mythological Scenes, Wu family shrine, Shantung,
- 454, 454
 - N

Nabis, 940

- Nabis, 940 Nadar (Gaspard Félix Tournachon), 909–10; Sarah Bernhardt, 910, 910 Nagarjunakonda, India, 436 Nagoya Castle, Japan, 488 Nakht, tomb of, 95, 96 Naltunai Isvaram Temple, Punjai, India, 438 Nanga school (Japanese art), 492–93 Nanni di Banco, 584–85, 600, 604; Quattro Santi Coronati, 584–85, 585 Naos, 140, 143; of Parthenon, 154 Napoleon Bonaparte, 74, 867, 873 Naram-Sin, of Akkad, 55, 56 Narthex, 279, 285; of Old St. Peter's, 259 Nasca Lines, 522–23, 522 Nash, John, 869–70; Royal Pavilion, Brighton,

- Nasca Lines, 522–23, 522
 Nasch, John, 869–70; Royal Pavilion, Brighton, 869–70, 869
 National Gallery. See East Building
 Native arts: definition of, 500; European conception of, 500–501; folk art and, 549; historical development in consideration of, 500–501; importance of religious symbolism in, 502; stylistic community of, 501–502
 Naturalism, 116, 829, 832–43; in Byzantine art, 294; in Early Christian art, 255, 263–64; in eighteenth-century art, 832–36; in Etruscan art, 195
 Nature: concept of in Chinese art, 450; imitation of, 4; Impressionistic view of, 933–34; Romanticism and, 866, 874, 881–85
 Naumberg Cathedral, West Germany, 413–14, 414

- 414
 Navajo culture and art, 530
 Nave, 259; of Amiens Cathderal, 394, 396; of Chartres Cathedral, 388; in Early Medieval pe-riod, 337; of Florence Cathedral, 416, 416; in Romanesque architecture, 350, 353–54; of Salis-bury Cathedral, 409, 409
 Nave arcades, 359
 Nave in Elorence Cathedral, 417

- Nave arcades, 359 Nave bays, in Florence Cathedral, 417 Nave elevation, tripartite, 392 Nave vaulting, six-part, 386–87 Nave wall, in Chartres Cathedral, 392, 392; of Cologne Cathedral, 411, 411; in Laon Cathe-dral, 392, 392; in Notre Dame, 387, 388 Near East, ancient, 42–71. See also specific civiliza-tions and city, pames
- tions and city names Nebamun, tomb of, 94–95, 95–96, 95, 96 Nebuchadnezzar, 66
- Necking, 141

1041, 1041

Ni Tsan, 466

- Necking, 141 Necropolis at Cerveteri, 190, 190 Needlework, in Romanesque art, 372–73, 372 Neo-Babylonia, 64–65; temple to Bel of, 64 Neo-Platonism, 623, 635 Neo-Sumerian period, 49–50 Neoclassicism, 832, 845–53 Neolithic art, 37; abstract symbolism in, 45–46; architecture, 37–39 Nentune and Amphitrite (Gossaert), 733–34, 734
- Neptune and Amphitrite (Gossaert), 733–34, 734 Nerezi, art of, 291–92, 292 Net, Manuel, 1054–55; Mujer Pegada Series No. 2,
- Neri, Manuel, 1054–55; Mujer Pegada Series No. 2, 1054–55, 1054
 Nero, 198, 225, 236; Domus Aurea of, 210–11, 210
 Nervi, Pier Luigi, 1044–45, 1046; Palazzetto dello Sport, Rome, 1044–45, 1045
 Netherlands, sixteenth-century art in, 732–38
 Neumann, Balthasar, 830–31; Vierzehnheiligen chapel, West Germany, 830–31, 830
 Nevelson, Louise, 1039; Tropical Garden II, 1039, 1039

New Guinea, native arts of, 544-47, 545, 546 New Ireland wood carvings (malanggan), 544 Newman, Barnett, 1040-41; Vir Heroicus Sublimis,

New Objectivity, 972–73 New Palace period (Minoan art), 109–18 New Sacristy, San Lorenzo, Florence, 658 New Wave cinema, 1071–72 New York Action Painting, 1033–35 New Zealand, native arts of, 544, 544

Niaux, cave paintings in, 30 Nicholas of Cusa, 561, 705 Nicholson, Ben, 998 Nièpce, Joseph Nicéphore, 892

1130 INDEX

- Ospedale degli Innocenti, Florence (Brunel-leschi), 593, 594 Ostia, 203; insulae in, 217, 217 Ostrogoths, 240, 272, 320 Otto, Frei, 1045–46; Olympic Stadium, Munich, 1045–46, 1045

- Otto III Enthroned Receiving the Homage of Four Parts of the Empire, 344, 345 Ottoman Empire: architecture of, 309–11; art of,
- 311 12
- Ottonian period, in Early Medieval art, 338–45 Outbreak, The (Kollwitz), 969, 969 Oxbow, The (Connecticut River near Northampton)
- (Cole), 884, 885

P

Pacher, Michael, 720–21; St. Wolfgang Forces the Devil to Hold His Prayerbook, 720–21, 720
Padua, fifteenth-century art in, 591–92
Paganini (Delacroix), 876–77, 877
Pagaquini (Ingres), 876–77, 876
Pagoda, 473, 473
Pagoda of the Temple of the Six Parsen Temple

- Pagoda of the Temple of the Six Banyan Trees, China, 473, 473
- Pagoda, 473, 473
 Pagoda of the Temple of the Six Banyan Trees, China, 473, 473
 Pagoda of the Temple of the Six Banyan Trees, China, 473, 473
 Paik, Nam June, 1068–69; Global Groove, 1068–69, 1069; Paradise Now, 1068
 Painting, 479–86, 488–89, 492–94; Abstract Expressionist, 1032–36; abstract figuration in, 987–90; abstract symbolism in, 992–97; activist, 1084–85; Art Nouveau, 955; Baroque, 765–805; Byzantine, 290–97; Carolingian, 330–32; Color-Field, 953; Color-Field abstractionist, 1040–44; Cubist, 959–65; Dada, 975–77; early Christian, 262–67; Egyptian, 86–87, 88, 94–96; Etruscan, 190–92; expressionisti figuration in, 1051–52, 1054–57; Expressionistic, 968–70, 972–74; Fauvist, 957–59; fifteenth-century Flemish, 695–716; fifteenth-century French, 716–18; fif-teenth-century German, 718–21; fifteenth-century Italian, 598–608, 618–631; French Ro-coco, 823–25; Geometric and Archaic, 129–34; glazes in, 694–95; Greek mural, 164; Greek vase, 164–66; High Renaissance Italian, 634–40, 644–60, 665–66, 668–72, 679–91; Indian, 438– 41; Islamic, 311; Late Minoan, 111–16; Manner-ism in, 668–72; Maya, 511–12; mediums for, 694–95; Metaphysical, 979–80; Minimalist, 1047–48; naturalism in, 829, 832–43; Neoclas-sic, 848–51; North American native, 528; oils in, 694–95; Ottonian, 342–45; on panels, 215–16; Postmodernist, 1079–80; Realism in, 882–91, 913–17; Renaissance Italian, 598–608, 618–31, 634–40, 644–49, 656–57, 668–72, 679–91; resto-ration techniques, 573n; in Roman republic, 206–16; Romanticism in, 853–57, 871–81; six-teenth-century French, 738–42; sixteenth-century German, 721–32; sixteenth-century Dutch, 732–38; sixteenth-century Spanish, 742– 47; with tempera, 695; Yamato-e style of, 481– 82, 484–85, 488. See also Landscape painting; Mural painting; Wall painting Painting (Miró), 985, 985
 Pairnon-Pair, cave paintings in, 28
 Pakistan, native art of, 549
 Palace at Khnibat al-Mafjar, Jordan, 305, 305

- Palace Ladies, tomb of Yung-t'ai, China, 460-61, 461

Palatine Chapel, Aachen, 335, 335 Palatine Hill, 225

- Palazzetto dello Sport, Rome (Nervi), 1044-45, 1045
- Palazzo Caprini, Rome, 642–43, 642 Palazzo dei Conservatori (Palace of the Conserva-
- tors), Rome, 660 Palazzo dei Senatori (Palace of the Senators),
- Rome, 660 Palazzo del Tè, Mantua (Giulio Romano), 673-75,
- 674 Palazzo di Parte Guelfa, 597 Palazzo Farnese, Rome, 766, 767 Palazzo Medici-Riccardi, Florence (Michelozzo di Bartolommeo), 597, 597 Palazzo Pubblico, Siena, 418–19, 419 Palazzo Vecchio, Florence, 645 Paleolithic art, 28–36 Palestine, ancient, 46 Palestine, 195, 2012–202: bronze cists of, 195

- Palestrina, 195, 201-202; bronze cists of, 195

Palette of Narmer, Hierakonpolis, 76-78, 76, 101,

development of, 588-89, 608-609, 703; reverse,

Perus pre-Columbian cultures and art, 519–23
Perus pre-Columbian cultures and art, 519–23
Perugino (Pietro Vannucci), 626–27, 645; Christ Delivering the Keys of the Kingdom to St. Peter, 626, 626, 645

Pest House at Jaffa (Gros), 872–73, 873 Petrie, Flinders, 74, 82 Pfaff, Judy, 1074–75; Rock/Paper/Scissors, 1074–75,

1074
Phiale Painter, 165–66; Hermes Bringing the Infant Dionysos to Papposilenos, 165, 165
Phidias, 154, 163, 164, 166, 868
Philadelphia Savings Fund Society Building (Howe and Lescaze), 1008, 1008
Philip the Arab, 239–40, 239, 248
Philosopher Giving a Lecture at the Orrery (Wright of Derby), 838–39, 839
Philosophical Bordello (Picasso), 959
Photo sculptures, 1076
Photo-Secession group, 1010
Photoperaphy: activism in, 1114–18; activist, 1082;

Photo-Secession group, 1010 Photography: activism in, 1114–18; activist, 1082; calotype process in, 895–96; carte de visite, 910– 11; Dadaist, 978–79; daguerreotype process in, 891–93; development of portraiture in, 909–10; documentary forms of, 1009–13, 1018; expres-sionist figuration in, 1052–53; Modernism in, 1009–13, 1114–18; and optical realism, 865–66; panorama in, 893; Pictorialist, 909; Realism and, 891–96, 906–11, 917–19; used in conjunc-tion with painting, 880: Vorticist movement in.

tion with painting, 880; Vorticist movement in, 966–67; Woodburytype process in, 910

966-67; Woodburytype process in, 910
Photomontage, 978
Photoscreen process, 1061
Pi (disk), China, 452, 452
Piano, Renzo, 1077-78; Georges Pompidou National Center of Art and Culture, Paris (with Rogers), 1077-78, 1078
Piazza Armerina, Sicily, Villa at, 244-46, 244, 245
Picasso, Pablo, 949, 959-64; Bathers, 9, 9; Blue Period of, 959, 1026; Guernica, 1026-27, 1026; Les Demoiselles d'Avignon, 959-60, 960, 1026; Philosophical Bordello, 959; Still Life with Chair-Caning, 962, 962; Three Musicians, 963-64, 963, 1026, 1035
Pictograph, 37

Pictorial style, 917–18
Picture plane, 935
Piero della Francesca, 604–606, 800, 932; Annunciation from Legend of the True Cross, 605–606, 605; Resurrection, 606, 606; The Flagellation of Christ, 604–605, 604
Pieta (Michelangelo), 850
Pieta corean (group stopp), 596

Pietra serena (grey stone), 596 Pilate Demanding That the People Choose Between Jesus and Barabbas (Rossano Gospels), 266, 266

Pilorina cermain, 741–42; Descent from the Cross, 742, 742

Pinakotheke, 159
Pine Trees (Hasegawa Tohaku), 488, 489
Pippo Spano (Andrea del Castagno), 602, 602
Piranesi, Giovanni Battista, 259, 846; Carceri 14, 853–54, 854; interior of St. Paul's, 259, 259; Views of Rome, 259, 259, 846, 853–54
Pisa, 349; cathedral group of, 358–60, 359
Pisa Cathedral, baptistry of, 562, 563
Pisano, Andrea, 564; south door of baptistry, Florence Cathedral, 564, 564; The Visitation, 564, 564

Pisano, Giovanni, 563; The Annunciation and the

Pisano, Giovanni, Sos; The Annuhalation and the Nativity, 563, 563
 Pisano, Nicola, 562–63; pulpit of baptistry, Pisa Cathedral, 562, 562; The Annunciation and the Nativity, 563, 563
 Pissarro, Camille, 924–25; Place du Théâtre Fran-cais, 924–25, 925
 Pithoi, 109, 111
 Pisca du, Théâtre Français (Pissarro), 924–25, 925

Place du Théâtre Français (Pissarro), 924-25, 925

Plane, concept of, 8 Plank idols, 107 Plato, 128, 138, 140, 144, 166, 589; philosophy of

Platonic Academy of Philosophy, 582, 608, 623 Platonic Idea, 667

Pictorial arts, specialized terms in, 17 Pictorial style, 917–18

Pictograph, 37

Pinakotheke, 159

Plan, in architecture, 14

forms of, 53

Paleolithic period, 42 Pluvium, 205 Podium, 189

Pointed arches, 409 Pointillism, 931n

564

267; true linear, 588; twisted, 34 Perspective illusionism, 773–75

134 Paliotto, Sant' Ambrogio, Milan, 333-34, 333

Patiotto, Sant' Ambrogio, Milan, 333–34, 333 Palladian Classicism, 818, 819–21 **Palladio, Andrea**, 676–79, 689, 813, 820; San Gior-gio Maggiore, Venice, 679, 679, 689; Villa Rotonda, near Vicenza, 678–79, 678, 851 Pallava model of temple, 442–43 Panathenaic frieze, Parthenon, Athens, 158–59, 232

- Panel of Hesire, Saqqara, 77–78, 77 Panel painting in Roman republic, 215–16 Pannini, Giovanni, 228; Interior of the Pantheon, 228
- Panofsky, Erwin, 78, 84, 395–96, 638, 701 Panorama camera, 893 Panorama of Paris (Martens), 893, 893

Panoramas, 885

- Pantheon, Rome, 14, 226–28, 227, 228, 260 Panthéon, Ste. Geneviéve, Paris (Soufflot), 846, 846
- Pantocrater, with the Virgin, Angels, and Saints, The, Monreale, Sicily, 292–93, 293 Pantomime, 264, 341–42
- Paolozzi, Eduardo, 1058-59; Wittgenstein in New York, 1058–59, 1058 Pavier collé, 963
- Papuan Gulf, native arts of, 544–47, 545
- Papyrus, 265 Paradise of Amitabha, Cave 139A, Tunhuang, China, 460, 460

- China, 460, 460 Paradise Sects, 456, 459, 483 Parchment (lambskin), 265 Parisienne, La, Knossos, 113–14, 114 Paris Opéra (Garnier), 871, 871 Paris Psalter, 294, 295 Parma Cathedral, Italy, 666–67 Parmigianino (Girolamo Francesco Maria Maz-
- zola), 669; Madonna with the Long Neck, 669, 669 Parthenon, Athens (Iktinos and Kallikrates), 154– 59, 155–59; Panathenaic frieze of, 158–59
- 99, 150–59, ranathenaic meze of, 156–59 Parting of Lot and Abraham, The, Santa Maria Mag-giore, Rome, 263–64, 264 Passage grave, 38 Passion of Sacco and Vanzetti, The (Shahn), 1023,
- 1023
- Pastels, 833-34 Pastoral Symphony (Giorgione and/or Titian?), 683– 84, 683, 920
- Patinir, Joachim, Landscape with St. Jerome, 735,
- Patna, palace at (ancient Pataliputra), 428–29, 428 Pattern and Decoration Painting, 1086–87 Pauline Borghese as Venus (Canova), 867–68, 867 Pausanias, 119, 142, 160, 163, 171
- Paxton, Joseph, 946; Crystal Palace, London, 946, 946
- Pazzi Chapel, Florence (Brunelleschi), 595-97, 595, 596
- Peace and Salvation, Wall of Understanding (Walker), 1084.1084
- Peaceful City (Ambrogio Lorenzetti), 577–78, 578 Peaceful Country (Ambrogio Lorenzetti), 578–79, 578
- Peach Tree Plaza, Atlanta (Portman), 1078-79, 1078

- 10/8 Peasant Dance, The (Bruegel), 737, 737 Peasants' War, The (Kollwitz), 969 Pebble mosaics, 184 Pediment, 141, 146; broken, 241 **Pei, I. M.**, 1046; East Building, National Gallery, Washington, D.C., 1046–47, 1046–47 Penates, 189 Pendontives, 285
- Pendentives, 285
- People's Republic of China, 470–71. See also China Peplos Kore, Acropolis, Athens, 137, 137 Performance Art, 974, 1070–71, 1080–81, 1087–88 Pergamon, 174, 231; plan of acropolis in, 183–84,
- Pericles, 126, 153, 154, 160 Peripteral colonnade, 143
- Peripteral temple, 140
- Peristyle, 181, 205

68-69

- Perpendicular (Tudor) style of Gothic architecture, 410
- Perrault, Claude, 806; east façade of the Louvre, Paris (with Le Brun and Le Vau), 806, 806 Persepolis, palace at, 66–68, 66–68; sculpture in,

Persian Empire. See Achaemenid Persia Persistence of Memory, The (Dali), 984–85, 984 Perspective, concept of, 10; di sotto in sù, 629; her-ringbone, 207; orthogonals in, 207; Renaissance

Realism, 235–36, 885–86, 896; in art, 249–51; descriptive, 267; in Early Medieval art, 345; effect of photography on, 891–96, 906–11, 917–19; in Greek art, 174–75; in Japanese art, 493–94; natural subjects and, 874; in Neolithic art, 45–46; in nineteenth-century art, 865, 874; in painting, 886–91, 913–17; in Roman Empire art, 230–31; Romantic responses to, 913–19; in sculpture, 911–13, 919; themes of, 896–900; variations of form in, 900–906

form in, 900–906 Rebecca and Eliezer at the Well (Vienna Genesis), 266,

Reclining Figure (Moore), 991–92, 992 Rectangular-bay system, 391–92, 395 Red, Blue, Green (Kelly), 1048, 1048 Red Room (Harmony in Red) (Matisse), 958, 958

Red Room (Harmony in Red) (Matisse), 958, 958 Red-figure technique of vase painting, 132–33 Redon, Odilon, 942; The Cyclops, 942, 942 Reimann, Walter, 970–71; The Cabinet of Dr. Caligari (set), 970–71, 971 Reims Cathedral, France, 401–402, 401, 402 Relief: flattening of, 235; in sculpture, 27 Relief carving: Aztec, 517–18; Egyptian, 86–87; Maya, 511–12; Tiahuanaco, 523–24 Relief from stupa, Amaravati, India, 436, 436 Relief with dancers and musicians, Aurangabad, India, 434–35, 435

Relief with dancers and musicians, Aurangaoad, India, 434–35, 435 Relief sculpture: Assyrian, 61–63; Chinese, 454; Indian, 433–35; Renaissance, 741–42, 742 Religious Procession in the Kursk District, A (Repin), 084–005–005

904–905, 905 **Rembrandt van Rijn**, 789–95; Self-Portrait, 792, 792; Supper at Emmaus, 790–91, 790, 791; Syndies of the Cloth Guila, 793, 793; The Return of the Prodigal Son, 791, 791; The Three Crosses, 794, 794 Renaissance, definition of, 694 Renaissance, culture and art of: architecture, 592– 97, 609–13, 640–44, 658–64, 673–79; engraving, 618–19; Flemish, 695–716, French, 716–18, 738– 42; frescoes, 620–21, 625–27, 653–56, 664–67; German, 718–32; Humanism in, 582, 608; Inter-national style in. 698–99; Italian (fifteenth cen-

German, 718–32; Humanism in, 582, 608; Inter-national style in, 698–99; Italian (fifteenth cen-tury), 581–631; Italian (sixteenth century), 634– 91; Mannerism in, 667–75; manuscript illumi-nation, 698–99; Netherlandish, 732–38; paint-ing, 598–608, 618–31, 634–40, 644–49, 656–57, 668–72, 679–91, 694–748; perspective in, 588– 89, 608–609; sculpture, 582–92, 613–18, 649–53, 672–73; Spanish, 742–47. *See also* Proto-Renais-sance

Reni, Guido, 766; Aurora, 766, 768 Renoir, Auguste, 925–26; Le Moulin de la Galette, 926, 926

926, 926 Rent Collection Courtyard, The, China, 469, 469 Repin, Ilya, 904–905; A Religious Procession in the Kursk District, 904–905, 905 Repoussé masks, Mycenae, 121–22, 122 Representation: abstraction and, 32, 983–88; in art, 17–21; and artistic style, 19–20; invention of, 28

Research Group for Visual Art (Group de Recherche d'Art Visuel), 1047

a' Art Visuel), 1047 "Reserve" Head of a Prince, Gizeh, 85, 85 Resurrection (Grünewald), 725–26, 725 Resurrection (Piero della Francesca), 606, 606 Retables (altar screens), 718 Return from Cythera (Watteau), 823–24, 824 Return of the Prodigal Son, The (Greuze), 841–42 Return of the Prodigal Son, The (Rembrandt), 791, 701

Revelation to St. John: Enthroned Christ with Signs of the Evangelists, St. Sever, France, 376, 376 Revelers, Tomb of the Leopards, Tarquinia, 190–

Revelers, Vulci (Brygos Painter), 134, 134 Revelers, Vulci (Euthymides), 133–34, 133 Reverse perspective, 267 **Reynolds, Sir Joshua**, 834–35; Lord Heathfield, 834–35, 834

854–35, 834 Rhyton (Minoan vessel), 112 *Riace Bronzes*, 149–50, 149, 150 Rib vault, 409; four-paneled, 395; in Gothic archi-tecture, 383–84, 384 Rib-vaulting, 355–58 **Ribera, José de**, 775–76; *The Martyrdom of St. Bar-tholomevo*, 775–76, 776 **Bichardeon Hanry Hokcon** 947, 48, 1005, Mar

Richardson, Henry Hobson, 947-48, 1005; Mar-

shall Field Warehouse, Chicago, 948, 948 Riefenstahl, Leni, 1020–22; Blue Light, 1020; Tri-umph of the Will, 1020–22, 1021

Riemenschneider, Tilman, 720; The Assumption of

the Virgin, 720, 720

Reproductions, printed, 865-66

266

904-905, 905

sance

of, 28

791

91, 191

- Pollaiuolo, Antonio, 618–20; Battle of the Ten Nudes, 618–19, 619; Hercules and Antaeus, 618, 618; Hercules and Deianira, 619–20, 620 Pollice Verso (Thumbs Down!) (Gérôme), 916–17,
- 916 Pollock, Jackson, 1032-33, 1070; Lucifer, 1033,
- 1033
 Polonnaruwa, Sri Lanka, 441–42
 Polydoros (with Agesander and Athenodoros), 176; Head of Odysseus, 176–77, 177; Laocoön group, 176, 176, 673, 673, 918–19; Odysseus' Helmsman Falling, 176, 177
 Polygnotos, 164, 165, 195, 215
 Polykleitos, 163–64, 164, 166, 167, 230; Dory-phoros, 163

- *Phoros, 163* **Polykleitos the Younger,** 171 Pompeii: architecture, 203–205; atrium houses, 189; city plan, 203, 203; excavation of, 202–203; forum of, 203–205, 204; painting, 206; wall painting, 206–12 *Pompey the Great*, 198–99, 199 Pont du Card, Nimon, 218, 218

- Pont du Gard, Nimes, 218, 218 Pont Neuf, The (Jouvin), 925, 925 Pontormo, Jacopo da, 668–69; The Descent from the Cross, 668–69, 668
- Pop Art, 1057–62 Porch of the Confessors, Chartres Cathedral, 400– 401, 400
- Porch of the Maidens, Acropolis, Athens, 161-62, 161

Porphyry, 248-49

- Porta, Giacomo della, 663, 752; façade of Il Gesú, 752-53, 752
- Porta Nigra (Black Gate), Trier, 243–44, 243 Portal, Romanesque design of, 363–64, 363, 366–
- Portal sculpture, Romanesque, 372 Portico, 227
- Portinari Altarpiece, The (Hugo van der Goes), 710, 710
- 710
 Portinari, Tommaso, 710, 711
 Portman, John, 1078–79; Peach Tree Plaza, Atlanta, 1078–79, 1078
 Portrait bottle, Moche, Peru, 520, 520
 Portrait Head of a Ruler, Elam(?), 55–56, 56
 Portrait of a Lady, Rome, 237, 237
 Portrait of a Lady (Rogier van der Weyden), 708, 708

- 708
- 708 Portrait of a Young Man (Botticelli), 622–23, 622 Portrait of a Young Man (Bronzino), 670–71, 670 Portrait of Paul Revere (Copley), 835–36, 835 Portrait sculpture: in Roman Empire, 236–40; in Roman republic, 198–99. See also Sculpture Portraiture: naturalism in, 833–36; photographic, 909–10
- 909-10
- Portuguese, The (Braque), 960–61, 961 Post-and-lintel construction, 15, 93–94, 189, 241 Post-Impressionism, 931–40
- Post-Painterly Abstraction, 1047–48 Postmodernism, 968, 1076–79 Potsherds, 107

Potter's wheel, 108

- Pottery: in ancient Greece, 129-34; Japanese, 476,
- Alter Minoan, 116–18; polychrome style of decoration in, 108
 Poussin, Nicolas, 801–803; Et in Arcadia Ego, 802, 802; The Burial of Phocion, 803–804, 804
 Poussinistes 876

- Poussinistes, 876
 Power figure, Songye, Zaire, 539, 539
 Pozzo, Fra Andrea, 775; The Glorification of St. Ignatius, 774, 775
- natuus, 774, 775 Prabhutaratna and Sakyamuni, China, 456–457, 457 "Prairie house," 1000 **Praxiteles**, 166–67, 170, 407, 685; Aphrodite of Cnidos, 167; Hermes and Dionysos, 166, 166 Pre-Columbian art, 502–503. See also individual cultures and countries
- Pre-Raphaelite Brotherhood, 913–14 Precisionists, 1013–14 Predella, 565, 598

- Predella, 565, 598 Prehistoric art, periods in, 28n Presentation, The (Broederlam), 696, 696, 698 Priene, 182–83; city plan of, 181 Priestess Celebrating the Rites of Bacchus (diptych of the Nicomachi and the Symmachi), 269, 269 Priests with Attendant, Dura-Europos, 271, 271 **Primaticcio, Francesco**, 738–39; Venus Reproving Love (with Rosso Fiorentino), 738–39, 739 Princess Buonanarte-Gabrielli (Disdéri), 910, 911

- Princess Buonaparte-Gabrielli (Disdéri), 736–39, 739
 Printasking, Japanese, 495–97
 Prints, mass-produced, 865–66
 Pritchard, Thomas F., 837; iron bridge, Coalbrookdale (with Darby III), 837–38, 837

- Procession, Ara Pacis Augustae, Rome, 231–32, 231, 232
- Productivism, 1018–20 Productivist Constructivism, 995, 1019–20
- Program, in architecture, 15
- Projection on the Martin Luther Kirche (Wodiczko), 1088, 1089 "Proletkult," 1019–20

- Prophet figure (Donatello), 588, 588 Prophet Jeremiah (Isaiah?), The, St. Pierre, Moissac, 366–67, 366 Prophet's House, Medina, 300 Propylaeum, 259–60 Propylaeum, 259–60

- Propylaia, Acropolis, Athens, 159-60, 159
- Prostyle temple, 140 Proto-Geometric vase (Dipylon cemetery), 129, 129
- Proto-Neolithic period, 42
- Proto-Neolithic period, 42 Proto-Renaissance in Italy, 560–62; contact with Classical Antique style, 564; depiction of human figure in, 563, 569; fresco painting in, 569, 572; International style in, 574–76; maniera greca style in, 564–65; naturalistic representa-tion in, 561, 564; painting, 564–79; perspective in, 569; sculpture, 562–64; siena school, 565– 67, 574–79

- Protoliterate period, in Sumer, 50 Protoliterate period, in Sumer, 50 Psalm 150 (Utrecht Psalter), 332, 332 Psalter of St. Louis, 404–406, 405 Pseudoperipteral construction, 200 Psychostasis ("soul-raising") of Hu-Nefer, Thebes, 102, 102
- 102, 102
 Pucelle, Jean, 698; David before Saul (Belleville Breviary), 697, 698
 Puget, Pierre, 811–12; Milo of Crotona, 811–12, 811
 Pugin, A. W. N., 869; Houses of Parliament, London (with Barry), 869, 869
 Purism, 1001–1002
 Puvis de Chavannes, Pierre, 917; The Sacred Grove, 917, 917
 Pulon temples of Egypt. 91, 92

- Pylon temples of Egypt, 91–93 Pyramid of the Moon, Teotihuacán, 506, 506 Pyramid of the Sun, Teotihuacán, 506, 506 Pyramids: Egyptian, 78–83, 78–82, 99–1 Moche, 521; Teotihuacán, 506–507, 506 99-101;

Q

- Qiblah, 299, 308 Qiblah wall, 300
- Quadrant vaults, 350
- Quarton, Enguerrand, 717, The Avignon Pietà, 717–18, 717
- 717-18, 717
 Quattro Santi Coronati (Nanni di Banco), 584-85, 585, 600, 604
 Queen Mother Head, Benin, Nigeria, 535-36, 535
 Queen Nofretari, Tell el-Amarna, 97, 237
 Queen Nofretari, Thebes, 18
 Queer's Megaron, Knossos, 112, 112
 Quetzalcóatl (Borgia Codex), 514, 514
 Quirinal Hill, 223

R

- Radiating chapels, Amiens Cathedral, 394; St. Denis, 382–83, 382, 383
- Radio Tower in Berlin (Moholy-Nagy), 1006–1007, 1007

1059

- Radiocarbon dating, 27 Raft of the Medusa (Géricault), 873–74, 873, 1026 Raigo style (Japanese art), 583 Raimondi Stone, Chavín de Huantar, Peru, 519–20, 519
- Raimondi, Marcantonio, 721, 880, 920
- Ramayana scene, Lara Jonggrang, Java, 443, 443 Ramses II, 90–91, 90, 101
- Rape of the Daughters of Leucippus, The (Rubens), 782-83, 782
- Rape of the Sabine Women (Giovanni da Bologna), 672-73, 673
- Raphael (Raffaello Santi), 644-49, 674; Baldassare Kaphael (Rattaello Santi), 644–49, 674; Baldassare Castiglione, 649, 649; Galatea, 647–49, 648; Ma-donna with the Goldfinch (Madonna del Cardellino), 645, 646; The School of Athens, 646–47, 647; Stanza della Segnatura, 645–47, 647; The Mar-riage of the Virgin, 645, 645
 Rathas, Mahabalipuram, India, 436–37, 436
 Rauschenberg, Robert, 1059–60; Estate, 1059, 1059

Ravenna, art of, 272–82 Ray, Man, 976, 979, 981; Rayograph, 979, 979 Rayograph (Ray), 979, 979

Rayonnant style, in Gothic architecture, 392–400,

- Rietveldt, Gerrit, 1004–1005; Schröder House, Utrecht, Netherlands, 1004–1005, 1004 Rigaud, Hyacinthe, 823, 876; Louis XIV, 823, 823 Robie House, Chicago (Wright), 999–1000, 999, 1000

- Robie House, Chicago (Wright), 999–1000, 999, 1000
 Robinson, Henry Peach, 907–908; study for a composite drawing, 908, 908; Women and Children in the Country, 907–908, 908
 Rock-cut tombs, of Egypt, 87–88, 87, 88
 Rock-cut tombs, of Egypt, 87–88, 87, 88
 Rock-shelter paintings, 37
 Rock/Paper/Scissors (Pfaff), 1074–75, 1074
 Rococo style, 818, 821–30
 Rodin, Auguste, 911–13, 972; Balzac, 913, 913; Burghers of Calais, 912–13, 912, 1051; The Thinker, 8, 8, 9; Walking Man, 911–12, 912
 Rogers, Richard, 1077–78; Georges Pompidou National Center of Art and Culture, Paris (with Piano), 1077–78, 1078
 Röhrig, Walter, 970–71; The Cabinet of Dr. Caligari (set), 970–71, 971
 Roman Empire, 216–17, 240; architectural revolution in, 224–26; architecture and public works in, 217–30, 240–44, 247; baths in, 228–30; development of water systems in, 217; Early Empire period in, 216–40; Late Empire period in, 240–51; mosaics in, 244–46; official conservatism in, 220–21; portrait sculpture in, 236–40; sculpture and monumental relief in, 230–36, 248–51 248 - 51
- Romanesque art: architecture in, 349-61; compared to Gothic, 380–81; manuscript illumina-tion in, 373–77, 374–77; needlework in, 372–73, 373; revival of stone sculpture in, 362; sculpture

- 373; revival of stone sculpture in, 362; sculpture in, 362–72 Romanias, 254 Romano, Giulio, 673–75; The Fall of the Giants, 675, 675; Palazzo del Te, 673–75, 674 Romantic Gothic architecture, 844–45, 868–69 Romanticism, 832, 843–45, 853–57; in figure painting, 871–81; Neoclassic taste in, 867–68; in pinetenth-century art 866–84: and Realism
- painting, 8/1–81; Neoclassic taste in, 807–80; interenth-century art, 866–84; and Realism, 913–19; visionary art and, 940–45
 Rome, republic of, 196–98; architecture in, 200–206; city planning in, 202–205; painting and mosaic in, 206–16; portrait sculpture in, 198–99
 Ronchamp. See Notre Dame du Haut (Le Corbus-

ier)

Rosa, Salvator, 773; St. John the Baptist in the Wil-

derness, 773, 773 Rose window, 397, 397 Rosetta Stone, 74

- Rossano Gospels, The (Codex Rossanensis), 266-67, 266
- Rossellino, Antonio, 614-15; Matteo Palmieri, 614-15, 615
- 614–15, 615
 Rossellino, Bernardo, 613–14; tomb of Leonardo Bruni, Santa Croce, Florence, 613–14, 614
 Rosso Fiorentino, 669, 738–39; Moses Defending the Daughters of Jethro, 669, 738; Venus Re-proving Love (with Primaticcio), 738–39, 739
 Rosso Medardo 930; Comversation in the Garden,

- proving Love (with Primaticcio), 738–39, 739 Rosso, Medardo, 930; Conversation in the Garden, 930, 931
- Rothko, Mark, 953, 1040; Four Darks in Red, 1041, 1042
- Rotulus, 265
- Rotunda, 227 Rotunda, 227 Rouault, Georges, 968–69, 1054; The Old King, 968–69, 968
- 968–69, 968 Rouen Cathedral (façade) (Monet), 12, 924, 924 Rousseau, Henri, 19, 942–43, 1054; The Sleeping Gypsy, 942, 943 Royal Academy of Art, 819 Royal Academy of Painting and Sculpture, 806 Royal church of Monreale, Sicily, 292, 293 Royal Crescent, Bath (Wood the Younger), 847,

- Royal Pavilion, Brighton, 869–70, 869 Royal Portals, Chartres Cathedral, 388–89, 389,
- 390, 400
- 390, 400 Rubénistes, 876 **Rubens, Peter Paul**, 780–86, 1032; Arrival of Marie de' Medici at Marseilles, 783–84, 784; The Eleva-tion of the Cross, 780–81, 781; The Lion Hunt, 783, 783; The Rape of the Daughters of Leucippus, 782– 83, 782; Thomas Howard, Earl of Arundel, 784–85, 785
- Rublëv, Andrei, 296–97; The Old Testament Trinity Prefiguring the Incarnation, 296–97, 296
- Rude, François, 870; La Marseillaise, Arc de Tri-omphe, Paris, 870, 870 Rue Transnonain (Daumier), 888–89, 888, 1026 Ruins of Baalbek (Wood), 845
- Ruins of Palmyra (Wood), 845

- Ruisdael, Jacob van, 797–98, 803; View of Haarlem from the Dunes at Overveen, 798, 798, 803, 906 Runge, Philipp Otto, 881–82; The Times of Day: Morning, 882, 882 Ruscha, Edward, 1062; Noise, Pencil, Broken Pencil, Cheap Western, 1062, 1062

San Carlo alle Quattro Fontane, Rome (Borromin), 761–62, 762
San Francesco, Arezzo, 605–606
San Giobbe Altarpiece (Bellini), 680–81, 681
San Giorgio Maggiore, Venice (Palladio), 679, 679
San Miniato al Monte, Florence, 360–61, 360
San Vitale, Ravenna, 278–83, 278–81
Sanzaccaria Altarpiece (Bellini), 680, 681
Sanctuary of Fortuna Primigenia, Palestrina, 201–202, 201

Sand painting, 530, 531 Sander, August, 1016; Lackarbeiter (Varnisher), 1016, 1016

1016, 1016 Sandy Linton and His Boat and Bairns (Hill and Ad-amson), 895–96, 895 Sangallo, Antonio da, the Younger, 643–44; Far-nese Palace, 643–44, 643–44 Sangallo, Giuliano da, 613; Santa Maria delle Carceri, Prato, 612, 613, 643

Sansovino, Andrea, 676 Sansovino, Jacopo, 676–77; State Library of San Marco, 676, 677; La Zecca (Mint), Venice, 676,

Sant' Ambrogio, Milan, 354–56, 355, 356 Sant' Andrea, Mantua (Alberti), 611–12, 611–12,

Sant' Apollinare in Classe, Ravenna, 275-78, 276,

Sant' Apollinare Nuovo, Ravenna, 274-75, 274-

Sant' Egidio, Florence, 711 Sant' Eligio degli Orifici, Rome (Bramante and Raphael), 764, 764

Santa Maria degli Angeli, Florence (Brunelleschi),

Santa Maria della Consolazione, Todi, 642, 642 Santa Maria della Salute, Venice (Longhena), 765,

765 Santa Maria della Vittoria, Rome, 758–60, 759 Santa Maria delle Carceri, Prato (Giuliano da San-gallo), 612, 613, 613, 643 Santa Maria delle Grazie, Milan, 636 Santa Maria Novella, Florence (Alberti), 600 Santa Pudenziana, Rome, 263, 263, 276 Santa Sabina 341

Santa Sabina, 341 Santa Subina, 341 Santa Susanna, Rome, 754, 754 Santo Domingo, church of, Cuzco, Peru, 525, 525 Santo Spirito, Florence, 594, 595 Santo Tomé, church of, Toledo, Spain, 746 Santorini, ruins of, 114–16, 114–15

Santorini, ruins of, 114–16, 114–15 Sarah Bernhardt (Nadar), 910, 910 Sarcophagi, 87; Etruscan, 192–93, 192 Sarcophagus from Cerveteri, 192–93, 192 Sargent, John Singer, 902–903; The Daughters of Edward Darley Boit, 903, 903 Sarsen stones, 38–39 Saturation, of color, 13 Saturn Devouring His Children (Goya), 888, 888 Scale, concept of, 11 Scenes of War from Standard of Ur, 52, 53 Schapiro, Miriam, 1086–87; Anatomy of a Kimono, 1086–87, 1086

1086–87, 1086 Schöffer, Nicolas, 1063–64; Spatiodynamic Tower, 1063–64, 1063

1063-64, 1063
 Scholastic philosophy, 381, 382, 390, 561; Gothic architecture and, 395-97
 Schongauer, Martin, 721; St. Anthony Tormented by the Demons, 721, 721
 School of Athens (Raphael), 646-47, 647

Schröder House, Utrecht, Netherlands (Riet-veldt), 1004–1005, 1004 Schwitters, Kurt, 978–79, 1039; Merz, 19, 978–79,

Scientia of light, 384
Scopas, 167–68, 175; Warrior's Head, Temple of Athena Alea, 167–68, 167
Scream, The (Munch), 944, 944
Scribe Eadwine, The (Canterbury Psalter), 376–77, 277

Scribe Ezra Rewriting the Sacred Records, 376-77,

Scroll painting, Japanese, 481 Sculpture: Abstract Expressionist, 1036; abstract figuration in, 990–92; activism in, 1018–20; ac-

tivist, 1083–84; additive technique in, 16; African, 534–39; Baroque, 756–61, 811–12; Byzan-tine, 297–98; Chinese, 455–57, 455–67, 459–60, 459, 470, 470; Cubist, 967–70; Dada, 975; early

School, concept of, 6 School of Fountainebleau, 738-39

376

376

Santa Costanza, Rome, 260–61, 261 Santa Costanza, Rome, 260–61, 261 Santa Croce, Florence, 572–74, 572–74

202, 201

753

596-97, 596

765

- Russian art: Byzantine artistic influence in, 289– 90; icons in, 296–97
- Rustication, 243
- Ryder, Albert Pinkham, 944-45, 1032; Death on a Pale Horse, 944-45, 945

S

- S-curve, importance of in Late Gothic art, 407, 583
- Saar, Bettye, 1084–85; The Liberation of Aunt Je-mima, 1085, 1085
- Sacra conversazione, 603, 703

- Sacra conversazione, 603, 703 Sacral-idyllic scenes, 213 Sacred Grove, The (Puvis de Chavannes), 917, 917 Sacred and Profane Love (Titian), 684–85, 684 Sacrifice of Iphigenia, The (Veroli Casket), 297, 297 Sacrifice of Isaac, The (Brunelleschi), 583–84, 583 Sacrifice of Isaac, The (Ghiberti), 583–84, 583 Sage Kuya, The, Invoking the Amida Buddha, Japan, 484, 484 St. Ambrose 333

- St. Ambrose, 333
- St. Anne Altarpiece (Metsys), 732–33, 733 St. Anthony Tormented by the Demons (Schon-gauer), 721, 721
- St. Audomarus (Omer), 373 St. Basil, 325
- St. Benedict, 325
- St. Bernard, 402
- St. Bernard, 402
 St. Catherine, church of the monastery of, Mount Sinai, Egypt, 283–84, 283
 St. Denis, Paris, 384; choir of, 403; royal abbey of, 381–84, 382, 383
 St. Dmitri at Vladimir, Soviet Union, 290, 290
 St. Dominic, 381
 St. Elizabeth, Marburg, 412–13, 412
 St. Etienne, Caen, 356–58, 357
 St. Francis Altarpizee (Berlinghieri), 564–65, 565
 St. Francis of Assisi, 380–81

- St. Francis Altarpiece (Berlinghieri), 564–65, 565
 St. Francis of Assisi, 380–81
 St. Francis Preaching to the Birds (St. Francis Altarpiece), 564–65, 565
 St. George, 375
 St. George (Donatello), 586–87, 587
 St. George and the Dragon (Moralia in Job), 374, 375
 St. James (Santiago), Compostela, 348
 St. James Led to Martyrdom (Mantegna), 627–28, 627, 720

- 627, 720
- St.
- St
- St.
- John the Baptist (Rosa), 773, 773 John the Evangelist (Donatello), 16 John Lateran, church of, 260 Lazare, Autun, France, 368–69, 368 Lucy Altarpiece (Domenico Veneziano), 603– St. 604, 603

- 604, 603 St. Maclou, Rouen, France, 407, 407 St. Mark (Donatello), 586, 586 St. Mark's, Venice, 288–90, 288, 290, 292–94, 294 St. Matthew (Book of Lindisfarne), 328–29, 329, 332 St. Matthew (Coronation Gospels), 330–31, 331 St. Michael, Hildesheim, West Germany, 339–41, 330–41 339 - 41
- St. Michael the Archangel (diptych), 269-70, 270, 271
- *St. Onesiphorus and St. Porphyrius,* Church of St. George, Thessaloniki, 264, 264 St. Pantaleimon, Nerezi, 292

- George, Inessatoniki, 204, 204
 St. Pantaleimon, Nerezi, 292
 St. Paul's Cathedral, London, 814–15, 814
 St. Peter's, the Vatican, Rome, 640–42, 641, 662– 63, 662–63, 753–55, 753, 754, 756–58, 756
 St. Philibert, Tournus, 350–51, 350
 St. Pierre, Moissac, 365–68, 365, 366, 367
 St. Riquier, Centula, France, 338, 338
 St. Sernin, Toulouse, 351–52, 351, 352, 362, 362
 St. Trophine, church of, 371–72, 371
 St. Wolfgang Forces the Devil to Hold His Prayerbook (Pacher), 720–21, 720
 Saint-Gaudens, Augustus, 919; Adams Memo-rial, Washington, D.C., 919, 919
 Sainte Chapelle, Paris, 398–99, 398, 404
 Sakyamuni Buddha, China, 455, 455
 Salisbury Cathedral, England, 408–10, 408, 409
 Salon de la Princesse, Hôtel de Soubise, Paris (Boffrand), 822, 822
 "Schon Noir", orue paintinger Nieuw, 20

(Boffrand), 822, 822 "Salon Noir" cave paintings, Niaux, 30 Samarra, 305; Great Mosque of, 300–301, 300 San Brizio Chapel, Orvieto Cathedral, 625

Still Life in Studio (Daguerre), 892-93, 892

934

Stoas, 127, 181

Still life painting, 797 Still Life with Chair-Caning (Picasso), 962, 962 Still Life with Peaches, Herculaneum, 211, 211 Still Life with Peppermint Bottle (Cézanne), 934–35,

Stoas, 127, 181
Stone Age, art in. See Cave paintings, Cave sculpture, Paleolithic art
Stone carving, Chavín de Huantar, 519–20
Stone masonry, Inca, 524, 525
Stonehneg, 38–39, 38, 39, 119
Storage jar, Psyra, 109, 109
Store, The (Oldenburg), 1060, 1060
Stoss, Veit, 718–20; The Death and Assumption of the Virgin from Altar of the Virgin Mary, 718–20, 719
Strashourg Cathodral, 412, 412, 400

Strasbourg Cathedral, 413, 413, 869 Strasbourg Cathedral, 413, 413, 869 Strawberry Hill (Walpole), 844–45, 844, 868 Striegt, Berlin (Kirchner), 970, 970 Stringcourses, 597 Stringed incrustation, 359–60

Stuart, James, 845; Doric portico, Hagley Park, 845, 845

O43, O43
 Stubbs, George, 854–55, 985; Horse Being De-voured by a Lion, 854–55, 855
 Stucco relief, in Islamic art, 306–307
 Study After Velásquez's Painting of Pope Innocent X (Bacon), 1052, 1052
 Handra H

(Bacon), 1052, 1052 Stupa, Borobudur, Java, 442, 442 Stupas, India, 429–30, 429, 430 Stylobate, 141; of Parthenon, 154–55 Su Tung-p'o, 463–64 Subjects Bringing Gifts to the King, Persepolis, 69 Suchou school, China, 467 Sup pottery, 476

Suchou school, China, 467 Sue pottery, 476 Suger (abbot of St. Denis), 382–84 Sui dynasty, China, 456–58 Sullivan, Louis, 948–49, 1005, 1044; Carson, Pirie, Scott building, Chicago, 949, 949, 954; Guaranty (Prudential) Building, Buffalo, New York, 948, 948

Sultan Hasan, madrasah and mausoleum of, 307– 308, 307 Sultan Muhammad, 312

Sultan Muhammad, 312
Sumerian art, 59, 184; animal representation, 53– 55; architecture, 48–50; conventionalization of art in, 52–53; cylinder seals in, 54–55; emphasis on eyes in art of, 51–52; intaglio in, 54–55; sculpture in, 50–55; ziggurat in, 48–50
Sunday Afternoon on the Island of La Grande Jatte (Seurat), 931–32, 932
Superga, Turin (Juvara), 827, 827
Supper At Emmaus (Rembrandt), 790–91, 790, 791
Supper Party, The (Van Honthorst), 786–87, 787
Suprematisin, 993–94
Suprematist Composition: Aeroplane Fluino

Flying

Suprematist Composition: Aeroplane (Malevich), 994, 994 Surrealism, 974, 979–87 Surrounded Islands (Christo), 1090–91, 1090

Suspension, 15 Suspension, 15 Sutton Hoo ship burial, Suffolk, England, 323,

Suzuki Harunobu, 496; The Evening Glow of the Andon, 927, 927 Swing, The (Fragonard), 825–26, 825 Sylvester, John, 20; The Maori Chief Tupai Kupa, 20,

Symbolism, 940–41; in nineteenth-century art, 917; in Early Christian art, 263–64. See also Ab-stract figuration; Abstract symbolism Syndics of the Cloth Guild (Rembrandt), 793, 793 Synthetic Cubism, 962–65, 1023

T

Taberna, 224 Tables of the Skeleton and Muscles of the Human Body (Albinus), 838 Tablinium, 205

T'ai-ho Tien (Hall of Supreme Harmony), China, 472, 472 Taj Mahal, Agra, India, 308–309, 308 Takayoshi(?), illustration from The Tale of Genji,

Talbot, William Henry Fox, 885, 894–95, 979; Bo-tanical Specimen, 894, 895
 Tale of Genji, The, 481, 481
 Tamamushi Shrine, Japan, 479–80, 479
 Tamil Nadu, India, 438

Tanne Vadu, India, 438
 Tang dynasty, China, 459–62; effects of, on Japanese art, 478–79; tomb figurines, 462, 462
 Tange, Kenzo, 497
 Tanner, Henry Ossawa, 905; The Thankful Poor, 905, 905

Christian, 267–71; Egyptian, 83–85, 88, 94–96; environmental, 1064; Eskimo, 526; Etruscan, 192–95; expression in, 240; Expressionist, 971– 72; formalist abstractionist, 1047–49; freestand-ing, 15; French Rococo, 850–51; full round, 35; Futuristic, 965–66; Gestural Abstract Expres-sionism in, 1036; Gothic, 388–90, 400–402; Greek, 134–39, 149–53, 161–64, 166–70, 172– 80; Hellenistic, 173–80; High Renaissance Ital-ian, 651–53, 672–73; Impressionistic, 930; In-dian, 431–33, 433–38; Japanese, 476–77, 478– 79, 484; kinetic, 1062–64; Late Minoan, 116–18; Mannerism in, 672–73; Maya, 511–12; Minimal-ist, 1048–49; mobile, 997–98; Modernism in, 953; native arts as, 501; Neoclassic, 850–51; in North America native arts, 526–27; organic ab-straction in, 1039–40; Ottonian, 341–42; Phildian style in, 162; Polynesian, 542–43, 542; Pop Art, 1060–61; proto-Renaissance Italian, 562–64; Realism in, 911–13, 919; relationship of, to architecture, 362; relief in, 15, 27; Renais-sance Italian, 582–92, 613–18, 649–53, 672–73; Roman copies of Greek statues, 163; in Roman Empire, 230–36, 248–51; Romanesque, 362–72; specialized terms in, 15–17; subtractive method of, 84; subtractive technique in, 16; Sumerian, 50–55; tactile values in, 16; Tiahuanaco, 252–24; Toltec, 518. See also Portrait sculpture Scythians, animal style of, 321–22, 321 Seagram Building, New York (Mies van der Rohe and Johnson), 1008, 1044, 1044 Seascape and Rough Waves (Le Gray), 906–907, 907 Seated Boxer, Rome (Apollonius), 179–80, 179 Seated Boxer, Rome (Apollonius), 179–80, 179 Seated Buddha, Gandhara, 432, 432 Seated Buddha Preaching the First Sermon, Sarnath, 432, 432

Seated Buddha Preaching the First Sermon, Sarnath, 432, 432 Seated Figure with Raised Arms, Colima, 505, 505

Seated Figure with Raised Arms, Colima, 505, 505 Seated Goddess, Catal Hüyük, 44, 44 Seated Youth (Lehmbruck), 8, 8, 9, 972 Section, in architecture, 14 Self-Portrait (Rembrandt), 792, 792 Self-Portrait (Vigée-Lebrun), 836, 836 Selim II, mosque of, 309–11, 310–11 Selimiye Cami (Mosque of Selim II), 309–11, 310– 11

11

Semicircular arches, 383

Semiotics, 6–7 Semivault, 276

Senmut with Princess Nefrua, Thebes, 94, 94 Separation of Light and Darkness (Michelangelo),

- 654 Serdab (of Egyptian tomb), 79 Serpent Mound, Ohio, 527–28, 528 Serpentine line, 9 Sesotris III, Temple of Medamud, 88, 88 Sesshu, 485–86; Landscape, 486, 486 Seti I Offering, Abydos, 101–102, 102 Seurat, Georges, 931–33; Sunday Afternoon on the Island of La Grande Jatte, 931–32, 932 Severe style, in Greek art, 149–53 Severus, 225, 226; Octagonal Hall (Domus Aurea), Rome, 225–26, 226 Seville, Spain (Cartier-Bresson), 1017, 1017

Soulle, Jane (2007), 2007 Shafe (2007), 2007 Shafe

Sham Gothic ruin, Hagley Park (Miller), 845, 845 Sham Gothic ruin, Hagley Park (Miller), 845, 845 Shang dynasty, China, 450–51 She-Wolf of the Capitol, Rome, 194, 194 Sheeler, Charles, 1012–13; Upper Deck, 1013, 1013 Shell gorget (Mississippian culture), 527, 527 Shen Chou, 467

Sheridan, Sonia Landy, 1065–66; Drawing in Time: My New Black Book No. 2, 1065–66, 1066 Shigisan Engi, The (Legends of Mount Fuji), 481–82, 482

Shino ware, 488

Shinto shrines, 477–78, 477–78 Shoji screens, 487 Shokintei (Pavilion of the Pine Lute), 486–87, 487 Shrine of Lady Tachibana, Japan, 478–79, 479 Shubun, 485 Siena Cathedral, 588

Siena, Palazzo Pubblico of, 418-19, 419

Siena school, in proto-Renaissance, 565-67, 574-

Signorelli, Luca, 625–26; The Damned Cast into Hell, 625–26, 625

Sikhara (tower), 435–36 Silver work, Navajo, 530 Sinan the Great. See Koça

- Singing gallery, 310 Sistine Chapel, Rome, 626, 653-57, 653-57, 663-65
- Siva as Mahadeva, Elephanta, India, 434, 434 Siva as Nataraja (Lord of the Dance), Punjai, India, 438, 438

- Siva temples, 442–43 Skeletal architecture, 228 Skyscraper model (Mies van der Rohe), 1007– 1008, 1007
- Skull, Itamul, New Guinea, 546, 546 Slave Ship, The (Turner), 883–84, 884 Sleep of Reason Produces Monsters, The (Goya), 857, 857, 886–87
- Sleeping Gypsy, The (Rousseau), 19, 942, 943 Slide projection, 1088–89 Sluter, Claus, 695–96; The Well of Moses, 695–96,
- Smalto (glass paste), 184, 215 Smith, David, 1036; Cubi XXVI, 1036, 1036 Smithson, Robert, 1089–90; Spiral Jetty, 1089–90, 1089

- Snake Goddess, Knossos, 118, 118 Snow, Michael, 1072; \leftrightarrow , 1072, 1072 Soap Bubble Set (Cornell), 986–87, 986 Social Realism, 1032
- Social realism in People's Republic of China, 470-

- Soak-stain, 1041, 1043 Soft ground, 969, 969n Soldier Poised for Hand-to-Hand Combat, China, 453, 453
- Soldiers of the Imperial Bodyguard, China, 453, 453

- ⁴⁵³Soldiers of the Imperial Bodyguard, China, 453, 453
 Soldiers of the Imperial Bodyguard, China, 453, 453
 Solomon R. Guggenheim Museum, New York (Wright), 1036–37, 1037
 Son Punished, The (Greuze), 841–42, 842
 Songye culture and art, 539–40, 539
 Soothsayers Recompense, The (De Chirico), 980, 980
 Sorcerer, Ariège, 33–34, 34
 Soufflot, Jacques-Germain, 846; Panthéon, Ste. Geneviéve, 846, 846
 South America, pre-Columbian cultures and art of, 518–26. See also culture names
 Southern Sung dynasty, China, 464–66
 Southern Sung dynasty, China, 464–66
 Southworth, Albert Sands, 893–94; Early Operation under Ether (with Hawes), 893–94, 894
 Space, architecture of, 247; concept of, 8
 Spanish art: Baroque, 775–80; cave paintings, 28; sixteenth-century, 742–47
 Spanish Levant, 50; Mesolithic art in, 36–37
 Spatiodynamic Tower, Liège, Belgium (Schöffer), 1063–44, 1063

- Spatiodynamic Tower, Liège, Belgium (Schöffer), 1063-64, 1063
- Speyer Cathedral, West Germany, 353–55, 353, 354

354 Spiral Jetty (Smithson), 1089–90, 1089 Spirit of the Dead Watching (Gauguin), 938–39, 938 Spirit figure, Papuan Gulf, 545, 545 Spiritualism in Roman art, 207–208 Spoils from the Temple in Jerusalem, 232–33, 233 Spotted Horses and Negative Hand Imprints, Pech-Merle 30–31, 31 Merle, 30-31, 31

- Spranger, Bartholomeus, 734; Hercules and Om-phale, 734, 734

phale, 734, 734 Spring Happening, A (Kaprow), 1070–71, 1070 Springtime Fresco, The, Santorini, 114, 114 Square schematism, 351, 354, 355, 361, 391 Squares Arranged According to the Laws of Chance (Arp), 977–78, 977 Squinches, 288 Sri Lanke, art in 441, 42

Squincnes, 200 Sri Lanka, art in, 441–42 Srirangam Temple, India, 438 Staatliche Bauhaus, Das, 1005–1006, 1006 Stained glass, armature to strengthen, 403; Gothic

Stained glass, armature to strengthen, 403; Gothic creations in, 393, 402–404 Standard of Ur, 52–53, 53, 56, 184 Staraz della Segnatura, the Vatican, Rome (Raph-ael), 645–47, 647 Starry Night (Van Gogh), 936–37, 937 State Library, Venice (Sansovino), 676, 677 Statue of Queen Niparasu, Susa, 65, 65 Stave church, Urnes, Norway, 324–25, 325 State the State State, Mohenjo-Daro, Pakistan, 426, 427 Steerage, The (Stieglitz), 1010, 1010 Stele, 432 Stele of Hammurabi, Susa, 58, 58 Stepped pyramid, 507, 511 Stepped Pyramid of King Zoser, 79–80, 79, 80 Stereograph, 925, 925n Stieglitz, Alfred, 1010; The Steerage, 1010, 1010 Still Life (Kalf), 14

- Tansey, Mark, 1079–80; Triumph of the New York School, 1080, 1080 Tao-chi, 468; Landscape, 468, 469

- Tapa (bark cloth), 542 Tara (bark cloth), 542 Tara Brooch, Ireland, 326, 326 Target with Four Faces (Johns), 1070, 1070 Tarquina, painting in, 190–91, 191 Tatami mats, 497

- Tatami mats, 497 **Tatlin, Vladimir**, 995, 1018–20; Monument to the Third International, 1019–20, 1019 Tattooing, 542, 543–44, 543 **Tawaraya Sotatsu**, 492; Deer and Calligraphy (with Hon-Ami Koetsu), 492, 492 Tea ceremony of Japan, 486–88 Technique definition of 7.8
- Technique, definition of, 7–8 Tectiforms, 30
- Tell Asmar, 65 "Tellus" Relief from the Ara Pacis Augustae, Rome, 231, 231
- tempera, 215, 546 Tempietto, The, Rome (Bramante), 640–41, 640 Temple I (Temple of the Giant Jaguar), Tikal, Guatemala, 510–11, 510 Temple of Amen-Mut-Khonsu, Luxor, 93, 94 Temple of Aphaia at Aegina, 144, 146–48, 147 Temple of Apollo at Didyma (Miletus), 180–81, 180

- Temple of Artemis, Corfu, 146–47, 147 Temple of Athena Nike, Acropolis, Athens, 160,

- 160 Temple of "Fortuna Virilis," Rome, 200, 200 Temple of Hera at Olympia, 142 Temple of Hera I, Paestum, 142–44, 143, 144 Temple of Hera II, Paestum, 142–43, 143–44, 144– 45, 145 Temple of Horus, Edfu, 91–92, 91 Temple of Horus, Edfu, 91–92, 91 Temple of Mars Ultor (Mars the Avenger), Rome, 221
- Temple mural, Bonampak, Mexico, 513, 513 Temple of Queen Hatshepsut, Deir el-Bahri, 89–90, 89
- Temple of Quetzalcóatl, Teotihuacán, Mexico, 506, 507 Temple of Ramses II, Abu Simbel, Nubia, 90–91, 90,

- Temple of Ramses II, Abu Simbel, Nubia, 90–91, 90, 91
 Temple of the "Sibyl" ("Vesta") at Tivoli, 200, 200
 Temple of the Sun, Cuzco, Peru, 525–26, 525
 Temple of Zeus at Olympia, pedimental sculptures of, 151–53, 152
 Temples: Aztec, 517, 518; Cambodian, 445; Etruscan, 189; Greek, 139–48, 153–64, 180–81; Hindu, 433–38; Japanese, 477–78, 484; Maya, 510–11, 512–13; Roman, 200–202, 200–202; Teotihuacán, 506–507, 506
 Ten Books of Architecture, 220
 Ten Conveniences and the Ten Enjoyments of Country Life, The (Buson and Ikeno Taiga), 493
 Tenothitlán, Mexico, 516–18; Great Temple of, 517–18, 517
 Tent buildings of Upper Egypt, 80
 Teostenae, 184, 214; glass, 262; marble, 262
 Tetracks, The, Venice, 248–49, 248, 251, 255, 268
 Textule design, Chinese, 469–70
 Texture, concept of, 14
 Thailand, art of, 443
 Thamugadis, 218–19, 219
 Thankful Poor, The (Tanner), 905, 905
 Theodora and Attendants, San Vitale, Ravenna, 280, 281, 282
 Theory Sculpture: Counting (Bochner), 1073

- 281, 282
- 281, 282 Theory of Sculpture: Counting (Bochner), 1073 **Theotokoppulos, Domenikos**. See El Greco Thinker, The (Rodin), 8, 8, 9 Third Day of Creation, The (Bosch), 715, 716 Third of May, 1808, The (Gova), 887–88, 887, 1026 Third-Class Carriage, The (Daumier), 888–89, 889 Thirty-Six Views of Mt. Fuji (Katsushika), 497 Tholos, 120, 121, 171, 172, 641 Thomas Houpard. Earl of Arundel (Rubens), 784–85,

- Thomas Howard, Earl of Arundel (Rubens), 784-85, 785

- Three Cows and One Horse, Lascaux, 31 Three Crosses, The (Rembrandt), 794, 794 Three Forms (Hepworth), 997, 997 Three Goddesses, Parthenon, Athens, 157–58, 157, 162 - 63

- Three Musicians (Picasso), 963–64, 963, 1035 Three Transitions (Campus), 1067–68, 1068 Three Women in a Village Church (Leibl), 903, 904, 905
- Three-handled jar with papyrus decoration, Knossos, 116, 116

Thumbs Down! (Pollice Verso) (Gérôme), 916-17, 916

Tufa, as building material, 189 Tula, Mexico, 516, 516 Tumulus, 189–90

Tuscan ornamentation, 415

Tz'u-chou ware, 465

ture, 352

101

208

1003

852.853

20, 820

Tung Ch'i-ch'ang, 467-68; Autumn Mountains, 468, 468

Tung Yuan, 463 Tunhuang sanctuaries, 456–57 Tunnel vaults, 224–25; in Romanesque architec-

Turner, Joseph Mallord William, 883; The Slave Ship, 883–84, 884

Tuscany, Romanesque architecture of, 358–60 Tutankhamen: death mask of, 100, 100; innermost coffin of, 99, 99; tomb of, 75, 99–101, 99, 100,

Twittering Machine (Klee), 9, 989, 989, 1063 Two Children Are Threatened by a Nightingale (Ernst), 982–83, 982 Two Exact Rules on Dark and Light Floor (Mangold),

Two Exact Kitles on Dark and Light Floor (Maligold), 1073–74, 1073 Two Fridas, The (Kahlo), 987, 987 Two Lions (Dürer), 19, 19 Tympanum, 363; of Chartres Cathedral, 389; dec-oration of, in Romanesque architecture, 365, 368–71; of Strasbourg Cathedral, 413

U

Uaxactún, Guatemala, 509–10, 509 Uccello, Paolo, 601–602, 932; The Battle of San Romano, 601, 601 Ugolino and His Children (Carpeaux), 918–19, 919

Ulysses in the Land of the Lestrygonians, Rome, 208,

Un Chien Andalou (An Andalusian Dog) (Dali and

Buñuel), 983–84, 983 Unfinished Bound Slave (Michelangelo), 17 Unique Forms of Continuity in Space (Boccioni), 966,

Unité d'Habitation, Marseilles (Le Corbusier),

852, 853 Untitled (Judd), 1048–49, 1049 Untitled (Your Gaze Hits the Side of My Face) (Kruger), 1087, 1087 Upper Deck, The (Sheeler), 1013, 1013 Ur: royal lyre from tomb of Queen Puabi of, 53– 54, 54; ziggurat at, 49–50, 49, 50 Ur, Standard of, 52–53, 53 Urbanism. See City planning Urnes style, in Viking art, 325 Utagawa Toyokumi I, 496 Utopian art, 998–1007 Utrecht Psalter, 332, 332

Van Der Zee, James, 1014; Future Expectations, 1014, 1015

Van Dyck, Anthony, 785–86; Charles I Dis-mounted, 785–86, 785 Vanbrugh, John, 819–20; Blenheim Palace, 819–

Vasari, Giorgio, 600, 600n, 603, 662, 845
Vase painting, in Greek art, 128–34
Vater, Sohn, Heiliger Geist (Kiefer), 1056–57, 1056
Vatican Vergil, 265–66, 265
Vault, 83; barrel, 224–25; concrete, 202; development of, in Gothic architecture, 383–84, 384; groin, 225; High Gothic, 391–92; Romanesque styles of, 350–52, 355–56; tunnel, 224–25
Vault systems, Roman, 224–25, 225
Vecelli: Tiziano. See Titian

Vault systems, Koman, 224–25, 225
Vecelli, Tiziano. See Titian
Veduta (characteristic scenes). 833
Velázquez, Diego, 776–80, 887; Juan de Pareja, 777–78, 778; Las Meninas (The Maids-in-waiting), 778–79, 779, 903; Los Borrachos (The Drinkers), 776–77, 777; The Surrender of Breda ("The Lances"), 1080
Venice, Benaiseance art of 675, 91

Venices 7, 1000 Venice, Renaissance art of, 675–91 Venturi, Robert, 1077; Brant-Johnson House, Vail, Colorado, 1077, 1077 Venus, Cupid, Folly, and Time (Bronzino), 670, 670 Venus de Milo (Aphrodite of Melos), 177–78, 178

Z0, 620 Vaphio Cups, The, 122–23, 123, 128 Varnisher (Lackarbeiter) (Sander), 1016, 1016 Vasarely, Victor, 1046–47; Orion, 1047, 1047 Vasari, Giorgio, 600, 600n, 603, 662, 845

Value, concept of, 11-12, 13

United States Part II (Anderson), 1080, 1081 University of Virginia, Charlottesville (Jefferson),

Uji Bridge, Japan, *489* Ukhaydir, palace at, 303–304, 303 Ukiyo-e, 495

- Ti, tomb of, 86, 86

- Ti Watching a Hippopotamus Hunt, 86, 94 Tiahuanaco, Bolivia, 523–24 Tiananmen Square, China, 471 **Tiepolo, Giambattista**, 828, 886–87; The Apotheosis of the Pisani Family, 828, 829 Tigirl (Benyon), 1066–67, 1067 Tikal, Guatemala, 510–11, 510

- Tikal, Guatemala, 510–11, 510
 Tikal, Guatemala, 510–11, 510
 Timber-frame construction, 334–35, 334
 Timgad, 22, 218–19, 219
 Tinguely, Jean, 1062–63; Homage to New York, 1062–63, 1063; Metamatic machines, 1062
 Tintoretto (Jacopo Robusti), 689–90; The Last Supper, 689, 689; The Miracle of the Slave, 688–89, 688
 Tiryns, citadel of, 119–20
 Titian (Tiziano Vecelli), 684–88, 694, 920; Christ Crowned with Thorns, 687–88, 687; Madonna of the Pesaro Family, 685, 685; Man with the Glove, 687, 687; Pastoral Symphony(?), 683–84, 683, 920; Sacred and Profane Love, 684–85, 684; Venus of Urbino, 685–86, 686
 Tingit helmet, 532

- Carouno, 685–86, 686 Tlingit helmet, 532 **Toba Sojo**, 482–83; animal caricatures of, 483, 482 Tokonoma (shallow alcove), 486 **Toledo, Juan Bautista de**, 744; Escorial, 744–45, 744–45

- Toltec culture and art, 515, 516 Tomb of the Leopards, Tarquinia, 190–91, 191 Tomb of Mausolus, 167

- Tomb of Mausolus, 167 Tomb of Orcus (Hades), Tarquinia, 191–92, 191 Tomb of the Reliefs, Cerveteri, Italy, 189, 190 Tomb mounds (Japan), 477 Toranas (gateways), 429, 430 *Toreador Fresco, The,* Knossos, 112–13, 113 Torhalle (gatehouse of Lorsch Monastery), 335– 36, 336
- 36. 336

- Tori Busshi, 478; *The Shaka Triad*, 478, 478 Torii (ceremonial gates), 477 Torii Kiyonaga, 496 Torii Kiyotada, actor of the Ichikawa clan, 495, 495

- 495 Tornabuoni, Giovanna, 621–22, 621 Tosa school (Japan), 488 Toshusai Sharaku, 496 Toulouse-Lautrec, Henri de, 939–40; At the Mou-lin Rouge, 939–40, 939
- Tournachon, Gaspard Félix. See Nadar Toussaint L'Ouverture. See L'Ouverture Series No. 36

1073

- Tower of Bayon, Angkor Thom, 447, 447 Trabeated architecture, 241, 242 Tradition, the, 865–66, 922 **Traini, Francesco**, 579 Trajan, 216, 222–24, 234–35, 234, 254; Column of,
- Transept, 259, 355; in Early Medieval architecture, 337, 339; in Notre Dame, 388 Transfiguration of Jesus, The, Monastery of St. Catherine, Mt. Sinai, 283–84, 283 Travelers Among Mountains and Streams (Fan K'uan), 463, 463

K'uan), 463, 463 Treasury of the Siphnians, Delphi, 145–46, 146, 161–62; frieze from, 146, 146 Très Riches Heures du Duc de Berry, Les (Limbourg Brothers), 698–99, 699 Triangular and Square Numbers (Bochner), 1073,

Tribute Money, The (Masaccio), 599, 599, 636 Trier (ancient Augusta Trevirorum), 243–44 Triforium, development of, 385; in High Gothic architecture, 392; in Laon Cathedral, 385; in Noteo Dame, 297

architecture, 392; in Laon Cathedral, 503, in Notre Dame, 387 Triglyphs, 141, 142; of Parthenon, 158 Trilithons, 39, 39 Trip to the Moon (Méliès), 981, 981 Triton Fountain, Rome, 761, 761 Triumph of Death, The (Buffalmacco or Traini?), 579, 579

579, 579 Triumph of the New York School (Tansey), 1080, 1080 Triumph of Titus, Arch of Titus, Rome, 233, 233 Triumph of Venice, The (Veronese), 690, 691 Triumph of the Will (Riefenstahl), 1020–22, 1021 Triumphal arch, 232 Trois Frères, Paleolithic art in, 33–34 Trolley, New Orleans (Frank), 1082, 1083 Travised Corden II (Neuvelson), 1039

Tudor (perpendicular) style of Gothic architec-ture, 410

Tropical Garden II (Nevelson), 1039, 1039

Tsung Ping, 458 Tuc d'Audoubert, Paleolithic art in, 35

Trumeau, 363, 366

Venus Reproving Love (Rosso Fiorentino and Primaticcio), 738–39, 739
Venus of Urbino (Titian), 685–86, 686
Venus of Willendorf, 36, 36, 44, 1055
Venicon 198–226

- Verism, 198, 236 Verism, 198, 236 Vermeer, Jan, 795–96; Young Woman with a Water Jug, 795, 796 Veroli Casket, 297, 297

- Veronese (Paolo Cagliari), 690; Christ in the House of Levi, 690, 690; The Triumph of Venice, 690, 691 Verrocchio, Andrea del, 616–17, 635; Bartolommeo Colleoni, 617, 617; David, 616–17, 617 Versailles, Palace of, 806–10, 807–10 Vespasian, 237

- Versailles, Palace of, 806–10, 807–10
 Vespasian, 237
 Victory Stele of Naram-Sin, 56, 56
 Video art, 1067–69
 Vienna Genesis, 265–66, 266
 Vierzehnheiligen chapel, near Staffelstein, Germany (Neumann), 830–31, 830
 Vietnam Memorial, Washington, D.C. (Lin), 1092–93, 1093
 View of Haarlem from the Dunes at Overveen (Van Ruisdael), 798, 798
 View of Haarlem, from the Dunes at Overveen (Van Ruisdael), 798, 798
 View of Rome (Piranesi), 259, 846, 853–54
 Vigée-Lebrun, Elisabeth Louise, 836; Self-Portrait, 836, 836
 Vignola, Giacomo da, 752; plan of II Gesù (with Giacomo della Porta), 752–53, 753
 Vignon, Pierre, 867; La Madeleine, Paris, 867, 867
 Vila at Piazza Armerina, Sicily, 244–46, 244, 245
 Villa Boscoreale, Pompeii, 206, 207
 Villa Boscorease, Pompeii, 209, 209
 Villa Farnesina, Rome, 647–48
 Villa ot the Mysteries, Pompeii, 207–208, 207
 Villa Rotonda, Vicenza (Palladio), 678–79, 678, 821, 851

- 821, 851 Villa Savoye, Poissy-sur-Seine (Le Corbusier), 1002–1003, 1003 Vir Heroicus Sublimis (Newman), 1041, 1041 Virgin with the Canon van der Paele, The (Jan van Eyck), 703, 704, 704 Virgin and Child with St. Anne and the Infant St. John, The (Leonardo), 12, 636, 636, 645 Virgin of Paris, The, Notre Dame, Paris, 406–407, 406
- *Virgin of the Rocks, The* (Leonardo), 635–36, 636 Virginia State Capitol (Jefferson), 853 Virtual image, 1066 Virtupaksha Temple, Pattadakal, India, 437 *Viscount Lepic and His Daughters* (Degas), 927–28, 028
- 928

- Vishnu temple, Deogarh, India, 435, 435 Vision quest, 509 Visionary art, 940–45 Visitation, The (Pisano), 564, 564 Visitation, The, Reims Cathedral, 401–402, 401, 562

- 562 Visiting card photographs, 910–11 Visualization, 1012 Visvanatha Temple, Khajuraho, India, 437, 437 Vitruvius, 189, 220, 608, 609, 820 Vladimir Madonna, The, 5, 296, 296 Voltaire Seated (Houdon), 836, 836, 837, 868 Volume, concept of, 11–12 Volutes, 141 Vorticist movement. 966–67

ABCDULGI-J 01234567

8 9

Vorticist movement, 966-67 Vortographs, 966–67 Voussoirs, 363, 363

- Wait, The (Kienholz), 1083–84, 1083
 Walker, William, 1084; Peace and Salvation, Wall of Understanding, 1084, 1084
 Walking Man (Rodin), 911–12, 912
 Wall painting: architectural style in, 206–209, 206, 207; incrustation style in, 206, 206; intricate style in, 209–11; ornate style in, 209; Pompeiian, 206–12
- Wall painting from a Samnite house, Herculaneum, 206
- Wall painting from the cubiculum, Villa Bos-coreale, Pompeii, 206, 207 Wall painting from Villa Boscotrecase, Pompeii, 209, 209

- 209, 209
 Wall-vault system, 352
 Walpole, Horace, 844, 868; Strawberry Hill, 844–45, 844, 868
 Wang Meng, 466
 Wang Wei (fifth century), 458
 Ware Wei (sighth contury), 461

- Wang Weil, 400
 Wang Weil (fifth century), 458
 Wang Weil (eighth century), 451
 War Monument (Barlach), 972, 972; head, study for War Monument, 972–73, 973
 Warhol, Andy, 1061; Marilyn Diptych, 1061, 1061
 Warka, 47, 52; Female Hend, 50–51, 50, 137; White Temple of, 48–49, 48, 49
 Warm, Hermann, 970–71; The Cabinet of Dr. Caligari (set), 970–71, 971
 Warrior, Riace, 149–50, 149, 150
 Warrior Vase, The, Mycenae, 122–23, 123
 Warrior's Head, Temple of Athena Alea, Tegea (Scopus), 167–68, 167
 Watteau, Antoine, 823–24, 876, 1/Indifférent, 823, 823; Return from Cythera, 823–24, 824
 We Are (Gilbert and George), 1076, 1076
 Weaving: Chilkat, 532, 532; Navajo, 530
 Webster, Elon, 534; False Face mask, 534, 534
 Weight shift (ponderation), 586

- Weight shift (ponderation), 586 Weimar School of Arts and Crafts, 1005 Well of Moses, The (Sluter), 695–96, 696 Well Scene, Lascaux, 33, 36, 128 Welliver, Neil, 1074; Deep Pool, 1074, 1074 Wan Changeming 467

- Wen Cheng-ming, 467 Wen Cheng-ming, 467 West, Benjamin, 842–43; The Death of General Wolfe, 842–43, 843 Westminster Abbey, 410 Weston, Edward, 1011–12; Cabbage Leaf, 1011, 1012
- 1012
- Wet fresco technique, 113 Weyden, Rogier van der, 707–708, 717; Portrait of a Lady, 708, 708; The Escorial Deposition, 707– 708, 707

- 708, 707
 708, 707
 Wheel, representing life cycle, 428–29, 428
 Whistler, James Abbott McNeill, 929–30; Nocturne in Blue and Gold, 929–30, 930
 White Plum Blossoms in the Spring (Korin), 493
 White Temple, Warka, 48–49, 48
 White Temple, Warka, 48–49, 48
 White Temple, Warka, 48–49, 48
 White, Robert, 970–71; The Cabinet of Dr. Caligari, 970–71, 971
 Wild Bush Spirit (Baule), Ivory Coast, 541
 Wilegelmus, 364, 369; Creation and Temptation of Adam and Eve, 364, 364
 William the Englishman. 408: Canterbury Cathese
- William the Englishman, 408; Canterbury Cathe-
- dral, 408-409, 408 William of Sens, 408; Salisbury Cathedral, 408-409, 408

- Winged Human-Headed Bull (Lamassu), Khorsabad, 60-61, 60
 Wittgenstein in New York (Paolozzi), 1058-59, 1058
 Witz, Conrad, 718; The Miraculous Draught of Fish, 718, 719
 Wodiczko, Krzysztof, 1088-89; Projection on the Martin Luther Kirche, 1088, 1089
 Wolvinus, 333, 369; Paliotto, 333, 333
 Woman Combing Her Hair (Gonzalez), 967, 967
 Woman of the Velcha Family, Tomb of Orcus (Hades), Tarquinia, 191-92, 191
 Womanhouse, 1086
 Women and Children in the Country (Robinson), 907-908, 908
 Wood, John, the Younger, 847; Circus and Royal

Wonder und Children in the Country (Kobinson), 907–908, 908
Wood, John, the Younger, 847; Circus and Royal Crescent, Bath, 847, 847
Wood as medium in Viking art, 324
Wood block printing, 726–27; Japanese, 495–97
Wood carving, Melanesian, 544
Woodburytype process, 910
Wren, Christopher, 814–15, 820; St. Paul's Cathe-dral, London, 814–15, 814
Wright of Derby, Joseph, 838–39; A Philosopher Giving a Lecture at the Orrery, 838–39, 839
Wright, Frank Lloyd, 949, 999–1001, 1003; Kauf-mann House (Fallingwater), 1001, 1001; Robie House, 999–1000, 999, 1000; Solomon R. Gug-genheim Museum, 1036–37, 1037
Wu Chen, 466; Bamboo, 467, 467
Wu family shrines, Shantung, 454, 454

Y

Yamato-e (Japanese painting style), 481–82, 484– 85, 488 Yasti (mast), 429

Yasti (mast), 429 Ying-ch'ing glaze, 465 Yoruba culture and art, 537–38, 537 Young Fisherman Fresco, Santorini, 115–16, 115 Young Woman with a Water Jug (Vermeer), 796, 796 Young Woman Exercising, Villa at Piazza Armerina, Sicily, 244, 245 Yu, China, 452, 452

Yüan dynasty, China, 466–67 Yücatán, pre-Columbian culture and art of, 507, 514, 515–16. *See also* Maya civilization Yung-t'ai, tomb paintings of, 460–61, 461 Yunkang, China, 456, 456

Z

Zaire, culture and art of, 539–40, 539 Zapotec culture and art, 514 Zavattni, Cesare, 1082; Bicycle Thieves (script),

1082 Zecca (Mint), La, Venice (Sansovino), 676, 677 Zen Buddhism, 464–65, 485–86, 487, 1030 Zen rock gardens, Katsura Palace, 492 Ziggurat, 48–49, 301, 507; at Ur, 49–50, 49, 50 Zoopraxiscope, 902 Zoser (king of Egypt), 77; tomb of, 79–80, 79, 80, 81

Zuccone (Donatello), 588, 588 Zuñi culture and art, 529–30 Zurbarán, Francisco de, 776; St. Francis in Medita-tion, 776, 776, 850

1082

81